ARTIST'S & GRAPHIC DESIGNER'S MARKET 2017

HOW AND WHERE TO SELL YOUR ART

Noel Rivera, Editor

NORTH LIGHT BOOKS
CINCINNATI, OHIO
artistsmarketonline.com

Publisher and Community Leader, Fine Art Community: Jamie Markle
Senior Content Director, North Light Books: Mona Clough
Market Books Assistant, North Light Books: Andrew Dunn

Artist's Market Online website: artistsmarketonline.com
Artist's Network website: artistsnetwork.com
North Light Shop website: northlightshop.com

Distributed in Canada by Fraser Direct
100 Armstrong Avenue
Georgetown, ON, Canada L7G 5S4
Tel: (905) 877-4411

Distributed in the U.K. and Europe by F&W Media International, LTD
Brunel House, Forde Close, Newton Abbot, TQ12 4PU, UK
Tel: (+44) 1626 323200, Fax: (+44) 1626 323319
E-mail: enquiries@fwmedia.com

ISSN: 1075-0894
ISBN-13: 978-1-4403-4657-6
ISBN-10: 1-4403-4657-7

33614057751850

Project managed by Noel Rivera
Cover design by Paisley Stone
Interior design by Geoffrey Raker
Interior layout by Christina Richards
Production coordinated by Debbie Thomas

Attention Booksellers: This is an annual directory of F+W Media, Inc. Return deadline for this edition is December 31, 2017.

fw
a content + ecommerce company

CONTENTS

RESOURCES

INDEXES

FROM THE EDITOR

I'm very excited to introduce myself as the new editor of *Artist's & Graphic Designer's Market*! For this edition, I've put together some great articles that I hope will inform and guide you as you seek to grow and improve your creative business. Topics include maintaining your motivation, making teaching part of your freelance career, searching for gallery representation, protecting your intellectual property, and more.

You'll also find features on a variety of topics to help keep your business running smoothly, as well as inspiring interviews with five successful creatives. And, as always, we've included more than 1,800 individually verified market contacts (complete with payment information!).

Keep creating and good luck!

C. Noël Rivera

Noel Rivera
art.design@fwmedia.com
www.artistsmarketonline.com

P.S. Don't forget to register at **Artist's Market Online, which you get FREE for a year with the purchase of this book**. With your free 1-year subscription, you'll be able to search market contacts, track your submissions, read up on the latest market news, and much more. Use the activation code from the front insert to access your free subscription today.

HOW TO USE THIS BOOK

If you're picking up this book for the first time, you might not know quite how to start using it. Your first impulse might be to flip through and quickly make a mailing list, submitting to everyone with hopes that *someone* might like your work. Resist that urge. First you have to narrow down the names in this book to those who need your particular art style. That's what this book is all about. We provide the names and addresses of art buyers along with plenty of marketing tips. You provide the hard work, creativity, and patience necessary to hang in there until work starts coming your way.

Listings

The book is divided into market sections, from galleries to art fairs. (See the Table of Contents for a complete list.) Each section begins with an introduction containing information and advice to help you break into that specific market. Listings are the meat of this book. In a nutshell, listings are names, addresses, and contact information for places that buy or commission artwork, along with a description of the type of art they need and their submission preferences.

Articles and Interviews

Throughout this book you will find helpful articles and interviews with working artists and experts from the art world. These articles give you a richer understanding of the marketplace by sharing the featured artists' personal experiences and insights. Their stories, and the lessons you can learn from other artists' feats and follies, give you an important edge over the competition.

HOW ARTIST'S & GRAPHIC DESIGNER'S MARKET WORKS

Following the instructions in the listings, we suggest you send samples of your work (not originals) to a dozen (or more) targeted markets. The more companies you send to, the greater your chances of a positive response. Establish a system to keep track of whom you submit your work to and send follow-up mailings to your target markets at least twice a year.

How to Read Listings

The first thing you'll notice about many of the listings in this book is the group of symbols that appears before the name of each company. (You'll find a quick-reference key to the symbols on the back inside cover of the book.) Here's what each symbol stands for:

- ✚ Market new to this edition
- ✪ Canadian market
- ◗ International market
- ⌂ Market prefers to work with local artists/designers

Each listing contains a description of the artwork and/or services the company prefers. The information often reveals how much freelance artwork is used, whether computer skills are needed, and which software programs are preferred.

In some sections, additional subheads help you identify potential markets. Magazine listings specify needs for cartoons and illustrations. Galleries specify media and style.

Editorial comments, denoted by ◖, give you extra information about markets, such as company awards, mergers and insight into a company's staff or procedures.

It might take a while to get accustomed to the layout and language in the listings. In the beginning, you will encounter some terms and symbols that might be unfamiliar to you. Refer to the Glossary to help you with terms you don't understand.

Working With Listings

1. Read the entire listing to decide whether to submit your samples. Do not use this book simply as a mailing list of names and addresses. Reading listings carefully helps you narrow your mailing list and submit appropriate material.

2. Read the description of the company or gallery in the first paragraph of the listing. Then jump to the **Needs** or **Media** heading to find out what type of artwork is preferred. Is it the type of artwork you create? This is the first step to narrowing your target market. You should send your samples only to places that need the kind of work you create.

3. Send appropriate submissions. It seems like common sense to research what kind of samples a listing wants before sending off just any artwork you have on hand. But believe it or not, some artists skip this step. Some art directors have pulled their listings from *Artist's & Graphic Designer's Market* because they've received too many inappropriate submissions. Look under the **First Contact & Terms** heading to find out how to contact the market and

FREQUENTLY ASKED QUESTIONS

1 **How do companies get listed in the book?** No company pays to be included—all listings are free. Every company has to fill out a detailed questionnaire about their art needs. All questionnaires are screened to make sure the companies meet our requirements. Each year we contact every company in the book and ask them to update their information.

2 **Why aren't other companies I know about listed in this book?** We may have sent these companies a questionnaire, but they never returned it. Or if they did return a questionnaire, we may have decided not to include them based on our requirements. If you know of a market you'd like to see in the book, send an e-mail request to art. design@fwmedia.com.

3 **I sent some samples to a company that stated they were open to reviewing the type of work I do, but I have not heard from them yet, and they have not returned my materials. What should I do?** At the time we contacted the company, they were open to receiving such submissions. However, things can change. It's a good idea to contact any company listed in this book to check on their policy before sending them anything. Perhaps they have not had time to review your submission yet. If the listing states that they respond to queries in one month, and more than a month has passed, you can send a brief e-mail to the company to inquire about the status of your submission. Some companies receive a large volume of submissions, so you must be patient. Never send originals when you are querying—always send copies. If for any reason your samples are never returned, you will not have lost forever the opportunity to sell an important image. It is a good idea to include a SASE (self-addressed, stamped envelope) with your submissions, even if the listing does not specifically request that you do so. This may facilitate getting your work back.

4 **A company says they want to publish my artwork, but first they will need a fee from me. Is this a standard business practice?** No, it is not a standard business practice. You should never have to pay to have your art reviewed or accepted for publication. If you suspect that a company may not be reputable, do some research before you submit anything or pay their fees. The exception to this rule is art fairs. Most art fairs have an application fee, and usually there is a fee for renting booth space. Some galleries may also require a fee for renting space to exhibit your work (see the gallery market section for more information).

what to send. Some companies and publishers are very picky about what kinds of samples they like to see; others are more flexible.

What's an inappropriate submission? Here's an example: Suppose you want to be a children's book illustrator. Don't send samples of your cute animal art to *Business Law Today*

magazine—they would rather see law-related subjects. Use the Niche Marketing Index to find listings that accept children's illustrations. You'd be surprised how many illustrators waste their postage sending the wrong samples—which, of course, alienates art directors. Make sure all your mailings are *appropriate ones.*

4. Consider your competition. Under the **Needs** heading, compare the number of freelancers who contact the company with the number they actually work with. You'll have a better chance with listings that use a lot of artwork or work with many artists.

5. Look for what they pay. In most sections, you can find this information under **First Contact & Terms**. In the Book Publishers section, publishers list pay rates under headings pertaining to the type of work they assign, such as **Text Illustration** or **Book Design**.

At first, try not to be too picky about how much a listing pays. After you have a couple of assignments under your belt, you might decide to send samples only to medium- or high-paying markets.

6. Be sure to read the Tips. This is where art directors describe their pet peeves and give clues for how to impress them. Artists say the information within the **Tips** helps them get a feel for what a company might be like to work for.

These steps are just the beginning. As you become accustomed to reading listings, you will think of more ways to mine this book for your potential clients. Some of our readers tell us they peruse listings to find the speed at which a magazine pays its freelancers. In publishing, it's often a long wait until an edition or book is actually published, but if you are paid "on acceptance," you'll get a check soon after you complete the assignment and it is approved by the art director.

When looking for galleries, savvy artists often check to see how many square feet of space are available and what hours the gallery is open. These details all factor in when narrowing down your search for target markets.

Pay Attention to Copyright Information

It's also important to consider what rights companies buy. It is preferable to work with companies that buy first or one-time rights. If you see a listing that buys "all rights," be aware you may be giving up the right to sell that particular artwork in the future. See the "Copyright Basics" article in this section for more information.

Look for Specialties and Niche Markets

Read listings closely. Most describe their specialties, clients, and products within the first paragraph. If you hope to design restaurant menus, for example, target agencies that have restaurants for clients. If you prefer illustrating people, you might target ad agencies whose clients are hospitals or financial institutions. If you like to draw cars, look for agencies with clients in the automotive industry, and so on. Many book publishers specialize, too. Look

for a publisher who specializes in children's books if that's the type of work you'd like to do. The Niche Marketing Index lists possible opportunities for specialization.

Read Listings for Ideas

You'd be surprised how many artists found new niches they hadn't thought of by browsing the listings. One greeting card artist read about a company that produces mugs. Inspiration struck. Now this artist has added mugs to her repertoire, along with paper plates, figurines, and rubber stamps—all because she browsed the listings for ideas!

Sending Samples

Once you narrow down some target markets, the next step is sending them samples of your work. As you create your samples and submission packets, be aware that your package or postcard has to look professional. It must be up to the standards art directors and gallery dealers expect. There are examples throughout this book of some great samples sent out by other artists. Make sure your samples rise to that standard of professionalism.

See You Next Year

Use this book for one year. Highlight listings, make notes in the margins, fill it with Post-it notes. In November of 2017, our next edition—the *2018 Artist's & Graphic Designer's Market*—starts arriving in bookstores. By then, we'll have collected hundreds of new listings and changes in contact information. It is a career investment to buy the new edition every year. (And it's deductible! See the "How to Stay on Track & Get Paid" article in this section for information on tax deductions.)

COMPLAINT PROCEDURE

If you feel you have not been treated fairly by a company listed in *Artist's & Graphic Designer's Market*, we advise you to take the following steps:

- First, try to contact the company. Sometimes one e-mail or letter can quickly clear up the matter.
- Document all your correspondence with the company. If you write to us with a complaint, provide the details of your submission, the date of your first contact with the company, and the nature of your subsequent correspondence.
- We will enter your complaint into our files.
- The number and severity of complaints will be considered in our decision whether to delete the listing from the next edition.
- We reserve the right to not list any company for any reason.

Join a Professional Organization

Artists who have the most success using this book are those who take the time to read the articles to learn about the bigger picture. In our interviews, you'll learn what has worked for other artists and what kind of work impresses art directors and gallery dealers.

You'll find out how joining professional organizations such as the Graphic Artists Guild (www.gag.org) or the Society of Illustrators (www.societyillustrators.org) can jump-start your career. You'll find out the importance of reading trade magazines such as *HOW* (www. howdesign.com), *PRINT* (www.printmag.com) and *Greetings etc.* (www.greetingsmag azine.com) to learn more about the industries you hope to approach. You'll learn about trade shows, art reps, shipping, billing, working with vendors, networking, self-promotion, and hundreds of other details it would take years to find out about on your own. Perhaps most importantly, you'll read about how successful artists overcame rejection through persistence.

Hang In There!

Being professional doesn't happen overnight. It's a gradual process. It may take two or three years to gain enough information and experience to be a true professional in your field. So if you really want to be a professional artist, hang in there. Before long, you'll feel that heady feeling that comes from selling your work or seeing your illustrations on greeting cards or in magazines. If you really want it and you're willing to work for it, it *will* happen.

HOW TO STAY ON TRACK & GET PAID

As you launch your artistic career, be aware that you are actually starting a small business. It is crucial that you keep track of the details, or your business will not last very long. The most important rule of all is to find a system to keep your business organized and stick with it.

YOUR DAILY RECORD-KEEPING SYSTEM

Every artist needs to keep a daily record of art-making and marketing activities. Before you do anything else, visit an office supply store and pick out the items listed below (or your own variations of these items). Keep it simple so you can remember your system and use it on automatic pilot whenever you make a business transaction.

What You'll Need:

- A packet of colorful file folders or a basic Personal Information Manager on your smartphone, tablet, or computer.
- A notebook or legal pad to serve as a log or journal to keep track of your daily art-making and art-marketing activities.
- A small pocket notebook to keep in your car to track mileage and gas expenses.

How to Start Your System

Designate a permanent location in your studio or home office for two file folders and your notebook. Label one red file folder "Expenses." Label one green file folder "Income." Write in your daily log book each and every day.

Every time you purchase anything for your business, such as envelopes or art supplies, place the receipt in your red Expenses folder. When you receive payment for an assignment or painting, photocopy the check or place the receipt in your green Income folder.

Keep Track of Assignments

Whether you're an illustrator or fine artist, you should devise a system for keeping track of assignments and artworks. Most illustrators assign a job number to each assignment they receive and create a file folder for each job. Some arrange these folders by client name; others keep them in numerical order. The important thing is to keep all correspondence for each assignment in a spot where you can easily find it.

Pricing Illustration and Design

One of the hardest things to master is what to charge for your work. It's difficult to make blanket statements on this topic. Every slice of the market is somewhat different. Nevertheless, there is one recurring pattern: Hourly rates are generally paid only to designers working in-house on a client's equipment. Freelance illustrators working out of their own studios are almost always paid a flat fee or an advance against royalties.

If you don't know what to charge, begin by devising an hourly rate, taking into consideration the cost of materials and overhead as well as what you think your time is worth. If you're a designer, determine what the average salary would be for a full-time employee doing the same job. Then estimate how many hours the job will take and quote a flat fee based on these calculations.

There is a distinct difference between giving the client a job estimate and a job quote. An estimate is a ballpark figure of what the job will cost but is subject to change. A quote is a set fee which, once agreed upon, is pretty much carved in stone. Make sure the client understands which you are negotiating. Estimates are often used as a preliminary step in itemizing costs for a combination of design services such as concepting, typesetting, and printing. Flat quotes are generally used by illustrators, as there are fewer factors involved in arriving at fees.

For recommended fees for different services, refer to the *Graphic Artists Guild Handbook of Pricing & Ethical Guidelines* (www.gag.org). Many artists' organizations have standard pay rates listed on their websites.

As you set fees, certain stipulations call for higher rates. Consider these bargaining points:

- **Usage (rights).** The more rights purchased, the more you can charge. For example, if the client asks for a "buyout" (to buy all rights), you can charge more, because by relinquishing all rights to future use of your work, you will be losing out on resale potential.

PRICING YOUR FINE ART

There are no hard-and-fast rules for pricing your fine artwork. Most artists and galleries base prices on market value—what the buying public is currently paying for similar work. Learn the market value by visiting galleries and checking prices of works similar to yours. When you're starting out, don't compare your prices to established artists but to emerging talent in your region. Consider these factors when determining price:

- **Medium.** Oils and acrylics cost more than watercolors by the same artist. Price paintings higher than drawings.
- **Expense of materials.** Charge more for work done on expensive paper than for work of a similar size on a lesser grade paper.
- **Size.** Though a large work isn't necessarily better than a small one, as a rule of thumb you can charge more for the larger work.
- **Scarcity.** Charge more for one-of-a-kind works like paintings and drawings than for limited editions such as lithographs and woodcuts.
- **Status of artist.** Established artists can charge more than lesser-known artists.
- **Status of gallery.** Prestigious galleries can charge higher prices.
- **Region.** Works usually sell for more in larger cities like New York and Chicago.
- **Gallery commission.** The gallery will charge from 30 to 50 percent commission. Your cut must cover the cost of materials, studio space, taxes, and perhaps shipping and insurance, as well as enough extra to make a profit. If materials for a painting cost $25, matting and framing cost $37, and you spent five hours working on it, make sure you get at least the cost of material and labor back before the gallery takes its share. Once you set your price, stick to the same price structure wherever you show your work. A $500 painting by you should cost $500 whether it is bought in a gallery or directly from you. To do otherwise is not fair to the gallery and devalues your work.

As you establish a reputation, begin to raise your prices—but do so cautiously. Each time you graduate to a new price level, it will be that much harder to revert to former prices.

- **Turnaround time.** If you are asked to turn the job around quickly, charge more.
- **Budget.** Don't be afraid to ask about a project's budget before offering a quote. You won't want to charge $500 for a print ad illustration if the ad agency has a budget of $40,000 for that ad. If the budget is that big, ask for higher payment.
- **Reputation.** The more well known you are, the more you can charge. As you become established, periodically raise your rates (in small steps) and see what happens.

What Goes in a Contract?

Contracts are simply business tools used to make sure everyone agrees on the terms of a project. Ask for one any time you enter into a business agreement. Be sure to arrange for the specifics in writing or provide your own. A letter stating the terms of agreement signed by both parties can serve as an informal contract. Several excellent books, such as *Legal Guide for the Visual Artist* and *Business and Legal Forms for Illustrators*, both by Tad Crawford (Allworth Press), contain negotiation checklists and tear-out forms, and provide sample contracts you can copy. The sample contracts in these books cover practically any situation you might encounter.

The items specified in your contract will vary according to the market you're dealing with and the complexity of the project. Nevertheless, here are some basic points you'll want to cover:

Commercial Contracts

- **A description** of the service(s) you're providing.
- **Deadlines** for finished work.
- **Rights sold. Your fee.** Hourly rate, flat fee, or royalty.
- **Kill fee.** Compensatory payment received by you if the project is canceled.
- **Changes fees.** Penalty fees to be paid by the client for last-minute changes.
- **Advances.** Any funds paid to you before you begin working on the project.
- **Payment schedule.** When and how often you will be paid for the assignment.
- **Statement regarding return of original art.** Unless you're doing work for hire, your artwork should always be returned to you.

Gallery Contracts

- **Terms of acquisition or representation.** Will the work be handled on consignment? What is the gallery's commission?
- **Nature of the show(s).** Will the work be exhibited in group or solo shows or both?
- **Timeframes.** If a work is sold, when will you be paid? At what point will the gallery return unsold works to you? When will the contract cease to be in effect?
- **Promotion.** Who will coordinate and pay for promotion? What does promotion entail? Who pays for printing and mailing of invitations? If costs are shared, what is the breakdown?
- **Insurance.** Will the gallery insure the work while it is being exhibited and/or while it is being shipped to or from the gallery?
- **Shipping.** Who will pay for shipping costs to and from the gallery?

- **Geographic restrictions.** If you sign with this gallery, will you relinquish the rights to show your work elsewhere in a specified area? If so, what are the boundaries of this area?

How to Send Invoices

If you're a designer or illustrator, you will be responsible for sending invoices for your services. Clients generally will not issue checks without them, so mail or fax an invoice as soon as you've completed the assignment. Illustrators are generally paid in full either upon receipt of illustration or upon publication. Most graphic designers arrange to be paid in thirds, billing the first third before starting the project, the second after the client approves the initial roughs, and the third upon completion of the project.

Standard invoice forms allow you to itemize your services. The more you spell out the charges, the easier it will be for your clients to understand what they're paying for. Most freelancers charge extra for changes made after approval of the initial layout. Keep a separate form for change orders and attach it to your invoice.

If you're an illustrator, your invoice can be much simpler, as you'll generally be charging a flat fee. It's helpful, in determining your quoted fee, to itemize charges according to time, materials, and expenses. (The client need not see this itemization; it is for your own purposes.) Most businesses require your Social Security number or tax ID number before they can cut a check, so include this information in your bill. Be sure to put a due date on each invoice; include the phrase "payable within 30 days" (or other preferred time frame) directly on your invoice. Most freelancers ask for payment within ten to thirty days. Sample invoices are featured in *Business and Legal Forms for Illustrators* and *Business and Legal Forms for Graphic Designers*, both by Tad Crawford (Allworth Press).

If you're working with a gallery, you will not need to send invoices. The gallery should send you a check (generally within thirty days) each time one of your pieces is sold.

To ensure that you are paid in a timely manner, call the gallery periodically to touch base. Let the director or business manager know that you are keeping an eye on your work. When selling work independently of a gallery, give receipts to buyers and keep copies for your records.

Take Advantage of Tax Deductions

You have the right to deduct legitimate business expenses from your taxable income. Art supplies, studio rent, printing costs, and other business expenses are deductible against your gross art-related income. It is imperative to seek the help of an accountant or tax preparation service in filing your return. In the event your deductions exceed profits, the loss will lower your taxable income from other sources.

To guard against taxpayers fraudulently claiming hobby expenses as business losses, the IRS requires taxpayers to demonstrate a "profit motive." As a general rule, you must show a profit for three out of five years to retain a business status. If you are audited, the burden of proof will be on you to validate your work as a business and not a hobby. The nine criteria the IRS uses to distinguish a business from a hobby are:

- the manner in which you conduct your business
- expertise
- amount of time and effort put into your work
- expectation of future profits
- success in similar ventures
- history of profit and losses
- amount of occasional profits
- financial status
- element of personal pleasure or recreation

If the IRS rules that you paint for pure enjoyment rather than profit, they will consider you a hobbyist. Complete and accurate records will demonstrate to the IRS that you take your business seriously.

Even if you are a hobbyist, you can deduct expenses such as supplies on Schedule A, but you can only take art-related deductions equal to art-related income. If you sold two $500 paintings, you can deduct expenses such as art supplies, art books, and seminars only up to $1,000. Itemize deductions only if your total itemized deductions exceed your standard deduction. You will not be allowed to deduct a loss from other sources of income.

Figuring Deductions

To deduct business expenses, you or your accountant will fill out a 1040 tax form (not 1040EZ) and prepare a Schedule C, which is a separate form used to calculate profit or loss from your business. The income (or loss) from Schedule C is then reported on the 1040 form. In regard to business expenses, the standard deduction does not come into play as it would for a hobbyist. The total of your business expenses need not exceed the standard deduction.

There is a shorter form called Schedule C-EZ for self-employed people in service industries. It can be applicable to illustrators and designers who have receipts of $25,000 or less and deductible expenses of $2,000 or less. Check with your accountant to see if you qualify.

Deductible expenses include advertising costs, brochures, business cards, professional group dues, subscriptions to trade journals and arts magazines, legal and professional services, leased office equipment, office supplies, business travel expenses, etc. Your accountant can give you a list of all 100-percent and 50-percent deductible expenses. Don't forget to deduct the cost of this book!

CAN I DEDUCT MY HOME STUDIO?

If you freelance full time from your home and devote a separate area to your business, you may qualify for a home office deduction. If eligible, you can deduct a percentage of your rent or mortgage as well as utilities and expenses like office supplies and business-related telephone calls.

The IRS does not allow deductions if the space is used for purposes other than business. A studio or office in your home must meet three criteria:

- The space must be used exclusively for your business.
- The space must be used regularly as a place of business.
- The space must be your principle place of business.

The IRS might question a home office deduction if you are employed full time elsewhere and freelance from home. If you do claim a home office, the area must be clearly divided from your living area. A desk in your bedroom will not qualify. To figure out the percentage of your home used for business, divide the total square footage of your home by the total square footage of your office. This will give you a percentage to work with when figuring deductions. If the home office is 10 percent of the square footage of your home, deduct 10 percent of expenses such as rent, heat, and air conditioning.

The total home office deduction cannot exceed the gross income you derive from its business use. You cannot take a net business loss resulting from a home office deduction. Your business must be profitable three out of five years; otherwise, you will be classified as a hobbyist and will not be entitled to this deduction.

Consult a tax advisor before attempting to take this deduction, as its interpretations frequently change.

For additional information, refer to IRS Publication 587, Business Use of Your Home, which can be downloaded at www.irs.gov or ordered by calling (800)829-3676.

As a self-employed "sole proprietor," there is no employer regularly taking tax out of your paycheck. Your accountant will help you put money away to meet your tax obligations and may advise you to estimate your tax and file quarterly returns.

Your accountant also will be knowledgeable about another annual tax called the Social Security Self-Employment tax. You must pay this tax if your net freelance income is $400 or more.

The fees of tax professionals are relatively low, and they are deductible. To find a good accountant, ask colleagues for recommendations, look for advertisements in trade publications, or ask your local Small Business Association.

Whenever Possible, Retain Your Independent Contractor Status

Some clients automatically classify freelancers as employees and require them to file Form W-4. If you are placed on employee status, you may be entitled to certain benefits, but a portion of your earnings will be withheld by the client until the end of the tax year and you could forfeit certain deductions. In short, you may end up taking home less than you would if you were classified as an independent contractor.

The IRS uses a list of twenty factors to determine whether a person should be classified as an independent contractor or an employee. This list can be found in IRS Publication 937. Note, however, that your client will be the first to decide how you'll be classified.

Report All Income to Uncle Sam

Don't be tempted to sell artwork without reporting it on your income tax. You may think this saves money, but it can do real damage to your career and credibility—even if you are never audited by the IRS. Unless you report your income, the IRS will not categorize you as a professional, and you won't be able to deduct expenses. And don't think you won't get caught if you neglect to report income. If you bill any client in excess of $600, the IRS requires the client to provide you with a Form 1099 at the end of the year. Your client must send one copy to the IRS and a copy to you to attach to your income tax return. Likewise, if you pay a freelancer over $600, you must issue a 1099 form. This procedure is one way the IRS cuts down on unreported income.

Register With the State Sales Tax Department

Most states require a 2–7 percent sales tax on artwork you sell directly from your studio or at art fairs, or on work created for a client. You must register with the state sales tax department, which will issue you a sales permit or a resale number and send you appropriate forms and instructions for collecting the tax. Getting a sales permit usually involves filling out a form and paying a small fee. Reporting sales tax is a relatively simple procedure. Record all sales taxes on invoices and in your sales journal. Every three months, total the taxes collected and send it to the state sales tax department.

In most states, if you sell to a customer outside of your sales tax area, you do not have to collect sales tax. However, this may not hold true for your state. You may also need a business license or permit. Call your state tax office to find out what is required.

Save Money on Art Supplies

As long as you have the above sales permit number, you can buy art supplies without paying sales tax. You will probably have to fill out a tax-exempt form with your permit number at the sales desk where you buy materials. The reason you do not have to pay sales tax on art

supplies is that sales tax is only charged on the final product. However, you must then add the cost of materials into the cost of your finished painting or the final artwork for your client. Keep all receipts in case of a tax audit. If the state discovers that you have not collected sales tax, you will be liable for tax and penalties.

If you sell all your work through galleries, they will charge sales tax, but you still need a sales permit number to get a tax exemption on supplies.

Some states claim "creativity" is a nontaxable service, while others view it as a product and therefore taxable. Be certain you understand the sales tax laws to avoid being held liable for uncollected money at tax time. Contact your state auditor for sales tax information.

Save Money on Postage

When you send out postcard samples or invitations to openings, you can save big bucks by mailing in bulk. Fine artists should send submissions via first-class mail for quicker service and better handling. Package flat work between heavy cardboard or foam core, or roll it in a cardboard tube. Include your business card or a label with your name and address on the outside of the packaging material in case the outer wrapper becomes separated from the inner packing in transit.

Protect larger works—particularly those that are matted or framed—with a strong outer surface, such as laminated cardboard, Masonite, or light plywood. Wrap the work in polyfoam, heavy cloth, or bubble wrap, and cushion it against the outer container with spacers to keep it from moving. Whenever possible, ship work before it is glassed. If the glass breaks en route, it may destroy your original image. If shipping large framed work, contact a museum in your area for more suggestions on packaging.

The US Postal Service will not automatically insure your work, but you can purchase up to $5,000 worth of coverage. Artworks exceeding this value should be sent by registered mail, which can be insured for up to $25,000. Certified packages travel a little slower but are easier to track.

Consider special services offered by the post office, such as Priority Mail, Express Mail Next Day Service, and Special Delivery. For overnight delivery, check to see which air freight services are available in your area. Federal Express automatically insures packages for $100 and will ship art valued up to $500. Their 24-hour computer tracking system enables you to locate your package at any time.

The United Parcel Service automatically insures work for $100, but you can purchase additional insurance for work valued as high as $25,000 for items shipped by air (there is no limit for items sent on the ground). UPS cannot guarantee arrival dates but will track lost packages. It also offers Two-Day Blue Label Air Service within the US and Next Day Service in specific ZIP code zones.

Before sending any original work, make sure you have a copy (digital, photocopy, slide, or transparency) in your files. Always make a quick address check by phone before putting your package in the mail.

Send Us Your Business Tips

If you've used a business strategy we haven't covered, please e-mail us at art.design@fwmedia. com. We may feature you and your work in a future edition.

COPYRIGHT BASICS

//

As creator of your artwork, you have certain inherent rights over your work and can control how each one of your works is used until you sell your rights to someone else. The legal term for these rights is called *copyright*. Technically, any original artwork you produce is automatically copyrighted as soon as you put it in tangible form.

To be automatically copyrighted, your artwork must fall within these guidelines:

- **It must be your original creation.** It cannot be a *copy* of somebody else's work.
- **It must be "pictorial, graphic, or sculptural."** Utilitarian objects, such as lamps or toasters, are not covered, although you can copyright an illustration featured on a lamp or toaster.
- **It must be fixed in "any tangible medium, now known or later developed."** Your work, or at least a representation of a planned work, must be created in or on a medium you can see or touch, such as paper, canvas, clay, a sketch pad, or even a website. It can't just be an idea in your head. An idea cannot be copyrighted.

Copyright Lasts for Your Lifetime Plus Seventy Years

Copyright is *exclusive*. When you create a work, the rights automatically belong to you and nobody else but you until those rights are sold to someone else.

Works of art created on or after January 1978 are protected for your lifetime plus seventy years.

The Artist's Bundle of Rights

One of the most important things you need to know about copyright is that it is not just a *singular* right. It is a *bundle* of rights you enjoy as creator of your artwork:

- **Reproduction right.** You have the right to make copies of the original work.
- **Modification right.** You have the right to create derivative works based on the original work.
- **Distribution rights.** You have the right to sell, rent, or lease copies of your work.
- **Public performance right.** You have the right to play, recite, or otherwise perform a work. (This right is more applicable to written or musical art forms than to visual art.)
- **Public display right.** You have the right to display your work in a public place.

This bundle of rights can be divided up in a number of ways so that you can sell all or part of any of those exclusive rights to one or more parties. The system of selling parts of your copyright bundle is sometimes referred to as *divisible copyright*. Just as a land owner can divide up his property and sell it to many different people, the artist can divide up his rights to an artwork and sell portions of those rights to different buyers.

Divisible Copyright: Divide and Conquer

Why is divisible copyright so important? Because dividing up your bundle and selling parts of it to different buyers will help you get the most payment for each of your artworks. For any one of your artworks, you can sell your entire bundle of rights at one time (not advisable!) or divide each bundle pertaining to that work into smaller portions and make more money as a result. You can grant one party the right to use your work on a greeting card and sell another party the right to print that same work on T-shirts.

Divisible Copyright Terms

Clients tend to use legal jargon to specify the rights they want to buy. The terms below are commonly used in contracts to indicate portions of your bundle of rights. Some terms are vague or general, such as "all rights." Other terms are more specific, such as "first North American rights." Make sure you know what each term means before signing a contract.

- **One-time rights.** Your client buys the right to use or publish your artwork or illustration on a one-time basis. One fee is paid for one use. Most magazine and book cover assignments fall under this category.
- **First rights.** This is almost the same as one-time rights, except that the buyer is also paying for the privilege of being the first to use your image. He may use it only once unless the other rights are negotiated. Sometimes first rights can be further broken down geographically. The buyer might ask to buy **first North American rights**, meaning he would have the right to be the first to publish the work in North America.

COPYRIGHT RESOURCES

The U.S. Copyright website (www.copyright.gov), the official site of the U.S. Copyright Office, is very helpful and will answer just about any question you can think of. Information is also available by phone at (202)707-3000. Another great site, called the Copyright Website, is located at www.benedict.com.

A couple of great books on the subject are *Legal Guide for the Visual Artist* by Tad Crawford (Allworth Press) and *The Business of Being an Artist* by Daniel Grant (Allworth Press).

- **Exclusive rights.** This guarantees the buyer's exclusive right to use the artwork in his particular market or for a particular product. Exclusive rights are frequently negotiated by greeting card and gift companies. One company might purchase the exclusive right to use your work as a greeting card, leaving you free to sell the exclusive rights to produce the image on a mug to another company.
- **Promotional rights.** These rights allow a publisher to use an artwork for promotion of a publication in which the artwork appears. For example, if *The New Yorker* bought promotional rights to your cartoon, they could also use it in a direct mail promotion.
- **Electronic rights.** These rights allow a buyer to place your work on electronic media such as websites. Often these rights are requested with print rights.
- **Work for hire.** Under the Copyright Act of 1976, section 101, a "work for hire" is defined as "(1) a work prepared by an employee within the scope of his or her employment; or (2) a work specially ordered or commissioned for use as a contribution to a collective work, as part of a motion picture or other audiovisual work . . . if the parties expressly agree in a written instrument signed by them that the work shall be considered a work made for hire." When the agreement is "work for hire," you surrender all rights to the image and can never resell that particular image again. If you agree to the terms, make sure the money you receive makes it well worth the arrangement.
- **All rights.** Again, be aware that this phrase means you will relinquish your entire copyright to a specific artwork. Before agreeing to the terms, make sure this is an arrangement you can live with. At the very least, arrange for the contract to expire after a specified date. Terms for all rights—including time period for usage and compensation—should be confirmed in a written agreement with the client.

Since legally your artwork is your property, when you create an illustration for a magazine you are, in effect, temporarily "leasing" your work to the client for publication.

Chances are you'll never hear an art director ask to lease or license your illustration, and he may not even realize he is leasing, not buying, your work. But most art directors know that once the magazine is published, the art director has no further claims to your work, and the rights revert back to you. If the art director wants to use your work a second or third time, he must ask permission and negotiate with you to determine any additional fees you want to charge. You are free to take that same artwork and sell it to another buyer.

However, if the art director buys "all rights," you cannot legally offer that same image to another client. If you agree to create the artwork as "work for hire," you relinquish your rights entirely.

What Licensing Agents Know

The practice of leasing parts or groups of an artist's bundle of rights is often referred to as *licensing*, because (legally) the artist is granting someone a "license" to use his work for a limited time for a specific reason. As licensing agents have come to realize, it is the exclusivity of the rights and the ability to divide and sell them that make them valuable. Knowing exactly what rights you own, which you can sell, and in what combinations, will help you negotiate with your clients.

Don't Sell Conflicting Rights to Different Clients

You also have to make sure the rights you sell to one client don't conflict with any of the rights sold to other clients. For example, you can't sell the exclusive right to use your image on greeting cards to two separate greeting card companies. You can sell the exclusive greeting card rights to one card company and the exclusive rights to use your artwork on mugs to a separate gift company. You should always get such agreements in writing and let both companies know your work will appear on other products.

When to Use the Copyright © and Credit Lines

A copyright notice consists of the word "Copyright" or its symbol ©, the year the work was created or first published, and the full name of the copyright owner. It should be placed where it can easily be seen, on the front or back of an illustration or artwork. It's also common to print your copyright notice on the back of reproductions or photographs of your artwork.

Under today's laws, placing the copyright symbol on your work isn't absolutely necessary to claim copyright infringement and take a plagiarist to court if he steals your work. If you browse through magazines, you will often see the illustrator's name in small print near the illustration, *without* the Copyright ©. This is common practice in the magazine industry. Even though the © is not printed, the illustrator still owns the copyright unless

the magazine purchased all rights to the work. Just make sure the art director gives you a credit line near the illustration.

Usually you will not see the artist's name or credit line next to advertisements for products. Advertising agencies often purchase all rights to the work for a specified time. They usually pay the artist generously for this privilege and spell out the terms clearly in the artist's contract.

How to Register a Copyright

The process of registering your work is simple. Visit the United States Copyright Office website at www.copyright.gov to file electronically. You can still register with paper forms, but this method requires a higher filing fee. To request paper forms, call (202)707-9100 or write to the Library of Congress, Copyright Office-COPUBS, 101 Independence Ave. SE, Washington, DC 20559-6304, Attn: Information Publications, Section LM0455 and ask for package 115 and circulars 40 and 40A. Cartoonists should ask for package 111 and circular 44. They will send you a package containing Form VA (for visual artists).

You can register an entire collection of your work rather than one work at a time. That way you will have to pay only one fee for an unlimited number of works. For example, if you have created a hundred works between 2014 and 2016, you can complete a copyright form to register "the collected works of Jane Smith, 2014–2016." But you will have to upload digital files or send either slides or photocopies of each of those works.

Why Register?

It seems like a lot of time and trouble to complete the forms to register copyrights for all your artworks. It may not be necessary or worth it to you to register every artwork you create. After all, a work is copyrighted the moment it's created anyway, right? The benefits of registering are basically to give you additional clout in case an infringement occurs and you decide to take the offender to court. Without a copyright registration, it probably wouldn't be economically feasible to file suit, because you'd be entitled to only your damages and the infringer's profits, which might not equal the cost of litigating the case. If the works are registered with the US Copyright Office, it will be easier to prove your case and get reimbursed for your court costs.

Likewise, the big advantage of using the Copyright © also comes when and if you ever have to take an infringer to court. Since the Copyright © is the clearest warning to potential plagiarizers, it is easier to collect damages if the © is in plain sight.

Register with the US Copyright Office those works you fear are likely to be plagiarized before or shortly after they have been exhibited or published. That way, if anyone uses your work without permission, you can take action.

Deal Swiftly With Plagiarists

If you suspect your work has been plagiarized and you have not already registered it with the Copyright Office, register it immediately. You have to wait until it is registered before you can take legal action against the infringer.

Before taking the matter to court, however, your first course of action might be a well-phrased letter from your lawyer telling the offender to "cease and desist" using your work, because you have a registered copyright. Such a warning (especially if printed on your lawyer's letterhead) is often enough to get the offender to stop using your work.

Don't Sell Your Rights Too Cheaply

Recently a controversy has been raging about whether or not artists should sell the rights to their works to stock illustration agencies. Many illustrators strongly believe selling rights to stock agencies hurts the illustration profession. They say artists who deal with stock agencies, especially those who sell royalty-free art, are giving up the rights to their work too cheaply.

Another pressing copyright concern is the issue of electronic rights. As technology makes it easier to download images, it is more important than ever for artists to protect their work against infringement.

Log on to www.theispot.com and discuss copyright issues with your fellow artists. Join organizations that crusade for artists' rights, such as the Graphic Artists Guild (www.gag.org) or The American Institute of Graphic Arts (www.aiga.org). Volunteer Lawyers for the Arts (www.vlany.org) is a national network of lawyers who volunteer free legal services to artists who can't afford legal advice. A quick Internet search will help you locate a branch in your state. Most branches offer workshops and consultations.

PROMOTING YOUR WORK

//

So, you're ready to launch your freelance art or gallery career. How do you let people know about your talent? One way is by introducing yourself to them by sending promotional samples. Samples are your most important sales tool, so put a lot of thought into what you send. Your ultimate success depends largely on the impression they make.

We divided this article into three sections, so whether you're a fine artist, illustrator, or designer, check the appropriate heading for guidelines. Read individual listings and section introductions thoroughly for more specific instructions. As you read the listings, you'll see the term SASE, short for self-addressed, stamped envelope. Enclose a SASE with your submissions if you want your material returned. If you send postcards or tearsheets, no return envelope is necessary. Many art directors want only nonreturnable samples, because they are too busy to return materials, even with SASEs. So read listings carefully and save stamps.

ILLUSTRATORS & CARTOONISTS

You will have several choices when submitting to magazines, book publishers, and other illustration and cartoon markets. Many freelancers send a cover letter and one or two samples in initial mailings. Others prefer a simple postcard showing their illustrations. Here are a few of your options:

Postcard. Choose one (or more) of your illustrations or cartoons that represent your style, then have the image(s) printed on postcards. Have your name, address, phone number, e-mail, and website printed on the front of the postcard or in the return address corner. Somewhere on the card should be printed the word "Illustrator" or "Cartoonist." If you use one or two colors, you can keep the cost below $200. Art directors like postcards because

they are easy to file or tack on a bulletin board. If the art director likes what she sees, she can always call you for more samples.

Promotional sheet. If you want to show more of your work, you can opt for an 8½" × 11" color or black-and-white printed image or photocopy of your work. No matter what size sample you send, never fold the page. It is more professional to send flat sheets, in a 9" × 12" envelope along with a typed query letter, preferably on your own professional stationery.

Tearsheets. After you complete assignments, acquire copies of any printed pages on which your illustrations appear. Tearsheets impress art directors because they are proof that you are experienced and have met deadlines on previous projects.

Photographs. Some illustrators have been successful sending photographs, but printed samples are preferred by most art directors.

Query or cover letter. A query letter is a nice way to introduce yourself to an art director for the first time. One or two paragraphs stating your desire and availability for freelance work is all you need. Include your phone number and e-mail address.

E-mail submissions. E-mail is a great way to introduce your work to potential clients. When sending e-mails, provide a link to your website or JPEGs of your best work.

DESIGNERS & DIGITAL ARTISTS

Plan and create your submission package as if it were a paying assignment from a client. Your submission piece should show your skill as a designer. Include one or both of the following:

Cover letter. This is your opportunity to show you can design a beautiful, simple logo or letterhead for your own business card, stationery, and envelopes. Have these all-important pieces printed on excellent-quality bond paper. Then write a simple cover letter stating your experience and skills.

Sample. Your sample can be a copy of an assignment you've completed for another client or a clever self-promotional piece. Design a great piece to show off your capabilities.

Stand Out From the Crowd

You may have only a few seconds to grab art directors' attention as they make their way through the "slush pile" (an industry term for unsolicited submissions). Make yourself stand out in simple, effective ways:

Tie in your cover letter with your sample. When sending an initial mailing to a potential client, include a cover letter of introduction with your sample. Type it on a great-looking letterhead of your own design. Make your sample tie in with your cover letter by repeating a design element from your sample on your letterhead. List some of your past clients within your letter.

Send artful invoices. After you complete assignments, a well-designed invoice (with one of your illustrations or designs strategically placed on it, of course) will make you look

PRINT AND MAIL THROUGH THE USPS

If you're looking for a convenient, time-saving, and versatile service for printing and mailing promotional postcards, consider the US Postal Service. USPS offers a postcard service through several partner sites. You can have promotional postcards printed in a variety of sizes and buy as many or as few as you need.

One drawback of going through the USPS and its partner sites is that you can't order extra postcards to keep on hand—cards must be addressed online and are mailed out for you automatically. But you can essentially create a personal database and simply click on an address and mail a promo card whenever needed. You can upload different images and create postcards that are geared to specific companies. (When you visit the site, click on "Create Greeting Cards & Postcards!" in the Shipping & Mailing section.)

professional and help art directors remember you—and hopefully think of you for another assignment.

Follow up with seasonal promotions. Many illustrators regularly send out holiday-themed promo cards. Holiday promotions build relationships while reminding past and potential clients of your services. It's a good idea to get out your calendar at the beginning of each year and plan some special promos for the year's holidays.

Are Portfolios Necessary?

You do not need to send a portfolio when you first contact a market. But after buyers see your samples they may want to see more, so have a portfolio ready to show. Many successful illustrators started their careers by making appointments to show their portfolios. But it is often enough for art directors to see your samples. Some markets in this book have drop-off policies, accepting portfolios one or two days a week. You will not be present for the review and can pick up the work a few days later, after they've had a chance to look at it. Since things can get lost, include only duplicates that can be insured at a reasonable cost. Only show originals when you can be present for the review. Label your portfolio with your name, address, and phone number.

Portfolio Pointers

The overall appearance of your portfolio affects your professional presentation. It need not be made of high-grade leather to leave a good impression. Neatness and careful organization are essential whether you're using a three-ring binder or a leather case. The most popular portfolios are simulated leather with puncture-proof sides that allow the inclusion of loose samples. Choose a size that can be handled easily. Avoid the large "student-size" books, which are too big to fit easily on an art director's desk. Most artists choose 11" × 14" or 18" ×

24". If you're a fine artist and your work is too large for a portfolio, bring a digital portfolio on a smartphone or tablet or a few small samples.

- **Don't include everything you've done in your portfolio.** Select only your best work, and choose pieces relevant to the company you are approaching. If you're showing your book to an ad agency, for example, don't include greeting card illustrations.
- **Show progressives.** In reviewing portfolios, art directors look for consistency of style and skill. They sometimes like to see work in different stages (roughs, comps, and finished pieces) to examine the progression of ideas and how you handle certain problems.
- **Your work should speak for itself.** It's best to keep explanations to a minimum and be available for questions if asked. Prepare for the review by taking along notes on each piece. If the buyer asks a question, take the opportunity to talk a little bit about the piece in question. Mention the budget, time frame, and any problems you faced and solved. If you're a fine artist, talk about how the piece fits into the evolution of a concept and how it relates to other pieces you've shown.
- **Leave a business card.** Don't ever walk out of a portfolio review without leaving the buyer a sample to remember you by. A few weeks after your review, follow up by sending a small promo postcard or other sample as a reminder.

FINE ARTISTS

Send a 9" × 12" envelope containing whatever materials galleries request in their submission guidelines. Usually that means a query letter, images, and résumé, but check each listing for specifics. Some galleries like to see more. Here's an overview of the various components you can include:

- **Digital images or slides.** Send eight to twelve digital images (JPEGs on a disk) or slides of similar work in a plastic slide sleeve (available at art supply stores). Slide submissions are less common these days, but if you do submit slides, protect them by inserting slide sheets between two pieces of cardboard. Ideally, images should be taken by a professional photographer, but if you want to photograph them yourself, refer to *The Quick & Easy Guide to Photographing Your Artwork* by Roger Saddington (North Light Books). Label each image with your name, the title of the work, the medium, and the dimensions of the work. For slides, also include an arrow indicating the top of the slide. Include a list of titles and suggested prices gallery directors can refer to as they review the disk or slides. Make sure the list is in the same order as the images on the disk or the slides. Type your name, address, phone number, e-mail, and website at the top of the list. Don't send a variety of unrelated work. Send work that shows one style or direction.

- **Query letter or cover letter.** Type one or two paragraphs expressing your interest in showing at the gallery, and include a date and time when you will follow up.
- **Résumé or bio.** Your résumé should concentrate on your art-related experience. List any shows your work has been included in, with dates. A bio is a paragraph describing where you were born, your education, the work you do, and where you have shown in the past.
- **Artist's statement.** Some galleries require a short statement about your work and the themes you're exploring. Your statement should show you have a sense of vision. It should also explain what you hope to convey in your work.
- **Portfolios.** Gallery directors sometimes ask to see your portfolio, but they can usually judge from your JPEGs or slides whether your work would be appropriate for their galleries. Never visit a gallery to show your portfolio without first setting up an appointment.
- **SASE.** If you need material returned to you, don't forget to include a SASE.

ART OF BUSINESS

DIY Customer Service

by Jen Cushman

Most business advice gurus don't see it as a sexy, attention-getting topic, like money. But customer service is about money. More importantly, it's about your brand and your reputation, which over the span of a career is eminently more important than short-term profit and loss.

When making a sale, you must keep in mind the period of time following the sale. If a problem arises with your handmade goods, your customer will contact you. How you handle the issue will determine not only if you'll keep the money from the sale, but if you'll ever receive another dime from that customer. Also, remember that in this social-media era, one unhappy customer can express displeasure on your Facebook business page, your Twitter account, your Instagram feed, and your blog. You can always delete negative comments and reviews, but common sense dictates handling the situation before it goes public.

Good customer service begins with communication, and that starts with always including a business card along with any in-person or online purchase. This card should have your name, business name, website, social-media URLs, and e-mail address. Letting customers contact you by phone is your choice. If you have a brick-and-mortar business, I think it's essential to have a business phone. However, these days many people only have a cell phone. I prefer people contact me via e-mail, and I always respond promptly.

Next, be sure you have a written return policy and post it on your website, blog, online store—wherever you sell. If you're doing trunk shows, fairs, or festivals, create business cards specifically for these shows and print your return policy on the back. Being clear on your policies from the beginning will solve 85 percent of your customer-service problems. Without a written policy in place, business etiquette favors the buyer.

When someone contacts you with an issue, respond immediately. If you can't constantly monitor e-mails, be sure to set an auto-responder on your e-mail saying you're away and will reply as soon as possible. If you have a business phone, be sure to record

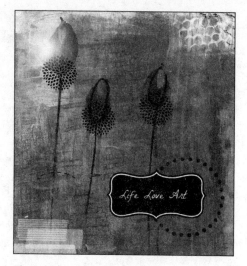

Flower Series 1 by Jen Cushman.

an outgoing message with a similar message. Not responding to a problem is the worst thing to do. For the customer, frustration increases and trust begins to crumble.

Another hallmark of good customer service is keeping your cool. No one likes to be yelled at or even spoken to harshly. If a customer treats you this way, take a deep breath and do your best to let it go. This is not about you; it's about your product. Makers, in particular, have a difficult time with this because they're so close to the work they do. Listen to the customer to discover the root of the problem, and then solve it to the best of your ability. The solution may not always result in a refund. You may need to repair an item or trade it out for another piece. Some customers will have buyer's remorse, but that may not be your problem if you have clear return and refund policies in place.

In business, as in life, you cannot please all of the people all of the time. When customer-service challenges arise, think of them as opportunities for vital hands-on skill building. A change in thinking will result in a change of being.

Q. I make jewelry, and one of my customers contacted me about returning one of my bracelets that broke when she wore it. Of course I will repair it, but who's responsible for the shipping charges, the customer or me?

A. This is a great question and it applies to not just jewelry, but to all handmade merchandise. You should first ask yourself if breakage happens often with the items you make. If it does, it's not good for your bottom line or your reputation. If you've only been making jewelry for a short amount of time, I hope you're "test driving" your designs to see how they hold up with daily wearing before you add a price tag. Here is my philosophy about repairs and returns: Aficionados of handmade goods evaluate a pur-

chase in terms of desire, quality, and price, usually in that order. When higher-priced handmade items break, customers feel as though the piece did not live up to its perceived value. With inexpensive items, people often rationalize that damage is somehow permissible because it didn't cost that much to begin with. In the latter case, most people don't take the time to contact the maker if a piece breaks. If they do, it usually indicates that the buyer has an emotional attachment to the piece. Immediately making repairs or replacing an item constitutes good customer service. Exceptional customer service often means also paying for shipping. Demonstrating excellent customer service to someone who already admires your work usually results in a lifetime customer.

A finished piece of jewelry by Jen Cushman.

Q. I hate sales. I'm an artist. I want to spend my time making my art. Should I hire a sales rep to do my selling?

A. If you truly, deep down in the core of your being, hate sales, you have two options: Make art as a passion and not a living, or put on your big girl (or big boy) panties and change your attitude. Of course you can hire a sales rep. The fine art sales reps I've met have a passion for discovering great artists and making it easier for them to do what they do best: make art. Sales reps can provide incredible marketing manpower for your business, get you access to clients, and generate income for you.

However, there's a larger issue here that I'm concerned about. Being a successful CEO of your business means that you take it seriously and take responsibility for every aspect of your company. You may dislike sales, and doing it definitely takes you away from

making art, but selling is the principal cog in your company. Spend some time reading and researching what business experts have to say about selling in the new economy (which has changed drastically from the old hard-sell approach). Maybe some new information will open your mind to a new way of thinking about marketing and selling your work. Then ask yourself whether a sales rep is the right choice for you.

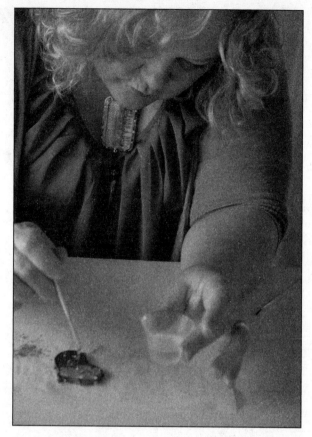

Artist Jen Cushman works on a jewelry piece.

Jen Cushman is a former journalist who found mixed-media art fourteen years ago and never looked back. She's the author of *Making Metal Jewelry: How to Stamp, Forge, Fold, and Form Metal Jewelry Designs* and *Explore, Create, Resinate: Mixed-Media Techniques Using ICE Resin*. Jen writes "The Mixed-Media Metalsmith" column for *Cloth Paper Scissors* and teaches at national and international venues. She's also Vice President/Partner of Susan Lenart Kazmer LLC/ICE Resin®.

Excerpted from the Summer 2015 issue of *Artists & Makers* magazine. Used with the kind permission of *Artists & Makers*, an F+W Media, Inc. publication. (www.artistsnetwork.com)

THE ART OF BRAND MARKETING

by Britta Hages

Let's face it, in today's world, an artist will get nowhere without the help of marketing.

For all intents and purposes, marketing is the lifeblood of any successful brand and, ultimately, it's what makes or breaks most rising artists, be they designers, illustrators, or someone who's just really good with a paintbrush.

If you're an artist (which you probably are, if you're reading this) then you're most likely already familiar with creating a personal brand. In fact, that's probably the least of your worries! Most artists have perfected their brand over time, whether by tweaking their logo, fine-tuning their motto, or revamping their website.

But creating a brand is just the first step in building your artistic platform.

In other words, in a sea of artists, it's important to stand out. And you can't just stand out because your brand happens to look prettier than the others. The cold reality is that dreaming up a brand is the easy part; the hard part is marketing it so the world comes to recognize it instantaneously.

One could go so far as to say that building a brand's notoriety is an art form unto itself. After all, not only does the artist have to mold the brand from nothing but a lump of an idea, but they must chip away at the bad parts—piece by piece—until the end result is a solid structural platform that will attract an audience's attention.

It's no wonder that full-time artist and longtime sculptor Emily Coleman is hardly a newbie when it comes to the concept of self-promotion. Building her business from the ground up, Emily learned how to advertise her brand long before the influence of social media platforms, such as Facebook and Twitter, had their successful starts.

Tired of working 80-hour weeks with barely a dent in her bills, she branched out into teaching sculpture courses before pursuing a full-time art career. According to Emily, she learned fast that promotion was always the key to advancing her brand.

"Marketing has become a more interactive experience and will always be changing as technology advances," said Emily. "I always try my best to stay on top of the latest trends and grow along with them rather than being stuck in the same routines over and over. Keeping marketing ideas fresh is the same idea as keeping the creativity flowing through my art work."

So how does Emily stay fresh? Well, for one thing, she gets to know her audience.

"My main demographic is young adults. They often love animals, fantasy, and nature," which is a big pull to-

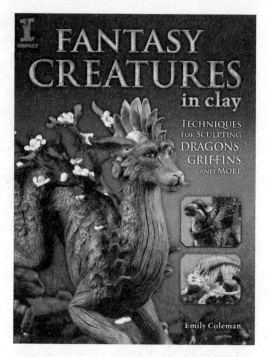

Fantasy Creatures in Clay by Emily Coleman was published through IMPACT and features a variety of Emily's signature dragons and a fantastical griffin.

ward Emily's fantasy-esque brand. Furthermore, they're the ideal audience for online promotion as they are, in large part, the moving force behind pop culture.

It's no secret that more and more millennials are redefining how art is discovered. They do this mainly by ditching standard fine art galleries and museums for social media platforms such as Instagram, Pinterest, and DeviantArt. In fact, the online auction site Invaluable recently released a survey that showed how nearly 23 percent of Americans find artwork via popular social media channels.

So by appealing to her online audience through selective fonts, image styles, color schemes, and other visual cues, Emily ensures that her brand stays mainstream in accordance with popular opinion. Likewise, she keeps on her toes by continually posting to major social media outlets such as Facebook, Twitter, Tumblr, and Instagram on a regular basis.

According to Emily, "Staying up-to-date with the most popular social media outlets is super important for younger audiences. Everything is always changing and it's important for me to never stay comfortable!" She also does this by frequently updating her personal website and extensive e-mail list, all the while somehow managing to attend several conventions and art shows every year.

Emily's ability to market herself and make herself so accessible to her young adult audience is a major reason why her self-published book, *Creature Sculpt*, caught the eye of IMPACT Books, a major young-adult art instruction imprint.

"IMPACT is very interested in working with established artists that already have a decent following and those that are familiar with marketing themselves to some degree," said Emily. "Giving them my previous sales numbers, follower counts, website hits, and various other stats helped sway them to publish the book."

Emily's book with IMPACT, *Fantasy Creatures in Clay*, hit stores in 2014

Autumn Spirit is a dragon sculpture by Emily Coleman, which she uses as gallery art in her book *Fantasy Creatures in Clay*. Many of the techniques she used to create *Autumn Spirit* are described in the book.

and received a write-up in *MAKE:* magazine after she approached Jason Babler, the creative director. The positive review urged audiences to go out and buy the book because it "hits the mark on so many levels."

"I have no doubt it helped quite a bit with sales," said Emily in regards to the article. Little did she know that her steadfast promotion of the book, before it came out, would lead to IMPACT creating its first-ever YouTube book trailer. The trailer, based off of *Fantasy Creatures in Clay*, became a popular success.

"That was a complete surprise for me," said Emily. "They only sent it over to me once it was finished and I loved it! It is definitely a fun promotional item." In the end, the trailer garnered the attention of online retail phenomenon, Amazon, which immediately embedded it where the book is now sold in its virtual store.

In her downtime, when she isn't releasing new books, Emily is forced to get creative with her social outreach and how she grows her brand. She'll often post links to her website or online shop, and occasionally runs contests or giveaways to increase her social media following.

"I also have an e-mail list where I send out exclusive coupons and early product release announcements," said Emily. "All of these things encourage people to share posts and spread the word."

Likewise, she's discovered that cross-promotion happens to be one of the most effective tools to use in building her brand. "My peers and I share each other's posts on social media," said Emily, "and we also collaborate on art projects together, which end up appealing to both of our audiences." One of her more notable collaborations was with Poly-

form, the maker of Sculpey clays, and it led to the company's sponsorship of Emily at the Maker Faire 2015.

With a book deal, sponsorship, and a large number of commissioned art projects, Emily acknowledges that keeping up with social media can be, at times, a bit challenging. But one only needs to look at how her sculpting career has taken off to know that she's handled the challenge superbly. In many ways, she credits marketing for making her a better artist.

"Marketing forces you to be confident in your work. If you can't convince yourself that your time and work are worth it, how will you convince others? As artists, we are our own worst critics so this is definitely a huge obstacle to overcome. But ultimately, it causes you to believe in yourself and the work you produce."

It's hard to believe that someone with Emily's national recognition could have, at one time, doubted her artistic qualities. Yet, the not-so-big secret in the art world is that

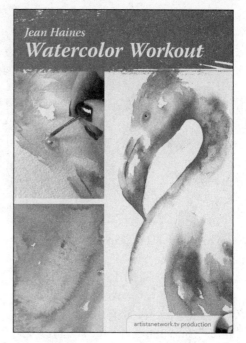

Watercolor Workout is one of Jean's first DVDs published by ArtistsNetwork.tv. It demonstrates how to complete a painting by approaching it using multiple "watercolor workout" techniques.

self-doubt is firmly embedded in the job description of any artist, whether they work on a local, national, or global scale. Just ask international watercolorist and bestselling author, Jean Haines.

"I came into my career as a professional artist by accident," said Jean. What started out as a hobby, and attending a beginner's class to gain confidence, ultimately led her down the path of artistic stardom. According to Jean, many of the students preferred her loose style to that of the teacher. Before she knew it, she was getting teaching requests left and right. So began her art career!

Despite her overwhelming teaching success on a national level, Jean didn't initially look upon herself as a brand in need of marketing. Over time, though, she understood the necessity in doing so. "When I created my website," said Jean, "I started thinking about how it represented me and all I do. It was my first personal window and entrance to the global art world, and it had to be right."

Following soon after her website came her popular blog: *Watercolours With Life*. The blog, which she utilizes as a diary-styled platform, is updated frequently and has the same

Jean Haines uses several Daniel Smith Extra Fine Watercolors as a part of her signature set, alongside her signature dot card, which are featured in all of her ArtistsNetwork.tv DVDs.

magnetic appeal as Jean herself. She often shares her inner musings and stories of her travels for workshops that she later plugs on Facebook, Twitter, and other social forums.

"Having a social online presence has made a huge impact on my art career and still does," said Jean. "I have many more followers than I did before I started marketing my work."

But Jean is adamant that the biggest secret to marketing her brand isn't in sharing her own work, but in sharing others'. "If you share generously, others are more inclined to talk about you in a positive way. So being kind is possibly the biggest marketing asset we can possess."

Her advice shouldn't be taken lightly. With four bestselling books under her belt, a signature paint set from the Daniel Smith Extra Fine Watercolors line, and a new series of DVDs coming out, she's on the fast track to the top, and her career seems to be gaining more momentum every day.

With workshops across Europe, including her native United Kingdom, and revolving door invitations to Canada, the United States, and Australia, it's a surprise that Jean even finds time to paint. She's adamant though, that she aims to keep painting as her priority.

"My art is my life," said Jean. "Promotion is a secondary factor to what I do and achieve."

For something that takes second place in her life, Jean sure has a knack for it. She even jokes that her next book will be about giving advice to artists on how they should market themselves, since it's one of the most common questions she fields from newbies and old hats alike. Most of them, however, would probably be surprised to hear that Jean attributes her marketing success to simple boredom.

"I know that my boredom threshold isn't very good. I tire of seeing the same things, and that goes for advertising. I think we all, to a limit, get tired of seeing repetition. We love see-

ing new ideas, and this is what is so exciting about marketing. It does change and gives us endless possibilities," said Jean.

Some of Jean's marketing strategies range from giving free advice to free online tutorials or even jurying at art shows. She's also keen on attracting new audiences to her website by writing features for art outlets such as *The Artist's Magazine* and *PAINT* magazine, among others. According to Jean, "If you market in the same places, you are only attracting the same audience."

Which might provide a little insight into why she's created her newest set of DVDs with F+W Media, a company founded in America. This past spring, Jean flew out to Cincinnati, Ohio, to film a series of painting DVDs via their digital art imprint, ArtistsNetwork.tv, that will be released in the fall of 2016.

"This company is on the ball, and I loved working with them," said Jean. "That too is the key to success. Work with people whom you respect, who have great professionalism, and who know how to promote you at your best."

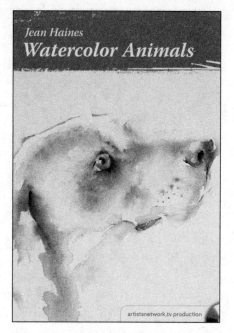

Watercolor Animals explores how to build up animal paintings, starting with simple eye exercises and working toward a finished piece. These techniques are applicable to most animals, including dogs and cats.

While on set, Jean said she didn't waste a single minute. On top of shooting four DVDs, she also filmed additional teaching clips to be used for promotional bonus content. "I believe if we are given an opportunity, we should show our appreciation to the host and give as much as we can. In fact, in life I've found to be successful, the more you give, the more comes back to you."

Which certainly begs the question: Just how much have artists like Emily and Jean given to garner such successful careers?

The answer might never be made known. But, telling by their stories, they had to work hard to get where they are today. And undoubtedly, they had to market themselves even harder.

Britta Hages is a former full-time book and video editor who has worked on a handful of bestsellers. Now she spends her time freelance writing for magazines, books, and other print and digital media. Visit www.brittahages.com to learn more about her fiction and nonfiction content, and to read her writerly musings.

MOMENTUM

Finding (and Maintaining) Motivation as a Freelance Artist

by Allison Ranieri

Making your living as a freelance artist can be tough. In fact, it usually is. Not only is it a never-ending battle of figuring out where your next job is going to come from (a problem that slowly gets easier for most as they make more contacts and build relationships with clients), but also an internal battle of struggling to find the motivation to get up every day without the urgency of a time clock looming overhead. It's just like a gym routine: When you make your own rules, it's a lot easier to break them.

There is one word that holds the key to maintaining productivity and ultimately achieving repeated success in a freelance career: *momentum*. On a smaller scale, the continued drive to keep creating is necessary to remain inspired, keep hands busy, and hold fully formed habits in place. In the bigger picture, one must continuously, steadily work on a project, all the while looking forward to and preparing for the next one to come.

It's pretty simple: You have to show up. You have to do the work, and then you have to keep doing it. Once you get into a rhythm, keep it up. I like to think of my creative process, once I get on a roll, like the constant chugging of a train in the back of my head.

This concept of momentum is all well and good, but, as every creative person knows, sometimes motivation and inspiration can come to a grinding halt for no particular reason. It starts and stops at the whim of your muse, you might say. Well, how fair is that? And, how exactly do you recover when you've had the inspirational wind knocked out of you? There is no one easy answer for how to get going again once you've lost motivation. Or, perhaps, there are many easy answers; it's just the implementation of the advice that isn't so easy.

Showing up and doing the work is important, but it's equally important to know when to step back and give yourself a break.

Sometimes, the cause of sudden motivation failure can be external. For instance, unexpected events, such as the emotional trauma of a breakup or the death of someone close, can not just momentarily derail a freelance career's path, but also the freelancer's life. When one is struggling to cope emotionally with an onslaught of feelings, the furthest thing from one's mind is the work that has to be done. And, if it does crop up, it is typically a distressed thought: "Oh my gosh, I have so much to do," or "Oh, no, that deadline is so soon. I'm in trouble." Anguish creeps into the creative thought process and creates a type of negativity that is toxic to productivity.

Speaking from my own recent real-life experience with the sudden loss of motivation due to external circumstances, I can say that there's one simple thing I've done that has prevented me from self-sabotaging over the fact that my creative productivity hasn't been as high as it would be under normal circumstances: I simply allowed myself to let go for a while. If you're grieving, for instance, how fair is it to your already fragile psyche to start kicking yourself when you're down by berating yourself for all the work you're not doing? (Hint: It's not fair at all.)

Learning to lean in to the oncoming wave of emotion and distress that has come into your life is, in my experience, the best and healthiest way to deal with unexpected loss of motivation. As long as you can weather the oncoming storm enough to tie up loose ends before you take a mental and physical break from your work, there is nothing wrong with doing so. Oftentimes, artists are the last people to even think of giving themselves permission to do this.

More frequent than external life events that stop us in our tracks, unexplained loss of motivation can hit for apparently no reason at all. "Why???" we shriek, hands in the air

and a look of utter distress upon our faces as we stare at a blank canvas or piece of paper. It absolutely makes no sense! You've done your part. You've shown up and done the work, but for some reason, your muse decided to take the day off. When this kind of sudden motivation loss happens, it's usually better to just keep working.

A pie I made and a drawing of the pie done for my weekly YouTube channel. The consistency of releasing a video every week keeps me motivated.

Forcing yourself to go through the motions is extremely important. It may seem like the last thing you want to do, but trust me—your momentum will pick up again, and you won't even know what happened.

Of course, going through the motions is key, but knowing how to do it smartly is even more critical. Knowing yourself and the things you like and are good at creating is crucial to surviving during times of creative drought. When all else fails and you're at a loss in front of that blank page, stick with what you know.

For instance, I know that I love to draw portraits. And who's always around to use as a model? Me. So, when I'm feeling creatively stuck, a good starting point for me is to churn out a couple of selfies, or maybe a couple drawings of the outfits I've worn during the week. It may seem silly, but it truly gets my right brain moving again. Before I know it, the colors I used in my warm-up drawings have worked their way into inspiring a color palette I need for a current project I'm stuck on.

So, nine times out of ten, it's best to just keep working when random artist's block strikes. But what about that other one time? You've had your nose to the grindstone, burning the midnight oil, and you're still spinning your wheels. At this point, it is again important to look up from your work. Walk away from your desk. Take a walk outside. Literally. Do all of these things and forget about your work. Forget about your frustration and remember what

it's like to live. Remember the things that bring you joy outside of what you do for a living. This reacquaintance with life and the things you love can be as invigorating as a breath of fresh air, and it will breathe new life into your projects and your personal work.

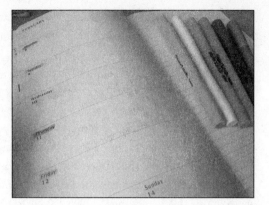

Making habitual planning a part of my life not only helps me organize my day, but my mind. Utilize whatever system you find useful—highlighters, tabs, hourly schedules, etc.

Freelancing as an artist is a wonderful profession. It is rewarding in many ways: obviously creatively, but also emotionally, psychologically, and often, spiritually (whatever that may mean to you). But it doesn't come with an employee handbook. There's no time clock, no uniform, and of course, no direct-deposited check in your bank account every two weeks. It's one thing to get the ball rolling creatively, but nobody's around to tell you how to keep it going. And that is the inherently scary, and ultimately exciting, part of working for yourself.

So you're back on your feet, feeling creative again and working hard on a project. But, how do you keep the momentum going so you don't fall into another creative rut? Well, there are lots of ways. I'll tell you a few that work pretty well for me.

First and foremost, create good habits. If you're working for yourself, you need to set your own schedule. Setting a specific time you want to wake up every day (and organizing everything you do in any given day fairly rigidly around certain times) will get you into a routine. Habits are important because, not only do they shape what you physically do in a day, but they shape how you think. Your thought process will be constantly in motion if you remain aware that you'll be moving on to the next thing in an hour, thirty minutes, or even right now.

Next, record your habits. Set yourself a schedule and stick to it. Writing down what you have to do is essential to actually accomplishing it. Something about the act of putting pen to paper and scribbling out goals is a huge step to making them a reality. I find that it's important not only to write out the big goals but also to write out the smaller steps that are necessary to accomplish those goals. Checking those steps off my to-do list helps me complete a task more quickly and with fewer obstacles.

Beyond making to-do lists, plan everything. Plan your hour, plan your day, plan your week, plan your month. And when you've done all of that planning, make a five-year plan. Seriously! Being able to map out goals even five years down the road will keep you motivat-

ed in the long term, and it will bring you that much closer to actually accomplishing your dreams rather than sitting on them for months or even years.

Finally, hold yourself accountable. By this, I mean put yourself out there. Ever seen people who want to lose weight post a pre-gym selfie every day until they reach their goal weight? Do something similar. A mistake many young freelancers and starting artists make is to wait. It's easy to get into a mindset that you have to wait to put your work out there until you're "good enough." But this mindset needs to be eliminated fast before you work yourself into self-induced frustration and artist's block, and you find yourself back at a nine-to-five job. Here's a hint that should come in that hypothetical employee freelancing handbook: you will never find your work good enough. It may sound sad to say, but there is so much truth in this statement. The eternal struggle to be good enough is the ultimate motivation to learn more, do more, and work harder.

So when I say to put your work out there, I mean create a manageable bundle of social media accounts and start posting. Post works in progress, post finished pieces, post your supplies, and post about your thought process. Nothing shows true motivation like someone who frequently updates their social media and demonstrates growth in their work. And if you add enough key hashtags, people will notice your work. It may take months, or even years, but I've gotten jobs from work I posted on Instagram two years previously. It will happen.

To be successful, to stay motivated, and to keep creating, you must keep yourself driven by your own habits and a regimented lifestyle that you create for yourself. Being your own boss and being successful means creating structure. It's letting your left brain do the planning so your right brain doesn't just run free. Because, let's face it, your right brain, when left unchecked, will eventually get the idea that eating ice cream and binge-watching television is what you should do for hours on end. (It's not. Unless it's your self-appointed day off.)

But it's equally important to acknowledge the stagnant times. To accept that the creative train, if you want to call it that, does make stops occasionally, and you should be okay with that. Crafting your own career, one that has staying power in your life, requires taking into account that you are human. That you need breaks sometimes, and yes, you do need TV and ice cream, or a walk and a power bar. Whatever your thing is. Ultimately, freelancing as a creative is not just a career, it's a lifestyle.

Allison Ranieri is a freelance illustrator and creative person who self-published her first book, *Habitat*, in 2014. She is a self-proclaimed morning person and finds her own motivation by having fun with what she creates. Visit her website at allisonranieri.com.

MAKE A GREAT PORTFOLIO

by Luke McLaughlin

In a visual industry, a strong portfolio is crucial. Learn how to make it better with Google Analytics and A/B testing.

Less Is More

The first and most important rule of a great portfolio is to use as few images as possible to show the best work that you can do. A common mistake for beginners is to put all of their work into their portfolio. At the beginning, this might be because they only have enough completed work to make a small portfolio, but as your body of work grows, it's important to make your portfolio concise. In the fast-paced world in which you are trying to establish your business, you need to get your message across quickly. A bloated portfolio that doesn't communicate the strengths of your business quickly and effectively will result in missed opportunities.

Another problem with larger portfolios is that any work in your portfolio that is below average will lower the quality of the entire portfolio. People will judge your ability based on the worst work in your portfolio. Having a single bad image in your portfolio can turn it from an asset to a liability and cost you business. This is why you should have a small portfolio. Six to ten images of your very best work is a great place to start. Once you have your first portfolio, you can use A/B testing to see if portfolios with more images work better for your clients. (We will discuss A/B testing with Google Analytics later on.)

Your portfolio should visually tell people about the kind of work that you do and what you specialize in. It's better to have a portfolio with just a few very good examples of your work than trying to cover all the bases. Each piece in your portfolio should be a statement. Ask yourself why each image is in your portfolio. If you don't have a good answer, take it out.

Specialize

Tell one story; don't confuse people. When people look at your work, they want to know what kind of work they are going to get if they hire you. Most successful creatives have a niche, a particular style or area of expertise. You might be able to do all sorts of jobs, and it may be that once people gain confidence in you as a professional that you are asked to do work outside of your comfort zone, but it is far better to be the best at one thing rather than average at everything. This should come through in your portfolio. Make a portfolio that showcases the kind of work that you are the best at and shows why you are better than your competition.

You might find out that the area where you feel you are strongest is extremely competitive, or that an area where you don't feel as strong is actually your strongest field because of lower levels of competition. If you are finding that one area seems to be much harder to get business in than another, go with what works—even if it wasn't your initial plan. As a small business, one of your biggest advantages is the flexibility to pivot from one business model to another more easily than a larger business.

Market Research

Now that you know the basics, it's time to size up the competition. Try to find other people who have a business similar to yours and take a look at their portfolios. Your goal should be to make your portfolio at least as good as the portfolios that you find. If you find a competitor with a great portfolio, bookmark it and compare it to yours later on to see if you have been able to achieve your goal. If your portfolio is below the standard of your competition, you will have to work a lot harder to get clients. If your portfolio is as good as it can possibly be, you will have a great chance at attracting the best clients and growing your business.

Dos and Don'ts

Do use high quality images. You always want to use high quality and high resolution images for your portfolio. If you use watermarks on your images, make sure they are not distracting. It's easy for a watermark to completely ruin the visual impact of an image.

Don't use huge files in your portfolio. While you need a very large file size for printing, if you use print resolution files for your portfolio, it will take longer to download and may not display correctly on some devices. (Hint: At the moment, the HD standard of 1920 × 1080 pixels is a great size for files that will be accessed digitally. Eventually the 4k standard of 4096 × 2160 pixels will replace it.)

Do look at your portfolio on a wide variety of devices. You want your portfolio to look great on computers, tablets, and phones. Ask your friends to look on their devices and let you know if they have any problems viewing your portfolio.

Do watch people looking at your portfolio. Which images do they spend the most time on? If your best work is at the end of your portfolio, try moving it to the front. If people are struggling

Make sure your portfolio looks good on different types of devices and screen sizes.

to navigate your digital portfolio, change the formatting or gallery to make it easier to view.

Don't have two images with the exact same subject. Although you don't want an inconsistent and confusing portfolio, you also want to avoid duplicates. Try to avoid having any two images that are too similar to each other or feature the same subject.

Multiple Portfolios

If you want to show a particular client that you are capable of working in a style or area that isn't in your main portfolio, you can consider having separate portfolios for each style. This will make it easier for people to understand what you are trying to do. People should see your portfolio and be confident in what you do, not confused.

You can have more than one portfolio for different clients. You can have digital portfolios on your website and in addition have specialized portfolios that you can e-mail to clients in order to get a particular job. If your clients might buy prints of your work, it can help to show them a professionally printed portfolio rather than or in addition to your digital portfolio. (We'll discuss more about print portfolios later on.)

Formats for Digital Portfolios

I use four formats of portfolios on a regular basis. Most of them contain the same images, but I use each format to show my work in different situations.

Website Portfolios

Your portfolio on your website should be the first thing that people find when they search for you online. It should either be on the home page of your website or just one click away from the landing page. Use meta tags on your portfolio page to describe the subject matter of your portfolio in general terms so that people searching for those things will have a chance of finding your portfolio in an image search. You can use a variety of gallery plugins

for the CMS (content management system) that you use to make your portfolio, but the key thing is to make it easy to use and intuitive for the viewer. Once you have your portfolio set up, watch some people using it. If they struggle to navigate, use a different gallery or change the settings to make it more intuitive.

Cloud Portfolios

I use cloud services like Dropbox and Google Drive to send clients specialized portfolios based on the type of images that they are looking for. By using a cloud service, I can quickly create a folder containing the images that I want my prospective client to see and send it to them instantly without changing anything on my website or web portfolio page. (Hint: If you send someone a link to a folder with a cloud service you can correct mistakes or alter your portfolio even after you have sent it.)

PDF Portfolios

PDF portfolios are the happy middle between an online portfolio and a print portfolio. You can keep a PDF of your best work on your tablet or phone to show people when they ask you what you specialize in. This way you always have a professionally presented portfolio in your pocket. It's easy to make a PDF of your portfolio. You can use Adobe Acrobat or you can convert a web page, a Word document, or a Powerpoint to a PDF. PDFs are also ready to print. If you have a great PDF portfolio that you have had success with showing clients in person, why not use it as the basis for a professionally printed portfolio?

Print Portfolios

Originally, portfolios were selections of printed work that you would show your clients in person, but now people often have their work available to view only online. When online portfolios first became available, having an online portfolio made you stand out because it showed that you were different. Now that everyone has an online portfolio, you can stand out by having a professionally printed portfolio once again. It costs more, but it gives you an opportunity to show someone your portfolio in person. While you can e-mail a client a link to your online portfolio for free, showing someone your work professionally presented in a print portfolio can really set you apart.

You can get your PDF portfolio printed and bound on high quality paper through an online or local print service. Make sure they specialize in high quality prints of images and that they use good inks and papers. At a local shop you can see examples of their printed work hands on, and most online printers will send you a sample of their work for free or for a nominal cost. (Hint: For the best results, your files should be 300 dpi in the size that they will be printed.)

Some potential clients will ask for a print portfolio, so it's still worth keeping a collection of high-quality prints of your best work.

Try to always get sample prints made first before you make an expensive order. It's usually a lot cheaper per copy to get more than one print made at a time. You will want to have more than one copy anyway in case yours gets damaged or if you have left a copy with a client. Once you have a few copies of your printed portfolio, make sure that you store them carefully and don't let them get damaged. Keep and transport them in an envelope or sleeve to make sure they last. If a portfolio is damaged, it loses its appeal and makes you look unprofessional. Try to keep your print portfolios pristine and only use them when showing your work to serious clients.

A/B Testing the Old Fashioned Way

Make two versions of your portfolio using any of the formats that we have talked about. Next, show each portfolio to your friends and family and ask them to pick which one they like better. Unlike asking for a critique of your portfolio, which can be difficult, this makes it easier for them to tell you what they really think. This is an effective way to get actionable feedback from friends and family who might not want to criticize your work to your face. It's also quick and easy for people to tell you which version they like better, even if they aren't sure exactly why.

Using Google Analytics for A/B Testing

A great way to see the quality of your portfolio is to use analytics. While it's fun to keep track of your page views and watch your online presence grow, it's often hard to tell exactly what tactics and strategies are resulting in an actual improvement for your business. One of the best ways to improve your online portfolio is to use A/B testing with Google Analytics Experiments. (Hint: Google Analytics refers to A/B tests as "experiments.")

It's really easy to set up an A/B test for your online portfolio for free. First, make two versions of your portfolio. Then set up your website with Google Analytics. If your website uses a CMS such as Wordpress, Squarespace, or others, follow the instructions for the one that you use. Once you have Analytics installed on your site, setting up an A/B test is easy if you know where to find it. Sign into Analytics, click on the section for your website, and follow these simple steps:

1. Click on the "Behavior" tab.
2. Click "Experiments."
3. Fill in the form. Put the URL for both of the versions that you want people to see: your original portfolio page (A) and your test page (B).

Finally, follow the instructions to insert the code that the form generates into the page that you are testing. The form has a troubleshooting section that will make sure that it is set up correctly, so you will know right away once you have it configured.

You can use more than two versions as well, if your website gets enough traffic, but it's probably easier to start out with two versions. A/B testing has become one of the most powerful tools for media companies to improve their online presence, and

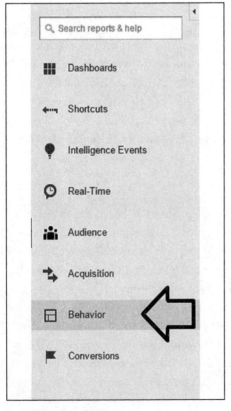

Click the "Behavior" tab.

Click "Experiments."

it doesn't have to cost anything. You should use it too.

Go Back Through Your Portfolio at Least Once a Year

If you are busy, you might not realize how long it has been since you last looked at your portfolio. When you first make your portfolio, put a reminder in your calendar for the next year to remind yourself to update your portfolio. A great idea is to always update your portfolio in the first week of a new year or the week of your birthday. Updating your portfolio is a chance to assess your progress and see how much you have improved.

Luke McLaughlin is based in Oxford, England. Find out more about what he is working on at www.lucasmclaughlin.com.

Content Experiments - Create a new experiment

1 Choose an experiment objective

Name for this experiment

Portfolio A-B Test

Objective for this experiment ⑦

Select a metric ▾ - or - Create a new objective

Percentage of traffic to experiment ⑦

100% ▾

Email notification for important changes

OFF

Advanced Options ⑦

Next Step Save for Later Discard

2 Configure your experiment

3 Setting up your experiment code

4 Review and start

Fill out the form.

A CLASS ACT

by Jeanne Rosier Smith

Ready to share your painting skills? Here are some tips for first-time teachers....

Perhaps you're thinking it's time to branch out and share some of the knowledge you've stored up from years of painting experience. Or maybe you've had requests from fellow painters to teach what you know. That's what happened to me fifteen years ago, and my decision to start teaching has shaped my art and sustained my career.

Teaching was a natural choice for me; I taught college English for ten years before becoming a full-time artist. But even those without formal teaching experience may find that leading art classes can be a source of inspiration and income. Seasoned teachers often say that teaching provides a greater awareness of their own approach to painting. For newer teachers, like Dave Kaphammer, instructing others can refine one's own process. "Having to articulate my ideas solidifies them for me," he says. "Describing and explaining those ideas as I'm painting helps keep them in the forefront." He, like many of us who teach, has learned that you become a much better artist because you're a teacher.

If you're considering offering classes, here are a few tips for starting and growing this side of your artistic life:

Maintain a Library

Invest in classic reference books, and stay up-to-date on new releases and blogs. Then, when you're teaching a class on painting snow, for example, you might check to see what Elizabeth Mowry, Richard McKinley, John Carlson, or Liz Haywood-Sullivan have said about it. I also allow my students to borrow my references for a week or two.

I completed *Bartlett's Beach Road* during a recent class demonstration.

Get the Word Out

Give demonstrations at local art organizations; bring cards and mention your classes during your demo. Be sure to provide a sign-up sheet for your periodic e-mails about class offerings.

Offer to teach a series at a local community school or art center. These classes will give you more experience and help to build a following.

Create an e-newsletter. Sign up for a free or low-cost e-mail service, such as Mailchimp or Constant Contact, and build an address list, so those interested in following your art can stay connected.

Keep a consistent schedule. I've held my classes on Tuesdays for the past eleven years. Students rely on that and make their plans accordingly.

Find the Space

Virtually any space can become your classroom if you have willing students and a little imagination. When I began teaching art classes at home, I lived in a three-bedroom, split-level house in New Jersey, and I had four students who would paint around my dining room table. As the classes grew, I purchased inexpensive collapsible metal easels, and we gradually took over the living room and family room, covering sofas and carpets with drop cloths.

After moving to Massachusetts, I held class in my kitchen—counters bared and chairs cleared, drop cloths on all surfaces. Finally, I converted an unfinished basement into a permanent classroom space with good lighting, cement paint, more easels, and tables.

Cover Your Bases

Keep good financial records, including a separate account for your teaching business. Create a class registration form, and include a statement of clear policies for issues such as missed classes, refunds, and cancellations. A printed policy eliminates confusion and helps you manage sticky situations.

My basement classroom contains critique space and shelving that allows for painting storage. GE ultraviolet lights, half in "sunny daylight" and half in "cool daylight," provide affordable, balanced lighting.

If you teach at home, check your homeowners' insurance to be sure you're covered with adequate liability insurance in the event of an injury or accident. If you live in a snowy area, make sure that access to your classroom is safe and ice-free at all times.

Keep in mind that you're also the registrar, the principal, and the janitor. Expect administrative, planning, and cleaning duties to take roughly an extra two days per month.

Create a Flexible Program

My classes run by the month. This keeps registration affordable and flexible, allows for fluctuations in students' schedules, and maintains a consistent program. Topics change each month, depending on seasons, students' developing needs and interests, or my own inspiration. I have students of all levels; the monthly topic structure ensures that we all keep exploring and pushing ourselves to the next level.

Take a Break

Each of my classes runs for two-and-a-half hours. I start most sessions with a short lesson or demonstration of 20–30 minutes, after which students begin their own work. Two traditions have developed that I've found useful. First, we hold an hour-long critique during the last class of each monthly session. The critique allows everyone a chance to develop a critical eye and vocabulary, get positive and constructive feedback on their own work, and cement their understanding of concepts within a larger perspective.

Second, in the middle of every class we go upstairs for a brief cappuccino break. Artists are often reluctant to step away from their work mid-session, but this short break al-

lows them to return with fresh eyes and renewed energy. It also fosters relaxed interaction and creates a chance to talk about art topics.

Find a Balance

In many ways, teaching art is the perfect accompaniment to the working artist's painting time. I cherish the quiet and solitude of my studio, but my students' energy and enthusiasm invigorates and inspires me, and balances all my alone time.

Taking a coffee break allows students to go back to their works-in-progress with fresh eyes.

Liz Haywood-Sullivan explains how important this exchange with students has been for her. "As artists, we tend to work mostly in isolation with our thoughts and materials; we thrive on feedback from family, friends, collectors, and students," she says. "Some of my most valuable lessons have come from my students."

Additionally, painting sales are hard to predict, and we never know when those gallery checks will arrive in the mail. Teaching, on the other hand, is reliable income that can help sustain the working artist through both lean and prosperous times.

Finding a workable balance and preserving precious studio time is key. For me, this means teaching three classes—morning, afternoon, and evening—one day per week. This allows me a late-afternoon break for ferrying kids to activities and for fixing dinner. It's a long day, but the enthusiasm of my students keeps me going. The payoff occurs during the rest of my week, which is kept free, allowing me to paint and do everything else.

With three weekly classes, occasional weekend workshops, and a yearly student show, my little dining table group has grown into a school. In my view, it's the perfect job—and the commute can't be beat.

Jeanne Rosier Smith is a professional pastelist living in Sudbury, Massachusetts. Visit www.jeannesmithart.com to see examples of her work and get more information about her classes.

Excerpted from the April 2015 issue of *Pastel Journal* magazine. Used with the kind permission of *Pastel Journal*, a publication of F+W Media, Inc. (www.artistsnetwork.com).

TAXING SITUATIONS

by Leonard D. Duboff

It takes more than great art to get a gallery's attention.

Q. I'm not really interested in making a living with my artwork, but I have sold a couple of pieces this year. Do I have to declare those sales as business earnings and pay both income and social security taxes on those earnings?

A. You must declare the income from sales of your artwork on your income-tax return whether you make art as a hobby or as a business. Social Security and Medicare taxes (together called self-employment tax), are due only if you sell your artwork as a business. You might think it would always be best to claim that your art-making is a hobby rather than a profession so you can avoid paying self-employment tax, but there are at least two reasons why that's not a good idea.

First, if you create and sell art as a business, all of your legitimate expenses are deductible on your tax return. If you spent more money making and selling your artwork than you earned from it, you can apply that loss against other income, whether your own or that of your spouse (if you file jointly). If, on the other hand, you make art as a hobby, your deductions are limited to the amount of income you made from that hobby. Furthermore, you would have to deduct those expenses as miscellaneous itemized deductions, and they can't be deducted at all if you don't itemize. Even if you do itemize, your expenses can be deducted only to the extent that they exceed two percent of your adjusted gross income.

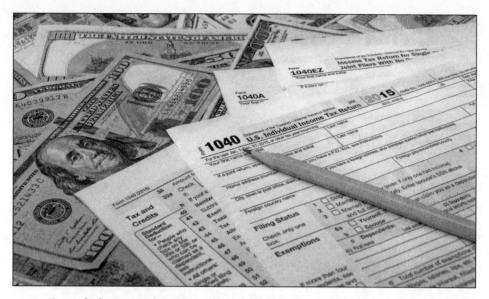

Second, the Internal Revenue Service (IRS) may conclude that your art-making is a business rather than a hobby and that, therefore, you do owe self-employment tax. If this happens, the IRS may impose significant interest charges and penalties. On the other hand, if you claim to be operating a business, the IRS may decide that you're actually making art as a hobby and disallow some or all of your deductions. This situation could also lead to you being charged interest and penalties. It is, therefore, important for you to characterize your work accurately as a hobby or as a business.

On what criteria do you base your characterization? Tax laws presume that a person is engaged in a business, as opposed to a hobby, if a net profit results from the activity during three out of five consecutive years, ending with the tax year in question. If your art business hasn't had three profitable years in the last five, the IRS may contend that you're making art as a hobby. When determining whether you intended to make a profit, the IRS looks at factors such as whether you carried on the activity in a businesslike manner. That is, did you have a separate bank account for your business, keep appropriate records, have business cards? Other factors include how much education and experience you have related to the activity, how much time and effort you spend on the activity and whether you need the income for living expenses.

Income Deductions

Q. As a working artist, what deductions can I take on my earnings?

A. All of the ordinary and necessary expenses you incur in connection with your art business are deductible. As noted earlier, though, if you're engaged in a hobby rather

than a business, you can take deductions only to offset income from your art hobby. Either way, potential deductions include the following:

- art supplies such as paints, brushes, canvases, etc.
- framing
- studio space
- office supplies
- books and magazines related to your business
- mileage for travel related to your business—either actual costs or the standard deduction—check irs.gov for tax year rate updates
- parking charges, subway and bus tickets, and tolls for travel related to your business
- trade association dues
- copyright registration fees
- fees to enter juried shows
- agents' commissions and fees for online sellers
- classes to improve your skills
- costs associated with maintaining a website
- legal and accounting fees
- amounts paid to employees
- some travel and entertainment expenses (such as hotel stays, meals, and art museum admissions) for which you can show a business purpose

Some of these expenses, however, may not be fully deductible in the year incurred. For example, purchases of office equipment with useful lives of more than one year are considered capital expenditures that cannot normally be fully deducted in the year of purchase. Instead, the cost of the item must be depreciated over its useful life, as determined by the tax code. You can, however, expense up to $25,000 plus an adjustment for inflation for items that would otherwise have to be depreciated if you're operating as a business. This is known as the Section 179 deduction. (Visit section179.org for updated information for the current tax year and after.)

In addition, some supplies sometimes must be deducted as part of "cost of goods sold" rather than deducted when they're purchased. Furthermore, there are strict rules for certain deductions, such as expenses related to travel and entertainment.

As noted in the response to the previous question, if your art is a hobby, related expenses can be deducted only if you itemize and only to the extent they (plus any other miscellaneous itemized deductions you have) exceed two percent of your adjusted gross income.

If you're unsure about how to take any of these deductions, talk to a tax advisor or lawyer; errors on your tax return may result in interest charges and penalties.

Record Keeping Tips

Q. What records should an artist keep for tax purposes?

A. The first step in keeping business records that allow you to maximize your deductions is to open a business checking account. Try to pay all of your business expenses through this account. You may also want to obtain a credit card for your business. For those occasions when you pay for expenses out of your personal funds, you should fill out an expense reimbursement form and attach your receipts to this form before writing yourself a check out of the business bank account.

You should keep receipts and, if applicable, invoices and canceled checks for expenses, although there are a couple of exceptions to this requirement. IRS guidelines provide that documentary evidence isn't necessary for travel, entertainment, gifts or transportation expenses if either of the following conditions apply: the expense (other than for lodging) is less than $75, or you have a transportation expense for which a receipt is not readily available (such as a bus ticket). If you can obtain a receipt in these circumstances, do so, since this may help you avoid problems proving your expenses in the future. If you don't have a receipt for an expense like this, make sure you record the date, amount, place, description, and business purpose for the expense.

You don't have to keep original receipts, though. The IRS says it's fine to scan or photograph your receipts and then throw out the originals. Just make sure the digital versions of the receipts are legible and accessible, and retain a secure backup copy.

You should also record the reason for each expense (even if you have a receipt) in an expense diary, kept either on paper or digitally. This is most easily done with a paper diary small enough to fit in your pocket or with an application on your smart phone—so you can keep your diary with you at all times. Keep track of all expenses as they occur. If you don't, you may lose valuable deductions for small charges that add up to significant amounts. It's especially easy to forget the cost of things like parking, tolls, and cab fares. If you drive in connection with your business, make sure you keep a mileage log showing not only your mileage, but also the date, destination, and reason for the trip.

You also need to keep records of all money you earn from the sale of your artwork, such as bank deposit slips, receipt books, invoices, and credit card charge slips.

Leonard D. Duboff has testified in Congress in support of laws for creative people, including the Visual Artists Rights Act of 1990. A practicing attorney and pioneer in the field of art law, he has also assisted in drafting numerous states' art laws and has authored more than twenty books. For further information, visit dubofflaw.com. Note: The author thanks Christy King, Esq., of The DuBoff Law Group and Sean Kim of Paxton, Miller & Kim, CPAs for their assistance with this article.

Adapted from the March 2015 issue of *The Artists Magazine*. Used with the kind permission of *The Artist's Magazine*, a publication of F+W Media, Inc. Visit artistsnetwork.com to subscribe.

ARTIST ASSISTANTS

......................................

by Daniel Grant

To be an artist is to run a small- or a large-scale business involving billing, bookkeeping, photographic documentation, record keeping, sales, promotion and marketing, shipping, inventory, purchasing office and material supplies, as well as design and production of items to be sold—and, in some or all of these realms, assistants may be needed.

Now in her 70s, painter Susan Schwalb claimed that she doesn't have "the time or the patience" to learn how to do all but the simplest tasks on her computer—and hers is a big job. The Watertown, Massachusetts artist had been attempting to inventory every artwork she has ever created as a professional (title, medium, dimensions, framed or not, where signed, where exhibited, where and when sold, sale price and current location, as well as an image) in a computer database. Her lawyer, offering some estate planning advice, recommended that she get a better handle on what she has in her possession and where other works are. "I'm creating my own catalogue raisonnée, which may be very useful when exhibitions are planned," she said. All well and good, but Schwalb still needs someone to do this work for her, because she cannot, and her choice of employees are young artists.

"I advertise for assistants by word-of-mouth and through the art schools around here," including the Art Institute of Boston, the Massachusetts College of Art and Design, and the

School of the Boston Museum of Fine Arts. Schwalb believes that artists have a better understanding of what she as an artist needs and considers important, than a computer geek who may have only the technical know-how. She also looks for artists who have been out of school for at least a year and can commit to working for her one day per week, year-round.

It is not uncommon for successful artists to have assistants, but there is no specific job description for them as there is for, say, dental assistants or sous-chefs. While Schwalb's principal concern is the computer inventorying of her artwork, her assistants occasionally have been asked to crate her work for shipping or to write a letter. "It's nice if they can talk on the phone," she said, adding that no one has been asked to cook or clean for her. And, while assistants have helped put her canvases into frames, she hasn't had them work on the surface of the canvas—making the artwork is her sole dominion.

If the job sounds a bit all over the board, that's par for the course. The want ad that artist Lesley Dill places from time to time calls for someone who is "talented, cheerful, peaceful, and hard-working," The only specific requirement is "strong wrists," because her assistant will be cutting flat metal and wire. The "peaceful" part actually is pretty important as well because "we work in total silence," Dill says. She believes most talk is distracting and full of the woes besetting her assistants' lives, noting that, "I'm not Mom. I'm not a shrink." Dill asks those who work for her to "leave their troubles at the door and view the studio as the focus of all their attention and energies."

Not so with New York City artist Jeff Koons, whose eighty or so full-time assistants are hired on the basis of their portfolios, which need to show competence at photorealistic and academic painting. "About half of the employees here have master's degrees," said studio assistant Jaclyn Santos, who noted that most of them paint directly on Koons' canvases, although not all at the same time.

There are various benefits and drawbacks to working as an artist's studio assistant, but probably the chief attraction is the potential entrée to the professional art world that it represents to younger artists. For Schwalb's assistants, they learn how to organize a career; those working for Koons share in the artistic process; and the assistants of both Schwalb and Koons have the opportunity to meet the people (collectors, critics, curators, dealers, and other artists) who come into the studios. Visitors strike up conversations with assistants that may result in exhibitions and sales of the assistants' own work. While this seldom happens, assistants do generally learn something from their experience about how the art world operates, how an artist sets up his or her studio, and how the business of art really works.

"I had a naive expectation," Gina Campanella said, "that I would work for an established artist who was part of a gallery, and that person would help me get into a gallery." Naive, perhaps, but many young artists have that same expectation, or they believe that through the collectors, dealers, and critics who walk into the established artist's studio, they will meet someone who becomes a buyer, seller, or champion of their artwork. In most

instances, the artist wants an assistant to do the tedious chores that he or she doesn't want to do, and the relationship may not advance much beyond boss and employee. Still, Campanella, who graduated Skidmore College in 1989 and set to work as an artist's assistant, first for Michael David, later for Joyce Kozloff and Barbara Zucker, approached her plan with a strategy. She wanted to work for a woman artist because "I thought a woman artist would be more of a mentor to me," taking interest in her work and helping launch her career.

Artist Susan Schwalb.

In fact, some of her hopes were realized. A print publisher who visited Michael David's studio when Campanella was still working for him, struck up a conversation with her, took her out to lunch and introduced her to artist Joyce Kozloff. Kozloff, for whom she soon went to work as an assistant, introduced Campanella to Barbara Zucker, and it was Zucker who recommended her to fill a short-term teaching spot (a sabbatical replacement) at the University of Vermont where Zucker herself worked. Both Kozloff and Zucker also chipped in $250 each to pay for Campanella to attend the Vermont Studio Center as an artist-in-residence. Campanella became part of a network of artists. "Joyce has never missed a show I've had," she said. By working for some artists who are more established, Campanella learned something about what it is to be an artist. "I saw how they found materials and how they researched their subjects," she said. Through conversations in the studio, she understood "how their personal and professional lives intertwined."

From time to time, lightning strikes: A dealer visiting Peter Halley's studio struck up a conversation with one of his assistants, George Rush, and began to talk about Rush's own work. Later, that dealer made a studio visit and eventually gave a show of Rush's work at his gallery. A similar circumstance occurred with Carroll Dunham in Dorothea Rockburne's studio.

The downsides of being an assistant to an artist are manifold. Pay is rarely good ($10 per hour, maybe $15 for the lucky ones), and benefits (health insurance, paid sick or vacation days, retirement plans, etc.) are nonexistent.

Credit for work done on an artist's own piece is not given, and assistants with a degree in art may find it demeaning to sweep an artist's floor or fetch the mail. "Who is supposed to clean the floors?" Brooklyn installation artist Whitfield Lovell asked. "Am I supposed to

get on my hands and knees to clean the floors? I don't ask my assistants to clean my whole house, just the studio. They are here to make my life easier, and that's not negotiable."

Often, the pluses and minuses get all mixed together, as do the various tasks that studio assistants are asked to do. "Tom Sachs wants the highest skills for the lowest wage," said Liz Ensz, a fiber artist who worked for Sachs for one year (starting at $15 per hour, ending at $17 per hour). She created various components for a lunar module installation based on photographs that the artist gave her. The elements were made of fiberglass, resin, and Styrofoam. "I got to make some really cool things," she said.

During that year, the number of assistants in the studio ranged from six to fourteen. Ensz got the job through another of Sachs' assistants, J.J. Peet, who was the boyfriend of one of her former teachers at the Minneapolis College of Art and Design. "His referral was enough," she said. "Tom trusted J.J.'s judgment, since he was his main builder." Her interview with Sachs consisted of the artist looking at online images of her work. Sachs then decided where she would fit in."

At the end of her year as a studio assistant, the artwork was exhibited at New York's Gagosian Gallery. Ensz and the other assistants came to the opening, but all the applause there was for Sachs. "I don't feel weird about that at all," she said. "I'm actually grateful for the experience. I learned more in Tom's studio than I did in art school."

Not every studio assistant finds the anonymity of the job as easy to swallow. "I do think about not getting credit," said Claire Taylor, an artist who worked for sculptor Tara Donovan for nine months. "It's her work, her ideas, but her work ends up becoming your whole life; it just consumes you. It is very hard after eight hours of constant work in her studio to come home and push yourself to do your own work."

Donovan never asked to see Taylor's portfolio but gave her a day-long tryout, gluing Styrofoam cups together in a particular pattern, which in fact was one of the activities she did regularly for a large project that the artist was developing. In addition, during that nine-month period of working in her studio, Taylor repaired Mylar disco balls and rolled adhesive tape loops, connecting them and spraying it all with a sealant.

Most of the five to ten other assistants in the studio were similarly aspiring artists, and Taylor claimed that an unstated element in the tryout was determining if she could mesh with everybody. "Everyone is constantly around each other, in a relatively confined space, and you don't want tensions to interfere with the work that needs to be done." In fact, she found that people generally got along really well. "If someone doesn't want to talk all day, no one makes you talk, no one takes it personally. Everyone knows what it's like to roll tape all day."

There is a variety of ways to learn if an artist needs an assistant. The principal dealer for an artist is often in touch with the studio and may be a good source of information. Other artists often know which studios are more likely to hire assistants, perhaps offering

a reference or an introduction. Some artists advertise their need for assistants in the Jobs in the Arts section of the New York Foundation for the Arts' website or on Craigslist.com. Artists sometimes contact art schools when they need help, and these institutions also may arrange internships and assistantships for their current students and alumni.

Artist Joyce Kozloff.

Katharine Schutta, director of career development at the School of the Art Institute of Chicago, noted that during an interview, "It's important that you know and express excitement about the artist's work." It also helps to bring up the skills that the would-be assistant has to offer. Much of the actual job will be administrative, such as preparing artworks for shipment, record keeping, developing and updating a website, researching grant opportunities, photographing art, or proofreading a press release. "And you may be just fetching things," Schutta said.

The tenure of a studio assistant ranges from a few months to a few years, on average, depending upon what a given artist needs and how long someone is willing to work in a role in which promotions, raises, and industry recognition—the rewards of other types of employment—almost never occur. In general, it is a job for the young, and those who tire of it probably have passed a certain point in their sense of who they are as artists. For many studio assistants, working for an artist is a type of postgraduate training, an introduction to the full-time artistic life. For the few who become successful artists, the contacts they make, the sense they have developed of how to make contacts, the ideas they gain of how a studio is run, the understanding they gain of what it is to go day after day to a studio and come up with something to do will help them pursue their goals and avoid mistakes that might derail a career.

On occasion, a studio assistant learns something else that helps them develop a career, although perhaps a different career than they may have assumed. Carmella Saraceno stretched canvases for Jean-Michel Basquiat, glued plates onto canvases for Julian Schnabel

Artist Lesley Dill.

and "was invited to every party and every opening," she said. However, she discovered her real calling after she began working with sculptor Alice Aycock. "I had heard through some people that Alice Aycock needed a truck unloaded." Saraceno went to Aycock's Manhattan studio at 8:30 the next morning and spent the day pulling out and hauling one piece of lumber after another up to the artist's studio. (She was the one woman among several men.) The lumber didn't fit easily into the freight elevator at the studio, but Saraceno took charge of directing the process of maneuvering the pieces in and out. "Alice watched me do this all day long and, at the end of the day, she asked me if I wanted to work for her."

The "work" was varied, to say the least. "I got the keys if she was locked out. I got the car before it was towed," and she offered comfort when the artist had a blow-out with her then-husband. More importantly, Saraceno figured out how to put together and install the public sculptures for which Aycock provided designs. "Alice never said no to any project. Something would come up; someone would say use this space, and she'd say 'yes' and then try to figure out how to do it. Someone would ask her to do a project that involved electrical power, and she'd say 'okay, I can do electrical,' but she knew nothing about electrical."

In 1990, Saraceno started her own business in Chicago, called Methods and Materials, that helps artists, art galleries, corporations, museums, and public arts agencies rig, assemble, install, uninstall, and relocate large-scale artworks. "What I do now is figure out how to do things," she said. "I wouldn't be doing this if not for having worked for Alice Aycock."

Her business currently employs nine artists, who are afforded health insurance and 401K pension plans.

Developing one's own artistic voice and generating the energy to create one's own art, however, may begin to seem futile for artists' assistants when confronted with daily reminders of how sought-after an employer's artwork is. If working for an artist is conceived as a means of establishing a career as an artist, artists' assistants should stay alert to signs that their apprenticeship may have lasted too long and is becoming an obstacle to their own careers. One who recognized that possibility was Constantin Brancusi, the Romanian-born sculptor who left Rodin's studio saying "Nothing will ever grow in the shade of a big tree."

The artists' assistants of today are far different from the journeymen apprentices of the Middle Ages or Renaissance. Then, the relationship between master artist and apprentice was that of teacher and pupil, and young hopefuls were contracted out to artists for specified periods of time, doing certain duties in exchange for instruction. Often, these duties included helping the artist complete a piece. One began as an apprentice, became a journeyman and then a master, in turn. The studio of Peter Paul Rubens, for example, had such promising apprentices as Anthony van Dyck and Franz Snyders, who worked directly on the master's paintings.

By the 17th century, the officially recognized art academies in Europe spelled the end of the guild system, as apprenticeships gave way to ateliers (the artist as teacher), academies, and the art schools we know today. With the advent of Romanticism, there was a greater emphasis on individual style and on working alone. Being able to do the same kind of art as one of the great masters was no longer highly regarded, as distinctiveness became the predominant artistic virtue.

Today, being an artist's assistant tends to have less to do with learning how to make art and more about learning the business side of being an artist—all the while taking out the trash and answering the phone.

Daniel Grant is the author of several books, including *The Business of Being an Artist* and *The Fine Artist's Career Guide* (Skyhorse Publishing).

THE PERFECT PAIR

by Jeanne Rosier Smith

Pursuing gallery representation involves a delicate balance of finesse and self-assessment.

You have a growing body of work, you've polished your résumé, and you're ready to break into the commercial gallery market. The search for a gallery can be daunting, but a few simple considerations can make the process less intimidating. Your goal is to establish a good, long-lasting relationship. Like any search of this kind, this one begins with a strong sense of yourself and what you're after. The next steps might be risky, but a few basic rules of common sense and courtesy will save you time and help you avoid awkward encounters.

To glean insight from both sides of this important relationship, I solicited advice from artists Barbara Jaenicke of Roswell, Georgia, and Jean Hirons of Rockville, Maryland, as well as gallery owners Sherry Rhyno of Gallery 31 in Orleans, Massachusetts, and Larry Powers of Powers Gallery in Acton, Massachusetts.

Get Ready

Before you start a search for representation, take time to assess your artwork from the perspective of a gallery owner. A track record of sales and exhibitions, particularly in juried national shows, demonstrates both professionalism and marketability. Jaenicke—whose work is represented by Stonehart Gallery in Evergreen, Colorado; Weiler House Fine Art Gallery in Fort Worth, Texas; Watson Gallery in Atlanta, Georgia.; and Raiford Gallery in Roswell, Georgia—has noticed that most galleries want to represent artists who have already achieved a measure of success. She strongly recommends artists spend time building their résumé

Barbara Jaenicke, who paints pastel landscapes, such as *Enchanted Evening* (16" × 20"), credits her background in marketing for her success in securing gallery representation.

and reputation before looking for a gallery. "Once your work is gaining ground, you'll have an easier time enticing a gallery to take you on," she says.

Do Your Homework

Do you paint barns, seascapes, western landscapes, abstracts? The style, subject matter, and market value of your art will strongly dictate your gallery targets. "Do your homework first to see if you're a match for the gallery," advises Powers. You'll save yourself immeasurable time and energy and avoid rejection by carefully researching prospective galleries before approaching them.

While the Internet allows instant access to vast amounts of information, Rhyno points to the importance of researching galleries in person. Five minutes in a gallery will reveal whether it's worth pursuing. Visits will also help emerging artists more accurately assess and price their own work.

An in-person visit is especially important for the pastel artist, as it might help determine how a gallery feels about carrying work done in that medium. It's best to find a gallery

that will sell pastel work enthusiastically. "They are out there," Jaenicke notes. "Paint what you're passionate about, in the medium you love. This will always come across in your work."

Make Contact

Once you've identified potential galleries, be respectful of their policies, following any posted guidelines for artist inquiries to the letter. Gallery owners and artists unanimously agree that the first contact should be arranged in advance, through an e-mail or phone call. Powers observes that acquiring a new artist is "like dating" and requires finesse. He points out that "successful galleries are pretty busy, and if you're busy trying to make sales, you don't have time for sudden interruptions."

Once you've secured a meeting, Powers advises, "Don't be shy about what you're doing. Be confident. You're doing what you love to do." A gallery is a business, and the gallerist will be evaluating you as a potential long-term business partner. Show that you're professional, reliable, responsive, and easy to work with. Bring a portfolio, along with a selection of originals. Powers suggests the portfolio include enough variety to show what you're capable of, but at the same time he cautions artists to be selective.

"The best portfolios," Rhyno says, "have great quality paintings, are painted in series, and are clearly marked with titles, medium, size, framed size, and price." The résumé and cover letter, she adds, should be succinct and reveal your personality and skills.

Hirons' success story began when she e-mailed a gallery director after reviewing the policy on the gallery's website. "Then I called her about 30 minutes later. She was happy that I called and suggested that I bring in some pieces for her to see. She kept two of them." A gallery relationship often begins this way, with a trial piece or two. This allows the relationship to grow slowly with minimal commitment. An early sale, as happened in Hirons' case, can confirm the artist's place and lead to growing representation. She's now represented by three galleries: Colorwheel Gallery 65 in McLean, Virginia; Rogers Gallery in Mattapoisett, Massachusetts; and Waverly Street Gallery in Bethesda, Maryland.

If At First You Don't Succeed

Powers cautions artists not to be discouraged by a rejection, as often it may be an issue of space or similarity. As you create a potential gallery list, prepare a backup list at the same time. In the event of rejections or a lack of response, you can immediately turn to the backup list as your next step, and double your chance of success.

The Power of Self-Promotion

Like most institutions, gallery owners rely on recommendations, so maintaining good relationships with your art-related contacts may pay off through word of mouth. Let it be known that you're actively seeking representation, and cultivate relationships over time with your

Jean Hirons, creator of *Winter Light* (20" × 24") and other landscape work in pastel, began a relationship with her gallery by contacting the gallery director to arrange a visit.

favorite galleries. Jaenicke points to self-promotion as an essential and often-overlooked way of gaining gallery representation. She notes that with the exception of her first gallery, each of the galleries representing her has pursued her, rather than the reverse. The artist credits her success to her marketing background, which pushed her to use social media extensively—through blogs, competitions, and other opportunities.

Powers explains that his gallery came to represent a stable of more than seventy-five artists using a variety of tactics: "The fun part of what we do is the way it all happens. It's a blend of things. Artists searching us out—we love that; we're flattered. Sometimes it's word of mouth. Sometimes I'll see an artist and go check him out. We want to stay fresh, and it's always exciting to see what's new."

Jeanne Rosier Smith is a professional pastelist living in Sudbury, Massachusetts. Visit www.jeannesmithart.com to see examples of her work and get more information about her classes.

Excerpted from the August 2015 issue of *Pastel Journal* magazine. Used with the kind permission of *Pastel Journal*, a publication of F+W Media, Inc. (www.artistsnetwork.com).

ETIQUETTE FOR ARTISTS

by Daniel Grant

There is an etiquette for juried art shows and fairs and, like much etiquette, a lot of it is unspoken, just known—like where you put the soup spoon in a place setting.

At art shows, violating etiquette is apt to be brought up whenever an artist is found to have broken one of the rules. Sometimes, it is the artist who is clearly at fault, knowingly disobeying a rule that the show sponsor has set; at other times, show sponsors create rules that may force artists to choose between following the stated guidelines (causing them to act against their own best interests) and dishonesty. The fact that there is no standardization among the thousands of shows and fairs annually taking place around the United States means that artists themselves must tailor their own practices (and ethics) to conform to the rules of this or that event.

One rule on which there is general agreement is that artists should not substitute another work for the piece that was submitted to a jury. The desire to make a substitution may come about when an artist sells a juried piece before the show begins. Not all collectors will allow the works they bought to be part of a show (the piece may be damaged, for instance), and this puts the artist in a bind: Should the artist hold off on a sale, withdraw from the show, or ask if the show sponsor will accept something else? Moral: Artwork is not interchangeable; a work that is submitted for an exhibition should be available, and sales may have to wait.

Another point on which most agree is that the same work should not be submitted to two or more different shows, taking place at the same time, in order for an artist to see which

Know what mediums and styles the show you're applying to will accept before entering.

is the best show in which to participate. If the artist's work is accepted into more than one show, it means that another artist's work was rejected, and the show sponsors may also have to scramble to fill an empty space. Moral: Artists should learn about a show before they enter their work, not afterwards, and commit themselves fully to the event.

Artists should also not fudge the issue of medium, which sometimes comes up in shows of watercolors. Some watercolor shows accept acrylics and gouaches, even pen-and-ink drawings with a watercolor wash, while others are adamant about only transparent watercolors. The Midwest Watercolor Society has been so concerned about what is called a watercolor that it tests accepted entries to see if their medium is truly transparent. "You can't always tell from the digital file sent in with the application if opaque or white paint is used, but you can see it when the artwork is in front of you," said Robin Berry, a member of the board of directors of the Transparent Watercolor Society of America. "Those works have to be removed." Moral: Artists who are in doubt about what is allowable have every right to ask; perhaps the rules are overly fussy, but artists should not knowingly submit work that goes against a sponsor's stated aim.

While most show and fair sponsors earn their money from visitor admissions, concessions, and booth or entry fees, some also take a commission on sales occurring at the event. In some instances, collectors are required to purchase works through the show sponsor rather than through the artist, but most shows rely on an honor system: The artist tells the

sponsor what he or she sold and pays a commission (usually between 10–20 percent, and sometimes as much as 30 percent). Frequently, when a commission is charged, the sponsor is able to lower booth fees for artists and even eliminate jurying fees. Moving the financial underpinnings of a show from up-front money (fees paid by artists) to money earned (through sale of artwork) requires more of the sponsor to promote the event and bring in likely buyers. This shift should be encouraged by honesty on the part of participating artists.

Some gray areas in show etiquette may also arise. Certain show and fair sponsors require that participating artists donate a work—perhaps for an auction or as a door prize or for the sponsor's permanent collection (when the sponsor is an art institution)—but which work? Should a painter contribute a painting, or a print, or even a sketch? Must the donation be representative of the artist's best-known work, or can it be just anything? Often, the prospectus does not indicate what the donation should be, and artists are left with an ethical decision—to give away the type of work that got them into this show, or just donate something small or inexpensive (or both) with their name on it. Probably, the latter option makes the most sense, especially if a donated piece is to be used as a door prize. Some artists create a line of less expensive pieces, and one of these would fulfill the requirements of the sponsor.

The length of time between when an artist submits a work to a juried show and when it is accepted may be months, and significant changes may happen in the artist's career in the meantime. Awards may be won, works sold, rave reviews published. Frequently, show sponsors require that artists put a price on work they are submitting for jurying; by the time of the actual show, an artist may want a much higher price, which could be accommodated in a gallery situation, but is likely to cause hardship to a show sponsor who has printed up hundreds or thousands of brochures with prices noted in them. The sponsor would have to reprint the entire brochure with the correction or pencil in a change on every brochure or leave the brochure as is and hear from annoyed visitors to the show. The Massachusetts-based Cambridge Art Association, for its part, informs artists that the organization "will not permit changes in price upon acceptance." Price hikes cause hard feelings on the part of the sponsor, while what now seem like artificially low prices will irritate the artist. Moral: Sticking by one's word means adhering to the price originally set. A better moral: Show sponsors ought not put artists in the position of losing money and should scrap the pre-show pricing requirement.

Not everything is cut-and-dried, however. Some shows require that every work on display be for sale, which may be attractive to visitors but not to artists. Artists may not want to sell works with personal meaning to them, or they may have a ready buyer (or have even sold the piece already). They may want the piece to be available for another show. A not-un-common solution for artists is to give the piece a very high price ($10,000, whereas it otherwise would go for $1,500) in order to discourage sales and get around the Not-for-Sale problem. Other show sponsors set price limits for works on display, which is again appealing to

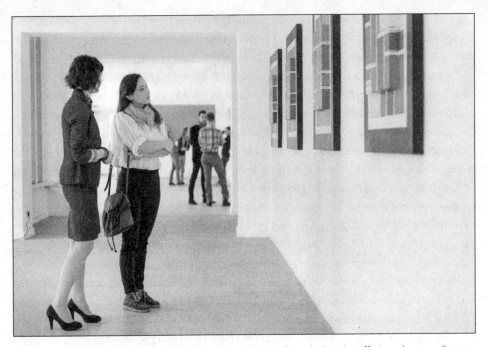

Gallery-represented artists should never undercut their gallery dealers by offering cheaper direct sales to buyers.

visitors but may cause hardship for artists who could charge more at other shows. Just as in the required donation problem, show sponsors place artists in an ethical bind: irritate the sponsors or hurt their own career opportunities.

In some cases, a show sponsor will request artists to indicate the value of submitted artwork, not for the purposes of listing a price but for insurance purposes (in the event of damage or destruction). That valuation should not be inflated. Artists would be wise to read a prospectus carefully, determining a course of action based on the rules the sponsor has established; perhaps they simply should not enter shows and fairs that make unpalatable demands.

Some conflicts between artists or between artists and show sponsors may not be avoidable. An artist may choose to enter the same work in a great many shows, which will likely irritate other artists (and show sponsors) who are unhappy at seeing the same piece again and again. However, the public does not travel the show circuit as artists do and is unlikely to see the work repeatedly; artists create works for potential buyers rather than for other artists.

An artist may submit a favorite work to juries for years, which may also annoy fellow artists who only send in slides of their newer work. Many show sponsors require that all work submitted has been created within the past two years, in part because they want annual shows to have a different look every year for the public. (For instance, the Tallahassee

Watercolor Society's 28th Tri-State Juried Water Media Exhibition, which was held at the Museum of Fine Arts at Florida State University on May 20-July 1, 2016, noted in its prospectus that "Paintings must be executed after January 1, 2014.") Newness, of course, is not an artistic criterion, but good etiquette in the art world is often a mixture of strong principle and the assumed needs of the market.

The subjects of etiquette and ethics for artists do not end with juried art events but also extend to relations with their collectors, galleries, and dealers. For instance, telling the truth: "I once seriously considered taking on a young artist who sent me follow-up material claiming to have shown at the Metropolitan Museum, the Whitney, and other major museums," said Louis Newman, director of New York's David Findlay Jr. Gallery. "When I called to express my astonishment that he did not tell me to begin with about these impressive credentials, he revealed that he actually never showed *in* these museums but *at* them," such as on the steps of the Metropolitan, where he would set up a display of his work for tourists, visitors, and other passersby. Newman added that "needless to say," this artist was "out the door as far as we were concerned."

What should we call this? A fib, puffery, misinformation, half-truth, fairy tale, or just an outright lie? It probably doesn't matter, as the prospective dealer lost confidence that he ever could trust this artist to be truthful. Perhaps the moral of this story is that you should always assume a worst-case scenario if you are ever caught not telling the truth. "Art is a lie that makes us realize truth," Pablo Picasso told an interviewer in 1923, but artists also need to adhere to a less lofty form of truthfulness. They must comply with stated rules, offer accurate information about themselves and their artwork, and avoid exaggeration so that they will be trusted by collectors, dealers, and shows sponsors—even when the rules and questions seem unfair and arbitrary.

In addition to outright lies, there are instances of what might be called "prize inflation," an example of which is the bronze sculptor in New Mexico who told an interviewer for a daily newspaper there that she won first place—two different times—at the National Sculpture Society in New York City, according to the article, which appeared in *The Daily News* in late March 2013. "One of our board members read that article and e-mailed it to me," said Gwen Pier, executive director of the National Sculpture Society. "We keep records on our winners, and while that artist did win modest prizes back in 1978 and 1982, they weren't first prizes." At a distance of 30-plus years and 2,000 miles from the Society's headquarters, this might seem relatively minor. Still, the Society is a national organization with members all over the country, and artists should keep in mind that anything in print also is likely to end up online, shrinking the span between one place and another.

For artists represented by a gallery, many artists are happy to leave the mechanics of selling works to their dealers. Still, some of those same artists may sell works out of their studios and, in fact, find that collectors prefer to buy from them directly, instead of from

Once accepted to a juried show, an artist should never substitute a different work for the original.

their dealers. Frequently, those collectors believe that they can purchase artwork for less money than when a dealer is involved—the price may be halved, these buyers think, because there won't be a 50 percent gallery commission. As a rule, artists should never undersell their dealers and, if they do, artists should not be surprised if their dealers drop them. However, some artist-dealer issues are less clear-cut, especially when the artist also sells his or her work directly.

For instance, dealers frequently, or even regularly, offer discounts off the stated price—usually, 10 percent—to encourage potential buyers. Is it equally permissible for the artist to offer the same percentage discount when selling their work privately? Considering the fact that dealers generally charge a 50 percent commission for sales of the artwork they are representing, what is wrong with an artist even taking a 50 percent discount for a studio sale?

Artists and their dealers may have opposing views on this. For artists, it is just as viable for the artist to sell work with a discount as the dealer. On the other hand, Gilbert Edelson, former administrative vice-president and counsel of the Art Dealers Association of America, says "A discount by the artist undercuts the dealer, even if the discount and the final price is the same as what the collector would get at the gallery. Collectors talk to each other: 'Don't buy from that dealer—you'll get a better price from the artist.' This hurts the dealer and eventually the artist after the dealer decides he no longer wants to handle the artist because the artist has become his competitor." He recommends that artists tell people who

want to buy their work directly that they do not sell from their studios and that the buyer should "go to my dealer." Or, the artists should just not offer a discount of any sort, which alleviates the problem.

In general, the only time that artists might sell work at a larger discount is when they sell, rather than commission, their artwork to their dealers—known as a "trade" discount, which may be as large as 40 or 50 percent, in effect the regular gallery price minus the regular dealer commission.

No less thorny is the question of whether or not an artist owes his or her dealer a commission on the sale of a work from that artist's studio. For instance, a work is exhibited in the dealer's gallery and then returned to the artist; if someone who may have seen that work on display approaches the artist directly to purchase it, is the dealer owed a commission?

Again, artists and dealers view this issue differently, although there is no unanimity of opinion on either side. Many surveyed artists have said, "If the dealer couldn't sell it, I wouldn't owe him anything," while sculptor Alice Aycock says, "I would owe the dealer a commission, but maybe not the full 50 percent. I would try to figure out what the dealer has done and what I've done, basing the amount of the commission on that."

However, George Adams, co-owner of New York City's Frumkin/Adams Gallery, took the view that the dealer is owed the regularly agreed-upon commission because "the sale would not have been made but for the patronage of the gallery. A gallery provides all kinds of support services as well as a forum for presenting the artist's work, and the dealer would rightly expect that these costs would be paid for by the commission."

At times, an artist who is in a long-standing relationship with a gallery or dealer privately sells a work that was never even displayed in the gallery, and the commission question arises again.

In this instance, one might easily understand an artist's decision not to pay a dealer commission for a sale when the dealer had nothing to do with it. On the other hand, dealers themselves consider that some commission may be due them, claiming that the artist's name and brand— the reputational elements that brought the collector to the artist's studio in the first place—were the direct result of the dealer's efforts.

The issue of whether or not to pay the dealer's commission, of course, only applies to artists who are not in "exclusive" relationships with their dealers—that is, they have not formally agreed to name the dealer as their sole agent for sales. In some instances, artists write into the consignment agreements with their dealers that collectors whom the artist has personally cultivated are an aspect of the market that fall outside the realm of exclusivity.

In general, it is wise for artists to discuss these and other issues with their dealers at the beginning of the relationship, formalizing their agreements in either a letter or formal contract, and amending as circumstances arise. You don't want the dealer to find out that something has been taking place behind his or her back. As an example of this kind of ne-

gotiation, it is not uncommon that the artist (who has the final word on the prices for his or her work) allows the gallery to discount works a certain percentage but demands that this discount be deducted entirely from the dealer's commission.

Some dealers do far more than others for the artists they represent, of course, and some artist-dealer relationships seem more adversarial than mutual. In order to minimize direct competition between the two, for instance, many dealers discourage their artists from selling privately in the same market area. In an ideal and a practical sense, the dealer and the artist should be working toward the same goals. The payment of a commission tests this bond.

Daniel Grant is the author of several books, including *The Business of Being an Artist* and *The Fine Artist's Career Guide* (Skyhorse Publishing).

ART AND THE STEAL

Protecting Your Intellectual Property

......................................

by Sean J. Miller

//

Artists who show their work online risk being ripped off, but those who fight back can triumph.

It was October, and fiber artist Mimi Kirchner was slammed with holiday orders. Kirchner, who works from her home studio outside of Boston, was being featured on the popular home décor and gift website One Kings Lane. Her handmade wool dolls sold out in just two hours, and the overflow sales cleared out her Etsy shop. Then the e-mails started.

A supporter told Kirchner that Cody Foster, Inc., a wholesale supplier for West Elm and other chains, had possibly pirated the design of her lumberjack doll, turning it into Christmas ornaments. At the time of the fall 2013 incident, she says, "I didn't even think about it. I didn't pursue this legally because I knew it would be a huge amount of emotional energy, and even if I fought them, it wouldn't result in very much money."

Kirchner's story isn't unusual in this day and age of artists and makers putting their work on the Internet for all to see. While tactics such as watermarking photos may dissuade some from blatantly copying designs, that hardly deters others.

Kirchner wasn't the only independent artist that Cody Foster, Inc., was accused of ripping off. Artist and author Lisa Congdon claims she had her 2011 illustration of a reindeer pirated by the company and transformed into ornaments. "The copy is so blatant—down to the design elements on the animals' jackets—that it literally made my stomach turn when I saw it," Congdon wrote in a blog post in 2013, when the ornaments were discovered.

Between Congdon's blogging and Kirchner's social media posts, a host of online supporters who became aware of the transgressions were further galvanized. "It was sort of

like the (expletive) hit the fan because it wasn't just me," says Kirchner.

The Internet has created a new Golden Age for the arts. From Pinterest to Instagram to Tumblr, artists are able to build a worldwide audience of fans and customers. But with exposure comes dangers. These sites give intellectual property (IP) pirates an opportunity to pilfer, and in some cases the artists have little recourse. Other retailers that have been accused of knocking off artists' work include Zara, Urban Outfitters and Anthropologie.

IP piracy by corporate behemoths is just part of the problem. Artists say there's also a growing issue with what's called "design

Fiber artist Mimi Kirchner says her lumberjack dolls were copied and made into ornaments.

creep," wherein a company will start selling a product that is somewhat different from the original. Artists may not ever realize their work has been appropriated; the lucky ones often find out through social media or e-mails from strangers who happen to notice similarities.

"I don't really know which is the major threat: major companies or smaller guys nipping at me," says James Soares, an artist and designer based in New Bedford, Massachusetts. Soares creates modern, geometric designs that are available as prints or applied to bags, pillows, and clocks sold through his own website and the online retail site Society6. Earlier this year, a customer contacted Soares to say that Urban Outfitters had taken a design strikingly similar to his and put it on a skirt.

He tried to order one of the garments online, he says, but the company caught wind of it and stopped selling the skirts before he could buy one. Soares didn't want to comment on his dispute with Urban Outfitters, but says the courts are an inconvenient way for

artists to fight IP theft: "Unless I want to spend half my time chasing thieves, there's no redress." However, some argue that not taking action gives companies even more incentive to take advantage of artists.

Soares believes that artists should be able to go through a small claims legal process and tap into the revenue stream of the entity selling their designs. It would be a kind of shotgun marriage, he says, "but it would save us both time, and they could continue selling the product."

The legality of IP theft gets even more complicated when it crosses international borders. Kirchner maintains that a Dutch clothing company

Kirchner's 2014 line of limited-edition ornaments for West Elm included this fox and raccoon. (Photo courtesy of West Elm.)

sold a line in Australia that incorporated one of her designs. Kirchner's husband contacted the company's attorney, and she received a settlement "equal to what I probably would have gotten paid if they had just hired me to do a licensing job."

Kirchner's experience with Cody Foster also had a happy ending. After the online kerfuffle over the pirated designs, West Elm announced it was pulling all Cody Foster products.

"We require from our suppliers and the vendors that we work with that they are attributing the work appropriately," says Abigail Jacobs, a spokeswoman for the company. "If we ever think that that's not the case, then that's someone we would end a relationship with, as we did in the case of Cody Foster."

In a best-case-scenario twist, West Elm took notice of Kirchner's designs in the wake of the dispute, and she has since designed a line of ornaments for the retailer. "It's a validation, in an odd kind of way, when West Elm buys your stolen design," says Kirchner. "Nobody's going to steal it if it's not good."

West Elm currently collaborates with independent designers through their innovative Designers + Makers program, which allows them, according to the website, "[to] help emerging and established artists and makers reach new markets while preserving the integrity of their designs."

While some artists continue to struggle with copyright infringement, Kirchner shrugs off the notion that continuing to post her work online could lead to more IP theft. "The two times that I have been ripped off by companies, I have really come out better for it," she says.

"The first time I got a really nice financial settlement, and the second time I got a licensing deal with West Elm. Honestly, they had never heard of me until this whole thing blew up. They looked at my work, and I have a line of my ornaments with West Elm now. It has my name on it. I'm their artist collaborator. I think that maybe I'm the only person who came out on top here."

The Best Defense Is a Good Copyright Registration

How can artists protect their online work from being stolen? While there's no sure-fire way to guarantee security against piracy, attorneys and agents agree on one thing: Artists should register their work with the U.S. Copyright Office. If an artist does decide to take a case to court, that documentation can be a huge asset.

"Having a registration in place for your work is really important," says Scott Burroughs, a copyright attorney with the Culver City, California law firm Doniger/Burroughs. "If you don't have [copyright] registration in place, you can still proceed with your claims. You just have to obtain a registration after the infringement, and then you're limited in that you're not able to recover attorney's fees and damages."

Burroughs adds, "The civil court system is in place to even the playing field. It's really a powerful tool that the artist has to protect themselves."

Sean J. Miller is a journalist and playwright based in Los Angeles, CA.

Excerpted from the Spring 2015 issue of *Artists & Makers* magazine. Used with the kind permission of *Artists & Makers*, an F+W Media, Inc. publication. (www.northlightshopcom)

DREAMS FROM NIGHTMARES

An Interview with Peter Sís

by Will Hillenbrand

Illustrator Peter Sís draws from his experiences living under Communist rule in Czechoslovakia and the creative freedom that followed.

Filmmaker, illustrator, and author are just three words to describe Peter Sís—a creative genius and winner of a Golden Bear Award, eight New York Times Book Review Best Illustrated Book of the Year awards, three Caldecott Honor Book awards, and a MacArthur Fellowship, among others. He also illustrated *The Whipping Boy*, which was awarded the Newbery Medal.

Sís attended the Academy of Arts, Architecture and Design in Prague and the Royal College of Art in London before he was commissioned by the Czech government, in 1984, to create an animated film for the Summer Olympic Games taking place in the U.S. The film was cancelled, but Sís was granted asylum and stayed in the U.S. Here, he talks to accomplished illustrator Will Hillenbrand.

Peter, the question that I'd like to start with is actually a quotation: "What is essential is invisible to the eye." It's a quotation that comes from Antoine de Saint-Exupéry, one of whose books you've just illustrated. That quote was also on Fred Rogers's office wall.

Just the quotation in itself is wonderful. For me, it has other meanings because I grew up in a society that wasn't open. It was essential that lots of things worked as a hidden message. I appreciate that you would mention Mr. Rogers. Not growing up in

A spread from *Madlenka* (the circle on the right page is a cut out) shows the protagonist visiting her neighbor Eduardo's store. Madlenka says, "His store feels like a rain forest," and accordingly, Sís illustrated the store in lush greens with an abundance of plants and produce.

Madlenka, written and illustrated by Peter Sís (Frances Foster Books, 2000)

America—I came over here at age 33—there were some things I had to catch up on. Mr. Rogers was one of those things. I didn't know what was happening in children's television, but Mr. Rogers struck me. His was much slower and kinder than other television programs. If I look back, he was assuring me that there are things in America that are kind to children.

I think one of the reasons I did a book about Antoine de Saint-Exupéry was that he was like Mr. Rogers in his work; Saint-Exupéry did lots of very sensitive, smart things. He was a pilot and he also wrote books, but also he was a curious human being with a pure heart. In his books and in his life, he showed so much care for all people and what was happening to this world. He has another quotation that I think of very often about how there are more and more stores where you can buy almost everything, but you cannot buy friends in stores, and friends are most important in your life. These are the little things he said in the 1930s, but they're so meaningful today, too.

It's the essential bedrock past all the business of our world. With your work, and with that book, there are parallels: conflict, war, and adventure. If I were working with a young illustration student and said, "Put those in your work," she might say, "How do I draw them?" Well, you draw from your experience.

Being uprooted, being an immigrant, and coming to a completely different country … it's like going from one planet to another. As a boy, I always loved to draw. I liked to draw stories, and then I got into illustration by coincidence. I think what I was trying to do was to still be that little boy who loves stories but, of course, I had to fit within a

certain concept and business concern, which was publishing houses and editors. I was lucky with the editors but, if I look back, what I did was try to be like that boy who's playing; I was trying different styles. I was telling different stories.

At this point, I've been living in America longer than I lived in my home country and it's funny because I don't feel like it. I think lots of my work comes from that in-between moment—growing up with these fairy tales from the Brothers Grimm or Hans Christian Andersen and the graphic style of Europe, and then coming to the new country. I thought for many years that I could bring these two worlds together because, I thought, they're not that far apart, but now I'm almost giving up. Whenever I get close, there's still a gap there.

The movement called Surrealism—we think of Dali and Magritte—your work touches that. There's a mythology that's connected to your work, which is rooted very deeply, not only in time, but also in the child's experience.

People want to say "Surrealism" or "Pointillism." They want to put art in one box, but I think these images contain much more, and when we don't know exactly what to call it, we call it by a name.

I also went to art school for a number of years. In Europe, as it often still is, you'd go to art school and, even if you were studying to become an illustrator or animator, you'd say, "I'm an artist! I can't be doing commercial art." I was almost relieved to find out later, in America, that there are people who study illustration, and they're almost like my grandfather who made signs for stores and restaurants. You get a job, you get dimensions, you do it, you turn it in and you get money. You don't say, "I'm trying to create this very moody painting."

When I was a little boy, I had a spine injury and couldn't move. I was bedridden for almost a year when there were no televisions and no computers, and I would be given all kinds of books. I loved the books where I could find lots of stories going on in little details, like stories outside of the stories or under the stories. I'd already read the main story; I knew it was about Little Red Riding Hood, but then I was looking for different leaves and berries in the forest. I like to think that I am writing for somebody who has time to find all kinds of things.

It was most telling when I was in Virginia and I went to this juvenile detention center for a book talk. It was strange to go to any kind of prison in America. These boys had studied my books for a month! I was sitting with them and they would say, "Why did you put a brick in this corner?" It was the most detailed analysis of what I did. Other children are busier, or maybe I don't hear from the children who somehow find the time.

That's interesting, Peter, because you've touched on time. There was a vacuum of time created for you, and these young people have time. With film, in which

A dragon!

Even the leaves have dragon faces in this spread from *Komodo!*

Komodo!, written and illustrated by Peter Sís (Greenwillow Books, 1993).

you have a background, and with books, the element that we introduce to our audience or require of them is time.

That's an amazing observation because I was just trying to explain to my kids that time didn't exist in the same way when I grew up, thanks to politics. Now I can say it was the Cold War. We couldn't travel anywhere; we couldn't leave where we were. We had time to talk about whatever was happening or not happening and do drawings that we thought had no purpose because they weren't going anywhere. Time stood still. Somebody would come through Prague, say a tourist from Germany, and we'd say, "Wow, what is he doing here?" Now, of course, it's so different. There's no time for anything. I think my productivity in America comes from the fact that for so many years I was stuck in this time warp, not able to do anything, so I was eager to do something because all of a sudden I could.

One of the comments we might get as illustrators is, "That looks like it took a lot of time." Well, it does, but we don't pick up a book and say, "I love this because it took time." We love a book because it resonates and connects with us. We have this tapestry that, if we give ourselves permission and the time to go there, is richly rewarding.

I know it's happened a few times when I was doing something and thought, "Where did I come up with this? This is really taking a long time," but it was essential for what I was trying to do. I was just looking at the great interview you did with David Macaulay (July/August 2014), and thinking about his cathedrals and mosques and again I

see his intentions. The idea is there beforehand, and it's not a question of, "How many bricks will it take?"

It's what we experience as artists. We're committed to this space, this page we're making; it's going to take time. How does that feed you?

It feeds me and it doesn't feed me. I think I might be done with a project, but then I realize that time moved in some different way than the time in general life, and that observation, for me, is striking now. How did time fly by so quickly? Both of our kids left home for college and everything changed fundamentally. Lots of books for me are, "Oh, this is when Madeline was losing a tooth; I did this book then," or, "This is when Matej liked trucks." What happened to time? How come they're grown up now? It only took 20 books!

I also think you're very humble. That being said, I can take a look at your collective body of work and say, "It's going to live outside of time." Your works are, individually and collectively, classics.

I have to go back to when I got a chance to do my first book in this country and think of how exceptionally lucky I was to get into this situation. Who knows how much more time it would have taken if Maurice Sendak hadn't helped me, because he didn't have to help me at all.

Can you talk a little bit about Sendak and that relationship?

It was very strange. I was in Los Angeles making a film. The film didn't work and I was without a job, trying to go to other film companies and say that I had some ideas. People thought my ideas were too "surrealistic." I got offered a job doing backgrounds for the show *The Smurfs*. I was seriously thinking about it, and now I'm glad I didn't take it, but it was $450 weekly, and I didn't go for it. I was basically frustrated. There I was, in Los Angeles as a new immigrant; I couldn't get a job. I didn't know what to do. I taught, but the school didn't like my way of teaching because I was not kind enough to the paying students.

Then, the head of the Los Angeles Municipal Art Gallery, Josine Ianco Starrels, whose father is actually one of the founders of Dada, took some Xeroxes of my art and sent them to Maurice Sendak in Connecticut. He called me in Los Angeles and said, "So, you want to do children's books." I was at the end of any ideas about what I should be doing. I had gone to art school in Prague and in London. I had done illustration but I also did animation. I also did rock music record covers, and I was hoping I would be sort of a hip guy who paints the rock-and-roll drum kits and posters. Illustrators were always very gentle, quiet people, so I had never said, "I solely want to do illustration." All of a sudden, I have a phone call from Maurice Sendak. I didn't know Maurice Sen-

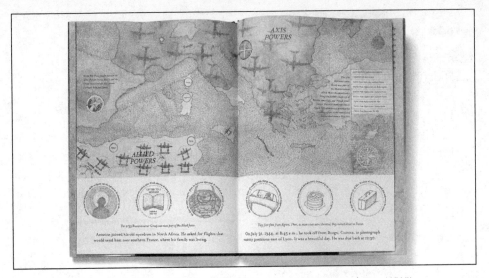

A spread from *The Pilot and the Little Prince,* showing a map of air routes during WWII.
The Pilot and the Little Prince: The Life of Antoine de Saint-Exupéry, written and illustrated by Peter Sís (Frances Foster Books, 2014).

dak as well as an American kid knew him. Only later did I find *Higglety Pigglety Pop! Or, There Must Be More to Life.* I thought, "This is fantastic!"

He offered to help me. He talked to me for about an hour and wanted to know what I thought about democracy, what I thought about Reagan, what I thought about the libraries and the chances of poor people buying books. "This is 1982," he said. "Publishing is deadly. It's about money now." Since then, I've known he had a dark side. I was fresh off the boat and thought the American Dream was, "If I can do something, I will." Sendak said, "Don't think that, and most of all what are you doing living in Los Angeles if you want to create thoughtful books?" I said, "This is where I came. I don't know any other place in America." He said, "You have to immediately move out of there because it's the most terrible and pretentious place." Then he said, "Keep on drawing; you will hear from me again."

Sendak called me next when he was in Los Angeles. I only found out recently that he was getting a big award at the American Library Association Conference, the Laura Ingalls Wilder Award. He called me and he said, "Okay, I'm in LA and I could introduce you to three or four publishers who would look at your work." I thought, "I'll get into books, and I'll turn them into films. In America, if you make books, you will probably sell a few million copies because there are so many millions of people," so I was clueless. When I came to New York, I was expecting that Greenwillow Books would take care of the apartment where I would live and also give me some money to buy clothes. I was still not sure about capitalist societies so I went and said, "Here I am," and they went,

"Okay, so here you are; welcome to New York! We will see more of you and we will give you a contract." I thought, "Is that it? I have to find a place to stay now?

I have to find and buy the table, chair and ink?"

My first book I wanted to dedicate to Maurice Sendak because it wouldn't have happened without him, and I still have a letter from him where he said, "I don't think you should do that." He said I should dedicate it to my mother. Later, I sent him all my new books, but I didn't really see him too often because I got married and had kids, and he was always such a smart man but pessimistic about what was going on in politics and in the world. I was more like, "No, everything is going great!" In fact, he was right. I think so often about that first hour when he told me how things would be. I also come from the Czech community; we always expect some foreign army to take over and destroy everything and, if you ask somebody how he is, he says, "It's terrible. I'm really bad and tomorrow's going to be even worse." It's an attitude for centuries, and Sendak was somehow feeding into this, for me. I already was dealing with the fact that I couldn't go back home. I couldn't be exposed to that negativity (the remembrance of suffering and invasions) because it was a dark force taking over me, but now I'm sorry, because he's not here.

You ended up receiving this very nice award, the Mazza Medallion of Excellence for Artistic Diversity, last night. It encompasses media—a mastery of many different media—and techniques, so we should probably talk a little about technique.

I love technique but I don't feel I'm experimenting enough. I still feel guilty 50 years later that, during art school, when I could have studied graphic techniques, we were experiencing revolution in Prague. I spent most of the time in the streets and cafes talking and demonstrating instead of in the studio, etching a plate. We had a whole studio in the school devoted to the tradition of graphic arts. I only went as far as the lithographic stone. It's a gap in my life, and now I try to do similar things with pen and ink and, of course, that becomes something completely different, so in a way, I have a big problem in life trying to resolve what I sketch and how I think visually and how I finish the art. My sketchbooks or my dummies are very free flowing. I can do them in just a few days, and I put together collages of different things that are visual references, and they've got a certain flow and they've got a certain elegance. Then, when I get to the finish, there's some big psychological problem and I think, "Oh my God, I'm in the United States of America. This book might be seen by many people." It's stage fright.

I really prefer my sketches. With my last book, about Saint-Exupéry (see page 94), I did five different dummies. I was playing and I enjoyed it. I just finished a book about ice cream, in which I've tried to simplify, because ice cream should be simple-pure color and joy. The publishers said, "No, no, you should do something with maps and you

The Berlin Wall falls in *The Wall: Growing Up Behind the Iron Curtain*. Throughout the book, Sís conveys himself as a boy on a bike. On the left page, the boy is flying.

The Wall: Growing Up Behind the Iron Curtain, written and illustrated by Peter Sís (Frances Foster Books, 2007).

should include somebody like this… ," but we all deal with it. You sort of paint yourself into a box.

Well, to a point, and maybe that's the template that we fit in; that's our box! I'm going to look at one page here in *The Pilot and The Little Prince*, and in this particular page we have a painting at the top and we have ink at the bottom. Is that watercolor?

Actually, that book is mostly watercolor except for two illustrations. Watercolor goes with the air and flying. Since our daughter was born, I've been trying to have things look as if they're emerging from the background. To celebrate her birth, I began creating the book *The Three Golden Keys* in 1992 in which I played a lot because, at that time, I had a chance to try everything. I was doing lots of editorial illustrations so I ran lots of tests, doing work for *Time* magazine or the *Atlantic Monthly*. I was trying a technique and then I'd say, "I really like this. I can use it later." At that time I was using a lot of gesso, then oil pastel, then layers of oil pastel, letting it dry, and then I would take an X-Acto knife and scratch the surface. I liked the idea; it was almost like etching, but I was creating these amazing colorful and textural mysteries, and it led to this.

My wife was pregnant and she said, "I don't think this residue from oil pastel is really good for anybody," so I switched to watercolor. That still brought lots of questions on her part so then I established a studio outside of the house, but I lost the continuity in the book so there is only one picture of scratching into oil pastel.

In Exupéry's book *Night Flight* he actually has a chance to describe his own crash. People asked, was he guilty? Did he fall asleep? So he wrote a book about his life, about

flying, and then he says, "We are flying and see this beacon of light and we are high in the clouds and all of a sudden we hit the sand." For five days he and his mechanic had only grapes, half a bottle of red wine and some chocolate. They were not prepared and they were wandering in the desert. It was an incredible miracle that they hit the sand. The wings broke off, and because of the character of the sand in the Libyan desert, the two were able to sort of slide into their landing, and they ran away quickly because they thought the plane was going to explode. It didn't explode, but the whole plane was in pieces in the desert; they didn't know where they were, and they were wandering. So the idea in *The Pilot and the Little Prince* is that they go in different directions and they meet a little fennec (a desert fox), which would become the fox in *The Little Prince*. I knew from the beginning how I wanted to draw this story, because everything in the book was supposed to be the personification of something: for example, what he sees from the air reminds him of faces or people. I wanted the color to be like a night in the desert: you can see but it's dark. I used watercolor, and I went over it many, many, many times to make these deep shades of color.

And here, in the same book, we've got the tanks at the bottom, and the script?

You know it's annoying because the wet watercolor is so much brighter than when it dries; the printing cannot do it justice. The watercolor also determined that I had to have a studio with an oven because I would dry the pictures in front of the oven. At one point I was cooking while I was making pictures. Those were the days of grease sparks!

That's mixed media! Tell me how you think about color when you're making your books. Do you have colors for certain things that resonate with you?

I'd say the colors are determined by my vision of the book at the end. With Saint Exupéry, because he's flying and it's his story of flying, there are lots of blues and lots of oceans. I remember in the book on Darwin (*The Tree of Life: A Book Depicting the Life of Charles Darwin—Naturalist, Geologist & Thinker*, published by Farrar, Straus & Giroux) because it's set in the Victorian time, I thought grays, beiges and greens. Columbus (*Follow the Dream: The Story of Christopher Columbus*, published by Knopf Books for Young Readers), many years ago, was done with lots of blues, just because it was oceans ("In fourteen hundred and ninety-two, Columbus sailed the ocean blue.") again. These were large oil paintings I could leave on the floor. Then came the kids and crawling! The pictures got smaller, and I would not leave them on the floor overnight.

Now, of course, with *The Wall*, you have this motif of walls. The motif seems a reflection of your own experience, whether expressed through your account of Galileo's (*Starry Messenger: Galileo Galilei*, published by Farrar, Straus & Giroux, paperback published by Square Fish) struggle with conventional thinking or, as it is here in *The Wall*, with a visual motif.

Sís illustrated one of his father's stories from Tibet in *Tibet: Through the Red Box.*

Tibet: Through the Red Box, written and illustrated by Peter Sís (Frances Foster Books, 1998).

I think it's the most important motif in my work. When I look back, I think, how can somebody tell you, "You cannot cross this wall! You need permission to cross this wall. We'll keep you." It's interesting how, when you're born here, as my kids were, being American, you don't understand. My son, even today, even with all these books I did, said, "If you didn't like it (in Prague), why didn't you just go away?" and I go, "You couldn't go away! You were stuck there." It's a Czech saying that, "If you have a full stomach, you don't believe the hungry person." So walls were always in my work as the main message. Some people find the motif offensive; people who have families or relatives who were killed in the Communist camps say, "Well, this is about some walls. It was more than that. It was about life and death; it was about freedom." But, for me, the right to really be free or to pursue happiness, it's the most important, and it's restricted by a wall.

I think that when children experience this, when they see it, they know. They see that in your Mozart book (*Play, Mozart, Play!,* published by Greenwillow Books). What Mozart's doing in that book is following the rules of his own creative self, but he also blossoms from inside. I think what a child relates to, and the child in me relates to, is that there are walls and barriers in our lives, and some of these, of course, are real political experiences. Making it personal, that's what you've done, so that a child can relate.

I remember Maurice Sendak was so upset when he wanted to be an activist with *We Are All in the Dumps with Jack and Guy.* Because they were Sendak's, store owners put piles of these books everywhere, expecting a Christmas bonanza, and then, when they realized the book was really about poverty and AIDS, the books just got trashed. Book-

sellers started to remove them, and it was incredibly painful. I remember that Sendak and I spoke, and he felt as if he had this important message for the world about how the world should behave, and people, for commercial reasons, didn't want to see it, just as he'd warned me when I first got into illustration.

I think art, at some point, can agitate. To make the pearl we need a grain of sand. I'd like to talk about Madlenka before we end. I love the way you did the perspective, but I also wanted to talk about how the typography developed, even on this page where the type circles the page and then it turns into the following page. It's almost like a little wiggle of the tooth—the tooth is getting loose here, I think. Also, let's talk about cutting windows in a page so the reader sees through it to different worlds. In a way, you're celebrating the diversity that the artist's eye sees in beauty and variety—and not the sameness of things.

That was a very joyful time because we were in downtown Manhattan, and my daughter was a very energetic little girl. Day to day, I realized that everybody on that block was from a different country. For me, it was something worth celebrating. The idea of the tooth also happened coincidentally, and I think the design of the type, if I'm not mistaken, was due to our director, Filomena Tuosto, the wife of illustrator Ed Young. I liked the idea of entering different worlds by having almost a third dimension—going into those worlds.

I'm a huge fan of your work and I appreciate so much the carefulness and the thoughtfulness, and that you're sharing your work with the people that are most important to me—the young people that see the world new.

What you said today about the children and how they see the world new—that's what I need to hear. I got a little bit of that from my own children, but once they started getting bigger, it happened less and less often, and now I was just thinking that I have to find some way to remind myself of that message. Children do not write letters to authors anymore. It would be nice to have some sort of discussion with the kids to know what they think because I'm completely missing that. What you said was very much appreciated because that keeps me going.

For more information about Peter Sís, visit www.petersis.com.

Will Hillenbrand has interviewed David Macaulay, Tomie dePaola, Melissa Sweet, Kevin Hawkes and Ashley Bryan for *The Artist's Magazine*. His latest book is *Snowman's Story* (Two Lions, 2014). Visit his website at www.willhillenbrand.com.

Excerpted from the July/August 2015 issue of *The Artist's Magazine*. Used with the kind permission of *The Artist's Magazine*, a publication of F+W Media, Inc. (www.artistsnetwork.com)

FULL STEAM AHEAD: FORGING A UNIQUE BUSINESS IN GRAPHIC ART

An Interview With Seth Lyons

by Tina Topping

"It's been a very mixed bag of experiences, each presenting new challenges and a development of new skills." —Seth Lyons

Seth Lyons of Columbus, Ohio has been working diligently as an artist for over twenty years, most recently tackling commissions and selling his intricate fantasy illustrations. Floating between hand sketches and digital coloring, his work has a unique stained-glass quality that draws the viewer into the frame. He attends a variety of conventions and festivals, recently appearing at the Tri-State Comic-Con in Huntington, West Virginia, as well as Cincinnati's Comic Expo and the International Steampunk Symposium. His illustrations can be seen in comics such as *Stiletto Heights* and *Johnnie Zombie*, and he produced his own book, *Abnormal Bureau of Investigation*, in 2011.

The Benefits of Additional Training

Seth's personal approach with customers and the improvement of his technical expertise as a graphic designer has helped create a long-term, growing business. He began his journey as a working artist by earning a bachelor of arts in fine arts from Otterbein College, as well as an associate of applied science in visual communications from Sinclair Community College. He feels it was helpful to get both degrees. "The Fine Arts program allowed me to

harness my artistic skills, while the Visual Communications program focused on the digital and professional aspects of being a graphic designer." This combined training gave Seth an edge over other graduates by teaching him how to create in a digital platform, making him attractive to a wider range of employers. He interned as a 3-D animator while in college, building on the art experience he had already achieved by working for a silkscreen printer.

His journey of the past two decades began right after graduating high school, where his early days were spent in silk-screening companies, learning color separation skills by hand. As digital media became more prevalent, he continued with silk-screening jobs. "Later on, I worked for a broad spectrum print company that did everything from textile printing to vehicle wraps."

Tools of the Trade

His favorite medium has changed over the years. Seth used to prefer pen and ink on Bristol or illustration board, but now it's more mixed media. And while he still uses the computer, he finds himself venturing toward hand coloring versus digital. "I miss the total control the computer provides, but relish the challenge of honing my skills to achieve the look I want by hand. It forces you to focus more because there is no Undo button. I still love the pen and ink, but find I get a better product by using different colored inks for my outline work."

Nerissa Along the Reef
Seth's obsession over the tiniest detail is apparent here, including the proper placement of every scale on Nerissa's tail.

Seth doesn't limit himself to the same tools for every project. "I'll use any tool available in order to achieve the look I want. That means paint, markers, colored pencils, acetone, and more." Early in his career, it was more pen and ink with digital enhancements. At that time, the process was more involved, especially with color separations. Seth recalls, "Razor blades, Zipatone, Rubylith, and Amberlith were commonly used to do color separations by hand, until the computer phased them out. I would still do line drawings and would have to process them on a clear photographic stat. I don't miss that labor-intensive process!" This willingness to step out of his comfort zone has made him adept at using dif-

ferent tools, which also makes his illustrations more unique and recognizable as Seth Lyons pieces.

Multiple Sources of Income

Seth has always recognized the importance of multiple streams of income, often working as a part-time freelancer in addition to his full-time job. He would do illustration work ranging from private commissions to comic art. "It's been a very mixed bag of experiences, each presenting new challenges and a development of new skills."

Maintaining strong relationships with previous employers and clients has provided Seth these opportunities for side projects. This highlights the importance of staying on good terms with contacts both inside and outside the industry. "The self-employed na-

Navigation of the Sword of Damocles
An interesting spin on the "Sword of Damocles" phrase.

ture of this business can be feast or famine, so I've found it beneficial to take on part-time work, as well." Repeat customers are the life-blood of any business, but it's often difficult to gain this type of following when doing single commissions. It's important to remember that the relationship doesn't end when the artwork is delivered. The friends and family of that client will see the work, and if the client speaks highly of them, that artist could receive referral projects.

Seth's part-time freelance work has been quite varied. "A fair amount of my work is for textile printing. They'll need custom illustrations and come to me for help. It ranges from T-shirts to pamphlet work." He's also done comic illustrations, logo work, yard signage, vehicle graphics, and storyboards for a local video company. At times, this wide variety of projects has made him feel like a jack-of-all-trades, master of none. And while there are days when he wishes he had focused more on one area and specialized in it, Seth concedes it might not have been as interesting as the array of freelance work he's been doing. This growing experience in a broad range of industries makes him even more marketable.

Finding His Niche

Every artist brings a unique set of talents and interests to their projects, and it can be challenging to find a type of work that is completely engaging. Seth found his niche in Ste-

ampunk, which is a genre that weaves modern technology with the Victorian era. It's often described as "the future that could have been" and has inspired countless movies, books, and music. Many fans cite *20,000 Leagues Under the Sea* by Jules Verne and *The Time Machine* by H. G. Wells as inspirations for the current Steampunk movement, where futurist machines were imagined against a backdrop of elegant surroundings from the nineteenth century.

"I love Steampunk illustrations. Something about the aesthetic always intrigued me." Seth's incredible attention to detail naturally lends itself to the intricate nature of metalwork designs found in this genre. But while his work is recognizable as Steampunk, Seth doesn't feel that he's a purist. His

Steampunk Frankenstein Family
An eerie green glow is woven throughout, from the cylinders in the background to the brooch on The Bride's corset.

Steampunk creations are truly one-of-a-kind and stand apart from the typical fare. "I like to bring other cultures and fantasy aspects into the work, and I try to depict a bigger world than just that of the Victorian mainstream."

Seth often works with cohesive themes and illustrates several pictures in a series. One of his earlier Steampunk series was influenced by Lewis Carroll's *Alice in Wonderland*. Featured characters included the Jabberwock and Alice with the White Rabbit. Taking characters from Victorian-era literature and adding Steampunk elements is a specialty of his. Another perfect example is his more recent *Steampunk Frankenstein Family* illustration, based on the early 1800s novel by Mary Shelley. "Conceptually, I wanted to do a Steampunk series of classic monsters. The Frankenstein clan seemed a natural fit for both the genre and a family portrait composition." Seth had the concept in mind, but the challenge was translating that to paper and making it fun, but not campy. He's always striving to add interesting details and provide as much information as possible without overwhelming the viewer.

Discovering this niche has given Seth a path for showcasing and selling his art. He's able to target this fan base online and attend special events, much like gaining a following for comic illustrations by targeting comic events. His first-time vending at a Steampunk convention was during the International Steampunk Symposium in Cincinnati, Ohio in 2015. These special events account for a sizable amount of Seth's overall sales and give him an op-

portunity to meet potential clients in person.

An Eye for Detail

Seth's illustrations are constantly evolving, and he's able to see a progression from his earlier pieces to now. "The compulsion for detail has always been there. It's time consuming, but worth it. It's one of the elements that sets my work apart." He's been known to obsess over the tiniest details. In doing so, viewers find something new each time they see one of his drawings. When possible, he even hides his signature, so that it blends into the overall composition. "I'll render anything just to bring an observer back into the piece and engage them."

Wonderland Ensemble
A perfect example of Seth's interesting character placement, viewers often comment that they find new little characters every time they see this illustration.

"I do a lot of comic illustrations, and I always have fun with big collage pieces or scenes with multiple characters." His record is 655 characters in one mind-boggling piece. "I enjoy creating these massively intricate pieces, because people have to really look to find out what is going on in my work. I'll even deliberately hide things for the viewer to find."

Seth has also drawn some illustrations for literary conventions that have a wide array of contrasting imagery and themes, which makes it difficult to develop a cohesive image. Again, his eye for detail made all the difference. "The end results are very rewarding when you feel like you've finally succeeded."

Growing the Business

For most creative people, it's daunting to manage and grow a business while also bringing artistic visions to life. Seth feels the best way to ultimately become successful as an artist is to

find a partner with a head for the business tasks that need to be done. Some aspects are important for the artist to do on their own, such as networking. As Seth mentioned, he's found additional work simply by keeping in touch with past clients and employers.

When it comes to growing his business, using a personal touch has worked best for Seth. After going to trade shows and seeing artists who never looked up from their drawings, he began to see a correlation between their lack of customer contact and low sales. "You have to sell yourself first and engage the customer in a genuine and comfortable manner. You never know who

La Madame En Rouge
Every pebble in the sidewalk and every fold in Madame's fabric is clearly visible here.

you'll meet and what potential opportunities could be present." And there may be times when the artist (as a business owner) gives incentives to the audience and finds interesting ways to engage them. "I did a panel at a show last spring and attendance wasn't as high as I would have hoped. However, I put a positive spin on it by giving away original art pieces to those who attended, to show my appreciation." It didn't take long for word of his generosity to spread throughout the rest of the show, which encouraged more people to visit his booth. "A little goodwill goes a long way."

Seth is a natural networker, which is crucial to gaining new clients. When asked about the best places to network, he answers as honestly as possible. "I guess online is the easiest answer. I prefer the personal touch you get at trade shows. You never actually know when your next networking opportunity will arise. I've even gained work while subbing on a recreational soccer team, so you just never know!"

The story of how Seth came to have his work showcased in a vintage clothing store is very interesting. "I had a chance meeting with the proprietor of The Alley Vintage and Costumes, where I ended up showing her a piece I had finished called *Oz Reimagined*. It had some Steampunk elements in it and a vintage feel to it. This led to being asked if I had similar pieces, because they could be sold on consignment through the store." Seth felt he needed to seize the opportunity, and began drawing more and more Steampunk illustrations. Rather than displaying his original artwork in a gallery, where it would be competing with other artists, Seth displays his illustrations in a store filled with vintage clothing and jewelry. It's a clever partnership that works well.

A Proper Attitude

Seth's biggest regret overall is not overcoming his fear of not being good enough and taking the risk to go into business for himself earlier in his career. "I wish I had ventured out on my own sooner, when I was younger and had more energy." But keeping a positive attitude and overcoming setbacks is imperative to keeping the business going and improving as an artist.

He offers this one bit of advice for anyone wanting to be a working artist: "Never be satisfied with your work! Always strive to become better and push your limits." When he finishes a piece, Seth tries to think of five things he could have done differently. This way, he already knows what he can improve for the next illustration. It's also important not to become attached to the final product. "I don't love my own work to the point it's difficult to let it go. I finish a project and move on to the next, trying to apply those new ideas or lessons I just learned." For Seth, the journey and opportunity to grow in his craft is just as important as the illustration itself.

No matter how many years experience an owner has, they will still make mistakes. Just as it's important to push through the first loss of a project or refusal of a bid, it's important to get familiar with failure and not see it as an ending. "There are days I still feel like that, but it comes back to having a positive mindset. That's the great thing about failures and mistakes. They allow us to learn from them. So it's more an evolution in attitude than anything else. I make mistakes every day. The goal is to not repeat them. To learn and grow."

Seth Lyons is a professional graphic artist located in Columbus, Ohio. He has illustrated for various independent publishing companies in addition to producing his own book *Abnormal Bureau of Investigation*. Original pieces are available at www.sethlyonsgallery.storenvy.com and facebook.com/SethLyons.7.

Tina Topping is a writer and performer who lives in Cincinnati, Ohio with her husband and daughter. She's currently the art editor for *Carpe Nocturne Magazine*.

FROM SARDONIC TO SERENE:SEEKING THE SPIRITUAL IN THE LANDSCAPE
An Interview with Kevin T. Kelly

by Daniel Brown

Kevin T. Kelly's paintings attest to the artist's journey from comic commentary to Zen-like states of contemplation.

It was as a studio assistant in New York City to Pop artist Tom Wesselmann that Kevin T. Kelly first evinced a Neo-Pop sensibility. Kelly's work in this genre has been acclaimed for the brilliance of its hypersaturated color and the flatness of the compositions, making his style a kind of hybrid between painting and graphic design. Showing the influence of popular culture and manifestations of same through the appropriation of the look of comic books, Kelly's work frequently skips the lighter side of Pop. Like Andy Warhol, Kelly understands Pop's darker intentions. The Neo-Pop world is a dystopia, after all.

Manifesting an interest in gender issues, Kelly's Neo-Pop work chronicles an increasing lack of communication between men and women and between individual people and the larger world within which they live and interact. Many of the pictures are thus overtly political, while often laugh-out-loud funny—art with a real bite. In his own words, the subject is "dysfunction; it's about lack of communication," sometimes made overt in thought balloons from the world of cartoons.

Allegories of the Human Condition

Kelly also insightfully addresses America's obsession with sex. Typically, if a Kelly man and woman are pictured making love, each or both have a cartoon balloon over their heads with

Situational Awareness (acrylic on canvas, 54" × 108") shows an extreme emotional dissonance.

images from the media feeding their sexual fantasies, as neither man nor woman is thinking of the other. Kelly is brilliant in depicting this feeding frenzy of media images that devolve into the most private parts of our lives, as he recognizes the extent to which sex remains America's great Achilles' heel. A variation on that theme may include a man and a woman gazing into each other's eyes while in the background warplanes are crashing and a soldier drowns.

Kelly's Neo-Pop universe is a world in which Pop psychology has run amok and where people shop for self-esteem; his name for these compositions is allegories, whose effect, he says, "is akin to the sharpened end of a stick, demanding one's immediate attention—a veritable assault of the senses—they were intended to be humorous, but given the sardonic subtext, they were ultimately tragic comedies about the human condition!" As Chicken Little would have it, the sky may indeed be falling, but a typical, white middle-class American would not be paying attention, or particularly care.

Formalism & the Floating World

What Kelly learned from his stint in Wesselmann's studio (1988–1994) seems to be more stylistic and formalist than narrative; he comments that "formalism was Wesselmann's narrative." Kelly also absorbed formalist ideas, both stylistic and sexual, from Japanese Ukiyo-e prints, in particular, and probably interpreted male/female/middle class values as indeed a "floating world" from which the Ukiyo-e word derives—viewing America as also a kind of masked world of fantasy. Kelly's Neo-Pop work, often collaged or collage influenced, is constructed out of contours and planes and the interactions thereof, and the frequent use of negative space interacts with positive space.

A Shift in Perception

Kelly's complete change—from Neo-Pop allegories to transcendent landscapes—began in 2009. It was a radical break, both in tone, narrative intent, design and structure. Approaching his 50th birthday, Kelly found himself in what he calls "a full blown midlife crisis." Turning inward, he re-evaluated his belief system, began meditating and hiking, and took up tai chi. "This shift had a profound effect on my approach," he says. "The tenor changed from shouting at the viewer to whispering." He explains: "After twenty years of visually screaming at people with my paintings, I'd moved in the opposite direction, looking at the space between the words, the silence in the talking—and contemplating what Taoists refer to as nothingness, that space or instance that precedes thought, yet gives birth to everything."

Whale Branch River (acrylic on canvas, 39" × 44") shows a river in Beaufort, S.C. The moss-covered stones of the foreground repeat the shapes of the clouds in the sky to suggest balance and a benign duality.

As a result, a new depth entered his sensibility, along with a longing for spiritual renewal and a romantic examination of the religio-spiritual aspects of landscape, linking his work to the Hudson River School painters of the nineteenth century in sensibility, if not in perception or design. As in his Neo-Pop works, Kelly retains a very tight sense of composition with very few visual elements in each landscape. One can readily call his landscapes reductionist, even minimalist. He continues using blocks of very flat and highly saturated color to stylize these spaces, a technique that gives us more of a sense of a place than a likeness of same.

Away From the Literal

As far as composition goes, Kelly describes the change this way: "In purposefully avoiding many of the conventions typically associated with successful landscape painting—use of foreground elements, dynamic angles, and linear perspective, etc.—I arrive at more the 'feeling' of a space rather than the literal depiction of it. The paintings might perhaps be more appropriately described as 'innerscapes,' or as my friend artist W.D. Gaither aptly put it, 'imaginary windows on the scenes,' in which the image has a feeling of being recalled or imagined rather than directly observed."

Kelly's color in these landscapes "vibrates," to use his word, as he uses complementary colors that approach the same value, thus creating reverberation. He prefers to push

color beyond the real, mentioning Paul Gauguin as a primary influence, preferring the nearly surreal color of Post-Impressionism. As his imagery changes, this hyper-saturated color remained fairly constant, as did the flat effect. "Although I've always considered myself an artist and I make paintings, I never thought of myself as a painter, at least in the traditional sense," says Kelly.

Masking Tape as a Tool

Devoid of visible brushstrokes, crisp-edged in outline, the landscapes depend on an unusual tool: rolls and rolls of masking tape that Kelly uses to isolate parts so he can paint within the

The curvilinear road implies infinite space in *Barns at Dusk* (acrylic on museum board, 12¾" × 17¾"). The rectilinear geometry of the buildings plays off the curve of the road, while the light in the far left outbuilding draws us with its warmth, and may represent enlightenment.

mask. "There is," he says, "an intuitive element to the process that belies the simplicity of it. I continually evaluate and refine the lines as I'm applying and cutting the masking tape. The process is more akin to 'drawing with tape' as opposed to any traditional painting process." Because so much of the surface is masked, Kelly says he is virtually painting blind. "I don't know exactly what I've got," he says, "until I peel the tape off."

The pictures, betraying no brushstrokes, almost look as if they're airbrushed until the viewer comes close and discerns the linear demarcations that indicate the prior presence of the masking tape. When making his "blends" of colors, he uses a bristle house painting brush; for smaller blends he uses Princeton series 6300 flats. Individual works like Midwinter Evening (not shown) are so flat that they feel as if they might be Japanese screens; the similarity between Kelly's landscapes and much of traditional Japanese painting is remarkable. Japanese screens and paintings from the Edo and Heian periods, in particular, look completely contemporary to our (often jaded) eyes; natural elements in these works are often overscaled, thrust forward into the picture plane and severely reduced to the most essential visual information, with large blocks of negative space as active in the compositions as positive elements are.

Landscapes of Transcendence

When Kelly moved from the mostly strictly rectilinear composition in his Neo-Pop work to curvilinear elements in most of the landscapes, it was a radical difference, implying the kind of rapid movement of a landscape seen while traveling in a car, at some speed, enhancing that sense of transience common to contemporary life and also essential to the Japanese

aesthetic, where the transitory equates to the most beautiful, the most meaningful. If you think of Kelly's compositions in this genre as snippets from photographs, the contemporary sense of transience merges with the ineffable infinite of Japanese art, and the combination and effect are transcendentally beautiful. Each landscape reflects aspects of the artist's spiritual search, which is the narrative within all the landscapes.

In *Twilight Perry County* (acrylic and gouache on watercolor paper mounted on panel, 7¾" × 10") Kelly works with a gradient of color from the top of the sky downwards. He leaves out borders and boundary lines at either end of the composition, implying infinite space while also dividing the composition at the midline.

The curve represents an infinite journey, a literal and spiritual one, concurrently. It also becomes an element of a road, making us, the viewers, the journeymen as well as the art patrons or visitors to a gallery. These dual roles force us to see Kelly's individual works in different ways at the same time, and it's quite a postmodern feat, a superior accomplishment with such spare means.

The Return to the Inner World

It can thus be argued that each of his landscape paintings serves as a kind of Zen koan, capturing what Kelly calls "a feeling, an impression, a new layer of intimacy." Many of his most compelling images, such as *Barns at Dusk* (page 110), *Devou Dusk* (not shown), and *Twilight Perry County* (above), represent dusk, that magical time of transformation from day into night, that time of day when things quiet down and return from the outer world to the inner world. Each work manifests Kelly's interest in interior transformation and meditative change. Some are acrylic, others gouache, but the effect is the same. In *Barns at Dusk* (page 110) an outbuilding attached to the large barn on the left has one light on, and that's our guiding light in Kelly's landscapes: quiet, out of the way, intensely spiritual.

Indeed, each of these paintings may represent the solitary journey of the seeker, and his quieter color and curvilinear compositions are the key to each painting as a koan. We often feel as if we are floating in these Kelly landscapes, a symbolic state known to all who meditate, all who turn inwards for enlightenment.

Kelly mentions his new search for the spiritual as a major inspiration for this shift into landscape painting, but his core belief in reductivism remains in the new work, from which he has also eliminated all evidence of human life. It's easy to try to visualize Kelly land-

scapes blown up into large stage sets or designs, screens, or even something like Matissean cutouts, as the scale of the landscapes can seem to grow and submerge before our eyes. The landscapes can be viewed, too, as images that grow out of meditation and its altered states; the elimination of compositional elements and reduction into small, often geometric components, is the kind of radical simplification that great art often becomes as an artist's sense of sureness and confidence matures. The viewer, along with the artist,

Kelly rented the warehouse in Covington, Kentucky, shown here for sixteen weeks to accommodate painting the commission *Pullman Square*, a mural consisting of six canvases, each 144" × 44".

becomes the lonely, solitary traveler on the (mountain) road, as in Asian art, and by using design elements from the twentieth and twenty-first centuries, Kelly, an unintended Post Modernist, allows us to jump through centuries of visual thinking and back, while grounding us in the complexly simple, as Japanese Zen gardens are meant to do.

Midwestern in Origin

It is evidence of our multicultural world that many, if not most, of these landscapes are based upon Midwestern scenes, hilly and curvilinear, which maximize what the artist can do with a small space. As natural elements feel as if they're moving, be they trees or rocks or water, we feel enveloped in psychedelic landscapes, invented, imagined, and real concurrently.

Through these means, Kelly's landscapes invoke a deep sense of peace and harmony within time. In their hybrid combinations of American minimalism and Japanese reductivism, they offer the viewer an intense spiritual jolt, wherein the sparest of painterly means creates epiphanies in and for the viewer, reminding us that landscape as a genre can still be infinitely refreshed and replenished. Kelly's nature has secrets behind every curve, and his attempts at revealing those secrets are bold and brave and as fresh as those spiritual jolts that these paintings both reflect and create.

To learn more about Kevin T. Kelly, visit www.kevintkelly.com.

Daniel Brown is the editor-in-chief of the online art journal AEQAI (aeqai.com), as well as an independent art consultant. He has degrees in political science and Asian art history from Middlebury College and the University of Michigan. He lives in Cincinnati.

Excerpted from the September 2015 issue of *The Artist's Magazine*. Used with the kind permission of *The Artist's Magazine*, a publication of F+W Media, Inc. (www.artistsnetwork.com)

UNSCRIPTED MASTERPIECES
Interviews with Gilles Beloeil and Lauren Airriess

by Michael Woodson

Using Photoshop and other digital programs, conceptualizing the "bigger picture" for video games and film is what drives these illustrators' dreams.

Gilles Beloeil remembers his childlike astonishment when seeing a painting for the first time as if it were yesterday, for he still engages with art as if that initial experience were happening again and anew. "I'm moved by traditional painters such as Diego Velázquez and Claude Monet, but also contemporary painters like Richard Schmid and David Leffel," he says. "When I'm inspired, I feel a sense of admiration and happiness—like when your jaw drops in front of a great landscape in real life. I try to recreate these sensations in my own work."

Beloeil's interest in visual art has followed him throughout his life. "I was passionate about comic books," he says, remembering his childhood ambition to become a comic book artist. "During my adolescence, film interested me even more, but I kept drawing comic books on the side." It wasn't until the mid-1990s when the Internet was more easily accessed that he discovered Adobe Photoshop, which led him to a job as a Web designer. In 2007, the video game company Ubisoft hired him to work in its cinematic department. "In 2008, the *Assassin's Creed* video game franchise needed some concept art and I took the chance," he says. "I haven't left the brand since."

Concept art functions as a blueprint for illustrators to communicate ideas for film, video games, animation, comic books, and other media. Concept artists, illustrators, and matte painters work almost exclusively digitally and mostly with Photoshop, Beloeil says. "Digital software is only a tool. Painting is painting. If a person knows how to paint, to draw,

Assassin's Creed 3 by Gilles Beloeil
Concept Art (digital media).

knows values, understands design and composition, working digitally is just a matter of taking the time to learn a new medium."

Beloeil's current studio has the basics: an easel and a computer, art books and magazines filled with the works of colleagues and classics, and an assortment of Tintin figurines from *The Adventures of Tintin.* "I keep them around to remind me of my passion for comics," he says. It's a quiet, comfortable space, but not quite home. "I don't have the studio of my dreams yet but I'm working on it."

Aside from his work with Ubisoft, Beloeil has worked as a matte painter and currently teaches beginning artists at Computer Graphics Master Academy, an online art school based in California. One lesson he instills in his students is how to increase depth in images, though he admits drawing is something he still struggles with. "Compositional balance of an image is difficult for me to find because there are no rules," he says. "It's just how you feel about the image."

Beloeil focuses on the design of the environment and then incorporates his subjects (or "characters") into the world in ways that make them feel integral. He uses Photoshop, ArtRage, Softimage XSI and SketchUp, but notes that 95 percent of the job is done in Photoshop. "The software is perfect," he says, "logical, clear, easy to use, and very powerful." He alternates between using a Wacom Intuos tablet and a Wacom Cintiq tablet for initial sketches and drawings, renderings, and the finished products. His technique as a matte painter was to go as far as he could and work from that in Photoshop, translating the physical painting into a digital concept. "Since I need faster results as a concept artist, I draw and paint directly, or I use some very basic three-dimensional shapes to help with perspective for complex scenes," he says.

Beloeil has also worked in oil for six years—his oil painting *Long Shadow* was an Honorable Mention in *The Artist's Magazine*'s 2014 Annual Art Competition—and looks forward to experimenting with watercolor. "Watercolor's very different from oil, the process be-

ing reversed," he says. "Life's too short to stick with one medium; who knows what I'll explore next!"

For Lauren Airriess, her workplace needs to mirror her emotional state. "I must have a place for everything and keep it very tidy," she says about her studio. "I can't have a focused mind if my physical space isn't focused." The clean, idyllic structure of that space—sketchbooks propped in designated shelves, separate desks for her digital work and her pen-and-paper work, a hillside view and folk music playing in the background—lends itself to the type of work Airriess produces. Her concept art is organized and sprawling: bright sunlight beams through openings in doors and windows; vast interiors have high ceilings and stark decor. Even her preliminary sketches have a controlled-chaos sensibility. What's void in her studio, she fills with creativity in her work.

Farmhouse Cellar and Tree by Lauren Airriess (digital media).

From a young age Airriess knew she wanted to be an artist, but what kind of artist she didn't know. "I was mostly acting and singing, but I carried a sketchbook with me everywhere," she says. "As I got older, my focus moved away from the performing arts and into fine art and animation." That focus has driven her to Walt Disney Animation Studios, where she was commissioned to create concept art for the 2010 animated movie *Tangled*, a retelling of the German fairy tale "Rapunzel."

Airriess also enjoys traditional drawing with pen on paper, sometimes adding watercolor or gouache. "When I'm working it's almost always digital, using Photoshop and a Cintiq, but recreationally, I like drawing with pen and pencil because it's not fussy and I can work quickly." She doesn't like to use expensive materials for fear of wasting them if the final product is one she isn't proud of. "I think that's why digital is so much easier for me," she concludes. "No wasted material!"

For concept design, her process begins with a conversation with the director, during which she makes sure to discuss whatever goals or objectives her piece is supposed to accomplish. Then she brainstorms, writing down any feelings that pop into her head. Often,

Airriess seeks the advice of her colleagues. "I find inspiration through other artists who capture the same feeling or idea that I'm going for," she says.

When working in Photoshop, Airriess typically wields two different brushes without using masks, filters, overlays, or selections. "I try to paint on the computer as if

Emerald City Design by Lauren Airriess (digital media).

it were a canvas. Like my physical workspace, my digital workspace needs to be tidy, with clearly organized layers and folders."

Despite her work in pen-and-paper, watercolor, and concept art, Airriess can't wait to try her hand at other media. "I tried painting with oils for the first time about a year ago and I loved it," she says. "It's tough for me to get my head around messier mediums because I like to have everything controlled and clean."

Her advice is simple: learn from those who came before you. "Every painter has looked to another painter for guidance," she says. "No one can create in a vacuum. Find your inspiration through the masters." She notes that having a solid foundation in your skill set is just as important as having the creative ideas themselves, but one cannot exist without the other. "If you find yourself up against a wall creatively, get outside and refill your creative well."

Michael Woodson is an associate editor of *The Artist's Magazine* and a freelance photographer.

Excerpted from the November 2015 issue of *The Artist's Magazine*. Used with the kind permission of *The Artist's Magazine*, a publication of F+W Media, Inc. (www.artistsnetwork.com)

GALLERIES

//

Most artists dream of seeing their work in a gallery. It's the equivalent of "making it" in the art world. That dream can be closer than you realize. The majority of galleries are actually quite approachable and open to new artists. Though there will always be a few austere establishments manned by snooty clerks, most are friendly places where people come to browse and chat with the gallery staff.

So don't let galleries intimidate you. The majority of gallery curators will be happy to take a look at your work if you make an appointment or e-mail JPEGs to them. If they feel your artwork doesn't fit their gallery, most will steer you toward a more appropriate one.

A Few Guidelines

- **Never walk into a gallery without an appointment** expecting to show your work to the director. When we ask gallery directors about their pet peeves, they always mention the talented newcomer walking into the gallery with paintings in hand. Most galleries prefer or even require electronic submissions. (Refer to the listings for more specific information on each gallery's preferred submission method.) Following the gallery's guidelines, send a polished package of about eight to twelve images, either by e-mail or on disk. If you prefer to work with slides and the gallery will accept them, send neatly labeled, mounted duplicate slides of your work in plastic slide sheets. Do not send original slides, as you will need them to reproduce later. Send a SASE, but realize your packet may not be returned.
- **Seek out galleries that show the type of work you create.** Most galleries have a specific "slant" or mission. A gallery that shows only abstract works will not be interested in your realistic portraits.

TYPES OF GALLERIES

As you search for the perfect gallery, it's important to understand the different types of spaces and how they operate. The route you choose depends on your needs, the type of work you do, your long-term goals, and the audience you're trying to reach.

- **Retail or commercial galleries.** The goal of the retail gallery is to sell and promote the work of artists while turning a profit. Retail galleries take a commission of 40 to 50 percent of all sales.
- **Co-op galleries.** Co-ops exist to sell and promote artists' work, but they are run by artists. Members exhibit their own work in exchange for a fee, which covers the gallery's overhead. Some co-ops also take a small commission of 20 to 30 percent to cover expenses. Members share the responsibilities of gallery-sitting, sales, housekeeping, and maintenance.
- **Rental galleries.** The rental gallery makes its profit primarily through renting space to artists and therefore may not take a commission on sales (or will take only a very small commission). Some rental spaces provide publicity for artists, while others do not. Showing in this type of gallery is risky. Rental galleries are sometimes thought of as "vanity galleries" and, consequently, do not have the credibility other galleries enjoy.
- **Nonprofit galleries.** Nonprofit spaces will provide you with an opportunity to sell your work and gain publicity, but will not market your work aggressively because their goals are not necessarily sales-oriented. Nonprofits generally take a small commission of 20 to 30 percent.
- **Museums.** Though major museums primarily show work by established artists, many small museums are open to emerging artists.
- **Art consultancies.** Consultants act as liaisons between fine artists and buyers. Most take a commission on sales (as would a gallery). Some maintain small gallery spaces and show work to clients by appointment.

- **Visit as many galleries as you can.** Browse for a while and see what type of work they sell. Do you like the work? Is it similar to yours in quality and style? What about the staff? Are they friendly and professional? Do they seem to know about the artists the gallery represents? Do they have convenient hours? If you're interested in a gallery outside your city and you can't manage a personal visit before you submit, read the listing carefully to make sure you understand what type of work is shown there. Check out the gallery's website to get a feel for what the space is like, or ask a friend or relative who lives in that city to check out the gallery for you.

- **Attend openings.** You'll have a chance to network and observe how the best galleries promote their artists. Sign each gallery's guest book or ask to be placed on galleries' mailing lists. That's also a good way to make sure the gallery sends out professional mailings to prospective collectors.

Showing in Multiple Galleries

Most successful artists show in several galleries. Once you've achieved representation on a local level, you might be ready to broaden your scope by querying galleries in other cities. You may decide to be a "regional" artist and concentrate on galleries in surrounding states. Some artists like to have East Coast and West Coast representation.

If you plan to sell work from your studio or from a website or other galleries, be up front with each gallery that shows your work. Negotiate commission arrangements that will be fair to you and all involved.

Pricing Your Fine Art

A common question of beginning artists is "What do I charge for my paintings?" There are no hard and fast rules. The better known you become, the more collectors will pay for your work. Though you should never underprice your work, you must take into consideration what people are willing to pay. Also keep in mind that you must charge the same amount for a painting sold in a gallery as you would for work sold from your studio.

Juried Shows, Competitions, and Other Outlets

It may take months, maybe years, before you find a gallery to represent you. But don't worry; there are plenty of other venues in which to show your work. Get involved with your local art community. Attend openings and read the arts section of your local paper. You'll see there are hundreds of opportunities.

Enter group shows and competitions every chance you get. Go to the art department of your local library and check out the bulletin board, then ask the librarian to direct you to magazines that list "calls to artists" and other opportunities to exhibit your work. Subscribe to the Art Deadlines List, available online (www.artdeadlineslist.com). Join a co-op gallery and show your work in a space run by artists for artists.

Another opportunity to show your work is through local restaurants and retail shops that exhibit the work of local artists. Ask the managers how you can get your art on their walls. Become an active member in an arts group. It's important to get to know your fellow artists. And since art groups often mount exhibitions of their members' work, you'll have a way to show your work until you find a gallery to represent you.

5+5 GALLERY

620 Fort Washington Ave., Suite 3N, New York NY 10040. (718)624-6048. **E-mail:** gallery1@fodde.com. **Website:** www.5plus5gallery.com. **Contact:** Raphael Foddé, director. Online gallery only. No exhibitions. Overall price range: $300-15,000; most work sold at $1,200.

MEDIA Exhibits paper, pastel, pen & ink, watercolor.

TERMS Artwork is accepted on consignment (50% commission).

SUBMISSIONS E-mail attachments only. Finds artists through submissions.

TIPS "Submit a very simple, short and to-the-point artist's statement and CV."

440 GALLERY

440 Sixth Ave., Brooklyn NY 11215. (718)499-3844. **E-mail:** gallery440@verizon.net. **Website:** www.440gallery.com. **Contact:** Amy Williams, Administrative Director. Estab. 2005. 440 is an artist run gallery. We maintain our membership at approximately 15 artists and occasionally seek a new member when an individual moves or leaves the group. There is a membership fee plus a donation of time. All prospective members must submit a portfolio and be interviewed. In addition to members' solo exhibitions, we host 2 national juried exhibitions each year, in the summer and winter, with an outside curator making selections. Located in Park Slope (Brooklyn), the gallery is approximately 400 sq. ft. with 2 exhibition areas (the solo gallery in the front and Project Space in the back). Open Tuesday-Friday, 4-7; weekends, 11-7. Patrons are primarily from the New York City regions, especially Brooklyn. "Due to our proximity to popular Brooklyn destinations, we are visited often by tourists interested in culture and art." Overall price range: $100-12,000 with prices set by the artist. Average length of an exhibition is 4 weeks.

MEDIA Our artists most frequently exhibit painting, collage/assemblage, photography, printmaking and sculpture.

TERMS Artwork is accepted on consignment and there is a 30% commission on sales for members and on sales in juried shows. Gallery provides email, online and social media marketing in addition to some print media.

SUBMISSIONS "For consideration as a member, please e-mail a query including a link to your website, which should include a résumé. For an application to our juried shows, visit our website and find the 'Call for Entry' link."

TIPS We currently have a two-year limited membership as well as a full membership category.

ACADEMY GALLERY

8949 Wilshire Blvd., Beverly Hills CA 90211. (310)247-3000. **Fax:** (310)859-9619. **E-mail:** Via online contact form. **Website:** www.oscars.org. **Contact:** Moray Greenfield, theater operations. Estab. 1992. Exhibitions focus on all aspects of the film industry and the filmmaking process. Sponsors 3-5 exhibitions/year. Average display time: 3 months. Open all year; Tuesday–Friday, 10-5; weekends, 12-6. Gallery begins in building's Grand Lobby and continues on the 4th floor. Total square footage is approximately 8,000. Clients include students, senior citizens, film aficionados and tourists.

SUBMISSIONS Call or write to arrange a personal interview to show portfolio of photographs, slides and transparencies. Must be film process or history related.

ACA GALLERIES

529 W. 20th St., 5th Floor, New York NY 10011. (212)206-8080. **E-mail:** info@acagalleries.com. **Website:** www.acagalleries.com. Estab. 1932. For-profit gallery. The area of specialty is American, European and Contemporary art (ACA = American Contemporary Artists). "Founded in 1932, the American Contemporary Art Galleries are dedicated to representing and exhibiting prominent Contemporary and Modern artists. We exhibit traditional art forms such as painting, drawing and sculpture. We do not show photography, installation, video or new media. We handle established, mid-career artists that have had solo museum exhibitions and have major books or catalogs written about them that are not self-published." Exhibited artists include Faith Ringgold (painting, drawing, soft sculpture) and Anita Huffington (sculpture), Herb Alpert, Hyman Bloom Estate, Ilya Bolowsky, Alan Davie, Edgar Jerins, Richard Mayhew and more. Sponsors 6-8 exhibits/year. Average display time: 6-8 weeks. Open Tuesday-Saturday, 10:30-6. Clients include local community, international collectors, curators, upscale. 25% of sales are to corporate collectors. Overall price range: $1,000-6 million.

MEDIA Most frequently exhibits acrylic, ceramics, collage, drawing, fiber, mixed media, oil, paper, pastel,

pen & ink, sculpture, watercolor.

STYLE Considers all styles, all genres. Most frequently exhibits color field, expressionism, impressionism, postmodernism, surrealism.

TERMS Artwork is accepted on consignment (10-50% commission). Retail price set by both artist and gallery. Gallery provides insurance, promotion, contract. Accepted work should be framed. Requires exclusive representation locally.

SUBMISSIONS Submission guidelines available online. "If you fit the above criteria, you may submit your artwork for consideration during the months of June and July. It will take approximately 6-8 weeks to review your submission and any work received after July 31 will not be reviewed. Please do not call the gallery to follow up on your submission, to set up an appointment for a studio visit, or ask us to recommend alternate galleries. We will contact you if we are interested."

ADIRONDACK LAKES CENTER FOR THE ARTS

3446 St. Rt. 28, Blue Mountain Lake NY 12812. (518)752-7715; (518)352-7715. **Fax:** (518)352-7333. **E-mail:** office@adirondackarts.org. **Website:** www.adirondackarts.org. **Contact:** Jamie Strader, interim executive director. Estab. 1967. Nonprofit galleries in multi-arts center. Represents 107 emerging, mid-career and established artists/year. Sponsors 6-8 shows/year. Average display time: 4–8 weeks. Open Thursday-Saturday, 10–4; July and August, daily. Closed Dec.–March. Located on Main Street next to post office; 176 sq. ft.; "pedestals and walls are white, some wood and very versatile." Clients include tourists, summer owners and year-round residents. 90% of sales are to private collectors, 10% corporate collectors. Overall price range: $100-10,000; most work sold at $100-1,000. Accepts work on consignment (30% commission). Retail price set by the artist. Gallery provides insurance, contract; shares promotion. Prefers artwork framed. Finds artists through word of mouth, art publications and artists' submissions.

MEDIA Considers all media and all types of prints. Most frequently exhibits paintings, sculpture, wood and fiber arts.

STYLE Exhibits all styles. Genres include landscapes, Americana, wildlife and portraits.

SUBMISSIONS Send query letter with slides or photos and bio. Annual submission deadline early December; selections complete by February 1. Files

"slides, photos and bios on artists we're interested in." Reviews submissions once/year. See website for details: www.adirondackarts.org

TIPS "We love to feature artists who can also teach a class in their media for us. It increases interest in both the exhibit and the class."

AGORA GALLERY

530 W. 25th St., New York NY 10001. (212)226-4151. **E-mail:** info@agora-gallery.com. **Website:** www.agora-gallery.com. **Contact:** Angela Di Bello, director. Estab. 1984. For-profit gallery. Represents emerging, mid-career and established artists. Sponsors 19 exhibits/year. Average display time: 3 weeks. Open Tuesday–Saturday, 11-6. Closed national holidays. Located in the heart of New York City's Chelsea art district, with expansive gallery space on 1st and 2nd floors on an exclusive gallery block. Clients include local, tourists, upscale collectors.

MEDIA Acrylic, collage, digital, drawing, mixed media, oil, pastel, photography, sculpture, watercolor.

STYLE Considers all styles.

TERMS There is a representation fee. There is a 30% commission to the gallery; 70% to the artist. Retail price set by the gallery and the artist. Gallery provides insurance and 18 months of promotion services.

SUBMISSIONS Guidelines available online (www.agora-gallery.com/artistinfo/GalleryRepresentation.aspx). Portfolio submitted through website and must include 5 images with titles, medium, and dimensions, biography, and artist statement.

✚ AKEGO AND SAHARA GALLERY

50 Washington Ave., Endicott NY 13760. (607)821-2540. **E-mail:** info@africaresource.com. **Website:** www.africaresource.com/house. **Contact:** Azuka Nzegwu, managing director. Estab. 2007. A for-profit, alternative space, for-rent gallery, and art consultancy. Exhibits emerging, mid-career, and established artists. Represents or exhibits 3-4 artists per year. Sponsors 3 total exhibits a year. Average display time: 3-4 months. Model release and property release are required. Open Monday-Friday, 9–6. Clients include local community, students, tourists, and upscale. Has contests and residencies available. See website for further details.

MEDIA Considers all media, and prints.

STYLE Considers all styles and genres.

TERMS Artwork is accepted on consignment and there is a 40% commission. There is a rental fee for space covering 1 month. Retail price set by the gallery and the artist. Gallery provides insurance, promotion, and contract. Does not require exclusive representation locally. Artists should call, e-mail query letter with a link to the artist's website, mail portfolio for review, or send query letter with artist's statement, bio, résumé, and reviews. Responds in 1 week. Finds artists through word of mouth, submissions, portfolio reviews, referrals by other artists, as well as other means.

AKRON ART MUSEUM

1 S. High St., Akron OH 44308. (330)376-9185. **Fax:** (330)376-1180. **E-mail:** mail@akronartmuseum.org. **Website:** www.akronartmuseum.org. Located on the corner of East Market and South High Streets in the heart of downtown Akron. Open Wednesday–Sunday, 11-5; Thursday, 11-9. Closed Monday and Tuesday. Closed holidays.

TERMS "Please submit a brief letter of interest, résumé, and 20-25 representative images (slides, snapshots, JPEGs on CD, DVDs or website links). Do not send original artworks. If you would like your material returned, please include a SASE." Allow 2-3 months for review.

SUBMISSIONS "Send professional-looking materials with high-quality images, a résumé and an artist's statement. Never send original prints."

ALASKA STATE MUSEUM

395 Whittier St., Juneau AK 99801-1718. (907)465-2901. **Fax:** (907)465-2151. **E-mail:** jackie.manning@alaska.gov. **Website:** www.museums.alaska.gov. **Contact:** Jackie Manning, curator of exhibitions. Estab. 1900. Approached by 80 artists/year; exhibits 6 emerging, mid-career and established artists. The museum sponsors 10 exhibits/year. Average display time: 6-10 weeks. Downtown location exhibiting temporary and permanent exhibitions in a new building.

MEDIA Considers all media. Most frequently exhibits painting, photography, sculpture, new media and mixed media. Considers engravings, etchings, linocuts, lithographs, mezzotints, serigraphs and woodcuts.

STYLE Considers all styles.

SUBMISSIONS Finds Alaskan artists through submissions and portfolio reviews every 2 years. Register for e-mail notification at: http://list.state.ak.us/soalists/Museum_Exhibits_Events_Calendar.

JEAN ALBANO GALLERY

215 W. Superior, Chicago IL 60654. (312)440-0770. **Fax:** (312)440-3103. **E-mail:** jeanalbano@aol.com; info@jeanalbanogallery.com. **Website:** www.jeanalbanogallery.com. **Contact:** Jean Albano Broday, director. Estab. 1985. Represents 24 mid-career artists. Somewhat interested in seeing the work of emerging artists. Exhibited artists include Martin Facey and Jim Waid. Average display time: 5 weeks. Open Tuesday–Friday, 10-5; Saturday, 11-5; and by appointment. Located downtown in River North gallery district; 1,600 sq. ft.; 60% of space for special exhibitions; 40% of space for gallery artists. Clientele 80% private collectors, 20% corporate collectors. Overall price range: $1,000-20,000; most work sold at $2,500-6,000.

MEDIA Considers oil, acrylic, sculpture and mixed media. Most frequently exhibits mixed media, oil and acrylic. Prefers nonrepresentational, nonfigurative and abstract styles.

TERMS Accepts artwork on consignment (50% commission). Retail price set by gallery and artist; shipping costs are shared.

SUBMISSIONS Send query letter with résumé, bio, SASE and well-labeled slides (size, name, title, medium, top, etc.). Write for appointment to show portfolio. Responds in 6 weeks. If interested, gallery will file bio, résumé and selected slides.

TIPS "We look for artists whose work has a special dimension in whatever medium. We are interested in unusual materials and unique techniques."

ALBUQUERQUE MUSEUM

2000 Mountain Rd., NW, Albuquerque NM 87104. (505)243-7255. **Website:** www.cabq.gov/museum. Glenn Fye, photo archivist. **Contact:** Andrew Connors, curator of art. Estab. 1967. Nonprofit municipal museum. Located in Old Town, west of downtown.

STYLE Mission is to collect, promote, and showcase art and artifacts from Albuquerque, the state of New Mexico, and the Southwest and influences on art of the Southwest. Rarely hosts single-artist exhibitions, focusing instead on thematic or group shows and work from the permanent collection.

SUBMISSIONS Artists may send portfolio for exhibition consideration: slides, photos, disk, artist statement, résumé, SASE.

ALEX GALLERY

2106 R St. NW, Washington DC 20008. (202)667-2599. **E-mail:** alexgallerydc@gmail.com; info@alex-galleries.com. **Website:** www.alexgalleries.com. Estab. 1985. Retail gallery and art consultancy. Represents 20 emerging and mid-career artists. Exhibited artists include Willem de Looper, Gunter Grass and Olivier Debre. Sponsors 8 shows/year. Average display time: 1 month. Open Tuesday–Saturday, 11-5; and by appointment. Located in the heart of a gallery neighborhood; 2 floors of beautiful turn-of-the-century townhouse; a lot of exhibit space. Clientele: diverse; international and local. 50% private collectors; 50% corporate collectors. Overall price range: $1,500-60,000.

MEDIA Considers oil, acrylic, watercolor, pastel, mixed media, collage, sculpture, photography, original handpulled prints, lithographs, linocuts and etchings. Most frequently exhibits painting, sculpture and works on paper.

STYLE Exhibits expressionism, abstraction, color field, impressionism and realism; all genres. Prefers abstract and figurative work.

TERMS Accepts artwork on consignment. Retail price set by gallery and artist. Gallery provides insurance, promotion and contract; shipping costs are shared.

SUBMISSIONS Send query letter with résumé, slides, bio, SASE and artist's statement. Write for appointment to show portfolio, which should include slides and transparencies. Responds in 2 months.

⌂ CHARLES ALLIS ART MUSEUM

1801 N. Prospect Ave., Milwaukee WI 53202. (414)278-8295. **E-mail:** jsterr@cavtmuseums.org. **Website:** www.charlesallis.org. **Contact:** John Sterr, executive director. Estab. 1947. The Charles Allis Art Museum exhibits emerging, mid-career and established artists that have lived or studied in Wisconsin. Exhibited artists include Anne Miotke (watercolor); Evelyn Patricia Terry (pastel, acrylic, multi-media). Sponsors 3 exhibits/year. Average display time: 3 months. Open all year; Wednesday–Sunday, 1–5. Located in an urban area, historical home, 3 galleries. Clients include local community, students and tourists. 10% of sales are to corporate collectors. Overall price range: $200–6,000.

MEDIA Considers acrylic, collage, drawing, installation, mixed media, oil, pastel, pen & ink, sculpture, watercolor and photography. Print types include engravings, etchings, linocuts, lithographs, serigraphs and woodcuts.

TERMS Artwork can be purchased during run of an exhibition; a 30% commission fee applies. Retail price set by the artist. Museum provides insurance, promotion and contract. Accepted work should be framed. Does not require exclusive representation locally. Accepts only artists from or with a connection to Wisconsin.

SUBMISSIONS Finds artists through submissions to Request for Proposals which can be found at www.charlesallis.org/news.html.

AMERICAN PRINT ALLIANCE

302 Larkspur Turn, Peachtree City GA 30269-2210. **E-mail:** director@printalliance.org. **Website:** www.printalliance.org. **Contact:** Carol Pulin, director. Estab. 1992. Nonprofit arts organization with online gallery and exhibitions, travelling exhibitions, and journal publication; Print Bin: a place on website that is like the unframed, shrink-wrapped prints in a bricks-and-mortar gallery's "print bin." Approached by hundreds of artists/year; represents dozens of artists/year. "We only exhibit original prints, artists' books and paperworks." Usually sponsors 2 travelling exhibits/year—all prints, paperworks and artists' books. Most exhibits travel for 2 years. Hours depend on the host gallery/museum/arts center. "We travel exhibits throughout the US and occasionally to Canada." Overall price range for Print Bin: $150–3,200; most work sold at $300-500.

MEDIA Considers and exhibits original prints, paperworks, artists' books. Also all original prints including any combination of printmaking techniques; no reproductions/posters.

STYLE Considers all styles, genres and subjects; the decisions are made on quality of work.

TERMS Individual subscription: $32-39. Print Bin is free with subscription. "Subscribers eligible to enter juried traveling exhibitions but must pay for framing and shipping to and from our office." Gallery provides promotion.

SUBMISSIONS Subscribe to journal, *Contemporary Impressions* (www.printalliance.org/alliance/al_subform.html). Send one slide and signed permission form www.printalliance.org/gallery/printbin_info.html). Returns slide if requested with SASE. Usually does not respond to queries from nonsubscribers. Files slides and permission forms. Finds artists through submissions to the gallery or Print Bin, and

especially portfolio reviews at printmakers conferences. "Unfortunately, we don't have the staff for individual portfolio reviews, though we may—and often do—request additional images after seeing one work, often for journal articles. Generally about 100 images are reproduced per year in the journal."

TIPS "See the Standard Forms area of our website (www.printalliance.org/library/li_forms.html) for correct labels on slides and much, much more about professional presentation."

AMERICAN SOCIETY OF ARTISTS

ASA, P.O. Box 1326, Palatine IL 60078. (847)991-4748 or (312)751-2500. **E-mail:** asoaartists@aol.com. **Website:** www.americansocietyofartists.org. **Contact:** Helen Del Valle, membership chairman. Estab. 1972. "Our members range from internationally known artists to unknown artists—quality of work is the important factor."

TERMS Responds in 2 weeks.

SUBMISSIONS Submit 4 images of your work and 2 of your display set-up (résumé/show listing helpful), or send SASE and 4 slides/photographs that represent your work and one of your display set-up; request membership information and application.Submit to Asoaartists@aol.com or to ASA, PO Box 1326, Palatine IL 60078

TIPS Accepted work should be framed, mounted or matted. Accepted members may participate in lecture and demonstration service.

THE ANN ARBOR ART CENTER GALLERY SHOP

117 W. Liberty St., Ann Arbor MI 48104. (734)994-8004. **Fax:** (734)994-3610. **E-mail:** nrice@ annarborartcenter.org; sbingham@annarborartcenter.org. **Website:** www.annarborartcenter.org. **Contact:** Nathan Rice, gallery curator; Samantha Bingham, gallery curator. Estab. 1909. Represents over 350 artists, primarily Michigan and regional. Gallery shop purchases support the Art Center's community outreach programs. "We are the only organization in Ann Arbor that offers hands-on art education, art appreciation programs and exhibitions all in one facility." Open Monday–Friday, 10-7; Saturday, 10-6; Sunday, 12-5.

○ The Ann Arbor Art Center also has exhibition opportunities for Michigan artists in its exhibition gallery and art consulting program.

MEDIA Considers original work in virtually all 2D and 3D media, including jewelry, prints and etchings, ceramics, glass, fiber, wood, photography and painting.

STYLE The gallery specializes in well-crafted and accessible artwork. Many different styles are represented, including innovative contemporary.

TERMS Submission guidelines available online. Accepts work on consignment. Retail price set by artist. Offers member discounts and payment by installments. Exclusive area representation not required. Gallery provides contract; artist pays for shipping.

SUBMISSIONS "The Art Center seeks out artists through the exhibition visitation, wholesale and retail craft shows, networking with graduate and undergraduate schools, word of mouth, in addition to artist referral and submissions."

ANTON ART CENTER

125 Macomb Place, Mount Clemens MI 48043. (586)469-8666. **Fax:** (586)469-4529. **E-mail:** information@theartcenter.org. **E-mail:** information@ theartcenter.org. **Website:** www.theartcenter.org. **Contact:** Phil Gilchrist, Executive Director. Estab. 1969. Nonprofit art center. Represents emerging, mid-career, and established artists. Over 400 members. Sponsors 10-14 shows/year. Average display time: 1 month. Open Tuesday-Saturday, 10-5; Closed Monday & Sunday. Located in downtown Mount Clemens, Michigan; 10,000 sq. ft. The Anton Art Center is housed in the historic Carnegie Library Building, listed in the State of Michigan Historical Register. A 2006 addition created new classroom and exhibit space as well as a gift shop featuring handmade items. Overall price range: $5-1,000; most work sold at $50-200.

MEDIA Main Gallery Space & Community Art Gallery. Open to all media.

STYLE Exhibits all styles, all genres.

TERMS The Anton Art Center receives a 40% commission on sales of original works.

SUBMISSIONS Send résumé, artist statement, image list, 10 images (JPEG on disk) and SASE (if you want materials returned). Finds artists through word of mouth, membership, and in response to open calls publicized through e-mail, social media, and website. Submission guidelines available on website: www. theartcenter.org.

TIPS "Visit our website to sign up for our e-mail list; all calls for artists are publicized via e-mail. General

artist portfolio submissions and exhibition proposals are accepted year-round. All materials reviewed by exhibition committee."

ARC GALLERY & EDUCATIONAL FOUNDATION

2156 N. Damen Ave., Chicago IL 60647. (773)252-2232. **E-mail:** info@arcgallery.org. **Website:** www.arcgallery.org. **Contact:** Iris Goldstein, President. Estab. 1973. Nonprofit gallery. Exhibits emerging, mid-career and established artists. 21 members review work for solo and group shows on an ongoing basis. Visit website for prospectus. Exhibited artists include Miriam Schapiro. Average display time: 1 month. Located in the West Town neighborhood; 1,600 sq. ft. Clientele: 80% private collectors, 20% corporate collectors. Overall price range: $50-40,000; most work sold at $200-4,000.

MEDIA Considers all media. Most frequently exhibits painting, sculpture (installation) and photography.

STYLE Exhibits all styles and genres. Prefers post-modern and contemporary work.

TERMS There is a rental fee for space. Rental fee covers 1 month. No commission taken on sales. Gallery provides promotion; artist pays shipping costs. Prefers framed artwork.

SUBMISSIONS See website (www.arcgallery.org/call-for-entries.aspx) for info or send e-mail query. Reviews are ongoing. Call for deadlines. Digital images are accepted.

ARIZONA STATE UNIVERSITY ART MUSEUM

P.O. Box 872911, Tenth St. and Mill Ave., Tempe AZ 85287-2911. (480)965-2787. **Fax:** (480)965-5254. **Website:** asuartmuseum.asu.edu. **Contact:** Gordon Knox, director. Estab. 1950. Has 3 facilities and approximately 8 galleries of 2,500 square feet each; mounts approximately 15 exhibitions/year. Average display time 3-4 months.

MEDIA Considers all media. Greatest interests are contemporary art, crafts, video, and work by Latin American and Latino artists.

SUBMISSIONS "Interested artists should submit slides to the director or curators."

THE ARKANSAS ARTS CENTER

501 E. Ninth St., Little Rock AR 72202. (501)372-4000. **Fax:** (501)375-8053. **E-mail:** contact@arkarts.com; info@arkansasartscenter.org. **Website:** www.arkansasartscenter.org. **Contact:** Brian Lang, chief curator. Museum art school, children's theater and traveling exhibition service. Estab. 1930s. Exhibits the work of emerging, mid-career and established artists. Sponsors 25 shows/year. Average display time: 12 weeks. Open Tuesday–Saturday, 10-5; Sunday, 11-5. Located downtown; 10,000 sq. ft.; 60% of space for special exhibitions.

MEDIA Most frequently exhibits drawings and crafts.

STYLE Exhibits all styles and all genres.

TERMS "Work in the competitive exhibitions (open to artists in Arkansas and 6 surrounding states) is for sale; we usually charge 10% commission."

SUBMISSIONS Send query letter with samples, such as photos or slides.

TIPS "Write for information about exhibitions for emerging and regional artists, and various themed exhibitions."

ARNOLD ART

210 Thames St., Newport RI 02840. (401)847-2273 or (800)352-2234. **Fax:** (401)848-0156. **E-mail:** info@arnoldart.com. **Website:** www.arnoldart.com. **Contact:** William Rommel, owner. Estab. 1870. Retail gallery. Represents 40 emerging, mid-career and established artists. Exhibited artists include John Mecray, Willard Bond. Sponsors 4 exhibits/year. Average display time: 1 month. Open Monday-Saturday, 9:30-5:30; Sunday, 12-5. Clientele: local community, students, tourists and Newport collectors. 1% of sales are to corporate clients. Overall price range: $100-35,000; most work sold at $600.

MEDIA Considers oil, acrylic, watercolor, pastel, pen & ink, drawings, mixed media. Most frequently exhibits oil and watercolor.

STYLE Genres include marine sailing, classic yachts, America's cup, yachting/sailing.

TERMS Accepts work on consignment (40% commission). Retail price set by artist. Exclusive area representation not required. Gallery provides promotion.

SUBMISSIONS Send e-mail. Call or e-mail for appointment to show portfolio of originals. Returns materials with SASE.

TIPS To make your submissions professional you must "frame them well."

THE ARSENAL GALLERY

The Arsenal Bldg., Room 20, Central Park, 830 Fifth Ave., New York NY 10065. (212)360-8163. **Fax:**

(212)360-1329. **E-mail:** artandantiquities@parks.nyc. gov; jennifer.lantzas@parks.nyc.gov. **Website:** www. nycgovparks.org/art. Jennifer Lantzas, public art coordinator. Estab. 1971. Nonprofit gallery. Approached by 100 artists/year. Exhibits 6 emerging, mid-career and established artists. Average display time: 6-7 weeks. Open all year; Monday-Friday, 9-5. Closed holidays and weekends. 100 linear feet of wall space on the 3rd floor of the Administrative Headquarters of the Parks Department located in Central Park. Clients include local community, students, tourists and upscale. Overall price range: $100-30,000.

MEDIA Considers all media except 3D work.

STYLE Considers all styles.

TERMS Retail price set by the artist. Does not require exclusive representation locally.

SUBMISSIONS Files résumé and photocopies.

ART@NET INTERNATIONAL GALLERY

E-mail: artnetg@yahoo.com. **Website:** www.artnet. com. **Contact:** Yavor Shopov-Bulgari, director. Estab. 1998. For-profit online gallery. Approached by 150 artists/year. Represents 20 emerging, mid-career and established artists. Exhibited artists include Nicolas Roerich (paintings) and Yavor Shopov (photography). Sponsors 15 exhibits/year. Average display time: permanent. Open all year; Monday-Sunday, 24 hours. "Online galleries like ours have a number of unbelievable advantages over physical galleries and work far more efficiently, so they are expanding extremely rapidly and taking over many markets held by conventional galleries for many years. Our gallery exists only online, giving us a number of advantages both for our clients and artists. Our expenses are reduced to the absolute minimum, so we charge our artists lowest commission in the branch (only 10%) and offer to our clients lowest prices for the same quality of work. Unlike physical galleries, we have over 100 million potential online clients worldwide and are able to sell in over 150 countries without need to support offices or representatives everywhere. We mount cohesive shows of our artists, which are unlimited in size and may be permanent. Each artist has individual 'exhibition space' divided to separate thematic exhibitions along with bio and statement. We are just hosted in the Internet space, otherwise our organization is the same as of a traditional gallery." Clients include collectors and business offices worldwide; 30% corporate collectors. Overall price range: $150-50,000.

MEDIA Considers ceramics, crafts, drawing, oil, pastel, pen & ink, sculpture, and watercolor. Most frequently exhibits photos, oil, and drawing. Considers all types of prints.

STYLE Considers expressionism, geometric abstraction, impressionism and surrealism. Most frequently exhibits impressionism, expressionism and surrealism. Also considers Americana, figurative work, florals, landscapes, and wildlife.

TERMS Artwork is accepted on consignment, and there is a 10% commission and a rental fee for space of $1/image per month or $5/image per year (first 6 images are displayed free of rental fee). Retail price set by the gallery or the artist. Gallery provides promotion. Accepted work should be matted. Does not require exclusive representation locally. "Every exhibited image will contain your name and copyright as watermark and cannot be printed or illegally used, sold or distributed anywhere."

SUBMISSIONS E-mail portfolio for review. E-mail attached scans of 900×1200 pixels (300 dpi for prints or 900 dpi for 36mm slides) as JPEG files for IBM computers. "We accept only computer scans; no slides, please." E-mail artist's statement, bio, résumé, and scans of the work. Cannot return material. Responds in 6 weeks. Finds artists through submissions, portfolio reviews, art exhibits, art fairs, and referrals by other artists.

TIPS "E-mail us a tightly edited selection of less than 20 scans of your best work. All work must be very appealing and interesting, and must force any person to look over it again and again. Main usage of all works exhibited in our gallery is for limited edition (photos) or original (paintings) wall decoration of offices and homes. Photos must have the quality of paintings. We like to see strong artistic sense of mood, composition, light and color, and strong graphic impact or expression of emotions. We exhibit only artistically perfect work in which value will last for decades. We would like to see any quality work facing these requirements on any media, subject or style. No distractive subjects. For us only quality of work is important, so new artists are welcome. Before you send us your work, ask yourself, 'Who and why will someone buy this work? Is it appropriate and good enough for this purpose?' During the exhibition, all photos must be available in signed limited edition museum quality 8×10 or larger matted prints."

ART 3 GALLERY

44 W. Brook St., Manchester NH 03101. (603)668-6650; (800)668-9983. **Fax:** (603)668-5136. **E-mail:** info@art3gallery.com. **Website:** www.art3gallery. com. **Contact:** Joni Taube, owner. Estab. 1980. For-profit gallery and art consultancy. Exhibits emerging, mid-career, and established artists. Approached by 50+ artists a year; represents of exhibits 180+ artists. Exhibited artists include James Aponorich (oil paitning) and Stan Moeller (oil painting). Sponsors 4 exhibits/year. Average display time: 2-3 months. Open Monday-Friday, 9-4. Located in Downtown Manchester in a 2-story, 2,000-sq.-ft. exhibit space. Clients include local community, tourists, and upscale clients. Overall price range: $150-20,000. Most work sold at $1,000.

MEDIA Considers acyrlic, ceramics, collage, drawing, fiber, glass, mixed media, oil, paper, pastel, pen & ink, sculpture, and watercolor. Most frequently exhibits oil, acrylic, and sculpture. Considers the following prints: etchings, linocuts, lithographs, serigraphs, and woodcuts.

STYLE Considers all styles and genres.

TERMS Artwork is accepted on consignment and there is a 50% commission. Retail price set by the gallery and artist. Gallery provides insurance, promotion, and contract. Accepted artwork should be framed, mounted, and matted. Does not require exlcusive local representation.

SUBMISSIONS E-mail query letter with link to artist's website or JPEG samples at 72 dpi. Materials returned with SASE. Responds if interested in 4 weeks. Finds artists through word of mouth, submissions, art exhibits, art fairs, and referrals by other artists.

ART CENTER OF BATTLE CREEK

265 E. Emmett St., Battle Creek MI 49017. (269)962-9511. **Fax:** (269)969-3838. **E-mail:** artcenterofbc@yahoo.com. **Website:** www.artcenterofbattlecreek. org. Estab. 1948. Represents 150 emerging, mid-career and established artists. 90% private collectors, 10% corporate clients. Exhibition program offered in galleries, usually 3-4 solo shows each year, 2 artists' competitions, and a number of theme shows. Also offers Michigan Artworks Shop featuring work for sale or rent. Average display time: 1-2 months. Three galleries, converted from church—handsome high-vaulted ceiling, arches lead into galleries on either side. Welcoming, open atmosphere. Overall price range: $20-1,000; most work sold at $20-300. Open Tuesday–Friday, 10-5; Saturday, 11-3; closed Sunday, Monday and major holidays.

MEDIA Considers oil, acrylic, watercolor, pastel, pen & ink, drawings, mixed media, collage, works on paper, sculpture, ceramic, craft, fiber, glass, photography and original handpulled prints.

STYLE Exhibits painterly abstraction, minimalism, impressionism, photorealism, expressionism, neo-expressionism and realism. Genres include landscapes, florals, Americana, portraits and figurative work. Prefers Michigan artists.

TERMS Accepts work on consignment (40% commission). Retail price set by artist. Exclusive area representation not required. Gallery provides insurance, promotion and contract; artist pays for shipping.

SUBMISSIONS Michigan artists receive preference. Send query letter, résumé, brochure, slides and SASE. Slides returned; all other material is filed.

TIPS "Contact us before mailing materials. We are working on several theme shows with groupings of artists."

⊕ ART CENTER OF BURLINGTON

301 Jefferson St., Burlington IA 52601. (319)754-8069. **Fax:** (319)754-4731. **E-mail:** artsforliving@ artcenterofburlington.com. **Website:** www. artcenterofburlington.com. Estab. 1974. Exhibits the work of mid-career and established artists. May consider emerging artists. Sponsors 10 shows/year. Average display time: 3 weeks. Open Monday-Friday, 10–5; Saturday, 10-4. 15,000 sq. ft. total space; 4,500 sq. ft. for exhibitions. Overall price range: $25-1,000; most work sold at $75-500.

MEDIA Considers all visual media. Most frequently exhibits two-dimensional work.

STYLE Exhibits all styles.

TERMS Accepts work on consignment (25% commission). Retail price set by artist. Gallery provides promotion and contract; artist pays for shipping. Prefers artwork framed.

SUBMISSIONS Send query letter with résumé, slides, bio, brochure, photographs, SASE and reviews.

ART CENTER/SOUTH FLORIDA

924 Lincoln Rd., Suite 205, Miami Beach FL 33139. (305)674-8278. **Fax:** (305)674-8772. **E-mail:** email@artcentersf.org. **Website:** www.artcentersf.org. **Contact:** Cherese Crockett, exhibitions and artist rela-

tions manager. Estab. 1984. Nonprofit organization. The ACSF has one of the most rigorous nonprofit exhibition schedules in South Florida. A monthly exhibition schedule allows for comprehensive programming and assures that the ACSF can react to current trends. Curatorial initiatives from outside sources are the make-up of the majority of exhibits. Our exhibitions primarily focus on contemporary media, current aesthetic issues, contextual linkages and community awareness. Exhibits group shows by emerging artists. Average display time: 1-2 month. Open Monday–Thursday, 12-9; Friday & Saturday, 11-10; Sunday , 11-9. Clients include local community, students, tourists and upscale. Overall price range: $500-5,000. Office hours: 9:30-5:30.

MEDIA Considers all media except craft. Most frequently exhibits painting, sculpture, drawings and installation.

STYLE Exhibits themed group shows, which challenge and advance the knowledge and practice of contemporary arts.

TERMS Retail price set by the artist. Gallery provides insurance and promotion. Gallery receives 10% commission from sales. Accepted work should be ready to install. Does not require exclusive representation locally.

SUBMISSIONS Artists apply with a proposal for an exhibition. It is then reviewed by a panel. See website for more details.

ART ENCOUNTER

5720 S. Arville Street, Suite 119, Las Vegas NV 89118. (702)227-0220 or (800)395-2996. **Fax:** (702)227-3353. **E-mail:** scottf@artencounter.com. **Website:** www.artencounter.com. Estab. 1992. Retail gallery. "We have become one of the most popular destinations for locals as well as tourists. Conveniently located a short distance from the strip, we sell distinct works of art that utilize several styles and media. We also offer award-winning custom framing and our certified on staff appraiser (seen on History Channel's *Pawn Stars*)." Open Monday-Friday, 8:30-5. Clients include upscale tourists, locals, designers and casino purchasing agents.

ARTISTS' COOPERATIVE GALLERY

405 S. 11th St., Omaha NE 68102. (402)342-9617. **E-mail:** artistscoopgallery@gmail.com. **Website:** www.artistsco-opgallery.com. Estab. 1974. Sponsors 12 exhibits/year. Average display time: 1 month. Gallery sponsors all-member exhibits and outreach exhibits; individual artists sponsor their own small group exhibits throughout the year. Overall price range: $100-5,000. Open Tuesday–Thursday, 11-5; Friday-Saturday, 11-10; Sunday, 12-6. Thursdays during holiday season and summer hours until 10 p.m.

MEDIA Considers oil, acrylic, watercolor, pastel, drawings, mixed media, collage, paper, sculpture, ceramic, fiber, glass, photography, woodcuts, serigraphs. Most frequently exhibits sculpture, acrylic, oil, and ceramic.

STYLE Exhibits all styles and genres.

TERMS Charges no commission. Reviews transparencies. Accepted work should be framed work only. "Artist must be willing to work 13 days per year at the gallery. We are a member-owned-and-operated cooperative. Artist must also serve on one committee."

SUBMISSIONS Send query letter with résumé, SASE. Responds in 2 months.

TIPS "Write for membership application. Membership committee screens applicants August 1-15 each year. Responds by September 1. New membership year begins October 1. Members must pay annual fee of $400. Our community outreach exhibits include local high school photographers and art from local elementary schools."

ARTISTS' GALLERY

Emerson Cultural Center, 111 S. Grand Ave., #106, Bozeman MT 59715. (406)587-2127. **E-mail:** surrattmarci@gmail.com. **Website:** www.artistsgallerybozeman.com. **Contact:** Marci Surratt. Estab. 1992. Retail and cooperative gallery. Represents the work of 20 local emerging and mid-career artists, 20 members. Sponsors 12 shows/year. Average display time 3 months. We are open Monday–Saturday, 10-5; some evenings until 8. Located near downtown; 900 sq. ft.; located in Emerson Cultural Center with other galleries, studios, etc. Clients include tourists, upscale and local community.

MEDIA Considers oil, acrylic, watercolor, pastel, pen & ink, drawing, mixed media, collage, paper, sculpture, ceramics and glass, woodcuts, engravings, linocuts and etchings. Most frequently exhibits oil, watercolor, and ceramics.

STYLE Exhibits painterly abstraction, impressionism, photorealism and realism. Exhibits all genres. Prefers realism, impressionism, and western.

TERMS Co-op membership fee plus donation of time (20% commission). Rental fee for space; covers 1 month. Retail price set by the artist. Gallery provides promotion. Prefers artwork framed.

SUBMISSIONS "We take local artists who are able to share sitting in the gallery. We occasionally take consigners for 3D items." Application is available on website. Call or write for appointment to show actual work.

THE ART LEAGUE, INC.

105 N. Union St., Alexandria VA 22314. (703)683-1780. **Fax:** (703)683-5786. **E-mail:** gallery@theartleague. org. **Website:** www.theartleague.org. Estab. 1954. "Our engaging exhibition schedule makes the Art League Gallery an intriguing art space for gallery visitors in the D.C. metropolitan area to view original art of all media by talented artists from throughout Washington and the Mid-Atlantic region." Interested in emerging, mid-career and established artists. 1,200-1,400 members. Sponsors 7-8 solo and 14 group shows/year. Average display time: 1 month. Located in the Torpedo Factory Art Center. Accepts artists from metropolitan Washington area, northern Virginia and Maryland. 75% of sales are to private collectors, 25% corporate clients. Overall price range: $50-4,000; most work sold at $150-500.

MEDIA Considers all media. Most frequently exhibits watercolor, oil, and photographs. Considers all types of prints.

STYLE Exhibits all styles and genres. Prefers impressionism, painted abstraction, and realism. "The Art League is a membership organization open to anyone interested."

TERMS Accepts work by jury on consignment (40% commission) and co-op membership fee plus donation of time. Retail price set by artist. Offers customer discounts (designers only) and payment by installments (if requested on long term). Exclusive area representation not required.

SUBMISSIONS Work juried monthly for each new show from actual work (not slides). Work received for jurying on first Monday evening/Tuesday morning of each month; pick-up nonselected work throughout rest of week.

TIPS "Artists find us and join/exhibit as they wish within framework of our selections jurying process. It is more important that work is of artistic merit rather than salable."

ART LEAGUE OF HOUSTON

1953 Montrose Blvd., Houston TX 77006. (713)523-9530. **Fax:** (713)523-4053. **E-mail:** jennifer@ artleaguehouston.org; alh@artleaguehouston.org. **Website:** www.artleaguehouston.org. **Contact:** Jennifer Ash. Estab. 1948. Nonprofit gallery. Represents emerging and mid-career artists. Sponsors 12 individual and group shows/year. Each season, ALH presents contemporary art in a variety of media in its 2 gallery spaces. Average display time 3-4 weeks. Located in a contemporary metal building; 1,300 sq. ft., specially lighted with a smaller inner gallery/video room. Open Tuesday–Friday, 9-5; Saturday, 12-5. Clientele: general, artists and collectors. Overall price range: $100-5,000; most artwork sold at $100-2,500.

MEDIA Considers all media.

STYLE Exhibits contemporary avant-garde, socially aware work. Features "high-quality artwork reflecting serious aesthetic investigation and innovation. Additionally the work should have a sense of personal vision."

TERMS 30% commission. Retail price set by artist. Exclusive area representation not required. Gallery provides insurance, promotion and contract; artist pays for shipping.

SUBMISSIONS Must be a Houston-area resident. Send query letter, résumé and slides that accurately portray the work. Portfolio review not required. Submissions reviewed once a year in mid-June, and exhibition agenda determined for upcoming year.

ART MUSEUM OF GREATER LAFAYETTE

102 S. Tenth St., Lafayette IN 47905. (765)742-1128. **Fax:** (765)742-1120. **E-mail:** glenda@artlafayette.org. **Website:** www.artlafayette.org. **Contact:** Glenda McClatchey, administrative assistant. Estab. 1909. Museum. Temporary exhibits of American and Indiana art, work by emerging, mid-career and established artists from Indiana and the midwest. 1,340 members. Sponsors 16-18 shows/year. Average display time: 10 weeks. Located 6 blocks from city center; 3,318 sq. ft.; 5 galleries. Open every day, 11-4. Clientele includes Purdue University faculty, students and residents of Lafayette/West Lafayette and 14 county area.

STYLE Exhibits all styles. Genres include landscapes, still life, portraits, abstracts, nonobjective and figurative work.

TERMS Accepts art from local artists for consignment in gift shop (30% mark-up).

SUBMISSIONS Send query letter with résumé, digital portfolio, artist's statement, and letter of intent.

TIPS "Indiana artists specifically encouraged to apply."

ARTQUOTE INTERNATIONAL, LLC

4653 Chelsea Lane, Bloomfield Hills MI 48301. (248)470-5912. **Fax:** (248)851-6090. **E-mail:** artquote@comcast.net. **Contact:** M. Burnstein. Art consultancy; for-profit, wholesale gallery; corporate art and identity programs. Estab. 1985. Exhibits established artists. Exhibited artists include Andy Warhol (screenprints) and Bill Mack (sculpture). Clients include local community. Most sales are to corporate collectors. Does not sell art at retail prices. Supplier to Fortune 100 corporations (global).

SUBMISSIONS Depends on corporate client. Finds artists through "established network of channels."

THE ARTS CENTER

P.O. Box 363, 115 Second St., SW, Jamestown ND 58401. (701)251-2496. **Fax:** (701)251-1749. **E-mail:** sjeppson@jamestownarts.com. **Website:** www.jamestownarts.com. **Contact:** Sally Jepson, gallery manager. Estab. 1981. Nonprofit gallery. Sponsors 8 solo and 4 group shows/year. Average display time 6 weeks. Interested in emerging artists. Overall price range: $50-600; most work sold at $50-350.

STYLE Exhibits contemporary, abstraction, impressionism, primitivism, photorealism and realism. Genres include Americana, figurative and 3D work.

TERMS 20% commission on sales from regularly scheduled exhibitions. Retail price set by artist. Gallery provides insurance, promotion and contract; shipping costs are shared.

SUBMISSIONS Send query letter, résumé, brochure, slides, photograph and SASE. Write for appointment to show portfolio. Invitation to have an exhibition is extended by Arts Center gallery manager.

TIPS "We are interested in work of at least 20-30 pieces, depending on the size."

THE ARTS COMPANY

215 Fifth Ave., Nashville TN 37219. (615)254-2040; (877)694-2040. **Fax:** (615)254-9289. **E-mail:** art@theartscompany.com. **Website:** www.theartscompany.com. **Contact:** Anne Brown, owner. Estab. 1996. Art consultancy, for-profit gallery. Estab. 1996. Over 6,000 sq. ft. of gallery space on 2 floors. Overall price range: $10-35,000; most work sold at $300-3,000.

We are not accepting artist submissions at this time.

MEDIA Considers all media. Most frequently exhibits painting, photography and sculpture.

STYLE Exhibits all styles and genres. Frequently exhibits contemporary outsider art.

TERMS Artwork is accepted on consignment. Gallery provides insurance and contract. Accepted work should be framed. Requires exclusive representation locally.

SUBMISSIONS "We prefer an initial info packet via e-mail." Send query letter with artist's statement, bio, brochure, business card, photocopies, résumé, reviews, SASE, CD. Returns material with SASE. Finds artists through word of mouth, art fairs/exhibits, submissions, referrals by other artists.

TIPS "Provide professional images on a CD along with a professional bio, résumé."

ARTS ON DOUGLAS

Atlantic Center for the Arts, 123 Douglas St., New Smyrna Beach FL 32168. (386)428-1133. **Fax:** (386)428-5008. **E-mail:** mmartin@artsondouglas.net. **Website:** www.artsondouglas.net. **Contact:** Meghan Martin, gallery director. Estab. 1996. Represents 50 professional Florida artists and exhibits 8 established artists/year. Average display time: 1 month. Open all year; Tuesday-Friday, 10-5; Saturday, 11-3. 5,000 sq. ft. of exhibition space. Clients include local community, tourists and upscale. Accepts only professional artists from Florida. Returns material with SASE. Send a query letter and include a CD with 6 current images, bio, CV and artist's statement.

MEDIA Considers all media except installation.

STYLE Considers all styles and genres.

TERMS Overall price range varies. Artwork is accepted on consignment (50% commission). Retail price set by the artist. Gallery provides insurance and promotion. Accepted work should be framed.

SUBMISSIONS Artists may want to call gallery prior to sending submission package—not always accepting new artists.

ART SOURCE L.A., INC.

2801 Ocean Park Blvd., #7, Santa Monica CA 90405. (310)452-4411 or (800)721-8477. **Fax:** (310)452-0300. **E-mail:** info@artsourcela.com. **Website:**

www.artsourcela.com. **Contact:** Francine Ellman, president. Estab. 1980. Artwork is accepted on consignment (50% commission). No geographic restrictions. Finds artists through art fairs/exhibitions, submissions, referrals by other artists, portfolio reviews and word of mouth.

MEDIA Considers fine art in all media, including works on paper/canvas, sculpture, giclée and a broad array of accessories handmade by American artists. Considers all types of prints.

TERMS "Send minimum of 20 slides or photographs (laser copies are not acceptable) clearly labeled with your name, title and date of work, size and medium. Catalogs and brochures of your work are welcome. Also include a résumé, price list and SASE. We will not respond without a return envelope." Also accepts e-mail submissions. Responds in 30 days if interested.

SUBMISSIONS Submission guidelines available on website.

TIPS "Be professional when submitting visuals. Remember, first impressions can be critical! Submit a body of work that is consistent and of the highest quality. Work should be in excellent condition and already photographed for your records. Framing does not enhance presentation to the client."

ARTSPACE

0 E. Fourth St., Richmond VA 23224. (804)232-6464. **E-mail:** artspaceorg@gmail.com. **Website:** www.artspacegallery.org. Nonprofit gallery. Estab. 1988. Approached by 100 artists/year. Represents about 50 emerging, mid-career artists. Sponsors approximately 2 exhibits/year. Average display time: 1 month. Open all year; Tuesday-Sunday, 12-4. Located in the newly designated Arts District in Manchester, in Richmond VA. Brand new gallery facilities; 4 exhibition spaces; 3,000 sq. ft. Clients include local community, students, tourists and upscale. 2% of sales are to corporate collectors. Overall price range: $100-800; most work sold at $450.

MEDIA Considers all media and all types of prints. Most frequently exhibits photography, painting and sculpture.

STYLE Considers all styles and genres.

TERMS There are exhibition fees; 33% commission. Retail price set by the artist. Gallery provides insurance and contract. Accepted work should be framed, mounted and matted. Pedestals available for sculpture. Does not require exclusive representation locally.

SUBMISSIONS Send query letter with artist's statement, bio, résumé, and proposal form from website. Images should be sent digitally, either by e-mail or CD. Responds to queries in 3 weeks. If accepted, all materials submitted are filed. Finds artists through referrals by other artists, submissions and word of mouth.

ARTSPACE/LIMA

65-67 Town Square, Lima OH 45801. (419)222-1721. **E-mail:** artspacelima@woh.rr.com. **Website:** www.artspacelima.com. Kay VanMeter. **Contact:** operations manager. Estab. 1955. Nonprofit gallery. Sponsors 15 shows/year. Average display time: 6 weeks. Open Tuesday–Friday, 10-5; Saturday, 10-2. Located downtown; 286 running ft. 100% of space for special exhibitions. Clientele local community. 80% private collectors, 5% corporate collectors. Overall price range: $300-6,000; most work sold at $500-1,000.

MEDIA Considers all media and all types of prints. Most frequently exhibits painting, sculpture, drawing.

STYLE Exhibits all styles of contemporary and traditional work.

TERMS Accepts work on consignment (40% commission). Retail price set by the artist. Gallery provides insurance, promotion and contract. Artwork must be ready to hang.

SUBMISSIONS Send query letter with résumé, jpeg samples, artist's statement and SASE. Responds only if interested within 6 weeks. Files résumé.

THE ART STORE

233 Hale St., Charleston WV 25301. (304)345-1038. **Fax:** (304)345-1858. **E-mail:** gallery@theartstorewv.com. **Website:** www.theartstorewv.com. "The Art Store is dedicated to showing original 20th-century and contemporary American art by leading local, regional and nationally recognized artists. Professional integrity, commitment and vision are the criteria for artist selection, with many artists having a history of exhibitions and museum placement. Painting, sculpture, photography, fine art prints and ceramics are among the disciplines presented. A diverse series of solo, group and invitational shows are exhibited throughout the year in the gallery." Retail gallery. Represents 50 mid-career and established artists. Sponsors 11 shows/year. Average display time: 4 weeks. Open Tuesday–Friday, 10-5:30; Saturday, 10-5; anytime by appointment. Located in a upscale shopping area; 2,000 sq. ft.; 50% of space for special exhibitions. Clientele: professionals, executives, decora-

tors. 80% private collectors, 20% corporate collectors. Overall price range: $200-8,000; most work sold at $2,000.

MEDIA Considers oil, acrylic, watercolor, pastel, mixed media, works on paper, ceramics, wood and metal.

STYLE Exhibits expressionism, painterly abstraction, color field and impressionism.

TERMS Accepts artwork on consignment (50% commission). Retail price set by gallery and artist. Gallery provides insurance, promotion and shipping costs from gallery. Prefers artwork unframed.

SUBMISSIONS Send query e-mail.

ART WITHOUT WALLS, INC.

P.O. Box 341, Sayville NY 11782. (631)567-9418. **Fax:** (631)567-9418. **E-mail:** artwithoutwalls@outlook.com. **Contact:** Sharon Lippman, executive director. Estab. 1985. Nonprofit gallery. Approached by 300 artists/year. Represents 100 emerging, mid-career and established artists. Sponsors 10 exhibits/year. Average display time: 1 month. Open daily, 9-5. Closed December 22-January 5 and Easter week. Overall price range: $1,000-25,000; most work sold a0t $3,000-5,000. "Sponsoring the upcoming Museum Without Walls, an award-winning fine art exhibition that allows both the profesional and emerging artist the opportunity to connect with the viewer in a public space. Artwork is accepted on consignment (20% commission). Retail price set by the artist. Gallery provides promotion and contract. Accepted work should be framed, mounted and matted. Finds artists through submissions, portfolio reviews and art exhibits." Annual show every year 2nd week of June in Central Park. Interested artists should e-mail or call for more information. Also accepting volunteers for website design and maintenance for non-profit.

MEDIA "Considers all media and all types of prints. Most frequently exhibits painting, sculpture, and drawing."

STYLE Considers all styles and genres. Most frequently exhibits impressionism, expressionism, post-modernism.

SUBMISSIONS Mail portfolio for review. Send query letter with artist's statement, brochure, photographs, résumé, reviews, SASE, and slides. Returns material with SASE. Responds in 1 month. Files artist résumé, slides, photos, and artist's statement.

TIPS Work should be properly framed with name, year, medium, title, and size.

THE ASHBY-HODGE GALLERY OF AMERICAN ART

Central Methodist University, 411 Central Methodist Square, Fayette MO 65248. (660)248-6324 (gallery) or (660)248-6304 (office). **Fax:** (660)248-2622. **E-mail:** dgebhard@centralmethodist.edu. **Website:** www.centralmethodist.edu/ashbyhodge/index.php. **Contact:** Denise Gebhardt, Curator. Estab. 1993. Nonprofit gallery. "The Ashby Collection of oil paintings, lithographs, drawings, and acrylics, mainly represents the work of American Regionalist artists. Although the Ashby Collection is the principal focus of the gallery, special exhibits are scheduled throughout the year." Exhibits the work of 200 artists in permanent collection. Exhibited artists include Robert MacDonald Graham, Jr., Birger Sandzen, George Caleb Bingham, Thomas Hart Benton, Thomas Moran, Charles Banks Wilson. Sponsors 4 shows/year. Average display time: 2 months. Open Sunday, Tuesday, Thursday, 1:30-4:30 and by appointment. on lower level of Classic Hall. Clientele local community and surrounding areas of Mid-America. Physically impaired accessible. Tours by reservation.

MEDIA Considers all media. Most frequently exhibits acrylic, lithographs, oil and fibers.

STYLE Exhibits Midwestern regionalists. Genres include portraits and landscapes. Prefers realism.

TERMS Accepts work on consignment (30% commission). Retail price set by the gallery. Gallery provides insurance and promotion; shipping costs are shared. Prefers artwork framed.

SUBMISSIONS Accepts primarily Midwestern artists. Send query letter with résumé, slides, photographs and bio. Call for appointment to show portfolio of photographs, transparencies and slides. Finds artists through recommendations and submissions.

ASIAN AMERICAN ARTS CENTRE

111 Norfolk St., New York NY 10002. **Fax:** (360)283-2154. **E-mail:** aaacinfo@artspiral.org. **Website:** www.artspiral.org. Estab. 1974. "Our mission is to promote the preservation and creative vitality of Asian American cultural growth through the arts, and its historical and aesthetic linkage to other communities." Exhibits should be Asian American or significantly influenced by Asian culture and should be entered

into the archive—a historical record of the presence of Asia in the US. Interested in "creative art pieces." Average display time: 6 weeks. Open Monday–Friday, 12:30-6:30 (by appointment).

TERMS 30% "donation" on works sold. Sometimes buys photos outright.

SUBMISSIONS Send dupes of slides, résumé, artist's statement, bio, and online form to be entered into the archive. These will be kept for users of archive to review. Recent entries are reviewed once/year for the art centre's annual exhibition.

ATELIER GALLERY

153 King St., Charleston SC 29401. **E-mail:** gabrielle@theateliergalleries.com. **Website:** www.theateliergalleries.com. **Contact:** Gabrielle Egan, curator and owner. Estab. 2008. Fine art gallery. Exhibits mid-career, and established artists. Represents or exhibits 60 artists. For exhibited artists, see website. Open Monday-Friday, 10-6; Sundays, by chance. Closed Holidays. Clients include local community, students, tourists, upscale, and artists and designers. Overall price range: $50-15,000. Most work sold in the $2,500-5,000 range.

MEDIA Accepts acrylic, ceramics, collage, drawing, fiber, glass, mixed media, oil, paper, pastel, pen & ink, sculpture, and watercolor.

STYLE Exhibits expressionism, geometric abstraction, hyper realism, minimalism, pattern painting and painterly abstraction. Interested in figurative work and florals.

TERMS Artwork is accepted on consignment with a 50% comission. Retail price set by the gallery and artist. Gallery provides insurance, promotion, and contract. Atelier requires exclusive representation within 250 miles of the gallery in downtown Charleston SC.

SUBMISSIONS E-mail query letter along with 6 images of the most current body of work. Please include medium, dimensions, framing specifications, pricing. Also provide all artist contact information to include website, e-mail, and telephone number. Atelier Gallery will contact each artist via e-mail once the submission has been reviewed. If more information is needed, the gallery will request it directly.

ATHENAEUM MUSIC AND ARTS LIBRARY

1008 Wall St., La Jolla CA 92037. (858)454-5872. **E-mail:** press@ljathenaeum.org; echildrey@ljathenaeum.org. **Website:** www.ljathenaeum.org. **Contact:** Elena Childrey. Estab. 1899. Nonprofit gallery. Represents/exhibits emerging, mid-career and established artists. "The Athenaeum Music & Arts Library, located in the heart of La Jolla, in San Diego County, is one of only 16 nonprofit membership libraries in the US. This rare cultural institution, an important one to the greater San Diego area, offers a depth and accessibility of resources and programs found nowhere else in the region." Exhibited artists include Ming Mur-Ray, Italo Scanga and Mauro Staccioli. Sponsors 8 exhibitions/year. Average display time: 2 months. Open Tuesday, Thursday–Saturday, 10-5:30; Wednesday, 10-8:30. Located downtown La Jolla. An original 1921 building designed by architect William Templeton Johnson 12-foot high wood beam ceilings, casement windows, Spanish-Italianate architecture. 100% of space for special exhibitions. Clientele tourists, upscale, local community, students, and Athenaeum members. 100% private collectors. Overall price range: $100-1,000; most work sold at $100-500.

MEDIA Considers all media, all types of prints. Most frequently exhibits painting, multimedia, and book art.

STYLE Exhibits all styles. Genres include florals, portraits, landscapes and figurative work.

TERMS Artwork is accepted on consignment, and there is a 25% commission. Retail price set by the artist. Gallery provides insurance and promotion; shipping costs are shared. Prefers artwork framed.

SUBMISSIONS Artists must be considered and accepted by the art committee. Send query letter with slides, bio, SASE and reviews. Write for appointment to show portfolio of photographs, slides and transparencies. Responds in 2 months. Files slide and bio only if there is initial interest in artist's work.

TIPS Finds artists through word of mouth and referrals.

ATLANTIC GALLERY

548 W. 28th St., Suite 540, New York NY 10001. (212)219-3183. **E-mail:** info@atlanticgallery.org. **Website:** www.atlanticgallery.org. **Contact:** Jeff Miller, president. Estab. 1974. Cooperative gallery. There is a co-op membership plus a donation of time required. Approached by 50 artists/year; represents 24 emerging, mid-career and established artists. Exhibited artists include Ragnar Naess (sculptor), Sally Brody (oil, acrylic), and Whitney Hansen (oil). Average display time: 4 weeks. Gallery open Tuesday, Wednesday, Fri-

day, Saturday, 12-6; Thursday, 12-9. Closed August. Located in Chelsea. Has kitchenette. Clients include local community, tourists and upscale clients. 2% of sales are to corporate collectors. Overall price range: $100-13,000. Most work sold at $1,500-5,000. Finds artists through word of mouth, submissions, art exhibits, referrals by other artists.

MEDIA Considers all media. Considers all types of prints. Most frequently exhibits watercolor, acrylic and oil.

STYLE Considers all styles and genres. Most frequently exhibits impressionism, realism, imagism.

TERMS Artwork is accepted on consignment, and there is a 20% commission. There is a 10% commission. Rental fee for space covers 4 weeks. Retail price set by the artist. Gallery provides promotion and contract. Accepted work should be framed. Does not require exclusive representation locally. Currently accepting artists.

SUBMISSIONS Call or write to arrange a personal interview to show CD and artwork. Send query letter with artist's statement, bio, brochure, SASE and CD or slides. Returns material with SASE. Responds in 2 weeks. Files only accepted work.

ATLAS GALLERIES, INC.

535 N. Michigan Ave., Chicago IL 60611. (312)329-9330; (312)649-0999. **E-mail:** Via online contact form. **Website:** www.atlasgalleries.com. Estab. 1967. For-profit gallery. Exhibits established artists. Sponsors 14 exhibits/year. Average display time: 2 days solo/ then permanently with collection. Two locations on Michigan Avenue's Magnificent Mile. See website for hours of both locations. Clients include local community, tourists, upscale. 5% of sales are to corporate collectors. Overall price range: $200-100,000; most work sold at $2,000.

MEDIA Considers acrylic, ceramics, collage, drawing, glass, mixed media, oil, paper, pastel, pen & ink, sculpture, and watercolor. Most frequently exhibits oil, acrylic, and sculpture. Considers prints of engravings, etchings, linocuts, lithographs, serigraphs, woodcuts, and giclée.

STYLE Considers all styles and genres. Most frequently exhibits impressionism, surrealism/post modern. Exhibits all genres.

TERMS Artwork is accepted on consignment or bought outright. Retail price set by the gallery. Gallery provides insurance, promotion, and contract. Requires exclusive representation locally.

SUBMISSIONS Send query letter with artist's statement, bio, photocopies, photographs, and slides. Returns material with SASE. Responds to queries if interested within 3 months. Does not file materials unless we are interested in artist. Finds artists through art exhibits, portfolio reviews, referrals by other artists, submissions, and word of mouth.

AUROBORA PRESS

340 Walnut Ave., Ketchum ID 83340. (415)546-7880. **E-mail:** monotype@aurobora.com. **Website:** www.aurobora.com. **Contact:** Michael Liener, founder/director. Estab. 1993. Retail gallery and fine arts press. Invitational Press dedicated to the monoprint and monotype medium. Represents/exhibits emerging, mid-career and established artists. Exhibited artists include William T. Wiley, David Ireland, Stephan De Staebler, Tony Delap. Sponsors 10 shows/year. Average display time: 6-8 weeks. Open Tuesday–Saturday, 10-5; and by appointment. Located Sun Valley, ID; 1,500 sq. ft.; Clientele includes collectors, individuals, and art consultants. Overall price range: $1,200-30,000; most work sold at $1,500-4,000.

Aurobora Press invites artists each year to spend a period of time in residency working with Master Printers.

MEDIA Publishes monotypes and other unique works on paper.

TERMS Retail price set by gallery and artist. Gallery provides promotion.

SUBMISSIONS By invitation only.

ALAN AVERY ART COMPANY

315 E. Paces Ferry Rd., Atlanta GA 30305. (404)237-0370. **E-mail:** info@alanaveryartcompany.com. **Website:** www.alanaveryartcompany.com. **Contact:** Alan Avery, owner. Estab. 1983. Retail gallery and corporate sales consultants. Represents/exhibits over 60 artists, from emerging to Modern Masters. Exhibited artists include Roy Lichtenstein, Jim Dine, Robert Rauschenberg, Andy Warhol, Caio Fonseca, Larry Gray, Robert Kipniss, Lynn Davison and Russell Whiting. Sponsors 6-8 shows/year. Average display time: 6-8 weeks. Open all year; Tuesday–Saturday, 11-5; Saturday, 11-5 and by appointment. Located: Buckhead; 6,700 sq. ft.; 25-year-old converted restaurant. 50-60% of space for special exhibitions; 40-50% of space for gallery artists. Clientele: upscale, local, re-

gional, national and international. 70% private collectors, 30% corporate collectors. Overall price range: $1,500-150,000.

MEDIA Considers all media. Most frequently exhibits painting, sculpture, and works on paper.

STYLE Exhibits expressionism, conceptualism, color field, painterly abstraction, postmodern works and realism. Genres include landscapes, Americana, and figurative work. Prefers realism, abstract, and figurative.

TERMS Artwork is accepted on consignment (negotiable commission). Retail price set by gallery. Gallery pays promotion and contract. Shipping costs are shared. Prefers framed artwork.

SUBMISSIONS Currently not accepting artist submissions. When open, submission guidelines will be available online. Send query letter with résumé, at least 20 images, bio, prices, medium, sizes, and SASE. Reviews every 6 weeks. Finds artists through submissions, word of mouth, research, and referrals by other artists. Submission guidelines available online.

TIPS "Be as complete and professional as possible in presentation. We provide submittal process sheets, listing all items needed for review. Following these sheets is important."

SARAH BAIN GALLERY

110 W. Birch St., Suite 1, Brea CA 92821. (714)990-0500. **E-mail:** info@sarahbaingallery.com. **Website:** www.sarahbaingallery.com. For-profit gallery. A commercial art gallery located in downtown Anaheim. Exhibits emerging and mid-career artists. Approached by 200 artists/year; represents or exhibits 24 artists. Sponsors 12 total exhibits/year. Average display time: 1 month. Open Wednesday–Thursday, 11-6; Friday and Saturday, 11-9; Sunday, 11-6; or by appointment. Clients include local community, students, tourists and upscale. Overall price range: $700-15,000; most work sold at $4,000.

MEDIA Considers acrylic, drawing, mixed media, oil. Most frequently exhibits drawing, mixed media, paintings in representational or figurative style.

STYLE Exhibits representational or figurative.

TERMS Artwork is accepted on consignment. Retail price set by the gallery. Gallery provides promotion. Accepted work should be framed and mounted. Prefers only representational or figurative art.

SUBMISSIONS Submission guidelines available online. Mail portfolio for review. Send query letter with slides. Returns material with SASE. Responds to que-

ries in 1 month.

TIPS "Show a consistent, comprehensive body of work as if it were its own show ready to be hung."

BAKEHOUSE ART COMPLEX

561 NW 32nd St., Miami FL 33127. (305)576-2828. **Fax:** (305)576-0316. **E-mail:** ademello@baclf.org; info@baclf.org. **Website:** www.bacfl.org. **Contact:** Ananda DeMello, director of exhibitions. Estab. 1986. A not-for-profit organization dedicated to attracting emerging and mid-career artists in South Florida to a workplace that provides affordable studios, exhibition galleries and professional development opportunities. Represents more than 100 emerging and mid-career artists. 65 tenants, more than 50 associate artists. Sponsors numerous shows and cultural events annually. Average display time: 3-5 weeks. Gallery open daily, 12-5. Located in Wynwood Art District; 3,200 sq. ft. gallery; 33,000 sq. ft. retro-fitted commercial bakery, 17 ft. ceilings. Clientel: 80% private collectors, 20% corporate collectors. Overall price range: $500-10,000.

MEDIA Considers all media.

STYLE Exhibits all styles, all genres.

TERMS Co-op membership fee plus donation of time. Rental fee for studio space. Retail price of art set by the artist.

SUBMISSIONS Submission guidelines available online. Accepts artists to juried membership. Send query letter for application or download online.

TIPS "Don't stop painting, sculpting, etc., while you are seeking representation. Daily work (works-in-progress, studies) evidences a commitment to the profession. Speaking to someone about your work while you are working brings an energy and an urgency that moves the art and the gallery representation relationship forward."

BAKER ARTS CENTER

624 N. Pershing Ave., Liberal KS 67901. (620)624-2810. **Fax:** (620)624-7726. **E-mail:** dianemarsh@bakerartscenter.org. **Website:** www.bakerartscenter.org. **Contact:** Diane Marsh, art director. Estab. 1986. Nonprofit gallery. Exhibits emerging, mid-career, and established artists. Approached by 6-10 artists a year. Represents of exhibits 6-10 artists. Exhibited artists include J. McDonald (glass) and J. Gustafson (assorted). Sponsors 5 total exhibits/year. 1 photography exhibit/year. Model and property release are preferred. Average display time: 40-50

days. Open Tuesday-Friday, 9-5; Saturdays, 2-5. Closed Christmas, Thanksgiving and New Year's Eve. Clients include local community, students, and tourists. Overall price range: $10-1,000. Most work sold at $400.

MEDIA Considers all media. Most frequently exhibits glass, mixed media, and acrylic. Considers engravings, etchings, linocuts, lithographs, and woodcuts.

STYLE Considers all stlyes and genres

TERMS Artwork is accepted on consignment and there is a 30% commission fee. Retail price set by the artist. Gallery provides promotion, and contract. Accepted work should be framed, mounted, and matted.

SUBMISSIONS Write to arrange personal interview to show portfolio or e-mail query letter with link to artist's website or JPEG samples at 72 dpi. Returns material with SASE. Responds in 2-4 weeks. Finds artists through word of mouth, submissions, art exhibits, and referrals by other artists.

BALZEKAS MUSEUM OF LITHUANIAN CULTURE ART GALLERY

6500 S. Pulaski Rd., Chicago IL 60629. (773)582-6500. **Fax:** (773)582-5133. **E-mail:** info@balzekasmuseum. org. **Website:** www.balzekasmuseum.org. **Contact:** Stanley Balzekas, Jr., president. Estab. 1996. Museum, museum retail shop, nonprofit gallery, rental gallery. Approached by 20 artists/year. Sponsors 2 photography exhibits/year. Average display time: 6 weeks. Open daily, 10-4. Closed Christmas, Easter and New Year's Day. Overall price range: $150-6,000. Most work sold at $545.

MEDIA Considers all media and all types of prints.

STYLE Considers all styles and genres.

TERMS Artwork is accepted on consignment and there is a 33⅓% commission. Retail price set by the gallery. Gallery provides promotion. Accepted work should be framed.

SUBMISSIONS Write to arrange a personal interview to show portfolio. Cannot return material. Responds in 2 months. Finds artists through word of mouth, art exhibits, and referrals by other artists.

BANNISTER GALLERY

Rhode Island College, Roberts Hall, 124, 600 Mt. Pleasant Ave., Providence RI 02908-1991. (401)456-9765. **Fax:** (401)456-9718. **E-mail:** bannistergallery@ ric.edu; jmontford@ric.edu; theweb@ric.edu. **Website:** www.ric.edu/bannister. **Contact:** James Mont-

ford, gallery director. Estab. 1978. Nonprofit gallery. Represents emerging, mid-career, and established artists. Sponsors 9 shows/year. Average display time: 3 weeks. Open Tuesday–Friday, 12-8 (during academic year). Located on college campus; 1,600 sq. ft.; features spacious, well-lit gallery space with off-white walls, gloss black tile floor; 2 sections with 9-foot and 12-foot ceilings. 100% of space for special exhibitions. Clientele: students and public.

MEDIA Considers all media and all types of original prints. Most frequently exhibits painting, photography, and sculpture.

STYLE Exhibits all styles.

TERMS Artwork is exhibited for educational purposes—gallery takes no commission. Retail price set by artist. Gallery provides insurance, promotion, and limited shipping costs from gallery. Prefers artwork framed.

SUBMISSIONS Send query letter with résumé, slides, bio, brochure, SASE and reviews. Files addresses, catalogs and résumés.

KENISE BARNES FINE ART

1947 Palmer Ave., Larchmont NY 10538. (914)834-8077. **E-mail:** Kenise@KBFA.com. **Website:** www. kenisebarnesfineart.com. **Contact:** Kenise Barnes, director. Estab. 1994. Fine art gallery. Works with 300 artists/year; exhibits 30 emerging and mid-career artists/year. See website for artists. Sponsors 12 exhibits/year. Average display time: 5-6 weeks. Open Tuesday–Saturday, 10-5:30 and by appointment. Clients include residential, hospitality and corporate collectors nationwide. 20% of sales are to corporate collectors. Overall price range: $1,000-15,000; most work sold at $5-8,000.

STYLE Exhibits abstract and representational art.

TERMS Gallery provides insurance and promotion. Requires exclusive representation locally.

SUBMISSIONS "Although we are not currently looking for new artists, the director does review work on a rolling basis. See gallery website for artist submission policies. If we would like to make a studio visit, we will contact you."

DAVID BARNETT GALLERY

1024 E. State St., Milwaukee WI 53202. (414)271-5058. **Fax:** (414)271-9132. **E-mail:** inquiries@ davidbarnettgallery.com. **Website:** www. davidbarnettgallery.com. Estab. 1966. Retail and

rental gallery and art consultancy. "From Picasso to Rembrandt, from Old Masters to emerging Wisconsin artists, we provide a spectacular selection of art. With over 5,000 works of art in our current inventory, the gallery presents a vast variety of mediums and styles in every price range. Our gallery also brings an array of quality services that meet your art needs." Represents 300-400 emerging, mid-career and established artists. Exhibited artists include Claude Weisbuch and Carol Summers. Sponsors 12 shows/year. Average display time: 1 month. Open Tuesday–Friday, 11-5:30; Saturday, 11-5. Located downtown at the corner of State and Prospect; 6,500 sq. ft.; Victorian-Italianate mansion built in 1875, 3 floors of artwork displayed. 25% of space for special exhibitions. Clientele: retail, corporations, interior decorators, private collectors, consultants, museums and architects. 20% private collectors, 10% corporate collectors. Overall price range: $50-375,000; most work sold at $1,000-50,000.

MEDIA Considers oil, acrylic, watercolor, pastel, pen & ink, drawings, mixed media, collage, sculpture, ceramic, fiber, glass, photography, bronzes, marble, woodcuts, engravings, lithographs, wood engravings, serigraphs, linocuts, etchings, and posters. Most frequently exhibits prints, drawings, and oils.

STYLE Exhibits expressionism, neo-expressionism, primitivism, painterly abstraction, surrealism, imagism, conceptualism, minimalism, postmodern works, impressionism, realism, and photorealism. Genres include landscapes, florals, Southwestern, Western, wildlife, portraits, and figurative work. Prefers old master graphics, contemporary, and impressionistic.

TERMS Accepts artwork on consignment (50% commission). Retail price set by gallery and artist. Sometimes offers customer discounts and payment by installment. Gallery provides insurance and promotion; artist pays for shipping. Prefers artwork framed.

SUBMISSIONS Send query letter with slides, bio, brochure, and SASE. "We return everything if we decide not to carry the artwork." Finds artists through agents, word of mouth, various art publications, sourcebooks, submissions, and self-promotions.

BARRON ARTS CENTER

582 Rahway Ave., Woodbridge NJ 07095. (732)634-0413. **Fax:** (732)634-8633. **E-mail:** barronarts@twp.woodbridge.nj.us. **Website:** www.twp.woodbridge.nj.us/Departments/BarronArtsCenter/tabid/251/Default.aspx. **Contact:** Cynthia Knight, director. Estab. 1977. Nonprofit gallery. Interested in emerging, mid-career and established artists. Sponsors several solo and group shows/year. Average display time: 1 month. Clients include culturally minded individuals mainly from the central New Jersey region. 80% of sales are to private collectors, 20% corporate clients. Overall price range: $200-5,000. Gallery hours during exhibits: Monday-Friday, 11-4; Sunday, 2-4; Closed holidays.

MEDIA Considers oil, acrylic, watercolor, pastel, pen & ink, drawings, mixed media, collage, works on paper, sculpture, ceramic, craft, fiber, glass, installation, photography, performance, and original handpulled prints. Most frequently exhibits watercolor, oils, photography, and mixed media.

STYLE Exhibits painterly abstraction, impressionism, photorealism, realism, and surrealism. Genres include landscapes and figurative work. Prefers painterly abstraction, photorealism, and realism.

TERMS Accepts work on consignment. Retail price set by artist. Exclusive area representation not required. Gallery provides insurance, promotion, and contract; artist pays for shipping.

SUBMISSIONS Send query letter, résumé, and dvds, flash drive. Call for appointment to show portfolio if necessary. Résumés and dvds/flash drives are filed.

TIPS Most common mistakes artists make in presenting their work are improper matting and framing.

⊕ BASILICA HUDSON, THE BACK GALLERY

110 S. Front St., Hudson NY 12534. (518)822-1050. **E-mail:** info@basilicahudson.org. **Website:** www.basilicahudson.org. Estab. 2014. Artists, designers, and photographers should contact general manager. Alternative space, nonprofit gallery, rental gallery. Exhibits for emerging, mid-career, and established artists. Approached by 100 artists a year. Exhibited artists include Jack Walls and Hotbd. Sponsors 2 total exhibits per year; 1 photographer exhibit a year. Model release and property release are required. We require insurance. Average display time: 2 months. Open on weekend from 12p.m.–5p.m. and by appointment. Closed November–March. The Back Gallery is a 2,000 sq. ft. converted industrial space. All white inside with exposed brick facade. Clients include local community, students, tourists, and upscale. Overall price range of work sold varies. We are a space for artists with representation to showcase their work. We do not handle sales. Considers acrylic, fiber, paper,

and other media. Most frequently exhibits installations, acrylic and mixed media. Considers all types of prints. Rental fee for space varies on a case-by-case basis. Retail price of the art set by the artist. Gallery provides promotion. Does not require exclusive representation locally. For submissions, artists should call, email query letter with link to artist's website. Does no return material if SASE is enclosed. Responds if interested within 1 month. Finds artists through word of mouth, submissions, portfolio reviews, referrals by other artists. The gallery does not organize competitions. Gallery organizes workshops. Be professional!

BATON ROUGE GALLERY, INC.

1515 Dalrymple Dr., Baton Rouge LA 70808. (225)383-1470. **E-mail:** jandreasen@batonrougegallery.org. **Website:** batonrougegallery.org. **Contact:** Jason Andreasen, executive director. Estab. 1966. Nonprofit contemporary art gallery. One of the oldest professional artist cooperative galleries in the US. Exhibits the work of over 50 professional artists. 300 community members. Presents 12 exhibitions annually. Monthly exhibitions at the gallery feature the work of current artist members including photographers, painters, sculptors, stained-glass artists, printmakers, ceramists, multi-media, and installation artists. The opening receptions are held for each exhibition on the first Wednesday of every month from 7p.m.–9p.m. and are free and open to the public. Average display time: 1 month. Open Tuesday–Sunday, 12p.m.–6p.m. Located in BREC's historic City Park Pavilion. Overall price range: $100–10,000; most work sold at $200-2,000.

○ The gallery presents monthly exhibitions, primarily focusing on professional contemporary artists who have strong ties to Louisiana. Opening receptions are held on the first Wednesday of each month (excluding January and November). Many cultural programs are also offered year-round.

MEDIA All media considered. Most frequently exhibits 2D works including painting, photography, and drawing, in addition to sculpture works.

STYLE Exhibits all cotemporary styles and genres.

TERMS Co-op membership fee plus donation of time. Gallery takes 40% commission on work sold.

SUBMISSIONS Membership and guest exhibitions are selected by a screening committee selected from artist members. The screening committee reviews applications in October of each year. Artist requirements and application for submissions are available online.

SETH JASON BEITLER FINE ARTS

250 NW 23rd St., Suite 202, Miami FL 33127. (305)438-0218. **Fax:** (800)952-7026. **E-mail:** info@sethjason.com. **Website:** www.sethjason.com. **Contact:** Seth Beitler, owner. Estab. 2000. For-profit gallery, art consultancy. Approached by 300 artists/year. Represents 40 mid-career, established artists. Exhibited artists include Florimond Dufoor, oil paintings; Terje Lundaas, glass sculpture. Sponsors 5 exhibits/year. Average display time: 2-3 months. Open Tuesday-Saturday, 12-5, and by appointment. Clients include local community and upscale. 5-10% of sales are to corporate collectors. Overall price range: $2,000-300,000; most work sold at $5,000.

MEDIA Considers acrylic, glass, mixed media, sculpture, drawing, oil. Most frequently exhibits sculpture, painting, photography. Considers etchings, linocuts, lithographs.

STYLE Exhibits color field, geometric abstraction and painterly abstraction. Most frequently exhibits geometric sculpture, abstract painting, photography. Genres include figurative work and landscapes.

TERMS Artwork is accepted on consignment (50% commission). Retail price set by the gallery. Gallery provides insurance, promotion, and contract. Accepted work should be mounted.

SUBMISSIONS Write to arrange personal interview to show portfolio of photographs, slides, transparencies. Send query letter with artist's statement, bio, photographs, résumé, SASE. Returns material with SASE. Responds to queries in 2 months. Files photos, slides, transparencies. Finds artists through art fairs, portfolio reviews, referrals by other artists, and word of mouth.

TIPS "Send easy-to-see photographs. E-mail submissions for quicker response."

CECELIA COKER BELL GALLERY

Coker College Art Dept., 300 E. College Ave., Hartsville SC 29550. (843)383-8150. **E-mail:** artgallery@coker.edu. **Website:** www.ceceliacokerbellgallery.com. **Contact:** Jean Grosser, gallery director & department chair. "A campus-located teaching gallery that exhibits a variety of media and styles to expose students and the community to the breadth of possibility for expression in art. Exhibits include regional, national, and international artists with an empha-

sis on quality and originality. Shows include work from emerging, mid, and late career artists." Sponsors 5 solo shows/year, with a 4-week run for each show. Open Monday–Friday, 10-4 (when classes are in session).

MEDIA Considers all media including installation and graphic design. Most frequently exhibits painting, photography, sculpture/installation, and mixed media.

STYLE Considers all styles. Not interested in conservative/commercial art.

TERMS Retail price set by artist (sales are not common). Exclusive area representation not required. Gallery provides insurance, promotion, and contract; shipping costs are shared.

SUBMISSIONS Send résumé, 15-20 JPEG files on CD (or upload them to a Dropbox account) with a list of images, statement, résumé, and SASE. Reviews, web pages, and catalogues are welcome, though not required. If you would like response, but not your submission items returned, simply include an e-mail address. Visits by artists are welcome; however, the exhibition committee will review and select all shows from the JPEGs submitted by the artists.

BENNETT GALLERIES AND COMPANY

5308 Kingston Pike, Knoxville TN 37919. (865)584-6791. **Fax:** (865)588-6130. **E-mail:** info@bennettgalleries.com. **Website:** www.bennettgalleries.com. Estab. 1985. Retail gallery. Represents emerging and established artists. "Rick Bennett has spent years traveling the world, establishing relationships with artists, craftsmen and small family-owned furniture makers, bringing to Bennett Galleries one-of-a-kind pieces for your home. Whether traveling in Italy, France or throughout the US, the Bennetts are constantly on the lookout for people who still do hand-made work. Every piece is unique, each with its own story. This search for unusual, top-quality merchandise has filled the gallery with unique works of art, fine furnishings, distinctive jewelry and crafts." Exhibited artists include Richard Jolley, Carl Sublett, Scott Duce, Andrew Saftel, Akira Blount, Scott Hill, Marga Hayes McBride, Grace Ann Warn, Timothy Berry and Cheryl Warrick. Sponsors 10 shows/year. Average display time: 1 month. Open all year; Monday–Thursday, 10-6; Friday–Saturday, 10-5:30. Located in West Knoxville. Clientele: 80% private collectors, 20% corporate collectors. Overall price range: $200-20,000; most work sold at $2,000-8,000.

MEDIA Considers oil, acrylic, watercolor, pastel, drawing, mixed media, works on paper, sculpture, ceramic, craft, photography, glass, original handpulled prints. Most frequently exhibits painting, ceramic/clay, wood, glass, and sculpture.

STYLE Exhibits contemporary works in abstraction, figurative, narrative, realism, contemporary landscape, and still life.

TERMS Accepts artwork on consignment (50% commission). Retail price set by the gallery and the artist. Sometimes offers customer discounts and payment by installments. Gallery provides insurance on works at the gallery, promotion, and contract. Prefers artwork framed. Shipping to gallery to be paid by the artist.

SUBMISSIONS Accepts artwork on consignment (50% commission). Retail price set by the gallery and the artist. Sometimes offers customer discounts and payment by installments. Gallery provides insurance on works at the gallery, promotion and contract. Prefers artwork framed. Shipping to gallery to be paid by the artist.

MONA BERMAN FINE ARTS

78 Lyon St., New Haven CT 06511. (203)562-4720. **E-mail:** info@monabermanfinearts.com. **Website:** www.monabermanfinearts.com. **Contact:** Mona Berman, Director. Estab. 1979. Located near downtown; 1,400 sq. ft. Sells most styles, except figurative and large scale sculpture. Prefers abstract, landscape, and transitional. 50% commission; net 30 days. Retail price is set by gallery and artist. *Retail prices must be consistent regardless of sales venue.* Customer discounts and payment by installment are available. Dealer provides insurance; artist pays for shipping. Prefers artwork unframed. Finds artists through word of mouth, art publications and sourcebooks, submissions and self-promotions, and other professionals' recommendations. "We will not carry artists who do not maintain consistent retail pricing. We are not a gallery; please do not submit if you are looking for an exhibition venue. Our primary business is art consultanting. We continue to be busy selling high-quality art and related services to the corporate, architectural, design and private sectors."

TERMS Accepts e-mail submissions or links to website **only** with retail prices included. Portfolios are reviewed only after images have been reviewed. Responds in 1 month. No phone calls please. Contact by e-mail only.

BERTONI GALLERY

(845)469-0993. **Fax:** (845)469-6808. **E-mail:** bertoni@optonline.net. **Website:** www.bertonigallery.com. **Contact:** Rachel Bertoni, owner. Estab. 2000. For-profit gallery, rental gallery, art consultancy. Custom picture framing services available. Estab. 2000. Exhibits emerging, mid-career and established artists. Approached by 15 artists/year; represents 5 artists/year. Exhibited artists include Mae Bertoni (award winning master watercolorist); Marylyn Vanderpool (watercolors); and Mike Jarosko (oil). Sponsors 5 exhibits/year. Average display time: 2 months. Open Thursday-Sunday, 11-6. Clients include local community, tourists. 10% of sales are to corporate collectors. Overall price range: $100-1,500; most work sold at $400.

MEDIA Considers all media. Most frequently exhibits watercolor, oil, mixed media. Considers all types of prints.

STYLE Exhibits all styles and genres.

TERMS Artwork is accepted on consignment (40% commission); or artwork is bought outright for 50% of retail price. The space can be rented, commission fees would change; rental fee covers 2 months. Retail price set by the artist. Accepted work should be professionally framed, mounted, matted.

SUBMISSIONS Send query letter with artist's statement, résumé, and photographs. Returns material with SASE. Responds to queries in 2 weeks. Finds artists through word of mouth and referrals by other artists.

TIPS "Submit materials via e-mail or in a neat manner with SASE for easy return."

TOM BINDER FINE ARTS

825 Wilshire Blvd., #708, Santa Monica CA 90401. (800)332-4278. **Fax:** (800)370-3770. **E-mail:** info@artman.net. **Website:** www.artman.net. **Contact:** Tom Binder, owner. For-profit gallery. Exhibits established artists. Clients include local community, tourists, and upscale. Overall price range: $200-5,000.

See additional listing in the Posters & Prints section.

MEDIA Considers all media; types of prints include etchings, lithographs, posters, and serigraphs.

STYLE Considers all styles and genres.

TERMS Artwork is accepted on consignment or bought outright. Retail price set by the gallery. Gallery provides insurance. Accepted work should be framed.

Write to arrange a personal interview to show portfolio. Returns material with SASE. Responds in 2 weeks.

BIRMINGHAM BLOOMFIELD ART CENTER

1516 S. Cranbrook Rd., Birmingham MI 48009. (248)644-0866. **E-mail:** annievangelderen@bbartcenter.org. **Website:** www.bbartcenter.org. **Contact:** Annie VanGelderen, president and CEO. Estab. 1962. Nonprofit gallery shop and gallery exhibit space. Represents emerging, mid-career, and established artists. Presents ongoing exhibitions in 4 galleries. Open all year; Monday-Thursday, 9-6; Friday-Saturday, 9-5; second Sundays, 1-4. Suburban location. 70% of space for gallery artists. Clientele upscale, local. 100% private collectors. Overall price range: $50-25,000.

MEDIA Considers 2D and 3D fine art in all media. Most frequently exhibits 3D work: jewelry, glass, ceramics, fiber, mixed media sculpture; and 2D work: painting, printmaking, drawing, mixed-media, and video.

STYLE Exhibits all styles.

SUBMISSIONS Send query letter with résumé, website address, digital images (preferred), photographs, review, artist's statement, and bio.

TIPS "We consider conceptual content, technique, media, presentation and condition of work as well as professionalism of the artist."

BLACKFISH GALLERY

420 NW Ninth Ave., Portland OR 97209. (503)224-2634. **E-mail:** director@blackfish.com. **Website:** www.blackfish.com. **Contact:** Damara Bartlett, director. Estab. 1979. Retail cooperative gallery. Represents 30 emerging and mid-career artists. Exhibited artists include Michael Knutson (oil paintings). Sponsors 12 shows/year. Open all year; Tuesday–Saturday, 11-5 and by appointment. Located downtown, in the Northwest Pearl District; 2,500 sq. ft.; street-level, garage-type overhead wide door, long, open space (100' deep). Typically 70% of space for feature exhibits by 1 or 2 member artists, and 30% for member artists or invited guests. 80% of sales are to private collectors, 20% corporate clients. Overall price range: $250-12,000; most artwork sold at $500-2,000.

MEDIA Considers oil, acrylic, watercolor, pastel, pen & ink, drawings, mixed media, collage, sculpture, ceramic, photography, woodcuts, wood engravings, linocuts, engravings, mezzotints, etchings, lithographs, pochoir, and serigraphs. Most frequently exhibits

paintings, sculpture, and prints.

STYLE Exhibits expressionism, neo-expressionism, painterly abstraction, surrealism, conceptualism, minimalism, color field, postmodern works, impressionism and realism.

TERMS Accepts work on consignment from invited artists (50% commission); co-op membership includes monthly dues plus donation of time (40% commission on sales). Retail price set by artist with assistance from gallery on request. Customer discounts and payment by installment are available. Gallery provides insurance, promotion, and contract, and shipping costs from gallery. Prefers artwork framed.

SUBMISSIONS Accepts only artists from northwest Oregon and southwest Washington ("unique exceptions possible"); "must be willing to be an active cooperative member; write for details." Send query letter with résumé, slides, SASE, reviews, and statement of intent. Write for appointment to show portfolio of photographs and slides. Reviews throughout the year. Responds in 1 month. Files material only if exhibit invitation extended. Finds artists through agents, visiting exhibitions, word of mouth, various art publications and sourcebooks, submissions/self-promotions, and art collectors' referrals.

TIPS "Understand particularities of cooperative gallery membership. Call or write for an information packet. Do not bring work or slides to us without first having contacted us by phone, mail, or e-mail."

BLACKWELL ST. CENTER FOR THE ARTS

P.O. Box 808, Denville NJ 07834-0808. (201)337-2143. **E-mail:** wblakeart2004@yahoo.com. **Website:** www. blackwell-st-artists.org. **Contact:** Wanda Blake. Estab. 1983. Nonprofit group. Exhibits the work of approximately 15 or more emerging and established artists. Sponsors 3-4 group shows/year. Average display time: 1 month. Overall price range: $100-5,000; most work sold at $150-350.

MEDIA Considers oil, acrylic, watercolor, pastel, pen & ink, drawings, mixed media, collage, paper, sculpture, ceramics, photography, egg tempera, woodcuts, wood engravings, linocuts, engravings, mezzotints, etchings, lithographs, and serigraphs. Most frequently exhibits oil, photography, and pastel.

STYLE Exhibits all styles and genres. Prefers painterly abstraction, realism, and photorealism.

TERMS Membership fee plus donation of time; 20% commission. Retail price set by artist. Sometimes offers payment by installments. Exclusive area representation not required. Artist pays for shipping. Prefers artwork framed.

SUBMISSIONS Send query letter with résumé, brochure, slides, photographs, bio, and SASE. Call or write for appointment to show portfolio of originals and slides. Responds in 1 month. Files slides of accepted artists. All material returned if not accepted or under consideration.

TIPS "Show one style of work and pick the best. Less is more. Slides and/or photos should be current work. Enthusiasm and organization are big pluses!"

BLOUNT-BRIDGERS HOUSE/HOBSON PITTMAN MEMORIAL GALLERY

130 Bridgers St., Tarboro NC 27886. (252)823-4159. **E-mail:** edgecombearts@embarqmail.com; info@ BBArtCenter.org. **Website:** www.edgecombearts.org. Estab. 1982. Museum. Approached by 20 artists/year. Exhibits 6 emerging, mid-career, and established artists. Sponsors 8 exhibits/year. Average display time: 6 weeks. Open Tuesday-Friday, 10-4; closed weekends December-April; open weekends, 2-4, by appointment only May-December. Closed major holidays. Located in historic house in residential area of small town; gallery on 2nd floor is accessible by passenger elevator. Room is approximately 48×20 sq. ft. Clients include local community, students and tourists. Overall price range: $250-5,000; most work sold at $500.

MEDIA Considers acrylic, ceramics, collage, craft, drawing, fiber, glass, mixed media, oil, paper, pastel, pen & ink, and watercolor. Most frequently exhibits oil, watercolor, and ceramic. Considers all types of prints.

STYLE Considers all styles and genres.

TERMS Artwork is accepted on consignment and there is a 30% commission. Retail price set by the artist. Gallery provides insurance and limited promotion. Accepted work should be framed. Does not require exclusive representation locally. Accepts artists from southeast and Pennsylvania.

SUBMISSIONS Send portfolio of photographs, slides or transparencies. Send query letter with artist's statement, bio, SASE, and slides. Returns material with SASE. Responds in 3 months. Finds artists through word of mouth, submissions, art exhibits, and referrals by other artists.

BLUE GALLERY

118 Southwest Blvd., Kansas City MO 64108. (816)527-0823. **E-mail:** kellyk@bluegalleryonline.com. **Website:** www.bluegalleryonline.com. **Contact:** Kelly Kuhn, owner/director. Estab. 2000. A for-profit gallery. Exhibits emerging, mid-career, and established artists. Approached by hundreds of artists a year; represents or exhibits 45 artists a year. Sponsors 12 total exhibits/year. Average display time: 30 days. Open Tuesday-Saturday, 10-5:30 or by appointment. Clients include local community, tourists, and upscale establishments among others. A large percentage is sold to corporate collectors. Overall price range: $50-80,000. Finds artists through word of mouth, submissions, portfolio reviews, art exhibits, art fairs, and referrals by other artists.

MEDIA Acylic, ceramics, collage, craft, drawing, fiber, glass, installation, mixed media, oil, paper, pastel, pen & ink, sculpture, and watercolor. Considers all media, but most frequently exhibits paintings.

STYLE Considers all styles but prefers contemporary. Exhibits Americana, figurative work, florals, landscapes, portraits, and Southwestern pieces among others.

TERMS Artwork is accepted on consignment. Retail price set by the artist. Gallery provides insurance, promotion, and contract. Accepted work should be framed. Requires exclusive representation locally.

SUBMISSIONS E-mail query letter with link to artist's website and JPEG samples at 72 dpi. Mail portfolio for review. Send query letter with artist's statement, bio, brochure, business card, photocopies, résumé, reviews, and SASE. Returns material with SASE. Responds in 3 months.

BLUE MOUNTAIN GALLERY

530 W. 25th St., 4th Floor, New York NY 10001. (646)486-4730. **Fax:** (646)486-4345. **E-mail:** info@bluemountaingallery.org. **Website:** www.bluemountaingallery.org. Estab. 1980. Artist-run cooperative gallery. Exhibits 32 mid-career artists. Sponsors 13 solo and 1 group shows/year. Display time is 3 weeks. "We are located on the 4th floor of a building in Chelsea. We share our floor with 2 other well-established cooperative galleries. Each space has white partitioning walls and an individual floor-plan." Clients include art lovers, collectors, and artists. 90% of sales are to private collectors, 10% corporate clients.

Open Tuesday–Saturday, 11-6. Overall price range: $100-8,000; most work sold at $100-4,000.

MEDIA Considers painting, drawing, and sculpture.

STYLE "The base of the gallery is figurative but we show work that shows individuality, commitment, and involvement with the medium."

TERMS Co-op membership fee plus donation of time. Retail price set by artist. Exclusive area representation not required. Gallery provides insurance, some promotion, and contract; artist pays for shipping.

SUBMISSIONS Send name and address with intent of interest and sheet of 20 good slides. "We cannot be responsible for material return without SASE." Finds artists through artists' submissions and referrals.

TIPS "This is a cooperative gallery, so it is important to represent artists who can contribute actively to the gallery. We look at artists who can be termed local or in-town more than out-of-town artists and would choose the former over the latter. The work should present a consistent point of view that shows individuality. Expressive use of the medium used is important also."

ⓘ BLUE SPIRAL 1

38 Biltmore Ave., Asheville NC 28801. (828)251-0202. **Fax:** (828)251-0884. **E-mail:** jsours@bluespiral1.com. **Website:** www.bluespiral1.com. Estab. 1991. Retail gallery. "Blue Spiral 1 presents work by exceptional Southern artists and object makers in a beautifully renovated building in the heart of downtown Asheville. The light-filled, 15,000-sq.-ft. gallery spans 3 floors connected by an open stairway. This spacious setting allows Blue Spiral 1 to offer considerable diversity, affording accessibility to various tastes and aesthetics." Represents emerging, mid-career, and established artists living in the Southeast. Over 100 exhibited artists including Julyan Davis, John Nickerson, Suzanne Stryk, Greg Decker, and Will Henry Stephens. Sponsors 15-20 shows/year. Average display time: 6-8 weeks. Open Monday–Saturday, 10-6; Sunday, 12-5. Located downtown 2 blocks south of Pack Square next to the Fine Arts Theatre; historic building. 50% of space for special exhibitions; 50% of space for gallery artists. Clientele: "across the range;" 90% private collectors, 10% corporate collectors. Overall price range: less than $100-50,000; most work sold at $100-2,500.

MEDIA Considers all media. Most frequently exhibits painting, clay, sculpture, and glass.

STYLE Exhibits all styles, all genres.

TERMS Accepts work on consignment (50% commission). Retail price set by the artist. Gallery provides insurance, promotion, and contract; artist pays shipping costs to and from gallery. Prefers framed artwork.

SUBMISSIONS Accepts only artists from Southeast. Send query letter with résumé, slides, prices, statement, and SASE. Responds in 3 months. Incude SASE for items to be returned. Finds artists through word of mouth, referrals, and travel. Submission guidelines available online.

TIPS "Work must be technically well executed and properly presented."

BOCA RATON MUSEUM OF ART

501 Plaza Real, Minzer Park, Boca Raton FL 33432. (561)392-2500. **Fax:** (561)391-6410. **E-mail:** info@ bocamuseum.org. **Website:** www.bocamuseum.org. Estab. 1950. Represents established artists. 5,500 members. Exhibits change every 2-3 months. Open all year; Tuesday, Wednesday, Friday, 10-5; Thursday, 10-8; Saturday and Sunday, 12-5. Located one mile east of I-95 in Mizner Park; 44,000 sq. ft.; national and international temporary exhibitions and impressive second-floor permanent collection. Three galleries—1 show permanent collection, 2 for changing exhibitions. 66% of space for special exhibitions.

MEDIA Considers all media. Exhibits modern masters including Braque, Degas, Demuth, Glackens, Klee, Matisse, Picasso, and Seurat; 19th- and 20th-century photographers; pre-Columbian, and African art; contemporary sculpture.

SUBMISSIONS "Contact executive director in writing."

TIPS "Photographs of work of art should be professionally done if possible. Before approaching museums, an artist should be well represented in solo exhibitions and museum collections. Their acceptance into a particular museum collection, however, still depends on how well their work fits into that collection's narrative and how well it fits with the goals and collecting policies of that museum."

⏻ BOEHM GALLERY

Palomar College, 1140 W. Mission Rd., San Marcos CA 92069-1487. (760)744-1150 ext. 2304. **Website:** www.palomar.edu/art/BoehmGallery.html. Estab. 1966. Nonprofit gallery. Represents/exhibits mid-career artists. May be interested in seeing the work of emerging artists in the future. Generally exhibits 30 or more artists/year in solo and group exhibitions, supplemented with faculty, student work. Exhibited artists include top illustrators, crafts people, painters, and sculptors. Sponsors 6 shows/year. Average display time: 4-5 weeks. Open fall and spring semester; Monday and Thursday, 10-4; Tuesday, 11-8; Wednesday, 2-8; Friday, 10-2; closed Saturday, Sunday, Monday, and school holidays. Located on the Palomar College campus in San Marcos; 2,000 sq. ft.; 100% of space for special exhibitions. Clientele regional community, artists, collectors, and students. "Prices range dramatically depending on exhibition type and artist; $25 for student works to $10,000 for paintings, drawings, oils, and installational sculptural works."

MEDIA Considers all media; all types of prints. Most frequently exhibits installation art, painting, sculpture, glass, illustration, quilts, ceramics, furniture design, and photography.

STYLE Exhibits all styles. Styles vary. Exhibits primarily group exhibits based on either a medium or theme or genre.

TERMS If artwork is sold, gallery retains 10% gallery "donation." Gallery provides insurance and promotion.

SUBMISSIONS Accepts primarily artists from Southern California. Send query letter with résumé, slides, reviews, and bio. Call or write for appointment to show portfolio of photographs and slides. Responds in 2-3 months. Files artist bio and résumé. Finds artists through "artist network, other reviewed galleries, or university visits or following regional exhibitions, and referrals from other professional artists and crafts people."

TIPS Advises artists to show "clear focus for art exhibition and good slides. Lucid, direct artist statement. Be willing to take part in group exhibits—we have very few strictly 'solo' shows and then only for very prominent artists. Be professional in your contacts and presentations and prompt in meeting deadlines. Have a unified body of work which is identifiable as your expression."

BRADBURY GALLERY

P.O. Box 2339, Fowler Center, 201 Olympic Dr., State University AR 72467-1920. (870)972-2567. **Fax:** (870)972-3748. **E-mail:** lchristensen@astate. edu. **Website:** http://bradburyartmuseum.org/. Estab. 2001. "The Bradbury Gallery was established in January 2001 by a generous endowment in honor of

Charlotte (Chucki) Bradbury, an alumna of Arkansas State University who later became a member of the ASU Board of Trustees. The Bradbury Gallery features changing exhibitions of contemporary art in all mediums and programs that promote the understanding of art and its significance to society. Regionally, nationally and internationally recognized artists are represented to inform viewers of cultural developments across the US and around the world. The Bradbury Gallery is also the site of the Delta National Small Prints Exhibition, an annually held, nationally recognized juried print show. Founded in 1996 by Arkansas State professor Evan Lindquist, the Delta National Exhibition has received great acclaim as it has grown to be one of the country's foremost annual competitions for prints. Open during academic school year; Tuesday-Saturday, 12-5; Sunday, 2-5. Located on university campus in the Fowler Center (201 Olympic Dr.); 5,400 sq. ft. All exhibitions are admission free and open to the public. Clientele: students/university faculty and staff/community.

SUBMISSIONS Send query letter with résumé, CD/DVD, and SASE or submit all materials via e-mail. Responds only if interested within 2 months. Files résumé.

RENA BRANSTEN GALLERY

1639 Market St., San Francisco CA 94103. (415)982-3292. **Fax:** (415)982-1807. **E-mail:** info@renabranstengallery.com; china@renabranstengallery.com; rena@renabranstengallery.com. **Website:** www.renabranstengallery.com. Jenny Baie, Director Trish Bransten, Director. **Contact:** Rena Bransten, owner. Estab. 1974. For-profit gallery. Approached by 200 artists/year; represents or exhibits 12-15 artists. Average display time: 4-5 weeks. Open Tuesday–Friday, 10:30-5:30; Saturday, 11-5. Usually closed the last week of August and the first week of September. Retail price(s) set by the gallery and the artist.

MEDIA Considers all media and all styles of contemporary art; exhibits prints (etchings, lithographs, silk screens) if included in one of our artists' inventory. Highly unlikely to take on a dedicated printmaker as it is not our main area of focus.

STYLE Considers all styles of contemporary art. Retail price set by the gallery and the artist.

TERMS Send material via JPEGs at 72 dpi or website link via e-mail, rather than snail mail submissions.

TIPS Finds artists through word of mouth, art fairs and exhibits, submissions, portfolio reviews, and referrals by other artists.

BRENAU UNIVERSITY GALLERIES

500 Washington St., SE, Gainesville GA 30501. (770)534-6263. **Website:** www.galleries.brenau.edu. **Contact:** Nichole Rawlings, gallery director; Allison Lauricella, gallery manager. Estab. 1980s. Nonprofit gallery. Exhibits emerging, mid-career, and established artists. Sponsors 7-9 shows/year. Average display time: 6-8 weeks. Open all year; Monday-Thursday, 10-4. Located near downtown; 3,958 sq. ft., 4 galleries—the main one in a renovated 1914 neoclassical building, another in an adjacent renovated Victorian building dating from the 1890s, the third in the center for performing arts, the fourth in the Brenau University Downtown Center. 100% of space for special exhibitions. Clientele: tourists, upscale, local community, students. "Although sales do sometimes occur as a result of our exhibits, we do not currently take any percentage, except in our invitational exhibitions. Our purpose is primarily educational."

MEDIA Considers all media.

STYLE Exhibits wide range of styles. "We intentionally try to plan a balanced variety of media and styles."

TERMS Retail price set by the artist. Gallery provides insurance and promotion; shipping costs are shared, depending on funding for exhibits. Prefers artwork framed. "Artwork must be framed or otherwise ready to exhibit."

SUBMISSIONS Send query letter/email with résumé, 10-20 images, photographs, and bio. Responds within months if possible. Finds artists through referrals, direct viewing of work, and inquiries.

TIPS "Be persistent, keep working, be organized and patient. Take good images and develop a body of work. Galleries are limited by a variety of constraints—time, budgets, location, taste—and rejection does not mean your work may not be good; it may not fit for other reasons at the time of your inquiry."

BROADHURST GALLERY

2212 Midland Rd., Pinehurst NC 28374. (910)295-4817. **E-mail:** judy@broadhurstgallery.com. **Website:** broadhurstgallery.com. Estab. 1990. Retail gallery. "Original art is displayed using 4500 sq. ft. of display area inside and outside sculpture in the garden." Represents/exhibits 25 established artists/year. Sponsors about 4 large shows and lunch and Artist

Gallery Talks on most Fridays. Average display time: 1-3 months. Open all year; Monday, Tuesday, Thursday, and Friday, 11-5; Saturday, 1-4; and by appointment. Art placement and interior design services available. Located on the main road between Pinehurst and Southern Pines; 3,000 sq. ft.; lots of space, ample light, large outdoor sculpture garden. 50% of space for special exhibitions; 50% of space for gallery artists. Clientele: people building homes and remodeling, also collectors. 80% private collectors, 20% corporate collectors. Overall price range: $5,000-40,000; most work sold at $5,000 and up.

MEDIA Considers oil, acrylic, watercolor, pastel, mixed media and collage. Most frequently exhibits oil and sculpture (stone and bronze).

STYLE Exhibits all styles, all genres.

TERMS Retail price set by the artist. Gallery provides insurance, promotion and contract; shipping costs are shared. Prefers artwork framed.

SUBMISSIONS Send query letter with résumé, slides or photographs, and bio. Write for appointment to show portfolio of originals and slides. Responds only if interested within 3 weeks. Files résumé, bio, slides or photographs. Finds artists through agents, exhibitions, word of mouth, various art publications and sourcebooks and artists' submissions.

TIPS "Talent is always the most important factor, but professionalism is very helpful."

BROOKFIELD CRAFT CENTER

286 Whisconier Rd., P.O. Box 122, Brookfield CT 06804-0122. (203)775-4526. **Fax:** (203)740-7815. **E-mail:** director@brookfieldcraft.org; info@brookfieldcraft.org. **Website:** www.brookfieldcraft.org. **Contact:** Howard Lasser, executive director. Estab. 1954. Exhibits emerging, mid-career, and established craft artists. Approached by 100 artists/year; represents 400+ craft artists.

MEDIA Considers functional and sculptural ceramics, fiber arts, jewelry and fine metals, forged metals, glass, mixed media, and wood. Most frequently exhibits clay, metal, wood, fiber.

STYLE Original, handmade work by American artisans, one-of-a-kind items.

TERMS Work is accepted on consignment (50% commission); net 30 days. Retail price of the art set by the artist. Gallery provides insurance, promotion, and contract.

SUBMISSIONS E-mail photographs or website links, or send query letter with brochure. Returns material with SASE. Responds to queries in 2 weeks to 1 month. Finds artists through art fairs/exhibits, portfolio reviews, referrals by other artists, submissions and word of mouth.

BROOKLYN BOTANIC GARDEN— STEINHARDT CONSERVATORY GALLERY

1000 Washington Ave., Brooklyn NY 11225. (718)623-7200. **E-mail:** steinhardt@bbg.org. **Website:** www.bbg.org/steinhardt_conservatory_gallery. Estab. 1988. Nonprofit botanic garden gallery. Represents emerging, mid-career and established artists. 20,000 members. Sponsors 10-12 shows/year. Average display time: 4-6 weeks. Open all year; Tuesday–Friday, 8-6, Saturday and Sunday, 10-6. Located near Prospect Park and Brooklyn Museum; 1,200 sq. ft.; part of a botanic garden, gallery adjacent to the tropical, desert, and temperate houses. Clients include BBG members, tourists, collectors. 100% of sales are to private collectors. Overall price range: $75-7,500; most work sold at $75-500.

MEDIA Considers all media and all types of prints. Most frequently exhibits watercolor, oil, and photography.

STYLE Exhibits all styles. Genres include landscapes, florals, and wildlife.

TERMS Accepts work on consignment (20% commission). Retail price set by the artist. Gallery provides insurance, promotion, and contract; artist pays shipping costs to and from gallery. Artwork must be framed or ready to display unless otherwise arranged. Artists hang and remove their own shows.

SUBMISSIONS Work must reflect the natural world. Send query letter with curriculum vitae, 8 to 10 visuals indicating title, date, materials used, and dimensions of the work (if sending JPEGs of the work, please use a resolution of 300 dpi or higher), and a description of the exhibit stating why BBG is an appropriate venue. Further guidelines available online.

TIPS "Artists' groups contact me by submitting résumé and slides of artists in their group. We favor seasonal art which echoes the natural events going on in the garden. Large format, colorful works show best in our multi-use space."

BRUNNER GALLERY

215 N. Columbia St., Covington LA 70433. (985)893-0444. **Fax:** (985)893-4332. **E-mail:** sbrunner@brunnergallery.com; curator@brunnergallery.

com. **Website:** www.brunnergallery.com. **Contact:** Susan Brunner, owner/director. Estab. 1997. For-profit gallery. "Over the years, Brunner Gallery has grown to be one of the most popular and recognized contemporary art galleries in the South. Located in Historic Downtown Covington on New Orleans' Northshore, and rotates exhibitions in Downtown Baton Rouge at the Hilton Baton Rouge Capitol Center." Approached by 400 artists/year. Exhibits 45 emerging, mid-career, and established artists. Sponsors 10-12 exhibits/year. Average display time: 1 month. Open by appointment. Located 45 minutes from metropolitan New Orleans, 1 hour from capital of Baton Rouge and Gulf Coast; 2,500 sq. ft. Building designed by Rick Brunner, artist and sculptor, and Susan Brunner, designer. Clients include local community, tourists, upscale and professionals. 20% of sales are to corporate collectors. Overall price range: $200-10,000; most work sold at $1,500-3,000.

MEDIA Considers all media. Types of prints include etchings and monoprints.

STYLE Considers all styles and genres. Most frequently exhibits abstraction, expressionism, and conceptualism.

TERMS Artwork is accepted on consignment (50% commission) or bought outright for 90-100% of retail price (net 30 days). Retail price set by the gallery and the artist. Gallery provides insurance, promotion, and contract. Accepted work should be framed. Requires exclusive representation locally.

SUBMISSIONS "We welcome submissions according to certain guidelines (found online). Please read them carefully. We are not able to critique your work because of time constraints; however, we are interested in seeing the newest work from Louisiana and across the US. We will send a response when your submission has been reviewed. Should we wish to consider your work for a second review, we will contact you by telephone or e-mail."

TIPS "In order for us to offer representation to an artist, it is necessary for us to consider whether the artist will be a good fit for the private and corporate collectors who make up our client base. We request that each image include not only the title, dimensions and medium, but also the retail price range."

BRYAN MEMORIAL GALLERY

180 Main St., P.O. Box 340, Jeffersonville VT 05464. (802)644-5100. **Fax:** (802)644-8342. **E-mail:** info@ bryangallery.org. **Website:** www.bryangallery.org. Estab. 1984. Exhibits over 200 artists throughout the year in a schedule of revolving exhibitions. Artist membership fee required. "There is at least one juried exhibit and one open exhibit for members each year." Open Thursday–Sunday, 11-4 (spring and fall); daily, 11-5 (summer); by appointment at any time.

TERMS Membership is available online. Contact the gallery through e-mail after reviewing the website. Include artist's information, such as URL and small samples if possible.

CADEAUX DU MONDE

P.O. Box 212, Newport RI 02840. (401)935-8591. **E-mail:** info@cadeauxdumonde.com. **Website:** www. cadeaux-du-monde.myshopify.com. **Contact:** Katie Dyer, owner. **Owner:** Katie Dyer. Retail gallery. Estab. 1987. Represents emerging, mid-career, and established artists. Exhibited artists include John Lyimo and A.K. Paulin. Clients include tourists, upscale, local community, and students. 95% of sales are to private collectors, 5% corporate collectors. Overall price range: $20-5,000; most work sold at $100-300. Finds artists through submissions, word of mouth, referrals by other artists, visiting art fairs, and exhibitions.

MEDIA Considers all media suitable for display in a stairway setting for special exhibitions. No prints.

STYLE Exhibits folk art. "Style is unimportant; quality of work is deciding factor. We look for unusual, offbeat, and eclectic."

SUBMISSIONS Send query letter with résumé, 10 slides, bio, photographs, and business card. Call for appointment to show portfolio of photographs or slides. Responds only if interested. Finds artists through submissions, word of mouth, referrals by other artists, visiting art fairs, and exhibitions.

TIPS Artists who want gallery representation should "present themselves professionally; treat their art and the showing of it like a small business; arrive on time and be prepared; and meet deadlines promptly."

THE CAROLE CALO GALLERY

320 Washington St., Easton MA 02357. **Website:** http://www.stonehill.edu/community-global-engagement/carole-calo-gallery/. **Contact:** Candice Smith Corby, gallery director. Nonprofit, college gallery. Approached by 4-8 artists/year, represents/exhibits 10-20 artists/year. Closed during the summer when school is not in session. Clients include local community and students.

MEDIA Considers all media. Most frequently exhibits paintings, drawings, and sculpture. Considers all types of prints.

STYLE Considers all styles and genres.

TERMS Proceeds of sales go to the artist, sales are not common. Price set by the artist. Gallery provides insurance and promotion. Accepted work should be framed and mounted.

SUBMISSIONS Mail portfolio for review. Include artist's statement, bio, résumé, SASE, and CD. Returns material with SASE. Responds in 6 months. Files "interesting" materials. Finds artists through word of mouth, submissions, art exhibits, and referrals by other artists.

WILLIAM CAMPBELL CONTEMPORARY ART

4935 Byers Ave., Ft. Worth TX 76107. (817)737-9566. **Fax:** (817)737-5466. **E-mail:** wcca@flash.net. **Website:** www.williamcampbellcontemporaryart.com. **Contact:** William Campbell, owner/director. Estab. 1974. Sponsors 8-10 exhibits/year. Average display time: 5 weeks. Sponsors openings; provides announcements, press releases, installation of work, insurance, cost of exhibition. Overall price range: $500-20,000.

TERMS Charges 50% commission. Reviews transparencies. Accepted work should be mounted. Requires exclusive representation within metropolitan area.

SUBMISSIONS Send CD (preferred) and résumé by mail with SASE. Responds in 1 month.

THE CANTON MUSEUM OF ART

1001 Market Ave. N,, Canton OH 44702. (330)453-7666. **Fax:** (330)453-1034. **Website:** www.cantonart.org. Nonprofit gallery. Represents emerging, mid-career, and established artists. Although primarily dedicated to large-format touring and original exhibitions, the CMA occasionally sponsors solo shows by local and original artists. Average display time: 6 weeks.

MEDIA Considers all media. Most frequently exhibits oil, watercolor, and photography.

STYLE Considers all styles. Most frequently exhibits painterly abstraction, postmodernism, and realism.

TERMS "While every effort is made to publicize and promote works, we cannot guarantee sales, although from time to time sales are made, at which time a 25% charge is applied." One of the most common mistakes in presenting portfolios is "sending too many materi-als. Send only a few slides or photos, a brief bio, and an SASE."

CANTRELL GALLERY

8206 Cantrell Rd., Little Rock AR 72227. (501)224-1335. **E-mail:** cantrellgallery@sbcglobal.net. **Website:** www.cantrellgallery.com. **Contact:** Helen Scott or Cindy Scott-Huisman. Estab. 1970. Wholesale/retail gallery. "Cantrell Gallery is family owned and operated. In the beginning we were in a tiny storefront downtown, and our name was Art Fair. Today our business has grown to over 5,000 sq. ft. of showroom and production space. We get to know our clients and form a lasting relationship with them." Represents/exhibits 120 emerging, mid-career, and established artists/year. Exhibited artists include Boulanger, Dali, G. Harvey, Warren Criswell, N. Scott, and Robin Morris. Sponsors 8-12 shows/year. Average display time: 1 month. Open all year; Monday–Saturday, 10-5; or by appointment. Located in the strip center; "we have several rooms and different exhibits going at one time." Clientele: collectors, retail, decorators, museums. Overall price range: $100-10,000; most work sold at $250-3,000.

MEDIA Considers oil, acrylic, watercolor, pastel, pen & ink, drawing, mixed media, collage, paper, sculpture, woodcut, engraving, lithograph, wood engraving, mezzotint, serigraphs, linocut, etching. Most frequently exhibits etchings, watercolor, mixed media, oils and acrylics. Looking for outsider art.

STYLE Exhibits eclectic work, all genres.

TERMS Gallery provides insurance and promotion; shipping costs are shared. Prefers artwork unframed.

SUBMISSIONS Send query letter with résumé, 5 photos and bio. Write for appointment to show portfolio of originals. Responds in 2 months. Files all material. Finds artists through agents, by visiting exhibitions, word of mouth, art publications and sourcebooks, artists' submissions.

TIPS "Be professional. Be honest. Place a retail price on each piece, rather than only knowing what 'you need to get' for the piece. Don't spread yourself too thin in any particular area—only show in one gallery in any area."

CARNEGIE ARTS CENTER

204 W. Fourth St., Alliance NE 69301. (308)762-4571. **Fax:** (308)762-4571. **E-mail:** art@carnegieartscenter.com. **Website:** www.carnegieartscenter.com. **Contact:** Rose Pancost, Gallery Director. Estab. 1933. Vi-

sual art gallery. Represents 300 emerging, mid-career and established artists/year. 350 members. Exhibited artists include Liz Enyeart (functional pottery) and Silas Kern (handblown glass). Sponsors 12 shows/year. Average display time: 6 weeks. Open all year; Tuesday-Saturday, 10-4; Memorial Day, Labor Day, Sunday, 1-4. Located downtown; 2,346 sq. ft.; renovated Carnegie library built in 1911. Clients include tourists, upscale, local community, and students. 90% of sales are to private collectors; 10% corporate collectors. Overall price range: $10-2,000; most work sold at $10-300.

MEDIA Considers all media and all types of prints. Most frequently exhibits pottery, blown glass, 2D, acrylics, bronze sculpture, watercolor, oil, and silver jewelry.

STYLE Exhibits all styles and genres. Most frequently exhibits realism, modern realism, geometric, abstraction.

TERMS Accepts work on consignment (35% commission). Retail price set by the artist. Gallery provides promotion. Shipping costs negotiated. Prefers framed artwork.

SUBMISSIONS Accepts only quality work. Send query. Write for appointment to show portfolio of photographs, slides or transparencies. Responds within 1 month, only if interested. Files résumé and contracts. Finds artists through submissions, word of mouth, referrals by other artists, visiting art fairs and exhibitions.

TIPS "Presentations must be clean, 'new' quality—that is, ready to meet the public. Two-dimensional artwork must be nicely framed with wire attached for hanging. Unframed prints need protective wrapping in place."

CEDARHURST CENTER FOR THE ARTS

2600 Richview Rd., P.O. Box 923, Mt. Vernon IL 62864. (618)242-1236. **Fax:** (618)242-9530. **Website:** www.cedarhurst.org. **Contact:** Rusty Freeman, director of visual arts. Estab. 1973. Museum. Exhibits emerging, mid-career, and established artists. Average display time: 6 weeks. Open all year; Tuesday–Saturday, 10-5; Sunday, 1-5; closed Mondays and federal holidays.

SUBMISSIONS Call or send query letter with artist's statement, bio, résumé, and digital images.

CENTER FOR DIVERSIFIED ART

P.O. Box 641062, Beverly Hills FL 34465. **E-mail:** diversifiedart101@gmail.com. **Website:** www.diversifiedart.org. **Contact:** Anita Walker, founder and director. Estab. 2010. Nonprofit gallery. Exhibits emerging, mid-career and established artists. Approached by 12 artists/year; represents or exhibits about 24 artists currently. Exhibited artists include David Kontra (acrylics) and Linda Litteral (sculptor). We specialize in visual art that has a social and/or environmental theme that raises awareness. Sponsors 1 exhibit/year, photography is included in our annual exhibit. One piece from each of our artists is shown indefinitely in our online gallery and publications. We are a web-based gallery and sponsor 1 brick and mortar exhibition a year. We also use visual art to go with educational material that we produce and publish. Many of our artists have a strong commitment to raising awareness. Clients include the local community and students. Price range: $150-4,000.

MEDIA Considers all media and all types of prints (prints must be a limited edition and include a certificate of authenticity).

STYLE Considers all styles that have a social and/or environmental theme that raises awareness.

TERMS Artwork is accepted on consignment and there is a 20% commission. Retail price set by the artist. Gallery provides promotion. Accepted work should be framed.

SUBMISSIONS Please make sure your work has a social and/or environmental theme that raises awareness before submitting. E-mail query letter with link to artist's website, 3 JPEG samples at 72 dpi, résumé and how your work relates to raising awareness on social and/or environmental issues. Responds only if interested within 1 month. Finds artists through word of mouth, art exhibits, submissions, portfolio reviews, and referrals by other artists.

TIPS Follow the directions above.

CENTRAL MICHIGAN UNIVERSITY ART GALLERY

Wightman 132, Central Michigan University, Mt. Pleasant MI 48859. (989)774-3800. **E-mail:** gochelas@cmich.edu. **Website:** www.uag.cmich.edu. **Contact:** Anne Gochenour, gallery director. Estab. 1970. Nonprofit academic gallery. Exhibits emerging, mid-career, and established contemporary artists. Past artists include Sandy Skoglund, Michael Ferris, Blake Williams, John Richardson, Valerie Allen, Randal Crawford, Jane Gilmor, Denise Whitebread Fanning, Alynn Guerra, Dylan Miner. Sponsors 14 exhibits/

year (2-4 curated). Average display time: 1 month. Open August-May while exhibits are present; Tuesday–Friday, 11-6; Saturday, 11-3. Clients include local community, students and tourists.

MEDIA Considers all media and all types of prints. Most frequently exhibits sculpture, prints, ceramics, painting, and photography.

STYLE Considers all styles.

TERMS Buyers are referred to the artist. Gallery provides insurance, promotion, and contract. Accepted work should be framed. Does not require exclusive representation locally.

SUBMISSIONS Send query letter with artist's statement, bio, résumé, reviews, and images on CD. Responds within 2 months, only if interested. Finds artists through word of mouth, submissions, portfolio reviews, art exhibits, and referrals by other artists.

CHABOT FINE ART GALLERY

P.O. Box 623, Greenville RI 02828. (401)432-7783. **Fax:** (401)432-7783. **E-mail:** chris@chabotgallery. com. **Website:** www.chabotgallery.com. **Contact:** Chris Chabot, director. Estab. 2007. Rental gallery. Approached by 50 artists/year; represents 30 emerging, mid-career, and established artists. Exhibited artists include Lee Chabot (owner of the gallery). Sponsors 12 total exhibits/year; 1 photography exhibit/year. Average display time: 30 days. Open Tuesday-Saturday, 12-6, or by appointment or chance. The gallery is located on Historic Federal Hill in Providence. It has over 1,000 sq. ft of exhibition space and a sculpture courtyard garden that is open in the warmer months. Clients include local community, tourists, upscale. 10% corporate collectors. Overall price range: $1,200-10,000. Most work sold at $3,500.

MEDIA Considers all media except craft. Most frequently exhibits oil, acrylics, and watercolor.

STYLE Considers all styles and genres. Most frequently exhibits abstract, impressionism, abstract expressionism.

TERMS Artwork is accepted on consignment with a 50% commission. Retail price is set by the gallery and artist. Gallery provides insurance, promotion, and contract. Accepted work should be framed, mounted, and matted.

SUBMISSIONS Mail portfolio for review. Send query letter with artist's statement, bio, résumé, CD with images, and SASE. Returns material with SASE. Responds in 1 month. Files all submitted material. Finds

artist through word of mouth, submissions, portfolio reviews, art exhibits, and referrals by other artists.

TIPS Be professional in your presentation, have good images in your portfolio, and submit all necessary information.

THE CHAIT GALLERIES DOWNTOWN

218 E. Washington St., Iowa City IA 52240. (319)338-4442. **Fax:** (319)338-3380. **E-mail:** attendant@thegalleriesdowntown.com; terri@ thegalleriesdowntown.com; bpchait@aol.com. **Website:** www.chaitgalleries.com. **Contact:** Benjamin Chait, director. Estab. 2003. For-profit gallery. Approached by 100 artists/year. Represents 150 emerging, mid-career, and established artists. Exhibited artists include Benjamin Chait (giclée), Corrine Smith (mixed media), Mary Merkel-Hess (fiber sculpture), Tam Bodkin Bryk (oil on canvas), Young Joo Yoo (gold and sterling silver jewelry), Nancy Lindsay (landscape paintings), and Ulfert Wilke (ink on paper). Sponsors 12 exhibits/year. Average display time: 90 days. Open all year; Monday–Friday, 11-6; Saturday, 10-5; Sunday, 12-4. Located in a downtown building restored to its original look (circa 1883), with 14-ft. molded ceiling and original 9-ft. front door. Professional museum lighting and scamozzi-capped columns complete the elegant gallery. Clients include local community, students, tourists, upscale. Overall price range: $50-10,000; most work sold at $250-1,000.

MEDIA Considers all media, all types of prints, all styles, and all genres.

STYLE Considers all styles.

TERMS Call; mail portfolio for review. Returns material with SASE. Responds to queries in 2 weeks. Or, stop in anytime during normal business hours with a couple samples. Finds artists through art fairs, exhibits, portfolio reviews, and referrals by other artists.

SUBMISSIONS Artwork is accepted on consignment, and there is a 50% commission. Retail price set by the gallery and the artist. Gallery provides insurance, promotion, and contract. Accepted work should be framed. Requires exclusive representation locally.

CHAPMAN FRIEDMAN GALLERY

1835 Hampden Court, Louisville KY 40205. (502)584-7954. **E-mail:** friedman@imagesol.com. **Website:** www.imagesol.com. **Contact:** Julius Friedman, owner. Estab. 1992. For-profit gallery. Approached by 100 or more artists/year. Represents or exhibits 25 art-

ists. Sponsors 7 exhibits/year. Average display time: 1 month. Open by appointment only. Located downtown; approximately 3,500 sq. ft. with 15-ft. ceilings and white walls. Clients include local community and tourists. 5% of sales are to corporate collectors. Overall price range: $75-10,000; most work sold at more than $1,000.

MEDIA Considers all media except craft. Types of prints include engravings, etchings, lithographs, posters, serigraphs, and woodcuts. Most frequently exhibits painting, ceramics, and photography. Exhibits color field, geometric abstraction, primitivism realism, painterly abstraction. Most frequently exhibits abstract, primitive, and color field. Artwork is accepted on consignment (50% commission). Retail price set by the artist. Gallery provides insurance, promotion, and contract. Accepted work should be framed.

TERMS Send query letter with artist's statement, bio, brochure, photographs, résumé, slides, and SASE. Returns material with SASE. Responds to queries in 1 month. Finds artists through portfolio reviews and referrals by other artists.

CINCINNATI ART MUSEUM

953 Eden Park Dr., Cincinnati OH 45202. (513)639-2941. **E-mail:** information@cincyart.org. **Website:** www.cincinnatiartmuseum.org. Estab. 1881. Exhibits 6-10 emerging, mid-career, and established artists/year. Sponsors 20 exhibits/year. Average display time: 3 months. Open Tuesday–Sunday, 11-5. Closed Mondays, Thanksgiving, Christmas, New Year's Day, Martin Luther King, Jr. Day, Presidents Day, Memorial Day, Fourth of July, and Labor Day. General art museum with a collection spanning 6,000 years of world art. Over 100,000 objects in the collection with exhibitions on view annually. Clients include local community, students, tourists, and upscale.

MEDIA Considers all media and all types of prints. Most frequently exhibits paper, mixed media, and oil.

STYLE Considers all styles and genres.

SUBMISSIONS Send query letter with artist's statement, photographs, reviews, SASE, and slides.

⊙ CITYARTS, INC.

525 Broadway, Suite 602, New York NY 10012. (212)966-0377. **Fax:** (212)966-0551. **E-mail:** info@cityarts.org. **Website:** www.cityarts.org. Estab. 1968. CITYarts brings young people and professional artists together to create public art. Through this creative process, CITYarts empowers youth and connects children locally and around the world to become active participants in transforming communities. Funded by foundations, corporations, government, and friends, CITYarts is a nonprofit public art organization involved in arts education and community development. Open all year; Monday–Friday, 9:30-5:30. Office located in Soho; however, "the city is our gallery." We have 300 murals located throughout all 5 of New York City's boroughs. As well as our Young Minds Build Bridges Program, which works to connect youth globally to engage in the conversation for peace. Through this program we have brought CITYarts projects to 65 countries and created 5 global mosaic Peace Walls. We represent emerging, mid-career, and established artists and typically produce 4-8 projects/year.

MEDIA Our murals are a permanent testament to our youth and their positive contribution to their communities.

SUBMISSIONS If you are interested in becoming involved with CITYarts, sign up to volunteer on our website, or send an email inquiry.

CLAMPART

531 W. 25th St., Ground Floor, New York NY 10001. (646)230-0020. **E-mail:** info@clampart.com; portfolioreview@clampart.com. **Website:** www.clampart.com. **Contact:** Brian Paul Clamp, Director. Estab. 2000. Sponsors 8-12 exhibits/year. Average display time: 5 weeks. Open Tuesday–Saturday, 11-6; closed the last 2 weeks of August. Located on the ground floor on Main Street in Chelsea. Medium-sized exhibition space.

MEDIA Considers acrylic, collage, drawing, mixed media, oil, paper, pastel, pen & ink, and watercolor. Considers all types of prints. Most frequently exhibits photo, oil and paper.

STYLE Exhibits conceptualism, geometric abstraction, minimalism, and postmodernism. Considers genres including figurative work, florals, landscapes, and portraits. Most frequently exhibits postmodernism, conceptualism, and minimalism.

TERMS E-mail query letter with artist's statement, bio and JPEGs. Cannot return material. Responds to queries in 2 weeks. Clients include local community, tourists and upscale. 5% of sales are to corporate collectors. Overall price range: $300-50,000; most work sold at $2,000. Artwork is accepted on consignment (50% commission). Retail price set by the gallery. Gal-

lery provides insurance, promotion, and contract. Does not require exclusive representation locally.

SUBMISSIONS "Include a bio and well-written artist statement. Do not submit work to a gallery that does not handle the general kind of work you produce." Accepted work should be framed, mounted and matted. Finds artists through portfolio reviews, referrals by other artists and submissions.

CATHARINE CLARK GALLERY

248 Utah St., San Francisco CA 94103. (415)399-1439. **Fax:** (415)543-1338. **E-mail:** info@cclarkgallery.com; associate@cclarkgallery.com; cc@cclarkgallery.com. **Website:** www.cclarkgallery.com. **Contact:** Catherine Clark, owner/director. Estab. 1991. Retail gallery. Represents 25+ emerging and mid-career artists. Curates 8-12 shows/year. Average display time: 4-6 weeks. Open all year. Located downtown San Francisco; 3,000 sq. ft., including video project room. 90% of space for special exhibitions. Clientele: 95% private collectors, 5% corporate collectors. Overall price range: $200-$300,000; most work sold at $2,000-$5,000.

MEDIA Considers painting, sculpture, installation, photography, printmaking, video, and new genres. Most frequently exhibits painting, sculpture, installation, and new genres.

STYLE Exhibits all styles and genres.

TERMS Accepts work on consignment (50% commission). Retail price set by gallery and artist. Offers customer payment by installments. Gallery provides insurance, promotion, and contract; shipping costs are shared. Prefers artwork framed.

SUBMISSIONS Submission review is limited. Send query e-mail before sending submissions. Submissions will not be returned without SASE.

CLAY CENTER'S AVAMPATO DISCOVERY MUSEUM

1 Clay Square, Charleston WV 25301. (304)561-3570. **E-mail:** lferguson@theclaycenter.org; info@theclaycenter.org. **Website:** www.theclaycenter.org. **Contact:** R. Lewis Ferguson. Estab. 1974. Museum gallery. Represents emerging, mid-career, and established artists. Sponsors 6 shows/year. Average display time: 2-3 months. Open all year; Wednesday-Saturday, 10-5; Sunday, 12-5. Located inside the Clay Center for the Arts & Sciences.

MEDIA Considers oil, acrylic, watercolor, pastel, pen & ink, drawings, mixed media, collage, works on paper, sculpture, installations, photography, and prints.

STYLE Considers all styles and genres.

TERMS Retail price set by artist. Gallery pays shipping costs. Prefers framed artwork.

SUBMISSIONS Send query letter with bio, résumé, brochure, slides, photographs, reviews, and SASE. Write for appointment to show portfolio of slides. Responds within 2 weeks, only if interested. Files everything or returns in SASE.

THE CLAY PLACE

One Walnut St., Carnegie PA 15106. (412)489-5240. **E-mail:** info@clayplacestandard.com. **Website:** www.clayplaceatstandard.com. Estab. 1973. Retail gallery. Represents 50 emerging, mid-career, and established artists. Exhibited artists include Jack Troy and Kirk Mangus. Sponsors 7 shows/year. Open Monday-Friday, 9-4:30. Located in small shopping area; 1,200 sq. ft. 50% of space for special exhibitions. Overall price range: $10-2,000; most work sold at $40-100.

MEDIA Considers ceramic, sculpture, glass and pottery. Most frequently exhibits clay, glass, and enamel.

TERMS Accepts artwork on consignment (50% commission) or buys outright for 50% of retail price (net 30 days). Retail price set by artist. Sometimes offers customer discounts and payment by installments. Gallery provides insurance, promotion, and shipping costs from gallery. We also sell books, tools, equipment, and supplies.

SUBMISSIONS Prefers only clay, some glass, and enamel. Send query letter with résumé, slides, photographs, bio, and SASE. Write for appointment to show portfolio. Portfolio should include actual work rather than slides. Responds in 1 month. Does not reply when busy. Files résumé. Does not return slides. Finds artists through visiting exhibitions and art collectors' referrals.

TIPS "Functional pottery sells well. Emphasis on form, surface decoration. Some clay artists have lowered quality in order to lower prices. Clientele look for quality, not price."

⌂ COAST GALLERIES

P.O. Box 223519, Carmel CA 93922. (831)625-8688. **E-mail:** gary@coastgalleries.com. **Website:** www.coastgalleries.com. **Contact:** Gary Koeppel, president/CEO. Estab. 1958. Retail galleries. Represents 300 emerging, mid-career, and established artists and craftsmen. Sponsors 3-4 shows/year. Open daily, all

year. Locations in Big Sur and Hana HI (Maui). Each gallery was designed specifically for its location and clientele. The Hana Coast Gallery features Hawaiiana; the Big Sur Coast Gallery features American Master Crafts and contemporary fine arts. The Big Sur Gallery is constructed from recycled municipal redwood water tanks and is one of the largest galleries of American crafts in the US. Big Sur has 7,500 sq. ft. of retail space and Hana has 2,500 sq. ft. Clientele: 90% private collectors, 10% corporate collectors. Overall price range: $25-60,000; most work sold at $400-4,000. See websites for hours and details on each gallery: www.coastgalleries.com and www.hanacoastgallery.com.

MEDIA Considers all media; paintings, prints, posters, sculpture, art glass.

STYLE Exhibits impressionism and realism. Genres include landscape, marine, abstract, and wildlife.

TERMS Accepts fine art and master crafts on consignment and buys some master crafts outright (net 30 days). Retail price set by gallery. Gallery provides insurance, promotion, and contract; artist pays for shipping. Requires framed artwork.

SUBMISSIONS Accepts only artists from Hawaii for Hana gallery; coastal and wildlife imagery and American crafts for Big Sur gallery. Send query letter with bio, brochure, images, and contact info; SASE mandatory if materials are to be returned. Write or e-mail info@coastgalleries.com for appointment. Owner responds to all inquiries.

COLEMAN FINE ART

79 Church St., Charleston SC 29401. (843)853-7000. **E-mail:** info@colemanfineart.com. **Website:** www.colemanfineart.com. Estab. 1974. Retail gallery; gilding, frame making, and restoration. Exclusive representatives for watercolor artist Mary Whyte, b. 1953. Open all year; Tuesday–Saturday, 10-6; Sunday and Monday, by chance. "Both a fine art gallery and restoration studio, Coleman Fine Art has been representing regional and national artists for over 30 years. Located on the corner of Church and Tradd streets, the gallery reinvigorates one of the country's oldest art studios." Clientele: tourists, upscale, and locals. 95-98% private collectors, 2-5% corporate collectors. Overall price range: $3,000-80,000.

MEDIA Considers oil, watercolor, pastel, pen & ink, drawing, sculpture. Most frequently exhibits watercolor, oil, and sculpture.

STYLE Exhibits impressionism and realism. Genres include portraits, landscapes, still lifes, and figurative work.

TERMS Accepts work on consignment (45% commission); net 30 days. Retail price set by the gallery and the artist. Gallery provides promotion and contract. Shipping costs are shared. Prefers artwork framed.

SUBMISSIONS Send query letter with digital CD of most recent work, reviews, and biography. E-mail for appointment to show portfolio. Finds artists through submissions.

COMPLEMENTS ART GALLERY

2131 Providence Pike, North Smithfield RI 02896. (401)766-6800. **Fax:** (401)766-6868. **E-mail:** teri@complementsartgallery.com. **Website:** www.complementsartgallery.com. Estab. 1986. Retail gallery. Represents hundreds of international and New England emerging, mid-career, and established artists. Exhibited artists include Fairchild and Hatfield. Sponsors 6 shows/year. Average display time: 2-3 weeks. Open all year; Monday–Friday, 9-5; Saturday, 9-4. 3,500 sq. ft. "We have a piano and beautiful hardwood floors, also a great fireplace." 20% of space for special exhibitions; 60% of space for gallery artists. Clientele: upscale. 40% private collectors, 15% corporate collectors. Overall price range: $25-$10,000; most work sold at $600-2,000.

MEDIA Considers all media except offset prints. Types of prints include engravings, lithographs, wood engravings, mezzotints, serigraphs, and etchings. Most frequently exhibits serigraphs, oils.

STYLE Exhibits expressionism, painterly abstraction, impressionism, photorealism, realism, and imagism. Genres include florals, portraits, and landscapes. Prefers realism, impressionism, and abstract.

TERMS Accepts work on consignment (30% commission) or bought outright for 50% of retail price (90 days). Retail price set by the gallery. Gallery provides insurance, promotion, and contract. Shipping costs are shared. Prefers artwork unframed.

SUBMISSIONS Size limitation due to wall space. Paintings no larger than 40×60, sculpture not heavier than 150 pounds. Send query letter with résumé, bio, 6 slides or photographs. Call for appointment to show portfolio of photographs and slides. Responds in 1 month. Files all materials from artists. Finds artists through word of mouth, referrals by other artists, visiting art fairs and all exhibitions and artist's submissions.

TIPS "Artists need to have an idea of the price range of their work and provide interesting information about themselves."

CONE EDITIONS

17 Powder Spring Rd., East Topsham VT 05076. (802)439-5751. **Fax:** (802)439-6501. **E-mail:** cathy@cone-editions.com. **Website:** www.cone-editions.com. **Contact:** Cathy Cone. Printmakers, publishers and distributors of computer and digitally made works of art. Estab. 1980. Represents/exhibits 12 emerging, mid-career and established artists/year. Exhibited artists include Norman Bluhm and Wolf Kahn. Sponsors 4 shows/year. Average display time: 3 months. Open all year; Monday-Friday, 9-5. Located downtown; 1,000 sq. ft.; post and beam, high ceilings, natural light. 50% of space for special exhibitions; 50% of space for gallery artists. Clientele: private, corporate. 40% private collectors, 60% corporate collectors. Overall price range: $300-5,000; most work sold at $500-1,500.

MEDIA Considers computer and digital art and computer prints. Most frequently exhibits iris ink jet print, digitial monoprint and digital gravure.

STYLE Exhibits expressionism, minimalism, color field, painterly abstraction, and imagism.

TERMS Artwork is accepted on consignment (50% commission). Retail price set by the artist. Gallery provides promotion; shipping costs are shared. Prefers artwork unframed.

SUBMISSIONS Prefers computer and digital art. Contact through e-mail. Call for appointment to show portfolio on CD. Responds in 1-3 weeks. Files slides and CD.

TIPS "We find most of the artists we represent by referrals of our other artists."

CONTEMPORARY ART MUSEUM ST. LOUIS

3750 Washington Blvd., St. Louis MO 63108. (314)535-4660. **Fax:** (314)535-1226. **E-mail:** mnguyen@camstl.org. **Website:** www.camstl.org. **Contact:** Melanie Nguyen. Estab. 1980. Nonprofit museum. "A noncollecting museum dedicated to exhibiting contemporary art from international, national, and local established and emerging artists." Open Wednesday, 10-5; Thursday-Friday, 10-8; and Saturday-Sunday, 10-5. Located mid-town, Grand Center; 27,200 sq. ft. building designed by Brad Cloepfil, Allied Works.

CONTEMPORARY ARTS CENTER (LAS VEGAS)

CAC @ Emergency Arts, 6th and Fremont, Suite 154, P.O. Box 582, Las Vegas NV 89125. (702)496-0569. **E-mail:** info@lasvegascac.org. **Website:** www.lasvegascac.org. Estab. 1989. Nonprofit gallery. Sponsors more than 9 exhibits/year. Average display time: 1 month. Gallery open Thursday-Friday, 3-7; Saturday-Sunday, 2-7, and by appointment. Closed Thanksgiving, Christmas, New Year's Day. 1,200 sq. ft. Clients include tourists, local community and students. 75% of sales are to private collectors, 25% corporate collectors. Overall price range: $200-4,000. Most work sold at $400. Artwork is accepted through annual call for proposals of self-curated group shows. Gallery provides insurance, promotion, contract.

MEDIA Considers all media and all types of prints. Exhibits conceptualism, group shows of contemporary fine art. Genres include all contemporary art/all media.

CONTEMPORARY ARTS CENTER (NEW ORLEANS)

900 Camp St., New Orleans LA 70130. (504)528-3805. **Fax:** (504)528-3828. **E-mail:** jfrancino@cacno.org; info@cacno.org. **Website:** www.cacno.org. **Contact:** Jennifer Francino, visual arts manager. Estab. 1976. Alternative space, nonprofit gallery. Exhibits emerging, mid-career, and established artists. Open all year; Wednesday-Monday, 11-5. Closed holidays. Located in Arts District of New Orleans; renovated/converted warehouse. Clients include local community, students, tourists, and upscale.

MEDIA Considers all media and all types of prints. Most frequently exhibits painting, sculpture, installation, and photography.

STYLE Considers all styles. Exhibits anything contemporary.

TERMS Artwork is accepted on loan for curated exhibitions. Retail price set by the artist. CAC provides insurance and promotion. Accepted work should be framed. Does not require exclusive representation locally. The CAC is not a sales venue, but will refer inquiries. CAC receives 20% on items sold as a result of an exhibition.

SUBMISSIONS Send query letter with bio, SASE and slides or CDs. Responds in 4 months. Files letter and bio—slides when appropriate. Finds artists through word of mouth, submissions, art exhibits, art

fairs, referrals by other artists, professional contacts, and periodicals.

TIPS "Use only one slide sheet with proper labels (title, date, medium and dimensions)."

THE CONTEMPORARY AUSTIN

700 Congress Ave., Austin TX 78701. (512)453-5312 (downtown) or (512)458-8191 (Laguna Gloria). **E-mail:** info@thecontemporaryaustin.org; curatorial@thecontemporaryaustin.org. **Website:** www.thecontemporaryaustin.org. Estab. 1911. Showcasing two renowned and architecturally unique locations, The Contemporary Austin brings multidisciplinary exhibitions, engaging programs, and enticing special events to the city's visual arts landscape.

TERMS "We are not a commercial gallery."

SUBMISSIONS Send query letter with résumé, slides and SASE attn: Artist Submission. Responds only if interested within 3 months. Files slides, résumé and bio. Material returned only when accompanied by SASE. Common mistakes artists make are "not enough information, poor slide quality, too much work covering too many changes in their development."

COOS ART MUSEUM

235 Anderson Ave., Coos Bay OR 97420. (541)267-3901. **E-mail:** info@coosart.org. **Website:** www.coosart.org; www.facebook.com/coosartmuseum. Estab. 1950. Not-for-profit corporation; 3rd-oldest art museum in Oregon. Mounts 4 juried group exhibitions/year of 85-150 artists; 20 curated single/solo exhibits/year of established artists; and 6 exhibits/year from the permanent collection. 5 galleries allow for multiple exhibits mounted simultaneously, averaging 6 openings/year. Average display time: 6-9 weeks. Open Tuesday–Friday, 10-4; Saturday, 1-4. Closed Sunday, Monday and all major holidays. Free admission during evening of the 1st Friday of the month (Wine Walk), 5-8. Clients include local community, students, tourists and upscale.

MEDIA For curated exhibition, considers all media including print, engraving, litho, serigraph. Posters and giclées not considered. Most frequently exhibits paintings (oil, acrylic, watercolor, pastel), sculpture (glass, metal, ceramic), drawings, etchings, and prints.

STYLE Considers all styles and genres. Most frequently exhibits primitivism, realism, postmodernism, and expressionism.

TERMS Gallery floor sales are accepted. Retail price set by the artist. Museum provides insurance, promotion, and contract. Accepted work should be framed, mounted, and matted. Accepts only artists from Oregon or Western United States.

SUBMISSIONS Send query letter with artist's statement, bio, résumé, SASE, digital files on CD or links to website. Responds to queries in 6 months. Never send originals of slides, résumés, or portfolios. Exhibition committee reviews 2 times/year—schedule exhibits 2 years in advance. Files proposals. Finds artists through portfolio reviews and submissions.

TIPS "Have complete files electronically on a website or CD. Have a written positioning statement and proposal of show as well as letter(s) of recommendation from a producer/curator/gallery of a previous curated exhibit. Do not expect us to produce or create the exhibition. You should have all costs figured ahead of time and submit only when you have work completed and ready. We do not develop artists. You must be professional."

CORE NEW ART SPACE

900 Sante Fe Dr., Denver CO 80204. (303)297-8428. **E-mail:** corenewartspace@gmail.com. **Website:** www.corenewartspace.com. Estab. 1981. Cooperative, alternative and nonprofit gallery. Exhibits 24 emerging and mid-career artists. Sponsors 10 solo and 6 group shows/year. Average display time: 3 weeks. Open Thursday, 12-6; Friday, 12-9; Saturday, 12-6; Sunday, 1-4. Located Santa Fe Arts district. Accepts mostly artists from front range Colorado. Clientele: 97% private collectors; 3% corporate clients. Overall price range: $75-3,000; most work sold at $100-600.

MEDIA Considers all media. Specializes in cutting edge work. Prefers quality rather than marketability.

STYLE Exhibits expressionism, neo-expressionism, painterly abstraction, conceptualism; considers all styles and genres, but especially contemporary and alternative (nontraditional media and approach), including installations.

TERMS Co-op membership fee plus donation of time. Retail price set by artist. Exclusive area representation not required. Also rents annex space to nonmembers for $125-275/3 week run.

SUBMISSIONS Send query letter with SASE. Quarterly auditions to show portfolio of originals, slides, and photographs. Request membership application. "Our gallery gives an opportunity for emerging art-

ists in the metro-Denver area to show their work. We run 6 open juried shows a year. There is an entry fee charged, and a 25% commission is taken on any work sold. The member artists exhibit in a 2-person show once a year. Member artists generally work in more avant-garde formats, and the gallery encourages experimentation. Members are chosen by slide review and personal interviews. Due to time commitments we require that they live and work in the area." Finds artists through invitations, word of mouth, art publications.

TIPS "We want to see challenging art. If your intention is to manufacture coffee-table and over-the-couch art for suburbia, we are not a good place to start."

CORNERHOUSE GALLERY AND FRAME

3318 First Ave. NE, Suite A, Cedar Rapids IA 52402. (319)365-4348. **E-mail:** info@cornerhousegallery. com. **Website:** www.cornerhousegallery.com. Estab. 1976. For-profit gallery. "Innovation and creativity by experienced professionals. Features primarily local and Midwestern artists, as well as a few national and international artists." Exhibits emerging, mid-career and established artists. Approached by 75 artists/year. Sponsors 4 or more exhibits/year. Open Monday–Friday, 10-5:30; Saturday, 10-4. Located on main street through Cedar Rapids in the Kenwood Plaza. Clients include local community, students, tourists, upscale, and corporate. Overall price range: $200-20,000; most work sold at $1,000.

MEDIA Considers all media. Most frequently exhibits glass, oil, and sculpture. Considers all prints except posters.

STYLE Considers all styles. Genres include figurative work, florals, and landscapes.

TERMS Artwork is accepted on consignment and there is a 50% commission. Retail price is set by the artist.

SUBMISSIONS Call, e-mail or write to arrange personal interview to show portfolio of photographs, slides, transparencies or CDs, résumés and reviews with SASE. Returns material with SASE.

TIPS "Good photos of work, websites with enough work to get a feel for the overall depth and quality."

COURTHOUSE GALLERY, LAKE GEORGE ARTS PROJECT

1 Amherst St., Lake George NY 12845. (518)668-2616. **E-mail:** mail@lakegeorgearts.org. **Website:** www.lakegeorgearts.org. **Contact:** Laura Von Rosk, gallery director. Estab. 1986. Nonprofit gallery. Approached by 200 artists/year. Exhibits 10-15 emerging, mid-career and established artists. Sponsors 6 exhibits/year. Average display time: 5-6 weeks. Open all year; Tuesday-Friday, 12-5; Saturday, 12-4. Closed mid-December to mid-January. Clients include local community, tourists and upscale. Overall price range: $100-5,000; most work sold at $500.

MEDIA Considers all media and all types of prints. Most frequently exhibits painting, mixed media, and sculpture.

STYLE Considers all styles and genres.

TERMS Artwork is accepted on consignment and there is a 25% commission. Retail price set by the artist. Gallery provides insurance, promotion, and contract. Accepted work should be framed, mounted, and matted.

SUBMISSIONS Mail portfolio for review. Deadline: January 31. Send query letter with artist's statement, bio, résumé, SASE and slides. Returns material with SASE. Finds artists through word of mouth, submissions, portfolio reviews, art exhibits, art fairs, and referrals by other artists.

JAMES COX GALLERY AT WOODSTOCK

4666 Rt. 212, Willow NY 12495. (845)679-7608. **Fax:** (845)679-7627. **E-mail:** info@jamescoxgallery.com. **Website:** www.jamescoxgallery.com. Estab. 1990. Retail gallery. Represents 10 mid-career and established artists. Exhibited artists include Leslie Bender, Bruce North, Paola Bari and Mary Anna Goetz. Represents estates of 5 artists including James Chapin, Margery Ryerson, Joseph Garlock and Elaine Wesley. Sponsors 5 shows/year. Average display time: 1 month. Open all year; Tuesday–Sunday, 10-5, winter hours: Tuesday–Friday, 10-5, or by appointment. Elegantly restored Dutch barn. 50% of space for special exhibitions. Clients include New York City residents (within 50-mile radius) and tourists. 65% of sales are to private collectors. Overall price range: $500-50,000; most work sold at $1,000-10,000.

MEDIA Considers oil, watercolor, pastel, drawing, ceramics, and sculpture. Considers "historic Woodstock, art." Most frequently exhibits oil paintings, watercolors, sculpture.

STYLE Exhibits impressionism, realism. Genres include landscapes and figurative work. Prefers expressive or evocative realism, painterly landscapes, and stylized figurative work.

TERMS Accepts work on consignment (50% commission). Retail price set by the artist. Gallery provides promotion; artist pays shipping costs to and from gallery. Prefers artwork framed.

SUBMISSIONS Prefer submissions by e-mail. Prefers only artists from New York region. Send query letter with résumé, bio, brochure, photographs, CD, SASE and business card. Responds in 3 months. Files material on some artists for special, theme or group shows.

TIPS "Be sure to enclose SASE and be patient for response. Also, please include information on present pricing structure."

MILDRED COX GALLERY AT WILLIAM WOODS UNIVERSITY

One University Ave., Fulton MO 65251. (573)592-4244; (800)995-3159 ext. 4244. **E-mail:** nicole. petrescu@williamwoods.edu. **Website:** www. williamwoods.edu. **Contact:** Nicole Petrescu, gallery coordinator. Estab. 1970. Nonprofit gallery. Approached by 20 artist/year; exhibits 8 emerging, mid-career, and established artists/year. Exhibited artists include Elizabeth Ginsberg and Frank Stack. Average display time: 1 month. Open Monday–Friday, 9-6; Saturday-Sunday, 1-4, while class is in session. Located in the Gladys Woods Kemper Center for the Arts; within large movable walls; 300 running feet. Clients include local community, students, upscale and foreign visitors. Overall price range: $800-10,000; most work sold at $800-1,000. Gallery takes no commission. "Our mission is education."

MEDIA Considers all media. Most frequently exhibits drawing, painting and sculpture. Considers all prints except commercial off-set.

STYLE Exhibits expressionism, geometric abstraction, impressionism, surrealism, painterly abstraction, and realism. Most frequently exhibits figurative and academic. Genres include Americana, figurative work, florals, landscapes, and portraits.

TERMS Artists work directly with person interested in purchase. Retail price of the art set by the artist. Gallery provides insurance and contract. Accepted work should be framed and matted. Does not require exclusive representation locally. Artists are selected by a committee from JPEG files or original presentation to faculty committee.

SUBMISSIONS Write to arrange a personal interview to show portfolio or send query letter with artist's statement, résumé, and JPEGs to gallery director via e-mail. Does not reply to queries. Artist should call or e-mail. Files slides, statement, and résumé until exhibit concludes. Finds artists through word of mouth.

COYOTE WOMAN GALLERY

160 E. Main St., Harbor Springs MI 49740. **E-mail:** office@coyotewomangallery.com; submissions@ coyotewomangallery.com. **Website:** www. coyotewomangallery.com. Estab. 1992. For-profit gallery. Exhibits emerging and established artists. Represents or exhibits 50+ artists such as Daniel Roache (sculpture). Clients include local community, tourists, and upscale clientele. Overall price range: $25-4,000.

MEDIA Considers acrylic, ceramics, drawing, fiber, glass, mixed media, oil, pastel, sculpture, and watercolor, among others. Displays etchings, lithographs, serigraphs, woodcuts, and other forms of prints.

STYLE Considers geometric abstraction, impressionism, and painterly abstraction. Considers all genres.

TERMS Artowrk is accepted on consignment and there is a 50% commission. Gallery provides insurance and promotion. Accpeted work should be framed. Requires exclusive representation locally. Only represents American artists.

SUBMISSIONS Send query letter with artist's statement, bio, photoraphs, and résumé. Materials returned with SASE. Responds in 4 weeks. Finds artists throughs ubmissions, art exhibits, art fairs, and referrals by other artists.

CRAFT & FOLK ART MUSEUM (CAFAM)

5814 Wilshire Blvd., Los Angeles CA 90036. (323)937-4230. **E-mail:** info@cafam.org. **Website:** www.cafam. org. Estab. 1973. "Located on Los Angeles' prestigious Museum Row, CAFAM is the city's only institution exclusively dedicated to celebrating craft, design and folk act. CAFAM's dynamic exhibitions feature established and emerging artists whose work is rooted in both traditional and contemporary craft and design. Through its exhibitions and programs, CAFAM challenges established ideas about craft and folk art." Sponsors 6 shows/year. Average display time: 2-3 months. Open Tuesday–Friday, 11-5; Saturday–Sunday, 12-6. Located on Miracle Mile; features design, contemporary crafts, international folk art.

MEDIA Considers all media; most frequently exhibits contemporary use of ceramics, found objects,

wood, fiber, glass, textiles, and paper.

STYLE Exhibits all styles, all genres.

SUBMISSIONS Submission details online.

CRAFT ALLIANCE GALLERY

6640 Delmar Blvd., St. Louis MO 63130. (314)725-1177 ext. 322. **Fax:** (314)725-2068. **E-mail:** gallery@craftalliance.org. **Website:** www.craftalliance.org. Nonprofit arts center with exhibition and retail galleries. Estab. 1964. Represents approximately 500 emerging, mid-career and established artists. Exhibition spaces sponsor 10-12 exhibits/year. Open Tuesday-Thursday, 10-5; Friday-Saturday, 10-6; Sunday, 11-5. Located in University City in the Delmar Loop Shopping District. Clients include local community, students, tourists, and upscale. Retail gallery price range $20 and up. Most work sold at $100.

MEDIA Considers ceramics, metal, fiber, and glass. Most frequently exhibits jewelry, glass, and clay. Doesn't consider prints.

STYLE Exhibits contemporary craft.

TERMS Exhibition artwork is sold on consignment and there is a 50% commission. Artwork is bought outright. Retail price set by the gallery and the artist. Gallery provides insurance and promotion. Requires exclusive representation locally.

SUBMISSIONS Call or write to arrange a personal interview to show portfolio of slides or call first, then send slides or photographs. Returns material with SASE.

TIPS "Call and talk. Have professional slides and attitude."

CREATIVE GROWTH ART CENTER GALLERY

355 24th St., Oakland CA 94612. (510)836-2340, ext.15. **E-mail:** info@creativegrowth.org. **Website:** www.creativegrowth.org. Estab. 1978. Nonprofit gallery. Represents 100 emerging and established artists; 100 adults with disabilities work in our adjacent studio. Exhibited artists include Dwight Mackintosh, Nelson Tygart. Sponsors 10 shows/year. Average display time: 5 weeks. Open Monday–Friday, 10-4:30; Saturday 10-3. Located downtown; 1,200 sq. ft.; classic large white room with movable walls, track lights; visible from the street. 25% of space for special exhibitions; 75% of space for gallery artists. Clientele: private and corporate collectors. 90% private collectors, 10% corporate collectors. Overall price range: $50-4,000; most work sold at $100-250.

This gallery concentrates mainly on the artists who work in an adjacent studio, but work from other regional or national artists may be considered for group shows. Only outsider and brut art are shown. Most of the artists have not formally studied art, but have a raw talent that is honest and real with a strong narrative quality.

MEDIA Considers oil, acrylic, watercolor, pastel, pen & ink, drawing, mixed media, collage, paper, sculpture, ceramics, fiber, woodcuts, engravings, lithographs, wood engravings, mezzotints, serigraphs, linocuts, and etchings. Most frequently exhibits (2D) drawing and painting; (3D) sculpture, hooked rug/tapestries.

STYLE Exhibits expressionism, primitivism, color field, naive, folk art, brut. Genres include landscapes, florals, and figurative work. Prefers brut/outsider, contemporary, expressionistic.

TERMS Accepts work on consignment (40% commission). Retail price set by the gallery. Gallery provides insurance, promotion, and contract; artist pays shipping costs to and from gallery. Prefers artwork framed.

SUBMISSIONS Prefers only brut, naive, outsider; works by adult artists with disabilities. Send query letter with résumé, slides, bio. Write for appointment to show portfolio of photographs and slides. Responds only if interested. Files slides and printed material. Finds artists through agents, by visiting exhibitions, word of mouth, various art publications and sourcebooks, submissions, and networking.

TIPS "Peruse publications that feature brut and expressionistic art (example *Raw Vision*)."

D5 PROJECTS

2525 Michigan Ave., Suite B7, Santa Monica CA 90404. (310)315-1937. **Fax:** (310)315-9688. **E-mail:** info@robertbermangallery.com. **Website:** www.robertbermangallery.com. **Contact:** Robert Berman, owner. For profit gallery. Approached by 200 artists/year; exhibits 25 mid-career artists. Sponsors 12 exhibits/year. Average display time: 1 month. Open Tuesday-Saturday, 11-6. Closed December 24-January 1 and last 2 weeks of August. Located in Bergamot Station Art Center in Santa Monica. Clients include local community, students, tourists, and upscale. Overall price range: $600-30,000; most work sold at $4,000.

MEDIA Considers all media. Most frequently exhibits oil on canvas.

STYLE Considers contemporary.

SUBMISSIONS "We currently accept submissions via e-mail *only* as URL address or no more than 3 images sent as attachments, JPEG or GIF. All 3 not to exceed 1.5 MB total. Images exceeding 1.5 MB will not be considered. If we receive slide submissions without a SASE, they will not be considered."

✪ DALES GALLERY

537 Fisgard St., Victoria, British Columbia V8W 1R3 Canada. (250)383-1552. **E-mail:** dalesgallery@shaw. ca. **Website:** www.dalesgallery.ca. **Contact:** Alison Trembath. Estab. 1976. Art gallery and framing studio. Approached by 200 artists/year, Sponsors 10 exhibits/year. Average display time: 4 weeks. Open all year; Monday-Friday, 10-5; Saturday, 11-4. Gallery situated in Chinatown (Old Town); approximately 650 sq. ft. of space—warm and inviting with brick wall and large white display wall. Clients include local community, students, tourists, and upscale. Overall price range: $100-4000; most work sold at $800.

MEDIA Considers all media including photography. Most frequently exhibits oils, photography, and sculpture.

STYLE Exhibits both solo and group artists.

TERMS Accepts work on consignment (40% commission). Retail price set by both gallery and artist. Accepted work should be framed by professional picture framers. Does not require exclusive representation locally.

SUBMISSIONS Please e-mail images. Portfolio should include contact number and prices. Responds within 2 months, only if interested. Finds artists through word of mouth, art exhibits, submissions, art fairs, portfolio reviews, and referral by other artists.

DALLAS MUSEUM OF ART

1717 N. Harwood St., Dallas TX 75201. (214)922-1200. **Fax:** (214)922-1350. **Website:** www.dma.org. Estab. 1903. Museum. Exhibits emerging, mid-career and established artists. Average display time: 3 months. Open Tuesday—Sunday, 11-5; Thursday, 11-9; Late Night Fridays (3rd Friday of the month, excluding December) the museum is open until midnight. General admission is free. Clients include local community, students, tourists, and upscale.

MEDIA Exhibits all media and all types of prints.

STYLE Exhibits all styles and genres.

SUBMISSIONS Does not accept unsolicited submissions. Call to request information.

DAVIDSON GALLERIES

313 Occidental Ave. S., Seattle WA 98104. (206)624-7684. **E-mail:** sam@davidsongalleries.com. **Website:** www.davidsongalleries.com. **Contact:** Sam Davidson, owner. Estab. 1973. Retail gallery. Estab. 1973. Represents 150 emerging, mid-career and established artists. Sponsors 36 shows/year. Average display time: 3 weeks. Open all year; Tuesday-Saturday, 10-5:30. Located in old, restored part of downtown; 3,200 sq. ft.; "beautiful antique space with columns and high ceilings built in 1890." 50% of space for special antique and modern works on paper; 50% of space for contemporary works on paper. Clientele: 90% private collectors, 10% corporate collectors. Overall price range: $50-70,000; most work sold at $250-5,000.

MEDIA Considers works on paper only: drawing (all types), watercolor, mixed media, pastel, woodcuts, wood engravings, linocuts, engravings, mezzotints, etchings, lithographs, **limited interest** in photography, digital manipulation, or collage.

STYLE Exhibits expressionism, neo-expressionism, primitivism, painterly abstraction, postmodern works, realism, surrealism, impressionism.

TERMS Accepts work on consignment (50% commission). Retail price set by gallery and artist. Gallery provides insurance, promotion and contract; shipping costs are one way.

SUBMISSIONS Send query letter, e-mail a reference to a website or send a disc with appropriate descriptions and SASE. Responds in 6 weeks.

TIPS "Impressed by a simple straight-forward presentation."

THE DAYTON ART INSTITUTE

456 Belmonte Park N., Dayton OH 45405-4700. (937)223-5277. **Fax:** (937)223-3140. **E-mail:** info@daytonart.org. **Website:** www.daytonartinstitute.org. Estab. 1919. Museum. Galleries open Tuesday-Saturday, 11-5; Thursday, 11-8; Sunday, 12-5.

STYLE Interested in fine art.

DEL MANO GALLERY

3051 Via Maderas, Altadena CA 91001. (818)421-2133. **E-mail:** gallery@delmano.com. **Website:** www.delmano.com. Estab. 1973. Online retail gallery representing more than 300 emerging, mid-career and established artists. Interested in seeing the work of emerging artists working in wood, glass, ceramics, fiber, and metal. Gallery deals heavily in

turned and sculpted wood, showing works by David Ellsworth, William Hunter and Ron Kent. Gallery hosts approximately 12 "online" exhibitions per year. Past exhibitions remain accessible on the website and there is a special section ("Artist Gallery") for individual artists to present available work. Work in this section is changed on a regular basis. Clients include professionals and affluent collectors. Overall price range: $300-30,000. Most work sold in the $500-5,000 range.

MEDIA Considers contemporary art in craft media: ceramics, glass, wood, fiber. No prints. Most frequently exhibits wood, ceramics, jewelry.

STYLE Exhibits all styles and genres.

TERMS Artist retains the work until sold. Gallery pays for shipping and pays artist prior to shipping. Retail price set by gallery and artist. Customer discounts and payment by installment are available. 10-mile exclusive area representation required. Gallery provides insurance, promotion and shipping costs from gallery. Prefers artwork framed.

SUBMISSIONS E-mail images for review to Ray Leier (rayl@delmano.com) along with résumé, piece information, and prices.

THE DELAWARE CONTEMPORARY

200 S. Madison St., Wilmington DE 19801. (302)656-6466. **E-mail:** kscarlett@thedcca.org. **Website:** www.thedcca.org. **Contact:** Katy Scarlett, curatorial assistant. Estab. 1980. Alternative space, museum retail store, nonprofit gallery. Approached by more than 800 artists/year; exhibits 50 artists. Sponsors 30 total exhibits/year. Average display time 6 weeks. Gallery open Tuesday, Thursday, Friday, and Saturday, 10-5; Wednesday and Sunday, 12-5. Closed on Monday and major holidays. Seven galleries located along Wilmington riverfront.

MEDIA Considers all media, including contemporary crafts.

STYLE Exhibits contemporary, abstract, figurative, conceptual, representational and nonrepresentational, painting, sculpture, installation, and contemporary crafts.

TERMS Accepts work on consignment (35% commission). Retail price is set by the gallery and the artist. Gallery provides insurance and promotion; shipping costs are shared. Prefers contemporary art.

SUBMISSIONS Send query letter with artist's statement, bio, SASE, 10 slides. Returns material with SASE.

Responds within 6 months. Finds artists through word of mouth, submissions, portfolio reviews, art exhibits, referrals by other artists.

DETROIT ARTISTS MARKET

4719 Woodward Ave., Detroit MI 48201. (313)832-8540. **Fax:** (313)832-8543. **E-mail:** info@detroitartistsmarket.org. **Website:** www.detroitartistsmarket.org. Estab. 1932. Nonprofit gallery. Exhibits the work of emerging, mid-career and established artists; 1,000 members. Sponsors 8-10 shows/year. Average display time: 6 weeks. Open Tuesday–Saturday, 11-6. Located in midtown Detroit; 2,600 sq. ft.; 85% for special exhibitions. Clientele: "extremely diverse client base, varies from individuals to the Detroit Institute of Arts." 95% private collectors; 5% corporate collectors. Overall price range: $200-75,000; most work sold at $100-500.

MEDIA Considers all media. No posters. Most frequently exhibits paintings, glass and multimedia.

STYLE All contemporary styles and genres.

TERMS Prefers artists from the metro Detroit region. Accepts artwork on consignment (33% commission). Retail price set by artist. Gallery provides insurance. Artist pays all shipping costs.

SUBMISSIONS "Artists and artwork shown is selected by a jury (from submitted call-for-entry applications), exhibition curator or by invitation from DAM (for the Elements gallery—our regular sales gallery which we have in addition to the main exhibition gallery)."

TIPS "Detroit Artists Market educates the Detroit metropolitan community about the work of emerging and established Detroit and Michigan artists through exhibitions, sales and related programs."

DINNERWARE ARTSPACE

101 W. Sixth St., Tucson AZ 85701. (520)869-3166. **E-mail:** dinnerwareartspace@gmail.com. **Website:** dinnerwareartspace.org. **Contact:** David Aguirre, director. Estab. 1979. Considers all media. Most frequently exhibits painting and sculpture. Considers all types of prints.

STYLE Most frequently exhibits group theme exhibitions in all media including art installations, video, performance art, and spoken word. Dinnerware organizes workshops in silk screen, etching press, kids arts, ceramics, fiber arts and more.

TERMS Varied.

SUBMISSIONS E-mail query with résumé, images, website or Facebook link.

TIPS Subscribe to e-mail list to get updates on upcoming exhibition opportunities. Check Dinnerware's Facebook page for updates.

DISTRICT OF COLUMBIA ARTS CENTER (DCAC)

2438 18th St. NW, Washington DC 20009. (202)462-7833. **E-mail:** info@dcartscenter.org. **Website:** dcartscenter.org. **Contact:** Michael Matason, gallery manager. Estab. 1989. Nonprofit gallery and performance space. Exhibits emerging and mid-career artists. Sponsors 7-8 shows/year. Average display time: 1-2 months. Open Wednesday–Sunday, 2-7; later when there is a theater performance. Located "in Adams Morgan, a downtown neighborhood; 132 running exhibition feet in exhibition space and a 52-seat theater." Clientele: all types. Overall price range: $200-10,000; most work sold at $600-1,400.

MEDIA Considers all media including fine and plastic art. "No crafts." Most frequently exhibits painting, sculpture, and photography.

STYLE Exhibits all styles. Prefers "innovative, mature, and challenging styles."

TERMS Accepts artwork on consignment (30% commission). Artwork only represented while on exhibit. Retail price set by the gallery and artist. Offers payment by installments. Gallery provides promotion and contract; artist pays for shipping. Prefers artwork framed.

SUBMISSIONS Send query letter with résumé, slides, bio, and SASE. Portfolio review not required. Responds in 4 months. More details are available on website.

TIPS "We strongly suggest the artist be familiar with the gallery's exhibitions and the kind of work we show strong, challenging pieces that demonstrate technical expertise and exceptional vision. Include SASE if requesting reply and return of slides!"

DOLPHIN GALLERIES

230 Hana Hwy., Suite 12, Kahalui HI 96732. (800)669-5051. **Fax:** (808)873-0820. **E-mail:** christianadams@dolphingalleries.com; info@dolphingalleries.com. **Website:** www.dolphingalleries.com. **Contact:** Christian Adams, director of sales and artist development. Estab. 1976. For-profit galleries. Exhibits emerging, mid-career and established artists. Exhibited artists include Alexei Butirskiy, Craig Alan and Dr. Seuss. Sponsors numerous exhibitions/year, "running at all times through 4 separate fine art or fine jewelry galleries." Average display time "varies from 1-night events to a 30-day run." Open 7 days/week, 9 a.m. to 10 p.m. Located in luxury resort, high-traffic tourist locations thoughout Hawaii. Gallery locations on Maui are at Whalers Village in Kaanapali and in Wailea at the Shops at Wailea. On the Big Island of Hawaii, Dolphin Galleries is located at the Kings Shops at Waikoloa. Clients include local community and upscale tourists. Overall price range: $100-100,000; most work sold at $1,000-5,000.

○ The above address is for Dolphin Galleries' corporate offices. Dolphin Galleries has 4 locations throughout the Hawaiian islands—see website for details.

MEDIA Considers all media. Most frequently exhibits oil and acrylic paintings and limited edition works of art. Considers all types of mediums.

STYLE Most frequently exhibits impressionism, figurative art, and sculpture. Considers American contemporary landscapes, portraits, and florals.

TERMS Artwork is accepted on consignment with promotion and contract. Retail price set by the gallery. Gallery provides insurance, promotion, and contract. Gallery happy to work with artist on a variety of terms. Requires exclusive representation locally.

SUBMISSIONS Submit via e-mail. Finds artists mainly through referrals by other artists, exhibitions, artist and agent submissions, portfolio reviews, and word of mouth.

M.A. DORAN GALLERY

3509 S. Peoria Ave., Tulsa OK 74105. (918)748-8700. **E-mail:** maryann@madorangallery.com. **Website:** www.madorangallery.com. Estab. 1979. Retail gallery. Represents 45 emerging, mid-career and established artists/year. Exhibited artists include P.S. Gordon and Otto Duecker. Sponsors 10 shows/year. Average display time: 1 month. Open all year; Tuesday–Saturday, 10:30-6. Located central retail Tulsa; 2,000 sq. ft.; up and downstairs, Soho-like interior. 50% of space for special exhibitions; 50% of space for gallery artists. Clients include upscale. 65% of sales are to private collectors; 35% corporate collectors. Overall price range: $500-40,000; most work sold at $5,000.

MEDIA Considers all media except pen & ink, paper, fiber and installation; types of prints include woodcuts, engravings, lithographs, wood engravings, mez-

zotints, serigraphs, linocuts, and etchings. Most frequently exhibits oil paintings, watercolor, and crafts.

STYLE Exhibits painterly abstraction, impressionism, photorealism, realism, and imagism. Exhibits all genres. Prefers landscapes, still life, and fine American crafts.

TERMS Accepts work on consignment (50% commission). Retail price set by the gallery and artist. Gallery provides insurance and promotion; shipping costs are shared. Prefers artwork framed.

SUBMISSIONS "Please submit a CD with 20 current images. Include a typed sheet with corresponding information. If submitting slides/photos, clearly label (title, year, medium, size). Please include a résumé—education, solo exhibitions distinct from group shows, awards, publications, etc., an artist statement—further explanation about your technique(s), concept, vision, etc. Please include an SASE. We appreciate your effort and a response will be sent within 30 days."

DOT FIFTYONE GALLERY

187 NW 27th St., Miami FL 33127. (305)573-9994, ext. 450. **E-mail:** info@dotfiftyone.com; dot@dotfiftyone.com. **Website:** www.dotfiftyone.com. Estab. 2003. Sponsors 12 exhibits per year. Average display time: 30 days. Clients include the local community, tourists, and upscale corporate collectors. Art sold for $1,000-20,000 (avg. $5,000) with a 50% commission. Prices are set by the gallery and the artist. Gallery provides insurance, promotion, and contract. Work should be framed, mounted, and matted.

TERMS E-mail 5 JPEG samples at 72 dpi.

DUCK CLUB GALLERY

2333 N. College, Fayetteville AR 72703. (479)443-7262. **Website:** www.duckclubgallery.com. Estab. 1980. Retail gallery. Represents mid-career and established artists. May be interested in seeing the work of emerging artists in the future. Exhibited artists include Terry Redlin, Jane Garrison and Linda Cullers. Displays work "until it sells." Open all year; Monday-Friday, 10-5:30; Saturday, 10-2. Located midtown; 1,200 sq. ft. 100% of space for gallery artists. Clientele: tourists, local community, students; "we are a university community." 80% private collectors, 20% corporate collectors. Overall price range: $50-400; most work sold at $50-200.

MEDIA Considers all media including wood carved decoys. Considers engravings, lithographs, serigraphs, etchings, posters. Most frequently exhibits limited edition and open edition prints and poster art.

STYLE Exhibits all styles and genres. Prefers wildlife, local art, and landscapes.

TERMS Buys outright for 50% of retail price (net 30 days). Retail price set by the artist. Gallery provides insurance and promotion; artist pays for shipping. Prefers artwork unframed.

SUBMISSIONS Send query letter with brochure, photographs and business card. Write for appointment to show portfolio. Finds artists through word of mouth, referrals by other artists, visiting art fairs and exhibitions, submissions, referrals from customers.

TIPS "Please call for an appointment. Don't just stop in. For a period of time, give exclusively to the gallery representing you. Permit a gallery to purchase 1 or 2 items, not large minimums."

DUCKTRAP BAY TRADING COMPANY

20 Main St., Camden ME 04843. (207)236-9568. **E-mail:** info@ducktrapbay.com. **Website:** www.ducktrapbay.com. **Contact:** Tim and Joyce Lawrence, owners. Estab. 1983. Retail gallery. "Our marine and wildlife art gallery features over 200 artists whose work spans from carving to painting, sculpture, scrimshaw, jewelry, ship models, and much more!" Represents 200 emerging, mid-career and established artists/year. Exhibited artists include Sandy Scott, Stefane Bougie, Yvonne Davis, Beki Killorin, Jim O'Reilly and Gary Eigenberger. Open daily 10-5. Located downtown waterfront; 2 floors, 3,000 sq. ft. 100% of space for gallery artists. Clientele: tourists, upscale. 70% private collectors, 30% corporate collectors. Overall price range: $250-120,000; most work sold at $250-2,500.

MEDIA Considers watercolors, oil, acrylic, pastel, pen & ink, drawing, paper, sculpture, bronze, and carvings. Types of prints include lithographs. Most frequently exhibits woodcarvings, watercolor, acrylic, and bronze.

STYLE Exhibits realism. Genres include nautical, wildlife and landscapes. Prefers marine and wildlife.

TERMS Accepts work on consignment (40% commission) or buys outright for 50% of the retail price (net 30 days). Retail price set by the artist. Gallery provides insurance and minimal promotion; artist pays for shipping. Prefers artwork framed.

SUBMISSIONS Send query letter with 10-20 slides or photographs. Call or write for appointment to show portfolio of photographs. Files all material. Finds art-

ists through word of mouth, referrals by other artists and submissions.

TIPS "Find the right gallery and location for your subject matter. Have at least 8-10 pieces or carvings or 3-4 bronzes."

DURHAM ART GUILD

120 Morris St., Durham NC 27701. (919)560-2713. **E-mail:** gallerydirector@durhamartguild.org. **Website:** www.durhamartguild.org. **Contact:** Katie Seiz, gallery director. Estab. 1948. Nonprofit gallery. Represents/exhibits 500 emerging, mid-career, and established artists/year. Sponsors more than 20 shows/year, including an annual juried art exhibit. Average display time: 6 weeks. Open all year; Monday-Saturday, 9-9; Sunday, 1-6. Free and open to the public. Located in center of downtown Durham in the Arts Council Building; 3,600 sq. ft.; large, open, movable walls. 100% of space for special exhibitions. Clientele: general public; 80% private collectors, 20% corporate collectors. Overall price range: $100-14,000; most work sold at $200-1,200.

MEDIA Considers all media. Most frequently exhibits painting, sculpture and photography.

STYLE Exhibits all styles, all genres.

TERMS Artwork is accepted on consignment (30-40% commission). Retail price set by the artist. Gallery provides insurance and promotion. Artist installs show. Prefers artwork framed.

SUBMISSIONS Artists must be 18 years or older. Send query letter with résumé, slides and SASE. "We accept slides for review by February 1 for consideration of a solo exhibit or special projects group show." Finds artists through word of mouth, referral by other artists, call for slides.

TIPS "Before submitting slides for consideration, be familiar with the exhibition space to make sure it can accommodate any special needs your work may require."

⚙ EAST END ARTS

133 E. Main Street, Riverhead NY 11901. (631)727-0900. **Fax:** (631)727-0966. **E-mail:** info@eastendarts.org. **Website:** www.eastendarts.org. **Contact:** Patricia Snyder, Executive Director. Estab. 1972. Gallery, Gift Shop, School of the Arts, Events and Arts Center. Located in the historic Davis-Corwin House (circa 1840). Exhibits the juried work of artists of all media. Presents seven shows annually most of which are juried group exhibitions. Exhibits include approximately 300 artists/year, ranging from emerging to mid-career to professional exhibitors of all ages. Average exhibition time: 4-6 weeks. Clientele small business and private collectors. Overall price range: $100-8,000; most work sold at $100-1,500. Open Tuesday–Saturday, 10a.m–4 p.m. www.eastendarts.org/gallery

STYLE Exhibits contemporary, abstract, naive, non-representational, photorealism, realism, postpop works, projected installations, and assemblages. "Being an organization relying strongly on community support, we aim to serve the artistic needs of our constituency and also expose them to current innovative trends within the art world. Therefore, there is not a particular genre bias; we are open to all art media."

TERMS Accepts work on consignment (30% commission). Retail price for art sold through our juried exhibits is set by the artist. Exclusive area representation not required.

SUBMISSIONS Submission guidelines available at www.eastendarts.org/gallery

TIPS "Visit, become a member and join our email list for more information on shows, events, workshops, opportunities for artists, and more! All work must be framed and wired for hanging. Artwork with clean gallery edge (no staples) is also accepted. Presentation of artwork is considered when selecting work for shows."

EASTERN SHORE ART CENTER

401 Oak St., Fairhope AL 36532. (251)928-2228. **E-mail:** kate@esartcenter.com. **Website:** www.esartcenter.com. **Contact:** Kate Fisher, executive director. Estab. 1957. Museum. Exhibits emerging, mid-career and established artists. Average display time: 1 month. Open Tuesday-Friday, 10-4; Saturday, 10-2. Open all year. Located downtown; 8,000 sq. ft. of galleries.

⚙ Artists applying to Eastern Shore should expect to wait at least a year for exhibits.

MEDIA Considers all media and prints.

STYLE Exhibits all styles and genres.

TERMS Accepts works on consignment (25% commission). Retail price set by artist. Gallery provides insurance, promotion, and contract. Prefers artwork framed.

SUBMISSIONS Send query letter with résumé and slides. Write for appointment to show portfolio of originals and slides.

TIPS "Conservative, realistic art is appreciated more and sells better."

⬤ E BRACKNELL GALLERY; MANSION SPACES

South Hill Park Arts Centre, Ringmead, Bracknell, Berkshire RG12 7PA, United Kingdom. (44)(0)1344-484-123. **Website:** www.southhillpark.org.uk. **Contact:** Ron McAllister, chief executive and programming. Estab. 1991. Alternative space/nonprofit gallery. Approached by at least 50 artists/year; exhibits several shows of emerging, mid-career, and established artists. "Very many artists approach us for the Mansion Spaces; all applications are looked at." Exhibited artists include Billy Childish (painting), Simon Roberts (photography) and Ed Piebn (digital installation/mixed media). Average display time: 2 months. Open all year; call or check website for hours. Located "within a large arts centre that includes theatre, cinema, studios, workshops and a restaurant; one large room and one smaller with high ceilings, plus more exhibiting spaces around the centre." Clients include local community and students.

MEDIA Considers all media. Most frequently exhibits painting, sculpture, live art, installations, group shows, video-digital works, craftwork (ceramics, glasswork, jewelery). Considers all types of prints.

STYLE Considers all styles and genres.

TERMS Artwork is accepted on consignment, and there is a 25% commission. Retail price set by the artist. Gallery provides insurance, promotion, and contract.

SUBMISSIONS Send query letter with artist's statement, bio and photographs. Returns material with SASE. Responds to queries only if interested. Files all material "unless return of photos is requested." Finds artists through invitations, art exhibits, referrals by other artists, submissions, and word of mouth.

TIPS "We have a great number of applications for exhibitions in the Mansion Spaces. Make yours stand out! Exhibitions at the Bracknell Gallery are planned 2-3 years in advance."

PETER ELLER GALLERY & APPRAISERS

(505)268-7437. **E-mail:** peter@peterellerart.com. **Website:** www.peterellerart.com. **Contact:** Peter Eller. Estab. 1981. Private dealer buys, sells, and does fee appraisals. Specializing in Albuquerque artists and minor New Mexico masters, 1925-1985. Overall price range $1,000-75,000.

MEDIA Considers acrylic, ceramics, drawing, mixed media, oil, pastel, pen & ink, sculpture, watercolor, engravings, etchings, linocuts, lithographs, mezzotints, serigraphs, and woodcuts. Most frequently exhibits oil, sculpture, and acrylic.

STYLE Considers all styles and genres. Most frequently exhibits Southwestern realism and geometric abstraction.

TERMS Primarily accepts consignments of resale works. Holds shows for contemporary artists occasionally.

SUBMISSIONS Call or write to arrange a personal interview to show portfolio or photographs. Finds artists through word of mouth and art exhibits.

EMEDIALOFT.ORG

744 Washington St., #A-629, New York NY 10014-2035. (646)368-5623. **Website:** www.emedialoft.org. **Contact:** CT Rhodes, director. Estab. 1982. Alternative space. Exhibits highly original mid-career artists. Sponsors 4-6 exhibits/year. Average display time: 2 months. Open during announced shows; or by appointment. Located in the Highline/Meatpacking/West Village neighborhood of Manhattan in New York City. Overall price range: $5-50,000; most work sold at $500-2,000. Two artists studios for artists-in-residence and archives/library.

MEDIA Contemporary art, photography, mixed media, oil, watercolor, collage, prints. Frequently exhibits new media, performance, readings, sound-art video, artists' books, artist's objects, image/text, and conceptual art. Most all are editions or sequences.

STYLE Themes relate to art from the subconscious, even if it looks recognizable or figurative, including landscapes or objects. No political art, no abstraction. "Art so original, it's hard to categorize."

SUBMISSIONS E-mail 250 words and 5 JPEGs (72 dpi max, 300 pixels on longest side). Or send query letter with "anything you like, but no SASE—sorry, we can't return anything. We may keep you on file, but please do not call." Responds to queries only if interested.

THOMAS ERBEN GALLERY

526 W. 26th St., Floor 4, New York NY 10001. (212)645-8701. **Fax:** (212)645-9630. **E-mail:** info@thomaserben.com. **Website:** www.thomaserben.com. Estab. 1996. For-profit gallery. Approached by 100 artists/year. Represents 15 emerging, mid-career and established artists. Exhibited artists include Preston Scott Cohen (architecture) and Tom Wood (photography). Average display time 5-6 weeks. Open all

year; Tuesday-Saturday, 10-6 (Monday–Friday in July). Closed Christmas/New Year's and August. Clients include local community, tourists and upscale.

MEDIA Considers all media. Most frequently exhibits photography, paintings and installation.

STYLE Exhibits contemporary art.

SUBMISSIONS Mail portfolio for review. Returns material with SASE. Responds in 1 month.

ETHERTON GALLERY

135 S. Sixth Ave., Tucson AZ 85701. (520)624-7370. **Fax:** (520)792-4569. **E-mail:** info@ethertongallery.com. **Website:** www.ethertongallery.com. Hannah Glasson, Daphne Srinivasan. **Contact:** Terry Etherton. Estab. 1981. Retail gallery and art consultancy. Specializes in vintage, modern and contemporary photography. Represents 50+ emerging, mid-career and established artists. Exhibited artists include Kate Breakey, Harry Callahan, Jack Dykinga, Elliott Erwitt, Mark Klett, Danny Lyon, Rodrigo Moya, Luis Gonzalez Palma, Lisa M. Robinson, Frederick Sommer, Joel-Peter Witkin and Alex Webb. Sponsors 3-5 shows/year. Average display time: 8 weeks. Open year round. Located in downtown Tucson; 3,000-sq.-ft. gallery in historic building with wood floors and 16-ft. ceilings. Clientele: 50% private collectors, 25% corporate collectors, 25% museums. Overall price range: $800-50,000; most work sold at $2,000-5,000. Media: Considers all types of photography, painting, works on paper. Etherton Gallery purchases 19th-century, vintage, and classic photography; occasionally purchases contemporary photography, and artwork. Interested in seeing work that is "well-crafted, cutting-edge, contemporary, issue-oriented."

MEDIA Considers all types of photography, oil, acrylic, drawing, mixed media, collage, original hand pulled prints, woodcuts, wood engravings, linocuts, engravings, mezzotints, etchings, and lithographs. Most frequently exhibits photography, painting, and mixed media.

STYLE Exhibits expressionism, neo-expressionism, primitivism, postmodern works. Genres include landscapes, portraits, and figurative work. Prefers expressionism, primitive/folk, and postmodern. Interested in seeing work that is "cutting-edge, contemporary, issue-oriented. No decorator art."

TERMS Accepts work on consignment (50% commission). Buys outright for 50% of retail price (net 30 days). Retail price set by gallery and artist. Gallery provides insurance and promotion; shipping costs are shared. Prefers framed artwork.

SUBMISSIONS A maximum of 10-20 images JPEGs, résumé, artist statement, bio, reviews. Materials not returned. Responds in 6 weeks if interested.

EVERHART MUSEUM

1901 Mulberry St., Scranton PA 18510-2390. (570)346-7186. **Fax:** (570)346-0652. **E-mail:** curator@everhart-museum.org. **Website:** www.everhart-museum.org. **Contact:** Curatorial department. Estab. 1908. "The Everhart Museum is one of the oldest museums in the state and part of the early 20th-century regional museum movement." Exhibits established artists. 2,400 members. 15 gallery spaces providing display area for permanent and temporary exhibitions. Open Monday, Thursday, Friday, 12-4; Saturday, 10-5; Sunday, 12-5; closed in January for routine maintenance; closed on Easter, July 4th, Thanksgiving, and Christmas. Located in urban park; 300 linear feet. 20% of space for special exhibitions.

MEDIA Considers all media.

STYLE Prefers regional, Pennsylvania artists but also national and international artists that feature science and culture in their work.

TERMS Museum provides insurance, promotion and shipping costs. 2D artwork must be framed.

SUBMISSIONS "Exhibition proposals are reviewed on an on-going basis by the curatorial department. Use the Exhibit Proposal form in order to have your proposal considered for display. If you are including work samples, slides, CDs, or other materials, please include a SASE if you would like your materials returned. Digital submissions and web portfolios also considered. Please do not send original material as the Everhart Museum accepts no responsibility for materials lost or damaged. Please note that the Everhart Museum receives many exhibition proposals each year so we would encourage you to contact a number of venues for your proposed exhibition. For additional information, or should you have difficulty downloading the online Exhibit Proposal form, please contact the curatorial department."

EVERSON MUSEUM OF ART

401 Harrison St., Syracuse NY 13202. (315)474-6064. **Fax:** (315)474-6943. **E-mail:** everson@everson.org; smassett@everson.org. **Website:** www.everson.org. **Contact:** Sarah Massett, assistant director. Estab. 1897. Museum. "In fitting with the works it houses, the

Everson Museum building is a sculptural work of art in its own right. Designed by renowned architect I.M. Pei, the building itself is internationally acclaimed for its uniqueness. Within its walls, Everson houses roughly 11,000 pieces of art; American paintings, sculpture, drawings, graphics and one of the largest holdings of American ceramics in the nation." Open all year; Wednesday, Friday & Sunday, noon-5; Thursday noon-8; Saturday 10-5; closed Monday & Tuesday. Located in a distinctive I.M. Pie-designed building in downtown Syracuse, NY. The museum features 4 large galleries with 24-ft. ceilings, back lighting and oak hardwood, a sculpture court, Art Zone for children, a ceramic study center and 5 smaller gallery spaces.

EVOLVE THE GALLERY

P.O. Box 5944, Sacramento CA 95817. (916) 572-5123. **E-mail:** info@evolvethegallery.com. **Website:** www.evolvethegallery.com. **Contact:** A. Michelle Blakeley, co-owner. Estab. 2010. For-profit and art consultancy gallery. Approached by 250+ artists/year. Represents emerging, mid-career and established artists. Exhibited artists include Richard Mayhew (master fine artist, watercolor), Corinne Whitaker (pioneer digital painter), Ben F. Jones (prominent international artist). Sponsors 12+ exhibits/year. Model and property release required. Average display time: 1 month. Open Thursday-Saturday, by appointment. Clients include local community, students, tourists, upscale. 1% of sales are to corporate collectors. Overall price range: $1-10,000. Most work sold at $3,000.

MEDIA Considers all media (except craft).

STYLE Exhibits conceptualism, geometric abstraction, neo-expressionism, postmodernism, and painterly abstraction.

TERMS Artwork is accepted on consignment and there is a 50% commission. Retail price of the art set by the artist; reviewed by the gallery. Gallery provides insurance, promotion, contract. Accepted work should be framed, mounted.

SUBMISSIONS E-mail with link to artist's website, JPEG samples at 72 dpi. Must include artist statement and CV. Materials returned with SASE. Responds only if interested (within weeks). Finds artists through word of mouth, submissions, portfolio reviews, art exhibits, art fairs, referrals by other artists.

FALKIRK CULTURAL CENTER

1408 Mission Ave. at E St., San Rafael CA 94901. (415)485-3328. **E-mail:** Beth. Goldberg@cityofsanrafael.org. **Website:** www.falkirkculturalcenter.org. **Contact:** Beth Goldberg, curator. Estab. 1974. Nonprofit gallery. Approached by 500 artists/year. Exhibits 350 emerging, mid-career and established artists. Sponsors 8 exhibits/year. Average display time 2 months. Open Tuesday-Friday, 1-5; Saturday, 10-1; by appointment. Three galleries located on second floor with lots of natural light (UV filtered). National historic place (1888 Victorian) converted to multi-use cultural center. Clients include local community, students, tourists and upscale.

MEDIA Considers all media and all types of prints. Most frequently exhibits painting, sculpture, and works on paper.

SUBMISSIONS Marin County and San Francisco Bay Area artists only. Send artist's statement, bio, résumé, and slides. Returns material with SASE. Responds within 3 months.

FARMINGTON VALLEY ARTS CENTER'S FISHER GALLERY

25 Arts Center Lane, Avon CT 06001. (860)678-1867. **Fax:** (860)674-1877. **E-mail:** info@artsfvac.org. **Website:** www.artsfvac.org. **Contact:** Sandy Buerkler. Estab. 1974. Nonprofit gallery. Exhibits the work of 100 emerging, mid-career, and established artists. Open all year; Wednesday-Saturday, 12-4; or by appointment. Located in Avon Park North just off Route 44; 850 sq. ft.; "in a beautiful 19th-century brownstone factory building once used for manufacturing." Clientele: upscale contemporary art craft buyers. Overall price range: $35-500; most work sold at $50-100.

MEDIA Considers "primarily crafts," also some mixed media, works on paper, ceramic, fiber, glass and small prints. Most frequently exhibits jewelry, ceramics and fiber.

STYLE Exhibits contemporary, handmade craft.

TERMS Accepts artwork on consignment (50% commission). Retail price set by the artist. Gallery provides promotion and contract; shipping costs are shared. Requires artwork framed where applicable.

SUBMISSIONS Send query letter with résumé, bio, digital images, SASE. Responds only if interested.

FAR WEST GALLERY

2817 Montana Ave., Billings MT 59101. (800)793-7296. **E-mail:** farwest@180com.net. **Website:** www.farwestgallery.com. **Contact:** Sondra Daly, manager. Estab. 1994. Retail gallery. Represents emerging,

mid-career and established artists. Exhibited artists include Joe Beeler, Dave Powell, Kevin Red Star, and Stan Natchez. Sponsors 4 shows/year. Average display time: 6-12 months. Open all year, Monday-Saturday, 9-6. Located in downtown historic district in a building built in 1910. Clientele: tourists. Overall price range: $1-9,500; most work sold at $300-700.

MEDIA Considers all media and all types of prints. Most frequently exhibits Native American beadwork, oil, and craft/handbuilt furniture.

STYLE Exhibits all styles. Genres include Western and Americana. Prefers Native American beadwork, Western bits, spurs, memorabilia, oil, watercolor, and pen & ink.

TERMS Buys outright for 50% of retail price. Retail price set by the gallery and the artist. Gallery provides insurance and promotion.

FAYETTE ART MUSEUM

530 Temple Ave., Fayette AL 35555. (205)932-8727. **E-mail:** fayetteartmuseum@yahoo.com. **Website:** fayetteartmuseum.vpweb.com. Estab. 1969. Exhibits the work of emerging, mid-career, and established artists. Located in downtown Fayette Civic Center; 16,500 sq. ft. "Over 4,000 pieces in the permanent art collection with over 500 running feet of display space on the main floor of the Civic Center and 6 folk art galleries downstairs, as well as a gallery used for the director/curators office. Artists include internationally known and Fayette native Jimmy Lee Sudduth; Rev. Benjamin F. Perkins; Mr. Fred Webster of Berry; Sybil Gibson of Jasper; Jessi LaVon of central Alabama; Wanda Teel of north Alabama; Lois Wilson of Fayette; Moses T and Doug Odom of south Alabama; and Margarette Scruggs of Walker County." Open all year; Monday–Friday, 9-12 and 1-4; and by appointment for group tours.

MEDIA Considers all media and all types of prints. Most frequently exhibits oil, watercolor, and mixed media.

STYLE Exhibits expressionism, primitivism, painterly abstraction, minimalism, postmodern works, impressionism, realism, and hard-edge geometric abstraction. Genres include landscapes, florals, Americana, wildlife, portraits, and figurative work.

TERMS Shipping costs negotiable. Prefers artwork framed.

SUBMISSIONS Send query letter with résumé, brochure, and photographs. Write for appointment to show portfolio of photographs. Files possible exhibit material.

TIPS "Do not send expensive mailings (slides, etc.) before calling to find out if we are interested. We want to expand collection. Top priority is folk art from established artists."

FINE ARTS CENTER GALLERY

P.O. Box 1920, Jonesboro AR 72467. (870)972-3050. **Fax:** (870)972-3932. **Website:** www.astate.edu/college/fine-arts/art. Estab. 1968. Represents/exhibits 3-4 emerging, mid-career and established artists/year. Sponsors 3-4 shows/year. Average display time: 1 month. Open fall, winter and spring, Monday-Friday 10-5. Located on Arkansas State University campus; 1,868 sq. ft.; 60% of time devoted to special exhibitions, 40% to student work. Clientele include students and community.

MEDIA Considers all media and prints. Most frequently exhibits painting, sculpture and photography.

STYLE Exhibits conceptualism, photorealism, neo-expressionism, minimalism, hard-edge geometric abstraction, painterly abstraction, postmodern works, realism, impressionism, and pop. "No preference except quality and creativity."

TERMS Exhibition space only, artist responsible for sales. Retail price set by the artist. Gallery provides promotion and contract; shipping costs are shared. Prefers artwork framed.

SUBMISSIONS Send query letter with résumé, CD/DVD, and SASE to: FAC Gallery Director, c/o Department of Art, Arkansas State University, P.O. Box 1920, State University AR 72467. Portfolio should be submitted on CD/DVD only. Responds only if interested within 2 months. Files résumé. Finds artists through call for artists published in regional and national art journals.

TIPS Show us 20 digital images of your best work. Don't overload us with lots of collateral materials (reprints of reviews, articles, etc.). Make your vita as clear as possible.

FLEISHER/OLLMAN GALLERY

1216 Arch St., 5A, Philadelphia PA 19107. (215)545-7562. **Fax:** (215)545-6140. **E-mail:** info@fleisher-ollmangallery.com. **Website:** www.fleisher-ollmangallery.com. **Contact:** John Ollman, owner. Estab. 1952. Retail gallery. "In addition to our modern and contemporary interests (among them Joseph Cornell, H.C. Westermann, Ed Ruscha, and

Alfred Jensen), the gallery continues to showcase the most significant American vernacular artists of the 20th-century, including the exclusive representation of Felipe Jesus Consalvos and the Philadelphia Wireman." Represents 12 emerging and established artists. Exhibited artists include James Castle and Bill Traylor. Sponsors 10 shows/year. Average display time: 5 weeks. Open Tuesday–Friday, 10:30-5:30; Saturday, 12-5; closed Saturdays, June–July; August, generally open during regular hours, but call first. Located downtown; 4,500 sq. ft. 75% of space for special exhibitions. Clientele primarily art collectors. 90% private collectors, 10% corporate collectors. Overall price range: $2,500-100,000; most work sold at $2,500-30,000.

MEDIA Considers oil, acrylic, watercolor, pastel, pen & ink, drawing, mixed media, and collage. Most frequently exhibits drawing, painting and sculpture.

STYLE Exhibits self-taught and contemporary works.

TERMS Accepts artwork on consignment (commission) or buys outright. Retail price set by the gallery. Gallery provides insurance and promotion; shipping costs are shared. Prefers artwork framed.

SUBMISSIONS Artists wishing to submit portfolios for review should include a CD with images, a bio or CV, and SASE if you would like your materials returned. "Due to the volume of e-mail we receive, we cannot respond to all unsolicited electronic submissions."

TIPS "Be familiar with our exhibitions and the artists we exhibit."

FLORIDA STATE UNIVERSITY MUSEUM OF FINE ARTS

530 W. Call St., Room 250, Fine Arts Bldg., Tallahassee FL 32306-1140. (850)644-6836. **Fax:** (850)644-7229. **E-mail:** mofa@fsu.edu. **Website:** www.mofa.fsu.edu. Estab. 1970. Shows work by over 100 artists/year; emerging, mid-career and established. Sponsors 12-22 shows/year. Average display time 3-4 weeks. Located on the university campus; 16,000 sq. ft. 50% for special exhibitions.

MEDIA Considers all media, including electronic imaging and performance art. Most frequently exhibits painting, sculpture, and photography.

STYLE Exhibits all styles. Prefers contemporary figurative and nonobjective painting, sculpture, printmaking, photography.

TERMS "Interested collectors are placed into direct contact with the artists; the museum takes no commission." Retail price set by the artist. Museum provides promotion and shipping costs to and from the museum for invited artists.

TIPS "The museum offers a yearly international competition and catalog: The Tallahassee International. Visit website for more information."

THE FLYING PIG, LLC

N6975 State Hwy. 42, Algoma WI 54201. (920)487-9902. **Fax:** (920)487-9904. **E-mail:** info@theflyingpig.biz. **Website:** www.theflyingpig.biz. **Contact:** Susan Connor, owner/member. Estab. 2002. For-profit gallery. Located along Lake Michigan in Kewaunee County. Exhibits approximately 150 regional, national and international artists. Open daily, 10-5 (May-October); Friday-Sunday, 10-5 (November-January). Clients include local community, tourists and upscale. Overall price range: $5-2,000; most work sold at $300.

MEDIA Considers all media.

STYLE Exhibits impressionism, minimalism, painterly abstraction, and primitivism realism. Most frequently exhibits primitivism realism, impressionism, and minimalism. Genres include outsider and visionary.

TERMS Artwork is accepted on consignment (50% commission) or bought outright for 50% of retail price, net 15 days. Retail price set by the artist. Gallery provides insurance, promotion and contract. Accepted work should be framed. Does require exclusive representation locally.

SUBMISSIONS Send query letter with artist's statement, bio and photographs. Returns material with SASE. Responds to queries in 3 weeks. Files artist's statement, bio and photographs if interested. Finds artist's through art fairs and exhibitions, referrals by other artists, submissions, word of mouth, and online.

FOCAL POINT GALLERY

321 City Island Ave., City Island NY 10464. (718)885-1403. **E-mail:** ronterner@gmail.com. **Website:** www.focalpointgallery.net. **Contact:** Ron Terner, photographer/director. Estab. 1974. Retail gallery and alternative space. Interested in emerging and mid-career artists. Sponsors 12 group shows/year. Average display time: 3-4 weeks. Clients include locals and tourists. Overall price range: $175-750; most work sold at $300-500.

MEDIA Considers all media. Most frequently exhibits photography, watercolor, oil. Also considers etchings, giclée, color prints, silver prints.

STYLE Exhibits all styles. Most frequently exhibits painterly abstraction, conceptualism, expressionism. Genres include figurative work, florals, landscapes, portraits. Open to any use of photography.

TERMS Accepts work on consignment. Exclusive area representation required. Customer discounts and payment by installment are available. Gallery provides promotion. Artwork must be framed. There is a $20 hanging fee for each piece. Takes 30% commission.

TIPS "Care about your work."

TORY FOLLIARD GALLERY

233 N. Milwaukee St., Milwaukee WI 53202. (414)273-7311. **Fax:** (414)273-7313. **E-mail:** info@toryfolliard.com. **E-mail:** info@toryfolliard.com. **Website:** www.toryfolliard.com. Jeff Townsend, Tory Folliard. **Contact:** Kim Storage. Estab. 1988. Retail gallery. Represents emerging and established artists. Exhibited artists include Tom Uttech, Fred Stonehouse, TL Solien, Eric Aho, and John Wilde. Sponsors 8-9 shows/year. Average display time: 4-5 weeks. Open all year; Tuesday-Friday, 11-5; Saturday, 11-4. Located downtown in historic Third Ward; 4,000 sq. ft.

STYLE Exhibits expressionism, abstraction, realism and surrealism.

GANNON & ELSA FORDE GALLERIES

1500 Edwards Ave., Bismarck ND 58501. (701)224-5520. **Fax:** (701)224-5400. **E-mail:** michelle_lindblom@bsc.nodak.com. **Website:** www.bismarckstate.com. **Contact:** Michelle Lindblom, gallery director. College gallery. Represents emerging, mid-career, and established art exhibitions. Sponsors 6 shows/year. Average display time: 6 weeks. Open all year; Monday-Thursday, 7-9; Friday, 7:30-4; Sunday, 3-7. Summer exhibit is college student work (May-August). Located on Bismarck State College campus; high traffic areas on campus. Clientele all. 80% private collectors, 20% corporate collectors. Overall price range: $50-10,000; most work sold at $50-3,000.

MEDIA Considers oil, acrylic, watercolor, pastel, drawing, mixed media, collage, paper, sculpture, ceramics, fiber, photography, woodcut, engraving, lithograph, wood engraving, mezzotint, serigraphs, linocut, and etching. Most frequently exhibits painting media (all), mixed media, and sculpture.

STYLE Exhibits expressionism, neo-expressionism, painterly abstraction, surrealism, impressionism, photorealism, hard-edge geometric abstraction and realism, all genres.

TERMS Accepts work on consignment (20% commission). Retail price set by the artist. Gallery provides insurance on premises, promotion, contract, and shipping costs from gallery; artist pays shipping costs to gallery. Prefers artwork framed.

SUBMISSIONS Send query letter with résumé, slides, bio and SASE. Call or write for appointment to show portfolio of photographs and slides. Responds in 2 months. Files résumé, bio, photos if sent. Finds artists through word of mouth, art publications, artists' submissions, visiting exhibitions.

TIPS "Because our gallery is a university gallery, the main focus is to expose the public to art of all genres. However, we do sell work, occasionally."

FOSTER/WHITE GALLERY

220 Third Ave. S., Seattle WA 98104. (206)622-2833. **Fax:** (206)622-7606. **E-mail:** seattle@fosterwhite.com; artistsubmissions.fosterwhite@gmail.com. **Website:** www.fosterwhite.com. **Contact:** Phen Huang, owner/director. Retail gallery. Estab. 1973. Represents 45 emerging, mid-career, and established artists. Interested in seeing the work of local emerging artists. Exhibited artists include Alden Mason, Bobbie Burgers, Will Robinson, Guy Laramee, and the Northwest Masters. Average display time: 1 month. Open all year; Tuesday-Saturday, 10-6; closed Sunday. Located in historic Pioneer Square; 7,500 sq. ft. Clientele private, corporate and public collectors. Overall price range: $300-35,000; most work sold at $2,000-8,000.

MEDIA Considers oil, acrylic, watercolor, pastel, pen & ink, drawing, mixed media, collage, paper, sculpture, ceramics, craft, fiber, glass, and installation.

TERMS Gallery provides insurance, promotion, and contract.

SUBMISSIONS E-mail submissions are prefered. Guidelines available online. Responds in 1-2 month.

⌂ FOUNDRY GALLERY

2118 8th St., NW, Washington DC 20001. (202)232-0203. **E-mail:** info@foundrygallery.org. **Website:** www.foundrygallery.org. president@foundrygallery.org. **Contact:** Fran Abrams, President. Estab. 1971. Cooperative gallery and alternative space. "Founded

to encourage and promote Washington area artists and to foster friendship with artists and arts groups within the Washington area. Foundry Gallery is known in the Washington area for its promotion of contemporary works of art." Interested in established and emerging artists. Sponsors 12 solo and 12 group shows by members (solo shows occur approximately every 1½ to 2 years. Average display time: 1 month. Open Wednesday-Sunday, 1-7. Clientele: 80% private collectors; 20% corporate clients. Overall price range: $200-2,500; most work sold at $200-1,400.

MEDIA Considers oil, acrylic, watercolor, pastel, pen & ink, drawings, mixed media, collage, paper, sculpture, ceramic, fiber, glass, installation, photography, woodcuts, engravings, mezzotints, etchings, pochoir, and serigraphs. Most frequently exhibits painting, sculpture, paper, and photography.

STYLE Exhibits "serious artists in all mediums and styles." Prefers nonobjective expressionism, abstract, and figurative.

TERMS Co-op membership fee plus initiation fee at time required; 30% commission. Retail price set by artist. Offers customer discounts. Exclusive area representation not required. Gallery provides promotion, contract, and website presence. Gallery does not provide insurance.

SUBMISSIONS See website for membership application. Send query e-mail with 5 or more large JPEG attachments to membership@foundrygallery.org or a letter with JPEGs on a CD. Portfolios reviewed at monthly meeting and succeed upon 2/3 vote of members. Finds artists through submissions. Members are primarily local artists who pool their resources to support the gallery. A few exhibition opportunities are available for artists residing outside the Washington area and Foundry keeps a list of interested "guest artists."

TIPS "Have a coherent body of work, professionally presented. Show your very best, strongest work. Looking for fresh, accomplished, distinctive work. Visit gallery to ascertain whether the work fits in."

FREEPORT ART MUSEUM

121 N. Harlem Ave., Freeport IL 61032. (815)235-9755. **Fax:** (815)235-6015. **E-mail:** info@freeportartmuseum.org. **Website:** www.freeportartmuseum.org. **Contact:** Jessica J. Modica, director. Estab. 1975. Interested in emerging, mid-career, and established artists. Sponsors primarily group shows. Clientele:

30% tourists, 60% local, 10% students. Average display time 8 weeks.

MEDIA Considers all media and prints.

STYLE Exhibits all styles and genres.

TERMS Gallery provides insurance while on display and promotional postcards and e-mails; artist pays shipping costs. Artwork must be ready to hang; frames are strongly encouraged. Visit FAM's website for directions on sending exhibition proposal materials.

GALERIE BONHEUR

2534 Seagrass Dr., Palm City FL 34990. (314)409-6057. **E-mail:** gbonheur@aol.com, galeriebonheur@gmail.com. **Website:** www.galeriebonheur.com. **Contact:** Laurie Ahner, Yoko Kiyoi. Estab. 1980. **Owner:** Laurie Carmody Ahner. Private retail and wholesale gallery. Focus is on international folk art. Estab. 1980. Represents 60 emerging, mid-career and established artists/year. Exhibited artists include Milton Bond and Justin McCarthy. Sponsors 6 shows/year. Average display time: 1 year. Open all year; by appointment. Located in Clayton, Misouri (a suburb of St. Louis); 75% of sales to private collectors. Overall price range: $25-25,000; most work sold at $50-1,000.

MEDIA Considers oil, acrylic, watercolor, pastel, pen & ink, drawing, mixed media, collage, paper, sculpture, ceramics, and craft. Most frequently exhibits oil, acrylic, and metal sculpture.

STYLE Exhibits expressionism, primitivism, impressionism, folk art, self-taught, outsider art. Genres include landscapes, florals, Americana, and figurative work. Prefers genre scenes and figurative.

TERMS Accepts work on consignment (50% commission). Retail price set by the gallery and the artist. Gallery provides promotion; artist pays shipping costs to and from gallery. Prefers artwork framed.

SUBMISSIONS Prefers only self-taught artists. Send query letter with bio, photographs and business card. Write for appointment to show portfolio of photographs. Responds within 6 weeks, only if interested. Finds artists through agents, visiting exhibitions, word of mouth, art publications, sourcebooks, and submissions.

TIPS "Be true to your inspirations. Create from the heart and soul. Don't be influenced by what others are doing; do art that you believe in and love and are proud to say is an expression of yourself. Don't copy;

don't get too sophisticated or you will lose your individuality!"

THE GALLERIES AT CLEVELAND STATE UNIVERSITY

1307 Euclid Ave., Cleveland OH 44115-2214. (216)687-2103. **Fax:** (216)687-9394. **E-mail:** t.knapp@csuohio.edu. **Website:** www.csuohio.edu/artgallery/. **Contact:** Tim Knapp, assistant director. Exhibits 50 emerging, mid-career, and established artists. Exhibited artists include Joel Peter Witkin and Buzz Spector. Sponsors 6 shows/year. Average display time: 6 weeks. Open Tuesday, Wednesday, and Thursday, 12-5; Friday, 12-7; Saturday, 12-7. Other times by appointment only. Call for summer hours. Located downtown 4,500 sq. ft. (250 running ft. of wall space). 100% of space for special exhibitions. Clientele: students, faculty, general public. 85% private collectors, 15% corporate collectors. Overall price range: $250-50,000; most work sold at $300-1,000.

MEDIA Considers all media.

STYLE Exhibits all styles and genres. Prefers contemporary. Looks for challenging work.

TERMS 25% commission. Sales are not a priority. Gallery provides insurance, promotion, shipping costs to and from gallery; artists handle crating. Prefers artwork framed.

SUBMISSIONS By invitation. Unsolicited inquiries may not be reviewed.

TIPS "Submissions recommended by galleries or institutions are preferred."

GALLERY 72

1806 Vinton St., Omaha NE 68108. (402) 496-4797. **E-mail:** info@gallery72.com. **Website:** www.gallery72.com. **Contact:** John A. Rogers, owner. Estab. 1972. Represents or exhibits 20 artists. Sponsors 4 solo and 6 group shows/year. Average display time: 4-5 weeks. Gallery open Wednesday-Saturday, 10:00 am to 6:00 pm; by appointment and for special events. 1,800 sq. ft. of gallery space, 160 ft. of wall space.

MEDIA Considers oil, acrylic, digital, watercolor, pastel, pen & ink, drawings, mixed media, collage, sculpture, ceramic, installation, photography, original prints, and posters. Most frequently exhibits paintings, prints, and sculpture.

STYLE Exhibits hard-edge geometric abstraction, color field, minimalism, impressionism, and realism. Genres include landscapes and figurative work. Most frequently exhibits color field/geometric, impressionism, and realism.

TERMS Artwork is accepted on consignment (50% commission). Gallery provides insurance, promotion. Requires exclusive representation locally.

SUBMISSIONS Call, e-mail or write to arrange personal interview to show portfolio. Send query letter with artist's statement, brochure, photocopies, résumé. Accepts digital images. Finds artists through word of mouth, submissions, art exhibits.

GALLERY 110 COLLECTIVE

110 Third Ave. S., Seattle WA 98104. (206)624-9336. **E-mail:** director@gallery110.com. **Website:** www.gallery110.com. **Contact:** Paula Maratea Fuld, director. Estab. 2002. "Gallery 110 presents contemporary art in a wide variety of media in Seattle's premiere gallery district, historic Pioneer Square. Our artists are emerging and established professionals, actively engaged in their artistic careers. We aspire to present fresh exhibitions of the highest professional caliber. The exhibitions change monthly and consist of solo, group and/or thematic shows." Open Wednesday-Saturday, 12-5; hosts receptions every first Thursday of the month, 6-8. Overall price range: $125-3,000; most work sold at $500-800.

SUBMISSIONS "Please follow directions on our website if you are interested in becoming an artist member. New members considered on a space available basis. Some membership duties apply."

TIPS "We want to know that the artist has researched us. We want to see original and creative works that shows the artist is aware of both contemporary art and art history. We seek artists who intend to actively contribute and participate as a gallery member."

GALLERY 218

207 E. Buffalo St., Suite 218, Milwaukee WI 53202. (414)643-1732. **E-mail:** director@gallery218.com. **Website:** www.gallery218.com. **Contact:** Judith Hooks, president/director. Estab. 1990. Nonprofit gallery, cooperative gallery, alternative space. "Gallery 218 is committed to providing exhibition opportunities to area artists. 218 sponsors exhibits, poetry readings, performances, recitals, and other cultural events. 'The audience is the juror.'" Represents emerging, mid-career and established artists/year. Exhibited artists include Judith Hooks, Bernie Newman, Jared Plock, Daniel Fleming, Kathryn Kmet, Jean Marc Richel. Sponsors 12 shows a year. Average display time 1 month. Open all year; Thursday-Friday,

12-5; Saturday. Located just south of downtown; 1,500 sq. ft.; warehouse-type space, wooden floor, halogen lights; includes information area. 100% of space for gallery artists. 75% private collectors, 25% corporate collectors. Overall price range $200-5,000; most work sold at $200-600.

Gallery 218 has a "brick-and-mortar" gallery as well as a great website, which provides lots of links to helpful art resources.

MEDIA Considers all media except crafts. Considers linocuts, monotypes, woodcuts, mezzotints, etchings, lithographs, and serigraphs. Most frequently exhibits paintings/acrylic, photography, mixed media.

STYLE Exhibits expressionism, conceptualism, photorealism, neo-expressionism, minimalism, hard-edge geometric abstraction, painterly abstraction, postmodern works, realism, and surrealism. Prefers abrtract expressionism, fine art photography, personal visions.

TERMS There is a yearly co-op membership fee plus a monthly fee, and donation of time (25% commission.) Membership good for 1 year. There is a rental fee for space; covers 1 month. Group shows at least 8 times a year (small entry fee). Retail price set by the artist. Gallery provides promotion; artist pays for shipping. Prefers artwork framed.

SUBMISSIONS Prefers only adults (21 years plus), no students (grad students OK), serious artists pursuing their careers. E-mail query letter with résumé, business card, slides, photographs, bio, SASE, or request for application with SASE. E-mail for appointment to show portfolio of photographs, slides, résumé, bio. Responds in 1 month. Files all. Finds artists through referrals, visiting art fairs, submissions. "We advertise for new members on a regular basis."

TIPS "Don't wait to be 'discovered.' Get your work out there not just once, but over and over again. Don't get distracted by material things, like houses, cars, and real jobs. Be prepared to accept suggestions and/or criticism. Read entry forms carefully."

GALLERY 400 AT UIC

University of Illinois, Chicago, 400 S. Peoria St. (MC 034), Chicago IL 60607. (312)996-6114. **Fax:** (312)355-3444. **E-mail:** gallery400@uic.edu. **Website:** gallery400.uic.edu. **Contact:** Lorelei Stewart, director. Estab. 1983. Nonprofit gallery. Approached by 500 artists/year; exhibits 55 artists. Sponsors 6 exhibits/year. Average display time: 6 weeks. Open Tuesday–Friday, 10-6; Saturday, 12-6. Clients include local community, students, tourists and upscale.

MEDIA Considers drawing, installation, painting, photography, design, architecture, mixed media, and sculpture.

STYLE Exhibits conceptualism, minimalism, and postmodernism. Most frequently exhibits contemporary conceptually based artwork.

TERMS Gallery provides insurance and promotion.

SUBMISSIONS Check info section of website for guidelines (gallery400.uic.edu/interact-page/propose-an-exhibition—2). Responds in 4 months. Finds artists through word of mouth, art exhibits, referrals by other artists.

TIPS "Follow the proposal guidelines on the website. We do not respond to e-mail submissions that do not follow the guidelines."

GALLERY 825

Los Angeles Art Association, 825 N. La Cienega Blvd., Los Angeles CA 90069. (310)652-8272. **E-mail:** peter@laaa.org. **Website:** www.laaa.org. **Contact:** Peter Mays, executive director. Estab. 1925. Holds approximately 1 exhibition/month. Average display time 4-5 weeks. Fine art only. Exhibits all media.

MEDIA Considers all media and original handpulled prints. "Fine art only. No crafts." Most frequently exhibits mixed media, oil/acrylic and watercolor.

STYLE Exhibits all styles.

TERMS Retail price set by artist. Gallery provides promotion.

SUBMISSIONS Submit 2 pieces created during the last 3 years, 3 8×10 digital printouts of additional artwork, artist statement, membership application (available online) and nonrefundable $35 application fee. See website for more details. Membership screenings are held 3 times a year, at the beginning and middle of each calendar year. Dates will be posted 3 months prior to screening. If accepted there is a $250 annual member fee.

TIPS "Bring work produced in the last 3 years. No commercial work (e.g., portraits/advertisements)."

GALLERY 1988

Gallery 1988 (West), 7308 Melrose Ave., Los Angeles CA 90046. (323)937-7088. **E-mail:** gallery1988west@gmail.com; gallery1988east@gmail.com. **Website:** www.gallery1988.com. Estab. 2004. Exhibits emerging artists. Approached by 300 artists/year; represents

or exhibits 100 artists. Sponsors 15 exhibits/year. Average display time: 3 weeks. Open Wednesday-Sunday, 11-6; closed Monday, Tuesday, and national holidays. Located in the heart of Hollywood; 1,250 sq. ft. with 20-ft.-high walls. Clients include local community, students, upscale. Overall price range: $75-15,000; most work sold at $750.

○ Second location: Gallery 1988 (East) 7021 Melrose Ave., Los Angeles CA 90038.

MEDIA Considers acrylic, drawing, oil, paper, pen & ink. Most frequently exhibits acrylic, oil, pen & ink. Types of prints include limited edition giclées and limited edition screenprints.

STYLE Exhibits surrealism and illustrative work. Prefers character-based works.

TERMS Artwork is accepted on consignment. Retail price set by both the artist and gallery. Gallery provides insurance, promotion, contract. Accepted work should be framed.

SUBMISSIONS "If you are interested in submitting your work for review, please send an e-mail with 'submission' in the subject line. You can include a website link or several JPEGs of your work. Also include medium, dimensions and retail prices. If we feel your work would be a good fit for a future show at the gallery, we will contact you. Unfortunately, we cannot respond to all submissions due to the high volume we receive."

TIPS "Keep your e-mail professional and include prices. Stay away from trying to be funny, which you'd be surprised to know happens a *lot*. We are most interested in the art."

⌂ THE GALLERY AT PETERS VALLEY SCHOOL OF CRAFT

19 Kuhn Rd., Layton NJ 07851. (973)948-5202. **Fax:** (973)948-0011. **E-mail:** gallery@petersvalley.org. **Website:** www.petersvalley.org. **Contact:** Brienne Rosner, gallery manager. Estab. 1977. "National Delaware Water Gap Recreation Area in the Historic Village of Bevans, Peters Valley School of Craft hosts a large variety of workshops in the spring and summer. The Gallery is located in an old general store; first floor retail space and second floor rotating exhibition gallery."

TERMS E-mail query with link to website and JPEG samples.

GALLERY JOE

302 Arch St., Philadelphia PA 19106. (215)592-7752. **Fax:** (215)238-6923. **E-mail:** mail@galleryjoe.com. **Website:** galleryjoe.com. Retail and commercial exhibition gallery. Represents/exhibits 15-20 emerging, mid-career and established artists. Exhibited artists include Astrid Bowlby and Rob Matthews. Sponsors 6 shows/year. Average display time: 6 weeks. Open Wednesday–Saturday, 12-5:30; or by appointment. Located in Old City; 1,400 sq. ft. 100% of space for gallery artists. 80% private collectors, 20% corporate collectors. Overall price range: $1,000-25,000; most work sold at $2,000-10,000.

MEDIA Only exhibits sculpture and drawing.

STYLE Exhibits representational/abstract.

TERMS Artwork is accepted on consignment (50% commission). Retail price set by the gallery and the artist. Gallery provides insurance and promotion. Artist pays for shipping costs. Prefers artwork framed.

SUBMISSIONS Send query letter with résumé, slides, reviews and SASE. Responds within 6 months. Finds artists by visiting galleries and through referrals. Not currently reviewing portfolios.

GALLERY M

180 Cook St., Suite 101, Denver CO 80206. (303)331-8400. **Website:** www.gallerym.com. Estab. 1996. For-profit gallery. "Gallery M brings to Denver contemporary fine art, photography, sculpture, and new media that is the quality and diversity found in New York, Los Angeles, San Francisco, and Europe. Features the work of more than 30 national and international artists." Average display time: 6-12 weeks. Open Monday–Saturday, 10-6. Overall price range: $1,000-75,000.

MEDIA Considers acrylic, collage, drawing, glass, installation, mixed media, oil, paper, pastel, pen & ink, watercolor, engravings, etchings, linocuts, lithographs, mezzotints, serigraphs, woodcuts, photography, and sculpture.

STYLE Exhibits color field, expressionism, geometric abstraction, neo-expressionism, postmodernism, primitivism, realism, and surrealism. Considers all genres.

TERMS Retail price set by the gallery and the artist. Gallery provides insurance and promotion. Requires exclusive local and regional representation.

SUBMISSIONS "Artists interested in showing at the gallery should visit the Artist Submissions section of our website (under Site Resources). The gallery pro-

vides additional services for both collectors and artists, including our quarterly newsletter, *The Art Quarterly*."

⌂ GALLERY NAGA

67 Newbury St., Boston MA 02116. (617)267-9060. **Fax:** (617)267-9040. **E-mail:** mail@gallerynaga.com. **Website:** www.gallerynaga.com. Estab. 1977. Retail gallery. "Our primary focus is painting and we represent many of the most highly regarded painters working in Boston and New England. In addition, exceptional contemporary photographers, printmakers, and sculptors exhibit with us." Represents 30 emerging, mid-career, and established artists. Sponsors 9 shows/year. Average display time: 1 month. Open Tuesday–Saturday, 10-5 (September-June). Located in the neo-Gothic church building (Church of the Covenant) at the corner of Berkeley and Newbury Streets. Clientele: 90% private collectors, 10% corporate collectors. Overall price range: $500-60,000; most work sold at $2,000-10,000.

MEDIA Considers oil, acrylic, mixed media, photography, studio furniture. Most frequently exhibits painting and furniture.

STYLE Exhibits expressionism, painterly abstraction, postmodern works, and realism. Genres include landscapes, portraits, and figurative work. Prefers expressionism, painterly abstraction, and realism.

TERMS Accepts work on consignment (50% commission). Retail price set by gallery and artist. Gallery provides insurance and promotion; artist pays for shipping. Prefers artwork framed.

SUBMISSIONS "We review unsolicited material 3 times a year on a rolling schedule. We accept a maximum of 20 images (slide, hard copy, MAC-formatted JPEG), a bio and, if applicable, a SASE. If you would like to e-mail JPEGs of 3 images (include the works' sizes and materials), we'll quickly suggest whether or not we think a complete presentation is warranted."

TIPS "We focus on Boston and New England artists. We exhibit the most significant studio furniture makers in the country. Become familiar with any gallery to see if your work is appropriate before you make contact."

GALLERY NORTH

90 N. Country Rd., Setauket NY 11733. (631)751-2676. **E-mail:** info@gallerynorth.org. **Website:** www. gallerynorth.org. **Contact:** Judith Levy, director. Regional arts center. "Our mission is to present exhibitions of exceptional contemporary artists and artisans, especially those from Long Island and the nearby regions; to assist and encourage artists by bringing their work to the attention of the public; and to stimulate interest in the arts by presenting innovative educational programs. Exhibits the work of emerging, mid-career and established artists from Long Island and throughout the Northeast. The Gallery North community involves regional and local artists, collectors, art dealers, corporate sponsors, art consultants, businesses and schools, ranging from local elementary students to the faculty and staff at Long Island's many colleges and universities including our neighbor, Stony Brook University and the Stony Brook Medical Center. With our proximity to New York City and the East End, our region attracts a wealth of talent and interest in the arts." Located in the Historic District of Setauket LI, NY, in an 1840s farm house, 1 mile from the State University at Stony Brook. Open year-round; Tuesday–Saturday, 10-5; Sunday, 12-5; closed Monday.

STYLE "Works to be exhibited are selected by our director, Judith Levy, with input from our Artist Advisory Board. We encourage artist dialogue and participation in gallery events and community activities and many artists associated with our gallery offer ArTrips and ArTalks, as well as teaching in our education programs. Along with monthly exhibitions in our 1,000-sq.-ft. space, our Gallery Shop strives to present the finest handmade jewelry and craft by local and nationally recognized artisans."

SUBMISSIONS To present work to the gallery, send an e-mail with 2-5 medium-sized images, price list (indicating title, size, medium, and date), artist's statement, biography, and link to website. "We encourage artists to visit the gallery and interact with our exhibitions." Visit the website for more information.

GARVER GALLERY

18 South Bedford St #318, Madison WI 53703. (608)256-6755. **E-mail:** jack@garvergallery.com. **Website:** www.garvergallery.com. Estab. 1972. Retail gallery. "Whether your taste is traditional or contemporary, there's something for everyone. Every month we feature a show of new artwork. One month it might be an invitational art glass show, the next it may be a watercolor show." Represents 100 emerging, mid-career, and established artists/year. Exhibited artists include Lee Weiss,Gregg Kreutz, Harold Altman. Sponsors 11 shows/year. Average display time:

1 month. Open Monday–Saturday, 10-5; or by appointment. Located downtown; 200 sq. ft.; older refurbished building in unique downtown setting. 33% of space for special exhibitions; 95% of space for gallery artists. Clientele: private collectors, gift-givers, tourists. 40% private collectors, 10% corporate collectors. Overall price range: $100-10,000; most work sold at $100-1,000.

MEDIA Considers oil, pen & ink, paper, fiber, acrylic, drawing, sculpture, glass, watercolor, mixed media, ceramics, pastel, collage, craft, woodcuts, wood engravings, linocuts, engravings, mezzotints, etchings, lithographs, and serigraphs. Most frequently exhibits watercolor, oil.

STYLE Exhibits all styles. Prefers landscapes, still lifes, and abstraction.

TERMS Accepts work on consignment (50% commission) or buys outright for 50% of retail price (net 30 days). Retail price set by gallery. Gallery provides promotion and contract, artist pays shipping costs both ways. Prefers artwork framed.

SUBMISSIONS Send query letter with résumé, 8 photographs, bio, brochure, photographs, and SASE. Write for appointment to show portfolio, which should include originals, photographs, and slides. Responds within 1 month, only if interested. Files announcements and brochures.

TIPS "Don't take it personally if your work is not accepted in a gallery. Not all work is suitable for all venues. Send us an e-mail and we'll be happy to put you on our mailing list."

DAVID GARY LTD. FINE ART

po box 619, Millburn NJ 07041. (973)467-9240. **E-mail:** davidgaryfineart@gmail.com. **Website:** www.davidgaryfineart.com. Estab. 1971. Retail and wholesale gallery. Represents 17-20 mid-career and established artists. Exhibited artists include John Talbot and Theo Raucher. Sponsors 3 shows/year. Average display time: 3 weeks. Open all year. Located in the suburbs; 2,000 sq. ft.; high ceilings with sky lights. Clients include "upper income." 70% of sales are to private collectors, 30% corporate collectors. Overall price range: $250-25,000; most work sold at $1,000-15,000.

MEDIA Considers oil, acrylic, watercolor, drawings, sculpture, pastel, woodcuts, engravings, lithographs, wood engravings, mezzotints, linocuts, etchings, and serigraphs. Most frequently exhibits oil, original graphics, and sculpture.

STYLE Exhibits primitivism, painterly abstraction, surrealism, impressionism, realism, and collage. All genres. Prefers impressionism, painterly abstraction, and realism.

TERMS Accepts artwork on consignment (50% commission). Retail price set by gallery and artist. Gallery services vary; artist pays for shipping. Prefers artwork unframed.

SUBMISSIONS Send query letter with résumé, photographs and reviews. Call for appointment to show portfolio of originals, photographs, and transparencies. Responds in 2 weeks. Files "what is interesting to gallery."

TIPS "Have a basic knowledge of how a gallery works, and understand that the gallery is a business."

SANDRA GERING, INC.

14 E. 64th St., New York NY 10065. (646)336-7183. **E-mail:** info@sandrageringinc.com. **Website:** www.geringlopez.com. **Contact:** Laura Bloom, director. Estab. 1991. For-profit gallery. Exhibits emerging, mid-career, and established artists. Gallery open Tuesday–Friday, 10-6; Saturday, 11-5. Located in the historic Crown Building.

MEDIA Considers mixed media, oil, sculpture, and digital. Most frequently exhibits computer-based work, electric (light) sculpture and video/DVD.

STYLE Exhibits geometric abstraction. Most frequently exhibits cutting edge.

TERMS Artwork is accepted on consignment.

SUBMISSIONS Send e-mail query with link to website and JPEGs. Cannot return material. Responds within 6 months, only if interested. Finds artists through word of mouth, art fairs/exhibits, and referrals by other artists.

GIACOBBE-FRITZ FINE ART

702 Canyon Rd., Santa Fe NM 87501. (505)986-1156. **Fax:** (505)986-1158. **E-mail:** deborah@giacobbefritz.com. **Website:** www.giacobbefritz.com. **Contact:** Deborah Fritz, art consultant. Estab. 2000. For-profit gallery. Approached by 300+ artists/year. Represents 16 emerging, mid-career and established artists. Exhibits paintings, sculpture and graphics by outstanding emerging and established artists. Sponsors 12-20 exhibits/year. Average display time: 2 weeks. Open all year; Monday-Sunday, 10-5. Located on historic Canyon Road, Santa Fe's famous street of galleries. Classic

1890 adobe with 5 exhibit rooms. Clients include local community, tourists, and upscale.

MEDIA Considers acrylic, collage, mixed media, oil, pastel, sculpture, watercolor, and etchings. Prints include etchings and mezzotints. Most frequently exhibits oil, sculpture, and acrylic.

STYLE Exhibits impressionism, abstract, and realism. Considers all styles including expressionism, impressionism, surrealism, and patinerly abstraction. Genres include figurative work, landscapes, and figures.

TERMS Artwork is accepted on consignment and there is a 50% commission. Retail price set by the gallery. Gallery provides insurance, promotion, and contract. Accepted work should be framed. Requires exclusive representation locally. No agents.

SUBMISSIONS Call, write, or e-mail to arrange a personal interview to show portfolio of photographs, transparencies, and slides. Prefers to receive e-mailed portfolios. Send query letter with artist's statement, bio, photocopies, photographs, SASE, slides, and CD. Returns material with SASE only. Responds to queries in 2 weeks. Finds artists through art fairs, art exhibits, portfolio reviews, referrals by other artists, submissions, word of mouth.

TIPS "Enclose SASE, brief query letter, and a few samples of your best work."

GLOUCESTER ARTS ON MAIN

6580-B Main St., Gloucester VA 23061. (804)824-9464. **Fax:** (804)824-9469. **E-mail:** curator@gloucesterarts.org. **Website:** www.gloucesterarts.org. **Contact:** Kay Van Dyke, Founder. Estab. 2010. Nonprofit, rental gallery. Alternative space. Exhibits emerging, mid-career, and established artists. Approached by 15 artists/year; represents or exhibits 60 artists currently. Exhibited artists include Harriett McGee (repoussee and mixed media) and Victoria Watson (animal drawings). Sponsors 12 exhibits/year, 1-2 photography exhibits/year. There are always photos on exhibit. Average display is one month or length of rental contract. Open Tuesday-Saturday, 12-6; weekend events, 6-9. Located on walkable Main Street near restaurants and other shops, small town near major cities in Eastern Virginia. Very flexible gallery space with 120+ ft. of perimeter exhibition space and 96 ft. of movable walls. 4,000 sq. ft. total exhibition space. Clients include the local community, students, tourists, and upscale clients. 10% of sales are to corporate collectors. Price range: $20-7,500. Most work sold at $300.

MEDIA Considers all media. Most frequently exhibits paintings (oil, acrylic and watercolor), 2D and 3D metal work, and photography. Considers all types of prints except posters.

STYLE Considers all styles. Most frequently exhibits painterly abstraction, impressionism, and realism. Considers all genres.

TERMS Artwork is accepted on consignment and there is a 30% commission with a rental fee for wall or shelf space. Retail price set by the artist. Gallery provides promotion and contract. Accepted work should be framed, matted, and mounted. Prefers to represent artists from Eastern Virginia.

SUBMISSIONS E-mail query letter with link to artist's website, JPEG samples at 72 dpi, résumé, artist's statement, and bio; or call for appointment to show portfolio. Jury system responds within 2 weeks. Finds artists through word of mouth, art exhibits, submissions, portfolio reviews, and referrals by other artists.

TIPS Work should be presented for jury ready to exhibit, i.e., framed or mounted appropriately. Digital images presented for review should be clear, cropped, and professional in appearance at high resolution.

GOLD/SMITH GALLERY

8 McKown St., Boothbay Harbor ME 04538. (207)633-6252. **E-mail:** goldsmithgallerybbh@gmail.com. **Website:** goldsmithgallery.net. Estab. 1974. Retail gallery. Represents 30 emerging, mid-career, and established artists. Exhibited artists include John Vander and John Wissemann. Sponsors 6 shows/year. Average display time: 6 weeks. Open May-October; Monday-Saturday, 10-5. Located downtown across from the harbor. 1,500 sq. ft.; traditional 19th century house converted to contemporary gallery. 75% of space for special exhibitions; 25% of space for gallery artists. Clientele: residents and visitors. 90% private collectors, 10% corporate collectors. Overall price range: $350-5,000; most work sold at $1,000-2,500.

○ One of 2 Gold/Smith Galleries. The other is in Sugar Loaf; the 2 are not affiliated with each other. Artists creating traditional and representational work should try another gallery. The work shown here is strong, self-assured and abstract.

MEDIA Considers oil, acrylic, watercolor, pastel, pen & ink, drawing, mixed media, collage, paper, sculpture, photography, woodcuts, engravings, wood engravings, and etchings. Most frequently exhibits

acrylic and watercolor.

STYLE Exhibits expressionism, painterly abstraction, "emphasis on nontraditional work." Prefers expressionist and abstract landscape.

TERMS Commission 50%. Retail price set by the artist. Gallery provides insurance and promotion; artist pays shipping costs to and from gallery. Prefers artwork framed.

SUBMISSIONS No restrictions—emphasis on artists from Maine. Send query letter with slides, bio, photographs, SASE, reviews, and retail price. Write for appointment to show portfolio of originals. Responds in 2 weeks. Artist should write the gallery.

TIPS "Present a consistent body of mature work. We need 12 to 20 works of moderate size. The sureness of the hand and the maturity interest of the vision are most important."

GRAND RAPIDS ART MUSEUM

101 Monroe Center St. NW, Grand Rapids MI 49503. (616)831-1000. **E-mail:** rplatt@artmuseumgr. org; info@artmuseumgr.org. **Website:** www. artmuseumgr.org. Estab. 1910. Exhibits established artists. Sponsors 3 exhibits/year. Average display time 4 months. Open all year; Tuesday-Thursday, 10-5; Friday, 10-9; Sunday, 12-5. Closed Mondays and major holidays. Located in the heart of downtown Grand Rapids, the Grand Rapids Art Museum presents exhibitions of national caliber and regional distinction. The museum collection spans Renaissance to modern art, with particular strength in 19th- and 20th-century paintings, prints and drawings. Clients include local community, students, tourists.

MEDIA Considers all media and all types of prints. Most frequently exhibits paintings, prints, and drawings.

STYLE Considers all styles and genres. Most frequently exhibits impressionist, modern and Renaissance.

THE GRAPHIC EYE GALLERY OF LONG ISLAND

402 Main St., Port Washington NY 11050. (516)883-9668. **Website:** www.graphiceyegallery.com. Estab. 1974. Represents 25 artists. Sponsors solo, 2-3 person and 4 group shows/year. Average display time: 1 month. Interested in emerging and established artists. Overall price range: $35-7,500; most artwork sold at $500-800. Open Thursday-Sunday, 12-5.

MEDIA Considers mixed media, collage, works on paper, pastels, photography, paint on paper, woodcuts, wood engravings, linocuts, engravings, mezzotints, etchings, lithographs, serigraphs, and monoprints.

STYLE Exhibits impressionism, expressionism, realism, primitivism, and painterly abstraction. Considers all genres.

TERMS Co-op membership fee plus donation of time. Retail price set by artist. Offers payment by installments. Exclusive area representation not required. Prefers framed artwork.

SUBMISSIONS Send query letter with résumé, SASE, slides and bio. Portfolio should include originals and slides. "When submitting a portfolio, the artist should have a body of work, not a 'little of this, little of that.' Finds artists through visiting exhibitions, word of mouth, artist's submissions, and self-promotions.

TIPS "Artists must produce their *own* work and be actively involved. We have a competitive juried art exhibit annually. Open to all artists who work on paper."

GREENHUT GALLERIES

146 Middle St., Portland ME 04101. (207)772-2693 or (888)772-2693. **E-mail:** info@greenhutgalleries.com. **Website:** www.greenhutgalleries.com. **Contact:** Peggy Greenhut Golden, owner. Estab. 1977. Retail gallery. Represents/exhibits 20 emerging and mid-career artists/year. Sponsors 12 shows/year. Exhibited artists include Connie Hayes (oil/canvas), Sarah Knock (oil/canvas). Average display time: 3 weeks. Open all year; Monday–Friday, 10-5:30; Saturday, 10-5. Located in downtown, Old Port; 3,000 sq. ft. with neon accents in interior space. 60% of space for special exhibitions. Clientele tourists and upscale. 55% private collectors, 10% corporate collectors. Overall price range: $500-12,000; most work sold at $600-3,000.

MEDIA Considers acrylic, paper, pastel, sculpture, drawing, oil, watercolor. Most frequently exhibits oil, watercolor, pastel.

STYLE Considers all styles; etchings, lithographs, mezzotints. Genres include figurative work, landscapes, still life, seascape. Prefers landscape, seascape, and abstract.

TERMS Artwork is accepted on consignment (50% commission). Retail price set by the gallery and artist. Gallery provides insurance and promotion. Artists pays for shipping costs. Prefers artwork framed (museum quality framing).

SUBMISSIONS Accepts only artists from Maine or New England area with Maine connection. Send query letter with slides, reviews, bio, and SASE. Call for appointment to show portfolio of slides. Responds in 1 month. Finds artists through word of mouth, referrals by other artists, visiting art shows and exhibitions, and submissions.

TIPS "Visit the gallery and see if you feel your work fits in."

CARRIE HADDAD GALLERY

622 Warren St., Hudson NY 12534. (518)828-1915. **E-mail:** carriehaddadgallery@verizon.net. **Website:** www.carriehaddadgallery.com. **Contact:** Carrie Haddad, owner; Linden Scheff, director. Estab. 1991. Art consultancy, for-profit gallery. Hailed as the premier gallery of the Hudson Valley, the Carrie Haddad Gallery presents 8 large exhibits/year and includes all types of painting, both large and small sculpture, works on paper and a variety of techniques in photography." Approached by 50 artists/year; represents or exhibits 60 artists. Open daily, 11-5; closed Wednesday.

MEDIA Considered: paintings, work on paper, no posters or reproductions.

STYLE Exhibits expressionism, impressionism, and postmodernism. Genres include figurative work, landscapes, and abstract.

TERMS Artwork is accepted on consignment and there is a 50% commission. Retail price set by the artist. Gallery provides insurance and promotion. Requires exclusive representation locally.

SUBMISSIONS The gallery is not looking to add new artists to the gallery, but artists may submit websites or CDs of their work by sending the information to the gallery.

JUDITH HALE GALLERY

1693 Copenhagen Dr., Solvang CA 93463. (805) 686-2322. **E-mail:** info@judithhalegallery.com. **Website:** www.judithhalegallery.com. **Contact:** Judith Hale, owner. Estab. 1987. Retail Art Gallery. Represents 70 mid-career and established artists. Exhibited artists include Dirk Foslien, Howard Carr, Kelly Donovan and Mehl Lawson. Sponsors 4 shows/year. Average display time: 6 months. Open daily 10-6. Located downtown; 2,100 sq. ft.; "the gallery is eclectic and inviting, an old building with 6 rooms." 20% of space for special exhibitions which are regularly rotated and rehung. Clientele: homeowners, tourists, decorators,

collectors. Overall price range: $500-15,000; most work sold at $500-5,000.

Representing nationally recognized artists, including Ted Goerschner, Dave DeMatteo, Dirk Foslien, Betty Carr, Grace Schlesier. Located within Solvang Antiques.

MEDIA Considers oil, acrylic, watercolor, pastel, sculpture, engravings, and etchings. Most frequently exhibits watercolor, oil, acrylic, and sculpture.

STYLE Exhibits impressionism and realism. Genres include landscapes, florals, western, and figurative work. Prefers figurative work, western, florals, landscapes, structure. No abstract or expressionistic.

TERMS Accepts work on consignment (50% commission). Retail price set by artist. Offers payment by installments. Gallery arranges reception and promotion; artist pays for shipping. Prefers artwork framed.

SUBMISSIONS "Call ahead, or email images or a link to your website. Send query letter with bio, brochure, photographs, business card, and reviews. Call for an appointment to show portfolio. Responds in 2 weeks.

TIPS "Create a nice portfolio. See if your work is comparable to what the gallery exhibits. Do not plan your visit when a show is on; make an appointment for a future time. Rotate artwork in a reasonable time, if unsold. Bring in your best work."

HALLWALLS CONTEMPORARY ARTS CENTER

341 Delaware Ave., Buffalo NY 14202. (716)854-1694. **Fax:** (716)854-1696. **E-mail:** john@hallwalls.org; carolyn@hallwalls.org. **Website:** www.hallwalls.org. **Contact:** John Massier, visual arts curator; Carolyn Tennant, media arts director. Estab. 1974. Nonprofit multimedia organization. "Our mission is to bring the newest and most challenging work in the contemporary arts to the interested public, whether in painting and sculpture, conceptual art, experimental film, video art and activism, documentary film, performance, fiction, jazz, new music, or any number of other art forms that make up our eclectic programming mix." Sponsors 10 exhibits/year. Average display time: 6 weeks. Open Tuesday–Friday, 11-6; Saturday, 11-2.

MEDIA Considers all media including film, video, sound, multimedia, and web-based work.

STYLE Exhibits all styles and genres. "Contemporary cutting-edge work which challenges traditional cultural and aesthetic boundaries."

TERMS Retail price set by artist. "Sales are not our focus. If a work does sell, we suggest a donation of 15% of the purchase price." Gallery provides insurance.

SUBMISSIONS Send material by mail for consideration. Work not returned within 3 months will be kept for up to a year for further review.

HAMPTON III GALLERY, LTD.

3110 Wade Hampton Blvd., Taylors SC 29687. (864)268-2771. **E-mail:** Sandy@HamptonIIIGallery.com. **Website:** www.hamptoniiigallery.com. **Contact:** Sandra Rupp, director. Estab. 1970. Approached by 20 artists/year; exhibits 25 mid-career and established artists/year. Exhibited artists include Carl Blair (oil paintings) and Darell Koons (acrylic paintings). Sponsors 8 exhibits/year. Artists are chosen by director and shows are produced for artists who are part of the gallery roster. Average display time: 4-6 weeks. Open all year: Tuesday–Friday, 1-5; Saturday 10-5. Located 3 miles outside of downtown Greenville SC; 1 large exhibition room in center with 7 exhibition rooms around center gallery. Clients include local community and upscale. 5% of sales are to corporate collectors. Overall price range: $200-15,000; most work sold at $2,500.

MEDIA Considers acrylic, ceramics, collage, drawing, mixed media, oil, paper, pastel, pen & ink, sculpture, and watercolor. Most frequently exhibits oil and watercolor. Also considers engravings, etchings, linocuts, lithographs, mezzotints, serigraphs, and woodcuts.

STYLE Exhibits color field, expressionism, geometric abstraction, imagism, impressionism, and painterly abstraction. Most frequently exhibits painterly abstraction and realism. Considers all genres.

TERMS Artwork is accepted on consignment (40% commission). Retail price of the art set by the artist. Gallery provides insurance, promotion, and contract. Accepted work should be framed. Requires exclusive representation locally.

SUBMISSIONS Send query letter with artist's statement, bio, reviews, SASE, and slides. Returns material with SASE. Responds to queries in 3 months. Finds artists through art exhibits, referrals by other artists, and word of mouth.

HAMPTON UNIVERSITY MUSEUM

Hampton University, 100 E. Queen St., Hampton VA 23668. (757)727-5308. **Fax:** (757)727-5170. **E-mail:** museum@hamptonu.edu. **Website:** museum.hamptonu.edu. **Contact:** Dr. Vanessa Thaxton-Ward, curator of collections. Estab. 1868. Exhibits established artists. Exhibited artists include Elizabeth Catlett and Jacob Lawrence. Exhibits 2-3 changing exhibitions/year. Average display time: 12-18 weeks. Open Monday–Friday, 8-5; Saturday, 12-4; closed on Sunday, major and campus holidays. Located on the campus of Hampton University. Presents a bi-annual exhibition, *New Power Generation: A National Juried Exhibition* featuring contemporary art by people of African descent.

MEDIA Considers all media and all types of prints. Most frequently exhibits oil or acrylic paintings, ceramics, and mixed media.

STYLE Permanent exhibits include African-American, African, and Native American art.

SUBMISSIONS For more information about New Power Generation, please forward your mailing address and e-mail to vanessa.thaxton-ward@hamptonu.edu.

HANA COAST GALLERY

5031 Hana Hwy., Hana HI 96713. (808)248-8636. **Fax:** (808)248-7332. **E-mail:** info@hanacoast.com. **Website:** www.hanacoast.com. Estab. 1990. Retail gallery and art consultancy. Represents 78 established artists. Sponsors 12 group shows/year. Average display time: 1 month. Open 7 days a week, 9-5. Open all year. Located in the Hotel Hana-Maui at Hana Ranch; 3,000 sq. ft.; "an elegant ocean-view setting in one of the top small luxury resorts in the world." 20% of space for special exhibitions. Clientele ranges from very upscale to highway traffic walk-ins. 85% private collectors, 15% corporate collectors. Overall price range: $150-50,000; most work sold at $1,000-6,500.

MEDIA Considers oil, acrylic, watercolor, pastel, mixed media, collage, works on paper, sculpture, ceramic, craft, fiber, glass, photography, original hand-pulled prints, engravings, lithographs, pochoir, wood engravings, mezzotints, serigraphs and etchings. Most frequently exhibits oil, watercolor, and original prints.

STYLE Exhibits expressionism, primitivism, impressionism and realism. Genres include landscapes, florals, portraits, figurative work, and Hawaiiana. Prefers landscapes, florals, and figurative work. "We also display decorative art and master-level craftwork, particularly turned-wood bowls, blown glass, fiber, bronze sculpture, and studio furniture.

TERMS Accepts artwork on consignment (60% commission). Retail price set by gallery and artist. Gallery provides insurance, promotion, and shipping costs from gallery. Framed artwork only.

SUBMISSIONS *Accepts only full-time Hawaii resident artists.* Send query letter with résumé, slides, bio, brochure, photographs, SASE, and reviews. Write for appointment to show portfolio after query and samples submitted. Portfolio should include originals, photographs, slides, and reviews. Responds only if interested within 1 week. If not accepted at time of submission, all materials will be returned.

TIPS "Know the quality and price level of artwork in our gallery and know that your own art would be companionable with what's being currently shown. Be able to substantiate the prices you ask for your work. We do not offer discounts, so the mutually agreed upon price/value must stand the test of the market."

JOEL AND LILA HARNETT MUSEUM OF ART AND PRINT STUDY CENTER

University of Richmond Museums, 28 Westhampton Way, Richmond VA 23173. (804)289-8276. **Fax:** (804)287-1894. **E-mail:** rwaller@richmond.edu; museums@richmond.edu. **Website:** museums.richmond.edu. **Contact:** Richard Waller, executive director. Estab. 1968. Represents emerging, mid-career, and established artists. Sponsors 6 exhibitions/year. Average display time 6 weeks. Open academic year; with limited summer hours May-August. Located on university campus; 5,000 sq. ft. 100% of space for special exhibitions.

MEDIA Considers all media and all types of prints. Most frequently exhibits painting, sculpture, prints, photography, and drawing.

STYLE Exhibits all styles and genres.

TERMS Work accepted on loan for duration of special exhibition. Retail price set by the artist. Museum provides insurance, promotion, contract, and shipping costs. Prefers artwork framed.

SUBMISSIONS Send query letter with résumé, 8-12 images on CD, brochure, SASE, reviews, and printed material if available. Write for appointment to show portfolio of "whatever is appropriate to understanding the artist's work." Responds in 1 month. Files résumé and other materials the artist does not want returned (printed material, CD, reviews, etc.).

WILLIAM HAVU GALLERY

1040 Cherokee St., Denver CO 80204. (303)893-2360. **Fax:** (303)893-2813. **E-mail:** info@williamhavugallery.com. **Website:** www.williamhavugallery.com. **Contact:** Bill Havu, owner and director; Nick Ryan, gallery administrator. For-profit gallery. "Engaged in an ongoing dialogue through its 7 exhibitions a year with regionalism as it affects and is affected by both national and international trends in realism and abstraction. Strong emphasis on mid-career and established artists." Approached by 120 artists/year; represents or exhibits 50 artists. Sponsors 1 photography exhibit/year. Average display time 6-8 weeks. Open Tuesday–Friday, 10-6; Saturday, 11-5; 1st Friday of each month, 10-8; Sundays and Mondays by appointment. Closed Christmas and New Year's Day. Overall price range $250-15,000. Most work sold at $1,000-4,000.

MEDIA Considers acrylic, ceramics, collage, drawing, mixed media, oil, paper, pastel, pen & ink, sculpture, and watercolor. Most frequently exhibits painting, prints. Considers etchings, linocuts, lithographs, mezzotints, woodcuts, monotypes, monoprints, and silkscreens.

STYLE Exhibits expressionism, geometric abstraction, impressionism, minimalism, postmodernism, surrealism, and painterly abstraction. Most frequently exhibits painterly abstraction and expressionism.

TERMS Artwork is accepted on consignment (50% commission). Retail price set by the gallery and the artist. Gallery provides insurance, promotion, and contract. Accepted work should be framed. Primarily accepts only artists from Rocky Mountain/Southwestern region.

SUBMISSIONS "Please submit a representative sampling of your current body of work. We prefer to receive digital printouts, printed cards, and invitations, or other easily reviewed formats. If you prefer, you may submit CDs, e-mail a link to your website or include these materials in an e-mail. Mailed materials will only be returned if you have provided an SASE. Please also include: A current résumé listing your contact information, education, exhibition history, collections, and awards. An artist statement. Any other supporting materials (reviews, articles, etc.). An SASE for the return of your materials. (If you do not provide an SASE, your materials will not be returned to you.) We ask that you please not contact the gallery

regarding the status of your portfolio review. Portfolios are reviewed only periodically, so it may be many months before the gallery reviews your materials. If, after evaluating your materials, we have an interest, we will be in touch with you to discuss next steps."

TIPS "Always mail a portfolio packet. We do not accept walk-ins or phone calls to review work. Explore our website or visit gallery to make sure work would fit with the gallery's objective. Archival-quality materials play a major role in selling fine art to collectors. We only frame work with archival-quality materials and feel its inclusion in work can 'make' the sale."

HAYLEY GALLERY

270 E. Main St., New Albany OH 43054. (614)855-4856. **E-mail:** hayley@hayleygallery.com. **Website:** hayleygallery.com. Matthew Sutherland, gallery manager. **Contact:** Hayley Deeter, owner. Estab. 2007. For-profit gallery. Exhibits emerging, mid-career, and established local Ohio artists. Approached by hundreds of artists a year; represents or exhibits 60 artists. Exhibited artists include Todd Buschur (painting) and Laurie Clements (painting). Sponsors 10 total exhibits/year. Average display time: depends on artist. Open Tuesday-Thursday, 12-8; Friday-Saturday, 1-9; closed Sunday-Monday (open Sundays in December only from 1-4). Always available by appointment at 614-580-3596. Clients include the local community, interior designers and upscale clients. 5% of sales are to corporate collectors. Overall price range: $75-5,000; most work sold at $1,000.

MEDIA Considers acrylic, jewelry, ceramics, fiber, glass, wood, mixed media, oil, paper, and sculpture. Does not consider photography.

TERMS Artwork is accepted on consignment with a 50% commission. Retail price set by the gallery and the artist. Gallery provides insurance, promotion, and contract. Accepted work should be wired, framed or gallery wrapped. Only accepts artists from Ohio.

SUBMISSIONS E-mail query letter with link to artists website or JPEG samples at 72 dpi to hayley@hayleygallery.com or mail disc, artist's statement, and bio for review. Does not return materials. Responds in 1 week. Finds artists through word of mouth, submissions, art exhibits, art fairs, and referrals by other artists.

TIPS "Artists seen by appointment only."

MARIA HENLE STUDIO

55 Company St., Christiansted, St. Croix 00820, Virgin Islands. (340)718-0372. **E-mail:** henletina@gmail.com. **Website:** www.mariahenlestudio.com. Estab. 1993. For-profit gallery. Exhibits mid-career and established artists. Approached by 4 artists/year; represents or exhibits 7 artists. Sponsors 4 exhibits/year. Average display time: 1 month. Hours vary, call for details. Located in an 18th-century loft space in historical Danish West Indian town; 750 sq. ft. Clients include local community, tourists, upscale. 10% of sales are to corporate collectors. Overall price range: $600-6,000; most work sold at $600.

MEDIA Considers all media. Most frequently exhibits painting, photography, printmaking. Types of prints include etchings, mezzotints.

STYLE Considers all styles. Most frequently exhibits realism, primitive realism, impressionism. Genres include figurative work, landscapes, Caribbean.

TERMS Artwork is accepted on consignment (40% commission). Retail price set by the artist. Gallery provides promotion. Accepted work should be matted. Requires exclusive representation locally.

SUBMISSIONS Send query letter with artist's statement, bio, brochure. Returns material with SASE. Responds in 4 weeks. Files promo cards, brochures, catalogues. Finds artists through art exhibits, referrals by other artists, submissions.

TIPS "Present good slides or photos neatly presented with a clear, concise bio."

MARTHA HENRY, INC. FINE ART

400 E. 57th St., Suite 7L, New York NY 10022. (212)308-2759. **E-mail:** mh@marthahenry.com. **Website:** www.marthahenry.com. **Contact:** Martha Henry, president. Estab. 1987. Art consultancy and appraisals. Specialist in American art from the 19th century to the present, including: African American, American, contemporary and emerging, figurative expressionism (1950s–'60s), School of Hans Hofmann, self-taught and folk. Exhibits emerging, mid-career, and established artists, specializing in art by African-Americans. Approached by over 20 artists/year; exhibits 1-2 artists/year. Exhibited artists include Jan Muller (oil paintings), Mr. Imagination (sculpture), Chicano prison drawings, and Bob Thompson (oil paintings, drawings). Sponsors 2 exhibits/year. Average display time: 4–6 weeks. Open all year; by appointment only. Located in a private gallery in an

apartment building. 0% of sales are to corporate collectors. Overall price range: $5,000-200,000; most work sold under $50,000.

TERMS Considers all artists, with emphasis on African-American artists and secondary market works.

SUBMISSIONS Finds artists through art fairs and exhibits, referrals by other artists, submissions, word of mouth, and press.

HENRY ART GALLERY

University of Washington, 15th Ave. NE and NE 41st St., Seattle WA 98195. (206)543-2280. **Fax:** (206)685-3123. **E-mail:** press@henryart.org. **Website:** www.henryart.org. **Contact:** Luis Croquer, deputy director of exhibitions, collections and programs. Estab. 1927. Contemporary Art Museum. Exhibits emerging, mid-career, and established domestic and international artists. Presents approx. 20 exhibitions/year. Open Wednesday, Saturday, Sunday 11-4; Thursday-Friday, 11-9. Located on the University of Washington campus. Visitors include local community, students, and tourists.

MEDIA Considers all media. Most frequently exhibits photography, video, and installation work. Exhibits all types of prints.

STYLE Exhibits contemporary art.

TERMS Does not require exclusive representation locally.

SUBMISSIONS Send query letter with artist statement, résumé, SASE, 10-15 images. Returns material with SASE. Finds artists through art exhibitions, exhibition announcements, individualized research, periodicals, portfolio reviews, referrals by other artists, submissions, and word of mouth.

HENRY STREET SETTLEMENT/ABRONS ART CENTER

466 Grand St., New York NY 10002. (212)598-0400; (212)766-9200. **E-mail:** info@henrystreet.org; jdurham@henrystreet.org. **Website:** www.abronsartcenter.org. **Contact:** Jonathan Durham, director of exhibitions and AIRspace. Alternative space, nonprofit gallery, community center. "The Abrons Art Center brings innovative artistic excellence to Manhattan's Lower East Side through diverse performances, exhibitions, residencires, classes, and workshops for all ages and arts-in-education programming at public schools. Holds 9 solo photography exhibits/year. Open Tuesday-Friday, 10-10; Saturday, 9-10; Sunday, 11-6. Closed major holidays.

MEDIA Considers all media and all types of prints. Most frequently exhibits mixed media, sculpture, and painting.

STYLE Considers all styles and genres.

TERMS Artwork is accepted on consignment (20% commission). Gallery provides insurance and contract.

SUBMISSIONS Send query letter with artist's statement, résumé and SASE. Returns material with SASE. Files résumés. Finds artists through word of mouth, submissions, and referrals by other artists.

HERA GALLERY

P.O. Box 336, Wakefield RI 02880. (401)789-1488. **E-mail:** info@heragallery.org. **Website:** www.heragallery.org. Estab. 1974. Cooperative gallery. "Hera Gallery/Hera Educational Foundation was a pioneer in the development of alternative exhibition spaces across the U.S. in the 1970s and one of the earliest women's cooperative galleries. Although many of these galleries no longer exist, Hera is proud to have not only continued, but also expanded our programs, exhibitions and events." The number of photo exhibits varies each year. Average display time: 6 weeks. Open Wednesday, Thursday, Friday, 1-5; Saturday, 10-4; or by appointment. Closed during the month of January. Sponsors openings; provides refreshments and entertainment or lectures, demonstrations, and symposia for some exhibits. Call for information on exhibitions. Overall price range: $100-10,000.

MEDIA Considers all media and original handpulled prints.

STYLE Exhibits installations, conceptual art, expressionism, neo-expressionism, painterly abstraction, surrealism, conceptualism, postmodern works, realism, and photorealism, basically all styles. "We are interested in innovative, conceptually strong, contemporary works that employ a wide range of styles, materials and techniques. Prefers a culturally diverse range of subject matter that explores contemporary social and artistic issues important to us all."

TERMS Co-op membership. Gallery charges 30% commission. Retail price set by artist. Sometimes offers customer discount and payment by installments. Gallery provides promotion; artist pays for shipping and shares expenses such as printing and

postage for announcements. Works must fit inside a 6'6"×2'6" door.

SUBMISSIONS Inquire about membership and shows. Responds in 6 weeks. Membership guidelines and application available on website or mailed on request. Finds artists through word of mouth, advertising in art publications, and referrals from members.

TIPS "Hera exhibits a culturally diverse range of visual and emerging artists. Please follow the application procedure listed in the membership guidelines. Applications are welcome at any time of the year."

GERTRUDE HERBERT INSTITUTE OF ART

506 Telfair St., Augusta GA 30901-2310. (706)722-5495. **Fax:** (706)722-3670. **E-mail:** ghia@ghia.org. **Website:** www.ghia.org. **Contact:** Rebekah Henry, executive director. Estab. 1937. Nonprofit gallery. Exhibits 40 emerging, mid-career, and established artists in 5 solo/group shows annually. Exhibited artists include John Kingerlee, Luis Cruz Azaceta, Tom Nakashima. Sponsors 5 exhibits/year. Average display time: 6-8 weeks. Open Monday-Friday, 10-5; Saturdays by advance appointment only; closed first week in August, December 15-31. Located in historic 1818 Ware's Folly mansion. Clients include local community, tourists, and upscale. Approx. 5% of sales are to corporate collectors. Overall price range: $100-5,000; most work sold at $500.

MEDIA Considers all media except craft. Considers all types of prints.

STYLE Exhibits all styles.

TERMS Artwork is accepted on consignment (35% commission). Retail price set by the artist. Gallery provides insurance and promotion. Accepted works on paper must be framed and under Plexiglas. Does not require exclusive representation locally.

SUBMISSIONS Send query letter with artist statement, bio, brochure, résumé, reviews, SASE, slides or CD of current work. Returns material with SASE. Responds to queries quarterly after expeditions review committee meets. Finds artists through art exhibits, referrals by other artists and submissions.

THE HIGH MUSEUM OF ART

1280 Peachtree St. NE, Atlanta GA 30309. (404)733-4400. **E-mail:** highmuseum@woodruffcenter.org. **Website:** www.high.org. Estab. 1905. Exhibits emerging, mid-career and established artists. Has over 11,000 works of art in its permanent collection. The museum has an extensive anthology of 19th- and 20th-century American art; significant holdings of European paintings and decorative art; a growing collection of African-American art; and burgeoning collections of modern and contemporary art, photography and African art. Open Tuesday-Thursday, Saturday, 10-5; Friday, 10-9; Sunday, 12-5; closed Mondays and national holidays. Located in midtown Atlanta. "The museum's building, designed by noted architect Richard Meier, opened to worldwide acclaim in 1983 and has received many design awards, including 1991 citation from the American Institute of Architects as one of the 'ten best works of American architecture of the 1980s.' Meier's 135,000-sq.-ft. facility tripled the museum's space, enabling the institution to mount more comprehensive displays of its collections. In 2003, to celebrate the 20th anniversary of the building, the High unveiled enhancements to its galleries and interior, and a new chronological installation of its permanent collection. Three new buildings, designed by Italian architect Renzo Piano, more than double the museum's size to 312,000 sq. ft. This allows the High to display more of its growing collection, increase educational and exhibition programs, and offer new visitor amenities to address the needs of larger and more diverse audiences. The expansion strengthens the High's role as the premier art museum in the Southeast and allows the museum to better serve its growing audiences in Atlanta and from around the world." Clients include local community, students, tourists, and upscale.

MEDIA Considers all media and prints.

STYLE Considers all styles and genres.

TERMS Retail price is set by the gallery and the artist. Gallery provides insurance, promotion and contract.

SUBMISSIONS Call, e-mail or write to arrange a personal interview to show portfolio of slides, artist's statement, bio, résumé, and reviews. Returns materials with SASE.

HOCKADAY MUSEUM OF ART

302 Second Ave. E., Kalispell MT 59901. (406)755-5268. **E-mail:** development@hockadaymuseum.org. **Website:** www.hockadaymuseum.org. Estab. 1968. Located in the historic downtown, 2,650 sq. ft., 1906 Carnegie Library. Permanent collection includes Jogn Fery, Russell Chatham, Charles Marion Russell, Ace Powell, O.C. Seltzer, David Shaner, Rudy Autio and more. Seeking artists for exhibition including emerging, mid-career and established artists. Artists inter-

ested in exhibiting can access all information under the artist opportunities section on the the website.

STYLE Will consider all media, styles and genres.

TERMS Gallery provides contract, insurance, promotion and shipping one way. Submissions are reviewed twice a year in September and January.

HOOSIER SALON PATRONS ASSOCIATION & GALLERY

711 E. 65th St., Indianapolis IN 46220. (317)669-6051. **E-mail:** info@hoosiersalon.org; ddole@hoosiersalon.org. **Website:** www.hoosiersalon.org. Estab. 1925. Nonprofit fine art gallery. Membership of 500 emerging, mid-career and established artists. Sponsors 7 exhibits/year (6 in gallery, 1 juried show each year at the Indiana Historical Society). Average display time: 5-6 weeks. Open Thursday-Sunday, 1-4. Closed over Christmas week. Gallery is in the Carmel Arts District as part of a business building. Gallery occupies about 2,200 sq. ft. Clients include local community and tourists. 20% of sales are to corporate collectors. Overall price range $50-5,000; most work sold at $1,000.

○ This gallery opened a new location in 2001 at 507 Church St., New Harmony IN 47631; (812)682-3970.

MEDIA Considers acrylic, ceramics, collage, drawing, fiber, mixed media, oil, paper, pastel, pen & ink, sculpture, watercolor, and hand-pulled prints. Most frequently exhibits oil, watercolor, and pastel.

STYLE Exhibits traditional impressionism to abstract. Considers all genres.

TERMS Artwork is accepted on consignment and there is a 60% commission. Retail price set by the artist. Gallery provides insurance and contract. Accepted work must be exhibit ready. Requires membership. Criteria for membership is 1 year's residence in Indiana. Accepts only artists from Indiana (1 year residency). Gallery only shows artists who have been in one annual exhibit (show of approx. 200 artists each year).

SUBMISSIONS Call or e-mail for membership and Annual Exhibition information. Responds ASAP. We do not keep artists' materials unless they are members. Finds artists through word of mouth, art exhibits, and art fairs.

TIPS While not required, all mats, glass, etc., need to be archival-quality. Because the association is widely regarded as exhibiting quality art, artists are generally careful to present their work in the most professional way possible.

EDWARD HOPPER HOUSE ART CENTER

82 N. Broadway, Nyack NY 10960. (845)358-0774. **E-mail:** info@hopperhouse.org; caroleperry@edwardhopperhouse.org. **Website:** www.edwardhopperhouse.org. **Contact:** Carole Perry, director. Estab. 1971. Nonprofit gallery, historic house. Approached by 200 artists/year. Exhibits 100 emerging, mid-career, and established artists. Sponsors 9 exhibits/year. Average display time 5 weeks. Open Thursday–Sunday, 1-5; or by appointment. The house was built in 1858. There are 4 gallery rooms on the first floor. Clients include local community, students, tourists, upscale. Overall price range $100-12,000; most work sold at $750.

MEDIA Considers all media and all types of prints except posters. Most frequently exhibits watercolor, photography, oil.

STYLE Considers all styles and genres. Most frequently exhibits realism, abstraction, expressionism.

TERMS Artwork is accepted on consignment and there is a 35% commission. Retail price set by the artist. Gallery provides insurance, promotion, and contract. Accepted work should be framed, mounted and matted. Does not require exclusive representation locally.

SUBMISSIONS Call or check website for submission guidelines. Send query letter with artist's statement, bio, brochure, business card, photocopies, photographs, résumé, reviews, SASE, and slides. Returns material with SASE. Files all materials unless return specified and paid. Finds artists through art fairs, art exhibits, portfolio reviews, referrals by other artists, submissions, and word of mouth.

TIPS "When shooting slides, don't have your artwork at an angle and don't have a chair or hands in the frame. Make sure the slides look professional and are an accurate representation of your work."

HUDSON GALLERY

5645 N. Main St., Sylvania OH 43560. (419)885-8381. **Fax:** (419)885-8381. **E-mail:** info@hudsongallery.net. **Website:** www.hudsongallery.net. **Contact:** Scott Hudson, director. Estab. 2003. For-profit gallery. Approached by 30 artists a year; represents or exhibits 90 emerging, mid-career, and established artists. Sponsors 10 exhibits/year. Average display time 1 month. Open Tuesday-Friday, 10-6; Saturday,

10-3. This street-level gallery has over 2,000 sq. ft. of primary exhibition space. Clients include local community, tourists, and upscale. 5% of sales are to corporate collectors. Overall price range $50-10,000.

MEDIA Considers acrylic, ceramics, collage, drawing, fiber, glass, mixed media, oil, paper, pastel, sculpture, watercolor, engravings, etchings, linocuts, lithographs, mezzotints, serigraphs, woodcuts. Most frequently exhibits acrylic, oil, ceramics.

STYLE Considers all styles and genres.

TERMS Artwork is accepted on consignment and there is a 40% commission. Retail price of the art set by the gallery and artist. Gallery provides insurance, promotion, and contract.

SUBMISSIONS Call, e-mail, write or send query letter with artist's statement, bio, JPEGs; include SASE. Material returned with SASE. Responds within 4 months. Finds artists through word of mouth, submissions, portfolio reviews, and referrals by other artists.

TIPS Follow guidelines on our website.

HUDSON GUILD GALLERY

441 W. 26th St., New York NY 10001. (212)760-9837. **Fax:** (212)760-9801. **E-mail:** info@hudsonguild.org; jfurlong@hudsonguild.org. **Website:** www.hudsonguild.org. **Contact:** Jim Furlong, director. Estab. Hudson Guild Gallery, 1948; Guild Gallery II, 2001. Represents emerging, mid-career, community-based, and established artists. Sponsors 12 shows/year. Average display time: 8 weeks. Open all year. Located in West Chelsea; 1,200 sq. ft.; community center galleries in a New York City neighborhood. 100% of space for special exhibitions. 100% of sales are to private collectors.

Additional gallery: Guild Gallery II, 119 Ninth Ave., New York NY 10011.

MEDIA Considers oil, acrylic, watercolor, pastel, pen & ink, drawings, mixed media, collage, paper, sculpture, original handpulled prints, woodcuts, wood engravings, linocuts, engravings, mezzotints, etchings, lithographs, pochoir, and serigraphs. Most frequently exhibits paintings, sculpture, and graphics. Looking for artist to do an environmental installation.

STYLE Exhibits all styles and genres.

TERMS Accepts work on consignment (20% commission). Retail price set by artist. Gallery provides insurance; artist pays for shipping. Prefers artwork framed.

SUBMISSIONS Send query letter, résumé, JPEGs by e-mail, or photos with SASE. Responds in 1 month. Finds artists through visiting exhibitions, word of mouth, various art publications and sourcebooks, artists' submissions/self-promotions, art collectors' referrals.

TIPS "Medium or small works by emerging artists are more likely to be shown in group shows than large work."

HYDE PARK ART CENTER

5020 S. Cornell Ave., Chicago IL 60615. (773)324-5520. **Fax:** (773)324-6641. **E-mail:** generalinfo@hydeparkart.org; aquinn@hydeparkart.org. **Website:** hydeparkart.org. **Contact:** Allison Peters Quinn, director of exhibition & residency programs. Estab. 1939. Nonprofit gallery & art school. Exhibits primarily Chicago-based artists. Sponsors approximately 15 exhibitions/year. Average display time: 3 months. Office hours Monday–Friday, 9-5. Gallery open Monday–Thursday, 10-8; Friday-Saturday, 10-5; Sunday, 12-5. "Primary focus on Chicago area artists at all levels of their career." Clientele: general public. Overall price range: $100-10,000.

MEDIA Considers all media. Interested in seeing "innovative work by emerging artists; also interested in proposals from curators and individual proposals from artists for new projects."

TERMS Accepts work "for exhibition only." Retail price set by artist. Sometimes offers payment by installment. Exclusive area representation not required. Gallery provides insurance and contract.

SUBMISSIONS Send cover letter, résumé, CD with 10-15 images, artist's statement of 250-400 words, and SASE attn: Allison Peters Quinn, director of exhibitions.

TIPS "Do not bring work in person."

ICEBOX QUALITY FRAMING & GALLERY

1500 Jackson St. NE, Suite #443, Minneapolis MN 55413. (612)788-1790. **E-mail:** icebox@bitstream.net. **Website:** www.iceboxminnesota.com. Estab. 1988. Exhibition, promotion, and sales gallery. Represents photographers and fine artists in all media, predominantly photography. "A sole proprietorship gallery, Icebox sponsors installations and exhibits in the gallery's 2,200-sq.-ft. space in the Minneapolis Arts District." Overall price range: $200-2,500; most work sold at $200-800.

MEDIA Considers mostly photography, with the

door open for other fine art with some size and content limitations.

STYLE Exhibits photos of multicultural, environmental, landscapes/scenics, rural, adventure, travel, and fine art photographs from artists with serious, thought-provoking work. Interested in alternative process, documentary, erotic, historical/vintage.

TERMS Charges 50% commission.

SUBMISSIONS "Send letter of interest telling why and what you would like to exhibit at Icebox. Include only materials that can be kept at the gallery and updated as needed. Check website for more details about entry and gallery history."

TIPS "Be more interested in the quality and meaning of your artwork than in a way to make money. Unique thought provoking artwork of high quality is more likely suited." Not interested in wall decor art.

ILLINOIS ARTISANS PROGRAM

James R. Thompson Center, 100 W. Randolph St., Suite 2-200, Chicago IL 60601. (312)814-5321. **E-mail:** illinoisartisans@museum.state.il.us. **Website:** www.museum.state.il.us/programs/illinois-artisans. Estab. 1985. "The Illinois Artisans Program was created in 1985 by Governor James R. Thompson to sustain and encourage local contemporary craft made in Illinois. The primary mission of the program is to draw national and statewide attention to the rich tradition of craft in the state and to provide venues to the display and sales of work by juried artists. Three not-for-profit venues operate under statutory authority of the Illinois State Museum Society to display and sell Illinois Artisans work in a range of media in curated gallery stores, art sprees, craft festivals, exhibitions and other events held at our 3 locations: Illinois Artisans, Chicago; The Museum Store, Illinois State Museum, 502 S. Spring St., Springfield IL 62706; and Southern Illinois Art & Artisans Center, 14967 Gun Creek Trail, Whittington IL 62897-1000."

MEDIA "The Illinois Artisans Program is continually looking for talented new artists to join the program." All areas of arts and crafts, including folk, traditional, contemporary, and ethnic, as well as fine art forms are eligible. Over 1,800 artists have been jury selected into the IAP. Once selected, their work can be shown at 1 or more Illinois Artisans locations.

STYLE Exhibits all styles. "Seeks contemporary, traditional, folk, and ethnic arts from all regions of Illinois."

TERMS Accepts work on consignment (50% commission). Retail price set by gallery and artist. Sometimes offers customer discounts. Exclusive area representation not required.

SUBMISSIONS Applications are due twice a year (March 28 and October 12) and reviewed by a jury panel. Artists should submit 8 images, artist statement and information about each image on a CD. Cost per application is $30. Artists are required to live and work within Illinois and work must be handmade and original. Criteria can be reviewed and the application downloaded on the website: www.museum.state.il.us/artisans.

TIPS "Great work can be rejected because of poor or blurry photographs. Work is judged on quality, excellence of concept, and/or adherence to traditional design."

ILLINOIS STATE MUSEUM CHICAGO GALLERY

100 W. Randolph, Suite 2-100, Chicago IL 60601. (312)814-5322. **E-mail:** jstevens@museum.state.il.us. **Website:** www.museum.state.il.us/ismsites/chicago/exhibitions.html. **Contact:** Jane Stevens, gallery administrator. Estab. 1985. Museum. Exhibits emerging, mid-career and established artists. Sponsors 2-3 shows/year. Average display time: 5 months. Open all year. Located "in the Chicago loop, in the James R. Thompson Center designed by Helmut Jahn." 100% of space for special exhibitions.

MEDIA All media considered, including installations.

STYLE Exhibits all styles and genres, including contemporary and historical work.

TERMS "We exhibit work but do not handle sales." Gallery provides insurance and promotion; artist pays for shipping. Prefers artwork framed.

SUBMISSIONS Accepts only artists from Illinois. Send résumé, 12-20 JPEGs on a CD, bio and SASE.

IMPACT ARTIST GALLERY, INC.

Tri-Main Center, Suite 545, 2495 Main St., Buffalo NY 14214. (716)833-3110. **E-mail:** exdirector@gmail.com. **Website:** http://www.impactartistsgallery.org/. Estab. 1993. "A cooperative members' gallery for women artists, one of a few in the nation. We mount 10 or more exhibitions of visual art each year, including 2-4 national juried shows, a members-only show, and several community service exhibits." Approached by 500

artists/year. Represents 310 emerging, mid-career and established artists. Open all year; Wednesday–Saturday, 11-4; most Saturdays, 1-4. Clients include local community, tourists and upscale.

MEDIA Considers all media except glass, installation, and craft. Considers engravings, etchings, lithographs, serigraphs, and woodcuts.

STYLE Considers all styles. Most frequently exhibits expressionism, painterly abstraction, surrealism. Considers all genres.

TERMS Artwork is accepted on consignment and there is a 25% commission. Retail price set by the artist. Gallery provides promotion. Accepted work should be framed, matted and ready for hanging. Does not require exclusive representation locally. Women's art except for Fall National Show and Summer Statewide Show.

SUBMISSIONS Write to arrange a personal interview to show portfolio of slides. Mail portfolio for review. Send query letter with SASE and slides. Responds in 2 months. Files artist statement and résumé.

INDIANAPOLIS ART CENTER

820 E. 67th St., Indianapolis IN 46220. (317)255-2464. **E-mail:** kyleh@indplsartcenter.org. **Website:** www.indplsartcenter.org. **Contact:** Kyle Herrington, director of exhibitions. Estab. 1934. "The Indianapolis Art Center is one of the largest community art facilities in the United States not connected with a university, welcoming more than 250,000 visitors a year. The mission of the Indianapolis Art Center is to engage, enlighten and inspire our community by providing interactive art education, outreach to underserved audiences, support of artists, and exposure to the visual arts. The Art Center's campus includes the Marilyn K. Glick School of Art, a 40,000 sq. ft. facility designed by renowned architect Michael Graves. The building houses 11 state-of-the-art studios, 5 public art galleries, a 224-seat auditorium, and a library. It also features ArtsPark, a 9-acre outdoor creativity and sculpture garden that includes public art and is located in one of Indianapolis' most popular and diverse neighborhoods. The park is connected to one of the city's most utilized greenway trail systems, the Monan Trail."

TERMS "The Indianapolis Art Center Exhibitions Department accepts proposals for gallery and ArtsPark exhibits from June–December each year. Generally we are looking for exhibits to book 2 years out or more. Proposals will be accepted starting June 1–December 31. All works insured while on site and a stipend may be available in curated exhibitions. For further information about the gallery sizes and contract terms, please contact us."

SUBMISSIONS "Any artist may submit a proposal to be considered for a solo or group exhibition by sending a complete artist's packet to: Indianapolis Art Center, ATTN: Exhibits Department, 820 E. 67th St., Indianapolis, IN 46220. Your proposal should include the following items on a CD or DVD: an artist statement, not to exceed 1 page; a résumé or biography, not to exceed 3 pages; 12-15 images of individual works (details may be included); a list with title, medium, size, and year completed for each image. Videos may also be submitted, as well as videos of interactive and/or performance work. NOTE: your proposal materials WILL NOT be returned to you. While all proposals will be given equal consideration, artists living or working within 250 miles of Indianapolis are especially encouraged to apply. All proposals collected during the year will be reviewed on a rolling basis. Proposals may be kept for upwards of 3 years by the exhibitions department for future consideration."

INDIAN UPRISING GALLERY

P.O. Box 1582, Bozeman MT 59771. (406)586-5831. **E-mail:** info@indianuprisinggallery.com. **Website:** www.indianuprisinggallery.com. "Dedicated exclusively to American Indian contemporary art featuring the unique beauty and spirit of the Plains Indians." The gallery specializes in ledger drawings, painted hides, jewelry. Artists include Linda Haukaas, Donald Montileaux, Dwayne Wilcox, Pauls Szabo, Jackie Bread. Conducts business by private appointment and e-commerce only.

MEDIA Considers all media. Most frequently exhibits contemporary works by gallery artists.

TERMS Buys outright at wholesale price. On occasion takes consignments.

SUBMISSIONS Accepts only Native American artists of the Plains region. Send résumé, slides, bio, and artist's statement. Write for appointment to show portfolio of photographs. Responds in 2 weeks. Finds artists through visiting museums and juried art shows.

INDIVIDUAL ARTISTS OF OKLAHOMA

P.O. Box 60824, Oklahoma City OK 73146. (405)232-6060. **Fax:** (405)232-6061. **E-mail:** kbrown@iaogallery. org. **Website:** www.iaogallery.org. **Contact:** Kendall

Brown. Estab. 1979. Alternative space. "IAO creates opportunities for Oklahoma artists by curating and developing socially relevant exhibitions in one of the finest gallery spaces in the region." Approached by 60 artists/year; represents or exhibits 30 artists. Sponsors 10 photography exhibits/year. Average display time: 3-4 weeks. Open Tuesday–Saturday, 12-6. Gallery is located in downtown art district, 2,300 sq. ft. with 10 ft. ceilings and track lighting. Overall price range: $100-2,000; most work sold at $400.

MEDIA Considers all media. Most frequently exhibits photography, painting, installation.

STYLE Considers all styles. Most frequently exhibits "bodies of work with cohesive style and expressed in a contemporary viewpoint." Considers all genres.

SUBMISSIONS Mail portfolio for review. Send artist's statement, bio, photocopies or slides, résumé, and SASE. Returns material with SASE. Responds in 3 months. Finds artists through word of mouth, art exhibits, and referrals by other artists.

TIPS "IAO is committed to sustaining and encouraging emerging and established artists in all media who are intellectually and aesthetically provocative or experimental in subject matter or technique."

IVANFFY-UHLER GALLERY

(760)730-9166. **E-mail:** info@ivanffyuhler.com; paul@ivanffyuhler.com. **Website:** www.ivanffyuhler.com. **Contact:** Paul Uhler, director. Estab. 1990. Online gallery. Represents 20 mid-career and established artists/year. Clientele: upscale, local community, tourists. 85% private collectors, 15% corporate collectors. Overall price range: $1,000-20,000; most work sold at $1,500-4,000.

MEDIA Considers oil, acrylic, watercolor, pastel, pen & ink, drawing, mixed media, collage, paper, sculpture, woodcuts, engravings, lithographs, wood engravings, mezzotints, serigraphs, linocuts, and etchings. Most frequently exhibits oils, mixed media, sculpture.

STYLE Exhibits neo-expressionism, painterly abstraction, surrealism, postmodern works, impressionism, hard-edge geometric abstraction, postmodern European school. Genres include florals, landscapes, figurative work.

TERMS Shipping costs are shared.

SUBMISSIONS Currently not accepting submissions.

JAILHOUSE GALLERY

310 North Center Ave., Hardin MT 59034. (406)665-3239. **E-mail:** jhghardin@hotmail.com. **Website:** www.jailhousegallery.org. Estab. 1978. Nonprofit gallery. Represents 25 emerging, mid-career and established artists/year. Exhibited artists include Gale Running Wolf, Sr. and Mary Blain. Sponsors 9 shows/year. Average display time 6 weeks. Open all year; January-April; Tuesday-Friday, 9:30-5:30; Saturday 9:30-3:30; May-December; Tuesday-Saturday, 9:30-5:30. Located downtown; 1,440 sq. ft. 75% space for special exhibitions; 25% of space for gallery artists. Clientele: all types. 95% private collectors, 5% corporate collectors. Overall price range $20-2,000; most work sold at $20-500.

MEDIA Considers all media and all types of prints. Most frequently exhibits mixed media, watercolor, and pen & ink.

STYLE Exhibits all styles and all genres. Prefers western, Native American, and landscapes.

TERMS Accepts work on consignment (30% commission). Retail price set by the gallery. Gallery provides insurance, promotion, and contract. Artist pays shipping costs.

SUBMISSIONS Send query letter with résumé, business card, artist's statement, and bio. Call for appointment to show portfolio of photographs. Responds in 3 weeks. Finds artists through word of mouth, referrals by other artists, visiting art fairs and exhibitions, and artists' submissions.

ASHOK JAIN GALLERY

58 Hester St., New York NY 10002. (212)969-9660. **Fax:** (212)969-9715. **E-mail:** info@ashokjaingallery.com. **Website:** www.ashokjaingallery.com/. Estab. 1991. Retail gallery. Represents 30 emerging artists. Exhibited artists include Fernando Pomalaza and Pauline Gagnon. Open all year; Tuesday–Saturday, 11-5; or by appointment. Located in New York Gallery Bldg. 100% of space for special exhibitions. Clients include corporate and designer. 50% of sales are to private collectors, 50% corporate collectors. Overall price range: $1,000-20,000; most work sold at $5,000-10,000.

MEDIA Considers oil, acrylic, and mixed media. Most frequently exhibits oil, acrylic, and collage.

STYLE Exhibits painterly abstraction. Prefers abstract and landscapes.

TERMS Accepts work on consignment (50% commission). Retail price set by artist. Offers customer discount. Gallery provides contract; artist pays for shipping costs. Prefers artwork framed.

SUBMISSIONS "If you are interested in submitting materials to our gallery, please mail a current résumé as well as a representative set of images (maximum of 20) along with a SASE if you wish to have your materials returned. You may e-mail your materials or mail them to our gallery for consideration."

ALICE AND WILLIAM JENKINS GALLERY

600 St. Andrews Blvd., Winter Park FL 32792. (407)671-1886. **Fax:** (407)671-0311. **E-mail:** btiffany2000@yahoo.com. **Website:** www.crealde. org. **Contact:** Barbara Tiffany, director of painting and drawing department. Estab. 1980. The Jenkins Gallery mission is to exhibit the work of noted and established Florida artists, as well as to introduce national and international artists to the Central Florida region. Each of the 4-6 annual exhibitions are professionally curated by a member of the Crealdé Gallery Committee or a guest curator.

JESSEL GALLERY

1019 Atlas Peak Rd., Napa CA 94558. (707)257-2350. **Fax:** (707)257-2396. **E-mail:** jesselgallery@napanet. net. **Website:** www.jesselgallery.com. **Contact:** Jessel Miller, owner. Estab. 1984. Retail gallery. Represents 10 major artists. Exhibited artists include Terry Sauve, Timothy Dixon, Daniel Mundy, Susan Hoehn, Erin Dertner, Richard McDaniels, and Jessel Miller. Sponsors 2-6 shows/year. Average display time: 1 month. Open all year; 7 days/week, 10-5. Located 1 mile out of town; 15,000 sq. ft. 20% of space for special exhibitions; 50% of space for gallery artists. Clientele: upper income collectors. 95% private collectors, 5% corporate collectors. Overall price range: $25-10,000; most work sold at $2,000-3,500.

MEDIA Considers oil, acrylic, watercolor, pastel, collage, sculpture, ceramic, and craft. Most frequently exhibits oil, watercolor, and pastel.

STYLE Exhibits painterly abstraction, photorealism, realism, and traditional. Genres include landscapes, florals, and figurative work. Prefers Napa landscape and abstract.

TERMS Accepts work on consignment (50% commission). Retail price set by gallery. Gallery provides promotion; artist pays for shipping costs. Prefers artwork framed.

SUBMISSIONS Send query letter with résumé, slides, bio, SASE, and reviews. Call or email Website.

STELLA JONES GALLERY

201 St. Charles Ave., New Orleans LA 70170. (504)568-9050. **Website:** www.stellajonesgallery.com. **Contact:** Stella Jones. Estab. 1996. For-profit gallery. "The gallery provides a venue for artists of the African diaspora to exhibit superior works of art. The gallery fulfills its educational goals through lectures, panel discussions, intimate gallery talks, and exhibitions with artists in attendance." Approached by 40 artists/year; represents or exhibits 45 artists. Sponsors 1 photography exhibit/year. Average display time 6-8 weeks. Open Monday–Saturday, 12-5. Located on 1st floor of corporate 53-story office building downtown, 1 block from French Quarter. Overall price range $500-150,000. Most work sold at $5,000.

MEDIA Considers all media. Most frequently exhibits oil and acrylic. Considers all types of prints except posters.

STYLE Considers all styles. Most frequently exhibits postmodernism and geometric abstraction. Exhibits all genres.

TERMS Artwork is accepted on consignment (50% commission). Retail price set by the artist. Gallery provides insurance, promotion, and contract. Accepted work should be framed. Requires exclusive representation locally.

SUBMISSIONS To show portfolio of photographs, slides and transparencies, mail for review. Send query letter with artist's statement, bio, brochure, business card, photocopies, photographs, résumé, reviews, SASE, and slides. Returns material with SASE. Responds in 1 month. Finds artists through word of mouth, submissions, portfolio reviews, art exhibits, and referrals by other artists.

TIPS "Send organized, good visuals."

JRB ART AT THE ELMS

2810 North Walker Ave, Oklahoma City OK 73103. (405)528-6336. **Fax:** (405)528-6337. **E-mail:** jreedbelt@jrbartgallery.com. **Website:** www. jrbartgallery.com. **Contact:** Joy Reed Belt, director. Estab. 2003. JRB Art at the Elms presents a diverse roster of emerging, established, and internationally-exhibited artists who create in a wide range of media, including paintings, drawings, sculpture, ceramics, glass, fine crafts, functional objects, fiber art, fine art prints, and photographs. This award-winning

gallery in Oklahoma City's Paseo Arts District, with its historic 8,000 sq. ft. exhibition space, changes its exhibits monthly in a gracious environment that fosters a dialogue between the arts and the larger community while providing quality art for first-time buyers as well as individual, corporate and museum collections.

JVA ART GROUP

4151 Taylor St., San Diego CA 92110. (619)299-3232. **Fax:** (619)299-8709. **E-mail:** contact@jvaartgroup. com. **Website:** www.jvaartgroup.com. Estab. 1972. Retail gallery and art consultancy. Represents emerging, mid-career, and established artists. Exhibited artists include Susan Singleton and Reed Cardwell. Average display time: 1 month. Open Monday–Thursday, 8-5; Friday, 8:30-1. 1,000 sq. ft.; 100% of space for gallery artists. Clientele: upscale, business, decorators, health facilities, hotels, resorts, liturgical and residential artwork with interior designers, architects, landscape architects, developers, and space planners. 50% private collectors, 50% corporate collectors. Overall price range: $175-10,000; most work sold at $450-1,000. Other services include giclée printing, online artist resource (slide collection), custom commission work available and beginning to do governmental work.

MEDIA Considers all media and all types of prints. Most frequently exhibits paintings, sculpture, monoprints.

STYLE Exhibits all styles. Genres include all genres, especially florals, landscapes, and figurative work. Prefers abstract, semirealistic, and realistic.

TERMS Artwork is accepted on consignment and there is a 50% commission. Retail price set by the artist. Gallery provides insurance. Gallery pays for shipping from gallery. Artist pays for shipping to gallery. Prefers artwork unframed.

SUBMISSIONS Send query letter with résumé and slides. Call for appointment to show portfolio of slides. Responds in 2 weeks. Files slides, biographies, information about artist's work. Finds artists through submissions and referrals.

HAL KATZEN GALLERY

11 E. 78th St., Suite 2, New York NY 10075. (212)925-9777. **E-mail:** hkatzen916@aol.com. **Website:** www. artnet.com/galleries/hal-katzen-gallery. **Contact:** Hal Katzen. Estab. 1986. For-profit gallery. Estab. 1984. Exhibits established artists. Open Monday-Friday,

10-6; closed August. Clients include local community, tourists and upscale. 10-20% of sales are to corporate collectors. Overall price range: $2,000-20,000; most work sold at $5,000.

MEDIA Considers acrylic, collage, drawing, oil, paper, pen & ink, sculpture, and watercolor. Most frequently exhibits paintings, works on paper, and sculpture. Considers all types of prints.

STYLE Considers all styles and genres.

TERMS Artwork is accepted on consignment or is bought outright. Accepts only established artists.

KAVANAUGH ART GALLERY

131 Fifth St.,, W. Des Moines IA 50265. (515)279-8682. **Fax:** (515)279-7609. **E-mail:** info@kagwdm. com. **Website:** www.kavanaughgallery.com. **Contact:** Carole Kavanaugh, director. Estab. 1990. Retail gallery. Represents 100 mid-career and established artists/year. May be interested in seeing the work of emerging artists in the future. Exhibited artists include Kati Roberts, Don Hatfield, Dana Brown, Gregory Steele, August Holland, Ming Feng, and Larry Guterson. Sponsors 3-4 shows/year. Average display time: 3 months. Open all year; Monday–Saturday, 10-5. Located in Valley Junction shopping area; 10,000 sq. ft. 70% private collectors, 30% corporate collectors. Overall price range: $300-20,000; most work sold at $800-3,000.

MEDIA Considers all media and all types of prints. Most frequently exhibits oil, acrylic, and pastel.

STYLE Exhibits color field, impressionism, realism, florals, portraits, Western, wildlife, southwestern, landscapes, Americana, and figurative work. Prefers landscapes, florals, and western.

TERMS Accepts work on consignment (50% commission). Retail price set by the artist. Gallery provides insurance, promotion, and contract. Shipping costs are shared. Prefers artwork unframed.

SUBMISSIONS Send query letter with résumé, bio, and photographs. Portfolio should include photographs. Responds in 3 weeks. Files bio and photos. Finds artists through word of mouth, referrals by other artists, visiting art fairs and exhibitions, submissions.

TIPS "Get a realistic understanding of the gallery/ artist relationship by visiting with directors. Be professional and persistent."

THE KENTUCK ART CENTER

503 Main Ave., Northport AL 35476. (205)758-1257. **Fax:** (205)758-1258. **E-mail:** kentuck@kentuck.org. **Website:** www.kentuck.org. **Contact:** Amy Echols, executive director. Estab. 1980. Nonprofit gallery. "The Kentuck Art Center presents monthly exhibitions, showcasing the work of both established artists and of up-and-comers. Sometimes traditional, sometimes visionary, always authentic, Kentuck brings art to the community and builds community with art. The annual Kentuck Festival of Art began in 1971." Approached by 400 artists/year. Represents 100 artists/year. Sponsors 24 exhibits/year. Average display time: 1 month. Open Tuesday–Friday, 9-5; Saturday, 10-4:30; closed major holidays. Clients include local community. Overall price range: $150-10,000.

MEDIA Considers all media. Most frequently exhibits mixed media, natural materials, painting, pottery, and outsider art.

STYLE Considers all styles.

TERMS Artwork is accepted on consignment and there is a 40% commission on shop sales; 30% on exhibition sales. Retail price set by the artist. Gallery provides insurance, promotion, and contract. For insurance purposes, artist must provide inventory manifest with photos of works, description, and value (even for not-for-sale items). Accepted work should be mounted.

SUBMISSIONS Submission instructions available online. Finds artists through word of mouth, submissions, portfolio reviews, art exhibits and referrals by other artists.

ANGELA KING GALLERY

241 Royal St., New Orleans LA 70130. (504)524-8211. **Fax:** (504)566-1944. **E-mail:** angela@angelakinggallery.com. **Website:** www.angelakinggallery.com. **Contact:** Angela King, gallery director. Estab. 1977. Formerly Hanson Gallery. For profit gallery. Represents 22 emerging, mid-career and established artists. Exhibited artists include Frederick Hart (sculptor) and Leroy Neiman (all mediums). Sponsors 6 exhibits/year. Average display time: ongoing to 3 weeks. Open Monday–Saturday, 10-5; Sundays and holidays, 11-5. Clients include local community, tourists and upscale. Overall price range: $650-100,000; most work sold at $4,000.

MEDIA Considers acrylic, drawing, oil, pastel, sculpture, and watercolor. Most frequently exhibits oil, pastel, and acrylic. Considers etchings, lithographs, and serigraphs.

STYLE Exhibits impressionism, neo-expressionism, and surrealism. Considers all styles. Genres include figurative work and landscapes.

TERMS Retail price set by the gallery and the artist. Gallery provides insurance. Requires exclusive representation locally.

SUBMISSIONS Write to arrange a personal interview to show portfolio of photographs and slides. Mail portfolio for review. Send query letter with artist's statement, bio, brochure, photographs, résumé, reviews, SASE, and slides. Responds in 6 weeks. Finds artists through word of mouth, submissions, art exhibits, and art fairs.

TIPS "Archival-quality materials play a major role in selling fine art to collectors."

KINGSTON GALLERY

450 Harrison Ave., #43, Boston MA 02118. (617)423-4113. **E-mail:** sgarr@kingstongallery.com. **Website:** www.kingstongallery.com. **Contact:** Shana Garr. Estab. 1982. Cooperative gallery. Exhibits the work of 24 emerging, mid-career and established artists. Sponsors 12+ shows/year. Average display time: 1 month. Open Wednesday-Sunday, 12-5. Located in downtown Boston (South End); 1,300 sq. ft.; large, open room with 12 ft. ceiling and smaller center gallery—can accommodate large installation. Overall price range: $100-7,000; most work sold at $600-3,000.

MEDIA Considers all media. 20% of space for special exhibitions.

STYLE Exhibits all styles.

TERMS Co-op membership requires dues plus donation of time. Artist must fulfill monthly co-op responsibilities. 25% commission charged on sales by members. Retail price set by the artist. Sometimes offers payment by installments. Gallery provides insurance, some promotion, and contract. Rental of center gallery by arrangement.

SUBMISSIONS Accepts only artists from the greater Boston area for membership. Send query letter with résumé, slides, SASE, and "any pertinent information. Slides are reviewed every other month. Gallery will contact artist within 1 month." Does not file material but may ask artist to re-apply in future.

TIPS "Please include thorough, specific information on slides—size, price, etc."

KIRSTEN GALLERY, INC.

5320 Roosevelt Way NE, Seattle WA 98105. (206)522-2011. **E-mail:** kirstengallery@qwestoffice.net. **Website:** www.kirstengallery.com. **Contact:** Richard Kirsten, president. Estab. 1974. Retail gallery. Represents 60 emerging, mid-career and established artists. Exhibited artists include Birdsall and Daiensai. Sponsors 4 shows/year. Average display time: 1 month. Open Wednesday–Sunday, 11-5. 3,500 sq. ft.; outdoor sculpture garden. 40% of space for special exhibitions; 60% of space for gallery artists. 90% private collectors, 10% corporate collectors. Overall price range: $75-15,000; most work sold at $75-2,000.

MEDIA Considers oil, acrylic, watercolor, mixed media, sculpture, glass, and offset reproductions. Most frequently exhibits oil, watercolor, and glass.

STYLE Exhibits surrealism, photorealism and realism. Genres include landscapes, florals, Americana. Prefers realism.

TERMS Accepts work on consignment (50% commission). Retail price set by artist. Offers payment by installments. Gallery provides promotion; artist pays shipping costs. "No insurance; artist responsible for own work."

SUBMISSIONS Send query letter with résumé, slides, and bio. Write for appointment to show portfolio of photographs. Responds in 2 weeks. Files bio and résumé. Finds artists through visiting exhibitions and word of mouth.

TIPS "Keep prices down. Be prepared to pay shipping costs both ways. Work is not insured (send at your own risk). Send the best work—not just what you did not sell in your hometown. Do not show up without an appointment."

MARIA ELENA KRAVETZ ART GALLERY

Peatonal 25 De Mayo 240, X5000 ELF Cordoba, Argentina. (54) 351 4239451. **Fax:** (54) 351 4271776. **E-mail:** mek@mariaelenakravetzgallery.com. **Website:** www.mariaelenakravetzgallery.com. **Contact:** Maria Elena Kravetz, director. Estab. 1998. For-profit gallery. Approached by 30 artists/year; exhibits 16 emerging and mid-career artists/year. Exhibited artists include Marina Gazulla and Tania Abrile (paintings); Anna Mazzoni (fiber arts); Edgardo de Bortoli (glass art); Noel Loeschbor (fiber art), and Marcelo Marques (paintings). Average display time: 60 days. Located in the main downtown of Cordoba city. Overall price range: $500-10,000; most work sold at $1,500-5,000.

MEDIA Considers all media. Most frequently exhibits glass sculpture and mixed media. Considers etchings, linocuts, lithographs, and woodcuts.

STYLE Considers all styles. Most frequently exhibits neo-expressionism and painterly abstraction. Considers all genres.

TERMS Artwork is accepted on consignment (30% commission). Retail price set by the artist. Requires exclusive representation locally. Prefers only artists from South America and emphasizes sculptors.

SUBMISSIONS Mail portfolio for review. Cannot return material. Responds to queries in 1 month. Finds artists through art fairs and exhibits, portfolio reviews, referrals by other artists, submissions, and word of mouth.

TIPS Artists "must indicate a website to make the first review of their works, then give an e-mail address to contact them if we are interested in their work."

LA ARTISTS GALLERY

(818) 634-5549. **E-mail:** susan100art@yahoo.com. **Website:** www.laartists.com. 6650 Franklin Ave., Hollywood CA 90028. (323)461-0047. **Fax:** (323)960-3357. **E-mail:** susan100art@yahoo.com. **Website:** www.laartists.com. **Director:** Susan Anderson. Alternative space. Estab. 2000. Approached by 25 artists/year. Represents 25 mid-career artists. Exhibited artists include Dan Shupe, Esau Andrade. Gallery not open to walk-ins. Open by appointment. Clients include upscale dealers, designers, private clients. 10% of sales are to corporate collectors. Overall price range: $1,500-5,000.

MEDIA Considers collage, oil, sculpture, watercolor. Most frequently exhibits oil on canvas. Considers all types of prints.

STYLE Exhibits neo-expressionism, postmodernism, figurative, contemporary, folk. Most frequently exhibits figurative/contemporary.

TERMS Artwork is accepted on consignment (10-50% commission). Retail price set by the artist.

SUBMISSIONS Write to arrange personal interview to show portfolio of photographs. Mail portfolio for review. Returns material with SASE. Does not reply to queries.

TIPS "Keep submissions really short and enclose photographs, not slides."

THE LAB

2948 16th St., San Francisco CA 94103. (415)864-8855. **E-mail:** thelabs@thelab.org. **Website:** www.thelab. org. Estab. 1983. Nonprofit gallery and alternative space. Exhibits numerous emerging, mid-career artists/year. Interested in seeing the work of emerging artists. Sponsors 5-7 shows/year. Average display time: 1 month. Open all year; Thursday–Saturday, 1-6 (during exhibitions). 40×55 ft.; 17 ft. height; 2,200 sq. ft.; white walls. Doubles as a performance and gallery space. Clientele: artists and Bay Area communities.

○ The LAB often curates panel discussions, performances or other special events in conjunction with exhibitions. They also sponsor an annual conference and exhibition on feminist activism and art.

MEDIA Considers all media with emphasis on interdisciplinary and experimental art. Most frequently exhibits installation art, interdisciplinary art, media art, and group exhibitions.

TERMS Artists receive honorarium from the art space. Work can be sold, but that is not the emphasis.

SUBMISSIONS Submission guidelines online. Finds artists through word of mouth, submissions, calls for proposals.

TIPS Ask to be put on their mailing list to get a sense of the LAB's curatorial approach and interests.

LAKE GEORGE ARTS PROJECT/ COURTHOUSE GALLERY

Old County Courthouse, 1 Amherst St., Lake George NY 12845. (518)668-2616. **E-mail:** mail@ lakegeorgearts.org. **Website:** www.lakegeorgearts. org. Estab. 1986. Alternative space; nonprofit gallery. "Presents 5-7 exhibitions yearly of regional and national contemporary visual artists in all media." Approached by 200 artists/year; exhibits 8-15 artists/ year. Average display time: 5 weeks. Open Tuesday–Friday, 12-5; Saturday, 12-4 (during exhibitions); all other times by request.

MEDIA Exhibits all media.

STYLE Considers all styles.

TERMS Artwork is accepted on consignment (25% commission). Retail price set by the artist. Gallery provides insurance, promotion, contract.

SUBMISSIONS Annual deadline for open call is January 31. Send artist's statement, résumé, 10-12 images (slides or CD), image script, and SASE. Guidelines available online. Returns material with SASE.

Finds artists through art exhibits, portfolio reviews, referrals by other artists, submissions, word of mouth.

TIPS "Do not send e-mail submissions or links to website. Do not send original art. Review guidelines on website."

LANCASTER MUSEUM OF ART

135 N. Lime St., Lancaster PA 17602. **E-mail:** info@ lmapa.org. **Website:** www.lmapa.org. Estab. 1965. Nonprofit organization. "The Lancaster Museum of Art is recognized as one of the largest cultural organizations in the region responsible for an extensive collection of works by contemporary regional artists." Represents over 100 emerging, mid-career, and established artists/year. 900+ members. Open Tuesday–Saturday, 10-4; Sunday, 12-4. Located downtown Lancaster; 4,000 sq. ft.; neoclassical architecture. 100% of space for special exhibitions. 100% of space for gallery artists. Overall price range: $100-25,000; most work sold at $100-10,000.

MEDIA Considers all media.

TERMS Accepts work on consignment. Retail price set by the artist. Gallery provides insurance; shipping costs are shared. Artwork must be ready for presentation.

SUBMISSIONS Send query letter with résumé, slides, photographs or CDs, SASE, and artist's statement for review by exhibitions committee. Annual deadline February 1.

TIPS Advises artists to submit quality slides and well-presented proposal. "No phone calls."

LANDING GALLERY

409 Main Street, Rockland ME 04841. (207)2391223. **E-mail:** landinggallery@gmail.com. **Website:** www. landingart.com. **Contact:** Bruce Busko, president. Estab. 1985. For-profit gallery. Approached by 40 artists/year. Exhibits 35 emerging, mid-career, and established artists. Exhibited artists include Bruce Busko (oil/mixed media), Irma Cerese (acrylic), Dorothy Simpsom Krause (mixed media), Roberta (photography), Michael Kahn (photography), Maria Nevelson (assemblage), Diana Godfrey (acrylic), and Bjorn Rundquist (oil). Sponsors 6 exhibits/year. Average display time: 1 month. Open 6 months, May through October; Monday-Saturday, 10-5; Sunday, 12-5; closed Tuesdays all year, Sundays in summer. Located in mid-coast Maine next to the Farnsworth Art Museum and part of a 25 member gallery community. 2,600 sq. ft. on 2 floors with skylights, granite floors and 24-ft.

ceilings. The gallery building and Landing Gallery Garden Courtyard are in the center of town. Clients include local community, tourists, and upscale. 5% of sales are to corporate collectors. Overall price range: $100-12,000; most work sold at $400-1,500.

MEDIA Considers all media. Most frequently exhibits paintings, photographs, and sculpture. Considers engravings, etchings, lithographs, mezzotints, and serigraphs.

STYLE Considers all styles. Most frequently exhibits realism, abstract, and impressionism. Considers figurative work, florals, and landscapes.

TERMS Artwork is accepted on consignment (50% commission). Retail price set by the gallery. Gallery provides insurance, promotion, and contract. Accepted work should be framed. Requires exclusive representation in a 100-mile radius.

SUBMISSIONS E-mail or call to arrange a personal interview to show portfolio of photographs, slides, and transparencies. Mail portfolio for review. Send query letter with artist's statement, bio, brochure, business card, photocopies, photographs, résumé, reviews, SASE, and slides. Returns material with SASE. Responds in 2 weeks. Files photos, slides, photocopies, and information. Finds artists through word of mouth, submissions, portfolio reviews, art exhibits, art fairs, and referrals by other artists.

TIPS "Permanence denotes quality and professionalism."

ROBERT LANGE STUDIOS

2 Queen St., Charleston SC 29401. (843)805-8052. **E-mail:** info@robertlangstudios.com. **Website:** www.robertlangestudios.com. Estab. 2005. For-profit gallery. Approached by 100+ artists/year. Exhibits mid-career artists. Exhibited artists include Robert Lange, Amy Lind, and Nathan Durfee. Sponsors 12 exhibits/year. Average display time: 6 months. Open Monday–Sunday, 11-5. Gallery located in an historic area; 3000+ sq. feet. Clients include: local community, tourists, upscale. Overall price range: $200-20,000. Most work sold at $2,000.

MEDIA Considers acrylic, collage, installation, pen & ink, mixed media, sculpture, drawing, oil. Most frequently exhibits oil.

STYLE Considers all styles. Most frequently exhibits surrealism, conceptualism. Considers all genres. Most frequently exhibits figurative work, landscapes, and portraits.

TERMS Artwork accepted on consignment with a 50% commission. Retail price set by the artist. Gallery provides insurance, promotion, contract. Accepted work should be framed. Requires exclusive representation locally.

SUBMISSIONS Artists should e-mail query letter with link to website and 8 JPEG samples at 72 dpi. Responds in 1 week. Files images and contact info. Finds artists through submissions and referrals by other artists.

TIPS Have a nice website!

LATINO ARTS, INC.

1028 S. Ninth St., Milwaukee WI 53204. (414)384-3100. **Website:** www.latinoartsinc.org. Nonprofit gallery. Represents emerging, mid-career, and established artists. Sponsors up to 5 individual and group exhibitions/year. Average display time 2 months. Open all year; Monday-Friday, 9-8. Latino Arts, Inc. is located in the United Community center on the near southeast side of Milwaukee (gallery is in the main building on the UCC campus); 1,200 sq. ft.; one-time church. Clientele: the general Hispanic community. Overall price range: $100-2,000.

MEDIA Considers all media, all types of prints. Most frequently exhibits original 2D and 3D works and photo exhibitions.

STYLE Exhibits all styles, all genres. Prefers artifacts of Hispanic cultural and educational interests.

TERMS "Our function is to promote cultural awareness (not to be a sales gallery)." Retail price set by the artist. Artist is encouraged to donate 15% of sales to help with operating costs. Gallery provides insurance, promotion, contract, shipping costs to gallery; artist pays shipping costs from gallery. Prefers artwork framed.

SUBMISSIONS Send query letter with résumé, slides, bio, business card, and reviews. Call or write for appointment to show portfolio of photographs and slides. Responds in 2 weeks. Finds artists through recruiting, networking, advertising, and word of mouth.

LAWNDALE ART CENTER

4912 Main St., Houston TX 77002. (713)528-5858. **Fax:** (713)528-4140. **E-mail:** askus@lawndaleartcenter.org. **Website:** www.lawndaleartcenter.org. **Contact:** Dennis Nance, Exhibitions & Programming Director. Estab. 1979. Nonprofit gallery, museum, alternative space. Exhibits emerging, mid-career and established

artists. Approached by 1,200 artists/year. Exhibits 150 artists. Sponsors 25 exhibits/year; approx. 5 photography exhibits/year. Model/property release preferred. Average display time: 5 weeks. Open Monday—Friday, 10–5; Saturday, 12–5; closed Sunday, Christmas Eve until New Year's Day, President's Day, Memorial Day, Independence Day, Labor Day, Columbus Day, and Thanksgiving. "Located at the edge of Downtown in the Museum District, Lawndale includes 4 museum-quality galleries, 3 artist studios, an outdoor sculpture garden, and annual rotating mural wall." Clients include: local community, students, tourists, upscale, artists, collectors, art enthusiasts, volunteers, young professionals.

MEDIA Considers all media. Gallery provides insurance, promotion, contract. Prefers artists from Houston TX and surrounding area.

TERMS "Visit the proposal section of our website: www.lawndaleartcenter.org/exhibitions/proposals.shtml." Does not accept mailed proposals. All proposals must be made online. Finds artists through word of mouth, submissions, referrals by other artists.

SUBMISSIONS Finds artists through word of mouth, submissions, referrals by other artists.

TIPS "Please visit us or our website to learn about what type of work we exhibit and how we accept submissions to artists before contacting."

SHERRY LEEDY CONTEMPORARY ART

2004 Baltimore Ave., Kansas City MO 64108. (816)221-2626. **Fax:** (816)221-8689. **E-mail:** sherryleedy@sherryleedy.com. **Website:** www.sherryleedy.com. **Contact:** Sherry Leedy, director. Estab. 1985. Retail gallery. Represents 50 mid-career and established artists. Exhibited artists include Jun Kaneko, Mike Schultz, Vera Mercer, and more. Sponsors 6 shows/year. Average display time: 6 weeks. Open Tuesday–Saturday, 11-5, and by appointment. 5,000 sq. ft. of exhibit area in 3 galleries. Clients include established and beginning collectors. 50% of sales are to private collectors, 50% corporate clients. Overall price range: $50-100,000; most work sold at $3,500-35,000.

MEDIA Considers all media and one-of-a-kind or limited-edition prints; no posters. Most frequently exhibits painting, photography, ceramic sculpture, and glass.

STYLE Considers all styles.

TERMS Accepts work on consignment (50% commission). Retail price set by gallery in counsultation with the artist. Sometimes offers customer discounts and payment by installment. Exclusive area representation required. Gallery provides insurance, promotion; shipping costs are shared. Prefers artwork framed.

SUBMISSIONS E-mail query letter, résumé, artist's statement, and digital images or link to website. No work will be reviewed in person without a prior appointment.

TIPS "Please allow 3 months for gallery to review submissions."

LEEPA-RATTNER MUSEUM OF ART

600 E. Klosterman Road, Tarpon Springs FL 34689. (727)712-5762. **E-mail:** lrma@spcollege.edu. **Website:** http://www.leeparattner.com/. **Contact:** Ann Larsen, Director. Estab. 2002. The Leepa-Rattner Museum of Art is a modern and contemporary art museum with more than 6,000 works of 20th and 21st century art in its collections. The museum displays extensive works by its original benefactors, renowned figurative expressionist, Abraham Rattner, abstract expressionist, Allen Leepa, and Esther Gentle, print-maker, sculptor, and painter. It holds a collection of works by notable 20th century artists such as Pablo Picasso, Marc Chagall, Fernand Léger, and Henry Moore. In addition, it contains a significant collection from the former Gulf Coast Museum of Art, as well as contemporary art from private donors, including photography, prints, fine art crafts, paintings, and sculptures of the Southeastern United States. Besides the 17,000-square-foot museum, the Leepa-Rattner features a 140-seat auditorium, open lobby, and Isabelle's Museum Store. Along with the eight permanent exhibitions, unique works from a wide variety of famed artists such as Andy Warhol and Clyde Butcher are presented every 10 to 12 weeks. Open Tuesday, Wednesday, Saturday, 10-5; Thursday, 10-8; Friday, 10-4; Sunday, 1-5; closed Mondays and major holidays. Located on the Tarpon Springs campus of St. Petersburg College.

MEDIA Considers all types of media and prints. Mostly exhibits 20th-century artwork.

STYLE Considers all genres.

LEGION ARTS

1103 Third St., SE, Cedar Rapids IA 52401-2305. (319)364-1580. **Fax:** (319)362-9156. **E-mail:** info@legionarts.org. **Website:** www.legionarts.org. **Contact:** Mel Andringa, producing director. Estab. 1991. Alternative space, nonprofit gallery. Approached by 50 artists/year. Exhibits 15 emerging artists.

Exhibited artists include Bill Jordan (photographs), Paco Rosic (spray can murals). Sponsors 15 exhibits/year. Average display time 2 months. Open Wednesday–Sunday, 11-6. Closed July and August. Located in south end Cedar Rapids; old Czech meeting hall, 2 large galleries and off-site exhibits; track lights, carpet, ornamental tin ceilings. 65 events a year. Clients include local community. Overall price range $50-500; most work sold at $200.

MEDIA Considers all media and all types of prints. Most frequently exhibits painting, mixed media, and installation.

STYLE Considers all styles. Most frequently exhibits postmodernism, conceptualism, and surrealism.

TERMS Artwork is accepted on consignment and there is a 30% commission. Retail price set by the artist. Gallery provides insurance and promotion. Accepted work should be framed. Requires exclusive representation locally.

SUBMISSIONS Send query letter with artist's statement, bio, SASE and slides. Responds in 6 months. Files résumé, sample slide and statement. Finds artists through word of mouth, art exhibits, and art trade magazines.

LEHIGH UNIVERSITY ART GALLERIES

420 E. Packer Ave., Bethlehem PA 18015. (610)758-3619; (610)758-3615. **Fax:** (610)758-4580. **E-mail:** rv02@lehigh.edu. **Website:** www.luag.org. **Contact:** Ricardo Viera, director/curator. Sponsors 5-8 exhibits/year. Average display time 6-12 weeks. Sponsors openings. Exhibits fine art/multicultural, Latin American. Interested in all types of works.

TERMS Arrange a personal interview to show portfolio. Send query letter with SASE. Responds in 1 month.

SUBMISSIONS "Don't send more than 10 slides or a CD."

LE MUR VIVANT FINE ART

Website: www.corporart.co.uk/exhibitions. **Contact:** Caro Lyle Skyrme. Estab. 1996. Sponsors 10 exhibits/year. Average display time 3 weeks. Collaboration considered with new artists. By appointment only. Gallery space is 2 connected rooms each approximately 12×15. Space: 30' long. Offices in central London, Westminster. High ceilings, Victorian shop. Clientele: local community, tourists, upscale media and theater people. 20% corporate collectors. Overall price range $1,000-20,000; most work sold at $5,000-20,000 (£2,500-10,000).

MEDIA Considers all media. Most frequently exhibits oil on canvas or board, watercolor, mixed media.

STYLE Exhibits color field, expressionism, imagism, impressionism, neo-expressionism, painterly abstraction, postmodernism, and surrealism. Most frequently exhibits abstract expressionism, impressionism, magic realism, and surrealism. Considers all genres including Northern Romantic and photo-realism.

TERMS "We work on flexible percentages depending on standing of artist and potential following. We take smaller percentage from already established artists with excellent C.V. and good client list as we can rely on many sales. Retail price set with collaboration of the artist. Gallery provides contract. Accepted work should be framed or mounted by artist as agreed. Requires exclusive representation locally. Prefers only fully professional artists with excellent curriculum vitae.

SUBMISSIONS Write to arrange a personal interview to show portfolio of photographs, PowerPoint slides, transparencies. Send query letter with artist's statement, bio, photographs, résumé, and SASE. Portfolio should include good photos or slides etc. Full curriculum vitae detailing college and professional experience. Returns material with SAE. Replies only if interested within 1 month. Finds artists through word of mouth, submissions, portfolio reviews, art exhibits, referrals by other artists, from college graduate shows, Royal Academy exhibitions, public shows, and magazines.

TIPS "Send neatly presented details of past work/exhibitions/galleries, good quality transparencies, photos and/or slides. Do not expect to walk in and have your work looked at by a staff member in the middle of a business day!"

DAVID LEONARDIS GALLERY

1346 N. Paulina St., Chicago IL 60622. (312)863-9045. **E-mail:** david@dlg-gallery.com. **Website:** www.DLG-gallery.com. **Contact:** David Leonardis, owner. Estab. 1992. For-profit gallery. Approached by 100 artists/year. Represents 12 emerging, mid-career, and established artists. Exhibited artists include Kristen Thiele and Christopher Makos. Average display time: 30 days. Open by appointment. Clients include local community, tourists, upscale. 10% of sales are to corporate collectors. Overall price range: $50-5,000; most work sold at $500.

MEDIA Most frequently exhibits painting, photog-

raphy, and lithography. Considers lithographs and serigraphs.

STYLE Exhibits pop. Most frequently exhibits contemporary, pop, folk, photo. Genres include figurative work and portraits.

TERMS Artwork is accepted on consignment, and there is a 50% commission. Retail price set by the gallery and the artist. Gallery provides promotion. Accepted work should be framed. Does not require local representation. Prefers artists who are professional and easy to deal with.

SUBMISSIONS E-mail. Responds only if interested. E-mails and JPEGs are filed. Finds artists through word of mouth, art exhibits, and referrals by other artists.

⌂ LEOPOLD GALLERY

324 W. 63rd St., Kansas City MO 64113. (816)333-3111. **Fax:** (816)333-3616. **E-mail:** email@leopoldgallery. com. **Website:** www.leopoldgallery.com. **Contact:** Paula Busser, assistant director. Estab. 1991.

MEDIA Considers all media. Most frequently exhibits oils, acrylics, blown glass, ceramic, stainless steel. Some works on paper.

STYLE Considers all styles and genres. Most frequently exhibits abstraction, impressionism, conceptual.

SUBMISSIONS E-mail query letter with JPEG samples or link to website. Mail query letter with résumé, printed images, reviews, SASE, and disk with images. Returns material with SASE. Responds to queries in 2 months. Finds artists through submissions, portfolio reviews, referrals by clients and artists.

RICHARD LEVY GALLERY

514 Central Ave., SW, Albuquerque NM 87102. (505)766-9888. **Fax:** (505)242-4279. **E-mail:** info@ levygallery.com. **Website:** www.levygallery.com. Estab. 1991. "Comprised of contemporary art of all mediums by emerging and established regional, national, and international artists. The gallery shows 6-8 exhibitions/year and participates in selected art fairs." Open Tuesday–Saturday, 11-4; closed during art fairs (always noted on voice message). Located on Central Ave. between 5th and 6th. Clients include upscale.

MEDIA Considers all media. Most frequently exhibits paintings, prints and photography.

STYLE Contemporary art.

SUBMISSIONS Submissions by e-mail preferred.

"Please include images and any other pertinent information (artist's statment, bio, etc.). When sending submissions by post, please include slides or photographs and SASE for return of materials."

TIPS "Portfolios are reviewed at the gallery by invitation or appointment only."

LIBERTY VILLAGE ARTS CENTER

410 Main St., Chester MT 59522. (406)759-5652. **E-mail:** gfisher@bresnan.net. **Website:** www. centralmontana.com/listings. Estab. 1976. Nonprofit gallery. Represents 12-20 emerging, mid-career, and established artists/year. Sponsors 6-12 shows/year. Average display time: 6-8 weeks. Open all year; Tuesday–Friday, 12:30-4:30. Located near a school; 1,000 sq. ft.; former Catholic Church. Clients include tourists and local community. 100% of sales are to private collectors. Overall price range: $100-2,500; most work sold at $250-500.

MEDIA Considers all media; types of prints include woodcuts, lithographs, mezzotints, serigraphs, linocuts, and pottery. Most frequently exhibits paintings in oil, water, acrylic, b&w photos, and sculpture assemblages.

STYLE Considers all styles. Prefers contemporary and historic.

TERMS Accepts work on consignment (30% commission) or buys outright for 40% of retail price. Retail price set by the gallery. Gallery provides insurance and promotion; shipping costs are shared. Prefers artwork framed or unframed.

SUBMISSIONS Send query letter with slides, bio and brochure. Portfolio should include slides. Responds only if interested within 1 year. "Artists should cross us off their list." Files everything. Finds artists through word of mouth and seeing work at shows.

TIPS "Artists make the mistake of not giving us enough information and permission to pass information on to other galleries."

LIMNER GALLERY

123 Warren St., Hudson NY 12534. (518)828-2343. **E-mail:** thelimner@aol.com. **Website:** www.slowart. com. **Contact:** Tim Slowinski, director. Estab. 1987. Artist-owned alternative retail (consignment) gallery. Represents emerging and mid-career artists. Hosts periodic thematic exhibitions of emerging artists selected by competition, cash awards up to $1,000. Entry available for SASE or from website. Sponsors 6-8 shows/year. Average display time: 1 month. Open

Thursday-Saturday, 12-5; Sunday, 12-4. Located in storefront 400 sq. ft. 60-80% of space for special exhibitions; 20-40% of space for gallery artists. Clients include lawyers, real estate developers, doctors, architects. 95% of sales are to private collectors, 5% corporate collectors. Overall price range: $300-10,000.

MEDIA Considers all media, all types of prints except posters. Most frequently exhibits painting, sculpture, and works on paper.

STYLE Exhibits primitivism, surrealism, political commentary, satire, all styles, postmodern works, all genres. "Gallery exhibits all styles but emphasis is on nontraditional figurative work."

TERMS Accepts work on consignment (50% commission). Retail price set by the gallery and the artist. Gallery provides promotion and contract; artist pays shipping costs to and from gallery. Prefers artwork framed.

SUBMISSIONS Send query letter with résumé, slides, bio and SASE. Call for appointment to show portfolio of originals, photographs, slides, and transparencies. Responds in 3 weeks. Files slides, résumé. Finds artists through word of mouth, art publications and sourcebooks, submissions.

LIZARDI/HARP GALLERY

P.O. Box 91895, Pasadena CA 91109. (626)791-8123. **Fax:** (626)791-8887. **E-mail:** lizardiharp@earthlink. net. **Contact:** Grady Harp, director. Estab. 1981. Retail gallery and art consultancy. Represents 15 emerging, mid-career and established artists/year. Exhibited artists include Wes Hempel, Gerard Huber, and José Parra. Sponsors 4 shows/year. Average display time: 2 months. Open all year; Tuesday-Saturday, by appointment only. 80% private collectors, 20% corporate collectors. Overall price range: $900-80,000; most work sold at $2,000-15,000.

MEDIA Considers oil, acrylic, watercolor, pastel, pen & ink, drawing, mixed media, sculpture, installation, photography, lithographs, and etchings. Most frequently exhibits works on paper and canvas, sculpture, photography.

STYLE Exhibits representational art. Genres include landscapes, figurative work (both portraiture and narrative), and still life. Prefers figurative, landscapes, and experimental.

TERMS Accepts work on consignment (50% commission). Retail price set by the gallery and the artist.

Gallery provides insurance, promotion, contract; artist pays shipping costs.

SUBMISSIONS Send query letter with artist's statement, résumé, 20 slides, bio, photographs, SASE, and reviews. Write for appointment to show portfolio of photographs, slides, and transparencies. Responds in 1 month. Files "all interesting applications." Finds artists through studio visits, group shows, submissions.

TIPS "Timelessness of message (rather than trendy) is a plus. Our emphasis is on quality or craftsmanship, evidence of originality, and maturity of business relationship concept." Artists are encouraged to send an artist's statement with application and at least 10-20 JPEGs.

ANNE LLOYD GALLERY

125 N. Water St., Decatur IL 62523-1025. **E-mail:** sue@decaturarts.org. **Website:** www.decaturarts. org. **Contact:** Sue Powell, gallery director. Estab. 2004. Nonprofit gallery. Approached by 10 artists/year. Represents 20 artists. Exhibits emerging, mid-career, and established artists. Exhibited artists include Seth Casteel (photographer) and Rob O'Dell (watercolor). Sponsors 8 exhibits/year, 1 photography exhibit. Average display time: 1 month. Open Monday–Friday, 8:30-4:30; Saturday, 10-2. Closed major holidays. Located within the Madden Arts Center (community arts center owned/operated by Decatur Area Arts Council) in downtown Decatur IL. Approx. 1,500 sq. ft. space with 113 linear feet wall space; 14 ft. ceilings; 10 ft. high gallery cloth walls. Excellent track/grid lighting. Clients include local community, students, and tourists. 1% of sales are to corporate collectors. Overall price range: $100-5,000. Most work sold at $100-500.

MEDIA Considers all media except installation. Considers all types of prints. Considers all styles. Most frequently exhibits acrylic, oil, and watercolor.

STYLE Considers all styles and genres. Most frequently exhibits abstract representational, conceptual.

TERMS Artwork is accepted on consignment and there is a 35% commission. Retail price set by the artist. Museum provides insurance, promotion, and contract. Accepted work should be framed or mounted. Does not require exclusive representation locally. Art must be appropriate for a family-type venue.

SUBMISSIONS Call; e-mail query letter with link to website and JPEG samples at 72 dpi; or send query letter with artist's statement, bio, CD with images. Can

also mail portfolio for review. Material is returned with SASE. Responds in 4 weeks. Files bio, statement, images, contact info. Finds artists through art exhibits, referrals by other artists, portfolio reviews, art fairs, research online, submissions, and word of mouth.

TIPS "Please include 6-10 images on a CD. This is important."

LOCUST PROJECTS

3852 N. Miami Ave., Miami FL 33127. (305)576-8570. **E-mail:** info@locustprojects.org. **Website:** www.locustprojects.org. **Contact:** Locust Projects. Estab. 1998. Not-for-profit experimental art space. 5,000 sq. ft. Exhibited artists include Theaster Gates (sculpture/installation), Francesca DiMattio (mural/installation), and Ruben Ochoa (sculpture/installation). Sponsors 6+ exhibits/year. Average display time: 4-6 weeks. Open Tuesday–Saturday, 10-5; and by appointment.

MEDIA Most frequently exhibits site-specific installation.

STYLE Exhibits contemporary work.

TERMS Gallery provides promotion. Does not require exclusive representation locally.

SUBMISSIONS Submission details available online.

LONG BEACH ARTS GALLERY

5372 Long Beach Blvd., Long Beach CA 90805. (562)423-9689. **E-mail:** lba@longbeachart.org. **Website:** www.longbeachart.org. Estab. 1924. Since 1924, Long Beach Arts has been a nonprofit art organization and an on-going collaborative venture between local artists and the community. The gallery hosts a wide variety of juried, group exhibitions in most media. Open Wednesday–Sunday, 12-4 (during open exhibitions only).

STYLE Color field, conceptualism, expressionism, impressionism, minimalism, neo-expressionism, primitive realism, surrealism, and painterly abstraction. Considers all genres.

TERMS Artwork is accepted on consignment with a 30% commission. Call or e-mail for further information.

LONGVIEW MUSEUM OF FINE ARTS

215 E. Tyler St., Longview TX 75601. (903)753-8103. **Fax:** (903)753-8217. **E-mail:** fineart@lmfa.org. **Website:** www.lmfa.org. **Contact:** Renee Hawkins, director. Estab. 1958. Contemporary regional art museum representing approximately 12 artists per year plus high school invitational. 840 members. Open all year except Thanksgiving weekend and 2 weeks at year's end; Tuesday–Friday, 10-4; Saturday, 10-2. Located downtown. 35% of space for special exhibitions. Clientele: members, visitors (local and out-of-town), and private collectors. Over 450 objects in private collection. Offers 10% discount to museum members.

MEDIA Most frequently exhibits painting, photography, sculpture, pottery and glass.

TERMS Gallery exhibitors are provided insurance and promotion.

SUBMISSIONS Send website or CD with vitae. Finds artists through art publications and shows in other areas.

LOS ANGELES MUNICIPAL ART GALLERY

4800 Hollywood Blvd., Los Angeles CA 90027. **E-mail:** exh_scanty@sbcglobal.net; info@lamag.com. **Website:** www.lamag.org. **Contact:** Scott Canty, curator. Estab. gallery 1971; support group LAMAGA 1954. City-run, municipally-owned gallery. Exhibits emerging, mid-career, and established artists. Sponsors 8 total exhibits/year. Average display time is 8 weeks. Open Thursday-Sunday, 12-5. A 10,000 sq foot city-run facility located in Barnsdall Park in Hollywood, CA. Clients include local community, students, tourists, and upscale clientele.

MEDIA Accepts all media.

TERMS Gallery provides insurance and promotion.

SUBMISSIONS "Visit our website at lamag.org for upcoming show opportunities." Files artists and proposals of interests. Finds artists through word of mouth, submissions, portfolio review, art exhibits, art fairs, referrals by other artists and the DCA Slide Registry.

LOYOLA UNIVERSITY CHICAGO

Department of Fine and Performing Arts, 1020 W Sheridan Road, Suite 1200, Chicago IL 60660. (773)508-8400. **E-mail:** boxoffice@luc.edu. **Website:** www.luc.edu/dfpa.

STYLE Considers all styles and genres.

MAIN STREET GALLERY

330 Main St., Ketchikan AK 99901. (907)225-2211. **E-mail:** info@ketchikanarts.org; marnir@ketchikanarts.org. **Website:** www.ketchikanarts.org. **Contact:** Marni Rickelmann, program director. Estab. 1953. Nonprofit gallery. Exhibits emerging, mid-career, and established artists. Number of artists represented or exhibited varies based on applications.

Applications annually accepted for March 1 deadline. Sponsors 11 total exhibits/year. Model and property release are preferred. Average display time 20 days- 1 month. Open Monday-Friday, 9-5; Saturday 11- 3. Closed last 2 weeks of December. Located in downtown Ketchikan, housed in renovated church. 800 sq. ft. Clients include local community, students, tourists, upscale. Overall price range of work sold $20-4,000. Most work sold at $150.

MEDIA Considers all media, most frequently exhibits acrylic, mixed media, and oil. Considers all types of prints.

STYLE Considers all styles.

TERMS There is a membership fee plus a donation of time. There is a 25% commission. Retail price set by the artist. Gallery provides insurance, promotion, and contract. Accepted work should be framed and mounted.

SUBMISSIONS E-mail query letter with link to artist's website, 10 JPEG samples at 72 dpi or résumé and proposal. March 1 gallery exhibit deadline for September-August season. Returns material with SASE. Responds in 2 months from March 1 deadline. Files all application materials. Finds artists through word of mouth, submissions, art exhibits, and referrals from other artists.

TIPS Respond clearly to application.

MALTON GALLERY

3804 Edwards Rd., Cincinnati OH 45209. (513)321- 8614. **E-mail:** srombis@maltonartgallery.com. **Website:** www.maltonartgallery.com. **Contact:** Sylvia Rombis, director. Estab. 1974. Retail gallery. Represents about 100 emerging, mid-career, and established artists. Exhibits 20 artists/year. Exhibited artists include Alexa McNeill, Mark Chatterley, Terri Hallman and Dan Miller. Sponsors 7 shows/year (2-person shows alternate with display of gallery artists). Average display time: 1 month. Open all year; Tuesday-Saturday, 11-5; or by appointment. Located in high-income neighborhood shopping district; 2,500 sq. ft. Clientele: private and corporate. Overall price range: $250-10,000; most work sold at $1,000-8,000.

MEDIA Considers oil, acrylic, drawing, sculpture, watercolor, mixed media, pastel, collage, and original handpulled prints.

STYLE Exhibits all styles. Genres include contemporary landscapes, figurative and narrative and abstractions work.

TERMS Accepts work on consignment only (50% commission). Retail price set by artist (sometimes in consultation with gallery). Gallery provides insurance, promotion and contract; artist pays shipping costs to gallery. Prefers unframed works for canvas; unframed works for paper.

SUBMISSIONS E-mail query letter with résumé, pictures, reviews, bio, and SASE. Responds in 4 months. Files résumé, review, or any printed material.

TIPS "Never drop in without an appointment. Be prepared and professional in presentation. This is a business."

BEN MALTZ GALLERY

Otis College of Art & Design, Ground Floor, Bronya and Andy Galef Center for Fine Arts, 9045 Lincoln Blvd., Los Angeles CA 90045. (310)665-6905. **E-mail:** galleryinfo@otis.edu. **Website:** www.otis. edu/benmaltzgallery. Estab. 1957. Nonprofit gallery. Exhibits local, national and international emerging, mid-career and established artists. Sponsors 4-6 exhibits/year. Average display time: 1-2 months. Open Tuesday–Friday, 10-5 (Thursday, 10-9); Saturday-Sunday 12-4; closed Mondays and major holidays. Located near Los Angeles International Airport (LAX); approximately 3,520 sq. ft.; 14-ft. walls. Clients include students, Otis community, local and city community, regional art community, artists, collectors and tourists.

MEDIA Fine art/design. Considers all media, most frequently exhibits paintings, drawings, mixed media, sculpture, and video.

SUBMISSIONS Submission guidelines available online. Submissions via Internet only. Do not send other materials unless requested by the gallery after your initial submission has been reviewed.

TIPS "Follow submission guidelines and be patient. Attend opening receptions when possible to familiarize yourself with the gallery, director, curators and artists."

MANITOU ART CENTER

513 Manitou Ave., Manitou Springs CO 80829. (719)685-1861. **E-mail:** director@thebac.org. **Website:** www.thebac.org. Estab. 1988. The MAC is a nonprofit gallery situated in 2 renovated landmark buildings in the Manitou Springs National Historic District located at 513 and 515 Manitou Ave. Art studios for rent and often include equipment. The Manitou Art Center sponsors 16 exhibits/year in our 5 galleries.

Average display time: 6 weeks-2 months. Gallery open most days, 8-8; closed Tuesday. Overall price range: $50-3,000. Most work sold at $300.

MEDIA Photos of environmental, landscapes/scenics, wildlife, gardening, rural, adventure, health/fitness, performing arts, travel. Interested in alternative process, avant garde, documentary, fashion/glamour, fine art.

TERMS "Artwork is accepted for our open submission and shows and there is a 30% commission." The gallery provides insurance, promotion, and a basic contract. Accepted work should be framed and ready to hang.

SUBMISSIONS Write to arrange a personal interview to show portfolio. "We often find artists through word of mouth, submissions, art exhibits, and referrals by other artists."

MARIN MUSEUM OF CONTEMPORARY ART

500 Palm Dr., Novato CA 94949. (415)506-0137. **Fax:** (415)506-0139. **E-mail:** info@marinmoca.org. **Website:** www.marinmoca.org. **Contact:** Heidi LaGrasta, executive director. Estab. 2007. Nonprofit gallery. Exhibits emerging, mid-career, and established artists. Sponsors 15+ exhibits/year. Model and property release is preferred. Average display time: 5 weeks. Open Wednesday-Sunday, 11-4; closed Thanksgiving, Christmas, New Year's Day. MarinMOCA is located in historic Hamilton Field, a former Army Air Base. The Spanish-inspired architecture makes for a unique and inviting exterior and interior space. Houses 2 exhibition spaces—the Main Gallery (1,633 sq. ft.) and the Ron Collins Gallery (750 sq. ft.). Part of the Novato Arts Center, which also contains approximately 50 artist studios and a classroom (offers adult classes and a summer camp for children). Clients include local community, students, tourists, upscale. Overall price range: $200-20,000; most work sold at $500-1,000.

MEDIA Considers all media except video. Most frequently exhibits acrylic, oil, sculpture/installation.

STYLE Considers all prints, styles, and genres.

TERMS Artwork is accepted on consignment and there is a 40% commission. Retail price of the art set by the artist. Gallery provides insurance, promotion (for single exhibition only, not representation), contract (for consignment only, not representation). Accepted work should be framed (canvas can be unframed, but prints/collage/photos should be framed).

"We do not have exclusive contracts with, nor do we represent artists."

SUBMISSIONS "We are currently not accepting portfolio submissions at this time. Please visit our website for updates. If you are interested in gallery rental, please contact Heidi LaGrasta." Finds artists through word of mouth and portfolio reviews.

TIPS "Keep everything clean and concise. Avoid lengthy, flowery language and choose clear explanations instead. Submit only what is requested and shoot for a confident, yet humble tone. Make sure images are good quality (300 dpi) and easily identifiable regarding title, size, medium."

MARIN-PRICE GALLERIES

7022 Wisconsin Ave., Chevy Chase MD 20815. (301)718-0622. **E-mail:** fmp@marin-price.com. **Website:** www.marin-price.com. Estab. 1992. Retail/wholesale gallery. Represents/exhibits 25 established painters and 4 sculptors/year. Exhibited artists include Joseph Sheppard, March Avery, William Woodward, Jeremiah Stermer, Jenness Cortez and others. Sponsors 24 shows/year. Average display time: 3 weeks. Open Monday–Saturday, 10:30-7; Sunday, 12-5. 1,500 sq. ft. 50% of space for special exhibitions. Clientele: upscale. 90% private collectors, 10% corporate collectors. Overall price range: $5,000-75,000; most work sold at $6,000-18,000.

MEDIA Considers oil, drawing, watercolor, and pastel. Most frequently exhibits oil, watercolor, and pastels.

STYLE Exhibits expressionism, photorealism, neo-expressionism, primitivism, realism, and impressionism. Genres include landscapes, florals, Americana, and figurative work.

TERMS Retail price set by the gallery and the artist. Gallery provides insurance, promotion and contract. Artist pays for shipping costs to and from the artist. Prefers artwork framed.

SUBMISSIONS Prefers only oils. Send query letter with résumé, photo prints, bio, and SASE. Responds in 6 weeks. Will not respond to electronic submissions.

⌂ MARKEIM ARTS CENTER

104 Walnut St., Haddonfield NJ 08033. (856)429-8585. **E-mail:** markeim@verizon.net. **Website:** www.markeimartcenter.org. **Contact:** Elizabeth H. Madden, executive director. Estab. 1956. Nonprofit gal-

lery. Sponsors 10-11 exhibits/year. Average display time: 4 weeks. Overall price range: $75-1,000; most work sold at $350.

MEDIA Considers all media. Must be original. Most frequently exhibits paintings, photography and sculpture.

STYLE Exhibits all styles and genres.

TERMS Charges 30% commission. Accepted work should be framed, mounted or unmounted, matted or unmatted. Artists from New Jersey and Delaware Valley region are preferred. Work must be professional and high quality.

SUBMISSIONS Send slides by mail for consideration. Include SASE, résumé, and letter of intent. Responds in 1 month.

TIPS "Be patient and flexible with scheduling. Look not only for one-time shows, but for opportunities to develop working relationships with a gallery. Establish yourself locally and market yourself outward."

MARLBORO GALLERY

Prince George's Community College, Largo MD 20477. (301)645-0965. **E-mail:** beraulta@pgcc.edu. **Website:** academic.pgcc.edu/art/gallery. **Contact:** Thomas Berault, Curator/Director. Estab. 1976. Interested in emerging, mid-career, and established artists. Sponsors 2 solo and 2 group shows/year. Average display time: 5 weeks. Seasons for exhibition: August-April. 2, 100 sq. ft. with 10-ft. ceilings and 25-ft. clear story over 50% of space track lighting (incandescent) and daylight. Clientele: 100% private collectors. Overall price range: $50-4,000; most work sold at $300-2,500. "We are open to all serious artists and all media. We will consider all proposals without prejudice." Retail price set by artist. Exclusive area representation not required. Gallery provides insurance. Artist pays for shipping. Artwork must be ready for display.

MEDIA Considers all media. Most frequently exhibits acrylics, oils, photographs, watercolors, and sculpture.

STYLE Exhibits mainly expressionism, neo-expressionism, realism, photorealism, minimalism, primitivism, painterly abstraction, conceptualism, and imagism. Exhibits all genres.

TERMS Send cover letter with résumé, CD or digital media, SASE, photographs, artist's statement and bio.

SUBMISSIONS Responds every 6 months. Finds artists through word of mouth, visiting exhibitions, and submissions. Impressed by originality. "Indicate

if you prefer solo shows or will accept inclusion in group show chosen by gallery."

MATHIAS FINE ART

10 Mathias Dr., Trevett ME 04571. (207)633-7404. **Website:** www.mathiasfineart.com. **Contact:** Cordula Mathias, president. Estab. 1991. For-profit gallery. Approached by 20-30 artists/year. Represents 15-20 emerging, mid-career, and established artists. Exhibited artists include Brenda Bettinson and John Lorence. Sponsors 6 exhibits/year. Average display time: 2 months. Open all year, by appointment. Located in mid-coast area of Maine; 400 sq. ft. combination of natural and artificial lighting. Clients include local community, tourists, and upscale. Percentage of sales to corporate collectors varies. Overall price range: $50-25,000; most work sold at $1,200.

MEDIA Considers acrylic, collage, drawing, original prints, mixed media, oil, paper, and pen & ink. Most frequently exhibits painting, drawing, and photography. Considers all types of prints except posters.

STYLE Considers all styles and genres.

TERMS Artwork is accepted on consignment and there is a 50% commission. Retail price set by the gallery and the artist. Gallery provides promotion and contract. Accepted work should be framed and matted. Requires exclusive representation locally. Prefers paintings or works on paper. Prefers artists who can deliver and pick up.

SUBMISSIONS Send query letter with bio, photographs, résumé, reviews and photographs. Returns material with SASE. Responds in 6 weeks. Files CV, artist's statement, visuals if of interest within 6-18 months. Finds artists through word of mouth, submissions, portfolio reviews, art exhibits, and referrals by other artists.

TIPS "Send clearly labeled photographs, well organized vita, and an informative artist's statement. Archival-quality materials are 100% essential in selling fine art to collectors."

NEDRA MATTEUCCI GALLERIES

1075 Paseo De Peralta, Santa Fe NM 87501. (505)982-4631. **Fax:** (505)984-0199. **E-mail:** pr@matteucci.com. **Website:** matteucci.com. Estab. 1972. For-profit gallery. Main focus of gallery is on deceased artists of Taos, Santa Fe, and the West. Approached by hundreds of artists/year. Represents approx. 35 established artists. Exhibited artists include Dan Ostermiller and Glenna Goodacre. Sponsors 3-5 exhibits/

year. Average display time: 1 month. Open all year; Monday–Saturday, 9-5. Clients are upscale.

MEDIA Considers drawing, oil, pen & ink, sculpture, and watercolor. Most frequently exhibits oil, watercolor, and bronze sculpture.

STYLE Exhibits impressionism. Most frequently exhibits impressionism, modernism, and realism. Genres include Americana, figurative work, landscapes, portraits, Southwestern, Western, and wildlife.

TERMS Artwork is accepted on consignment. Retail price set by the gallery and the artist.

SUBMISSIONS Write to arrange a personal interview to show portfolio. Send query letter with bio, photographs, résumé and SASE.

⌂ MAUI HANDS

1169 Makawao Ave, Makawao HI 96768 (808)573-2021. **Fax:** (808)573-2022. **E-mail:** panna@mauihands.com. **Website:** www.mauihands.com. **Contact:** Panna Cappelli, owner. Estab. 1992. For-profit gallery. Approached by 50-60 artists/year. Continuously exhibits 300 emerging, mid-career and established artists. Exhibited artists include Linda Whittemore (abstract monotypes) and Steven Smeltzer (ceramic sculpture). Sponsors 15-20 exhibits/year; 2 photography exhibits/year. Average display time: 1 month. Open Monday-Sunday, 10-7; weekends 10-6; closed on Christmas and Thanksgiving. Three spaces: #1 on Main Highway, 1,200 sq. ft. gallery, 165 sq. ft. exhibition; #2 on Main Highway, 1,000 sq. ft. gallery, 80 sq. ft. exhibition; #3 in resort, 900 sq. ft. gallery, 50 sq. ft. exhibition. Clients include local community, tourists, and upscale. 3% of sales are to corporate collectors. Overall price range: $10-7,000. Most work sold at $350.

MEDIA Considers all media. Most frequently exhibits oils, pastels, and mixed media. Considers engravings, etchings, linocuts, lithographs, and serigraphs.

STYLE Considers painterly abstraction, impressionism, and primitivism realism. Most frequently exhibits impressionism and painterly abstraction. Genres include figurative work, florals, landscapes, and portraits.

TERMS Artwork accepted on consignment with a 55% commission. Retail price of the art set by the gallery and artist. Gallery provides insurance and promotion. Artwork should be framed, mounted, and matted, as applicable. Only accepts artists from Hawaii.

SUBMISSIONS Artists should call, write to arrange personal interview to show portfolio of original pieces, e-mail query letter with link to artist's website (JPEG samples at 72 dpi,) or send query letter with artist's statement, bio, brochure, photographs, résumé, business cards, and reviews. Responds in days. All materials filed. Finds artists through word of mouth, submissions, portfolio reviews, art exhibits, art fairs, and referrals by other artists.

TIPS "Best to submit your work via e-mail."

ERNESTO MAYANS GALLERY

601 Canyon Rd., Santa Fe NM 87501. (505)983-8068. **E-mail:** arte2@aol.com; ernestomayansgallery@gmail.com. **Website:** ernestomayansgallery.com. **Contact:** Ernesto Mayans, director. Estab. 1977. Publishers, retail gallery, and art consulacy. Publishes books, catalogs and portfolios. Overall price range: $200-$5,000. Considers oil, acrylic, watercolor, pastel, pen & ink, drawings, mixed media, sculpture, photography, and original, handpulled prints. Most frequently exhibits oil, photography, and lithographs. Exhibits 20th-century American and Latin American art. Genres include landscapes and figurative work. "We exhibit Digital Chromogenic prints on Metallic Paper by Sibylle Szaggars-Redford, Photogravures by Unai San Martin; Pigment prints by Pablo Mayans, Digital prints by Eric Olson, Silver Gelatin prints by Richard Faller (Vintage Southwest Works) and Johanna Saretzki and Sean McGann (Nudes), Jack Arnold, Tony Bonanno.

TERMS Accepts work on consignment (50% commission). Retail price set by gallery and artist. Requires exclusive representation within area. "Please call before submitting." Arrange a personal interview to show portfolio. Send query by mail with SASE for consideration. Size limited to 11×20 maximum. Responds in 2 weeks.

MCGOWAN FINE ART, INC.

10 Hills Ave., Concord NH 03301. (603)225-2515. **Fax:** (603)225-7791. **E-mail:** art@mcgowanfineart.com. **Website:** www.mcgowanfineart.com. **Contact:** Sarah Chaffee, owner/art consultant. Estab. 1980. Retail gallery and art consultancy. Represents emerging, mid-career, and established artists. Sponsors 8 shows/year. Average display time: 1 month. Located just off Main Street. 50% of space for special exhibitions. Clients include residential and corporate. Most work sold at $125-9,000. Open Tuesday–Friday, 10-6 (though frequently in store on Mondays); Saturday, 10-2; or by ap-

pointment; closed Memorial and Labor Day weekends, Christmas (and Dec. 26), New Year's Day.

MEDIA Considers oil, acrylic, watercolor, pastel, mixed media, collage, works on paper, sculpture, woodcuts, wood engravings, linocuts, engravings, mezzotints, etchings, lithographs, and serigraphs. Most frequently exhibits sculpture, watercolor, and oil/acrylic.

STYLE Exhibits painterly abstraction, landscapes, etc.

TERMS Accepts work on consignment (50% commission). Retail price set by artist. Gallery provides insurance and promotion; negotiates payment of shipping costs. Prefers artwork unframed.

SUBMISSIONS Send query letter with résumé, 5-10 slides and bio. Responds in 1 month. Files materials.

TIPS "I am interested in the number of years you have been devoted to art. Are you committed? Do you show growth in your work?"

MCLEAN PROJECT FOR THE ARTS

McLean Community Center, 1234 Ingleside Ave., McLean VA 22101. (703)790-1953. **E-mail:** info@mpaart.org. **Website:** www.mpaart.org. Nonprofit visual arts center; alternative space. Estab. 1962. Represents emerging, mid-career and established artists from the mid-Atlantic region. Exhibited artists include Yuriko Yamaguchi and Christopher French. Sponsors 12-15 shows/year. Average display time: 5-6 weeks. Open Tuesday–Friday, 10-4; Saturday, 11-5. Luminous "white cube" type of gallery, with moveable walls; 3,000 sq. ft. 85% of space for special exhibitions. Clientele: local community, students, artists' families. 100% private collectors. Overall price range: $200-15,000; most work sold at $800-1,800.

MEDIA Considers all media except graphic design and traditional crafts; all types of prints except posters. Most frequently exhibits painting, sculpture, and installation.

STYLE Exhibits all styles, all genres.

TERMS Artwork is accepted on consignment (25% commission). Retail price set by the artist. Gallery provides insurance and promotion. Artist pays for shipping costs. Prefers framed artwork (if on paper).

SUBMISSIONS Accepts only artists from Maryland, District of Columbia, Virginia and some regional mid-Atlantic. Send query letter with résumé, slides, reviews, and SASE. Responds within 4 months. Artists' bios, slides and written material kept on file for 2 years. Finds artists through referrals by other artists

and curators, and by visiting exhibitions and studios.

TIPS "Visit the gallery several times before submitting proposals, so that the work you submit fits the framework of art presented."

MERIDIAN MUSEUM OF ART

628 25th Ave., P.O. Box 5773, Meridian MS 39302. (601)693-1501. **E-mail:** meridianmuseum@bellsouth.net. **Website:** www.meridianmuseum.org. Estab. 1970. Represents emerging, mid-career, and established artists. Interested in seeing the work of emerging artists. Open Wednesday-Saturday, 11-5. Located downtown; 3,060 sq. ft. These figures refers to exhibit spaces only. The entire museum is about 6,000 sq. ft.; housed in renovated Carnegie Library building, originally constructed 1912-13. 50% of space for special exhibitions. Clientele: general public. Overall price range: $150-2,500; most work sold at $300-1,000.

MEDIA Considers all media.

STYLE Exhibits all styles, all genres.

TERMS Work available for sale during exhibitions. Retail price set by the artist. Gallery provides insurance and promotion; shipping costs are shared. Prefers framed artwork.

SUBMISSIONS Prefers artists from Mississippi, Alabama, and the Southeast. Send query letter with résumé, digital images, bio, and SASE. Responds in 3 months. Finds artists through submissions, referrals, work included in competitions, and visiting exhibitions.

MESA CONTEMPORARY ARTS AT MESA ARTS CENTER

P.O. Box 1466, Mesa AZ 85211. (480)644-6561; (480)644-6567. **E-mail:** patty.haberman@mesaartscenter.com; Boxoffice@mesaartscenter.com. **Website:** www.mesaartscenter.com. **Contact:** Patty Haberman, curator. Estab. 1980.

MEDIA Considers all media including sculpture, painting, printmaking, photography, fibers, glass, wood, metal, video, ceramics, installation, and mixed.

STYLE Exhibits all styles and genres. Interested in seeing contemporary work.

TERMS Charges 25% commission. Retail price set by artist. Gallery provides insurance, promotion, and contract; pays for shipping costs from gallery. Requires framed artwork.

SUBMISSIONS Send a query letter or postcard with a request for a prospectus. After you have reviewed prospectus, send slides of up to 4 works (may include

details if appropriate). "We do not offer portfolio review. Artwork is selected through national juried exhibitions." Files slides and résumés. Finds artists through gallery's placement of classified ads in various art publications, mailing news releases, and word of mouth.

TIPS "Scout galleries to determine their preferences before you approach them. Have professional quality slides. Present only your very best work in a professional manner."

R. MICHELSON GALLERIES

132 Main St., Northampton MA 01060. (413)586-3964. **Fax:** (413)587-9811. **E-mail:** RM@rmichelson.com; PG@RMichelson.com. **Website:** www.rmichelson.com. **Contact:** Richard Michelson, owner and president. Estab. 1976. Retail gallery. Represents 100 emerging, mid-career, and established artists/year. Exhibited artists include Barry Moser and Leonard Baskin. Sponsors 12 shows/year. Average display time 1 month. Open all year; Monday-Wednesday, 10-6; Thursday-Saturday, 10-9; Sunday, 12-5. Located downtown; Northampton gallery has 5,500 sq. ft.; 50% of space for special exhibitions. Clientele: 80% private collectors, 20% corporate collectors. Overall price range $100-75,000; most artwork sold at $1,000-125,000.

MEDIA Considers all media and all types of prints. Most frequently exhibits oil, egg tempera, watercolor and lithography.

STYLE Exhibits illustration, realism, expressionism, and photorealism.

TERMS Accepts work on consignment (commission varies). Retail price set by gallery and artist. Payment by installment is available. Gallery provides promotion; shipping costs are shared.

SUBMISSIONS Prefers Pioneer Valley artists. Not taking on new artists at this time.

MILL BROOK GALLERY & SCULPTURE GARDEN

236 Hopkinton Rd., Concord NH 03301. (603)226-2046. **E-mail:** artsculpt@mindspring.com. **Website:** www.themillbrookgallery.com. Estab. 1996. Exhibits 70 artists. Sponsors 1 photography exhibit/year. Average display time 6 weeks. Gallery open Tuesday–Sunday, 11-5, April 1–December 24; and by appointment. Outdoor juried sculpture exhibit. Three rooms inside for exhibitions, 1,800 sq. ft. Overall price range $8-30,000. Most work sold at $500-1,000.

MEDIA Considers acrylic, ceramics, collage, drawing, glass, mixed media, oil, pastel, sculpture, watercolor, etchings, mezzotints, serigraphs and woodcuts. Most frequently exhibits oil, acrylic and pastel.

STYLE Considers all styles. Most frequently exhibits color field/conceptualism, expressionism. Genres include landscapes. Prefers more contemporary art.

TERMS Artwork is accepted on consignment (50% commission). Retail price set by the artist. Gallery provides insurance, promotion, and contract. Accepted work should be framed and matted.

SUBMISSIONS Provides insurance, promotion and contract. Accepted work should be framed and matted. Write to arrange a personal interview to show portfolio of photographs, slides. Send query letter with artist's statement, bio, photocopies, photographs, résumé, slides, SASE. Submission of artwork: Accept CDs, websites, slides, and digital images. Responds to all artists within month, only if interested. Finds artists through word of mouth, submissions, art exhibits, referrals by other artists.

MILLS POND HOUSE GALLERY

Smithtown Township Arts Council, Smithtown Township Arts Council, 660 Rt. 25 A, St. James NY 11780. **E-mail:** gallery@stacarts.org. **Website:** www.stacarts.org. **Contact:** Gallery coordinator. Nonprofit gallery. Sponsors 7 exhibits/year (1 Juried Photography) (6 Juried Fine Art). Average display time: 4 weeks. Open Wednesday–Friday, 10-4; weekends, 12-4. Considers all types of original artwork, media and styles. Prices set by the artist. Gallery provides insurance and promotion. Work should be framed. Clients: local and national community. Digital entries. Entry information on www.stacarts.org

HAROLD J. MIOSSI ART GALLERY

1504 Colusa Ave., San Luis Obispo CA 93405. (805)546-3201 (Fine Arts Dept.). **Website:** www.cuesta.edu. Estab. 1965. Formerly Cuesta College Art Gallery. Exhibits the work of emerging, mid-career, and established artists. Exhibited artists include Italo Scanga and JoAnn Callis. Sponsors 8 shows/year. Average display time: 4½ weeks. Open all year. 1,300 sq. ft.; 100% for special exhibitions. Overall price range: $250-5,000; most work sold at $400-1,200.

MEDIA Considers all media and all types of prints. Most frequently exhibits painting, sculpture, and photography.

STYLE Exhibits all styles, mostly contemporary.

TERMS Accepts work on consignment (20% commission). Retail price set by artist. Customer payment by installment available. Gallery provides insurance, promotion, and contract; shipping costs are shared. Prefers artwork framed.

SUBMISSIONS Gallery currently not accepting applications. Send query letter with artist statement, slides, bio, brochure, SASE and reviews. Call for appointment to show portfolio. Responds in 6 months. Finds artists mostly by reputation and referrals, sometimes through slides.

TIPS "We have a medium budget, thus cannot pay for extensive installations or shipping. Present your work legibly and simply. Include reviews or a coherent statement about the work. Don't be too slick or too sloppy."

MOBILE MUSEUM OF ART

4850 Museum Dr., Mobile AL 36608-1917. (251)208-5200; (251)208-5221. **E-mail:** dklooz@mobilemuseumofart.com. **Website:** www.mobilemuseumofart.com. **Contact:** Donan Klooz, curator of exhibitions. Clientele: tourists and general public. Sponsors 6 solo and 12 group shows/year. Average display time: 6-8 weeks. Interested in emerging, mid-career, and established artists. Overall price range: $100-5,000; most artwork sold at $100-500.

MEDIA Considers all media and all types of visual art.

STYLE Exhibits all styles and genres. "We are a general fine arts museum seeking a variety of styles, media, and time periods." Looking for "historical significance."

TERMS Accepts work on consignment (20% commission). Retail price set by artist. Exclusive area representation not required. Gallery provides insurance, promotion, contract; shipping costs are shared. Prefers framed artwork.

SUBMISSIONS Send query letter with résumé, brochure, business card, slides, photographs, bio, and SASE. Write to schedule an appointment to show a portfolio, which should include slides, transparencies, and photographs. Replies only if interested within 3 months. Files résumés and slides. All material is returned with SASE if not accepted or under consideration.

TIPS "Be persistent but friendly!"

MONTEREY MUSEUM OF ART - LA MIRADA

720 Via Mirada, Monterey CA 93940. (831)372-3689. **Fax:** (831)372-5680. **E-mail:** info@montereyart.org. **Website:** www.montereyart.org. **Contact:** curatorial department. Estab. 1959. Nonprofit museum. Exhibits the work of emerging, mid-career, and established artists. Average display time: 3-4 months.

MEDIA Considers all media.

STYLE Exhibits contemporary, abstract, impressionistic, figurative, landscape, primitive, nonrepresentational, photorealistic, Western, realist, neo-expressionistic, and postpop works.

TERMS No sales. Museum provides insurance, promotion, and contract; shipping costs are shared.

SUBMISSIONS Send query letter, résumé, 20 slides, and SASE. Portfolio review not required. Résumé and cover letters are filed. Finds artists through agents, visiting exhibitions, word of mouth, various art publications and sourcebooks, submissions/self promotions, art collectors' referrals.

THE MUNSON GALLERY

1455 Main St., Chatham MA 02633. (508)237-5038. **E-mail:** art@munsongallery.net. **Website:** www.munsongallery.com. Estab. 1860. Art consultancy. "One of America's oldest art galleries." Approached by 400 artists/year; exhibits 50 emerging, mid-career, and established artists/year. Exhibited artists include Elmer Schooley (oils on canvas) and Richard Segalman (oils, watercolors and monoprints). Sponsors 9 shows/year. Average display time: 3 weeks. Open all year; Monday-Friday, 9:30-5; weekends, 10-5. Located in a complex that houses about 10 contemporary art galleries. 100% of space for gallery artists. Clientele upscale locals and tourists. Overall price range: $450-150,000; most work sold at $2,000.

MEDIA Considers all media. Considers engravings, etchings, linocuts, lithographs, monotypes, woodcuts, and aquatints. Most frequently exhibits oils, watercolor, pastel.

STYLE Exhibits "contemporary representational, not too much abstract, except in sculpture." Genres include florals, southwestern, landscapes.

TERMS Accepts work on consignment (50% commission). Retail price set by the artist. Gallery provides promotion. Accepted work should be framed.

SUBMISSIONS Send query letter with artist's statement, bio, photographs, résumé, SASE, and slides. Call or write for appointment to show portfolio of photo-

graphs, slides, and transparencies. Responds as soon as possible. Finds artists through portfolio reviews, referrals by other artists, submissions, and word of mouth. Files bios occasionally, announcements.

TIPS "At the moment, the gallery is not taking on any new artists, though portfolios will be reviewed. We will not actually be adding any new artists to our roster for at least a year. Submissions welcome, but with the understanding that this is the case."

THE CATHERINE G. MURPHY GALLERY

Visual Arts Bldg., St. Catherine University, 2004 Randolph Ave., St. Paul MN 55105. (651)690-6637. **E-mail:** kmdaniels@stkate.edu. **Website:** www.stkate. edu/gallery. **Contact:** Kathy Daniels, director. Estab. 1973. Nonprofit gallery. "The Catherine G. Murphy Gallery presents 6-7 exhibitions during each academic calendar year (September–May). These exhibitions are selected a year to a year and a half in advance of the actual show. Five-six of the venues are exhibitions selected from outside proposals representing local, national and international artists. The fifth exhibition, April-May, is set aside for the annual Senior Art Student Juried Show." Represents emerging, mid-career and nationally and regionally established artists. Open Monday–Friday, 8-8; Saturday and Sunday, 12-6 (see website for a list of university holidays and gallery closings). Located in the Visual Arts Building on the campus of St. Catherine University; 1,480 sq. ft.

◔ Gallery shows 75% women's art since it is part of an all-women's undergraduate program.

MEDIA Considers a wide range of media for exhibition.

STYLE Considers a wide range of styles.

TERMS Artwork is loaned for the period of the exhibition. Gallery provides insurance. Shipping costs are shared. Prefers artwork framed.

SUBMISSIONS Send query letter with résumé, bio, artist's statement, CDs, checklist of images (title, size, medium, etc.), and color reproductions of 2-3 images. Include SASE for return of materials. Responds in 6 weeks. Files résumé and cover letters. Serious consideration is given to artists who do group proposals under one inclusive theme. Complete submission guidelines available online.

MICHAEL MURPHY GALLERY M

2701 S. MacDill Ave., Tampa FL 33629. (813)902-1414. **Fax:** (813)835-5526. **Website:** www. michaelmurphygallery.com. **Contact:** Michael

Murphy. Estab. 1988. For-profit gallery. Approached by 100 artists/year; exhibits 35 artists. Sponsors 1 photography exhibit/year. Average display time: 1 month. See website for current gallery hours. Overall price range: $500-15,000; most work sold at less than $1,000. "We provide elegant, timeless artwork for our clients' home and office environment as well as unique and classic framing design. We strongly believe in the preservation of art through the latest technology in archival framing."

MEDIA Considers all media. Most frequently exhibits acrylic, oil, and watercolor. Considers all types of prints.

STYLE Considers all styles. Most frequently exhibits color field, impressionism, and painterly abstraction. Considers all genres.

TERMS Artwork is accepted on consignment and there is a 50% commission. Retail price set by the gallery. Accepted work should be framed. Requires exclusive representation locally.

SUBMISSIONS Send query with artist's statement, bio, brochure, business card, photocopies, photographs, résumé, reviews, SASE, and slides. Cannot return material. Responds to queries only if interested in 1 month. Files all materials. Finds artists through art fairs and exhibits, portfolio reviews, referrals by other artists, submissions, and word of mouth.

MUSEO ITALOAMERICANO

Fort Mason Center, Bldg. C, San Francisco CA 94123. (415)673-2200. **Fax:** (415)673-2292. **E-mail:** sfmuseo@ sbcglobal.net. **Website:** www.museoitaloamericano. org. Estab. 1978. Museum. Approached by 80 artists/ year. Exhibits 15 emerging, mid-career, and established artists/year. Exhibited artists include Sam Provenzano. Sponsors 7 exhibits/year. Average display time: 3-4 months. Open all year; Tuesday-Sunday, 12-4; closed major holidays. Located in the San Francisco Marina District with beautiful view of the Golden Gate Bridge; 3,500 sq. ft. of exhibition space. Clients include local community, students, tourists, upscale, and members. Free admission.

MEDIA Considers all media and all types of prints. Most frequently exhibits mixed media, paper, photography, oil, sculpture, and glass.

STYLE Considers all styles and genres related to Italian or Italian Americans. Most frequently exhibits primitivism realism, geometric abstraction, figurative, and conceptualism; 20th-century and contemporary art.

TERMS "The museum sells pieces in agreement with the artist; and if it does, it takes 25% of the sale." Gallery provides insurance and promotion. Accepted work should be framed, mounted, and matted. Accepts only Italian or Italian-American artists.

SUBMISSIONS Submissions accepted with artist's statement, bio, brochure, photography, résumé, reviews, SASE, and slides or CDs. Returns material with SASE. Responds in 2 months. Files 2 slides, bio, and artist's statement for each artist. Finds artists through word of mouth and submissions.

TIPS Looks for "good-quality slides and clarity in statements and résumés. Be concise."

MUSEUM OF ART, DELAND, FLORIDA, INC.

600 N. Woodland Blvd., DeLand FL 32720. (386)734-4371. **E-mail:** Contact@MoArtDeLand.org. **Website:** www.moartdeland.org. **Contact:** David Fithian, curator of art and exhibitions. Estab. 1951. Exhibits the work of established artists. "The mission of the Museum shall be to promote and showcase Florida art, and emerging and established Florida artists, by providing a wide range of exceptional cultural experiences, exhibitions, and educational and interpretive programming made available to a diverse statewide audience of all ages." Sponsors 8-10 shows/year. Open Tuesday–Saturday, 10-4; Sunday, 1-4. Located near downtown; 5,300 sq. ft.; in the Cultural Arts Center; 18 ft. carpeted walls, 2 gallery areas, including a modern space. Clientele: 85% private collectors, 15% corporate collectors. Overall price range: $100-30,000; most work sold at $300-5,000.

MEDIA Considers oil, acrylic, watercolor, pastel, works on paper, sculpture, ceramic, woodcuts, wood engravings, engravings, and lithographs. Most frequently exhibits painting, sculpture, photographs, and prints.

STYLE Exhibits contemporary art, the work of Florida artists, expressionism, surrealism, impressionism, realism, and photorealism; all genres. Interested in seeing work that is finely crafted and expertly composed, with innovative concepts and professional execution and presentation. Looks for "quality, content, concept at the foundation—any style or content meeting these requirements considered."

TERMS Accepts work on consignment for exhibition period only. Retail price set by artist. Gallery provides insurance, promotion and contract; shipping costs may be shared.

SUBMISSIONS Send résumé, slides, bio, brochure, SASE, and reviews. Files slides and résumé. Reviews slides twice a year.

TIPS "Artists should have a developed body of artwork and an exhibition history that reflects the artist's commitment to the fine arts. Museum contracts 2-3 years in advance. Label each slide with name, medium, size and date of execution."

M.G. NELSON FAMILY GALLERY AT THE SAA

Springfield Art Association, 700 N. Fourth St., Springfield IL 62702. (217)523-2631. **Fax:** (217)523-3866. **E-mail:** director@springfieldart.org. **Website:** www.springfieldart.org. **Contact:** Betsy Dollar, executive director. Estab. 1913. Nonprofit gallery. Exhibits emerging, mid-career and established artists. Sponsors 13 total exhibits/year, including theme-based shows 2-3 times/year. Average display time: 1 month. Open Monday-Friday, 9-5; Saturday, 10-3. Closed Sundays and Christmas-New Year's Day. Located at the Springfield Art Association, campus includes a historic house, museum, and community art school. Clients include local community, students, tourists and upscale clients. 5% of sales are to corporate collectors. Overall price range: $10-5,000; most work sold under $100.

MEDIA Considers all media. Most frequently exhibits paintings (pastel, acrylic, watercolor, oil), mixed media, and sculpture. Considers engravings, etchings, linocuts, lithographs, mezzotints, serigraphs, woodcuts, and alternative forms.

STYLE Considers all styles and genres.

TERMS Artwork is accepted on consignment and there is a 30% commission. Retail price set by the artist. Gallery provides insurance, promotion, and contract. Accepted work should be framed, mounted, and matted—ready to hang.

SUBMISSIONS Call or e-mail query letter with link to artist's website or JPEG samples at 72 dpi. Responds in 2 weeks. Will return material with SASE. Files CV, résumé, printed samples, and business cards. Find artists through word of mouth, submissions, portfolio reviews, art exhibits, art fairs, and referrals by other artists.

TIPS "Good quality images with artist's name included in file name."

NEVADA MUSEUM OF ART

160 W. Liberty St., Reno NV 89501. (775)329-3333. **Fax:** (775)329-1541. **Website:** www.nevadaart.org. **Contact:** Ann Wolfe, senior curator and deputy director. Estab. 1931. Sponsors 12-15 exhibits/year. Average display time: 2-3 months.

MEDIA Considers all media.

STYLE Exhibits all styles and genres.

TERMS Acquires art "by committee following strict acquisition guidelines per the mission of the institution."

SUBMISSIONS Send query letter with slides. Write to schedule an appointment to show a portfolio. "No phone calls and no e-mails, please."

TIPS "We are a museum of ideas. While building upon our founding collections and values, we cultivate meaningful art and societal experiences, and foster new knowledge in the visual arts by encouraging interdisciplinary investigation. The Nevada Museum of Art serves as a cultural and educational resource for everyone."

NEW HARMONY GALLERY OF CONTEMPORARY ART

506 Main St., New Harmony IN 47631. (812)682-3156. **E-mail:** gholstein@usi.edu. **Website:** www.nhgallery. com. **Contact:** Garry Holstein, director. Estab. 1975. Nonprofit gallery. Provides an exhibition space for current Midwestern artists to promote discourse about and access to contemporary art in the southern Indiana region. Approached by 25 artists/year. Represents 7 emerging and mid-career artists. Exhibited artists include Patrick Dougherty, sculpture/installation. Sponsors 7 exhibits/year. Average display time: 6 weeks. Open Tuesday–Saturday, 10-5; Sundays, 12-4 (April-December). Clients include local community, students, tourists, and upscale.

MEDIA Considers all media

STYLE Considers all styles including contemporary. No genre specified.

TERMS Artwork is accepted on consignment and there is a 35% commission. Gallery provides insurance, promotion, and contract. Accepted work should be framed, mounted and matted. Does not require exclusive representation locally. Prefers midwestern artists.

SUBMISSIONS Send query letter with artist's statement, bio, résumé, SASE, and jpgs. Finds artists through art fairs, art exhibits, portfolio reviews, and submissions.

NEW VISIONS GALLERY, INC.

1000 N. Oak Ave., Marshfield WI 54449. (715)387-5562. **E-mail:** info@newvisionsgallery.com. **Website:** www.newvisionsgallery.org. Estab. 1975. Nonprofit educational gallery. Represents emerging, mid-career, and established artists. Located in the lobby of Marshfield Clinic with additional office space and support on the lower level. The facilities are donated to the community program by Marshfield Clinic. "New Visions organizes a dynamic series of changing exhibitions which are displayed in a 1,600-sq.-ft. secure, climate-controlled gallery. Exhibits change every 6-8 weeks and feature a variety of art forms, including national traveling exhibitions, significant works on loan from private and public collections and quality regional art." Does not represent artists on a continuing basis but does accept exhibition proposals. Average display time: 6 weeks. Open all year; Monday–Friday, 9-5:30. Includes a small gift shop with original jewelry, notecards and crafts at $10-100. "We do not show country crafts."

MEDIA Considers all media.

STYLE Exhibits all styles and genres.

TERMS Accepts work on consignment (35% commission). Retail price set by artist. Gallery provides insurance and promotion. Prefers artwork framed.

SUBMISSIONS Send query letter with artist's statement, résumé, SASE, image list, and a CD with 8-10 images in JPEG format. "Images should be at 72 dpi and should not exceed 250 KB. Image files should be labeled with your last name, first initial and number corresponding to the number on your image list (ex. doej-01.jpg)." The image list should include the image file name, artwork title, size of artwork and art medium.

NEXUS/FOUNDATION FOR TODAY'S ART

1400 N. American St., Philadelphia PA 19122. **E-mail:** info@nexusphiladelphia.org. **Website:** www.nexusphiladelphia.org. Estab. 1975. Alternative space; cooperative, nonprofit gallery. Approached by 40 artists/year; represents or exhibits 20 artists. Sponsors 2 photography exhibits/year. Average display time 1 month. Open Wednesday–Sunday, 12-6; closed July and August. Located in Fishtown, Philadelphia; 2 gallery spaces, approximately 750 sq. ft. each. Overall price range: $75-1,200. Most work sold at $200-400.

MEDIA Considers acrylic, ceramics, collage, craft,

drawing, fiber, glass, installation, mixed media, oil, paper, pen & ink, and sculpture. Most frequently exhibits installation and mixed media.

STYLE Exhibits conceptualism, expressionism, neo-expressionism, postmodernism, and surrealism. Most frequently exhibits conceptualism, expressionism, and postmodernism.

TERMS There is no commission for artwork sold by member artists; 30% commission on sales by artists outside of the organization.

SUBMISSIONS Membership reviews are held twice a year in September and February. Artists may submit an applicaton at any time throughout the year. Incomplete applications will not be considered for review. Notification of results will be made within one week of the scheduled review. Applicants cannot be presently enrolled in school and must live within a 50-mile radius of Philadelphia. Go to www.nexusphiladelphia. org/images/memberapp.pdf for an application form.

TIPS "Get great slides made by someone who knows how to take professional slides. Learn how to write a cohesive and understandable artist statement."

NICOLAYSEN ART MUSEUM

400 E. Collins St., Casper WY 82601. (307)235-5247. **E-mail:** info@thenic.org. **Website:** www.thenic.org. **Contact:** Brooks Joyner, executive director. Estab. 1967. Regional contemporary art museum. Average display time: 3-4 months. Interested in emerging, mid-career, and established artists. Sponsors 10 solo and 10 group shows/year. Open all year. Clientele 90% private collectors, 10% corporate clients.

MEDIA Considers all media with special attention to regional art.

STYLE Exhibits all subjects.

TERMS Accepts work on consignment (40% commission). Retail price set by artist. Exclusive area representation not required. Gallery provides insurance, promotion, and shipping costs from gallery.

SUBMISSIONS Send résumé, statement and biography as well as images in digital format. "Due to the volume of correspondence we receive, we may not be able to respond directly to each and every submission, and we cannot assume responisibility for or guarantee the return of any materials that are submitted."

NICOLET COLLEGE ART GALLERY

5355 College Dr., P.O. Box 518, Rhinelander WI 54501. (715)365-4556. **E-mail:** kralph@nicoletcollege.

edu; inquire@nicoletcollege.edu. **Website:** www.nicoletcollege.edu/about/creative-arts-series/art-gallery/index.html. **Contact:** Katy Ralph, gallery director. Exhibits 9-11 different shows each year including the Northern National Art Competition. The deadline for the annual competition is in May. For a prospectus, or more information, contact gallery director, Katy Ralph.

TERMS Call or e-mail for further information.

NKU GALLERY

Northern Kentucky University, Nunn Dr., Highland Heights KY 41099. (859)572-5148. **Fax:** (859)572-6501. **E-mail:** knight@nku.edu. **Website:** artscience.nku. edu/departments/art/galleries.html. **Contact:** David Knight, director of collections and exhibitions. Estab. 1970. University galleries. Represents emerging, mid-career and established artists. Sponsors 10 shows/year. Average display time: 1 month. Open Monday-Friday, 9-9, or by appointment; closed major holidays and between Christmas and New Year's. Located 8 miles from downtown Cincinnati; 3,000 sq. ft.; 2 galleries—1 small and 1 large space with movable walls. 100% of space for special exhibitions. 90% private collectors, 10% corporate collectors. Overall price range: $25-3,000; most work sold at $500.

MEDIA Considers all media and all types of prints. Most frequently exhibits painting, printmaking, and photography.

STYLE Exhibits all styles, all genres.

TERMS Retail price set by the artist. Gallery provides insurance, promotion, and contract; shipping costs are shared. Prefers framed artwork, "but we are flexible." Commission rate is 20%.

SUBMISSIONS "Proposals from artists must go through our art faculty to be considered." Unsolicited submissions/proposals from outside the NKU Department of Visual Arts are not accepted. Unsolicited submissions will be returned to sender.

NO MAN'S LAND MUSEUM

214 E Ave., Goodwell OK 73939. (580)349-2670. **E-mail:** nmlhs@ptsi.net. **Website:** nmlhs.org. Estab. 1934. Represents emerging, mid-career, and established artists. Sponsors 12 shows/year. Average display time: 1 month. Open Tuesday–Saturday, 10-4 (June-August); Tuesday–Friday, 10-12 and 1-3; Saturday, 10-4 (September-May); other times by appointment. Located adjacent to university campus. 10% of space for special exhibitions. Clientele: general, tour-

ist. 100% private collectors. Overall price range: $20-1,500; most work sold at $20-500.

MEDIA Considers all media and all types of prints. Most frequently exhibits oils, watercolors, and pastels.

STYLE Exhibits primitivism, impressionism, photo-realism, and realism. Genres include landscapes, florals, Americana, Southwestern, Western, and wildlife. Prefers realist, primitive, and impressionist.

TERMS "Sales are between artist and buyer; museum does not act as middleman." Retail price set by the artist. Gallery provides promotion and shipping costs to and from gallery. Prefers artwork framed.

SUBMISSIONS Send query letter with résumé, brochure, photographs, and reviews. Call or write for appointment to show portfolio of photographs. Responds only if interested within 3 weeks. Files all material. Finds artists through art publications, exhibitions, news items, word of mouth.

NORMANDALE COLLEGE CENTER GALLERY

9700 France Ave. S., Bloomington MN 55431. (952)481-8121. **Website:** www.normandale.edu/community/fine-arts-gallery. **Contact:** Kristoffer Holmgren. Estab. 1975. Exhibits 6 emerging, mid-career, and established artists/year. Sponsors 6 shows/year. Average display time: 2 months. Open all year. Suburban location; 30 running feet of exhibition space. 100% of space for special exhibitions. Clientele students, staff and community. Overall price range: $25-750; most artwork sold at $100-200.

MEDIA Considers all media and all types of prints. Most frequently exhibits watercolor, photography, and prints.

STYLE Exhibits all styles and genres.

TERMS "We collect 10% as donation to our foundation." Retail price set by artist. Gallery provides insurance, promotion, and contract; artist pays for shipping. Prefers framed artwork.

SUBMISSIONS "Send query letter; we will send application and info." Portfolio should include slides. Responds in 2 months. Files application/résumé.

NORTHCOTE GALLERY

110 Northcote Rd., London SW11 6QP, United Kingdom. **E-mail:** info@northcotegallery.com. **Website:** www.northcotegallery.com. Estab. 1992. Art consultancy, wholesale gallery. Approached by 100 artists/year. Represents 30 emerging, mid-career and estab-

lished artists. Exhibited artists include Daisy Cook and Robert McKellar. Sponsors 16 exhibits/year. Average display time: 3-4 weeks. Open all year; Tuesday-Friday, 11-7; Saturday, 11-6. Located in southwest London. 1 large exhibition space, 1 smaller space; average of 35 paintings exhibited/time. Clientele local community and upscale. 50% corporate collectors. Overall price range: $400-12,000; most work sold at $1,500.

MEDIA Considers acrylic, ceramics, drawing, glass, mixed media, oil, paper, photography, sculpture, watercolor, engravings, etchings, and lithographs.

STYLE Exhibits conceptualism, expressionism, impressionism, painterly abstraction, and postmodernism. Considers all genres.

TERMS Artwork is accepted on consignment (45% commission). Retail price set by the gallery. Gallery provides promotion. Accepted work should be framed.

SUBMISSIONS Send query letter with artist's statement, bio, brochure, photograph, résumé, reviews, and SASE. Returns material with SASE. Responds in 4-6 weeks. Finds artists through word of mouth, submissions, portfolio reviews, and referrals by other artists.

NORTHWEST ART CENTER

Minot State University, 500 University Ave. W., Minot ND 58707. (701)858-3264. **Fax:** (701)858-3894. **E-mail:** nac@minotstateu.edu. **Website:** www.minotstateu.edu/nac. Estab. 1969.

MEDIA Considers all media. Special interest in printmaking, works on paper, contemporary art and drawings.

STYLE Exhibits all styles, all genres.

TERMS Accepted work should be framed and mounted. Artwork is accepted on consignment with a 30% commission. Retail price set by the artist. Gallery provides insurance, promotion and contract.

SUBMISSIONS Send query letter with artist's statement, photocopies bio, résumé, and reviews. Returns material with SASE. Responds, if interested, within 3 months. Finds artists through art exhibits, submissions, referrals by other artists and entries in our juried competitions.

NOYES ART GALLERY

119 S. Ninth St., Lincoln NE 68508. (402)475-1061. **E-mail:** julianoyes@aol.com. **Website:** www.noyesartgallery.com. **Contact:** Julia Noyes, owner.

Estab. 1992. For-profit gallery. "The Noyes Gallery is a co-op type art gallery, featuring approximately 65 artist members, showing their work and volunteering their time to help operate the business. The gallery features a variety of original painting, photos, pottery, and jewelry. We have recently expanded the gallery adding a classroom and additional display space to our facility." Average display time: 1 month minimum. ("If mutually agreeable, this may be extended or work exchanged.") Open Monday–Saturday, 10-5. Located downtown, near historic Haymarket District; 3,093 sq. ft.; renovated 128-year-old building. 25% of space for special exhibitions. Clientele: private collectors, interior designers, and decorators. 90% private collectors, 10% corporate collectors. Overall price range: $100-20,000; most work sold at $200-2550.

MEDIA Considers oil, acrylic, watercolor, pastel, pen & ink, drawings, mixed media, collage, paper, sculpture, ceramic, fiber, glass, and photography; original handpulled prints, woodcuts, wood engravings, linocuts, engravings, mezzotints, etchings, lithographs, and serigraphs. Most frequently exhibits oil, watercolor and mixed media.

STYLE Exhibits expressionism, neo-expressionism, impressionism, realism, photorealism. Genres include landscapes, florals, Americana, wildlife, figurative work. Prefers realism, expressionism, photorealism.

TERMS Accepts work on consignment (15 to 35% commission). Retail price set by artist (sometimes in conference with director). Gallery provides promotion and contract; patron pays for shipping.

SUBMISSIONS Send query CD with résumé, slides, bio, SASE; label slides or CD concerning size, medium, price, top, etc. Submit at least 6-8 Reviews submissions monthly. Responds in 1 month. Files résumé, bio and slides of work by accepted artists (unless artist requests return of slides).

NUANCE GALLERIES

804 S. Dale Mabry, Tampa FL 33609. (813)875-0511. **E-mail:** nuancegalleries@earthlink.net. **Website:** www.nuancegalleries.com. **Contact:** Robert Rowen, owner. Estab. 1981. Retail gallery. Represents 70 emerging, mid-career, and established artists. Sponsors 3 shows/year. Open all year; Monday-Friday, 10-5; Saturday, 10-4. 3,000 sq. ft. "We've reduced the size of our gallery to give the client a more personal touch. We have a large extensive front window area."

MEDIA Specializing in watercolor, original mediums, and oils.

STYLE "The majority of the work we like to see are realistic landscapes, escapism pieces, bold images, bright colors, and semitropical subject matter. Our gallery handles quite a selection, and it's hard to put us into any one class."

TERMS Accepts work on consignment (50% commission). Retail price set by gallery and artist. Offers customer discounts and payment by installments. Gallery provides insurance and contract; shipping costs are shared.

SUBMISSIONS Send query letter with slides and bio, SASE if you want slides/photos returned. Portfolio review requested if interested in artist's work.

TIPS "Be professional; set prices (retail) and stick with them. There are still some artists out there that are not using conservation methods of framing. As far as submissions, we would like local artists to come by to see our gallery and get the idea of what we represent. Tampa has a healthy growing art scene, and the work has been getting better and better. But as this town gets more educated, it is going to be much harder for up-and-coming artists to emerge."

OPENING NIGHT GALLERY

2836 Lyndale Ave. S., Minneapolis MN 55408-2108. (612)872-2325. **Fax:** (612)872-2385. **E-mail:** deen@onframe-art.com; info@onframe-art.com. **Website:** www.onframe-art.com. **Contact:** Deen Braathen. Estab. 1975. Rental gallery. Approached by 40 artists/year; represents or exhibits 15 artists. Sponsors 1 photography exhibit/year. Average display time 6-10 weeks. Gallery open Monday–Friday, 8:30-5; Saturday, 10:30-4. Overall price range $300-12,000. Most work sold at $2,500.

MEDIA Considers acrylic, ceramics, collage, drawing, fiber, glass, oil, paper, sculpture, and watercolor.

STYLE Exhibits local and regional art.

TERMS Artwork is accepted on consignment, and there is a 50% commission. Retail price set by the gallery. Gallery provides insurance, promotion, and contract.

SUBMISSIONS "E-mail Deen with cover letter, artist statement, and visuals."

ORANGE COUNTY CENTER FOR CONTEMPORARY ART

117 N. Sycamore St., Santa Ana CA 92701. (714)667-1517. **E-mail:** info.occca@gmail.com. **Website:** www.

occca.org. Cooperative, nonprofit gallery. Exhibits emerging and mid-career artists. 18 members. Sponsors 8-10 shows/year. Average display time: 1 month. Open all year; Thursday—Sunday, 12-5; closed major holidays. Opening receptions first Saturday of every month, 6-10 p.m. Gallery space: 5,500 sq. ft. 25% of time for gallery artists exhibitions; 75% of time for collaboration, calls for art and curatorial exhibitions. Membership fee: $30/month.

MEDIA Considers all media-contemporary work.

TERMS Co-op membership fee plus a donation of time. Retail price set by artist.

SUBMISSIONS Accepts artists generally in and within 50 miles of Orange County. E-mail 3 images of current work format the items with "your_name_title. jpeg;" include a brief description of your work, an exhibition résumé, and a website link to your work. Subject line of e-mail should read "New membership submission (your name, date)." Responds in 1 week. More information about the membership process is available online.

TIPS "This is an artist-run nonprofit. Send SASE for application prospectus. Membership involves 10 hours per month of volunteer work at the gallery or gallery-related projects."

OXFORD GALLERY

267 Oxford St., Rochester NY 14607. (585)271-5885. **E-mail:** info@oxfordgallery.com. **Website:** www.oxfordgallery.com. Estab. 1961. Retail gallery. Represents 60 emerging, mid-career, and established artists. Sponsors 6 shows/year. Average display time: 5 weeks. Open all year; Tuesday-Friday, 12-5; Saturday, 10-5; and by appointment. Located "on the edge of downtown; 1,000 sq. ft.; large gallery in a beautiful 1924 building." Overall price range: $100-30,000; most work sold at $1,000-2,000.

MEDIA Considers oil, acrylic, watercolor, pastel, pen & ink, drawings, mixed media, collage, paper, sculpture, ceramic, fiber, original handpulled prints, woodcuts, engravings, lithographs, wood engravings, mezzotints, serigraphs, linocuts, and etchings.

STYLE All styles.

TERMS Accepts artwork on consignment (50% commission). Retail price set by gallery and artist. Gallery provides promotion and contract.

SUBMISSIONS Send query letter or e-mail with résumé, digital images, bio, and SASE. Responds in 3 months.

TIPS "Have good photos done of your artwork. Have a professional résumé and portfolio. Do not show up unannounced and expect to show your work. Either send in your information or call to make an appointment. An artist should have enough work to have a solo show (20-30 pieces). This allows an artist to be able to supply more than one gallery at a time, if necessary. It is important to maintain a strong body of available work."

PAINTERS ART GALLERY

30517 St. Rt. 706 E., Ashford WA 98304. (360)569-2644. **E-mail:** mtwoman2@centurytel.net. **Website:** www.painterartbeads.com and www.paintersartgallery.com. **Contact:** Joan Painter, owner. Estab. 1971. Retail gallery. Represents 3 emerging, mid-career, and established artists. Open all year. Hours are chaotic, please call ahead to be sure you will not be wasting a trip. Located 5 miles from the entrance to Mt. Rainier National Park; 1,200 sq. ft. 70% of space for work of gallery artists. Clientele: collectors and tourists. Overall price range: $10-7,500; most work sold at $300-2,500.

○ It is a very informal, outdoors atmosphere.

MEDIA Considers oil, acrylic, watercolor, pastel, mixed media. "I am seriously looking for totem poles and outdoor carvings." Most frequently exhibits oil, pastel, and acrylic.

STYLE Exhibits primitivism, surrealism, imagism, impressionism, realism, and photorealism. All genres. Prefers Mt. Rainier themes and wildlife. "Indians and mountain men are a strong sell."

TERMS Accepts artwork on consignment (30% commission). Retail price set by gallery and artist. Gallery provides promotion; artist pays for shipping. Prefers artwork framed.

SUBMISSIONS Send query letter or call. "I can usually tell over the phone if artwork will fit in here." Portfolio review requested if interested in artist's work. Does not file materials.

TIPS "Sell paintings and retail price items for the same price at mall and outdoor shows that you price them in galleries. I have seen artists underprice the same paintings/items, etc., when they sell at shows. Do not copy the style of other artists. To stand out, have your own style."

PAINTER'S CHAIR FINE ART GALLERY

223 Sherman Ave., Coeur d'Alene ID 83814. (208)667-3606. **E-mail:** info@painterschairfineart.com. **Website:** www.painterschairfineart.com.

MEDIA Considers all media.

STYLE Exhibits all styles from realism and impressionism to contemporary and abstract. Genres include, but are not limited to, landscapes, floral, still life, Western, and wildlife.

TERMS Accepts artwork on consignment. Retail price set by gallery and artist. Gallery provides promotion and contract; artist pays for shipping. Prefers artwork framed.

SUBMISSIONS Submit portfolio with introduction letter, bio, photographs/slides, SASE (for return of materials if desired), website, and other useful information. Gallery prefers portfolio and/or website submissions via e-mail. Files all material for 6-12 months. See website for further details.

TIPS "Painter's Chair Fine Art Gallery now has a complete custom frame shop with 23 years experience in framing."

✚ PALLADIO GALLERY

2231 Central Ave., Memphis TN 38104. (901)276-1251. **E-mail:** rollin@galleryfiftysix.com. **Website:** www.galleryfiftysix.com. Blog: www.galleryfiftysix.blogspot.com. **Contact:** Rollin Kocsis, director. Estab. 2008. For-profit gallery. Approached by 35 artists/year; represents or exhibits 24 emerging, mid-career and established artists. Exhibited artists include John Armistead (oil on canvas), Bryan Blankenship (painting and ceramics), Terry Kenney, and Joseph Morzuch (painting). Sponsors 12 exhibits/year. Model and property release are preferred. Average display time: 1 month. Open Monday-Saturday, 10-5. Contains 1 large room with 1 level. Clients include local community, students, tourists and upscale. Overall price range: $200-3,000. Most work sold at $750.

MEDIA Considers acrylic, ceramics, collage, drawing, fiber, glass, mixed media, oil, pastel, pen & ink, sculpture, watercolor. Most frequently exhibits oil on canvas, acrylic on canvas, assemblages. Considers engravings, etchings, linocuts, serigraphs, woodcuts.

STYLE Considers color field, expressionism, geometric abstraction, imagism, impressionism, pattern painting, postmodernism, primitivism realism, surrealism, painterly abstraction. Most frequently exhibits realism, abstract, expressionism. Considers all genres. No nudes.

TERMS Artwork is accepted on consignment and there is a 50% commission. Gallery provides promotion and contract. Accepted work should be gallery wrapped or frames with black or natural wood finish. Requires exclusive representation locally.

SUBMISSIONS E-mail 8-12 JPEGs. Write to arrange personal interview to show portfolio of photographs, e-mail JPEG samples at 72 dpi or send query letter with artist's statement, bio, brochure, business card, photographs, résumé, reviews, and SASE. Material returned with SASE. Responds in 2 weeks. Files JPEGs, CDs, photos. Finds artists through word of mouth, submissions, portfolio reviews, art exhibits, and referrals by other artists.

TIPS "Send good quality photos, by e-mail, with all important information included. Not interested in installations or subject matter that is offensive, political, sexual, or religious."

PARADISE CENTER FOR THE ARTS

321 Central Ave., Faribault MN 55021. (507)332-7372. **E-mail:** info@paradisecenterforthearts.org. **Website:** www.paradisecenterforthearts.org. **Contact:** Operations Manager - Julie Fakler. Formerly Faribault Art Center, Inc. Nonprofit gallery. Represents 26-30 emerging and mid-career artists/year. 650 members. Sponsors 8 theatre shows/year. Auditorium features regular events including comedy, live music, and special events. Average display time: 6-8 weeks. Open all year; Tuesday–Saturday, 12-5; Thursday, 12-8 and 1 hour before all events. Education classes in all mediums. Located downtown; 1,600 sq. ft. 50% of space for special exhibitions; 50% of space for gallery artists. Clientele: local and tourists. 90% private collectors.

MEDIA Considers all media and all types of prints.

STYLE Open.

TERMS Accepts work on consignment (30% commission). Retail price set by the artist. Artist pays for shipping. Prefers artwork framed.

SUBMISSIONS Accepts local and regional artists. Send query letter with CD with 6-10 JPEG images, artist résumé, and artist's statement. Call or write for appointment to show portfolio of photographs. Artists are to follow "The Call for Artists" on the Paradise website. Finds artists through word of mouth, referrals by other artists, visiting art fairs and exhibitions and submissions.

TIPS "Artists should respond quickly upon receiving reply."

● PARK WALK GALLERY

20 Park Walk, London SW10 0AQ, United Kingdom. 44(0) 207-351-0410. **E-mail:** mail@jonathancooper. co.uk. **Website:** www.jonathancooper.co.uk. **Contact:** Jonathan Cooper, gallery owner. Estab. 1988. Approached by 5 artists/year. Gallery represents 30 artists. Approached 60 artists/year. Exhibited artists include Kate Nessler. Sponsors 8 exhibits/year. Average display time: 3 weeks. Open all year; Monday-Saturday, 10-6:30; Sunday, 11-4. Located in Park Walk,which runs between Fulham Road to Kings Road. Clientele: upscale. 10% corporate collectors. Most work sold at £2,000-20,000.

MEDIA Considers drawing, mixed media, oil, paper, pastel, pen & ink, photography, sculpture, watercolor. Most frequently exhibits watercolor, oil, and sculpture.

STYLE Exhibits conceptualism, impressionism. Genres include florals, landscapes, wildlife, equestrian.

TERMS Artwork is accepted on consignment (50% commission). Retail price set by the gallery. Gallery provides promotion. Requires exclusive representation locally.

SUBMISSIONS Call to arrange a personal interview to show portfolio. Returns material with SASE. Responds in 1 week. Finds artists through submissions, portfolio reviews, art exhibits, art fairs, referrals by other artists.

TIPS "Include full curriculum vitae and photographs of work."

THE PARTHENON

2500 West End Ave., Nashville TN 37203. (615)862-8431. **Fax:** (615)880-2265. **E-mail:** info@parthenon. org. **Website:** www.parthenon.org. Estab. 1931. Nonprofit gallery in a full-size replica of the Greek Parthenon. Exhibits the work of emerging to mid-career artists. Sponsors 3-4 shows/year. Average display time: 3-4 months. Clientele: general public, tourists. Overall price range: $300-2,000. "We also house a permanent collection of American paintings (1765-1923)."

MEDIA Considers "nearly all" media.

STYLE "Interested in both objective and nonobjective work. Professional presentation is important."

TERMS "Sales request a 20% donation." Retail price set by artist. Gallery provides a contract and limited promotion. The Parthenon does not represent artists on a continuing basis.

SUBMISSIONS Send images via CD, résumé and artist's statement addressed to curator.

TIPS "We plan our gallery calendar at least one year in advance." Find us on Facebook: "The Parthenon in Nashville."

PENTIMENTI GALLERY

145 N. Second St., Philadelphia PA 19106. **Website:** www.pentimenti.com. **Contact:** Christine Pfister, director. Estab. 1992. Commercial gallery. Represents 20-30 emerging, mid-career, and established artists. Sponsors 7-9 exhibits/year. Average display time: 4-6 weeks. Open all year; Tuesday by appointment; Wednesday-Friday, 11-5; Saturday, 12-5; closed Sundays, August, Christmas, and New Years. Located in the heart of Old City cultural district in Philadelphia.

MEDIA Considers all media. Most frequently exhibits paintings of all media.

STYLE Exhibits conceptualism, minimalism, postmodernism, painterly abstraction, and representational works. Most frequently exhibits postmodernism, minimalism, and conceptualism.

TERMS Artwork is accepted on consignment. Retail price set by the gallery and the artist. Gallery provides insurance and promotion. Requires exclusive representation locally.

SUBMISSIONS Please review our guidelines in our website.

PETERS VALLEY SCHOOL OF CRAFT

19 Kuhn Rd., Layton NJ 07851. (973)948-5202. **Fax:** (973)948-0011. **E-mail:** gallery@petersvalley.org; info@petersvalley.org. **Website:** www.petersvalley. org. **Contact:** Brienne Rosner, gallery manager. Estab. 1970. Nonprofit exhibition and retail gallery. Approached by about 100 artists/year. Represents about 350 artists. Exhibited artists include William Abranowitz and Clyed Butcher. Average display time vaires for store items. Gallery exhibitions approx. 1 month duration. Open year round, call for hours. Located in northwestern New Jersey in Delaware Water Gap National Recreation Area; 2 floors; approximately 3,000 sq. ft. Clients include local community, students, tourists, and upscale. 5% of sales are to corporate collectors. Overall price range $5-3,000; most work sold at $100-300.

MEDIA "Focuses its programs on fine contemporary crafts in mediums such as ceramics, metals (both fine and forged), glass, wood, photography, fibers (surface

design and structural), print." Considers all media and all types of prints. Also exhibits nonreferential, mixed media, collage, and sculpture.

TERMS Artwork is accepted on consignment and there is a 60% commission. Retail price set by the gallery in conjunction with artist. Gallery provides insurance and promotion. Accepted work should be framed, mounted, and matted.

SUBMISSIONS Submissions reviewed on an ongoing basis. Send e-mail with artist's statement, bio, résumé, and images. Responds in 2 months. Finds artists through submissions, art exhibits, art fairs, and referrals by other artists. "Submissions must be neat and well-organized throughout."

◑ PHILLIPS GALLERY

444 E. 200 S., Salt Lake City UT 84111. (801)364-8284. **Fax:** (801)364-8293. **Website:** www.phillipsgallery.com. **Contact:** Meri DeCaria, director/curator. Estab. 1965. Retail gallery, art consultancy, rental gallery. Represents 80 emerging, mid-career, and established artists/year. Exhibited artists include Denis Phillips, Connie Borup, Hyunmee Lee, Cordell Taylor. Sponsors 10 shows/year. Average display time: 1 month. Open all year; Tuesday-Friday, 11-6; Saturday, 11-4; closed December 25-January 1. Located downtown; has 3 floors at 2,000 sq. ft. and a 2,400 sq. ft. sculpture deck on the roof. 40% private collectors, 60% corporate collectors. Overall price range: $100-18,000; most work sold at $200-4,000.

MEDIA Considers all media, woodcuts, engravings, lithographs, wood engravings, linocuts, etchings. Most frequently exhibits oil, acrylic, sculpture/steel.

STYLE Exhibits expressionism, conceptualism, neo-expressionism, minimalism, pattern painting, primitivism, color field, hard-edge geometric abstraction, painterly abstraction, postmodern works, realism, surrealism, impressionism. Genres include Western, Southwestern, landscapes, figurative work, contemporary. Prefers abstract, neo-expressionism, conceptualism.

TERMS Accepts work on consignment (50% commission). Gallery does not provide insurance and promotion; shipping costs are shared. Prefers artwork framed.

SUBMISSIONS Accepts only artists from western region/Utah. Accepts digital submissions only. Finds artists through word of mouth, referrals.

PIERRO GALLERY OF SOUTH ORANGE

Baird Center, 5 Mead St., South Orange NJ 07079. (973)378-7754. **Fax:** (973)378-7833. **E-mail:** pierrogallery@southorange.org; smartiny@southorange.org; arts@southorange.org. **Website:** www.pierrogallery.org. **Contact:** Sandy Martiny, gallery director. Estab. 1994. Nonprofit gallery. Approached by 75-185 artists/year; represents or exhibits 25-50 artists. Average display time: 5 weeks. Open Wednesday–Thursday, 2-7; Friday, 1-4; Saturday, 1-4 and by appointment; closed July-August. Overall price range: $100-10,000; most work sold at $800.

TERMS Artwork is accepted on consignment, and there is a 15% commission. Gallery provides insurance, promotion, contract. Accepted work should be framed.

SUBMISSIONS Mail portfolio for review. Send cover letter, biography and/or résumé, brief artist statement, up to 3 reviews/press clippings, representation of work in either CD or DVD format; no more than 10 labeled representative images. Responds in 2 months from review date. Finds artists through word of mouth, submissions, portfolio reviews, referrals by other artists.

◑ POCATELLO ART CENTER GALLERY & SCHOOL

444 N. Main St., Pocatello ID 83204. (208)232-0970. **E-mail:** pocartctr@ida.net. **Website:** www.pocatelloartctr.org. Estab. 1970. Nonprofit gallery featuring work of artist/members. Represents approximately 60 emerging, mid-career, and established artists/year. Approximately 150 members. Exhibited artists include Barbara Ruffridge, Jerry Younkin, Onita Asbury and Barbara Swanson. Sponsors 10-12 shows/year. Average display time: 2 months. Open all year; Monday-Friday, 10-4 (varies occasionally). Located downtown in "Old Town." "We sponsor the 'Sagebrush Arts Fest each year, usually in September, on the Idaho State University campus." We hold classes, feature all levels of artists, and are a gathering place for artists. Clientele: tourists, local community, students, and artists. 100% private collectors. Overall price range: $25-1,000; most work sold at $25-300.

MEDIA Considers oil, acrylic, watercolor, pastel, pen & ink, drawing, mixed media, collage, paper, sculpture, ceramics, high-end craft, fiber, glass, and photography; types of prints include woodcuts, engravings, wood engravings, serigraphs, linocuts, and etchings.

Most frequently exhibits watercolor, oil, and pastel.

STYLE Exhibits expressionism, neo-expressionism, primitivism, painterly abstraction, surrealism, minimalism, impressionism, photorealism, hard-edge geometric abstraction, realism, and imagism. Exhibits all genres. Prefers impressionism, realism, and painterly abstraction.

TERMS Co-op membership fee plus donation of time. Donations-monetary. Retail price set by the artist. Gallery provides promotion; hand-delivered works only. Prefers artwork framed.

SUBMISSIONS Accepts only artists from Southeast Idaho. Memberships open to all artists and persons interested in the visual arts. Send query letter or visit gallery. Finds artists through word of mouth, referrals by other artists, visiting art fairs and exhibitions.

TIPS "Have work ready to hang."

POLK MUSEUM OF ART

800 E. Palmetto St., Lakeland FL 33801-5529. (863)688-7743, ext. 241 or 289. **Fax:** (863)688-2611. **E-mail:** kpope@polkmuseumofart.org. **Website:** www.polkmuseumofart.org. **Contact:** Kalisa Pope, curatorial assistant. Estab. 1966. Approached by 75 artists/year; represents or exhibits 3 artists. Sponsors 15 exhibits/year. Open Tuesday-Saturday, 10-5; Sunday, 1-5; closed Mondays and major holidays; reduced hours June-August. Four different galleries of various sizes and configurations. "Because we are a small institution, we do not regularly review submissions. Our curator will be happy to look at your slides, but he may not be able to respond immediately."

MEDIA Considers all media. Most frequently exhibits prints, photos, and paintings. Considers all types of prints except posters.

STYLE Considers all styles and genres, provided the artistic quality is very high.

TERMS Gallery provides insurance, promotion, and contract. Accepted work should be framed.

SUBMISSIONS Mail portfolio for review. Send query letter with artist's statement, bio, résumé, and SASE. Returns material with SASE. Reviews 2-3 times/year and responds shortly after each review. Files slides or CDs and résumé.

PORTFOLIO ART GALLERY

2007 Devine St., Columbia SC 29205. (803)256-2434. **E-mail:** portfolioartgal@gmail.com. **Website:** www. portfolioartgal.com. **Contact:** Judith Roberts, gallery director. Estab. 1980. Retail gallery and art consultancy. Represents 40-50 emerging, mid-career, and established artists. Exhibited artists include Junko Ono Rothwell, Sigmund Abeles, Holle Black, and Shannon Bueker. Sponsors 3 shows/year. Average display time: 3 months. Open Monday–Friday, 11-6; Saturday, 10-6. Located in a 1930s shopping village, 1 mile from downtown; 2,000 sq. ft.; features 12-ft. ceilings. 100% of space for work of gallery artists. "A unique feature is glass shelves where matted and small to medium pieces can be displayed without hanging on the wall." Clientele: professionals and collectors. Overall price range: $150-5,000; most work sold at $600-3,000.

Gallery director Judith Roberts has a fine arts degree with an intensive in printmaking and is a former art teacher. Also named "A Top 100 Retailer of American Crafts."

MEDIA Considers oil, acrylic, watercolor, pastel, mixed media, collage, works on paper, sculpture, ceramic, glass, original handpulled prints, woodcuts, wood engravings, linocuts, engravings, mezzotints, etchings, lithographs, and serigraphs. Most frequently exhibits oils, acrylics, ceramics and sculpture, and original jewelry.

STYLE Exhibits neo-expressionism, painterly abstraction, imagism, minimalism, color field, impressionism, and realism. Genres include landscapes and figurative work. Prefers landscapes/seascapes, painterly abstraction, and figurative work. "I especially like mixed-media pieces, original prints, and oil paintings. Pastel medium and watercolors are also favorites, as well as kinetic sculpture and whimsical clay pieces."

TERMS Accepts work on consignment (40% commission). Retail price set by gallery and artist. Offers payment by installments. Gallery provides insurance, promotion and contract; artist pays for shipping. Artwork may be framed or unframed.

SUBMISSIONS Send query letter with bio and images via e-mail, CD or slides. Write for appointment to show portfolio of originals, slides, photographs, and transparencies. Responds within 1 month, only if interested. Files tearsheets, brochures, and slides. Finds artists through visiting exhibitions and referrals.

TIPS "The most common mistake beginning artists make is showing all the work they have ever done. I want to see only examples of recent best work—unframed, originals (no copies)—at portfolio reviews."

PORT WASHINGTON PUBLIC LIBRARY

One Library Dr., Port Washington NY 11050. (516)883-4400. **E-mail:** library@pwpl.org. **Website:** www.pwpl.org/artgallery. Estab. 1970. Nonprofit gallery. Represents 10-12 emerging, mid-career, and established artists/year. 23 members. Exhibited artists include Frank Stella, Robert Dash. Sponsors 10-12 shows/year. Average display time: 1 month. Open all year; Monday, Tuesday, Thursday, Friday, 9-9; Wednesday, 11-9; Saturday, 9-5; Sunday, 1-5 (except in the summer). See website for holiday closings. 972 sq. ft. Overall price range: up to $100,000.

MEDIA Considers all media and all types of prints.

STYLE Exhibits all styles.

TERMS Price set by the artist. Gallery provides insurance and promotion.

SUBMISSIONS Send query letter with résumé, slides, bio, SASE. Or contact via online submission form. Responds in 1 month. Artist should call library. Finds artists through word of mouth, referrals by other artists, visiting art fairs and exhibitions, and submissions.

POSNER FINE ART

1212 S. Point View St., Los Angeles CA 90035. (323)933-3664. **Fax:** (323)933-3417. **E-mail:** info@ posnerfineart.com. **Website:** www.posnerfineart. com. **Contact:** Wendy Posner, Owner. Estab. 1960. Private fine art dealer and art publisher. Represents 200 emerging, mid-career, and established artists. By appointment only. Clientele: upscale and collectors; 50% private collectors, 50% corporate collectors. Overall price range: $25-50,000; most work sold at $500-10,000.

○ See additional listing in the Posters & Prints section.

MEDIA Considers oil, acrylic, watercolor, pastel, mixed media, collage, works on paper, sculpture, ceramics, original hand-pulled prints, engravings, etchings, lithographs, posters, and serigraphs. Most frequently exhibits paintings, sculpture, and original prints.

STYLE Exhibits painterly abstraction, minimalism, impressionism, realism, photorealism, pattern painting, and hard-edge geometric abstraction. Genres include florals and landscapes. Prefers abstract, trompe l'oeil, realistic.

TERMS Accepts work on consignment (50% commission). Retail price set by the gallery. PFA provides insurance and promotion; shipping costs are shared. Prefers unframed artwork.

SUBMISSIONS E-mail query letter with résumé and images. Responds in 2 weeks, only if interested. Finds artists through submissions and art collectors' referrals.

TIPS Looking for artists for corporate and private collections.

THE PRINT CENTER

1614 Latimer St., Philadelphia PA 19103. (215)735-6090. **Fax:** (215)735-5511. **E-mail:** info@printcenter. org. **Website:** www.printcenter.org. Estab. 1915. Exhibits emerging, mid-career, and established artists. Approached by 500 artists/year. Sponsors 11 exhibits/year. Average display time: 2 months. Open all year Tuesday-Saturday, 11-6; closed Christmas Eve to New Year's Day. Gallery houses 3 exhibit spaces as well as a separate Gallery Store. Located in historic Rittenhouse area of Philadelphia. Clients include local community, students, tourists, and collectors. 30% of sales are to corporate collectors. Overall price range: $15-15,000; most work sold at $200.

MEDIA Considers all forms of printmaking and photography. Accepts original artwork only—no reproductions.

STYLE Considers all styles and genres.

TERMS Accepts artwork on consignment (50%). Retail price set by the artist. Gallery provides insurance, promotion and contract. Accepted work should be ready to hang for exhibitions; unframed for gallery store. Does not require exclusive representation locally. Only accepts prints and photos.

SUBMISSIONS Must be member to submit work—member's work is reviewed by curator and gallery store manager. See website for membership application. Finds artists through submissions, art exhibits and membership.

THE PROPOSITION

2 Extra Place, New York NY 10003. (212)242-0035. **E-mail:** info@theproposition.com. **Website:** www. theproposition.com. Estab. 2002. For-profit gallery. Exhibits emerging and mid-career artists. Represents or exhibits 20+ artists/year. Currently not accepting unsolicited submissions. Exhibited artists include: Balint Zsako (drawing, collage, works on paper); Dane Patterson (drawing, painting, works on paper); Megan Burns (painting); Jason Gringler (mixed media, painting, work on paper); Mike Park (painting,

video); Tim Evans (painting, video, works on paper); Huang Yan (sculpture); Mickalene Thomas (paintings, photos); Shinique Smith (multimedia, works on paper, installation, video, conceptual); Kyung Jeon (drawing, painting); Alfredo Martinez (sculpture, drawing, painting, performance). Average display time: 1 month. Overall price range: $0-20,000; most works on paper sold at $3,000; most paintings sold at $6,000.

PUCKER GALLERY, INC.

240 Newbury St., 3rd Floor, Boston MA 02116. (617)267-9473. **Fax:** (617)424-9759. **E-mail:** contactus@puckergallery.com; destiny@puckergallery.com. **Website:** www.puckergallery.com. **Contact:** Bernard H. Pucker, owner/director; Destiny M. Barletta, director. Estab. 1967. Retail gallery. Represents 50 emerging, mid-career, and established artists. Exhibited artists include modern masters such as Picasso, Chagall, Braque, and Samuel Bak and Brother Thomas. Sponsors 10 shows/year. Average display time: 4-5 weeks. Open all year. Located in the downtown retail district. 20% of space for special exhibitions. Clientele: private clients from Boston, all over the US. and Canada. 90% private collectors, 10% corporate clients. Overall price range: $20-200,000; most artwork sold at $5,000-20,000.

MEDIA Considers all media. Most frequently exhibits paintings, prints and ceramics.

STYLE Exhibits all styles.

TERMS Terms of representation vary by artist, "usually it is consignment." Retail price set by gallery. Gallery provides promotion; artist pays shipping. Prefers artwork unframed.

SUBMISSIONS Send query letter with résumé, slides, bio and SASE. Write for appointment to show portfolio of originals and slides. Responds in 3 weeks. Files résumés.

PUMP HOUSE CENTER FOR THE ARTS

P.O. Box 1613, Chillicothe OH 45601. **E-mail:** pumphouseartgallery@aol.com. **Website:** www.pumphouseartgallery.com. **Contact:** Priscilla V. Smith, director. Estab. 1991. Nonprofit gallery. Approached by 6 artists/year; represents or exhibits more than 50 artists. Sponsors 8 exhibits/year. Average display time: 6 weeks. Open Tuesay-Saturday, 11-4; Sunday, 1-4. Overall price range: $150-600; most work sold at $300. Facility is also available for rent (business meetings, reunions, weddings, receptions or rehearsals, etc.).

MEDIA Considers all media and all types of prints. Most frequently exhibits oil, acrylic, and watercolor.

STYLE Considers all styles and genres.

TERMS Artwork is accepted on consignment (30% commission). Gallery provides insurance and promotion. Accepted work should be framed, matted, and wired for hanging. The Pump House reserves the right to reject any artwork deemed inappropriate.

SUBMISSIONS Call or stop in to show portfolio of photographs, slides, originals or prints. Send query letter with bio, photographs, SASE, and slides. Returns material with SASE. Responds in 1 month. Finds artists through word of mouth, submissions, portfolio reviews, art fairs/exhibits, and referrals by other artists.

TIPS "All artwork must be original designs, framed, ready to hang (wired—no sawtooth hangers)."

QUEENS COLLEGE ART CENTER

Benjamin S. Rosenthal Library, Flushing NY 11367. (718)997-3770. **Fax:** (718)997-3753. **E-mail:** tara.mathison@qc.cuny.edu; artcenter@qc.cuny.edu. **Website:** www.queenscollegeartcenter.org. **Contact:** Tara Tye Mathison, director and curator. Estab. 1955. Average display time: 6-8 weeks. Overall price range: $100-3,000.

MEDIA Considers all media.

STYLE Open to all styles and genres; decisive factors are originality and quality.

TERMS Charges 40% commission. Accepted work can be framed or unframed, mounted or unmounted, matted or unmatted. Sponsors openings.

SUBMISSIONS Online preferred or send query letter with résumé, samples and SASE. Responds in 1-2 months.

✪ MARCIA RAFELMAN FINE ARTS

10 Clarendon Ave., Toronto, Ontario M4V 1H9, Canada. (416)920-4468. **Fax:** (416)968-6715. **E-mail:** info@mrfinearts.com. **Website:** www.mrfinearts.com. **Contact:** Marcia Rafelman, president; Meghan Richardson, gallery director. Estab. 1984. Semiprivate gallery. Average display time: 1 month. Gallery is centrally located in Toronto; 2,000 sq. ft. on 2 floors. Clients include local community, tourists and upscale. 40% of sales are to corporate collectors. Overall price range: $800-25,000; the average selling price is now $2,500.

MEDIA Considers all media. Most frequently exhib-

its photography, painting and graphics. Considers all types of prints.

STYLE Exhibits geometric abstraction, minimalism, neo-expressionism, primitivism, and painterly abstraction. Most frequently exhibits high realism paintings. Considers all genres except Southwestern, Western and wildlife.

TERMS Artwork is accepted on consignment (50% commission); net 30 days. Retail price set by the gallery and the artist. Gallery provides insurance, promotion and contract. Requires exclusive representation locally.

SUBMISSIONS Mail or e-mail portfolio for review; include bio, photographs, reviews. Responds within 2 weeks, only if interested. Finds artists through word of mouth, submissions, art fairs, referrals by other artists.

RAHR-WEST ART MUSEUM
610 N. Eighth St., Manitowoc WI 54220. (920)686-3090. **E-mail:** rahrwest@manitowoc.org. **Website:** www.rahrwestartmuseum.org. Estab. 1950. Five thematic exhibits, preferably groups of mid-career and established artists. Sponsors 8-10 shows/year. Average display time: 6-8 weeks. Open all year; Tuesday-Friday, 10-4; Saturday and Sunday, 11-4. Closed Mondays and major holidays. Clients include local community and tourists. Overall price range: $50-2,200; most work sold at $150-200.

MEDIA Considers all media and all types of original prints except posters or glicée prints. Most frequently exhibits painting, pastel and original prints.

STYLE Considers all styles. Most frequently exhibits impressionism, realism and various abstraction. Genres include figurative work, florals, landscapes and portraits.

TERMS Artwork is accepted on consignment and there is a 30% commission. Retail price set by the artist. Gallery provides insurance. Accepted work should be framed with hanging devices attached.

SUBMISSIONS Send query letter with artist's statement, bio, SASE and slides. Returns material only if requested with SASE if not considered. Otherwise slides are filed with contact info and bio. Responds only if interested.

RAIFORD GALLERY
1169 Canton St., Roswell GA 30075. (770)645-2050. **Fax:** (770)992-6197. **E-mail:** raifordgallery@mindspring.com. **Website:** www.raifordgallery.

com. Estab. 1996. For-profit gallery. Approached by many artists/year. Represents 400 mid-career and established artists. Exhibited artists include Marianne van der Haar (paintings), Dale Rayburn (monotypes), and Richard Jacobus (metal). Open Tuesday–Saturday, 10-5. Located in historic district of Roswell; 4,500 sq. ft. in an open 2-story timber-frame space. Clients include local community, tourists, and upscale. Overall price range: $10-2,000; most work sold at $200-300.

MEDIA Considers all media except installation. Most frequently exhibits painting, glass, and turned wood.

STYLE Exhibits contemporary American art and craft.

TERMS Artwork is accepted on consignment, and there is a 50% commission. Retail price set by the artist. Gallery provides insurance, promotion, and contract. Accepted work should be framed and/or ready for hanging. Requires exclusive representation locally.

SUBMISSIONS Call or write to show to review board original work, portfolio of photographs. Send query e-mail with artist's statement, website, bio, photo attachements. Finds artists through submissions, portfolio reviews, art exhibits, and art fairs.

REHOBOTH ART LEAGUE, INC.
12 Dodds Lane, Rehoboth Beach DE 19971. (302)227-8408. **Fax:** (302)227-4121. **E-mail:** info@rehobothartleague.org. **Website:** www.rehobothartleague.org. Estab. 1938. Nonprofit gallery; offers education in visual arts. Exhibits the work of 1,000 emerging, mid-career, and established artists. Sponsors 10-12 shows/year. Average display time: 4-5 weeks. Open January through December. Located in a residential area near the beach; "3½ acres, rustic gardens, built in 1743; listed in the National Register of Historic Places; excellent exhibition and studio space. Regional setting attracts artists and arts advocates." 100% of space for special exhibitions. Clientele: members, artists (all media), arts advocates.

MEDIA Considers all media and all types of prints.

STYLE Exhibits all styles and all genres.

TERMS Accepts artwork on consignment (30% commission) from members. Retail price set by the artist. Gallery provides insurance and promotion. Artist pays for shipping. Prefers artwork framed for exhibition, unframed for browser sales.

SUBMISSIONS Send query letter with résumé,

slides and bio. Write to schedule an appointment to show a portfolio, which should include appropriate samples. Responds in 6 weeks. Files bios and slides in Member's Artist Registry.

RIVER GALLERY

400 E. Second St., Chattanooga TN 37403. (423)265-5033, ext. 5. **E-mail:** art@river-gallery.com; details@river-gallery.com. **Website:** www.river-gallery.com. **Contact:** Mary R. Portera, owner/director. Estab. 1992. Retail gallery. Represents 100 emerging, mid-career and established artists/year. Exhibited artists include Michael Kessler and Scott E. Hill. Sponsors 12 shows/year. Open Monday–Saturday, 10-5; Sunday, 1-5; and by appointment. Located in Bluff View Art District in downtown area; 2,500 sq. ft.; restored early New Orleans-style 1900s home; arched openings into rooms. 20% of space for special exhibitions; 80% of space for gallery artists. Clients include upscale tourists, local community. 95% of sales are to private collectors, 5% corporate collectors. Overall price range $5-10,000; most work sold at $200-2,000.

MEDIA Considers all media. Most frequently exhibits oil, original prints, photography, watercolor, mixed media, fiber, clay, jewelry, wood, glass and sculpture.

STYLE Exhibits all styles and genres. Prefers painterly abstraction, impressionism, photorealism.

TERMS Accepts work on consignment (50% commission). Retail price set by the gallery. Gallery provides free gift wrap, insurance, promotion, and contract; shipping costs are shared. Prefers artwork framed.

SUBMISSIONS Send query letter with résumé, slides, bio, photographs, SASE, reviews, and artist's statement. Call or e-mail for appointment to show portfolio of photographs and slides. Files all material unless we are not interested then we return all information. Can also submit via form on website. Finds artists through word of mouth, referrals by other artists, visiting art fairs and exhibitions, submissions, ads in art publications.

ROCKPORT CENTER FOR THE ARTS

902 Navigation Circle, Rockport TX 78382. (361)729-5519. **Fax:** (361)729-3551. **E-mail:** info@rockportartcenter.com. **Website:** www. rockportartcenter.com. Estab. 1969. Rockport Center for the Arts is a hub of creative activity on the Texas Gulf Coast. Two parlor galleries are dedicated entirely to the works of its member artists, while the main gallery allows the center to host local, regional, national, and internationally acclaimed artists in both solo and group exhibitions. In 2000, the Garden Gallery was added, allowing the center for the first time to simultaneously feature 3 distinct exhibitions, at times displaying over 100 original works of art. Today, the building also houses 2 visual arts classrooms and an outdoor sculpture garden featuring works by internationally acclaimed artists. A well-furnished pottery studio is always active, and includes a kiln room which hosts daily firings. Visitors enjoy the exhibitions, education programs and gift shop, as well as the Annual Rockport Art Festival every July 4th weekend. Gallery hours vary. Call, e-mail or visit website for more information.

ROGUE GALLERY & ART CENTER

40 S. Bartlett, Medford OR 97501. (541)772-8118. **E-mail:** info@roguegallery.org; kim@roguegallery. org. **Website:** www.roguegallery.org. **Contact:** Kim Hearon, executive director. Estab. 1961. Nonprofit sales rental gallery. Represents emerging, mid-career and established artists. Sponsors 8 shows/year. Average display time: 6 weeks. Open all year; Tuesday–Friday, 10-5; Saturday, 11-3. Located downtown Medford; main gallery 240 running ft. (2,000 sq. ft.); rental/sales and gallery shop, 1,800 sq. ft.; classroom facility, 1,700 sq. ft. "This is the only gallery/art center/exhibit space of its kind in the region, excellent facility, good lighting." 33% of space for special exhibitions; 33% of space for gallery artists. 95% of sales to private collectors. Overall price range: $100-5,000; most work sold at $400-1,000.

MEDIA Considers all media and all types of prints. Most frequently exhibits mixed media, drawing, installation, painting, sculpture, watercolor.

STYLE Exhibits all styles and genres.

TERMS Accepts work on consignment (40% gallery; 60% artist). Retail price set by the artist. Gallery provides insurance, promotion and contract; in the case of main gallery exhibit.

SUBMISSIONS Accepts submissions for main gallery once a year. See our website www.roguegallery. org/calls_to_artists.html for dates and instructions.

ALICE C. SABATINI GALLERY

Topeka & Shawnee County Public Library, 1515 SW Tenth Ave., Topeka KS 66604-1374. (785)580-4515. **Website:** www.tscpl.org. **Contact:** Zan Popp, exhibit curator. Estab. 1976. Nonprofit gallery. Exhibits emerging, mid-career, and established artists. Spon-

sors 6-8 shows/year. Average display time: 6 weeks. Open all year; Monday-Friday, 9-9; Saturday, 9-6; Sunday, 12-9. Located 1 mile west of downtown; 2,500 sq. ft.; security, track lighting, plex top cases; 5 moveable walls. 100% of space for special exhibitions and permanent collections. Overall price range: $150-5,000.

MEDIA Considers any media meeting educational mission. "We help people 'get' art. Emphasis currently on group and topical exhibits with educational potential."

STYLE Exhibits realism, abstraction, neo-expressionism, modern and postmodern arts, functional and fine art ceramic and crafts.

TERMS Retail price set by artist. Gallery provides insurance; artist pays for shipping costs. Prefers artwork framed. Does not handle sales, also does not take commission.

SUBMISSIONS Usually accepts regional artists. Send query letter with résumé and 12-24 images and description of educational goals. Call or write for appointment to show portfolio. Responds iannually. Files résumé. Finds artists through visiting exhibitions, word of mouth, and submissions.

TIPS "Research galleries to find out if your work is a good match. Send good quality images to best represent your work. Include information about yourself (bio, artist's statement), and also describe what projects you have going on. We plan 1-2 years in advance, and we look for originality."

SAMEK ART MUSEUM OF BUCKNELL UNIVERSITY

Elaine Langone Center, Lewisburg PA 17837. (570)577-3792. **Fax:** (570)577-3215. **E-mail:** gas019@bucknell.edu. **Website:** www.bucknell.edu/samek. **Contact:** Greg Stuart. Estab. 1983. Nonprofit gallery. Exhibits emerging, mid-career, and established international and national artists. Sponsors 6 shows/year. Average display time: 6 weeks. Open all year; Tuesday-Sunday, 12-5; Thursday, 11-8; Saturday-Sunday, 1-4. Located on campus; 3,500 sq. ft. including main gallery, project room and Kress Study Collection Gallery.

MEDIA Considers all media, traditional and emerging media. Most frequently exhibits painting, sculpture, works on paper, and video.

STYLE Exhibits all styles, genres, and periods.

TERMS Retail price set by the artist. Gallery provides insurance, promotion (local) and contract; artist pays

shipping costs to and from gallery. Prefers artwork framed or prepared for exhibition.

SUBMISSIONS Send query letter with résumé, slides and bio. Write for appointment to show portfolio of originals. Responds in 12 months. Files bio, résumé, slides. Finds artists through museum and gallery exhibits, and through studio visits.

TIPS "Most exhibitions are curated by the director or by a guest curator."

SAN DIEGO ART INSTITUTE

1439 El Prado, San Diego CA 92101. (619)236-0011. **Fax:** (619) 236-1974. **E-mail:** cgold@sandiego-art.org. **Website:** www.sandiego-art.org. **Contact:** Celia Gold. Estab. 1941. Nonprofit gallery. Average display time: 4-6 weeks. Open Tuesday–Saturday, 10-5; Sunday 12-5. Closed major holidays and all Mondays. 8,000 sq. ft. Located in the heart of Balboa Park.

MEDIA All media welcome.

STYLE Open.

SUBMISSIONS Calls for Art are posted at: sandiego-art.org.

SANGRE DE CRISTO ARTS CENTER AND BUELL CHILDREN'S MUSEUM

210 N. Santa Fe Ave., Pueblo CO 81003. (719)295-7200. **E-mail:** mail@sdc-arts.org. **Website:** sdc-arts.org. Estab. 1972. Nonprofit gallery and museum. Exhibits emerging, mid-career, and established artists. Sponsors 20 shows/year. Average display time: 10 weeks. Open Tuesday–Thursday, 11-5; Friday, 11-7; Saturday–Sunday 12-5. Admission $8 adults; $6 children, military and seniors 65+. Located "downtown, right off 98B from Interstate I-25;" 16,000-sq.-ft.; 7 galleries, 1 showing a permanent collection of Western art; changing exhibits in the other 6. Also a new 12,000 sq. ft. children's museum with changing, interactive exhibits. Clientele: "We serve a 19-county region and attract 200,000 visitors yearly." Overall price range: $50-100,000; most work sold at $50-2,500.

MEDIA Considers all media.

STYLE Exhibits all styles. Genres include Southwestern, regional, and contemporary.

TERMS Accepts work on consignment (40% commission). Retail price set by artist. Gallery provides insurance, promotion, contract, and shipping costs. Prefers artwork framed.

SUBMISSIONS Send query letter with portfolio of slides. Responds in 2 months.

SAPER GALLERIES

433 Albert Ave., East Lansing MI 48823. (517)351-0815. **E-mail:** roy@sapergalleries.com. **Website:** www.sapergalleries.com. **Contact:** Roy C. Saper, director. Estab. 1978; new building constructed in 1986. Displays the work of 150 artists, mostly mid-career, and artists of significant national prominence. Exhibited artists include Picasso, Peter Max, Rembrandt. Sponsors 2 shows/year. Average display time: 2 months. Open all year. Located downtown; 5,700 sq. ft. 50% of space for special exhibitions. Clients include students, professionals, experienced, and new collectors. 80% of sales are to private collectors, 20% corporate collectors. Overall price range: $100-100,000; most work sold at $1,000.

MEDIA Considers oil, acrylic, watercolor, pastel, drawings, mixed media, collage, paper, sculpture, ceramic, craft, glass, and original handpulled prints. Considers all types of prints except offset reproductions. Most frequently exhibits intaglio, serigraphy, and sculpture. "Must be of highest professional quality."

STYLE Exhibits expressionism, painterly abstraction, surrealism, postmodern works, impressionism, realism, photorealism, and hard-edge geometric abstraction. Genres include landscapes, florals, southwestern, and figurative work. Prefers abstract, landscapes, and figurative. Seeking extraordinarily talented, outstanding artists who will continue to produce exceptional work.

TERMS Accepts work on consignment (negotiable commission); or buys outright for negotiated percentage of retail price. Retail price set by the artist. Offers payment by installments. Gallery provides insurance, promotion and contract; shipping costs are shared. Prefers artwork unframed (gallery frames). Best way to present your work is through website link or online portfolio.

SUBMISSIONS Prefers digital pictures e-mailed to roy@sapergalleries.com. Call for appointment to show portfolio of originals or photos of any type. Responds in 1 week. Files any material the artist does not need returned. Finds artists mostly through New York Art Expo.

TIPS "Present your very best work to galleries that display works of similar style, quality, and media. Must be outstanding, professional quality. Student quality doesn't cut it. Must be great. Be sure to include prices."

✿ SAW GALLERY INC.

67 Nicholas St., Ottawa, Ontario K1N 7B9 Canada. (613)236-6181. **Fax:** (613)238-4617. **E-mail:** sawgallery@artengine.ca. **Website:** www.galeriesawgallery.com. **Contact:** Tam-Ca Vo-Van, director. Estab. 1973. Alternative space. Approached by 100 artists/year. Represents 8-30 emerging and mid-career artists. Average display time: 4-5 weeks. Open all year; Tuesday–Saturday, 11-6. Clients include local community, students, tourists, and other members. Sales conducted with artist directly.

MEDIA Considers all media. Most frequently exhibits installation, mixed media, media arts (video/film/computer). Considers all types of prints.

STYLE Exhibits cutting edge contemporary art. Most frequently exhibits art attuned to contemporary issues. Considers critical and contemporary (avant-garde art).

TERMS All sales arranged between interested buyer and artist directly. Retail price set by the artist. Gallery provides insurance, promotion, and contract. Does not require exclusive representation locally. Accepts only art attuned to contemporary issues.

SUBMISSIONS Send artist's statement, bio, résumé, reviews (if applicable), SASE, 10 slides. Returns material with SASE. Responds in 1-6 months. Proposals are reviewed in June and December. Files curriculum vitae. Finds artists through word of mouth, submissions, referrals by other artists, calls for proposals, advertising in Canadian art magazines.

TIPS "Have another artist offer an opinion of the proposal and build on the suggestions before submitting."

SCHERER GALLERY

3700 South Westport Ave., #1806, Sioux Falls SD 57106. (800)957-2673. **E-mail:** scherergallery@sedona.net. **Website:** www.scherergallery.com. **Contact:** Tess and Marty Scherer, owners. Estab. 1968. Online gallery. Represents over 30 mid-career and established artists. Interested in seeing the work of emerging artists. Exhibited artists include Tamayo, Hundertwasser, Friedlaender, Delaunay, Calder, and Barnet.

MEDIA Considers nonfunctional glass sculpture; paintings and other works on paper including handpulled prints in all mediums; and kaleidoscopes.

STYLE Exhibits color field, minimalism, surrealism, expressionism, modern and post modern works. Looking for artists "with a vision. Work that shows creative handling of the medium(s) and uniqueness

to the style." Specializes in handpulled graphics, artglass and kaleidoscopes.

TERMS Accepts work on consignment (50% commission). Retail price set by artist. Exclusive area representation required. Gallery provides insurance, promotion, and contract; shipping costs are shared.

SUBMISSIONS Send query letter, résumé, bio, at least 12 slides (no more than 30), photographs, and SASE. Follow up with a call for appointment to show portfolio. Responds in 1 month.

TIPS "Persevere! Don't give up!" Considers "originality and quality of the work."

WILLIAM & FLORENCE SCHMIDT ART CENTER

Southwestern Illinois College, 2500 Carlyle Ave., Belleville IL 62221. (618)222-5278. **Website:** www.swic.edu/TheSchmidt. **Contact:** Jessica Mannisi. Estab. 2002. Nonprofit gallery. Exhibits emerging, mid-career, and established artists. Sponsors 10-12 exhibits/year. Average display time: 6-8 weeks. Open Monday–Wednesday, 9-4; Thursday, 9-7; Friday, 10-4; Saturday, 12-4; closed during college holidays. Clients include local community, students and tourists.

MEDIA Considers all media.

STYLE Considers all styles.

SUBMISSIONS Mail portfolio for review. Send query letter with artist's statement, bio, and digital images. Finds artists through art fairs and exhibits, portfolio reviews, referrals by other artists, submissions, and word of mouth. May email portfolio submission to Jessica.Mannisi@swic.edu.

SCOTTSDALE MUSEUM OF CONTEMPORARY ART

7374 E. Second St., Scottsdale AZ 85251. (480)874-4639. **E-mail:** smoca@sccarts.org. **Website:** www.smoca.org. **Contact:** Tim Rogers, director. Approached by 30-50 artists/year. "Arizona's only museum devoted to the art, architecture, and design of our time." Sponsors 12 exhibits/year. Average display time: 10 weeks. See website for summer and fall/winter hours. Located in downtown Scottsdale; more than 20,000 sq. ft. of exhibition space. Clients include local community, students, and tourists.

MEDIA Considers all media.

STYLE Considers works of contemporary art, architecture, and design.

SUBMISSIONS Send query letter with artist's statement, bio, images, résumé, and reviews via the submissions process on smoca.org/opportunities.

SCULPTURECENTER

44-19 Purves St., Long Island City NY 11101. (718)361-1750. **E-mail:** cvaldez@sculpture-center.org. **Website:** www.sculpture-center.org. **Contact:** Claire Valdez. Estab. 1928. Alternative space, nonprofit gallery. Exhibits emerging and mid-career artists. Sponsors 8-10 shows/year. Average display time: 2-4 months. Open all year; Thursday–Monday, 11-6. Does not actively sell work.

MEDIA Considers drawing, mixed media, sculpture, and installation. Most frequently exhibits sculpture, installations, and video installations.

TERMS Not for profit museum. Does not sell work.

SUBMISSIONS "SculptureCenter is able to view work from artists with whom we are not familiar during our annual In Practice open call. If you'd like to be notified by e-mail when the next call is opened, please sign up for our e-mail list. You don't need to sign up a second time if you're already on our list. Artist materials submitted outside of the In Practice open call will be reviewed, but due to the volume of requests we receive every day, we regret that we are not able to reply to submissions. If your work appears both appropriate and timely for us to consider, we will contact you for a more formal review. Before sending materials, we ask that you first familiarize yourself with SculptureCenter by reviewing our past exhibitions and mission. We are unable to return submitted materials. We do not accept e-mail submissions."

SCULPTURESITE GALLERY

Jack London Village, 14301 Arnold Dr. Suite 8, Glen Ellen CA 95442. (707)933-1300. **E-mail:** info@sculpturesite.com. **Website:** www.sculpturesite.com. Estab. 1990. Retail gallery. Represents 70 emerging, mid-career, and established artists. Sponsors 5 sculpture shows/year. Average display time: 3-4 months. Open daily, 10-5. Clients include local community, nationwide, worldwide, upscale. Overall price range: $1,000-100,000; most work sold at $5,000-20,000.

MEDIA Considers sculpture, mixed media, ceramic, and glass. Most frequently exhibits sculpture. No crafts. "No paintings or works on paper, please."

STYLE Exhibits only contemporary abstract and abstract figurative.

TERMS Accepts artwork on consignment. Retail price set by artist in cooperation with gallery. Gallery provides insurance. Exclusive area representation required.

SUBMISSIONS Digital images are best; or send e-mail link to your website for review. Responds 2-3 times per year.

TIPS "We suggest artists visit us if possible; and, in any case, check website before submitting."

SELECT ART

1025 Levee St., Dallas TX 75207. (214)521-6833. **Fax:** (214)760-9722. **E-mail:** selart@swbell.net. **Website:** selectartusa.com. **Contact:** Paul Adelson, owner. Estab. 1986. Private art gallery. Represents 25 emerging, mid-career and established artists. Open all year; Monday–Friday, 9-5 by appointment only. Located in the art/design district. 4,000 sq. ft. Provides art for major public spaces—corporate and health care. Overall price range: $500-15,000.

MEDIA Considers oil, fiber, acrylic, sculpture, glass, watercolor, mixed media, ceramic, pastel, collage, photography, woodcuts, linocuts, engravings, etchings, and lithographs. Prefers monoprints and paintings on paper.

STYLE No photography at this time. No impressionism or realism. Prefers abstraction and outdoor sculpture in all mediums.

TERMS Accepts work on consignment (50% commission). Retail price set by consultant and artist. Sometimes offers customer discounts. Provides contract (if the artist requests one). Consultant pays shipping costs from gallery; artist pays shipping to gallery. Prefers artwork unframed.

SUBMISSIONS "No florals or wildlife." Send query letter with résumé, bio, and SASE. Responds within 1 month, only if interested. Files bio, price list. Finds artists through word of mouth and referrals from other artists.

TIPS "Be timely when you say you are going to send artwork, etc."

SILVERMINE GUILD GALLERY

1037 Silvermine Rd., New Canaan CT 06840. (203)966-9700. **Website:** www.silvermineart.org. **Contact:** Jeffrey Mueller, gallery director. Estab. 1922. Nonprofit gallery. Represents 300 emerging, mid-career, and established artists/year. Sponsors 24 shows/year. Average display time: 1 month. Open Wednesday–Saturday, 12-5; Sunday, 1-5. 5,000 sq. ft. 95% of space for gallery artists. Clientele: private collectors, corporate collectors. Overall price range: $250-10,000; most work sold at $1,000-2,000.

MEDIA Considers all media and all types of prints. Most frequently exhibits paintings, sculpture, and ceramics.

STYLE Exhibits all styles.

TERMS Accepts guild member work on consignment (50% commission). Co-op membership fee plus donation of time (50% commission.) Retail price set by the gallery and the artist. Gallery provides insurance, promotion, and contract. Prefers artwork framed.

SUBMISSIONS Send query letter.

SIOUX CITY ART CENTER

225 Nebraska St., Sioux City IA 51101-1712. (712)279-6272. **Fax:** (712)255-2921. **E-mail:** siouxcityartcenter@sioux-city.org; aharris@sioux-city.org; tbehrens@sioux-city.org. **Website:** www.siouxcityartcenter.org. **Contact:** Todd Behrens, curator. Estab. 1938. Museum. Exhibits emerging, mid-career, and established artists. Approached by 50 artists/year; represents or exhibits 2-3 artists. Sponsors 15 total exhibits/year. Average display time: 10-12 weeks. Gallery open Tuesday, Wednesday, Friday, Saturday, 10-4; Thursday 10-9; Sunday 1-4; closed on Mondays and municipal holidays. Located in downtown Sioux City; 2 galleries, each 40×80 ft. Clients include local community, students, and tourists.

MEDIA Considers all media and types of prints. Most frequently exhibits paintings, sculpture, and mixed media.

STYLE Considers all styles and genres.

TERMS Artwork is accepted on consignment with a 30% commission. "However, the purpose of our exhibitions is not sales." Retail price of the art set by the artist. Gallery provides insurance, promotion, and contract.

SUBMISSIONS Artwork should be framed. Only accepts artwork from upper-Midwestern states. E-mail query letter with link to artist's website; JPEG samples at 72 dpi. Or send query letter with artist's statement, résumé, and digital images. Returns materials if SASE is enclosed. Responds, only if interested, within 6 months. Files résumé, statement, and images if artist is suitable. Finds artists through word of mouth, art exhibits, submissions, art fairs, portfolio reviews, and referrals by other artists.

SNYDERMAN-WORKS GALLERY

303 Cherry St., Philadelphia PA 19106. (215)238-9576. E-mail: Leigh@snyderman-works.com. **Website:** www.snyderman-works.com. **Contact:** Leigh Werrell. Estab. 1965. Retail gallery. Represents 200 emerging, mid-career, and established artists. Exhibited artists include Eileen Sutton, Larry Spaid, Ron Meyers, Gary Magakis, Doug Herren, Graceann Warn, Yvonne Bobrowicz. Sponsors 10 shows/year. Average display time: 2 months. Open all year; Tuesday–Saturday, 10-6; openings 1st Friday of every month 5:30-8:30. Exhibitions usually change on a monthly basis except through the summer. Located downtown ("Old City"); 3,000 sq. ft. 65% of space for special exhibitions. Clientele designers, lawyers, businessmen and women, students. 90% private collectors, 10% corporate collectors. Overall price range: $50-10,000; most work sold at $200-600.

MEDIA Considers ceramic, fiber, glass, photography and metal jewelry. Most frequently exhibits jewelry, ceramic, and fiber.

STYLE Exhibits all styles.

TERMS Accepts artwork on consignment (50% commission); some work is bought outright. Gallery provides insurance, promotion, and contract; shipping costs are shared.

SUBMISSIONS Send query letter with résumé, 5-10 photos, and SASE. Files résumé and slides, if interested.

TIPS "Most work shown is one-of-a-kind. We change the gallery totally for our exhibitions. In our gallery, someone has to have a track record so that we can see the consistency of the work. We would not be pleased to see work of one quality once and have the quality differ in subsequent orders, unless it improved. Always submit slides with descriptions and prices instead of walking in cold. Enclose a SASE. Follow up with a phone call. Try to have a sense of what the gallery's focus is so your work is not out of place. It would save everyone some time."

SOHN FINE ART—GALLERY & GICLÉE PRINTING

69 Church St., Lenox MA 01240. (413)551-7353. **E-mail:** info@sohnfineart.com. **Website:** www. sohnfineart.com. **Contact:** Cassandra Sohn, owner. Estab. 2011. Alternative space and for-profit gallery. Approached by 25-50 artists/year; represents or exhibits 12-20 emerging, mid-career, and established artists.

Exhibited artists include Greg Gorman, Matchuska, Fran Forman, John Atchley, Seth Resnick, Savannah Spirit, Burce Checefsky, Cassandra Sohn, etc. Average display time: 1-3 months. Open Thursday-Monday, 10-5. Located in the Berkshires of Western Massachusetts. The area is known for arts and culture and full of tourists. 80% of the population are 2nd home owners from New York and Boston. Clients include local community, tourists, and upscale. Overall price range: $300-6,000. Most work sold for $300-2,500.

MEDIA Considers photography and sculpture.

STYLE Considers all styles and genres.

TERMS Artwork is accepted on consignment and there is a 50% commission. Retail price of the art set by the artist. Gallery provides insurance, promotion, and contract. Accepted work should be framed, mounted, and matted. Requires exclusive representation locally.

SUBMISSIONS E-mail query letter with link to artist's website and JPEG samples at 72 dpi. Material cannot be returned. Responds only if interested. Finds artists through word of mouth, art exhibits, submissions, art fairs, portfolio reviews, and referrals by other artists.

SOUTH ARKANSAS ARTS CENTER

110 E. Fifth St., El Dorado AR 71730. (870)862-5474. **E-mail:** info@saac-arts.org. **Website:** www.saac-arts.org. Estab. 1963. Nonprofit gallery. Exhibits the work of 30 emerging, mid-career, and established artists. Hosts 15-20 shows/year including a national juried art competition each summer. Average display time: 1 month. 3,600 sq. ft. of exhibit space in 3 galleries attached to a larger community arts center in the middle of town. Open Monday–Friday, 9-5; appointments scheduled by special arrangement on weekends; closed on major holidays (see website for details). Overall price range: $50-1,500; most work sold at $200-600.

MEDIA Considers all fine art, mixed media, 3D work, and prints. Most frequently exhibits watercolor, pastels, and mixed media.

STYLE Exhibits all styles.

TERMS Accepts work on consignment (35% commission). Retail price set by the artist. Gallery provides insurance and promotion; contract and shipping may be negotiated. All work must be gallery display ready, framed prefered.

SUBMISSIONS Send exhibit query by e-mail or by

mail to SAAC office. Include images of artist work and information about the artist or an artist statement. Materials sent will not be returned to artist.

TIPS "We exhibit a wide variety of works by local, regional and national artists. With 3 gallery spaces, we have space to display works of all types, including a large gallery that is excellent for 3D works and large pieces."

SOUTH DAKOTA ART MUSEUM

South Dakota State University, P.O. Box 2250, Brookings SD 57007. (605)688-5423. **Fax:** (605)688-4445. **E-mail:** stacy.buehner@sdstate.edu. **Website:** www.southdakotaartmuseum.com. Sponsors 15 exhibits/year. Average display time: 4 months. Open Monday-Friday, 10-5; Saturday, 10-4; Sunday, 12-4; closed state holidays and Sundays, January–March. Seven galleries offer 26,000 sq. ft. of exhibition space.

MEDIA Considers all media and all types of prints. Most frequently exhibits painting, sculpture, and fiber.

STYLE Considers all styles.

TERMS Please visit website for additional details.

SPACES

2220 Superior Viaduct, Cleveland OH 44113. (216)621-2314. **E-mail:** msimmons@spacesgallery.org. **Website:** www.spacesgallery.org. **Contact:** Marilyn Ladd-Simmons, gallery manager. Estab. 1978. "SPACES is is a presenting contemporary art venue dedicated to artists who explore and experiment. Located on the west side of downtown Cleveland, SPACES currently operates 3 programs to feature the excellent works of our curated artists: R&D (Research & Development), SWAP (SPACES World Artists Program), and the Vault. Public projects feature artists who push boundaries by experimenting with new forms of expression and innovative uses of media, presenting work of emerging artists and established artists with new ideas. The SPACES World Artist Program is a residency program that gives national, international, and regional artists the opportunity to create new work and interact with the Northeast Ohio community. The R&D program invites artists curators and other cultural group, solo, or event-oriented. The Vault functions as a media flat file—a converted walk-in safe where audiences can experience a variety of video and audio art." Sponsors 8-12 shows/year. Average display time: 8 weeks. Open Tuesday–Wednesday, Friday-Sunday, 12-5; Thursday, 12-8. Located in Cleveland, Ohio.

MEDIA Considers all media. Most frequently exhibits installation, painting, sculptures, video, and experimental. Our Mission: SPACES is the resource and public forum for artists who explore and experiment.

STYLE "Style not relevant; presenting challenging new ideas is essential."

TERMS Artists are provided honoraria, and 25% commission is taken on work sold. Gallery provides insurance, promotion, and contract.

SUBMISSIONS Contact SPACES for deadline and application.

SPAIGHTWOOD GALLERIES, INC.

P.O. Box 1193, Upton MA 01568-6193. (508)529-2511. **E-mail:** sptwd@verizon.net. **Website:** www.spaightwoodgalleries.com. **Contact:** Sonja Hansard-Weiner, president; Andy Weiner, director. Estab. 1980. Exhibits mostly established artists. Presents 3-4 exhibits/year. Average display time: 3 months. Open Saturday-Sunday, 12-6 and by appointment. Located in a renovated former Unitarian Church; basic space is 90×46 ft; ceilings are 25 ft. high at center, 13 ft. at walls. See website for views of the gallery. "Clients include mostly Internet and visitors drawn by Internet; we are currently trying to attract visitors from Boston and vicinity via advertising and press releases." 2% of sales are to corporate collectors. Overall price range: $175-500,000; most work sold at $1,000-4,000.

MEDIA Considers all media except installations, photography, glass, craft, fiber. Most frequently exhibits original prints, drawings, and ceramic sculpture, occasionally paintings.

STYLE Exhibits Old Masters to contemporary; most frequently Old Master prints and drawings, modern, contemporary, impressionist, and postimpressionist. "Work shown is part of our inventory; we buy mostly at auction. In the case of some artists, we buy directly from the artist or the publisher; in a few cases we have works on consignment."

TERMS Retail price set by both artist and gallery. Accepted work should be unmatted and unframed. Requires exclusive representation locally.

SUBMISSIONS Prefers link to website with bio, exhibition history and images. Returns material with SASE. Responds to queries only if interested. Finds artists through art exhibits (particularly museum shows), referrals by other artists, books.

TIPS "Make high-quality art."

B.J. SPOKE GALLERY

299 Main St., Huntington NY 11743. (631)549-5106. E-mail: manager@bjspokegallery.com. **Website:** www.bjspokegallery.com. **Contact:** Gallery Manager. Estab. 1975. Cooperative and nonprofit gallery exhibiting artists on Long Island. Artists showing at the gallery are well represented in numerous public and private collections. "Our artworks are for sale in the gallery and through this online exhibit space." Exhibits the work of 26 emerging, mid-career, and established artists. Sponsors 2-3 invitationals and juried shows/year. Average display time: 1 month. Open all year. Open Tuesday–Sunday, 11-5; Friday, 11-9. "Located in center of town; 1,400 sq. ft.; flexible use of space; 3 separate gallery spaces." 66% of space for special exhibitions. Overall price range: $300-2,500; most work sold at $900-1,600. Artist is eligible for a 2-person show every 2 years. Artist Members can exhibit work 10 months of the year.

MEDIA Considers all media except crafts, all types of printmaking. Most frequently exhibits paintings, prints, photography, and sculpture. Jewelry is also available.

STYLE Exhibits all styles and genres. Prefers painterly abstraction, realism, and expressionism.

TERMS Co-op membership fee, help with 1 or more gallery committees, sitting one day per month . Monthly fee covers rent, other gallery expenses. Retail price set by artist. Gallery receives 35% commission. Gallery provides promotion and publicity.

THE STATE MUSEUM OF PENNSYLVANIA

300 North St., Harrisburg PA 17120. (717)787-4980. **E-mail:** ra-phstatemuseum@pa.gov. **Website:** www.statemuseumpa.org. Offers visitors 4 floors representing Pennsylvania's story, from Earth's beginning to the present. Features archaeological artifacts, minerals, paintings, decorative arts, animal dioramas, industrial and technological innovations, and military objects representing the Commonwealth's heritage. Number of exhibits varies. Average display time: 2 months. Open Wednesday–Saturday, 9-5; Sunday, 12-5. Overall price range: $50-3,000.

MEDIA Considers all media and all types of prints.

STYLE Exhibits all styles and genres.

TERMS Artwork is sold in gallery as part of annual Art of the State exhibition only. Connects artists with interested buyers. No commission. Accepted work should be framed. Art must be created by a native or resident of Pennsylvania, or contain subject matter relevant to Pennsylvania.

SUBMISSIONS Send material by mail for consideration; include SASE. Responds in 1 month.

STATE OF THE ART GALLERY

120 W. State St., Ithaca NY 14850. (607)277-1626. **E-mail:** gallery@soag.org. **Website:** www.soag.org. Estab. 1989. Cooperative gallery. Sponsors 12 exhibits/year. Average display time: 1 month. Open Wednesday-Friday, 12-6; weekends, 12-5. Located in downtown Ithaca; 2 rooms; about 1,100 sq. ft. Overall price range: $100-6,000; most work sold at $200-500.

MEDIA Considers all media and all types of prints. Most frequently exhibits sculpture, paintings, mixed media.

STYLE Considers all styles and genres.

TERMS There is a co-op membership fee plus a donation of time. There is a 10% commission for members, 30% for nonmembers. Retail price set by the artist. Gallery provides promotion and contract. Accepted work must be ready to hang.

SUBMISSIONS Write for membership application. Finds artists through word of mouth, submissions, portfolio reviews, art exhibits, referrals by other artists.

STATE STREET GALLERY

1804 State St., La Crosse WI 54601. (608)782-0101. **Contact:** Ellen Kallies, president. Estab. 2000. Retail gallery. Approached by 15 artists/year. Represents 40 emerging, mid-career, and established artists. Exhibited artists include Diane French, Jerry Riness, Kathie Wheeler, Sara Lubinski, among others. Sponsors 6 exhibits/year. Average display time: 4-6 months. Open Tuesday, Thursday and Friday, 10-4; Wednesday 11:15-5:15; Saturday 10-2; other times by chance or appointment; closed Saturdays in July. Located across from the University of Wisconsin/La Crosse on one of the main east/west streets. "We are next to a design studio; parking behind gallery." Clients include local community, tourists, upscale. 40% of sales are to corporate collectors, 60% to private collectors. Overall price range: $150-25,000; most work sold at $500-5,000.

MEDIA Considers acrylic, collage, drawing, glass, mixed media, oil, pastel, sculpture, watercolor, and photography. Most frequently exhibits oil, dry pigment, drawing, watercolor, and mixed media collage. Considers all types of prints.

STYLE Considers all styles and genres. Most frequently exhibits contemporary representational, realistic watercolor, collage.

TERMS Artwork is accepted on consignment (40% commission). Retail price set by the gallery and the artist. Gallery provides insurance, promotion, contract. Accepted work should be framed and matted.

SUBMISSIONS Call to arrange a personal interview or mail portfolio for review. Send query letter with artist's statement, photographs or slides. Returns material with SASE. Responds in 1 month. Finds artists through word of mouth, art exhibits, art fairs, and referrals by other artists.

TIPS "Be organized; be professional in presentation; be flexible! Most collectors today are savvy enough to want recent works on archival-quality papers/boards, mattes, etc. Have a strong and consistant body of work to present."

PHILIP J. STEELE GALLERY AT ROCKY MOUNTAIN COLLEGE OF ART + DESIGN

1600 Pierce St., Denver CO 80214. (303)225-8575. **E-mail:** cstell@rmcad.edu. **Website:** www.rmcad.edu. **Contact:** Cortney Stell, gallery director. Estab. 1962. For-profit college gallery. Represents emerging, mid-career, and established artists. Sponsors 10-12 shows/year. Exhibited artists include Christo, Herbert Bayer, Andy Warhol, and others. Average display time: 1 month. Open all year; Monday–Friday, 11-4. Located in the Mary Harris Auditorium building on the southeast corner of the quad. Clientele: local community, students, faculty.

MEDIA Considers all media and all types of prints.

STYLE Exhibits all styles.

TERMS Artists sell directly to buyer; gallery takes no commission. Retail price set by the artist. Gallery provides insurance and promotion; artist pays shipping costs to and from gallery.

SUBMISSIONS Submission guidelines available online.

TIPS Impressed by "professional presentation of materials, good-quality slides or catalog."

STEVENSON UNIVERSITY ART GALLERY

1525 Greenspring Valley Rd., Stevenson MD 21153. (443)352-4491. **Fax:** (410)352-4500. **E-mail:** exhibitions@stevenson.edu. **Website:** www.stevenson.edu/stuarteffects. **Contact:** Matt Laumann, cultural programs manager. Estab. 1997. Sponsors 10 exhibits/year across 3 museum quality gallery spaces, Universty Art Gallery, St. Paul Companies Pavilion, and the new School of Design Galery. Average display time:

6 weeks. Gallery open Monday, Tuesday, Wednesday, Friday, 11-5; Thursday, 11-8; Saturday, 1-4. "Since its 1997 inaugural season, the Stevenson University Art Gallery has presented a dynamic series of substantive exhibitions in diverse media and has achieved the reputation as a significant venue for regional artists and collectors. The museum quality space was designed to support the Baltimore arts community, provide greater opportunities for artists, and be integral to the educational experience of Stevenson students."

MEDIA Considers all media. Most frequently exhibits painting, sculpture, photography, and works on paper, installation and new media.

STYLE Considers all styles and genres. "We are looking for artwork of substance by artists from the mid-Atlantic region."

TERMS "We facilitate inquiries directly to the artist." Gallery provides insurance. *Accepts artists from mid-Atlantic states only; emphasis on Baltimore artists.*

SUBMISSIONS Write to show portfolio. Send artist's statement, bio, résumé, reviews, portfolio link or CD. Responds in 3 months. Finds artists through word of mouth, submissions, portfolio reviews, referrals by other artists.

TIPS "Be clear, concise. Have good representatation of your images."

STILL POINT ART GALLERY

Shanti Arts LLC, 193 Hillside Rd., Brunswick ME 04011. (207)837-5760. **Fax:** (207)725-4909. **E-mail:** info@stillpointartgallery.com. **Website:** www.stillpointartgallery.com. **Contact:** Christine Cote, owner/director. Estab. 2009. For-profit online gallery. Exhibits emerging, mid-career and established artists. Approached by 300 artists/year. Represents 25 artists. Sponsors 4 juried shows/year. Distinguished artists earn representation and publication in gallery's art journal, *Still Point Arts Quarterly*. Model and property release preferred. Average display time: 14 months.

MEDIA Considers all media. Most frequently exhibits painting and photography. Considers engravings, etchings, serigraphs, linocuts, woodcuts, lithographs, and mezzotints.

STYLE Considers all styles and genres.

TERMS Retail price set by the artist. Gallery takes no commission from sales. Gallery provides promotion. Respond to calls for artists posted on website.

TIPS "Follow the instructions posted on our website."

STUDIO GALLERY

2108 R St. NW, Washington DC 20008. (202)232-8734. **E-mail:** info@studiogallerydc.com. **Website:** www.studiogallerydc.com. Estab. 1964. Cooperative and non-profit gallery. Exhibits the work of 30 emerging, mid-career and established local artists. Sponsors 11 shows/year. Average display time: 1 month. Gallery for rent the last of August. Open Wednesday-Friday, 1-6; Saturday, 12-6. Located downtown in the Dupont Circle area; 700 sq. ft.; "gallery backs onto a courtyard, which is a good display space for exterior sculpture and gives the gallery an open feeling." Location also available for rent. Clientele: private collectors, art consultants, and corporations. 85% private collectors; 8% corporate collectors. Overall price range: $300-10,000; most work sold at $500-3,000.

MEDIA Considers glass, oil, acrylic, watercolor, pastel, pen & ink, drawings, mixed media, collage, works on paper, sculpture, ceramic, fiber, original handpulled prints, woodcuts, lithographs, monotypes, linocuts, and etchings. Most frequently exhibits oil, acrylic, and paper.

STYLE Considers all styles. Most frequently exhibits abstract and figurative paintings, landscapes, indoor and outdoor sculpture, and mixed media.

TERMS Co-op membership fee plus a donation of time (65% commission).

SUBMISSIONS Send query letter with SASE. Artists must be local or willing to drive to Washington for monthly meetings and receptions. Artist is informed as to when there is a membership opening and a selection review. Files artist's name, address, telephone.

TIPS "This is a cooperative gallery. Membership is decided by the gallery membership. Ask when the next review for membership is scheduled. An appointment for a portfolio review with the director is required before the jurying process, however. Dupont Circle is an exciting gallery scene with a variety of galleries. First Fridays every month from 6-8 for all galleries of Dupont Circle."

⊙ STUDIO SEVEN ARTS

400 Main St., Pleasanton CA 94566. (925)846-4322. **E-mail:** info@studiosevenarts.com. **Website:** www.studiosevenarts.com. Estab. 1981. Retail gallery. Represents/exhibits established artists. Sponsors 10 shows/year. Average display time: 5 weeks. Open Sunday–Thursday, 10-7; Friday-Saturday, 10-9. Located in historic downtown Pleasanton; 2,500 sq. ft.; excellent lighting from natural and LED sources. 30% of space for special exhibitions; 70% of space for gallery artists. Clientele "wonderful, return customers." 99% private collectors, 1% corporate designer collectors. Overall price range: $100-80,000.

MEDIA Considers oil, acrylic, watercolor, pastel, drawing, mixed media, collage, paper, sculpture, ceramics, fine craft, glass, woodcuts, engravings, lithographs, mezzotints, serigraphs, and etchings. Most frequently exhibits oil, acrylic, etching, watercolor, handblown glass, jewelry, and sculpture.

STYLE Exhibits painterly abstraction and impressionism. Genres include landscapes and figurative work. Prefers landscapes, figurative, and abstract.

TERMS Work only on consignment. Retail price set by the artist. Gallery provides promotion and contract and pays shipping costs.

SUBMISSIONS end query e-mail with several examples of work representing current style. Call for appointment to show portfolio of originals. Responds only if interested within 1 month. Finds artists through word of mouth and "my own canvassing."

SUMNER MCKNIGHT CROSBY, JR. GALLERY

Arts Council of Greater New Haven, 70 Audubon St., 2nd Floor, New Haven CT 06510. (203)772-2788. **Fax:** (203)772-2262. **E-mail:** info@newhavenarts.org. **Website:** www.newhavenarts.org. Estab. 1985. Formerly Small Space Gallery. Alternative space. Interested in emerging artists. Sponsors 10 group shows/year. Average display time: 1-2 months. Open to Arts Council members only.

MEDIA Considers all media.

STYLE Exhibits all styles and genres. "The Gallery was established to provide our artist members with an opportunity to show their work. Particularly those who were just starting their careers. We're not a traditional gallery, but an alternative art space." Shows are promoted through *The Arts Paper*, the Arts Council's coprehensive arts and entertainment paper, as well as on our website; announcements are also posted on a variety of online calendars.

TERMS Arts Council requests 10% donation on sale of each piece. Retail price set by artist. Exclusive area representation not required. Gallery provides insurance (up to $10,000) and promotion.

SUBMISSIONS Send images, résumé and bio, attn: Debbie Hesse (dhesse@newhavenarts.org). Call (203)772-2788, ext. 17 to inquire about becoming an artist member.

SWOPE ART MUSEUM

25 S. Seventh St., Terre Haute IN 47807. (812)238-1676. **E-mail:** info@swope.org. **Website:** www.swope.org. **Contact:** Marianne Richter, executive director. Estab. 1942. Nonprofit museum. Approached by approximately 10 artists/year. Represents 1-3 mid-career and established America artists. Average display time: 6 and 12 weeks. Open all year; Tuesday–Friday, 10-5; Saturday, 12-5; closed national holidays. Located in downtown Terre Haute, Indiana, in an Italian Renaissance-revival building with art deco interior.

MEDIA Considers all media. Most frequently exhibits paintings, sculpture, and works on paper. Considers all types of prints except posters.

STYLE Exhibits American art of all genres. Exhibits permanent collection with a focus on mid-20th-century regionalism and Indiana artists but includes American art from all 50 states from 1800s to today.

TERMS Focuses on local and regional artists (size and weight of works are limited because we do not have a freight elevator).

SUBMISSIONS Send query letter with artist's statement, brochure, CD or slides, résuméand SASE (if need items returned). Returns material with SASE. Responds in 5 months. Files only what fits the mission statement of the museum for special exhibitions. Finds artists through word of mouth and annual juried exhibition at the museum.

TIPS The Swope has physical limitations due to its historic interior but is willing to consider newer media, unconventional media, and installations.

⌂ SWORDS INTO PLOWSHARES PEACE CENTER AND GALLERY

33 E. Adams Ave., Detroit MI 48226. (313)963-7575. **E-mail:** swordsintoplowshares313@gmail.com. **Website:** www.swordsintoplowsharesdetroit.org. Estab. 1985. Nonprofit peace center and gallery. Presents 3-4 major shows/year. Open Thursday & Saturday, 12- 4pm. Located in downtown Detroit in the Theater District; 2,881 sq. ft.; 1 large gallery, 3 small galleries. 100% of space for special exhibitions. Can be used as a one-day rental facility. Clients include walk-ins, church, school, and community groups. 100% of sales are to private collectors. Overall price range: $75-6,000; most work sold at $75-700.

MEDIA Considers all media and all types of prints.

TERMS Retail price set by the artist. Gallery provides insurance and promotion.

SUBMISSIONS Accepts artists primarily from Michigan and Ontario. Send query letter with statement on how work relates to social justice themes & sample artwork. Replies within 2 months. Finds artists through lists from Michigan Council of the Arts and Windsor Council of the Arts.

SYNCHRONICITY FINE ARTS

106 W. 13th St., New York NY 10011. (646)230-8199. **E-mail:** jsa@synchroncityspace.com; contact@synchroncityspace.com. **Website:** www.synchronicityspace.com. **Contact:** John Amato, director. Estab. 1989. Nonprofit gallery. Approached by several hundred artists/year. Average display time: 1 month. Open Tuesday-Saturday, 12-6. Closed for 2 weeks in August. Clients include local community, students, tourists and upscale. 20% of sales are to corporate collectors. Overall price range: $1,500-10,000; most work sold at $3,000-5,000.

MEDIA Considers acrylic, collage, drawing, mixed media, oil, paper, pastel, pen & ink, sculpture, watercolor, engravings, etchings, mezzotints, and woodcuts. Most frequently exhibits oil, sculpture, and photography.

STYLE Exhibits color field, expressionism, impressionism, postmodernism, and painterly abstraction. Most frequently exhibits semiabstract and semirepresentational abstract. Genres include figurative work, landscapes, and portraits.

TERMS Retail price set by the gallery. Gallery provides insurance, promotion, and contract. Accepted work should be framed, mounted, and matted.

SUBMISSIONS Write or call to arrange a personal interview to show portfolio of photographs, slides, and transparencies. Send query letter with photocopies, photographs, résumé, SASE, and slides. Returns material with SASE. Files materials unless artist requests return. Finds artists through submissions, portfolio reviews, art exhibits, and referrals by other artists.

LILLIAN & COLEMAN TAUBE MUSEUM OF ART

2 N. Main St., Minot ND 58703. (701)838-4445. **E-mail:** taube@srt.com; taube2@srt.com. **Website:** www.taubemuseum.org. Doug Pfliger, Gallery Manager. **Contact:** Nancy Walter, Executive Director. Estab. 1970. Established nonprofit organization. Sponsors 1-2 photography exhibits/year. Average display time: 4-6 weeks. Located in a renovated historic landmark building with room to show 2 exhibits simultaneously.

Overall price range: $15-225. Most work sold at $40-100.

MEDIA Considers oil, acrylic, watercolor, pastel, pen & ink, drawings, mixed media, collage, works on paper, sculpture, ceramic, fiber, glass, photograph, woodcuts, engravings, lithographs, serigraphs, linocuts, and etchings. Most frequently exhibits watercolor, acrylic, and mixed media.

STYLE Exhibits all styles and genres. Prefers figurative, Americana, and landscapes. No "commercial-style work (unless a graphic art display)." Interested in all media.

TERMS Accepts work on consignment (30% commission, members; 40% nonmembers). Retail price set by artist. Offers discounts to gallery members and sometimes payment by installments. Gallery provides insurance, promotion, and contract; pays shipping costs from gallery or shipping costs are shared. Requires artwork framed.

SUBMISSIONS Send query letter with résumé and slides. Write for appointment to show portfolio of good quality photographs and slides. "Show variety in your work." Files material interested in. Finds artists through visiting exhibitions, word of mouth, submissions of slides, and members' referrals.

TIPS "We will take in a small show to fill in an exhibit. Show your best. When shipping show, be uniform on sizes and frames. Have flat backs to pieces so work does not gouge walls. Be uniform on wire placement. Avoid sawtooth hangers."

TEW GALLERIES, INC.

425 Peachtree Hills Ave., #24, Atlanta GA 30305. (404)869-0511. **Fax:** (404)869-0512. **E-mail:** jules@tewgalleries.com; info@tewgalleries.com. **Website:** www.tewgalleries.com. **Contact:** Jules Bekker, director. Estab. 1987. For-profit gallery. "TEW Galleries is recognized as a leading contemporary fine art institution in Atlanta. The gallery has an established reputation for its representation of national and international artists and presents a broad spectrum of works in styles ranging from traditional to contemporary, including abstract, landscape, and figurative art. The gallery also focuses on the best of the next generation of emerging talent and regularly features young artists who have a defined direction alongside established contemporaries." Exhibits selected emerging and mid-career artists. Approached by over 200 artists/year; represents or exhibits 10-20

artists/year in solo and group exhibitions. Exhibited artists include Brian Rutenberg (oil), Deedra Ludwig (encaustic, mixed media, oil, pastel painting) and Kimo Minton (polychrome woodcut panels and sculpture). Sponsors 7 exhibits/year. Average display time: 28 days. Open Monday–Friday, 10-5; Saturday, 11-5. Located in a prestigious arts and antiques complex. Total of 3,600 sq. ft. divided over 3 floors. Clients include upscale and corporate. 15% of sales are to corporate collectors. Overall price range: $1,800-40,000; most work sold at $8,500 or less. Consignment only.

MEDIA Fine art: paintings, sculpture and drawings. Considers all media except craft and photography. Most frequently exhibits oil on canvas, works on paper, and small to medium scale sculptures.

STYLE Considers all styles.

TERMS Artwork is accepted on consignment and there is a 50% commission. Retail price set by the gallery and the artist. Requires exclusive representation locally.

SUBMISSIONS Reviews artist submissions on an ongoing basis. Artists may send a submission by e-mail, with a maximum of 8 digital images. Links to websites are also welcome. Please be aware that we *do not* accept submissions by postal mail. With all submissions, please include a biographical history, résumé, and other material that supports your work.

TIPS "We kindly ask that artists not show up at the gallery and ask us to review their artwork. We do review everything sent to us and appreciate your attention to our submissions policy."

NATALIE AND JAMES THOMPSON ART GALLERY

Department of Art & Art History, San Jose State University, San Jose CA 95192-0089. (408)924-4723. **Fax:** (408)924-4326. **E-mail:** thompsongallery@sjsu.edu. **Website:** www.sjsu.edu. **Contact:** Jo Farb Hernandez, director. Nonprofit gallery. Approached by 100 artists/year. Sponsors 6 exhibits/year of emerging, mid-career and established artists. Average display time: 1 month. Open during academic year; Tuesday, 10-4, 6-7:30; Monday, Wednesday-Friday, 10-4; closed semester breaks, summer, and weekends. Clients include local community, students, and upscale.

MEDIA Considers all media and all types of prints.

STYLE Considers all styles and genres.

TERMS Retail price set by the artist. Gallery provides insurance, transportation, and promotion. Accepted

work should be framed or ready to display. Does not require exclusive representation locally.

SUBMISSIONS Send query letter with artist's statement, bio, résumé, reviews, SASE, and slides. Returns material with SASE.

THORNE-SAGENDORPH ART GALLERY

Keene State College, 229 Main St., Keene NH 03435-3501. (603)358-2720. **E-mail:** thorne@keene.edu. **Website:** www.keene.edu/tsag. **Contact:** Brian Wallace, director. Estab. 1965. Nonprofit gallery. In addition to exhibitions of national and international art, the Thorne shows local artist as well as KSC faculty and student work. 600 members. Exhibited artists include Jules Olitski and Fritz Scholder. Sponsors 5 shows/year. Average display time: 4-6 weeks. Open Saturday-Wednesday, 12-5; Thursday and Friday evenings till 7; summer: Wednesday-Sunday, 12-5; closed Monday and Tuesday. Follows academic schedule. Located on campus; 4,000 sq. ft.; climate control, security. 50% of space for special exhibitions. Clients include local community and students.

MEDIA Considers all media and all types of prints.

STYLE Exhibits Considers all styles.

TERMS Gallery takes 40% commission on sales. Retail price set by the artist. Gallery provides insurance, promotion and contract; shipping costs are shared. Artwork must be framed.

SUBMISSIONS Artist's portfolio should include photographs and transparencies. Responds only if interested within 2 months. Returns all material.

THROCKMORTON FINE ART

145 E. 57th St., 3rd Floor, New York NY 10022. (212)223-1059. **Fax:** (212)223-1937. **E-mail:** info@throckmorton-nyc.com. **Website:** www.throckmorton-nyc.com. **Contact:** Spencer Throckmorton, owner; Norberto Rivera, photography. Estab. 1993. For-profit gallery. A New York-based gallery specializing in vintage and contemporary photography of the Americas for over 25 years. Its primary focus is Latin American photographers. The gallery also specializes in Chinese jades and antiquities, as well as pre-Columbian art. Located in the Hammacher Schlemmer Building; 4,000 sq. ft.; 1,000 sq. ft. exhibition space. Clients include local community and upscale. Approached by 50 artists/year; represents or exhibits 20 artists. Sponsors 5 photography exhibits/year. Average display time: 2 months. Open Tuesday–Saturday, 11-5. Overall price range: $1,000-10,000; most work sold at $2,500.

MEDIA Most frequently exhibits photography, antiquities. Also considers gelatin, platinum, and albumen prints.

STYLE Exhibits expressionism. Genres include Latin American.

TERMS Retail price of the art set by the gallery. Gallery provides insurance and promotion. Requires exclusive representation locally. Accepts only artists from Latin America. Prefers only b&w and color photography.

SUBMISSIONS Call or write to arrange personal interview to show portfolio of photographs. Returns material with SASE. Responds to queries only if interested within 2 weeks. Files bios and résumés. Finds artists through portfolio reviews, referrals by other artists, and submissions.

TIBOR DE NAGY GALLERY

724 Fifth Ave., New York NY 10019. (212)262-5050. **Fax:** (212)262-1841. **E-mail:** info@tibordenagy.com. **Website:** www.tibordenagy.com. **Contact:** Andrew Arnot and Eric Brown, owners. Estab. 1949. Retail gallery. The gallery focus is on painting within the New York School traditions, and photography. Represents emerging and mid-career artists. Sponsors 12 shows/year. Average display time: 1 month. Open Tuesday–Saturday, 10-5:30; summer hours: Monday–Friday, 10-5:30; closed December 24–January 3. Located midtown; 3,500 sq. ft. 100% of space for work of gallery artists. 60% private collectors, 40% corporate collectors. Overall price range: $1,000-100,000; most work sold at $5,000-20,000.

MEDIA Considers oil, pen & ink, paper, acrylic, drawings, sculpture, watercolor, mixed media, pastel, collage, etchings, and lithographs. Most frequently exhibits oil/acrylic, watercolor, and sculpture.

STYLE Exhibits representational work as well as abstract painting and sculpture. Genres include landscapes and figurative work. Prefers abstract, painterly realism, and realism.

SUBMISSIONS Gallery is not looking for submissions at this time.

TILT GALLERY

7077 E. Main St., Suite 14, Scottsdale AZ 85251. (602)716-5667. **E-mail:** info@tiltgallery.com. **E-mail:** melanie@tiltgallery.com. **Website:** www.tiltgallery.com. **Contact:** Melanie Craven, gallery owner. Estab. 2005. For-profit gallery. "A contemporary fine art gal-

lery specializing in hand applied photographic processes and mixed media projects." Represents or exhibits 30 emerging and established artists. Exhibited artists include France Scully Osterman and Mark Osterman, Aline Smithson, Jill Enfield, Anna Strickland. Sponsors 8 exhibits/year; 7 photography exhibits/year. Average display time: 1 month. Open Tuesday-Saturday, 10:30-5:30; Thursday (night art walk), 7-9; and by appointment. Please inquire about our designer packages and Young Collectors Program.

TMCC ART GALLERIES

Truckee Meadows Community College, 7000 Dandini Blvd., RDMT 321, Reno NV 89503-4304. (775)674-7698. **Fax:** (775)674-4853. **Website:** www.tmcc.edu/artgalleries. Estab. 1991. "Truckee Meadows Community College (TMCC) provides the opportunity for visual artists working with a diversity of socio/cultural themes, a variety of styles, and different genres, to exhibit their works in the college's art galleries. The goals of the art galleries are to promote dialogue between artists and the public, and to specifically provide an educational arts forum dedicated to innovative programming and artistic excellence for Washoe County and the TMCC campus community. The exhibitions in the TMCC art galleries also serve as a great educational resource for our art history, studio art, and art appreciation classes who write papers about the work as well as reaching out to other departments whom utilize visual vocabulary in their curriculum. TMCC Art Galleries are open during regular school hours." TMCC operates 7 galleries: TMCC Main Gallery, Erik Lauritzen Gallery, Red Mountain Gallery, Red Mountain Student Gallery, Atrium Gallery, Meadowood Center Galleries, and Veterans Upward Bound Gallery.

J. TODD GALLERIES

572 Washington St. (Rt. 16), Wellesley MA 02482. (781)237-3434. **E-mail:** fineart@jtodd.com. **Website:** www.jtodd.com. **Contact:** Jay Todd, owner. Estab. 1980. Retail gallery. "Thousands of works by living US and European artists." Represents 55 emerging, mid-career, and established artists. Sponsors 2-3 shows/year. Average display time: 1 month. Open Tuesday–Saturday, 10:30-5:30; Sunday (October 17-April 10), 1-5; closed Sunday, May through mid-October; open other times by appointment. Located 15 miles west of Boston; 4,000 sq. ft.; vast inventory, professionally displayed; 6 showrooms. 30% of space for special exhibitions; 70% of space for gallery artists. Clientele: residential and corporate; 75% private collectors, 25% corporate collectors. Overall price range: $500-40,000; most work sold at $1,000-15,000.

MEDIA Considers oil, acrylic, watercolor, pen & ink, drawing, mixed media, woodcuts, engravings, lithographs, wood engravings, mezzotints, serigraphs, linocuts, and etchings. Most frequently exhibits oils, woodcuts, and etchings. "We do not accept pastels, giclées, or sculpture."

STYLE Exhibits primitivism, modern, contemporary, postmodern works, impressionism, and realism. Genres include landscape, seascape, nautical, urban scenes, abstracts, interiors, florals, figurative work, and still life. Prefers landscapes, abstracts, figures, and still lifes.

TERMS Accepts work on consignment (negotiable commission). Retail price set by the artist. Gallery provides promotion. Prefers unframed artwork.

SUBMISSIONS Submit via e-mail. "We are mostly interested in oils on canvas. We will consider acrylics and watercolor only if you have a proven track record in the $1,000 and above price range. We are *not* currently accepting pastel, graphics, or sculpture. Please allow 3 weeks to get a response." See website for complete submission instructions.

TOUCHSTONE GALLERY

901 New York Ave. NW, Washington DC 20001-2217. (202)347-2787. **E-mail:** info@touchstonegallery.com. **Website:** www.touchstonegallery.com. Estab. 1976. Cooperative member gallery. Representing 50 artists in various media uses exhibiting a new show monthly. "Our newly renovated contemporary space is available for event rental. Located near the heart of the bustling Penn Quarter district in downtown Washington D.C., our large beautifully lit gallery can be found at street level and is easily accessible. Open Wednesday and Thursday, 11-6; Friday, 11-8; Saturday and Sunday, 12-5; closed Christmas–New Year's Day. Overall price range: $400-7,000. As a functioning co-op gallery, there is a monthly membership fee, plus a donation of time. A 40% commission is taken from sold works. To become a member, visit the website for further information, or contact the gallery directly.

UAB VISUAL ARTS GALLERY

Abroms-Engel Institute for the Visual Arts, 1221 10th Ave. S, Birmingham AL 35205. (205)975-6436. **Fax:** (205)975-2836. **E-mail:** aeiva@uab.edu. **Website:** www.uab.edu/cas/aeiva. Nonprofit university gallery. Rep-

resents emerging, mid-career, and established artists. Sponsors 10-12 exhibits/year. Average display time: 3-4 weeks. Open Monday-Thursday, 11-6; Friday, 11-5; Saturday, 1-5; closed Sundays and holidays. Located on 1st floor of Humanities Building, a classroom and office building, 2 rooms with a total of 2,000 sq. ft. and 222 running ft. Clients include local community, students, and tourists.

MEDIA Considers all media except craft. Considers all types of prints.

STYLE Considers all styles and genres.

SUBMISSIONS Write to arrange a personal interview to show portfolio of slides. Send query letter with artist's statement, bio, brochure, photographs, résumé, reviews, SASE, and slides. Returns material with SASE. The gallery does not consider unsolicited exhibition proposals.

ULRICH MUSEUM OF ART

Wichita State University, 1845 Fairmount St., Wichita KS 67260-0046. (316)978-3664. **Fax:** (316)978-3898. **E-mail:** ulrich@wichita.edu. **Website:** www.ulrich. wichita.edu; www.facebook.com/ulrichmuseum; www. twitter.com/ulrichmuseum. **Contact:** Bob Workman, director. Estab. 1974. Wichita's premier venue for modern and contemporary art. Presents 6 shows/year with emerging, mid-career and established artists. Open Tuesday-Friday, 11-5; Saturday-Sunday, 1-5; closed Mondays and major/university holidays. Located in the southwest section of the Wichita State University campus. Gallery admission, parking, and guided, group tours are free.

MEDIA "Exhibition program includes all range of media."

STYLE "Style and content of exhibitions aligns with leading contemporary trends."

UPSTREAM PEOPLE GALLERY

5607 Howard St., Omaha NE 68106-1257. (402)991-4741. **E-mail:** shows@upstreampeoplegallery.com. **Website:** www.upstreampeoplegallery.com. **Contact:** Laurence Bradshaw, curator. Estab. 1998. Exclusive online virtual gallery with over 40 international exhibitions in the archives section of the website. Represents mid-career and established artists. Approached by approximately 250-500 artists/year; represents or exhibits 20,000 artists. Sponsors appx. 12 total exhibits/year and 7 photography exhibits/year. Average display time: 12 months to 7 years. Overall price range: $100-60,000; most work sold at $300.

MEDIA Considers all media, stills of video, and film. Most frequently exhibits oil, acrylic, and ceramics.

STYLE Considers all prints, styles, and genres. Most frequently exhibits neo-expressionism, realism, and surrealism.

TERMS Artwork is accepted on consignment; there is no commission if the artists sells, but a 20% commission if the gallery sells. Retail price set by the artist. Gallery provides promotion and contract.

SUBMISSIONS Accepted work should be photographed. Call or write to arrange personal interview to show portfolio, e-mail query letter with link to website and JPEG samples at 72 dpi, or send query letter with artist's statement and CD/DVD. Returns material with SASE. Responds to queries within 1 week. Files résumés. Finds artists through art exhibits, referrals, and online and magazine advertising.

TIPS "Make sure all photographs of works are in focus."

URBAN INSTITUTE FOR CONTEMPORARY ARTS

2 Fulton West, Grand Rapids MI 49503. (616)454-7000. **E-mail:** curator@uica.org. **Website:** www.uica.org. Estab. 1977. Alternative space and nonprofit gallery. Approached by 250 artists/year; represents or exhibits 20 artists. Sponsors 3-4 photography exhibits/year. Average display time: 6 weeks. Galleries open Tuesday-Saturday, 12-9; Sunday, 12-6.

MEDIA Considers all media. Most frequently exhibits mixed media, avant garde, and nontraditional.

STYLE Exhibits conceptualism and postmodernism.

TERMS Gallery provides insurance, promotion, and contract.

SUBMISSIONS Check website for gallery descriptions and how to apply. Send query letter with artist's statement, bio, résumé, reviews, SASE, application fee, and slides. Returns material with SASE. Does not reply. Artist should see website, inquire about specific calls for submissions. Finds artists through submissions.

TIPS "Get submission requirements before sending materials."

VALE CRAFT GALLERY

230 W. Superior St., Chicago IL 60654. (312)337-3525. **Fax:** (312)337-3530. **E-mail:** valecraft@sbcglobal.net. **Website:** www.valecraftgallery.com. **Contact:** Peter Vale, owner. Estab. 1992. Retail gallery. "Vale Craft Gallery exhibits and sells contemporary American fine craft and sculpture including works in clay, fiber,

metal, glass, wood, and mixed media. Vale Craft Gallery features colorful textiles, beautiful glass objects, handcrafted furniture, innovative ceramics, whimsical sculpture, and unique jewelry." Represents 100 emerging, mid-career artists/year. Exhibited artists include Tana Acton, Mark Brown, Tina Fung Holder, John Neering and Kathyanne White. Sponsors 4 shows/year. Average display time: 3 months. Open all year; Tuesday–Friday, 10:30-5:30; Saturday, 11-5. Located in River North gallery district near downtown; 2,100 sq. ft.; lower level of prominent gallery building; corner location with street-level windows provides great visibility. Clientele: private collectors, tourists, people looking for gifts, interior designers, and art consultants. Overall price range: $50-2,000; most work sold at $100-500.

MEDIA Considers paper, sculpture, ceramics, craft, fiber, glass, metal, wood, and jewelry. Most frequently exhibits fiber wall pieces, jewelry, glass, ceramic sculpture, and mixed media.

STYLE Exhibits contemporary craft. Prefers decorative, sculptural, colorful, whimsical, figurative, and natural or organic.

TERMS Accepts work on consignment (50% commission). Retail price set by the artist. Gallery provides insurance, promotion, contract, and shipping costs from gallery; artist pays shipping costs to gallery.

SUBMISSIONS Accepts only craft media. No paintings, prints, or photographs. By mail: send query letter with résumé, bio or artist's statement, reviews if available, 10-20 slides, CD of images (in JPEG format) or photographs (including detail shots if possible), price list, record of previous sales, and SASE if you would like materials returned to you. By e-mail: include a link to your website or send JPEG images, as well as any additional information listed above. Call for appointment to show portfolio of originals and photographs. Responds in 2 months. Files résumé (if interested). Finds artists through submissions, art and craft fairs, publishing a call for entries, artists' slide registry, and word of mouth.

TIPS "Call ahead to find out if the gallery is interested in showing the particular type of work that you make. Try to visit the gallery ahead of time or check out the gallery's website to find out if your work fits into the gallery's focus. I would suggest you have at least 20 pieces in a body of work before approaching galleries."

VIRIDIAN ARTISTS, INC.

548 W. 28th St., Suite 632, New York NY 10001. (212)414-4040. **Website:** www.viridianartists.com. **Contact:** Vernita Nemec, director. Estab. 1968. Artist-owned gallery. Approached by 200 artists/year. Exhibits 25-30 emerging, mid-career, and established artists/year. Sponsors 15 total exhibits/year; 2-4 photography exhibits/year. Average display time: 3 weeks. Open Tuesday–Saturday, 12-6; closed in August. "Classic gallery space with 3 columns, hardwood floor, white walls, and track lights, approximately 1,100 sq. ft. The gallery is located in Chelsea, the prime area of contemporary art galleries in New York City." Clients include: local community, students, tourists, upscale, and artists. 15% of sales are to corporate collectors. Overall price range: $100-8,000; most work sold at $1,500.

MEDIA Considers all media except craft, traditional glass and ceramic, unless it is sculpture. Most frequently exhibits paintings, photography and sculpture. Considers engravings, etchings, linocuts, lithographs, mezzotints, serigraphs, woodcuts, and monoprints/limited edition digital prints.

STYLE Mostly contemporary, but considers all styles. Most frequently exhibits paintingly abstraction, imagism, and neo-expressionism. "We are not interested in particular styles, but in professionally conceived and professionally executed contemporary art. Eclecticism is our policy. The only unifying factor is quality. Work must be of the highest technical and aesthetic standards."

TERMS Artwork accepted on consignment with a 30% commission. There is a co-op membership fee plus a donation of time with a 30% commission. Retail price of the art is set by the gallery and artist. Gallery provides promotion and contract. "Viridian is an artist-owned gallery with a director and gallery assistant. Artists pay gallery expenses through monthly dues, but the staff takes care of running the gallery and selling the art. The director writes the press releases, helps install exhibits and advises artists on all aspects of their career. We try to take care of everything but making the art and framing it." Prefers artists who are familiar with the NYC art world and are working professionally in a contemporary mode which can range from realistic to abstract to conceptual and anything in between.

SUBMISSIONS Submitting art for consideration is a 2-step process: first through website or JPEGs, then if accepted at that level, by seeing 4-6 samples of the

actual art. Artists should call, e-mail query letter with link to artist's website or JPEG samples at 72 dpi (include image list) or send query letter with artist's statement, bio, reviews, CD with images, and SASE. Materials returned with SASE. Responds in 2-4 weeks. Files materials of artists who become members. Finds artists through word of mouth, submissions, art exhibits, portfolio reviews, or referrals by other artists.

TIPS "Present current art completed within the last 2 years. Our submission procedure is in 2 stages: first we look at websites, JPEGs that have been e-mailed, or CDs that have been mailed to the gallery. When e-mailing JPEGs, include an image list with title, date of execution, size, media. Also, include a bio and artist's statement. Reviews about your work are helpful if you have them, but not necessary. If you make it through the first level, then you will be asked to submit 4-6 actual artworks. These should be framed or matted, and similar to the work you want to show. Realize it is important to present a consistency in your vision. If you do more than one kind of art, select what you feel best represents you, for the art you show will be a reflection of who you are."

VISUAL ARTS CENTER, WASHINGTON PAVILION OF ARTS & SCIENCE

301 S. Main, Sioux Falls SD 57104. (605)367-6000. **E-mail:** info@washingtonpavilion.org. **Website:** washingtonpavilion.org. Estab. 1961. Nonprofit museum. "The Visual Arts Center brings the visual arts to children and adults through exhibitions, education, collections and special events, and is devoted to building, preserving and conserving its collections for South Dakotans and worldwide audiences. Produces approximately 16 exhibitions a year. Includes the Raven Children's Studio and the Palidino-Holms Sculpture Garden." Open Monday–Thursday, Saturday, 10-5; Friday, 10-8; Sunday, 12-5.

⚙ VOLCANO ART CENTER

Crater Rim Dr., Hawai'i Volcanoes National Park, (808)967-7565. **E-mail:** gallery@volcanoartcenter.org. **Website:** www.volcanoartcenter.org. **Contact:** Emily C. Weiss. Estab. 1974. Nonprofit gallery to benefit arts education; nonprofit organization. Represents over 200 emerging, mid-career, and established artists/year. 1,000 member organization. Exhibited artists include Dietrich Varez, Marian Berger, Michael & Misato Mortara, and Brad Lewis. Sponsors 8 shows/year. Average display time: 6 weeks. Open Monday-Sunday, 9-5. Lo-cated in Hawaii Volcanoes National Park; 3,000 sq. ft.; in the historic 1877 Volcano House Hotel. 15% of space for special exhibitions; 85% of space for gallery artists. Clientele affluent travelers from all over the world. 95% private collectors, 5% corporate collectors. Overall price range: $20-12,000; most work sold at $50-400.

MEDIA Considers all media, all types of prints. Most frequently exhibits wood, ceramics, glass, and 2D.

STYLE Prefers traditional Hawaiian, contemporary Hawaiian and contemporary fine crafts.

TERMS Accepts work on consignment (50% commission). Only artists residing within the state of Hawaii eligible representation at VAC Gallery. for 10% discount to VAC members. Gallery provides promotion and contract; artist pays shipping costs to gallery. Exhibiting artists must be Volcano Art Center members. Submission guidelines available online. Out of state artists are considered for classes and workshops on an ongoing basis.

SUBMISSIONS Prefers work relating to the area and by Hawaii resident artists. Call for appointment to show portfolio. Responds if interested within 2 months. Files information on represented artists.

THE VON LIEBIG ART CENTER

585 Park St., Naples FL 34102. (239)262-6517. **Website:** www.naplesart.org. **Contact:** Jack O'Brien, curator. Estab. 1954. The Von Liebig Art Center is operated by the Naples Art Association, a nonprofit 501(c)3 organization located in downtown Naples and presents changing exhibitions of contemporary art by regionally, nationally and internationally recognized artists at the Von Liebig Art Center and around Naples. Its education program offers professional studio art courses and workshops in painting, printmaking, drawing, photography, ceramics, sculpture, and applied arts. A lecture series features visiting speakers who cover dynamic and stimulating topics in art. Five major outdoor art festivals are held annually and Art in the Park, an NAA members' outdoor art festival, is held the first Saturday of each month, November-April. Over 14 exhibitions are installed each year including *Camera USA: National Photography Award* held each summer, *National Art Encounter*, the non-juried *Show of Shows Exhibition* and many juried exhibitions. The Naples Art Association holds a collection of approximately 200 works of art created after 1950 by accomplished artists who have lived in or had a connection to Florida.

Artwork is selected by a committee and accessioned through donations.

MEDIA Considers artwork in all media.

STYLE Considers all styles. Festivals feature both fine art and fine craft.

TERMS 30% commission on artwork sold during exhibitions. Artists participating in exhibitions may wish to acquire insurance to cover loss or damage.

SUBMISSIONS For more information on current exhibition and festival opportunities visit www.naplesart.org. For more information on the major outdoor art festivals, visit www.juriedartservices.com. For more information on Art in the Park, and to apply, visit www.naplesart.org/content/art-park.

TIPS Membership in the Naples Art Association offers many benefits. For more information, and to become a member, visit www.naplesart.org.

WAILOA CENTER

200 Piopio St., Hilo HI 96720. (808)933-0416. **E-mail:** wailoa@yahoo.com. **Contact:** Codie M. King, director. Hawaii State Parks, Department of Land & Natural Resources. Focus is on propagation of the culture and arts of the Hawaiian Islands and their many ethnic backgrounds. Estab. 1967. Represents/exhibits 300 emerging, mid-career, and established artists. Interested in seeing work of emerging artists. Sponsors 24 shows/year. Average display time: 1 month. Open all year; Monday-Tuesday, Thursday-Friday, 8:30-4:30; Wednesday, 12-4:30; closed weekends and state holidays. Located downtown; 10,000 sq. ft.; 4 exhibition areas. Clientele: tourists, upscale, local community, and students. Overall price range: $25-25,000; most work sold at $1,500.

MEDIA Considers all media and most types of prints. No giclée prints; original artwork only. Most frequently exhibits mixed media.

STYLE Exhibits all styles.

TERMS "We cannot sell, but will refer buyer to artist." Gallery provides some promotion. Artist pays for shipping, invitation, and reception costs. Artwork must be framed.

SUBMISSIONS Send query letter with résumé, slides, photographs, and reviews. Call for appointment to show portfolio of photographs and slides. Responds in 3 weeks. Finds artists through word of mouth, referrals by other artists, visiting art fairs and exhibitions, submissions.

TIPS "We welcome all artists, and try to place them in the best location for the type of art they create. Call first to let us review what you have."

WALKER'S POINT CENTER FOR THE ARTS

839 S. Fifth St., Milwaukee WI 53204. (414)672-2787. **Fax:** (414)755-1960. **E-mail:** ana@wpca-milwaukee.org; staff@wpca-milwaukee.org. **Website:** www.wpca-milwaukee.org. **Contact:** Ana Melo, Executive Director. Estab. 1987. Alternative space and nonprofit gallery. Represents emerging and established artists; 200+ members. Exhibited artists include Colin Dickson, Chris Silva, Josie Osborne and Shane Walsh. Sponsors 6-8 shows/year. Average display time: 2 months. Open Tuesday–Saturday, 12-5. Located in the heart of the historic Walker's Point neighborhood; 6,000-sq.-ft. brick building.

MEDIA Considers all media. Prefers installation, sculpture and video.

STYLE Considers all styles. Our gallery often presents work with Latino themes.

TERMS We are nonprofit and do not provide honorarium. Gallery assumes a 30% commission. Retail prices set by the artist. Gallery provides insurance with written contract. Prefers artwork framed.

SUBMISSIONS Please visit the website for art submission guidelines.

WASHINGTON PRINTMAKERS GALLERY

1641 Wisconsin Ave. NW, Washington DC 20007. (202)669-1497. **E-mail:** info@washingtonprintmakers.com. **Website:** www.washingtonprintmakers.com. Estab. 1985. Cooperative gallery. Exhibits 40 emerging and mid-career artists/year. Exhibited artists include Lee Newman, Max-Karl Winkler, Trudi Y. Ludwig and Margaret Adams Parker. Sponsors 12 exhibitions/year. Average display time: 1 month. Open Wednesday-Sunday, 12-5; closed on New Year's Day, Easter, 4th of July, Thanksgiving, Christmas. Located just outside DC proper on the Red Line Metro. 100% of space for gallery artists. Clientele: varied. 90% private collectors, 10% corporate collectors. Overall price range: $65-1,500; most work sold at $200-400.

MEDIA Considers all types of original prints, hand pulled by artist. No posters. Most frequently exhibits etchings, lithographs, serigraphs, relief prints.

STYLE Considers all styles and genres.

TERMS Co-op membership fee plus donation of time (40% commission). Retail price set by artist. Gallery

provides promotion. Purchaser pays shipping costs of work sold.

SUBMISSIONS Send query letter. Call for appointment to show portfolio of original prints. Responds in 1 month.

TIPS "There is a monthly jury for prospective members. Call to find out how to present work. We are especially interested in artists who exhibit a strong propensity for not only the traditional conservative approaches to printmaking, but also the looser, more daring and innovative experimentation in technique."

WASHINGTON PROJECT FOR THE ARTS

10 I St. SW, Washington DC 20024. (202)234-7103. **Fax:** (202)234-7106. **E-mail:** info@wpadc.org; pnesbett@ wpadc.org; smay@wpadc.org; lgold@wpadc.org. **Website:** www.wpadc.org. **Contact:** Christopher Cunetto, membership manager. Estab. 1975. Alternative space that exhibits emerging, mid-career, and established artists. Approached by 1,500 artists/year, exhibits 800 artists. Sponsors 12 exhibits/year. Average display time of 4 weeks. WPA is located in the Capitol Skyline Hotel. We exhibit throughout the hotel and in various museums and venues throughout the region. Clients include local community, students, tourists and upscale. 5% of sales are to corporate collectors. Overall price range of works sold $100-5,000. Most work sold at $500-1,000.

MEDIA Considers all media. Most frequently exhibits performance, painting, drawing, and photography. Considers all types of prints.

STYLE Considers all styles, most frequently exhibits contemporary works.

TERMS Artwork is accepted on consignment and there is a 50% commission. Retail price set by the artist. Gallery provides insurance, promotion, and contract. Accepted work should be framed.

SUBMISSIONS E-mail query letter with link to artist's website. Responds in 2 months. Finds artists through word of mouth, submissions, portfolio reviews, art exhibits, and referrals by other artists.

TIPS Use correct spelling, make sure packages/submissions are tidy.

⌂ WEST END GALLERY

5425 Blossom St., Houston TX 77007. (713)861-9544. **E-mail:** kpackl1346@aol.com. **Contact:** Kathleen Packlick. Estab. 1991. Retail gallery. Exhibits emerging and mid-career artists. Open all year. Located 5 minutes from downtown Houston; 800 sq. ft. "The gallery shares the building (but not the space) with West End Bicycles." 75% of space for special exhibitions; 25% of space for gallery artists. Clientele: 100% private collectors. Overall price range: $30-2,200; most work sold at $300-600.

MEDIA Considers oil, pen & ink, acrylic, drawings, watercolor, mixed media, pastel, collage, woodcuts, wood engravings, linocuts, engravings, mezzotints, etchings, lithographs, and serigraphs. Prefers collage, oil, and mixed media.

STYLE Genres include landscapes, florals, wildlife, portraits, and figurative work.

TERMS Accepts work on consignment (40% commission). Retail price set by artist. Prefers framed artwork.

SUBMISSIONS Accepts only artists from Houston area. Send query letter and SASE. Portfolio review requested if interested in artist's work.

WALTER WICKISER GALLERY

210 11th Ave., Suite 303, New York NY 10001. (212)941-1817. **Fax:** (212)625-0601. **E-mail:** wwickiserg@aol.com. **Website:** www.walterwickisergallery.com. Estab. 1992. For-profit gallery. Specializing in contemporary American and Asian painting. Located in the prestigious fine art building in Chelsea. Shows only established artists. The Wickiser Gallery has received numerous reviews in *ARTnews*, *Art in America* and many other internationally recognized publications. Work by many of the gallery's artists have been exhibited at American museums including the Metropolitan Museum of Art, the Whitney Museum of American Art, the High Museum of Art in Georgia, the Dallas Museum of Art in Texas, and the New Britain Museum of American Art in Connecticut. Open Tuesday–Saturday, 11-6.

WOMEN & THEIR WORK ART SPACE

1710 Lavaca St., Austin TX 78701. (512)477-1064. **Fax:** (512)477-1090. **Website:** www.womenandtheirwork. org. **Contact:** Chris Cowden, executive director. Estab. 1978. Alternative space, nonprofit gallery. Approached by more than 200 artists/year; sponsors 6 solo shows of emerging and mid-career women artists. Average display time: 6 weeks. Open Monday–Friday,10-6; Saturday, 12-5; closed December 24–January 2, and other major holidays. Clients include Austinites, students, tourists, and upscale. Exhibition space is 2,000 sq. ft. Overall price range: $500-5,000; most work sold at $800-2,000. 10% of sales are to corporate collectors.

MEDIA Considers all media. Most frequently exhibits photography, sculpture, installation, and painting.

STYLE Exhibits contemporary works of art.

TERMS Selects artists through an artist advisory panel and curatorial/jury process. Pays artists to exhibit. Takes 25% commission if something is sold. Retail price set by the gallery and the artist. Gallery provides insurance, promotion, and contract. Accepts Texas women in solo shows as well as out-of-state in one solo show. See website for more information.

SUBMISSIONS See website for current call for entries. Entries are now online. Online slide registry on website for members. Finds artists through submissions and annual juried process.

WOODWARD GALLERY

133 Eldridge St., Ground Floor, New York NY 10002. (212)966-3411. **Fax:** (212)966-3491. **E-mail:** art@ woodwardgallery.net. **Website:** www.woodwardgallery. net. Estab. 1994.

MEDIA Considers acrylic, collage, drawing, mixed media, oil, paper, pastel, pen ink, sculpture, watercolor. Most frequently exhibits canvas, paper, and sculpture. Considers all types of prints.

STYLE Most frequently exhibits realism/surrealism, pop, abstract and landscapes, graffiti. Genres include figurative work, florals, landscapes, and portraits.

TERMS Artwork is bought outright (net 30 days) or consigned. Retail price set by the gallery.

SUBMISSIONS "Call before sending anything! Send query letter with artist's statement, bio, brochure, photocopies, photographs, reviews, and SASE. Returns material with SASE. Finds artists through referrals or submissions. Policy posted on website—please adhere carefully to directions for artist review criteria."

WORCESTER CENTER FOR CRAFTS GALLERIES

25 Sagamore Rd., Worcester MA 01605. (508)753-8183. **E-mail:** ccasey4@worcester.edu. **Website:** www. worcestercraftcenter.org. **Contact:** Candace Casey, gallery director. Estab. 1856. Nonprofit rental gallery. Dedicated to promoting artisans and American crafts. Has several exhibits throughout the year, including 1 juried catalog show and 2 juried craft fairs in May and November. Exhibits student, faculty, visiting artists, regional, national, and international artists. Open all year; Monday-Saturday, 10-5. Located at edge of downtown; 2,205 sq. ft. (main gallery); track lighting, security. Overall price range: $20-400; most work sold at $65-100.

MEDIA Considers all media except paintings and drawings. Most frequently exhibits wood, metal, fiber, ceramics, glass, and photography.

STYLE Exhibits all styles.

TERMS Artwork is accepted on consignment (40% commission). Retail price set by the artist. Gallery provides insurance, promotion and contract. Shipping costs are shared.

SUBMISSIONS Call for appointment to show portfolio of photographs and slides. Responds in 1 month.

WORLD FINE ART

179 E. Third St., Suite 16, New York NY 10009-7705. (646)539-9622. **E-mail:** info@worldfineart. com. **Website:** www.worldfineart.com. **Contact:** O'Delle Abney, director. Estab. 1992. Online gallery since 2010. Publishes a weekly video newsletter at http://nycgalleryopenings.com/. Services listed at www.worldfineart.com/join.html. Arranges group exhibitions around the New York City area.

TERMS Responds to queries in 1 week. Nonexclusive agent to 12 current portfolio artists. Finds artists online.

TIPS "Have website available or send JPEG images for review to info@worldfineart.com."

RIVA YARES GALLERY

3625 Bishop Lane, Scottsdale AZ 85251. (480)947-3251 (Scottsdale). **Fax:** (480)947-4251 (Scottsdale). **E-mail:** art@rivayaresgallery.com. **Website:** www. rivayaresgallery.com. Estab. 1963. Retail gallery. Represents 30-40 emerging, mid-career, and established artists/year. Exhibited artists include Rodolfo Morales and Esteban Vicente. Sponsors 12-16 shows/year. Average display time: 3-6 weeks. Call for the hours of each gallery. Scottsdale gallery located in downtown area; 8,000 sq. ft.; national design award architecture; international artists. 50% of space for special exhibitions; 50% of space for gallery artists. Clientele: collectors. 90% private collectors; 10% corporate collectors. Overall price range: $1,000-1 million; most work sold at $20,000-50,000.

MEDIA Considers all media except craft and fiber and all types of prints. Most frequently exhibits paintings (all media), sculpture, and drawings.

STYLE Exhibits expressionism, photorealism, neo-expressionism, minimalism, pattern painting, color field, hard-edge geometric abstraction, painterly abstraction, realism, surrealism, and imagism. Prefers abstract ex-

pressionistic painting and sculpture, surrealistic sculpture, and modern schools' painting and sculpture.

TERMS Accepts work on consignment (50% commission). Retail price set by the artist. Gallery provides insurance, promotion and contract; gallery pays for shipping from gallery; artist pays for shipping to gallery. Prefers artwork framed.

SUBMISSIONS Not accepting new artists at this time.

TIPS "Few artists take the time to understand the nature of a gallery and if their work even applies."

YEISER ART CENTER INC.

200 Broadway St., Paducah KY 42001. (270)442-2453. **E-mail:** jewhite@theyeiser.org. **Website:** www.theyeiser.org. **Contact:** Joshua E. White, director. Estab. 1957. Nonprofit gallery. Exhibits emerging, mid-career, and established artists. 450 members. Sponsors 7-8 shows/year. Average display time: 6-8 weeks. Open Tuesday–Saturday, 10-5. Located downtown; 1,800 sq. ft.; "in historic building that was farmer's market." 90% of space for special exhibitions. Clientele: professionals and collectors. 90% private collectors. Overall price range: $200-8,000; most artwork sold at $200-1,000.

MEDIA Considers all media. Prints considered include original handpulled prints, woodcuts, wood engravings, linocuts, mezzotints, etchings, lithographs, and serigraphs.

STYLE Exhibits all styles and genres.

TERMS Gallery takes 40% commission on all sales (60/40 split). Expenses are negotiated.

SUBMISSIONS Send résumé, slides, bio, SASE, and reviews. Responds in 3 months.

TIPS "Do not call. Give complete information about the work—media, size, date, title, price. Have good-quality slides of work, indicate availability, and include artist statement. Presentation of material is important."

YELLOWSTONE GALLERY

P.O. Box 472, Gardiner MT 59030. (406)848-7306. **E-mail:** YellowstoneArt@aol.com. **Website:** www.yellowstonegallery.com. Estab. 1983. Retail gallery. Represents 20 emerging and mid-career artists/year. Exhibited artists include Mary Blain and Nancy Glazier. Sponsors 2 shows/year. Average display time: 2 months. Located downtown; 3,000 sq. ft. 25% of space for special exhibitions; 50% of space for gallery artists. Clientele: tourist and regional. 90% private collectors, 10% corporate collectors. Overall price range: $25-8,000; most work sold at $75-600.

MEDIA Considers oil, acrylic, watercolor, ceramics, craft, and photography; types of prints include wood engravings, serigraphs, etchings, and posters. Most frequently exhibits watercolors, oils, and limited edition, signed and numbered reproductions.

STYLE Exhibits impressionism, photorealism, and realism. Genres include Western, wildlife, and landscapes. Prefers wildlife realism, Western, and watercolor impressionism.

TERMS Accepts work on consignment (45% commission). Retail price set by the artist. Gallery provides contract; artist pays for shipping. Prefers artwork framed.

SUBMISSIONS Send query letter with brochure or 10 slides. Write for appointment to show portfolio of photographs. Responds in 1 month. Files brochure and biography. Finds artists through word of mouth, regional fairs and exhibits, mail, and periodicals.

TIPS "Don't show up unannounced without an appointment."

LEE YOUNGMAN GALLERIES

1316 Lincoln Ave., Calistoga CA 94515. (707)942-0585 or (800)551-0585. **E-mail:** leeyg@comcast.net. **Website:** www.leeyoungmangalleries.com. **Contact:** Ms. Lee Love Youngman, owner. Estab. 1985. Retail gallery. "We feature a broad selection of work by important national and regional artists." Represents 40 established artists. Exhibited artists include Ralph Love and Paul Youngman. Sponsors 3 shows/year. Average display time: 1 month. Open Monday–Saturday, 10-5; Sunday, 11-4. Located downtown; 3,000 sq. ft.; "contemporary décor." Clientele 100% private collectors. Overall price range: $500-24,000; most artwork sold at $1,000-3,500.

MEDIA Considers oil, acrylic, watercolor, and sculpture. Most frequently exhibits oils, bronzes, and alabaster.

STYLE Exhibits impressionism and realism. Genres include landscapes, Figurative and still life. Interested in seeing American realism.

TERMS Accepts work on consignment (50% commission). Retail price set by gallery. Customer discounts and payment by installment are available. Gallery provides insurance and promotion. Artist pays for shipping to and from gallery. Prefers framed artwork.

SUBMISSIONS "No unsolicited portfolios." Portfolio review requested if interested in artist's work. "The most common mistake artists make is coming on weekends, the busiest time, and expecting full attention." Finds artists through publication, submissions, and owner's knowledge.

TIPS "Don't just drop in—make an appointment. No agents. While quality and eye appeal are paramount, we also select with an eye towards investment and potential appreciation for our collectors."

ZENITH GALLERY

1429 Iris St. NW, Washington DC 20012. (202)783-2963. **Fax:** (202)783-0050. **E-mail:** margery@zenithgallery.com; art@zenithgallery.com. **Website:** www.zenithgallery.com. **Contact:** Margery E. Goldberg, founder/owner/director. Estab. 1978. For-profit gallery. Exhibits emerging, mid-career, and established artists. Open Friday and Saturday, 12-6 and by appointment. Three rooms; 2,400 sq. ft. of exhibition space. Clients include local community, tourists and upscale. 50% of sales are to corporate collectors. Overall price range: $5,000-15,000.

MEDIA Considers all media.

TERMS Requires exclusive representation locally for solo exhibitions.

SUBMISSIONS Send query e-mail or letter with artist's statement, bio, résumé, reviews, brochures, USB flash drive, SASE. Returns material with SASE. Responds to most queries if interested. Finds artists through art fairs/exhibits, portfolio reviews, referrals by other artists, submissions, and word of mouth.

TIPS "The review process can take anywhere from one month to one year. Please be patient and do not call the gallery for acceptance information." Visit website for detailed submission guidelines before sending any materials.

MAGAZINES

//

Magazines are a major market for freelance illustrators. The best proof of this fact is as close as your nearest newsstand. The colorful publications competing for your attention are chock-full of interesting illustrations, cartoons, and caricatures. Since magazines are generally published on a monthly or bimonthly basis, art directors look for dependable artists who can deliver on deadline and produce quality artwork with a particular style and focus.

Art that illustrates a story in a magazine or newspaper is called "editorial illustration." Art directors look for the best visual element to hook the reader into the story. In some cases this is a photograph, but often, especially in stories dealing with abstract ideas or difficult concepts, an illustration makes the story more compelling. A whimsical illustration can set the tone for a humorous article, or an edgy caricature of movie stars in boxing gloves might work for an article describing conflicts within a film's cast. Flip through a dozen magazines in your local drugstore, and you will quickly see that each illustration conveys the tone and content of articles while fitting in with the magazine's "personality." The key to success in the magazine arena is matching your style to appropriate publications.

Target Your Markets

Read each listing carefully. Knowing how many artists approach each magazine will help you understand how stiff your competition is. (At first, you might do better submitting to art directors who aren't swamped with submissions.) Look at the preferred subject matter to make sure your artwork fits the magazine's needs. Note the submission requirements and develop a mailing list of markets you want to approach.

Visit newsstands and bookstores. Check the cover and interior; if illustrations are used, flip to the masthead (usually a box in one of the beginning pages), and note the art director's

HELPFUL RESOURCES

- A great source for new magazine leads is in the business section of your local library. Ask the librarian to point out the business and consumer editions of the *Standard Rate and Data Service* (*SRDS*) and *Bacon's Newspaper and Magazine Directory*. These huge directories list thousands of magazines and will give you an idea of the magnitude of magazines published today. Another good source is a yearly directory called *Samir Husni's Guide to New Magazines*, also available in the business section of the public library and online at www.mrmagazine.com. *Folio* magazine provides information about new magazine launches and redesigns.

- Each year the Society of Publication Designers sponsors a juried competition, the winners of which are featured in a prestigious exhibition. For information about the annual competition, contact the Society of Publication Designers at (212)223-3332 or visit their website at www.spd.org.

- Networking with fellow artists and art directors will help you find additional success strategies. The Graphic Artists Guild (www.gag.org), The American Institute of Graphic Artists (www.aiga.org), your city's Art Directors Club (www.adcglobal.org) or branch of the Society of Illustrators (www.societyillustrators.org) hold lectures and networking functions. Attend one event sponsored by each organization in your city to find a group you are comfortable with, then join and become an active member.

name. The circulation figure is also relevant; the higher the circulation, the higher the art director's budget (generally). When art directors have a good budget, they tend to hire more illustrators and pay higher fees.

Look at the credit lines next to each illustration. Notice which illustrators are used often in the publications you wish to work with. You will see that each illustrator has a very definite style. After you have studied dozens of magazines, you will understand what types of illustrations are marketable.

Although many magazines can be found at a newsstand or library, some of your best markets may not be readily available. If you can't find a magazine, check the listing in *Artist's & Graphic Designer's Market* to see if sample copies are available. Keep in mind that many magazines also provide artists' guidelines on their websites.

Create a Promo Sample

Focus on one or two consistent styles to present to art directors in sample mailings. See if you can come up with a style that is different from every other illustrator's style, if only slightly. No matter how versatile you may be, limit the styles you market to one or two. That way, you'll be more memorable to art directors. Choose a style or two that you enjoy and

can work in relatively quickly. Art directors don't like surprises. If your sample shows a line drawing, they expect you to work in that style when they give you an assignment. It's fairly standard practice to mail nonreturnable samples: either postcard-size reproductions of your work, photocopies, or whatever is requested in the listing. Some art directors like to see a résumé, while others do not.

More Marketing Tips

- **Don't overlook trade magazines and regional publications.** While they may not be as glamorous as national consumer magazines, some trade and regional publications are just as lavishly produced. Most pay fairly well, and the competition is not as fierce. Until you can get some of the higher-circulation magazines to notice you, take assignments from smaller magazines. Alternative weeklies are great markets as well. Despite their modest payment, there are many advantages to working with them. You develop your signature style and learn how to communicate with art directors and to work quickly to meet deadlines. Once the assignments are done, the tearsheets become valuable samples to send to other magazines.

- **Develop a spot illustration style in addition to your regular style.** "Spots"— illustrations that are half-page or smaller—are used in magazine layouts as interesting visual cues to lead readers through large articles or to make filler articles more appealing. Though the fee for one spot is less than for a full layout, art directors often assign five or six spots within the same issue to the same artist. Because spots are small in size, they must be all the more compelling. So send art directors a sample showing a few powerful small pieces along with your regular style.

- **Be prepared to share your work electronically.** Art directors often require illustrators to fax or e-mail sketched or preliminary illustrations so layouts can be reviewed and suggestions can be offered. Invest in a scanner if you aren't already working digitally.

- **Get your work into competition annuals and sourcebooks.** The term "sourcebook" refers to the creative directories published annually to showcase the work of freelancers. Art directors consult these publications when looking for new styles. Many listings mention if an art director uses sourcebooks. Some directories such as *The Black Book*, *American Showcase*, and *RSVP* carry paid advertisements costing several thousand dollars per page. Other annuals, like the *PRINT Regional Design Annual* or *Communication Arts Illustration Annual*, feature award winners of various competitions.

- **Consider working with a rep.** If after working successfully on several assignments, you decide to make magazine illustration your career, consider contracting with an artists' representative to market your work for you. (See the Artists' Representatives section.)

A&U MAGAZINE

25 Monroe St., Suite 205, Albany NY 12210. (518)426-9010. **Fax:** (518)436-5354. **Website:** www.aumag.org. **Contact:** Chael Needle, managing editor. Estab. 1991. Circ. 180,000. Monthly 4-color literary magazine. "*A&U* is an AIDS publication. Our audience is everyone affected by the AIDS crisis." Art guidelines are free for #10 SASE with first-class postage.

CARTOONS Approached by 10 cartoonists/year. Buys 1 cartoon/year. Prefers work relating to HIV/AIDS disease. Prefers single panel, double panel or multiple panel humorous, b&w washes, color washes or line drawings.

ILLUSTRATION Approached by 15 illustrators/year. Buys 5 illustrations/issue. Features humorous illustration, realistic illustrations, charts & graphs, informational graphics, medical illustration, spot illustrations and computer illustration of all subjects affected by HIV/AIDS. Prefers all styles and media. Assigns 50% of illustrations to well-known or "name" illustrators; 25% to experienced, but not well-known illustrators; 25% to new and emerging illustrators. 50% of freelance illustration demands knowledge of Adobe Illustrator or Photoshop.

FIRST CONTACT & TERMS Submission guidelines available online.

TIPS "We would like to get cutting-edge and unique illustrations or cartoons about the HIV/AIDS crisis, they can be humorous or nonhumorous."

⊕ AARP THE MAGAZINE

601 E St. NW, Washington DC 20049. (888)687-2277. **E-mail:** exhibits@aarp.org; member@aarp.org. **Website:** www.aarp.org/magazine. **Contact:** art/design director. Estab. 2002. Circ. 21 million. Bimonthly 4-color magazine emphasizing health, lifestyles, travel, sports, finance and contemporary activities for members 50 years and over.

ILLUSTRATION Approached by 200 illustrators/year. Buys 30 freelance illustrations/issue. Assigns 60% of illustrations to well-known or "name" illustrators; 30% to experienced but not well-known illustrators; 10% to new and emerging illustrators. Works on assignment only. Considers digital, watercolor, collage, oil, mixed media and pastel.

FIRST CONTACT & TERMS Samples are filed "if I can use the work." Do not send portfolio unless requested. Portfolio can include original/final art, tearsheets, slides and photocopies and samples to keep. Originals are returned after publication. Buys first rights. Pays on completion of project: $700-3,500.

TIPS "We generally use people with strong conceptual abilities. I request samples when viewing portfolios."

AD ASTRA

To the Stars, National Space Society, P.O. Box 98106, Washington DC 20090. (202)429-1600. **Fax:** (703)435-4390. **E-mail:** adastra@nss.org. **Website:** www.nss.org/adastra. **Contact:** Katherine Brick, Editor. Estab. 1989. Circ. 25,000. Quarterly feature magazine popularizing and advancing space exploration and development for the general public interested in all aspects of the space program.

ILLUSTRATION Illustrators: Send postcard sample or slides. "Color slides are best."

DESIGN Designers: Send query letter with brochure and photographs. Samples not filed are returned by SASE. Responds in 6 weeks. Pays $100-300 color cover; $25-100 color inside. "We do commission original art from time to time." Fees are for one-time reproduction of existing artwork. Considers rights purchased when establishing payment. Pays designers by the project.

FIRST CONTACT & TERMS Needs freelancers for multimedia design. Works with 40 freelancers/year. Uses freelancers for magazine illustration. Buys 10 illustrations/year. "We are looking for original artwork on space themes, either conceptual or representing specific designs, events, etc." Prefers acrylics, then oils and collage. "Show a set of slides showing planetary art, spacecraft and people working in space. I do not want to see 'science-fiction' art. Label each slide with name and phone number. Understand the freelance assignments are usually made far in advance of magazine deadline."

ADVENTURE CYCLIST

Adventure Cycling Association, Box 8308, Missoula MT 59807. (406)721-1776, ext. 222. **Fax:** (406)721-8754. **E-mail:** magazine@adventurecycling.org. **Website:** www.adventurecycling.org/adventure-cyclist. **Contact:** Alex Strickland. Estab. 1975. Circ. 45,500. Journal of adventure travel by bicycle, published 9 times/year.

ILLUSTRATION Send digital samples. Samples are filed. Buys 1 illustration/issue. Has featured illustrations by Margie Fullmer, Ludmilla Tomova, Ed Jenne, and Anita Dufalla. Works on assignment only.

FIRST CONTACT & TERMS Will contact artist for portfolio review if interested. Pays on publication, $75-500. Buys one-time rights. Originals returned at job's completion.

🌀 AFRICAN PILOT

Wavelengths 10 (Pty) Ltd., 6 Barbeque Heights, 9 Dytchley Rd., Barbeque Downs, Midrand 1684, South Africa. +27 (0)11-466-8524/6. **Fax:** +27 (0)86 767-4333. **E-mail:** editor@africanpilot.co.za. **Website:** www.africanpilot.co.za. **Contact:** Athol Franz, editor. Estab. 2001. Circ. 7,000+ online; 6,600+ print. "*African Pilot* is southern Africa's premier monthly aviation magazine. It publishes a high-quality magazine that is well known and respected within the aviation community of southern Africa. The magazine offers a number of benefits to readers and advertisers, including a weekly e-mail Aviation News, annual service guide, aviation training supplement, executive wall calendar and an extensive website. The monthly aviation magazine is also available online as an exact replica of the paper edition, but where all major advertising pages are hyperlinked to the advertisers' websites. The magazine offers clean layouts with outstanding photography and reflects editorial professionalism as well as a responsible approach to journalism. The magazine offers a complete and tailored promotional solution for all aviation businesses operating in the African region."

FIRST CONTACT & TERMS Send e-mail with samples. Samples are kept on file. Portfolio not required. Credit line given.

TIPS "*African Pilot* is an African aviation specific publication and therefore preference is given to articles, illustrations and photographs that have an African theme. The entire magazine is online in exactly the same format as the printed copy for the viewing of our style and quality. Contact me for specific details on our publishing requirements for work to be submitted. Submit articles together with a selection of about 10 thumbnail pictures so that a decision can be made on the relevance of the article and what pictures are available to illustrate the article. If we decide to go ahead with the article, we will request high-res images from the portfolio already submitted as thumbnails."

ALARM

Alarm Press, 900 N. Franklin St., Suite 300, Chicago IL 60610. (312)341-1290. **E-mail:** info@alarmpress. com; akoellner@alarmpress.com. **Website:** www. alarmpress.com/alarm-magazine. *ALARM*, published 6 times/year, "does one thing, and it does it very well: it publishes the best new music and art in *ALARM* Magazine and alarmpress.com. From our headquarters in a small Chicago office, along with a cast of contributing writers spread across the country, we listen to thousands of CDs, view hundreds of gallery openings, and attend lectures and live concerts in order to present inspirational artists who are fueled by an honest and contagious obsession with their art."

🖸 Art event listings should be e-mailed to artlistings@alarmpress.com.

FIRST CONTACT & TERMS Submit by e-mail with the subject line "ALARM Magazine Submissions." "Please send your work as part of the body of an e-mail; we cannot accept attachments." Alternatively, submissions may be sent by regular mail to Submissions Dept. "*ALARM* is not responsible for the return, loss of, or damage to unsolicited manuscripts, unsolicited artwork, or any other unsolicited materials. Those submitting manuscripts, artwork, or any other materials should not send originals."

ALASKA

301 Arctic Slope Ave., Suite 300, Anchorage AK 99518-3035. **E-mail:** editor@alaskamagazine.com. **Website:** www.alaskamagazine.com. **Contact:** Michelle Theall, editor; Corrynn Cochran, photo editor. Estab. 1935. Circ. 180,000. Monthly 4-color regional consumer magazine featuring Alaskan issues, stories and profiles exclusively.

ILLUSTRATION Approached by 200 illustrators/ year. Buys 1-4 illustrations/issue. Has featured illustrations by Bob Crofut, Chris Ware, Victor Juhaz, and Bob Parsons. Features humorous and realistic illustrations. Works on assignment only. Assigns 50% to new and emerging illustrators. 50% of freelance illustration demands knowledge of Illustrator, Photoshop, and QuarkXPress.

FIRST CONTACT & TERMS Send postcard or other nonreturnable samples. Accepts Mac-compatible disk submissions. Samples are not returned. Responds only if interested. Will contact artist for portfolio review if interested. Buys first North American serial rights and electronic rights; rights purchased vary according to project. Pays on publication. Pays illustrators $125-300 for color inside; $400-600 for 2-page spreads; $125 for spots.

TIPS "We work with illustrators who grasp the visual in a story quickly and can create quality pieces on tight deadlines."

⌂ ALASKA BUSINESS MONTHLY

Alaska Business Publishing, 501 W. Northern Lights Blvd., Suite 100, Anchorage AK 99503-2577. (907)276-4373; (800)770-4373. **Fax:** (907)279-2900. **E-mail:** editor@akbizmag.com. **Website:** www.akbizmag.com. **Contact:** Susan Harrington, Managing Editor; David Geiger, Art Director. Estab. 1985. Circ. 12,000-15,000. *Alaska Business Monthly*, produced in Alaska for Alaskans and other US and international audiences interested in business affairs of the 49th state. Aims to provide a thorough and objective analysis of issues and trends of interest to the Alaska business community. Featuring stories about individuals, organizations and companies shaping the Alaskan economy, *Alaska Business Monthly* emphasizes the importance of enterprise and strives for statewide business coverage.

TIPS "We usually use local photographers for photos and employees for illustrations. Read the magazine before submitting anything."

ALFRED HITCHCOCK MYSTERY MAGAZINE

Dell Magazines, 44 Wall Street, Suite 904, New York NY 10005-2401. (212)686-7188. **E-mail:** alfredhitchcockmm@dellmagazines.com or via online contact form. **Website:** www.themysteryplace.com/ahmm. **Contact:** associate art director. Estab. 1956. Circ. 202,470. Monthly b&w magazine with 4-color cover emphasizing mystery fiction. Accepts previously published artwork. Original artwork returned at job's completion. Art guidelines available with #10 SASE and first-class postage.

ILLUSTRATION Approached by 300 illustrators/year. Buys 2-3 illustrations/issue. Prefers semirealistic, realistic style. Works on assignment only. Considers pen & ink. Send query letter with printed samples, photocopies or tearsheets and SASE.

FIRST CONTACT & TERMS Guidelines at: www.themysteryplace.com/ahmm/guidelines. Illustrators: Send follow-up postcard sample every 3 months. Samples are filed or returned by SASE. Responds only if interested. "No phone calls." Portfolios may be dropped off every Tuesday and should include b&w and color tearsheets. "No original art please." Rights purchased vary according to project. **Pays on acceptance;** $1,000-1,200 for color cover; $100 for b&w in-

side; $35-50 for spots. Finds artists through submissions drop-offs, RSVP.

TIPS "No close-up or montages. Show characters within a background environment."

ALL ANIMALS MAGAZINE

2100 L St. NW, Washington DC 20037. **Fax:** (301)721-6468. **E-mail:** jcork@humanesociety.org. **Website:** www.humanesociety.org. **Contact:** Jennifer Cork, creative director. Estab. 1954. Circ. 550,000. Bimonthly 4-color membership magazine focusing on the Humane Society of the United States news and animal protection issues.

FIRST CONTACT & TERMS Features realistic, conceptual and spot illustration. Work by assignment only. themes vary by story. E-mail link to portfolio website or mail samples to above address. Pays on acceptance; $700 for 2-page spreads; $100-300 for spots.

ALTERNATIVE THERAPIES IN HEALTH AND MEDICINE

3140 Neil Armstrong Blvd., Suite 307, Eagan MN 55121. (877)904-7951. **Fax:** (651)344-0774. **E-mail:** rpalmer@innovisionhm.com; cgustafson@innovisionhm.com. **Website:** www.alternative-therapies.com. **Contact:** Randy Palmer, creative director; Craig Gustafson managing editor. Estab. 1995. Circ. 25,000. Bimonthly trade journal. "*Alternative Therapies* is a peer-reviewed medical journal established to promote integration between alternative and cross-cultural medicine with conventional medical traditions." Sample copies available.

ILLUSTRATION Buys 6 paintings/year. Purchases fine art for the covers, not graphic art or cartoons.

FIRST CONTACT & TERMS Send e-mail with samples or link to website. Responds within 10 days. Will contact artist if interested. Samples should include subject matter consistent with impressionism, expressionism and surrealism. Buys one-time and reprint rights. Pays on publication; negotiable. Accepts previously published artwork. Originals returned at job's completion. Finds artists through websites, galleries and word of mouth.

AMERICAN FITNESS

15250 Ventura Blvd., Suite 200, Sherman Oaks CA 91403. (800)446-2322, ext. 200. **E-mail:** americanfitness@afaa.com. **Website:** www.afaa.com. **Contact:** Meg Jordan, editor. Estab. 1983. Circ. 42,900. Bimonthly magazine for fitness and health profession-

als. Official publication of the Aerobics and Fitness Association of America, the world's largest fitness educator. Send postcard promotional sample. Acquires one-time rights. Accepts previously published material. Original artwork returned after publication. Approached by 12 illustrators/month. Assigns 2 illustrations/issue. Works on assignment only.

ILLUSTRATION Prefers "very sophisticated" 4-color line drawings. Subjects include fitness, exercise, wellness, sports nutrition, innovations and trends in sports, anatomy and physiology, body composition. "Excellent source for never-before-published illustrators who are eager to supply full-page lead artwork."

THE AMERICAN LEGION MAGAZINE

P.O. Box 1055, Indianapolis IN 46206-1055. (317)630-1253; (317) 630-1298. **Fax:** (317)630-1280. **E-mail:** magazine@legion.org; mgrills@legion.org; hsoria@legion.org. **Website:** www.legion.org. **Contact:** Matt Grills, cartoon editor; Holly Soria, art director. Estab. 1919. Circ. 2,550,000. Emphasizes the development of the world at present and milestones of history; 4-color general-interest magazine for veterans and their families. Monthly. Original artwork not returned after publication.

CARTOONS Uses 3 freelance cartoons/issue. Receives 150 freelance submissions/month. "Experience level does not matter and does not enter into selection process." Especially needs general humor in good taste. "Generally interested in cartoons with broad appeal. Those that attract the reader and lead us to read the caption rate the highest attention. Because of tight space, we're not in the market for spread or multipanel cartoons but use both vertical and horizontal single-panel cartoons. Themes should be home life, business, sports and everyday Americana. Cartoons that pertain only to one branch of the service may be too restricted for this magazine. Service-type gags should be recognized and appreciated by any ex-service man or woman. Cartoons that may offend the reader are not accepted. Liquor, sex, religion and racial differences are taboo."

FIRST CONTACT & TERMS Cartoonists: "No roughs. Send final product for consideration." Usually responds within 1 month. Buys first rights. Pays on acceptance; $150.

TIPS "Artists should submit their work as we are always seeking new slant and more timely humor. Black & white submissions are acceptable, but we purchase only color cartoons. Want good, clean humor—something that might wind up on the refrigerator door. Consider the audience!"

AMERICAN LIBRARIES

American Library Association, 50 E. Huron St., Chicago IL 60611. (800)545-2433. **E-mail:** americanlibraries@ala.org. **Website:** http://americanlibrariesmagazine.org/submissions/. Estab. 1907. Circ. 51,000. Bimonthly professional 4-color journal of the American Library Association for its members, providing independent coverage of news and major developments in and related to the library field. Sample copy $6. Art guidelines available with SASE and first-class postage.

CARTOONS Approached by 15 cartoonists/year. Buys no more than 1 cartoon/issue. Themes related to libraries only. Average payment $50.

ILLUSTRATION Approached by 20 illustrators/year. Buys 1-2 illustrations/issue. Assigns 25% of illustrations to new and emerging illustrators. Works on assignment only.

FIRST CONTACT & TERMS Cartoonists: Send query letter with brochure and finished cartoons. Illustrators: Send query letter with brochure, tearsheets and résumé. Samples are filed. Does not respond to submissions. To show a portfolio, mail tearsheets, photographs and photocopies. Portfolio should include broad sampling of typical work with tearsheets of both b&w and color. Buys first rights. **Pays on acceptance.**

TIPS "I suggest inquirer go to a library and take a look at the magazine first." Sees trend toward "more contemporary look, simpler, more classical, returning to fewer elements."

AMERICAN LITERARY REVIEW

University of North Texas, P.O. Box 311307, Denton TX 76203-1307. (940)565-2755. **E-mail:** americanliteraryreview@gmail.com. **Website:** www.americanliteraryreview.com. **Contact:** Bonnie Friedman, editor in chief. Estab. 1990.

"Send up to 5 original photographs in a standard web-readable format (we prefer JPEG). Each photograph should have a title. We are looking for work that exhibits technical skill and artistic merit to incorporate into our online journal."

AMERICAN SCHOOL BOARD JOURNAL

1680 Duke St., Alexandria VA 22314. (703)838-6739. **Fax:** (703)549-6719. **E-mail:** editorial@asbj.com. **Website:** www.asbj.com. **Contact:** Kathleen Vail, managing editor. Estab. 1891. Circ. 36,000. National monthly magazine for school board members and school administrators. Sample copies available.

ILLUSTRATION Buys 40-50 illustrations/year. Considers all media. Send postcard sample.

FIRST CONTACT & TERMS Illustrators: Send follow-up postcard sample every 3 months. Will not accept samples as e-mail attachment. Please send URL. Responds only if interested. Art director will contact artist for portfolio review of tearsheets if interested. Buys one-time rights. Pays on acceptance. Pays $1,200 maximum for color cover; $250-350 for b&w, $300-600 for color inside. Finds illustrators through agents, sourcebooks, online services, magazines, word of mouth and artist's submissions.

TIPS "We're looking for new ways of seeing old subjects—children, education, management. We also write a great deal about technology and love high-tech, very sophisticated mediums. We prefer concept over narrative styles."

ANALOG

Dell Magazines, 44 Wall St., Suite 904, New York NY 10005-2401. (212)686-7188; (203)866-6688. **E-mail:** analog@dellmagazines.com. **Website:** www.analogsf. com. **Contact:** Victoria Green, senior art director; Trevor Quachri, editor. Estab. 1930. Circ. 80,000. Monthly consumer magazine. Art guidelines free for #10 SASE with first-class postage or free online.

CARTOONS Prefers single panel cartoons.

ILLUSTRATION Buys 4 illustrations/issue. Prefers science fiction, hardware, robots, aliens and creatures. Considers all media.

FIRST CONTACT & TERMS Cartoonists: Send query letter with photocopies or tearsheets and SASE. Samples are not filed and are returned by SASE. Illustrators: Send query letter with printed samples or tearsheets and SASE. Send follow-up postcard sample every 4 months. Accepts disk submissions compatible with QuarkXPress 7.5/version 3.3. Send EPS files. Files samples of interest, others are returned by SASE. Responds only if interested. "No phone calls." Portfolios may be dropped off every Tuesday and should include b&w and color tearsheets and transparencies. "No original art please, especially oversized." Buys one-time rights. Pays on acceptance. Pays cartoonists $35 minimum for b&w cartoons. Pays illustrators $1,200 for color cover; $125 minimum for b&w inside; $35-50 for spots. Finds illustrators through *Black Book*, *LA Workbook*, *American Showcase* and other reference books.

ANALOG SCIENCE FICTION & FACT

Dell Magazines, 44 Wall St., Suite 904, New York NY 10005-2401. **E-mail:** analog@dellmagazines. com. **Website:** www.analogsf.com. **Contact:** Trevor Quachri, editor. Estab. 1930. Circ. 50,000. Monthly magazine for general future-minded audience. "We are interested in professional-level, mostly realistic work. Photographs are not normally used, but artists illustrating for us have worked with photos, using surrealistic effects. The illustration must be able to visually interpret the story in such a way that it accurately represents the story, hooks the reader into reading it, and doesn't give away the ending. The subject matter of the stories usually contain a wide range of things that you must be able to draw. We would like to see an ability to illustrate an entire scene; one that not only has a character or characters but also has a detailed background. You must know anatomy, perspective, balance, and figure proportions. We are not a comic book company, so please don't send samples of comics pages."

ILLUSTRATION Payment $125 for b&w interiors; $1,200 for color cover.

FIRST CONTACT & TERMS Send 4-6 samples of best work; do not send originals. Reviews photocopies, stats, slides, transparencies, tearsheets. Include SASE.

ARTHRITIS TODAY

Arthritis Foundation, 1330 W. Peachtree St., Suite 100, Atlanta GA 30309. **Website:** www.arthritistoday.org. Estab. 1987. Circ. 650,000. Bimonthly consumer magazine. "*Arthritis Today* is the official magazine of the Arthritis Foundation. The award-winning publication is more than the most comprehensive and reliable source of information about arthritis research, care and treatment. It is a magazine for the whole person—from their lifestyles to their relationships. It is written both for people with arthritis and those who care about them." Originals returned at job's completion. Sample copies available. 20% of freelance work demands knowledge of Illustrator, QuarkXPress or Photoshop.

ILLUSTRATION Approached by over 100 illustrators/year. Buys 5-10 illustrations/issue. Works on assignment only; stock images used in addition to original art.

FIRST CONTACT & TERMS Illustrators: Send query letter with brochure, tearsheets, photostats, slides (optional) and transparencies (optional). Samples are filed. Publication will contact artist for portfolio review if interested. Portfolio should include color tearsheets, photostats, photocopies, final art and photographs. Buys first-time North American serial rights. Other usage negotiated. **Pays on acceptance.** Finds artists through sourcebooks, Internet, other publications, word of mouth, submissions.

TIPS "No limits on areas of the magazine open to freelancers. Two to 3 departments in each issue use spot illustrations. Submit tearsheets for consideration. No cartoons."

THE ARTIST'S MAGAZINE

F+W, a Content + eCommerce Company, 10151 Carver Rd., Suite 200, Blue Ash OH 45242. (513)531-2690, ext. 11731. **Fax:** (513)891-7153. **Website:** www.artistsmagazine.com. **Contact:** Maureen Bloomfield, editor-in-chief; Brian Roeth, senior art director. Circ. 100,000. Emphasizes the techniques of working artists for the serious beginning, amateur and professional artist. Published 10 times/year. Sample copy available for $5.99 US, $8.99 Canadian or international; remit in US funds. Sponsors 3 annual contests. Pays illustrators $350-1,000 for color inside, $100-500 for spots. Occasionally accepts previously published material. Returns original artwork after publication. Must be related to art and artists.

CARTOONS Cartoonists: Contact cartoon editor, senior art director, Brian Roeth. Send query letter with brochure, photocopies, photographs and tearsheets to be kept on file. Prefers photostats or tearsheets as samples. Samples not filed are returned by SASE. Buys 1-2 cartoons/year. Buys first rights. Pays on acceptance. Pays cartoonists $65.

ILLUSTRATION Buys 2-3 illustrations/year. Has featured illustrations by Penelope Dullaghan, A. Richard Allen, Robert Carter, Chris Sharp and Brucie Rosch. Features concept-driven illustration. Works on assignment only.

ASIAN ENTERPRISE MAGAZINE

Asian Business Ventures, Inc., P.O. Box 1126, Walnut CA 91788. (909)896-2865 or (909)319-2306. **E-mail:** willyb@asianenterprise.com; alma.asianent@gmail.com; almag@asianenterprise.com. **Website:** www.asianenterprise.com. Estab. 1993. Circ. 100,000. Monthly trade publication. "The largest Asian small business focus magazine in the US"

CARTOONS Buys 12 cartoons/year. Prefers business-humorous, single-panel, political, b&w line drawings.

ILLUSTRATION Buys 12 illustrations/issue. Features cariatures of politicians, humorous illustration and spot illustrations of business subjects. 100% of freelance illustrations demands knowledge of Photoshop, PageMaker and QuarkXPress.

FIRST CONTACT & TERMS Cartoonists: Send query letter with samples. Illustrators: Send query letter with tearsheets. Accepts disk submissions. Send TIFF files. Samples are filed. Responds only if interested. Portfolio review not required. Buys one-time rights. Negotiates rights purchased. Pays on publication. Pays cartoonists $25-50 for b&w, $25-50 for comic strips. Pays illustrators $25-50 for b&w, $200 maximum for color cover; $25-50 for b&w inside. Finds illustrators through promo samples and word of mouth.

ASIMOV'S SCIENCE FICTION

Dell Magazines, 44 Wall St., Suite 904, New York NY 10005. **E-mail:** asimovs@dellmagazines.com. **Website:** www.asimovs.com. **Contact:** Sheila Williams, editor; Victoria Green, senior art director. Estab. 1977. Circ. 50,000. Monthly b&w with 4-color cover magazine of science fiction and fantasy. Art guidelines available for #10 SASE with first-class postage.

CARTOONS Prefers single-panel, b&w washes or line drawings with or without gagline. "No comic book artists. Realistic work only, with science fiction/fantasy themes. Show characters with a background environment." Pays cartoonists $35 minimum. Pays illustrators $600-1,200 for color cover. Accepts previously published artwork. Original artwork returned at job's completion. Approached by 20 cartoonists/year. Buys 10 cartoons/year. Address cartoons to Brian Bieniowski.

ILLUSTRATION Accepts illustrations done with Illustrator and Photoshop. No longer buys interior illustration.

FIRST CONTACT & TERMS Now accepts submissions online. Portfolios may be dropped off every Tuesday and should include b&w and color tearsheets.

Cartoonists: Send query letter with printed samples, photocopies and/or tearsheets, and SASE. Accepts disk submissions compatible with QuarkXPress version 3.3. Send EPS files. Samples are filed or returned by SASE. Responds only if interested. Buys one-time and reprint rights. Pays on acceptance. Commissions 2 covers/year; the rest are second-time rights or stock images.

➕ ASK

E-mail: ask@askmagkids.com. **Website:** www.cricketmag.com. Estab. 2002. "*Ask* is a magazine of arts and sciences for curious kids ages 7-10 who like to find out how the world works."

ILLUSTRATION Illustrations are by assignment only. Please *do not* send original artwork. Send postcards, promotional brochures, or color photocopies. Be sure that each sample is marked with your name, address, phone number, and website or blog. Art submissions will not be returned.

FIRST CONTACT & TERMS Send submissions to: Art Submissions Coordinator, Cricket Media, 70 E. Lake St., Suite 800, Chicago IL 60601. Buys print, digital, promotional rights.

ASPEN MAGAZINE

P.O. Box 4577, Aspen CO 81611. (970)300-3071. **E-mail:** aklein@modernluxury.com. **Website:** www.aspenmagazine.com; www.modernluxury.com/aspen. **Contact:** Alan Klein. Circ. 18,300. Bimonthly 4-color city magazine with the emphasis on Aspen and the valley. Accepts previously published artwork. Original artwork returned at job's completion. Sample copies and art guidelines available.

ILLUSTRATION Approached by 15 illustrators/year. Buys 2 illustrations/issue. Themes and styles should be appropriate for editorial content. Considers all media. Send query letter with tearsheets, photostats, photographs, slides, photocopies and transparencies. Samples are filed. Responds only if interested. Call for appointment to show a portfolio, which should include thumbnails, roughs, tearsheets, slides and photographs. Buys first, one-time or reprint rights. Pays on publication.

ASSOCIATION OF COLLEGE UNIONS INTERNATIONAL

One City Centre, 120 W. Seventh St., Suite 200, Bloomington IN 47404-3925. (812)245-2284. **Fax:** (812)245-6710. **E-mail:** acui@acui.org; alangeve@ acui.org. **Website:** www.acui.org. **Contact:** Andrea Langeveld, marketing designer. Estab. 1914. Professional higher education association magazine covering "multicultural issues, creating community on campus, union and activities programming, managing staff, union operation, professional development and student development."

〇 Also publishes hardcover and trade paperback originals. See listing in the Book Publishers section for more information.

ILLUSTRATION Works on assignment only. Considers all kinds of illustration.

DESIGN Needs designers for production.

FIRST CONTACT & TERMS Illustrators: Send query letter with résumé, photocopies, tearsheets, photographs, websites or color transparencies of college student union activities. Designers: Send query letter with résumé and samples. Samples are filed. Responds only if interested. Negotiates rights purchased. Pays by project.

TIPS "We are a volunteer-driven association. Most people submit work on that basis. We are on a limited budget."

ASTRONOMY

Kalmbach Publishing, 21027 Crossroads Circle, P.O. Box 1612, Waukesha WI 53187-1612. (800)533-6644. **Fax:** (262)798-6468. **Website:** www.astronomy.com. **Contact:** David J. Eicher, editor; LuAnn Williams Belter, art director (for art and photography). Estab. 1973. Circ. 108,000. Monthly consumer magazine emphasizing the study and hobby of astronomy. Published by Kalmbach Publishing. Also see listings for *Classic Toy Trains, Finescale Modeler, Model Railroader, Model Retailer, Bead and Button* and *Trains*.

ILLUSTRATION Send query letter. "If you are submitting digital images, please send TIFF or JPEG files to us via our FTP site. Send duplicate images by mail for consideration." Samples are filed and not returned. Buys one-time rights. Finds illustrators through word of mouth and submissions. Approached by 20 illustrators/year. Buys 2 illustrations/issue. Has featured illustrations by James Yang, Gary Baseman. Considers all media. 10% of freelance illustration demands knowledge of Photoshop, Illustrator, InDesign.

FIRST CONTACT & TERMS Illustrators: Send query letter. "If you are submitting digital images, please send TIFF or JPEG files to us via our FTP site. Send duplicate images by mail for consideration." Sam-

ples are filed and not returned. Buys one-time rights. Finds illustrators through word of mouth and submissions.

A.T. JOURNEYS

Appalachian Trail Conservancy Headquarters, P.O. Box 807, 799 Washington St., Harpers Ferry WV 25425-0807. (304)535-6331. **Fax:** (304)535-2667. **E-mail:** editor@appalachiantrail.org; journeys@appalachiantrail.org. **Website:** www.appalachiantrail. org. **Contact:** Editor. Circ. 50,000. Estab. 1925. *A.T. Journeys*, published 4 times/year, features "the people, places, and events that make up the Appalachian Trail community." Membership publication focuses on the stories of people who experience and support the Appalachian Trail, as well as conservation-oriented stories related to the Appalachian Mountain region. Published 4 times/year. Sometimes accepts previously published material. Returns original artwork after publication. Sample copy and art guidelines available for legitimate queries.

ILLUSTRATION Buys 8-12 illustrations/issue. Accepts all styles and media; computer generated (identified as such) or manual. Original artwork should be directly related to the Appalachian Trail.

FIRST CONTACT & TERMS Illustrators: Send query letter with samples to be kept on file. Prefers nonreturnable postcards, photocopies, or tearsheets as samples. Samples not filed are returned by SASE. Responds in 2 months. "All images should be identified as either 'donation' or 'permission and payment required.'" Buys first North American serial rights, second serial (reprint) rights, Web reprint rights. Negotiates rights purchased. Pays on publication. No kill fee. 30% freelance written. Byline given. Pays on acceptance; $25-$250 for b&w, color. Finds most artists through references, word of mouth, and samples received through the mail.

ATLANTA MAGAZINE

260 Peachtree St., Suite 300, Atlanta GA 30303. (404)527-5500. **Fax:** (404)527-5575. **E-mail:** sfennessy@atlantamagazine.com. **Website:** www. atlantamagazine.com. **Contact:** Steve Fennessy, editor. Estab. 1961. Circ. 66,000. Monthly 4-color consumer magazine.

ILLUSTRATION Buys 3 illustrations/issue. Has featured illustrations by Fred Harper, Harry Campbell, Jane Sanders, various illustrators repped by Wanda Nowak, various illustrators repped by Gerald &

Cullen Rapp, Inc. Features caricatures of celebrities, fashion illustration, humorous illustration and spot illustrations. Prefers a wide variety of subjects. Style and media depend on the story. Assigns 60% of illustrations to well-known or "name" illustrators; 30% to experienced but not well-known illustrators; 10% to new and emerging illustrators.

FIRST CONTACT & TERMS Illustrators: Send nonreturnable postcard sample. Samples are filed. Will contact artist for portfolio review if interested. Buys first rights. **Pays on acceptance.** Finds freelancers through promotional samples, artists' reps, *The Alternative Pick*.

AUTHORSHIP

National Writers Association, 10940 S. Parker Rd., #508, Parker CO 80134. (303)841-0246. **E-mail:** natlwritersassn@hotmail.com. **Website:** www. nationalwriters.com. Estab. 1950s. Circ. 4,000. Quarterly magazine. "Our publication is for our 3,000 members and is cover-to-cover about writing."

FIRST CONTACT & TERMS Cartoonists: Samples are returned. Responds in 4 months. Buys first North American serial and reprint rights. Pays on acceptance. Pays cartoonists $25 minimum for b&w. Illustrators: Accepts disk submissions. Send TIFF or JPEG files.

TIPS "We only take cartoons slanted to writers."

AUTOMOBILE MAGAZINE

831 S. Douglas St., El Segundo CA 90245. **Website:** www.automobilemag.com. **Contact:** art director. Estab. 1986. Circ. 650,000. Monthly 4-color automobile magazine for upscale lifestyles. Art guidelines are specific for each project.

ILLUSTRATION Buys illustrations mainly for spots and feature spreads. Works with 5-10 illustrators/year. Buys 2-5 illustrations/issue. Works on assignment only. Considers airbrush, mixed media, colored pencil, watercolor, acrylic, oil, pastel and collage. Needs editorial and technical illustrations.

FIRST CONTACT & TERMS Send query letter with brochure showing art style, résumé, tearsheets, slides, photographs or transparencies. Show automobiles in various styles and media. "This is a full-color magazine; illustrations of cars and people must be accurate." Samples are returned only if requested. "I would like to keep something in my file." Responds to queries/submissions only if interested. Buys first rights and one-time rights. Pays $200 and up for color inside.

Pays $2,000 maximum depending on size of illustration. Finds artists through mailed samples.

TIPS "Send samples that show cars drawn accurately with a unique style and imaginative use of medium."

AUTO RESTORER

i5 Publishing, Inc., 3 Burroughs, Irvine CA 92618. (213)385-2222. **Fax:** (213)385-8565. **E-mail:** tkade@i5publishing.com. **Website:** www. autorestorermagazine.com. **Contact:** Ted Kade, editor. Estab. 1989. Circ. 60,000. Monthly b&w consumer magazine with focus on collecting, restoring and enjoying classic cars and trucks. Originals returned at job's completion. Sample copies available for $7.

ILLUSTRATION Technical drawings that illustrate articles in black ink are welcome. Approached by 5-10 illustrators/year. Buys 1 illustration/issue. Prefers technical illustrations and cutaways of classic/collectible automobiles through 1979. Considers pen & ink, watercolor, airbrush, acrylic, marker, colored pencil, oil, charcoal, mixed media, and pastel.

FIRST CONTACT & TERMS Illustrators: Send query letter with SASE, slides, photographs, and photocopies. Samples are filed or returned by SASE if requested by artist. Responds to the artist only if interested. Buys one-time rights. Pays on publication; technical illustrations negotiable. Finds artists through submissions.

TIPS Areas most open to freelance work are technical illustrations for feature articles and renderings of classic cars for various sections.

BABYBUG

Cricket Media, Inc., 13625A Dulles Technology Dr., Herndon VA 20171. (703)885-3400. **Website:** www. cricketmedia.com. Estab. 1994. Circ. 45,000. "*Babybug*, a look-and-listen magazine, presents simple poems, stories, nonfiction, and activities that reflect the natural playfulness and curiosity of babies and toddlers."

ILLUSTRATION "Please *do not* send original artwork. Send postcards, promotional brochures, or color photocopies. Be sure that each sample is marked with your name, address, phone number and website or blog. Art submissions will not be returned."

FIRST CONTACT & TERMS Send submissions to: Art Submissions Coordinator, Cricket Media, 70 E. Lake St., Suite 800, Chicago IL 60601. Please allow 3-6 months response time. Acquires print and digital rights, plus promotional rights.

BACKPACKER MAGAZINE

Cruz Bay Publishing, Inc., Active Interest Media Co., 5720 Flatiron Pkwy., Boulder CO 80301. **E-mail:** dlewon@backpacker.com; mhorjus@aimmedia.com; caseylyons@aimmedia.com; khostetter1@gmail.com. **Website:** www.backpacker.com. **Contact:** Dennis Lewon, editor-in-chief; Casey Lyons, senior editor; Maren Horjus, assistant editor; Kristin Hostetter, gear editor. Estab. 1973. Circ. 340,000. Approached by 200-300 illustrators/year. Buys 10 illustrations/issue. *Backpacker* does not buy cartoons. 60% of freelance illustration demands knowledge of FreeHand, Photoshop, Illustrator, QuarkXPress.

TIPS "Know the subject matter, and know *Backpacker* magazine."

BALTIMORE

1000 Lancaster St., Suite 400, Baltimore MD 21202. (443)873-3900. **E-mail:** wmax@ baltimoremagazine.net; mjane@baltimoremagazine. net; blauren@balimoremagazine.net; iken@ baltimoremagazine.net; cron@baltimoremagazine. net; wlydia@baltimoremagazine.net. **Website:** www.baltimoremagazine.net. **Contact:** Send correspondence to the appropriate editor: Max Weiss (lifestyle, film, pop culture, general inquiries); Jane Marion (food, travel); Lauren Bell (style, home, beauty, wellness); Ken Iglehart (business, special editions); Ron Cassie (politics, environment, health, sports); Lydia Woolever (calendar, events, party pages). Estab. 1907. Circ. 70,000. Monthly city magazine featuring news, profiles, and service articles. Sample copies available for $4.99. Considers all media, depending on assignment. 10% of freelance work demands knowledge of InDesign, FreeHand, Illustrator, or Photoshop, or any other program that is saved as a TIFF or PICT file. All art is freelance: humorous front pieces, feature illustrations, etc.

CARTOONS Does not use cartoons.

ILLUSTRATION Samples are filed. Will contact for portfolio review if interested. Originals returned at job's completion. Buys one-time rights. Pays on publication: $200-1,500 for color inside; 60 days after invoice. Finds artists through sourcebooks, publications, word of mouth, submissions. Approached by 1,000 illustrators/year. Buys 4 illustrations/issue. Works on assignment only.

FIRST CONTACT & TERMS Send postcard sample. Accepts disk submissions.

BALTIMORE JEWISH TIMES

11459 Cronhill Dr., Suite A, Owings Mills MD 21117. (410)902-2300. **Fax:** (410)902-2338. **E-mail:** artdirector@jewishtimes.com; mjaffe@jewishtimes.com; editor@jewishtimes.com. **Website:** www.jewishtimes.com. **Contact:** Maayan Jaffe, managing editor; Lindsey Bridwell, art director. Circ. 10,000. Weekly b&w tabloid with 4-color cover. Emphasizes special interests to the Jewish community for largely local readership. Sample copies available.

O Alter Communications also publishes *Style*, a Baltimore lifestyle magazine. See www.alteryourview.com for more information on these publications.

ILLUSTRATION Approached by 50 illustrators/year. Buys 4-6 illustrations/year. Works on assignment only. Prefers high-contrast, b&w illustrations.

FIRST CONTACT & TERMS Illustrators: Send query letter with brochure showing art style or tearsheets and photocopies. Samples not filed are returned by SASE. Responds if interested. To show a portfolio, mail appropriate materials or write/call to schedule an appointment. Portfolio should include original/final art, final reproduction/product and color tearsheets and photostats. Buys first rights. Pays on publication: $500 for b&w or color cover; $50-100 for b&w inside. Accepts previously published artwork. Returns original artwork after publication, if requested.

TIPS Finds artists through word of mouth, self-promotion and sourcebooks. Sees trend toward "more freedom of design integrating visual and verbal."

BARTENDER ® MAGAZINE

Foley Publishing, P.O. Box 157, Spring Lake NJ 07762. (732)449-4499. **Fax:** (732)974-8289. **E-mail:** barmag2@gmail.com. **Website:** bartender.com/mixologist.com. **Contact:** Jackie Foley, editor. Estab. 1979. Circ. 150,000. Quarterly 4-color trade journal emphasizing restaurants, taverns, bars, bartenders, bar managers, owners, etc. Prefers bar themes; single-panel. Works on assignment only.

CARTOONS Send query letter with finished cartoons. Buys first rights. Approached by 10 cartoonists/year. Buys 3 cartoons/issue. Pays cartoonists $25 for b&w and color .

ILLUSTRATION Send query letter with brochure. Samples are filed. Negotiates rights purchased. Pays on publication. Approached by 5 illustrators/year.

Buys 1 illustration/issue. Pays illustrators $500 for color cover.

DESIGN Considers any media.

TIPS Prefers bar themes.

BAY WINDOWS

28 Damrell St., Suite 204, Boston MA 02127. (617)464-7280. **Fax:** (617)464-7286. **E-mail:** letters.baywindows@gmail.com. **Website:** www.baywindows.com. **Contact:** editorial design manager. Estab. 1983. Circ. 60,000. Weekly newspaper "targeted to politically-aware lesbians, gay men and other political allies publishing nonerotic news and features"; b&w with 2-color cover. Sample copies available.

CARTOONS Approached by 25 cartoonists/year. Buys 1-2 cartoons/issue. Buys 50 cartoons/year. Preferred themes include politics and lifestyles. Prefers double and multiple panel, political and editorial cartoons with gagline; b&w line drawings.

ILLUSTRATION Approached by 60 illustrators/year. Buys 1 illustration/issue. Buys 50 illustrations/year. Works on assignment only. Preferred themes include politics; "humor is a plus." Considers pen & ink and marker drawings. Needs computer illustrators familiar with Illustrator or FreeHand.

FIRST CONTACT & TERMS Cartoonists: Send query letter with roughs. Samples are returned by SASE if requested by artist. Illustrators: Send query letter with photostats and SASE. Samples are filed. Responds in 6 weeks, only if interested. Portfolio review not required. Rights purchased vary according to project. Pays on publication. Accepts previously published artwork. Original artwork returned after publication.

⊙⊙ BC OUTDOORS HUNTING AND SHOOTING

Outdoor Group Media, 7261 River Place, 201a, Mission, British Columbia V4S 0A2 Canada. (604)820-3400 or (800)898-8811. **Fax:** (604)820-3477. **E-mail:** info@outdoorgroupmedia.com; mmitchell@outdoorgroupmedia.com; production@outdoorgroupmedia.com; bcoutdoors@cdsglobal.ca; mmitchell@outdoorgroupmedia.com. **Website:** www.bcoutdoorsmagazine.com. **Contact:** Mike Mitchell, editor. Estab. 1945. Circ. 30,000. Biannual 4-color magazine, emphasizing fishing, hunting, camping, wildlife/conservation in British Columbia. Original artwork returned after publication unless

bought outright. Works on assignment only. Samples returned by SASE (nonresidents include IRC). Reports back on future assignment possibilities. Subject matter and the art's quality must fit with publication. Buys first North American serial rights or all rights on a work-for-hire basis. Interested in outdoors, wildlife (BC species only) and activities as stories require.

○ "Send us material on fishing and hunting. We generally just send back nonrelated work."

ILLUSTRATION Approached by more than 10 illustrators/year. Buys 4-6 illustrations/year. Format b&w line drawings and washes for inside and color washes for inside. Has featured illustrations by Ian Forbes, Brad Nickason and Michael McKinell. Prefers local artists. Pays on publication; $40 minimum for spots.

FIRST CONTACT & TERMS Arrange personal appointment to show portfolio or send samples of style.

THE BEAR DELUXE MAGAZINE

Orlo, 240 N. Broadway, #112, Portland OR 97227. **E-mail:** bear@orlo.org. **Website:** www.orlo.org. **Contact:** Tom Webb, editor-in-chief; Kristin Rogers Brown, art director. Estab. 1993. Circ. 19,000. "*The Bear Deluxe Magazine* is a national independent environmental arts magazine publishing significant works of reporting, creative nonfiction, literature, visual art, and design. Based in the Pacific Northwest, it reaches across cultural and political divides to engage readers on vital issues effecting the environment. Published twice per year, *The Bear Deluxe* includes a wider array and a higher percentage of visual artwork and design than many other publications. Artwork is included both as editorial support and as standalone or independent art. It has included nationally recognized artists as well as emerging artists. As with any publication, artists are encouraged to review a sample copy for a clearer understanding of the magazine's approach. Unsolicited submissions and samples are accepted and encouraged. *The Bear Deluxe* has been recognized for both its editorial and design excellence."

CARTOONS Approached by 50 cartoonists/year. Buys 5 cartoons/issue. Prefers work related to environmental, outdoor, media, arts. Prefers single-panel, political, humorous, b&w line drawings. Buys first rights. Pays on publication. Cartoonists should continue to send us their latest and greatest, not just samples.

ILLUSTRATION Pays illustrators $200 for b&w or color cover; $15-75 for b&w or color inside; $15-75 for 2-page spreads; $20 for spots.

FIRST CONTACT & TERMS Send postcard sample and nonreturnable samples. Accepts Mac-compatible disk submissions. Send EPS, TIFF, or JPEG files. Samples are filed or returned by SASE. Responds only if interested. Portfolios may be dropped off by appointment. "If you submit via e-mail, send PDF format files only, or a URL address for us to visit. (Note on e-mail submissions and URL suggestions, we still prefer hard-copy work samples but will consider electronic submissions and links. We cannot, however, guarantee a response to electronic submissions.) Always include an appropriately stamped SASE for the return of materials. No faxes. *The Bear Deluxe* assumes no liability for submitted work samples."

TIPS "Most of our work (besides cartoons) is assigned out as editorial illustration or independent art. Indicate whether an assignment is possible for you. Indicate your fastest turn-around time. We sometimes need people who can work with 2- to 3-week turn-around or faster."

BIRD WATCHER'S DIGEST

P.O. Box 110, Marietta OH 45750. (740)373-5285 or (800)879-2473. **E-mail:** editor@birdwatchersdigest.com; submissions@birdwatchersdigest.com. **Website:** www.birdwatchersdigest.com. **Contact:** Bill Thompson III, editor. Estab. 1978. Circ. 42,000. *BWD* is a nontechnical magazine interpreting ornithological material for amateur observers, including the knowledgeable birder, the serious novice and the backyard bird watcher; strives to provide good reading and good ornithology. Rarely buys rights for art/graphic design.

FIRST CONTACT & TERMS Accepts high-res (300 dpi) digital images via Dropbox or HighTail. See guidelines online.

BIRMINGHAM PARENT

Evans Publishing LLC, 3590-B Hwy 31S. #289, Pelham AL 35124. (205)987-7700. **Fax:** (205)987-7600. **E-mail:** carol@biringhamparent.com. **Website:** www.birminghamparent.com. **Contact:** Carol Evans, publisher/editor. Estab. 2004. Circ. 30,000. Monthly magazine serving parents of families in Central Alabama/Birmingham with news pertinent to them. Art guidelines free with SASE or on website.

CARTOONS Approached by 12-20 cartoonists/year.

Buys 1-2 cartoons/year. Prefers fun, humorous, parenting issues, nothing controversial. Format: single panel. Media: color washes.

ILLUSTRATION Approached by 2 illustrators/year. Assigns 5% of illustrations to new and emerging illustrators. 95% of freelance work demands computer skills. Freelancers should be familiar with InDesign, QuarkXPress, Photoshop.

FIRST CONTACT & TERMS E-mail submissions accepted with link to website. Portfolio not required. Pays cartoonists $0-25 for b&w or color cartoons. Pays on publication. Buys electronic rights, first North American serial rights. Magazine is completely online, so permission must be granted for use in the magazine.

TIPS "We do very little freelance artwork. We are still a small publication and don't have space or funds for it. Our art director provides the bulk of our needs. It would have to be outstanding for us to consider purchasing right now."

BITCH: A FEMINIST RESPONSE TO POP CULTURE

Bitch Media, 4930 NE 29th Ave., Portland OR 97211-7034. (503)282-5699. **E-mail:** bitch@bitchmagazine.com. **Website:** www.bitchmedia.com. **Contact:** Art director. Estab. 1996. Circ. 80,000. Quarterly 2-color magazine "devoted to incisive commentary on our media-driven world. We examine popular culture in all its forms for women and feminists of all ages."

ILLUSTRATION Approached by 300 illustrators/year. Buys 3-7 illustrations/issue. Features conceptual, fashion, and humorous illustration, some portraits and hand lettering. Work on assignment only. Prefers b&w ink drawings and photo collage, or selective use of color. Assigns 85% of illustrations to experienced but not well-known illustrators; 12% to new and emerging illustrators; 3% to well-known or "name" illustrators.

FIRST CONTACT & TERMS Send postcard sample, nonreturnable samples. Samples are filed and are not returned. Will contact artist for portfolio review if interested. Finds illustrators through magazines and word of mouth.

TIPS "We have a few illustrators we work with regularly, but we are open to others. Our circulation has been doubling annually, and we are distributed internationally. Read our magazine and send something we might like. Please review our contributors guidelines online for more specifics, at bitchmagazine.org/writers-guidelines#illustratorsguidelines. No stock submissions."

BIZTIMES MILWAUKEE

BizTimes Media, 126 N. Jefferson St., Suite 403, Milwaukee WI 53202-6120. (414) 277-8181. **Fax:** (414) 277-8191. **E-mail:** shelly.tabor@biztimes.com. **Website:** www.biztimes.com. **Contact:** Shelly Tabor, art director. Estab. 1995. Circ. 13,500. Biweekly business news magazine covering southeastern Wisconsin region.

ILLUSTRATION Uses 1-2 illustrations/year. Features business concepts, charts & graphs, computer, humorous illustration, information graphics and realistic illustrations. Prefers business subjects in simpler styles that reproduce well on thin, glossy paper. Assigns 75% of work to new and emerging illustrators.

FIRST CONTACT & TERMS Illustrators: Send postcard sample and follow-up postcard every year. Will contact artist for portfolio review if interested. Buys one-time rights for print and online usage. Pays illustrators $200-400 for color cover; $80-100 for inside. **Pays on acceptance.**

TIPS "Conceptual work wanted! Audience is business men and women in southeast Wisconsin. Need ideas relative to today's business issues/concerns (insurance, law, banking, commercial real estate, health care, manufacturing, finance, education, technology, retirement). One- to 2-week turnaround."

BLACK ENTERPRISE

260 Madison Ave., 11th Floor, New York NY 10016. (212)242-8000, (312) 664-8667, or (310) 552-6900. **E-mail:** beeditors@blackenterprise.com. **Website:** www.blackenterprise.com. Estab. 1970. Circ. 450,000. Monthly 4-color consumer magazine targeting African Americans and emphasizing personal finance, careers and entrepreneurship.

ILLUSTRATION Approached by over 100 illustrators/year. Buys 10 illustrations/issue. Has featured illustrations by Ray Alma, Cecil G. Rice, Peter Fasolino. Features humorous and spot illustrations, charts & graphs, computer illustration on business subjects. Assigns 10% of illustrations to new and emerging illustrators. 50% of freelance illustration demands knowledge of Illustrator and Photoshop.

FIRST CONTACT & TERMS Illustrators: Send postcard sample. Samples are filed. After introductory mailing, send follow-up postcard every 3 months. Re-

sponds only if interested. Portfolios may be dropped off Monday-Friday and should include color finished, original art and tearsheets. Buys first rights. **Pays on acceptance**; $200-800 for color inside; $800-1,000 for 2-page spreads. Finds illustrators through agents, artist's submissions and *Directory of Illustration*.

BLOOMBERG MARKETS MAGAZINE

731 Lexington Ave., New York NY 10022-1331. (212)318-2000. **E-mail:** bloombergmag@bloomberg. net. **Website:** www.bloomberg.com. **Contact:** art director. Circ. 300,000. Monthly financial/business magazine.

ILLUSTRATION Has featured Doug Ross, Steven Biver and Lisa Ferlic.

FIRST CONTACT & TERMS Illustrators: Send nonreturnable postcard sample. After introductory mailing, send follow-up postcard sample every 6 months. Responds only if interested. Pays illustrators $450 for color inside. Buys one-time rights. Find freelancers through artists' submissions.

BLUELINE

120 Morey Hall, Dept. of English and Communication, Postdam NY 13676. (315)267-2044. **Fax:** (315) 267-3256. **E-mail:** blueline@potsdam.edu. **Website:** bluelinemagadk.com. **Contact:** Donald McNutt, editor; Caroline Downing, art editor; Donald McNutt, nonfiction editor; Stephanie Coyne-Deghett, fiction editor; Rebecca Lehmann, poetry editor. Estab. 1979. Circ. 400. Open to all artists. Editors are interested in art in all media suitable for 2D b&w or color reproduction that addresses in some way the concerns and experiences of the Adirondacks and regions of similar spirit. There is no entry fee. The editors review all submissions from July 1-November 30. Editorial decisions are made by mid-February. Accepted work will be retained until the publication of the journal (in May/June). Work not accepted will be returned by mid-February. *Blueline* reserves one-time publishing rights. All other rights are the property of the artist. Payment in copies.

FIRST CONTACT & TERMS Do not send original art. Submission is by .jpg files only.

⊚ BREWERS ASSOCIATION

P.O. Box 1679, Boulder CO 80306. (303)447-0816 or (888)822-6273. **E-mail:** allison@brewersassociation. org; info@brewersassociation.org. **Website:** www. brewersassociation.org. **Contact:** Jill Redding, edi-

tor; Kristi Switzer, publisher; Allison Seymour, art director. Estab. 1978. "Our nonprofit organization hires illustrators for 2 magazines, *Zymurgy* and *The New Brewer*, each published bimonthly. *Zymurgy* is the journal of the American Homebrewers Association. The goal of the AHA division is to promote public awareness and appreciation of the quality and variety of beer through education, research and the collection and dissemination of information." Circ. 25,000. "*The New Brewer* is the journal of the Brewers Association. It offers practical insights and advice for breweries that range in size from less than 500 barrels per year to more than 800,000. Features articles on brewing technology and problem solving, pub and restaurant management, and packaged beer sales and distribution, as well as important industry news and industry sales and market share performance." Circ. 10,000.

ILLUSTRATION Approached by 50 illustrators/year. Buys 3-6 illustrations/year. Prefers beer and homebrewing themes. Considers all media.

DESIGN Prefers local design freelancers with experience in Photoshop, QuarkXPress, Illustrator.

FIRST CONTACT & TERMS Illustrators: Send postcard sample or query letter with printed samples, photocopies, tearsheets; follow-up sample every 3 months. Accepts disk submissions with EPS, TIFF or JPEG files. "We prefer samples we can keep." No originals accepted; samples are filed. Responds only if interested. Art director will contact artist for portfolio review if interested. Buys one-time rights. Pays 60 days net on acceptance. Pays illustrators $700-800 for color cover; $200-300 for b&w inside; $200-400 for color inside. Pays $150-300 for spots. Finds artists through agents, sourcebooks and magazines (Society of Illustrators, *Graphis*, *PRINT*, *Colorado Creative*), word of mouth, submissions. Designers: Send query letter with printed samples, photocopies, tearsheets.

TIPS "Keep sending promotional material for our files. Anything beer-related for subject matter is a plus. We look at all styles."

BRIDE'S MAGAZINE

Condé Nast, 4 Times Square, New York NY 10036. **Website:** www.brides.com. Estab. 1934. Circ. 336,598. Bimonthly 4-color; "classic, clean, sophisticated design style." Original artwork is returned after publication.

ILLUSTRATION Buys illustrations mainly for spots and feature spreads. Buys 5-10 illustrations/is-

sue. Works on assignment only. Considers pen & ink, airbrush, mixed media, colored pencil, watercolor, acrylic, collage and calligraphy. Needs editorial illustrations.

FIRST CONTACT & TERMS Illustrators: Send postcard sample. In samples or portfolio, looks for "graphic quality, conceptual skill, good 'people' style; lively, young but sophisticated work." Samples are filed. Will contact for portfolio review if interested. Portfolios may be dropped off every Monday-Thursday and should include color and b&w final art, tearsheets, photographs and transparencies. Buys one-time rights or negotiates rights purchased. Pays on publication; $250-350 for b&w or color inside; $250 minimum for spots. Finds artists through word of mouth, magazines, submissions/self-promotions, sourcebooks, artists' agents and reps, attending art exhibitions.

✚ BUGLE

Rocky Mountain Elk Foundation, 5705 Grant Creek, Missoula MT 59808. (406)523-4500. **Fax:** (800)225-5355. **E-mail:** bugle@rmef.org. **E-mail:** conservationeditor@rmef.org; huntingeditor@rmef.org; assistanteditor@rmef.org; photos@rmef.org. **Website:** www.rmef.org. Estab. 1984. Circ. 185,000.

BUSINESS & COMMERCIAL AVIATION

The McGraw-Hill Companies, PMB 327, 54 Danbury Rd., Ridgefield CT 06877-4019. (800)525-5003. **Fax:** (888)385-1428. **Website:** www.aviationweek.com. **Contact:** William Garvey, editor-in-chief. Circ. 55,000. Monthly technical publication for corporate pilots and owners of business aircraft. 4-color; "contemporary design."

ILLUSTRATION Works with 12 illustrators/year. Buys 12 editorial and technical illustrations/year. Uses artists mainly for editorials and some covers. Especially needs full-page and spot art of a business-aviation nature. "We generally only use artists with a fairly realistic style. This is a serious business publication and graphically conservative. Need artists who can work on short deadline time." 70% of freelance work demands knowledge of Photoshop, Illustrator, QuarkXPress and FreeHand.

FIRST CONTACT & TERMS Illustrators: Query with samples and SASE. Responds in 1 month. Photocopies OK. Buys all rights, but may reassign rights to artist after publication. Negotiates payment. Pays on acceptance.

◑ BUSINESS LONDON

P.O. Box 7400, London, Ontario N5Y 4X3 Canada. (519)471-2907. **Fax:** (519)473-7859. **E-mail:** gord.delamont@sunmedia.ca. **Website:** www.businesslondon.ca. **Contact:** Gord Delamont, publisher and editor. Circ. 14,000. Monthly magazine "covering London and area businesses, entrepreneurs, building better businesses." Sample copies not available; art guidelines not available.

CARTOONS Approached by 2 cartoonists/year. Buys 1 cartoon/issue. Prefers business-related line art. Prefers single panel, humorous b&w washes and line drawings without gagline.

ILLUSTRATION Approached by 5 illustrators/year. Buys 2 illustrations/issue. Has featured illustrations by Nigel Lewis and Scott Finch. Features humorous and realistic illustration; informational graphics and spot illustration. Assigns 50% of illustrations to experienced but not well-known illustrators; 50% to new and emerging illustrators. Prefers business issues. Considers all media. 10% of freelance illustration demands knowledge of Photoshop 3, Illustrator 5.5, QuarkXPress 3.2.

FIRST CONTACT & TERMS Send query letter with roughs and printed samples. Accepts disk submissions compatible with QuarkXPress 7/version 3.3, Illustrator 5.5, Photoshop 3, TIFFs or EPS files. Samples are filed and are not returned. Responds only if interested. Art director will contact artist for portfolio review of b&w, color, final art, photographs, slides and thumbnails if interested. Pays on publication. Buys first rights. Finds illustrators through artist's submissions.

TIPS "Arrange personal meetings, provide vibrant, interesting samples, start out cheap! Quick turnaround is a must."

BUSINESS TRAVEL NEWS

116 W. 32nd St., 14th Floor, New York NY 10001. (646)380-6248. **E-mail:** jchan@thebtngroup.com. **Website:** www.businesstravelnews.com. **Contact:** Jonathan Chan, art director. Estab. 1984. Circ. 50,000. Monthly 4-color trade publication focusing on business and corporate travel news/management.

ILLUSTRATION Approached by 300 illustrators/year. Buys 4-8 illustrations/month. Features charts & graphs, computer illustration, conceptual art, informational graphics and spot illustrations. Preferred subjects: business concepts, electronic business and

travel. Assigns 30% of illustrations to well-known, experienced and emerging illustrators.

FIRST CONTACT & TERMS Illustrators: Send postcard or other nonreturnable samples. Samples are filed. Buys first rights. **Pays on acceptance.** Finds illustrators through artists' promotional material and sourcebooks.

TIPS "Send your best samples. We look for interesting concepts and print a variety of styles. Please note we serve a business market."

BUSINESSWEEK

1221 Ave. of the Americans, 3rd Floor, New York NY 10020-1001. (212)318-2000 or (212)512-2511. **Website:** www.businessweek.com. **Contact:** Diane Daley. Malcolm Frouman, art director. Weekly business magazine to keep readers informed on important news that affects the business community in the U.S. and abroad. Circ. 985,025.

ILLUSTRATION Approached by hundreds of illustrators/year. Buys 50 illustrations/year. Has featured illustrations by Steven Brodner. Features caricatures of politicians, charts & graphs, humorous, informational and spot illustrations of business. Assigns 5% to new and emerging illustrators. 10% of freelance illustration demands knowledge of Illustrator and QuarkXPress.

FIRST CONTACT & TERMS Illustrators: Send postcard sample with URL. After introductory mailing, send follow-up postcard sample every 3 months. Samples are filed. Responds only if interested. Portfolio not required. Pays illustrators $1,000-2,000 for color cover; $450-1,000 for color inside. Pays on publication. Negotiates rights purchased. Finds freelancers through artists' submissions and sourcebooks.

⊙ CALIFORNIA HOME & DESIGN

680 Second St., San Francisco CA 94107. (888)260-4269 or (818)487-2080. **Fax:** (818)487-4550. **Website:** www.californiahomedesign.com. Estab. 1994. Circ. 52,500. Bimonthly magazine of Northern California lifestyle. Sample copy free with 9×10 SASE and first-class postage.

ILLUSTRATION Approached by 100 illustrators/year. Buys 6 illustrations/year. Prefers financial, fashion. Considers all media. 50% of freelance illustration demands knowledge of Photoshop, Illustrator, QuarkXPress.

DESIGN Needs freelancers for design and production. Prefers local design freelancers. 100% of freelance work demands knowledge of Photoshop, Illustrator, QuarkXPress.

FIRST CONTACT & TERMS Illustrators: Send postcard sample or query letter with printed samples. Accepts disk submissions compatible with QuarkXPress (EPS files). Designers: Send printed samples. Samples are filed. Responds only if interested. Buys one-time rights. Pays on publication. Pays illustrators $100-250 for spots. Finds illustrators through submissions.

TIPS "Read our magazine."

CALIFORNIA LAWYER

Daily Journal Corp., 44 Montgomery St., Suite 500, San Francisco CA 94104. (415)296-2400. **Fax:** (415)296-2440. **E-mail:** cl_contributingeditor@dailyjournal.com; bo_links@dailyjournal.com. **Website:** www.callawyer.com. **Contact:** Bo Links, legal editor; Marsha Sessa, art director. Estab. 1981. Circ. 140,000. "Monthly magazine about groundbreaking cases, compelling controversies, and fascinating personalities. Our publication seeks to go beyond the headlines of the day with both lively writing and in-depth reporting."

ILLUSTRATION Approached by 100 illustrators/year. Buys 12-18 illustrations/year. Has featured illustrations by William Duke, Phil Foster, Thomas Ehretsmann, James Steinberg, Doug Fraser, Edward Kinsella, Richard Borge, Jack Black, Hal Mayforth, Stuart Briers, Ismael Roldan, Dan Page, and Asaf Hanuka. Features caricatures of celebrities/politicians, realistic illustration, charts & graphs, humorous illustration, computer illustration, informational graphics, spot illustrations. Preferred subjects: business, politics, law.

FIRST CONTACT & TERMS Send postcard sample, URL. After introductory mailing, send follow-up postcard every 2 or 3 months.

CALYX

P.O. Box B, Corvallis OR 97339. (541)753-9384. **Fax:** (541)753-0515. **E-mail:** info@calyxpress.org; editor@calyxpress.org. **Website:** www.calyxpress.org. **Contact:** Brenna Crotty, senior editor. Estab. 1976. Circ. 6,000. "CALYX exists to publish fine literature and art by women and is dedicated to publishing the work of all women, including women of color, older women, working class women and other voices that need to be

heard. We are committed to discovering and nurturing developing writers."

○ "We publish color art inside *CALYX* now. Separate guidelines for electronic art are available."

FIRST CONTACT & TERMS Visual art should be submitted (1) electronically via CD or e-mail; or (2) 5×7 or 8×10 glossy photographs; or (3) 35mm slides. Limit of 6 images/photos/slides. All art media are considered. Please include list of all images/photos/slides with your name, titles, media, dimensions. Also mark the top of the work. Make sure all the proper information is included when sending art electronically. Include a 50-word biographical statement and a separate 50-word statement about your artwork. Submit art separately from prose and poetry.

○ CANADIAN BUSINESS

Rogers Media, 1 Mount Pleasant Rd., 11th Floor, Toronto, Ontario M4Y 2Y5 Canada. (416)764-2000. **E-mail:** letters@canadianbusiness.com. **Website:** www. canadianbusiness.com. Circ. 85,000. Biweekly 4-color business magazine focusing on Canadian management and entrepreneurs.

ILLUSTRATION Approached by 200 illustrators/year. Buys 5-10 illustrations/issue. Has featured illustrations by Gerard Dubois, Joe Morse, Seth, Gary Taxali, Dan Page. Features conceptual illustrations, portraits, caricatures and infographics of business subjects. Assigns 70% of illustrations to well-known or "name" illustrators; 30% to new and emerging illustrators. 50% of freelance illustration demands knowledge of Illustrator and Photoshop.

FIRST CONTACT & TERMS Illustrators: Send postcard sample, printed samples and photocopies. Accepts Mac-compatible disk submissions. Responds only if interested. Will contact artist for portfolio review if interested. **Pays on acceptance**; $1,000-2,000 for color cover; $300-1,500 for color inside; $300 for spots. Finds illustrators through magazines, word of mouth and samples.

○ CANADIAN GARDENING

Transcontinental Media G.P., TVA Publications, 1010 Sérigny Street, Longueuil, Quebec J4k 5G7 Canada. (416)733-7600 or (514) 848-7000. **E-mail:** online form. **Website:** www.canadiangardening.com. Estab. 1990. Circ. 152,000. Special interest magazine published 8 times/year. "A down-to-earth, indispensable magazine for Canadians who love to garden."

ILLUSTRATION Approached by 50 illustrators/year. Prefers using Canadian artists. Buys 2 illustrations/issue. Considers all media. 50% of freelance illustration demands knowledge of Photoshop, Illustrator and InDesign.

FIRST CONTACT & TERMS Illustrators: Send query letter with tearsheets. Accepts disk submissions compatible with Slide Show, InDesign, Illustrator or Photoshop (Mac). Samples are filed and are not returned. Responds only if interested. Buys first rights. Pays within 45 days, $50-250 (CDN) for spots.

✚ ORSON SCOTT CARD'S INTERGALACTIC MEDICINE SHOW

Website: intergalacticmedicineshow.com; oscigms. com. **Contact:** Edmund R. Schubert, editor. Estab. 2005. All illustrations and artwork are by assignment only. Fill out online submission form to be invited to send samples. Pays $400 for color illustration and $200 for b&w illustration.

FIRST CONTACT & TERMS Acquires international exclusive rights in any language or any medium for one year from date of first publication, nonexclusive electronic and/or online rights in perpetuity.

CATALINA

(212)851-3427. **Fax:** (212)202-7608. **E-mail:** cat@ catalinamagazine.com; cathy@catalinamagazine. com. **Website:** www.catalinamagazine.com. Estab. 2001. Bimonthly consumer magazine for Hispanic women between 24 and 54 focusing on careers, beauty, food, parenting, relationships, health and travel.

ILLUSTRATION Approached by 100 illustrators/year. Buys 10 illustrations/year. Preferred subjects: families, Hispanic women, fashion, health, career.

FIRST CONTACT & TERMS Illustrators: Send postcard sample. After introductory mailing, send follow-up postcard sample every 6 months. Responds only if interested. Buys one-time rights.

CAVE WALL

Cave Wall Press, LLC, P.O. Box 29546, Greensboro NC 27429-9546. **E-mail:** editor@cavewallpress.com. **Website:** www.cavewallpress.com. Biannual magazine dedicated to publishing the best in contemporary poetry. "Visit our website to see a few images of work we have published or purchase a sample copy. We are looking for fine art in b&w. Follow the submission guidelines on our website." Sample copy: $5.

"At the moment we are accepting art submissions year-round. This issue is subject to change. Refer to our website for updates. We publish graphic works and drawings in b&w with no gray values. We do not publish photography or other work with gray tones. Response time can take up to 4 months. *Cave Wall* acquires one-time publication rights for artwork."

ILLUSTRATION Illustrators paid $3,000-$4,500. 12-15 freelance illustrators/year.

FIRST CONTACT & TERMS Send postcard sample or e-mail with URL and samples. Send 5-10 8½×11 reproductions (photocopies accepted) to the address above. Include artist, title of work, medium, and date on the back of each print. If the work has been published before, please let us know where. Include SASE for response. Please do not send originals or other materials that need to be returned. If your work is accepted for publication, we will send you the specifications for submitting each piece as a digital file. Follow up every 6-12 months. Samples kept on file for possible future assignments. Samples are not returned. Buys all rights. Send query letter with b&w photocopies. Samples not kept on file, returned only by SASE. Responds in 1-3 months. Guidelines free with SASE, available on website, or via e-mail request.

CED (COMMUNICATIONS, ENGINEERING & DESIGN)

Advantage Business Media, 100 Enterprize Dr., Suite 600, Rockaway NJ 07866. **E-mail:** brian.santo@ advantagemedia.com. **Website:** www.cedmagazine. com. **Contact:** Brian Santo, editor. Estab. 1978. Circ. 25,000. Monthly trade journal; "the premier magazine of broadband technology." Sample copies and art guidelines available.

ILLUSTRATION Works on assignment only. Features caricatures of celebrities, realistic illustration, charts and graphs, informational graphics and computer illustrations. Prefers cable TV industry themes. Considers watercolor, airbrush, acrylic, colored pencil, oil, charcoal, mixed media, pastel, computer disk formatted in Photoshop, Illustrator or FreeHand.

FIRST CONTACT & TERMS Contact only through artist rep. Samples are filed. Portfolio should include final art, b&w/color tearsheets, photostats, photographs and slides. Rights purchased vary according to project. Pays on acceptance. Most illustration done in-house. Pays illustrators $400-800 for color

cover; $125-400 for b&w and color inside; $250-500 for 2-page spreads; $75-175 for spots. Accepts previously published work. Original artwork not returned at job's completion.

TIPS "Be willing to change in mid course; be willing to have finished work rejected. Make sure you can draw and work fast."

CHARISMA

600 Rinehart Rd., Lake Mary FL 32746. (407)333-0600. **Fax:** (407)333-7100. **E-mail:** charisma@ charismamedia.com; sean.roberts@charismamedia. com. **Website:** www.charismamedia.com. **Contact:** Joe Deleon, magazine design director. Circ. 200,000. Publishes religious magazines and books for general readership. Illustrations used for text illustrations, promotional materials, book covers, children and gift books, dust jackets. Illustration guidelines free with SASE.

FIRST CONTACT & TERMS Illustrators: Send nonreturnable promotional postcard, tearsheets, color copies or other appropriate promotional material. Accepts digital submissions. Send query letter with samples. Provide résumé, business card, brochure, flyer or tearsheets to be kept on file for possible future assignments. Works with freelancers on assignment only. Keeps samples on file. Simultaneous submissions and previously published work OK. Pays $5-75 for b&w; $50-550 for color spots; $100-550 for color covers. Payment negotiable. Pays on publication. Credit line given. Buys one-time, first-time, book, electronic and all rights; negotiable.

CHARLESTON MAGAZINE/CHARLESTON HOME/CHARLESTON WEDDINGS

P.O. Box 1794, Mt. Pleasant SC 29465-1794. (843)971-9811 or (888)242-7624. **E-mail:** mmonk@ charlestonmag.com. **Website:** www.charlestonmag. com. **Contact:** Melinda Smith-Monk, art director. Estab. 1974. Circ. 20,000. Monthly 4-color consumer magazine. *Charleston Home* is quarterly, *Charleston Weddings* is 2 times/year with a more regional and national distribution. "Indispensible resource for information about modern-day Charleston SC, addresses issues of relevance and appeals to both visitors and residents." Art guidelines are free with #10 SASE and first-class postage.

ILLUSTRATION Approached by 35 illustrators/year. Buys 1 illustration/issue. Features realistic illustrations, informational graphics, spot illustrations, com-

puter illustration. Prefers business subjects, children, families, men, pets, women and teens. 35% of freelance illustration demands knowledge of Illustrator, Photoshop, FreeHand, PageMaker, QuarkXPress.

FIRST CONTACT & TERMS Illustrators: Send postcard sample and follow-up postcard every month or send query letter with printed samples. Accepts Mac-compatible disk submissions. Samples are filed or returned by SASE. Responds only if interested. Rights purchased vary according to project. Finds illustrators through sourcebooks, artists' promo samples, word of mouth.

TIPS "Our magazine has won several design awards and is a good place for artists to showcase their talent in print. We welcome letters of interest from artists interested in semester-long, unpaid internships-at-large. If selected, artists would provide 4-5 illustrations for publication in return for masthead recognition and sample tearsheets. Staff internships (unpaid) also available on-site in Charleston SC. Send letter of interest and samples of work to art director."

CHARLOTTE MAGAZINE

Morris Visitor Publications, 214 W. Tremont Ave., Suite 303, Charlotte NC 28203. (704)335-7181. **Fax:** (704)335-3757. **E-mail:** richard. thurmond@charlottemagazine.com. **Website:** www. charlottemagazine.com. **Contact:** Richard Thurmond, publisher. Circ. 40,000. Monthly 4-color city-based consumer magazine for Charlotte and surrounding areas. Sample copy for $6.

ILLUSTRATION Approached by many illustrators/year. Buys 1-5 illustrations/issue. Features caricatures of celebrities and politicians; computer illustration; humorous illustration; natural history, realistic and spot illustration. Prefers wide range of media/conceptual styles. Assigns 20% of illustrations to new and emerging illustrators.

FIRST CONTACT & TERMS Illustrators: Send postcard sample and follow-up postcard every 6 months. Send nonreturnable samples. Accepts e-mail submissions. Send EPS or TIFF files. Samples are filed. Responds only if interested. Portfolio review not required. Finds illustrators through promotional samples and sourcebooks.

TIPS "We are looking for diverse and unique approaches to illustration. Highly creative and conceptual styles are greatly needed. If you are trying to get your name out there, we are a great avenue for you."

➕ ⟳ CHATELAINE

1 Mount Pleasant Rd., 8th Floor, Toronto, Ontario M4Y 2Y5 Canada. (416)764-2000. **Fax:** (416)764-1888. **E-mail:** storyideas@chatelaine.rogers.com; brendan. fisher@chatelaine.rogers.com. **Website:** www. chatelaine.com. **Contact:** Laura Brown, managing editor; Brendan Fisher, deputy art director. Monthly consumer magazine for contemporary Canadian woman, focusing on health, fashion, beauty, home decorating and trend.

⟳ Also publishes French edition.

ILLUSTRATION Features caricatures of celebrities/politicians, fashion, humorous and spot illustrations of business, children, families, and women.

FIRST CONTACT & TERMS Illustrators: Send postcard sample with link to website. After introductory mailing, send follow-up postcard sample every 6 months. Responds only if interested. Buys one-time rights.

CHEF

704 N. Wells St., 2nd Floor, Chicago IL 60654. (312)849-2220. **Fax:** (312)849-2174. **E-mail:** cjohnson@talcott.com; moneill@talcott.com. **Website:** www.chefmagazine.com. **Contact:** Claire Johnson, managing editor; Megan O'Neill, associate editor. Circ. 42,000. Trade publication for chefs who manage commercial and noncommercial kitchens, catering firms, restaurants, hotels/resorts/casinos, culinary schools, country clubs, universities, health care facilities. Reports on latest food service tools, food safety issues, and profiles on chefs.

CARTOONS Approached by 50 cartoonists/year. Buys 2 cartoons/year. Prefers cooking/chef related themes. Prefers single panel and humorous.

ILLUSTRATION Approached by 100 illustrators/year. Buys 5 illustrations/year. Features cooking, catering and cafeterias. Assigns 50% to new and emerging illustrators.

FIRST CONTACT & TERMS Cartoonists: Send 2-3 photocopies with link to website. Illustrators: Send postcard sample. After introductory mailing, send follow-up postcard every 6 months. Responds only if interested. At this time, no payment offered for cartoons or illustrations. Finds freelancers through artists' submissions.

TIPS "Only interested in work related to cooking, kitchens, chefs and catering."

CHEMICAL WEEK

IHS, 2 Grand Central Tower, 140 E. 45th St., 40th Floor, New York NY 10017. (212)884-9528. **Fax:** (212)884-9514. **Website:** www.chemweek.com. **Contact:** Nanette Santiago, global advertising sales. Estab. 1908. Circ. 23,000. Bimonthly, 4-color trade publication emphasizing commercial developments in specialty chemical markets.

ILLUSTRATION Features charts and graphs, computer illustration, informational graphics, natural history illustration, realistic illustrations, medical illustration of business subjects. Prefers bright colors and clean look. Assigns 100% of illustrations to experienced but not well-known illustrators. 100% of freelance illustration demands knowledge of Illustrator, Photoshop, QuarkXPress.

FIRST CONTACT & TERMS Illustrators: Send nonreturnable postcard sample and follow-up postcard every 6 months. Accepts Mac-compatible disk submissions. Send EPS or TIFF files. Samples are filed and are not returned. Responds only if interested. Portfolio review not required. Rights purchased vary according to project. Pays on publication; $500-800 for color.

TIPS "Freelancers should be reliable and produce quality work. Promptness and the ability to meet deadlines are most important."

CHESAPEAKE BAY MAGAZINE

601 Sixth St, Annapolis MD 21403. (410)263-2662. **Fax:** (410)267-6924. **E-mail:** editor@chesapeakebaymagazine.com. **Website:** www.chesapeakebaymagazine.com. **Contact:** Ann Levelle, managing editor. Estab. 1972. Circ. 25,000. Monthly 4-color magazine focusing on the boating environment of the Chesapeake Bay, including its history, people, places, events, environmental issues and ecology. Original artwork returned after publication upon request. Sample copies free for SASE with first-class postage. Art guidelines available.

ILLUSTRATION Pays illustrators $75-200 for quarter-page or spot illustrations; up to $500-800 for spreads—4-color inside. Approached by 12 illustrators/year. Buys 2-3 technical and editorial illustrations/issue. Has featured illustrations by Jim Paterson, Kim Harroll, Jan Adkins, Tamzin B. Smith, Marcy Ramsey, Peter Bono, Stephanie Carter and James Yang. Assigns 50% of illustrations to new and emerging illustrators. Considers pen & ink, watercolor, collage, acrylic, marker, colored pencil, oil, charcoal, mixed media and pastel. Also digital. Usually prefers watercolor or acrylic for 4-color editorial illustration. "Style and tone are determined by the artist after he/she reads the story."

DESIGN "Our magazine design is relaxed, fun, and oriented toward people who enjoy recreation on the water. Boating interests remain the same. But for the Chesapeake Bay boater, water quality and the environment are more important now than in the past. Colors brighter. We like to see samples that show the artist can draw boats and understands our market environment. Send tearsheets or send website information. We're always looking. Artist should have some familiarity with the appearance of different types of boats, boating gear and equipment."

FIRST CONTACT & TERMS Illustrators: Send query letter with résumé, tearsheets and photographs. Samples are filed. Make sure to include contact information on each sample. Responds only if interested. Publication will contact artist for portfolio review if interested. Portfolio should include "anything you've got." No b&w photocopies. Buys one-time rights.

TIPS "Price decided when contracted."

CHESS LIFE

P.O. Box 3967, Crossville TN 38557. (931)787-1234. **Fax:** (931)787-1200. **E-mail:** dlucas@uschess.org; fbutler@uschess.org. **Website:** www.uschess.org. **Contact:** Daniel Lucas, editor; Francesca "Frankie" Butler, art director. Estab. 1939. Circ. 85,000. Official publication of the United States Chess Federation. Contains news of major chess events with special emphasis on American players, plus columns of instruction, general features, historical articles, personality profiles, tournament reports, cartoons, quizzes, humor and short stories. Monthly b&w with 4-color cover. Design is "heavy with chess games." Accepts previously published material and simultaneous submissions. Sample copy for SASE with 6 first-class stamps; art guidelines for SASE with first-class postage. *Chess Life* commissioned cover rate $400; inside full page $100; half page $50; quarter page $25. Works on assignment, but will also consider unsolicited work.

CARTOONS Approached by 5-10 cartoonists/year. Buys 0-12 cartoons/year. All cartoons must be chess related. Prefers single panel with gagline; b&w line drawings.

ILLUSTRATION Approached by 30-50 illustrators/year. Works with 4-5 illustrators/year from freelancers. Buys 4-5 illustrations/year. Uses artists mainly for cartoons and covers.

FIRST CONTACT & TERMS Send query letter with samples or e-mail Frankie Butler at fbutler@uschess.org. Responds in 2 months. Negotiates rights purchased. Pays on publication.

CICADA

E-mail: cicada@cicadamag.com. **Website:** www.cricketmag.com/cicada. Estab. 1998. Circ. 6,000. "*Cicada* is a YA lit/comics magazine fascinated with the lyric and strange and committed to work that speaks to teens' truths. We publish poetry, realistic and genre fiction, essay, and comics by adults and teens. (We are also inordinately fond of Viking jokes.) Our readers are smart and curious; submissions are invited but not required to engage young adult themes." Bimonthly literary magazine for ages 14 and up. Publishes 6 issues/year.

FIRST CONTACT & TERMS Send portfolio with samples to cicada@cricketmedia.com with "Online Portfolio Sample" as the subject line. For comic submissions, e-mail a short pitch/sketch(es) and a link to online portfolio with "Comic Submission" as the subject line. Please *do not* send final art. Please allow up to 3–6 months response time.

⊙ CINCINNATI CITYBEAT

811 Race St., 5th Floor, Cincinnati OH 45202. (513)665-4700. **Fax:** (513)665-4368. **E-mail:** rsylvester@citybeat.com. **Website:** www.citybeat.com. Estab. 1994. Circ. under 50,000. Weekly alternative newspaper emphasizing Cincinnati issues, arts and events.

ILLUSTRATION Buys 6-12 illustrations/year. Assigns 90% of illustrations to local artists.

FIRST CONTACT & TERMS Illustrators: Submit PDF samples of work via e-mail, will respond only if interested. Please do not send paper samples. Buys one-time rights. Pays on publication.

TIPS "Please research alternative weeklies before contacting the art director. She reports receiving far too many inappropriate submissions."

CITY & SHORE MAGAZINE

500 E. Broward Blvd., 9th Floor, Ft. Lauderdale FL 33394-3019. (954)356-4686. **E-mail:** mgauert@sun-sentinel.com. **Website:** www.cityandshore.com.

Contact: Mark Gauert, editor and publisher. Estab. 2000. Circ. 42,000. Bimonthly "luxury lifestyle magazine published for readers in South Florida." Sample copies available for $4.95.

ILLUSTRATION "We rarely use illustrations, but when we do, we prefer sophisticated, colorful styles, with lifestyle-oriented subject matter. We don't use illustration whose style is dark or very edgy."

FIRST CONTACT & TERMS Accepts e-mail submissions with image file.

CITY LIMITS

Community Service Society of New York, 31 E. 32nd St., 3rd Floor, New York NY 10016. (212)481-8484, ext. 313. **E-mail:** editor@citylimits.org. **Website:** www.citylimits.org. **Contact:** Jarrett Murphy, executive editor and publisher. Estab. 1976. Monthly urban affairs magazine covering issues important to New York City's low- and moderate-income neighborhoods, including housing, community development, the urban environment, crime, public health and labor. Originals returned at job's completion. Sample copies for 9×12 SAE and 4 first-class stamps. "Our production schedule is tight, so publication is generally within 2 weeks of acceptance, as is payment."

CARTOONS Send query letter with finished cartoons and tearsheets. Buys 5 cartoons/year. Prefers N.Y.C. urban affairs—social policy, health care, environment and economic development. Prefers political cartoons; single, double or multiple panel b&w washes and line drawings without gaglines. Buys first rights and reprint rights. Pays cartoonists $50 for b&w.

ILLUSTRATION Send postcard sample or query letter with tearsheets, photocopies, photographs and SASE. Buys 2-3 illustrations/issue. Has featured illustrations by Noah Scalin. Must address urban affairs and social policy issues, affecting low- and moderate-income neighborhoods, primarily in New York City. Considers pen & ink, watercolor, collage, airbrush, mixed media and anything that works in b&w. Samples are filed. Responds in 1 month. Request portfolio review in original query. Buys first rights. Pays $50-100 for b&w cover; $50 for b&w inside; $25-50 for spots. Pays on publication.

TIPS Finds artists through other publications, word of mouth and submissions. "Our niche is fairly specific. Freelancers are welcome to call and talk."

CKI MAGAZINE

Circle K International, 3636 Woodview Trace, Indianapolis IN 46268. (317)217-6174. **Fax:** (317)879-0204. **E-mail:** ckimagazine@kiwanis.org. **Website:** www. circlek.org. Estab. 1968. Circ. 12,000. Digital magazine published 1-4 times/year for college-age students, emphasizing service, leadership, etc. Free sample copy with SASE and 3 first-class postage stamps.

○ Kiwanis International also publishes *Kiwanis* and *Key Club* magazines.

ILLUSTRATION Approached by more than 30 illustrators/year. Buys 1-2 illustrations/issue. Works on assignment only. Needs editorial illustration. "We look for variety."

FIRST CONTACT & TERMS Send query letter with photocopies, photographs, tearsheets and SASE. Samples are filed. Will contact for portfolio review if interested. Portfolio should include tearsheets and slides. Originals and sample copies returned to artist at job's completion. **Pays on acceptance:** $100 for b&w cover; $250 for color cover; $50 for b&w inside; $150 for color inside.

CLARETIAN PUBLICATIONS

205 W. Monroe, Chicago IL 60606. (312)236-7782. **Fax:** (312)236-8207. **E-mail:** Bruggersc@claretians. org. **Website:** www.uscatholic.org. **Contact:** Carrie Bruggers, design/production editor. Estab. 1960. Circ. 20,000. Monthly magazine "covering the Catholic family experience and social justice." Sample copies and art guidelines available.

ILLUSTRATION Approached by 20 illustrators/year. Buys 4 illustrations/issue. Considers all media.

FIRST CONTACT & TERMS Illustrators: Send postcard sample and query letter with printed samples and photocopies or e-mail with an attached website to visit. Accepts disk submissions compatible with EPS or TIFF. Samples are filed. Responds only if interested. Art director will contact artist for portfolio review if interested. Negotiates rights purchased. **Pays on acceptance.** $100-400 for color inside.

CLEVELAND MAGAZINE

City Magazines, Inc., 1422 Euclid Ave., Suite 730, Cleveland OH 44115. (216)771-2833. **Fax:** (216)781-6318. **E-mail:** gleydura@clevelandmagazine.com; miller@clevelandmagazine.com. **Website:** www. clevelandmagazine.com. **Contact:** Kristen Miller, design director; Steve Gleydura, editor. Estab. 1972. Circ.

50,000. Monthly city magazine, with 4-color cover, emphasizing local news and information.

CARTOONS "We do not publish gag cartoons, but do print editorial illustrations with a humorous twist."

ILLUSTRATION Approached by 100 illustrators/year. Buys 3-4 editorial illustrations/issue on assigned themes. Sometimes uses humorous illustrations. 40% of freelance work demands knowledge of InDesign, Illustrator or Photoshop. "Full-page editorial illustrations usually deal with local politics, personalities and stories of general interest. Generally, we are seeing more intelligent solutions to illustration problems and better techniques."

FIRST CONTACT & TERMS Please provide self-promotions, JPEG samples or tearsheets via e-mail or mail to be kept on file for possible future assignments. Responds if interested. Illustrators: Send postcard sample with brochure or tearsheets.

TIPS "Artists are used on the basis of talent. We use many talented college graduates just starting out in the field. The economy has drastically affected our budgets; we pick up existing work as well as commissioning illustrations."

⊕ CLICK

E-mail: click@cricketmedia.com. **Website:** www. cricketmag.com. "*Click* is a science and exploration magazine for children ages 3-7. Designed and written with the idea that it's never too early to encourage a child's natural curiosity about the world, *Click's* 40 full-color pages are filled with amazing photographs, beautiful illustrations, and stories and articles that are both entertaining and thought-provoking."

ILLUSTRATION Illustrations are by assignment only. PLEASE DO NOT send original artwork. Send postcards, promotional brochures, or color photocopies. Be sure that each sample is marked with your name, address, phone number, and website or blog. Art submissions will not be returned.

FIRST CONTACT & TERMS Send submissions to: Art Submissions Coordinator, Cricket Media, 70 E. Lake St., Suite 800, Chicago IL 60601. Buys print, digital, promotional rights.

CLOUD RODEO

E-mail: editors@cloudrodeo.org; submit@ cloudrodeo.org. **Website:** cloudrodeo.org. "We want your problems deploying a term liek nonelen. We want your isolated photographs of immense

locomotives slogged down by the delirium of drunken yet pristine jungles. We want the one eye you caught on fire doing alchemy. The world you collapsed playing architect. We want what you think is too. We want you to anesthetize this aesthetic. Your Enfer, your Ciel, your Qu'importe. We want all your to to sound out."

ILLUSTRATION "If you are sending us art, photography, audio, or any other medium, attach your work as a .JPEG, TIFF, PDF, RTF, WPF, GIF, PNG, or MP3/MP4A file. If somehow your work can't be transmitted or best represented by these file types, shoot us an e-mail at editors@cloudrodeo.org, and we'll do our best to accommodate."

FIRST CONTACT & TERMS "Simultaneous submissions are encouraged provided you notify us if your work has found another cloud to call rodeo. Please send these notification e-mails as responses to your original submission. Please provide a little cover letter in the body of your e-mail even if it's just to say hi. We want to be able to say hi back. Please limit your submissions to 1 prose piece, 5 pieces of art, or 5 poems at a time. Should we publish your work, all we ask is for first electronic publishing rights. After that the rights will revert to you, although your work will be archived on the site where it will be available for you to spam your friends with, which we encourage wholeheartedly."

TIPS "Let's get weird."

COBBLESTONE

E-mail: cobblestone@cricketmedia.com. **Website:** www.cricketmedia.com. Circ. 15,000. "Cobblestone is interested in articles of historical accuracy and lively, original approaches to the subject at hand." American history magazine for ages 8-14.

ILLUSTRATION Illustrations are by assignment only. Please *do not* send original artwork. Send postcards, promotional brochures, or color photocopies. Be sure that each sample is marked with your name, address, phone number, and website or blog. Art submissions will not be returned.

FIRST CONTACT & TERMS Send submissions to: Art Submissions Coordinator, Cricket Media, 70 E. Lake St., Suite 800, Chicago IL 60601.

TIPS "Study issues of the magazine for style used. Send updated samples once or twice a year to help keep your name and work fresh in our minds. Send nonreturnable samples we can keep on file; we're always interested in widening our horizons."

➕ ⊙ COMMON GROUND

Common Ground Publishing, 3152 W 8th Ave., Vancouver, British Columbia V6K 2C3 Canada. (604)733-2215. **Fax:** (604)733-4415. **E-mail:** editor@commonground.ca. **Website:** www.commonground.ca. Estab. 1982. Circ. 70,000. Monthly consumer magazine focusing on health and cultural activities and holistic personal resource directory. Accepts previously published artwork and cartoons. Original artwork is returned at job's completion. Sample copies for SASE with first-class Canadian postage or International Postage Certificate.

ILLUSTRATION Approached by 20-40 freelance illustrators/year. Buys 1-2 freelance illustrations/issue. Prefers all themes and styles. Considers cartoons, pen & ink, watercolor, collage and marker.

FIRST CONTACT & TERMS Illustrators: Send query letter with brochure, photographs, SASE, and photocopies. Samples are filed or are returned by SASE if requested by artist. Responds only if interested. Buys one-time rights. More guidelines available online. Payment varies.

TIPS "Send photocopies of your top 1-3 inspiring works in b&w or color. Can have all 3 on one sheet of 8½×11 paper or all-in-one color copy. I can tell from that if I am interested."

COMMONWEAL

Commonweal Foundation, 475 Riverside Dr., Room 405, New York NY 10115. (212)662-4200. **Fax:** (212)662-4183. **E-mail:** editors@commonwealmagazine.org. **Website:** www.commonwealmagazine.org. **Contact:** Paul Baumann, editor; Tiina Aleman, production editor. Estab. 1924. Circ. 20,000. Journal of opinion edited by Catholic laypeople concerning public affairs, religion, literature and the arts, full color. Biweekly. See website to order complimentary copies and for submission guidelines. Become familiar with publication before mailing submissions.

CARTOONS Send query letter with finished cartoons. Approached by 20+ cartoonists/year. Buys 1-2 cartoons/issue from freelancers. Prefers simple lines and high-contrast styles. Prefers single panel, with or without gagline. Has featured cartoons by Baloo.

ILLUSTRATION Approached by 20+ illustrators/year. Buys 1-2 illustrations/issue from freelancers.

Prefers high-contrast illustrations that speak for themselves. First contact: Send query letter with tearsheets, photographs. Send SASE and photocopies to Tiina Aleman, production editor. Samples are filed or returned by SASE if requested by artist. Responds in 4 weeks. To show a portfolio, mail tearsheets, photographs and photocopies. Buys nonexclusive rights.

TIPS Pays cartoonists $15. Pays illustrators $15. Pays on publication.

⊕ CONSTRUCTION EQUIPMENT OPERATION AND MAINTENANCE

4403 First Ave., SE, Suite 400, Cedar Rapids IA 52402. (319)366-1597 or (800)774-0438. **Fax:** (319)362-8808. **E-mail:** chuckparks@constpub.com. **Website:** www. constructionpublications.com. Estab. 1948. Circ. 67,000. Bimonthly b&w tabloid with 4-color cover. Covers heavy construction and industrial equipment for contractors, machine operators, mechanics and local government officials involved with construction. Free sample copy.

CARTOONS Buys 8-10 cartoons/issue. Interested in themes "related to heavy construction industry" or "cartoons that make contractors and their employees 'look good' and feel good about themselves"; single panel.

FIRST CONTACT & TERMS Cartoonists: Send finished cartoons and SASE. Responds in 2 weeks. Original artwork not returned after publication. Buys all rights, but may reassign rights to artist after publication. Reserves right to rewrite captions.

CONVERGENCE: AN ONLINE JOURNAL OF POETRY AND ART

E-mail: clinville@csus.edu. **Website:** www. convergence-journal.com. **Contact:** Cynthia Linville, managing editor. Estab. 2003. "We look for well-crafted work with fresh images and a strong voice. Work from a series or with a common theme has a greater chance of being accepted. Seasonally-themed work is appreciated (spring and summer for the January deadline, fall and winter for the June deadline). Please include a 75-word bio with your work (bios may be edited for length and clarity). A cover letter is not needed. Absolutely no simultaneous or previously published submissions."

FIRST CONTACT & TERMS Submit up to six jpegs of your work, 72 dpi, medium sized. Please include a 75 word third-person bio with your work (bios may be edited for length and clarity). A cover letter is not needed. Absolutely no simultaneous or previously published submissions. Submit work to clinville@ csus.edu with "Convergence" in the subject line.

DAVID C. COOK

4050 Lee Vance View, Colorado Springs CO 80918. (719)536-0100 or (800)708-5550. **Website:** www. davidccook.com. Publisher of teaching booklets, books, take-home papers for Christian market, "all age groups." Art guidelines available for SASE with first-class postage only.

ILLUSTRATION Buys about 10 full-color illustrations/month. Has featured illustrations by Richard Williams, Chuck Hamrick and Ron Diciani. Assigns 5% of illustrations to new and emerging illustrators. Features realistic illustration, Bible illustration, computer and spot illustration. Works on assignment only.

FIRST CONTACT & TERMS Illustrators: Send tearsheets, color photocopies of previously published work; include self-promo pieces. No samples returned unless requested and accompanied by SASE. **Pays on acceptance;** $400-700 for color cover; $250-400 for color inside; $150-250 for b&w inside; $500-800 for 2-page spreads; $50-75 for spots. Considers complexity of project, skill and experience of artist, and turnaround time when establishing payment. Buys all rights.

TIPS "We do not buy illustrations or cartoons on speculation. Do *not* send book proposals. We welcome those just beginning their careers, but it helps if the samples are presented in a neat and professional manner. Our deadlines are generous but must be met. Fresh, dynamic, the highest of quality is our goal; art that appeals to everyone from preschoolers to senior citizens; realistic to humorous, all media."

COPING WITH CANCER

P.O. Box 682268, Franklin TN 37068-2268. (615)790-2400. **E-mail:** editor@copingmag.com; info@ copingmag.com. **Website:** www.copingmag.com/ cwc. Estab. 1987. Circ. 90,000. "*Coping With Cancer* is a bimonthly, nationally-distributed consumer magazine dedicated to providing the latest oncology news and information of greatest interest and use to its readers. Readers are cancer survivors, their loved ones, support group leaders, oncologists, oncology nurses and other allied health professionals. The style is very conversational and, considering its sometimes technical subject matter, quite comprehensive to the layman. The tone is upbeat and generally positive,

clever and even humorous when appropriate, and very credible." Sample copy available for $3. Art guidelines for SASE with first-class postage. Guidelines are available on the website.

COSMOPOLITAN

Hearst Corp., 300 W. 57th St., New York NY 10019-3791. (212)649-2000. **E-mail:** cosmo@ hearst.com; youtellcosmo@hearst.com. **Website:** www.cosmopolitan.com. Estab. 1886. Circ. 3 million. Monthly 4-color consumer magazine for contemporary women covering a broad range of topics including beauty, health, fitness, fashion, relationships and careers.

ILLUSTRATION Approached by 300 illustrators/ year. Buys 10-12 illustrations/issue. Features beauty, humorous and spot illustration. Preferred subjects include women and couples. Prefers trendy fashion palette. Assigns 5% of illustrations to new and emerging illustrators.

FIRST CONTACT & TERMS Send postcard sample and follow-up postcard every 4 months. Samples are filed. Responds only if interested. Buys first North American serial rights. Pays on acceptance. Finds illustrators through sourcebooks and artists' promotional samples.

CRICKET

Website: www.cricketmag.com. Estab. 1973. Circ. 73,000. *Cricket* is a monthly literary magazine for ages 9-14. Publishes 9 issues/year. Art is commissioned separately from text. Accepts illustrations in various media: pencil, ink, watercolor, acrylic, oil, pastels, scratchboard and woodcut. Guidelines available online.

ILLUSTRATION "Please do not send original artwork. Send postcards, promotional brochures, or color photocopies. Be sure that each sample is marked with your name, address, phone number and website or blog. Art submissions will not be returned."

FIRST CONTACT & TERMS Send submissions to: Art Submissions Coordinator, Cricket Media, 70 E. Lake St., Suite 800, Chicago IL 60601.

TIPS "*Cricket* would like to reach as many children's illustrators and authors as possible for original contributions, but our standards are very high, and we will accept only top-quality material. Art should be realistic and humorous, but not caricatures or 'cartoony.'"

DAIRYBUSINESS

DairyBusiness Communications, 6437 Collamer Road, East Syracuse NY 13057. (315)703-7979, ext. 229. **Website:** www.dairybusiness.com. Estab. 1922. Circ. 10,051. Monthly trade journals, *DairyBusiness West* and *DairyBusiness East*, with audience comprised of "Western-based milk producers, herd size 100 and larger, all breeds of cows, covering the 17 Western states." Accepts previously published artwork. Samples copies and art guidelines available. Not currently accepting freelance work for stories or photographs.

ILLUSTRATION Approached by 5 illustrators/year. Buys 1-4 illustrations/issue. Works on assignment only. Preferred themes "depend on editorial need." Considers 3D and computer illustration.

FIRST CONTACT & TERMS Send query letter with brochure, tearsheets and résumé. Samples are filed or are returned by SASE if requested by artist. Responds in 2 weeks. Write for appointment to show portfolio of thumbnails, tearsheets and photographs. Buys all rights. Pays on publication; $100 for b&w, $200 for color cover; $50 for b&w, $100 for color inside.

TIPS "We have a small staff. Be patient if we don't get back immediately. A follow-up letter helps. Being familiar with dairies doesn't hurt. Quick turnaround will put you on the 'A' list."

DAKOTA COUNTRY

P.O. Box 2714, Bismarck ND 58502. (701)255-3031. **Fax:** (701)255-5038. **E-mail:** jon@ dakotacountrymagazine.com. **Website:** www. dakotacountrymagazine.com. Estab. 1979. Circ. 14,200. Monthly hunting and fishing magazine with readership in North and South Dakota. Features stories on hunting/fishing/conservation. Basic 3-column format, 2 and 4 columns accepted, glossy full-color throughout magazine, 4-color cover, feature layout. Accepts previously published artwork. Original artwork is returned after publication. Sample copies for $4; art guidelines with SASE and first-class postage.

CARTOONS Likes to buy cartoons in volume. Prefers outdoor themes, hunting and fishing. Prefers multiple or single panel cartoon with gagline; b&w line drawings.

ILLUSTRATION Features humorous and realistic illustration of the outdoors. Portfolio review not required.

FIRST CONTACT & TERMS Send query letter with samples of style. Samples not filed are returned by SASE. Responds to queries/submissions within 2 weeks. Negotiates rights purchased. Pays on acceptance. Pays cartoonists $15 per cartoon, b&w. Pays illustrators $20-25 for b&w inside; $12-30 for spots.

TIPS "Always need good-quality hunting and fishing line art and cartoons."

DELAWARE TODAY MAGAZINE

3301 Lancaster Pike, Suite 5C, Wilmington DE 19805. (302)656-1809. **E-mail:** dostroski@delawaretoday. com. **Website:** www.delawaretoday.com. **Contact:** Drew Ostroski, managing editor. Circ. 25,000. Monthly 4-color magazine emphasizing regional interest in and around Delaware. Features general interest, historical, humorous, interview/profile, personal experience and travel articles. "The stories we have are about people and happenings in and around Delaware. Our audience is middle-aged (40-45) people with incomes around $79,000, mostly educated. We try to be trendy in a conservative state." Needs computer-literate freelancers for illustration.

ILLUSTRATION Buys approximately 1-2 illustrations/issue. Has featured illustrations by Nancy Harrison, Tom Deja, Wendi Koontz, Craig LaRontonda and Jacqui Oakley. "I'm looking for different styles and techniques of editorial illustration!" Works on assignment only. Open to all styles.

FIRST CONTACT & TERMS Send postcard sample. "Will accept work compatible with QuarkXPress 7.5/version 4.0. Send EPS or TIFF files (RGB)." Send printed color promos. Samples are filed. Responds only if interested. Publication will contact artist for portfolio review if interested. Portfolio should include printed samples, color or b&w tearsheets and final reproduction/product. Pays on publication; $200-400 for cover; $100-150 for inside. Buys first rights or one-time rights. Finds artists through submissions and self-promotions.

TIPS "Be conceptual, consistent and flexible."

DERMASCOPE MAGAZINE

Aesthetics International Association, 310 E. Interstate 30, Suite B107, Garland TX 75043. (469)429-9300. **Fax:** (469)429-9301. **E-mail:** amanda@dermascope. com. **Website:** www.dermascope.com. **Contact:** Amanda Strunk-Miller, managing editor. Estab. 1978. Circ. 16,000. Monthly magazine/trade journal, 128 pages, for aestheticians, plastic surgeons, and stylists. Articles should include quality images, graphs, or charts when available. Sample copies and art guidelines available.

ILLUSTRATION Approached by 5 illustrators/year. Prefers illustrations of "how-to" demonstrations. Considers digital media. 100% of freelance illustration demands knowledge of Photoshop, Illustrator, InDesign, Fractil Painter.

⊕ DIG INTO HISTORY

E-mail: dig@cricketmedia.com. **Website:** www. cricketmedia.com. Estab. 1999. *Dig into History* is an archaeology magazine for kids ages 10-14. Publishes entertaining and educational stories about discoveries, artifacts, and archaeologists.

ILLUSTRATION Illustrations are by assignment only. PLEASE DO NOT send original artwork. Send postcards, promotional brochures, or color photocopies. Be sure that each sample is marked with your name, address, phone number, and website or blog. Art submissions will not be returned.

FIRST CONTACT & TERMS Send submissions to: Art Submissions Coordinator, Cricket Media, 70 E. Lake St., Suite 800, Chicago IL 60601. Buys print, digital, promotional rights.

DUCTS

E-mail: vents@ducts.org. **Website:** www.ducts.org. **Contact:** Mary Cool, editor in chief; Tim Tomlinson, fiction editor; Lisa Kirchner, memoir editor; Amy Lemmon, poetry editor; Jacqueline Bishop, art editor. Estab. 1999. Circ. 12,000. Semiannual. *Ducts* is a webzine of personal stories, fiction, essays, memoirs, poetry, humor, profiles, reviews, and art. "*Ducts* was founded in 1999 with the intent of giving emerging writers a venue to regularly publish their compelling, personal stories. The site has been expanded to include art and creative works of all genres. We believe that these genres must and do overlap. *Ducts* publishes the best, most compelling stories, and we hope to attract readers who are drawn to work that rises above."

FIRST CONTACT & TERMS Submission period is January 1 through August 31. Accepts submissions by e-mail to art@ducts.org. Guidelines on website.

THE EAST BAY MONTHLY

Telegraph Media, 1305 Franklin St., Suite 501, Oakland CA 94612. (510)238-9101. **Fax:** (510)238-9163. **Website:** www.themonthly.com. Andreas Jones, art

director. Estab. 1970. Circ. 62,000. Monthly consumer tabloid; 4-color. Editorial features are general interests (art, entertainment, business owner profiles) for an upscale audience. Sample copy and guidelines available for SASE with 5-ounce first-class postage.

CARTOONS Approached by 75-100 cartoonists/year. Buys 3 cartoons/issue. Prefers single-panel, b&w line drawings; "any style, extreme humor."

ILLUSTRATION Approached by 150-200 illustrators/year. Buys 0-1 illustrations/issue. Prefers pen & ink, watercolor, acrylic, colored pencil, oil, charcoal, mixed media and pastel. No nature or architectural illustrations.

DESIGN Occasionally needs freelancers for design and production. 100% of freelance design requires knowledge of Adobe CS.

FIRST CONTACT & TERMS Cartoonists: Send query letter with finished cartoons, or e-mail kartoons@themonthly.com. Illustrators: Send postcard sample or query letter with tearsheets and photocopies, or e-mail artdirector@themonthly.com. Designers: Send query letter with résumé, photocopies, or tearsheets. Accepts submissions on CD, Mac-compatible with Adobe CS. Samples are filed or returned by SASE. Responds only if interested. Write for appointment to show portfolio of thumbnails, roughs, b&w tearsheets, and slides, or e-mail to artdirector@themonthly.com. Buys one-time rights. Pays 15 days after publication. Pays cartoonists $35 for b&w. Pays illustrators $100-200 for b&w inside; $25-50 for spots. Pays for design by project. Accepts previously published artwork. Originals returned at job's completion.

ELECTRICAL APPARATUS

Barks Publications, Inc., Suite 901, 500 N. Michigan Ave., Chicago IL 60611. (312)321-9440. **Fax:** (312)321-1288. **E-mail:** eamagazine@barks.com. **Website:** www.barks.com/eacurr.html. **Contact:** Elizabeth Van Ness, publisher; Kevin N. Jones, senior editor. Estab. 1967. Circ. 16,000. Monthly 4-color magazine emphasizing industrial electrical/mechanical maintenance. Original artwork not returned at job's completion. Sample copy $5.

CARTOONS Buys 3-4 cartoons/issue. Has featured illustrations by Joe Buresch, Martin Filchock, James Estes, John Paine, Bernie White and Mark Ziemann. Prefers themes relevant to magazine content; with gagline. "Captions are edited in our style."

ILLUSTRATION "We have staff artists, so there is little opportunity for freelance illustrators, but we are always glad to hear from anyone who believes he or she has something relevant to contribute."

FIRST CONTACT & TERMS Cartoonists: Send query letter. Responds in 3 weeks. Buys all rights. Pays $125-125 for b&w and color single panels and strips.

TIPS "We prefer single-panel cartoons that portray an industrial setting, ideally with an electrical bent. We also use cartoons with more generic settings and tailor the gaglines to our needs."

ELECTRONIC MUSICIAN

NewBay Media, LLC., 28 E. 28th St., 12th Floor, New York NY 10016. (212)378-0400. **E-mail:** sjones@musicplayer.com; asavona@nbmedia.com. **Website:** www.emusician.com. **Contact:** Sarah Jones, editor; Tony Savona, vice president/content director. Estab. 1986. Circ. 30,000. Monthly consumer magazine for music how-to. Sample copies and art guidelines available on request.

CARTOONS Approached by 100 cartoonist/year. Buys 12 cartoons/year. Prefers humorous.

ILLUSTRATION Approached by 500 illustrators/year. Buys 12 illustrations/year. Has featured Colin Johnson, Kitty Meek. Prefers computer and realistic illustrations of music. Assigns 80% to new and emerging illustrators. 50% of freelance illustrations demands knowledge of whatever software they do best.

FIRST CONTACT & TERMS Cartoonists/Illustrators: Send postcard sample with samples and tearsheets. After introducing mailing, send follow-up postcard sampled every 6 months. Accepts e-mail submissions with link to website. Prefers Mac-compatible, JPEG files. Samples are filed. Company will contact artist for portfolio review if interested. Portfolio should include finished art. Pays cartoonists $100-400 for b&w. Pays illustrators $800-1,200 for color cover. Pays on publication. Buys one-time rights. Finds freelancers through artists' submissions.

EMERGENCY MEDICINE

7 Century Dr., Suite 302, Parsippany NJ 07054-4609. **E-mail:** mdales@frontlinemedcom.com; imnews@frontlinemedcom.com. **Website:** www.emedmag.com. **Contact:** Mary Jo Dales, editorial director. Estab. 1969. Circ. 80,000. Emphasizes emergency medicine for emergency physicians, emergency room personnel, medical students. Monthly. Returns original artwork after publication. Art guidelines not available.

ILLUSTRATION Works with 10 illustrators/year. Buys 1-2 illustrations/issue. Has featured illustrations by Scott Bodell, Craig Zuckerman and Steve Oh. Features realistic, medical and spot illustration. Assigns 70% of illustrations to well-known or "name" illustrators; 30% to experienced, but not well-known illustrators. Works on assignment only.

FIRST CONTACT & TERMS Send postcard sample or query letter with brochure, photocopies, photographs, tearsheets to be kept on file. Samples not filed are not returned. Accepts disk submissions. To show a portfolio, mail appropriate materials. Responds only if interested. Buys first rights. Pays $1,200-1,700 for color cover; $200-500 for b&w inside; $500-800 for color inside; $250-600 for spots.

ESQUIRE

Hearst Media, 300 W. 57th St., New York NY 10019. (212)649-4158. **E-mail:** editor@esquire.com. **Website:** www.esquire.com. Estab. 1933. Circ. 720,000. Contemporary culture magazine for men ages 28-40 focusing on current events, living trends, career, politics, and the media.

FIRST CONTACT & TERMS Illustrators: Send postcard mailers. Drop off portfolio on Wednesdays for review.

�‌ EVENT

Douglas College, P.O. Box 2503, New Westminster, British Columbia V3L 5B2 Canada. (604)527-5293. **Fax:** (604)527-5095. **E-mail:** event@douglascollege.ca. **Website:** www.eventmags.com. Estab. 1971. Circ. 1,000. For "those interested in literature and writing" b&w with 4-color cover. Published 3 times/year. Art guidelines available on website.

CARTOONS No cartoons or illustrations.

ILLUSTRATION Buys approximately 3 photographs/year. Has featured photographs by Mark Mushet, Lee Hutzulak and Anne de Haas. Assigns 50% of photographs to new and emerging photographers. Uses freelancers mainly for covers. "We look for art that is adaptable to a cover, particularly images that are self-sufficient and don't lead the reader to expect further artwork within the journal. Please send photography/artwork (no more than 10 images) to *EVENT*, along with SASE (Canadian postage, or IRCs, or USD $1) for return of your work. We also accept e-mail submissions of cover art. We recommend that you send low-res versions of your photography/art as small JPEG or PDF attachments. If we are interested, we will request

high-res files. We do not buy the actual piece of art; we only pay for the use of the image." Pays $150 on publication. Credit line given. Buys one-time rights.

TIPS "On the cover of each issue we present the work of a notable or up-and-coming Canadian visual artist. It is our goal to support and encourage a thriving literary community in Canada while maintaining our international reputation for excellence."

⊕ FACES

E-mail: faces@cricketmedia.com. **Website:** www.cricketmedia.com. Estab. 1984. Circ. 15,000. "Published 9 times/year, *Faces* covers world culture for ages 9-14. It stands apart from other children's magazines by offering a solid look at 1 subject and stressing strong editorial content, color photographs throughout, and original illustrations. *Faces* offers an equal balance of feature articles and activities, as well as folktales and legends."

ILLUSTRATION Illustrations are by assignment only. **PLEASE DO NOT** send original artwork. Send postcards, promotional brochures, or color photocopies. Be sure that each sample is marked with your name, address, phone number, and website or blog. Art submissions will not be returned.

FIRST CONTACT & TERMS Send submissions to: Art Submissions Coordinator, Cricket Media, 70 E. Lake St., Suite 800, Chicago IL 60601. Buys print, digital, promotional rights.

FAMILY CIRCLE

Meredith Corp., 805 Third Ave., 24th Floor, New York NY 10022. **Website:** www.familycircle.com. Lisa Kelsey, art director. **Contact:** Cassie Kreitner, editorial assistant; Lisa Kelsey, art director. Estab. 1932. Circ. 4.2 million. Supermarket-distributed publication for women/homemakers covering areas of food, home, beauty, health, child care and careers. 17 issues/year. Submissions should focus on families with children ages 8-16. Does not accept previously published material. Original artwork returned after publication.

ILLUSTRATION Buys 2-3 illustrations/issue. Works on assignment only.

FIRST CONTACT & TERMS Provide query letter with nonreturnable samples or postcard sample to be kept on file for future assignments. Do not send original work. Prefers transparencies, postcards or tearsheets as samples. Responds only if interested. Prefers to see finished art in portfolio. Submit portfolio by appointment. All art is commissioned for

specific magazine articles. Negotiates rights. **Pays on acceptance.**

➕ ⏏ FAMILY TIMES, INC.

5775 Wayzata Blvd., Suite 810, St. Louis Park MN 55416. (952)922-6186. **Fax:** (952)922-3637. **E-mail:** aobrien@familytimesinc.com. **Website:** www. familytimesinc.com. **Contact:** Annie O'Brien, art director. Estab. 1991. Circ. 60,000. Bimonthly tabloid. Sample copies available with SASE. Art guidelines available, e-mail for guidelines.

○ Publishes *Family Times, Baby Times, Grand Times* and *Best of Times.*

ILLUSTRATION Approached by 6 illustrators/year. Buys 10 illustrations/year. Has featured illustrations by primarily local illustrators. Preferred subjects: children, families, teen. Preferred all media. Assigns 2% of illustrations to new and emerging illustrators. Freelancers should be familiar with Illustrator, Photoshop. E-mail submissions accepted with link to website, accepted with image file at 72 dpi. Mac-compatible. Prefers JPEG. Samples are filed. Responds only if interested. Portfolio not required. Company will contact artist for portfolio review if interested. Pays illustrators $300 for color cover, $100 for b&w inside, $225 for color inside. Pays on publication. Buys one-time rights, electronic rights. Finds freelancers through artists' submissions, sourcebooks, online.

FIRST CONTACT & TERMS Illustrators: Send query via e-mail with samples or link to samples.

TIPS "Looking for fresh, family friendly styles and creative sense of interpretation of editorial."

FAST COMPANY

7 World Trade Center, New York NY 10007-2195. (212)389-5300. **Fax:** (212)389-5496. **E-mail:** pr@ fastcompany.com. **Website:** www.fastcompany.com. **Contact:** Lori Hoffman, managing editor. Estab. 1996. Circ. 750,000. Monthly cutting edge business publication supplying readers with tools and strategies for business today.

ILLUSTRATION Approached by "tons" of illustrators/year. Buys approximately 20 illustrations/issue. Has used illustrations by Bill Mayer, Ward Sutton and David Cowles. Considers all media.

FIRST CONTACT & TERMS Illustrators: Send postcard sample or printed samples, photocopies. Accepts disk submissions compatible with QuarkXPress for Mac. Send EPS files. Send all samples to the attention of Julia Moburg. Samples are filed and not returned. Responds only if interested. Rights purchased vary according to project. Pays on acceptance: $300-1,000 for color inside; $300-500 for spots. Finds illustrators through submissions, illustration annuals, *Workbook* and *Alternative Pick.*

FAULTLINE JOURNAL OF ART & LITERATURE

University of California, Irvine, Dept. of English, 435 Humanities Instructional Bldg., Irvine CA 92697-2650. (949)824-1573. **E-mail:** faultline@uci.edu. **Website:** faultline.sites.uci.edu. Pushcart prize-winning journal. "We publish new poetry, fiction, translations, and artwork in an annual spring issue, and feature the work of emerging and established writers from the US and abroad."

○ "Even though this is not a paying market, this high-quality literary magazine would be an excellent place for fine artists to gain exposure. Postcard samples with a website address are the best way to show us your work."

FIRST CONTACT & TERMS Submit up to 5 8×10 color or b&w prints for consideration. Slides might be required if accepted.

FEDERAL COMPUTER WEEK

1105 Media, Inc., 8609 Westwood Center Dr., Suite 500, Vienna VA 22182. (703)876-5100 or (703)876-5096. **E-mail:** tschneider@fcw.com. **Website:** www. fcw.com. **Contact:** Troy Schneider, editor-in-chief. Estab. 1987. Circ. 120,000. Trade publication for federal, state and local government information technology professionals.

ILLUSTRATION Approached by 50-75 illustrators/year. Buys 5-6 illustrations/month. Features charts & graphs, computer illustrations, informational graphics, spot illustrations of business subjects. Assigns 5% of illustrations to well-known or "name" illustrators; 85% to experienced but not well-known illustrators; 10% to new and emerging illustrators.

FIRST CONTACT & TERMS Send postcard or other nonreturnable samples. Accepts Mac-compatible disk submissions. Samples are filed. Will contact artist for portfolio review if interested. Rights purchased vary according to project. Pays $800-1,200 for color cover; $600-800 for color inside; $200 for spots. Finds illustrators through samples and sourcebooks.

TIPS "We look for people who understand 'concept' covers and inside art, and very often have them talk directly to writers and editors."

FIRST FOR WOMEN

Bauer Publishing, 270 Sylvan Ave., Englewood Cliffs NJ 07632. (201)569-6699. **E-mail:** contactus@firstforwomen.com. **Website:** www.firstforwomen.com. Estab. 1988. Circ. 1.4 million. Mass market consumer magazine for younger women, published every 3 weeks. Sample copies and art guidelines available upon request.

Designed for the busy woman. Articles concerning health, beauty, real life stories, home and food.

CARTOONS Buys 10 cartoons/issue. Prefers humorous cartoons; single-panel b&w washes and line drawings. Prefers themes related to women's issues.

ILLUSTRATION Approached by 100 illustrators/year. Works on assignment only. Preferred themes are humorous, sophisticated women's issues. Considers all media, but prefers vector art.

FIRST CONTACT & TERMS Illustrators/Infographics Designers: Send query letter with any sample or promo that can be kept on file. Samples are filed and will be returned by SASE only if requested. Responds only if interested. Will contact artist for portfolio review if interested. Buys one-time rights. **Pays on acceptance.** Pays artists between $150-400 depending on complexity of project. Finds artists through promo mailers and sourcebooks.

FLORIDA REALTOR

7025 Augusta National Dr., Orlando FL 32822-5017. (407)438-1400. **Fax:** (407)438-1411. **E-mail:** magazine@floridarealtors.org. **Website:** www.floridarealtors.org/magazine. Estab. 1925. Circ. 119,562. Monthly trade publication covers news and issues of the Florida real estate industry, including sales practices, brokerage management, market trends, legislation and legal matters.

FIRST CONTACT & TERMS Approached by 100 illustrators/year. Buys 10 illustrations/year. Features real estate professionals at work. Send postcard samples with URL. After introductory mailing, send follow-up postcard sample every 6 months. Pays illustrators $100 for color inside. Pays on publication. Buys one-time rights. Finds freelancers through artists' submissions.

FOCUS ON THE FAMILY

8605 Explorer Dr., Colorado Springs CO 80920. (719)531-5181. **Fax:** (719)531-3424. **E-mail:** thrivingfamilysubmissions@family.org. **Website:** www.family.org. Estab. 1977. Circ. 2.7 million. Publishes magazines. Specializes in religious-Christian. Publishes 12 titles/year.

FIRST CONTACT & TERMS Send query letter with photocopies, printed samples, résumé, SASE and tearsheets portraying family themes. Send follow-up postcard every year. Samples are filed. Responds in 2 weeks. Will contact artist for portfolio review of photocopies of artwork portraying family themes if interested. Buys first, one-time or reprint rights. Finds freelancers through agents, sourcebooks and submissions.

FOGGED CLARITY

(231)670-7033. **E-mail:** editor@foggedclarity.com; submissions@foggedclarity.com. **Website:** www.foggedclarity.com. **Contact:** Editors. Estab. 2008. Circ. between 15,000 and 22,000 visitors per month. "*Fogged Clarity* is an arts review that accepts submissions of poetry, fiction, nonfiction, music, visual art, and reviews of work in all mediums. We seek art that is stabbingly eloquent. Our print edition is released once every year, while new issues of our online journal come out at the beginning of every month. Artists maintain the copyrights to their work until they are monetarily compensated for said work. If your work is selected for our print edition and you consent to its publication, you will be compensated."

FIRST CONTACT & TERMS Reviews GIF, JPEG, PNG, TIFF, PSD, AI, and PDF files, at least 700 pixels.

FOLIATE OAK LITERARY MAGAZINE

University of Arkansas-Monticello, P.O. Box 3460, Monticello AR 71656. (870)460-1247. **E-mail:** foliateoak@uamont.edu. **Website:** www.foliateoak.com. **Contact:** Online submission manager. Estab. 1973. Circ. 500. "We are a university general literary magazine publishing new and established artists." Has featured Terry Wright, Brett Svelik, Lucita Peek, David Swartz and Fariel Shafee.

FIRST CONTACT & TERMS Online submission manager must be used to submit all artwork.

TIPS "We are unable to pay our contributors but we love to support freelancers. We solicit work for our online magazine and our annual print anthology. Read submission guidelines online."

FOLIO

10 Gate St., Lincoln's Inn Fields, London WCZA 3HP United Kingdom. +44 0207-242-9562. **Fax:** +44 0207 242-1816. **E-mail:** info@folioart.co.uk. **Website:** www.folioart.co.uk. "Folio is an illustration agency based in London. We pride ourselves on representing illustrators and artists of a particularly high quality and versatility." Exclusive representation required. Finds new talent through submissions and recommendations.

FIRST CONTACT & TERMS "Send a query letter, bio, résumé and digital images. Will respond if interested. Portfolio should include b&w, roughs, finished art and digital images."

FOLIO:

10 Norden Place, Norwalk CT 06855. (203)854-6730, (203)899-8433, or (203)899-8427. **Fax:** (203)854-6735. **E-mail:** bmickey@accessintel.com. **Website:** www.foliomag.com. **Contact:** Bill Mickey, editor. Circ. 9,380. Trade magazine covering the magazine publishing industry. Sample copies with SASE and first-class postage.

ILLUSTRATION Approached by 200 illustrators/year. Buys 150-200 illustrations/year. Works on assignment only. Artists' online galleries welcome in lieu of portfolio.

FIRST CONTACT & TERMS Illustrators: Send postcard samples or photocopies or other appropriate samples. No originals. Samples are filed and returned by SASE if requested by artist. Responds only if interested. Call for appointment to show portfolio of tearsheets, slides, final art, photographs and transparencies. Buys one-time rights. Pays by the project.

TIPS "Art director likes to see printed 4-color and b&w sample illustrations. Do not send originals unless requested. Computer-generated illustrations are used but not always necessary. Charts and graphs must be Mac-generated."

FOODSERVICE AND HOSPITALITY

Kostuch Media, Ltd., 23 Lesmill Rd., #101, Toronto, Ontario M3B 3P6 Canada. (416)447-0888. **Fax:** (416)447-5333. **E-mail:** web@kostuchmedia.com. **Website:** www.foodserviceworld.com. **Contact:** Margaret Moore, art director. Estab. 1973. Circ. 25,000. Monthly business magazine for foodservice industry/operators. Sample copies available. Art guidelines available.

Also publishes *Hotelier Magazine.*

ILLUSTRATION Approached by 30 illustrators/year. Buys 1 illustration/issue. Prefers serious/businessy/stylized art for *Hotelier Magazine*; casual free and fun style for *Foodservice and Hospitality.* Considers all media.

FIRST CONTACT & TERMS Illustrators: Send query letter with printed samples and tearsheets or postcards. Samples are filed. Responds only if interested. Art director will contact artist for portfolio review of final art and tearsheets if interested. Portfolios may be dropped off every Monday and Tuesday. Buys one-time rights. Pays on publication; $500 minimum for color cover; $300 minimum for color inside. Finds illustrators through sourcebooks, word of mouth, artist's submissions.

FORBES MAGAZINE

499 Washington Blvd., Jersey City NJ 07310. (800)295-0893; (212)620-1887. **E-mail:** readers@forbes.com. **Website:** www.forbes.com. **Contact:** art director or editors. Estab. 1917. Circ. 950,000. Biweekly business magazine read by company executives and those who are interested in business and investing. Art guidelines not available.

ILLUSTRATION Assigns 20% of illustrations to new and emerging illustrators.

FIRST CONTACT & TERMS "Assignments are made by one of 5 art directors. We do not use, nor are we liable for, ideas or work that a *Forbes* art director didn't assign. We prefer contemporary illustrations that are lucid and convey an unmistakable idea with wit and intelligence. No cartoons please. Illustration art must be rendered on a material and size that can be separated on a drum scanner or submitted digitally. We are prepared to receive art on ZIP, Scitex, CD, floppy disk, or downloaded via e-mail. Discuss the specifications and the fee before you accept the assignment. **Pays on acceptance** whether reproduced or not. Pays up to $3,000 for a cover assignment and an average of $450 to $700 for an inside illustration depending on complexity, time and the printed space rate. Dropping a portfolio off is encouraged. Deliver portfolios by 11 a.m. and plan to leave your portfolio for a few hours or overnight. Call first to make sure an art director is available. Address the label to the attention of the Forbes Art Department and the individual you want to reach. Attach your name and local phone number to the outside of the portfolio. Include a note stating when you need it. Robin Regensberg, the art traffic

coordinator, will make every effort to call you to arrange for your pickup. Samples: Do not mail original artwork. Send printed samples, scanned samples or photocopies of samples. Include enough samples as you can spare in a portfolio for each person on our staff. If interested, we'll file them. Otherwise they are discarded. Samples are returned only if requested."

TIPS "Look at the magazine to determine if your style and thinking are suitable. The art director and associate art directors are listed on the masthead, located within the first ten pages of an issue. The art directors make assignments for illustration. We get a large number of requests for portfolio reviews and many mailed promotions daily. This may explain why, when you follow up with a call, we may not be able to acknowledge receipt of your samples. If the work is memorable and we think we can use your style, we'll file samples for future consideration."

GAME & FISH

3330 Chastain Meadows Pkwy. NW, Suite 200, Kennesaw GA 30144. (770)953-9222. **Fax:** (678)279-7512. **E-mail:** ken.dunwoody@imoutdoors.com. **Website:** www.gameandfishmag.com. **Contact:** Ken Dunwoody, editorial director; Ron Sinfelt, photo editor; Allen Hansen, graphic artist. Estab. 1975. Circ. 570,000 for 28 state-specific magazines. Publishes 29 different monthly outdoor magazines, each covering the fishing and hunting opportunities in a particular state or region (see individual titles to contact editors). Original artwork is returned after publication. Sample copies available.

ILLUSTRATION Approached by 50 illustrators/year. Buys illustrations mainly for spots and feature spreads. Buys 1-5 illustrations/issue. Considers pen & ink, watercolor, acrylic, and oil.

FIRST CONTACT & TERMS Illustrators: Send query letter with photocopies. "We look for an artist's ability to realistically depict North American game animals and game fish or hunting and fishing scenes." Samples are filed or returned only if requested. Responds only if interested. Portfolio review not required. Buys first rights. Pays 2½ months prior to publication; $25 minimum for b&w inside; $75-100 for color inside.

TIPS "We do not publish cartoons, but we do use some cartoonlike illustrations which we assign to artists to accompany specific humor stories. Send us some samples of your work, showing as broad a range

as possible, and let us hold on to them for future reference. Being willing to complete an assigned illustration in a 4-6 week period and providing what we request will make you a candidate for working with us."

⌂ GEORGIA MAGAZINE

Georgia Electric Membership Corp., P.O. Box 1707, 2100 E. Exchange Place, Tucker GA 30085. (770)270-6500. **E-mail:** laurel.george@georgiaemc.com. **Website:** www.georgiamagazine.org. **Contact:** Laurel George, editor. Estab. 1945. Circ. 500,000. Monthly consumer magazine promoting electric co-ops. "GEORGIA Magazine is the most widely read magazine for and about Georgians. Each issue celebrates the Georgia lifestyle in word and photo, revealing the spirit of its people and the flavor of its past in a friendly, conversational tone. Feature articles and departments focus on what's in it for the reader, bringing home the story in a useful, personal way that touches their lives directly. Copies are mailed each month to members of Georgia's electric co-ops."

CARTOONS Approached by 20 cartoonists/year. Buys 2 cartoons/year. Prefers electric industry theme. Prefers single-panel, humorous, 4-color, or b&w washes and line drawings.

ILLUSTRATION Approached by 20 illustrators/year. Prefers electric industry theme. Considers all media. 50% of freelance illustration demands knowledge of Illustrator and InDesign.

DESIGN Uses freelancers for design and production. Prefers local designers with magazine experience. 80% of design demands knowledge of Photoshop, Illustrator, and InDesign.

FIRST CONTACT & TERMS Cartoonists: Send query letter with photocopies. Samples are filed and not returned. Illustrators: Send postcard sample or query letter with photocopies. Designers: Send query letter with printed samples and photocopies. Accepts disk submissions compatible with InDesign. Samples are filed or returned by SASE. Responds in 3 months if interested. Rights purchased vary according to project. **Pays on acceptance.** Pays cartoonists $50 for b&w, $50-100 for color. Pays illustrators $50-100 for b&w, $50-200 for color. Finds illustrators through word of mouth and submissions.

GLAMOUR

Condé Nast, 4 Times Square, 16th Floor, New York NY 10036. (212)286-2860. **Fax:** (212)286-8336. **Website:** www.glamour.com. **Contact:** Cyndi Leive, edi-

tor-in-chief. Estab. 1939. Circ. 2.3 million. Monthly. Covers fashion and issues concerning working women (ages 20-35). Originals returned at job's completion. Sample copies available on request. 5% of freelance work demands knowledge of Illustrator, QuarkXPress, Photoshop and FreeHand.

CARTOONS Buys 1 cartoon/issue.

ILLUSTRATION Buys 1 illustration/issue. Works on assignment only. Considers all media.

FIRST CONTACT & TERMS Illustrators: Send postcard-size sample. Samples are filed and not returned. Publication will contact artist for portfolio review if interested. Rights purchased vary according to project. Pays on publication.

GLAMOUR LATINOAMERICA

Conde Nast, 4 Times Square, New York NY 10036. (212)286-2860. **E-mail:** miguelgarcia@condenast. com. **Website:** www.glamour.mx. **Contact:** art director. Estab. 1998. Circ. 406,760. Monthly consumer magazine for the contemporary Hispanic woman. Covers the latest trends in fashion and beauty, health, relationships, careers and entertainment.

ILLUSTRATION Approached by 100 illustrators/year. Buys 40 illustrations/year. Features fashion caricatures of celebrities, fashion illustration and spot illustrations. Assigns 10% to new and emerging illustrators. Illustrators: Send postcard sample with link to website. After introductory mailing, send follow-up postcard sample every 6 months. Responds only if interested.

FIRST CONTACT & TERMS Illustrators: $150-400 for color inside. Buys one-time rights. Finds freelancers through submissions.

THE GOLFER

59 E. 72nd St., New York NY 10021. **E-mail:** info@thegolferinc.com. **Website:** www.thegolferinc.com. Estab. 1994. Circ. 253,000. Bimonthly "sophisticated golf magazine with an emphasis on travel and lifestyle."

ILLUSTRATION Approached by 200 illustrators/year. Buys 6 illustrations/issue. Considers all media.

FIRST CONTACT & TERMS Send postcard sample. "We will accept work compatible with QuarkXPress 3.3. Send EPS files." Samples are not filed and are not returned. Responds only if interested. Rights purchased vary according to project. Pays on publication. Payment to be negotiated.

TIPS "I like sophisticated, edgy, imaginative work. We're looking for people to interpret sport, not draw a picture of someone hitting a ball."

GOLF TIPS MAGAZINE

Werner Publishing Corp., 12121 Wilshire Blvd., 12th Floor, Los Angeles CA 90025-1176. (310)820-1500. **Fax:** (310)820-5008. **E-mail:** editors@golftipsmag. com. **Website:** www.golftipsmag.com. Estab. 1986. Circ. 300,000. Monthly 4-color consumer magazine featuring golf instruction articles.

ILLUSTRATION Approached by 100 illustrators/year. Buys 3 illustrations/issue. Has featured illustrations by Phil Franke, Scott Matthews, Ed Wexler. Features charts and graphs, humorous illustration, informational graphics, realistic and medical illustration. Preferred subjects men and women. Prefers realism or expressive, painterly editorial style or graphic humorous style. Assigns 30% of illustrations to well-known or "name" illustrators; 50% to experienced but not well-known illustrators; 20% to new and emerging illustrators. 15% of freelance illustration demands knowledge of Illustrator, Photoshop and FreeHand.

FIRST CONTACT & TERMS Submission guidelines available online at www.golftipsmag.com/submissions.html. Illustrators: Send postcard or other nonreturnable samples. Accepts Mac-compatible disk submissions. Send EPS or TIFF files. Samples are filed. Will contact artist for portfolio review if interested. Rights purchased vary according to project. Pays on publication; $500-700 for color cover; $100-200 for b&w inside; $250-500 for color inside; $500-700 for 2-page spreads. Finds illustrators through *LA Workbook*, *Creative Black Book* and promotional samples.

TIPS "Look at our magazine and you will see straightforward, realistic illustration, but I am also open to semi-abstract, graphic humorous illustration, gritty, painterly, editorial style, or loose pen & ink and watercolor humorous style."

⋔ GRAND RAPIDS MAGAZINE

Gemini Publications, 549 Ottawa Ave. NW, Suite 201, Grand Rapids MI 49503. (616)459-4545. **Fax:** (616)459-4800. **E-mail:** cvalade@geminipub.com; info@geminipub.com. **Website:** www.grmag.com. Estab. 1964. Circ. 20,000. Monthly general interest life and style magazine designed for those who live in the Grand Rapids metropolitan area or desire to maintain contact with the community. Original artwork returned after publication. Local artists only.

CARTOONS Buys 2-3 cartoons/issue. Prefers Michigan, Western Michigan, Lake Michigan, city, issue, consumer/household, fashion, lifestyle, fitness and travel themes.

ILLUSTRATION Buys 2-3 illustrations/issue. Prefers Michigan, Western Michigan, Lake Michigan, city, issue, consumer/household, fashion, lifestyle, fitness and travel themes.

FIRST CONTACT & TERMS Cartoonists/illustrators: Send query letter with samples. Samples not filed are returned by SASE. Responds in 1 month. To show a portfolio, mail printed samples and final reproduction/product or call for an appointment. Buys all rights. Pays on publication. Pays cartoonists $35-50 for b&w. Pays illustrators $200 minimum for color cover; $40 minimum for b&w inside; $40 minimum for color inside.

TIPS "Particular interest in those who are able to capture the urban lifestyle."

GREENPRINTS

P.O. Box 1355, Fairview NC 28730. (828)628-1902. **E-mail:** pat@greenprints.com. **Website:** www.greenprints.com. **Contact:** Pat Stone, managing editor. Estab. 1990. Circ. 11,000. Quarterly magazine "that covers the personal—*not* how-to—side of gardening." Sample copy for $5; art guidelines available on website or free with #10 SASE and first-class postage.

ILLUSTRATION Approached by 46 illustrators/year. Works with 15 illustrators/issue. Has featured illustrations by Claudia McGehee, P. Savage, Marilynne Roach, and Jean Jenkins. Assigns 30% of illustrations to emerging and 5% to new illustrators. Prefers plants and people. Considers b&w only.

TIPS "Read our magazine and study the style of art we use. Can you do both plants and people? Can you interpret as well as illustrate a story?"

GUERNICA MAGAZINE

112 W. 27th St., Suite 600, New York NY 10001. **E-mail:** editors@guernicamag.com; art@guernicamag.com; publisher@guernicamag.com. **Website:** www.guernicamag.com. **Contact:** See masthead online for specific editors. Estab. 2005. "*Guernica*, published bi-weekly, is one of the web's most acclaimed new magazines. 2009: *Guernica* is called a 'great online literary magazine' by *Esquire*. *Guernica* contributors come from dozens of countries and write in nearly as many languages."

FIRST CONTACT & TERMS Submit via online submissions manager.

GUITAR PLAYER

NewBay Media, LLC, c/o Guitar World, 28 E. 28th St., 12th Floor, New York NY 10016. (212)378-0400. **E-mail:** asavona@nbmedia.com. **Website:** www.guitarplayer.com. **Contact:** Tony Savona, VP/Corporate Director. Estab. 1975. Circ. 150,000. Monthly 4-color magazine focusing on technique, artist interviews, etc.

ILLUSTRATION Approached by 15-20 illustrators/week. Buys 5 illustrations/year. Works on assignment only. Features caricatures of celebrities; realistic, computer and spot illustration. Assigns 33% of illustrations to new and emerging illustrators. Prefers conceptual, "outside, not safe" themes and styles. Considers pen & ink, watercolor, collage, airbrush, digital, acrylic, mixed media and pastel.

FIRST CONTACT & TERMS Send query letter with brochure, tearsheets, photographs, photocopies, photostats, slides and transparencies. Accepts Mac-compatible disk submissions. Samples are filed. Responds only if interested. Will contact artist for portfolio review if interested. Buys first rights. Pays on publication.

HADASSAH MAGAZINE

40 Wall St., 8th Floor, New York NY 10005. **Fax:** (212)451-6257. **E-mail:** magazine@hadassah.org. **Website:** www.hadassahmagazine.org. **Contact:** Elizabeth Barnea. Circ. 255,000. Bimonthly consumer magazine chiefly of and for Jewish interests—both in the US and in Israel.

ILLUSTRATION Approached by 50 freelance illustrators/year. Works on assignment only. Features humorous, realistic, computer and spot illustration. Prefers themes of news, Jewish/family, Israeli issues, holidays.

FIRST CONTACT & TERMS Samples are filed or are returned by SASE. Write for appointment to show portfolio of original/final art, tearsheets and slides. Buys first rights. Pays on publication. Payment depends on size and usage.

HARPER'S MAGAZINE

666 Broadway, 11th Floor, New York NY 10012. (212)420-5720. **E-mail:** readings@harpers.org; scg@harpers.org. **Website:** www.harpers.org. **Contact:** Ellen Rosenbush, editor. Estab. 1850. Circ. 230,000.

Monthly 4-color literary magazine. "The nation's oldest continually published magazine providing fiction, satire, political criticism, social criticism, essays." *Harper's Magazine* encourages national discussion on current and significant issues in a format that offers arresting facts and intelligent opinions.

ILLUSTRATION Approached by 250 illustrators/year. Buys 5-10 illustrations/issue. Has featured illustrations by Ray Bartkus, Steve Brodner, Istvan Banyai, Andrea Ventura, Hadley Hooper, Ralph Steadman, Raymond Verdaguer, Andrew Zbihlyj, Danijel Zezelj. Features intelligent concept-oriented illustration. Preferred subjects: literary, artistic, social, fiction-related. Prefers intelligent, original thought and imagery in any media. Assigns 25% of illustrations to new and emerging illustrators.

TIPS "Intelligence, originality, and beauty in execution are what we seek. A wide range of styles is appropriate; what counts most is content."

HIGH COUNTRY NEWS

119 Grand Ave., P.O. Box 1090, Paonia CO 81428. (970)527-4898. **E-mail:** brianc@hcn.org; cindy@hcn.org. **E-mail:** editor@hcn.org; photos@hcn.org. **Website:** www.hcn.org. **Contact:** Brian Calvert, managing editor; Cindy Wehling, art director. Estab. 1970. Circ. 25,000. Biweekly nonprofit newspaper. Covers environmental, public lands and community issues in the 10 western states.

CARTOONS Buys 1 editorial cartoon/issue. Only issues affecting Western environment. Prefers single panel, political, humorous on topics currently being covered in the paper. Color or b&w. Professional quality only.

ILLUSTRATION Considers all media if reproducible.

FIRST CONTACT & TERMS Cartoonists: Send query letter with finished cartoons and photocopies. Illustrators: Send query letter with printed samples and photocopies. Accepts e-mail and disk submissions compatible with QuarkXPress and Photoshop. Samples are filed or returned by SASE. Responds only if interested. Rights purchased vary according to project. Pays on publication. Pays cartoonists $50-125 depending on size used. Pays illustrators $100-200 for color cover; $35-100 for inside. Finds illustrators through magazines, newspapers and artist's submissions. Mail photos to the attention of Cindy Wehling, art director, or via e-mail at cindy@hcn.org.

HIGHLIGHTS FOR CHILDREN

803 Church St., Honesdale PA 18431. (570)253-1080. **Fax:** (570)251-7847. **E-mail:** customerservice@highlights.com. **Website:** www.highlights.com. **Contact:** Christine French Cully, editor-in-chief. Estab. 1946. Circ. approximately 1.5 million. Monthly 4-color magazine for children ages 6-12. Art guidelines available on Highlights.com.

CARTOONS Interested in upbeat, positive cartoons involving children, family life or animals; single or multiple panel. "One flaw in many submissions is that the concept or vocabulary is too adult, or that the experience necessary for its appreciation is beyond our readers. Frequently, a wordless self-explanatory cartoon is best."

ILLUSTRATION Buys 30 illustrations/issue. Works on assignment only. Prefers "realistic and stylized work; upbeat, fun, more graphic than cartoon." Pen & ink, colored pencil, watercolor, marker, cut paper and mixed media are all acceptable. Discourages work in fluorescent colors.

FIRST CONTACT & TERMS Cartoonists: Send roughs or finished cartoons and SASE. Illustrators: Send query letter with photocopies, SASE and tearsheets. Samples are kept on file. Buys all rights on a work-for-hire basis. Pays on acceptance. Pays cartoonists $20-40 for line drawings. Pays illustrators $50-$700 for color inside. "We are always looking for good hidden pictures. We require a picture that is interesting in itself and has the objects well-hidden. Usually an artist submits pencil sketches. In no case do we pay for any preliminaries to the final hidden pictures. Hidden pictures should be submitted to Juanita Galuska."

TIPS "We have a wide variety of needs, so I would prefer to see a representative sample of an illustrator's style."

HOME BUSINESS MAGAZINE

20711 Holt Ave., #807, Lakeville MN 55044. **E-mail:** editor@homebusinessmag.com. **Website:** www.homebusinessmag.com. Estab. 1993. Circ. 105,000. Bimonthly consumer magazine. *"Home Business Magazine* covers every angle of the home-based business market including: cutting edge editorial by well-known authorities on sales and marketing, business operations, the home office, franchising, business opportunities, network marketing, mail order and other subjects to help readers choose, manage and prosper

in a home-based business; display advertising, classified ads and a directory of home-based businesses; technology, the Internet, computers and the future of home-based business; home-office editorial including management advice, office set-up, and product descriptions; business opportunities, franchising and work-from-home success stories." Sample copies free for 10×13 SASE and $2.53 in first-class postage.

ILLUSTRATION Approached by 100 illustrators/year. Buys several illustrations/issue. Features natural history illustration, realistic illustrations, charts & graphs, informational graphics, spot illustrations and computer illustration of business subjects, families, men and women. Prefers pastel and bright colors. Assigns 40% of illustrations to well-known or "name" illustrators; 40% to experienced but not well-known illustrators; 20% to new and emerging illustrators. 100% of freelance illustration demands knowledge of Illustrator and QuarkXPress.

FIRST CONTACT & TERMS Illustrators: Send query letter with printed samples, photocopies and SASE. Send electronically as JPEG files. Responds only if interested. Will contact artist for portfolio review if interested. Buys reprint rights. Negotiates rights purchased. Pays on publication. Finds illustrators through magazines, word of mouth or via Internet.

HONOLULU MAGAZINE

PacificBasin Communications, 1000 Bishop St., Suite 405, Honolulu HI 96813. (808)537-9500. **Fax:** (808)537-6455. **E-mail:** kristinl@honolulumagazine. com. **Website:** www.honolulumagazine.com. Michael Keany, managing editor. **Contact:** Kristin Lipman, senior art director. Estab. 1888. Circ. 30,000. Monthly 4-color city/regional magazine reporting on current affairs and issues, people profiles, lifestyle. Readership is generally upper income (based on subscription). Contemporary, clean, colorful and reader-friendly design. Original artwork is returned after publication. Sample copies for SASE with first-class postage. Art guidelines available free for SASE.

ILLUSTRATION Buys illustrations mainly for spots and feature spreads. Buys 2-6 illustrations/issue. Has featured illustrations by Rob Barber, Dean Hayashi and Charlie Pedrina. Assigns 10% of illustrations to new and emerging illustrators. Works on assignment only. Considers any media but not pencil work.

FIRST CONTACT & TERMS Illustrators: Send postcard or published sample showing art style.

Looks for local subjects, conceptual abilities for abstract subjects (editorial approach) likes a variety of techniques. Knowledge of Hawaii a must. Samples are filed or are returned only if requested with a SASE. Responds only if interested. Write to schedule an appointment to show a portfolio which should include original/final art and color and b&w tearsheets. Buys first rights or one-time rights. Pays 60 days after publication; $300-500 for cover; $100-350 for inside; $75-150 for spots. Finds artists through word of mouth, magazines, submissions, attending art exhibitions.

TIPS "Needs both feature and department illustration—best way to break in is with small spot illustration. Prefers art on ZIP disk or e-mail. Friendly and professional attitude is a must. Be a very good conceptual artist, professional, fast, and, of course, a sense of humor."

HORSE ILLUSTRATED

I-5 Publishing, P.O. Box 12106, Lexington KY 40580. (800)546-7730. **E-mail:** horseillustrated@ i5publishing.com. **Website:** www.horseillustrated. com. **Contact:** Elizabeth Moyer, editor. Estab. 1976. Circ. 160,660. Monthly consumer magazine providing "information for responsible horse owners." Art guidelines available on website.

○ "Readers are primarily adult horsewomen, ages 18-40, who ride and show mostly for pleasure, and who are very concerned about the well being of their horses."

HORTICULTURE

F+W, a Content + eCommerce Company, 10151 Carver Rd., Suite 200, Blue Ash OH 45242. (513)531-2690. **Fax:** (513)891-7153. **E-mail:** edit@hortmag.com. **Website:** www.hortmag.com. Circ. 160,000. Monthly magazine for all levels of gardeners (beginners, intermediate, highly skilled). "*Horticulture Magazine* strives to inspire and instruct avid gardeners of every level." Art guidelines available.

ILLUSTRATION Approached by 75 freelance illustrators/year. Buys up to 3 illustrations/issue. Works on assignment only. Features realistic illustration; informational graphics; spot illustration. Assigns 20% of illustrations to new and emerging illustrators. Prefers tight botanicals; garden scenes with a natural sense to the clustering of plants; people; hands and "how-to" illustrations. Considers all media.

FIRST CONTACT & TERMS Send query letter with brochure, résumé, SASE, tearsheets, slides. Samples

are filed or returned by SASE. Art director will contact artist for portfolio review if interested. Buys one-time rights. Pays 1 month after project completed. Payment depends on complexity of piece; $800-1,200 for 2-page spreads; $150-250 for spots. Finds artists through word of mouth, magazines, submissions/self-promotions, sourcebooks, agents/reps, art exhibits.

HOW MAGAZINE

F+W, a Content + eCommerce Company, 10151 Carver Rd., Suite 200, Blue Ash OH 45242. (513)531-2690. **E-mail:** bridgid.mccarren@fwcommunity.com; editorial@howdesign.com. **Website:** www.howdesign.com. **Contact:** Bridgid McCarren, community content director. Estab. 1985. Circ. 40,000. Bimonthly trade journal covering creativity, business and technology for graphic designers. Sample copy available for $8.50.

 Sponsors 2 annual conferences for graphic artists, as well as annual Promotion, International, Interactive and In-House Design competitions. See website for more information.

ILLUSTRATION Approached by 100 illustrators/year. Buys 4-8 illustrations/issue. Works on assignment only. Considers all media, including photography and computer illustration.

FIRST CONTACT & TERMS Illustrators: Send nonreturnable samples. Accepts disk submissions. Responds only if interested. Buys first rights or reprint rights. Pays on publication: $350-1,000 for color inside. Original artwork returned at job's completion.

TIPS "Send good samples that reflect the style and content of illustration commonly featured in the magazine. Be patient; art directors get a lot of samples."

HR MAGAZINE

1800 Duke St., Alexandria VA 22314. (703)548-3440 or (800)283-7476. **E-mail:** hrmag@shrm.org. **Website:** www.shrm.org. Estab. 1948. Circ. 250,000+. Monthly trade journal dedicated to the field of human resource management.

ILLUSTRATION Approached by 70 illustrators/year. Buys 6-8 illustrations/issue. Prefers people, management and stylized art. Considers all media.

FIRST CONTACT & TERMS Illustrators: Send query letter with printed samples. Accepts disk submissions. Illustrations can be attached to e-mails. *HR Magazine* is Mac-based. Samples are filed. Art director will contact artist for portfolio review if interested. Rights purchased vary according to project. Requires

artist to send invoice. Pays within 30 days. Finds illustrators through sourcebooks, magazines, word of mouth and artist's submissions.

IEEE SPECTRUM

IEEE, 3 Park Ave., 17th Floor, New York NY 10016. (212)419-7555. **E-mail:** m.montgomery@ieee.org; b.palacio@ieee.org; e.vrielink@ieee.org. **Website:** www.spectrum.ieee.org. **Contact:** Mark Montgomery, Senior Art Director; Brandon Palacio, Deputy Art Director; Erik Vrielink, Associate Art Director. Estab. 1964. Circ. 385,000. Monthly nonprofit technology magazine serving electrical and electronics engineers worldwide.

ILLUSTRATION Buys 5-7 illustrations/issue. Features editorial illustrations and informational graphics. Preferred subjects include technology and science. Assigns 30% to new and emerging illustrators.

FIRST CONTACT & TERMS Illustrators: Send samples in print or digital formats, or URL to online portfolio. Samples are filed and are not returned. Responds only if interested. Art director will contact artist for portfolio review if interested. Purchases print edition first rights and permanent rights for website and future digital editions. Pays on acceptance. Finds illustrators through *American Showcase, Workbook*.

TIPS "Our primary needs are artists who can interpret complex technical information into compelling editorial concepts and information graphics."

THE ILLUSTRATED NEWS

P.O. Box 63, Freeport MN 56331. (320)285-2124. **E-mail:** sam@illustratedxtra.com. **E-mail:** sam@illustratedxtra.com. **Website:** www.illustratedxtra.com. **Contact:** Samuel J. Flaa. Estab. 2015. Circ. 5,000.

CARTOONS Buys approximately 65 B&W cartoons each year. Humorous single panel preferred.

ILLUSTRATION Buys approximately 7 B&W illustrations each year.

IMAGE BY DESIGN LICENSING

Suite 3, 107 Bancroft, Hitchin, Herts SG4 1NB, United Kingdom. 44(0) 1462 422244. **E-mail:** lucy@ibd-licensing.co.uk. **Website:** www.ibd-licensing.co.uk. **Contact:** Lucy Brenham. Agency specializing in art licensing. Serves fine artists, illustrators, and photographers. Interested in reviewing fine art, design, and photography.

FIRST CONTACT & TERMS Send a link to a website with résumé, bio, brochure of work, photocopies or digital images in low-res JPEG format.

TIPS "Be aware of current trends."

⌂ THE INDEPENDENT WEEKLY

P.O. Box 1772, Durham NC 27702. (919)286-1972. **Fax:** (919)286-4274. **E-mail:** mmills@indyweek. com. **Website:** www.indyweek.com. **Contact:** Maxine Mills, art director. Circ. 50,000. Weekly 4-color cover tabloid; general interest alternative.

ILLUSTRATION Buys 5-10 illustrations/year. Prefers local (North Carolina) illustrators. Has featured illustrations by Tyler Bergholz, Keith Norvel, V. Cullum Rogers, Nathan Golub. Works on assignment only. Considers pen and ink; b&w, computer generated art and color.

FIRST CONTACT & TERMS Samples are filed or are returned by SASE if requested. Responds only if interested. Pays on publication; $150 for cover illustrations; $25-50 for inside illustrations.

TIPS "Have a political and alternative point of view. Understand the peculiarities of newsprint. Be easy to work with. No prima donnas."

INDUSTRYWEEK

The Penton Media Bldg., 1300 E. Ninth St., Cleveland OH 44114. (216)696-7000. **E-mail:** Bill.Szilagyi@ penton.com. **Website:** www.industryweek.com. **Contact:** Bill Szilagyi, art director. Estab. 1882. Circ. 200,000+. Weekly business magazine written for industry executives and key decision makers looking for insight into the latest business developments in the manufacturing world.

ILLUSTRATION Approached by 150 illustrators/ year. Buys 75 illustrations/year. Has featured illustrations by Patrick Corrigan, Dave Joly, Vala Kondo. Features humorous, informational and spot illustrations of business. Assigns 10% to new and emerging illustrators. 10% of freelance illustration demands knowledge of Illustrator.

FIRST CONTACT & TERMS Illustrators: Send query letter with URL. After introductory mailing, send follow-up postcard sample every 2-3 months. Accepts e-mail submissions with link to website. Prefers JPEG files. Samples are filed. Responds only if interested. Art director will contact artist for portfolio review if interested. Pays illustrators $250-700 for color inside.

Pays on publication. Buys one-time rights. Finds freelancers through artists' submissions.

IN THE FRAY

113 Schumacher Dr., New Hyde Park NY 11040-3644. (347)850-3935. **E-mail:** art@inthefray.org. **Website:** www.inthefray.org. **Contact:** Benjamin Gottlieb, art director. Estab. 2001. Biweekly, online publication. In the Fray publishes personal stories on global issues, with the goal of understanding other people and encouraging empathy and tolerance.

CARTOONS Approached by 1-2 cartoonists. Does not currently purchase cartoons, but has in the past.

ILLUSTRATION Approached by 20 freelance illustrators each year. Does not currently purchase illustrations, but has in the past. Feature realistic illustration, informational graphics, computer illustration, spot illustrations, humorous and caricatures of celebrities/politicians. Preferred subjects include children, families, men, women, teens and politics. Gives 100% of assignments to new and emerging illustrators.

FIRST CONTACT & TERMS Send e-mail with JPEG samples at 72 dpi. Keeps samples on file, please provide business card to be kept on file for possible future assignments. Responds only if interested, send nonreturnable samples. Company will contact artist for portfolio review if interested.

ISLANDS

460 N. Orlando Ave., Suite 200, Winter Park FL 32789. (407)628-4802. **E-mail:** editor@islands.com. **Website:** www.islands.com. **Contact:** Audrey St. Clair, managing editor. Estab. 1981. Circ. 500,000. 4-color travel magazine "exclusively about islands," published 8 times/year. Internships available for graphic artist students, photography, etc. Latest print issue has apps.

ILLUSTRATION Buys 0-1 illustrations/issue. Needs editorial illustration. Considers all media.

FIRST CONTACT & TERMS Illustrators: Send query letter with tearsheets. Samples are filed. Responds only if interested. Buys first rights or one-time rights. **Pays on acceptance;** $100-400 per image inside. Original artwork returned after publication.

⌂ JEWISH ACTION

Orthodox Union, 11 Broadway, New York NY 10004. (212)563-4000. **E-mail:** ja@ou.org. **Website:** www. ou.org/jewish_action. **Contact:** Nechama Carmel, editor; Rashel Zywica, assistant editor. Estab. 1986. Circ. 40,000. Quarterly magazine "published by Or-

thodox Union for members and subscribers. Orthodox Jewish contemporary issues." Sample copies can be seen on website.

CARTOONS Approached by 2 cartoonists/year. Prefers themes relevant to Jewish issues. Prefers single, double, or multiple panel, political, humorous b&w washes and line drawings with or without gaglines.

ILLUSTRATION Approached by 4-5 illustrators. Considers all media. Assigns 50% of illustrations to experienced but not well-known illustrators; 50% to new and emerging illustrators. Knowledge of Photoshop, Illustrator, and QuarkXPress "not absolutely necessary, but preferred."

DESIGN Needs freelancers for design and production. Prefers local design freelancers only.

FIRST CONTACT & TERMS Send query letter with photocopies and SASE. Accepts disk submissions. Prefer QuarkXPress TIFF or EPS files. Can send ZIP disk. Samples are not filed and are not returned. Responds only if interested. Art director will contact artist for portfolio review of photographs if interested. Buys one-time rights. Pays within 6 weeks of publication. Pays cartoonists $20-50 for b&w. Pays illustrators $25-75 for b&w, $50-300 for color cover; $50-200 for b&w, $25-150 for color inside. Finds illustrators through submissions.

TIPS Looking for "sensitivity to Orthodox Jewish traditions and symbols. Be aware that models must be clothed in keeping with Orthodox laws of modesty. Make sure to include identifying details. Don't send work depicting religion in general. We are specifically Orthodox Jewish."

JOURNAL OF ACCOUNTANCY

AICPA, 220 Leigh Farm Rd., Durham NC 27707. (919)402-4500. **Fax:** (919)402-4505. **E-mail:** mjohnstone@aicpa.org. **Website:** www.aicpa.org; www.journalofaccountancy.com. **Contact:** Michael Schad Johnstone, art director. Circ. 400,000. Monthly 4-color magazine of the American Institute of Certified Public Accountants that focuses on the latest news and developments related to the field of accounting for CPAs; corporate/business format.

ILLUSTRATION Approached by 200 illustrators/year. Buys 2-6 illustrations/issue. Prefers business, finance and law themes. Accepts mixed media, pen & ink, airbrush, colored pencil, watercolor, acrylic, oil, pastel and digital. Works on assignment only. 35% of freelance work demands knowledge of Illustrator, QuarkXPress and FreeHand.

FIRST CONTACT & TERMS Send query letter with brochure showing art style. Samples not filed are returned by SASE. Portfolio should include printed samples and tearsheets. Buys first rights. Pays on publication: $1,200 for color cover; $200-600 for color inside. Accepts previously published artwork. Original artwork returned after publication. Finds artists through submissions/self-promotions, sourcebooks and magazines.

TIPS "We look for indications that an artist can turn the ordinary into something extraordinary, whether it be through concept or style. In addition to illustrators, I also hire freelancers to do charts and graphs. In portfolios, I like to see tearsheets showing how the art and editorial worked together."

KALEIDOSCOPE

701 S. Main St., Akron OH 44311-1019. (330)762-9755. **Fax:** (330)762-0912. **E-mail:** kaleidoscope@udsakron. org. **Website:** www.kaleidoscopeonline.org. **Contact:** Gail Willmott, editor in chief. Estab. 1979. Art of all media, from watercolor and charcoals to collage, sculpture, and photography; 5-10 works maximum.

FIRST CONTACT & TERMS Art must be submitted at 72 dpi, RGB or JPEG files. The photos should have neutral background with the art as the main focus. Include caption information: title, dimensions, and medium. All rights revert to artist upon publication.

KASHRUS MAGAZINE

The Kashrus Institute, P.O. Box 204, Brooklyn NY 11204. (718)336-8544. **Fax:** (718)336-8550. **E-mail:** editorial@kashrusmagazine.com. **Website:** www. kashrusmagazine.com. **Contact:** Rabbi Yosef Wikler, editor. Estab. 1981. Circ. 10,000. "The periodical for the kosher consumer. We feature updates including mislabeled kosher products and recalls. Important for vegetarians, lactose intolerant, and others with allergies."

CARTOONS Prefers food, dining, or Jewish humor cartoons.

FIRST CONTACT & TERMS Send query letter with photographs, call for follow-up. Byline given. Pays on publication. Submit seasonal materials 2 months in advance. Responds in 2 weeks.

⌂ KC MAGAZINE

Anthem Publishing, 4303 W. 119th St., Leawood KS 66209. (913)894-6923. **Website:** www.kcmag.com. Estab. 1994. Circ. 31,000. Monthly lifestyle-oriented magazine, celebrating living in Kansas City. "Life's Better in KC" including: dining, shopping, home décor, and local personalities." Sample copies available with SASE and first-class postage, or online.

ILLUSTRATION Approached by 100-200 illustrators/year. Buys 3-5 illustrations/issue. Works on assignment only. Prefers conceptual editorial style. Considers all media. 25% of freelance illustration demands knowledge of Illustrator and Photoshop. Prefers local freelancers only.

DESIGN Does not need freelancers for design and production. Prefers local freelancers only. 100% of freelance work demands knowledge of Photoshop, Illustrator, and QuarkXPress.

FIRST CONTACT & TERMS Illustrators: Send postcard-size sample or query letter with tearsheets, photocopies, and printed samples. Accepts disk submissions compatible with Mac files (EPS, TIFF, Photoshop, etc.). Samples are filed. Will contact artist for portfolio review if interested. Pays on acceptance; rates vary by project.

TIPS "We have a high-quality, clean, cultural, creative format. Look at magazine before you submit."

KENTUCKY LIVING

Kentucky Association of Electric Co-Ops, P.O. Box 32170, Louisville KY 40232. (502)451-2430. **Fax:** (502)459-1611. **E-mail:** e-mail@kentuckyliving.com. **Website:** www.kentuckyliving.com. **Contact:** Anita Travis Richter, editor. Estab. 1948. Circ. 500,000. Monthly 4-color magazine emphasizing Kentucky-related and general feature material for Kentuckians living outside metropolitan areas.

CARTOONS Approached by 10-12 cartoonists/year.

ILLUSTRATION Buys occasional illustrations. Works on assignment only. Prefers b&w line art.

FIRST CONTACT & TERMS Illustrators: Send query letter with résumé and samples. Samples not filed and are returned only if requested. Buys one-time rights. **Pays on acceptance.** Pays cartoonists $30 for b&w. Pays illustrators $50 for b&w inside. Accepts previously published material. Original artwork returned after publication if requested.

KEY CLUB MAGAZINE

Kiwanis International, 3636 Woodview Trace, Indianapolis IN 46268. (317)875-8755. **E-mail:** keyclub@kiwanis.org; memberservices@kiwanis.org. **Website:** www.keyclub.org. Circ. 275,000. One printed/digital and one digital-only annual magazine with "contemporary design for mature teenage audience." Free sample copy for SASE with 3 first-class postage stamps.

○ Kiwanis International also publishes *Circle K* and *Kiwanis* magazines; see separate listings in this section.

ILLUSTRATION Buys 3 editorial illustrations/issue. Works on assignment only.

FIRST CONTACT & TERMS Include SASE. Responds in 2 weeks. Simultaneous submissions OK. Original artwork is returned after publication by request. Buys first rights. Pays on receipt of invoice: $50 for b&w inside and $150 for color inside.

KIPLINGER'S PERSONAL FINANCE

1100 13th St. NW, Washington DC 20005. (202)887-6400 or (646)695-7046. **E-mail:** jbodnar@kiplinger.com; alex@rosengrouppr.com. **Website:** www.kiplinger.com. **Contact:** Janet Bodnar, editor; Stacie Harrison, art director; Alex Kutler, account executive. Estab. 1947. Circ. 800,000. Monthly 4-color magazine covering personal finance issues such as investing, saving, housing, cars, health, retirement, taxes, and insurance.

ILLUSTRATION Approached by 350 illustrators/year. Buys 4-6 illustrations/issue. Works on assignment only. Has featured illustrations by Alison Sieffer, Harry Campbell, Dan Page, Mark Smith, A. Richard Allen and James O'Brien. Features computer, conceptual editorial and spot illustration. Assigns 5% of illustrations to new and emerging illustrators. Interested in editorial illustration in new styles, including computer illustration.

FIRST CONTACT & TERMS Illustration: Send postcard or e-mail samples. Accepts Mac-compatible CD submissions. Samples are filed or returned by SASE if requested by artist. Will contact artist for portfolio review if interested. Buys one-time rights. Pays on publication; $400-1,200 for color inside; $250-500 for spots. Finds illustrators through reps, online, magazines, *Workbook* and award books. Originals are returned at job's completion.

LADYBUG

Website: www.cricketmag.com. Estab. 1990. Circ. 125,000. *Ladybug* magazine is an imaginative magazine with art and literature for young children ages 3-6. Publishes 9 issues/year.

ILLUSTRATION "Please do not send original artwork. Send postcards, promotional brochures, or color photocopies. Be sure that each sample is marked with your name, address, phone number and website or blog. Art submissions will not be returned."

FIRST CONTACT & TERMS Send submissions to: Art Submissions Coordinator, Cricket Media, 70 E. Lake St., Suite 800, Chicago IL 60601. Acquires print and digital rights, plus promotional rights.

LATINA

Latina Media Ventures, LLC, 625 Madison Ave, 3rd Floor, New York NY 10022. (212)642-0200. **Fax:** (212)575-3088. **E-mail:** editor@latina.com; info@latina.com. **Website:** www.latina.com. Estab. 1996. Circ. 397,447. Monthly consumer magazine for Hispanic women living in the United States who have strong ties to their Latin roots. Features articles on successful Latina women, health, careers, family life, fitness, parenting, fashion, beauty and entertainment.

ILLUSTRATION Approached by 100 illustrators/year. Buys 10-15 illustrations/year. Features caricatures of Hispanic celebrities, humorous illustration and spot illustrations of families and women. Assigns 25% to new and emerging illustrators.

FIRST CONTACT & TERMS Send postcard sample with URL. After introductory mailing, send follow-up postcard sample every 4-6 months. Responds only if interested. Pays $100-400 for color inside. Buys one-time rights. Find freelancers through submissions.

⊕ LAW PRACTICE MANAGEMENT

American Bar Association Headquarters, 321 N. Clark St., Chicago IL 60654-7598. **Fax:** (312)988-5820. **E-mail:** pamela.mcdevitt@americanbar.org. **Contact:** Pamela McDevitt, section director. Estab. 1975. Circ. 20,833. 4-color trade journal for the practicing lawyer about "the business of practicing law." Published 8 times/year.

ILLUSTRATION Uses cover and inside feature illustrations. Uses all media, including computer graphics. Mostly 4-color artwork.

FIRST CONTACT & TERMS Illustrators: Send postcard sample or query letter with samples. Pays on publication. Very interested in high-quality, previously published works. Pay rates $200-350/illustration. Original works negotiable. Cartoons very rarely used.

TIPS "Topics focus on management, marketing, communications and technology."

LOG HOME LIVING

Home Buyer Publications, Inc., 4125 Lafayette Center Dr., Suite 100, Chantilly VA 20151. (703)222-9411; (800)826-3893. **Fax:** (703)222-3209. **E-mail:** editor@timberhomeliving.com. **Website:** www.loghome.com. Estab. 1989. Circ. 132,000. Monthly 4-color magazine "dealing with the aspects of buying, building and living in a log home. We emphasize upscale living (decorating, furniture, etc)." Accepts previously published artwork. Sample copies not available. Art guidelines with SASE with first-class postage. 20% of freelance work demands knowledge of QuarkXPress, Illustrator and Photoshop.

ILLUSTRATION Buys 2-4 illustrations/issue. Works on assignment only. Prefers editoral illustration with "a strong style—ability to show creative flair with not-so-creative a subject." Considers watercolor, airbrush, colored pencil, pastel and digital illustration.

DESIGN Needs freelancers for design and production occasionally. 100% of freelance work demands knowledge of Photoshop, Illustrator, QuarkXPress and InDesign.

FIRST CONTACT & TERMS Illustrators: Send postcard sample. Designers: Send query letter with brochure, résumé, and samples. Accepts disk submissions compatible with Illustrator, Photoshop and QuarkXPress. Samples are filed. Publication will contact artist for portfolio review if interested. Portfolio should include thumbnails, roughs, printed samples or color tearsheets. Buys all rights. Pays on acceptance. Pays illustrators $100-200 for b&w inside; $250-800 for color inside; $100-250 for spots. Pays designers by the project. Finds artists through submissions/self-promotions, sourcebooks.

THE LOOKOUT

Standard Publishing, 8805 Governor's Hill Dr., Suite 400, Cincinnati OH 45249. (513)931-4050. **Fax:** (513)931-0950. **E-mail:** lookout@standardpub.com. **Website:** www.lookoutmag.com. **Contact:** Kelly Carr, editor. Estab. 1894. Circ. 35,000. Weekly 4-color magazine for conservative Christian adults and young adults. Sample copy available for $1, or on website.

ILLUSTRATION "We no longer publish cartoons."

TIPS "Do not send e-mail submissions, unless we ask to see them on speculation; we publish strictly by theme list."

ⓐ LOS ANGELES MAGAZINE

5900 Wilshire Blvd., 10th Floor, Los Angeles CA 90036. (323)801-0100. **Fax:** (323)801-0105. **E-mail:** lamagedit@lamag.com. **Website:** www. losangelesmagazine.com. Circ. 170,000. Monthly 4-color magazine with a contemporary, modern design, emphasizing lifestyles, cultural attractions, pleasures, problems and personalities of Los Angeles and the surrounding area. Especially needs very localized contributors—custom projects needing person-to-person concepting and implementation. Previously published work OK. 10% of freelance work demands knowledge of QuarkXPress, Illustrator and Photoshop.

ILLUSTRATION Buys 10 illustrations/issue on assigned themes. Prefers general interest/lifestyle illustrations with urbane and contemporary tone. To show a portfolio, send or drop off samples showing art style (tearsheets, photostats, photocopies and dupe slides).

FIRST CONTACT & TERMS Pays on publication; negotiable.

TIPS "Show work similar to that used in the magazine. Study a particular publication's content, style and format. Then proceed accordingly in submitting sample work. We initiate contact of new people per *Showcase* reference books or promo flyers sent to us. Portfolio viewing is all local."

LULLWATER REVIEW

P.O. Box 122036, Atlanta GA 30322. **E-mail:** emorylullwaterreview@gmail.com. **Website:** www. lullwaterreview.wordpress.com. **Contact:** Aneyn M. O'Grady, editor-in-chief; Gabriel Unger, managing editor. Estab. 1990. Circ. 2,000. "We're a small, student-run literary magazine published out of Emory University in Atlanta, GA with two issues yearly—once in the fall and once in the spring. You can find us in the *Index of American Periodical Verse*, the *American Humanities Index* and as a member of the Council of Literary Magazines and Presses. We welcome work that brings a fresh perspective, whether through language or the visual arts."

FIRST CONTACT & TERMS Send an e-mail with photos. Samples kept on file. Portfolio should include b&w, color, photos and finished, original art. Credit line given when appropriate.

TIPS "Read our magazine. We welcome work of all different types, and we encourage submissions that bring a fresh or alternative perspective. Submit at least 5 works. We frequently accept 3-5 pieces from a single artist and like to see a selection."

THE MACGUFFIN

Schoolcraft College, 18600 Haggerty Rd., Livonia MI 48152. (734)462-4400, ext 5327. **E-mail:** macguffin@ schoolcraft.edu. **Website:** www.schoolcraft.edu/ macguffin. **Contact:** Steven A. Dolgin, editor; Gordon Krupsky, managing editor;. Estab. 1984. Circ. 500. Magazine covering the best new work in contemporary poetry, prose and visual art. "Our purpose is to encourage, support and enhance the literary arts in the Schoolcraft College community, the region, the state, and the nation. We also sponsor annual literary events and give voice to deserving new writers as well as established writers."

FIRST CONTACT & TERMS Send an e-mail with samples. "Please submit name and contact information with your work, along with captions." Portfolio not required. Credit line given.

ⓐ MAD MAGAZINE

DC Entertainment, 1700 Broadway, New York NY 10019. (212)506-4850. **E-mail:** submissions@ madmagazine.com. **Website:** www.madmag.com. Estab. 1952. Monthly magazine always on the lookout for new ways to spoof and to poke fun at hot trends.

ILLUSTRATION Approached by 300 illustrators/ year. Works with 50 illustrators/year. Has featured illustrations by Mort Drucker, Al Jaffee, Sergio Aragonès, Peter Kuper, Drew Friedman, Tom Richmond and Hermann Mejia. Features humor, realism, caricature.

DESIGN Uses local freelancers for design infrequently. 100% of freelance design demands knowledge of Illustrator, Photoshop, and QuarkXPress.

FIRST CONTACT & TERMS Illustrators: Send query letter with tearsheets and SASE. Samples are filed. Buys all rights. Pays $2,000 for color cover; $300-500 for inside. Finds illustrators through direct mail, sourcebooks (all).

TIPS "Know what we do! *MAD* is very specific. Everyone wants to work for *MAD*, but few are right for what *MAD* needs! Understand reproduction process, as well as give-and-take between artist and client."

✚ MAIN LINE TODAY

Today Media, Inc., 4645 West Chester Pike, Newtown Square PA 19073. (610)325-4630. **Fax:** (610)325-4636. **E-mail:** hrowland@mainlinetoday.com; tbehan@mainlinetoday.com; ilynch@mainlinetoday.com. **Website:** www.mainlinetoday.com. **Contact:** Hobart Rowland, editor in chief; Tara Behan, senior editor; Ingrid Lynch, art director. Estab. 1996. Circ. 20,000. Monthly consumer magazine providing quality information to the Main Line and western surburbs of Philadelphia. Sample copy available with #10 SASE and first-class postage.

ILLUSTRATION Approached by 100 illustrators/year. Buys 3-5 illustrations/issue. Considers acrylic, charcoal, collage, color wash, mixed media, oil, pastel and watercolor.

FIRST CONTACT & TERMS Send postcard sample or query letter with printed samples and tearsheets. Send follow-up postcard sample every 3-4 months. Samples are filed and not returned. Responds only if interested. Buys one-time and reprint rights. Pays on publication: $400 maximum for color cover; $125-250 for b&w or color inside; $125 for spots. Finds illustrators by word of mouth and submissions.

✚ MANAGING AUTOMATION (MA)

Thomas Publishing Co., LLC, 5 Penn Plaza, 9th Floor, New York NY 10001. (212)629-1503. **E-mail:** pgallof@thomaspublishing.com. **E-mail:** info@managingautomation.com. **Website:** www.managingautomation.com. **Contact:** Phillip Gallof, art production specialist. Estab. 1986. Circ. 100,000+. Monthly business magazine written for personnel involved in computer integrated manufacturing. Covers technical, financial and organizational concerns.

ILLUSTRATION Approached by 50 illustrators/year. Buys 10 illustrations/year. Features humorous, informational and spot illustrations of computers and business. Assigns 10% to new and emerging illustrators. 20% of freelance illustration demand knowledge of Illustrator and Photoshop.

FIRST CONTACT & TERMS Illustrators: Send postcard sample with URL. After introductory mailing, send follow-up postcard sample every 6 months. Accepts e-mail submissions with link to website. Prefers TIFF files. Samples are filed. Responds only if interested. Company will contact artist for portfolio review if interested. Pays $200-500 for color inside. Pays

on publication. Buys one-time rights. Finds freelancers through artists' submissions.

◯ MARKETING MAGAZINE

One Mount Pleasant Rd., 7th Floor, Toronto, Ontario M4Y 2Y5 Canada. (416)764-1563 or (416)764-1212. **E-mail:** Glenn.Taylor@marketingmag.rogers.com. **Website:** www.marketingmag.ca. **Contact:** Glenn Taylor, art director. Estab. 1980. Circ. 13,000. Weekly trade publication featuring news, commentary and articles on advertising, promotion, direct marketing, public relations and digital marketing in Canada. Sample copies available on request. Art guidelines available on website.

ILLUSTRATION Approached by 150 illustrators/year. Buys 10 illustrations/year. Features humorous illustration and spot illustrations of business.

FIRST CONTACT & TERMS Illustrators: Send postcard sample with tearsheets. Responds only if interested. Buys one-time rights.

MARKETWATCH

Dow Jones & Co., 1211 Avenue of the Americas, New York NY 10036. **Website:** www.marketwatch.com. Estab. 1992. *MarketWatch*, published by Dow Jones & Co., tracks the pulse of markets for engaged investors with more than 16 million visitors per month. The site is a leading innovator in the business news, personal finance information, real-time commentary and investment tools and data, with dedicated journalists generating hundreds of headlines, stories, videos and market briefs a day from 10 bureaus in the US, Europe and Asia.

ILLUSTRATION Approached by 200-300 illustrators/year. Buys 10 illustrations/issue. Works on assignment only. Considers pen & ink, airbrush, colored pencil, mixed media, collage, charcoal, watercolor, acrylic, oil, pastel and digital.

FIRST CONTACT & TERMS Illustrators: Send postcard-size sample. Samples are filed. Publication will contact artist for portfolio review if interested. Portfolio should include tearsheets and photocopies. Buys first and one-time rights. Pays 30 days from invoice; $1,500 for color cover; $400-700 for spots. Finds artists through sourcebooks and submissions.

MEN'S HEALTH

Rodale, Inc., 400 S. 10th St., Emmaus PA 18098. (212)697-2040. **E-mail:** mhonline@rodale.com. **Website:** www.menshealth.com. **Contact:** Kevin Donahue,

senior managing editor. Estab. 1987. Circ. 1,918,387. Men's fitness/lifestyle magazine. Art guidelines not available.

CARTOONS Buys 10 cartoons/year.

ILLUSTRATION Buys 100 illustrations/year. Has featured illustrations by Daniel Adel, Gary Taxali, Eboy, Mirkoilic, Jonathon Carlson. Features caricatures of celebrities/politicians, realistic illustration, charts & graphs, humorous illustration, medical illustration, computer illustration, informational graphics, spot illustrations. Prefer subjects about men. 100% of freelance work demands computer skills. Freelancers should be familiar with InDesign, Illustrator, Photoshop. E-mail submissions accepted with link to website. Samples are not filed and are not returned. Portfolio not required.

MICHIGAN OUT-OF-DOORS

P.O. Box 30235, Lansing MI 48912. (517)371-1041. **Fax:** (517)371-1505. **E-mail:** thansen@mucc.org; magazine@mucc.org. **Website:** www.michiganoutofdoors.com. **Contact:** Tony Hansen, editor. Estab. 1947. Circ. 40,000. Four-color magazine emphasizing hunting and fishing. Six print issues/year with 4 additional digital-only issues.

ILLUSTRATION "Following the various hunting and fishing seasons, we have a limited need for illustration material; we consider submissions 6-8 months in advance." Has featured illustrations by Ed Sutton and Nick Van Frankenhuyzen. Assigns 10% of illustrations to new and emerging illustrators.

FIRST CONTACT & TERMS Responds as soon as possible. **Pays on acceptance**; $30 for pen & ink illustrations in a vertical treatment.

MID-AMERICAN REVIEW

Bowling Green State University, Dept. of English, Bowling Green OH 43403. (419)372-2725. **E-mail:** mar@bgsu.edu; marsubmissions.bgsu.edu. **Website:** www.bgsu.edu/midamericanreview. **Contact:** Abigail Cloud, editor in chief; Lydia Munnell, fiction editor. Estab. 1981. Circ. 1,500. Semiannual literary magazine publishing "the best contemporary poetry, fiction, essays, and work in translation we can find. Each issue includes poems in their original language and in English." Reads all year. Originals are returned at job's completion. Sample copies available for $9.

ILLUSTRATION Approached by 10-20 illustrators/year. Uses 1 artwork per issue for the cover.

FIRST CONTACT & TERMS Send query letter with brochure, SASE, tearsheets, photographs, or photocopies. Samples are filed or are returned by SASE if requested. Buys first rights. Pays $50 when funding permits.

TIPS "*MAR* only publishes artwork on its cover. We like to use the same artist for 1 volume (2 issues). We are looking for full-color artwork for a front-to-back, full bleed effect. Visit our website!"

THE MILITARY OFFICER

201 N. Washington St., Alexandria VA 22314. (703)549-2311 or (800)234-6622. **E-mail:** editor@moaa.org; msc@moaa.org. **Website:** www.moaa.org. Estab. 1945. 4-color magazine for retired and active duty military officers of the uniformed services; concerns current military/political affairs; recent military history, especially Vietnam, Korea and Iraq; holiday anecdotes; travel; human interest; humor; hobbies; second-career job opportunities and military family lifestyle.

ILLUSTRATION Works with 9-10 illustrators/year. Buys 15-20 illustrations/year. Buys illustrations on assigned themes. Uses freelancers mainly for features and covers.

FIRST CONTACT & TERMS Send samples.

TIPS "We look for artists who can take a concept and amplify it editorially."

MODEL RAILROADER

Kalmbach Publishing Co., 21027 Crossroads Circle, P.O. Box 1612, Waukesha WI 53187-1612. **Website:** www.modelrailroader.com; mrr.trains.com. Circ. 230,000. Monthly magazine for hobbyists, rail fans. Sample copies available with 9×12 SASE and first-class postage. Art guidelines available.

○ Published by Kalmbach Publishing. Also publishes *Classic Toy Trains, Astronomy, Finescale Modeler, Model Retailer, Nutshell News* and *Trains.*

CARTOONS Prefers railroading themes. Prefers b&w line drawings with gagline.

ILLUSTRATION Prefers railroading, construction, how-to. Considers all media. 90% of freelance illustration demands knowledge of Photoshop 3.0, Illustrator 6.0, FreeHand 3.0, QuarkXPress 3.31 and Fractal Painter.

FIRST CONTACT & TERMS Submission guidelines available online.

⊕ MOMENT

4115 Wisconsin Ave. NW, Suite 10, Washington DC 20016. (202)363-6422. **Fax:** (202)362-2514. **E-mail:** editor@momentmag.com. **Website:** www.momentmag.com. **Contact:** Diane Bolz, arts editor. Estab. 1973. Circ. 65,000. Bimonthly Jewish magazine, featuring articles on religion, politics, culture and Israel. Accepts previously published artwork. Originals returned at job's completion. Sample copies available for $4.50.

CARTOONS Uses reprints and originals. Prefers political themes relating to Middle East, Israel and contemporary Jewish life.

ILLUSTRATION Buys 5-10 illustrations/year. Works on assignment only.

FIRST CONTACT & TERMS Send query letter. Samples are filed. Responds only if interested. Rights purchased vary according to project. Pays cartoonists minimum of $30 for ¼ page, b&w and color. Pays illustrators $30 for b&w; $225 for color cover; $30 for color inside (¼ page or less).

TIPS "We look for specific work or style to illustrate themes in our articles. Please know the magazine—read back issues!"

⌂ MONTANA MAGAZINE

Lee Enterprises, P.O. Box 8689, Missoula MT 59807. **E-mail:** editor@montanamagazine.com. **Website:** www.montanamagazine.com. Estab. 1970. Circ. 20,000. Bimonthly. Covers Montana recreation, history, people, wildlife. Geared to Montanans.

ILLUSTRATION Approached by 15-20 illustrators/year. Buys 1-2 illustrations/year. Prefers outdoors. Considers all media. Knowledge of InDesign, Photoshop, Illustrator helpful but not required. Send query letter via e-mail to editor@montanamagazine.com.

FIRST CONTACT & TERMS Submission guidelines available online.

TIPS "We work with local artists usually because of convenience and turnaround." No cartoons.

MORE

Meredith Corp., 125 Park Ave., New York NY 10017. **E-mail:** more@meredith.com. **Website:** www.more.com. **Contact:** Ila Stanger, managing editor. Estab. 1998. Circ. 1.8 million. Monthly publication focusing on the smart and sophisticated women, addressing real-life concerns, such as changing role of women in society, with advice on self-improvement, health, fashion, and style. Art guidelines available on website.

ILLUSTRATION Buys 20 illustrations/year. Features fashion and humorous illustration of men and women, health, relationships, office, politics, and the sophisticated look.

FIRST CONTACT & TERMS Illustrators: Send postcard sample. After introductory mailing, send follow-up postcard sample every 6 months. Accepts e-mail submission with link to website. Samples are filed. Responds only if interested. Company will contact artist for portfolio review if interested. Pays illustrators $200 for spot illustrations. Finds freelancers through artists' submissions and sourcebooks.

THE MORGAN HORSE-OFFICIAL BREED JOURNAL

American Morgan Horse Association, 4066 Shelburne Rd., Suite 5, Shelburne VT 05482-6908. (802)985-4944. **Fax:** (802)985-8897. **Website:** www.morganhorse.com. **Contact:** Publications department. Circ. 4,500-7,000 (numerous copies distributed at equine events). Emphasizes all aspects of the Morgan horse breed including educating Morgan owners, trainers and enthusiasts. Published monthly. Accepts previously published materials, simultaneous submissions. Original artwork returned after publication. Sample copy $5.

FIRST CONTACT & TERMS Illustrators: Send query letter with samples and tearsheets to editorial director: stephen@morganhorse.com. Buys all rights and negotiates rights purchased. **Pays on acceptance.**

⊗ MORPHEUS TALES

E-mail: morpheustales@gmail.com. **Website:** www.morpheustales.com. **Contact:** Adam Bradley, publisher. Estab. 2008. Circ. 1,000. Publishes experimental fiction, fantasy, horror, and science fiction. Publishes 4-6 titles/year.

ILLUSTRATION "Look at magazine and website for style." Portfolio should include b&w, color, finished, and original art.

FIRST CONTACT & TERMS Responds within 30 days. Model and property release are required. Publisher buys first rights, electronic rights, which may vary according to the project.

MOTHER JONES

Foundation for National Progress, 222 Sutter St., Suite 600, San Francisco CA 94108. (415)321-1700.

E-mail: query@motherjones.com. **Website:** www.motherjones.com. **Contact:** Mark Murrmann, photo editor; Ivylise Simones, creative director; Monika Bauerlein and Clara Jeffery, editors. Estab. 1976. Circ. 240,000. Bimonthly magazine covering politics, investigative reporting, social issues, and pop culture. Accepts previously published artwork. Originals returned at job's completion. Sample copies available.

○ *"Mother Jones* is a 'progressive' magazine—but the core of its editorial well is reporting (i.e., fact-based). No slant required. MotherJones.com is an online sister publication."

CARTOONS Approached by 25 cartoonists/year. Prints one cartoon/issue (6/year). Prefers full page, multiple-frame color drawings. Works on assignment only.

ILLUSTRATION "Approached by hundreds of illustrators/year. *Mother Jones* sees powerful, smart illustration as an essential part of serious journalism. Artists who have appeared in *Mother Jones* include Barry Blitt, Steve Brodner, Tomer Hanuka, Yuko Shimizu, and Ralph Steadman; and work from our pages has appeared in top illustration showcases from *American Illustration* to *Juxtapoz*. If this is where you're headed, we'd like to hear from you. It's best to give us a URL for a portfolio website. Or you can mail non-returnable samples or disks to: Carolyn Perot, art director. Please do not submit original artwork or any samples that will need to be returned. Assigns 90% of illustrations to well-known or 'name' illustrators; 5% to experienced but not well-known illustrators; 5% to new and emerging illustrators. Works on assignment only. Considers all media."

FIRST CONTACT & TERMS Cartoonists: Send query letter with postcard-size sample or finished cartoons. Illustrators: Send postcard-size sample or query letter with samples. Samples are filed or returned by SASE. Responds to the artist only if interested. Portfolio should include photographs, slides and tearsheets. Buys first rights. Pays on publication; payment varies widely. Finds artists through illustration books, other magazines, word of mouth.

MUSHING MAGAZINE

P.O. Box 1195, Willow AK 99688. (907)495-2468. **E-mail:** editor@mushing.com. **Website:** www.mushing.com. **Contact:** Greg Sellentin, publisher and executive editor. Estab. 1987. Circ. 10,000. Bimonthly "year-round, international magazine for all dog-powered sports, from sledding to skijoring to weight pulling to carting to packing. We seek to educate and entertain." Photo/art originals are returned at job's completion. Sample copies available for $5. Art guidelines available upon request.

CARTOONS Approached by 20 cartoonists/year. Buys up to 1 cartoon/issue. Prefers humorous cartoons; single panel b&w line drawings with gagline.

ILLUSTRATION Approached by 20 illustrators/year. Buys 0-1 illustrations/issue. Prefers simple; healthy, happy sled dogs; some silhouettes. Considers pen & ink and charcoal. Send query letter with SASE and photocopies. Accepts disk submissions if Mac compatible.

FIRST CONTACT & TERMS Cartoonists: Send query letter with roughs. Illustrators: Send EPS or TIFF files with hardcopy. Samples are returned by SASE if requested by artist. Prefers to keep copies of possibilities on file and use as needed. Responds in 6 months. Portfolio review not required. Buys first rights and reprint rights. Pays on publication. Pays cartoonists $25 for b&w and color. Pays illustrators $150 for color cover; $25 for b&w and color inside; $25 for spots. Finds artists through submissions.

TIPS "Be familiar with sled dogs and sled dog sports. We're most open to using freelance illustrations with articles on dog behavior, adventure stories, health and nutrition. Illustrations should be faithful and/or accurate to the sport. Cartoons should be faithful and tasteful (e.g., not inhumane to dogs)."

MUZZLE MAGAZINE

312 N. Geneva St., #5, Ithaca NY 14850. **E-mail:** muzzlemagazine@gmail.com. **Website:** www.muzzlemagazine.com. **Contact:** Stevie Edwards, editor-in-chief. Estab. 2010. Circ. About 300 unique viewers on average. Quarterly literary magazine. *Muzzle Magazine* aims to bring together the voices of poets from a diverse array of backgrounds, playing special homage to those from communities that are historically underrepresented in literary magazines. Muzzle takes submissions year round for poetry, art, interviews, poetry book reviews and poetry performance reviews. Sample copies available online. Art and photo submission guidelines available on website or via mail with SASE.

NA'AMAT WOMAN

505 Eighth Ave., Suite 12A04, New York NY 10018. (212)563-5222. **E-mail:** naamat@naamat.org; judith@

naamat.org. **Website:** www.naamat.org. **Contact:** Judith Sokoloff, editor. Estab. 1926. Circ. 10,000. Magazine for Jewish women, covering a wide variety of topics that are of interest to the Jewish community. Affiliated with NA'AMAT USA (a nonprofit organization). Sample copies available for $2 each or look online.

ILLUSTRATION Approached by 30 illustrators/year. Buys 2-3 illustrations/issue. We publish in 4-color through out the issue. Has featured illustrations by Julie Delton, Ilene Winn-Lederer, Avi Katz, Marilyn Rose and Yevgenia Nayberg.

FIRST CONTACT & TERMS Illustrators: Send query letter with tearsheets, or by e-mail. Samples are filed or are returned by SASE if requested by artist. Responds only if interested. Will contact artist for portfolio review if interested. Portfolio should include tearsheets and final art. Rights purchased vary according to project. Pays on publication. Pays illustrators $250 maximum for cover; $75-100 for inside. Finds artists through sourcebooks, publications, word of mouth, submissions. Originals are returned at job's completion.

TIPS "Give us a try! We're small, but nice."

⌂ NAILPRO

Creative Age Publications, 7628 Densmore Ave., Van Nuys CA 91406. (800)442-5667 or (818)782-7328. **Fax:** (818)782-7450. **E-mail:** nailpro@creativeage. com. **Website:** www.nailpro.com. **Contact:** Stephanie Lavery, executive editor. Estab. 1989. Circ. 65,000. Monthly trade magazine for the nail and beauty industry audience nail technicians. Sample copies available.

CARTOONS Prefers subject matter related to nail industry with a fashionable style. Prefers humorous color washes and b&w line drawings with or without gagline.

ILLUSTRATION Approached by tons of illustrators. Buys 3-4 illustrations/issue. Has featured illustrations by Kelley Kennedy, Nick Bruel and Kathryn Adams. Assigns 20% of illustrations to well-known or "name" illustrators; 70% to experienced but not well-known illustrators; 10% to new and emerging illustrators. Prefers whimsical computer illustrations. Considers all media. 85% of freelance illustration demands knowledge of Photoshop 5.5, Illustrator 8.0 and QuarkXPress 4.04.

DESIGN Needs freelancers for design, production and multimedia projects. Prefers local design freelancers only. 100% of freelance work demands knowledge of Photoshop 5.5, Illustrator 8.0 and QuarkXPress 4.04.

FIRST CONTACT & TERMS Cartoonists: Send query letter with samples. Responds only if interested. Rights purchased vary according to project. Illustrators: Send postcard sample. Designers: Send query letter with printed samples and tearsheets. Accepts disk submissions compatible with QuarkXPress 4.04, TIFFs, EPS files submitted on ZIP, JAZ or CD (Mac format only). Send samples to Attn: Art director. Samples are filed. Responds only if interested. Art director will contact artist for portfolio review of b&w, color, final art and tearsheets if interested. Buys first rights. Payment to cartoonists varies with projects. Pays on publication. Pays illustrators $350-400 for 2-page, full-color feature spread; $300 for 1-page; $250 for ½ page. Pays $50 for spots. Finds illustrators through *Workbook*, samples sent in the mail, magazines.

NAILS MAGAZINE

Bobit Business Media, 3520 Challenger St., Torrance CA 90503. (310)533-2400 (main) or (310)533-2537 (art director). **Fax:** (310)533-2507. **E-mail:** danielle. parisi@bobit.com. **Website:** www.nailsmag.com. **Contact:** Danielle Parisi, art director. Estab. 1982. Circ. 60,000. Monthly 4-color trade journal; "seeks to educate readers on new techniques and products, nail anatomy and health, customer relations, chemical safety, salon sanitation and business." Originals can be returned at job's completion. Sample copies available. Art guidelines vary. Needs computer-literate freelancers for design, illustration and production. 100% of freelance work demands knowledge of QuarkXPress, Illustrator or Photoshop.

ILLUSTRATION Buys 3 illustrations/issue. Works on assignment only. Needs editorial and technical illustration; charts and story art. Prefers "fashion-oriented styles." Interested in all media.

FIRST CONTACT & TERMS Illustrators: Send query letter with brochure and tearsheets. Samples are filed. Responds in 1 month or artist should follow up with call. Call for an appointment to show a portfolio of tearsheets and transparencies. Buys all rights. Pays on acceptance. Finds artists through self-promotion and word of mouth.

NATIONAL ENQUIRER

4950 Communication Ave., Boca Raton FL 33431. (561)997-7733. **Website:** www.nationalenquirer.com.

Circ. 2 million (readership 14 million). A weekly tabloid. Originals are returned at job's completion.

CARTOONS "We get 1,000-1,500 cartoons weekly." Buys 200 cartoons/year. Has featured cartoons by Norm Rockwell, Glenn Bernhardt, Earl Engelman, George Crenshaw, Mark Parisi, Marty Bucella and Vahan Shirvanian. Prefers animal, family, husband/wife and general themes. Nothing political or off-color. Prefers single panel b&w line drawings and washes with or without gagline. Computer-generated cartoons are not accepted. Prefers to do own coloration.

FIRST CONTACT & TERMS Cartoonists: Send query letter with good, clean, clear copies of finished cartoons. Samples are not returned. Buys first and one-time rights. Pays $200 for b&w plus $20 each additional panel. Editor will notify if cartoon is accepted.

TIPS "Study several issues to get a solid grasp of what we buy. Gear your work accordingly."

THE NATION

33 Irving Place, 8th Floor, New York NY 10003. E-mail: submissions@thenation.com. **Website:** www.thenation.com. Steven Brower, art director. **Contact:** Roane Carey, managing editory; Ange Mlinko, poetry editor. Estab. 1865. Circ. 100,000. Weekly journal of "left/liberal political opinion, covering national and international affairs, literature and culture." Sample copies available.

○ *The Nation's* art director works out of his design studio at Steven Brower Design. You can send samples to *The Nation* and they will be forwarded.

ILLUSTRATION Approached by 50 illustrators/year. Buys 1-3 illustrations/issue. Works with 15 illustrators/year. Has featured illustrations by Peter O. Zierlien, Ryan Inzana, Tim Robinson and Karen Caldecott. Buys illustrations mainly for spots and feature spreads. Works on assignment only. Considers all media.

FIRST CONTACT & TERMS "Queries can be sent using our online form or sent by regular mail (the form is preferred). If sending by regular mail, please double-space and include a SASE. Our standard payment for a comment is $150; for an article $350-500 depending on length. Payment for arts pieces is dependent on length; generally $225 and up. Samples are filed or are returned by SASE." Responds only if interested. Buys first rights. Pays $135 for color inside. Originals are returned after publication upon request.

TIPS "On top of a defined style, artist must have a strong and original political sensibility."

NATIONAL GEOGRAPHIC

P.O. Box 98199, Washington DC 20090-8199. **Fax:** (202)828-5460. **E-mail:** ngsforum@nationalgeographic.com. **Website:** www.nationalgeographic.com. **Contact:** Chris Johns, editor-in-chief. Estab. 1888. Circ. 9 million. *National Geographic* receives up to 30 inquiries a day from freelancers, most of which are not appropriate to their needs. Please make sure you have studied several issues before you submit. They have a roster of artists they work with on a regular basis, and it's difficult to break in, but if they like your samples they will file them for consideration for future assignments.

ILLUSTRATION Works with 20 illustrators/year. Contracts 50 illustrations/year. Interested in "full-color renderings of historical and scientific subjects. Nothing that can be photographed is illustrated by artwork. No decorative, design material. We want scientific geological cut-aways, maps, historical paintings, prehistoric scenes." Works on assignment only.

FIRST CONTACT & TERMS Send color copies, postcards, tearsheets, proofs or other appropriate samples. Art director will contact for portfolio review if interested. Samples are returned by SASE. Pays on acceptance; varies according to project.

TIPS "Do your homework before submitting to any magazine. We only use historical and scientific illustrations—ones that are very informative and very accurate. No decorative, abstract or portraits."

THE NATIONAL NOTARY

9350 De Soto Ave., Chatsworth CA 91311-4926. (800)876-6827. **E-mail:** publications@nationalnotary.org. **Website:** www.nationalnotary.org. Circ. 300,000. Bimonthly. Emphasizes "notaries public and notarization—goal is to impart knowledge, understanding and unity among notaries nationwide and internationally." Readers are notaries of varying primary occupations (legal, government, real estate and financial), as well as state and federal officials and foreign notaries. Original artwork not returned after publication. Sample copy $5.

○ Also publishes *Notary Bulletin*.

CARTOONS Approached by 5-8 cartoonists/year. Cartoons "must have a notarial angle"; single or multiple panel with gagline, b&w line drawings.

ILLUSTRATION Approached by 3-4 illustrators/year. Uses about 3 illustrations/issue; buys all from local freelancers. Works on assignment only. Themes vary, depending on subjects of articles. 100% of freelance work demands knowledge of Illustrator, QuarkXPress or FreeHand.

FIRST CONTACT & TERMS Cartoonists: Send samples of style. Illustrators: Send business card, samples and tearsheets to be kept on file. Samples not returned. Responds in 6 weeks. Call for appointment. Buys all rights. Negotiates pay.

TIPS "We are very interested in experimenting with various styles of art in illustrating the magazine. We generally work with Southern California artists, as we prefer face-to-face dealings."

NATIONAL REVIEW

215 Lexington Ave., New York NY 10016. (212)679-7330. **E-mail:** letters@nationalreview.com. **Website:** www.nationalreview.com. **Contact:** Luba Myts, art director. Circ. 150,000+. Emphasizes world events from a conservative viewpoint; bimonthly color publcation, design is "straight forward—the creativity comes out in the illustrations used." Originals are returned after publication. Uses freelancers mainly for illustrations of articles and covers.

CARTOONS Buys 6 cartoons/issue. Interested in "light political, social commentary on the conservative side."

ILLUSTRATION Buys 3-4 illustrations/issue. Especially needs portraits of political figures and conceptual editorial art. "I look for a strong graphic style; well-developed ideas and well-executed drawings." Style of Tim Bower, Jennifer Lawson, Janet Hamlin, Alan Nahigian. Works on assignment only.

FIRST CONTACT & TERMS Cartoonists: Send appropriate samples and SASE. Responds in 2 weeks. Illustrators: Send query letter with brochure showing art style or tearsheets and photocopies plus digital submissions. No samples returned. Responds to future assignment possibilities. Call for an appointment to show portfolio of final art. Include SASE. Buys first North American serial rights. Pays on publication. Pays cartoonists $50 for b&w. Pays illustrators $450 for color inside; $1,000 for color cover.

TIPS "Tearsheets and mailers are helpful in remembering an artist's work. Artists ought to make sure their work is professional in quality, idea and execution. Recent printed samples alongside originals help.

Changes in art and design in our field include fine art influence and use of more halftone illustration." A common mistake freelancers make in presenting their work is "not having a distinct style, i.e., they have a cross sample of too many different approaches to rendering their work. This leaves me questioning what kind of artwork I am going to get when I assign a piece."

NATION'S RESTAURANT NEWS

1166 Avenue of the Americas, 10th Floor, New York NY 10036. (212)204-4200; (212)204-4385. **E-mail:** joe.anderson@penton.com or via online contact form. **Website:** www.nrn.com. **Contact:** Joe Anderson, art director. Estab. 1967. Circ. 100,000. Weekly 4-color trade publication/tabloid.

ILLUSTRATION Buys 2-3 illustrations/year. Features illustrations of business subjects in the food service industry. Prefers pastel and bright colors. Assigns 5% of illustrations to well-known or "name" illustrators; 70% to experienced but not well-known illustrators; 25% to new and emerging illustrators. 20% of freelance illustration demands knowledge of Illustrator or Photoshop.

FIRST CONTACT & TERMS Illustrators: Send postcard sample or other nonreturnable samples, such as tearsheets. Accepts Mac-compatible disk submissions. Send EPS files. Samples are filed. Will contact artist for portfolio review if interested. Buys one-time rights. Pays on publication. Finds illustrators through *Creative Black Book* and *LA Work Book*, *Directory of Illustration* and *Contact USA*.

➕ NATURALLY

Internaturally LLC, 1240 Winchester Grade Road, Berkeley Springs WV 25411. (973)697-3552. **Fax:** (973)697-8313. **E-mail:** naturally@internaturally.com. **E-mail:** editor@internaturally.com. **Website:** www.internaturally.com. Estab. 1981. Circ. 35,000. Quarterly magazine covering family nudism/naturism and nudist resorts and travel. Sample copies available for $9.95 and $3.00 postage; art guidelines for #10 SASE with first-class postage.

CARTOONS Approached by 10 cartoonists/year. Buys approximately 3 cartoons/issue. Accepts only nudism/naturism.

ILLUSTRATION Approached by 10 illustrators/year. Buys approximately 3 illustrations/issue. Accepts only nudism/naturism. Considers all media.

FIRST CONTACT & TERMS Cartoonists: Send query letter with finished cartoons. Illustrators: Contact directly. Accepts all digital formats or hard copies. Samples are filed. Always responds. Buys one-time rights. Pays on publication. Pays cartoonists $20-80. Pays illustrators $200 for cover; $80/page inside. Fractional pages or fillers are prorated.

◎ NEO-OPSIS SCIENCE FICTION MAGAZINE

4129 Carey Rd., Victoria, British Columbia V8Z 4G5 Canada. (250)881-8893. **E-mail:** neoopsis@shaw.ca. **Website:** www.neo-opsis.ca. Buys first North American serial rights, electronic rights (for the issue). Only accepts fiction.

FIRST CONTACT & TERMS Send an e-mail with URL and JPEG samples at 72 dpi. Samples kept on file, not returned (Returned only by SASE). Responds only if interested. Pays on publication.

TIPS "Check the guidelines (on website) and the paid rate; if your work fits the genre and the rate is acceptable, then and only then, submit your work for consideration. It would also be nice if artists all had some examples of their work online so it is easy to see."

NEW HAMPSHIRE MAGAZINE

McLean Communications, Inc., 150 Dow St., Manchester NH 03101. (603)624-1442. **E-mail:** editor@nhmagazine.com; bcoles@nhmagazine.com; callen@nhmagazine.com. **Website:** www.nhmagazine.com. **Contact:** Rick Broussard, executive editor; Barbara Coles, managing editor; Chip Allen, creative director. Estab. 1986. Circ. 32,000. Monthly 4-color magazine emphasizing New Hampshire lifestyle and related content.

ILLUSTRATION Approached by 300 illustrators/year. Has featured illustrations by Brian Hubble and Stephen Sauer. Features lifestyle illustration, charts & graphs and spot illustration. Prefers conceptual illustrations to accompany articles. Assigns 50% to experienced but not well-known illustrators; 50% to new and emerging illustrators.

FIRST CONTACT & TERMS Send postcard sample and follow-up postcard every 3 months. Samples are filed. Portfolio review not required. Negotiates rights purchased. Pays on publication. Pays $75-250 for color inside; $150-500 for 2-page spreads; $125 for spots.

TIPS "Lifestyle magazines want 'uplifting' lifestyle messages, not dark or disturbing images."

NEW JERSEY MONTHLY

55 Park Place, P.O. Box 920, Morristown NJ 07963-0920. (973)539-8230. **Fax:** (973)538-2953. **E-mail:** kschlager@njmonthly.com. **Website:** www.njmonthly.com. **Contact:** Ken Schlager, editor. Estab. 1976. Circ. 92,000. Monthly city magazine focuses on topics related to the New Jersey regions, especially the New Jersey business community, political issues and human interest articles.

ILLUSTRATION Features New Jersey caricatures of business leaders, celebrities/politicians and humorous illustration of business, families, pets, cooking and health. Assigns 50% to new and emerging illustrators.

FIRST CONTACT & TERMS Illustrators: Send postcard sample. After introductory mailing, send follow-up postcard sample every 3-6 months. Samples are filed. Responds only if interested. Pays illustrators $100 for color inside. Buys one-time rights.

TIPS "Be familiar with New Jersey personalities and topics. Have a consistent style and professional presentation. Follow through with assignments. Be willing to take directions from art director."

NEW MEXICO MAGAZINE

Lew Wallace Bldg., 495 Old Santa Fe Trail, Santa Fe NM 87501-2750. (505)827-7447. **E-mail:** artdirector@nmmagazine.com. **Website:** www.nmmagazine.com. Estab. 1923. Circ. 100,000. Monthly regional magazine for residents and tourists to the state of New Mexico.

◎ Covers areas throughout the state. "We want to publish a lively editorial mix, covering both the down-home (like a diner in Tucumcari) and the upscale (a new bistro in world-class Santa Fe)." Explore the gamut of the Old West and the New Age.

ILLUSTRATION Buys 10 illustrations/year. Features spot illustrations. Assigns 5% to new and emerging illustrators.

FIRST CONTACT & TERMS Illustrators: Send postcard sample with URL. Responds only if interested. Pays illustrators $100 for color inside. Buys one-time rights. Find freelancers through artists' submissions.

NEW MOON GIRLS

New Moon Girl Media, P.O. Box 161287, Duluth MN 55816. (218)728-5507. **Fax:** (218)728-0314. **Website:** www.newmoon.com. Estab. 1992. Circ. 30,000. Bi-

monthly 4-color cover, 4-color inside consumer magazine. Sample copies are $7.

ILLUSTRATION Buys 3-4 illustrations/issue. Has featured illustrations by Andrea Good, Liza Ferneyhough, Liza Wright. Features realistic illustrations, informational graphics and spot illustrations of children, women and girls. Prefers colored work. Assigns 30% of illustrations to new and emerging illustrators.

FIRST CONTACT & TERMS Submission guidelines available online.

TIPS "Be very familiar with the magazine and our mission. We are a magazine for girls ages 8-14 and look for illustrators who portray people of all different shapes, sizes and ethnicities in their work. Women and girl artists preferred. See cover art guidelines at www.newmoon.org.

NEW REPUBLIC

1 Union Square West, 6th Floor, New York NY 10003. (202)508-4444. **E-mail:** letters@tnr.com. **Website:** www.tnr.com. (646) 404-4981. **Contact:** media. Estab. 1914. Circ. 40,000. Weekly political/literary magazine; political journalism, current events in the front section, book reviews and literary essays in the back; b&w with 4-color cover. Original artwork returned after publication. Sample copy for $4.94. 100% of freelance work demands computer skills.

CARTOONS Possible, not regular.

ILLUSTRATION Approached by 400 illustrators/year. Buys up to 5 or more illustrations/issue. Uses freelancers or photographers for cover art. Works on assignment only stand alone submissions also accepted. Prefers caricatures, portraits, and smart concepts 4-color.

FIRST CONTACT & TERMS Portfolio should include color photocopies. First-reproduction rights including web for duration of publication date unless otherwise negotiated. Pays on commission, kill fees may apply. Up to $1,200 for cover; $300-700 for b&w and color inside depending on space.

THE NEW YORKER

1 World Trade Center, New York NY 10007. **E-mail:** themail@newyorker.com. **Website:** www.newyorker.com. **Contact:** David Remnick, editor in chief. Estab. 1925. Circ. 938,600. A quality weekly magazine of distinct news stories, articles, essays, and poems for a literate audience. Emphasizes news analysis and lifestyle features.

CARTOONS Buys b&w cartoons. Receives 3,000 cartoons/week.

FIRST CONTACT & TERMS Cartoonists: Accepts unsolicited submissions by e-mail (as PDF attachment) by mail. Reviews unsolicited submissions every 1-2 weeks. Photocopies only. Strict standards regarding style, technique, plausibility of drawing. Especially looks for originality. Pays $575 minimum for cartoons. Contact cartoon editor. Illustrators: Mail samples, no originals. "Because of volume of submissions we are unable to respond to all submissions." No calls please. Emphasis on portraiture. Contact illustration department.

TIPS "Familiarize yourself with *The New Yorker*."

NEW YORK MAGAZINE

New York Media, Editorial Submissions, 75 Varick St., New York NY 10013. **E-mail:** nyletters@nymag.com. **E-mail:** editorialsubmissions@nymag.com. **Website:** nymag.com. Circ. 405,149. Emphasizes New York City life; also covers all boroughs for New Yorkers with upper-middle income and business people interested in what's happening in the city. Weekly. Original artwork returned after publication.

ILLUSTRATION Works on assignment only.

FIRST CONTACT & TERMS Illustrators: Send query letter with tearsheets to be kept on file. Prefers photostats as samples. Samples returned if requested. Call or write for appointment to show portfolio (drop-offs). Buys first rights. Pays $1,000 for b&w and color cover; $800 for 4-color, $400 for b&w full page inside; $225 for 4-color, $150 for b&w spot inside.

NITE-WRITER'S INTERNATIONAL LITERARY ARTS JOURNAL

158 Spencer Ave., Suite 100, Pittsburgh PA 15227. (412)882-5171. **E-mail:** nitewritersliteraryarts@gmail.com. **Website:** https://sites.google.com/site/nitewriterinternational/home. **Contact:** John Thompson. Estab. 1994. *Nite-Writer's International Literary Arts Journal* is an online literary arts journal. "We are 'dedicated to the emotional intellectual' with a creative perception of life."

FIRST CONTACT & TERMS Send as .jpg and at 800 pixels (please include title of work).

NORTH AMERICAN HUNTER

12301 Whitewater Dr., #260, Minnetonka MN 55343-4103. (952)936-9333. **E-mail:** editors@huntingclub.com; ads@scout.com; editors@scout.com. **Website:**

www.huntingclub.com. Estab. 1978. Circ. 700,000. Bi-monthly consumer magazines. *North American Hunter* is the official publication of the North American Hunting Club. Accepts previously published artwork. Originals are returned at job's completion. Sample copies available. Art guidelines for SASE with first-class postage. Needs computer-literate freelancers for illustration. 20% of freelance work demands computer knowledge of Illustrator, QuarkXPress, Photoshop or FreeHand.

○ This publisher also publishes *Cooking Pleasures* (circ. 300,000), *Handy* (circ. 900,000), *PGA Partners* (circ. 600,000), *Health & Wellness* (circ. 300,000), *Creative Home Arts* (circ. 300,000), *History* (circ. 300,000), *Street Thunder* (circ. 200,000) and *Gardening How-To* (circ. 500,000).

CARTOONS Approached by 20 cartoonists/year. Buys 3 cartoons/issue. Prefers humorous work portraying outdoorsmen in positive image; single panel b&w washes and line drawings with or without gagline.

ILLUSTRATION Approached by 40 illustrators/year. Buys 3 illustrations/issue. Prefers illustrations that portray wildlife and hunting and fishing in an accurate and positive manner. Considers pen & ink, watercolor, airbrush, acrylic, colored pencil, oil, charcoal, mixed media, pastel and electronic renderings.

FIRST CONTACT & TERMS Cartoonists: Send query letter with brochure. Illustrators: Send query letter with brochure, tearsheets, résumé, photographs and slides. Samples are filed. Portfolio review not required. Rights purchased vary according to project. **Pays on acceptance.**

⌂ **NORTH CAROLINA LITERARY REVIEW**
East Carolina University, Mailstop 555 English, Greenville NC 27858-4353. (252)328-1537. **Fax:** (252)328-4889. **E-mail:** nclrsubmissions@ecu.edu; bauerm@ecu.edu. **Website:** www.nclr.ecu.edu. **Contact:** Margaret Bauer. Estab. 1992. Circ. 750. Annual literary magazine with North Carolina focus. *NCLR* publishes poetry, fiction and nonfiction by and interviews with NC writers, and articles and essays about NC literature, literary history and culture. Sample copy available for $15.

○ Artists and graphic designers must have a North Carolina connection.

FIRST CONTACT & TERMS Send query letter with website address to show sample of work. If selected, art acquisitions editor will be in touch.

NOTRE DAME MAGAZINE
University of Notre Dame,, 500 Grace Hall, Notre Dame IN 46556-5612. (574)631-5335. **Fax:** (574)631-6767. **E-mail:** ndmag@nd.edu. **Website:** magazine.nd.edu. **Contact:** Kerry Temple, editor; Kerry Prugh, art director. Estab. 1972. Circ. 150,000. "We are a university magazine with a scope as broad as that found at a university, but we place our discussion in a moral, ethical, and spiritual context reflecting our Catholic heritage."

ILLUSTRATION Buys 5-8 illustrations/issue. Has featured illustrations by Raymond Verdaguer, Vivienne Fleshner, Cap Pannell and Stephanie Dalton Cowan. Works on assignment only.

FIRST CONTACT & TERMS "Don't send submissions—only tearsheets or samples." Tearsheets, photographs, brochures and photocopies OK for samples. Samples are returned by SASE if requested. Buys first rights.

TIPS "Create images that can communicate ideas. Looking for noncommercial style editorial art by accomplished, experienced editorial artists. Conceptual imagery that reflects the artist's awareness of fine art ideas and methods is the kind of thing we use. Sports action illustrations not used. Cartoons not used."

⌂ **NURSEWEEK**
1721 Moon Lake Blvd., Suite 540, Hoffman Estates IL 60169. (847)839-1700; (888) 206-3791. **Website:** www.nurse.com. Circ. over 1 million. "*Nurseweek* is a biweekly 4-color letter-size magazine mailed free to registered nurses nationwide. *Nurseweek* provides readers with nursing-related news and features that encourage and enable them to excel in their work and that enhance the profession's image by highlighting the many diverse contributions nurses make. In order to provide a complete and useful package, the publication's article mix includes late-breaking news stories, news features with analysis (including in-depth bimonthly special reports), interviews with industry leaders and achievers, continuing education articles, career option pieces and reader dialogue (Letters, Commentary, First Person)." Sample copy $3. Art guidelines not available. Needs computer-literate freelancers for production. 90% of freelance work

demands knowledge of QuarkXPress, Photoshop, Illustrator, Adobe Acrobat.

ILLUSTRATION Approached by 10 illustrators/year. Buys 1 illustration/year. Prefers pen ink, watercolor, airbrush, marker, colored pencil, mixed media and pastel. Needs medical illustration.

DESIGN Needs freelancers for design. 60% of design demands knowledge of Photoshop CS2, QuarkXPress 6.1, InDesign. Prefers local freelancers. Send query letter with brochure, résumé, SASE and tearsheets. Photographs: Stock photographs used 80%.

NUTRITION HEALTH REVIEW

P.O. Box #406, Haverford PA 19041. (610)896-1853. **Fax:** (610)896-1857. **Contact:** A. Rifkin, publisher. Estab. 1975. Circ. 285,000. Quarterly newspaper covering nutrition, health and medical information for the consumer. Sample copies available for $3. Art guidelines available.

CARTOONS Prefers single panel, humorous, b&w drawings.

ILLUSTRATION Features b&w humorous, medical and spot illustrations pertaining to health.

FIRST CONTACT & TERMS Cartoonists/illustrators: Send query letter with b&w photocopies. After introductory mailing, send follow-up postcard every 3-6 months. Samples are filed or returned by SASE. Responds in 6 months. Company will contact artist for portfolio review if interested. Pays cartoonists $20 maximum for b&w. Pays illustrators $200 maximum for b&w cover; $30 maximum for b&w inside. **Pays on acceptance.** Buys first rights, one-time rights, reprint rights. Finds freelancers through agents, artists' submissions, sourcebooks.

O&A MARKETING NEWS

KAL Publications, Inc., 559 S. Harbor Blvd., Suite A, Anaheim CA 92805-4525. (714)563-9300. **Fax:** (714)563-9310. **E-mail:** kathy@kalpub.com. **Website:** www.kalpub.com. Estab. 1966. Circ. 7,500. Bimonthly trade publication about the service station/petroleum marketing industry.

CARTOONS Approached by 10 cartoonists/year. Buys 1-2 cartoons/issue. Prefers humor that relates to service station industry. Prefers single panel, humorous, b&w line drawings.

FIRST CONTACT & TERMS Cartoonists: Send b&w photocopies, roughs, or samples and SASE. Samples are returned by SASE. Responds in 1 month. Buys one-time rights. Pays on acceptance; $10 for b&w.

TIPS "We run a cartoon (at least 1) in each issue of our trade magazine. We're looking for a humorous take on business—specifically the service station/petroleum marketing/carwash/quick lube industry that we cover."

OFFICEPRO

IAAP, 10502 N. Ambassador Dr., Suite 100, Kansas City MO 64153. (816)891-6600. **E-mail:** eallen@iaap-hq.org. **Website:** www.iaap-hq.org. **Contact:** Emily Allen, managing editor. Estab. 1945. Circ. 40,000. Trade journal published 8 times/year. Official publication of the International Association of Administrative Professionals. Emphasizes workplace issues, trends and technology. Sample copies available; contact subscription office at (816)891-6600, ext. 2236.

ILLUSTRATION Approached by 50 illustrators/year. Buys 20 or fewer illustrations/year. Works on assignment and purchases stock art. Prefers communication, travel, meetings and international business themes. Considers pen & ink, airbrush, colored pencil, mixed media, collage, charcoal, watercolor, acrylic, oil, pastel, marker and computer.

FIRST CONTACT & TERMS Illustrators: Send postcard-size sample or send query letter with brochure, tearsheets and photocopies. Samples are filed. Responds only if interested. Will contact artist for portfolio review if interested. Portfolio should include final art and tearsheets. Accepts previously published artwork. Originals returned at job's completion upon request only. Usually buys one-time rights, but rights purchased vary according to project. Pays $500-600 for color cover; $200-400 for color inside; $60-150 for b&w inside; $60 for b&w spots. Finds artists through word of mouth and artists' samples.

OFF THE COAST

Resolute Bear Press, P.O. Box 14, Robbinston ME 04671. (207)454-8026. **E-mail:** poetrylane2@gmail.com. **Website:** www.off-the-coast.com. **Contact:** Valerie Lawson, editor/publisher. Estab. 1994. "The mission of *Off the Coast* is to become recognized around the world as Maine's international poetry journal, a publication that prizes quality, diversity and honesty in its publications and in its dealings with poets. *Off the Coast*, a quarterly journal, publishes poetry, artwork and reviews. Arranged much like an anthology,

each issue bears a title drawn from a line or phrase from one of its poems."

FIRST CONTACT & TERMS "We accept b&w graphics and photos to grace the pages of *Off the Coast*, and color or b&w for the cover. Send 3-6 images in TIFF, PNG or JPEG format, minimum 300 dpi resolution. Please use submission manager: www.offthecoast.submittable.com/submit to send artwork."

OHIO MAGAZINE

Great Lakes Publishing Co., 1422 Euclid Ave., Suite 730, Cleveland OH 44115. (216)771-2833. **E-mail:** jvickers@ohiomagazine.com. **Website:** www.ohiomagazine.com. **Contact:** Jim Vickers, editor. Estab. 1978. Circ. 40,000.

ILLUSTRATION Approached by 100+ illustrators/year. Uses as needed. Assignment and stock illustrations used. Has featured illustrations by A.G. Ford, Neal Aspinall, Ellyn Lusis, Doug Boehm, D. Brent Campbell, Jeff Suntala, and Daniel Vasconcellos. Considers pen, ink, watercolor, acrylic, colored pencil, and oil.

DESIGN Freelance work demands knowledge of InDesign, Photoshop, and Illustrator CS4 or higher. Freelancers from Ohio or bordering states preferred.

TIPS "Please have a knowledge of the magazine and audience before submitting. Freelancers should send all queries electronically or through the mail. Telephone inquiries are strongly discouraged."

⌂ OKLAHOMA TODAY

P.O. Box 1468, Oklahoma City OK 73101-1468. (405)230-8450. **Fax:** (405)230-8650. **E-mail:** editorial@travelok.com. **Website:** www.oklahomatoday.com. **Contact:** Nathan Gunter, managing editor; Megan Rossman, photography editor. Estab. 1956. Circ. 35,000. Bimonthly regional, upscale consumer magazine focusing on all things that define Oklahoma and interest Oklahomans. Accepts previously published artwork. Originals are returned at job's completion. Sample copies available with SASE.

ILLUSTRATION Approached by 24 illustrators/year. Buys 5-10 illustrations/year. Has featured illustrations by Rob Silvers, Tim Jessel, Steven Walker and Deby Kaspari. Features caricatures of celebrities; natural history; realistic and spot illustration. Assigns 10% of illustrations to new and emerging illustrators. Considers pen & ink, watercolor, collage, airbrush, acrylic, marker, colored pencil, oil, charcoal and pas-

tel. 20% of freelance work demands knowledge of PageMaker, Illustrator and Photoshop.

FIRST CONTACT & TERMS Illustrators: Send query letter with brochure, résumé, SASE, tearsheets and slides. Samples are filed. Responds in days if interested; months if not. Portfolio review required if interested in artist's work. Portfolio should include b&w and color thumbnails, tearsheets and slides. Buys one-time rights. Finds artists through sourcebooks, other publications, word of mouth, submissions and artist reps.

TIPS Illustrations to accompany short stories and features are most open to freelancers. "Read the magazine. We enjoy working with local artists or those with Oklahoma connections."

ON EARTH

Natural Resources Defense Council, 40 W. 20th St., New York NY 10011. (212)727-4412. **E-mail:** onearth@nrdc.org. **Website:** www.onearth.org. **Contact:** Gail Ghezzi, art director. Estab. 1979. Circ. 140,000. Quarterly "award-winning environmental magazine exploring politics, nature, wildlife, science and solutions to problems."

ILLUSTRATION Buys 4 illustrations/issue.

FIRST CONTACT & TERMS Illustrators: Send postcard sample. "We will accept work compatible with InDesign CS4, QuarkXPress, Illustrator 8.0, Photoshop 5.5 and below." Responds only if interested. Buys one-time rights. Also may ask for electronic rights. Pays $100-300 for b&w inside. Payment for spots varies. Finds artists through sourcebooks and submissions.

TIPS "We prefer 4-color. Our illustrations are often conceptual, thought-provoking, challenging. We enjoy thinking artists, and we encourage ideas and exchange."

THE OPTIMIST

4494 Lindell Blvd., St. Louis MO 63108. (314)371-6000. **Fax:** (314)371-6006. **E-mail:** magazine@optimist.org. **Website:** www.optimist.org. Circ. 100,000. Quarterly 4-color magazine with 4-color cover that emphasizes activities relating to Optimist clubs in US and Canada (civic-service clubs). "Magazine is mailed to all members of Optimist clubs. Average age is 42; most are management level with some college education." Sample copy available with SASE.

CARTOONS Buys 2 cartoons/issue. Has featured cartoons by Joe Engesser, Randy Glasbergen and Tim

Oliphant. Prefers themes of general interest family-orientation, sports, kids, civic clubs. Prefers color, single-panel, with gagline. No washes.

FIRST CONTACT & TERMS Send query letter with samples. Send art on a Mac-compatible disk, if possible. Submissions returned by SASE. Buys one-time rights. **Pays on publication.**

TIPS "Send clear cartoon submissions, not poorly photocopied copies."

ORACLE MAGAZINE

Oracle Corp., 500 Oracle Pkwy., Redwood Shores CA 94065. (650)506-7000, (650)506-6859, or (800) 392-2999. E-mail: opubedit_us@oracle.com; richard.merchan@oracle.com. **Website:** www.oracle.com/technetwork/oramag/magazine. **Contact:** Richard Merchan, art director. Estab. 2000. Circ. 524,000. Bimonthly trade publication for information managers, database administrators and Oracle users.

ILLUSTRATION Approached by 200 illustrators/year. Buys 50 illustrations/year. Features informational graphics and spot illustrations of business and computers. Assigns 10% to new and emerging illustrators.

FIRST CONTACT & TERMS Illustrators: Send postcard sample with URL. After introductory mailing, send follow-up postcard sample every 3 months. Responds only if interested. Pays illustrators $250-1,000 for color inside. Pays on publication. Buys one-time rights. Finds freelancers through agents, artists' submissions, sourcebooks and word-of-mouth.

ORANGE COAST MAGAZINE

Orange Coast Kommunications, Inc., 3701 Birch St., Suite 100, Newport Beach CA 92660. (949)862-1133. **Fax:** (949)862-0133. **E-mail:** editorial@orangecoast.com. **Website:** www.orangecoast.com. **Contact:** Martin J. Smith, editor-in-chief. Estab. 1974. Circ. 52,000. Monthly 4-color local consumer magazine with celebrity covers.

ILLUSTRATION Approached by 100 illustrators/year. Has featured illustrations by Cathi Mingus, Gweyn Wong, Scott Laumann, Santiago Veeda, John Westmark, Robert Rose, Nancy Harrison. Features computer, fashion and editorial illustrations featuring children and families. Prefers serious subjects; some humorous subjects. Assigns 10% of illustrations to well-known or "name" illustrators; 40% to experienced but not well-known illustrators; 50% to new and emerging illustrators. 40% of freelance illustration demands knowledge of Illustrator or Photoshop.

FIRST CONTACT & TERMS Send postcard or other nonreturnable samples. Accepts Mac-compatible disk submissions. Send EPS files. Samples are filed. Responds in 1 month. Will contact artist for portfolio review if interested. Pays on acceptance: $175 for b&w or color inside; $75 for spots. Finds illustrators through artists' promotional samples.

TIPS "Looking for fresh and unique styles. We feature approximately 4 illustrators per publication. I've developed great relationships with all of them."

OREGON QUARTERLY

5228 University of Oregon, Eugene OR 97403. (541)346-5046; (541) 346-5047. **E-mail:** quarterly@uoregon.edu. **Website:** www.oregonquarterly.com. Estab. 1919. Circ. 100,000. Quarterly 4-color alumni magazine. Emphasizes regional (Northwest) issues and events as addressed by University of Oregon faculty members and alumni. Sample copies available for SASE with first-class postage.

ILLUSTRATION Approached by 25 illustrators/year. Buys 1-2 illustrations/issue, nearly always from artists previously purchased from.

FIRST CONTACT & TERMS Illustrators: E-mail query and link to website or portfolio. Responds only if interested. Portfolio review not required. Buys one-time rights for print and electronic versions. **Pays on acceptance**; rates negotiable. Accepts previously published artwork.

ORGANIC GARDENING

Rodale, 400 S. 10th St., Emmaus PA 18098-0099. **E-mail:** og@rodale.com. **Website:** www.organicgardening.com. **Contact:** Jim Oseland, editor in chief. Estab. 1942. Circ. 300,000. Magazine emphasizing gardening; 4-color; uncluttered design. "*Organic Gardening* is for gardeners who enjoy gardening as an integral part of a healthy lifestyle. Editorial shows readers how to grow flowers, edibles, and herbs, as well as information on ecological landscaping. Also covers organic topics including soil building and pest control." Published 6 times/year.

ILLUSTRATION Buys 10 illustrations/issue. Works on assignment only.

FIRST CONTACT & TERMS Illustrators: Send tearsheets. Samples are filed or are returned by SASE only. Occasionally needs technical illustration. Buys first rights or one-time rights. Sample copies available only with SASE.

TIPS "Our emphasis is 'how-to' gardening; therefore illustrators with experience in the field will have a greater chance of being published. Detailed and fine rendering quality is essential."

ORLANDO MAGAZINE

801 N. Magnolia Ave., Suite 201, Orlando FL 32803. (407)423-0618. **Fax:** (407)237-6258. **E-mail:** christine. dupont@orlandomagazine.com. **Website:** www. orlandomagazine.com. **Contact:** Christine Dupont, art director. Estab. 1946. Circ. 40,000. "We are a 4-color monthly city/regional magazine covering the Central Florida area—local issues, sports, home and garden, business, entertainment and dining." Accepts previously published artwork. Originals are returned at job's completion. Sample copies available.

ILLUSTRATION Buys 2-3 illustrations/issue. Has featured illustrations by T. Sirell, Rick Martin, Mike Wright, Jon Krause. Assigns 100% of illustrations to experienced, but not necessarily well-known illustrators. Works on assignment only. Needs editorial illustration.

DESIGN Needs freelancers for design and production.

FIRST CONTACT & TERMS Illustrators: Send postcard, brochure or tearsheets. Samples are filed and are not returned. Responds only if interested with a specific job. Portfolio review not required. Buys first rights, one-time rights or all rights (rarely). Pays for design by the project.

TIPS "Send appropriate samples. Most of my illustration hiring is via direct mail. The magazine field is still a great place for illustration. Have several ideas ready after reading editorial to add to or enhance our initial concept."

OUR STATE: CELEBRATING NORTH CAROLINA

P.O. Box 4552, Greensboro NC 27404. (336)286-0600 or (800)948-1409. **Fax:** (336)286-0100. **E-mail:** art_director@ourstate.com; editorial@ourstate. com; marketing@ourstate.com. **Website:** www. ourstate.com. editorial@ourstate.com. Estab. 1933. Circ. 170,000. Monthly 4-color consumer magazine featuring travel, history and culture of North Carolina. Art guidelines free with #10 SASE and first-class postage.

ILLUSTRATION Approached by 6 illustrators/year. Buys 1-10 illustrations/issue. Features representations of towns in North Carolina in every issue, plus var-ious illustrations for "down home" North Carolina stories. Prefers vintage/antique/literary look. Assigns 100% to new and emerging illustrators. 100% of freelance illustration demands knowledge of Illustrator.

FIRST CONTACT & TERMS Illustrators: Send e-mail with a link to work. Send postcard sample or nonreturnable samples. Samples are not filed and are not returned. Portfolio review not required. Buys one-time rights. Pays on publication: $400-600 for color cover; $75-350 for b&w inside; $75-350 for color inside; $350 for 2-page spreads. Finds illustrators through web searches, marketing mailings, resource books.

☯ OUTDOOR CANADA MAGAZINE

54 St. Patrick St., Toronto Ontario M5T 1V1, Canada. (416)599-2000. **E-mail:** editorial@outdoorcanada.ca. **Website:** www.outdoorcanada.ca. Estab. 1972. Circ. 90,000. 4-color magazine for Canadian anglers and hunters. Stories on fishing, hunting and conservation. Readers are 81% male. Publishes 6 regular issues/year. "We are looking for strong, attention-grabbing images that capture the love our readers have for hunting and fishing. We're interested in finding and cultivating new Canadian talent and appreciate submissions from new photographers and illustrators to add to our list."

ILLUSTRATION Approached by 12-15 illustrators/ year. Buys approximately 10 drawings/issue. Has featured illustrations by Malcolm Cullen, Stephen MacEachren and Jerzy Kolatch. Features humorous, computer and spot illustration. Assigns 90% to experienced, but not well-known illustrators; 10% to new and emerging illustrators. Uses freelancers mainly for illustrating features and columns. Uses pen & ink, acrylic, oil and pastel.

DESIGN Needs freelancers for multimedia. 20% of freelance work demands knowledge of Photoshop, Illustrator and Adobe InDesign.

FIRST CONTACT & TERMS Illustrators: Send postcard sample or tearsheets. Designers: Send brochure, tearsheets and postcards. Accepts disk submissions compatible with Illustrator 7.0. Send EPS, TIFF and PICT files. Buys first rights. Fees negotiated. Pays designers by the project. Artists should show a representative sampling of their work. Finds most artists through references/word of mouth.

TIPS "Meet our deadlines and our budget. Know our product. Fishing and hunting knowledge an asset."

✪ OWL

10 Lower Spadina Ave., Suite #400, Toronto, Ontario M5V 2Z2 Canada. (416)340-2700, ext. 318. **Fax:** (416)340-9769. **E-mail:** owl@owlkids.com. **Website:** www.owlkids.com. **Contact:** Tracey Jacklin; Angela Colucci. Estab. 1979. Circ. 67,900 in North America. 10 issues/year. Children's discovery magazine. Also publishes *Chirp* for ages 3-6 and *chikaDEE* for ages 6-9. Each issue contains photos, illustrations, an easy-to-read animal story, a craft project, fiction, puzzles, a science experiment and a pull-out poster. Originals returned at job's completion. Sample copies available. Uses all types of conventional methods of illustration. Digital illustrators should be familiar with Illustrator or Photoshop.

◐ The same company that publishes *chikaDEE* now also publishes *Chirp*, a science, nature and discovery magazine for preschoolers 2 to 6 years old, and *OWL*, a similar publication for children over 8 years old.

ILLUSTRATION Approached by 500-750 illustrators/year. Buys 3-7 illustrations/issue. Works on assignment only. Prefers animals, children, situations and fiction. All styles, loaded with humor but not cartoons. Realistic depictions of animals and nature. Considers all media and computer art. No b&w illustrations.

FIRST CONTACT & TERMS Illustrators: Send postcard sample, photocopies and tearsheets. Accepts disk submissions compatible with Illustrator 8.0. Send EPS files. Samples are filed or returned by SASE. Will contact for portfolio review if interested. Portfolio should include final art, tearsheets and photocopies. Buys all rights. Pays within 30 days of invoice. Finds artists through sourcebooks, word of mouth, submissions as well as looking in other magazines to see who's doing what.

TIPS "Please become familiar with the magazine before you submit. Ask yourself whether your style is appropriate before spending the money on your mailing. Magazines are ephemeral and topical. Ask yourself if your illustrations are editorial and contemporary. Some styles suit books or other forms better than magazines." Impress this art director by being "fantastic, enthusiastic and unique."

THE OXFORD AMERICAN

P.O. BOX 3235, Little Rock AR 72205. (501)374-0000. **Fax:** (501)374-0001. **E-mail:** editors@oxfordamerican. org. **Website:** www.oxfordamerican.org. **Contact:** Roger D. Hodge, editor; Eliza Bornè, managing editor. Circ. 55,000. Quarterly literary magazine. "The Southern magazine of good writing." Art guidelines on website.

◐ This award-winning magazine suspended publication in July 2003, but it relaunched in the fall of 2004 as a not-for-profit publication allied with the University of Central Arkansas.

ILLUSTRATION Approached by many artists/year. Uses a varying number of illustrations/year. Considers all media.

FIRST CONTACT & TERMS Prefers digital submissions (attach JPEGs to e-mail) or include link to website. Also accepts printed tearsheets, photocopies or postcard sample of work. Samples are filed. Responds only if interested. To have materials returned, send SASE. Art director will contact artist for portfolio review of final art and roughs if interested. Buys one-time rights. Pays on publication. Finds artists through word of mouth and submissions.

TIPS "See the magazine."

OYEZ REVIEW

Roosevelt University, Dept. of Literature & Languages, 430 S. Michigan Ave., Chicago IL 60605. **E-mail:** oyezreview@roosevelt.edu. **Website:** oyezreview. wordpress.com. Estab. 1965. Circ. 600 with an e-book available. Annual magazine of the Creative Writing Program at Roosevelt University, publishing fiction, creative nonfiction, poetry, and art. There are no restrictions on style, theme, or subject matter. Each issue has 100 pages: 92 pages of text and an 8-page b&w or color spread of 1 artist's work (usually drawing, painting or photography). In addition to the 8-page spread, the front and back cover feature the artist's work as well, totaling 10 pieces.

CARTOONS Now accepting submissions through Submittable as well as regular mail. No longer accepting e-mail submissions.

ILLUSTRATION Features realistic illustrations.

DESIGN Be familiar with InDesign software.

PACIFIC PRESS PUBLISHING ASSOCIATION

1350 North Kings Rd., Nampa ID 83687. (208)465-2500. **Fax:** (208)465-2531. **Website:** www.pacificpress. com. Estab. 1875. Book and magazine publisher. Specializes in Christian lifestyles and Christian outreach.

This association publishes magazines and books. Also see *Signs of the Times* listing for needs.

PACIFIC YACHTING

OP Publishing, Ltd., 1166 Alberni St., Suite 802, Vancouver, British Columbia V6E 3Z3 Canada. (604)428-0259. **Fax:** (604)620-0425. **E-mail:** editor@pacificyachting.com; ayates@oppublishing.com. **Website:** www.pacificyachting.com. **Contact:** Dale Miller, editor; Arran Yates, art director. Estab. 1968. Circ. 19,000. Monthly 4-color magazine focused on boating on the West Coast of Canada. Power/sail cruising only. Accepts previously published artwork. Original artwork returned at job's completion. Sample copies available for $6.95 cover price plus postage. Art guidelines not available.

CARTOONS Approached by 12-20 cartoonists/year. Buys 2-3 illustrations or cartoons/issue. Boating themes only; single panel b&w line drawings.

ILLUSTRATION Approached by 25 illustrators/year. Buys 10-20 illustrations/year. Has featured illustrations by Dave Alavoine, Roger Jackson and Tom Shardlow. Boating themes only. Considers pen & ink, watercolor, airbrush, acrylic, colored pencil, oil and charcoal.

FIRST CONTACT & TERMS Cartoonists and Illustrators: Send query letter with brochure and roughs. "Will keep on file and contact if interested." Illustrators: Call for appointment to show portfolio of appropriate samples related to boating on the West Coast. Buys one-time rights. Pays on publication. Pays cartoonists $25-50 for b&w. Pays illustrators $300 for color cover; $50-100 for color inside; $25-50 for spots.

TIPS "Know boats and how to draw them correctly. Know and love my magazine."

PAINT HORSE JOURNAL

American Paint Horse Association, P.O. Box 961023, Ft. Worth TX 76161-0023. (817)834-2742. **Fax:** (817)834-3152. **E-mail:** jhein@apha.com. **Website:** apha.com/phj/welcome. **Contact:** Jessica Hein, editor. Estab. 1966. Circ. 12,000. Monthly 4-color, official publication of breed registry of the American Paint Horse for people who raise, breed and show, or just appreciate Paints. Original artwork returned after publication if requested. Sample copy for $7 (includes shipping); artist's guidelines for SASE.

ILLUSTRATION Purchase a few illustrations each year.

FIRST CONTACT & TERMS Illustrators: Send business card and samples to be kept on file. Prefers snapshots of original art or photostats as samples. Samples returned by SASE if not filed. Responds in 1 month. Buys first rights but may wish to use small, filler art many times. Payment varies by project.

TIPS "No matter what style of art you use, you must include Paint Horse(s) with conformation acceptable (to the APHA). Horses of Arabian-type, Draft-type or Saddlebred-type conformation or with markings not appropriate for Paint Horses will not be considered. Please refer to our website to learn more about the breed and specifics at www.apha.com/breed."

PARABOLA MAGAZINE

20 W. 20th St., 2nd Floor, New York NY 10011. (212)822-8806; (510)548-1680. **E-mail:** editorial@parabola.org; ads-promo@parabola.org; info@parabola.org. **Website:** www.parabola.org. Estab. 1974. Circ. 40,000. Quarterly magazine of world myth, religious traditions and arts/comparative religion. Sample copies available. Art guidelines on website.

ILLUSTRATION Approached by 20 illustrators/year. Buys 4-6 illustrations/issue. Prefers traditional b&w high contrast. Considers all media.

FIRST CONTACT & TERMS Illustrators: Send postcard or query letter with printed nonreturnable samples, photocopies and SASE. Accepts disk submissions. Samples are filed. Responds only if interested. Buys one-time rights. Pays on publication (kill fee given for commissioned artwork only); $300 maximum for cover; $150 maximum for b&w inside. Pays $50-100 for spots. Finds illustrators through sourcebooks, magazines, word of mouth and artist's submissions. "We rarely commission cover."

TIPS "Familiarity with religious traditions and symbolism a plus. Timeless or classic look is preferred over trendy."

PARADE MAGAZINE

711 Third Ave., New York NY 10017-4014. (212)450-7000; (615) 327-0747; (212)478-1910; (312)948-0310. **E-mail:** mediarelations@parade.com; or via the online contact form. **Website:** www.parade.com. partners@amgparade.com; sollinick@amgparade. Circ. 32 million. Weekly emphasizing general-interest subjects.

Sample copies available. Art guidelines available with SASE and first-class postage.

ILLUSTRATION Works on assignment only.

DESIGN Needs freelancers for design. 100% of freelance work demands knowledge of Photoshop, Illustrator, InDesign and QuarkXPress. Prefers local freelancers.

FIRST CONTACT & TERMS Illustrators: Send query letter with brochure, résumé, business card, postcard or tearsheets to be kept on file. Designers: Send query letter with résumé. Call or write for appointment to show portfolio. Responds only if interested. Buys first rights, occasionally all rights. Pays for design by the project, by the day or by the hour depending on assignment.

TIPS "Provide a good balance of work."

PC MAGAZINE DIGITAL EDITION

Ziff Davis LLC., 28 E. 28th St., 11th Floor, New York NY 10016. (212)503-5216. **Website:** www.pcmag.com. **Contact:** Cynthia Passante, Creative Director. Estab. 1983. Circ. 125,000. Monthly consumer magazine featuring comparative lab-based reviews of current PC hardware and software. Sample copies available.

ILLUSTRATION Approached by 100 illustrators/year. Buys 2-3 illustrations/issue. Considers all media.

FIRST CONTACT & TERMS Send postcard sample or printed samples, photocopies, tearsheets. Accepts CD or e-mail submissions. Samples are filed. Portfolios may be dropped off and should include tearsheets and transparencies; art department keeps for one week to review. **Pays on acceptance.** Payment negotiable for cover and inside; $350 for spots.

PENNSYLVANIA LAWYER

100 South St., Harrisburg PA 17101. (717)238-6715. **E-mail:** editor@pabar.org. **Website:** www.pabar.org. Circ. 30,000. Bimonthly association magazine "featuring nuts and bolts articles and features of interest to lawyers." Sample copies with #10 SASE and first-class postage.

PERSIMMON HILL

1700 NE 63rd St., Oklahoma City OK 73111. (405)478-2250, ext. 213. **Fax:** (405)478-4714. **E-mail:** editor@nationalcowboymuseum.org. **Website:** www.nationalcowboymuseum.org. **Contact:** Judy Hilovsky. Estab. 1970. Circ. 7,500. Biannual 4-color journal of western heritage "focusing on both historical and contemporary themes. It features nonfiction articles on notable persons connected with pioneering the American West; art, rodeo, cowboys, ranching, floral and animal life; or other phenomena of the West of today or yesterday. Lively articles, well written, for a popular audience. Contemporary design follows style of *Architectural Digest, European Travel* and *Life*. Accepts no reprints. Pays on publication. Query with clips. We do not accept multiple submissions. Allow a minimum of 6 weeks for a response from the editor and editorial staff. Sample copy for $11.

TIPS "We are a western museum publication. Most illustrations are used to accompany articles. Work with our writers, or suggest illustrations to the editor that can be the basis for a freelance article or a companion story. More interest in the West means we have to provide more contemporary photographs and articles about what people in the West are doing today. Study the magazine first—at least 4 issues."

PEST MANAGEMENT PROFESSIONAL

North Coast Media, 1360 E. Ninth St., Suite 1070, Cleveland OH 44114. **E-mail:** PMPEditor@northcoastmedia.net. **Website:** www.mypmp.net. Estab. 1933. Circ. 21,298. Monthly trade publication for pest control specialists focusing on crawling and flying insect control, termite control, rodent and other pest control and public health issues.

FIRST CONTACT & TERMS Cartoonists/illustrators: Send postcard sample with URL. After introductory mailing, send follow-up postcard sample every 6 months. Samples are filed. Responds only if interested. Buys one-time rights. Finds freelancers through artists' submissions.

PHILADELPHIA WEEKLY

1617 JFK Blvd., Suite 1005, Philadelphia PA 19103. (215)563-7400. **E-mail:** abarbalios@philadelphiaweekly.com; editor@philadelphiaweekly.com. **Website:** www.philadelphiaweekly.com. **Contact:** Anastasia Barbalios, managing editor. Estab. 1971. Circ. 105,500. Alternative weekly, 4-color, tabloid focusing on news and opinion and arts and culture.

CARTOONS Approached by 25 cartoonists/year. Buys 0-1 cartoon/issue. Prefers single panel, multiple panel, political, humorous, b&w washes, b&w line drawings.

ILLUSTRATION Approached by scores of illustrators/year. Buys 3-5 illustrations/issue. Has featured illustrations by Brian Biggs, Jay Bevenour, James

McHugh. Features caricatures of celebrities and politicians; humorous, realistic and spot illustrations. Considers a wide range of styles.

FIRST CONTACT & TERMS Cartoonists: Send query letter with b&w photocopies. Illustrators: Send postcard sample or query letter with printed samples and photocopies. Send nonreturnable samples. Samples are filed and are not returned. Responds only if interested. Buys one-time rights. Pays on publication. Finds illustrators through promotional samples.

⊕ PHOENIX MAGAZINE

Cities West Publishing, Inc., 15169 N. Scottsdale Rd., Suite C-310, Scottsdale AZ 85254. (866)481-6970. **Fax:** (602)604-0169. **Website:** www.phoenixmag.com. Estab. 1966. Circ. 60,000. Monthly regional magazine for residents and visitors to Phoenix, Arizona covering local personality profiles, local culture and historical articles.

ILLUSTRATION Features local caricatures of celebrities/politicians and humorous illustration of business and politics.

FIRST CONTACT & TERMS Illustrators: Send postcard sample with URL. Samples are filed. Responds only if interested. Pays illustrators $100-200 for color inside. Buys one-time rights. Finds freelancers through artists' submissions.

PLANNING

American Planning Association, 205 N. Michigan Ave., Suite 1200, Chicago IL 60601. (312)431-9100. **Fax:** (312)786-6700. **E-mail:** slewis@planning.org; mstromberg@planning.org. **Website:** www.planning. org. **Contact:** Sylvia Lewis, editor; Joan Cairney, art director; Meghan Stromberg, executive editor. Estab. 1972. Circ. 44,000. Monthly magazine emphasizing urban planning for adult, college-educated readers who are regional and urban planners in city, state, or federal agencies or in private business, or university faculty or students.

FIRST CONTACT & TERMS Send query letter with samples; include SASE for return of material. Responds in 1 month. Previously published work OK. Pays on publication. Credit line given.

PLAYBOY MAGAZINE

9346 Civic Center Dr., #200, Beverly Hills CA 90210. **Fax:** (310)786-7440. **Website:** www.playboy.com. Estab. 1953. Monthly.

CARTOONS Playboy Enterprises, Inc., Cartoon Dept., 730 Fifth Ave., New York NY 10019.

ILLUSTRATION Approached by 700 illustrators/year. Prefers "uncommercial looking" artwork. Considers all media.

FIRST CONTACT & TERMS Illustrators: Send postcard sample or query letter with slides and photocopies or other appropriate sample. Does not accept originals. Samples are filed or returned. Responds in 2 weeks. Buys all rights. Pays on acceptance.

TIPS "No phone calls, only formal submissions of 5 pieces."

PLAYSTATION: THE OFFICIAL MAGAZINE

Future US, Inc., 4000 Shoreline Court, Suite 400, South San Francisco CA 94080. (650)872-1642. **Website:** www.futureus.com. **Contact:** art director. Estab. 1997. Circ. 400,000. Monthly 4-color consumer magazine focused on PlayStation video games for youth (preteens and older). Style is "comic booky." Free sample copies available.

CARTOONS Prefers multiple-panel, humorous b&w line drawings; manga/comic book style.

ILLUSTRATION Approached by 20-30 illustrators/year. Buys 24 illustrations/issue. Has featured illustrations by Joe Madureira, Art Adams, Adam Warren, Hajeme Soroyana, Royo, J. Scott Campbell and Travis Charest. Features comic-book style, computer, humorous, realistic and spot illustration. Preferred subject: video game characters. Assigns 80% of illustrations to well-known or "name" illustrators; 10% to experienced, but not well-known, illustrators; and 10% to new and emerging illustrators. 50% of freelance illustration demands knowledge of Illustrator and Photoshop.

FIRST CONTACT & TERMS Cartoonists: Send query letter with b&w and color photocopies and samples. Illustrators: Send postcard sample or non-returnable samples; send query letter with printed samples, photocopies and tearsheets. Accepts Mac-compatible disk submissions. E-mail JPEG or web link (preferred method). Samples are filed. Responds only if interested. Will contact artist for portfolio review if interested. Buys all rights. Pays on publication. Finds illustrators through magazines and word of mouth.

TIPS "If you're an artist, confident that your vision is unique, your quality is the best, ever evolving, send us samples!"

PN

PVA Publications, 2111 E. Highland Ave., Suite 180, Phoenix AZ 85016-4702. (602)224-0500. **E-mail:** andy@pvamag.com; anngarvey@pvamag.com; chuck@pvamag.com. **Website:** www.pvamag.com. **Contact:** Andy Nemann (article/editorial, text and photo submissions); Ann Garvey and Chuck McKenzie (cartoons and photos). Estab. 1947. Circ. 30,000. Monthly 4-color magazine emphasizing wheelchair living for wheelchair users, rehabilitation specialists and caregivers. Accepts previously published artwork. Original artwork not returned after publication. Sample copy free with large-size SASE and $4 postage.

CARTOONS Buys cartoons according to need. Prefers b&w line drawings with or without gagline depicting wheelchair living with medical and/or financial topics as themes. Accepted file formats are InDesign, Photoshop or Illustrator.

FIRST CONTACT & TERMS Submission guidelines available online. Prefers digital images, but will accept prints, slides and transparencies.

POCKETS

The Upper Room, P.O. Box 340004, Nashville TN 37203. (615)340-7333. **E-mail:** pockets@upperroom.org. **Website:** pockets.upperroom.org. **Contact:** Lynn W. Gilliam, editor. Estab. 1981. Magazine published 11 times/year. "*Pockets* is a Christian devotional magazine for children ages 6-12. All submissions should address the broad theme of the magazine. Each issue is built around one theme with material which can be used by children in a variety of ways. Scripture stories, fiction, poetry, prayers, art, graphics, puzzles, and activities are included. Submissions do not need to be overtly religious. They should help children experience a Christian lifestyle that is not always a neatly-wrapped moral package, but is open to the continuing revelation of God's will. Seasonal material, both secular and liturgical, is desired."

FIRST CONTACT & TERMS Send photos, contact sheets, prints, or digital images. Must be 300 dpi.

POETS AND ARTISTS (O&S)

Website: www.poetsandartists.com. **Contact:** Didi Menendez, publisher. Reviews books of poetry, chapbooks of poetry, and other magazines/journals. Reads poetry submissions year round. Sometimes upcoming themes are available online at website. Authors published include Denise Duhamel, Bob Hicok, Billy Collins, Ron Androla, Blake Butler, and Matthew Hittinger. "We are a multi-interactive publication focusing on art: figurative, representational, portraits, and poetry. We interview art collectors, poets, artists, gallery owners and art dealers to keep our readers in the know."

POPULAR SCIENCE

Bonnier Corporation, 2 Park Ave., 9th Floor, New York NY 10016. **E-mail:** queries@popsci.com; bown@bonniercorp.com. **Website:** www.popsci.com. **Contact:** Jill C. Shomer, managing editor. Estab. 1872. Circ. 1,450,000. "For the well-educated adult male, interested in science, technology, new products." Original artwork returned after publication. Art guidelines available.

ILLUSTRATION Uses 30-40 illustrations/issue. Has featured illustrations by Don Foley, P.J. Loughron, Andrew Grids and Bill Duke. Assigns 50% of illustrations to well-known or "name" illustrators; 40% to experienced but not well-known illustrators; 10% to new and emerging illustrators. Works on assignment only. Interested in technical 4-color art and 2-color line art dealing with automotive or architectural subjects. Especially needs science and technological pieces as assigned per layout.

FIRST CONTACT & TERMS Illustrators: Send postcard sample, photocopies or other nonreturnable samples. Responds only if interested. Samples kept on file for future assignments. "After seeing portfolios, I photocopy or photostat those samples I feel are indicative of the art we might use." Reports whenever appropriate job is available. Buys first publishing rights.

TIPS "More and more scientific magazines have entered the field. This has provided a larger base of technical artists for us. Be sure your samples relate to our subject matter (e.g., no rose etchings) and be sure to include a tearsheet for our files. I don't really need a high end, expensive sample. All I need is something that shows the type of work you do. Look at our magazine before you send samples. Our illustration style is very specific. If you think you fit into the look of our magazine, send a sample for our files."

PORTLAND REVIEW

Portland State University, P.O. Box 751, Portland OR 97207. **Website:** portlandreview.org. **Contact:** Alex Dannemiller, editor-in-chief. Estab. 1956. Circ. 1,500. A literary magazine covering short prose, poetry, photography, and art. Art guidelines available on website.

ILLUSTRATION Approached by 50 illustrators/year. We don't pay contributors. Features art illustrations and photography. Currently prefer Portland-based artists but international welcome.

FIRST CONTACT & TERMS Accepts submissions only through Submittable submission manager. Prefers Mac-compatible. Samples are not filed and not returned. Responds with acceptance in 2-4 months. Portfolio not required.

PRACTICELINK

415 2nd Ave., Hinton WV 25951. (502)272-3831 or (800)776-8383 Ext. 834. **Website:** www.practicelink. com. **Contact:** Barbara Barry, creative director; Tammy Hager, director. Estab. 1991. Circ. 80,000. Formerly *Unique Opportunities*. Quarterly career magazine for physicians. Audience is 80,000 physicians who will soon be looking for a new practice. Editorial focus is on physician career topics. Prefers files in JPEG, TIFF, or PDF format.

ILLUSTRATION Buys 1 illustration/issue. Works on assignment or stock. Considers pen ink, mixed media, collage, pastel and computer illustration. Must supply in digital format.

FIRST CONTACT & TERMS Views online portfolios. E-mail digital files. Buys first or one-time rights. Pays 30 days after acceptance; $950 for color cover; $300 for spots. Finds artists through Internet only. Do not send samples in the mail.

PRAIRIE JOURNAL OF CANADIAN LITERATURE

28 Crowfoot Terrace NW, P.O. Box 68073, Calgary, Alberta T3G 3N8 Canada. **E-mail:** prairiejournal@yahoo.com. **Website:** www.prairiejournal.org. Estab. 1983. Circ. 750. Biannual literary magazine. Sample copies available for $6 each; art guidelines and past cover art available for viewing online.

ILLUSTRATION Approached by 25 illustrators/year. Buys 6 illustrations/year. Has featured cover art by Amanda Rehagen and John Howard, illustrations by Hubert Lacey, Rita Diebolt and Lucie Chan. Considers artistic/experimental b&w line drawings or screened prints.

FIRST CONTACT & TERMS Illustrators: Send postcard sample or query letter with b&w photocopies. Samples are filed. Responds only if interested. Portfolio review not required. Acquires one-time rights. Pays $50 maximum (Canadian) for b&w cover and $25 maximum for inside drawings. Pays on publi-

cation. Finds freelancers through unsolicited submissions and queries.

TIPS "We are looking for b&w line drawings that are high-contrast and camera-ready copy. Never send originals through the mail."

PRAIRIE MESSENGER

Benedictine Monks of St. Peter's Abbey, P.O. Box 190, 100 College Drive, Muenster, Saskatchewan S0K 2Y0 Canada. (306)682-1772. **Fax:** (306)682-5285. **E-mail:** pm.canadian@stpeterspress.ca. **Website:** www.prairiemessenger.ca. **Contact:** Maureen Weber, associate editor. Estab. 1904. Circ. 4,000. Weekly Catholic publication published by the Benedictine Monks of St. Peter's Abbey in Muenster, Saskatchewan Canada. Has a strong focus on ecumenism, social justice, interfaith relations, aboriginal issues, arts and culture.

FIRST CONTACT & TERMS E-mail JPEG samples at 72dpi. If photos are accepted, high resolution is needed.

PREMONITIONS

13 Hazely Combe, Arrenton, Isle of Wight PO30 3AJ United Kingdom. **E-mail:** mail@pigasuspress.co.uk. **Website:** www.pigasuspress.co.uk. **Contact:** Tony Lee, editor.

FIRST CONTACT & TERMS Wants "quality color or b&w genre illustrations for A4 front and back covers. Also, talented artists wanted to produce sequential artwork for our unique 'graphic poems.'" Send photocopied samples of work, published or unpublished, to contribute.

THE PRESBYTERIAN RECORD

50 Wynford Dr., Toronto, Ontario M3C 1J7 Canada. (416)441-1111 or (800)619-7301, (905)833-6200 ex. 23. **Fax:** (416)441-2825. **E-mail:** record@presbyterianrecord.ca; online form. **Website:** www.presbyterianrecord.ca. Circ. 50,000. Published 11 times/year. Deals with family-oriented religious themes. Original artwork returned after publication. Simultaneous submissions and previously published work OK. Free sample copy and artists' guidelines for SASE with first-class postage.

CARTOONS Approached by 12 cartoonists/year. Buys 1-2 cartoons/issue. Interested in some theme or connection to religion.

ILLUSTRATION Approached by 6 illustrators/year. Buys 1 illustration/year on religion. Has featured

illustrations by Ed Schnurr, Claudio Ghirardo and Chrissie Wysotski. Features humorous, realistic and spot illustration. Assigns 50% of illustrations to new and emerging illustrators. "We are interested in excellent color artwork for cover." Any line style acceptable—should reproduce well on newsprint. Works on assignment only.

FIRST CONTACT & TERMS Cartoonists: Send roughs and SAE (nonresidents include IRC). Illustrators: Send query letter with brochure showing art style or tearsheets, photocopies and photographs. Will accept computer illustrations compatible with Quark XPress 4.1, Illustrator 8.0, Photoshop 6.0. Samples returned by SAE (nonresidents include IRC). Responds in 1 month. To show a portfolio, mail final art and color and b&w tearsheets. Buys all rights on a work-for-hire basis. Pays on publication. Pays cartoonists $25-50 for b&w. Pays illustrators $50-100 for b&w cover; $100-300 for color cover; $25-80 for b&w inside; $25-60 for spots.

TIPS "We don't want any 'cute' samples (in cartoons). We prefer some theological insight in cartoons; some comment on religious trends and practices."

PRESBYTERIANS TODAY

Presbyterian Church (USA), 100 Witherspoon St., Louisville KY 40202-1396. (502)569-5627. **Fax:** (502)569-8887. **E-mail:** editor@pcusa.org. **Website:** www.pcusa.org/today. **Contact:** Patrick David Heery, editor. Estab. 1867. Circ. 30,000. Denominational magazine published 8 times/year covering religion, denominational activities, and public issues for members of the Presbyterian Church (USA). "The magazine's purpose is to increase understanding and appreciation of what the church and its members are doing to live out their Christian faith."

ILLUSTRATION Works on assignment only. Media varies according to need.

PREVENTION

Rodale, Inc., 33 E. Minor St., Emmaus PA 18098-0099. **E-mail:** editor@prevention.com. **Website:** www.prevention.com. Estab. 1950. Circ. 3,150,000. Monthly consumer magazine covering health and fitness for women. Art guidelines available.

ILLUSTRATION Approached by 500-750 illustrators/year. Buys 1-2 spot illustrations/issue. Considers all media.

FIRST CONTACT & TERMS Illustrators: Send postcard sample or query letter with photocopies, tearsheets, URL. Samples are filed. Responds only if interested. Art director will contact artist for portfolio review of b&w, color, photographs, tearsheets, transparencies if interested. Buys rights for all media. Finds illustrators through www.ispot.com, magazines, submissions.

PRICK OF THE SPINDLE

P.O. Box 170607, Birmingham AL 35217. **E-mail:** pseditor@prickofthespindle.com. **Website:** www.prickofthespindle.com. **Contact:** Cynthia Reeser, editor-in-chief. Estab. 2007. Circ. 6,200 hits/day. Literary magazine published quarterly online, biannually in print. We accept artwork that shows imagination and skill that covers a broad range of themes and subjects. Sample copy available for $10. Art/photo submission guidelines available on website.

ILLUSTRATION Approached by approximately 150 freelancers/year. Buys 10-15 illustrations from freelancers/year. Featured artists include Rose Mambert, Regina Valluzzi and Loren Kantor. Features realistic, abstract and interpretive illustrations of general artistic subjects. Prefers b&w line drawings (for print edition—cover art and interior illustrations). 75% of assignments given to new and emerging illustrators. 10% of work demands computer skills. Artists should be familiar with Illustrator and Photoshop. Accepts prints in various sizes in glossy, matte, color or b&w, as well as images in digital format.

FIRST CONTACT & TERMS Send query letter or e-mail with résumé, prints and SASE (regular mail) or JPEG samples at 72 dpi. Keeps samples on file, provide résumé, business card or self-promotion piece to be kept on file for future assignments. Samples only return with SASE. Responds in 7 days. Will contact artist for portfolio review if interested. Portfolio should include b&w, color, finished art, original art, photographs. Considers simultaneous submissions and previously published work. Credit line given. Buys first North American rights. Willing to negotiate. Finds freelancers through submissions.

PRINT MAGAZINE

F+W Content + eCommerce Company, 10151 Carver Rd., Suite 200, Blue Ash OH 45242. (513)531-2690. **E-mail:** info@printmag.com. **Website:** www.printmag.com. **Contact:** Zachary Petit, editor. Estab. 1940. Circ. 55,000. Quarterly professional magazine for "art directors, designers and anybody else interested in graphic design." Art guidelines available.

FIRST CONTACT & TERMS Illustrators/designers: Send physical postcard samples or emails of work samples. Samples are filed. Responds only if interested. Art director will contact artist for portfolio review if interested. Buys first rights. Pays on acceptance. Finds illustrators through agents, sourcebooks, word of mouth and submissions.

TIPS "Read the magazine: We showcase design, typography, illustration and photography. We're also interested in individual creative approaches to design problems. Note: We have themed issues; please ask to see our editorial calendar."

PRISM INTERNATIONAL

Dept. of Creative Writing, Buch E462, 1866 Main Mall, University of British Columbia, Vancouver, British Columbia V6T 1Z1 Canada. (604)822-2514. **Fax:** (604)822-3616. **E-mail:** prismcirculation@gmail. com. **Website:** www.prismmagazine.ca. Estab. 1959. Circ. 1,200. Quarterly literary magazine. "We use cover art for each issue." Sample copies available for $12 each; art guidelines free for SASE with first-class Canadian postage.

ILLUSTRATION Buys 1 cover illustration/issue. Has featured illustrations by Mark Ryden, Mark Mothersbaugh, Annette Allwood, the Clayton Brothers, Maria Capolongo, Mark Korn, Scott Bakal, Chris Woods, Kate Collie and Angela Grossman. Features representational and non-representational fine art. Assigns 50% of illustrations to experienced but not well-known illustrators; 50% to new and emerging illustrators. "Most of our covers are full color artwork and sometimes photography; on occasion we feature a b&w cover."

FIRST CONTACT & TERMS Illustrators: Send postcard sample. Most samples are filed; those not filed are returned by SASE if requested by artist. Responds in 6 months. Portfolio review not required. Buys first rights. "Image may also be used for promotional purposes related to the magazine." Pays on publication: $300 Canadian and 2 copies of magazine. Original artwork is returned to the artist at job's completion. Finds artists through word of mouth and going to local exhibits.

TIPS "We are looking for fine art suitable for the cover of a literary magazine. Your work should be polished, confident, cohesive and original. Please send postcard samples of your work. As with our literary contest, we will choose work that is exciting and which reflects the contemporary nature of the magazine."

PROCEEDINGS

U.S. Naval Institute, 291 Wood Rd., Annapolis MD 21402-5034. (410)268-6110. **Fax:** (410)571-1703. **E-mail:** articlesubmissions@usni.org. **Website:** www. usni.org/magazines/proceedings. **Contact:** Fred H. Rainbow, editor-in-chief; Emily Martin, photo researcher. Estab. 1873. Circ. 60,000. Monthly 4-color magazine emphasizing naval and maritime subjects. "*Proceedings* is an independent forum for the sea services." Design is clean, uncluttered layout, "sophisticated." Accepts previously published material. Sample copies and art guidelines available.

CARTOONS Prefers cartoons assigned to tie in with editorial topics.

ILLUSTRATION Buys 1 illustration/issue. Works on assignment only. Has featured illustrations by Tom Freeman, R.G. Smith, and Eric Smith. Features humorous and realistic illustration; charts and graphs; informational graphics; computer and spot illustration. Needs editorial and technical illustration. "We like a variety of styles if possible. Do excellent illustrations and meet the requirement for military appeal." Prefers illustrations assigned to tie in with editorial topics.

FIRST CONTACT & TERMS Cartoonists: Send query letter with samples of style to be kept on file. Illustrators: Send query letter with printed samples, tearsheets, or photocopies. Accepts submissions on CD (call production manager for details). Samples are filed or are returned only if requested by artist. Responds only if interested. Publication will contact artist for portfolio review if interested. Negotiates rights purchased. Sometimes requests work on spec before assigning job. Pays cartoonists $25-50 for b&w, $50 for color. Pays illustrators $50 for b&w inside, $50-75 for color inside; $150-200 for color cover; $25 minimum for spots. "Contact us first to see what our needs are."

PROFIT

Rogers Media, 1 Mt. Pleasant Rd., 11th Floor, Toronto, Ontario M4Y 2Y5 Canada. (416)764-1402. **Fax:** (416)764-1404. **E-mail:** profit@profit.rogers.com. **Website:** www.profitguide.com. Estab. 1982. Circ. 84,632. Illustrators: Send postcard or other nonreturnable samples. Accepts Mac-compatible disk submissions. Samples are not returned. Will contact art-

ist for portfolio review if interested. Buys first rights. **Pays on acceptance**; $500-750 for color inside; $750-1,000 for 2-page spreads; $350 for spots. Pays in Canadian funds. Finds illustrators through promo pieces, other magazines.

ILLUSTRATION Buys 3-5 illustrations/issue. Has featured illustrations by Jerzy Kolacz, Jason Schneider, Ian Phillips. Features charts and graphs, computer, realistic and humorous illustration, informational graphics, and spot illustrations of business subjects. Assigns 50% of illustrations to well-known or "name" illustrations; 50% to experienced but not well-known illustrators.

THE PROGRESSIVE

30 W. Mifflin St., Suite 703, Madison WI 53703. (608)257-4626. **E-mail:** editorial@progressive.org. **Website:** www.progressive.org. **Contact:** Elizabeth Kunze, office manager. Estab. 1909. Monthly b&w plus 4-color cover political magazine. "Grassroots publication from a left perspective, interested in foreign and domestic issues of peace and social justice." Originals returned at job's completion. Free sample copy and art guidelines.

ILLUSTRATION Works with 50 illustrators/year. Buys 10 b&w illustrations/issue. Features humorous and political illustration. Has featured illustrations by Luba Lukova, Alex Nabaum and Seymour Chwast. Assigns 30% of illustrations to new and emerging illustrators. Needs editorial illustration that is "original, smart and bold." Works on assignment only.

FIRST CONTACT & TERMS Illustrators: Send query letter with tearsheets and/or photocopies. Samples returned by SASE. Responds in 6 weeks. Portfolio review not required. Pays $1,000 for b&w and color cover; $300 for b&w line or tone drawings/paintings/collage inside. Buys first rights. Do not send original art. Send samples, postcards or photocopies and appropriate postage for materials to be returned.

TIPS "Check out a copy of the magazine to see what kinds of art we've published in the past. A free sample copy is available by visiting our website."

PUBLIC CITIZEN NEWS

1600 20th St. NW, Washington DC 20009. (202)588-1000. **E-mail:** bblair@citizen.org. **Website:** www.citizen.org. **Contact:** Bridgette Blair, editorial and art director. Circ. 70,000. Bimonthly magazine emphasizing consumer issues for the membership of Public Citizen, a group founded by Ralph Nader in 1971. Accepts previously published material. Sample copy available with 9×12 SASE and first-class postage.

ILLUSTRATION Buys up to 2 illustrations/issue. Assigns 15% of illustrations to new and emerging illustrators. Prefers contemporary styles in pen & ink.

FIRST CONTACT & TERMS Illustrators: Send query letter with samples to be kept on file. Buys first rights or one-time rights. Pays on publication. Payment negotiable.

TIPS "Send several keepable samples that show a range of styles and the ability to conceptualize. We want cartoons that lampoon policies and politicians, as well as 4-color pen & ink or watercolor illustrations."

A PUBLIC SPACE

323 Dean St., Brooklyn NY 11217. (718)858-8067. **E-mail:** general@apublicspace.org. **Website:** www.apublicspace.org. **Contact:** Brigid Hughes, founding editor; Anne McPeak, managing editor.

○ *A Public Space*, published quarterly, "is an independent magazine of literature and culture. In an era that has relegated literature to the margins, we plan to make fiction and poetry the stars of a new conversation. We believe that stories are how we make sense of our lives and how we learn about other lives. We believe that stories matter." Single copy: $15; subscription: $36/year or $60/2 years.

FIRST CONTACT & TERMS Sample artwork, to be considered as story illustrations or as portfolios, can be sent to art@apublicspace.org. Please send no more than 4 low-res files. All artwork will be kept on file.

PUBLISHERS WEEKLY

71 W. 23rd St., #1608, New York NY 10010. (212)377-5500; (212) 377-5703. **E-mail:** cchiu@publishersweekly.com; dberchenko@publishersweekly.com. **Website:** www.publishersweekly.com. **Contact:** Clive Chiu, art director; Dan Berchenko, managing editor. Circ. 50,000. Weekly magazine emphasizing book publishing for "people involved in the creative or the technical side of publishing." Original artwork is returned to the artist after publication.

ILLUSTRATION Buys 75 illustrations/year. Works on assignment only. "Open to all styles."

FIRST CONTACT & TERMS Illustrators: Send postcard sample or query letter with brochure, tearsheets, photocopies. Samples are not returned. Responds only if interested. Pays on acceptance.

QUANTUM FAIRY TALES

E-mail: editor@quantumfairytales.com. **Website:** quantumfairytales.com. **Contact:** The Gnomies. Estab. October 2012.

FIRST CONTACT & TERMS Please e-mail art submissions with the following in the subject line: the words "art submission" and title. The e-mail should include name, e-mail address, age, and submission image as an attachment.

QUE ONDA!

P.O. Box 692150, Houston TX 77269-2150. (713)880-1133; (800)331-1374. **Fax:** (713)880-2322. **E-mail:** aida@queondamagazine.com; staff@queondamagazine.com. **Website:** www.queondamagazine.com. **Contact:** Aida Ulloa, art director; Oscar Guevara, assistant editor. Estab. 1993. Circ. 160,000. Biweekly bilingual magazine providing news and entertainment sources for Latino community in and around San Antonio and Houston areas. Focusing on local politics, area celebrities, health, sports and food.

ILLUSTRATION Approached by 20 illustrators/year. Buys 10 illustrations/year. Features caricatures of local celebrities/politicians, Latino community, sports, health and local politics. Assigns 50% to new and emerging illustrators.

FIRST CONTACT & TERMS Send postcard sample. After introductory mailing, send follow-up postcard sample every 6 months. Responds only if interested. Buys one-time rights.

QUILL & QUIRE

111 Queen St. E., Suite 320, Toronto, Ontario M5C 1S2 Canada. (416)364-3333. **Fax:** (416)595-5415. **E-mail:** sjager@quillandquire.com. **Website:** www.quillandquire.com. **Contact:** Shannon Jager, art director. Estab. 1935. Monthly magazine of the Canadian book trade. Features book news and reviews for publishers, booksellers, librarians, writers, students and educators.

ILLUSTRATION Approached by 25 illustrators/year. Buys 3 visuals/issue. Assigns 1 to 2 illustrations per issue, 11 issues per year. 100% of illustrations to experienced but not necessarily well-known illustrators. Considers pen & ink and collage. 10% of freelance illustration requires knowledge of Photoshop, Illustrator, InDesign and QuarkXPress.

FIRST CONTACT & TERMS Send postcard sample. Accepts disk submissions. Samples are filed. Responds only if interested. Negotiates rights purchased. Pays on acceptance. Finds illustrators through word of mouth, submissions, and updated database.

RANGER RICK

1100 Wildlife Center Dr., Reston VA 20190. **E-mail:** Use online contact form. **Website:** www.nwf.org/Kids/Ranger-Rick.aspx. Estab. 1967. Monthly 4-color children's magazine focusing on wildlife and conservation.

ILLUSTRATION Approached by 100-200 illustrators/year. Buys 4-6 illustrations/issue. Has featured illustrations by Danielle Jones, Jack Desrocher, John Dawson and Dave Clegg. Features computer, humorous, natural science and realistic illustrations. Preferred subjects children, wildlife and natural world. Assigns 1% of illustrations to new and emerging illustrators. 50% of freelance illustration demands knowledge of Illustrator, Photoshop.

FIRST CONTACT & TERMS Accepts Mac-compatible disk submissions. Samples are filed or returned by SASE. Responds in 3 months. Will contact artist for portfolio review if interested. Buys one-time rights. Pays on publication. Pay depends on project; $200-$2,500.

TIPS "Looking for new artists to draw animals using Illustrator, Photoshop and other computer drawing programs. Please read our magazine before submitting."

REAL ESTATE

RISMedia, Inc., 69 East Ave., Norwalk CT 06851. (800)724-6000. **Fax:** (203)855-1234. **E-mail:** christy@rismedia.com. **Website:** www.rismedia.com. **Contact:** Christy LaSalle, art director. Circ. 42,100. Monthly trade publication for real estate and relocation professionals.

ILLUSTRATION Approached by 50 illustrators/year. Buys 10 illustrations/year. Features families, houses, real estate topics and relocation. Assigns 50% to new and emerging illustrators.

FIRST CONTACT & TERMS Cartoonists: Send 2-3 photocopies of cartoons of real estate topics. Illustrators: Send postcard sample. After introductory mailing, send follow-up postcard sample every 4-6 months. Samples are filed. Responds only if interested. Buys one-time rights. Finds freelancers through artists' submissions.

⊕ REDBOOK MAGAZINE

Hearst Corp., Articles Department, Redbook, 300 W. 57th St., 22nd Floor, New York NY 10019. **Website:** www.redbookmag.com. Estab. 1903. Circ. 2,200,000. Monthly magazine "written for working women ages 25-45 who want to keep a balance between career and busy home lives." Offers information on fashion, food, beauty, nutrition, health, etc.

ILLUSTRATION Buys 3-7 illustrations/issue. Illustrations can be in any medium. Accepts fashion illustrations for fashion page.

FIRST CONTACT & TERMS Send quarterly postcard. Art director will contact for more samples if interested. Portfolio drop off any day, pick up 2 days later. Buys reprint rights or negotiates rights. Accepts previously published artwork. Original artwork returned after publication with additional tearsheet if requested.

TIPS "We are absolutely open to seeing new stuff, but look at the magazine before you send anything; we might not be right for you. Generally, illustrations should look new, of the moment, fresh, intelligent and feminine. Keep in mind that our average reader is 30 years old, pretty, stylish (but not too 'fashion-y'). We do a lot of health pieces, and many times artists don't think of health when sending samples to us—so keep that in mind, too."

RELIX

104 W. 29th St., 11th Floor, New York NY 10001. (646)230-0100. **Fax:** (646)230-0200. **E-mail:** dean@relix.com. **Website:** www.relix.com. Estab. 1974. Circ. 100,000. Bimonthly consumer magazine emphasizing independent music and the jamband scene.

FIRST CONTACT & TERMS Cartoonists: Send query letter with finished cartoons. Illustrators: Send query letter with SASE and photocopies. Samples are not filed and are returned by SASE if requested by artist. Responds to the artist only if interested. Portfolio review not required. Buys first-time rights. Pays on publication. Finds artists through word of mouth.

TIPS "Not looking for any skeleton artwork."

REP.

1166 Avenue of the Americas, 10th Floor, New York NY 10036. (212)204-4260. **E-mail:** sean.barrow@penton.com. **Website:** www.wealthmanagement.com. **Contact:** Sean Barrow, art director. Estab. 1976. Circ. 100,000. Monthly trade publication provides stockbrokers and investment advisors with industry news and financial trends.

ILLUSTRATION Approached by 100 illustrators/year. Buys 15 illustrations/year. Features spot illustrations of business.

FIRST CONTACT & TERMS Illustrators: Send postcard sample. Send electronically or via CD as 300 dpi JPEG files. After introductory mailing, send follow-up postcard sample every 6 months. Responds only if interested. Company will contact artist for portfolio review if interested. Pays illustrators $500-1,500 for cover. Pays 30 days after publication. Buys one-time rights. Finds freelancers through artists' submissions.

TIPS "If you wish to contribute, please spend some time familiarizing yourself with REP's various sections and features."

RESTAURANT HOSPITALITY

Penton Media, 1100 Superior Ave., Cleveland OH 44114. (216)931-9942. **E-mail:** chris.roberto@penton.com. **Website:** www.restaurant-hospitality.com. **Contact:** Chris Roberto, group creative director; Michael Sanson, editor-in-chief. Estab. 1919. Circ. 100,000. Monthly. Emphasizes "ideas for full-service restaurants" including business strategies and industry menu trends. Readers are restaurant owners/operators and chefs for full-service independent and chain concepts.

ILLUSTRATION Approached by 150 illustrators/year. Buys 3-5 illustrations per issue (combined assigned and stock). Prefers food- and business-related illustration in a variety of styles. Has featured illustrations by Mark Shaver, Paul Watson and Brian Raszka. Assigns 10% of illustrations to well-known or "name" illustrators; 60% to experienced but not well-known illustrators; and 30% to new and emerging illustrators. Welcomes stock submissions.

FIRST CONTACT & TERMS Illustrators: Postcard samples preferred. Follow-up card every 3-6 months. Buys one-time rights. Pays on acceptance. Payment range varies for full page or covers; $300-500 range for departments/features. Finished illustrations must be delivered as high-res digital. E-mail or download link preferred.

TIPS "I am always open to new approaches—contemporary, modern visuals that explore various aspects of the restaurant industry and restaurant experience.

Please include a web address on your sample so I can view an online portfolio."

THE ROANOKER

Leisure Publishing Co., 3424 Brambleton Ave., Roanoke VA 24018. (540)989-6138 or (800)548-1672. **Fax:** (540)989-7603. **E-mail:** jwood@leisurepublishing. com; krheinheimer@leisurepublishing.com. **Website:** www.theroanoker.com. **Contact:** Kurt Rheinheimer, editor; Austin Clark, creative director; Patty Jackson, production director. Estab. 1974. Circ. 10,000. Bimonthly general interest magazine for the city of Roanoke, VA, and the Roanoke valley. Originals are returned. Art guidelines not available.

ILLUSTRATION Approached by 20-25 freelance illustrators/year. Buys 2-5 illustrations/year.

FIRST CONTACT & TERMS Illustrators: Send query letter with brochure, tearsheets and photocopies. Samples are filed. Responds only if interested. No portfolio reviews. Buys one-time rights. Pays on publication; $100 for b&w or color cover; $75 for b&w or color inside.

TIPS "Works primarily on assignment. Welcomes a great story idea pertaining to the Roanoke Valley. Please *do not* call or send any material that needs to be returned."

ROBB REPORT

CurtCo Robb Media, LLC, 29160 Heathercliff Rd., Suite #200, Malibu CA 90265. (310)589-7700. **Fax:** (310)589-7701. **E-mail:** editorial@robbreport.com. **Website:** www.robbreport.com. Estab. 1976. Circ. 104,000. Monthly 4-color consumer magazine "for the luxury lifestyle, featuring exotic cars, investment, entrepreneur, boats, etc." Accepts previously published artwork. Original artwork is returned at job's completion. Art guidelines for SASE with first-class postage.

ROLLING STONE

Wenner Media, 1290 Avenue of the Americas, New York NY 10104. (212)484-1616. **Fax:** (212)484-1664. **E-mail:** rseditors@rollingstone.com. **Website:** www. rollingstone.com. **Contact:** Caryn Ganz, editorial director. Circ. 1.46 million. Monthly. Originals returned at job's completion. 100% of freelance design work demands knowledge of Illustrator, QuarkXPress, and Photoshop. (Computer skills not necessary for illustrators.) Art guidelines available.

ILLUSTRATION Approached by "tons" of illustrators/year. Buys approximately 4 illustrations/issue. Works on assignment only. Considers all media.

FIRST CONTACT & TERMS Illustrators: Send postcard sample and/or query letter with tearsheets, photocopies or any appropriate sample. Samples are filed. Does not reply. Portfolios may be dropped off every Tuesday before 3 p.m. and should include final art and tearsheets. Portfolios may be picked back up on Thursday after 3 p.m. "Please make sure to include your name and address on the outside of your portfolio." Publication will contact artist for portfolio review if interested. Buys first and one-time rights. Pays on acceptance; payment for cover and inside illustration varies; pays $300-500 for spots. Finds artists through word of mouth, *American Illustration*, *Communication Arts*, mailed samples, and drop-offs.

✪ ROOM

West Coast Feminist Literary Magazine Society, P.O. Box 46160, Station D, Vancouver, British Columbia V6J 5G5 Canada. **E-mail:** contactus@roommagazine. com. **Website:** www.roommagazine.com. Estab. 1975. Circ. 1,400. Quarterly literary journal. Emphasizes feminist literature for women and libraries. Original artwork returned after publication if requested. Sample copy for $12; art guidelines for SASE (nonresidents include 3 IRCs).

ILLUSTRATION Illustrators: Send photographs, slides, or original work as samples to be kept on file. Samples not kept on file are returned by SAE (nonresidents include IRC). Responds in 6 months. Buys first rights. Pays cartoonists $50 minimum for b&w, colour. Pays illustrators $50 minimum, b&w, colour. Pays on publication. Buys 3-5 illustrations/issue from freelancers. Prefers good realistic illustrations of women and b&w line drawings. Prefers pen & ink, then charcoal/pencil and collage.

RTOHQ: THE MAGAZINE

1504 Robin Hood Trail, Austin TX 78703. (800)204-2776. **Fax:** (512)794-0097. **E-mail:** nferguson@ rtohq.org; bkeese@rtohq.org. **Website:** www.rtohq. org. **Contact:** Neil Ferguson, art director; Bill Keese, executive editor. Estab. 1980. Circ. 5,500. Bimonthly publication for members of the Association of Progressive Rental Organizations, the national association of the rental-purchase industry. Sample copy free for catalog-size SASE with first-class postage.

ILLUSTRATION Buys 2-3 illustrations/issue. Has featured illustrations by Barry Fitzgerald, Aletha St. Romain, A.J. Garces, Edd Patton and Jane Marinsky. Features conceptual illustration. Assigns 15% of illustrations to new and emerging illustrators. Prefers cutting edge; nothing realistic; strong editorial qualities. Considers all media. Accepts computer-based illustrations (Photoshop, Illustrator).

FIRST CONTACT & TERMS Illustrators: Send postcard sample, query letter with printed samples, photocopies, or tearsheets. Accepts disk submissions (must be Photoshop-accessible EPS high-res at 300 dpi or Illustrator file). Samples are filed or returned by SASE. Responds in 1 month if interested. Rights purchased vary according to project. Pays on publication: $300-450 for color cover; $250-350 for color inside. Finds illustrators mostly through artist's submissions, some from other magazines.

TIPS "Must have a strong conceptual ability—that is, they must be able to illustrate for editorial articles dealing with business/management issues. We are looking for cutting-edge styles and unique approaches to illustration. I am willing to work with new, lesser-known illustrators."

RUNNER'S WORLD

Rodale, 400 S. Tenth St., Emmaus PA 18098-0099. (610)967-8441. **Fax:** (610)967-8883. **E-mail:** rwedit@rodale.com. **Website:** www.runnersworld.com. **Contact:** David Willey, editor-in-chief; Suzanne Perrault, managing editor; Benjamen Purvis, design director. Estab. 1966. Circ. 500,000. Monthly 4-color with a "contemporary, clean" design emphasizing serious, recreational running. Accepts previously published artwork "if appropriate." Returns original artwork after publication. Art guidelines not available. Illustration Approached by hundreds of illustrators/year. Works with 50 illustrators/year. Buys average of 10 illustrations/issue. Has featured illustrations by Sam Hundley, Gil Eisner, Randall Enos and Katherine Adams. Features humorous and realistic illustration; charts & graphics; informational graphics; computer and spot illustration. Assigns 40% of illustrations to well-known or "name" illustrators; 40% to experienced but not well-known illustrators; 20% to new and emerging illustrators. Needs editorial, technical and medical illustrations. "Styles include tightly rendered human athletes, graphic and cerebral interpretations of running themes. Also, *RW* uses medical il-

lustration for features on biomechanics." No special preference regarding media but appreciates electronic transmission. "No cartoons or originals larger than 11×14." Works on assignment only. 30% of freelance work demands knowledge of Illustrator, Photoshop or FreeHand.

FIRST CONTACT & TERMS Illustrators: Send postcard samples to be kept on file. Accepts submissions on disk compatible with Illustrator 5.0. Send EPS files. Publication will contact artist for portfolio review if interested. Buys one-time international rights. Pays $1,800 maximum for 2-page spreads; $400 maximum for spots. Finds artists through word of mouth, magazines, submissions/self-promotions, sourcebooks, artists' agents and reps and attending art exhibitions.

TIPS Portfolio should include "a maximum of 12 images. Show a clean presentation, lots of ideas and few samples. Don't show disorganized thinking. Portfolio samples should be uniform in size. Be patient!"

RURAL HERITAGE

P.O. Box 2067, Cedar Rapids IA 52406. (319)362-3027. **E-mail:** info@ruralheritage.com. **Website:** www.ruralheritage.com. **Contact:** Joe Mischka, editor. Estab. 1976. Circ. 9,500. Bimonthly farm magazine "published in support of modern-day farming and logging with draft animals (horses, mules, oxen)." Sample copy for $8 postpaid; art guidelines not available.

Editor stresses the importance of submitting cartoons that deal only with farming and logging using draft animals.

CARTOONS "Approached by not nearly enough cartoonists who understand our subject." Buys 2 or more cartoons/issue. Prefers bold, clean, minimalistic draft animals and their relationship with the teamster. "No unrelated cartoons!" Prefers single panel, humorous, b&w line drawings with or without gagline.

FIRST CONTACT & TERMS Cartoonists: Send query letter with finished cartoons and SASE. Samples accepted by US mail only. Samples are not filed (unless we plan to use them—then we keep them on file until used) and are returned by SASE. Responds in 2 months. Buys first North American serial rights or all rights rarely. Pays on publication; $10 for one-time rights; $20 for all rights.

TIPS "Know draft animals (horses, mules, oxen, etc.) well enough to recognize humorous situations intrin-

sic to their use or that arise in their relationship to the teamster. Our best contributors read *Rural Heritage* and get their ideas from the publication's content."

⊕ SACRAMENTO MAGAZINE

231 Lathrop Way, Suite A, Sacramento CA 95819. (916)426-1720. **E-mail:** miles@sacmag.com. **Website:** www.sacmag.com. **Contact:** Miles Harley, art director. Estab. 1975. Circ. 20,000. Monthly consumer lifestyle magazine with emphasis on home and garden, women, health features and stories of local interest. Accepts previously published artwork. Originals returned to artist at job's completion. Sample copies available.

ILLUSTRATION Approached by 100 illustrators/year. Buys 5 illustrations/year. Works on assignment only. Considers pen & ink, collage, airbrush, acrylic, colored pencil, oil, marker and pastel.

FIRST CONTACT & TERMS Illustrators: Send postcard sample. Accepts disk submissions. Send EPS files. Samples are filed and are not returned. Publication will contact artist for portfolio review if interested. Portfolio should include b&w and color tearsheets and final art. Buys one-time rights. Pays on publication; $300-400 for color cover; $200-500 for b&w or color inside; $100-200 for spots. Finds artists through submissions.

TIPS Sections most open to freelancers are departments and some feature stories.

⊕ SACRAMENTO NEWS & REVIEW

Chico Community Publishing, 1124 Del Paso Blvd., Sacramento CA 95815. (916)498-1234. **Fax:** (916)498-7920. **E-mail:** priscillag@newsreview.com. **Website:** www.newsreview.com. **Contact:** Rachel Leibrock, editor; Nick Miller, editor; Priscilla Garcia, creative director. Estab. 1989. Circ. 87,000. "An award-winning b&w with 4-color cover alternative newsweekly for the Sacramento area. We combine a commitment to investigative and interpretive journalism with coverage of our area's growing arts and entertainment scene." Occasionally accepts previously published artwork. Originals returned at job's completion. Art guidelines not available.

○ Also publishes issues in Chico, CA, and Reno, NV.

ILLUSTRATION Approached by 50 illustrators/year. Buys 1 illustration/issue. Works on assignment only. Features caricatures of celebrities and politicans; humorous, realistic, computer and spot illustrations. As-

signs illustrations to new and emerging illustrators. For cover art, needs themes that reflect content.

FIRST CONTACT & TERMS Illustrators: Contact via online submission form with link to portfolio website. Send postcard sample or query letter with tearsheets. Samples are filed. Publication will contact artist for portfolio review if interested. Buys first rights. Pays on acceptance. Finds artists through submissions.

TIPS "Looking for colorful, progressive styles that jump off the page. Have a dramatic and unique style—not conventional or common."

SALT HILL LITERARY JOURNAL

E-mail: salthillart@gmail.com. **Website:** www.salthilljournal.net. **Contact:** art editor. Circ. 1,000. *Salt Hill* seeks unpublished 2D art-drawings, paintings, photography, mixed media, documentation of 3D art, typographic art diagrams, maps, etc. for its semiannual publication. We offer all colors, shapes, and stripes.

FIRST CONTACT & TERMS See website for specifications.

THE SANDY RIVER REVIEW

University of Maine at Farmington, 114 Prescott St., Farmington ME 04938. **E-mail:** srreview@gmail.com. **E-mail:** submissions@sandyriverreview.com. **Website:** sandyriverreview.com. **Contact:** Nicole Byrne, editor. "*The Sandy River Review* seeks prose, poetry, and art submissions twice a year for our Spring and Fall issues."

FIRST CONTACT & TERMS Pays 3 contributor copies of the published issue. "Most of our art is published in b&w and must be submitted as 300-dpi quality, CMYK color mode, and saved as a TIFF file."

SANTA BARBARA MAGAZINE

2064 Alameda Padre Serra, Suite 120, Santa Barbara CA 93103. (805)965-5999. **Fax:** (805)965-7627. **E-mail:** alisa@sbmag.com. **Website:** www.sbmag.com. **Contact:** Alisa Baur, art director; Gina Tolleson, editor. Estab. 1975. Circ. 40,000. Bimonthly 4-color magazine with classic design emphasizing Santa Barbara culture and community. Original artwork returned after publication if requested.

ILLUSTRATION Approached by 20 illustrators/year. Works with 2-3 illustrators/year. Buys about 1-3 illustrations/year. Uses freelance artwork mainly for departments. Works on assignment only.

FIRST CONTACT & TERMS Send postcard, tearsheets or photocopies. To show a portfolio, mail b&w and color art, final reproduction/product and tearsheets; will contact if interested. Buys first rights. **Pays on acceptance**; approximately $275 for color cover; $175 for color inside. "Payment varies."

TIPS "Be familiar with our magazine."

SCIENTIFIC AMERICAN

75 Varick St., 9th Floor, New York NY 10013-1917. (212)451-8200. **E-mail:** editors@sciam.com. **Website:** www.sciam.com. **Contact:** Mariette DiChristina, editor-in-chief. Estab. 1845. Circ. 710,000. Monthly 4-color consumer magazine emphasizing scientific information for educated readers, covering geology, astronomy, medicine, technology and innovations.

ILLUSTRATION Approached by 100+ illustrators/year. Buys 15-30 illustrations/issue, mostly science-related, but there are oppurtunities for editorial art in all media. Assigns illustrations to specialized science illustrators, to well-known editorial illustrators, and to relative newcomers in both areas.

FIRST CONTACT & TERMS Illustrators: Send postcard sample or e-mail with link to website; followup in 6 months. Responds only if interested. Portfolio reviews done as time allows. Pays on acceptance; $750-2,000 for color inside; $350-750 for spots.

TIPS "We use all styles of illustration and you do not have to be an expert in science although some understanding certainly helps. The art directors at *Scientific American* are highly skilled at computer programs, have a broad-based knowledge of science, and closely guide the process. Editors are experts in their field and help with technical backup material. One caveat: content is heavily vetted here for accuracy, so a huge plus on the part of our illustrators is their ability to make changes and corrections cheerfully and in a timely fashion."

SCOUTING

Boy Scouts of America, 1325 W. Walnut Hill Lane, P.O. Box 152079, Irving TX 75015-2079. **Website:** www.scoutingmagazine.org. Estab. 1913. Circ. 1 million. Magazine published 6 times/year covering Scouting activities for adult leaders of the Boy Scouts, Cub Scouts, and Venturing. "We use about 4-6 cartoons in each issue. They are normally 1-panel, although we occasionally use a 1-column vertical 3-panel. Humor should be seen through the eyes of adults who are similar to our readers: volunteer leaders and/or parents of Cub Scouts or Boy Scouts. Avoid stereotypes such as dumb housewives, buxom blondes, lady drivers, lazy or dimwitted husbands, as well as common ethnic stereotypes. And especially avoid the stereotype of the fat Scoutmaster leading a brood of young Scouts through the woods. We emphasize more the self-reliance of the Scout and his patrol. Cartoons can feature uniformed Cub Scouts or Boy Scouts, but please be sure that you (1) know what the current uniform looks like, and (2) are familiar with the Scouting program. No smoking, hunting, or cruelty. New settings and situations are appreciated, as we get tired of deserted islands or thirsty men crawling throught the desert."

CARTOONS "Size: 8×10 or 5×7. Paper: White, any weight you are comfortable with. Finish: If you send pencil roughs and we like the idea, you will be contacted to do a finish. However, we prefer finished art in case we want to use a cartoon immediately." Pays $75 per cartoon for first rights. Pays on acceptance.

SCRAP

1615 L St. NW, Suite 600, Washington DC 20036-5664. (202)662-8547 or (202) 662-8500. **Fax:** (202)626-0947. **E-mail:** kentkiser@scrap.org. **Website:** www.scrap.org. **Contact:** Kent Kiser, publisher. Estab. 1987. Circ. 9,600. Bimonthly 4-color trade publication that covers all aspects of the scrap recycling industry.

CARTOONS "We occasionally run single-panel cartoons that focus on the recycling theme/business."

ILLUSTRATION Approached by 100 illustrators/year. Buys 0-2 illustrations/issue. Features realistic illustrations, business/industrial/corporate illustrations and international/financial illustrations. Prefered subjects business subjects. Assigns 10% of illustrations to new and emerging illustrators.

FIRST CONTACT & TERMS Illustrators: Send postcard sample. Samples are filed. Portfolio review not required. Buys first North American serial rights. Pays on acceptance; $1,200-2,000 for color cover; $300-1,000 for color inside. Finds illustrators through creative sourcebook, mailed submissions, referrals from other editors, and "direct calls to artists whose work I see and like."

TIPS "We're always open to new talent and different styles. Our main requirement is the ability and willingness to take direction and make changes if necessary. No prima donnas, please. Send a postcard to let us see what you can do."

SEA MAGAZINE

17782 Cowan, Suite C, Irvine CA 92614. (949)660-6150. **Fax:** (949)660-6172. **Website:** www.seamag.com. **Contact:** Mike Werling, managing editor. Estab. 1908. Circ. 55,000. Monthly 4-color magazine emphasizing recreational boating for owners or users of recreational powerboats, primarily for cruising and general recreation; some interest in boating competition; regionally oriented to 13 Western states. Accepts previously published artwork. Return of original artwork depends upon terms of purchase. Sample copy with SASE and first-class postage.

Also publishes *Go Boating* magazine.

ILLUSTRATION Approached by 20 illustators/year. Buys 10 illustrations/year mainly for editorial. Considers airbrush, watercolor, acrylic and calligraphy.

FIRST CONTACT & TERMS Illustrators: Send query letter with brochure showing art style. Samples are returned only if requested. Publication will contact artist for portfolio review if interested. Portfolio should include tearsheets and cover letter indicating price range. Negotiates rights purchased. Pays on publication; $50 for b&w, $250 for color inside (negotiable).

TIPS "We will accept students for portfolio review with an eye to obtaining quality art at a reasonable price. We will help start career for illustrators and hope that they will remain loyal to our publication."

SEATTLE WEEKLY

307 Third Ave. S., 2nd Floor, Seattle WA 98104. (206)623-0500. **Fax:** (206)467-4338. **E-mail:** editorial@seattleweekly.com; mbaumgarten@seattleweekly.com. **Website:** www.seattleweekly.com. **Contact:** Matt Baumgarten, editor in chief. Estab. 1976. Circ. 105,000. Weekly consumer magazine with emphasis on local and national issues and arts events. Accepts previously published artwork. Original artwork can be returned at job's completion if requested, "but you can come and get them if you're local." Sample copies available for SASE with first-class postage. Art guidelines not available.

ILLUSTRATION Approached by 30-50 freelance illustrators/year. Buys 3 freelance illustrations/issue. Works on assignment only. Prefers "sophisticated themes and styles."

FIRST CONTACT & TERMS Illustrators: Send query letter with tearsheets and photocopies. Samples are filed and are not returned. Does not reply, in which case the artists should "revise work and try again." To show a portfolio, mail b&w and color photocopies; "always leave us something to file." Buys first rights. Pays on publication; $200-250 for color cover; $60-75 for b&w inside.

TIPS "Give us a sample we won't forget. A really beautiful mailer might even end up on our wall, and when we assign an illustration, you won't be forgotten. All artists used must sign contract. Feel free to e-mail for a copy."

SHEEP! MAGAZINE

Countryside Publications, Ltd., 145 Industrial Dr., Medford WI 54451. (715)785-7979 or (800)551-5691. **Fax:** (715)785-7414. **E-mail:** sheepmag@tds.net; singersol@countrysidemag.com. **Website:** www.sheepmagazine.com. **Contact:** Nathan Griffith, editor. Estab. 1980. Circ. 11,000. Bimonthly publication covering sheep, wool, and woolcrafts. Accepts previously published work.

CARTOONS Approached by 30 cartoonists/year. Buys 5 cartoons/year. Considers all themes and styles. Prefers single panel with gagline.

ILLUSTRATION Approached by 10 illustrators/year. Buys 5 illustrations/year; no inside color. Considers pen & ink. Features charts & graphs, computer illustration, informational graphics, realistic, medical and spot illustrations. All art should be sheep related.

FIRST CONTACT & TERMS Cartoonists: Send query letter with brochure and finished cartoons. Illustrators: Send query letter with brochure, SASE and tearsheets. To show a portfolio, mail thumbnails and b&w tearsheets. Buys first rights or all rights. **Pays on acceptance.** Pays cartoonists $5-15 for b&w. Pays illustrators $75 minimum for b&w.

TIPS "Demonstrate creativity and quality work."

SHOW-ME PUBLISHING, INC.

Ingram's Magazine and Ingram's Awards, 2049 Wyandotte, Kansas City MO 64108. (816)842-9994. **Fax:** (816)474-1111. **E-mail:** msweeney@ingrams.com. **Website:** www.ingrams.com. "We publish a regional business magazine (*Ingram's*) and several business-to-business publications and websites covering Kansas and Missouri. We require all freelancers to allow us full usage/copyright and resale of all work done for our publications and websites." Has occasional use for graphic designers and photographers. Prefers local talent.

FIRST CONTACT & TERMS Send cover letter, résumé, references, and samples of work to HR Department. Portfolios are not returned. Do not send original work; send digital files on CD. Pays $15-20/hour for Internet design and photography and editorial is by the project on an agreed upon price.

SKIING MAGAZINE

Bonnier Corp., 5720 Flatiron Pkwy., Boulder CO 80301. (303)253-6300. **Fax:** (303)448-7638. **E-mail:** editor@skiingmag.com. **Website:** www.skinet.com/skiing. Estab. 1936. Circ. 430,000. Online publication emphasizing instruction, resorts, equipment and personality profiles. For new, intermediate and expert skiers. Published online. Previously published work OK "if we're notified." Sponsors summer internships. The internship is roughly 12 weeks long in Boulder, CO. All internships are unpaid. "Duties include working directly with the art director, photo editor and editorial staff on the development of pages from inception to final output, designing and flowing type in a number of our column and regular-section pages, and other design and production-related duties. Our staff is small and candidates will get an intimate knowledge of the day-to-day cycle of publishing a national magazine. We work with the Adobe Creative Suite 3. InDesign, Photoshop and Illustrator are all used on a daily basis. Proficiency in InDesign is critical. A passion for the sport of skiing is helpful, but not critical." Please e-mail résumé, cover letter, and portfolio or link to online portfolio to: mark@skiingmag.com.

CARTOONS Illustrators: Mail art and SASE. Responds immediately. Buys one-time rights. Pays on acceptance; $1,200 for color cover; $150-500 for color inside.

ILLUSTRATION Approached by 30-40 freelance illustrators/year. Buys 25 illustrations/year.

TIPS "The best way to break in is an interview and a consistent style portfolio. Then, keep us on your mailing list."

SKILLSUSA CHAMPIONS

14001 SkillsUSA Way, Leesburg VA 20176. (703)777-8810. **E-mail:** thall@skillsusa.org. **Website:** www.skillsusa.org/publications-news/skillsusa-champions-magazine/. **Contact:** Tom Hall, editor. Estab. 1965. Circ. 300,000. Quarterly 4-color magazine. "*SkillsUSA Champions* is primarily a features magazine that provides motivational content by focusing on successful members. SkillsUSA is an organization of more than 300,000 students and teachers in technical, skilled and service careers. Sample copies available.

ILLUSTRATION Approached by 4 illustrators/year. Works on assignment only. Prefers positive, youthful, innovative, action-oriented images. Considers pen & ink, watercolor, collage, airbrush, and acrylic.

DESIGN Needs freelancers for design. 100% of freelance work demands knowledge of Adobe CC.

FIRST CONTACT & TERMS Illustrators: Send postcard sample. Designers: Send query letter with brochure. Accepts files compatible with Adobe Illustrator and InDesign CC. Send Illustrator and EPS files. Portfolio should include printed samples, b&w and color tearsheets and photographs. Accepts previously published artwork. Originals returned at job's completion (if requested). Rights purchased vary according to project. Pays on acceptance. Pays illustrators $200-300 for color; $100-300 for spots. Pays designers by the project.

SKIPPING STONES: A MULTICULTURAL LITERARY MAGAZINE

P.O. Box 3939, Eugene OR 97403-0939. (541)342-4956. **E-mail:** editor@skippingstones.org. **Website:** www.skippingstones.org. **Contact:** Arun Toké, editor. Estab. 1988. Circ. 1,600 print, plus Web. "We promote multicultural awareness, international understanding, nature appreciation, and social responsibility. We suggest authors not make stereotypical generalizations in their articles. We like when authors include their own experiences, or base their articles on their personal immersion experiences in a culture or country." Has featured Lori Eslick, Xuan Thu Pham, Soma Han, Jon Bush, Zarouhie Abdalian, Paul Dix, Elizabeth Zunon and Najah Clemmons.

CARTOONS Humorous cartoons. Prefers multicultural, social issues, nature/ecology themes. Requests b&w washes and line drawings. Has featured cartoons by Lindy Wojcicki of Florida. Prefers cartoons by youth under age 19.

ILLUSTRATION Approached by 100 illustrators/year. Buys 10-20 illustrations/year. Has featured illustrations by Lori Eslick, Sarah Solie, Wisconsin; Alvina Kong, California; Elizabeth Wilkinson, Vermont; Inna Svjatova, Russia; Jon Bush, Massachusetts. Features humorous illustrations, informational graphics, natural history and realistic, authentic illustrations. Preferred subjects children and teens. Prefers pen &

ink. Assigns 80% of work to new and emerging illustrators. Recent issues have featured multicultural artists—their life and works.

FIRST CONTACT & TERMS Send query letter or e-mail with photographs (digital JPEGs at 72 dpi). Cartoonists: Send b&w photocopies and SASE. Illustrators: Send nonreturnable photocopies and SASE. Samples are filed or returned by SASE. Responds in 3 months if interested. Portfolio review not required. Buys first rights, reprint rights. Pays on publication 1-4 copies. No financial reimbursement. Finds illustrators through word of mouth, artists' promo samples.

TIPS "We are a multicultural magazine for youth and teens. We consider your work as a labor of love that contributes to the education of youth. We publish photoessays on various cultures and countries/regions of the world in each issue of the magazine to promote international and intercultural (and nature) understanding. Tell us a little bit about yourself, your motivation, goals, and mission."

SMITHSONIAN MAGAZINE

Capital Gallery, Suite 6001, MRC 513, P.O. Box 37012, Washington DC 20013. (202)275-2000. **E-mail:** smithsonianmagazine@si.edu. **Website:** www.smithsonianmag.com. **Contact:** Molly Roberts, photo editor; Jeff Campagna, art services coordinator. Circ. 2.3 million. Monthly consumer magazine exploring lifestyles, cultures, environment, travel and the arts. Smithsonian.com expands on *Smithsonian* magazine's in-depth coverage of history, science, nature, the arts, travel, world culture and technology.

○ Submit proposals online: www.smithsonianmag.com/contact-us.

ILLUSTRATION Approached by hundreds of illustrators/year. Buys 1-3 illustrations/issue. Illustrations are not the responsibility of authors, but it is helpful to know what photographic possibilities exist regarding your subject. Photographs published in the magazine are usually obtained through assignments, stock agencies or specialized sources. Submission guidelines: www.smithsonianmag.com/contact-us/submission-guidelines.html. Features charts and graphs, informational graphics, humorous, natural history, realistic and spot illustration.

FIRST CONTACT & TERMS Samples are filed. Responds only if interested. Will contact artist for portfolio review if interested. Buys first rights. Pays on

acceptance; $350-$1,200 for color inside. Finds illustrators through agents and word of mouth.

SOAP OPERA DIGEST

American Media, Inc., 4 New York Plaza, 2nd Floor, New York NY 10004. **E-mail:** sodask@soapoperadigest.com; sodsound@soapoperadigest.com. **Website:** www.soapdigest.com. Estab. 1976. Circ. 2 million. Emphasizes soap opera and prime-time drama synopses and news. Weekly. Accepts previously published material. Returns original artwork after publication upon request. Sample copy available for SASE.

TIPS "Review the magazine before submitting work."

SOLIDARITY MAGAZINE

UAW Solidarity House, 8000 E. Jefferson, Detroit MI 48214. (313)926-5000. **E-mail:** uawsolidarity@uaw.net. **Website:** www.uaw.org. Published by United Auto Workers. 4-color magazine for "1.3 million member trade union representing US, Canadian and Puerto Rican workers in auto, aerospace, agricultural-implement, public employment and other areas." Contemporary design.

CARTOONS Carries "labor/political" cartoons. Payment varies.

ILLUSTRATION Works with 10-12 illustrators/year for posters and magazine illustrations. Interested in graphic designs of publications, topical art for magazine covers with liberal-labor political slant. Looks for "ability to grasp our editorial slant."

FIRST CONTACT & TERMS Illustrators: Send postcard sample or tearsheets and SASE. Samples are filed. Pays $500-600 for color cover; $200-300 for b&w inside; $300-450 for color inside. Graphic Artists Guild members only.

SPIDER

70 E. Lake St., Suite 800, Chicago IL 60601. **E-mail:** spider@spidermagkids.com. **Website:** www.cricketmag.com/spider; www.spidermagkids.com. **Contact:** Submissions editor. Estab. 1994. Circ. 70,000. *SPIDER* is full-color, 8×10, 34 pages with a 4-page activity pullout for children ages 6-9. Features the world's best children's authors. Art samples and photos considered. For submission guidelines, visit submittable.cricketmag.com or www.cricketmag.com/submissions.

ILLUSTRATION "Please do not send original artwork. Send postcards, promotional brochures, or col-

or photocopies. Be sure that each sample is marked with your name, address, phone number and website or blog. Art submissions will not be returned."

FIRST CONTACT & TERMS Send submissions to: Art Submissions Coordinator, Cricket Media, 70 E. Lake St., Suite 800, Chicago IL 60601. Please allow 3-6 months response time. Acquires print and digital rights, plus promotional rights. "No advance list of themes. Do not query. Include exact word count. Prefers online submissions. Please allow 3-6 months response time."

SPITBALL: THE LITERARY BASEBALL MAGAZINE

5560 Fox Rd., Cincinnati OH 45239. **E-mail:** spitball5@hotmail.com. **Website:** www.spitballmag. com. **Contact:** Mike Shannon, editor in chief. Estab. 1981. Quarterly 2-color magazine emphasizing baseball, exclusively for "well-educated, literate baseball fans." *Spitball* has a regular column called "Brushes With Baseball" that features one artist and his/her work. Chooses artists for whom baseball is a major theme/subject. Prefers to buy at least one work from the artist to keep in its collection. Sometimes prints color material in b&w on cover. Returns original artwork after publication if the work is donated; does not return if purchased. Sample copy available for $6.

CARTOONS Prefers single-panel b&w line drawings with or without gagline. Prefers "old fashioned *Sport Magazine/New Yorker* type. Please, cartoonists, make them funny, or what's the point?"

ILLUSTRATION "We need 2 types of art illustration (for a story, essay or poem) and filler. All work must be baseball-related." Prefers pen & ink, airbrush, charcoal/pencil and collage. Interested artists should write to find out needs for specific illustration. Buys 3 or 4 illustrations/issue.

FIRST CONTACT & TERMS Cartoonists: Query with samples of style, roughs and finished cartoons. Illustrators: Send query letter with b&w illustrations or slides. Target samples to magazine's needs. Samples not filed are returned by SASE. Responds in 1 week. Negotiates rights purchased. Pays on acceptance. Pays cartoonists $10 minimum. Pays illustrators $20-40 for b&w inside.

TIPS "Usually artists contact us and if we hit it off, we form a long-lasting mutual admiration society. Please,

you cartoonists out there, drag your bats up to the *Spitball* plate! We like to use a variety of artists."

SPORTS AFIELD

Field Sports Publishing, 15621 Chemical Lane, Huntington Beach CA 92649. (714)373-4910. **E-mail:** letters@sportsafield.com. **Website:** www.sportsafield. com. **Contact:** Jerry Gutierrez, art director. Estab. 1887. Circ. 50,000. Bimonthly magazine. "*SA* is edited for hunting enthusiasts. We are the oldest outdoor magazine. We cater to the upscale hunting market, especially hunters who travel to exotic destinations like Alaska and Africa. We are not a deer hunting magazine, and we do not cover fishing."

ILLUSTRATION Hunting/wildlife themes only. Considers all media. Freelancers should be familiar with Photoshop, Illustrator, InDesign.

FIRST CONTACT & TERMS Illustrators: Send postcard sample or query letter with photocopies and tearsheets. Accepts disk submissions. Samples are filed. Responds only if interested. Will contact for portfolio of b&w or color photographs, slides, tearsheets and transparencies if interested. Buys first North American serial rights. Pays on publication; negotiable. Finds illustrators through *Black Book*, magazines, submissions.

⊕ SPORTS 'N SPOKES

The Magazine for Wheelchair Sports and Recreation, PVA Publications, 2111 E. Highland Ave., Suite 180, Phoenix AZ 85016-4702. (602)224-0500. **Fax:** (602)224-0507. **E-mail:** john@pvamag.com; andy@ pvamag.com; anngarvey@pvamag.com; chuck@ pvamag.com. **Website:** www.pvamag.com. **Contact:** Richard Hoover, editor; Tom Fjerstad, deputy editor; Andy Nemann, assistant editor; John Groth, editorial coordinator; Ann Garvey and Chuck McKenzie (cartoon and photo submissions). Estab. 1974. Circ. 25,000. 4-color magazine published 6 times a year. Consumer magazine with emphasis on sports and recreation for the wheelchair user. Accepts previously published artwork. Original artwork not returned after publication. Sample copy free with large SASE and $4 postage.

CARTOONS Buys cartoons according to need. Prefers b&w line drawings with or without gagline depicting some aspect of wheelchair sport or recreation.

ILLUSTRATION Works on assignment only. Considers pen & ink, watercolor and computer-generated

art. Accepted file formats are Illustrator, InDesign or Photoshop.

FIRST CONTACT & TERMS Submission guidelines available online. Prefers digital images, but will accept prints, slides and transparencies.

TIPS "We purchase cartoons depicting wheelchair sports and/or recreation, more humorous than cynical."

STANFORD MAGAZINE

Frances C. Arrillaga Alumni Center,, 326 Galvez St., Stanford CA 94305-6105. (650)725-0672. **E-mail:** gvirgili@stanford.edu; stanford.magazine@stanford.edu. **Website:** alumni.stanford.edu/get/page/magazine/home. **Contact:** Giorgia Virgili, art director. Estab. 1973. Circ. 105,000. Consumer magazine, "geared toward the alumni of Stanford University. Articles vary from photo essays to fiction to academic subjects." Accepts previously published artwork. Original artwork is returned at job's completion. Sample copies available.

ILLUSTRATION Approached by 200-300 illustrators/year. Buys 4-6 illustrations/issue. Works on assignment only. Interested in all styles.

FIRST CONTACT & TERMS Send samples only. Call for appointment to show portfolio. Buys onetime rights. **Pays on acceptance.**

TIPS "We're always looking for unique styles, as well as excellent traditional work. We like to give enough time for the artist to produce the piece."

STILL POINT ARTS QUARTERLY

Shanti Arts LLC, 193 Hillside Rd., Brunswick ME 04011. (207)837-5760. **Fax:** (207)725-4909. **E-mail:** info@stillpointartgallery.com. **Website:** www.stillpointartsquarterly.com. **Contact:** Christine Cote, editor. Estab. 2011. Circ. 2,000. Quarterly literary magazine and art journal focused on art, artists, artistry; for artists and art enthusiasts.

FIRST CONTACT & TERMS Send e-mail with URL and JPEG samples at 72 dpi. Samples are kept on file and not returned. Responds only if interested. Request portfolio review in original query. Portfolio should include photographs. Accepts images in digital format. Images may be submitted as JPEGs or ZIP at 300 dpi. Finds freelancers through submissions, word-of-mouth, magazines and internet.

TIPS "Read our magazine and our guidelines."

STONE SOUP

Children's Art Foundation, P.O. Box 83, Santa Cruz CA 95063-0083. (831)426-5557. **E-mail:** editor@stonesoup.com. **Website:** http://stonesoup.com. **Contact:** Ms. Gerry Mandel, editor. Estab. 1973. Bimonthly print and digital literary magazine entirely by kids age 13 and younger. Stories, poems, book reviews, illustrations. Artists age 13 and younger are encouraged to apply to be Stone Soup illustrators. Visit stonesoup.com to read our guidelines.

ILLUSTRATION Buys 12 illustrations/issue. Prefers complete and detailed scenes from real life. All art must be by children age 13 and younger.

FIRST CONTACT & TERMS Illustrators: Send query letter with color copies. Samples are not returned. Responds in one month. Buys all rights. Pays on publication; $15-$25 per illustration.

STRATEGIC FINANCE

10 Paragon Dr., Montvale NJ 07645. (201)474-1558. **Fax:** (201)474-1603. **E-mail:** mzisk@imanet.org. **Website:** www.imanet.org; www.strategicfinancemag.com. **Contact:** Mary Zisk, art director. Estab. 1919. Circ. 58,000. Monthly 4-color emphasizing management accounting for corporate accountants, controllers, chief financial officers, and treasurers.

ILLUSTRATION Approached by 4 illustrators/day. Buys 3 illustrations/issue.

FIRST CONTACT & TERMS Illustrators: Send nonreturnable postcard samples or e-mail link to online portfolio. Prefers financial and corporate themes. Looking for smart concepts and unique technique.

STUDENT LAWYER

ABA Publishing, Law Student Division, American Bar Association, 321 N. Clark St., Chicago IL 60654. (312)988-6049. **Fax:** (312)988-6365. **Website:** www.abanet.org/lsd/studentlawyer. **Contact:** Darhiana Mateo Téllez, editor. Estab. 1972. Circ. 32,000.

ILLUSTRATION Approached by 120 illustrators/year. Buys 8 illustrations/issue. Has featured illustrations by Sean Kane and Jim Starr. Features realistic, computer, and spot illustration. Assigns 50% of illustrations to experienced but not well-known illustrators; 50% to new and emerging illustrators. Needs editorial illustration with an "innovative, intelligent style." Works on assignment only. Needs computer-literate freelancers for illustration. No cartoons please.

FIRST CONTACT & TERMS Send postcard sample, brochure, tearsheets and printed sheet with a variety of art images (include name and phone number). Samples are filed. Call for appointment to show portfolio of final art and tearsheets. Buys 1-time rights. Pays on ac ceptance. $500-800 for color cover; $450-650 for color inside; $150-350 for spots.

TIPS "In your samples, show a variety of styles with an emphasis on editorial work."

SUN VALLEY MAGAZINE

Valley Publishing, LLC, 313 N. Main St., Hailey ID 83333. (208)788-0770. **Fax:** (208)788-3881. **E-mail:** adam@sunvalleymag.com; julie@sunvalleymag.com. **Website:** www.sunvalleymag.com. **Contact:** Adam Tanous, managing editor; Julie Molema, art director. Estab. 1973. Circ. 17,000. Consumer magazine published 3 times/year, "highlighting the activities and lifestyles of people of the Wood River Valley." Sample copies available. Art guidelines free for #10 SASE with first-class postage.

ILLUSTRATION Approached by 10 illustrators/year. Buys 3 illustrations/issue. Prefers forward, cutting edge styles. Considers all media.

FIRST CONTACT & TERMS Illustrators: Send query letter with SASE. Accepts disk submissions compatible with Macintosh, and/or InDesign. Send EPS files. Samples are filed. Does not report back. Artist should call. Art director will contact artist for portfolio review of b&w, color, final art, photostats, roughs, slides, tearsheets and thumbnails if interested. Buys first rights. Pays on publication; $350 cover; $80-240 inside.

TIPS "Read our magazine. Send ideas for illustrations and examples."

T+D

1640 King St., Box 1443, Alexandria VA 22313-1443. (703)683-8100 or (800)628-2783. **Website:** www.astd. org/Publications/Magazines/TD. Estab. 1945. Circ. 40,000. Monthly trade journal magazine that covers training and development in all fields of business. Accepts previously published artwork. Original artwork is returned at job's completion. Art guidelines not available.

ILLUSTRATION Approached by 20 freelance illustrators/year. Buys a limited number of freelance illustrations per issue. Works on assignment only. Has featured illustrations by Alison Seiffer, James Yang and Riccardo Stampatori. Features humorous, real-istic, computer and spot illustration. Assigns 10% of work to new and emerging illustrators. Prefers sophisticated business style. Considers collage, pen & ink, airbrush, acrylic, oil, mixed media, pastel.

FIRST CONTACT & TERMS Illustrators: Send postcard sample. Accepts disks compatible with Illustrator 9, FreeHand 5.0, Photoshop 5. Send EPS, JPEG or TIFF files. Use 4-color (process) settings only. Samples are filed. Responds to the artist only if interested. Write for appointment to show portfolio of tearsheets, slides. Buys one-time rights or reprint rights. Pays on publication; $700-1,200 for color cover; $350 for b&w inside; $350-800 for color inside; $800-1,000 for 2-page spreads; $100-300 for spots.

TIPS "Send more than one image if possible. Do not keep sending the same image. Try to tailor your samples to the art director's needs if possible."

TAMPA BAY MAGAZINE

2531 Landmark Dr., Suite 101, Clearwater FL 33761. (727)791-4800. **E-mail:** production@tampabaymagazine.com. **Website:** www.tampabaymagazine.com. Aaron Fodiman; Margaret Word Burnside. Estab. 1986. Circ. 40,000. Bimonthly local lifestyle magazine with upscale readership. Accepts previously published artwork. Sample copy available for $4.50. Submission guidelines available online.

CARTOONS Approached by 30 cartoonists/year. Buys 6 cartoons/issue. Prefers single-panel color washes with gagline.

ILLUSTRATION Approached by 100 illustrators/year. Buys 5 illustrations/issue. Prefers happy, stylish themes. Considers watercolor, collage, airbrush, acrylic, marker, colored pencil, oil and mixed media.

FIRST CONTACT & TERMS Cartoonists: Send query letter with finished cartoon samples. Illustrators: Send query letter with photographs and transparencies. Samples are not filed and are returned by SASE if requested. To show a portfolio, mail color tearsheets, slides, photocopies, finished samples and photographs. Buys one-time rights. Pays on publication. Pays cartoonists $15 for b&w, $20 for color. Pays illustrators $150 for color cover; $75 for color inside.

TECHNICAL ANALYSIS OF STOCKS & COMMODITIES

4757 California Ave. SW, Seattle WA 98116. (206)938-0570. **E-mail:** editor@traders.com. **Website:** www.traders.com. Estab. 1982. Circ. 60,000. Monthly trad-

ers' magazine for stocks, bonds, futures, commodities, options, mutual funds. Sample copy: $5. Art guidelines on website.

○ This magazine has received several awards, including the Step by Step Design Annual, American Illustration IX, XXIII, XIV, NY Society of Illustrators Annuals 40, 46, 48, 49. Separate listing for Technical Analysis, Inc., in the Book Publishers section.

CARTOONS Approached by 30 cartoonists/year. Buys 1-4 cartoons/issue. Prefers humorous cartoons, single-panel b&w line drawings with tagline related to industry.

ILLUSTRATION Approached by 100 illustrators/year. Buys 6 illustrations/issue. Works on assignment only. Features humorous, realistic, computer (occasionally) and spot illustrations.

FIRST CONTACT & TERMS Cartoonists: Send query letter with finished cartoons (nonreturnable copies only) or e-mail. Illustrators: Send e-mail JPEGs, brochure, tearsheets, photographs, photocopies, photostats, slides. Accepts submissions compatible with any Adobe products (PDF, TIFF, or EPS files). Samples are filed and are not returned. E-mail portfolio for review if interested. Portfolio should include b&w and color art, slides, photostats, photocopies, final art and photographs. Buys one-time rights and reprint rights. Pays on publication. Pays cartoonists $35 for b&w. Pays illustrators $135-350 for color cover; $165-220 for color inside; $105-150 for b&w inside. Accepts previously published artwork.

TIPS "Looking for creative, imaginative, and conceptual types of illustration that relate to articles' concepts. Also interested in caricatures with market charts and computers."

TERRAIN.ORG: A JOURNAL OF THE BUILT & NATURAL ENVIRONMENTS

(520)241-7390. **E-mail:** contact2@terrain.org. **Website:** www.terrain.org. **Contact:** Simmons Buntin, editor-in-chief. Estab. 1997. Circ. 250,000 visits/year. Tri-annual online literary journal. Terrain.org publishes a mix of literary and technical work—editorials, poetry, essays, fiction, articles, reviews, interviews and unsprawl case studies; plus artwork (the ARTerrain gallery plus photo essays and the like; only online for free at www.terrain.org. Terrain has an international audience. Sample copies available online. Art and photo submission guidelines available on website or via mail with SASE. Very general guidelines, query first for artwork.

ILLUSTRATION Approached by 1-2 freelance illustrators/year. Generally do not purchase freelance illustrations. Terrain.org has featured the illustrations of Tom Low, Paul Hoffman and Suzanne Stryk. Features realistic illustrations, informational graphics, computer illustration, charts & graphs, scientific, natural history, architectural and fine art. Prefers architectural and environmental subjects. Design format not important, as long as it can be converted to online formats.

FIRST CONTACT & TERMS Send e-mail with link to artist's website or JPEGS at 72 dpi. Keeps samples on file, include self-promotion piece to be kept on file for possible future assignments. Responds in 4 weeks. Considers simultaneous submissions and previously published work. Portfolio not required. "We do not pay for illustrations." Finds freelancers through submissions, word-of-mouth and Internet.

TIPS "Because Terrain.org is a self-funded, nonprofit endeavor, we currently do not pay for contributions, whether artwork, photographs or narrative. However, we truly value high-quality artwork and provide broad international exposure to work, particularly in each issue's ARTerrain gallery. We seek photo essays, hybrid forms and other work that takes advantage of our online medium (photo essays with audio, for example). Submit direct samples, or at least URLs to specific artwork. We unfortunately don't have time to investigate a full website or portfolio if all the artist sends is the home page link."

TEXAS MEDICINE

401 W. 15th St., Austin TX 78701. (800)880-1300, ext. 1385. **Fax:** (512)370-1300. **E-mail:** crystal. zuzek@texmed.org. **Website:** www.texmed.org. **Contact:** Crystal Zuzek, editorial contact. Circ. 35,000. Monthly trade journal published by Texas Medical Association for the statewide Texas medical profession. Sample copies and art guidelines available.

ILLUSTRATION Approached by 30-40 illustrators/year. Buys 4-6 illustrations/issue. Prefers medical themes. Considers all media.

FIRST CONTACT & TERMS Illustrators: Send postcard sample or query letter with photocopies. Accepts disk submissions of EPS or TIFF files for QuarkXPress 3.32. Samples are filed and are not returned. Responds only if interested. Art director will

contact artist for portfolio review of b&w, color, final art, photographs, photostats, tearsheets or transparencies if interested. Rights purchased vary according to project. Pays on publication. Payment varies; $350 for spots. Finds artists through agents, magazines and submissions.

TEXAS MONTHLY

Emmis Publishing LP, P.O. Box 1569, Austin TX 78767. (512)320-6900. **Fax:** (512)476-9007. **E-mail:** bsweany@texasmonthly.com. **Website:** www.texasmonthly.com. **Contact:** Brian D. Sweany, editor; Leslie Baldwin, photo editor; Stacy Hollister, director of editorial operations. Estab. 1973. Circ. 300,000. *Texas Monthly* is edited for the urban Texas audience and covers the state's politics, sports, business, culture and changing lifestyles. It contains lengthy feature articles, reviews and interviews, and presents critical analysis of popular books, movies and plays. Accepts previously published artwork. Originals are returned to artist at job's completion.

ILLUSTRATION Approached by hundreds of illustrators/year. Works on assignment only. Considers all media.

FIRST CONTACT & TERMS Art/graphic design illustrators: Send postcard sample of work or an e-mail with link to your website. Appropriate samples are filed or returned by SASE if requested by artist. Fees vary based on size and complexity of illustration.

TEXAS PARKS & WILDLIFE

4200 Smith School Rd., Bldg. D, Austin TX 78744. (800)937-9393. **Fax:** (512)389-8397. **E-mail:** magazine@tpwd.texas.gov. **Website:** www.tpwmagazine.com. Estab. 1942. Circ. 150,000.

ILLUSTRATION 10% of freelance illustration.

FIRST CONTACT & TERMS Illustrators: Send sample via PDF. Samples are not filed and are not returned. Responds only if interested. Buys one-time rights. Pays on publication; negotiable. Finds illustrators through magazines, word of mouth, artist's submissions.

TIPS "Read our magazine."

THRASHER

High Speed Productions, 1303 Underwood Ave., San Francisco CA 94124. (415)822-3083. **Fax:** (415)822-8359. **E-mail:** photos@thrashermagazine.com. **Website:** www.thrashermagazine.com. Estab. 1981. Circ. 200,000. Monthly 4-color magazine. "*Thrasher* is

the dominant publication devoted to the latest in extreme youth lifestyle, focusing on skateboarding, snowboarding, new music, videogames, etc." Originals returned at job's completion. Sample copies for SASE with first-class postage. Art guidelines available online. Needs computer-literate freelancers for illustration. Freelancers should be familiar with Illustrator or Photoshop.

CARTOONS Approached by 100 cartoonists/year. Has featured illustrations by Mark Gonzales and Robert Williams. Prefers skateboard, snowboard, music, youth-oriented themes. Assigns 100% of illustrations to new and emerging illustrators.

ILLUSTRATION Approached by 100 illustrators/year. Prefers themes surrounding skateboarding/skateboarders, snowboard/music (rap, hip hop, metal) and characters and commentary of an extreme nature. Prefers pen & ink, collage, airbrush, marker, charcoal, mixed media and computer media (Mac format).

FIRST CONTACT & TERMS Cartoonists: Send query letter with brochure and roughs. Illustrators: Send query letter with brochure, résumé, SASE, tearsheets, photographs and photocopies. Publication will contact artist for portfolio review if interested. Portfolio should include b&w and color tearsheets, photocopies and photographs. Rights purchased vary according to project. Negotiates payment for covers. Sometimes requests work on spec before assigning job. Pays on publication. Pays cartoonists $50 for b&w, $75 for color. Pays illustrators $75 for b&w, $100 for color inside.

TIPS "Send finished quality examples of relevant work with a bio/intro/résumé that we can keep on file and update contact info. Artists sometimes make the mistake of submitting examples of work inappropriate to the content of the magazine. Buy/borrow/steal an issue and do a little research. Read it. Desktop publishing is now sophisticated enough to replace all high-end prepress systems. Buy a Mac. Use it. Live it."

TIKKUN

2342 Shattuck Ave., Suite 1200, Berkeley CA 94704. (510)644-1200. **Fax:** (510)644-1255. **E-mail:** magazine@tikkun.org. **Website:** www.tikkun.org. **Contact:** managing editor. Estab. 1986. Circ. 41,000. Quarterly Jewish and interfaith critique of politics, culture and society; includes articles regarding Jewish and nonJewish issues, left-of-center politics. "Looks for art that evokes awe and wonder at the grandeur of

the universe or art that portrays the depth of human understanding, wisdom, love and humanity."

ILLUSTRATION Approached by 50-100 illustrators/year. Buys 1-5 illustrations/issue. Features symbolic and figurative illustration and political cartoons in color and b&w. Assigns 50% of illustrations to experienced, but not well known illustrators; 50% to new and emerging illustrators. Prefers line drawings.

FIRST CONTACT & TERMS Prefers electronic submissions. E-mail web link or JPEGs. Do not send originals; unsolicited artwork will not be returned. Accepts previously published material. Often we hold onto line drawings for last-minute use. Pays on publication. Artists must agree to these terms: Nonexclusive worldwide publishing rights for use of the images in *Tikkun* is, in the whole or in part, distributed, displayed and archived, with no time restriction.

TIPS Prefers art with progressive religious and ethical themes. "We invite you to send us a sample of a *Tikkun* article we've printed, showing how you would have illustrated it."

TIME

1271 Avenue of the Americas, New York NY 10020. **E-mail:** letters@time.com. **Website:** www.time.com. **Contact:** Nancy Gibbs, managing editor. Estab. 1923. Circ. 4 million. Weekly magazine covering breaking news, national and world affairs, business news, societal and lifestyle issues, culture and entertainment.

ILLUSTRATION Considers all media.

FIRST CONTACT & TERMS Send postcard sample, printed samples, photocopies or other appropriate samples. Accepts disk submissions. Samples are filed. Responds only if interested. Buys first North American serial rights. Payment is negotiable. Finds artists through sourcebooks and illustration annuals.

🌎 TOASTMASTER MAGAZINE

Toastmasters International, P.O. Box 9052, Mission Viejo CA 92690. 949-858-8255. **E-mail:** submissions@toastmasters.org. **Website:** www.toastmasters.org. **Contact:** submissions@toastmasters.org. Estab. Toastmasters International: Established in 1924. Read more at www.toastmasters.org/About/History. Circ. To 332,000 members in more than 15,400 clubs in 135 countries.. Monthly trade journal for association members. "Leadership, public speaking and communication are our topics."

☘💲 TODAY'S PARENT

Rogers Media, Inc., 1 Mt. Pleasant Rd., 8th Floor, Toronto, Ontario M4Y 2Y5 Canada. (416)764-2883. **Fax:** (416)764-2894. **E-mail:** editors@todaysparent.com. **Website:** www.todaysparent.com; website@todaysparent.com. **Contact:** Alicia Kowalewski, art director. Circ. 2 million. Monthly parenting magazine. Sample copies available.

ILLUSTRATION Send query letter with printed samples, photocopies or tearsheets.

FIRST CONTACT & TERMS Illustrators: Send follow-up postcard sample every year. Accepts disk submissions. Art director will contact artist for portfolio review of b&w and color photographs, slides, tearsheets and transparencies if interested. Buys first rights. **Pays on acceptance;** $100-300 for b&w and $250-800 for color inside. Pays $400 for spots. Finds illustrators through magazines, submissions and word of mouth.

TIPS Looks for "good conceptual skills and skill at sketching children and parents."

TRAINING MAGAZINE

P.O. Box 247, Excelsior MN 55331. (516)524-3504. **E-mail:** lorri@trainingmag.com. **Website:** www.trainingmag.com. **Contact:** Lorri Freifeld, editor-in-chief. Estab. 1964. Circ. 45,000. 4-color trade journal published 6 times/year covering job-related training and education in business and industry, both theory and practice, for audience training directors, personnel managers, sales and data processing managers, general managers, etc. Sample copies available with SASE and first-class postage.

ILLUSTRATION Works on assignment only. Prefers themes that relate directly to business and training. Styles are varied. Considers pen & ink, airbrush, mixed media, watercolor, acrylic, oil, pastel and collage.

FIRST CONTACT & TERMS Send postcard sample, tearsheets or photocopies. Accepts digital submissions. Samples are filed. Responds only if interested. Buys first rights or one-time rights. **Pays on acceptance.** Pays illustrators $1,500 for color cover; $500 for color inside; $100 for spots.

TIPS "Show a wide variety of work in different media and with different subject matter."

TRAINS

Kalmbach Publishing Co., P.O. Box 1612, Waukesha WI 53187-1612. (262)796-8776. **Fax:** (262)796-1142. **E-mail:** editor@trainsmag.com; photoeditor@trainsmag.com. **Website:** www.trn.trains.com. **Contact:** Jim Wrinn, editor; Tom Danneman, art director. Estab. 1940. Circ. 92,419. Monthly magazine about trains, train companies, tourist RR, latest railroad news. Art guidelines available online.

O Kalmbach Publishing also publishes *Classic Toy Trains, Astronomy, Finescale Modeler, Model Railroader, Classic Trains, Bead and Button, Birder's World.*

ILLUSTRATION 100% of freelance illustration demands knowledge of Photoshop CS 5.0, Illustrator CS 8.0.

FIRST CONTACT & TERMS Illustrators: Send query letter with printed samples, photocopies and tearsheets. Accepts disk submissions (opticals) or CDs, using programs above. Samples are filed. Art director will contact artist for portfolio review of color tearsheets if interested. Buys one-time rights. Pays on publication.

TIPS "Quick turnaround and accurately built files are a must."

TRAVEL + LEISURE

1120 Avenue of the Americas, 9th Floor, New York NY 10036. (212)382-5600. **E-mail:** TLPhoto@aexp.com. **Website:** www.travelandleisure.com. Monthly magazine emphasizing travel, resorts, dining and entertainment. Original artwork returned after publication. Art guidelines with SASE.

ILLUSTRATION Approached by 250-350 illustrators/year. Buys 1-15 illustrations/issue. Interested in travel and leisure-related themes. "Illustrators are selected by excellence and relevance to the subject." Works on assignment only.

FIRST CONTACT & TERMS Provide samples and business card to be kept on file for future assignment. Responds only if interested. E-mail form for queries available online. In most cases these are responded to the quickest.

TIPS No cartoons.

TREASURY & RISK

475 Park Ave. S., Room 601, New York NY 10016-6901. **E-mail:** mwaters@summitpronets.com. **Website:** www.treasuryandrisk.com. **Contact:** Meg Waters, editor-in-chief. Circ. 50,000. Monthly trade publication for financial/CFO-treasurers. Sample copies available on request.

ILLUSTRATION Buys 45-55 illustrations/year. Features business computer illustration, humorous illustration and spot illustrations. Prefers electronic media. Assigns 25% of illustrations to new and emerging illustrators. Freelance artists should be familiar with Illustrator and Photoshop.

FIRST CONTACT & TERMS Send postcard sample. After introductory mailing, send follow-up postcard sample every 3 months. Accepts e-mail submissions with link to website and image file. Prefers Mac-compatible JPEG files. Responds only if interested. Will contact artist for portfolio review if interested. Portfolio should include color and tearsheets. Pays illustrators $1,000-1,200 for color cover; $400 for spots; $500 for ½ page color inside; $650 for full page; $800 for spread. Buys first rights, one-time rights, reprint rights and all rights. Finds freelancers through agents, submissions, magazines and word of mouth.

TV GUIDE

11 W. 42nd St., 16th Floor, New York NY 10036. (212)852-7500. **Fax:** (212)852-7470. **Website:** www.tvguide.com. **Contact:** Mickey O'Connor, editor-in-chief. Estab. 1953. Circ. 9 million. Weekly consumer magazine for television viewers. Has featured illustrations by Mike Tofanelli and Toni Persiani.

O Focuses on all aspects of network, cable, and pay television programming and how it affects and reflects audiences.

ILLUSTRATION Approached by 200 illustrators/year. Buys 50 illustrations/year. Considers all media.

FIRST CONTACT & TERMS Illustrators: Send postcard sample. Samples are filed. Art director will contact artist for portfolio review of color tearsheets if interested. Negotiates rights purchased. **Pays on acceptance;** $1,500-4,000 for color cover; $1,000-2,000 for full page color inside; $200-500 for spots. Finds artists through sourcebooks, magazines, word of mouth, submissions.

UBM ADVANSTAR

Advanstar Coomunications Inc., 2450 Colorado Ave., Suite 300 East, Santa Monica CA 90404. (310)857-7500. **Fax:** (210)857-7510. **Website:** www.advanstar.com; ubmadvanstar.com. Estab. 1909. Publishes 15 health-related publications and special products. Uses

freelance artists for "most editorial illustration in the magazines."

CARTOONS Prefers general humor topics (workspace, family, seasonal); also medically related themes. Prefers single-panel b&w drawings and washes with gagline.

ILLUSTRATION Interested in all media, including 3D, electronic and traditional illustration. Needs editorial and medical illustration that varies "but is mostly on the conservative side." Works on assignment only.

FIRST CONTACT & TERMS Cartoonists: Send unpublished cartoons only with SASE group art director. Buys first world publication rights. Samples are filed. Responds only if interested. Write for portfolio review. Buys nonexclusive worldwide rights. Pays $1,000-1,500 for color cover; $250-800 for color inside; $200-600 for b&w. Accepts previously published material. Originals are returned at job's completion.

UROLOGY TIMES

UBM Medica, 125 W. First St., Duluth MN 55802. (440)891-2758. **Fax:** (440)756-5229. **Website:** www. urologytimes.com. Estab. 1972. Circ. 10,000. Monthly trade publication. The leading news source for urologists. Art guidelines available.

ILLUSTRATION Buys 6 illustrations/year. Has featured illustrations by DNA Illustrations, Inc. Assigns 25% of illustrations to new and emerging illustrators. 90% of freelance work demands computer skills. Freelancers should be familiar with Illustrator, Photoshop. E-mail submissions accepted with link to website. Prefers TIFF, JPEG, GIF, EPS. Samples are filed. Art director will contact artist for portfolio review if interested. Portfolio should include finished art and tearsheets. Pays on publication. Buys multiple rights. Finds freelancers through artists' submissions.

FIRST CONTACT & TERMS Illustrators: Send postcard sample with photocopies.

U.S. KIDS MAGAZINES

1100 Waterway Blvd., Indianapolis IN 46202. (317)634-1100; (800)558-2376. **E-mail:** editor@ saturdayeveningpost.com; jackandjill@ emailcustomerservice.com; humptydumpty@ emailcustomerservice.com. **Website:** www. uskidsmags.com; www.turtlemag.org. Estab. 1979. Circ. 300,000. Emphasizes health, nutrition, exercise and safety for children 2-5 years. Published 6 times/ year; 4-color. Original artwork not returned after

publication. Sample copy for $1.75; art guidelines with SASE and first-class postage. Needs computer-literate freelancers familiar with Macromedia FreeHand and Photoshop for illustrations.

ILLUSTRATION Approached by 100 illustrators/ year. Works with 20 illustrators/year. Buys 15-30 illustrations/issue. Interested in "stylized, humorous, realistic and cartooned themes; also nature and health." Works on assignment only.

FIRST CONTACT & TERMS Illustrators: Send query letter with good photocopies and tearsheets. Accepts disk submissions. Samples are filed or are returned by SASE. Responds only if interested. Portfolio review not required. Buys all rights. Pays on publication: $275 for color cover, $35-90 for b&w inside, $70-155 for color inside, $35-70 for spots. Finds most artists through samples received in mail.

TIPS "Familiarize yourself with our magazine and other children's publications before you submit any samples. The samples you send should demonstrate your ability to support a story with illustration."

UTNE READER

1503 SW 42nd St, Topeka KS 66609. (785)274-4300 or (800)678-5779. **E-mail:** editor@utne.com. **Website:** www.utne.com. **Contact:** Carolyn Lang, art director. Estab. 1984. Circ. 250,000. Bimonthly digest featuring articles and reviews from the best of alternative media; independently published magazines, newsletters, books, journals and websites. Topics covered include national and international news, history, art, music, literature, science, education, economics and psychology.

O *Utne Reader* seeks to present a lively diversity of illustration and photography "voices." We welcome artistic samples which exhibit a talent for interpreting editorial content.

FIRST CONTACT & TERMS "We are always on the lookout for skilled artists with a talent for interpreting editorial content, and welcome examples of your work for consideration. Because of our small staff, busy production schedule, and the volume of samples we receive, however, we ask that you read and keep in mind the following guidelines. We ask that you not call or e-mail seeking feedback, or to check if your package has arrived. We wish we could be more generous in this regard, but we simply don't have the staff or memory capacity to recall what has come in (SASEs and reply cards will be honored). Send sam-

ples that can be quickly viewed and tacked to a bulletin board. Single-sided postcards are preferred. Make sure to include a link to your online portfolio so we can easily view more samples of your work. *Do not send* cover letters, résumés, and gallery or exhibition lists. Be assured, if your art strikes us as a good fit for the magazine, we will keep you in mind for assignments. Clearly mark your full name, address, phone number, website address and e-mail address on everything you send. Please do not send original artwork or original photographs of any kind."

☯ VALLUM: CONTEMPORARY POETRY

5038 Sherbrooke West, P.O. Box 23077, CP Vendome, Montreal, Quebec H4A 1T0 Canada. **E-mail:** info@vallummag.com; editors@vallummag.com. **Website:** www.vallummag.com. **Contact:** Joshua Auerbach and Eleni Zisimatos, editors. Estab. 2000. Poetry/fine arts magazine published twice/year. Publishes exciting interplay of poets and artists. Content for magazine is selected according to themes listed on website.

FIRST CONTACT & TERMS Material is not filed but is returned upon request by SASE. E-mail response is preferred.

✚ VANITY FAIR

Conde Nast Publications, Inc., 1472 Broadway, New York NY 10036. **E-mail:** letters@vf.com. **Website:** www.vanityfair.com. Monthly consumer magazine. Does not use previously published artwork. Original artwork returned at job's completion. 100% of freelance design work demands knowledge of QuarkXPress and Photoshop.

ILLUSTRATION Approached by "hundreds" of illustrators/year. Buys 3-4 illustrations/issue. Works on assignment only. "Mostly uses artists under contract."

VEGETARIAN JOURNAL

P.O. Box 1463, Baltimore MD 21203-1463. (410)366-8343. **E-mail:** vrg@vrg.org. **Website:** www.vrg.org. **Contact:** Debra Wasserman, editor. Estab. 1982. Circ. 20,000. Accepts previously published artwork. Originals returned at job's completion upon request. Sample copies available for $4.

CARTOONS Approached by 4 cartoonists/year. Buys 2 cartoons/year. Prefers humorous cartoons with an obvious vegetarian theme; single panel b&w line drawings.

ILLUSTRATION Approached by 20 illustrators/year.

FIRST CONTACT & TERMS Cartoonists: Send query letter with roughs. Illustrators: Send query letter with photostats. Samples are not filed and are returned by SASE if requested by artist. Responds in 2 weeks. Portfolio review not required. Rights purchased vary according to project. Pays on acceptance. Pays cartoonists $25 for b&w. Pays illustrators $25-50 for b&w/color inside. Finds artists through word of mouth and job listings in art schools.

TIPS Areas most open to freelancers are recipe section and feature articles. "Review magazine first to learn our style. Send query letter with photocopy sample of line drawings of food."

VIM & VIGOR

1010 E. Missouri Ave., Phoenix AZ 85014. (602)395-5850 or (219)836-0130. **Fax:** (602)395-5853. **Website:** www.comhs.org/vim_vigor/. Estab. 1985. Circ. 800,000. Quarterly consumer magazine focusing on health. Originals returned at job's completion. Sample copies available. Art guidelines available.

☯ The company publishes many other titles as well.

ILLUSTRATION Approached by 100 illustrators/year. Buys 10 illustrations/issue. Works on assignment only. Considers mixed media, collage, charcoal, acrylic, oil, pastel and computer.

FIRST CONTACT & TERMS Illustrators: Send postcard sample with tearsheets and online portfolio/website information. Accepts disk submissions. Samples are filed. Rights purchased vary according to project. Pays on acceptance. Finds artists through agents, Web sourcebooks, word of mouth and submissions.

VIRGINIA TOWN & CITY

P.O. Box 12164, Richmond VA 23241. (804)649-8471. **Fax:** (804)343-3758. **E-mail:** dparsons@vml.org;email@vml.org. **Website:** www.vml.org. **Contact:** David Parsons, editor. Estab. 1965.

CARTOONS "Currently none appear, but we would use cartoons focusing on local government problems and issues."

FIRST CONTACT & TERMS Publication will contact artist for portfolio review if interested. Rights purchased vary according to project. Pays on acceptance. Pays $25 for b&w. Pays illustrators $50-75 for b&w and $55 for color cover; $25-45 for b&w and $35 for color inside.

TIPS "We occasionally need illustrations of local government services. For example, police, firefighters, education, transportation, public works, utilities, cable TV, meetings, personnel management, taxes, etc. Usually b&w. Illustrators who can afford to work or sell for our low fees, and who can provide rapid turnaround should send samples of their style and information on how we can contact them."

VISUAL STUDIO MAGAZINE

1105 Media, 4 Venture, Suite 150, Irvine CA 92618. (949)265-1520. **E-mail:** privacy@1105media.com. **Website:** reddevnews. com. **Contact:** mdomingo@1105media.com; whernandez@1105media.com. Estab. 1990. Circ. 50,000. Twice-monthly 4-color trade publication for corporate software managers.

ILLUSTRATION Approached by 40 illustrators/year. Features charts & graphs, informational graphics, spot illustrations and computer illustration of business subjects. Has featured illustrations by Ryan Etter and Greg Mably. Assigns 50% of illustrations to experienced, but not well-known illustrators; 50% to new and emerging illustrators.

FIRST CONTACT & TERMS E-mail submissions or PDF files. Samples are filed. Responds in 1 month. Portfolio review not required. Pays $400 for spots.

TIPS "Illustrate technology concepts in a unique way."

VOGUE PATTERNS

120 Broadway, 34th Floor, New York NY 10271. **E-mail:** mailbox@voguepatterns.com or via online contact form. **Website:** voguepatterns.mccall.com. Manufacturer of clothing patterns with the *Vogue* label. Uses freelance artists mainly for fashion illustration for the *Vogue Patterns* catalog and editorial illustration for *Vogue Patterns* magazine. "The nature of catalog illustration is specialized; every button, every piece of top-stitching has to be accurately represented. Editorial illustration assigned for our magazine should have a looser editorial style. We are open to all media."

ILLUSTRATION Assigns 18 editorial illustration jobs and 100-150 fashion illustration jobs/year. Looking for "sophisticated modern fashion and intelligent creative and fresh editorial."

FIRST CONTACT & TERMS Illustrators: Send query letter with résumé, tearsheets, slides or photographs. Samples not filed are returned by SASE. Call or write for appointment to drop-off portfolio. Pays for design by the hour, illustration by the project.

TIPS "Drop off comprehensive portfolio with a current business card and sample. Make sure name is on outside of portfolio. When a job becomes available, we will call illustrator to view portfolio again."

WASHINGTON CITY PAPER

1400 Eye St. NW, Suite 900, Washington DC 20005. (202)332-2100. **Fax:** (202)332-8500. **E-mail:** mail@washingtoncitypaper.com; listings@washingtoncitypaper.com; contact@ washingtoncitypaper.com; ccauterucci@ washingtoncitypaper.com. **E-mail:** editor@ washingtoncitypaper.com. **Website:** www. washingtoncitypaper.com. Estab. 1981. Circ. 95,000. Weekly tabloid "distributed free in DC and vicinity. We focus on investigative reportage, arts, and general interest stories with a local slant." Art guidelines not available.

CARTOONS Only accepts weekly features, no spots or op-ed style work.

ILLUSTRATION Approached by 100-200 illustrators/year. Buys 2-8 illustrations/issue. Has featured illustrations by Michael Kupperman, Peter Hoey, Greg Houston, Joe Rocco, Susie Ghahremani, and Robert Meganck. Features caricatures of politicians; humorous illustration; informational graphics; computer and spot illustration. Considers all media, if the results do well in b&w.

FIRST CONTACT & TERMS Illustrators: Send query letter with printed or e-mailed samples, photocopies or tearsheets. Art director will contact artist for more if interested. Buys first-rights. Pays on publication which is usually pretty quick. Pays cartoonists $25 minimum for b&w. Pays illustrators $110 minimum for b&w cover; $220 minimum for color cover; $85 minimum for inside. Finds illustrators mostly through submissions.

TIPS "We are a good place for freelance illustrators, we use a wide variety of styles, and we're willing to work with beginning illustrators. We like illustrators who are good on concept and can work fast if needed. We avoid cliché D.C. imagery such as the Capitol and monuments."

WASHINGTON FAMILY MAGAZINE

11260 Roger Bacon Dr., Suite 20, Reston VA 20190. (703)318-1385. **Fax:** (703)318-5509. **E-mail:** editor@thefamilymagazine.com. **Website:** www.

washingtonfamily.com. Estab. 1992. Circ. 100,000. Monthly consumer parenting magazine. Art guidelines available by e-mail.

ILLUSTRATION Approached by 100 illustrators/year. Features computer illustration. Preferred subjects: children, families, women. Prefers bright colors with process colors of no more than 2 color mixes. Freelancers should be familiar with PageMaker, Illustrator, Photoshop. E-mail submissions not accepted. Prefers JPEG, high-res. Samples are filed. Portfolio not required. Pays illustrators 100 for color cover. Pays on publication. Buys one-time rights. Finds freelancers through artists' submissions.

FIRST CONTACT & TERMS Illustrators: Send postcard sample, brochure, samples.

WASHINGTONIAN MAGAZINE

1828 L St. NW, Suite 200, Washington DC 20036. (202)296-3600. **E-mail:** editorial@washingtonian.com. **Website:** www.washingtonian.com. Estab. 1965. Circ. 185,000. Monthly 4-color consumer lifestyle and service magazine.

ILLUSTRATION Approached by 200 illustrators/year. Buys 2-3 illustrations/issue. Has featured illustrations by Pat Oliphant, Chris Tayne and Richard Thompson. Features caricatures of celebrities, caricatures of politicians, humorous illustration, realistic illustrations, spot illustrations, computer illustrations and photo collage. Preferred subjects: men, women and creative humorous illustration. Assigns 20% of illustrations to new and emerging illustrators. 20% of freelance illustration demands knowledge of Photoshop.

FIRST CONTACT & TERMS Illustrators: Send postcard sample and follow-up postcard every 6 months. Send nonreturnable samples. Accepts Mac-compatible submissions. Send EPS or TIFF files. Responds only if interested. Will contact artist for portfolio review if interested. Buys first rights. Pays on acceptance. Finds illustrators through magazines, word of mouth, promotional samples, sourcebooks.

TIPS "We like caricatures that are fun, not mean and ugly. Want a well-developed sense of color, not just primaries."

WATERCOLOR ARTIST

F+W, a Content + eCommerce Company, 10151 Carver Rd., Suite 200, Blue Ash OH 45242. (513)531-2690. **Fax:** (513)891-7153. **E-mail:** wcamag@fwmedia.com. **Website:** www.watercolorartistmagazine.com. Con-

tact: Jennifer Hoffman, art director; Kelly Kane, editor. Estab. 1984. Circ. 44,000. (Formerly *Watercolor Magic*.) Bimonthly 4-color consumer magazine for artists to explore and master watermedia. "*Watercolor Artist* is the definitive source of how-to instruction and creative inspiration for artists working in water-based media." Art guidelines free for #10 SASE with first-class postage.

FIRST CONTACT & TERMS Illustration: Pays on publication. Finds illustrators through word of mouth, visiting art exhibitions, unsolicited queries, reading books.

TIPS "We are looking for watermedia artists who are willing to teach special aspects of their work and their techniques to our readers."

WEEKLY READER

Scholastic/Weekly Reader, P.O. Box 7502, Jefferson City MO 65102-9733. (914)242-4000 or (800)446-3355. **Website:** www.weeklyreader.com. Estab. 1928. Publishes educational periodicals, posters and books. "*Weekly Reader* teaches the news to kids pre-K through high school age. The philosophy is to connect students to the world." Publications are 4-color. Sample copies are available.

ILLUSTRATION Needs editorial and technical illustration. Style should be "contemporary and age-level appropriate for the juvenile audience." Buys more than 50 illustrations/week. *Works on assignment only.* Uses computer and reflective art.

FIRST CONTACT & TERMS Illustrators: Send brochure, tearsheets, SASE and photocopies. Samples are filed or are returned by SASE if requested by artist. Accepts previously published artwork. Original artwork is returned at job's completion. Payment is usually made within 3 weeks of receiving the invoice. Finds artists through submissions/self-promotions, sourcebooks, agents and reps. Some periodicals need quick turnarounds.

TIPS "Our primary focus is the children's and young adult marketplace. Art should reflect creativity and knowledge of audience's needs. Our budgets are tight, and we have very little flexibility in our rates. We need artists who can work with our budgets. Avoid using fluorescent dyes. Use clear, bright colors. Work on flexible board."

⊕ WESTWAYS

333 Fairview Rd., A327, Costa Mesa CA 92626. (714)885-2376. **Fax:** (714)885-2335. **E-mail:**

westways@aaa-calif.com; vaneyke.eric@aaa-calif.com. **Website:** www.calif.aaa.com/westways. **Contact:** Eric Van Eyke, art director. Estab. 1919. Circ. 3 million. Bimonthly lifestyle and travel magazine.

ILLUSTRATION Approached by 20 illustrators/year. Buys 2-6 illustrations/year. Works on assignment only. Preferred style is "arty-tasteful, colorful." Considers pen & ink, watercolor, collage, airbrush, acrylic, colored pencil, oil, mixed media and pastel.

FIRST CONTACT & TERMS Illustrators: Send e-mail with link to website or query letter with brochure, tearsheets and samples. Samples are filed. Responds only if interested; "could be months after receiving samples." Buys first rights. Pays on acceptance of final art: $250 minimum for color inside. Original artwork returned at job's completion.

WINDSURFING MAGAZINE

Bonnier Corporation, 460 N. Orlando Ave., Suite 200, Winter Park FL 32789. (407)628-4802 or (212)779-5000. **E-mail:** sarah.moore@bonniercorp.com; perri.dorset@bonniercorp.com. **Website:** windsurfingmag.com. **Contact:** Sarah Moore; Perri Dorset. Estab. 1981. Circ. 75,000. Consumer magazine "for windsurfers and those interested in the sport. Audience is 30ish, mostly male and affluent." 8 issues/year. Original artwork returned if requested at job's completion. One sample copy available to the artist. Art guidelines not available.

ILLUSTRATION Approached by 1-2 illustrators/year. Buys 15-20 illustrations/year, mostly maps. Works on assignment only. Prefers "maps and a fun cartoon-like style." Considers airbrush, watercolor and collage.

FIRST CONTACT & TERMS Illustrators: Send query letter with SASE, "samples of various styles and short bio listing where published material has appeared." Samples are filed or are returned by SASE if requested by artist. Responds only if interested as need arises. "Please do not call." To show a portfolio, mail color tearsheets, photostats, photographs and photocopies. Rights purchased vary according to project. Pays on publication; $50-400 average for color inside.

TIPS "Send a good selection of styles for us to review."

WOODENBOAT MAGAZINE

WoodenBoat Publications, Inc., P.O. Box 78, Brookline ME 04616. (207)359-4651. **Website:** www.woodenboat.com. **Contact:** Matthew P. Murphy,

editor. Estab. 1974. Circ. 90,000. Bimonthly magazine for wooden boat owners, builders and designers. Previously published work OK. Sample copy for $6. Art guidelines free for SASE with first-class postage.

ILLUSTRATION Approached by 10-20 illustrators/year. Buys 2-10 illustrations/issue on wooden boats or related items. Uses some illustration, usually by several regularly appearing artists, but occasionally featuring others.

DESIGN Not currently using freelancers.

FIRST CONTACT & TERMS Illustrators: Send postcard sample or query letter with printed samples and tearsheets. Designers: Send query letter with tearsheets, résumé and slides. Samples are filed. Does not report back. Artist should follow up with call. Pays on publication. Pays illustrators $50-400 for spots.

TIPS "We work with several professionals on an assignment basis, but most of the illustrative material that we use in the magazine is submitted with a feature article. When we need additional material, however, we will try to contact a good freelancer in the appropriate geographic area."

BOOK PUBLISHERS

///

Walk into any bookstore and start counting the number of images you see on books and calendars. The illustrations you see on covers and within the pages of books are, for the most part, created by freelance artists. Publishers rarely have enough artists on staff to generate such a vast array of styles. If you like to read and work creatively to solve problems, the world of book publishing could be a great market for you.

The artwork appearing on a book cover must grab readers' attention and make them want to pick up the book. It must show at a glance what type of book it is and who it is meant to appeal to. In addition, the cover has to include basic information such as title, the author's name, the publisher's name, blurbs, and price.

Most assignments for freelance work are for jackets/covers. The illustration on the cover, combined with typography and the layout choices of the designer, announce to the prospective readers the style and content of a book. Suspenseful spy novels tend to feature stark, dramatic lettering and symbolic covers. Fantasy and science fiction novels, as well as murder mysteries and historical fiction, might show a scene from the story on their covers. Visit a bookstore and then decide which kinds of books interest you and would be best for your illustration style.

Book interiors are also important. The page layouts and illustrations direct readers through the text and complement the story, particularly in children's books and textbooks. Many publishing companies hire freelance designers with computer skills to design interiors on a contract basis. Look within each listing for the subheading Book Design to find the number of jobs assigned each year and how much is paid per project.

PUBLISHING TERMS TO KNOW

- Mass market paperbacks are sold at supermarkets, newsstands, drugstores, etc. They include romance novels, diet books, mysteries, and novels by popular authors such as Stephen King.
- Trade books are the hardcovers and paperbacks found only in bookstores and libraries. The paperbacks are larger than those on the mass market racks and are printed on higher-quality paper and often feature matte-paper jackets.
- Textbooks contain plenty of illustrations, photographs, and charts to explain their subjects.
- Small press books are produced by small, independent publishers. Many are literary or scholarly in theme and often feature fine art on their covers.
- Backlist titles or reprints refer to publishers' titles from past seasons that continue to sell year after year. These books are often updated and republished with freshly designed covers to keep them up to date and attractive to readers.

Finding Your Best Markets

The first paragraph of each listing describes the types of books each publisher specializes in. You should submit only to publishers who specialize in the types of books you want to illustrate or design. There's no use submitting to a publisher of literary fiction if you want to illustrate children's picture books.

The publishers in this section are just the tip of the iceberg. You can find additional publishers by visiting bookstores and libraries and looking at covers and interior art. When you find covers you admire, write down the name of the books' publishers in a notebook. If the publisher is not listed in *Artist's & Graphic Designer's Market*, go to your public library and ask to look at a copy of *Literary Market Place*, also called *LMP*, published annually by Information Today, Inc. The cost of this large directory is prohibitive to most freelancers, but you should become familiar with it if you plan to work in the book publishing industry. Though it won't tell you how to submit to each publisher, it does give art directors' names. Also be sure to visit publishers' websites—many offer artist's guidelines.

How to Submit

Send one to five nonreturnable samples along with a brief letter. Never send originals. Most art directors prefer samples that can fit in file drawers. Bulky submissions are considered a nuisance. After sending your initial introductory mailing, you should follow up with postcard samples every few months to keep your name in front of art directors. If you want to e-mail TIFF or JPEG files, check the publishers' preferences to see if they will accept submissions via e-mail.

Getting Paid

Payment for design and illustration varies depending on the size of the publisher, the type of project, and the rights purchased. Most publishers pay on a per-project basis, although some publishers of highly illustrated books (such as children's books) pay an advance plus royalties. Small, independent presses may pay only in copies.

Children's Book Illustration

Working in children's books requires a specific set of skills. You must be able to draw the same characters in a variety of poses and situations. Many publishers are expanding their product lines to include multimedia projects. While a number of children's book publishers are listed in this book, *Children's Writer's & Illustrator's Market*, published by Writer's Digest Books, is an invaluable resource if you enter this field. Visit www.writersdigestshop.com to order the most recent edition. You may also want to consider joining the Society of Children's Book Writers and Illustrators (www.scbwi.org), an international organization that offers support, information, networking opportunities, and conferences.

HARRY N. ABRAMS, INC.

115 W. 18th St., 6th Floor, New York NY 10011. (212)206-7715. **Fax:** (212)519-1210. **E-mail:** abrams@ abramsbooks.com. **Website:** www.abramsbooks.com. **Contact:** Managing Editor. Estab. 1951. Publishes hardcover originals, trade paperback originals, and reprints. Types of books include fine art and illustrated books. Publishes 250 titles/year. 60% require freelance design. Visit website for art submission guidelines.

NEEDS Uses freelance designers to design complete books including jackets and sales materials. Uses illustrators mainly for maps and occasional text illustration. 100% of freelance design and 50% of illustration demands knowledge of Illustrator, InDesign or QuarkXPress, and Photoshop. Works on assignment only.

FIRST CONTACT & TERMS Send query letter with résumé, tearsheets, photocopies. Accepts disk submissions or Web address. Samples are filed "if work is appropriate." Samples are returned by SASE if requested by artist. Portfolio should include printed samples, tearsheets, and/or photocopies. Originals are returned at job's completion, with published product. Finds artists through word of mouth, submissions, attending art exhibitions and seeing published work.

DESIGN Assigns several freelance design jobs/year. Pays by the project.

⭘ ALLYN & BACON PUBLISHERS

445 Hutchinson Ave., Columbus OH 43235. **Website:** www.allynbaconmerrill.com. Find local rep to submit materials via online rep locator. Publishes more than 300 hardcover and paperback college textbooks/year. 60% require freelance cover designs. Our subject areas include education, psychology and sociology, political science, theater, music, and public speaking.

NEEDS Designers must be strong in book cover design and contemporary type treatment. 50% of freelance work demands knowledge of Illustrator, Photoshop and FreeHand.

JACKETS/COVERS Assigns 100 design jobs and 2-3 illustration jobs/year. Pays for design by the project, $500-1,000. Pays for illustration by the project, $500-1,000. Prefers sophisticated, abstract style in pen & ink, airbrush, charcoal/pencil, watercolor, acrylic, oil, collage, and calligraphy.

TIPS "Keep stylistically and technically up to date. Learn *not* to overdesign. Read instructions and ask

questions. Introductory letter must state experience and include at least photocopies of your work. If I like what I see, and you can stay on budget, you'll probably get an assignment. Being pushy closes the door. We primarily use designers based in the Boston area."

THE AMERICAN BIBLE SOCIETY

1865 Broadway, New York NY 10023-7505. (212)408-1200. **Fax:** (212)408-1512. **E-mail:** info@ americanbible.org. **Website:** www.americanbible. org. Company publishes religious products including Bibles/New Testaments, portions, leaflets, calendars, and bookmarks. Additional products include religious children's books, posters, seasonal items, teaching aids, audio casettes, videos, and CDs. Specializes in contemporary applications to the Bible. 90% requires freelance design. Book catalog on website.

NEEDS Approached by 50-100 freelancers/month. Works with 10 freelance illustrators and 20 designers/year. Uses freelancers for jacket/cover illustration and design, text illustration, book design and children's activity books. 90% of freelance work demands knowledge of Illustrator, QuarkXPress, Photoshop. Works on assignment only. 5% of titles require freelance art direction.

FIRST CONTACT & TERMS Send postcard samples of work or send query letter with brochure and tearsheets. Samples are filed or returned. *Please do not call.* Responds in 2 months. Product design department will contact artist for portfolio review if additional samples are needed. Portfolio should include final art and tearsheets. Buys all rights. Finds artists through artists' submissions, *The Workbook* (by Scott & Daughters Publishing) and *RSVP Illustrator.*

DESIGN Assigns 3-5 freelance interior book design jobs/year. Pays by the project.

JACKETS/COVERS Assigns 60-80 freelance design and 20 freelance illustration jobs/year. Pays by the project.

TEXT ILLUSTRATION Assigns several freelance illustration jobs/year. Pays by the project.

TIPS "Looking for contemporary, multicultural artwork/designs and good graphic designers familiar with commercial publishing standards and procedures. Have a polished and professional-looking portfolio or be prepared to show polished and professional-looking samples."

AMERICAN INSTITUTE OF CHEMICAL ENGINEERING

120 Wall St., Foor 23, New York NY 10005-4020. (800)242-4363. **Fax:** (203)775-5177. **E-mail:** kares@ aiche.org. **Website:** www.aiche.org. **Contact:** Karen Simpson, sales administrator. Estab. 1925. Book and magazine publisher of hardcover originals and reprints, trade paperback originals and reprints and magazines. Specializes in chemical engineering.

NEEDS Approached by 30 freelancers/year. Works with 17-20 freelance illustrators/year. Prefers freelancers with experience in technical illustration. Macintosh experience a must. Uses freelancers for concept and technical illustration. Also for multimedia projects. 100% of design and 50% of illustration demand knowledge of all standard Mac programs.

FIRST CONTACT & TERMS Send query letter with tearsheets. Accepts disk submissions. Samples are filed. Responds only if interested. Call for appointment to show portfolio of color tearsheets and electronic media. Buys first rights or one-time rights. Originals are returned at job's completion.

JACKETS/COVERS Payment depends on experience, style.

TEXT ILLUSTRATION Assigns 250 jobs/year. Pays by the hour.

AMERICAN PSYCHIATRIC PRESS, INC.

1000 Wilson Blvd., Suite 1825, Arlington VA 22209. (703)907-7322 or (800)368-5777. **Fax:** (703)907-1091. **E-mail:** appi@psych.org; ngray@psych.org. **Website:** www.appi.org. **Contact:** Nicole Gray, editorial support services manager. Estab. 1981. Imprint of American Psychiatric Association. Company publishes hardcover originals and textbooks. Specializes in psychiatry and its subspecialties. Publishes 60 titles/year. 10% require freelance illustration; 10% require freelance design. Book catalog free by request.

NEEDS Uses freelancers for jacket/cover design and illustration. Needs computer-literate freelancers for design. 100% of freelance work demands knowledge of QuarkXPress, Illustrator 3.0, PageMaker 5.0. Works on assignment only.

FIRST CONTACT & TERMS Designers: Send query letter with brochure, photocopies, photographs or tearsheets. Illustrators: Send postcard sample. Samples are filed. Promotions coordinator will contact artist for portfolio review if interested. Portfolio should include final art, slides and tearsheets. Rights purchased vary according to project.

DESIGN Pays by the project.

JACKETS/COVERS Pays by the project.

TIPS Finds artists through sourcebooks. "Book covers are now being done in CorelDraw 5.0 but will work with Mac happily. Book covers are for professional books with clean designs. Type treatment designs are done in-house."

AMHERST MEDIA, INC.

175 Rano St., Suite 200, Buffalo NY 14207. (716)874-4450. **Fax:** (716)874-4508. **E-mail:** submissions@ amherstmedia.com. **Website:** www.amherstmedia. com. **Contact:** Craig Alesse, publisher. Estab. 1974. Company publishes trade paperback originals. Types of books include instructional and reference. Specializes in photography, how-to. Publishes 40+ titles/year. Recent titles include: *Portrait Photographer's Handbook; Creating World Class Photography*. 20% require freelance illustration; 80% require freelance design.

NEEDS Approached by 12 freelancers/year. Works with 3 freelance illustrators and 3 designers/year. Uses freelance artists mainly for illustration and cover design. Also for jacket/cover illustration and design and book design. 80% of freelance work demands knowledge of InDesign or Photoshop. Works on assignment only.

FIRST CONTACT & TERMS Prefers digital submissions. Send brochure, résumé, and photographs. Samples are filed. Responds only if interested. Art director will contact artist for portfolio review if interested. Rights purchased vary according to project. Originals are returned at job's completion. Finds artists through word of mouth.

DESIGN Assigns 12 freelance design jobs/year. Pays for design by the hour $25 minimum; by the project $1,000.

JACKETS/COVERS Assigns 12 freelance design and 4 illustration jobs/year. Pays $200-1200. Prefers computer illustration (InDesign/Photoshop).

TEXT ILLUSTRATION Assigns 12 freelance illustration jobs/year. Pays by the project. Only accepts computer illustration (InDesign).

ANDREWS MCMEEL PUBLISHING

1130 Walnut St., Kansas City MO 64106. (816)581-8921 or (800) 851-8923. **E-mail:** tlynch@amuniversal.

com; marketing@amuniversal.com. **Website:** www. andrewsmcmeel.com. **Contact:** Tim Lynch, Creative Director. Estab. 1972. Publishes calendars: all formats, trade hardcover and paperback originals and reprints. Category of books include humor, gift, nonfiction, reference, puzzles and games, cookbooks. Specializes in calendars and comic strip collection books. Publishes 200 titles/year; 3% require freelance illustration; 10% require freelance design.

NEEDS Prefers freelancers experienced in book jacket design. Freelance designers must have working knowledge of Illustrator, Photoshop, QuarkXPress, or InDesign. Food photographers experienced in cook book photography.

FIRST CONTACT & TERMS Send sample sheets and web address or contact through artist's rep. Samples are filed and not returned. Responds only if interested. Portfolio review not required. Rights purchased vary according to project.

TIPS We want designers that communicate well and be flexible with design.

⌂ ANTARCTIC PRESS

7272 Wurzbach, Suite 204, San Antonio TX 78240. (210)614-0396. **E-mail:** submissions@antarctic-press. com. **Website:** www.antarctic-press.com. **Contact:** David Hutchison. Estab. 1985. Publishes CDs, mass market paperback originals and reprints, trade paperback originals and reprints. Types of books include adventure, comic books, fantasy, humor, juvenile fiction. Specializes in comic books. Publishes 18 titles/year. Recent titles include: *Gold Digger, President Evil, The Last Zombie, Time Lincoln*. 50% requires freelance illustration. Submission guidelines on website.

○ "Antarctic Press is among the top 10 publishers of comics in the United States. However, the difference in market shares between the top 5 publishers and the next 5 publishers is dramatic. Most of the publishers ranked above us have a far greater share of the market place. That being the case, we are an independent publisher with a small staff, and many of our employees have multiple responsibilities. Bigger companies would spread these responsibilities out among a larger staff. Additionally, we don't have the same financial power as a larger company. We cannot afford to pay high page rates; instead, we work on an advance and royalty system which is determined by sales or potential sales of a particular book. We pride ourselves on being a company that gives new talent a chance to get published and take a shot at comic stardom."

NEEDS Approached by 60-80 illustrators/year. Works with 12 illustrators/year. Prefers local illustrators. 100% of freelance illustration demands knowledge of Photoshop.

FIRST CONTACT & TERMS Digital submissions should be sent to Submissions Editor or David Hutchison. Do not send originals. Send copies only. Accepts e-mail submissions from illustrators. Prefers TIFF or JPEG files. Samples are filed or returned by SASE. Portfolios may be dropped off every Monday-Friday. Portfolio should include b&w, color finished art. All submissions must include finished comic book art, 10 pages minimum. Buys first rights. Rights purchased vary according to project. Finds freelancers through anthologies published, artist's submissions, Internet, word of mouth. Payment is made on royalty basis after publication.

TEXT ILLUSTRATION Negotiated.

TIPS "You must love comics and be proficient in doing sequential art."

APPALACHIAN MOUNTAIN CLUB BOOKS

5 Joy St., Boston MA 02108. (617)523-0636. **Fax:** (617)523-0722. **E-mail:** amcbooks@outdoors.org. **E-mail:** amcbooks@outdoors.org. **Website:** www. outdoors.org. Estab. 1876. Publishes trade paperback originals and reprints. Types of books include adventure, instructional, nonfiction, travel and children's nature books. Specializes in hiking guidebooks. Publishes 7-10 titles/year. Recent titles include: *Best Day Hikes*. 5% requires freelance illustration; 100% requires freelance design. Book catalog free for #10 SASE.

NEEDS Typesetting work for 7-10 books per year. Prefers local freelancers experienced in book design. 100% of freelance design demands knowledge of InDesign.

FIRST CONTACT & TERMS Designers: Send link to web portfolio. Illustrators: Send link to web portfolio. Samples are not returned. Will contact artist for portfolio review of book dummy, photocopies, photographs, tearsheets, thumbnails if interested.

DESIGN Assigns 1-3 freelance design jobs/year. Pays for design by the project, $800-1,500.

JACKETS/COVERS Assigns 1-3 illustration jobs/year.

ATHENEUM BOOKS FOR YOUNG READERS

Simon & Schuster, 1230 Avenue of the Americas, New York, NY 10020. **Website:** kids.simonandschuster.com. Estab. 1961. "Atheneum Books for Young Readers publishes books aimed at children, preschool through high school." Publishes hardcover originals, picture books for young kids, nonfiction for ages 8-12 and novels for middle-grade and young adults. Types of books include biography, historical fiction, history, nonfiction. Publishes 60 titles/year. 100% require freelance illustration. Book catalog free by request. Approached by hundreds of freelance artists/year.

NEEDS Approached by hundreds of freelance artists/year. Works with 40-50 illustrators/year. "We are interested in artists of varying media and are trying to cultivate those with a fresh look appropriate to each title." Send postcard sample of work or send query letter with tearsheets, résumé and photocopies. Samples are filed. Responds only if interested. Art director will contact artist for portfolio review if interested. Portfolio should include final art if appropriate, tearsheets, and folded and gathered sheets from any picture books you've had published. Rights purchased vary according to project. Originals are returned at job's completion. Finds artists through submissions, magazines ("I look for interesting editorial illustrators"), word of mouth.

TEXT ILLUSTRATION 100% of the books published require freelance illustration.

⌂ AUGSBURG FORTRESS PUBLISHERS

P.O. Box 1209, Minneapolis MN 55440-1209. (800)328-4648. **E-mail:** imagesub@augsburgfortress.org. **Website:** www.augsburgfortress.org. **Contact:** senior art director. Publishes hard cover and paperback Protestant/Lutheran books (90 titles/year), religious education materials, audiovisual resources, periodicals.

NEEDS Uses freelancers for marketing and product print design, illustration, video production, and web design. Freelancers should be familiar with Adobe Creative Cloud Suite. Freelancers work on contract. Bids for future assignment possibilities are sent out in conjunction with new product development, and schedules may vary. Please e-mail PDF samples or website portfolio links for review. Buys all rights on a work-fo-hire basis. Pay by project, and negotiates contracts for multi-project assignments.

FIRST CONTACT & TERMS "Please e-mail PDF samples or website portfolio links for review." Buys all rights on a work-for-hire basis. Pay by project, and negotiates contracts for multi-project assignments.

TIPS "Be knowledgeable of company product and Christian market."

BAEN BOOKS

P.O. Box 1188, Wake Forest NC 27588. (919)570-1640. **E-mail:** info@baen.com. **Website:** www.baen.com. Estab. 1983. Publishes science fiction and fantasy. Publishes 60-70 titles/year; 90% require freelance illustration/design. Book catalog free on request.

NEEDS Approached by 500 freelancers/year. Works with 10 illustrators and 3 designers/year. 50% of work demands computer skills.

FIRST CONTACT & TERMS Designers: Send query letter with résumé, color photocopies, color tearsheets and SASE. Illustrators: Send query letter with color photocopies, slides, color tearsheets and SASE. Samples are filed. Originals are returned to artist at job's completion. Buys exclusive North American book rights.

JACKETS/COVERS Pays by the project. Pays designers $200 minimum; pays illustrators $1,000 minimum.

TIPS Wants to see samples within science fiction/fantasy genre only. "Do not send b&w illustrations or surreal art. Please do not waste our time and your postage with postcards. Serious submissions only."

BARBOUR PUBLISHING, INC.

P.O. Box 719, Urichsville OH 44683. **E-mail:** submissions@barbourbooks.com. **Website:** www.barbourbooks.com. Estab. 1981. "Barbour Books publishes inspirational/devotional material that is nondenominational and evangelical in nature. We're a Christian evangelical publisher." Specializes in short, easy-to-read Christian bargain books. "Faithfulness to the Bible and Jesus Christ are the bedrock values behind every book Barbour's staff produces."

BEARMANOR MEDIA

P.O. Box 71426, Albany GA 31708. **E-mail:** books@benohmart.com. **Website:** www.bearmanormedia.com. **Contact:** Ben Ohmart, publisher. Estab. 2000. Publishes 60+ titles/year. Payment negotiable. Re-

sponds only if interested. Catalog available online or free with a 8×10 SASE submission.

TIPS "Potential freelancers should be familiar with our catalog and be computer savvy."

BECKER&MAYER!

11120 NE 33rd Place, Suite 101, Bellevue WA 98004. (425)827-7120. **Fax:** (425)828-9659. **E-mail:** infobm@ beckermayer.com. **Website:** www.beckermayer.com. Estab. 1973. Publishes nonfiction biography, humor, history and coffee table books. Publishes 100+ titles/ year. 10% require freelance design; 75% require freelance illustration. Book catalog available on website.

Ⓞ becker&mayer! is spelled in all lowercase letters with an exclamation mark.

NEEDS Works with 6 designers and 20-30 illustrators/year. Freelance design work demands skills in InDesign, Illustrator, Photoshop. Freelance illustration demands skills in Illustrator, Photoshop.

FIRST CONTACT & TERMS Designers: Send query letter with résumé and tearsheets. Illustrators: Send query letter, nonreturnable postcard sample, résumé and tearsheets. Does not accept e-mail submissions. Samples are filed. Responds only if interested. Will request portfolio review of color finished art, roughs, thumbnails, and tearsheets, only if interested. Rights purchased vary according to project.

TEXT ILLUSTRATION Assigns 30 freelance illustration jobs a year. Pays by the project.

TIPS "No phone calls!"

Ⓞ BLUE DOLPHIN PUBLISHING, INC.

P.O. Box 8, Nevada City CA 95959-0008. (530)477-1503. **Fax:** (530)265-0603. **E-mail:** bdolphin@ bluedolphinpublishing.com. **Website:** www. bluedolphinpublishing.com. **Contact:** Paul M. Clemens, president. Estab. 1985. Publishes hardcover and trade paperback originals. Types of books include biography, cookbooks, humor and self-help. Specializes in comparative spiritual traditions, lay psychology and health. Recent titles include *Vegan Inspiration, Consciousness Is All, Embracing the Miraculous, Mary's Message to the World, The Fifth Tarot,* and *The Fifth Gospel.* Publishes 20 titles/year; 25% require freelance illustration; 30% require freelance design. Books are "high quality on good paper, with laminated dust jacket and color covers." Book catalog free upon request.

NEEDS Works with 5-6 freelance illustrators and designers/year. Uses freelancers mainly for book cover design; also for jacket/cover and text illustration. "More hardcovers and mixed media are requiring box design as well." 50% of freelance work demands knowledge of PageMaker, QuarkXPress, FreeHand, Illustrator, Photoshop, CorelDraw, InDesign and other IBM-compatible programs. Works on assignment only.

FIRST CONTACT & TERMS Send postcard sample or query letter with brochure and photocopies. Samples are filed or are returned by SASE if requested. Responds "whenever work needed matches portfolio." Originals are returned to artist at job's completion. Sometimes requests work on spec before assigning job. Considers project's budget when establishing payment. Negotiates rights purchased. Considers buying second rights (reprint rights) to previously published work.

DESIGN Assigns 3-5 jobs/year. Pays by the hour, $10-15; or by the project, $300-900.

JACKETS/COVERS Assigns 5-6 design and 5-6 illustration jobs/year. Pays by the hour, $10-15; or by the project, $300-900.

TEXT ILLUSTRATION Assigns 1-2 jobs/year. Pays by the hour, $10-15; or by the project, $300-900.

TIPS "Send query letter with brief sample of style of work. We usually use local people, but are always looking for something special. Learning good design is more important than designing on the computer, but we are very computer-oriented. Basically we look for original artwork of any kind that will fit the covers for the subjects we publish. Please see our online catalog of over 250 titles to see what we have selected so far."

Ⓞ BLUEWOOD BOOKS

242 Aragon Blvd., San Mateo CA 94402. (650)548-0754. **Fax:** (650)548-0654. **E-mail:** bluewoodb@aol. com. Estab. 1990. Publishes trade paperback originals. Types of books include biography, history, nonfiction, and young adult. Publishes 4-10 titles/year. Titles include: *True Stories of Baseball's Hall of Famers, 100 Scientists Who Shaped World History,* and *American Politics in the 20th Century.* 100% require freelance illustration; 75% require freelance design. Catalog not available.

NEEDS Works with 5 illustrators and 3 designers/ year. Prefers local freelancers experienced in realis-

tic, b&w line illustration and book design. Uses free-lancers mainly for illustration and design. 80-100% of freelance design demands knowledge of Photoshop, Illustrator and QuarkXPress. 80-100% of freelance illustration demands knowledge of FreeHand, Photoshop, Illustrator and QuarkXPress.

FIRST CONTACT & TERMS Designers: Send query letter with brochure, photocopies, résumé, SASE and tearsheets. Illustrators: Send query letter with photocopies, résumé, SASE and tearsheets. Samples are filed. Responds only if interested. Will contact artist for portfolio review of photocopies, photographs, roughs, slides, tearsheets, thumbnails and transparencies if interested. Buys all rights.

DESIGN Assigns 4-10 freelance design jobs/year. Pays by the hour or project.

JACKETS/COVERS Pays by the project, $150-200 for color.

TEXT ILLUSTRATION Assigns 4-10 freelance illustration jobs/year. Pays $15-30 for each b&w illustration. Finds freelancers through submissions.

NICHOLAS BREALEY PUBLISHING

53 State St., 9th Floor, Boston MA 02109. (617)523-3801. **Fax:** (617)523-3708. **Website:** www.nicholasbrealey.com. **Contact:** Aquisitions Editor. Estab. 1992. Publishes paperback and hardcover originals. Types of books include text and reference. Specializes in global business, popular psychology, travel memoir, and crossing cultures. Recent titles: *Co-Active Coaching*, 3rd ed. by Henry Kimsey-House, Karen Kimsey-House and Phillip Sandahl; *Around India in 80 Trains* by Monisha Rajesh; *Breakthrough Branding* by Catherine Kaputa. Publishes 20 titles/year. Book catalog free by request.

NEEDS Approached by 20 freelancers/year. Works with 2-3 freelance illustrators/year. Prefers freelancers with experience in trade books, multicultural field. Uses freelancers mainly for jacket/cover design and illustration. 100% of freelance work demands knowledge of Illustrator, Photoshop, InDesign, and Quark.

FIRST CONTACT & TERMS Send query letter with brochure, tearsheets, résumé, and photocopies. Samples are filed or are returned by SASE if requested by artist. Will contact artist for portfolio review if interested. Portfolio should include b&w final art. Buys all rights. Originals are not returned. Finds artists through submissions and word of mouth.

JACKETS/COVERS Assigns 6 freelance illustration jobs/year. Pays by the project, $300-500.

TIPS First-time assignments are usually book jackets only; book jackets with interiors (complete projects) are given to "proven" freelancers. "We look for artists who have flexibility with schedule and changes to artwork. We appreciate an artist who will provide artwork that doesn't need special attention by prepress in order for it to print properly.

BROOKS/COLE PUBLISHING COMPANY

Cengage Learning, 10650 Toebben Dr., Independence, KY 41051. (800)354-9706. **Fax:** (800)487-8488. **Website:** www.brookscole.com; www.cengage.com. **Contact:** Art director. Estab. 1967. Specializes in hardcover and paperback college textbooks on mathematics, chemistry, earth sciences, physics, computer science, engineering and statistics. Publishes 100 titles/year. 85% requires freelance illustration. Books are bold, contemporary textbooks for college level.

NEEDS Works with 25 freelance illustrators and 25 freelance designers/year. Uses freelance artists mainly for interior illustration. Uses illustrators for technical line art and covers. Uses designers for cover and book design and text illustration. Also uses freelance artists for jacket/cover illustration and design. Works on assignment only.

FIRST CONTACT & TERMS Send query letter with brochure, résumé, tearsheets and photographs. Samples are filed or are returned by SASE. Art director will contact artist for portfolio review if interested. Portfolio should include roughs, tearsheets, final reproduction/product, photographs, slides and transparencies. Considers complexity of project, skill and experience of artist, project's budget and turnaround time in determining payment. Negotiates rights purchased. Not interested in second rights to previously published work unless first used in totally unrelated market. Finds illustrators and designers through word of mouth, magazines, submissions/self promotion, sourcebooks, and agents.

DESIGN Assigns 70 design and many illustration jobs/year. Pays by the project.

JACKETS/COVERS Assigns 90 design and many illustration jobs/year. Pays by the project.

TEXT ILLUSTRATION Assigns 85 freelance jobs/year. Prefers ink/Macintosh. Pays by the project.

TIPS "Provide excellent package in mailing of samples and cost estimates. Follow up with phone call.

Don't be pushy. Would like to see abstract and applied photography/illustration; single strong, memorable bold images."

CANDLEWICK PRESS

99 Dover St., Somerville MA 02144. (617)661-3330. **Fax:** (617)661-0565. **E-mail:** bigbear@candlewick. com. **Website:** www.candlewick.com. Estab. 1991. Publishes hardcover, trade paperback children's books. Publishes 200 titles/year. 100% require freelance illustration. Book catalog not available. Works with approx. 170 illustrators/year.

FIRST CONTACT & TERMS "If you think your illustration style is well-suited to our list, you may contact our art coordination associate by e-mail at illustratorsubmissions@candlewick.com. No phone calls or office visits please! We prefer to receive a link to your website or online portfolio with a brief summary highlighting relevant professional and publishing experience in the covering e-mail. If you would like to include specific samples, please attach JPEGs to your e-mail and ensure your name is present in the file name. We will contact you if we have or anticipate a project that suits your particular talents."

TEXT ILLUSTRATION Finds illustrators through agents, word of mouth, submissions, art schools. "We generally use illustrators with prior trade book experience."

CAPSTONE PRESS

1710 Roe Crest Dr., North Mankato MN 56003. (800)747-4992. **Fax:** (888)262-0705. **E-mail:** nf.il. sub@capstonepub.com;il.sub@capstonepub.com. **Website:** www.capstonepress.com. **Contact:** Dede Barton, photo director. Estab. 1991. Publishes juvenile nonfiction and educational books. Subjects include animals, ethnic groups, vehicles, sports, history, scenics. Photos used for text illustrations, promotional materials, book covers. "To see examples of our products, please visit our website." Submission guidelines available online.

FIRST CONTACT & TERMS Send query letter with stock list. E-mail résumé, sample artwork, and a list of previous publishing credits if applicable. Accepts images in digital format for submissions as well as for use. Digital images must be at least 8×10 at 300 dpi for publishing quality (TIFF, EPS or original camera file format preferred). Keeps samples on file. Responds in 6 months. Simultaneous submissions and previously published work OK. Pays after publication. Credit line

given. Looking to buy worldwide all language rights for print and digital rights. Producing online projects (interactive websites and books); printed books may be bound up into binders.

TIPS "Be flexible. Book publishing usually takes at least 6 months. Capstone does not pay holding fees. Be prompt. The first photos in are considered for covers first."

CENTERSTREAM PUBLICATION LLC

P.O. Box 17878, Anaheim CA 92817. (714)779-9390. **E-mail:** centerstrm@aol.com. **Website:** www. centerstream-usa.com. **Contact:** Ron Middlebrook, owner. Estab. 1982. "Centerstream is known for its unique publications for a variety of instruments. From instructional and reference books and biographies, to fun song collections and DVDs, our products are created by experts who offer insight and invaluable information to players and collectors." Publishes DVDs, audio tapes, and hardcover and softcover originals. Types of books include music reference, biography, music history and music instruction. Publishes 10-20 titles/year. Samples are not filed and are returned by SASE. Responds only if interested. Rights purchased vary according to project.

FIRST CONTACT & TERMS Accepts Mac-compatible submissions.

TEXT ILLUSTRATION 100% requires freelance illustration. Works with 3 illustrators/year. Approached by 12 illustrators/year.

CHURCH PUBLISHING INC.

19 E. 34th St., New York NY 10016. (800)223-6602. **Fax:** (212)779-3392. **E-mail:** nabryan@cpg.org. **Website:** www.churchpublishing.org. **Contact:** Nancy Bryan, editorial director. Estab. 1884. Company publishes trade paperback and hardcover originals and reprints. Specializes in spirituality, Christianity/contemporary issues.

NEEDS Works with illustrators as needed.

FIRST CONTACT & TERMS Samples are filed. Usually buys one-time rights. Finds artists through freelance submissions and web.

CLARION BOOKS

Houghton Mifflin Co., 215 Park Ave. S., New York NY 10003. **Website:** www.hmhco.com. Estab. 1965. Imprint publishes hardcover originals and trade paperback reprints. Book catalog free with SASE. Approached by "countless" freelancers. Works with 48

freelance illustrators/year. Uses freelancers mainly for picture books and novel jackets. Also for jacket/cover and text illustration. Pays by the project. "Be familiar with the type of books we publish before submitting. Send a SASE for a catalog or look at our books in the bookstore."

NEEDS Picture books, chapter books, middle grade novels and nonfiction, including historical and animal behavior. Publishes 60 titles/year. 90% requires freelance illustration.

FIRST CONTACT & TERMS Send children's book-related samples. Send query letter with tearsheets and photocopies. Samples are filed "if suitable to our needs." Responds only if interested. Portfolios may be dropped off every Monday. Art director will contact artist for portfolio review if interested. Rights purchased vary according to project. Originals are returned at job's completion.

TEXT ILLUSTRATION Assigns 48 freelance illustration jobs/year.

CRC MINISTRY SUPPORT SERVICES

1700 28th St. SE, Grand Rapids MI 49508-1407. (616)224-0780. **Fax:** (616)224-0834. **E-mail:** dheetderks@crcna.org. **Website:** www.crcna.org. Estab. 1866. Publishes hardcover and trade paperback originals and magazines. Types of books include instructional, religious, young adult, reference, juvenile and preschool. Specializes in religious educational materials. Publishes 4-6 titles/year. 85% require freelance illustration. 5% require freelance art direction.

NEEDS Approached by 30-45 freelancers/year. Works with 12-16 freelance illustrators/year. Prefers freelancers with religious education, cross-cultural sensitivies. Uses freelancers for jacket/cover and text illustration. Works on assignment only.

FIRST CONTACT & TERMS Send query letter with brochure, résumé, tearsheets, photographs, photocopies. Submissions will not be returned. Buys one-time rights. Originals are returned at job's completion.

JACKETS/COVERS Assigns 2-3 freelance illustration jobs/year. Pays by the project, $300-1,000.

TIPS "Be absolutely professional. Know how people learn and be able to communicate a concept clearly in your art."

CYCLE PUBLICATIONS, INC.

Van der Plas Publications, 1282 Seventh Ave., San Francisco CA 94112. (415)665-8214. **Fax:** (415)753-8572. **Website:** www.cyclepublishing.com. Estab. 1985. Book publisher. Publishes trade paperback originals. Types of books include instructional and travel. Specializes in subjects relating to cycling and bicycles. Publishes 6 titles/year. 20% require freelance illustration. Book catalog for SASE with first-class postage.

NEEDS Approached by 5 freelance artists/year. Buys 100 freelance illustrations/year. Uses freelance artists mainly for technical (perspective) and instructions (anatomically correct hands, posture). Also uses freelance artists for text illustration; line drawings only. Also for design. 50% of freelance work demands knowledge of CorelDraw and FreeHand. Works on assignment only.

FIRST CONTACT & TERMS Send query letter with tearsheets. Accepts disk submissions. Please include printout with EPS files. Samples are filed. Call "but only after we have responded to query." Portfolio should include photostats. Rights purchased vary according to project. Originals are not returned to the artist at the job's completion.

DESIGN Pays by the project.

TEXT ILLUSTRATION Assigns 5 freelance illustration jobs/year. Pays by the project.

TIPS "Show competence in line drawings of technical subjects and 2-color maps."

DA CAPO PRESS

Perseus Books Group, 44 Farnsworth St., 3rd Floor, Boston MA 02210. (617)252-5200. **Website:** www.dacapopress.com. Estab. 1975. Publishes hardcover originals, trade paperback originals, trade paperback reprints. Types of books include self-help, parenting, biography, memoir, coffee table books, history, travel, music, and film. Specializes in self-help, parenting, music and history (trade). Publishes 100 titles/year. 25% requires freelance design; 5% requires freelance illustration.

NEEDS Approached by 30+ designers and 30+ illustrators/year. Works with 10 designers and 1 illustrator/year.

FIRST CONTACT & TERMS Send query letter with résumé, URL, color prints/copies. Send follow-up postcard sample every 6 months. Prefers Mac-compatible, JPEG, and PDF files. Samples are filed. Responds only if interested. Portfolios may be dropped

off every Wednesday, Thursday and Friday and should include finished, printed samples. Rights purchased vary according to project. Finds freelancers through art competitions, artist submissions, Internet and word of mouth.

JACKETS/COVERS Assigns 20 freelance cover illustration jobs/year.

TIPS "Visit our website to view work produced/assigned by Da Capo."

DARK HORSE

10956 SE Main St., Milwaukie OR 97222. (503)652-8815. **Fax:** (503)654-9440. **E-mail:** dhcomics@darkhorse.com. **Website:** www.darkhorse.com. **Contact:** Submissions Dept. Estab. 1986. Publishes mass market and trade paperback originals. Types of books include comic books and graphic novels. Specializes in comic books. Book catalog available on website.

FIRST CONTACT & TERMS Send photocopies (clean, sharp, with name, address and phone number written clearly on each page). Do not submit via fax or e-mail. Samples are not filed and not returned. Responds only if interested. Company will contact artist for portfolio review if interested. Please see website for more detail guidelines.

TIPS "If you're looking for constructive criticism, show your work to industry professionals at conventions."

JONATHAN DAVID PUBLISHERS, INC.

68-22 Eliot Ave., Middle Village NY 11379. (718)456-8611. **Fax:** (718)894-2818. **Website:** www.jdbooks.com. **Contact:** David Kolatch, editorial director. Estab. 1948. Publishes hardcover and paperback originals. Types of books include biography, religious, young adult, reference, juvenile and cookbooks. Specializes in Judaica. Titles include: *Drawing a Crowd* and *The Presidents of the United States & the Jews*. Publishes 25 titles/year. 50% require freelance illustration; 75% require freelance design.

NEEDS Approached by numerous freelancers/year. Works with 5 freelance illustrators and 5 designers/year. Prefers freelancers with experience in book jacket design and jacket/cover illustration. 100% of design and 5% of illustration demand computer literacy. Works on assignment only.

FIRST CONTACT & TERMS Designers: Send query letter with résumé and photocopies. Illustrators: Send postcard sample and/or query letter with photocop-

ies, résumé. Samples are filed. Production coordinator will contact artist for portfolio review if interested. Portfolio should include color final art and photographs. Buys all rights. Originals are not returned. Finds artists through submissions.

DESIGN Assigns 15-20 freelance design jobs/year. Pays by the project.

JACKETS/COVERS Assigns 15-20 freelance design and 4-5 illustration jobs/year. Pays by the project.

TIPS First-time assignments are usually book jackets, mechanicals and artwork.

DAW BOOKS, INC.

Penguin Random House, 375 Hudson St., New York NY 10014-3658. (212)366-2096. **Fax:** (212)366-2090. **E-mail:** daw@us.penguingroup.com. **Website:** www.dawbooks.com. **Contact:** Peter Stampfel, submissions editor. Estab. 1971. Publishes hardcover and mass market paperback originals and reprints. Specializes in science fiction and fantasy. Publishes 72 titles/year. All require freelance illustration. Guidelines available on website.

NEEDS Works with numerous illustrators and 1 designer/year. Buys more than 36 illustrations/year. Works with illustrators for covers. Works on assignment only.

FIRST CONTACT & TERMS Send postcard sample or query letter with brochure, résumé, tearsheets, transparencies, photocopies, photographs and SASE. "Please don't send slides." Samples are filed or are returned by SASE only if requested. Responds in 3 days. Originals returned at job's completion. Call for appointment to show portfolio of original/final art, final reproduction/product and transparencies. Considers complexity of project, skill and experience of artist and project's budget when establishing payment. Buys first rights and reprint rights.

JACKETS/COVERS Pays by the project. "Our covers illustrate the story."

TIPS "We have a drop-off policy for portfolios. We accept them on Tuesdays, Wednesdays and Thursdays and report back within a day or so. Portfolios should contain science fiction and fantasy color illustrations *only*. We do not want to see anything else. Look at several dozen of our covers."

DC COMICS

1700 Broadway, 5th Floor, New York NY 10019-5905. (212)636-5400. **Website:** www.dccomics.com. Es-

tab. 1948. Publishes hardcover originals and reprints, mass market paperback originals and reprints, trade paperback originals and reprints. Types of books include adventure, comic books, fantasy, horror, humor, juvenile, science fiction. Specializes in comic books. Publishes 1,000 titles/year.

○ DC Comics does not accept unsolicited submissions. During a convention visit, drop off photocopied samples of your work. If representatives like what they see, a time is schedule for you the following day to meet a representative personally and discuss your artistic interests and portfolio.

DIAL BOOKS FOR YOUNG READERS

Imprint of Penguin Group (USA), 345 Hudson St., New York NY 10014. (212)366-2000. **Website:** www. penguin.com/children. Estab. 1961. Specializes in juvenile and young adult hardcover originals. Publishes 50 titles/year. 100% require freelance illustration. Books are "distinguished children's books."

NEEDS Approached by 400 freelancers/year. Works with 40 freelance illustrators/year. Prefers freelancers with some book experience. Works on assignment only.

FIRST CONTACT & TERMS Send query letter with photocopies, tearsheets and SASE. Samples are filed or returned by SASE. Responds only if interested. Considers complexity of project, skill and experience of artist and project's budget when establishing payment. Rights purchased vary.

JACKETS/COVERS Assigns 8 illustration jobs/year. Pays by the project.

TEXT ILLUSTRATION Assigns 40 freelance illustration jobs/year. Pays by the project.

TIPS "Never send original art. Never send art by e-mail, fax, or CD. Please do not phone, fax or e-mail to inquire after your art submission."

⚙ DUTTON CHILDREN'S BOOKS

Penguin Random House, 375 Hudson St., New York, NY 10014. **Website:** www.penguin.com. **Contact:** Julie Strauss-Gabel, vice president and publisher. Estab. 1852. Publishes hardcover, trade picture books and illustrated middle grade. Publishes 50-75 titles/year.

NEEDS Prefers local designers.

FIRST CONTACT & TERMS Send postcard sample, printed samples, tearsheets. Samples are filed or returned by SASE. Will contact artist for portfolio review if interested. Portfolios may be dropped off every Tuesday and picked up by end of the day. Do not send samples via e-mail.

JACKETS/COVERS Pays for illustration by the project $1,800-2,500.

⚙ EDWARD ELGAR PUBLISHING, INC.

The William Pratt House, 9 Dewey Ct., Northampton MA 01060. (413)584-5551. **Fax:** (413)584-9933. **E-mail:** elgarinfo@e-elgar.com. **Website:** www.e-elgar.com. Estab. 1986. Publishes hardcover originals and textbooks. Types of books include instructional, non-fiction, reference, textbooks, academic monographs, references in economics and business and law. Publishes 200 titles/year.

○ This publisher uses only freelance designers. Its academic books are produced in the United Kingdom. Direct marketing material is done in US. There is no call for illustration.

NEEDS Prefers local designers experienced in direct mail and academic publishing. 100% of freelance design demands knowledge of Photoshop, InDesign.

FIRST CONTACT & TERMS Send query letter with printed samples. Accepts Mac-compatible disk submissions. Samples are filed. Will contact artist for portfolio review if interested. Buys one-time rights or rights purchased vary according to project. Finds freelancers through word of mouth, local sources (i.e., phone book, newspaper, etc.).

FALCONGUIDES

246 Goose Lane, P.O. Box 480, Guilford CT 06437. (203)458-4500. **Website:** www.falcon.com. Book publisher. The Falcon line specializes in outdoor recreation topics such as hiking, biking, climbing, surfing, and other areas.

FIRST CONTACT & TERMS "We welcome solicited and unsolicited submissions from authors, agents and book packagers sent in hard copy by mail or other shipping carrier. We will not return any materials without a SASE containing sufficient postage. Never send original copies. We aren't responsible for the loss of any materials sent to us. No calls, please, unless you are a professional literary agent or have a book contract with GPP. Proposals should only be e-mailed to an editor by request." See website for complete proposal guidelines.

FANTAGRAPHICS BOOKS, INC.

7563 Lake City Way NE, Seattle WA 98115. (206)524-1967. **Fax:** (206)524-2104. **Website:** www. fantagraphics.com. **Contact:** Submissions Editor. Estab. 1976. Publishes hardcover and trade paperback originals and reprints. Types of books include contemporary, experimental, mainstream, historical, humor and erotic. "All our books are comic books or graphic stories." Publishes 100 titles/year. 10% require freelance illustration. Book catalog free by request. Art submission guidelines available on website.

○　See additional listing in the Magazines section.

NEEDS Approached by 500 freelancers/year. Works with 25 freelance illustrators/year. Must be interested in and willing to do comics. Uses freelancers for comic book interiors and covers.

FIRST CONTACT & TERMS Send query letter addressed to Submissions Editor with résumé, SASE, photocopies and finished comics work. Samples are not filed and are returned by SASE. Responds only if interested. Call or write for appointment to show portfolio of original/final art and b&w samples. Buys one-time rights or negotiates rights purchased. Originals are returned at job's completion. Pays royalties.

TIPS "We want to see completed comics stories. We don't make assignments, but instead look for interesting material to publish that is preexisting. We want cartoonists who have an individual style, who create stories that are personal expressions."

FARRAR, STRAUS & GIROUX FOR YOUNG READERS

Macmillan Children's Publishing Group, 175 Fifth Ave., New York NY 10010. (212)741-6900. **Fax:** (212)633-2427. **E-mail:** childrens.editorial@fsgbooks. com. **Website:** www.fsgkidsbooks.com. Estab. 1946. Book publisher. Publishes hardcover and trade paperback originals and trade paperback reprints. Publishes nonfiction and juvenile fiction. Publishes 200 titles/year. 20% require freelance illustration; 40% freelance design.

NEEDS Works with 12 freelance designers and 3-5 illustrators/year. Uses artists for jacket/cover and book design.

FIRST CONTACT & TERMS Submission guidelines available online.

DESIGN Assigns 40 freelance design jobs/year. Pays by the project.

JACKETS/COVERS Assigns 20 freelance design jobs/year and 10-15 freelance illustration jobs/year. Pays by the project.

TIPS The best way for a freelance illustrator to get an assignment is "to have a great portfolio."

FIRST BOOKS/INKWATER PRESS

6750 SW Franklin St., Suite A, Portland OR 97223. (503)968-6777. **Fax:** (503)968-6779. **E-mail:** design@ inkwaterpress.com. **Website:** www.inkwaterpress. com; www.inkwater.com. Estab. 1988. Publishes trade paperback originals. Publishes 100+ titles/year. 5% require freelance illustration.

NEEDS Works with 5 designers and 5 illustrators/ year. Uses freelance designers not illustrators mainly for interiors and covers.

FIRST CONTACT & TERMS Designers: Send any samples you want to send and SASE but *no original art.* Illustrators: Send query letter with a few photocopies or slides. Samples are filed or returned by SASE. Rights purchased vary according to project.

DESIGN Payment varies per assignment.

TIPS "Small samples get looked at more than anything bulky and confusing. Little samples are better than large packets and binders. Postcards are easy. Save a tree!"

FULCRUM PUBLISHING

4690 Table Mountain Dr., Suite 100, Golden CO 80403. **E-mail:** acquisitions@fulcrumbooks.com. **Website:** www.fulcrum-books.com. **Contact:** T. Baker, acquisitions editor. Estab. 1984. Publishes hardcover originals and trade paperback originals and reprints. Types of books include biography, Native American, reference, history, self help, children's, teacher resource books, travel, humor, gardening and nature. Specializes in history, nature, teacher resource books, travel, Native American, environmental and gardening. Publishes 30 titles/year. 15% requires freelance illustration; 15% requires freelance design. Book catalog free by request.

NEEDS Uses freelancers mainly for jacket/covers, text illustration, and book design. Works on assignment only.

FIRST CONTACT & TERMS We are a green company and therefore only accept e-mailed queries/ portfolios. Paper queries submitted via US Mail or any other means (including fax, FedEx/UPS, and even door-to-door delivery) will not be reviewed or

returned. Please help us support the preservation of the environment by e-mailing your query to acquisitions@fulcrumbooks.com.

DESIGN Pays by the project.

JACKETS/COVERS Pays by the project.

TEXT ILLUSTRATION Pays by the project.

TIPS Previous book design experience a plus.

GALISON/MUDPUPPY PRESS

28 W. 44th St., Suite 1411, New York NY 10036. (800)670-7441. **Fax:** (212)391-4037. **E-mail:** juanita@galison.com; ideas@galison.com. **Website:** www.galison.com. **Contact:** Juanita Dharmazi-Virani, art director. Publishes note cards, journals, stationery, children's products. Publishes 120 titles/year.

NEEDS Works with 20 illustrators. Some freelance design demands knowledge of Photoshop, Illustrator and QuarkXPress.

FIRST CONTACT & TERMS "To submit your artwork for consideration, please e-mail a letter and PDF files to juanita@galison.com. For Mudpuppy children's products, please submit artwork for consideration to cynthia@galison.com. We will contact you if a suitable project arises."

GALLAUDET UNIVERSITY PRESS

800 Florida Ave. NE, Washington DC 20002-3695. (202)651-5488. **Fax:** (202)651-5489. **E-mail:** gupress@gallaudet.edu. **Website:** gupress.gallaudet.edu. **Contact:** Ivey Pittle Wallace, assistant director (editorial). Estab. 1980. Publishes hardcover and trade paperback originals, hardcover and trade paperback reprints, DVDs, videotapes and textbooks. Types of books include reference, biography, coffee table books, history, instructional and textbook nonfiction. Specializes in books related to deafness. Publishes 12-15 new titles/year. 90% requires freelance design; 2% requires freelance illustration. Book catalog free on request.

NEEDS Approached by 10-20 designers and 30 illustrators/year. Works with 15 designers/year. 100% of freelance design work demands knowledge of Illustrator, PageMaker, Photoshop, and QuarkXPress.

FIRST CONTACT & TERMS Send query letter with postcard sample with résumé, sample of work, and URL. After introductory mailing, send follow-up postcard sample every 6 months. Accepts disk submissions. Prefers Windows-compatible, PDF files. Samples are filed. Responds only if interested. Company will contact artist for portfolio review if interest-

ed. Portfolio should include color finished art. Rights purchased vary according to project. Finds freelancers through Internet and word of mouth.

TIPS "Do not call us."

GIBBS SMITH

P.O. Box 667, Layton UT 84041. (801)544-9800. **Fax:** (801)544-8853. **E-mail:** debbie.uribe@gibbs-smith.com. **Website:** www.gibbs-smith.com. Estab. 1969. Imprints include Sierra Book Club for Children and Hill Street Press. Company publishes hardcover and trade paperback originals. Types of books include children's activity books, architecture and design books, cookbooks, humor, juvenile, western. Publishes 100 titles/year. 10% requires freelance illustration; 90% requires freelance design.

NEEDS Approached by 250 freelance illustrators and 50 freelance designers/year. Works with 5 freelance illustrators and 15 designers/year. Designers may be located anywhere with broadband service. Uses freelancers mainly for cover design and book layout, cartoon illustration, children's book illustration. 100% of freelance design demands knowledge of QuarkXPress or InDesign. 70% of freelance illustration demands knowledge of Photoshop, Illustrator and FreeHand.

DESIGN Assigns 90 freelance design jobs/year. Pays by the project.

JACKETS/COVERS Assigns 90 freelance design jobs and 5 illustration jobs/year. Pays for design by the project. Pays for illustration by the project.

TEXT ILLUSTRATION Pays by the project.

GLENCOE

McGraw-Hill Education, P.O. Box 182605, Columbus OH 43218. (646) 766-2574 or (800) 334-7344. **E-mail:** mhe_cust_service@mcgraw-hill.com. **Website:** www.glencoe.com; MHEonline.com. Estab. 1965. Publishes textbooks. Types of books include marketing and career education, art and music, health, computer technology. Specializes in most el-hi (grades 7-12) subject areas, as well as postsecondary career subjects. Publishes 350 titles/year.

○ Glencoe also has divisions in Peoria IL and Columbus OH with separate art departments.

NEEDS Approached by 50 freelancers/year. Works with 10-20 freelance illustrators and 10-20 designers/year. Prefers experienced artists. Uses freelance artists mainly for illustration and production. Also for jacket/cover design and illustration, text illustration and book design. 100% of design and 50% of illustra-

tion demand knowledge of Adobe, InDesign, or Illustrator on Mac. Works on assignment only.

FIRST CONTACT & TERMS Send nonreturnable samples. Accepts disk submissions compatible with above program. Samples are filed. Sometimes requests work on spec before assigning a job. Negotiates rights purchased. Originals are not returned.

DESIGN Assigns 10-20 freelance design and many illustration jobs/year. Pays by the project.

JACKETS/COVERS Assigns 10-20 freelance design jobs/year. Pays by the project.

TEXT ILLUSTRATION Assigns 20-30 freelance design jobs/year. Pays by the project.

GLOBE PEQUOT PRESS

246 Goose Lane, P.O. Box 480, Guilford CT 06437. (203)458-4500. **Website:** www.globepequot.com. **Contact:** design department. Estab. 1947. Publishes hardcover and trade paperback originals and reprints. Types of books include (mostly) travel, kayak, outdoor, cookbooks, instruction, self-help and history. Specializes in regional subjects New England, Northwest, Southeast bed-and-board country inn guides. Publishes 600 titles/year. 20% require freelance illustration; 75% require freelance design. Design of books is "classic and traditional, but fun." Book catalog available.

NEEDS Works with 10-20 freelance illustrators and 15-20 designers/year. Uses freelancers mainly for cover and text design and production. Also for jacket/cover and text illustration and direct mail design. Needs computer-literate freelancers for production. 100% of design and 75% of illustration demand knowledge of QuarkXPress 3.32, Illustrator 7.0, or Photoshop 5. Works on assignment only.

FIRST CONTACT & TERMS Send query letter with résumé, photocopies, and photographs. Accepts disk submissions compatible with QuarkXPress 3.32, Illustrator 7.0, or Photoshop 5. Samples are filed and not returned. Request portfolio review in original query. "Due to the volume of inquiries, we are unable to respond individually unless suitable work is available at that time." Art director will contact artist for portfolio review if interested. Portfolio should include roughs, original/final art, photostats, tearsheets, and dummies. Requests work on spec before assigning a job. Considers complexity of project, project's budget, and turnaround time when establishing payment. Buys all rights. Originals are not returned. Finds artists through word of mouth, submissions, self promotion, and sourcebooks.

DESIGN Pays by the hour or by the project for cover design.

JACKETS/COVERS Prefers realistic style. Pays by the hour or by the project.

TEXT ILLUSTRATION Pays by the project. Mostly b&w illustration, preferably computer-generated.

TIPS "Our books are being produced on Macintosh computers. We like designers who can use the Mac competently enough that their design looks as if it *hasn't* been done on the Mac."

GRAYWOLF PRESS

250 Third Ave. N., Suite 600, Minneapolis MN 55401. (651)641-0077. **Fax:** (651)641-0036. **Website:** www.graywolfpress.org. Estab. 1974. Publishes hardcover originals, trade paperback originals and reprints. Specializes in novels, nonfiction, memoir, poetry, essays and short stories. Publishes 30 titles/year. 100% require freelance cover design. Books use solid typography, strikingly beautiful and well-integrated artwork. Graywolf is recognized as one of the finest small presses in the nation.

NEEDS Works with 7 designers/year. Buys 25 illustrations/year (existing art only). Uses freelancers mainly for cover design only. Works on assignment only.

FIRST CONTACT & TERMS Send query letter with résumé and photocopies. Samples are returned by SASE if requested by artist. Editorial director will contact artist for portfolio review if interested. Portfolio should include b&w, color photostats and tearsheets. Negotiates rights purchased. Originals are returned at job's completion. Pays by the project.

JACKETS/COVERS Assigns 25 design jobs/year. Pays by the project, $800-1,200.

TIPS "Have a strong portfolio of literary (fine press) design."

GREENWOOD PUBLISHING

ABC-CLIO, P.O. Box 1911, Santa Barbara CA 93116-1911. (805)968-1911. **E-mail:** editorial@abc-clio.com; ccasey@abc-clio.com. **Website:** www.greenwood.com. **Contact:** Cathleen Casey, acquisitions department/Greenwood. Estab. 1964. (Formerly Libraries Unlimited/Teacher Ideas Press.) Specializes in hardcover and paperback original reference books concerning library science and school media for librarians, educa-

tors and researchers. Also publishes in resource and activity books for teachers. Publishes more than 60 titles/year. Book catalog free by request.

NEEDS Works with 4-5 freelance artists/year.

FIRST CONTACT & TERMS Designers send query letter with résumé and photocopies. Illustrators send query letter with photocopies. Samples not filed are returned only if requested. Considers complexity of project, skill and experience of artist, and project's budget when establishing payment. Buys all rights. Originals not returned.

JACKETS/COVERS Assigns 4-6 design jobs/year. Pays by the project, $500 minimum.

TEXT ILLUSTRATION Assigns 2-4 illustration jobs/year. Pays by the project.

TIPS "We look for the ability to draw or illustrate without overly loud cartoon techniques. Freelancers should have the ability to use 2-color effectively, with screens and screen builds. We ignore anything sent to us that is in 4-color. We also need freelancers with a good feel for typefaces."

GROSSET & DUNLAP

Penguin Group Publishers, 375 Hudson St., New York NY 10014-3657. (212)366-2000. **Website:** us.penguingroup.com. Publishes hardcover, trade paperback, and mass market paperback originals and board books for preschool and juvenile audience (ages 1-10). Specializes in "very young mass market children's books." Publishes more than 200 titles/year. 100% require freelance illustration; 10% require freelance design. Grosset & Dunlap publishes children's books that examine new ways of looking at the world of children. Many books by this publisher feature unique design components such as acetate overlays, 3D pop-up pages, or actual projects/toys that can be cut out of the book.

NEEDS Works with 100 freelance illustrators and 10 freelance designers/year. Buys 80 books' worth of illustrations/year. "Be sure your work is appropriate for our list." Uses freelance artists mainly for book illustration. Also for jacket/cover and text illustration and design. 100% of design and 50% of illustration demand knowledge of Illustrator 5.5, QuarkXPress 3.3, and Photoshop 2.5.

FIRST CONTACT & TERMS Designers: Send query letter with website address and tearsheets. Illustrators: Send postcard sample or query letter with résumé, photocopies, SASE, and tearsheets. Samples are

filed. Responds to the artist only if interested. Call for appointment to show portfolio, or mail slides, color tearsheets, transparencies and dummies. Rights purchased vary according to project. Originals are returned at job's completion.

⊕ GROUP PUBLISHING

1515 Cascade Ave., Loveland CO 80538. (970)669-3836 or (800)447-1070. **Fax:** (970)292-4373. **E-mail:** info@group.com. **Website:** www.group.com. Company publishes books, Bible curriculum products (including puzzles, posters, etc.), clip art resources and audiovisual materials for use in Christian education for children, youth and adults. Publishes 35-40 titles/year. Recent titles include: *Group's Scripture Scrapbook* series; *The Dirt on Learning*; *Group's Hands-On Bible Curriculum*; *Group's Treasure Serengeti Trek Vacation Bible School*; *Faith Weaver Bible Curriculum*.

See additional listing in the Magazines section.

NEEDS Uses freelancers for cover illustration and design. 100% of design and 50% of illustration demand knowledge of InDesign CS2, Photoshop 7.0, Illustrator 9.0. Occasionally uses cartoons in books and teacher's guides. Uses b&w and color illustration on covers and in product interiors.

FIRST CONTACT & TERMS Send query letter with nonreturnable b&w or color photocopies, slides, tearsheets or other samples. Accepts disk submissions. Samples are filed, additional samples may be requested prior to assignment. Responds only if interested. Rights purchased vary according to project.

JACKETS/COVERS Assigns minimum 15 freelance design and 10 freelance illustration jobs/year.

TEXT ILLUSTRATION Assigns minimum 20 freelance illustration projects/year. **Pays on acceptance.** Fees for color illustration and design work vary and are negotiable. Prefers b&w line or line and wash illustrations to accompany lesson activities.

TIPS "We prefer contemporary, nontraditional styles appropriate for our innovative and upbeat products and the creative Christian teachers and students who use them. We seek experienced designers and artists who can help us achieve our goal of presenting biblical material in fresh, new and engaging ways. Submit design/illustration on disk. Self promotion pieces help get you noticed. Have book covers/jackets, brochure design, newsletter or catalog design in your portfolio. Include samples of Bible or church-related illustration."

HARLEQUIN ENTERPRISES, LTD.

P.O. Box 5190, Buffalo NY 14240-5190. (888)432-4879. **E-mail:** CustomerService@Harlequin.com; public_relations@harlequin.ca. **Website:** www.harlequin.com. **Contact:** art director. Publishes mass-market paperbacks. Specializes in women's fiction. Publishes more than 100 titles/year. 15% require freelance design; 100% require freelance illustration. Book catalog not available.

NEEDS Approached by 1-3 designers and 20-50 illustrators/year. Works with 3 designers and 25 illustrators/year. 100% of freelance design work demands knowledge of Illustrator, Photoshop and InDesign.

FIRST CONTACT & TERMS Designers: Send postcard sample with brochure, photocopies, tearsheets and URL. Illustrators: Send postcard sample with brochure, photocopies, tearsheets and URL. After introductory mailing, send follow-up postcard sample every 6 months. Samples are filed and not returned. Does not reply. Company will contact artist for portfolio review if interested. Portfolio should include b&w and color tearsheets and color outputs. Buys all rights. Finds freelancers through art competitions, art exhibits/fairs, art reps, artist's submissions, competition/book credits, Internet, sourcebooks, word of mouth.

JACKETS/COVERS Assigns more than 50 freelance cover illustration jobs/year. Prefers variety of representational art—not just romance genre.

HARPERCOLLINS CHILDREN'S BOOKS/ HARPERCOLLINS PUBLISHERS

195 Broadway, New York NY 10007. (212)207-7000. **Website:** www.harpercollins.com. Publishes hardcover originals and reprints, trade paperback originals and reprints, mass market paperback originals and reprints, and audiobooks. 500 titles/year.

NEEDS Babies/children/teens, couples, multicultural, pets, food/drink, fashion, lifestyle. Send links to work. No attachments, please. "We are interested in seeing samples of map illustrations, chapter spots, full page pieces, etc. We are open to half-tone and line art illustrations for our interiors." Negotiates a flat payment fee upon acceptance. Will contact if interested. Catalog available online.

FIRST CONTACT & TERMS Art only, no mss. Only agented submissions to editorial departments. All unsolicted mss returned unopened.

TIPS "Be flexible and responsive to comments and corrections. Hold to scheduled due dates for work. Show work that reflects the kinds of projects you *want* to get, be focused on your best technique and showcase the strongest, most successful examples."

⬥ HARPERCOLLINS PUBLISHERS LTD. (CANADA)

2 Bloor St. E., 20th Floor, Toronto, Ontario M4W 1A8 Canada. (416)975-9334. **Website:** www.harpercollins.com. **Contact:** Neil Erickson, vice president production. Publishes hardcover, trade paperback and mass market paperback originals and reprints. Types of books include adventure, biography, coffee table books, fantasy, history, humor, juvenile, mainstream fiction, New Age, nonfiction, preschool, reference, religious, self-help, travel, true crime, western and young adult. Publishes 200 titles/year. 10% require freelance illustration; 25% require freelance design.

NEEDS Prefers freelancers experienced in mixed media. Uses freelancers mainly for illustration, maps, cover design. 100% of freelance design demands knowledge of Photoshop and Illustrator.

FIRST CONTACT & TERMS Designers: Send query letter with photocopies, tearsheets. Illustrators: Send postcard sample or query letter with photocopies, tearsheets. Does not accept disk submissions compatible with QuarkXPress. Send EPS or TIFF files. Samples are filed. Will contact artist for portfolio review "only after review of samples if I have a project they might be right for." Portfolio should include book dummy, photocopies, photographs, tearsheets. Rights purchased vary according to project.

DESIGN Pays by the project.

HARVEST HOUSE PUBLISHERS

990 Owen Loop N., Eugene OR 97402. (541)343-0123. **Fax:** (541)302-0731. **Website:** www.harvesthousepublishers.com. Estab. 1974. Specializes in hardcover and paperback editions of Christian evangelical adult fiction and nonfiction, children's books, gift books and youth material. Publishes 100-125 titles/year. Books are of contemporary designs that compete with the current book market.

NEEDS Works with 1-2 freelance illustrators and 4-5 freelance designers/year. Uses freelance artists mainly for cover art. Also uses freelance artists for text illustration. Works on assignment only.

FIRST CONTACT & TERMS Send query letter with brochure, résumé, tearsheets and photographs. Art

director will contact artist for portfolio review if interested. Requests work on spec before assigning a job. Originals may be returned at job's completion. Buys all rights. Finds artists through word of mouth and submissions/self-promotions.

DESIGN Pays by the project.

JACKETS/COVERS Assigns 100-125 design and less than 5 illustration jobs/year. Pays by the project.

TEXT ILLUSTRATION Assigns fewer than 5 jobs/year. Pays by the project.

HAY HOUSE, INC.

P.O. Box 5100, Carlsbad, CA 92018. (760)431-7695. **Fax:** (760)431-6948. **E-mail:** editorial@hayhouse.com. **Website:** www.hayhouse.com. Estab. 1985. Publishes hardcover originals and reprints, trade paperback originals and reprints, eBook/POD originals, CDs and DVDs. Types of books include self-help, mind-body-spirit, psychology, finance, health and fitness, nutrition, astrology and a limited amount of spiritual-themed fiction. Recent titles: *Goddesses Never Age* by Christiane Northrup, M.D.; *Co-creating at Its Best* by Dr. Wayne W. Dyer and Esther Hicks; *Don't Let Anything Dull Your Sparkle* by Doreen Virtue; *The Brain Fog Fix* by Dr. Mike Dow; *Medical Medium* by Anthony William. Publishes 50 titles/year; 40% require freelance illustration; 30% require freelance design.

NEEDS Approached by 50 illustrators and 5 designers/year. Works with 20 illustrators and 10 designers/year. Uses freelancers mainly for cover design and illustration. 80% of freelance design demands knowledge of Photoshop, Illustrator, InDesign. 50% of titles require freelance art direction.

FIRST CONTACT & TERMS Send e-mail or send nonreturnable samples to the address above. Art director will contact if interested. Buys all rights. Finds freelancers through word of mouth, submissions and online searches.

TIPS "We look for freelancers with experience in graphic design, desktop publishing, printing processes, production and illustrators with strong ability to conceptualize."

HEAVY METAL MEDIA, LLC

116 Pleasant St., Box 18, Easthampton MA 01027. (413)527-7481. **E-mail:** editor@heavymetal.com. **Website:** www.heavymetal.com. Estab. 1977. Publishes *Heavy Metal* magazine bi-monthly and monthly comic book series in the fantasy genres (specializing in science fiction, fantasy and horror). Submission guidelines available on website.

FIRST CONTACT & TERMS Responds within 1 week, but can take 3-12 months for a submission to be accepted for publication. Will begin publishing graphic novels in 2015.

TIPS "Please look over the kinds of work we publish carefully so you get a feel for what we are looking for."

⏎ HIPPOCRENE BOOKS, INC.

171 Madison Ave., Suite 1605, New York NY 10016. 212-685-4371. **E-mail:** info@hippocrenebooks.com. **Website:** www.hippocrenebooks.com. Estab. 1971. Publishes hardcover originals and trade paperback reprints. Types of books include cookbooks, history, nonfiction, reference, travel, dictionaries, foreign language, bilingual. Specializes in dictionaries, cookbooks. Publishes 60 titles/year.

NEEDS Approached by 150 illustrators and 50 designers/year. Works with 2 illustrators and 3 designers/year. Prefers local freelancers experienced in line drawings.

FIRST CONTACT & TERMS Designers: Send query e-mail with small attachment or website link.

JACKETS/COVERS Assigns 4 freelance design and 2 freelance illustration jobs/year. Pays by the project.

TEXT ILLUSTRATION Assigns 4 freelance illustration jobs/year. Pays by the project.

TIPS "We prefer traditional illustrations appropriate for gift books and cookbooks."

HOLIDAY HOUSE

425 Madison Ave., New York NY 10017. (212)688-0085. **Fax:** (212)421-6134. **E-mail:** info@holidayhouse.com. **Website:** www.holidayhouse.com. **Contact:** Claire Counihan, director of art and design. Specializes in hardcover children's books. Recent titles: *Washington at Valley Forge* by Russell Freedman; *Tornadoes* by Gail Gibbons; *The Carbon Diaries* by Saci Lloyd. Publishes 70 titles/year. 75% require illustration. Art submission guidelines available on website.

NEEDS Accepts art suitable for children and young adults only. Works on assignment only.

FIRST CONTACT & TERMS Send cover letter with photocopies and SASE. Submissions are not returned. Request portfolio review in original query. Responds only if interested. Originals are returned at job's completion. Finds artists through submissions and agents.

JACKETS/COVERS Assigns 5-10 freelance illustration jobs/year. Pays by the project.

TEXT ILLUSTRATION Assigns 35 freelance jobs/year (picture books). Pays royalty.

HOMESTEAD PUBLISHING

1068 14th St., San Francisco CA 94114. (307)733-6248 or (415)621-5039. **Website:** www.homesteadpublishing.net. **Contact:** art director. Estab. 1980. Publishes hardcover and paperback originals. Types of books include art, biography, history, guides, photography, nonfiction, natural history, and general books of interest. Publishes more than 6 print, 100 online titles/year. 75% require freelance illustration. Book catalog free for SASE with 4 first-class stamps.

NEEDS Works with 20 freelance illustrators and 10 designers/year. Prefers pen & ink, airbrush, pencil and watercolor. 25% of freelance work demands knowledge of PageMaker or FreeHand. Works on assignment only.

FIRST CONTACT & TERMS Submission guidelines available online.

DESIGN Assigns 6 freelance design jobs/year. Pays by the project.

JACKETS/COVERS Assigns 2 freelance design and 4 illustration jobs/year. Pays by the project.

TEXT ILLUSTRATION Assigns 50 freelance illustration jobs/year. Prefers technical pen illustration, maps (using airbrush, overlays, etc.), watercolor illustrations for children's books, calligraphy and lettering for titles and headings. Pays by the hour or by the project.

TIPS "We are using more graphic, contemporary designs and looking for exceptional quality."

HOUGHTON MIFFLIN HARCOURT COMPANY

222 Berkeley St., Boston MA 02116. (617)351-5000 or (800)225-5425. **E-mail:** corporate.communications@hmhpub.com. **Website:** www.hmhco.com. Estab. 1980. Company publishes hardcover originals. Types of books include juvenile, preschool and young adult. Publishes 60-70 titles/year. 100% requires freelance illustration; 10% requires freelance design.

⊙ Houghton Mifflin Harcourt now has a new imprint, Graphia, a high-end paperback book series for teens.

NEEDS Approached by 6-10 freelancers/year. Works with 50 freelance illustrators and 10 designers/year. Prefers artists with interest in or experience with children's books. Uses freelance illustrators mainly for jackets, picture books. Uses freelance designers primarily for photo essay books. 100% of freelance design work demands knowledge of QuarkXPress, Photoshop and Illustrator.

FIRST CONTACT & TERMS Please send samples through artist rep only. Finds artists through artist reps, sourcebooks, word of mouth.

DESIGN Assigns 10-20 freelance design jobs/year. Pays by the project.

JACKETS/COVERS Assigns 5-10 freelance illustration jobs/year. Pays by the project.

TEXT ILLUSTRATION Assigns up to 50 freelance illustration jobs/year. Pays by the project.

HOW BOOKS

F+W, a Content + eCommerce Company, 10151 Carver Rd., Suite 200, Blue Ash OH 45242. (513)531-2690. **Website:** www.howdesign.com. **Contact:** Brendan O'Neill, editorial director. Estab. 1985. "We look for material that reflects the cutting edge of trends, graphic design, and culture. Nearly all HOW Books are intensely visual, and authors must be able to create or supply art/illustration for their books."

FIRST CONTACT & TERMS Query via e-mail. Submit proposal package, outline, 1 sample chapter, sample art or sample design.

HUMANIX BOOKS

2200 NW Corporate Blvd., Suite 404, Boca Raton FL 33431. (855)371-7810 or (561)459-5997. **Fax:** (561)241-6448 or (855)371-7809. **E-mail:** info@humanixbooks.com. **Website:** www.humanixbooks.com. Estab. 1976. Publishes college textbooks, paperback trade, New Age and educational activity books. Publishes 30 titles/year. Trade paperbacks are 6×9 with 4-color covers. Book catalog for 9×12 SASE. Specify which imprint when requesting catalog. Learning or trade paperbacks.

⊙ No longer publishes children's fiction or picture books.

FIRST CONTACT & TERMS Send query letter with résumé, SASE and photocopies. Samples are filed or are returned by SASE if requested by artist. Rights purchased vary according to project.

DESIGN Pays by the project.

TIPS "Books on self-help and spirituality emphasized under current program. A new imprint on mysteries, started in 2008, is called Sleuth Hound Books."

IDW PUBLISHING

2765 Truxtun Rd., San Diego CA 92106. **E-mail:** letters@idwpublishing.com. **Website:** www. idwpublishing.com. Estab. 1999. Publishes hardcover, mass market and trade paperback originals. Types of books include comic books, illustrated novel and art book nonfiction. Publishes 20 titles/year. Submission guidelines available on website.

FIRST CONTACT & TERMS Send proposal with cover letter, photocopies (5 fully inked and lettered 8½×11 pages showing story and art), 1-page synopsis of overall story. Samples are not returned. Responds only if interested.

TIPS "Do not send original art. Make sure photocopies are clean, sharp, and easy to read. Be sure that each page has your name, address and phone number written clearly on it. Do not call."

IGNATIUS PRESS

1348 Tenth Ave., San Francisco CA 94122. (415)387-2324. **Fax:** (415)387-0896. **Website:** www.ignatius. com/Default.aspx. **Contact:** Roxanne Lum, art director. Estab. 1978. Company publishes Catholic theology and devotional books for lay people, priests and religious readers. Publishes 30 titles/year.

NEEDS Works with 1-2 freelance illustrators/year. Works on assignment only.

FIRST CONTACT & TERMS Will send art guidelines "if we are interested in the artist's work." Accepts previously published material. Send brochure showing art style or résumé and photocopies. Samples not filed and not returned. Responds only if interested. To show a portfolio, mail appropriate materials; "we will contact you if interested." Pays on acceptance.

JACKETS/COVERS Buys cover art from freelance artists. Prefers Christian symbols/calligraphy and religious illustrations of Jesus, saints, etc. (used on cover or in text). "Simplicity, clarity, and elegance are the rule. We like calligraphy, occasionally incorporated with Christian symbols. We also do covers with type and photography." Pays by the project.

TEXT ILLUSTRATION Pays by the project.

TIPS "I do not want to see any schmaltzy religious art. Since we are a nonprofit Catholic press, we cannot always afford to pay the going rate for freelance art, so we are always appreciative when artists can give us a break on prices and work *ad maiorem Dei gloriam*."

IMAGE COMICS

2001 Center St., 6th Floor, Berkeley CA 94704. **E-mail:** submissions@imagecomics.com. **Website:** www.imagecomics.com. **Contact:** Eric Stephenson, publisher. Estab. 1992. Publishes comic books, graphic novels. See this company's website for detailed guidelines.

NEEDS "We are looking for good, well-told stories and exceptional artwork that run the gamut in terms of both style and genre."

FIRST CONTACT & TERMS Send proposals only. See website for guidelines. No e-mail submissions. All comics are creator-owned. Image only wants proposals for comics, not "art submissions." Proposals/samples not returned. Do not include SASE. Responds as soon as possible.

TIPS "Please do not try to 'impress' us with all the deals you've lined up or testimonials from your Aunt Matilda. We are only interested in the comic."

IMPACT BOOKS

F+W Media, Inc., 10151 Carver Rd., Suite 200, Blue Ash OH 45242. **Fax:** (513)531-2686. **E-mail:** mona.clough@fwcommunity.com. **Website:** www.northlightshop.com; www.impact-books. com. **Contact:** Mona Clough, content director (art instruction for fantasy, comics, manga, anime, popular culture, science fiction, cartooning and body art). Estab. 2004. Publishes trade paperback originals. Specializes in illustrated art instruction books. Recent titles: *Furries Furever, Mastering Manga 2 With Mark Crilley, Shojo Fashion Manga Art School Boys, Winged Fantasy*. Publishes 9 titles/year.

IMPACT Books publishes titles that emphasize illustrated how-to-draw manga, graffiti and fantasy art instruction. Currently emphasizing Japanese-style (manga and anime), science fiction art and pop art. This market is for experienced artists who are willing to work with an IMPACT editor to produce a step-by-step how-to book about the artist's creative process.

NEEDS Approached by 30 author-artists/year. Works with 10 author-artists/year.

FIRST CONTACT & TERMS Send query letter via e-mail; digital art; résumé and URL, along with YouTube channel and other social media sites. Accepts Mac-compatible e-mail submissions (TIFF or

JPEG). Samples may be filed but are not returned. Responds only if interested. Company will contact artist for portfolio review of color finished art, digital art, roughs, photographs, tearsheets if interested. Buys world rights with royalty usually. Finds freelancers through referrals, submissions, conventions, Internet and word of mouth. Give notice if submitting simultaneously.

TIPS Submission guidelines available online www. artistnetwork.com/contactus and impact-books.com. Does not use freelance illustration, but may use freelance design.

INNER TRADITIONS/BEAR & COMPANY

1 Park St., Rochester VT 05767. (802)767-3174. **Fax:** (802)767-3726. **E-mail:** peris@innertraditions. com; customerservice@InnerTraditions.com; customerservice@innertraditions.com. **Website:** www.innertraditions.com. **Contact:** Peri Ann Swan, art director. Estab. 1975. Publishes hardcover originals and trade paperback originals and reprints. Types of books include self-help, psychology, esoteric philosophy, alternative medicine, Eastern religion, and art books. Recent titles: *Mystery of the Crystal Skulls*, *Thai Yoga Massage* and *Science and the Akashic Field*. Publishes 65 titles/year; 10% require freelance illustration; 5% require freelance design. Book catalog free by request.

NEEDS Works with 3-4 freelance illustrators and 3-4 freelance designers/year. 100% of freelance design demands knowledge of QuarkXPress, InDesign or Photoshop. Buys 10 illustrations/year. Uses freelancers for jacket/cover illustration and design. Works on assignment only.

FIRST CONTACT & TERMS Send query letter with résumé, tearsheets, photocopies, photographs, slides and SASE. Accepts disk submissions. Samples are filed if interested; returned by SASE if requested by artist. Responds only if interested. To show portfolio, mail tearsheets, photographs, slides and transparencies. Rights purchased vary according to project. Originals returned at job's completion. Pays by the project.

JACKETS/COVERS Assigns approximately 10 design and illustration jobs/year. Pays by the project.

⌂ INTERNATIONAL MARINE/RAGGED MOUNTAIN PRESS

90 Mechanic St., Camden ME 04843. **E-mail:** christopher.brown@mheducation.com. **Website:** www.mhprofessional.com/page.php?page=contact_ us/editorial_offices/contact_im_ragged_mountain. html. **Contact:** Christopher Brown. Estab. 1969. Imprint of McGraw-Hill. Specializes in hardcovers and paperbacks on marine (nautical) and outdoor recreation topics. Publishes 50 titles/year. 50% require freelance illustration. Book catalog free by request.

NEEDS Works with 20 freelance illustrators and 20 designers/year. Uses freelancers mainly for interior illustration. Prefers local freelancers. Works on assignment only.

FIRST CONTACT & TERMS Submission guidelines available online.

DESIGN Assigns 20 freelance design jobs/year. Pays by the project or by the hour.

JACKETS/COVERS Assigns 20 freelance design and 3 illustration jobs/year. Pays by the project or by the hour.

TEXT ILLUSTRATION Assigns 20 jobs/year. Prefers technical drawings. Pays by the hour or by the project.

TIPS "Do your research. See if your work fits with what we publish. Write with a résumé and sample; then follow with a call; then come by to visit."

JEWISH LIGHTS PUBLISHING

LongHill Partners, Inc., Sunset Farm Offices, Rt. 4, P.O. Box 237, Woodstock VT 05091. (802)457-4000. **Fax:** (802)457-4004. **E-mail:** editorial@jewishlights. com; sales@jewishlights.com. **Website:** www. jewishlights.com. **Contact:** Acquisitions Editor. Estab. 1990. Types of books include children's picture books, history, juvenile, nonfiction, reference, religious, self help, spirituality, life cycle, theology and philosophy, wellness. Specializes in adult nonfiction and children's picture books. Publishes 50 titles/year. 10% requires freelance illustration; 50% requires freelance design. Book catalog free on request.

○ "People of all faiths and backgrounds yearn for books that attract, engage, educate and spiritually inspire. Our principal goal is to stimulate thought and help all people learn about who the Jewish people are, where they come from, and what the future can be made to hold."

NEEDS Approached by 75 illustrators and 20 designers/year. Prefers freelancers experienced in fine arts, children's book illustration, typesetting and design. 100% of freelance design demands knowledge of QuarkXPress. 50% of freelance design demands knowledge of Photoshop.

FIRST CONTACT & TERMS Designers: Send postcard sample, query letter with printed samples, tearsheets. Illustrators: Send postcard sample or other printed samples. Samples are filed and are not returned. Portfolio review not required. Buys all rights. Finds freelancers through submission packets, websites, searching local galleries and shows, Graphic Artists' Guild's *Directory of Illustrators* and *Picture Book*.

DESIGN Assigns 40 freelance design jobs/year. Pays for design by the project.

JACKETS/COVERS Assigns 30 freelance design jobs and 5 illustration jobs/year. Pays for design by the project.

TIPS "We prefer a painterly, fine-art approach to our children's book illustration to achieve a quality that would intrigue both kids and adults. We do not consider cartoonish, caricature art for our children's book illustration."

KALMBACH PUBLISHING CO.

21027 Crossroads Circle, P.O. Box 1612, Waukesha WI 53186. (262)796-8776. **Fax:** (262)798-6468. **Website:** www.kalmbach.com. Estab. 1934. Types of books include reference and how-to books for serious hobbyists in the railfan, model railroading, plastic modeling, and toy train collecting/operating hobbies. Also publishes books and booklets on jewelry-making, beading and general crafts. Publishes 50+ new titles/year.

NEEDS 10-20% require freelance illustration; 10-20% require freelance design. Book catalog free upon request. Approached by 25 freelancers/year. Prefers freelancers with experience in the hobby field. Uses freelance artists mainly for book layout/design and line art illustrations. Freelancers should have the most recent versions of Adobe InDesign, Photoshop, and Illustrator. Projects by assignment only.

FIRST CONTACT & TERMS Send query letter with résumé, tearsheets, and photocopies. No phone calls please. Samples are filed and will not be returned. Art director will contact artist for portfolio review. Finds artists through word of mouth, submissions. Assigns 10-12 freelance design jobs/year. Pays by the project. Assigns 3-5 freelance illustration jobs/year. Pays by the project.

TIPS First-time assignments are usually illustrations or book layouts. Complex projects (e.g., track plans, 100+ page books) are given to proven freelancers. Admires freelancers who present an organized and visu-ally strong portfolio, who meet deadlines, and follow instructions carefully.

KAR-BEN PUBLISHING

Lerner Publishing Group, 241 First Ave. N, Minneapolis MN 55401. (612)215-6229. **E-mail:** editorial@karben.com. **Website:** www.karben.com. Estab. 1974. "Kar-Ben publishes 18-20 new titles on Jewish themes for young children and families each year." Publishes hardcover, trade paperback and electronic originals.

NEEDS Need children's text illustration, book covers and dust jackets.

FIRST CONTACT & TERMS Send postcard sample or e-mail with URL and samples. Follow up every 6-12 months. Samples kept on file for possible future assignments. Samples are not returned. Buys all rights. Illustrators paid $4,000-4,500. 12-15 freelance illustrators/year.

TIPS "Look at our catalog online for a sense of what we like—bright colors and lively composition."

KIRKBRIDE BIBLE CO., INC.

1102 Deloss St., Indianapolis IN 46203. (800)428-4385. **Fax:** (317)633-1444. **E-mail:** info@kirkbride.com. **Website:** www.kirkbride.com. Estab. 1915. Publishes Thompson Chain-Reference Bible hardcover originals and quality leather bindings styles and translations of the Bible. Types of books include reference and religious. Specializes in reference and study material. Publishes 6 main titles/year. Recent titles: *The Thompson Student Bible* and *The Thompson Chain-Reference Bible Centennial Edition*. 2% require freelance illustration; 10% require freelance design. Catalog available.

NEEDS Approached by 1-2 designers/year. Works with 1-2 designers/year. Prefers freelancers experienced in layout and cover design. Uses freelancers mainly for artwork and design. 100% of freelance design and most illustration demands knowledge of PageMaker, InDesign, Photoshop, Illustrator and QuarkXPress. 5-10% of titles require freelance art direction.

FIRST CONTACT & TERMS Designers: Send query letter with portfolio of recent works, printed samples and résumé. Illustrators: Send query letter with Photostats, printed samples and résumé. Accepts disk submissions compatible with QuarkXPress or Photoshop files 4.0 or 3.1. Samples are filed. Responds only if interested. Rights purchased vary according to project.

DESIGN Assigns 1 freelance design job/year. Pays by the hour $100 minimum.

JACKETS/COVERS Assigns 1-2 freelance design jobs and 1-2 illustration jobs/year. Pays for design by the project, $100-1,000. Pays for illustration by the project, $100-1,000. Prefers modern with traditional text.

TEXT ILLUSTRATION Assigns 1 freelance illustration/year. Pays by the project, $100-1,000. Prefers traditional. Finds freelancers through sourcebooks and references.

TIPS "Quality craftsmanship is our top concern, and it should be yours, too!"

KNOPF

Imprint of Random House, 1745 Broadway, New York NY 10019. **Fax:** (212)940-7390. **Website:** knopfdoubleday.com/imprint/knopf. Estab. 1915. Publishes hardcover originals for adult trade. Specializes in history, fiction, art and cookbooks. Publishes 200 titles/year.

○ Random House, Inc. and its publishing entities are not accepting unsolicited submissions via e-mail at this time.

NEEDS Prefers artists with experience in b&w. Uses freelancers mainly for cookbooks and biographies. Also for text illustration and book design.

FIRST CONTACT & TERMS Send query letter with SASE. Request portfolio review in original query. Artist should follow up. Sometimes requests work on spec before assigning a job. Originals are returned at job's completion.

TEXT ILLUSTRATION Pays by the project, $100-5,000; $50-150/illustration; $300-800/maps.

TIPS Finds artists through submissions, agents and sourcebooks. "Freelancers should be aware that Macintosh/Quark is a must for design and becoming a must for maps and illustration."

LAREDO PUBLISHING CO./RENAISSANCE HOUSE

465 Westview Ave, Englewood NJ 07631. (201)408-4048. **Fax:** (201)5690525. **E-mail:** info@renaissancehouse.net; laredo@renaissancehouse.net. **Website:** renaissancehouse.net. **Contact:** Sam Laredo, art director. Estab. 1991. Publishes children and juvenile books. Specializes in the development and management of educational and multicultural materials for young readers, Spanish and bilingual.

Publishes biographies, legends and multicultural with a focus on the Hispanic market. Recent titles include *Un Hombre Sincero (Marti's biography)* (International Book Award, 2014; Best Latino Focused Bilingual Children's Picture Book, Best Children's Non Fiction Picture Book, Best First Book Children & Youth); *Postcard from Copenhagen* (Bilingual); *I Do Not Want This on My Plate* (Purple Dragonfly Book Award); *Super Jack* (Purple Dragonfly Book Award); *Mother Oak*; *But, Mama, How Come Grandpa Comes To?*. Publishes 35 titles/year.

NEEDS Approached by 25 illustrators/year. Works with 10 designers/year.

FIRST CONTACT & TERMS Designers/illustrators: E-mail samples responds only if interested.

DESIGN Assigns 5 freelance design jobs/year. Pays for design by the project.

JACKETS/COVERS Pays for illustration by the project, page.

TEXT ILLUSTRATION Pays by the project, page.

LEE & LOW BOOKS

95 Madison Ave., #1205, New York NY 10016. (212)779-4400. **E-mail:** general@leeandlow.com. **Website:** www.leeandlow.com. Estab. 1991. Publishes hardcover originals for the juvenile market. Specializes in multicultural children's books. Publishes 12-15 titles/year. 100% require freelance illustration and design. Book catalog available.

NEEDS Approached by 100 freelancers/year. Works with 12-15 freelance illustrators and 4-5 designers/year. Uses freelancers mainly for illustration of children's picture books. 100% of design work demands computer skills. Works on assignment only.

FIRST CONTACT & TERMS Contact through artist rep or send query letter with brochure, résumé, SASE, tearsheets or photocopies. Samples of interest are filed. Art director will contact artist for portfolio review if interested. Portfolio should include color tearsheets and dummies. Rights purchased vary according to project. Originals are returned at job's completion.

DESIGN Pays by the project.

TEXT ILLUSTRATION Pays by the project.

TIPS "We want an artist who can tell a story through pictures and who is familiar with the children's book genre. We are now also developing materials for older children, ages 8-12, so we are interested in seeing work for this age group, too. Lee & Low Books makes

a special effort to work with writers and artists of color and encourages new talent. We prefer filing samples that feature children, particularly from diverse backgrounds."

LEGACY PRESS

17909 Adria Maru, Carson CA 90746. (800)532-4278. **E-mail:** info@rainbowpublishers.com. **Website:** www.rainbowpublishers.com. Estab. 1979. Publishes trade paperback originals. Types of books include religious books, reproducible Sunday School books for children ages 2-12, and Bible teaching books for children and adults. Recent titles include *Favorite Bible Families, Instant Bible Lessons, The Christian Girl's Guides, Bill the Warthog, Gotta Have God, God and Me*. Publishes 20 titles/year. Book catalog available for SASE with 2 first-class stamps.

NEEDS Approached by hundreds of illustrators and 50 designers/year. Works with 5-10 illustrators and 5-10 designers/year. 100% of freelance design and illustration demands knowledge of Illustrator, Photoshop, and InDesign.

FIRST CONTACT & TERMS Send query letter with printed samples, SASE, and tearsheets. Samples are filed or returned by SASE. Responds only if interested. Will contact artist for portfolio review if interested. Finds freelancers through samples sent and personal referrals. For submission directions, go to www. RainbowPublishers.com/submissions.apsx.

DESIGN Assigns 25 freelance design jobs/year. Pays for design by the project, $350 minimum. Pays for art direction by the project, $350 minimum.

JACKETS/COVERS Assigns 25 freelance design jobs and 25 illustration jobs/year. "Prefers computer generated-high energy style with bright colors appealing to kids." Pays for design and illustration by the project, $350 minimum. "Prefers designers/illustrators with some Biblical knowledge."

TEXT ILLUSTRATION Assigns 20 freelance illustration jobs/year. Pays by the project, $350 minimum. "Prefers b&w line art, preferably computer generated with limited detail yet fun."

TIPS "We look for illustrators and designers who have some Biblical knowledge and excel in working with a fun, colorful, high-energy style that will appeal to kids and parents alike. Designers must be well versed in InDesign, Illustrator and Photoshop, know how to visually market to kids and have wonderful conceptual ideas!"

LERNER PUBLISHING GROUP

1251 Washington Ave. N., Minneapolis MN 55401. (800)452-7236 or (612)332-3344. **Fax:** (612)337-7615. **E-mail:** editorial@karben.com. **Website:** www.karben.com; www.lernerbooks.com. Estab. 1957. Publishes educational books for young people. Subjects include animals, biography, history, geography, science and sports. Publishes 200 titles/year. 100% require freelance illustration. Book catalog free on request. Art submission guidelines available on website.

NEEDS Uses 10-12 freelance illustrators/year. Uses freelancers mainly for book illustration; also for jacket/cover design and illustration, book design and text illustration.

FIRST CONTACT & TERMS Submit samples that show skill specifically in children's book illustration. Do not send original art. Submit slides, JPEG, or PDF files on disk, color photocopies of full-color artwork, photocopies of b&w linework, or tearsheets.

TIPS "Send samples showing active children, not animals or still life. Don't send original art. Look at our books to see what we do."

LIPPINCOTT WILLIAMS & WILKINS

351 W. Camden St., Baltimore MD 21201. (401)528-4000 or (800)638-3030. **E-mail:** orders@lww.com. **Website:** www.lww.com. Estab. 1890. Publishes audio tapes, CDs, hardcover originals and reprints, textbooks, trade paperbook originals and reprints. Types of books include instructional and textbooks. Specializes in medical publishing. 100% requires freelance design.

⚋ See website for a listing of all locations.

NEEDS Approached by 20 illustrators and 20 designers/year. Works with 10 illustrators and 30 designers/year. Prefers freelancers experienced in medical publishing. 100% of freelance design demands knowledge of Illustrator, Photoshop, QuarkXPress.

FIRST CONTACT & TERMS Send query letter with printed samples and tearsheets. Accepts Mac-compatible disk submissions. Send EPS or TIFF files. Responds only if interested. Will contact artist for portfolio review if interested. Buys all rights. Finds freelancers through submission packets, word of mouth.

DESIGN Assigns 150 freelance design jobs/year. Pays by the project.

JACKETS/COVERS Assigns 150 freelance design jobs/year. Pays for design by the project. Prefers medical publishing experience.

TEXT ILLUSTRATION Assigns 150 freelance illustration jobs/year. Pays by the project. Prefers freelancers with medical publishing experience.

TIPS "We're looking for freelancers who are flexible and have extensive clinical and textbook medical publishing experience. Designers must be proficient in Quark, Illustrator and Photoshop and completely understand how design affects the printing (CMYK 4-color) process."

⊕ LLEWELLYN PUBLICATIONS

Imprint of Llewellyn Worldwide, Ltd., 2143 Wooddale Dr., Woodbury MN 55125. (651)291-1970. **Fax:** (651)291-1908. **E-mail:** customerservice@llewellyn.com. **E-mail:** submissions@llewellyn.com. **Website:** www.llewellyn.com. Estab. 1901. Book publisher. Publishes trade paperback, calendars and Tarot decks. Llewllyn is not a distributor for fine art, cards or previously printed artworks. Types of books include mystery/fiction, teens, New Age, astrology, alternative religion, self-help, spanish language, metaphysical, occult, health, and women's spirituality. Publishes 135 titles/year. Books have photography, realistic painting and computer generated graphics. 60% require freelance illustration.

NEEDS Approached by 200 freelancers/year. Licenses 15-20 freelance illustrations/year. Prefers freelancers with experience in book covers, New Age material and realism. Uses freelancers mainly for realistic paintings and drawings. Works on assignment only. Negotiates "License for Use Only."

JACKETS/COVERS Assigns 50+ freelance jobs/year. Pays by the illustration. Realistic style preferred, may need to research for project, should know/have background in subject matter.

TEXT ILLUSTRATION Assigns 20 freelance jobs/year. Pays by the project. Media and style preferred are pen & ink, vector based or pencil. Style should be realistic and anatomically accurate.

THE LYONS PRESS

The Globe Pequot Press, Inc., P.O. Box 480, 246 Goose Ln., Guilford CT 06437. (203)458-4500. **Fax:** (203)458-4668. **E-mail:** editorial@lyonspress.com. **Website:** www.lyonspress.com. Estab. 1984 (Lyons & Burford), 1997 (The Lyons Press). Publishes hardcover and trade paperback originals and reprints. Types of books include adventure, humor, biography, memoir, coffee table books, cookbooks, history, military history, instructional, reference, self-help, sporting (also hunting and fishing), and travel. Publishes 180 titles/year. Book catalog available.

MADISON HOUSE PUBLISHERS

4501 Forbes Blvd., Suite 200, Lanham MD 20706. (317)797-9993. **Fax:** (301)429-5748. **E-mail:** debdunlevy@thebookofsight.com. **Website:** www.rowmanlittlefield.com. Estab. 1984. Publishes hardcover and trade paperback originals. Specializes in biography, history and popular culture. Publishes 10 titles/year. 40% require freelance illustration; 100% require freelance jacket design. Book catalog free by request.

💬 Madison House is just one imprint of Rowman & Littlefield Publishing Group, which has 8 imprints.

NEEDS Approached by 20 freelancers/year. Works with 4 freelance illustrators and 12 designers/year. Prefers freelancers with experience in book jacket design. Uses freelancers mainly for book jackets. Also for catalog design. 80% of freelance work demands knowledge of Illustrator, QuarkXPress, Photoshop or FreeHand. Works on assignment only.

FIRST CONTACT & TERMS Send query letter with tearsheets, photocopies and photostats. Samples are filed or are returned by SASE if requested by artist. Responds to the artist only if interested. Call for appointment to show portfolio of roughs, original/final art, tearsheets, photographs, slides and dummies. Buys all rights. Interested in buying second rights (reprint rights) to previously published work.

JACKETS/COVERS Assigns 16 freelance design and 2 illustration jobs/year. Pays by the project. Prefers typographic design, photography and line art.

TEXT ILLUSTRATION Pays by project.

TIPS "We are looking to produce trade-quality designs within a limited budget. Covers have large type, clean lines; they 'breathe.' If you have not designed jackets for a publishing house but want to break into that area, have at least 5 'fake' titles designed to show ability. I would like to see more Eastern European style incorporated into American design. It seems that typography on jackets is becoming more assertive, as it competes for attention on bookstore shelf. Also, trends are richer colors, use of metallics."

⌂ MAPEASY, INC.

P.O. Box 80, Wainscott NY 11975. (631)537-6213. **Fax:** (631)537-4541. **E-mail:** lbechert@mapeasy.com; info@ mapeasy.com. **Website:** www.mapeasy.com. Estab. 1990. Publishes maps. 100% requires freelance illustration; 25% requires freelance design. Book catalog not available.

NEEDS Approached by 15 illustrators and 10 designers/year. Prefers local freelancers. 100% of freelance design and illustration demands knowledge of Illustrator, Photoshop and InDesign.

FIRST CONTACT & TERMS Send query letter with photocopies. Accepts Mac-compatible disk submissions. Samples are filed. Responds only if interested. Will contact artist for portfolio review if interested. Portfolio should include photocopies. Finds freelancers through ads and referrals.

TEXT ILLUSTRATION Pays by the hour.

MCGRAW-HILL EDUCATION

P.O. Box 182605, Columbus OH 43218. (630)789-4000 or (800)338-3987. **E-mail:** customerservice@ mcgraw-hill.com. **Website:** www.mheducation.com. Estab. 1969. Independent book producer/packager of textbooks and reference books. Specializes in social studies, history, geography, vocational, math, science, etc. 80% require freelance design.

NEEDS Approached by 30 freelance artists/year. Works with 4-5 illustrators and 5-15 designers/year. Buys 5-10 illustrations/year. Prefers artists with experience in textbooks, especially health, medical, social studies. Works on assignment only.

FIRST CONTACT & TERMS Send query letter with tearsheets and résumé. Samples are filed. Responds to the artist only if interested. To show portfolio, mail roughs and tearsheets. Rights purchased vary according to project. Originals returned at job's completion.

DESIGN Assigns 5-15 jobs/year. Pays by the project.

JACKETS/COVERS Assigns 1-2 design jobs/year. Pays by the project.

TIPS "Designers, if you contact us with samples we will invite you to do a presentation and make assignments as suitable work arises. Graphic artists, when working assignments we review our files. Enclose typical rate structure with your samples."

MCGRAW-HILL HIGHER EDUCATION GROUP

P.O. Box 182605, Columbus OH 43218. (877)833-5524 or (800)338-3987. **Fax:** (614)759-3749 or (614)759-3644. **E-mail:** customer.service@mcgraw-hill.com. **Website:** www.mhhe.com; www.mcgraw-hill.com. Estab. 1944. Publishes hardbound and paperback college textbooks. Specializes in science, engineering and math. Produces more than 200 titles/year. 10% require freelance design; 70% require freelance illustration.

NEEDS Works with 15-25 freelance designers and 30-50 illustrators/year. Uses freelancers for advertising. 90% of freelance work demands knowledge of PageMaker, Illustrator, QuarkXPress, Photoshop or FreeHand. Works on assignment only.

FIRST CONTACT & TERMS Prefers color 35mm slides and color or b&w photocopies. Send query letter with brochure, résumé, slides and/or tearsheets. "Do not send samples that are not a true representation of your work quality." Responds in 1 month. Accepts disk submissions. Samples returned by SASE if requested. Responds on future assignment possibilities. Buys all rights. Pays half contract for unused assigned work.

DESIGN Assigns 100-140 freelance design jobs/year. Uses artists for all phases of process. Pays by the project. Payment varies widely according to complexity.

JACKETS/COVERS Assigns 100-140 freelance design jobs and 20-30 illustration jobs/year. Pays $1,700 for 4-color cover design and negotiates pay for special projects.

TEXT ILLUSTRATION Assigns 75-100 freelance jobs/year. Considers b&w and color work. Prefers computer-generated, continuous tone, some mechanical line drawings; ink preferred for b&w.

TIPS "In the McGraw-Hill field, there is more use of color. There is need for sophisticated color skills—the artist must be knowlegeable about the way color reproduces in the printing process. Be prepared to contribute to content as well as style. Tighter production schedules demand an awareness of overall schedules. *Must* be dependable."

MITCHELL LANE PUBLISHERS, INC.

P.O. Box 196, Hockessin DE 19707. (302)234-9426. **Fax:** (866)834-4164. **E-mail:** barbaramitchell@ mitchelllane.com; customerservice@mitchelllane. com. **Website:** www.mitchelllane.com. **Contact:**

Barbara Mitchell, publisher. Estab. 1993. Publishes library bound originals. Types of books include biography. Specializes in multicultural biography for young adults. Publishes 50 titles/year; none require freelance illustration; none require freelance design.

NEEDS Approached by 20 illustrators and 5 designers/year. Works with 2 illustrators/year. Prefers freelancers experienced in illustrations of people. Looks for cover designers and interior book designers.

FIRST CONTACT & TERMS Send query letter with printed samples, photocopies. Interesting samples are filed and are not returned. Will contact artist for portfolio review if interested. Buys all rights.

JACKETS/COVERS Prefers realistic portrayal of people.

MONDIAL

203 W. 107th St., Suite 6C, New York, NY 10025. 212-864-7095. **Fax:** (208)361-2863. **E-mail:** contact@mondialbooks.com. **Website:** www.mondialbooks.com; www.librejo.com. **Contact:** Andrew Moore, editor. Estab. 1996. Publishes mainstream fiction, romance, history, and reference books. Specializes in linguistics. Payment on acceptance.

NEEDS Landscapes, travel and erotic. Printing rights are negotiated according to project. Illustrations are used for text illustration, promotional materials and book covers. Publishes 20 titles/year. Responds only if interested.

MORGAN KAUFMANN PUBLISHERS

Elsevier, 225 Wyman St., Waltham MA 02144. (781)663-5200. **Website:** www.mkp.com. Estab. 1984. Publishes computer science books for academic and professional audiences in paperback, hardback and book/CD-ROM packages. Publishes 60 titles/year. 75% require freelance interior illustration; 100% require freelance text and cover design; 15% require freelance design and production of 4-color inserts. Morgan Kaufmann is now part of Elsevier (www.elsevier.com).

NEEDS Approached by 150-200 freelancers/year. Works with 10-15 freelance illustrators and 10-15 designers/year. Uses freelancers for covers, text design and technical and editorial illustration, design and production of 4-color inserts. 100% of freelance work demands knowledge of at least one of the following Illustrator, QuarkXPress, Photoshop, Ventura, Framemaker, or laTEX (multiple software platform). Works on assignment only.

FIRST CONTACT & TERMS Send query letter with samples. Samples must be nonreturnable or with SASE. "No calls, please." Samples are filed. Production editor will contact artist for portfolio review if interested. Portfolio should include final printed pieces. Buys interior illustration on a work-for-hire basis. Buys first printing and reprint rights for text and cover design. Finds artists primarily through word of mouth and submissions.

DESIGN Pays by the project. Prefers Illustrator and Photoshop for interior illustration and QuarkXPress for 4-color inserts.

JACKETS/COVERS Pays by the project. Uses primarily stock photos. Prefers designers take cover design through production to film and MatchPrint. "We're interested in a look that is different from the typical technical publication." For covers, prefers modern, clean, spare design, with emphasis on typography and high-impact imagery.

TIPS "Although experience with book design is an advantage, sometimes artists from another field bring a fresh approach, especially to cover design."

MOUNTAIN PRESS PUBLISHING CO.

P.O. Box 2399, Missoula MT 59806. (406)728-1900 or (800)234-5308. **Fax:** (406)728-1635. **E-mail:** info@mtnpress.com. **Website:** www.mountain-press.com. **Contact:** Jennifer Carey, editor. Estab. 1948. Company publishes trade paperback originals and reprints; some hardcover originals and reprints. Types of books include western history, geology, natural history/nature. Specializes in geology, natural history, history, horses, western topics. Publishes 20 titles/year. Book catalog free by request.

NEEDS Prefers artists with experience in book illustration and design, book cover illustration. Uses freelance artists for jacket/cover illustration, text illustration and maps. 100% of design work demands knowledge of InDesign, Photoshop, Illustrator. Works on assignment only.

FIRST CONTACT & TERMS Send query letter with résumé, SASE and any samples. Samples are filed or are returned by SASE. Responds only if interested. Project editor will contact artist for portfolio review if interested. Buys one-time rights or reprint rights depending on project. Originals are returned at job's completion. Finds artists through submissions, word of mouth, sourcebooks and other publications.

DESIGN Pays by the project.

JACKETS/COVERS Pays by the project.

TEXT ILLUSTRATION Pays by the project.

TIPS "First-time assignments are usually book cover/jacket illustration or map drafting; text illustration projects are given to proven freelancers."

NBM PUBLISHING

160 Broadway, Suite 700, East Bldg., New York NY 10038. **E-mail:** nbmgn@nbmpub.com. **Website:** http://nbmpub.com. **Contact:** Terry Nantier, editor/art director. Estab. 1976. Publishes graphic novels for an audience of adults. Types of books include fiction, mystery and social parodies. Not accepting submissions unless for graphic novels.

Publisher reports too many inappropriate submissions from artists who "don't pay attention." Check their website for instructions before submitting, so you're sure that your art is appropriate for them.

NEW ENGLAND COMICS (NEC PRESS)

732 Washington St., Norwood MA 02062. (508)857-3530. **Fax:** (508)588-4704. **E-mail:** necsupport@newenglandcomics.com. **Website:** www.newenglandcomics.com. Types of books include comic books and games. Book catalog available on website.

NEEDS Seeking pencillers and inkers.

FIRST CONTACT & TERMS Send SASE and 2 pages of pencil or ink drawings derived from the submissions script posted on website. Responds in 2 weeks (with SASE only).

TIPS Visit website for submissions script. Do not submit original characters or stories. Do not call.

NORTH LIGHT BOOKS

F+W, a Content + eCommerce Company, 10151 Carver Rd., Suite 200, Blue Ash OH 45242. **Fax:** (513)891-7153. **E-mail:** mona.clough@fwcommunity.com. **Website:** www.fwcommunity.com; www.artistsnetwork.com; www.createmixedmedia.com. **Contact:** Mona Clough, content director art and mixed media. "North Light Books publishes art and craft books, including watercolor, drawing, mixed media and decorative painting that emphasize illustrated how-to art instruction. Currently emphasizing drawing, acrylic, creativity and inspiration." "We do not use freelance illustration. We do use freelance designers occasionally." Recent titles: *The Urban Sketcher, Creating Abstract Art, Zen Doodle, Oil Painting With the Masters, No Excuses Art Journaling, Acrylic Illuminations.*

NEEDS Approached by 100 author-artists/year. Works with 50 artists/year.

FIRST CONTACT & TERMS Send query letter via email with photographs, digital images. Accepts e-mail submissions. Samples are not filed and are not returned. Responds only if interested. Company will contact artist for portfolio review if interested. Buys all rights; exclusive rights with royalty for authors. Finds freelancers through art competitions, art exhibits, submissions, Internet and word of mouth. "Please tell us if you are submitting to multiple publishers at once if you submit simultaneously."

TIPS "Visit www.artistsnetwork.com/contactus and scroll down to download submission guidelines."

OCP (OREGON CATHOLIC PRESS)

5536 NE Hassalo, Portland, OR 97213. (800)548-8749. **Fax:** (800)462-7329. **E-mail:** liturgy@ocp.org;submissions@ocp.org. **Website:** www.ocp.org. **Contact:** Judy Urben, art director. Nonprofit publishing company, producing music and liturgical publications used in parishes throughout the U.S., Canada, England and Australia. 30% require freelance illustration. Catalog available with 9×12 SASE with first-class postage.

TIPS "I am always looking for appropriate art for our projects. We tend to use work already created on a one-time-use basis, as opposed to commissioned pieces. I look for tasteful, not overtly religious art."

ONSTAGE PUBLISHING

190 Lime Quarry Rd., Suite 106-J, Madison, AL 35758-8962. (256)461-0661. **E-mail:** onstage123@knology.net. **Website:** www.onstagepublishing.com. **Contact:** Dianne Hamilton, senior editor. Estab. 1999. Small, independent publishing house specializing in children's literature. "We currently publish chapter books, middle-grade fiction and YA. At this time, we only produce fiction books for ages 8-18."

NEEDS "Our chapter books need inside b&w line illustrations. All books need full color cover illustrations. Sample illustrations need to have one sample in full color to show your style and one sample in b&w to show your skill. The main characters in our books are children. We need to see how you portray children, especially children in action."

FIRST CONTACT & TERMS Please remember to include a cover letter and a SASE large enough, with

sufficient postage, to safely return your work if we do not put your work on file. Never send originals! The art director requests that you send your samples by mail. *Please do not send your work by e-mail or computer disk unless specifically requested.*

🍎 ORCHARD BOOKS

Hachette Children's Books, 50 Victoria Embankment, London EC4Y 0DZ United Kingdom. +44 (0)20-3122-6000. **Fax:** +44 (0)20-7873-6024. **E-mail:** ad@hachettechildrens.co.uk. **Website:** www. orchardbooks.co.uk. Estab. 1987. Publishes children's books. Specializes in picture books and novels for children and young adults. 100% require freelance illustration.

NEEDS Works on assignment only.

FIRST CONTACT & TERMS Designers: Send PDFs of portfolio. Illustrators: Send copies or PDFs of samples. Samples are filed or are returned by SASE only if requested. Responds to queries/submissions only if interested. Originals returned to artist at job's completion. Considers complexity of project, skill and experience of artist and project's budget when establishing payment. See website.

RICHARD C. OWEN PUBLISHERS, INC.

P.O. Box 585, Katonah NY 10536. (914)232-3903 or (800)336-5588. **Fax:** (914)232-3977. **E-mail:** richardowen@rcowen.com. **Website:** www.rcowen. com. **Contact:** Richard Owen, publisher. Estab. 1982. Company publishes children's books, juvenile fiction and nonfiction for 5-, 6- and 7-year-olds. Publishes 15-20 titles/year. 100% require freelance illustration.

💭 "Focusing on adding nonfiction for young children on subjects such as history, biography, social studies, science and technology; with human characters, buildings, structures, machines. Realistic but appealing to a child."

NEEDS Prefers freelancers with focus on children's books who can create consistency of character from page to page in an appealing setting. Uses freelancers for jacket/cover and text illustration. Works on assignment only.

FIRST CONTACT & TERMS Art director will contact artist if interested and has a suitable project available. Buys all rights. Original illustrations are returned at job's completion.

TIPS Be willing to work with the art director. All our books have a trade book look.

OXFORD UNIVERSITY PRESS

198 Madison Ave., New York NY 10016. (212)726-6000. **E-mail:** custserv.us@oup.com. **Website:** www. oup.com/us. Chartered by Oxford University. Specializes in fully illustrated, not-for-profit, contemporary textbooks emphasizing English as a second language for children and adults. Also produces wall charts, picture cards, CDs and cassettes.

NEEDS Approached by 1,000 freelance artists/year. Works with 100 illustrators and 8 designers/year. Uses freelancers mainly for interior illustrations of exercises. Also uses freelance artists for jacket/cover illustration and design. Some need for computer-literate freelancers for illustration. 20% of freelance work demands knowledge of QuarkXPress or Illustrator. Works on assignment only.

FIRST CONTACT & TERMS Send query letter with brochure, tearsheets, photostats, slides or photographs. Samples are filed. Art buyer will contact artist for portfolio review if interested. Artists work from detailed specs. Considers complexity of project, skill and experience of artist and project's budget when establishing payment. Artist retains copyright. Originals are returned at job's completion. Finds artists through submissions, artist catalogs such as *Showcase, Guild Book*, etc., occasionally from work seen in magazines and newspapers, other illustrators.

JACKETS/COVERS Pays by the project.

TEXT ILLUSTRATION Assigns 500 jobs/year. Uses black line, half-tone and 4-color work in styles ranging from cartoon to realistic. Greatest need is for natural, contemporary figures from all ethnic groups, in action and interaction. Pays for text illustration by the project, $45/spot, $2,500 maximum/full page.

TIPS "Please wait for us to call you. You may send new samples to update your file at any time. We would like to see more natural, contemporary, nonwhite people from freelance artists. Art needs to be fairly realistic and cheerful."

➕ PAPERCUTZ

160 Broadway, Suite 700E, New York NY 10038. (646)559-4681. **Fax:** (212)643-1545. **Website:** www. papercutz.com. Estab. 2004. "Independent publisher of graphic novels based on popular existing properties aimed at all ages." Publishes hardcover and paperback originals, distributed by MacMillan. Publishes 50 titles/year. Book catalog free upon request.

NEEDS Uses licensed characters/properties aimed at all ages. "Looking for professional comics writers able to write material for teens and tweens without dumbing down the work, and comic book artists able to work in animated or manga styles." Also has a need for inkers, colorists, letterers.

FIRST CONTACT & TERMS Send low-res files of comic art samples or a link to website. Attends New York comic book conventions, as well as the San Diego Comic-Con, and will review portfolios if time allows. Will respond eventually—generally will hold work until an appropriate project comes along. Please be incredibly patient. Pays an advance against royalties.

TIPS "Be familiar with our titles—that's the best way to know what we're interested in publishing. If you are somehow attached to a successful teen or tween property and would like to adapt it into a graphic novel, we may be interested."

◐ PARENTING PRESS, INC.

P.O. Box 75267, Seattle WA 98175. (206)364-2900 or (800)992-6657. **Fax:** (206)364-0702. **E-mail:** office@parentingpress.com. **Website:** www.parentingpress.com. **Contact:** Carolyn Threadgill, publisher. Estab. 1979. Publishes trade paperback originals and hardcover originals. Types of books include nonfiction: instruction and parenting. Specializes in parenting and social skill building books for children. 100% requires freelance design; 100% requires freelance illustration. Book catalog online.

NEEDS Approached by 10 designers/year and 100 illustrators/year. Works with 2 designers/year. Prefers local designers. 100% of freelance design work demands knowledge of Photoshop, QuarkXPress, and InDesign.

FIRST CONTACT & TERMS Send query letter with brochure, SASE, postcard sample with photocopies, photographs and tearsheets. After introductory mailing, send follow-up postcard sample every 6 months. Accepts e-mail submissions. Prefers Windows-compatible, TIFF, JPEG files. Samples returned by SASE if not filed. Responds only if interested. Company will contact artist for portfolio review if interested. Portfolio should include b&w or color tearsheets. Rights purchased vary according to project.

JACKETS/COVERS Pays for illustration by the project. Prefers appealing human characters, realistic or moderately stylized.

TEXT ILLUSTRATION Pays by the project or shared royalty with author.

TIPS "Be willing to supply 2-4 roughs before finished art."

PAULINE BOOKS & MEDIA

50 St. Paul's Ave., Boston MA 02130. (617)522-8911. **Fax:** (617)541-9805. **E-mail:** design@paulinemedia.com; editorial@paulinemedia.com. **Website:** www.pauline.org. Estab. 1932. Publishes hardcover and trade paperback originals. Religious publishers; types of books include adult books on catholic spirituality, prayer, scriptural spirituality, adult and children's lives of saints, marian themes, adult faith formation, media literacy formation, themes on the theology of the body, family life, prayer books, teacher resources, children's prayer books, children's bible stories, children's catechetical and reference books, children's Christmas and easter stories, seasonal activity books, pastoral resources, supplemental faith formation materials, children's inspirational biographies, children's conceptual picture books, children's faith-oriented stories, children's faith-oriented tales and legends picture books. Publishes 30-40 titles/year.

NEEDS Approached by 50 freelancers/year. Works with 10-15 freelance illustrators/year. Knowledge and use of InDesign, Illustrator, Photoshop, etc., is valued, but not necessary.

FIRST CONTACT & TERMS Postcards, tearsheets, photocopies, include website address if you have one. Samples are filed or returned by SASE. Responds only if interested. Rights purchased; work for hire or exclusive rights.

TEXT ILLUSTRATION Assigns 6-10 freelance illustration jobs/year. Pays by the project.

PAULIST PRESS

997 Macarthur Blvd., Mahwah NJ 07430. (201)825-7300. **Fax:** (201)825-8345. **E-mail:** submissions@paulistpress.com. **Website:** www.paulistpress.com. **Contact:** Trace Murphy, editorial director. Estab. 1865. Paulist Press publishes ecumenical theology, Roman Catholic studies, and books on scripture, liturgy, spirituality, church history, and philosophy, as well as works on faith and culture. "Our publishing is oriented toward adult-level nonfiction. We do not publish memoirs, poetry, or works of fiction, and we have scaled back on children's books."

NEEDS Works on assignment only.

JACKETS/COVERS Pays by the project.

PEACHTREE PUBLISHERS

1700 Chattahoochee Ave., Atlanta GA 30318-2112. (404)876-8761. **Fax:** (404)875-2578. **E-mail:** carmack@peachtree-online.com; hello@peachtree-online.com. **Website:** www.peachtree-online.com. **Social Media:** Facebook, Twitter, Peachtreepub.blogspot.com. **Contact:** Helen Harriss, acquisitions editor; Nicki Carmack, creative director. Estab. 1978. Publishes hardcover and trade paperback originals. Types of books include children's picture books, young adult fiction, early reader fiction, middle reader fiction and nonfiction, parenting, regional. Specializes in children's and young adult titles. Publishes 24-30 titles/year. 95% require freelance illustration. Call for catalog.

NEEDS Approached by 750 illustrators/year. Works with 15-20 illustrators. "We normally do not use book designers. When possible, send samples that show your ability to depict subjects or characters in a consistent manner. See our website to view styles of artwork we utilize."

JACKETS/COVERS Assigns 18-20 illustration jobs/year. Prefers acrylic, oils, watercolor, or mixed media on flexible material for scanning, or digital files. Pays for illustration by the project.

TEXT ILLUSTRATION Assigns 4-6 freelance illustration jobs/year. Pays by the project.

TIPS "We are an independent, award-winning, high-quality house with a limited number of new titles per season; therefore, each book must be a jewel. We expect the illustrator to bring creative insights which expand the readers' understanding of the storyline through visual clues not necessarily expressed within the text itself."

PELICAN PUBLISHING COMPANY

1000 Burmaster St., Gretna LA 70053. (504)368-1175. **Fax:** (504)368-1195. **E-mail:** editorial@pelicanpub.com. **Website:** www.pelicanpub.com. Estab. 1926. Publishes hardcover and paperback originals and reprints. Publishes 70 titles/year. Types of books include cookbooks, business/motivational, architecture, history, art and children's books. Books have a "high-quality, conservative and detail-oriented" look. Recent titles include: *The Maxims of General Patton*, *The Art of Brazilian Cooking*, *The Discovery of Longitude*.

NEEDS Approached by 2,000 freelancers/year. Works with 20 freelance illustrators/year. Uses freelancers for illustration and photo projects. Works on

assignment only. 100% of design and 50% of illustration demand knowledge of InDesign, Photoshop, Illustrator.

FIRST CONTACT & TERMS Designers: Send photocopies, photographs, SASE, slides and tearsheets. Illustrators: Send postcard sample or query letter with photocopies, SASE, slides and tearsheets. Samples are not returned. Responds on future assignment possibilities. Buys all rights. Originals are not returned.

DESIGN Pays by the project, $500 minimum.

JACKETS/COVERS Pays by the project, $150-500.

TEXT ILLUSTRATION Pays by the project, $50-250.

TIPS "Show your versatility. We want to see realistic detail and color samples."

PENGUIN GROUP (USA), INC.

375 Hudson St., New York NY 10014-3657. (212)366-2372. **Website:** www.penguinputnam.com. **Contact:** art director. Publishes hardcover and trade paperback originals.

NEEDS Works with 100-200 freelance illustrators and 100-200 freelance designers/year. Uses freelancers mainly for jackets, catalogs, etc.

FIRST CONTACT & TERMS Send query letter with tearsheets, photocopies, and SASE. Rights purchased vary according to project.

DESIGN Pays by the project; amount varies.

JACKETS/COVERS Pays by the project; amount varies.

PENGUIN RANDOM HOUSE

1745 Broadway, New York NY 10019. (212)782-9000. **E-mail:** atrandompublicity@randomhouse.com. **Website:** www.randomhouse.com. **Contact:** art director. Imprint publishes hardcover, trade paperback and reprints, and trade paperback originals. Types of books include adventure, coffee table books, cookbooks, children's books, fantasy, historical fiction, history, horror, humor, instructional, mainstream fiction, New Age, nonfiction, reference, religious, romance, science fiction, self-help, travel and western. Specializes in contemporary authors' work. 80% requires freelance illustration; 50% requires freelance design.

NEEDS Uses freelancers mainly for jacket/cover illustration and design for fiction and romance titles. 100% of design and 50% of illustration demands knowledge of Illustrator, QuarkXPress, Photoshop, and FreeHand. Works on assignment only.

FIRST CONTACT & TERMS Designers: Send résumé and tearsheets. Illustrators: Send postcard sample, brochure, résumé and tearsheets. Samples are filed. Request portfolio review in original query. Art director will contact artist for portfolio review if interested. Portfolio should include tearsheets. Buys first rights. Originals are returned at job's completion. Finds artists through *American Showcase, Workbook, The Creative Illustration Book*, artist's reps.

DESIGN Pays by the project.

JACKETS/COVERS Assigns 50 freelance design and 20 illustration jobs/year. Pays by the project.

TIPS "Study the product to make sure styles are similar to what we have done new, fresh, etc."

CLARKSON N. POTTER, INC.

Crown Publishers, Random House, Inc., 1745 Broadway, New York NY 10019. (212)782-9000. **E-mail:** crownosm@penguinrandomhouse.com. **Website:** www.clarksonpotter.com. Publishes hardcover originals and reprints. Types of books include coffee table books, cookbooks, gardening, crafts, gift, style, decorating. Specializes in lifestyle (cookbooks, gardening, decorating). Publishes 50-60 titles/year. 20% requires freelance illustration; 25% requires freelance design.

NEEDS Works with 10-15 illustrators and 15 designers/year. Prefers freelancers experienced in illustrating food in traditional styles and mediums and designers with previous book design experience. 100% of freelance design demands knowledge of Illustrator, Photoshop, QuarkXPress, InDesign.

FIRST CONTACT & TERMS Send postcard sample or query letter with printed samples, photocopies, tearsheets. Samples are filed and are not returned. Will contact artist for portfolio review if interested or portfolios may be dropped off any day. Negotiates rights purchased. Finds freelancers through submission packets, promotional postcards, Web sourcebooks, illustration annuals, and previous books.

DESIGN Assigns 20 freelance design jobs/year.

JACKETS/COVERS Assigns 20 freelance design and 15 illustration jobs/year. Pays for design by the project. Jackets are designed by book designer, i.e., the whole book and jacket are viewed as a package.

TEXT ILLUSTRATION Assigns 15 freelance illustration jobs/year.

TIPS "We no longer have a juvenile books department. We do not publish books of cartoons or humor. We look at a wide variety of design styles. We look at

mainly traditional illustration styles and mediums and are always looking for unique food and garden illustrations."

PRENTICE HALL COLLEGE DIVISION

Pearson Education, 200 Old Tappan Rd., Old Tappan NJ 07675. (201)236-7000. **Fax:** 201-767-5956. **E-mail:** communications@pearsoned.com; USAPermissions@pearsoned.com. **Website:** www.prenhall.com. Specializes in college textbooks in education and technology. Publishes 400 titles/year.

NEEDS Approached by 25-40 designers/freelancers/year. Works with 15 freelance designers/illustrators/year. Uses freelancers mainly for cover textbook design. 100% of freelance design and 70% of illustration demand knowledge of QuarkXPress 6.5, Illustrator and Photoshop CS.

FIRST CONTACT & TERMS Send query letter with résumé and tearsheets; sample text designs on CD in Mac format. Samples are filed and portfolios are returned. Responds if appropriate. Rights purchased vary according to project. Originals are returned at job's completion.

DESIGN Pays by the project.

TIPS "Send a style that works well with our particular disciplines."

PRO LINGUA ASSOCIATES

P.O. Box 1348, Brattleboro VT 05302-1348. (802)257-7779. **Fax:** (802)257-5117. **E-mail:** info@prolinguaassociates.com. **Website:** www.prolinguaassociates.com. **Contact:** Arthur A. Burrows, president. Estab. 1980. Publishes textbooks. Specializes in language textbooks. Recent titles: *Writing Strategies, Dictations for Discussion*. Publishes 3-8 titles/year. Some require freelance illustration. Book catalog free by request.

NEEDS Approached by 10 freelance artists/year. Works with up to 3 freelance illustrators/year. Uses freelance artists mainly for pedagogical illustrations of various kinds; also for jacket/cover and text illustration. Works on assignment only.

FIRST CONTACT & TERMS Send postcard sample or query letter with brochure, photocopies and photographs. Samples are filed. Responds in 1 month. Portfolio review not required. Buys all rights. Originals are returned at job's completion if requested. Finds artists through word of mouth and submissions.

TEXT ILLUSTRATION Assigns 1-3 freelance illustration jobs/year. Pays by the project, $200-1,200.

G.P. PUTNAM'S SONS, PENGUIN YOUNG READERS GROUP

345 Hudson St., 14th Floor, New York NY 10014. (212)366-2000. **Website:** www.penguin.com. **Contact:** Dave Kopka, Art Assistant. Publishes hardcover juvenile books. Publishes 65 titles/year.

NEEDS Picture book illustration on assignment only.

FIRST CONTACT & TERMS Provide printed samples or color copies to be kept on file for possible future assignments. Samples are returned by SASE only. Do not send samples via e-mail, original art, or CDs. If you are interested in illustrating picture books, we will need to see at least 3-4 sequential scenes of the same children or animals interacting in different settings.

QUITE SPECIFIC MEDIA GROUP, LTD.

7373 Pyramid Place, Hollywood CA 90046. (323)646-9934. **E-mail:** info@quitespecificmedia.com. **Website:** www.quitespecificmedia.com. Estab. 1967. Publishes hardcover originals and reprints, trade paperback reprints and textbooks. Specializes in costume, fashion, theater and performing arts books. Recent titles: *Understanding Fashion History*; *The Medieval Tailor's Assistant*. Publishes 12 titles/year. 10% require freelance illustration; 60% require freelance design.

○ Imprints of Quite Specific Media Group, Ltd. include Drama Publishers, Costume & Fashion Press, By Design Press, EntertainmentPro, and Jade Rabbit.

NEEDS Works with 2-3 freelance designers/year. Uses freelancers mainly for jackets/covers; also for book, direct mail and catalog design and text illustration. Works on assignment only.

FIRST CONTACT & TERMS Send query letter with brochure and tearsheets. Samples are filed. Responds only if interested. Rights purchased vary according to project. Originals not returned. Pays by the project.

RAINBOW BOOKS INC.

P.O. Box 430, Highland City FL 33846. (863)648-4420. **Fax:** (863)647-5951. **E-mail:** Info@RainbowBooksInc.com. **Website:** www.rainbowbooksinc.com. **Contact:** editorial department. Estab. 1978. Publishes hardcover and trade paperback originals. Types of books include instruction, adventure, biography, travel, self-help, mystery and reference. Specializes in nonfiction,

self-help, mystery fiction, and how-to. Recent titles: *False as the Day Is Long: A Keegan Shaw Mystery*; *Eavesdropping: As Real Women Talk About the Gifts and Challenges of Aging*; *Protecting Your Family's Assets in Florida: How to Legally Use Medicaid to Pay for Nursing Home and Assisted Living Care (2nd edition)*. Publishes 10-15 titles/year.

NEEDS All in-house.

RANDOM HOUSE CHILDREN'S BOOKS

1745 Broadway, New York NY 10019. (212)782-9000. **Website:** www.randomhouse.com. Estab. 1925. Largest English-language children's trade book publisher. Specializes in books for preschool children through young adult readers, in all formats from board books to activity books to picture books and novels. Recent titles: *How Many Seeds in a Pumpkin?*; *How Not to Start Third Grade*; *Spells & Sleeping Bags*; *The Power of One*. Publishes 250 titles/year. 100% require freelance illustration.

○ The Random House publishing divisions hire their freelancers directly. To contact the appropriate person, send a cover letter and résumé to the department head at the publisher as follows: "Department Head" (e.g., Art Director, Production Director), "Publisher/Imprint" (e.g., Knopf, Doubleday, etc.), 1745 Broadway, New York NY 10019.

NEEDS Works with 100-150 freelancers/year. Works on assignment only.

FIRST CONTACT & TERMS Send query letter with résumé, tearsheets and printed samples; no originals. Samples are filed. Negotiates rights purchased.

DESIGN Assigns 5 freelance design jobs/year. Pays by the project.

TEXT ILLUSTRATION Assigns 150 illustration jobs/year. Pays by the project.

❶○ RED DEER PRESS

195 Allstate Pkwy., Markham, Ontario L3R 4TB Canada. (905)477-9700. **Fax:** (905)477-9179. **E-mail:** rdp@reddeerpress.com. **Website:** www.reddeerpress.com. **Contact:** Richard Dionne, publisher. Estab. 1975. Please send queries by e-mail only. **Publisher:** Richard Dionne. Estab. 1975. Publishes hardcover and trade paperback originals. Types of books include contemporary and mainstream fiction, fantasy, biography, preschool, juvenile, young adult, sports, political science, and humor. Specializes in contemporary juvenile fiction and picture books for children. Re-

cent titles include *The Gospel Truth* and *The Carbon Rush*. 100% of titles require freelance illustration; 30% require freelance design. Book catalog available for SASE with Canadian postage.

NEEDS Approached by 50-75 freelance artists/year. Works with 10-12 freelance illustrators and 2-3 freelance designers/year. Buys 50 freelance illustrations/year. Prefers artists with experience in book and cover illustration. Also uses freelance artists for jacket/cover and book design and text illustration. Works on assignment only.

FIRST CONTACT & TERMS Send query letter with résumé by e-mail only. Terms on project basis.

DESIGN Assigns 3-4 design and 6-8 illustration jobs/year. Pays by the project.

JACKETS/COVERS Assigns 6-8 design and 10-12 illustration jobs/year. Pays by the project.

TEXT ILLUSTRATION Assigns 3-4 design and 4-6 illustration jobs/year. Pays by the project. May pay advance on royalties.

TIPS Looks for freelancers with a proven track record and knowledge of Red Deer Press. "Send a quality portfolio, preferably with samples of book projects completed."

✚ RED WHEEL/WEISER

65 Parker Street, Suite 7, Newburyport MA 01950. (978)465-0504. **Fax:** (978)465-0504. **E-mail:** submissions@rwwbooks.com; info@rwwbooks.com;. **Website:** www.redwheelweiser.com. **Contact:** Pat Bryce, acquisitions editor; Jim Warner, creative director. Estab. 1956. Publishes trade hardcover and paperback originals and reprints. Imprints: Red Wheel (spunky self-help); Weiser Books (metaphysics/oriental mind-body-spirit/esoterica); Conari Press (self-help/inspirational); Hampton Roads Publishing and Disinformation Books. Does not publish poetry or children's books. Publishes 50 titles/year.

NEEDS Uses freelancers for jacket/text design and illustration.

FIRST CONTACT & TERMS Designers: Send résumé, photocopies and tearsheets. Illustrators: Send photocopies, photographs, SASE and tearsheets. "We can use art or photos. I want to see samples I can keep." Samples are filed or are returned by SASE only if requested by artist. Responds only if interested. Originals are returned to artist at job's completion. To show portfolio, mail tearsheets, color photocopies. Considers complexity of project, skill and experience of artist, project's budget, turnaround time and rights purchased when establishing payment. Buys one-time nonexclusive royalty-free rights. Finds most artists through references/word of mouth, portfolio reviews and samples received through the mail.

JACKETS/COVERS Assigns 20 design jobs/year. Must have trade book design experience in the subjects we publish.

TIPS "Send samples by mail, preferably in color. We work electronically and prefer digital artwork or scans. Do not send drawings of witches, goblins and demons for Weiser Books; we don't put those kinds of images on our covers. Please take a moment to look at our books before submitting anything; we have characteristic looks for all imprints."

⌂ REGNERY PUBLISHING, INC.

Eagle Publishing, 300 New Jersey Ave. NW, Suite 500, Washington DC 20001-2253. (202)216-0600; (888)219-4747. **Fax:** (202)216-0612. **E-mail:** editorial@regnery.com; submissions@regnery.com. **Website:** www.regnery.com. **Contact:** Art Director. Estab. 1947. Publishes hardcover originals and reprints, trade paperback originals and reprints. Types of books include biography, history, nonfiction. Specializes in nonfiction. Publishes 30 titles/year. Recent titles include: *God, Guns and Rock & Roll* by Ted Nugent. 20-50% requires freelance design. Book catalog available for SASE.

NEEDS Approached by 20 illustrators and 20 designers/year. Works with 6 designers/year. Prefers local illustrators and designers. Prefers freelancers experienced in Mac, QuarkXPress and Photoshop. 100% of freelance design demands knowledge of QuarkXPress. 50% of freelance illustration demands knowledge of Photoshop, QuarkXPress.

FIRST CONTACT & TERMS "We will only accept proposals submitted by agents."

DESIGN Assigns 5-10 freelance design jobs/year. Pays for design by the project; negotiable.

JACKETS/COVERS Assigns 5-10 freelance design and 1-5 illustration jobs/year. Pays by the project; negotiable.

TIPS "We welcome designers with knowledge of Mac platforms and the ability to design 'bestsellers' under extremely tight guidelines and deadlines!"

ROBERTS PRESS

False Bay Books, 685 Spring St., PMB 161, Friday Harbor WA 98250. **E-mail:** submit-robertspress@falsebaybooks.com. **Website:** www.robertsbookpress.com. Estab. 2004. Publishes ebook originals and reprints, trade paperback originals and reprints, and audio books. Publishes fiction, including Christian fiction, fantasy, thrillers, mystery, women's fiction, family drama, juvenile fiction, mainstream fiction, science fiction, young adult and literary fiction, anthologies and multi-author collaborations. Recent titles include *The End of Law, Elemental, Drowning, Camouflage.*

SCHOLASTIC, INC.

557 Broadway, New York NY 10012. (212)343-6100. **Website:** www.scholastic.com. Scholastic Trade Books is an award-winning publisher of original children's books. Scholastic publishes more than 600 new hardcover, paperback and novelty books each year. The list includes the phenomenally successful publishing properties Harry Potter®, Goosebumps®, The 39 Clues™, I Spy™, and The Hunger Games; best-selling and award-winning authors and illustrators, including Blue Balliett, Jim Benton, Suzanne Collins, Christopher Paul Curtis, Ann M. Martin, Dav Pilkey, J.K. Rowling, Pam Muñoz Ryan, Brian Selznick, David Shannon, Mark Teague, and Walter Wick, among others; as well as licensed properties such as Star Wars® and Rainbow Magic®.

⏏ SCHOOL GUIDE PUBLICATIONS

606 Halstead Ave., Mamaroneck NY 10543. (800)433-7771. **E-mail:** mridder@schoolguides.com; info@schoolguides.com. **Website:** www.schoolguides.com. **Contact:** Myles Ridder, publisher. Estab. 1935. Types of books include reference and educational directories. Specializes in college recruiting publications. 1% requires freelance illustration; 1% requires freelance design.

NEEDS Approached by 10 illustrators and 10 designers/year. Prefers local freelancers. Prefers freelancers experienced in book cover and brochure design. 100% of freelance design and illustration demands knowledge of Illustrator, Photoshop, QuarkXPress.

FIRST CONTACT & TERMS Send e-mail query with samples. Send EPS files. Samples are filed. Responds only if interested. Will contact artist for portfolio review if interested. Rights purchased vary according to project. Finds freelancers through word of mouth.

SIMON & SCHUSTER

1230 Avenue of the Americas, New York NY 10020. (212)698-7000. **Website:** www.simonandschuster.com. Imprints include Pocket Books and Archway. Company publishes hardcover, trade paperback and mass market paperback originals, reprints and textbooks. Types of books include juvenile, preschool, romance, self-help, young adult and many others. Specializes in young adult, romance and self-help. Publishes 125 titles/year. Recent titles include *Plan of Attack* by Bob Woodward; *The Price of Loyalty* by Ron Suskind. 95% require freelance illustration; 80% require freelance design.

NEEDS Works with 50 freelance illustrators and 5 designers/year. Prefers freelancers with experience working with models and taking direction well. Uses freelancers for hand lettering, jacket/cover illustration and design, and book design. 100% of design and 75% of illustration demand knowledge of Illustrator and Photoshop. Works on assignment only.

FIRST CONTACT & TERMS Send query letter with tearsheets. Accepts disk submissions. Samples are filed and are not returned. Responds only if interested. Portfolios may be dropped off every Monday and Wednesday and should include tearsheets. Buys all rights. Originals are returned at job's completion.

TEXT ILLUSTRATION Assigns 50 freelance illustration jobs/year.

TECHNICAL ANALYSIS, INC.

4757 California Ave. SW, Seattle WA 98116-4499. (206)938-0570 or (800)832-4642. **E-mail:** cmorrison@traders.com. **Website:** www.traders.com. **Contact:** Christine Morrison, art director. Estab. 1982. Publishes trade paperback reprints, magazines and software. Types of books include instruction, reference, self-help and financial. Specializes in stocks, options, futures and mutual funds. Publishes 3 titles/year. 100% require freelance illustration; 10% require freelance design.

NEEDS Approached by 100 freelance artists/year. Works with 20 freelance illustrators/year. Buys 70 freelance illustrations/year. Uses freelance artists for magazine illustration; also for text illustration and direct mail design. Works on assignment only. Art awards for illustration include AI NY, 3×3, SI NY, HOW, StepintoDesign, Spectrum, SI LA, etc.

FIRST CONTACT & TERMS Send e-mail/postcards with links to artwork on website to cmorrison@traders.com. Will contact for possible assignment if interested. Buys first rights or reprint rights.

DESIGN Assigns 5 freelance design, 70 freelance illustration jobs/year. Pays by project.

JACKETS/COVERS Assigns 1 freelance design, 15 freelance illustration jobs/year. Pays by project.

TEXT ILLUSTRATION Assigns 5 freelance design and 70 freelance illustration jobs/year. Pays by the hour or by the project.

TIGHTROPE BOOKS

#207-2 College St., Toronto, Ontario M5G 1K3 Canada. (416)928-6666. **E-mail:** tightropeasst@gmail.com. **Website:** www.tightropebooks.com. **Contact:** Jim Nason, publisher. Estab. 2005. Publishes trade paperback originals.

NEEDS Publishes 12 titles/year. SASE returned. Responds only if interested. Catalog and guidelines free upon request and online.

FIRST CONTACT & TERMS Send an e-mail with résumé and artist's website, if available.

TILBURY HOUSE PUBLISHERS

WordSplice Studio, Inc., 12 Starr St., Thomaston ME 04861. (800)582-1899. **Fax:** (207)582-8772. **E-mail:** tilbury@tilburyhouse.com. **Website:** www.tilburyhouse.com. **Contact:** Audrey Maynard, children's book editor; Jonathan Eaton, publisher. Estab. 1990. Publishes hardcover originals, trade paperback originals. 10 titles/year.

FIRST CONTACT & TERMS Send photocopies of photos/artwork.

TIMEWELL

Bandanna Books, 1212 Punta Gorda St., #13, Santa Barbara CA 93103. **E-mail:** bandanna@cox.net. **Website:** www.bandannabooks.com; www.betabooks.us; www.timewell.us. Estab. 1975. The theme of TimeWell is to intermingle classic literature excerpts with contemporary writing, poems, art/graphic design based on a monthly theme. Publishes short pieces, no pay. Free to subscribe; sign up at the magazine.

TORAH AURA PRODUCTIONS

2710 Supply Avenue, Los Angeles CA 90040. (800)238-6724 or (800)689-0793. **Fax:** (323)585-0327. **E-mail:** misrad@torahaura.com. **Website:** www.torahaura.com. **Contact:** Jane Golub, art director. Estab. 1981. Publishes Jewish educational textbooks. Specializes in textbooks for Jewish schools. Recent titles: *Experiencing the Jewish Holidays, Experiencing the Torah.* Publishes 3-4 titles/year. 5% require freelance illustration. Book catalog free for 9×12 SASE with 10 first-class stamps.

NEEDS Approached by 50 illustrators and 20 designers/year. Works with 1-2 illustrators/year.

FIRST CONTACT & TERMS Illustrators: Send postcard sample and follow-up postcard every 6 months, printed samples, photocopies. Accepts Windows-compatible disk submissions. Samples are filed. Will contact artist for portfolio review if interested. Rights purchased vary according to project. Finds freelancers through submission packets.

TREEHAUS COMMUNICATIONS, INC.

906 W. Loveland Ave., P.O. Box 249, Loveland OH 45140. (800)638-4287. **Fax:** (513)683-2882. **E-mail:** treehaus@treehaus1.com. **Website:** www.treehaus1.com. Estab. 1973. Publisher. Specializes in books, periodicals, texts, TV productions. Product specialties are social studies and religious education. Recent titles: *The Stray; Rosanna the Rainbow Angel* (for children ages 4-8).

NEEDS Approached by 12-24 freelancers/year. Works with 2 or 3 freelance illustrators/year. Prefers freelancers with experience in illustrations for children. Works on assignment only. Uses freelancers for all work. 5% of work is with print ads. Needs computer-literate freelancers for illustration.

FIRST CONTACT & TERMS Send query letter with résumé, transparencies, photocopies and SASE. Samples sometimes filed or returned by SASE if requested by artist. Responds in 1 month. Art director will contact artist for portfolio review if interested. Portfolio should include final art, tearsheets, slides, photostats and transparencies. Pays for design and illustration by the project. Rights purchased vary according to project. Finds artists through word of mouth, submissions and other publisher's materials.

TIPS "We are looking for original style that is developed and refined. Whimsy helps."

TRIUMPH BOOKS

814 N. Franklin St., Chicago IL 60610. (312)337-0747. **Fax:** (312)280-5470. **Website:** www.triumphbooks.com. Estab. 1990. Publishes hardcover originals and reprints, trade paperback originals and reprints. Types of books include biography, coffee table books, humor, instructional, reference, sports. Specializes

in sports titles. Publishes 100 titles/year. 5% requires freelance illustration; 60% requires freelance design. Book catalog free for SASE.

NEEDS Approached by 5 illustrators and 5 designers/year. Works with 2 illustrators and 8 designers/year. Prefers freelancers experienced in book design. 100% of freelance design demands knowledge of Photoshop, InDesign, Illustrator, QuarkXPress.

FIRST CONTACT & TERMS Send query letter with printed samples, SASE. Accepts Mac-compatible disk submissions. Send TIFF files. Samples are filed or returned by SASE. Will contact artist for portfolio review if interested. Buys all rights. Finds freelancers through word of mouth, organizations (Chicago Women in Publishing), submission packets. "Because of the workload, phone calls will not be returned."

DESIGN Assigns 20 freelance design jobs/year. Pays for design by the project.

JACKETS/COVERS Assigns 30 freelance design and 2 illustration jobs/year. Pays for design by the project. Prefers simple, easy-to-read, in-your-face cover treatment.

TIPS "Most of our interior design requires a fast turnaround. We do mostly one-color work with occasional 2-color and 4-color jobs. We like a simple, professional design."

TYNDALE HOUSE PUBLISHERS, INC.

351 Executive Dr., Carol Stream IL 60188. (800)323-9400. **Fax:** (800)684-0247. **Website:** www.tyndale.com. Estab. 1962. Publishes hardcover and trade paperback originals. Specializes in children's books on "Christian beliefs and their effect on everyday life." Publishes 150 titles/year. 15% require freelance illustration.

NEEDS Approached by 200-250 freelance artists/year. Works with 5-7 illustrators.

FIRST CONTACT & TERMS Send query letter and tearsheets only. Samples are filed or are returned by SASE. Responds only if interested. Considers complexity of project, skill and experience of artist, project's budget and rights purchased when establishing payment. Negotiates rights purchased. Originals are returned at job's completion except for series logos.

JACKETS/COVERS Assigns 5-10 illustration jobs/year. Prefers progressive but friendly style. Pays by the project, no royalties.

TEXT ILLUSTRATION Assigns 1-5 jobs/year. Prefers progressive but friendly style. Pays by the project.

TIPS "Only show your best work. We are looking for illustrators who can tell a story with their work and who can draw the human figure in action when appropriate."

UNIVERSITY OF PENNSYLVANIA PRESS

3905 Spruce St., Philadelphia PA 19104. (215)898-6261. **Fax:** (215)898-0404. **E-mail:** agree@upenn.edu. **Website:** www.pennpress.org. **Contact:** Peter Agree, editor-in-chief. Estab. 1890. Publishes hardcover originals. Types of books include biography, history, nonfiction, landscape architecture, art history, anthropology, literature, and regional history. Publishes 80 titles/year. 10% requires freelance design.

NEEDS 100% of freelance work demands knowledge of Illustrator, Photoshop, and QuarkXPress.

FIRST CONTACT & TERMS Designers: Send query letter with photocopies. Illustrators: Send postcard sample. Accepts Mac-compatible disk submissions. Samples are not filed or returned. Will contact artist for portfolio review if interested. Portfolio should include book dummy and photocopies. Rights purchased vary according to project. Finds freelancers through submission packets and word of mouth.

DESIGN Assigns 2 freelance design jobs/year. Pays by the project.

JACKETS/COVERS Assigns 6 freelance design jobs/year. Pays by the project.

VOYAGEUR PRESS

Quayside Publishing Group, 400 First Ave. N., Suite 400, Minneapolis MN 55401. (800)458-0454. **Fax:** (612)344-8691. **Website:** http://voyageurpress.com. Estab. 1972. Publishes hardcover originals and reprints. Subjects include regional history, nature, popular culture, travel, wildlife, Americana, collectibles, lighthouses, quilts, tractors, barns and farms. Specializes in natural history, travel and regional subjects. Publishes 50 titles/year. 10% require freelance illustration; 10% require freelance design. Book catalog free by request.

NEEDS Approached by 100 freelance artists/year. Works with 2-5 freelance illustrators and 2-5 freelance designers/year. Prefers artists with experience in maps and book and cover design. Uses freelance artists mainly for cover and book design; also for jacket/cover illustration and direct mail and catalog design. 100% of design requires computer skills. Works on assignment only.

FIRST CONTACT & TERMS Send postcard sample and query letter with brochure, photocopies, SASE and tearsheets, list of credits and nonreturnable samples of work that need not be returned. Samples are filed. Responds only if interested. "We do not review portfolios unless we have a specific project in mind. In that case, we'll contact artists for a portfolio review." Usually buys first rights. Originals returned at job's completion.

DESIGN Assigns 2-5 freelance design jobs and 2-5 freelance illustration jobs/year.

JACKETS/COVERS Assigns 2-5 freelance design and 2-5 freelance illustration jobs/year.

TEXT ILLUSTRATION Assigns 2-5 freelance design and 2-5 design illustration jobs/year.

TIPS "We use more book designers than artists or illustrators, since most of our books are illustrated with photographs."

WATERBROOK MULTNOMAH PUBLISHING GROUP

Penguin Random House, 12265 Oracle Blvd., Suite 200, Colorado Springs CO 80921. (719)590-4999. **Fax:** (719)590-8977. **E-mail:** info@waterbrookmultnomah. com. **Website:** www.waterbrookmultnomah.com. Estab. 1996. Publishes audio tapes, hardcover, mass market paperback and trade paperback originals. Types of books include romance, science fiction, western, young adult fiction; biography, coffee table books, religious, self-help nonfiction. Specializes in Christian titles. Publishes 60 titles/year. 30% requires freelance design; 10% requires freelance illustration. Book catalog free on request.

NEEDS Approached by 10 designers and 100 illustrators/year. 90% of freelance design work demands knowledge of Illustrator, QuarkXPress and Photoshop.

FIRST CONTACT & TERMS Designer/illustrators: Send postcard sample with brochure, tearsheets. After introductory mailing, send follow-up postcard sample every 3 months. Samples are filed and not returned. Portfolio not required. Buys one-time rights, first North American serial rights. Finds freelancers through artist's submissions, Internet.

JACKETS/COVERS Assigns 2 freelance cover illustration jobs/year. Pays for illustration by the project.

TEXT ILLUSTRATION Assigns 4 freelance illustration jobs/year. Pays by the project.

ALBERT WHITMAN & COMPANY

250 S. Northwest Hwy., Suite 320, Park Ridge IL 60068. (800)255-7675. **Fax:** (847)581-0039. **E-mail:** submissions@albertwhitman.com. **Website:** www.albertwhitman.com. Estab. 1919. Publishes hardcover originals. Specializes in picture books for young children. Publishes 40 titles/year; 100% require freelance illustration. Responds "if we have a project that seems right for the artist. We like to see evidence that an artist can show the same children and adults in a variety of moods, poses and environments."

NEEDS Prefers working with artists who have experience illustrating picture books. Works on assignment only. Illustrators: Send postcard sample and tearsheets. "One sample is not enough. We need at least 3. Do *not* send original art through the mail."

WILLIAMSON BOOKS

6100 Tower Circle, Suite 210, Franklin TN 37067. **Website:** www.idealsbooks.com. Estab. 1983. Publishes trade paperback originals/casebound. Types of books include children's nonfiction (science, history, the arts), creative play, early learning, preschool and educational. Specializes in children's active hands-on learning. Publishes 8 titles/year. Book catalog free for 8½×11 SASE with 6 first-class stamps.

◯ This publisher is an imprint of Ideals Publications, a division of Guideposts.

NEEDS Approached by 100 illustrators and 10 designers/year. 100% of freelance design demands Quark computer skills. "We especially need illustrators whose art communicates with kids and has a vibrant style, as well as a sense of humor and quirky characterizations evident in illustrations. We are not looking for traditional or picture book styles." All illustrations must be provided in scanned, electronic form.

FIRST CONTACT & TERMS "Please do not e-mail large files to us. We prefer receiving postcards with references to your website. We really will look if we are interested." Designers: Send query letter with with website or brochure, photocopies, résumé, SASE. Illustrators: Send postcard sample and/or query letter with website or photocopies, résumé and SASE. Samples are filed. Responds only if interested.

DESIGN Pays for design by the project.

TIPS "We are actively seeking freelance illustrators and book designers to support our growing team. We are looking for full color distinctive illustration, along

with an 'energized' view of how-to illustrations (always drawn with personality as opposed to technical drawings). Go to the library and look up several of our books in our 4 series. You'll immediately see what we're all about. Then do a few samples for us. If we're excited about your work, you'll definitely hear from us. We always need designers who are interested in a nontraditional approach to kids' book design. Our books are award-winners, and design and illustration are key elements to our books' phenomenal success."

WORTHYKIDS/IDEALS

Worthy Publishing Group, 6100 Tower Circle, Suite 210, Franklin TN 37067. (615)932-7600. **E-mail:** idealsinfo@worthy-ideals.com. **Website:** www.idealsbooks.com. Estab. 1944. Company publishes hardcover originals and *Ideals* magazine. Specializes in nostalgia and holiday themes. Publishes 25-40 children's book titles and 2 magazine issues/year. 50% require freelance illustration. Guidelines available online.

NEEDS Approached by 100 freelancers/year. Works with 10-12 freelance illustrators/year. Prefers freelancers with experience in illustrating people, nostalgia, botanical flowers. Uses freelancers mainly for flower borders (color), people and spot art. Also for text illustration, jacket/cover and book design. Works on assignment only.

FIRST CONTACT & TERMS Art submission guidelines available online. Send to Attn: Art department.

TEXT ILLUSTRATION Assigns 75 freelance illustration jobs/year. Pays by the project. Prefers watercolor or gouache.

TIPS "Looking for illustrations with unique perspectives, perhaps some humor, that not only tells the story but draws the reader into the artist's world. We accept all styles."

GREETING CARDS, GIFTS, & PRODUCTS

//

The companies listed in this section contain some great potential clients for you. Although greeting card publishers make up the bulk of the listings, you'll also find many businesses that need images for all kinds of other products. We've included manufacturers of everyday items such as paper plates, napkins, banners, shopping bags, T-shirts, school supplies, personal checks, and calendars, as well as companies looking for fine art for limited edition collectibles.

TIPS FOR GETTING STARTED

Use the following tips as you prepare your greeting card or product submissions:

1. Read the listings carefully to learn exactly what products each company makes and the specific styles and subject matter they use.

2. Browse store shelves to see what's out there. Take a notebook and jot down the types of cards and products you see. If you want to illustrate greeting cards, familiarize yourself with the various categories of cards and note which images tend to appear again and again in each category.

3. Pay attention to the larger trends in society, such as diversity, patriotism, and the need to feel connected to others. Fads such as reality TV and scrapbooking, as well as popular celebrities, often show up in images on cards and gifts. Trends can also be spotted in movies and on websites.

GUIDELINES FOR SUBMISSION

- Do *not* send originals. Companies want to see photographs, photocopies, printed samples, computer printouts, tearsheets, or slides. Many also accept digital files on disk or via e-mail.

GREETING CARD BASICS

- Approximately 7 billion greeting cards are purchased annually, generating more than $7.5 billion in retail sales.

- Women buy more than 80% of all greeting cards.

- Seasonal cards express greetings for more than twenty different holidays, including Christmas, Easter, and Valentine's Day. Christmas cards account for 60 percent of seasonal greeting card sales.

- Everyday cards express nonholiday sentiments. The everyday category includes get well cards, thank you cards, sympathy cards, and a growing number of person-to-person greetings. There are cards of encouragement that say "Hang in there!" and cards to congratulate couples on staying together, or even getting divorced! There are cards from "the gang at the office" and cards to beloved pets. Check store racks for possible everyday occasions.

- Categories are further broken down into the following areas: traditional, humorous, and alternative. Alternative cards feature quirky, sophisticated, or offbeat humor.

- There are more than 3,000 greeting card publishers in America, ranging from small family businesses to major corporations.

- Artwork should be upbeat, brightly colored, and appropriate to one of the major categories or niches popular in the industry.
- Make sure each sample is labeled with your name, address, phone number, e-mail address, and website.
- Send three to five appropriate samples of your work to the contact person named in the listing. Include a brief cover letter with your initial mailing.
- Enclose a self-addressed, stamped envelope (SASE) if you need your samples back.
- Within six months, follow up with another mailing to the same listings and additional card and gift companies you have researched.

Don't Overlook the Collectibles Market

Limited edition collectibles, such as ornaments, figurines, and collector plates, appeal to a wide audience and are a lucrative niche for artists. To do well in this field, you have to be flexible enough to take suggestions. Companies test-market products to find out which images will sell the best, so they will guide you in the creative process. For a collectible plate, for example, your work must fit into a circular format or you'll be asked to extend the painting out to the edge of the plate.

Popular themes for collectibles include animals (especially kittens and puppies), children, dolls, TV nostalgia, patriotic, Native American, wildlife, religious (including madonnas and angels), gardening, culinary, and sports images.

E-Cards

Electronic greeting cards are very popular. Many can be sent for free, but they drive people to websites and can, therefore, be a smart marketing tool. The most popular e-cards are animated, and there is an increasing need for artists who can animate their own designs for the Internet, using Flash animation. Search the Internet and visit sites such as www.hallmark.com, www.bluemountain.com, and www.americangreetings.com to get an idea of the variety of images that appear on e-cards. Companies often post their design needs on their websites.

PAYMENT AND ROYALTIES

Most card and product companies pay set fees or royalty rates for design and illustration. Card companies almost always purchase full rights to work, but some are willing to negotiate for other arrangements such as greeting card rights only. If the company has ancillary plans in mind for your work (calendars, stationery, party supplies, or toys), they will probably want to buy all rights. In such cases, you may be able to bargain for higher payment. For more tips, see "Copyright Basics" in the Business Basics section.

4WALLS

4700 Lakeside Ave., 3rd Floor, Cleveland OH 44114. (216)881-8888. **Fax:** (216)274-9308. **E-mail:** gale@4walls.com. **Website:** www.4walls.com. **Contact:** Gale Flanagan, general manager. Estab. 1984. Produces fabrics/peel and stick accents/wallpaper/borders. Specializes in wallcovering, border and mural design, self-adhesive accents, also ultra-wide "mural" borders.

NEEDS Approached by 40-80 freelancers/year. Works with 20-40 freelancers/year. Buys hundreds of freelance designs and illustrations/year. Art guidelines free for SASE with first-class postage. Works on assignment and some licensing. Uses freelancers mainly for designs, color work. Looking for traditional, country, floral, texture, woven, menswear, children's and novelty styles. 50% of freelance design work demands computer skills. Wallcovering CAD experience a plus. Produces material for everyday.

FIRST CONTACT & TERMS Illustrators: Send query letter with photocopies, examples of work, résumé and SASE. Accepts disk submissions compatible with Illustrator or Photoshop files (Mac), also accepts digital files on CD or DVD. Samples are filed or returned by SASE on request. Responds in 1 month. Request portfolio review of color photographs and slides in original query, follow-up with letter after initial query. Rights purchased vary according to project. Pays by the project, $500-1,500, "but it varies." Finds freelancers through agents and local ads, word of mouth.

TIPS "Send great samples, especially childrens and novelty patterns, and also modern, organic textures and bold conteporary graphic work and digital files are very helpful. Study the market closely; do very detailed artwork."

KURT S. ADLER, INC.

7 W. 34th St., New York NY 10001. (212)924-0900. **E-mail:** info@kurtadler.com. **Website:** www.kurtadler.com. **Contact:** Howard Adler, president. Estab. 1946. Manufacturer and importer of Christmas ornaments and giftware products. Produces collectible figurines, decorations, gifts, ornaments.

NEEDS Prefers freelancers with experience in giftware. Considers all media. Will consider all styles appropriate for Christmas ornaments and giftware. Produces material for Christmas, Halloween.

FIRST CONTACT & TERMS Send query letter with brochure, photocopies, photographs. Responds within 1 month. Will contact for portfolio review if interested. Payment negotiable.

TIPS "We rely on freelance designers to give our line a fresh, new approach and innovative new ideas."

⚙ ALEF JUDAICA, INC.

15020 S. Figueroa St., Gardena CA 90248. (310)630-0024 or (800)262-2533. **Fax:** (310)808-0940. **E-mail:** sales@alefjudaica.com. **Website:** www.alefjudaica.com. Estab. 1979. Manufacturer and distributor of a full line of Judaica, including menorahs, Kiddush cups, greeting cards, giftwrap, tableware, etc.

NEEDS Approached by 15 freelancers/year. Works with 10 freelancers/year. Buys 75-100 freelance designs and illustrations/year. Prefers local freelancers with experience. Works on assignment only. Uses freelancers for new designs in Judaica gifts (menorahs, etc.) and ceramic Judaica. Also for calligraphy, pasteup and mechanicals. All designs should be upper scale Judaica.

FIRST CONTACT & TERMS Mail brochure, photographs of final art samples. Art director will contact artist for portfolio review if interested, or portfolios may be dropped off every Friday. Sometimes requests work on spec before assigning a job. Pays $300 for illustration/design; pays royalties of 10%. Considers buying second rights (reprint rights) to previously published work.

ALLPORT EDITIONS

716 NE Lawrence Ave., Portland OR 97232. (503)223-7268. **Fax:** (503)223-9182. **E-mail:** info@allport.com. **Website:** www.allport.com. Estab. 1982. Produces greeting cards. Specializes in regional designs (specifically depicting American cities and states). Currently only working with hand-rendered art (pen & ink, watercolor, acrylic, etc.). Does not use any photography. Art guidelines available on website.

NEEDS Approached by 200 freelancers/year. Works with 2-3 freelancers/year. Licenses 60 freelance designs and illustrations/year. Prefers art scaleable to card size. Produces material for holidays, birthdays and everyday. Submit seasonal material 1 year in advance.

FIRST CONTACT & TERMS Send query letter with photocopies and SASE. Accepts submissions on disk compatible with PC-formatted TIFF or JPEG files. Samples are filed or returned by SASE. Responds in 4-5 months if response is requested. Rights pur-

chased vary according to project. All contracts on royalty basis.

AMERICAN GREETINGS CORP.

1 American Rd., Cleveland OH 44144-2398. (216)252-7300. **Fax:** (216)252-6778. **Website:** www.corporate.americangreetings.com. Estab. 1906. Produces greeting cards, stationery, calendars, paper tableware products, giftwrap and ornaments. Also recruiting for AG Interactive.

NEEDS Prefers designers with experience in illustration, graphic design, surface design and calligraphy. Also looking for skills in motion graphics, Photoshop, animation and strong drawing skills. Usually works from a list of 100 active freelancers.

FIRST CONTACT & TERMS Apply online. Submission guidelines available online.

TIPS "Get a BFA in graphic design with a strong emphasis on typography."

AR-EN PARTY PRINTERS, INC.

3416 Oakton St., Skokie IL 60076. (847)673-7390. **Fax:** (847)673-7379. **E-mail:** customerservice@ar-en.net; artwork@ar-en.net. **Website:** www.ar-en.com. Estab. 1978. Produces stationery and paper tableware products. Makes personalized party accessories for weddings and all other affairs and special events.

NEEDS Works with 1-2 freelancers/year. Buys 10 freelance designs and illustrations/year. Works on assignment only. Uses freelancers mainly for new designs; also for calligraphy. Looking for contemporary and stylish designs, especially b&w line art (no grayscale) to use for hot stamping dyes. Prefers small (2×2) format.

FIRST CONTACT & TERMS Send query letter with brochure, résumé and SASE. Samples are filed or returned by SASE if requested by artist. Responds in 2 weeks. Will contact artist for portfolio review if interested. Rights purchased vary according to project.

TIPS "My best new ideas always evolve from something I see that turns me on. Do you have an idea/style that you love? Market it. Someone out there needs it."

ARTFUL GREETINGS

2104 Riddle Rd., Durham NC 27713. (919)598-7599. **Fax:** (919)598-1381. **E-mail:** myw@artfulgreetings.com. **Website:** www.artfulgreetings.com. Estab. 1990. Produces bookmarks, greeting cards, T-shirts and magnetic notepads. Specializes in multicultural subject matter, all ages.

NEEDS Approached by 200 freelancers/year. Works with 10 freelancers/year. Buys 20 freelance designs and illustrations/year. No b&w art. Uses freelancers mainly for cards. Considers bright color art, no photographs. Looking for art depicting people of all races. Prefers a multiple of 2 sizes: 5×7 and 5½×8. Produces material for Christmas, Mother's Day, Father's Day, graduation, Kwanzaa, Valentine's Day, birthdays, everyday, sympathy, get well, romantic, thank you, woman-to-woman and multicultural. Submit seasonal material 1 year in advance.

FIRST CONTACT & TERMS Designers: Send photocopies, SASE, slides, transparencies (call first). Illustrators: Send photocopies (call first). May send samples and queries by e-mail. Samples are filed. Artist should follow up with call or letter after initial query. Will contact for portfolio review of color slides and transparencies if interested. Negotiates rights purchased. Pays for illustration by the project, $50-100. Finds freelancers through word of mouth, NY Stationery Show.

ARTISTS TO WATCH

E-mail: submissions@artiststowatch.com. **Website:** www.artiststowatch.com. "Manufacturer of high-quality greeting cards featuring the work of contemporary national and international artists."

NEEDS Art submission guidelines available on the website. "We encourage illustrators, printmakers and photographers of all kind to submit. Please only 4-color images."

FIRST CONTACT & TERMS "E-mail small JPEG files or website URL. We will contact you if we'd like to see more. Use of artwork is compensated with royalty payments."

ART LICENSING

P.O. Box 2568, Manchester Center VT 05251. (802)362-3662. **Fax:** (802)549-8004. **E-mail:** jack@artlicensing.com. **Website:** www.artlicensing.com. Licenses art for wall decor, greeting cards, calendars, puzzles, rugs/floor mats, gift bags/gift wrap, T-shirts, fabric, iPhone/iPad cases, ornaments, figurines, rubber stamps, pillows, bedding, and other stationery products.

NEEDS Looking for variety of styles and subject matter. Art guidelines free for SASE with first-class postage. Considers all media and all styles. Produces material for all holidays.

FIRST CONTACT & TERMS Send color photocopies, photographs, tearsheets, CD or e-mail. Accepts disk submissions compatible with Mac. Samples are filed or returned by SASE only. Responds in 1 month. Will contact artist for portfolio review if interested.

ARTVISIONS: FINE ART LICENSING

E-mail: See website for contact form. **Website:** www.artvisions.com. **Contact:** Neil Miller, president. Estab. 1993. Licenses fine art and professional photography. Fine art and professional photography licensing only. Review guidelines on website. "Not currently seeking new talent. However, we are always willing to view the work of top-notch established artists. If you fit this category, please contact ArtVisions via the website contact form and include a link to a website where your art can be seen."

○ "To gain an idea of the type of art we license, please view our website. Artist *must* be able to provide high-res, professionally made digital files of artwork on DVD. We are firmly entrenched in the digital world, if you are not, then we cannot represent you."

FIRST CONTACT & TERMS Written contract provided.

TIPS "If you need advice about marketing your art, please visit: www.artistsconsult.com."

BARTON-COTTON, INC.

3030 Waterview Ave., Baltimore MD 21230. (800)348-1102. **Fax:** (410)565-5011. **E-mail:** info@bartoncotton.com;art.submission@bartoncotton.com. **Website:** www.bartoncotton.com. Produces religious greeting cards, commercial all-occasion, Christmas cards, wildlife designs and spring note cards. Licenses wildlife art, photography, traditional Christmas art for note cards, Christmas cards, calendars and all-occasion cards.

NEEDS Buys 150-200 freelance illustrations/year. Please submit no more then 15-20 pieces of your work in a neat and orderly format. When reviewing the artwork we are looking for concept, style, drawing skill, and color usage. Submit seasonal work any time. Free art guidelines for SASE with first-class postage and sample cards; specify area of interest (religious, Christmas, spring, etc.).

FIRST CONTACT & TERMS Send query letter with résumé, tearsheets, photocopies or slides. Submit full-color work only (watercolor, gouache, pastel, oil and acrylic). Previously published work and simultaneous submissions accepted. Responds in 1 month. Pays by the project. Pays on acceptance. "Please do not send original artwork at this time. Photos, color copies, digital files, slides or transparencies are great for initial review. Include your name, address, and phone number somewhere on each piece you provide."

TIPS "Spend some time studying current market trends in the greeting card industry. There is an increased need for creative ways to paint traditional Christmas scenes with up-to-date styles and techniques." See website for more guidelines.

BEISTLE CO.

1 Beistle Plaza, Shippensburg PA 17257-9623. (717)532-2131. **Fax:** (717)532-7789. **E-mail:** rlbuterbaugh@beistle.com. **Website:** www.beistle.com. **Contact:** Rick Buterbaugh, art directo. Estab. 1900. Manufacturer of paper and plastic decorations, party goods, gift items, tableware and greeting cards. Targets general public, home consumers through point-of-purchase displays, specialty advertising, school market and other party good suppliers.

NEEDS Approached by 250-300 freelancers/year. Works with 50 freelancers/year. Prefers artists with experience in designer gouache illustration. Also needs digital art (Mac platform or compatible). Art guidelines available. Looks for full-color, camera-ready artwork for separation and offset reproduction. Works on assignment only. Uses freelance artists mainly for product rendering and brochure design and layout. Prefers digital art using various styles and techniques. 50% of freelance design and 50% of illustration demand knowledge of QuarkXPress, Illustrator, Photoshop or Painter.

FIRST CONTACT & TERMS Send query letter with résumé and color reproductions with SASE. Samples are filed or returned by SASE. Art director will contact artist for portfolio review if interested. Sometimes requests work on spec before assigning a job. Pays by the project. Considers buying second rights (reprint rights) to previously published work. Finds artists through word of mouth, magazines, submissions/self-promotions, sourcebooks, agents, visiting artists' exhibitions, art fairs and artists' reps.

TIPS "Our primary interest is in illustration; often we receive freelance propositions for graphic design brochures, logos, catalogs, etc. These are not of interest to us as we are manufacturers of printed decorations. Send color samples rather than b&w."

BELLAMUSE

71 Nassau St., 2nd Floor. New York NY 10038. (212)727-0102;. **Fax:** (212)727-2102. **E-mail:** info@bellamuse.com. **Website:** www.bellamuse.com. Estab. 2003. "BellaMuse was established in 2003 by artist and typographer Alicia Peck. Alicia's work draws upon a love of writing, whimsy, humor, and antique illustrations. Little luxuries from BellaMuse are sold in upscale home stores and boutiques throughout the US."

NEEDS Produces conventional, formal, counter humor, alternative and cute cards and gifts. Categories include: Mother's Day, Christmas, Thanksgiving, graduation, birthday, Father's Day, Easter, Halloween, Valentine's Day, congratulations, wedding/anniversary, get-well/sympathy and everyday. Artists should be familiar with Adobe Illustrator, InDesign and Photoshop. Could use freelance Web design; designers should be familiar with Dreamweaver, Flash, GoLive and HTML. Submitted samples are kept on file. Seasonal material should be submitted 10 months in advance.

FIRST CONTACT & TERMS Send a query letter, e-mail or postcard sample including artist's URL, résumé, tearsheets and photographs. Follow up every 3 months.

BERGQUIST IMPORTS, INC.

1412 Hwy. 33 S., Cloquet MN 55720. (800)328-0853. **Fax:** (218)879-0010. **E-mail:** info@bergquistimports.com. **Website:** www.bergquistimports.com. Estab. 1948. Produces paper napkins, mugs and tile. Wholesaler of mugs, decorator tile, plates and dinnerware.

NEEDS Approached by 25 freelancers/year. Works with 5 freelancers/year. Buys 50 designs and illustrations/year. Prefers freelancers with experience in Scandinavian designs. Works on assignment only. Also uses freelancers for calligraphy. Produces material for Christmas, Valentine's Day and everyday. Submit seasonal material 6-8 months in advance.

FIRST CONTACT & TERMS Send query letter with brochure, tearsheets and photographs. Samples are returned, not filed. Responds in 2 months. Request portfolio review in original query. Artist should follow up with a letter after initial query. Portfolio should include roughs, color tearsheets and photographs. Rights purchased vary according to project. Originals are returned at job's completion. Requests work on spec before assigning a job. Pays by the project, $50-300; average flat fee of $100 for illustration/design; or royalties of 5%. Finds artists through word of mouth, submissions/self-promotions and art fairs.

BERWICK OFFRAY

2015 W. Front St., Berwick CA 18603. (800)237-9425; (570)752-5934. **Fax:** (570)752-5934. **E-mail:** customerservice@offray.com. **Website:** offray.com. Estab. 1900. Produces ribbons, gift bags, wrapping paper, tissues and more. "We're mainly a ribbon company. For ribbon designs we look to the textile design studios and textile-oriented people; children's designs, craft motifs, fabric trend designs, floral designs, Christmas designs, bridal ideas, etc. Our range of needs is wide, so we need various looks."

NEEDS Looking for artists able to translate a trend or design idea into a 1½" to 2½" width ribbon. Produce ribbons for fall, Christmas, Valentine's Day, Easter, bridal and everyday.

FIRST CONTACT & TERMS Send postcard sample or query letter with résumé or call.

BLOOMIN' FLOWER CARDS

3080 Valmont Rd., Boulder CO 80301. (800)894-9185, ext. 2. **E-mail:** flowers@bloomin.com. **Website:** bloomin.com. Estab. 1995. Produces greeting cards, stationery and gift tags—all embedded with seeds.

NEEDS Approached by 100 freelancers/year. Works with 1-5 freelancers/year. Buys 1-5 freelance designs and illustrations/year. Art guidelines available. Uses freelancers mainly for card images. Considers all media. Looking for florals, garden scenes, holiday florals, birds, and butterflies—bright colors, no photography. Produces material for Christmas, Easter, Mother's Day, Father's Day, Valentine's Day, Earth Day, birthdays, everyday, get well, romantic and thank you. Submit seasonal material 8 months in advance.

FIRST CONTACT & TERMS Accepts digital submissions only—show us samples of your work. Responds if interested. Finds freelancers through word of mouth, submissions, and local artists' guild.

TIPS "All submissions *must* be relevant to flowers and gardening."

BLUE MOUNTAIN ARTS, INC.

P.O. Box 4549, Boulder CO 80306. (303)449-0536 or (800)525-0642. **Fax:** (800)545-8573. **E-mail:** editorial@sps.com. **Website:** www.sps.com. Estab. 1970. Produces books, bookmarks, calendars, greeting cards, mugs and prints. Specializes in handmade-looking greeting cards, calendars and

books with inspirational or whimsical messages accompanied by colorful hand-painted illustrations.

NEEDS Art guidelines via e-mail. Uses freelancers mainly for hand-painted illustrations. Considers all media. Product categories include alternative cards, alternative/humor, conventional, cute, inspirational and teen. Submit seasonal material 10 months in advance. Art size should be 5×7 vertical format for greeting cards.

FIRST CONTACT & TERMS Send query letter with photocopies, photographs, SASE and tearsheets. Send no more than 5 illustrations initially. Or e-mail with subject line "Greeting Card Submission." No phone calls or faxes. Samples are filed or are returned by SASE. Responds in 2 months. Portfolio not required. Buys all rights. Pays freelancers flat rate: $150-250/illustration if chosen. Finds freelancers through submissions and word of mouth.

TIPS "We are an innovative company, always looking for fresh and unique art styles to accompany our sensitive or whimsical messages. We also welcome illustrated cards accompanied with your own editorial content. We strive for a handmade look. We love color! We don't want photography! We don't want slick computer art! Do in-store research to get a feel for the look and content of our products. We want illustrations for printed cards, not e-cards! We want to see illustrations that fit with our existing looks, and we also want fresh, new and exciting styles and concepts. Remember that people buy cards for what they say. The illustration is a beautiful backdrop for the message."

⊘⊙ BLUE MOUNTAIN WALLCOVERINGS

15 Akron Rd., Toronto, Ontario M8W 1T3 Canada. (800)219-2424; (866)563-9872. **Fax:** (800)741-2083. **E-mail:** info@blmtn.com. **Website:** www.blmtn.com. Produces wallpaper.

NEEDS Works with 20-50 freelancers/year. Prefers local designers/illustrators with experience in wallpaper. Art guidelines available. Product categories include conventional, country, juvenile and teen. 5% of freelance work demands knowledge of Photoshop.

FIRST CONTACT & TERMS Send brochure, photocopies and photographs. Samples are filed. Responds only if interested. Company will contact artist for portfolio review of color, finished art, original art, photographs, transparencies if interested. Buys rights for wallpaper or all rights. Pays freelancers by

the project. Finds freelancers through agents, artist submissions and word of mouth.

BON ART

66 Fort Point St., Norwalk CT 06855. (203)845-8888. **E-mail:** sales@bonartique.com. **Website:** www.bonartique.com. **Contact:** Brett Bonnist. Estab. 1980. Art publisher, poster company, licensing and design studio. Publishes/distributes fine art prints, canvas transfers, unlimited editions, offset reproductions and posters. Clients: Internet purveyors of art, picture frame manufacturers, catalog companies, distributors.

NEEDS Seeking decorative and fashionable art for the commercial and designer markets. Considers oil, acrylic, pastel, watercolor and mixed media. Artists represented include Eric Yang, Tom Butler, Mid Gordon, Martin Wiscombe, Julia Hawkins, Gloria Ericksen, Janet Stever, Xander Blue, Maxwell Hutchinson, Bennie Diaz and Joanna Velasquez. Editions are created by collaborating with the artist or by working from an existing painting. Approached by 500 artists/year. Publishes/distributes the work of 30 emerging artists/year.

FIRST CONTACT & TERMS E-mail or send query letter with brochure, samples, photographs, URL. Accepts e-mail submissions with image files or link to website. Prefers JPEG or PDF files. Samples are kept on file or returned by SASE if requested. Responds only if interested. Will contact artist for portfolio review if interested. Portfolio should include b&w, color, finished art, roughs, photographs. Pays flat fee or royalties. Offers advance when appropriate. Rights purchased vary according to project; negotiated. Requires exclusive representation. Provides insurance while work is at firm, shipping from firm, promotion and written contract. Finds artists through agents/reps, submissions, portfolio reviews, art fairs/exhibits, word of mouth, referrals by other artists, magazines, sourcebooks, Internet.

TIPS "We welcome submissions from a wide range of international artists. As leaders in the field of fine art publishing for the past 30 years, we believe in sharing our knowledge of the trends, categories and styles with our artists. Although interested in working with veterans of our industry, we actively recruit and encourage all accomplished artists to submit their portfolios—preferably by e-mail with links to images."

ASHLEIGH BRILLIANT ENTERPRISES

117 W. Valerio St., Santa Barbara CA 93101. (805)682-0531. **E-mail:** ashleigh@west.net; ashleigh@ashleighbrilliant.com. **Website:** www.ashleighbrilliant.com. **Contact:** Ashleigh Brilliant, president. Publishes postcards.

Prefers single-panel. Maximum size of artwork: 5½×3½, horizontal only. Samples are returned by SASE if requested by artist. Responds in 2 weeks. **Pays on acceptance;** minimum flat fee of $60. Buys all rights. Syndicate owns original art. "Our product is so unusual that freelancers will be wasting their time and ours unless they first carefully study our catalog. Our product is so unusual that freelancers will be wasting their time and ours unless they first carefully study our catalog."

NEEDS Buys up to 300 designs/year. Freelancers may submit designs for word-and-picture postcards, illustrated with line drawings.

FIRST CONTACT & TERMS Submit 5½×3½ horizontal b&w line drawings and SASE. Responds in 2 weeks. Buys all rights. Pays $60 minimum.

BRISTOL GIFT CO., INC.

8 North St., P.O. Box 425. Washingtonville NY 10992. (845)614-5777;. **E-mail:** info@bristolgift.net. **Website:** www.bristolgift.com. Estab. 1988. Specializes in framed pictures for inspiration and religious markets. Art guidelines available for SASE.

NEEDS Approached by 5-10 freelancers/year. Works with 2 freelancers/year. Buys 15-30 freelance designs and illustrations/year. Works on assignment only. Uses freelancers mainly for design; also for calligraphy, P-O-P displays, Web design and mechanicals. Prefers 16×20 or smaller. 10% of design and 60% of illustration require knowledge of PageMaker or Illustrator. Produces material for Christmas, Mother's Day, Father's Day and graduation. Submit seasonal material 6 months in advance.

FIRST CONTACT & TERMS Send query letter with brochure and photocopies. Samples are filed or returned. Responds in 2 weeks. Will contact artist for portfolio review if interested. Portfolio should include roughs. Requests work on spec before assigning a job. Originals are not returned. Pays by the project, $30-50 or royalties of 5-10%. Rights purchased vary according to project. Interested in buying second rights (reprint rights) to previously published artwork.

BRUSH DANCE, INC.

3060 El Cerrito Plaza, Suite 400, San Rafael CA 94530. **E-mail:** art@brushdance.com. **Website:** www.brushdance.com. **Contact:** April Welches-Greenhill. Estab. 1989. Produces greeting cards, stationery, blank journals, illustrated journals, boxed notes, calendars, holiday cards and magnets. The line of Brush Dance products is inspired by the interplay of art and words. "We develop products that combine powerful and playful words and images that act as daily reminders to inspire, connect, challenge and support."

NEEDS Approached by 200 freelancers/year. Works with 3-5 freelancers/year. Uses freelancers for illustration, photography and calligraphy. Looking for nontraditional work conveying emotion or message. "We are also interested in artists who are using both images and original words in their work."

FIRST CONTACT & TERMS Submission guidelines available online. "You can send us 3 to 4 images to get the ball rolling. Tell us something about you, too — we love feeling the connection between the art and the artist." Please limit custom formats to no larger than 11×14. Please do not send original artwork as we are unable to return your submissions. "We're a small company doing really really big things and while we review art on a continual basis and do our best to respond quickly, that time is sometimes longer so that we can give consideration to all of the wonderful submissions we receive. (Submitting electronically makes this part of the process easier on us and will probably yield a faster response time for you, too.)"

TIPS *"Please* do your research, and look at our website to be sure your work will fit into our line of products."

CALYPSO CARDS

166 Valley Street, Providence RI 02909. (978)287-5900. **Fax:** (978)287-5902. **E-mail:** nicky@calypsocards.com; info@calypsocards.com; submissions@calypsocards.com. **Website:** www.calypsocards.com. Estab. 2004. Produces greeting cards and fridge magnets. Specializes in greeting cards for all occasions and ages, with contemporary design.

NEEDS Works with 50-100 freelancers/year. Buys 200+ freelance design and illustrations/year. Art submission guidelines free on website. Product categories include alternative, counter humor, alternative/humor, inspirational, juvenile. Produces material for all

holidays and seasons. Submit seasonal material one year in advance.

FIRST CONTACT & TERMS E-mail query letter. Samples kept on file or returned with SASE. Responds only if interested. Portfolio not required. Buys rights for cards. Freelancers paid royalties of 8%. Finds freelancers through agents/reps, submissions, word-of-mouth and online.

TIPS "Send examples of work via e-mail. We will contact you within 3-4 months if interested."

CAPE SHORE, INC.

86 Downeast Dr., Yarmouth ME 04096. (800)343-2424. **Fax:** (800)457-7087. **E-mail:** webmail@cape-shore.com. **Website:** www.cape-shore.com. **Contact:** creative director. Estab. 1947. "Cape Shore is concerned with seeking, manufacturing and distributing a quality line of gifts and stationery for the souvenir and gift market." Licenses art by noted illustrators with a track record for paper products and giftware. Guidelines available online.

NEEDS Approached by 100 freelancers/year. Works with 50 freelancers/year. Buys 400 freelance designs and illustrations/year. Prefers artists and product designers with experience in gift product, hanging ornament and stationery markets. Art guidelines available free for SASE. Uses freelance illustration for boxed note cards, Christmas cards, ornaments, home accessories, ceramics and other paper products. Considers all media. Looking for skilled wood carvers with a warm, endearing folk art style for holiday gift products.

FIRST CONTACT & TERMS "Do not call; no exceptions." Send query letter with color copies. Samples are filed or are returned by SASE. Art director will contact artist for portfolio review if interested. Portfolio should include finished samples, printed samples. Pays for design by the project, advance on royalties or negotiable flat fee. Buys varying rights according to project. "Please submit your art on a cd with a few representative color copies. If your art is appropriate for us we will keep your portfolio on file and call you when we are interested in licensing it or commissioning something similar. If you would like your submission returned, please enclose a SASE."

TIPS "Cape Shore is looking for realistic detail, good technique, and traditional themes or very high quality contemporary looks for coastal as well as inland markets. We will sometimes buy art for a full line of

products, or we may buy art for a single note or gift item. Proven success in the giftware field a plus, but will consider new talent and exceptional unpublished illustrators."

CARDMAKERS

424 Fore St., Portland ME 04101. (207)761-4279. **E-mail:** info@cardmakers.com. **Website:** www.cardmakers.com. Estab. 1978. "We produce cards for special interests and greeting cards for businesses—primarily Christmas-themed. We also publish everyday cards for stockbrokers and boaters."

NEEDS Approached by more than 300 freelancers/year. Works with 5-10 freelancers/year. Buys approx. 10 designs and illustrations/year. Prefers professional-caliber artists. Art guidelines available on website only. "Please do not e-mail us for same." Works on assignment only. Uses freelancers mainly for greeting card design and calligraphy. Considers all media. "We market 5×7 cards designed to appeal to individual's specific interest-boating, building, cycling, stocks and bonds, etc." Prefers an upscale look. Submit seasonal ideas 6-9 months in advance.

FIRST CONTACT & TERMS Submit via online submission form. Artists may submit 6-8 JPEGs at 72 dpi.

TIPS "We like to see new work in the early part of the year. Getting published and gaining experience should be the main objective of freelancers entering the field. We favor fresh talent (but do also feature seasoned talent). PLEASE be patient waiting to hear from us! Make sure your work is equal to or better than that which is commonly found in use presently. Go to a large greeting card store. If you think you're as good or better than the artists there, continue!"

CENTRIC CORP.

6712 Melrose Ave., Los Angeles CA 90038. (323)936-2100. **Fax:** (323)936-2101. **E-mail:** centric@juno.com. **Website:** www.centriccorp.com. Estab. 1986. Produces products such as watches, pens, T-shirts, pillows, clocks, and mugs. Specializes in products that feature nostalgic, humorous, thought-provoking images or sayings on them and some classic licensed celebrities.

NEEDS Looking for freelancers who know Photoshop, InDesign and Illustrator well.

FIRST CONTACT & TERMS Send examples of your work. Pays when project is completed.

TIPS "Research the demographics of buyers who purchase Elvis, Lucy, Marilyn Monroe, James Dean, Betty

Boop and Bettie Page products to know how to 'communicate a message' to the buyer."

CITY MERCHANDISE, INC.

228 40th St., Brooklyn NY 11232. (718)832-2931. **Fax:** (718)832-2939. **E-mail:** city@citymerchandise.com. **Website:** www.citymerchandise.com. Produces calendars, collectible figurines, gifts, mugs, souvenirs of New York.

NEEDS Works with 6-10 freelancers/year. Buys 50-100 freelance designs and illustrations/year. "We buy sculptures for our casting business." Prefers freelancers with experience in graphic design. Works on assignment only. Uses freelancers for most projects. Considers all media. 50% of design and 80% of illustration demand knowledge of Photoshop, QuarkXPress, Illustrator. Does not produce holiday material.

FIRST CONTACT & TERMS Designers: Send query letter with brochure, photocopies, résumé. Illustrators or cartoonists: Send postcard sample of work only. Sculptors: Send résumé and slides, photos or photocopies of their work. Samples are filed. Include SASE for return of samples. Responds in 2 weeks. Portfolios required for sculptors only if interested in artist's work. Buys all rights. Pays by project.

COMSTOCK CARDS

1344 Disc Dr., #185, Sparks NV 89436. (800)326-7825. **Fax:** (888)266-2610. **E-mail:** production@cmpmarket. com. **Website:** www.comstockmarketplace.com. Estab. 1986. Produces greeting cards, giftbags and invitations. Styles include alternative and adult humor, outrageous and shocking themes. Art guidelines available for SASE with first-class postage.

NEEDS Approached by 250-350 freelancers/year. Works with 30-35 freelancers/year. "Especially seeking artists able to produce outrageous adult-oriented cartoons." Uses freelancers mainly for cartoon greeting cards. No verse or prose. Gaglines must be brief. Prefers 5×7 final art. Produces material for all occasions. Submit holiday concepts 6 months in advance.

FIRST CONTACT & TERMS Send query letter with SASE, tearsheets or photocopies. Samples are not usually filed and are returned by SASE if requested. Responds only if interested. Portfolio review not required. Originals are not returned. Pays royalties of 5%. Pays by the project, $50-150 minimum; may negotiate other arrangements. Buys all rights.

TIPS "Submit with SASE if you want material returned."

COURAGE CARDS

Courage Kenny Cards, 1750 Tower Blvd. North Mankato MN 56003. (800)992-6872. **E-mail:** artsearch@couragecenter.org. **Website:** www. couragecards.org. Estab. 1958. "Courage Cards is a greeting card company that produces a holiday card collection to support the programs of Courage Kenny Rehabilitation Institute, a nonprofit rehabilitation and resource center advancing the lives of people with disabilities."

NEEDS Seeking colorful holiday artwork that is appropriate for greeting cards, including traditional Christmas, city scenes, winter landscape, peace, international and fall seasonal images. Courage Cards supports the works of artists with a disability, but all artists are encouraged to enter the annual Courage Card Art Search.

FIRST CONTACT & TERMS Submit online, or call or e-mail name and address to receive Art Search guidelines, which are mailed in September for the November 30 entry deadline. Do not send original artwork! Responds within 5 months. Submissions returned with an SASE. Courage Cards pays a licensing fee of $400 per selected image chosen, which secures reprint rights for Courage Cards for 5 years. Artist retains ownership of their artwork. Artists are recognized through a nationwide distribution of more than 900,000 catalogs and promotional pieces, Internet, radio, TV and print advertising.

CREATIF LICENSING

31 Old Town Crossing, Mt. Kisco NY 10549-4030. (914)241-6211. **E-mail:** info@creatifusa.com. **Website:** www.creatifusa.com. Estab. 1975. "Creatif is a licensing agency that represents artists and brands." Licensing art for commercial applications on consumer products in the gift, stationery and home furnishings industries.

NEEDS Looking for unique art styles or concepts that are applicable to multiple products and categories.

FIRST CONTACT & TERMS Send e-mail query or letter with photocopies, photographs, SASE or tearsheets. Accepts e-mail attachments and will review website links. Responds in 1 month. Samples are returned with SASE. Creatif will obtain licensing agreements on behalf of the artists, negotiate and manage the licensing programs and pay royalties. Artists are responsible for filing all copyright and

trademark. Requires exclusive representation of artists. Also, the exclusivity is for "core" artists, meaning artists we work with day in day out. We will represent artists on a non-exclusive basis if their art has limited but specialized licensing application.

TIPS "We are looking to license talented and committed artists. It is important to understand current trends, and design with specific products in mind."

DALOIA DESIGN

100 Norwich E., West Palm Beach FL 33417-7910. (561)452-4150. **E-mail:** daloiades@aol.com. Estab. 1983. Produces art for stationery and gift products such as magnets, photo frames, coasters, bookmarks, home decor, etc.

NEEDS Approached by 20-30 freelancers/year. Uses freelancers for original and innovative product art. Freelancers must know software appropriate for project.

FIRST CONTACT & TERMS Send samples of your work to be filed and not returned. Responds only if interested. Payment "depends on project and use." Negotiates rights purchased.

TIPS "Keep an open mind, strive for excellence, push limitations."

DELJOU ART GROUP

1616 Huber St., Atlanta GA 30318. (404)350-7190 or (800)237-4638. **Fax:** (404)350-7195. **E-mail:** submit@ deljouartgroup.com. **Website:** www.deljouartgroup. com. Estab. 1980. Art publisher, distributor and gallery of original work as well as limited editions, hand-pulled originals, monoprints/monotypes, sculpture, fine art photography, fine art prints and paintings on paper and canvas. Clients: galleries, designers, corporate buyers and architects. Previous and current clients include Coca-Cola, Xerox, Exxon, Marriott Hotels, General Electric, Charter Hospitals, AT&T and more than 3,000 galleries worldwide, "forming a strong network throughout the world."

NEEDS Seeking creative, fine and decorative art for the designer market and serious collectors. Considers oil, acrylic, pastel, sculpture, mixed media and photography. Artists represented include Craig Alan, Yunessi, T.L. Lange, Michael Emani, Vincent George, Nela Soloman, Alterra, Ivan Reyes, Mindeli, Sanford Wakeman, Niro Vessali, Lee White, Alexa Kelemen, Bika, Kamy, Roya Azim, Jian Chang, Elya DeChino, Antonio Dojer, Emanuel Mattini, Lun Tse, Martin Quen, Cecil K. Seika, Prescott, J. Kani, Say and Mia

Stone. Editions are created by collaborating with the artist. Approached by 300 artists/year. Publishes the work of 10 emerging, 20 mid-career and 20 established artists/year.

FIRST CONTACT & TERMS "All submissions to be made via postal mail or e-mail. If sending hard copy material, it will be returned only if a self-addressed, postage-paid envelope is included.Send a minimum of 5 images from your portfolio. Images should be in JPG format, smaller than 5MB each. Please include the following for all artwork: Title, Medium, Dimensions, and Retail Pricing. Include all contact information including a biography, website, artist statement, exhibition history, email and phone number. Allow 4-6 weeks for the review process. If we select your work for further consideration we will contact you directly. Notifications are not sent for submissions which do not make it to the next phase of consideration. You may submit your work at a later date, please allow at least 2 months from your original submission date."

TIPS "We need landscape artists, 3D wall art (any media), strong figurative artists, sophisticated abstracts and soft-edge abstracts. We are also beginning to publish sculptures and are interested in seeing slides of such. We also have the largest gallery in the country. We have added an art consulting and hospitality division and need images in different categories for our print on demand collection."

DELTA CREATIVE, INC.

3225 Westech Dr., Norcross GA 30092. (800)842-4197. **E-mail:** advisor@deltacreative.com;general@ plaidonlinemail.com. **Website:** www.deltacreative. com. Estab. 1978. Produces art and novelty rubber stamps, kits, glitter pens, ink pads, papers, stickers, scrapbooking products.

NEEDS Approached by 30 freelance artists/year. Works with 10-20 freelance artists/year. Buys 200-300 freelance designs and illustrations/year. Uses freelance artists for calligraphy, P-O-P displays, and original art for rubber stamps. Considers pen & ink. Looks for whimsical, feminine style and fashion trends. Produces seasonal material Christmas, Valentine's Day, Easter, Hanukkah, Thanskgiving, Halloween, birthdays and everyday (includes wedding, baby, travel, and other life events). Submit seasonal material 9 months in advance.

FIRST CONTACT & TERMS Send nonreturnable samples. Samples are filed. Responds only if interested. Rights purchased vary according to project. Originals are not returned.

DESIGN DESIGN, INC.

19 La Grave Ave., Grand Rapids MI 49503. (616)771-8319; (866)935-2648. **E-mail:** susan.birnbaum@designdesign.us; retailhelp@designdesign.us; tom.vituj@designdesign.us. **Website:** www.designdesign.us. Estab. 1986. Specializes in greeting cards and paper-related product development.

NEEDS Uses freelancers for all of the above products. Considers most media. Produces cards for everyday and all holidays. Submit seasonal material 1 year in advance.

FIRST CONTACT & TERMS Send query letter with appropriate samples and SASE. Samples are not filed and are returned by SASE if requested by artist. To show portfolio, send color copies, photographs or slides. Do not send originals. Pays various royalties per product development.

EMERY-BURTON FINE CARDS & GIFTS

P.O. Box 31130, Seattle WA 98103. (866)617-1259. **Fax:** (866)617-8424. **E-mail:** info@Emery-Burton.com. **Website:** www.emery-burton.com. Produces greeting cards.

NEEDS Product categories include conventional, counter humor and cute. Produces material for Mother's Day, Valentine's Day, Christmas, birthday, cards for pets, congratulations, baby congrats, woman-to-woman, wedding/anniversary, getwell/sympathy and everyday. Seasonal material should be submitted 6 months in advance. Final art should be 5×7. 100% of freelance work demands computer skills; artists should be familiar with Illustrator, Photoshop and InDesign. No need for freelance Web design.

FIRST CONTACT & TERMS Send query letter with SASE, or e-mail digital images (TIFF at 300 dpi). Samples not kept on file; returned by SASE.

ENESCO GROUP, INC.

225 Windsor Dr., Itasca IL 60143. (630)875-5300. **E-mail:** dbernar@enesco.com. **Website:** www.enesco.com. Producer and importer of fine gifts, home decor and collectibles, such as resin, porcelain bisque and earthenware figurines, plates, hanging ornaments, bells, picture frames, decorative housewares. Clients gift stores, card shops and department stores.

NEEDS Works with multiple freelance artists/year. Prefers artists with experience in gift product and packaging development. Uses freelancers for rendering, illustration and sculpture. 50% of freelance work demands knowledge of Photoshop, QuarkXPress or Illustrator.

FIRST CONTACT & TERMS Submit via "product idea and artist submissions" form on website. Accepts .bmp, .flv, .gif, .jpg, .mov, .mpeg, .mpg, .png, .ppt, .rm, .tif or .wmv formats.

TIPS "All will be reviewed by our senior creative director, executive vice president and licensing director. If your talent is a good match to Enesco's product development, we will contact you to discuss further arrangements. Please do not send slides. Have a well-thought-out concept that relates to gift products before mailing your submissions."

EPIC PRODUCTS, INC.

2801 S. Yale St., Santa Ana CA 92704. (800)548-9791. **Fax:** (714)641-8217. **E-mail:** info@epicproductsinc.com. **Website:** www.epicproductsinc.com. Estab. 1978. Produces paper tableware products and wine and spirits accessories. "We manufacture products for the gourmet/housewares market; specifically products that are wine-related. Many have a design printed on them."

NEEDS Approached by 50-75 freelance artists/year. Works with 10-15 freelancers/year. Buys 25-50 designs and illustrations/year. Prefers artists with experience in gourmet/housewares, wine and spirits, gift and stationery.

FIRST CONTACT & TERMS Send query letter with résumé and photocopies. Samples are filed. Write for appointment to show portfolio. Portfolio should include thumbnails, roughs, final art, b&w and color. Buys all rights. Originals are not returned. Pays by the project.

FENTON ART GLASS CO.

700 Elizabeth St., Williamstown WV 26187. (304)375-6122. **Fax:** (304)375-7833. **E-mail:** askfenton@fentonartglass.com. **Website:** www.fentonartglass.com. Estab. 1905. Produces collectible figurines, gifts. Largest manufacturer of handmade colored glass in the US.

Design director Nancy Fenton says this company rarely uses freelancers because they have their own staff of artisans. "Glass molds aren't very forgiving," says Fenton. Consequently it's a difficult medium to work with. There

have been exceptions. "We were really taken with Linda Higdon's work," says Fenton, who worked with Higdon on a line of historical dresses.

NEEDS Uses freelancers mainly for sculpture and ceramic projects that can be translated into glass collectibles. Considers clay, ceramics, porcelain figurines. Looking for traditional artwork appealing to collectibles market.

FIRST CONTACT & TERMS Send query letter with brochure, photocopies, photographs, résumé and SASE. Samples are filed. Responds only if interested. Negotiates rights purchased. Pays for design by the project; negotiable.

FIDDLER'S ELBOW

101 Fiddler's Elbow Rd., Greenwich NY 12834. (518)692-9665. **Fax:** (518)692-9186. **E-mail:** john@fiddlerselbow.com; licensing@fiddlerselbow.com. **Website:** www.fiddlerselbow.com. **Contact:** John Gunther. Estab. 1974. Produces decorative doormats, pillows, totes, soft sculpture, kitchen textiles, mouse pads, mugs.

NEEDS Introduces 100+ new products/year. Currently uses freelance designs and illustrations. Looking for adult contemporary, traditional, dog, cat, horse, botanical, inspirational, humorous, nature and beach themes. Main images with supporting art helpful in producing collections.

FIRST CONTACT & TERMS Send digital or hardcopy submissions by mail. Samples are filed or returned by SASE. Responds generally within 4 months if interested. "Please, no phone calls."

TIPS "Please visit website first to see if art is applicable to current lines and products."

FISHER-PRICE

636 Girard Ave., E. Aurora NY 14052. (716)687-3000. **Fax:** (716)687-3636. **Website:** www.fisher-price.com. Estab. 1931. Manufacturer of toys and other children's products.

NEEDS Approached by 10-15 freelance artists/year. Works with 25-30 freelance illustrators and sculptors and 15-20 freelance graphic designers/year. Assigns 100-150 jobs to freelancers/year. Prefers artists with experience in children's style illustration and graphics. Works on assignment only. Uses freelancers mainly for product decoration (label art). Prefers all media and styles except loose watercolor. Also uses sculptors.

25% of work demands knowledge of FreeHand, Illustrator, Photoshop and FreeForm (sculptors).

FIRST CONTACT & TERMS Send query letter with nonreturnable samples showing art style or photographs. Samples are filed. Responds only if interested. Call to schedule an appointment to show a portfolio. Portfolio should include original, final art and color photographs and transparencies. Pays for design and illustration by the hour, $25-50. Buys all rights.

FOTOFOLIO, INC.

561 Broadway, New York NY 10012. (212)226-0923. **E-mail:** contact@fotofolio.com; submissions@fotofolio.com. **Website:** www.fotofolio.com. **Contact:** Submissions department. Estab. 1976. Publishes art and photographic postcards, greeting cards, notebooks, books, T-shirts and postcard books.

NEEDS Buys 60-120 freelance designs and illustrations/year. Reproduces existing works. Primarily interested in photography and contemporary art. Produces material for Christmas, Valentine's Day, birthday and everyday. Submit seasonal material 8 months in advance. Art guidelines with SASE with first-class postage.

FIRST CONTACT & TERMS "Fotofolio, Inc. reviews color and b&w photography for publication in postcard, notecard, poster and T-shirt formats. To submit your work, please make a well-edited selection of no more than 40 images, attn: Submissions. Fotofolio will accept photocopies, laser copies and promotional pieces only. Fotofolio will not accept digital images via e-mail to be downloaded or digital files submitted on disk. You may e-mail a website address where your work may be viewed. You'll be contacted if we are interested in seeing further work. Please note that Fotofolio, Inc. is not responsible for any lost or damaged submissions."

TIPS "When submitting materials, present a variety of your work (no more than 40 images) rather than one subject/genre."

THE FRANKLIN MINT

US Rt. 1, Franklin Center PA 19091-0001. (610)459-6000. **Website:** www.franklinmint.com. **Contact:** Cathy La Spada, artist relations manager. Estab. 1964. Franklin Center PA 19091-0001. (610)459-7975. **Fax:** (610)459-6463. **Website:** www.franklinmint.com. Estab. 1964. Direct response marketing of high-quality collectibles. Produces collectible porcelain plates, prints, porcelain and coldcast sculpture, figurines,

fashion and traditional jewelry, ornaments, precision diecast model cars, luxury board games, engineered products, heirloom dolls and plush, home decor items and unique gifts. Clients general public worldwide, proprietary houselist of 8 million collectors and 55 owned-and-operated retail stores. Markets products in countries worldwide, including USA, Canada, UK and Japan.

NEEDS Approached by 3,000 freelance artists/year. Contracts 500 artists/sculptors per year to work on 7,000-8,000 projects. Uses freelancers mainly for illustration and sculpture. Considers all media. Considers all styles. 80% of freelance design and 50% of illustration demand knowledge of PageMaker, FreeHand, Photoshop, Illustrator, QuarkXPress and 3D Studio Eclipse (2D). Accepts work in SGI format. Produces material for Christmas and everyday.

FIRST CONTACT & TERMS Send query letter, résumé, SASE and samples (clear, professional full-color photographs, transparencies, slides, greeting cards and/or brochures and tearsheets). Sculptors send photographic portfolios. Do not send original artwork. Samples are filed or returned by SASE. Responds in 2 months. Portfolio review required for illustrators and sculptors. Company gives feedback on all portfolios submitted. Payment varies.

TIPS "In search of artists and sculptors capable of producing high quality work. Those willing to take art direction and to make revisions of their work are encouraged to submit their portfolios."

THE FUNNY APRON CO.

P.O. Box 1780, Lake Dallas TX 75065-1780. (940)498-3308. **E-mail:** info@funnyaprons.com. **Website:** www.funnyaproncompany.com. **Contact:** EJ Tobin, Creative Director. Estab. 1992. "Our primary focus is now on our subdivision, The Funny Apron Co., that manufactures humorous culinary-themed aprons and T-shirts for the gourmet marketplace. Do not send greeting card submissions at this time"

NEEDS Works with 6 freelancers/year. Artists must be fax/e-mail accessible and able to work on fast turnaround. Check website to determine if your style fits our art direction. 100% of freelance work requires knowledge of Illustrator, CorelDraw, or programs with ability to electronically send vector-based artwork for screenprinting. Do not submit text or concepts. (Photoshop alone is not sufficient.) Currently not accepting text or concepts.

FIRST CONTACT & TERMS Send query letter with brochure, photographs, SASE and photocopies. E-mail inquiries must include a link to a website to view artwork. Do not send unsolicited attachments; they are automatically deleted. Samples are filed or returned by SASE if requested by artist. Company will contact artist if interested. Negotiates rights and payment terms. Finds artists via word of mouth from other freelancers or referrals from publishers.

GALISON/MUDPUPPY

28 W. 44th St., New York NY 10036. (212)354-8840. **E-mail:** sko@galison.com (Galison submissions); emily@galison.com (Mudpuppy submissions). **Website:** www.galison.com. Estab. 1978. Produces boxed greeting cards, stationery, puzzles, address books, specialty journals and fine paper gifts. Many projects are done in collaboration with museums around the world.

NEEDS Buys 100 designs and illustrations/year. Works on assignment only. Uses freelancers mainly for illustration. Considers all media. Also produces material for holidays (Christmas, Hanukkah and New Year). Submit seasonal material 1 year in advance. (Submit to above e-mails via PDF only.)

FIRST CONTACT & TERMS Send postcard sample, photocopies, résumé, tearsheets (no unsolicited original artwork) and SASE. Accepts submissions on disk compatible with Photoshop, Illustrator or QuarkXPress (but not preferred). Samples are filed. Responds only if interested. Request portfolio review in original query. Art director will contact artist for portfolio review if interested. Portfolio should include color photostats, slides, tearsheets and dummies. Originals are returned at job's completion. Pays by project. Rights purchased vary according to project. Finds artists through word of mouth, magazines and artists' reps.

TIPS "Looking for great presentation and artwork we think will sell and be competitive within the gift market. Please visit our website to see if your style is compatible with our design aesthetic."

GALLANT GREETINGS CORP.

5730 N. Tripp Ave., Chicago IL 60646. (800)621-4279; (847)671-6500. **Fax:** (847)671-7500. **E-mail:** info@gallantgreetings.com; custserv@gallantgreetings.com. **Website:** www.gallantgreetings.com. Estab. 1966. "Creator and publisher of seasonal and everyday greeting cards. Send low-res JPEG files (no more than 12 at a time) to the attention of our Creative Department, using the subject line 'New Art Submission'. If

you cannot send via e-mail we will accept color copies no larger than 8½×11. No original artwork, please! Include your name, address, phone number, e-mail address and date on each submission. Submissions will not be returned if we are not provided with a SASE. Please be patient! Our review committee receives many submissions, which we try to attend to in a timely manner. If we feel we have an immediate use for your work, we will notify you and discuss our process and compensation at that time."

FIRST CONTACT & TERMS Samples are filed or returned. Will respond within 3 weeks if interested. Do not send originals.

C.R. GIBSON

402 BNA Dr., Bldg. 100, Suite 600, Nashville TN 37217. (615)724-2900. **E-mail:** customerservice@crgibson. com. **Website:** www.crgibson.com. Producer of stationery and gift products, baby, kitchen and wedding collections. Specializes in baby, children, feminine, floral, wedding and kitchen-related subjects, as well as holiday designs. 80% require freelance illustration; 15% require freelance design. Gift catalog free by request.

NEEDS Approached by 200-300 freelance artists/year. Works with 30-50 illustrators and 10-30 designers/year. Assigns 30-50 design and 30-50 illustration jobs/year. Uses freelancers mainly for covers, borders and cards. 50% of freelance work demands knowledge of QuarkXPress, FreeHand and Illustrator. Works on assignment only.

FIRST CONTACT & TERMS Send query letter with brochure, résumé, tearsheets and photocopies. Samples are filed or are returned. Responds only if interested. Request portfolio review in original query. Portfolio should include thumbnails, finished art samples, color tearsheets and photographs. Return of original artwork contingent on contract. Sometimes requests work on spec before assigning a job. Interested in buying second rights (reprint rights) to previously published work. "Payment varies due to complexity and deadlines." Finds artists through word of mouth, magazines, artists' submissions/self-promotion, sourcebooks, agents, visiting artist's exhibitions, art fairs and artists' reps.

TIPS "The majority of our mechanical art is executed on the computer with discs and laser runouts given to the engraver. Please give a professional presentation of your work."

GLITTERWRAP, INC.

11 Executive Ave., Edison NJ 08817. (732)662-6700; (800)654-6960. **E-mail:** info@designergreetings.com; submissions@designergreetings.com. **Website:** www. glitterwrap.com. Estab. 1987. Produces giftwrap, gift totes, allied accessories, photo albums, diaries and stationery items for all ages—party and special occasion market.

NEEDS Art/graphic designer submissions: Works with 10-15 artists/year. Buys 10-30 designs and illustrations/year. Art guidelines available online. Prefers artists with experience in textile design who are knowledgeable in repeat patterns or surface, or designers who have experience with the gift industry. Considers many styles and mediums. Style varies with season and year. Consider trends and designs already in line, as well as up-and-coming motifs in gift market. Produces material for baby, wedding and shower, florals, masculine, Christmas, graduation, birthdays, Valentine's Day, Hanukkah and everyday. Submit seasonal material 9 months in advance.

FIRST CONTACT & TERMS Send an e-mail with samples in JPEG format at 150 dpi. Responds only if interested. Does not accept submissions via mail. Rights purchased vary according to project. Freelancers paid $200/project.

GLM CONSULTING

366 Amsterdam Ave., #159, New York NY 10024. (212)683-5830. **Fax:** (212)779-8564. **E-mail:** george@ glmconsultart.com. **Website:** www.glmconsultart. com. Estab. 1967. Sells reproduction rights of designs to manufacturers of multiple products around the world. Rep resents artists in 50 different countries. "Our clients specialize in greeting cards, giftware, giftwrap, calendars, postcards, prints, posters, stationery, paper goods, food tins, playing cards, tabletop, bath and service ware and much more. "

NEEDS Approached by several hundred artists/year. Seeking creative decorative art in traditional and computer media (Photoshop and Illustrator work accepted). Prefers artwork previously made with few or no rights pending. Graphics, sports, occasions (e.g., Christmas, baby, birthday, wedding), humorous, "soft touch," romantic themes, animals. Accepts seasonal/holiday material any time. Prefers artists/designers experienced in greeting cards, paper products, tabletop and giftware.

FIRST CONTACT & TERMS Please submit via e-mail, a link to your website or a sampling of your work, consisting of 6-10 designs which represent your collection as a whole. The sampling should show all range of subject matter, technique, style, and medium that may exist in your collection. Digital files should be submitted as e-mail attachments and in low-res. Low-res (LR) image files are typically 5×7, 72 dpi, CMYK, JPERG/TIFF/PDF format and are under 100 KB. "Once your art is accepted, we require original color art—Photoshop files on disc (TIFF, 300 dpi). We will respond only if interested." Pays on publication. No credit line given. Offers advance when appropriate. Sells one-time rights and exclusive product rights. Simultaneous submissions and previously published work OK. "Please state reserved rights, if any."

TIPS Recommends the annual New York SURTEX and Licensing shows. In portfolio samples, wants to see "a neat presentation, thematic in arrangement, consisting of a series of interrelated images (at least 6). In addition to having good drawing/painting/designing skills, artists should be aware of market needs and trends."

GOES LITHOGRAPHING CO.

111 Hallberg St., Delavan WI 53115. (800)348-6700. E-mail: sales@goeslitho.com. **Website:** www.goeslitho.com. **Contact:** Eric Goes. Estab. 1879. Produces stationery/letterheads, custom calendars to sell to printers and office product stores.

NEEDS Approached by 5-10 freelance artists/year. Works with 2-3 freelance artists/year. Buys 4-30 freelance designs and illustrations/year. Art guidelines for SASE with first-class postage. Uses freelance artists mainly for designing holiday letterheads. Considers pen & ink, color, acrylic, watercolor. Prefers final art 17×22, CMYK color compatible. Produces material for Christmas, Halloween and Thanksgiving.

FIRST CONTACT & TERMS "Send nonreturnable examples for your ideas." Responds in 1-2 months if interested. Pays $100-200 on final acceptance. Buys first rights and reprint rights.

TIPS "Keep your art fresh and be aggressive with submissions."

GRAHAM & BROWN

239 Prospect Plains Rd., Suite D201. Monroe Township NJ 08831. (609)395-9200; (800)554-0887. E-mail: publicrelations@grahambrownusa.com. Website: www.grahambrown.com. Estab. 1946. Produces residential wall coverings and home decor products.

NEEDS Prefers freelancers for designs. Also for artwork. Produces material for everyday.

FIRST CONTACT & TERMS Designers: Send query letter with photographs. Illustrators: Send postcard sample of work. Samples are filed or returned. Responds only if interested. Buys all rights. For illustration pays a variable flat fee.

GREAT ARROW GRAPHICS

2495 Main St., Suite 457, Buffalo NY 14214. (716)836-0408. **E-mail:** design@greatarrow.com. **Website:** www.greatarrow.com. **Contact:** Denise Ryan. Estab. 1981. Produces greeting cards and stationery. "We produce silkscreened greeting cards—seasonal and everyday—to a high-end design-conscious market."

NEEDS Approached by 150 freelancers/year. Works with 75 freelancers/year. Buys 350-500 images/year. Prefers freelancers with experience in silkscreen printing process. Uses freelancers for greeting card design only. Considers all 2D media. Looking for sophisticated, classic, contemporary or cutting edge styles. Requires knowledge of Illustrator or Photoshop. Produces material for all holidays and seasons. Submit seasonal material 1 year in advance.

FIRST CONTACT & TERMS Please send digital submissions with link to portfolio or JPEGs at 72 dpi. Limit e-mail attachment size to 5 MB. Responds in 6 weeks if we are interested. Art director will contact artist for portfolio review if interested. Portfolio should include color roughs, final art, photographs and transparencies. Originals are returned at job's completion. Pays royalties of 5% of net sales. Rights purchased vary according to project.

TIPS "We are interested in artists familiar with the assets and limitations of screenprinting, but we are always looking for fun new ideas and are willing to give help and guidance in the silkscreen process. Be original, be complete with ideas. Don't be afraid to be different .. forget the trends .. do what you want. Make your work as complete as possible at first submission. The National Stationery Show in New York City is a great place to make contacts."

⊕ HAMPSHIRE PEWTER CO.

350 Rt. 108, Unit 201. Somersworth NH 03878. (603)569-4944. **E-mail:** gifts@hampshirepewter.com. **Website:** www.hampshirepewter.com. Estab. 1974. Manufacturer of handcast pewter tableware,

accessories and Christmas ornaments. Clients jewelry stores, department stores, executive gift buyers, tabletop and pewter specialty stores, churches and private consumers.

NEEDS Works with 3-4 freelance artists/year. "Prefers New England or East Coast-based artists." Works on assignment only. Uses freelancers mainly for illustration and models. Also for brochure and catalog design, product design, illustration on product and model-making.

FIRST CONTACT & TERMS Please send e-mail with link to portfolio. Pays for design and sculpture by the hour or project. Considers complexity of project, client's budget and rights purchased when determining payment. Buys all rights.

TIPS "Inform us of your capabilities. For artists who are seeking a manufacturing source, we will be happy to bid on manufacturing of designs under private license to the artists, all of whose design rights are protected. If we commission a project, we intend to have exclusive rights to the designs by contract as defined in the Copyright Law, and we intend to protect those rights."

HARLAND CLARKE

15955 La Cantera Parkway, San Antonio TX 78256. (210)694-1473. **Website:** www.clarkeamerican.com. Estab. 1874. Produces checks and other products and services sold through financial institutions. "We're a national printer seeking original works for check series, consisting of 1, 3 or 5 scenes. Looking for a variety of themes, media and subjects for a wide market appeal."

NEEDS Uses freelancers mainly for illustration and design of personal checks. Considers all media and a range of styles. Prefers to see art at twice the size of a standard check.

FIRST CONTACT & TERMS Send postcard sample or query letter with résumé and brochure (or website if work is online). "Indicate whether the work is available; do not send original art." Samples are filed and are not returned. Responds only if interested. Rights purchased vary according to project. Payment for illustration varies by the project.

TIPS "Keep red and black in the illustration to a minimum for image processing."

MARIAN HEATH GREETING CARDS

9 Kendrick Rd., Wareham MA 02571. **E-mail:** info@viabella.com. **Website:** http://viabella.com/

marianheath/contact.php. **Contact:** Diane Reposa, licensing agent. Publishes greeting cards.

NEEDS Model and property release preferred. Art guidelines available with SASE.

FIRST CONTACT & TERMS Send color copies via e-mail or on CD as JPEG files. Submission should be clearly labeled with artists name and identifying number or title if available. Approached by 100 freelancers/year. Works with 35-45 freelancers/year. Buys 500 freelance designs and illustrations/year. Prefers freelancers with experience in social expression. Art guidelines free for SASE with first-class postage or e-mail requesting guidelines. Uses freelancers mainly for greeting cards. Considers all media and styles. Generally 5¼×7¼ unless otherwise directed. Will accept various sizes due to digital production/manipulation. 30% of freelance design and illustration work demands knowledge of Photoshop, Illustrator, QuarkXPress. Produces material for all holidays and seasons and everyday. Submit seasonal material 1 year in advance. "If you wish samples to be returned, please indicate so and include postage-paid packaging."

➕ HIGH RANGE DESIGNS

(208)787-2277. **E-mail:** hmiller@highrangedesigns.com; sales@highrangedesigns.com. **Website:** www.highrangedesigns.com. **Contact:** Hondo Miller, president. Estab. 1989. Produces T-shirts. "We produce screen-printed garments for recreational sport-oriented markets and resort markets, which includes national parks. Subject matter includes, but is not limited to, skiing, climbing, hiking, biking, fly fishing, mountains, out-of-doors, nature, canoeing and river rafting, Native American, wildlife and humorous sayings that are text only or a combination of text and art. Our resort market customers are men, women and kids looking to buy a souvenir of their vacation experience or activity. People want to identify with the message or art on the T-shirt."

The art guidelines for this company are detailed and include suggestions on where to place design on the garment. It is easiest to break into HRD with designs related to fly fishing, downhill skiing, snowboarding or river rafting.

NEEDS Approached by 20 freelancers/year. Works with 3-8 freelancers/year. Buys 10-20 designs and illustration/year. Prefers artists with experience in

screen printing. Uses freelancers mainly for T-shirt ideas, artwork and color separations.

FIRST CONTACT & TERMS Send query letter with résumé, SASE and photocopies. Accepts submissions on disk compatible with FreeHand 8.0 and Illustrator 8.0. Samples are filed or are returned by SASE if requested by artist. Responds in 6 months. Company will contact artist for portfolio review if interested. Portfolio should include b&w thumbnails, roughs and final art. Originals are returned at job's completion. Pays by the project, royalties of 5% based on actual sales. Buys garment rights.

TIPS "Familiarize yourself with screen printing and T-shirt art that sells. Must have knowledge of color separations process. We look for creative design styles and interesting color applications. Artists need to be able to incorporate the colors of the garments as part of their design thinking, as well as utilize the screen-printing medium to produce interesting effects and textures. However, sometimes simple is best. Four-color process will be considered if highly marketable. Be willing to work with us on design changes to get the most marketable product. Know the industry. Art that works on paper will not necessarily work on garments. No cartoons please."

HOFFMASTER GROUP, INC.

2920 N. Main St., Oshkosh WI 54901. (800)327-9774. **E-mail:** marketing@hoffmaster.com. **Website:** www. hoffmaster.com. Produces decorative disposable paper tableware including: placemats, plates, tablecloths and napkins for institutional and consumer markets. Printing includes offset, letterpress and up to 6 color flexographic napkin printing.

NEEDS Approached by 5-10 freelancers/year. Works with 3-4 freelancers/year. Prefers freelancers with experience in paper tableware products. Art guidelines and specific design needs based on current market are available from art managers. Looking for trends and traditional styles. Produces material for all holidays and seasons and everyday.

FIRST CONTACT & TERMS Send query letter with photocopies, résumé, appropriate samples by mail, fax or e-mail to marketing@hoffmaster.com. Ideas may be sent in a color rough sketch. Accepts submissions compatible with Adobe CS6. Samples are filed or returned by SASE if requested by artist. Responds in 90 days, only if interested. Creative manager will contact artist for portfolio review if interested. Prefers to buy artwork outright. Rights purchased vary according to project. Pays by the project. Amounts vary according to project. May work on a royalty arrangement for recognized properties. Finds freelancers through art fairs and artists' reps.

TIPS "Looking for new trends and designs appropriate for placemats, plates and napkins."

⊙ IGPC

161 Helen St., South Plainfield NJ 07080. (908)548-8088. **Fax:** (908)822-7379. **E-mail:** frontdesk@igpc. com; support@igpc.com. **Website:** www.igpc.net. Agent to foreign governments. "We produce postage stamps and related items on behalf of 40 different foreign governments."

NEEDS Approximately 10 freelance graphic artists. Prefers artists within metropolitan New York or Tri-State area. Must have extremely sophisticated computer, design and composition and prepress skills, as well as keen research ability. Artwork must be focused and alive (4-color). Artist's pricing needs to be competitive. Works on assignment only. Uses artists for postage stamp art. Must have expert knowledge of Photoshop and Quark/InDesign. Illustrator a plus.

FIRST CONTACT & TERMS E-mail only. Send samples as PDFs or link to a web portfolio. Art director will contact artist for portfolio review if interested. Portfolio should contain "4-color illustrations of realistic, flora, fauna, technical subjects, autos or ships." Sometimes requests work on spec before assigning a job. Pays by the project. Consider government allowance per project when establishing payment.

TIPS "Artists considering working with IGPC must have excellent drawing or rendering abilities in general or specific topics—e.g., flora, fauna, transport, famous people—typographical skills; the ability to create artwork with clarity and perfection. Familiarity with printing process and print call-outs a plus. Generally, the work we require is realistic art. In some cases, we supply the basic layout and reference material; however, we appreciate an artist who knows where to find references and can present new and interesting concepts. Initial contact should be made by appointment. "

INKADINKADO, INC.

1801 N. 12th St., Reading PA 19604, (800)523-8452. **Website:** www.inkadinkado.com. **Contact:** Mark Nelson, licensing contact; Pamela Keller, designer relations coordinator. Estab. 1978. Creates artistic rub-

ber stamps, craft kits, and craft accessories. Also offers licenses to illustrators depending upon number of designs interested in producing and range of style by artist. Distributes to craft, gift and toy stores and specialty catalogs.

NEEDS Works mainly with in house illustrators and designers. Uses freelancers mainly for illustration, lettering, line drawing, type design. Considers pen & ink. Themes include animals, education, holidays and nature. Prefers small; about 3×3. work demands knowledge of Photoshop, Illustrator and inDesign. Produces material for all holidays and seasons. Submit seasonal material 6-8 months in advance.

FIRST CONTACT & TERMS Designers and Illustrators: Send query letter with 6 non-returnable samples. Accepts submissions on disk. Samples are filed and not returned. Responds only if interested. Company will contact artist for portfolio review of b&w and final art if interested. Pays for illustration by the project, $100-250/piece. Rights purchased vary according to project. Stamps, pays $50-100/project.

TIPS "Work small. The average size of an artistic rubber stamp is 3×3. Line art without color stands the best chance of acceptance."

✚ THE INTERMARKETING GROUP

29 Holt Rd., Amherst NH 03031. (603)672-0499. **Contact:** Linda Gerson, president. Estab. 1985. Art licensing agent for all categories of consumer goods, including greeting cards, stationery, calendars, posters, paper products, tabletop, dinnerware, giftwrap, giftware, toys, needlecrafts, home furnishings and apparel.

NEEDS Approached by 100 freelancers/year. Works with 8 freelancers/year. Licenses work as developed by clients. Prefers freelancers with experience in full-color illustration. Uses freelancers mainly for tabletop, cards, giftware, calendars, paper tableware, toys, books, needlecraft, apparel, housewares. Will consider all media forms. "My firm generally represents illustrated styles of artworks for direct product applications. All works are themed. Prefers 5×7 or 12"×12" final art." Licenses exclusive art material for all holidays, seasons and everyday. Submit seasonal material 6 months in advance.

FIRST CONTACT & TERMS Send query letter with brochure, tearsheets, résumé, color copies, SASE. Samples are not filed and are returned by SASE. Responds in 3-4 weeks. Requests work on spec before assigning a job. Originals are returned at job's comple-

tion. Pays royalties from license agreements secured for artists of 2-10% plus advance against royalties. Licenses all rights. Considers licensing second rights (reprint rights) to previously published work. Finds new artists "mostly by referrals and via submissions. I do review trade magazines, attend art shows and other exhibits to locate suitable clients."

JILLSON & ROBERTS

3300 W. Castor St., Santa Ana CA 92704-3908. (714)424-0111. **Fax:** (714)424-0054. **E-mail:** sales@jillsonroberts.com. **Website:** www.jillsonroberts.com. **Contact:** art director. Estab. 1974. Specializes in gift wrap, totes, printed tissues and accessories using recycled/recyclable products. Art guidelines available on website.

NEEDS Works with 10 freelance artists/year. Prefers artists with experience in giftwrap design. Considers all media. "We are looking for colorful graphic designs as well as humorous, sophisticated, elegant or contemporary styles." Produces material for Christmas, Valentine's Day, Hanukkah, Halloween, graduation, birthdays, baby announcements and everyday. Submit 3-6 months before holiday.

FIRST CONTACT & TERMS Send color copies or photocopies. Samples are kept on file. Responds in up to 2 months. Simultaneous submissions to other companies is acceptable. "If your work is chosen, we will contact you to discuss final art preparation, procedures and payment."

TIPS "We are particularly interested in baby shower and wedding shower designs."

KALAN LP

97 S. Union Ave., Lansdowne PA 19050. (610)623-1900; (800) 345-8138. **E-mail:** submissions@kalanlp.com; support@kalanlp.com. **Website:** www.kalanlp.com. **Contact:** Chris Wiemer, art director. Estab. 1973. Produces giftbags, greeting cards, school supplies, stationery and novelty items such as keyrings, mouse pads, shot glasses and magnets.

NEEDS Approached by 50-80 freelancers/year. Buys 100 freelance designs and illustrations/year. Art guidelines are available. Uses freelancers mainly for fresh ideas, illustration and design. Considers all media and styles. Some illustration demands knowledge of Photoshop 7.0 and Illustrator 10. Produces material for major holidays such as Christmas, Mother's Day, Valentine's Day; plus birthdays and everyday. Submit seasonal material 9-10 months in advance.

FIRST CONTACT & TERMS Designers: Send query letter with photocopies, photostats and résumé. Illustrators and cartoonists: Send query letter with photocopies and résumé. Accepts disk submissions compatible with Illustrator 10 or Photoshop 7.0. Send EPS files. Samples are filed. Responds in 1 month if interested in artist's work. Will contact artist for portfolio review of final art if interested. Buys first rights. Pays by the project, $75 and up. Finds freelancers through submissions and newspaper ads.

⌂ KENZIG KARDS, INC.

2300 Julia Goldbach Ave., Ronkonkoma NY 11779-6317. (631)737-1584. **Fax:** (631)737-8341. **Contact:** Jerry Kenzig, president. Estab. 1999. Produces greeting cards and stationery. Specializes in greeting cards (seasonal and everyday) for a high-end, design-conscious market (all ages).

NEEDS Approached by 75 freelancers/year. Works with 3 freelancers/year. Prefers local designers/illustrators, but will consider freelancers working anywhere in the US. Art guidelines free with SAE and first-class postage. Uses freelancers mainly for greeting cards/design and calligraphy. Considers watercolor, colored pencils and most other mediums. Product categories include alternative/humor, business and cute. Produces material for baby congrats, birthday, cards for pets, Christmas, congratulations, everyday, get well, sympathy, Valentine's Day and wedding/anniversary. Submit seasonal material 6 months in advance. Art size should be 5×7 or 5¾×5¾ square. 20% of freelance work demands knowledge of Illustrator, QuarkXPress and Photoshop.

FIRST CONTACT & TERMS Send query letter with brochure, résumé and tearsheets. After introductory mailing, send follow-up postcard sample every 6 months. Samples are filed. Responds in 2 weeks. Company will contact artist for portfolio review if interested. Portfolio should include color, original art, roughs and tearsheets. Buys one-time rights and reprint rights for cards. Negotiates rights purchased. Pays freelancers by the project, $150-350; royalties (subject to negotiation). Finds freelancers through industry contacts (Kenzig Kards, Inc., is a member of the Greeting Card Association), submissions and word of mouth.

KID STUFF MARKETING

1401 NW Moundview Dr., Suite C. Topeka KS 66618. (785)862-3707. **E-mail:** jay@kidstuff.com. **Website:** www.kidstuff.com. **Contact:** Jay Thompson, senior director of creative. Estab. 1982. Produces collectible figurines, toys, kids' meal sacks, edutainment activities and cartoons for restaurants and entertainment venues worldwide.

NEEDS Approached by 50 freelancers/year. Works with 10 freelancers/year. Buys 30-50 freelance designs and illustrations/year. Works on assignment only. Uses freelancers mainly for illustration, activity or game development and sculpting toys. Looking for humorous, child-related styles. Freelance illustrators should be familiar with Photoshop, Illustrator and InDesign. Produces material for all holidays and everyday themes.

FIRST CONTACT & TERMS Illustrators and Cartoonists: Send e-mail with JPEG or PDF files or link to website. "I DO REVIEW ALL SUBMISSIONS, but only respond if interested." Pays by the project, $250-5,000 for illustration or game activities. Kid Stuff Marketing owns all rights of art or designs after purchase.

THE LANG CO.

P.O. Box 1605, Waukesha WI 53187. (800)967-3399. **Fax:** (262)523-2888. **Website:** www.lang.com. Estab. 1982. Produces high-quality linen-embossed greeting cards, stationery, calendars, boxes and gift items. Art guidelines available for SASE.

NEEDS Approached by 300 freelance artists/year. Works with 40 freelance artists/year. Uses freelancers mainly for card and calendar illustrations. Considers all media and styles. Looking for traditional and nonabstract country-inspired, folk, contemporary and fine art styles. Produces material for Christmas, birthdays and everyday. Submit seasonal material 6 months in advance.

FIRST CONTACT & TERMS Send query letter with SASE and brochure, tearsheets, photostats, photographs, slides, photocopies or transparencies. Samples are returned by SASE if requested by artist. Responds in 6 weeks. Pays royalties based on net wholesale sales. Rights purchased vary according to project.

TIPS "Research the company and submit compatible art. Be patient awaiting a response."

⌂ LANTERN COURT, LLC

P.O. Box 61613, Irvine CA 92602. (800)454-4018; (714)798-2270. **Fax:** (714)798-2281. **E-mail:** art@lanterncourt.com; customerservice@lanterncourt.com; seher.zaman@lanterncourt.com. **Website:** www.

lanterncourt.com. **Contact:** Seher Zaman, creative director. Estab. 2011. Lantern Court specializes in party supplies and paper goods for the Muslim community or anyone who appreciates Islamic art and design. Produces balloons, calendars, decorations, e-cards, giftbags, giftwrap/wrapping paper, greeting cards, paper tableware, and part supplies. Buys 10-30 freelance designs/illustrations each year. Prefers freelancers with experience in stationery design. Buys stock photos and offers assignments.

NEEDS Uses freelancers for font designs and new designs. Needs Islmaic themed and Muslim holiday related designs. Seasonal material should be submitted 10-12 months in advance. 100% of freelance work demands computer skills. Artists should be familiar with Illustrator, Photoshop, InDesign, and QuarkXPress.

FIRST CONTACT & TERMS Guidelines available free online. E-mail letter with digital images as JPEG or TIFF files at 300 dpi. Keeps samples on file; samples not returned. Responds only if interested. Company will contact artist for portfolio review if interested. Pays by the project. Buys one-time rights. Maximum payment $750.

TIPS "Please look at our website to be sure your work will fit into our line of products, or can be altered to fit in."

LEGACY PUBLISHING GROUP

75 Green St., Clinton MA 01510. (800)322-3866. **E-mail:** info@shoplegacy.com. **Website:** www.shoplegacy.com. **Contact:** art department. Produces bookmarks, calendars, gifts, Christmas and seasonal cards and stationery pads. Specializes in journals, note cards, address and recipe books, coasters, placemats, magnets, book marks, albums, calendars and grocery pads.

NEEDS Works with 8-10 freelancers/year. Buys 25-30 freelance designs and illustrations/year. Prefers traditional art. Art guidelines available for SASE. Works on assignment only. Uses freelancers mainly for original art for product line. Considers all color media. Looking for traditional, contemporary, garden themes and Christmas. Produces material for Christmas, everyday (note cards) and cards for teachers.

FIRST CONTACT & TERMS Illustrators: Send query letter with photocopies, photographs, résumé, tearsheets, SASE and any good reproduction or color copy. We accept work compatible with Adobe or QuarkXPress plus color copies. Samples are filed. Responds in 2 weeks. Company will contact artist for portfolio review if interested. Portfolio should include color photographs, slides, tearsheets and printed reproductions. Buys all rights. Pays by the project. Finds freelancers through word of mouth and artists' submissions.

TIPS "Get work out to as many potential buyers as possible. *Artist's & Graphic Designer's Market* is a good source. Initially, plan on spending 80% of your time on self-promotion."

THE LEMON TREE STATIONERY CORP.

95 Mahan St., West Babylon NY 11704. (631)253-2840 or (800)229-3710. **Fax:** (631)253-3369; (800)229-3709. **E-mail:** lucy@lemontreestationery.com. **Website:** www.lemontreestationery.com. **Contact:** Lucy Mleczko, president. Estab. 1969. Produces birth announcements, Bar Mitzvah and Bat Mitzvah invitations and wedding invitations.

NEEDS Buys 100-200 pieces of calligraphy/year. Prefers local designers. Works on assignment only. Uses Mac designers. Also for calligraphy, mechanicals, paste-up, P-O-P. Looking for traditional, contemporary work. 50% of freelance work demands knowledge of Photoshop, QuarkXPress, Illustrator.

FIRST CONTACT & TERMS Send query letter with résumé. Calligraphers send photocopies of work. Samples are not filed and are not returned. Responds only if interested. Company will contact artist for portfolio review of final art, photostats, thumbnails if interested. Pays for design by the project. Pays flat fee for calligraphy.

TIPS "Look around at competitors' work to get a feeling of the type of art they use."

LPG GREETINGS, INC.

813 Wisconsin St., Walworth WI 53184. (262)275-5600. **Fax:** (262)275-5609. **E-mail:** judy@lpgcards.com. **Website:** www.lpgcreative.com. **Contact:** Judy Cecchi, creative director. Estab. 1992. Specializes in boxed Christmas cards, everyday greeting cards, wall art, and other gift items.

NEEDS Approached by 50-100 freelancers/year. Works with 20 freelancers/year. Buys 70 freelance designs and illustrations/year. Uses freelancers mainly for original artwork for Christmas cards and wall art. Considers any media. Artwork can be vertical or horizontal; 5×7, 8×10 or 5.5×17. Submit seasonal material 1 year in advance.

FIRST CONTACT & TERMS Send e-mail with link to website samples. E-mail for art guidelines. Please do not send unsolicited samples via e-mail without prior contact; they will not be considered. Will contact artist for samples if interested. Rights purchased vary according to project. Pays for design by the project. For illustration: pays flat fee. Finds freelancers through word of mouth and artists' submissions.

MADISON PARK GREETINGS

The Madison Park Group, 800 S. Michigan St., Suite B. Seattle WA 98108. (206)324-5711 or (800)638-9622. **Fax:** (206)324-5822. **E-mail:** info@madpark.com. **Website:** www.madisonparkgreetings.com. Estab. 1977. Produces greeting cards, stationery.

NEEDS Approached by 1,000 freelancers/year. Works with 20 freelancers/year. Buys 100 freelance designs and illustrations/year. Art guidelines available free for SASE. Works on assignment only. Uses freelancers mainly for greeting cards; also for calligraphy. Considers all paper-related media. Produces material for Christmas, Easter, Mother's Day, Father's Day, graduation, New Years, Valentine's Day, birthdays, everyday, sympathy, get well, anniversary, baby congratulations, wedding, thank you, expecting, friendship. Are interested in floral and whimsical imagery, as well as humor." Submit seasonal material 10 months in advance.

FIRST CONTACT & TERMS "We are interested in receiving art submissions that offer a fresh, unique design perspective and enhance our current product line." Does not respond to unsolicited submissions unless interested. Guidelines available online.

MCGAW GRAPHICS, INC.

(888)426-2429 ext. 206. **Website:** www.mcgawgraphics.com. **Contact:** Katy Daly. Estab. 1979. Clients: specialty retailers, museum shops, wholesale framers, e-tailers, poster shops, galleries, frame shops.

FIRST CONTACT & TERMS If your work is not accepted, please remember that we choose work for publication and licensing based on current market trends, and that our opinion only pertains to our market segment, not to the aesthetic value of your work. Send your portfolio to attn: Acquisitions Department.

TIPS "Form and palette are critical to our decision process. We have a tremendous need for decorative pieces, especially new abstracts, landscapes and florals. There are a lot of prints and posters being published these days. Market your best material! Review our website before submitting. Send your best work."

MEAD

4751 Hempstead Station Dr., Kettering OH 45429. (937)495-6323; (800)565-5396. **Website:** www.ataglance.com; www.meadwestvaco.com. Publishes calendars, note cards, Christmas cards and other stationery items and books. Markets to a broad distribution channel, including better gifts, books, department stores and larger chains throughout US. Some sales to Europe, Canada and Japan. "We look for illustration and design that can be used in many ways: calendars, note cards, address books and more, so we can develop a collection. We license art that appeals to a widely female audience."

NEEDS Prefers work in horizontal format. No gag humor or cartoons. Art guidelines available for SASE with first-class postage or online.

FIRST CONTACT & TERMS Send query letter with brochure, résumé, photographs, slides, tearsheets and transparencies. Include an SASE for return of material. Responds within 6 weeks. Will contact artist for portfolio review if interested. Pays for illustration by the project, advance against royalty.

TIPS "Research what is selling and what's not. Go to gift shows and visit lots of stationery stores. Read all the trade magazines. Talk to store owners."

NALPAC, LTD.

1111 E. Eight Mile Rd., Ferndale MI 48220. (248)541-1140. Estab. 1971. Produces coffee mugs gift bags, trendy gift and novelty items, and T-shirts for gift and mass merchandise markets. Licenses all kinds of artwork for T-shirts, mugs and gifts.

NEEDS Approached by 10-15 freelancers/year. Works with 2-3 freelancers/year. Buys 70 designs and illustrations/year. Works on assignment only. Considers all media. Needs computer-literate freelancers for design, illustration and production. 60% of freelance work demands computer skills.

FIRST CONTACT & TERMS Send query letter with brochure, résumé, SASE, photographs, photocopies, slides and transparencies. Samples are filed or are returned by SASE if requested by artist. Responds in 1 month. Call for appointment to show portfolio. Usually buys all rights, but rights purchased may vary according to project. Also needs package/product designers, pay rate varies. Pays for design and illustra-

tion by the hour $10-25; or by the project $40-500, or offers royalties of 4-10%.

⭘ NATIONAL DESIGN CORP.

12121 Scripps Summit Dr., San Diego CA 92131. (800)366-7367 or (858)674-6040. **Fax:** (858)674-4166. **Website:** www.nationaldesign.com. Estab. 1985. Produces gifts, writing instruments and stationery accoutrements. Markets include gift/souvenir and premium markets.

NEEDS Works with 3-4 freelancers/year. Buys 3 freelance designs and illustrations/year. Prefers local freelancers only. Works on assignment only. Uses freelancers mainly for design illustration. Considers computer renderings to mimic traditional medias. Prefers children's and contemporary styles. 100% of freelance work demands knowledge of Illustrator and Photoshop. Produces material for Christmas and everyday.

FIRST CONTACT & TERMS Prefer submissions via e-mail/web link. Company will contact artist for final art if interested. Rights purchased vary according to project. Payments depends on complexity, extent of project(s).

TIPS "Fresh ideas always of interest."

NOBLEWORKS CARDS

500 Paterson Plank Rd., Union City NJ 07087. **E-mail:** info@nobleworksinc.com. **E-mail:** editor@nobleworkscards.com. **Website:** www.nobleworkscards.com. **Contact:** art department. Estab. 1981. "Lucky you. You found Noble Works Cards' online funny card store. Some might even say the world's funniest greeting cards. So what if those people also happen to work at NobleWorks? BTW we are also the publisher of just about all the cards here, and selling them wholesale is our main business. Publishing and wholesaling unique funny cards has been our main business for over 32 years. Irreverent, inappropriate humor, naughty cards, adult jokes and even mean, rude or sarcasm, are practially a religion, in fact, funny happy birthday wishes often make it into our prayers. Honest. Always pushing the envelope, our cards redefine the edge of sophisticated, sassy, and downright silly fun." Art guidelines available for SASE with first-class postage.

NEEDS Looking for humorous "off-the-wall" adult contemporary and editorial illustration. Produces material for Christmas, Mother's Day, Father's Day, graduation, Halloween, Valentine's Day, birthdays,

thank you, anniversary, get well, astrology, sympathy, etc. Submit seasonal material 18 months in advance.

FIRST CONTACT & TERMS Designers: Send query as an e-mail attachment. Illustrators and cartoonists: Send query as an e-mail attachment. Responds in 1 month. Buys reprint rights. Pays for design and illustration by the project. Finds freelancers through sourcebooks, illustration annuals, referrals.

⭘ NORTHERN CARDS

5035 Timberlea Blvd., Unit #9, Mississauga, Ontario L4W 2K9 Canada. (905)625-4083. **Website:** www.northerncards.com. Estab. 1992. Produces 3 brands of greeting cards.

NEEDS Approached by 200 freelancers/year. Works with 25 freelancers/year. Buys 75 freelance designs and illustrations/year. Uses freelancers for "camera-ready artwork and lettering." Art guidelines with SASE with first-class postage. Looking for traditional, sentimental, floral and humorous styles. Prefers 5½×7¾ or 5×7. Produces material for Christmas, Easter, Mother's Day, Father's Day, graduation, Valentine's Day, birthdays and everyday. Also sympathy, get well, someone special, thank you, friendship, new baby, good-bye and sorry. Submit seasonal material 6 months in advance.

FIRST CONTACT & TERMS Designers: Send query letter with brochure, photocopies, slides, résumé and SASE. Illustrators and Cartoonists: Send photocopies, tearsheets, résumé and SASE. Lettering artists send samples. Samples are filed or returned by SASE. Responds only if interested. Pays flat fee, $200 (CDN). Finds freelancers through newspaper ads, gallery shows and Internet.

THE NOTEWORTHY COMPANY

336 Forest Ave., Amsterdam NY 12010. (518)842-2660. Estab. 1954. Produces bags and coloring books. Advertising specialty manufacturer selling to distributors with clients in the health, real estate, banking and retail fields.

NEEDS Buys 25 illustrations/year. Prefers freelancers with experience in designing for flexographic printing. Works on assignment only. Uses freelancers mainly for stock bag art and coloring book themes.

FIRST CONTACT & TERMS Send query letter with brochure, résumé, samples and SASE. Samples are filed. Pays $200 for bag design.

⌂ NOVA MEDIA, INC.

1724 N. State St., Big Rapids MI 49307-9073. (231)796-4637. **E-mail:** trund@netonecom.net. **Website:** www.novamediainc.com. **Contact:** Thomas J. Rundquist, chairman. Estab. 1981. Specializes in CDs, CDs/cassettes, games, limited edition plates, posters, school supplies, T-shirts. Licenses e-prints.

NEEDS Seeking creative art for the serious collector. Considers oil, acrylic. Prefers expressionism, impressionism, abstract. Editions are created by collaborating with the artist or by working from an existing painting. Approached by 14 artists/year. Publishes/distributes the work of 2 emerging, 2 mid-career and 1 established artists/year. Also needs freelancers for design. Prefers local designers.

FIRST CONTACT & TERMS Send query letter with samples. Accepts e-mail submissions. Responds in 1 month. Keeps samples on file; does not return material. Simultaneous submissions and previously published work OK. Pays royalties of 10% or negotiates payment. No advance. Rights purchased vary according to project. Provides promotion.

TIPS "The most effective way to contact us is by e-mail or regular mail. Visit our website."

⊕ NOVO CARD PUBLISHERS, INC.

100 Shepard Ave., Wheeling IL 60090. (847)947-8090. **Fax:** (847)947-8775. **E-mail:** art@novocard.net. **Website:** www.novocard.net. Produces all categories of greeting cards.

NEEDS Approached by 200 freelancers/year. Works with 30 freelancers/year. Buys 300 or 400 pieces/year from freelance artists. Art guidelines free for SASE with first-class postage. Uses freelancers mainly for illustration and text. Also for calligraphy. Considers all media. Prefers crop size 5×7¾, bleed 5¼×8. Knowledge of Photoshop, Illustrator and QuarkXPress, and InDesign helpful. Produces material for all holidays and seasons and everyday. Submit seasonal material 8 months in advance.

FIRST CONTACT & TERMS Designers: Send brochure, photocopies, photographs and SASE. Illustrators and Cartoonists: Send photocopies, photographs, tearsheets and SASE. Calligraphers: Send b&w copies. Accepts disk submissions compatible with Macintosh QuarkXPress 4.0 and Windows 95. Art samples are not filed and are returned by SASE only. Written samples retained on file for future assignment with writer's permission. Responds in 2 months. Pays for design and illustration by the project, $75-200.

OATMEAL STUDIOS

P.O. Box 191, Rochester VT 05767. (800)628-6325. **Fax:** (413)663-3465. **E-mail:** dawn@oatmealstudios.com. **Website:** www.oatmealstudios.com. Publishes humorous greeting cards and notepads, creative ideas for everyday cards. Art guidelines available for SASE with first-class postage or on website.

NEEDS Approached by approximately 300 freelancers/year. Buys 100-150 freelance designs and illustrations/year. Considers all media.

FIRST CONTACT & TERMS Write for art guidelines; send query letter with SASE, roughs, printed pieces or brochure/flyer to be kept on file. "If brochure/flyer is not available, we ask to keep one sample printed piece; color or b&w photocopies also acceptable for our files." Samples are returned by SASE. Responds in 6 weeks.

TIPS "We are looking for fresh and fun-looking artwork in any media and style. Also, sophisticated, funky cartoony-type art (people and/or animals) with or without words. Color work is best, but we will look at black and white. Overall, we're looking for exciting, innovative, clever, humorous, fun, and most important, original designs and ideas. All work is speculative, so put your greeting cards ideas in rough sketch form. Be sure to include printed samples or tearsheets. If possible, you can provide us with a sample which we can keep on file for future assignments. **Please indicate which ones we can keep.** You will also need to include an SASE large enough to accommodate the return of your artwork. Our creative department often has concepts that call for a particular style. So even if you don't have specific greeting card ideas of your own, send us some samples of your work. Perhaps your style and our ideas will work well together. The size of our cards is 5"×7" and all artwork designed for us must match these requirements either exactly or proportionately. The cards are usually vertical and can be with or without a border. And last but not least, payment. We negotiate payment with each artist depending on the complexity of the work. We look forward to reviewing your work!"

THE OCCASIONS GROUP

Fax: (507)625-3388. **E-mail:** dknutson@theoccasionsgroup.com. **Website:** http://theoccasionsgroup.com. **Contact:** Deb Knutson,

creative director. Estab. 1967. Produces calendars, greeting cards, stationery, posters, memo pads, advertising specialties. Specializes in Christmas, everyday, dental, health care greeting cards and postcards, and calendars for businesses and professionals.

NEEDS Art guidelines available free for SASE. Works with 20-30 freelancers/year. Buys approximately 300 freelance designs and illustrations/year. Prefers freelancers with experience in greeting cards. Works on assignment only. Uses freelancers mainly for illustration, calligraphy, lettering, humorous writing, cartoons. Prefers traditional Christmas and contemporary and conservative cartoons. Some design work demands knowledge of Photoshop, Illustrator, QuarkXPress and InDesign. Produces material for Christmas, Thanksgiving, birthdays, everyday.

FIRST CONTACT & TERMS Designers: Send brochure, résumé, tearsheets. Illustrators and cartoonists: Send tearsheets. After introductory mailing, send follow-up postcard sample every 6 months. Calligraphers: Send photocopies of their work. Accepts Mac-compatible disk submissions. Samples are filed. Buys one-time or all rights. Pays for illustration by the project, $250-500. Finds freelancers through agents, other professional contacts, submissions and recommendations.

OHIO WHOLESALE, INC./KENNEDY'S COUNTRY COLLECTION

286 W. Greenwich Rd., Seville OH 44273. (330)769-5050. **Fax:** (330)769-5566. **E-mail:** annes@ohiowholesale.com; AnneV@ohiowholesale.com. **Website:** www.ohiowholesale.com. **Contact:** Anne Secoy, vice president of product development. Estab. 1978. Home décor, giftware, seasonal. Produces home décor, wall art, canvas, tabletop, seasonal decorations, gifts, ornaments and textiles.

NEEDS Prefers freelancers with experiences in home decor and giftware. Works with 16 freelancers/year. Buys 100 freelance designs/illustrations per year. Will consider wood, glass, resin, tin, canvas, acrylic, metal, fabric and paper mediums in the areas of religion, counter humor or inspirational pieces. Also produce materials for Christmas, Thanksgiving, Easter, Halloween, Grandparent's Day, St. Patrick's Day, woman-to-woman and everyday gifts. Seasonal materials should be submitted 18 months in advance. Artists should be familiar with Adobe Illustrator, Photoshop and QuarkXPress.

FIRST CONTACT & TERMS Send an e-mail query with brochure, photographs and SASE. Samples not kept on file. Company will contact artist for portfolio if interested. Pays by the project. Rights negotiated.

TIPS "Be able to work independently with your own ideas—use your 'gift' and think outside the box. *Wow me!*"

PAPERLINK

356 Kennington Rd., London SE11 4LD United Kingdom. (020)7582-8244. **Fax:** (020)7587-5212. **E-mail:** info@paperlink.co.uk; or via online contact form. **Website:** www.paperlink.co.uk. Estab. 1985. Produces contemporary art and humorous greeting cards.

NEEDS Product categories include alternative/humor, counter humor, cute, juvenile and teen. Produces material for Mother's Day, Father's Day, Christmas, Easter, Valentine's Day, graduation, congratulations, wedding/anniversary, birthday, baby congrats, get-well/sympathy, everyday and all holidays and seasons. No specific size needed for final art. 50% of freelance work demands computer skills. Artists should be familiar with Illustrator, Photoshop and QuarkXPress. No need for freelance design.

FIRST CONTACT & TERMS Submission guidelines available online.

PAPER MAGIC GROUP, INC.

54 Glenmaura National Blvd., Suite 200, Moosic PA 18507. (800)278-4085. **E-mail:** orders@papermagic.com. **Website:** www.papermagic.com. **Contact:** creative director. Estab. 1984. Produces greeting cards, stickers, vinyl wall decorations, 3D paper decorations. "We publish seasonal cards and decorations for the mass market. We use a wide variety of design styles."

NEEDS Works with 60 freelance artists/year. Prefers artists with experience in greeting cards. Work is by assignment; or send submissions on spec. Designs products for Christmas and Valentine's Day. Also uses freelancers for lettering and art direction.

FIRST CONTACT & TERMS Send query letter with résumé, samples (color photocopies) and SASE, Attn: Creative Director. Samples are filed or are returned by SASE if requested by artist. Originals not returned. Pays by the project. Buys all rights.

TIPS "Please, experienced illustrators only."

PAPER PRODUCTS DESIGN

60 Galli Dr., Suite 1. Novato CA 94949. (800)370-9998 or (415)883-1888. **Fax:** (415)883-1999. **E-mail:** carol@ppd.co. **Website:** www.paperproductsdesign.com. **Contact:** Carol Florsheim. Estab. 1992. Produces paper napkins, plates, designer tissue, giftbags and giftwrap, porcelain accessories. Specializes in high-end design, fashionable designs.

NEEDS Approached by 50-100 freelancers/year. Buys multiple freelance designs and illustrations/year. Artists do not need to write for guidelines. They may send samples to the attention of Carol Florsheim at any time. Uses freelancers mainly for designer paper napkins. Looking for very stylized/clean designs and illustrations. Prefers 6½×6½. Produces seasonal and everyday material. Submit seasonal material 9 months in advance.

FIRST CONTACT & TERMS Designers: Send brochure, photocopies, photographs, tearsheets. Samples are not filed and are returned if requested with SASE. Responds in 6 weeks. Request portfolio review of color, final art, photostats in original query. Rights purchased vary according to project. Pays for design and illustration by the project in advances and royalties. Finds freelancers through agents, *Workbook*.

TIPS "Shop the stores, study decorative accessories, fashion clothing. Read European magazines. We are a design house."

PICKARD CHINA

782 Pickard Ave., Antioch IL 60002. (847)395-3800. **Fax:** (847)395-3827. **E-mail:** info@pickardchina.com. **Website:** www.pickardchina.com. Estab. 1893. Manufacturer of fine china dinnerware. Clients: Upscale specialty stores and department stores. Current clients include Gearys, Marshall Field's and Gump's.

NEEDS Assigns 2-3 jobs to freelance designers/year. Prefers designers for china pattern development with experience in home furnishings. Tabletop experience is a plus but not required.

FIRST CONTACT & TERMS Send query letter with résumé and color photographs, tearsheets, slides or transparencies showing art styles. Samples are filed or are returned if requested. Art director will contact artist for portfolio review if interested. Negotiates rights purchased. May purchase designs outright, work on royalty basis (usually 2%) or negotiate nonrefundable advance against royalties.

THE POPCORN FACTORY

13970 W. Laurel Dr., Lake Forest IL 60045. (847)362-0028. **Fax:** (847)362-9680. **Website:** www.thepopcornfactory.com. Estab. 1979. Manufacturer of popcorn packed in exclusive designed cans and other gift items sold via e-commerce and catalog for Christmas, Halloween, Valentine's Day, Easter and year-round gift giving needs.

PORTERFIELD'S FINE ART LICENSING

4837 Tuttle Ave., Suite 410, Sarasota FL 34243. (800)660-8345 or (941)487-8581. **Fax:** (941)487-8582. **E-mail:** lance@porterfieldsfineart.com; art@porterfieldsfineart.com. **Website:** www.porterfieldsfineart.com. **Contact:** Lance J. Klass, president. Estab. 1994. Licenses representational, Christmas, holiday, seasonal, Americana, and many other subjects. "We're a major, internationally recognized full-service licensing agency and function as a full-service licensing representative for individual artists wishing to license their work into a wide range of consumer-oriented retail product categories. In addition to our top-rated art licensing portfolio site, we also run a major blog for artists on the business of art licensing at www.art-licensing.biz, where artists can learn the basics of how to go about licensing their work for commercial retail products. Stop by our site for more information about how to become a Porterfield's artist and have us represent you and your work for licenses in wall and home decor, home fabrics, stationery and all paper products, crafts, giftware and many other fields." Send sample JPEGs via e-mail or direct us to a site with your artwork, for fastest response. No mail submissions.

NEEDS Approached by as many as 1,000 artists/year. Licenses many designs and illustrations/year, but only takes 2-4 new artists each year. Prefers commercially oriented artists who can create beautiful pieces of art that people want to look at again and again, and that will help sell products to the core consumer, that is, "women over 30 who purchase 85% of all consumer goods in America." Art guidelines listed on website. Considers existing works first. Considers any media, oil, pastel, watercolor, acrylics, digital. "We are seeking artists who have exceptional artistic ability and commercial savvy, who study the market for trends and who would like to have their art and their talents introduced to the broad public. Artists must be willing to work hard to produce art for the market."

THE PRINTERY HOUSE

Conception Abbey, P.O. Box 12, 37112 State Hwy. VV, Conception MO 64433. (660)944-3110. **Fax:** (660)944-3116. **E-mail:** art@printeryhouse.org. **Website:** www.printeryhouse.org. **Contact:** Steve Hess, creative director. Estab. 1950. Publishes religious greeting cards. Licenses art for greeting cards and wall prints. Specializes in religious Christmas and all-occasion themes for people interested in religious, yet contemporary, expressions of faith. Card designs are meant to speak to the heart. They feature strong graphics, calligraphy and other appropriate styles.

NEEDS Approached by 100 freelancers/year. Works with 40 freelancers/year. Art guidelines and technical specifications available upon request. Uses freelancers for product illustration and lettering. Looking for dignified styles and solid religious themes. Has preference for high-quality, broad-edged pen lettering with simple backgrounds/illustrations. Produces seasonal material for Christmas and Easter as well as the religious birthday, get well, sympathy, thank you, etc. Digital work is accepted in Photoshop or Illustrator format.

FIRST CONTACT & TERMS Send query e-mail with résumé, JPEGs or PDFs with examples of work. Low-res samples may be submitted digitally in JPEG or PDF format to art@printeryhouse.org. Usually responds within 3-4 weeks. To show portfolio, e-mail appropriate materials only after query has been answered. "Generally, we continue to work with artists once we have accepted their work." Pays flat fee of $350-$650 for illustration/design, and $150-$250 for calligraphy. Usually buys exclusive reproduction rights for ink or paper use, but artist retains copyright for any other usage.

TIPS "Remember that our greeting cards need to have a definite Christian/religious dimension but not overly sentimental. Artwork must be appealing and of high quality. We sell mostly via mail-order catalogs and online, so artwork has to reduce well for those formats."

PRISMATIX, INC.

324 Railroad Ave., Hackensack NJ 07601. (800)222-9662. **Fax:** (201)525-2828. **E-mail:** info@prismatix.biz; sales@prismatix.biz. **Website:** www.prismatixinc.com. **Contact:** Miriam Salomon, vice president. Estab. 1977. Produces novelty humor programs. "We manufacture screen-printed novelties to be sold in the retail market."

NEEDS Works with 3-4 freelancers/year. Buys 100 freelance designs and illustrations/year. Works on assignment only. 90% of freelance work demands computer skills.

FIRST CONTACT & TERMS Send query letter with brochure, résumé. Samples are filed. Responds only if interested. Portfolio should include color thumbnails, roughs, final art. Payment negotiable.

PRUDENT PUBLISHING

65 Challenger Rd., 5th Floor. Ridgefield Park NJ 07660. (201)641-7900. **Fax:** (201)641-9356. **E-mail:** mfrancesco@prudentpublishing.com. **Website:** www.gallerycollection.com. Estab. 1928. Produces greeting cards. Specializes in business/corporate all-occasion and holiday cards. Art guidelines available.

NEEDS Buys calligraphy. Uses freelancers mainly for card design, illustrations and calligraphy. Considers traditional media. Prefers no cartoons or cute illustrations. Prefers 5½×7⅞ horizontal and vertical formats (or proportionate). Produces material for Christmas, Thanksgiving, birthdays, everyday, sympathy, get well and thank you.

FIRST CONTACT & TERMS Designers, illustrators and calligraphers: Send query letter with brochure, photostats, photocopies, tearsheets. Samples are filed or returned by SASE if requested. Responds ASAP. Portfolio review not required. Buys all rights. No royalty or licensing arrangements. Payment is negotiable. Finds freelancers through submissions, magazines, sourcebooks, agents and word of mouth.

P.S. GREETINGS

5730 N. Tripp Ave., Chicago IL 60646. (773)267-6150 or (800)621-8823. **Fax:** (773)267-6055. **E-mail:** artdirector@psgreetings.com. **Website:** www.psgreetings.com. Manufacturer of boxed greeting and counter cards. Artists' guidelines are posted on website, or send SASE.

NEEDS Receives submissions from 300-400 freelance artists/year. Works with 50-100 artists/year on greeting card designs. Publishes greeting cards for everyday and holidays. 70% of work demands knowledge of InDesign, Illustrator and Photoshop.

FIRST CONTACT & TERMS Send all submissions to the attention of Design Director. All requests as well as submissions must be accompanied by SASE. "Samples will *not* be returned without SASE!" Re-

sponds in 1 month. Pays flat fee. Buys exclusive worldwide rights for greeting cards and stationery. No phone calls, please.

TIPS "Our line includes a whole spectrum from everyday needs (florals, scenics, feminine, masculine, humorous, cute) to every major holiday (from New Year's to Thanksgiving) with a very extensive Christmas line. We continue to grow every year and are always looking for innovative talent."

✎ REALLY GOOD

Old Mast House, The Square, Abingdon, Oxon 0X14 5AR United Kingdom. +44 01235 537888. **Fax:** +44 01235 537779. **E-mail:** Online contact form. **Website:** www.reallygood.uk.com. **Contact:** David Hicks, managing director. Estab. 1987. Produces gifts, stationery, giftwrap, greeting cards. Works with several freelancers/year. Purchases 100+ designs/illustrations per year. Buys cards and stationery 3-5 year rights. Freelancers are paid royalites.

NEEDS Trendy, fun, graphic, modern designs. Seeks alternative, humor and trend designs. Produces material for Mother's Day, birthdays, Father's Day, Valentine's Day, congratulations, baby congratulations, woman-to-woman, wedding/anniversary, get-well/sympathy and everyday cards. Seasonal material should be submitted 12 months in advance.

FIRST CONTACT & TERMS E-mail letter with artist's URL and small JPEG/PDF samples. Samples not kept on file, returned by SASE. Company will contact if interested.

RECYCLED PAPER GREETINGS, INC.

111 N. Canal St., Suite 700, Chicago IL 60606-7206. (800)777-3331. **Website:** www.recycledpapergreetings. com. **Contact:** art director. Estab. 1971. "Since the beginning, we've always worked with independent artists because we value the power of true individual expression. Together, we create the most productive (and awesome) greeting cards out there. We take great pride in our family of independent artists, a family we are always looking to grow. Want to join our family?"

FIRST CONTACT & TERMS "Artwork should be designed to mimic a complete greeting card—message included (vertical 5×7). Please send up to 10 ideas Birthday ideas (labeled with your name, address and phone number). Please do not send holiday-specific cards, as we work far in advance of holidays. Do not send slides, disks, tearsheets, or original artwork. Recycled Paper Greetings is not responsible for any damage to artwork submitted. We suggest submitting color copies or photographs of your art. Do not send previously published cards. The review process can take up to 2 months. Simultaneous submissions to other companies are perfectly acceptable. If your work is chosen, we will contact you to discuss all of the details. If your work is not selected, we will return it to you. Thank you for your interest in Recycled Paper Greetings. Send submissions to the Art Department. E-mail low-res files (less than 2MB total) of formatted designs or links to your portfolio to: newartistsubs@ prgreetings.com."

THE REGAL LINE/ACME GRAPHICS

P.O. Box 2052, Cedar Rapids IA 52406. (319)364-0233. **E-mail:** info@regalline.com. **Website:** www.regalline. com. **Contact:** Jeff Scherrman, president. Estab. 1913. Produces printed merchandise used by funeral directors, such as acknowledgments, register books and prayer cards. Floral subjects, religious subjects and scenes are their most popular products. Art guidelines free for SASE.

○ Acme Graphics manufactures a line of merchandise for funeral directors. Floral subjects, religious subjects and scenes are their most popular products.

NEEDS Approached by 30 freelancers/year. Considers pen & ink, watercolor and acrylic. "We will send a copy of our catalog to show the type of work we do." Art guidelines available for SASE with first-class postage. Looking for religious, inspirational, church window, floral and nature art. Also uses freelancers for calligraphy and lettering.

FIRST CONTACT & TERMS Designers: Send query letter with résumé, photocopies, photographs, slides and transparencies. Illustrators: Send postcard sample or query letter with brochure, photocopies, photographs, slides and tearsheets. Accepts submissions on disk. Samples are not filed and are returned by SASE. Responds in 10 days. Call or write for appointment to show portfolio of roughs. Originals are returned. Requests work on spec before assigning a job. Pays by the project. Buys all rights.

TIPS "Send samples or prints of work from other companies. No modern art. Some designs are too expensive to print. Learn all you can about printing production. Please refer to website for examples of appropriate images!"

RIGHTS INTERNATIONAL GROUP, INC.

500 Paterson Plank Rd., Union City NJ 07087. (201)863-4500. **E-mail:** info@rightsinternational. com. **Website:** www.rightsinternational.com. Estab. 1996. Agency for cross licensing. Licenses images for manufacturers/publishers of giftware, stationery, posters and home furnishings.

○ See additional listing in the Posters & Prints section.

NEEDS Approached by 50 freelancers/year. Uses freelancers mainly for creative, decorative art for the commercial and designer market; also for textile art. Considers oil, acrylic, watercolor, mixed media, pastels and photography.

FIRST CONTACT & TERMS Submission guidelines available online.

RITE LITE, LTD.

333 Stanley Ave., Brooklyn NY 11207. (718)498-1700. **Fax:** (718)498-1251. **E-mail:** info@ritelite.com. **Website:** www.ritelite.com. Estab. 1948. Manufacturer and distributor of a full range of Judaica. Clients include department stores, galleries, gift shops, museum shops and jewelry stores.

NEEDS Looking for new menorahs, mezuzahs, children's Judaica, Passover and matza plates. Works on assignment only. Must be familiar with Jewish ceremonial objects or design. Also uses artists for illustration, and product design. Most of freelance work requires knowledge of Illustrator and Photoshop. Produces material for Hanukkah, Passover and other Jewish holidays. Submit seasonal material 1 year in advance.

FIRST CONTACT & TERMS Designers: Send query letter with brochure or résumé and photographs. Illustrators: Send photocopies. Do not send originals. Samples are filed. Responds in 1 month, only if interested. Art director will contact for portfolio review if interested. Portfolio should include color tearsheets, photographs and slides. Pays flat fee per design. Buys all rights. Finds artists through word of mouth.

TIPS "Be open to the desires of the consumers. Don't force your preconceived notions on them through the manufacturers. Know that there is one retail price, one wholesale price and one distributor price."

ROMAN, INC.

472 Brighton Dr., Bloomingdale IL 60108. (800)729-7662. **Website:** www.roman.com. Estab. 1963. Produces collectible figurines, decorative housewares, decorations, gifts, limited edition plates, ornaments. Specializes in collectibles and giftware to celebrate special occasions.

NEEDS Approached by 25-30 freelancers/year. Works with 3-5 freelancers/year. Uses freelancers mainly for graphic packaging design, illustration. Considers variety of media. Looking for traditional-based design. Roman also has an inspirational niche. 80% of freelance design and illustration demands knowledge of Photoshop, QuarkXPress, Illustrator. Produces material for Christmas, Mother's Day, graduation, Thanksgiving, birthdays, everyday. Submit seasonal material 1 year in advance.

FIRST CONTACT & TERMS Send query letter with photocopies. Samples are filed or returned by SASE. Responds in 2 months if artist requests a reply. Portfolio review not required. Pays by the project. Finds freelancers through submissions and word of mouth. "All submissions are submitted at your own risk and Roman cannot guarantee return of materials. Please do not send original artwork or prototypes. Allow 6-8 weeks for review. Please no phone calls."

THE SARUT GROUP

P.O. Box 110495, Brooklyn NY 11211. (718)387-7484 or (800)345-6404. **E-mail:** sarut@thesarutgroup.com. **Website:** www.thesarutgroup.com. **Contact:** Frederic Rambaud, vice president-marketing. Estab. 1979. Produces museum-quality science and nature gifts. "Marketing firm with 20 employees. 36 trade shows a year. No reps. All products are exclusive. Medium- to high-end market."

NEEDS Approached by 4-5 freelancers/year. Works with 4 freelancers/year. Uses freelancers mainly for new products. Seeks contemporary designs. Produces material for all holidays and seasons.

FIRST CONTACT & TERMS Samples are returned. Responds in 2 weeks. Write for appointment to show portfolio. Rights purchased vary according to project.

TIPS "We are looking for concepts; products, not automatically graphics."

● SECOND NATURE, LTD.

10 Malton Rd., London, W10 5UP United Kingdom. +44 (0)20 8960-0212. **Fax:** +44 (0)20 8960-8700. **E-mail:** via online contact form. **Website:** www. secondnature.co.uk. Greeting card publisher specializing in unique 3D/handmade cards and special finishes.

NEEDS Prefers interesting new contemporary but commercial styles. Also calligraphy and web design. Art guidelines available. Produces material for Christmas, Valentine's Day, Mother's Day and Father's Day. Submit seasonal material 19 months in advance.

FIRST CONTACT & TERMS Send query letter with samples showing art style. Samples not filed are returned only if requested by artist. Responds in 2 months. Originals are not returned at job's completion. Pays flat fee.

TIPS "We are interested in all forms of paper engineering or anything fresh and innovative."

PAULA SKENE DESIGNS

1250 45th St., Suite 240, Emeryville CA 94608. (510)654-3510. **Fax:** (510)654-3496. **E-mail:** paulaskenedesi@aol.com. **Website:** www.paulaskenedesigns.com.

NEEDS Works with 1-2 freelancers/year. Works on assignment only. Produces material for all holidays and seasons, everyday.

FIRST CONTACT & TERMS "Designers, artists, and illustrators: send tearsheets and photocopies. *Do not send more than 2 examples!* Samples are returned. Responds in 1 week. Buys all rights. Pays for design and illustration by the project."

SMART ALEX, INC.

1800 W. Grace St., #322, Chicago IL 60613. **E-mail:** submissions@smartalexinc.com. **Website:** www.smartalexinc.com. Estab. 1980. "From graphic artwork to cartooning, we employ a wide variety of artistic styles in our greeting cards." Works with 5 freelancers/year. Buys 20 freelance designs/year.

NEEDS We are always looking for funny lines, with a definite emphasis on humor for grown-ups. Our style of humor tends to be topical, witty, smart, ironic, or sexually suggestive. Send an e-mail with copy/samples in e-mail format.

FIRST CONTACT & TERMS Graphic submissions should be sent as an e-mail attachment, in JPEG format and at a resolution of 72 dpi.

TIPS "We like our cards to be: surprising without being shocking; a bit dirty without being filthy; we like to poke fun without being insulting. We prefer no sexual themes on Christmas Holidays cards, just funny and humorous."

SOUL

Old Mast House, The Square, Abingdon, Oxfordshire OX14 5AR United Kingdom. +44 1235 537816. **E-mail:** smile@souluk.com. **Website:** www.souluk.com. **Contact:** David Hicks, managing director. Estab. 1997. Produces giftware, greeting cards, notebooks, giftwrap, and other stationery items. Works with 5 freelancers/year. Purchases 100+ designs/illustrations per year. Buys 3-5 year license. Freelancers paid royalties.

NEEDS Contemporary, modern, trend greeting cards. Birthdays, Mother's Day, Father's Day, Easter, Valentine's Day, congratulations baby congratulations, woman-to-woman, wedding/anniversary, get-well/sympathy, everyday.

FIRST CONTACT & TERMS E-mail query letter with URL of artist's site or small JPEG/PDF samples of work. Samples not kept on file. Will contact if interested.

TIPS "Check our website first for style."

SPENCER'S

6826 Black Horse Pike, Egg Harbor Twp. NJ 08234-4197. **Website:** www.spencersonline.com. Estab. 1947. Retail gift chain located in approximately 850 stores in 43 states, including Hawaii and Canada. Includes 2 new retail chain stores named Spirit Halloween Superstores and ToyZam (toy chain). Products offered by store chain include: posters, T-shirts, games, mugs, novelty items, cards, 14K jewelry, neon art, novelty stationery. Spencer's offers different product lines, such as custom lava lights and Halloween costumes and products. Visit a store if you can to get a sense of what they offer.

NEEDS Prefers artists with professional experience in advertising design. Uses artists for illustration (hard line art, fashion illustration, airbrush). Also needs product and fashion photography (primarily jewelry), as well as stock photography. Uses a lot of freelance computer art. 50% of freelance work demands knowledge of InDesign, Illustrator, Photoshop and QuarkXPress. Also uses production and packaging companies. "You don't necessarily have to be local for freelance production."

FIRST CONTACT & TERMS Send postcard sample or query letter with *nonreturnable* brochure, résumé and photocopies, including phone number where you can be reached during business hours. Accepts submissions on disk. Will contact artist for portfo-

lio review if interested. Will contact only upon job need. Considers buying second rights (reprint rights) to previously published work. Finds artists through sourcebooks.

TIPS "Become proficient in as many computer programs as possible."

SUNSHINE ART STUDIOS, INC.

150 Kingswood Rd., P.O. Box 8465. Mankato MN 56002-8465. (800)873-7681. **Fax:** (800)232-3633. **E-mail:** cs@sunshinebusinessclass.com. **Website:** sunshinebusinessclass.com. Estab. 1921. Produces greeting cards, stationery and calendars that are sold in own catalog, appealing to all age groups.

NEEDS Works with 50 freelance artists/year. Buys 100 freelance designs and illustrations/year. Prefers artists with experience in greeting cards. Art guidelines available for SASE with first-class postage. Works on assignment only. Uses freelancers for greeting cards, stationery and gift items. Also for calligraphy. Considers all media. Looking for traditional or humorous look. Produces material for Christmas, birthdays and everyday. Submit seasonal material 6-8 months in advance.

FIRST CONTACT & TERMS Send query letter with brochure, résumé, SASE, tearsheets and slides. Samples are filed or are returned by SASE if requested by artist. Responds only if interested. Portfolio should include finished art samples and color tearsheets and slides. Originals not returned. Buys all rights.

SYRACUSE CULTURAL WORKERS

P.O. Box 6367, Syracuse NY 13217. (315)474-1132. **Fax:** (877)265-5399. **E-mail:** karenk@ syracuseculturalworkers.com. **Website:** www. syracuseculturalworkers.com. **Contact:** Karen Kerney, art director. Estab. 1982. Produces posters, note cards, postcards, greeting cards, T-shirts and calendars that are feminist, progressive, radical, multicultural, lesbian/gay allied, racially inclusive and honoring of elders and children. Publishes and distributes peace and justice resources through their Tools For Change catalog.

NEEDS Approached by many freelancers/year. Considers all media. Art guidelines available on website or free for SASE with first-class postage. Specifically seeking artwork celebrating peace-making diverstiy, people's history and community building. "Our mission is to help sustain a culture that honors diversity and celebrates community; that inspires and nurtures justice, equality and freedom; that respects our fragile Earth and all its beings; that encourages and supports all forms of creative expression." Themes include environment, positive parenting, positive gay and lesbian images, multiculturalism and cross-cultural adoption.

FIRST CONTACT & TERMS Send query letter with sample of work and SASE. Samples are filed or returned by SASE. Responds in 1 month with SASE. Will contact for portfolio review if interested. Buys one-time rights. Pays flat fee, $70-450; royalties of 4-6% gross sales. Finds artists through submissions and word of mouth.

TALICOR, INC.

901 Lincoln Pkwy., Plainwell MI 49080. (269)685-2345; (800)433-GAME (4263). **Fax:** (269)685-6789. **E-mail:** orders@talicor.com; or via online form. **Website:** www.talicor.com. Estab. 1971. Manufacturer and distributor of educational and entertainment games and toys. Clients chain toy stores, department stores, specialty stores and Christian bookstores.

NEEDS Works with 4-6 freelance illustrators and designers/year. Prefers local freelancers. Works on assignment only. Uses freelancers mainly for game design. Also for advertising, brochure and catalog design, illustration and layout; product design; illustration on product; P-O-P displays; posters and magazine design.

FIRST CONTACT & TERMS Send query letter with tearsheets, samples or postcards. Samples are not filed and are returned only if requested. Responds only if interested. Call or write for appointment to show portfolio. Pays for design and illustration by the project. Negotiates rights purchased. Accepts digital submissions via e-mail.

VAGABOND CREATIONS, INC.

2560 Lance Dr., Dayton OH 45409. (937)298-1124. **Fax:** (800)738-7237. **E-mail:** sales@vagabondcreations. net. **Website:** www.vagabondcreations.net. Publishes stationery and greeting cards with contemporary humor; also a line of coloring books. 99% of artwork used is provided by staff artists.

NEEDS Works with 3 freelancers/year. Buys 6 finished illustrations/year. Seeking line drawings, washes and color separations. Material should fit in standard-size envelope.

FIRST CONTACT & TERMS Query. Samples are returned by SASE. Responds in 2 weeks. Submit Christ-

mas, Valentine's Day, everyday and graduation material at any time. Originals are returned only upon request. Payment negotiated.

TIPS "Important! Currently we are *not* looking for additional freelance artists because we are very satisfied with the work submitted by those individuals working directly with us. Our current artists are very experienced and have been associated with us in some cases for over 30 years. We do not in any way wish to offer false hope to anyone, but it would be foolish on our part not to give consideration."

WANDA WALLACE ASSOCIATES

323 E. Plymouth, Suite 2, Inglewood CA 90302. (310)419-0376. **E-mail:** wandawallacefoundation@ yahoo.com. **Website:** www.wandawallacefoundation. org. **Contact:** Wanda Wallace, president. Estab. 1980. Nonprofit organization produces greeting cards and posters for general public appeal. "We produce black art prints, posters, originals and other media."

○ This publisher is doing more educational programs, touring schools nationally with artists.

NEEDS Approached by 10-12 freelance artists/year. Works with varying number of freelance artists/year. Buys varying number of designs and illustrations/ year from freelance artists. Prefers artists with experience in black/ethnic art subjects. Uses freelance artists mainly for production of originals and some guest appearances. Considers all media. Produces material for Christmas. Submit seasonal material 4-6 months in advance.

FIRST CONTACT & TERMS Send query letter with any visual aid. Some samples are filed. Policy varies regarding answering queries and submissions. Call or write to schedule an appointment to show a portfolio. Rights purchased vary according to project. Art education instruction is available. Pays by the project.

WARNER PRESS INC.

1201 E. Fifth St., Anderson IN 46012. (800)741-7721. **E-mail:** curtis@warnerpress.org. **Website:** www. warnerpress.org. **Contact:** Curtis Corzine, creative director. Estab. 1884. Warner Press produces church bulletins, church supplies, Christian Art boxed greeting cards, activity and coloring books, and ministry teaching resources. We produce products for the Christian marketplace. Our main markets are the Church and Christian bookstores. We provide products for all ages. Art submission guidelines available online. Works on assignment only. Warner Press uses freelancers for all products, as listed above. Considers media and photography. Work demands knowledge of Photoshop, Illustrator and InDesign.

NEEDS Approached by 50 freelancers/year. Works with 15-20 freelancers/year. Buys 200 freelance designs and illustrations/year. Works on assignment only. Uses freelancers for all products, including bulletins and coloring books. Considers all media and photography.

FIRST CONTACT & TERMS Send postcard or query letter with samples. Do not send originals. Creative director will contact artist for portfolio review if interested. Samples are filed for later review if necessary. Pays by the project. Buys all rights (occasionally varies).

TIPS "Subject matter must be appropriate for Christian market. Most of our art purchases are for children's materials."

ZITI CARDS

601 S. Sixth St., St. Charles MO 63301. (800)497-5908. **Fax:** (636)352-2146. **E-mail:** mail@ziticards. com. **Website:** www.ziticards.com. **Contact:** Salvatore Ventura, owner. Estab. 2006. Produces greeting cards. Specializes in holiday cards for architects, construction businesses and medical professionals. Art guidelines available via e-mail.

NEEDS Architecture, cities/urban, construction trades and medical imagery. All styles/media considered. Submit seasonal work 2 months in advance. Pays $50 advance and 5% royalties at the end of the season or flat fee. Finds freelancers through submissions.

FIRST CONTACT & TERMS Accepts e-mail submissions with image files or link to website. "E-mail attachments are preferred, but anything that accurately shows the work is fine." After introductory mailing, send follow-up postcard sample every 6 months. Samples are filed or returned by sase if requested. Responds only if interested.

POSTERS & PRINTS

///

Have you ever noticed, perhaps at the opening of an exhibition or at an art fair, that though you have many paintings on display, everybody wants to buy the same one? Do friends, relatives, and co-workers ask you to paint duplicates of work you've already sold? Many artists turn to the print market because they find certain images have a wide appeal and will sell again and again. This section lists publishers and distributors who can produce and market your work as prints or posters. It is important to understand the difference between the terms "publisher" and "distributor" before you begin your research. Art publishers work with you to publish a piece of your work in print form. Art distributors assist you in marketing a preexisting poster or print. Some companies function as both publisher and distributor. Look in the first paragraph of each listing to determine if the company is a publisher, distributor, or both.

RESEARCH THE MARKET

Some listings in this section are fine art presses, and others are more commercial. Read the listings carefully to determine which companies create editions for the fine art market or for the decorative market. Visit galleries, frame shops, furniture stores, and other retail outlets that carry prints to see where your art fits in. You may also want to visit designer showrooms and interior decoration outlets.

To further research this market, check each company's website or send for their catalog. Some publishers will not send their catalogs because they are too expensive, but you may be able to see one at a local poster shop, print gallery, upscale furniture store, or frame shop. Examine the colors in the catalogs to make sure the quality is high.

YOUR PUBLISHING OPTIONS

1. Working with a commercial poster manufacturer or art publisher. If you don't mind creating commercial images and following current trends, the decorative market can be quite lucrative. On the other hand, if you work with a fine art publisher, you will have more control over the final image.

2. Working with a fine art press. Fine art presses differ from commercial presses in that press operators work side by side with you every step of the way, sharing their experience and knowledge of the printing process. You may be charged a fee for the time your work is on the press and for the expert advice of the printer.

3. Working at a co-op press. Instead of approaching an art publisher, you can learn to make your own hand-pulled original prints—such as lithographs, monoprints, etchings, or silk-screens. If there is a co-op press in your city, you can rent time on a press and create your own editions. It can be rewarding to learn printing skills and have the hands-on experience. You also gain total control of your work. The drawback is you have to market your images yourself by approaching galleries, distributors, and other clients.

4. Self-publishing. Several national printing companies advertise heavily in artists' magazines, encouraging artists to publish their own work. If you are a savvy marketer who understands the ins and outs of trade shows and direct marketing, this is a viable option. However, it takes a large investment up front, whether you work with a printing company or choose to do everything on your own. If you contract with a printer, you could end up with a thousand prints taking up space in your basement. On the other hand, if you are a good marketer, you could end up selling them all and making a much larger profit than if you had gone through an art publisher or poster company.

 Another option is to create the prints yourself from your computer, using a high-quality digital printer and archival paper. You can make the prints as needed, which will save money.

5. Marketing through distributors. If you choose the self-publishing route but don't have the resources to market your prints, distributors will market your work in exchange for a percentage of sales. Distributors have connections with all kinds of outlets like retail stores, print galleries, framers, college bookstores, and museum shops.

What to Send

To approach a publisher, send a brief query letter, a short bio, a list of galleries that represent your work, and five to ten JPEGs, TIFFs, or slides. (Check the listing or submission

guidelines to see the type of samples they prefer.) It helps to send printed pieces or tearsheets as samples, as these show publishers that your work reproduces well and that you have some understanding of the publication process. Most publishers will accept digital submissions via e-mail or CD.

Signing and Numbering Your Editions

Before you enter the print arena, follow the standard method of signing and numbering your editions. You can observe how this is done by visiting galleries and museums and talking to fellow artists.

If you are creating a limited edition—with a specific, set number of prints—all prints should be numbered, such as 35/100. The larger number is the total number of prints in the edition; the smaller number is the sequential number of the actual print. Some artists hold out 10 percent as artist's proofs and number them separately with AP after the number (e.g., 5/100 AP). Many artists sign and number their prints in pencil.

Types of Prints

Original prints. Original prints may be woodcuts, engravings, linocuts, mezzotints, etchings, lithographs, or serigraphs (see Glossary for definitions). What distinguishes them is that they are produced by hand by the artist (and consequently often referred to as hand-

pulled prints). In a true original print, the work is created specifically to be a print. Each print is considered an original because the artist creates the artwork directly on the plate, woodblock, etching stone, or screen. Original prints are sold through specialized print galleries, frame shops, high-end decorating outlets, and fine art galleries.

Offset reproductions and posters. Offset reproductions, also known as posters and image prints, are reproduced by photochemical means. Since plates used in offset reproductions do not wear out, there are no physical limits on the number of prints that can be made. Quantities, however, may still be limited by the publisher in order to add value to the edition.

Giclée prints. As color-copier technology matures, inkjet fine art prints, also called giclées, are gaining popularity. Iris prints, images that are scanned into a computer and output on oversized printers, are even showing up in museum collections.

Canvas transfers. Canvas transfers are becoming increasingly popular. Instead of, and often in addition to, printing an image on paper, the publisher transfers the image onto canvas so the work has the look and feel of a painting. Some publishers market limited editions of 750 prints on paper, along with a smaller edition of 100 of the same image on canvas. The edition on paper might sell for about half the price (or a little less) than the price of the canvas transfer.

Pricing Criteria for Limited Editions and Posters

Because original prints are always sold in limited editions, they command higher prices than posters, which are not numbered. Since plates for original prints are made by hand, and as a result can withstand only a certain amount of use, the number of prints pulled is limited by the number of impressions that can be made before the plate wears out. Some publishers impose their own limits on the number of impressions to increase a print's value. These limits may be set as high as 700 to 1,000 impressions, but some prints are limited to just 250 to 500, making them highly prized by collectors.

A few publishers buy work outright for a flat fee, but most pay on a royalty basis. Royalties for hand-pulled prints are usually based on retail price and range from 5 to 20 percent, while percentages for posters and offset reproductions are lower (from 2½ to 5 percent) and are based on the wholesale price. Be aware that some publishers may hold back royalties to cover promotion and production costs; this is not uncommon.

Prices for prints vary widely depending on the quantity available; the artist's reputation; the popularity of the image; the quality of the paper, ink, and printing process. Because prices for posters are lower than for original prints, publishers tend to select images with high-volume sales potential.

Negotiating Your Contract

As in other business transactions, ask for a contract and make sure you understand and agree to all the terms before you sign. Make sure you approve the size, printing method, paper,

number of images to be produced, and royalty terms. Other things to watch for include insurance terms, marketing plans, and guarantees of a credit line or copyright notice.

Always retain ownership of your original work. Negotiate an arrangement in which you're selling publication rights only. You'll also want to sell rights for only a limited period of time. That way you can sell the image later as a reprint or license it for other use (e.g., as a calendar or note card). If you are a perfectionist about color, make sure your contract gives you final approval of your print. Stipulate that you'd like to inspect a press proof prior to the print run.

MORE INDUSTRY TIPS

Find a niche. Consider working within a specialized subject matter. Prints with Civil War themes, for example, are avidly collected by Civil War enthusiasts. But to appeal to Civil War buffs, every detail, from weapons and foliage in battlefields to uniform buttons, must be historically accurate. Signed limited editions are usually created in a print run of 950 or so and can average about $175–200; artists' proofs sell from between $195–250, with canvas transfers selling for $400–500. The original paintings from which images are taken often sell for thousands of dollars to avid collectors.

Sport art is another lucrative niche. There's a growing trend toward portraying sports figures from football, basketball, and racing (both sports car and horse racing) in prints that include both the artist's and the athlete's signatures. Movie stars and musicians from the 1950s (such as James Dean, Marilyn Monroe, and Elvis) are also cult favorites, but any specialized style (such as science fiction/fantasy or wildlife art) can be a marketable niche. See the Market Niche Index for more ideas.

Work in a series. It is easier to market a series of small prints exploring a single theme than to market single images. A series of similar prints works well in long hospital corridors, office meeting rooms, or restaurants. Paired images also are rather profitable. Hotels often purchase two similar prints for each of their rooms.

Study trends. If you hope to get published by a commercial art publisher or poster company, realize your work will have a greater chance of acceptance if you use popular colors and themes.

Attend trade shows. Many artists say it's the best way to research the market and make contacts. It's also a great way for self-published artists to market their work. DECOR Expo is held each year in four cities: Atlanta, New York, Orlando, and Los Angeles. For more information, call (888)608-5300 or visit www.decor-expo.com. Artexpo is held every spring in New York and now every fall in Las Vegas. The SOLO Independent Artists' Pavilion, a special section of Artexpo dedicated to showcasing the work of emerging artists, is the ultimate venue for artists to be discovered. See www.artexpos.com for more information.

ARNOLD ART STORE & GALLERY

210 Thames St., Newport RI 02840. (401)847-2273 or (800)352-2234. **Fax:** (401)848-0156. **E-mail:** info@arnoldart.com. **Website:** www.arnoldart.com. **Contact:** Bill Rommel, owner. Estab. 1870. Poster company; art publisher/distributor; gallery specializing in marine art. Publishes/distributes limited and unlimited editions, fine art prints, offset reproductions and posters.

NEEDS Seeking creative, fashionable, decorative art for the serious collector, commercial and designer markets. Considers oil, acrylic, watercolor, mixed media, pastel, pen & ink, sculpture. Prefers sailing images—America's Cup or other racing images. Artists represented include Kathy Bray, Thomas Buechner and James DeWitt. Editions are created by working from an existing painting. Approached by 100 artists/year. Publishes/distributes the work of 10-15 established artists/year.

MAKING CONTACT & TERMS Send query letter with 4-5 photographs. Samples are filed or returned by SASE. Call to arrange portfolio review. Pays flat fee, royalties or consignment. Negotiates rights purchased; rights purchased vary according to project. Provides advertising and promotion. Finds artists through word of mouth.

HERBERT ARNOT, INC.

250 W. 57th St., 10th Floor, Suite 1014, New York NY 10107. (212)245-8287; after-hours (917)570-7910. **E-mail:** arnotart@aol.com. **Website:** www.arnotart.com. **Contact:** Vicki Arnot, owner/partner with Peter Arnot. Art dealer of original paintings, color Kasimir Etching, and limited edition Luigi Rocca Giclées. Clients: art galleries, design firms and collectors.

NEEDS Seeking creative and decorative art for the serious collector and designer market. Considers oil and acrylic paintings in all styles. Considers sculpture. Has wide range of themes and styles "mostly traditional/impressionistic." Artists represented include Raymond Campbell, Claudio Simonetti, Guy Dessapt, MALVA, Estate of Christian Nesvadba, Gerhard Nesvadba, Claudia Fisher, Michael Minthorn, and many others. Distributes the work of 250 artists/year.

MAKING CONTACT & TERMS Send query letter with brochure, résumé, business card—photographs are discarded or returned by SASE. Responds in 1 month. Portfolios may be mailed, or by appointment. Provides promotion.

TIPS "Artist should be professional."

ART BROKERS OF COLORADO

7615 Jeffrey Lane, Colorado Springs CO 80919. (719)520-9177 or (800)210-9177. **Fax:** (719)633-5747. **E-mail:** artbrokers@aol.com. **Website:** www.artbrokers.com. Estab. 1991. Art publisher. Publishes limited and unlimited editions, posters and offset reproductions. Clients: galleries, decorators, frame shops.

NEEDS Seeking decorative art by established artists for the serious collector. Prefers oil, watercolor and acrylic. Prefers western theme. Editions created by collaborating with the artist. Approached by 20-40 artists/year. Publishes the work of 1-2 established artists/year.

MAKING CONTACT & TERMS Send query letter with photographs. Samples are not filed and are returned by SASE. Responds in 4-6 weeks. Company will contact artist for portfolio review of final art if interested. Pays royalties. Rights purchased vary according to project. Provides insurance while work is at firm.

TIPS Advises artists to attend all the trade shows and to participate as often as possible.

ART DALLAS, INC.

2325 Valdina St., Dallas TX 75207. (214)688-0244. **Fax:** (214)688-7758. **E-mail:** info@artdallas.com. **Website:** www.artdallas.com. **Contact:** Judy Martin, president. Estab. 1988. Art distributor, gallery, framing and display company. Distributes handpulled originals, offset reproductions. Clients: designers, architects. "Art Dallas, Inc. provides art and framing services to the design trade. Our goal is to provide the best, most complete service at the best possible price. The Gallery at Art Dallas, Inc. is a recently renovated 8,000 ft. showroom in the Dallas Design District. It is a commercial, working gallery with lots of table space. This allows our designers to spread out, facilitating the design of more than one project at a time."

NEEDS Seeking creative art for the commercial and designer markets. Considers mixed media. Prefers abstract, landscapes.

MAKING CONTACT & TERMS Send query letter with résumé, photocopies, slides, photographs and transparencies. Samples are filed or are returned. Call for appointment to show portfolio of slides and photographs. Pays flat fee $50-5,000. Offers advance when appropriate. Negotiates rights purchased.

ART SOURCE

1040 Ronsa Court, Mississauga, Ontario L4W 3Y4 Canada. (905)475-8181. **Fax:** (905)479-4966. **E-mail:** victoria.artsource@gmail.com. **Website:** www.artsource.ca. **Contact:** Victoria Fenninger, art director. Estab. 1978. Poster company and distributor. Publishes/distributes hand-pulled originals, limited editions, unlimited editions, canvas transfers, fine art prints, monoprints, monotypes, offset reproductions and posters. Clients: galleries, decorators, frame shops, distributors, corporate curators, museum shops and gift shops.

NEEDS Seeking creative, fashionable and decorative art for the designer market. Considers oil, acrylic, watercolor, mixed media, pastel and pen & ink. Editions are created by collaborating with the artist and by working from an existing painting. Approached by 50 artists/year. Publishes the work of 2 emerging, 5 mid-career and 8 established artists/year. Distributes the work of 2 emerging, 5 mid-career and 8 established artists/year.

MAKING CONTACT & TERMS Send query letter with brochure, photocopies, photographs, photostats, résumé, SASE, slides, tearsheets and transparencies. Accepts submissions via e-mail. Company will contact artist for portfolio review if interested. Portfolios may be dropped off every Monday and Tuesday. Portfolio should include color photographs, photostats, roughs, slides, tearsheets, thumbnails and transparencies. Artist should follow up with letter after initial query. Pays royalties of 6-12%; flat fee is optional. Payment is negotiable. Offers advance when appropriate. Negotiates rights purchased. Rights purchased vary according to project. Sometimes requires exclusive representation of artist. Provides advertising, promotion and written contract.

TIPS "We are looking for more original art for our distribution."

THE BENJAMAN GALLERY

419 Elmwood Ave., Buffalo NY 14222. (716)886-0898. **Fax:** (716)886-0546. **E-mail:** info@thebenjamangallery.com. **Website:** www.benjamangallery.com. Estab. 1970. Art publisher, distributor, gallery, frame shop and appraiser. Publishes and distributes handpulled originals, limited and unlimited editions, posters, offset reproductions and sculpture. Clients include P&B International.

NEEDS Seeking decorative art for the serious collector. Considers oil, watercolor, acrylic and sculpture. Prefers art deco and florals. Artists represented include Peter Max, Robert Blair, Joan Miro, Charles Birchfield, J.C. Litz, Jason Barr and Eric Dates. Editions created by collaborating with the artist. Approached by 20-30 artists/year. Publishes and distributes the work of 4 emerging, 2 mid-career and 1 established artists/year.

MAKING CONTACT & TERMS Send query letter with SASE, slides, photocopies, résumé, transparencies, tearsheets or photographs. Samples are filed or returned. Responds in 2 weeks. Company will contact artist for portfolio review if interested. Pays on consignment basis. Firm receives 30-50% commission. Offers advance when appropriate. Rights purchased vary according to project. Does not require exclusive representation of artist. Provides advertising, promotion, shipping to and from firm, written contract and insurance while work is at firm.

TIPS "Keep trying to join a group of artists and try to develop a unique style."

THE BLACKMAR COLLECTION

P.O. Box 537, Chester CT 06412. (860)526-9303. **E-mail:** carser@mindspring.com. Art publisher. Publishes offset reproduction and giclée prints. Clients: individual buyers.

NEEDS "We are not actively recruiting at this time." Artists represented include DeLos Blackmar, Blair Hammond, Gladys Bates and Keith Murphey. Editions are created by working from an existing painting. Approached by 24 artists/year. Publishes the work of 3 established artists/year. Provides advertising, in-transit insurance, insurance while work is at firm. Finds artists through personal contact. All sales have a buy back guarantee.

JOE BUCKALEW

1825 Annwicks Dr., Marietta GA 30062. (800)971-9530. **Fax:** (770)971-6582. **E-mail:** art@joebuckalew.com; joesart@bellsouth.net. **Website:** www.joebuckalew.com. Estab. 1990. Distributor and publisher. Distributes limited editions, canvas transfers, fine art prints and posters. Clients: frame shops, galleries, interior designers, corporate accounts, financial institutions.

NEEDS Seeking creative, fashionable, decorative art for the serious collector. Considers oil, acrylic and watercolor. Prefers florals, landscapes, Civil War

and sports. Approached by 25-30 artists/year. Distributes work of 10 emerging, 10 mid-career and 50 established artists/year. Art guidelines free with SASE and first-class postage.

MAKING CONTACT & TERMS Send sample prints. Accepts disk submissions. "Please call. Currently using a 460 commercial computer." Samples are filed or are returned. Does not reply. Artist should call. To show portfolio, artist should follow up with call after initial query. Portfolio should include sample prints. Pays on consignment basis. Firm receives 50% commission, paid net 30 days. Provides advertising on website, shipping from firm and company catalog. Finds artists through ABC shows, regional art & craft shows, frame shops, other artists.

TIPS "Paint your own style."

☯ CANADIAN ART PRINTS AND WINN DEVON ART GROUP INC.

Unit 110, 6311 Westminster Hwy., Richmond V7C 4V4 Canada. **E-mail:** artsubmissions@capandwinndevon. com. **Website:** www.capandwinndevon.com. Estab. 1965. Art publisher/distributor. Publishes or distributes open edition and limited edition, canvas & poster prints, and art cards. Clients: galleries, various interior design and decorators (homes, hospitality & tourism), frame shops, distributors, corporate curators, museums, giftshops and home décor retailers. Licenses all subjects of open editions for wallpaper, writing paper, placemats, books, etc.

NEEDS Seeking fashionable and decorative art for the commercial and designer markets. Considers oil, acrylic, watercolor, mixed media, pastel paintings, photography, and digital art. Prefers representational/transitional and florals, landscapes, abstracts, marine, decorative and street scenes. Editions created by collaborating with the artist and working from an existing painting. Approached by 300-400 artists/year. Publishes/distributes the work of more than 150 artists/year.

MAKING CONTACT & TERMS Send e-mail with low-res JPEGs, website, address or send query letter with photographs, SASE, slides, tearsheets, transparencies. Samples are not filed and are returned by SASE. Will contact artist for portfolio review if interested. Normally takes 4-6 weeks to review submissions. Pays range of royalties. Obtains licensing rights to publish. Provides promotion and advertising, in-transit insurance, insurance while work is at firm, shipping and

contract. Finds artists through art exhibitions, art fairs, word of mouth, art reps, Internet research and submissions.

TIPS "Keep up with trends by following decorating magazines."

CARPENTREE, INC.

2724 N. Sheridan, Tulsa OK 74115. (800)736-2787. **E-mail:** smorris@carpentree.com; jhobson@carpentree. com. **Website:** www.carpentree.com. **Contact:** Dan and Ginny Hobson, owners. Estab. 1976. Wholesale framed art manufacturer. Clients: decorators, frame shops, galleries, gift shops and museum shops.

NEEDS Seeking decorative art for the commercial market. Considers acrylic, mixed media, oil, pastel, pen & ink, sculpture, watercolor and photography. Prefers traditional, family-oriented, Biblical themes, landscapes. Editions created by collaborating with the artist and by working from an existing painting. Approached by 50 artists/year.

MAKING CONTACT & TERMS Send JPEG files only to smorris@carpentree.com. Prefers Windows compatible JPEG files. Do not send original art. Samples are not filed. Responds in 2-4 months. Portfolio not required. Negotiates payment. No advance. Negotiates rights purchased. Requires exclusive regional representation of artist. Provides advertising, promotion, and written contract. Finds artists through art exhibits/fairs and artist's submissions.

CHALK & VERMILION FINE ARTS

55 Old Post Rd., #2, Greenwich CT 06830. (203)869-9500. **Website:** www.chalk-vermilion.com. **Contact:** artist submission department. Estab. 1976. Art publisher. Publishes original paintings, hand-pulled serigraphs and lithographs, posters, limited editions and offset reproductions. Clients: 4,000 galleries worldwide.

NEEDS Publishes decorative art for the serious collector and the commercial market. Considers oil, mixed media, acrylic and sculpture. Editions created by collaboration. Approached by 350 artists/year.

MAKING CONTACT & TERMS Full submission guidelines available online. Send samples of your work (photos or slides), contact information, a resume and/or a biography and any other information you can share about yourself and your art.

CIRRUS EDITIONS

2011 S. Santa Fe Ave., Los Angeles CA 90021. (213)680-3473. **Fax:** (213)680-0930. **E-mail:** cirrus@ cirrusgallery.com. **Website:** www.cirrusgallery.com. **Contact:** Jean R. Milant, director. Produces limited edition hand-pulled originals. Clients: museums, galleries and private collectors.

NEEDS Seeking fine art for the serious collector and museums. Prefers abstract, conceptual work. Publishes and distributes the work of 6 emerging, 2 mid-career and 1 established artists/year.

MAKING CONTACT & TERMS Prefers CD or low-res JPEGs. Samples are returned by SASE. No illustrators, graphic designers or commercial art submissions.

CLAY STREET PRESS, INC.

1312 Clay St., Cincinnati OH 45202. (513)241-3232. **E-mail:** mpginc@iac.net. **Website:** www. patsfallgraphics.com. **Contact:** Mark Patsfall, owner. Estab. 1981. Art publisher and printer. Publishes fine art prints, hand-pulled original etchings, lithographs, woodcuts and silk screen prints in limited editions. Clients: architects, corporate curators, decorators, galleries and museum print curators.

NEEDS Works are conceptual/contemporary and are created by collaborating with the artist. Publishes the work of 2-3 emerging artists/year.

MAKING CONTACT & TERMS Contact through e-mail or phone.

✚ ◐ CLEARWATER PUBLISHING

161 MacEwan Ridge Circle NW, Calgary, Alberta T3K 3W3 Canada. (303)436-1982. **E-mail:** Wordguise@aol. com. **Website:** www.clearwaterpublishing.com/2010/ about. Estab. 1989. Fine art publisher. Handles giclées, canvas transfers, fine art prints and offset reproductions. Clients: decorators, frame shops, gift shops, galleries and museum shops. "Offers a large selection of images, including those of landscapes, children, wildlife, western and equine, sports, and folk art. These images are available in different formats—limited edition offset lithographs, canvas transfers, and giclée reproductions (on both paper & canvas) as well as art cards."

NEEDS Seeking artwork for the serious collector and commercial market. Considers acrylic, watercolor, mixed media and oil. Prefers high realism or impressionistic works. Artists represented can be seen on website.

MAKING CONTACT & TERMS Accepts e-mail submissions with link to website and image file; Windows-compatible. Prefers JPEGs. Samples are not filed or returned. Responds only if interested. Company will contact artist for portfolio review if interested. Portfolio should include slides. No advance. Requires exclusive representation of artist.

COLOR CIRCLE ART PUBLISHING, INC.

791 Tremont St., Box A, Suite N104, Boston MA 02118. (800)254-1795. **Fax:** (617)437-9217. **E-mail:** colorcircleart@gmail.com. **Website:** www.colorcircle. com. **Contact:** Bernice Robinson, co-founder/ marketing and administration. Estab. 1991. Art publisher. Publishes limited editions, unlimited editions, fine art prints, offset reproductions, posters. Clients: galleries, art dealers, distributors, museum shops. Current clients include Deck the Walls, Things Graphics, Essence Art.

NEEDS Seeking creative, decorative art for the serious collector and the commercial market. Considers oil, acrylic, watercolor, mixed media, pastel, pen & ink. Prefers ethnic themes. Artists represented include Paul Goodnight. Editions created by collaborating with the artist or by working from an existing painting. Approached by 12-15 artists/year. Publishes the work of 2 emerging, 1 mid-career artists/year. Distributes the work of 4 emerging, 1 mid-career artists/year.

MAKING CONTACT & TERMS Send query letter with slides. Samples are filed or returned by SASE. Responds in 2 months. Negotiates payment. Rights purchased vary according to project. Provides advertising, insurance while work is at firm, promotion, shipping from our firm and written contract. Finds artists through submissions, trade shows and word of mouth.

TIPS "We like to present at least 2 pieces by a new artist that are similar in theme, treatment or colors."

DARE TO MOVE

6621 83rd St. E., Puyallup WA 98371. (206)380-4378. **E-mail:** daretomove@aol.com. **Website:** www.daretomove.com. **Contact:** Steve W. Sherman, president. Estab. 1987. Art publisher, distributor. Publishes/distributes limited editions, unlimited editions, canvas transfers, fine art prints, offset reproductions. Licenses aviation and marine art for puzzles, note cards, bookmarks, coasters, etc. Clients

include art galleries, aviation museums, frame shops and interior decorators.

○ This company has expanded from aviation-related artwork to work encompassing most civil service areas. Steve Sherman likes to work with artists who have been painting for 10-20 years. He usually starts off distributing self-published prints. If prints sell well, he will work with artists to publish new editions.

NEEDS Seeking naval, marine, firefighter, civil service and aviation-related art for the serious collector and commercial market. Considers oil and acrylic. Editions are created by collaborating with the artist or working from an existing painting. Approached by 15-20 artists/year.

MAKING CONTACT & TERMS Send query letter with photographs, slides, tearsheets and transparencies. Samples are filed or sometimes returned by SASE. Artist should follow up with a call. Portfolio should include color photographs, transparencies and final art. Pays royalties of 10% commission of wholesale price on limited editions; 5% commission of wholesale price on unlimited editions. Buys one-time or reprint rights. Provides advertising, in-transit insurance, insurance while work is at firm, promotion, shipping from firm, and written contract.

TIPS "Present your best work professionally."

EDITIONS LIMITED GALLERIES, INC.

4090 Halleck St., Emeryville CA 94608. (510)923-9770, ext. 6998 or (800)228-0928. **Fax:** (510)923-9777. **E-mail:** submissions@editionslimited.com; customerservice@editionslimited.com. **Website:** www.editionslimited.com. **Contact:** Todd Haile, poster publishing; Christy Carleton, original art. Art publisher and distributor of limited open edition prints and fine art posters. Clients: contract framers, galleries, framing stores, art consultants and interior designers.

NEEDS Seeking art for the original and designer markets. Considers oil, acrylic and watercolor painting, monoprint, monotype, photography and mixed media. Prefers landscape, floral and abstract imagery. Editions created by collaborating with the artist or by working from existing works.

MAKING CONTACT & TERMS Send query letter with résumé, slides and photographs or JPEG files (8 inch maximum at 72 dpi) via e-mail. Samples are filed or are returned by SASE. Responds in 2 months.

Publisher/distributor will contact artist for portfolio review if interested. Payment method is negotiated. Negotiates rights purchased.

TIPS "We deal both nationally and internationally, so we need art with wide appeal. When sending slides or photos, send at least 6 so we can get an overview of your work. We publish artists, not just images."

ENCORE GRAPHICS & FINE ART

P.O. Box 32, Huntsville AL 35804. (256)509-7944. **E-mail:** encore@randenterprises.com; or by contact form. **Website:** www.egart.com. Estab. 1995. Poster company, art publisher, distributor. Publishes/distributes limited edition, unlimited edition, fine art prints, offset reproduction, posters. Clients: galleries, frame shops, distributors.

NEEDS Creative art for the serious collector. Considers all media. Prefers African-American and abstract. Art guidelines available on company's website. Artists represented include Greg Gamble, Tod Fredericks, Tim Hinton, Mario Robinson, Lori Goodwin, Wyndall Coleman, T.H. Waldman, John Will Davis, Burl Washington, Henry Battle, Cisco Davis, Delbert Iron-Cloud, Gary Thomas and John Moore. Also Buffalo Soldier Prints and historical military themes. Editions created by working from an existing painting. Approached by 15 artists/year. Publishes the work of 3 emerging artists, 1 mid-career artist/year. Distributes the work of 3 emerging, 2 mid-career and 3 established artists/year.

MAKING CONTACT & TERMS Send photocopies, photographs, résumé, tearsheets. Samples are filed. Responds only if interested. Company will contact artist for portfolio review of color, photographs, tearsheets if interested. Negotiates payment. Offers advance when appropriate. Requires exclusive representation of artist. Provides advertising, in-transit insurance, insurance while work is at firm, promotion, shipping from firm, written contract. Finds artists through the Internet and art exhibits.

TIPS "Prints of African Americans with religious themes or children are popular now. Paint from the heart."

ELEANOR ETTINGER, INC.

24 W. 57th St., New York NY 10019. (212)925-7474 (57th St.) or (212)925-7686 (Chelsea location). **Fax:** (212)925-7734. **E-mail:** eegallery@aol.com or via online contact form. **Website:** www.eegallery.com. **Contact:** Eleanor Ettinger, president. Estab. 1975. Art

dealer of limited edition lithographs, limited edition sculpture and unique works (oil, watercolor, drawings, etc.).

NEEDS Seeks classically inspired realistic work involving figurative, landscapes and still lifes for the serious collector. Considers oil, acrylic, mixed media. Prefers American realism.

MAKING CONTACT & TERMS Send query letter with visuals (slides, photographs, etc.), a brief biography, résumé (including a list of exhibitions and collections) and SASE for return of the materials. Responds in 3-4 weeks.

FAIRFIELD ART PUBLISHING

430 Communipaw Ave., 2nd floor west, Jersey City NJ 07304. (800)835-3539. **Fax:** (718)832-8432. **E-mail:** fairfieldart@gmail.com. **Website:** fairfieldartpublishing.com or fairfieldartgallery. com. **Contact:** Peter Lowenkron, vice president. Estab. 1996. Art publisher. Publishes posters, limited editions and offset reproductions. Clients: galleries, frame shops, museum shops, decorators, corporate curators, gift shops, manufacturers and contract framers.

NEEDS Decorative art for the designer and commercial markets. Considers photography, collage, oil, watercolor, pastel, pen & ink, acrylic. Artists represented include Daniel Pollera, Roger Vilar, Carol Saxe, Ellen Fisch and Eve Turek, etc.,etc.

MAKING CONTACT & TERMS Send query letter with slides, email with website address, JPEGS and or brochure. Samples are returned by SASE if requested by artist. Responds only if interested. Pays flat fee, or royalties of 7-15%. Offers advance when appropriate. Rights purchased vary according to project. Interested in buying second rights (reprint rights) to previously published artwork.

RUSSELL FINK GALLERY

P.O. Box 250, Lorton VA 22199. (703)550-9699. **Fax:** (703)339-6150. **E-mail:** info@russellfinkgallery.com. **Website:** russellfinkgallery.com. **Contact:** Russell A. Fink. Art publisher.

NEEDS Considers oil, acrylic and watercolor. Prefers wildlife and sporting themes. Prefers individual works of art; framed. "Submit photos or slides of at least near-professional quality. Include size, price, media and other pertinent data regarding the artwork. Also send personal résumé and be courteous enough to include SASE for return of any material

sent to me." Artists represented include Ray Harris-Ching, Ken Carlson, John Loren Head, Robert Abbett, Rod Crossman, Manfred Schatz and Chet Reneson.

MAKING CONTACT & TERMS Send query letter with slides or photographs to be kept on file. Call or write for appointment to show portfolio. Samples returned if not kept on file.

TIPS "Looks for composition, style and technique in samples. Also how the artist views his own art. Mistakes artists make are arrogance, overpricing, explaining their art and underrating the role of the dealer."

FORTUNE FINE ART

7825 E. Redfield Rd., Suite 105, Scottsdale AZ 85260. (480)946-1055. **E-mail:** carolv@fortunefa.com; inquiry@fortunefa.com. **Website:** www.fortunefa. com. **Contact:** Carol Vidic, Principal. Publishes fine art prints, hand-pulled serigraphs, giclées, originals, limited editions, offset reproductions, posters and unlimited editions. Clients: art galleries, dealers and designers.

NEEDS Seeking creative art for the serious collector. Considers oil on canvas, acrylic on canvas, mixed media on canvas and paper. Artists represented include John Powell, Daniel Gerhartz, Marilyn Simandle, Ming Feng, S. Burkett Kaiser and B. Nicole Klassen. Publishes and distributes the work of a varying number of emerging artists/year.

MAKING CONTACT & TERMS Send query letter with résumé, slides, photographs, biography and SASE or send digital images to carolv@fortunefa.com. Samples are not filed. Responds in 1 month. To show a portfolio, mail appropriate materials. Prefers exclusive representation of artist. Provides in-transit insurance, insurance while work is at firm, promotion and written contract.

TIPS "Establish a unique style, look or concept before looking to be published."

GALAXY OF GRAPHICS, LTD.

30 Murray Hill Pkwy., Suite 300, East Rutherford NJ 07073-2180. (201)806-2100. **Fax:** (201)806-2050. **E-mail:** clbuchweitz@gmail.com; susan.murphy@ kapgog.com. **Website:** www.galaxyofgraphics.com. Susan Murphy. **Contact:** Colleen Buchweitz, Art Director. Estab. 1983. Art publisher and distributor of open edition (unlimited) editions. Licensor of images for retail and home decor products such as wall art, kitchen textiles, bath accessories, stationery, etc.

Licensing handled by Susan Murphy. Clients: product manufacturers that sell to retail and online stores.

NEEDS Seeking landscape, floral, and decorative artists that are excited by home decor style trends. We are seeking artists that have a unique look and decorative approach to their work. Editions are created by collaborating with the artist or by working from an existing painting. Considers any media. "Any currently popular and generally accepted themes." Art guidelines free via e-mail request. Approached by several hundred artists/year. Publishes and distributes the work of 20 emerging and 20 mid-career and established artists/year.

MAKING CONTACT & TERMS "Please e-mail submissions or send color copies or a CD (in Mac-based files or JPEG format). Include a SASE if you would like your submission returned and write 'Artist Submission' above the address. We can take anywhere from 2-4 weeks to review your work so please be patient, as we carefully review each submission we receive.".

TIPS "We sell images that coordinate with changing home decor trends in style and color. Consider this the 'fashion' market for 2D Artists."

GALLERY GRAPHICS, INC.

P.O. Box 631, 2210 S. Main St., Ft. Scott KS 66701. (620)223-5190 ext. 7014. **Fax:** (620)223-6955. **E-mail:** info@gallerygraphics.com; britegraphix@gmail.com. **Website:** www.gallerygraphics.com. Estab. 1979. Wholesale producer and distributor of prints, cards, sachets, stationery, calendars, framed art, stickers. Clients: frame shops, craft shops, florists, pharmacies and gift shops.

NEEDS Seeking art with nostalgic look, country, Victorian, children, angels, florals, landscapes, animals—nothing abstract or nonrepresentational. Considers oil, watercolor, mixed media, pastel and pen & ink. 10% of editions created by collaborating with artist. 90% created by working from an existing painting.

MAKING CONTACT & TERMS Send query letter with brochure showing art style and tearsheets. Designers send photographs, photocopies and tearsheets. Accepts disk submissions compatible with IBM or Mac. Samples are filed or returned by SASE. Responds in 2 months. To show portfolio, mail finished art samples, color tearsheets. Can buy all rights or pay royalties. Provides a written contract.

TIPS "Please submit artwork on different subjects and styles. Some artists do certain subjects particularly well, but you don't know if they can do other subjects. Don't concentrate on just one area. Don't limit yourself, or you could be missing out on some great opportunities."

GEME ART, INC.

209 W. Sixth St., Vancouver WA 98660. (360)693-7772 or (800)426-4424. **Fax:** (360)695-9795. **E-mail:** gemeart@hotmail.com. **Website:** www.gemeart.com. Estab. 1966. Art publisher. Publishes fine art prints and reproductions in unlimited and limited editions. Clients: galleries, frame shops, art museums, manufacturers, craft shops. Licenses designs.

NEEDS Considers oil, acrylic, watercolor and mixed media. "We use a variety of styles from realistic to whimsical, catering to 'mid-America art market.' Artists represented include Lois Thayer, Crystal Skelley, Steve Nelson.

MAKING CONTACT & TERMS Send color slides, photos or brochure. Include SASE. Publisher will contact artist for portfolio review if interested. Simultaneous submissions OK. Payment on a royalty basis. Purchases all rights. Provides promotion, shipping from publisher and contract.

GLEEDSVILLE ART PUBLISHERS

5 W. Loudoun St., Leesburg VA 20175. (703)771-8055 or (800)771-8055. **Fax:** (703)771-8055. **E-mail:** buyart@gleedsvilleart.com. **Website:** www.gleedsvilleart.com/index.asp. **Contact:** Lawrence J. Thomas, president. Estab. 1999. Prints fine art prints, photography and graphic designs. Clients: art collectors, artists, photographers, decorators, distributors, frame shops and galleries.

NEEDS Seeking fine art and photography for the serious collector, commercial and designer markets. Considers all fine art mediums including photography and digital design. Editions created by collaborating with the artist.

MAKING CONTACT & TERMS The preferred method of submission is e-mail with low resolution files or link to website. Company will contact artist for portfolio review if interested. Pays royalties and requires exclusive representation or artist.

HADDAD'S FINE ARTS, INC.

3855 E. Mira Loma Ave., Anaheim CA 92806. (714)996-2100 or (800)942-3323. **Fax:** (714)996-4153.

E-mail: artmail@haddadsfinearts.com. **Website:** www.haddadsfinearts.com. **Contact:** art director. Estab. 1953. Art publisher and distributor. Produces unlimited edition offset reproductions and posters. Clients: galleries, art stores, museum stores and manufacturers. Sells to the trade only—no retail.

NEEDS Seeking creative and decorative art for the commercial and designer markets. Seeks traditional/transitional scenes: landscapes, floral, decorative, abstract contemporary, and more—broad subject mix. Editions created by collaborating with the artist or by working from an existing painting. Approached by 200-300 artists/year. Publishes the work of 10-15 emerging artists/year. Also uses freelancers for design. 20% of projects require freelance design. Design demands knowledge of QuarkXPress and Illustrator.

MAKING CONTACT & TERMS Submission guidelines available online. "We would like to see slides, color copies, photographs or other representative examples of your artwork. Please do not send original art or transparencies as we do not want your irreplaceable items to be lost or damaged en route. We can also accept PC-readable CDs and e-mailed files, but mailed materials are preferred (attn: Art Director). We appreciate receiving a SASE for the return of your materials. We are not able to accept any posters or prints already in distribution.".

HADLEY HOUSE PUBLISHING

4816 Nicollet Ave. S., Minneapolis MN 55419. (800)423-5390. **Fax:** (952)943-8098. **E-mail:** customerservice@hadleyco.com. **Website:** www.hadleyhouse.com. Estab. 1974. Art publisher, distributor. Publishes and distributes canvas transfers, fine art prints, giclées, limited and unlimited editions, offset reproductions and posters. Licenses all types of flat art. Clients: wholesale and retail.

NEEDS Seeking artwork with creative artistic expression and decorative appeal. Considers oil, watercolor, acrylic, pastel and mixed media. Prefers florals, landscapes, figurative and nostalgic Americana themes and styles. Art guidelines free for SASE with first-class postage. Artists represented include Nancy Howe, Steve Hamrick, Sueellen Ross, Collin Bogle, Lee Bogle and Bruce Miller. Editions are created by collaborating with artist and by working from an existing painting. Approached by 200-300 artists/year. Publishes the work of 3-4 emerging, 15 mid-career and 8 established artists/year. Distributes the work of 1 emerging and 4 mid-career artists/year.

MAKING CONTACT & TERMS Send query letter with brochure showing art style or résumé and tearsheets, slides, photographs and transparencies. Samples are filed or are returned. Responds in 2 months. Call for appointment to show portfolio of slides, original final art and transparencies. Pays royalties. Requires exclusive representation of artist or art. Provides insurance while work is at firm, promotion, shipping from firm, a written contract and advertising through dealer showcase.

TIPS "Build a market for your originals by affiliating with an art gallery or 2. Never give away your copyrights! When you can no longer satisfy the overwhelming demand for your originals, *that* is when you can hope for success in the reproduction market."

IMAGE CONNECTION

456 Penn St., Yeadon PA 19050. (610)626-7770. **Fax:** (610)626-2778. **E-mail:** sales@imageconnection.biz. **Website:** www.imageconnection.biz. **Contact:** Michael Markowicz, president. Estab. 1988. Publishes and distributes limited editions and posters. Represents several European publishers.

NEEDS Seeking fashionable and decorative art for the commercial market. Considers oil, pen & ink, watercolor, acrylic, pastel and mixed media. Prefers contemporary and popular themes, realistic and abstract art. Editions are created by collaborating with the artist and by working from an existing painting. Approached by 200 artists/year.

MAKING CONTACT & TERMS Send query letter with brochure showing art style or résumé, slides, photocopies, photographs, tearsheets and transparencies. Accepts e-mail submissions with link to website or Mac-compatible image file. Samples are not filed and are returned by SASE. Responds in 2 months. Will contact artist for portfolio review if interested. Portfolio should include b&w and color finished, original art, photographs, slides, tearsheets and transparencies. Payment method is negotiated. Offers advance when appropriate. Negotiates rights purchased. Requires exclusive representation of artist for product. Finds artists through art competitions, exhibits/fairs, reps, submissions, Internet, sourcebooks and word of mouth.

IMAGE CONSCIOUS

147 Tenth St., San Francisco CA 94103. **E-mail:** inquiries@imageconscious.com;jweiss@ imageconscious.com. **Website:** www.imageconscious. com. **Contact:** Jan Weiss, Creative Director. Estab. 1980. Wholesale fine art publisher and domestic and international distributor of offset and poster reproductions. Now licensing images as well. Clients: poster galleries, frame shops, department stores, design consultants, interior designers and gift stores.

NEEDS Seeking creative and decorative art for the designer market. Considers oil, acrylic, pastel, watercolor, tempera, mixed media and photography. Prefers individual works of art, pairs or unframed series. Editions created by collaborating with the artist and by working from an existing painting or photograph. Approached by hundreds of artists/year. Publishes the work of 4-6 emerging, 4-6 mid-career and 8-10 established artists/year. Distributes the work of 50 emerging, 200 mid-career and 700 established artists/year.

MAKING CONTACT & TERMS Send low-res e-mail submissions. No snail mail submissions. Please limit initial submissions to 10 images. Responds in 1 month. Publisher/distributor will contact artist for portfolio review if interested. No original art. Payment method is negotiated. Negotiates rights purchased. Provides promotion, shipping from firm and a written contract.

TIPS "Research the type of product currently in poster shops. Note colors, sizes and subject matter trends."

IMAGE SOURCE INTERNATIONAL

320 Main St., Unit B, Buzzards Bay MA 02532. (774)302-4076. **Fax:** (774)302-4973. **E-mail:** pdownes@isiposters.com; jwaters@isiposters.com. **Website:** www.isiposters.com. **Contact:** Patrick Downes; Jobe Waters, art director. Poster company, art publisher/distributor. Publishes/distributes unlimited editions, fine art prints, fine art prints, canvas and offset reproductions, posters. Clients: direct to retail chain stores, galleries, decorators, frame shops, distributors, architects, corporate curators, museum shops, gift shops, foreign distributors (Germany, Holland, Asia, South America).

○ Image Source International is one of America's fastest-growing publishers.

NEEDS Seeking fashionable, decorative art for the designer market. Considers oil, acrylic, pastel.

MAKING CONTACT & TERMS Send query letter with brochure, photocopies, photographs, résumé, slides, tearsheets, transparencies, postcards. Samples are filed and are not returned. Responds only if interested. Company will contact artist for portfolio review if interested. Pays flat fee or 10% royalty "that depends on artist and work and risk." Buys all rights for prints and posters. Does not require exclusive representation of artist.

TIPS Notes trends as sports art, neo-classical, nostalgic, oversize editions. "Think marketability. Watch the furniture market."

INSPIRATION ART & SCRIPTURE, INC.

(319)651-3419. **E-mail:** customerservice@ inspirationart.com. **Website:** www.inspirationart. com. Estab. 1993. Produces Christian posters. "We create and produce jumbo-sized (24×36) posters targeted at pre-teens (10-14), teens (15-18) and young adults (18-30). A Christian message appears on every poster. Some are fine art and some are very commercial. We prefer contemporary images." Art guidelines available on website or for SASE with first-class postage.

NEEDS Approached by 150-200 freelance artists/year. Works with 10-15 freelancers/year. Buys 10-15 designs, photos, illustrations/year. Christian art only. Uses freelance artists for posters. Considers all media. Looking for "something contemporary or unusual that appeals to teens or young adults and communicates a Christian message."

MAKING CONTACT & TERMS Submission guidelines available online.

TIPS "The better the quality of the submission, the better we are able to determine if the work is suitable for our use (slides are best). The more complete the submission (i.e., design, art layout, scripture, copy), the more likely we are to see how it may fit into our poster line. We do accept traditional work but are looking for work that is more commercial and hip. A poster needs to contain a Christian message that is relevant to teen and young adult issues and beliefs. Understand what we publish before submitting work. Visit our website to see what it is that we do. We are not simply looking for beautiful art, but rather we are looking for art that communicates a specific scriptural passage."

●◐⌂ INTERNATIONAL GRAPHICS

Walmsley GmbH, Junkersring 11, Eggenstein DE-76344 Germany. (49)(721)978-0620. **Fax:** (49)(721)978-0651. **E-mail:** LW@ig-team.de. **Website:** www.international-graphics.com. **Contact:** Lawrence Walmsley, president. Estab. 1981. Poster company, art publisher/distributor. Publishes/distributes limited editions, offset reproductions, posters, and silkscreens. Clients: galleries, framers, department stores, gift shops, card shops and distributors. Current clients include Art.com, Windsor Art, etc.

NEEDS "We are seeking creative, fashionable and decorative art for the commercial and designer markets. Also seeking Americana art for gallery clients." Considers oil, acrylic, watercolor, mixed media, pastel and photos. Prefers landscapes, florals, painted still lifes. Also photography is a big theme for us lately. Art guidelines are available free with a SASE with first-class postage. Artists represented include Christian Choisy, Benevolenza, Thiry, Magis, Marthe, Zacher-Finet, Shirin Donia, Panasenko, Valverde, Terrible, Gery Luger, and many more. Editions are created by working from an existing painting. Approached by 100-150 artists/year. Publishes the work of 10-20 emerging artists/year. Distributes the work of 10-20 emerging artists/year.

MAKING CONTACT & TERMS Send query letter with brochure, photocopies, photographs, photostats, résumé, slides, tearsheets, or an e-mail. Accepts disk submissions for Mac or Windows. Samples are filed and returned. Responds in 2 months. Will contact artist for portfolio review if interested. Negotiates payment on basis of per-piece-sold arrangement or percentage for print-on-demand sales. Needs first rights. Provides advertising, promotion, shipping from firm, and contract. Also works with freelance designers. Prefers local designers. Finds artists through exhibitions, word of mouth, submissions.

TIPS "Black-and-white photography, landscapes and still-life pictures are good at the moment. Earthtones are popular—especially lighter shades. At the end of the day, we seek the unusual, that has not yet been published."

◑ ISLAND ART PUBLISHERS

P.O. Box 952, Bragg Creek, Alberta T0L 0K0 Canada. (403)949-7767. **Fax:** (403)949-3224. **E-mail:** submissions@islandart.com; info@islandart.com. **Website:** www.islandart.com. **Contact:** Graham Thomson, art director. Estab. 1985. Art publisher, distributor and printer. Publishes and distributes art cards, posters, open-edition prints, calenders, bookmarks, giclées and custom products. Clients: galleries, museums, Federal and local governments, major sporting events, department stores, distributors, gift shops, artists and photographers. Art guidelines available for SASE or on website.

NEEDS See website for current needs and requirements. Considers oil, watercolor and acrylic. Prefers themes related to the Pacific Northwest. Editions are created by working from an existing painting. Approached by 100 artists/year. Publishes the work of 2-4 emerging artists/year.

MAKING CONTACT & TERMS Send submissions to Attn: Art director. Submit résumé/CV, tearsheets, slides, photographs, transparencies or digital files on CD/DVD (must be TIFF, EPS, PSD or JPEG files compatible with Photoshop). Please DO NOT send originals. Samples are not filed and are returned only by SASE if requested by artist. Responds in 3-6 months. Will contact artist for portfolio review if interested. Pays royalties of 5-10%. Licenses reproduction rights. Requires exclusive representation of artist for selected products only. Provides promotion, insurance while work is at firm, shipping from firm, written contract, fair trade representation and Internet service. Finds artists through art fairs, submissions and referrals.

TIPS "Provide a body of work along a certain theme to show a fully developed style that can be built upon. We are influenced by our market demands. Please review our submission guidelines before sending work on spec."

⌂ JADEI GRAPHICS, INC.

4943 McConnell Ave., Suite Y, Los Angeles CA 90066. (310)578-0082 or (800)717-1222. **Fax:** (310)823-4399. **E-mail:** info@jadeigraphics.com. **Website:** www.jadeigraphics.com. **Contact:** Art Director. Poster company that publishes limited edition, unlimited edition and posters. Clients: galleries, framers. Licenses calendars, puzzles, etc.

NEEDS Seeking creative, decorative art for the commercial market. Considers oil, acrylic, watercolor and photographs. Editions created by collaborating with the artist or by working from an existing painting. Approached by 100 artists/year. Publishes work of 3-5 emerging artists each year. Also needs freelancers for design. Prefers local designers only.

MAKING CONTACT & TERMS Materials submitted may include but are not limited to slides, photos, color copies or transparancies. Please do not send originals. Include a suitable SASE if you would like your materials returned. Up to 5 JPEG files of no more than 600k per file may be submitted electronically.

LOLA LTD. LT'EE

1817 Egret St. SW, Shallotte NC 28470-5433. (910)754-8002. **E-mail:** lolaltd@yahoo.com. **Contact:** Lola Jackson, owner. Distributor of limited editions, offset reproductions, unlimited editions, hand-pulled originals, antique prints and etchings. Clients: art galleries, architects, picture frame shops, interior designers, major furniture and department stores, industry and antique gallery dealers.

○ This distributor also carries antique prints, etchings and original art on paper and is interested in buying/selling to trade.

NEEDS Seeking creative and decorative art for the commercial and designer markets. "Hand-pulled graphics are our main area." Considers oil, acrylic, pastel, watercolor, tempera or mixed media. Prefers unframed series, up to 30×40 maximum. Artists represented include Buffet, White, Brent, Jackson, Mohn, Baily, Carlson, Coleman. Approached by 100 artists/year. Distributes the work of 5 emerging, 5 mid-career and 5 established artists/year. Distributes the work of 40 emerging, 40 mid-career and 5 established artists/year.

MAKING CONTACT & TERMS Send query letter with samples. Samples are filed or are returned only if requested. Responds in 2 weeks. Payment method is negotiated. "Our standard commission is 50%, less 50% off retail." Offers an advance when appropriate. Provides insurance while work is at firm, shipping from firm and written contract.

TIPS "We find we cannot sell black and white only. Leave wide margins on prints. Send all published print samples before end of May each year as our main sales are targeted for summer. We do a lot of business with birds, botanicals, boats and shells—anything nautical."

MARCO FINE ARTS

4860 W. 147th St., Hawthorne CA 90250. (310)615-1818. **E-mail:** info@mfatalon.com. **Website:** www.marcofinearts.com/contact_us.php. Publishes/distributes limited edition fine art prints and posters. Clients: galleries, decorators and frame shops.

NEEDS Seeking creative and decorative art for the serious collector and design market. Considers oil, acrylic and mixed media. Prefers landscapes, florals, figurative, Southwest, contemporary, impressionist, antique posters. Accepts outside serigraph and digital printing (giclée) production work. Editions created by collaborating with the artist or working from an existing painting. Approached by 80-100 artists/year. Publishes the work of 3 emerging, 3 mid-career and 3-5 established artists/year.

MAKING CONTACT & TERMS Send query letter with brochure, photocopies, photographs, photostats, résumé, SASE, slides, tearsheets and transparencies. Accepts disk submissions. Samples are filed and are returned by SASE. Responds only if interested. Company will contact artist for portfolio review or original artwork (show range of ability) if interested. Payment to be discussed. Requires exclusive representation of artist.

MCGAW GRAPHICS

(888)426-2429 ext. 206. **E-mail:** katy.daly@mcgawgraphics.com. **E-mail:** katy.daly@mcgawgraphics.com. **Website:** www.mcgawgraphics.com. **Contact:** Katy Daly. Art publisher. Publishes open edition prints and posters. Clients: e-tailers, specialty retailers, picture frame manufacturers, distributors, manufacturers, galleries and frame shops.

NEEDS Seeking creative, on-trend, and decorative art and photography for commercial and designer markets. Considers all media, including oil, watercolor, acrylic, pastel, digital illustration and mixed media.

MAKING CONTACT & TERMS Send a website link or at least 12-15 examples of your art in JPEG or PDF file-formats to katy.daly@mcgawgraphics.com. Choose a wide variety of images that you feel best represent your style and technique. Pays royalties. Usually requires exclusive representation of artist. Finds artists through submissions, sourcebooks, agents, art shows, galleries and word of mouth.

TIPS look for subjects with a universal appeal. Some subjects that would be appropriate are florals, still lifes, wildlife, landscapes and contemporary images/abstracts.

MILITARY GALLERY

821 E. Ojai Ave., Ojai CA 93023. (805)640-0057; (800)248-0317. **Fax:** (805)640-0059. **E-mail:**

enquiriesusa@militarygallery.com. **Website:** www.militarygallery.com. Estab. 1967. Art publisher and distributor. Publishes/distributes limited edition, unlimited edition, canvas transfers, fine art prints, offset reproduction and posters. Clients galleries and mail order.

NEEDS Seeking creative, fashionable and decorative art. Considers oil, acrylic, watercolor and pen & ink. Prefers aviation and maritime. Editions created by collaborating with the artist or by working from an existing painting. Approached by 10 artists/year. Publishes and distributes work of 1 emerging, 1 mid-career and 1 established artist/year.

MAKING CONTACT & TERMS Send query letter with photographs, slides, tearsheets and transparencies. Samples are not filed and are returned with SASE. Prefers high-res e-mail submissions. Responds in 1 month. Company will contact artist for portfolio review if interested. Portfolio should include photographs, tearsheets and transparencies. Payment negotiable. Buys all rights. Requires exclusive representation of artist. Provides advertising, promotion and written contract. Finds artists through word of mouth.

TIPS "Get to know us via our catalogs."

MUNSON GRAPHICS

7502 Mallard Way, Unit C, Santa Fe NM 87507. (888)686-7664. **Fax:** (505)424-6338. **E-mail:** sales@munsongraphics.com. **Website:** www.munsongraphics.com. Estab. 1997. Poster company, art publisher and distributor. Publishes/distributes limited edition, fine art prints and posters. Clients: galleries, museum shops, gift shops and frame shops.

NEEDS Seeking creative art for the serious collector and commercial market. Considers oil, acrylic, watercolor and pastel. Editions created by working from an existing painting. Approached by 75 artists/year. Publishes work of 3-5 emerging, 3-5 mid-career and 3-5 established artists/year. Distributes the work of 5-10 emerging, 5-10 mid-career and 5-10 established artists/year.

MAKING CONTACT & TERMS Send query letter with slides, SASE and transparencies. Samples are not filed and are returned by SASE. Responds in 1 month. Company will contact artist for portfolio review if interested. Negotiates payment. Offers advance. Rights purchased vary according to project. Provides written contract. Finds artists through art exhibitions, art fairs, word of mouth and artists' submissions.

MUSEUM MASTERS INTERNATIONAL

185 E. 85th St., Suite 27B, New York NY 10028. (212)360-7100. **Fax:** (212)360-7102. **E-mail:** MMIMarilyn@aol.com; Marilyn.Goldberg@museummasters.com. **Website:** www.museummasters.com. **Contact:** Marilyn Goldberg, president. Licensing agent for international artists and art estates. Distributor of limited editions, posters, tapestry and sculpture for galleries, museums and gift boutiques.

NEEDS Seeking artwork with decorative appeal for the designer market. Considers oil, acrylic, pastel, watercolor and mixed media.

MAKING CONTACT & TERMS E-mail with sample download of artwork offered. Samples are filed or returned. Call or write for appointment to show portfolio or mail slides and transparencies. Payment method is negotiated. Offers advance when appropriate. Negotiates rights purchased. Exclusive representation is not required. Provides insurance while work is at firm, shipping to firm and a written contract.

NEW YORK GRAPHIC SOCIETY

130 Scott Rd., Waterbury CT 06705. **E-mail:** donna@nygs.com. **Website:** www.nygs.com. **Contact:** Donna LeVan, vice president of publishing (contact via e-mail only, no phone calls). Estab. 1925. Specializes in fine art reproductions, prints, posters, canvases. Merged with print company Artbeats Inc.

NEEDS Buys 150 images/year; 125 are supplied by freelancers. "Looking for a variety of images."

MAKING CONTACT & TERMS Send query letter with samples to Attn: Artist Submissions. Does not keep samples on file; include SASE for return of material. Responds in 3 months. Payment negotiable. Pays on usage. Credit line given. Buys exclusive product rights. No phone calls.

TIPS "Visit website to review artist submission guidelines and to see appropriate types of imagery for publication."

OLD WORLD PRINTS, LTD.

8080 Villa Park Dr., Richmond VA 23228. (804)213-0600, ext. 634. **Fax:** (804)213-0700. **E-mail:** orders@theworldartgroup.com;artist@theworldartgroup.com. **Website:** www.oldworldprintsltd.com. Estab. 1973. Art publisher and distributor of open-edition, hand-printed reproductions of antique engravings as well as all subject matter of color printed art. Cli-

ents: retail galleries, frame shops and manufacturers, hotels and fund raisers.

○ Old World Prints reports the top-selling art in their 10,000-piece collection includes botanical and decorative prints.

NEEDS Seeking traditional and decorative art for the commercial and designer markets. Specializes in handpainted prints. Considers "b&w (pen & ink or engraved) art which can stand by itself or be hand painted by our artists or originating artist." Prefers traditional, representational, decorative work. Editions created by collaborating with the artist. Distributes the work of more than 1,000 artists. "Also seeking golf, coffee, tea, and exotic floral images."

MAKING CONTACT & TERMS Send query letter with brochure showing art style or résumé and tearsheets and slides. Samples are filed. Responds in 6 weeks. Write for appointment to show portfolio of photographs, slides and transparencies. Pays flat fee of $100/piece and royalties of 10% of profit. Offers an advance when appropriate. Negotiates rights purchased. Provides in-transit insurance, insurance while work is at firm, promotion, shipping from firm and a written contract. Finds artists through word of mouth.

TIPS "We are a specialty art publisher, the largest of our kind in the world. We are actively seeking artists to publish and will consider all forms of art."

OUT OF THE BLUE LICENSING, LLC

P.O. Box 727, Nokomis FL 34274. (941)966-4042. **E-mail:** ootblicensing@gmail.com. **Website:** www.ootblicensing.com. **Contact:** Michael Woodward, president; Jane Mason, licensing manager. Estab. 1986. "We are looking for decorative art and photography that we can license for product categories such as mass market canvas, posters/print and high-quality gicles for the home decor market as well as images for greeting cards, calendars, stationery and gift products. We specialize particularly in the home decor canvas and framed art market." We also require very high quality landscapes and panoramas for large scale murals. Must be very large quality digital files.

NEEDS "We need series and collections of art or photography that have wide consumer appeal. E-mail presentations only. Keep files to 250K JPEGs and around 12×10 at 72 dpi."

MAKING CONTACT & TERMS Terms are 50/50 with no expense to artist. Artist/photographer needs to provide high-res digital files if we agree on repre-

sentation. Submission guidelines are available on website at www.ootblicensing.com/submissions.html.

TIPS "Pay attention to trends and color palettes. Artists need to consider actual products when creating new art. Look at products in retail outlets and get a feel for what is selling well. Get to know the markets you want to sell your work to."

PENNY LANE PUBLISHING, INC.

1791 Dalton Dr., New Carlisle OH 45344. (937)849-1101 or (800)273-5263. **Fax:** (937)849-9666. **E-mail:** info@pennylanepublishing.com. **Website:** www.pennylanepublishing.com. Estab. 1993. Art publisher. Publishes limited editions, unlimited editions, offset reproductions. Clients: galleries, frame shops, distributors, decorators.

NEEDS Seeking creative, decorative art for the commercial market. Considers oil, acrylic, watercolor, mixed media, photography, pastel. Editions are created by collaborating with the artist or working from an existing painting. Approached by 100+ artists/year. Publishes the work of 20 emerging, 30 mid-career and 10 established artists/year.

MAKING CONTACT & TERMS Send query letter or e-mail with samples of artwork. Requirements for submissions via e-mail; send JPEG files @ 72 dpi; maximum file size 1 MB (not to exceed 10 MB per e-mail). "Please send a variety of images (at least 6-10 images) so we can get a good feel for the type of artwork you have available." Samples are filed or returned by SASE. Responds in 2-6 weeks. Will contact artist for portfolio review of color, final art, photographs, slides and tearsheets if interested. Pays royalties. Buys first rights. Requires exclusive representation of artist. Provides advertising, shipping from firm, promotion, written contract. Finds artists through art fairs and exhibitions, submissions, decorating magazines.

TIPS "Be aware of current color trends, and work in a series. Please review our website to see the style of artwork we publish."

⊘ PGM ART WORLD

Dieselstrasse 28, 85748 Garching Germany. +49 (89)3-20-02-150. **Fax:** +49 (89)3-20-02-250. **E-mail:** info@pgm.de. **Website:** www.pgm.de. Estab. 1969. International fine art publisher, distributor, gallery. Publishes/distributes limited and unlimited editions, offset reproductions, art prints, giclées, art cards and originals. Worldwide supplier to galleries, framers, distributors, decorators.

○ PGM publishes around 180 images/year and distributes more than 6,000 images. The company also operates 3 galleries in Munich.

NEEDS Seeking creative, fashionable and decorative art for the commercial and designer markets. Considers oil, acrylic, watercolor, mixed media, pastel, pen & ink, photography and digital art. Considers any accomplished work of any theme or style. Editions are created by working from an existing painting or high-resolution digital data. Approached by more than 420 artists/year.

MAKING CONTACT & TERMS Send query letter with photographs, slides, color copies, color prints or work in digital format (JPEG) on CD/DVD. Sent documentation will be returned. Responds within 1 month. Will contact artist for portfolio review if interested. Pays royalties per copies sold; negotiable. Requires exclusive representation of artist. Provides promotion of prints in catalogs and promotional material, presentation of artists (biography & photo) on website.

TIPS "Get as much worldwide exposure as possible at art shows and with own website."

● PORTER DESIGN

7 St. Andrews Terrace, Bath BA1 2QR United Kingdom. (01144)1225-680628 or (866)293-2079 (US office). **Fax:** (01144)1225-849156. **E-mail:** service@porter-design.com; pdny@porter-design.com (US office). **Website:** www.porter-design.com. **Contact:** Henry Porter and Mary Porter, partners. Estab. 1985. Publishes limited and unlimited editions and offset productions and hand-colored reproductions. Clients: international distributors, interior designers and hotel contract art suppliers. Current clients include Grand Image, Top Art, Harrods, hotels in the Caribbean and SE Asia.

NEEDS Seeking fashionable and decorative art for the designer market. Considers watercolor. Prefers 16th-19th century traditional styles. Artists represented include Victor Postolle, Joseph Hooker, Georg Ehret and Adrien Chancel. Editions are created by working from an existing painting. Approached by 10 artists/year. Publishes and distributes the work of 10-20 established artists/year.

MAKING CONTACT & TERMS Send query letter with brochure showing art style or résumé and photographs. Accepts disk submissions compatible with QuarkXPress on Mac. Samples are filed or are returned. Responds only if interested. To show portfolio, mail photographs. Pays flat fee or royalties. Offers an advance when appropriate. Negotiates rights purchased.

POSNER FINE ART

1212 S. Point View St., Los Angeles CA 90035. (323)933-3664. **Fax:** (323)933-3417. **E-mail:** info@posnerfineart.com. **Website:** www.posnerfineart.com. **Contact:** Wendy Posner, president. Estab. 1994. Art distributor and gallery. Distributes contemporary fine art prints, monoprints, sculpture and paintings. Clients: galleries, frame shops, distributors, architects, corporate curators, museum shops. Current clients include Renaissance Hollywood Hotel, Nuveen Investments, Fandango.

NEEDS Seeking creative art for the serious collector and commercial market. Considers oil, acrylic, watercolor, mixed media, sculpture. Prefers very contemporary style. Artists include David Shapiro, Chuck Arnoldi, Robert Cottingham, and Sam Francis. Editions are created by collaborating with the artist. Approached by hundreds of artists/year. Distributes the work of 5-10 emerging, 5 mid-career and 200 established artists/year. Art guidelines free with SASE (first-class postage).

MAKING CONTACT & TERMS E-mail submission. Responds in a few weeks. Pays on consignment basis; firm receives 50% commission. Buys one-time rights. Provides advertising, promotion, insurance while work is at firm. Finds artists through art fairs and exhibitions, word of mouth, submissions, art reps.

TIPS "Know color trends of design market. Look for dealer with same style in gallery. Send consistent work."

◑ POSTERS INTERNATIONAL

1180 Caledonia Rd., Toronto, Ontario M6A 2W5 Canada. (416)789-7156 or (800)363-2787. **Fax:** (416)789-7159. **E-mail:** info@picreativeart.com; art@picreativeart.com. **E-mail:** anna@picreativeart.com. **Website:** www.picreativeart.com. Estab. 1976. Poster company, art publisher. Publishes fine art posters and giclée prints. Licenses for gift and stationery markets. Clients: galleries, designers, art consultants, framing, manufacturers, distributors, hotels, restaurants, etc., around the world.

NEEDS Seeking creative, fashionable art for the commercial market. Considers oil, acrylic, watercolor, mixed media, b&w and color photography. Prefers

landscapes, florals, abstracts, photography, vintage, collage and tropical imagery. Editions are created by collaborating with the artist or by working from an existing painting. Approached by 100 artists/year.

MAKING CONTACT & TERMS Send query letter or e-mail with attachment, brochure, photographs. Responds in 2 months. Company will contact artist for portfolio review of photographs, tearsheets, thumbnails if interested. Pays flat fee or royalties of 10%. Rights purchased vary according to project. Provides advertising, promotion, shipping from firm, written contract. Finds artists through art fairs, art reps, submissions.

TIPS "Be aware of current home décor color trends and always work in a series of 2 or more per theme/subject. Visit home décor retailers in their wall décor area for inspiration and guidance before submitting artwork."

PROGRESSIVE EDITIONS

2586 Dunwin Dr., Unit 5A, Mississauga, Ontario L5L 1J5 Canada. (416)860-0983 or (800)487-1273. **Fax:** (416)367-2724. **E-mail:** info@progressivefineart.com. **Website:** www.progressiveeditions.com. Estab. 1982. Art publisher. Publishes handpulled originals, limited edition fine art prints and monoprints. Clients: galleries, decorators, frame shops, distributors.

NEEDS Seeking creative and decorative art for the serious collector and designer market. Considers oil, acrylic, watercolor, mixed media, pastel. Prefers figurative, abstract, landscape and still lifes. Editions created by working from an existing painting. Approached by 100 artists/year. Publishes the work of 4 emerging artists/year. Distributes the work of 10 emerging artists/year.

MAKING CONTACT & TERMS Send query letter with photographs, slides. Samples are not filed and are returned. Responds in 1 month. Will contact artist for portfolio review if interested. Negotiates payment. Offers advance when appropriate. Negotiates rights purchased. Requires exclusive representation of artist. Provides advertising, in-transit insurance, insurance while work is at firm, promotion, shipping and contract. Finds artists through exhibition, art fairs, word of mouth, art reps, sourcebooks, submissions, competitions.

TIPS "Develop organizational skills."

FELIX ROSENSTIEL'S WIDOW & SON, LTD.

33-35 Markham St., Chelsea Green, London SW3 3NR United Kingdom. (44)207-352-3551. **Fax:** (44)207-351-5300. **E-mail:** sales@felixr.com. **Website:** www.felixr.com. Estab. 1880. Publishes art prints and posters, both limited and open editions. Licenses all subjects on any quality product. Art guidelines on website.

NEEDS Seeking decorative art for the serious collector and the commercial market. Considers oil, acrylic, watercolor, mixed media and pastel. Prefers art suitable for homes or offices. Editions are created by collaborating with the artist or by working from an existing painting. Approached by 200-500 artists/year.

MAKING CONTACT & TERMS Send query letter with photographs. Samples are not filed and are returned by SASE. Responds in 2 weeks. Company will contact artist for portfolio review of final art and transparencies if interested. Negotiates payment. Offers advance when appropriate. Rights purchased vary according to project.

TIPS "We publish decorative, attractive, contemporary art."

SAGEBRUSH FINE ART

3065 S. West Temple, Salt Lake City UT 84115. (801)466-5136 or (800)643-7243. **Fax:** (801)466-5048. **E-mail:** Sales@sagebrushfineart.com. **E-mail:** submissions@sagebrushfineart.com. **Website:** www.sagebrushfineart.com. **Contact:** Pansy Winterburn, Sales Manager. Estab. 1991. Sagebrush Fine Art Licensing. Permission to Print and Licensing of fine art images.

Clients: frame shops, distributors, corporate curators, hospitality, mass retail and e-commerce.

NEEDS Seeking decorative art for the commercial and designer markets. Considers all media. Open to all themes and styles. Current artists include Jennifer Pugh, Ninalee Irani, Susan Comish, Katie Doucette and Jo Moulton. Editions created by collaborating with the artist or by working from an existing painting. Markets and presents the work of new and emerging artists.

MAKING CONTACT & TERMS Submission guidelines available online. Send to the attention of Pansy Winterburn. "We see a lot of art and in order for art to be reviewed, we prefer an emailed PDF presentation of your art portfolio along with any website information available. Once received, our art develop-

ment team reviews submissions for print and licensing potential. It can take 1-2 weeks before we get back to you with a response."

SCHLUMBERGER GALLERY

P.O. Box 2864, Santa Rosa CA 95405. (707)544-8356. **E-mail:** sande@schlumberger.org. **Website:** www.schlumbergergallery.com. Estab. 1986. Private art dealer, art publisher, distributor and gallery. Publishes and distributes limited editions, posters, original paintings and sculpture. Specializes in decorative and museum-quality art and photographs. Clients: collectors, designers, distributors, museums, galleries, film and television set designers.

NEEDS Seeking decorative art for the serious collector and the designer market. Prefers trompe l'oeil, realist, architectural, figure, portrait. Editions created by collaborating with the artist or by working from an existing painting. Approached by 50 artists/year.

MAKING CONTACT & TERMS Send query letter with tearsheets and photographs. Samples are not filed and are returned by SASE if requested by artist. Publisher/distributor will contact artist for portfolio review if interested. Portfolio should include color photographs and transparencies. Negotiates payment. Offers advance when appropriate. Rights purchased vary according to project. Provides advertising, in-transit insurance, insurance while work is at firm, promotion, shipping to and from firm, written contract and shows. Finds artists through exhibits, referrals, submissions and "pure blind luck."

TIPS "Strive for quality, clarity, clean lines and light, even if the style is impressionistic. Bring spirit into your images. It translates!"

SEGAL FINE ART

11955 Teller St., Unit C, Broomfield CO 80020. (303)926-6800. **Fax:** (303)926-0340. **E-mail:** poppysegal@gmail.com. **Website:** www.segalfineart.com. **Contact:** Ron Segal. Estab. 1986. Art publisher. Publishes limited edition giclées. Clients: bikers at motorcycle rallies. Artists represented include David Mann and Michael Kneeper.

◐ SJATIN ART B.V.

P.O. Box 7201, 5980 AE Panningen, The Netherlands. (31)77-475-1998. **E-mail:** art@sjatin.nl. **Website:** www.sjatin.nl. Estab. 1977. Art publisher. Publishes open editions, fine art prints. Licenses decorative art to appear on placemats, calendars, greeting cards, stationery, photo albums, embroidery, posters, canvas, textile, puzzles and gifts. Clients: picture framers, wholesalers, distributors of art print. Sjatin actively promotes worldwide distribution for artists they sign.

NEEDS Seeking decorative art for the commercial market. Considers oil, acrylic, watercolor, pastel. Prefers romantic themes, florals, landscapes/garden scenes, still lifes. Editions created by collaborating with the artist or by working from an existing painting. Approached by 50 artists/year. "We publish a very wide range of art prints and we sell copyrights over the whole world."

MAKING CONTACT & TERMS Submission guidelines available online.

TIPS "Follow the trends in interior decoration; look at the furniture and colors. I receive so many artworks that are beautiful and very artistic, but are not commercial enough for reproduction. I need designs which appeal to many many people, worldwide such as flowers, gardens, interiors and kitchen scenes. I do not wish to receive graphic art."

SOHN FINE ART—GALLERY & GICLÉE PRINTING

69 Church St., Lenox MA 01240. (413)551-7353. **E-mail:** info@sohnfineart.com. **Website:** www.sohnfineart.com. Art gallery and fine art archival giclée printing. Canvas, fine art prints, limited editions. Considers photography, mixed media and sculpture.

NEEDS Decorative art, fashionable art, for the serious collector, commercial market, or designer market.

MAKING CONTACT & TERMS Contact via query letter, postcard sample, or e-mail letter with digital images, photographs or transparencies. Work will not be returned.

SOMERSET FINE ART

P. O. Box 869, Fulshear TX 77441. (800)444-2540. **Fax:** (281)346-8901 281-346-8902. **E-mail:** jjenkins@somersethouse.com. **Website:** www.somersetfineart.com. **Contact:** J. Jenkins, art department. Estab. 1972. Leading publisher of fine art reproductions in limited and open editions; giclees on canvas and giclées on paper. Clients: independent galleries, decor and furniture stores in the United States, Canada, Australia, and other countries. Artists represented: Edward Aldrich, Bill Anton, Susan Blackwood, Rod Chase, Tim Cox, Robert Dawson, Michael Dudash, June Dudley, Larry Dyke, Ragan Gennusa, Nancy Glazier, Bruce Green, Martin Grelle, George Hallmark, G. Harvey,

David Mann, Robert Peters, Phillip Philbeck, Jim Rey, Richard Reynolds, James Seward, Kyle Sims, Claude Steelman, Andy Thomas, Evan Wilson, Bob Wygant.

NEEDS Fine art reproductions from original paintings or collaboration with the artist; considers oil, acrylic, watercolor, mixed media, pastel.

MAKING CONTACT & TERMS Send inquiry via e-mail or by letter to post office box; submissions by e-mail should include digital files in JPEG format or 10–12 slides or photos of work (include SASE) if by mail. Will review art on artist's website or submitted material; also include number/size/price of all paintings sold within last 24 months and gallery representation. Samples filed for future reference unless return is requested. Publisher will contact artist for portfolio review if interested. Pays royalties; artist retains painting and copyrights; written contract; company provides advertising, promotion, in-transit insurance for original art, and shipping.

JACQUES SOUSSANA GRAPHICS

37 Pierre Koenig St., Jerusalem 91041, Israel. (972)(2)6782678. **Fax:** (972)(2)6782426. **E-mail:** jsgraphics@soussanart.com. **Website:** www. soussanart.com. Estab. 1973. Art publisher. Publishes hand-pulled originals, limited editions, sculpture. Clients: galleries, decorators, frame shops, distributors, architects.

NEEDS Seeking decorative art for the serious collector and designer market. Considers oil, watercolor and sculpture. Editions are created by collaborating with the artist. Approached by 20 artists/year. Publishes/distributes the work of 5 emerging artists/year.

MAKING CONTACT & TERMS Send query letter with brochure, slides. To show portfolio, artist should follow up with letter after initial query. Portfolio should include color photographs.

SULIER ART PUBLISHING

PMB 55, 3735 Palomar Centre, Suite 150, Lexington KY 40513. (859)621-5511. **Fax:** (859)296-0650. **E-mail:** info@NeilSulier.com; or via online contact form. **Website:** www.neilsulier.com. **Contact:** Neil Sulier, art director. Art publisher and distributor. Publishes and distributes handpulled originals, limited and unlimited editions, posters, offset reproductions and originals. Clients: designers.

NEEDS Seeking creative, fashionable and decorative art for the serious collector and the commercial and designer markets. Considers oil, watercolor, mixed media, pastel and acrylic. Prefers impressionist. Editions created by collaborating with the artist or by working from an existing painting. Approached by 20 artists/year. Publishes the work of 5 emerging, 30 mid-career and 6 established artists/year. Distributes the work of 5 emerging artists/year.

MAKING CONTACT & TERMS Send query letter with brochure, slides, photocopies, résumé, photostats, transparencies, tearsheets and photographs. Samples are filed or are returned. Responds only if interested. Request portfolio review in original query. Artist should follow up with call. Publisher will contact artist for portfolio review if interested. Portfolio should include slides, tearsheets, final art and photographs. Pays royalties of 10%, on consignment basis or negotiates payment. Offers advance when appropriate. Negotiates rights purchased (usually one-time or all rights). Provides in-transit insurance, promotion, shipping to and from firm, insurance while work is at firm and written contract.

SUN DANCE GRAPHICS & NORTHWEST PUBLISHING

9580 Delegates Dr., Building B, Orlando FL 32837. (407)240-1091; (800)617-5532. **Fax:** (407)240-1951. **E-mail:** info@northwestpublishing.com. **Website:** www. northwestpublishing.com. Estab. 1996. Publishers and printers of giclée prints, fine art prints, and posters. Sun Dance Graphics provides trend-forward images to customers that manufacture for upscale hospitality, retail, and home furnishings markets. Primarily looking for images in sets/pairs with compelling color palette, subject, and style. Northwest Publishing provides fine art prints and posters in the following categories: classics, traditional, inspirational, contemporary, home and hearth, photography, motivationals, wildlife, landscapes and ethnic art.

NEEDS Approached by 300 freelancers/year. Works with 50 freelancers/year. Buys 200 freelance designs and illustrations/year. Art guidelines free for SASE with first-class postage. Works on assignment only. Looking for high-end art. 20% of freelance design work demands knowledge of Photoshop, Illustrator and QuarkXPress.

MAKING CONTACT & TERMS Art submissions may be electronic (e-mail low-res image or website link) or via mail. Please do not send original art unless specifically requested. Artists will be contacted if

there is interest in further review. All submissions are reviewed for potential inclusion in either line as well as for licensing potential, and are kept on file for up to 6 months. Art may be purchased or signed under royalty agreement. Royalty/licensing contracts will be signed before any images can be considered for inclusion in either line.

TIPS "Focus on style. We tend to carve our own path with unique, compelling and high-quality art, and as a result are not interested in 'me too' images."

JOHN SZOKE EDITIONS

24 W. 57th St., Suite 304, New York NY 10019. (212)219-8300. **E-mail:** info@johnszokeeditions.com. **Website:** www.johnszokeeditions.com. Estab. 1974. Located in Soho. Gallery hours: Tuesday-Saturday 10-5 or by appointment. Exhibits unique and limited edition works on paper, rare prints, limited-edition multiples. Modern Masters: Pablo Picasso and Henri Matisse. Clients: art dealers and collectors. 20% of sales to private collectors.

TAKU GRAPHICS

5763 Glacier Hwy., Juneau AK 99801. (907)780-6310 or (800)ART-3291. **Fax:** (907)780-6314. **E-mail:** takugraphics@gmail.com; info@takugraphics.com. **Website:** www.takugraphics.com. **Contact:** Adele Hamey. Estab. 1991. Distributor. Distributes handpulled originals, limited edition, unlimited edition, fine art prints, offset reproduction, posters, paper cast, bead jewelry and note cards. Clients: galleries and gift shops.

NEEDS Seeking art from Alaska and the Pacific Northwest exclusively. Considers oil, acrylic, watercolor, mixed media, pastel and pen & ink. Prefers regional styles and themes. Artists represented include JoAnn George, Barbara Lavalle, Byron Birdsall, Brenda Schwartz and Barry Herem. Editions created by working from an existing painting. Approached by 30-50 artists/year. Distributes the work of 50 emerging, 20 mid-career and 6 established artists/year.

MAKING CONTACT & TERMS Submission guidelines available online.

BRUCE TELEKY, INC.

87 35th St., 3rd Floor, Brooklyn NY 11232. (718)965-9690 or (800)835-3539. **Fax:** (718)832-8432. **E-mail:** sales@teleky.com. **Website:** www.teleky.com. **Contact:** Bruce Teleky, president. Estab. 1975. Clients include galleries, manufacturers and other distributors.

NEEDS Works from existing art to create open edition posters or works with artist to create limited editions. Visit our website to view represented artists. Also likes coastal images, music themes and Latino images. Uses photographs. Likes to see artists who can draw. Prefers depictions of African American and Carribean scenes or African themes.

MAKING CONTACT & TERMS Send query letter with digital files. Publisher will contact artist for portfolio review if interested. Payment negotiable.

VLADIMIR ARTS USA, INC.

2504 Sprinkle Rd., Kalamazoo MI 49001. (269)383-0032 or (800)678-8523. **E-mail:** vladimir@vladimirarts.com. **Website:** www.vladimirarts.com. Art publisher, distributor and gallery. Publishes/distributes handpulled originals, limited edition, unlimited edition, canvas transfers, fine art prints, monoprints, monotypes, offset reproduction, posters and giclée. Clients: galleries, decorators, frame shops, distributors, architects, corporate curators, museum shops, giftshops and West Point military market.

NEEDS Seeking creative, fashionable and decorative art for the serious collector, commercial market and designer market. Considers oil, acrylic, watercolor, mixed media, pastel, pen & ink and sculpture. Editions created by collaborating with the artist. Approached by 30 artists/year. Publishes work of 10 emerging, 10 mid-career and 10 established artists/year. Distributes work of 1-2 emerging, 1 mid-career and 1-2 established artists/year.

MAKING CONTACT & TERMS Send query letter with brochure, photocopies, photographs, and tearsheets. Samples are filed or returned with SASE. Responds only if interested. Company will contact artist for portfolio review if interested. Portfolio should include b&w, color, fine art, photographs and roughs. Negotiates payment. No advance. Provides advertising, promotion and shipping from our firm. Finds artists through art exhibitions, art fairs, word of mouth, Internet, art reps, sourcebooks, artists' submissions and watching art competitions.

TIPS "The industry is growing in diversity of color. There are no limits."

WILD APPLE GRAPHICS, LTD.

2513 W. Woodstock Rd., Woodstock VT 05091. (800)756-8359. **Fax:** (800)411-2775. **E-mail:** artsubmissions@wildapple.com. **E-mail:** artsubmissions@wildapple.com. **Website:** www.

wildapple.com. Estab. 1990. "Wild Apple publishes, distributes and represents a diverse group of contemporary artists. Clients: manufacturers, galleries, designers, poster distributors (worldwide) and framers. Licensing: Acting as an artist's agent, we present your artwork to manufacturers for consideration."

NEEDS "We are always looking for fresh talent and varied images to show." Considers oil, watercolor, acrylic, pastel, mixed media and photography. Publishes 400+ new works each year.

MAKING CONTACT & TERMS Submission guidelines available online.

WILD WINGS, LLC

2101 S. Hwy. 61, Lake City MN 55041. (800)445-4833. **Fax:** (651)345-2981. **E-mail:** info@wildwings.com; jgrippo@wildwings.com. **Website:** www.wildwings. com. **Contact:** Jackie Grippo, publishing & artist relations manager. Estab. 1968. Art publisher/distributor and gallery. Publishes and distributes limited editions and offset reproductions. Clients: retail and wholesale.

NEEDS Seeking artwork for the commercial market. Considers oil, watercolor, mixed media, pastel and acrylic. Prefers wildlife. Artists represented include David Maass, Lee Kromschroeder, Ron Van Gilder, Rosemary Millette, Michael Sieve and Persis Clayton Weirs. Editions are created by working from an existing painting. Approached by 300 artists/year. Publishes the work of 36 artists/year. Distributes the work of numerous emerging artists/year.

MAKING CONTACT & TERMS Send query letter with digital files or color printouts and résumé. Samples are filed and held for 6 months, then returned. Responds in 3 weeks if uninterested; 6 months if interested. Will contact artist for portfolio review if interested. Pays royalties for prints. Accepts original art on consignment and takes 40% commission. No advance. Requires exclusive representation of artist. Provides in-transit insurance, promotion, shipping to and from firm, insurance while work is at firm and a written contract. See website for further details.

WINN DEVON ART GROUP

Cap & Winn Devon, Unit 110, 6311 Westminster Hwy., Richmond, British Columbia V7C 4V4 Canada. (800)663-1166 or (604)276-4551. **Fax:** (888)744-8275 or (604)276-4552. **E-mail:** artsubmissions@ encoreartgroup.com. **Website:** www.winndevon.com. Art publisher. Publishes open and limited editions, offset reproductions, giclées and serigraphs. Clients: mostly trade, designer, decorators, galleries, retail frame shops.

NEEDS Seeking decorative art for the designer market. Considers oil, watercolor, mixed media, pastel, pen & ink and acrylic. Editions are created by working from an existing painting. Approached by 300-400 artists/year. Publishes and distributes the work of 0-3 emerging, 3-8 mid-career and 8-10 established artists/year.

MAKING CONTACT & TERMS Send query letter with brochure, slides, photocopies, résumé, photostats, transparencies, tearsheets or photographs. Samples are returned by SASE if requested by artist. Responds in 4-6 weeks. Publisher will contact artist for portfolio review if interested. Portfolio should include "whatever is appropriate to communicate the artist's talents." Payment is based on royalties. Copyright remains with artist. Provides written contract. Finds artists through art exhibitions, agents, sourcebooks, publications, submissions.

TIPS Advises artists to attend WCAF Las Vegas and DECOR Expo Atlanta. "Attend just to see what is selling and being shown, but keep in mind that this is not a good time to approach publishers/exhibitors with your artwork."

ADVERTISING, DESIGN, & RELATED MARKETS

This section offers a glimpse at one of the most lucrative markets for artists. Because of space constraints, the companies listed are just the tip of the proverbial iceberg. There are thousands of advertising agencies and public relations, design, and marketing firms across the country and around the world. All rely on freelancers. Look for additional firms in industry directories such as *The Black Book* and *Workbook*. Find local firms in the yellow pages and your city's business-to-business directory. You can also pick up leads by reading *Adweek, HOW, PRINT, Communication Arts*, and other design and marketing publications.

Find Your Best Clients

Read listings carefully to identify firms whose clients and specialties are in line with the type of work you create. (You'll find clients and specialties in the first paragraph of each listing.) For example, if you create charts and graphs, contact firms whose clients include financial institutions. Fashion illustrators should approach firms whose clients include department stores and catalog publishers. Sculptors and modelmakers might find opportunities with firms specializing in exhibition design.

Payment and Copyright

You will most likely be paid by the hour for work done on the firm's premises (in-house), and by the project if you take the assignment back to your studio. Most checks are issued 40–60 days after completion of assignments. Fees depend on the client's budget, but most companies are willing to negotiate, taking into consideration the experience of the freelancer, the lead time given, and the complexity of the project. Be prepared to offer an estimate for your services, and ask for a purchase order (P.O.) before you begin an assignment.

Some art directors will ask you to provide a preliminary sketch on speculation or "on spec," which, if approved by the client, can land you a plum assignment. If you are asked to create something "on spec" be aware that you may not receive payment beyond an hourly fee for your time if the project falls through. Be sure to ask up front about payment policy before you start an assignment.

If you're hoping to retain usage rights to your work, you'll want to discuss this up front, too. You can generally charge more if the client is requesting a buyout. If research and travel are required, make sure you find out ahead of time who will cover these expenses.

ADVANCED DESIGNS CORP.

1169 W. Second St., Bloomington IN 47403. (812)333-1922. **Fax:** (812)333-2030. **E-mail:** mmcgrath@doprad.com; service@doprad.com. **Website:** www.doprad.com. **Contact:** Matt McGrath, president. Estab. 1982. AV firm. Specializes in TV news broadcasts. Product specialties are the doppler radar and display systems.

NEEDS Prefers freelancers with experience. Works on assignment only. Uses freelancers mainly for TV/film (weather) and cartographic graphics. Needs computer-literate freelancers for production. 100% of freelance work demands skills in ADC Graphics.

FIRST CONTACT & TERMS Send query letter with résumé and SASE. Samples are not filed and are returned by SASE. Pays for design and illustration by the hour, $7 minimum. Will contact artist for portfolio review if interested. Rights purchased vary according to project. Finds artists through classifieds.

⌂ THE ADVERTISING CONSORTIUM

10536 Culver Blvd., Suite C, Culver City CA 90232. (310)287-2222. **Fax:** (310)287-2227. **E-mail:** theadco@pacbell.net. **Contact:** Kim Miyade. Estab. 1985. Ad agency. Full-service, multimedia firm. Specializes in print, collateral, direct mail, outdoor, broadcast, packaging, PR/Events.

NEEDS Works with 1 illustrator and 2 art directors/month. Prefers local artists only. Works on assignment only. Uses freelance artists and art directors for everything (none on staff), including brochure, catalog and print ad design and illustration and mechanicals and logos. 80% of work is with print ads. Also for multimedia projects. 100% of freelance work demands knowledge of PageMaker, QuarkXPress, FreeHand, Illustrator and Photoshop.

FIRST CONTACT & TERMS Send postcard sample or query letter with brochure, tearsheets, photocopies, photographs and anything that does not have to be returned. Samples are filed. Write for appointment to show portfolio. "No phone calls, please." Portfolio should include original/final art, b&w and color photostats, tearsheets, photographs, slides and transparencies. Pays for design by the hour, $60-75. Pays for illustration by the project, based on budget and scope.

TIPS Looks for "exceptional style."

AFA KRAUSE

45 West 10000 S., Suite #201, Sandy UT 84070. (801)486-7455. **Fax:** (801)486-7454. **Website:** www.afakrause.com. **Contact:** Bud Krause; Amber Hampshire. Formerly Alan Frank & Associates, Inc. Serves clients in travel, fast food chains and retailing. Clients include KFC, A&W, Taco Bell and Tuffy Automotive.

NEEDS Uses freelancers for illustrations, animation and retouching for annual reports, billboards, ads, letterheads, TV and packaging.

FIRST CONTACT & TERMS Mail art with SASE. Responds in 2 weeks. Minimum payment $500, animation; $100, illustrations; $200, brochure layout.

⌂ ALLEN & GERRITSEN

300 N. Second St., Suite 1001, Harrisburg PA 17101. (717)232-5554. **Website:** www.a-g.com. Estab. 1978. Full-service ad agency specializing in print collateral and ad campaigns. Product specialties are health care, banks, retail and industry.

○ Second location: 1619 Walnut St., 4th Floor, Philadelphia PA 19103; (215)667-8719.

NEEDS Prefers local artists with experience in comps and roughs. Works on assignment only. Uses freelancers mainly for advertising illustration and comps. Also uses freelancers for brochure design, mechanicals, retouching, lettering and logos. 50% of work is with print ads. 3% of design and 1% of illustration demands knowledge of Illustrator and Photoshop.

FIRST CONTACT & TERMS Designers: Send query letter with résumé. Illustrators: Send postcard sample, query letter or tearsheets. Samples are filed. Will contact artist for portfolio review if interested. Portfolio should include color thumbnails, roughs, original/final art, photographs. Pays for design and illustration by the project. Finds artists through sourcebooks and workbooks.

TIPS "Try to get a potential client's attention with a novel concept. Never, ever, miss a deadline. Enjoy what you do."

ANDERSON STUDIO, INC.

2609 Grissom Dr., Nashville TN 37204. (615)255-4807. **Fax:** (615)255-4812. **E-mail:** sherry@andersonstudioinc.com. **Website:** andersonstudioinc.com. **Contact:** Sherry Anderson. Estab. 1976. Specializes in T-shirts (designing and printing of art on T-shirts for retail/wholesale promotional market). Clients business, corporate retail, gift and specialty stores.

NEEDS Approached by 20 freelancers/year. Works with 1-2 freelance illustrators and 1-2 designers/year.

"We use freelancers with realistic (photorealistic) style. Works on assignment only. We need artists for automotive-themed art. Also motorcycle designs as seen in the current line of shirts produced for Orange County Choppers of the Discovery Channel. We're also in need of Hot Rod art and designs for T-shirts along with graphic work and logo designs of the same."

FIRST CONTACT & TERMS Send postcard sample or query letter with color copies, brochure, photocopies, photographs, SASE, slides, tearsheets and transparencies. Samples are filed and are returned by SASE if requested by artist. Portfolio should include slides, color tearsheets, transparencies and color copies. Sometimes requests work on spec before assigning a job. Pays for design and illustration by the project, $300-1,000 or in royalties per piece of printed art. Negotiates rights purchased. Considers buying second rights (reprint rights) to previously published work.

TIPS "Be flexible in financial/working arrangements. Most work is on a commission or flat buyout. We work on a tight budget until product is sold. Art-wise, the more professional, the better." Advises freelancers entering the field to "show as much work as you can. Even comps or ideas for problem solving. Let art directors see how you think. Don't send disks as they take too long to review. Most art directors like hard copy art."

⚙ ARIZONA CINE EQUIPMENT, INC.

2125 E. 20th St., Tucson AZ 85719. (520)623-8268. **Fax:** (520)623-1092. **E-mail:** Leejr@azcine.com. **Website:** www.azcine.com. Estab. 1967. Number of employees: 11. Approximate annual billing: $850,000. AV firm. Full-service, multimedia firm. Specializes in video. Product specialty is industrial.

NEEDS Approached by 5 freelancers/year. Works with 5 illustrators and 5 freelance designers/year. Prefers local artists. Uses freelancers mainly for graphic design. Also for brochure and slide illustration, catalog design and illustration, print ad design, storyboards, animation and retouching. 20% of work is with print ads. Also for multimedia projects. 70% of design and 80% of illustration demand knowledge of PageMaker, QuarkXPress, FreeHand, Illustrator or Photoshop.

FIRST CONTACT & TERMS Send query letter with brochure, résumé, photocopies, tearsheets, transparencies, photographs, slides and SASE. Samples are filed. Responds only if interested. Will contact artist for portfolio review if interested. Portfolio should include color thumbnails, final art, tearsheets, slides, photostats, photographs and transparencies. Pays for design by the project, $100-5,000. Pays for illustration by the project, $25-5,000. Buys first rights or negotiates rights purchased.

ASHCRAFT DESIGN

821 N. Nash St., El Segundo CA 90245. (424)247-9070. **E-mail:** bashcraft@AshcraftDesign.com. **Website:** www.ashcraftdesign.com. Specializes in corporate identity, display and package design and signage. Client list available upon request.

NEEDS Approached by 2 freelance artists/year. Works with 1 freelance illustrator and 2 freelance designers/year. Works on assignment only. Uses freelance illustrators mainly for technical illustration. Uses freelance designers mainly for packaging and production. Also uses freelance artists for mechanicals and model making.

FIRST CONTACT & TERMS Send query letter with tearsheets, résumé and photographs. Samples are filed and are not returned. Responds only if interested. To show a portfolio, e-mail samples or mail color copies. Pays for design and illustration by the project. Rights purchased vary according to project.

⚙ ASHER AGENCY

535 W. Wayne St., Ft. Wayne IN 46802. (260)424-3373 (Ft. Wayne); (859)273-5530 (Lexington); 800-900-7031. **E-mail:** hello@asheragency.com. **Website:** www.asheragency.com. Estab. 1974. Approximate annual billing: $12 million. Full service ad agency and PR firm. Clients: automotive firms, financial/investment firms, area economic development agencies, health care providers, fast food companies, gaming companies and industrial.

NEEDS Works with 5-10 freelance artists/year. Assigns 25-50 freelance jobs/year. Prefers local artists. Works on assignment only. Uses freelance artists mainly for illustration; also for design, brochures, catalogs, consumer and trade magazines, retouching, billboards, posters, direct mail packages, logos and advertisements.

FIRST CONTACT & TERMS Send query letter with brochure showing art style or tearsheets and photocopies. Samples are filed or are returned by SASE. Responds only if interested. Will contact artist for portfolio review if interested. Portfolio should include roughs, original/final art, tearsheets and final

reproduction/product. Pays for design by the hour, $40 minimum. Pays for illustration by the project, $40 minimum. Finds artists usually through word of mouth.

⚡ A.T. ASSOCIATES

63 Old Rutherford Ave., Charlestown MA 02129. (617)242-6004. **Website:** www.atadesign.net. Estab. 1976. Specializes in annual reports, industrial, interior, product and graphic design, model making, corporate identity, signage, display and packaging. Clients nonprofit companies, high tech, medical, corporate clients, small businesses and ad agencies. Client list available upon request.

NEEDS Approached by 20-25 freelance artists/year. Works with 3-4 freelance illustrators and 2-3 freelance designers/year. Prefers local artists; some experience necessary. Uses artists for posters, model making, mechanicals, logos, brochures, P-O-P display, charts/graphs and design.

FIRST CONTACT & TERMS Send résumé and nonreturnable samples. Samples are filed or are returned by SASE if requested by artist. Responds only if interested. Call to schedule an appointment to show a portfolio, which should include a "cross section of your work." Pays for design and illustration by the hour or by the project. Rights purchased vary according to project.

AURELIO & FRIENDS, INC.

14971 SW 43 Terrace, Miami FL 33185. (305)225-2434. **Fax:** (305)225-2121. **E-mail:** info@aurelioandfriends. com. **Website:** aurelioandfriends.com. **Contact:** Aurelio Sica, president; Nancy Sica, vice president. Estab. 1973. Number of employees: 3. Specializes in corporate advertising and graphic design. Clients: corporations, retailers, large companies, hotels and resorts.

NEEDS Approached by 4-5 freelancers/year. Works with 1-2 freelance illustrators and 3-5 designers/year. Uses freelancers for ad design and illustration, brochure, catalog and direct mail design. 50% of freelance work demands knowledge of Adobe Ilustrator and Photoshop.

FIRST CONTACT & TERMS Send brochure and tearsheets. Samples are filed. Will contact artist for portfolio review if interested. Portfolio should include b&w and color final art, photographs, roughs. Pays for design and illustration by the project. Buys all rights.

THE BAILEY GROUP, INC.

200 W. Germantown Pike, Plymouth Meeting PA 19462. (610)940-9030. **E-mail:** info@baileygp.com. **Website:** www.baileygp.com. Estab. 1985. Number of employees: 38. Specializes in package design, brand and corporate identity, sales promotion materials, corporate communications and signage systems. Clients: corporations (food, drug, health and beauty aids). Current clients include Aetna, Johnson & Johnson Consumer Products Co., Wills Eye Hospital and Welch's. Professional affiliations: AIGA, PDC, APP, AMA, ADC.

NEEDS Approached by 10 freelancers/year. Works with 3-6 freelance illustrators and 3-6 designers/year. Uses illustrators mainly for editorial, technical and medical illustration and final art, charts and airbrushing. Uses designers mainly for freelance production (*not* design), or computer only. Also uses freelancers for mechanicals, brochure and catalog design and illustration, P-O-P illustration and model-making.

FIRST CONTACT & TERMS Send query letter with brochure, résumé, tearsheets and photographs. Samples are filed. Responds only if interested. Will contact for portfolio review if interested. Portfolio should include finished art samples, color tearsheets, transparencies and artist's choice of other materials. May pay for illustration by the hour, $10-15; by the project, $300-3,000. Rights purchased vary according to project.

TIPS Finds artists through word of mouth, self-promotions and sourcebooks.

BASIC-BEDELL ADVERTISING & PUBLISHING

255 Limoneria Ave. #B, Ventura CA 93003. (805)650-1565; (805)695-0079. **E-mail:** barriebedell@gmail. com. **Contact:** Barrie Bedell, president. Specializes in advertisements, direct mail, how-to books, direct response websites and manuals. Clients publishers, direct response marketers, retail stores, software developers, Web entrepreneurs, plus extensive self-promotion of proprietary advertising how-to manuals.

⚡ This company's president is seeing "a glut of 'graphic designers,' and an acute shortage of 'direct response' designers."

NEEDS Uses artists for publication and direct mail design, book covers and dust jackets, and direct response websites. Especially interested in hearing from

professionals experienced in e-commerce and in converting printed training materials to electronic media, as well as designers of direct response websites.

FIRST CONTACT & TERMS Portfolio review not required. Pays for design by the project, $100-1,000 and up or royalties based on sales.

TIPS "There has been a substantial increase in the use of freelance talent and an increasing need for true professionals with exceptional skills and responsible performance (delivery as promised and 'on target'). It is very difficult to locate freelance talent with expertise in design of print publication and/or direct mail advertising, and websites with heavy use of type. E-mail query with website link or contact with personal letter and photocopy of one or more samples of work that needn't be returned."

BBDO NEW YORK

1285 Avenue of the Americas, New York NY 10019. (212)459-5000. **Website:** www.bbdo.com. Estab. 1891. Number of employees: 850. Approximate annual billing: $50 million. Ad agency; full-service multimedia firm. Specializes in business, consumer advertising, sports marketing and brand development. Clients include Lowe's, VW, FedEx, Pepsi, and Nike.

- BBDO art director told our editors he is always open to new ideas and maintains an open drop-off policy. If you call and arrange to drop off your portfolio, he'll review it, and you can pick it up in a couple days.

BEDA DESIGN

38663 Thorndale Place, Lake Villa IL 60046. (847)245-8939. **Fax:** (847)245-8939. **E-mail:** bedadesign@comcast.net. **Contact:** Lynn Beda, president. Estab. 1971. Design firm specializing in packaging, print material, publishing, film and video documentaries. Clients: business-to-business accounts, producers to writers, directors and artists. Approximate annual billing: $300,000.

NEEDS Web page builders in Mac platforms. Use skilled Mac freelancers for retouching, technical, illustration, production, Photoshop, QuarkXPress, Illustrator, Premiere, and Go Live. Use film and editorial writers and photographers.

FIRST CONTACT & TERMS Designers: Send query letter with brochure, photocopies and résumé. Illustrators: Send postcard samples and/or photocopies. Samples are filed and are not returned. Will contact for portfolio review if interested.

BARRY DAVID BERGER & ASSOCIATES, INC.

2 Eli Circle, East Hampton NY 11937. (631)324-4484. **Fax:** (631)329-5578. **E-mail:** bergerbarry@hotmail.com. **Website:** www.bergerdesign.com. Estab. 1977. Number of employees: 5. Approximate annual billing: $500,000. Specializes in brand and corporate identity, P-O-P displays, product and interior design, exhibits and shows, corporate capability brochures, advertising graphics, packaging, publications and signage. Clients: manufacturers and distributors of consumer products, office/stationery products, art materials, chemicals, health care, pharmaceuticals and cosmetics. Clients: Dennison, Timex, Sheaffer, Bausch & Lomb, and Kodak. Professional affiliations: IDSA, AIGA, APDF.

NEEDS Approached by 12 freelancers/year. Works with 5 freelance illustrators and 7 designers/year. Uses artists for advertising, editorial, medical, technical and fashion illustration, mechanicals, retouching, direct mail and package design, model-making, charts/graphs, photography, AV presentations and lettering. Needs computer-literate freelancers for illustration and production. 50% of freelance work demands computer skills.

FIRST CONTACT & TERMS Send query letter, then call for appointment. Works on assignment only. Send "whatever samples are necessary to demonstrate competence" including multiple roughs for a few projects. Samples are filed or returned. Responds immediately. Provide brochure/flyer, résumé, business card, tearsheets and samples to be kept on file for possible future assignments. Pays for design by the project, $1,000-10,000. Pays for illustration by the project.

TIPS Looks for creativity and confidence.

BERSON, DEAN, STEVENS

P.O. Box 3997, Westlake Village CA 91359. (877)447-0134, ext. 111. **E-mail:** info@bersondeanstevens.com. **Website:** www.bersondeanstevens.com. **Contact:** Lori Berson, owner. Estab. 1981. Specializes in marketing automation, branding, website design and development, content marketing, e-mail marketing, social media marketing, video production, collateral, direct mail, exhibits, signage, promotions and packaging. Clients: manufacturers, professional and finance service firms, ad agencies, corporations and movie studios. Professional affiliation: L.A. Ad Club.

NEEDS Approached by 50 freelancers/year. Works with 10-20 illustrators and 10 designers/year. Works

on assignment only. Uses illustrators mainly for brochures, packaging, and comps. Also for catalog, P-O-P, ad and poster illustration, lettering, logos and model-making. 90% of freelance work demands skills in Illustrator, InDesign, Photoshop, as well as web authoring, Dreamweaver, Flash/HTML, CGI, Java, etc. **FIRST CONTACT & TERMS** Send query letter with tearsheets and photocopies. Samples are filed. Will contact artist for portfolio review if interested. Pays for design and illustration by the project. Rights purchased vary according to project. Considers buying second rights (reprint rights) to previously published work. Finds artists through word of mouth, submissions/self-promotions, sourcebooks and agents.

BFL MARKETING COMMUNICATIONS

1399 Lear Industrial Pkwy., Avon OH 44011. (216)875-8860. **Fax:** (216)875-8870. **Website:** www.bflcom.com. Estab. 1955. Number of employees: 12. Approximate annual billing: $6.5 million. Marketing communications firm; full-service multimedia firm. Specializes in new product marketing, website design, interactive media. Product specialty is consumer home products. Client list available upon request. Professional affiliations: North American Advertising Agency Network, BPAA.

NEEDS Approached by 20 freelancers/year. Works with 5 freelance illustrators and 5 designers/year. Prefers freelancers with experience in advertising design. Uses freelancers mainly for graphic design, illustration; also for brochure and catalog design and illustration, lettering, logos, model making, posters, retouching, TV/film graphics. 80% of work is with print ads. Needs computer-literate freelancers for design, illustration, production and presentation. 50% of freelance work demands knowledge of FreeHand, Photoshop, QuarkXPress, Illustrator.

FIRST CONTACT & TERMS Send postcard-size sample of work or send query letter with brochure, photostats, tearsheets, photocopies, résumé, slides and photographs. Samples are filed or returned by SASE. Responds in 2 weeks. Artist should follow-up with call or letter after initial query. Will contact artist for portfolio review if interested. Portfolio should include b&w and color final art, photographs, photostats, roughs, slides and thumbnails. Pays by the project, $200 minimum.

TIPS Finds artists through *Creative Black Book*, *Illustration Annual*, *Communication Arts*, local interviews.

"Seeking specialist in Internet design, CD computer presentations and interactive media."

BLOCK & DECORSO

3 Claridge Dr., Verona NJ 07044. (973)857-3900. **Fax:** (973)857-4041. **E-mail:** bdecorso@blockdecorso.com. **Website:** www.blockdecorso.com. Estab. 1939. Approximate annual billing: $12 million. Product specialties are food and beverage, education, finance, home fashion, giftware, health care and industrial manufacturing. Professional affiliations: Ad Club of North Jersey.

NEEDS Approached by 100 freelancers/year. Works with 25 freelance illustrators and 25 designers/year. Prefers to work with "freelancers with at least 3-5 years experience as Mac-compatible artists and 'on premises' work as Mac artists." Uses freelancers for "consumer friendly" technical illustration, layout, lettering, mechanicals and retouching for ads, annual reports, billboards, catalogs, letterhead, brochures and corporate identity. Needs computer-literate freelancers for design and presentation. 90% of freelance work demands knowledge of QuarkXPress, Illustrator, Type-Styler and Photoshop.

FIRST CONTACT & TERMS To show portfolio, mail appropriate samples and follow up with a phone call. Pays for design by the hour; illustration by the project.

TIPS "We are fortunately busy—we use 4-6 freelancers daily. Be familiar with the latest versions of QuarkXpress, Illustrator and Photoshop. We like to see sketches of the first round of ideas. Make yourself available occasionally to work on premises. Be flexible in usage rights!"

BOYDEN & YOUNGBLUTT ADVERTISING & MARKETING

120 W. Superior St., Ft. Wayne IN 46802. (260)422-4499. **E-mail:** talk@b-y.net; info@b-y.net. **Website:** www.b-y.net. **Contact:** Jerry Youngblutt. Estab. 1990. Number of employees: 24. Ad agency. Full-service, multimedia firm. Specializes in magazine ads, collateral, web, media, social media, app development and television.

NEEDS Approached by 10 freelancers/year. Works with 3-4 development types and 5-6 designers/year. Uses freelancers mainly for collateral layout and web. Also for annual reports, billboards, brochure design and illustration, logos and model-making. Ten percent of work is with print ads, 40% web, 15% media,

and 35% TV. Needs computer-literate freelancers for design. 100% of freelance work demands knowledge of FreeHand, Photoshop, Adobe Ilustrator, Web Weaver and InDesign.

FIRST CONTACT & TERMS Send query letter with web links and résumé. Inquires are filed. Will contact artist for portfolio review if interested. Portfolio should include b&w and color final art. Pays for design and illustration by the project. Buys all rights.

TIPS Finds talent through sourcebooks, word of mouth and submissions. "Send a precise résumé with what you feel are your 'best' samples—less is more."

BRAINWORKS DESIGN GROUP, INC.

177 Van Ess Way, Carmel Highlands CA 93923. (831)657-0650. **Fax:** (831)574-3037. **E-mail:** alfred@ brainwks.com. **Website:** www.brainwks.com. Estab. 1970. Brainworks specializes in emotional response communication. Number of employees: 8. Specializes in graphic design, corporate identity, direct mail and publication, website design, research and e-blast campaigns. Clients: colleges, universities, nonprofit organizations; majority are colleges and universities.

○ Additional location: 221 W. 82nd St., Suite 8A, New York NY 10024; (201)240-5555.

NEEDS Prefers freelancers with experience in type, layout creative visual thinking. Works on assignment only. Uses freelancers mainly for web design; also for brochure, direct mail and poster design; lettering; and logos. 100% of design work demands knowledge of QuarkXPress, Illustrator, Photoshop and InDesign.

FIRST CONTACT & TERMS Send brochure or résumé, photocopies, photographs, tearsheets and transparencies. Samples are filed. Artist should follow up with call and/or letter after initial query. Will contact artist for portfolio review if interested. Portfolio should include thumbnails, roughs, final reproduction/product and b&w and color tearsheets, photostats, photographs and transparencies. Pays for design by the project, $100-1,000. Considers complexity of project and client's budget when establishing payment. Rights purchased vary according to project. Finds artists through sourcebooks and self-promotions.

TIPS "Creative thinking and a positive attitude are a plus." The most common mistake freelancers make in presenting samples or portfolios is that the "work does not match up to the samples they show."

LEO J. BRENNAN, INC.

1130 S. Lake Valley Dr., Fenton MI 48430. (248)362-3131. **Fax:** (248)362-2355. **E-mail:** lbrennan@ ljbrennan.com; request@ljbrennan.com. **Website:** www.ljbrennan.com. **Contact:** Leo Brennan, president. Estab. 1969. Number of employees: 3. Ad, PR and marketing firm. Clients: industrial, electronics, robotics, automotive, chemical, tooling, B2B.

NEEDS Works with 2 illustrators and 2 designers/ year. Prefers experienced artists. Uses freelancers for design, technical illustration, brochures, catalogs, retouching, lettering, keylining and typesetting; also for multimedia projects. 40% of work is with print ads. 100% of freelance work demands knowledge of non Mac software graphics programs.

FIRST CONTACT & TERMS Send query letter with résumé and samples. Samples not filed are returned only if requested. Responds only if interested. Call for appointment to show portfolio of thumbnails, roughs, original/final art, final reproduction/product, color tearsheets, and photographs. Payment for design and illustration varies. Buys all rights.

BRIGHT LIGHT PRODUCTIONS, INC.

602 Main St., Suite 810, Cincinnati OH 45202. (513)721-2574. **Fax:** (513)721-3329. **E-mail:** info@ brightlightusa.com. **Website:** www.brightlightusa. com. Estab. 1976. "We are a full-service film/video communications firm producing TV commercials and corporate communications."

NEEDS Works on assignment only. Uses artists for editorial, technical and medical illustration and brochure and print ad design, storyboards, slide illustration, animatics, animation, TV/film graphics and logos. Needs computer-literate freelancers for design and production. 50% of freelance work demands knowledge of Photoshop, Illustrator and After Effects.

FIRST CONTACT & TERMS Send query letter with brochure and résumé. Samples not filed are returned by SASE only if requested by artist. Request portfolio review in original query. Portfolio should include roughs and photographs. Pays for design and illustration by the project. Negotiates rights purchased. Finds artists through recommendations.

TIPS "Our need for freelance artists is growing."

⌂ BROMLEY COMMUNICATIONS

401 E. Houston St., San Antonio TX 78205-2615. (210)244-2000. **E-mail:** Ron.Landreth@bromley.biz. **Website:** www.bromley.biz. **Contact:** Ron Landreth, vice president creative director. Number of employees: 80. Approximate annual billing: $80 million. Estab. 1986. Full-service, multimedia ad agency and PR firm. Specializes in TV, radio and magazine ads, etc. Specializes in consumer service firms and Hispanic markets. Current clients include BellSouth, Burger King, Continental Airlines, Nestlé, Procter & Gamble.

NEEDS Approached by 3 artists/month. Prefers local artists only. Works on assignment only. Uses freelancers for storyboards, slide illustration, new business presentations and TV/film graphics and logos. 35% of work is with print ads. 25% of freelance work demands knowledge of PageMaker, QuarkXPress and Illustrator.

FIRST CONTACT & TERMS Send query letter with brochure and résumé. Samples are not filed and are returned by SASE only if requested by artist. Responds only if interested. Write for appointment to show portfolio.

BROWNING ADVERTISING

1 Browning Place, Morgan UT 84050. (801)876-2711. **Website:** www.browning.com. **Contact:** Advertising Production Manager. Estab. 1878. Distributor and marketer of outdoor sports products, particularly firearms. In-house agency for 2 main clients. In-house divisions include outdoor hunting products, firearms and accessories.

NEEDS View website for any upcoming freelance opportunites. Prefers freelancers with experience in outdoor sports hunting, shooting, fishing. Works on assignment only. Uses freelancers occasionally for design, illustration and production. Also for advertising and brochure layout, catalogs, product rendering and design, signage, P-O-P displays, and posters.

FIRST CONTACT & TERMS Send a digital query letter with résumé along with a link or a web address that can be accessed to view your work. Responds only if interested. Pays for design by the hour, $50-75. Pays for illustration by the project. Buys all rights or reprint rights.

CAHAN & ASSOCIATES

171 Second St., 5th Floor, San Francisco CA 94105. (415)621-0915. **E-mail:** info@cahanassociates. com; billc@cahanassociates.com. **Website:** www. cahanassociates.com. **Contact:** Bill Cahan, president. Estab. 1984. Specializes in annual reports, corporate identity, package design, signage, business and business collateral. Clients: public and private companies (real estate, finance and biotechnology). Client list available upon request.

NEEDS Approached by 50 freelance artists/year. Works with 5-10 freelance illustrators and 3-5 freelance designers/year. Works on assignment only. Uses freelance illustrators mainly for annual reports. Uses freelance designers mainly for overload cases. Also uses freelance artists for brochure design.

FIRST CONTACT & TERMS Send query letter with brochure, tearsheets, photostats, résumé, photographs, and photocopies. Samples are filed and are not returned. Responds only if interested. To show a portfolio, mail thumbnails, roughs, tearsheets, and transparencies. Pays for design or illustration by the hour or by the project. Negotiates rights purchased.

THE CALIBER GROUP

4007 E. Paradise Falls Dr., Suite 210, Tucson AZ 85712. (520)795-4500 (Tucson); (480)442-4505 (Tempe). **Fax:** (520)795-4565 (Tucson). **E-mail:** info@calibergroup. com; freelancing@calibergroup.com. **Website:** www. calibergroup.com. Estab. 1997. Specializes in annual reports, brand identity, corporate identity, display design, direct mail design, environmental graphics, package design, publication design and signage. Client list available upon request.

○ The creative team has won over 500 international, national and local awards.

NEEDS Approached by 100 freelance artists/year. Works with 10 freelance illustrators and 5-10 freelance designers/year. Works on assignment only. Uses designers and illustrators for brochure, poster, catalog, P-O-P and ad illustration, mechanicals, retouching, airbrushing, charts/graphs and audiovisual materials.

FIRST CONTACT & TERMS Send query letter with PDF samples and résumé. Samples are filed. Responds only if interested. Call to schedule an appointment to show portfolio. Portfolio should include roughs, original/final art. Pays for design by the hour and by the project. Pays for illustration by the project. Negotiates rights purchased.

TIPS When presenting samples or portfolios, designers and illustrators "sometimes mistake quantity for quality. Keep it short and show your best work."

CARNASE, INC.

300 E. Molino Rd., Palm Springs CA 92262. **E-mail:** carnase@carnase.com. **Website:** www.carnase.com. **Contact:** Tom Carnase, president. Estab. 1978. Specializes in annual reports, brand and corporate identity, display, package and publication design, signage and technical illustration. Clients: agencies, corporations, consultants, Brooks Brothers, *Fortune Magazine*, Calvin Klein, Saks Fifth Avenue (list too long to post).

NEEDS Approached by 60 freelance artists/year. Works with 2 illustrators and 1 designer/year. Prefers artists with 5 years experience. Works on assignment only. Uses artists for brochure, catalog, book, magazine and direct mail design and brochure and collateral illustration. Needs computer-literate freelancers. 50% of freelance work demands skills in QuarkXPress or Illustrator.

FIRST CONTACT & TERMS Send query letter with brochure, résumé and tearsheets. Samples are filed. Responds in 10 days. Will contact artist for portfolio review if interested. Portfolio should include digital prints and color tearsheets. Negotiates payment. Rights purchase vary according to project. Finds artists through word of mouth, magazines, submissions/self-promotions, sourcebooks and agents.

CGT MARKETING, LLC

275-B Dixon Ave., Amityville NY 11701. (631)842-4600. **Fax:** (631)842-6301. **E-mail:** info@cgtllc.net. **Website:** www.cgtmarketing.com. **Contact:** The Tobol Group, Mitch Tobol, president. Estab. 1981. Ad agency. Product specialties are business to business and business to consumer.

NEEDS Approached by 2 freelance artists/month. Works with 1 freelance illustrator and 4 designers/month. Works on assignment only. Uses freelancers for brochure, catalog and print ad design and technical illustration, retouching, billboards, posters, TV/film graphics, lettering and logos. 25% of work is with print ads. 75% of freelance work demands knowledge of QuarkXPress, Illustrator, Photoshop, GoLive or Dreamweaver.

FIRST CONTACT & TERMS Send query letter with SASE and tearsheets. Samples are filed or are returned by SASE. Responds in 1 month. Call for appointment to show portfolio or mail thumbnails, roughs, b&w and color tearsheets and transparencies. Pays for design by the hour. Pays for illustration by the project,

$300-1,500 ($50 for spot illustrations). Negotiates rights purchased.

⊙ CHAPPELLROBERTS

1600 E. Eighth Ave., Suite A-133, Tampa FL 33605. (813)281-0088. **E-mail:** info@chappellroberts.com. **Website:** www.chappellroberts.com. Estab. 1986. Number of employees: 20. Ad agency, PR firm, full-service multimedia firm. Specializes in integrated communications campaigns using multiple media and promotion. Professional affiliations: AIGA, PRSA, AAF, TBAF and AAAAS.

NEEDS Approached by 50 freelancers/year. Works with 15 freelance illustrators and designers/year. Prefers local artists with experience in conceptualization and production knowledge. Uses freelancers for billboards, brochure design and illustration, logos, mechanicals, posters, retouching and website production. 60% of work is with print ads. 80% of freelance work demands knowledge of Adobe Creative Suite 2, QuarkXPress 6.5.

FIRST CONTACT & TERMS E-mail query with samples in PDF files. Will contact artist for portfolio review if interested. Portfolio should include b&w and color final art, roughs and thumbnails. Pays for design by the hour, by the project, by the day. Pays for illustration by the project, negotiable. Refers to *Graphic Artists Guild Handbook* for fee structure. Rights purchased vary according to project. Finds artists through agents, sourcebooks, seeing actual work done for others, annuals (*Communication Arts*, *PRINT*, *One Show*, etc.).

TIPS Impressed by "work that demonstrates knowledge of product, willingness to work within budget, contributing to creative process, delivering on-time."

⊙ CLIFF & ASSOCIATES

10061 Riverside Dr., #808, Toluca Lake CA 91602. (323)876-1180. **Fax:** (323)876-5484. **E-mail:** design@cliffassoc.com. **Website:** www.cliffassoc.com. **Contact:** Gregg Cliff, owner/creative director. Estab. 1984. Number of employees: 10. Approximate annual billing: $1 million. Specializes in annual reports, corporate identity, direct mail, publication design and signage. Clients: Fortune 500 corporations and performing arts companies. Current clients include BP, IXIA, WSPA, IABC, Capital Research and ING.

NEEDS Approached by 50 freelancers/year. Works with 30 illustrators and 10 designers/year. Prefers local freelancers and Art Center graduates. Uses free-

lancers mainly for brochures; also for technical, "fresh" editorial and medical illustration, mechanicals, lettering, logos, catalog/book/magazine design, P-O-P and poster design and illustration, and model making. Needs computer-literate freelancers for design and production. 90% of freelance work demands knowledge of QuarkXPress, FreeHand, Illustrator, Photoshop, etc. **FIRST CONTACT & TERMS** Send query letter with résumé and a nonreturnable sample of work. Samples are filed. Will contact artist for portfolio review if interested. Portfolio should include thumbnails, b&w photostats and printed samples. Pays for design by the hour, $25-35. Pays for illustration by the project, $50-3,000. Buys one-time rights. Finds artists through sourcebooks.

COMMUNICATIONS ELECTRONICS, INC.

P.O. Box 1045, Ann Arbor MI 48106-1045. (734)996-8888. **E-mail:** ken.ascher@usascan.com. **Website:** www.usascan.com. **Contact:** Ken Ascher, editor. Estab. 1969.

NEEDS Approached by 300 freelancers/year. Works with 40 freelance illustrators and 40 designers/year. Uses freelancers for brochure and catalog design, illustration and layout, advertising, product design, illustration on product, P-O-P displays, posters and renderings. Needs editorial and technical illustration. Prefers pen & ink, airbrush, charcoal/pencil, watercolor, acrylic, marker and computer illustration. 60% of freelance work demands skills in PageMaker or InDesign.

FIRST CONTACT & TERMS Send query letter with brochure, résumé, business card, samples and tearsheets to be kept on file. Samples not filed are returned by SASE. Responds in 1 month. Will contact artist for portfolio review if interested. Pays for design and illustration by the hour, $10-120; by the project, $10-10,000; by the day, $40-500.

COMPASS MEDIA, INC.

175 Northshore Place, Gulf Shores AL 36542. (251)968-4600; (800)239-9880. **E-mail:** info@compassmedia.com. **Website:** www.compassmedia.com. Estab. 1988. Number of employees: 25-30. Approximate annual billing: $4 million. Integrated marketing communications agency and publisher. Specializes in tourism products and programs. Product specialties are business and consumer tourism. Current clients include Alabama Bureau of Tourism and Alabama Gulf Coast CVB. Client list available upon request.

NEEDS Approached by 5-20 designers/year. Works with 4-6 designers/year. Prefers freelancers with experience in digital and/or magazine work. Uses freelancers mainly for sales collateral, advertising collateral and illustration. 5% of work is with print ads. 100% of design demands skills in Photoshop and InDesign.

FIRST CONTACT & TERMS Designers: Send query letter with photocopies, résumé and tearsheets. Samples are filed and are not returned. Responds in 1 month. Art director will contact artist for portfolio review of slides and tearsheets if interested. Pays by the project, $100 minimum. Rights purchased vary according to project. Finds artists through sourcebooks, networking and print.

TIPS "Be fast and flexible. Have digital and/or magazine experience."

CONCORD DIRECT

Concord Litho, 92 Old Turnpike Rd., Concord NH 03301-7305. (603)410-1205. **Fax:** (603)224-5503. **E-mail:** dchristiansen@concord-direct.com. **Website:** www.directconcord.com. **Contact:** Deidre Christiansen, art resource coordinator. Estab. 1958. Number of employees: 50+. Integrated marketing communications, direct mail printer with in-house design department. Clients: non-profit.

NEEDS Approached by 20 illustrators/year. Work with 3 illustrators/year. Prefers illustrators with experience in watercolor, gouache, oil, acrylic. Buys stock photos. Pays $150-750. Works with beginning an established photographers. Uses photos for direct mail, greeting cards, calendars.

FIRST CONTACT & TERMS E-mail query letter with website and JPEG samples at 72 dpi. No Flickr or Facebook sites. Does not keep samples on file. Responds in 1 month. Illustration/photography: pays by the project, $200-700. Licensing fee per project or term. Pays on receipt of invoice. Credit line given. Buys one time rights and/or reprint rights; rights purchased vary according to project. Finds illustrators/photographers through agents, internet and industry trade shows (Surtex).

TIPS "Have a website with keyworded images and a search option. It's easier to forward to members of a design team, who need to quickly select from a variety of art styles. Use scans of artwork (never pho-

tographs) and have high resolution scans available within 2 business days when the image is licensed."

COUSINS DESIGN

330 E. 33rd St., New York NY 10016. (212)685-7190. **Fax:** (212)689-3369. **E-mail:** info@cousinsdesign.com. **Website:** www.cousinsdesign.com. **Contact:** Michael Cousins, president. Number of employees: 4. Specializes in packaging and product design. Clients: marketing and manufacturing companies. Professional affiliation: IDSA.

NEEDS Occasionally works with freelance designers. Prefers local designers. Works on assignment only.

FIRST CONTACT & TERMS Send nonreturnable postcard sample or e-mail website link. Samples are filed. Responds in 2 weeks only if interested. Write for appointment to show portfolio of roughs, final reproduction/product and photostats. Pays for design by the hour or flat fee. Considers skill and experience of artist when establishing payment. Buys all rights.

TIPS "Send great work that fits our direction."

CREATIVE COMPANY, INC.

726 NE Fourth St., McMinnville OR 97128. (866)363-4433. **Fax:** (503)883-6817. **E-mail:** jlmorrow@creativeco.com; optimize@creativeco.com. **Website:** www.creativeco.com. **Contact:** Jennifer Larsen Morrow. Estab. 1978. Specializes in branding, marketing-driven corporate identity, collateral, direct mail, packaging and ongoing marketing campaigns. Product specialties are food, financial services, colleges, manufacturing, pharmaceutical, medical, agricultural products.

NEEDS Works with 1-2 freelance designers and 1-2 illustrators/year. Prefers local artists. Works on assignment only. Uses freelancers for design, illustration, digital production (Mac), retouching and lettering. "Looking for clean, fresh designs!" 100% of design and 60% of illustration demand skills in InDesign, Illustrator and Photoshop.

FIRST CONTACT & TERMS Send query letter with brochure, résumé, online access to website, or PDF portfolio. Will contact for portfolio review if interested. "We require a portfolio review. Years of experience not important if portfolio is good. We prefer one-on-one review to discuss individual projects/time/approach." Pays for design by the hour or project, $50-90. Pays for illustration by the project. Considers complexity of project and skill and experience of artist when establishing payment.

TIPS Common mistakes freelancers make in presenting samples or portfolios are: "1) poor presentation, samples not mounted or organized; 2) not knowing how long it took them to do a job to provide a budget figure; 3) not demonstrating an understanding of the audience, the problem or printing process and how their work will translate into print or online 4) just dropping in without an appointment; 5) not following up periodically to update information or a résumé that might be on file."

CREATIVE CONSULTANTS

17510 E. Montgomery Ave., Greenacres WA 99016-8541. (509)326-3604. **E-mail:** solutions@creativeconsultants.com. **Website:** www.creativeconsultants.com. **Contact:** Edmond A. Bruneau, president. Estab. 1980. Approximate annual billing: $5,000. Ad agency and design firm. Specializes in collateral, logos, ads, annual reports, radio and TV spots. Product specialties are business and consumer. Client list available upon request.

NEEDS Approached by 20 illustrators and 25 designers/year. Works with 1–2 illustrators and designers/year. Uses freelancers mainly for animation, brochure, catalog and technical illustration, model-making and TV/film graphics. 36% of work is with print ads. Designs and illustration demands skills in Photoshop, InDesign, and Illustrator.

FIRST CONTACT & TERMS Designers: Send query letter. Illustrators: Send postcard sample of work and e-mail. Accepts disk submissions if compatible with Photoshop, InDesign, and Illustrator. Responds only if interested. Pays by the project. Buys all rights. Finds artists through Internet, word of mouth, reference books and agents.

THE CRICKET CONTRAST

29505 N. 146th St., Scottsdale AZ 85262. (602)390-4940. **E-mail:** cricket@thecricketcontrast.com. **Website:** www.thecricketcontrast.com. Estab. 1982. Specializes in providing solutions for branding, corporate identity, web page design, advertising, package and publication design, and traditional online printing. Clients: corporations. Professional affiliations: AIGA, Scottsdale Chamber of Commerce, Phoenix Society of Communicating Arts, Phoenix Art Museum, Phoenix Zoo.

NEEDS Approached by 25-50 freelancers/year. Works with 5 freelance illustrators and 5 designers/year. Uses freelancers for ad illustration, brochure design and illustration, lettering and logos. Needs computer-literate freelancers for design and production. 100% of freelance work demands knowledge of Illustrator, Photoshop, InDesign, and QuarkXPress.

FIRST CONTACT & TERMS Send photocopies, photographs and résumé via e-mail. Will contact artist for portfolio review if interested. Pays for design and illustration by the project. Negotiates rights purchased. Finds artists through self-promotions and sourcebooks.

TIPS "Beginning freelancers should send all info through e-mail."

CTCREATIVE

Valcourt Group, 214 W. River Rd., St. Charles IL 60174. (630)587-6000. **E-mail:** info@valcort.com. **Website:** www.ctcreative.com. Estab. 1989. Integrated marketing communications agency. Specializes in consulting, creative branding, collateral. Product specialties: health care, family. Current clients include Kidspeace, Cook Communications, Opportunity International.

NEEDS Works with 1-2 freelance illustrators and 2-3 designers/year. Needs freelancers for brochure design and illustration, logos, multimedia projects, posters, signage, storyboards, TV/film graphics. 20% of work is with print ads. 100% of freelance design demands skills in Illustrator and InDesign.

FIRST CONTACT & TERMS Designers: Send query letter with brochure and photocopies. Illustrators: Send postcard sample of work. Samples are filed. Responds only if interested. Portfolio review not required. Pays by the project. Buys all rights.

� JO CULBERTSON DESIGN, INC.

939 Pearl St., Denver CO 80203. (303)861-4303. **Contact:** Jo Culbertson, president. Estab. 1976. Number of employees: 1. Approximate annual billing: $75,000. Specializes in direct mail, packaging, publication and marketing design, annual reports, corporate identity, and signage. Clients: corporations, not-for-profit organizations. Current clients include Love Publishing Co., Gabby Krause Foundation, Jace Management Services, Vitamin Cottage, Sun Gard Insurance Systems. Client list available upon request.

NEEDS Approached by 2 freelancers/year. Works with 1 freelance illustrator/year. Prefers local freelancers only. Works on assignment only. Uses illustrators mainly for corporate collateral pieces, illustration and ad illustration. 50% of freelance work demands knowledge of QuarkXPress, Photoshop, CorelDraw.

FIRST CONTACT & TERMS Send query letter or e-mail with résumé, tearsheets and photocopies. Samples are filed. Responds only if interested. Artist should follow up with call. Portfolio should include b&w and color thumbnails, roughs and final art. Pays for design by the project, $250 minimum. Pays for illustration by the project, $100 minimum. Finds artists through file of résumés, samples, interviews.

� DAIGLE DESIGN, INC.

6606 Eagle Harbor Dr., Bainbridge Island WA 98110. (206)842-5356. **Fax:** (206)331-4222. **E-mail:** candace@daigle.com. **Website:** www.daigledesign.com. Geoff Daigle. **Contact:** Candace Daigle, creative director. Estab. 1987. Number of employees: 3. Approximate annual billing: $250,000. Design firm. Specializes in brochures, catalogs, logos, magazine ads, trade show displays, and websites. Product specialties are agriculture, law, nutraceuticals, furniture, real estate development, aviation, yachts, restaurant equipment, and automotive.

NEEDS Approached by 10 illustrators and 20 designers/year. Works with 5 illustrators and 5 designers/year. Prefers local designers with experience in Photoshop, After Effects, 3D Studio Max, V-Ray, Rhino, Illustrator, Dreamweaver, CSS and InDesign. Uses freelancers mainly for concept and production. Also for brochure design and illustration, lettering, logos, multimedia projects, signage, technical illustration and web page design. 50% of work is with print, 50% of design demands skills in Photoshop, Illustrator and InDesign; 50% of illustration demands skills in Photoshop, Illustrator.

FIRST CONTACT & TERMS Designers: Send query letter with résumé. Illustrators: Send query letter with photocopies. Accepts PDF submissions. Send JPEG files. Samples are filed and are not returned. Responds only if interested. Will contact for portfolio review of b&w, color, final art, digital photos/illustrations and tearsheets if interested. Pays for design by the hour, $35; pays for illustration by the project, $150-5,000. Buys all rights. Finds artists through submissions, reps, temp agencies and word of mouth.

DEFOREST GROUP

300 W. Lake St., Elmhurst IL 60126. (630)834-7200. **Fax:** (630)279-8410. **E-mail:** info@deforestgroup. com; leede@deforestgroup.com. **Website:** www.deforestgroup.com. Number of employees: 15. Marketing solutions, graphic design and digital photography firm.

NEEDS Approached by 50 freelance artists/year. Works with 3-5 freelance designers/year. Prefers artists with experience in PhotoShop, Illustrator and InDesign, and photographers with expertise in PhaseOne camera systems and PhotoShop. Freelance web designers and programmers are also utilized.

FIRST CONTACT & TERMS Send query letter with résumé and samples. Physical samples are filed or returned by SASE if requested by artist. To arrange for portfolio review artist should fax or e-mail. Pays for production by the hour, $25-75. Finds designers through word of mouth and artists' submissions.

TIPS "Be hardworking, honest, and good at your craft."

DESIGN ASSOCIATES GROUP, INC.

1828 Asbury Ave., Evanston IL 60201-3504. (847)425-4800. **E-mail:** info@designassociatesinc.com. **Website:** www.designassociatesinc.com. Estab. 1986. Number of employees: 5. Specializes in text and trade book design, corporate marketing and communications: annual reports, corporate branding/identity, website development, eCommerce and online store development, content management systems, mobile app development. Clients: corporations, publishers and institutions. Client list available upon request.

NEEDS Approached by 10-20 freelancers/year. Works with 100 freelance illustrators and 2 designers/year. Uses freelancers for design and production. 100% of freelance work demands knowledge of Illustrator, Photoshop and InDesign.

FIRST CONTACT & TERMS Send query letter with samples that best represent work. Accepts disk submissions. Samples are filed. Will contact artist for portfolio review if interested. Portfolio should include b&w and color samples.

DESIGN RESOURCE CENTER

424 Fort Hill Dr., Suite 118, Naperville IL 60540. (630)357-6008. **Fax:** (630)357-6040. **E-mail:** info@drcchicago.com. **Website:** www.drcchicago.com. Estab. 1990. "By leveraging consumer insights and smart design, we deliver strategic branding and package design with refreshing efficiency. Design Resource Center has been delivering brand design solutions that delight our clients and motivate consumers since 1990."

NEEDS "We supplement our staff of designer and production artists, and purchase illustrations and custom typography based on project needs. In most cases, we prefer production artists and designers work on site in our Naperville, Illinois office and must be highly skilled in Illustrator and Photoshop."

FIRST CONTACT & TERMS "Design and production: Please feel free to contact us via e-mail and include your résumé and portfolio. We pay hourly based on negotiated rate. Illustration and typography: Please feel free to contact us via e-mail and include your portfolio. Negotiated fees include all buyouts."

DEVER DESIGNS

14203 Park Center Dr., Suite 308, Laurel MD 20707. (301)776-2812. **Fax:** (866)665-1196. **E-mail:** info@deverdesigns.com. **Website:** www.deverdesigns.com. **Contact:** Kay Rosburg. Estab. 1985. Number of employees: 7. Specializes in annual reports, corporate identity and publication design. Clients: associations, nonprofit organizations, educational institutions, museums, government agencies.

NEEDS Approached by 100 freelance illustrators/year. Works with 0-5 freelance illustrators/year. Prefers artists with experience in editorial illustration. Uses illustrators mainly for publications.

FIRST CONTACT & TERMS Send postcard, samples or query letter with résumé and website. Accepts PDFs and disk submissions compatible with Photoshop, Illustrator or InDesign, but prefers hard copy samples which are filed. Will contact artist for portfolio review if interested. Pays for illustration by the project. Rights purchased vary according to project. Finds artists through referrals and sourcebooks.

TIPS Impressed by consistent quality.

⏏ ANTHONY DI MARCO

301 Aris Ave., Metairie LA 70005. (504)833-3122. **Website:** www.anthonydimarcostudio.com. **Contact:** Anthony Di Marco, creative director. Estab. 1972. Number of employees: 1. Specializes in illustration, sculpture, costume design, art and photo restoration and retouching. Current clients include Audubon Institute, Louisiana Nature and Science Center, Fair Grounds Race Course. Client list available upon request. Professional affiliations: Art Directors Designers Association, Entergy Arts Council, Louisiana

Crafts Council, Louisiana Alliance for Conservation of Arts.

NEEDS Approached by 50 or more freelancers/year. Works with 5-10 freelance illustrators and 5-10 designers/year. Seeks "local freelancers with ambition. Freelancers should have substantial portfolios and an understanding of business requirements." Uses freelancers mainly for fill-in and finish design, illustration, mechanicals, retouching, airbrushing, posters, model-making, charts/graphs. Prefers highly polished, finished art in pen & ink, airbrush, charcoal/pencil, colored pencil, watercolor, acrylic, oil, pastel, collage and marker. 25% of freelance work demands computer skills.

FIRST CONTACT & TERMS Send query letter with résumé, business card, slides, brochure, photocopies, photographs, transparencies and tearsheets to be kept on file. Samples not filed are returned by SASE. Responds in 1 week if interested. Call or write for appointment to show portfolio. Pays for illustration by the hour or by the project, $100 minimum.

TIPS "Keep professionalism in mind at all times. Put forth your best effort. Apologizing for imperfect work is a common mistake freelancers make when presenting a portfolio. Include prices for completed works (avoid overpricing). 3D works comprise more of our total commissions than before."

CHARLES DUFF ADVERTISING

301 W. Osborn Rd., Suite 3600, Phoenix AZ 85013. (800)234-2269; (602)285-1660. **Website:** www.farnam.com. **Fax:** (602)207-2193. **E-mail:** bdawes@mail.farnam.com. **Contact:** Brian Dawes, executive art director. Estab. 1948. Number of employees 13. Approximate annual billing $1 million. Ad agency. Full-service multimedia firm. Specializes in agri-marketing promotional materials, literature, audio, video, trade literature. Specializes in animal health. Charles Duff Advertising is the in-house ad agency for Farnam Companies, a multimillion dollar company specializing in horse care and agricultural products.

NEEDS Approached by 50 freelancers/year. Works with 10 freelance illustrators and 10 designers/year. Prefers freelancers with experience in animal illustration: equine, pets and livestock. Uses freelancers mainly for brochure, catalog and print ad illustration and retouching, billboards and posters. 35% of work is with print ads. Needs computer-literate freelancers for design, illustration, production and presentation.

25% of freelance work demands knowledge of Photoshop, QuarkXPress and Illustrator.

FIRST CONTACT & TERMS Send query letter with brochure, photocopies, SASE, résumé, photographs, tearsheets, slides or transparencies. Samples are filed or are returned by SASE if requested by artist. Responds in 2 weeks. Reviews portfolios "only by our request." Pays by the project, $100-500 for design; $100-700 for illustration. Buys one-time rights.

⊙ DYKEMAN ASSOCIATES, INC.

4115 Rawlins St., Dallas TX 75219. (214)587-2995. **E-mail:** info@dykemanassociates.com. **Website:** www.dykemanassociates.com. Estab. 1974. PR/marketing firm. Specializes in business, hospitality, sports, environmental, energy, health.

NEEDS Works with 5 illustrators and designers/year. Local freelancers preferred. Uses freelancers for editorial and technical illustration, brochure design, exhibits, corporate identification, POS, signs, posters, ads and all design and finished artwork for websites and printed materials. PC or Mac.

FIRST CONTACT & TERMS Request portfolio review in original query. Pays by the project, $300-3,000. "Artist makes an estimate; we approve or negotiate."

TIPS "Be enthusiastic. Present an organized portfolio with a variety of work. Portfolio should reflect all that an artist can do. Don't include examples of projects for which you only did a small part of the creative work. Have a price structure but be willing to negotiate per project. We prefer to use artists/designers/illustrators who will work with barter (trade) dollars and join one of our trade exchanges. We see steady growth ahead."

⊙ EJW ASSOCIATES, INC.

Crabapple Village Office Park, 1602 Abbey Court, Alpharetta GA 30004. (770)664-9322. **Fax:** (770)664-9324. **E-mail:** advertise@ejwassoc.com. **Website:** http://www.ejwassoc.com. **Contact:** Emil Walcek, *President.* Estab. 1982. Ad agency. Specializes in website design and development, eCommerce sites, adversting, corporate ID, brochures, and show graphics. Product specialty is business-to-business.

NEEDS Works with 1-2 freelance illustrators and designers/year. Prefers local freelancers with experience in open source coding (LAMP) for websites, and creatives with design/illustration and Photoshop expertise. Hires for assignment only. Uses freelancers to augment in-house capabilities when needed for

brochure, website development, catalog and print ad design and illustration, editorial, technical illustration and logos. 50% of work is with print ads. 75% of freelance work demands skills in FreeHand, Photoshop, Web coding, Flash.

FIRST CONTACT & TERMS Send query letter containing brief résumé/bio information. Responds only if interested. Pays for design by the hour, $20-80; or by the project. Buys all rights.

TIPS "We prefer freelancers with experience in nonconsumer, industrial or technology account work. Visit our website first, then e-mail or call. Do not send e-mail attachments."

THE EMERY GROUP

2707 Congress St., #2M, San Diego CA 92110. (619)299-0775 (San Diego); (915)532-3636 (El Paso). **E-mail:** tome@emerygroup.com. **Website:** www.emerygroup.com. Number of employees: 18. Ad agency. Specializes in automotive and retail firms, banks and restaurants. Clients: Texas National Bank and Horizon Co., Ltd.

○ Second location: 1519 Montana Ave., El Paso TX 79902.

NEEDS Approached by 3-4 freelancers/year. Works with 2-3 freelance illustrators and 4-5 designers/year. Uses freelancers mainly for design, illustration and production. Needs technical illustration and cartoons.

FIRST CONTACT & TERMS Works on assignment only. Send query letter with résumé and samples to be kept on file. Prefers tearsheets as samples. Samples not filed are returned by SASE. Will contact artist for portfolio review if interested. Sometimes requests work on spec before assigning a job. Pays for design by the hour, $15 minimum; by the project, $100 minimum; by the day, $300 minimum. Pays for illustration by the hour, $15 minimum; by the project, $100 minimum. Considers complexity of project, client's budget and turnaround time when establishing payment. Rights purchased vary according to project.

TIPS Especially looks for "consistency and dependability; high creativity; familiarity with retail, Southwestern and Southern California look."

ERICKSEN ADVERTISING & DESIGN, INC.

84 North Side Drive, Sag Harbor NY 11963. (631)725-2824. **E-mail:** bobericksen@me.com. **Website:** www.eadcom.com. **Contact:** Robert P. Ericksen, Creative Director. Estab. 1994. Full-service ad agency providing all promotional materials and commercial services for clients. Product specialties are promotional, commercial and advertising material. Current clients include Hearst Entertainment, BBC, National Geographic, CBS TV, Ambrose Video,

NEEDS Works with several freelancers/year. Assigns several jobs/year. Works on assignment only. Uses freelancers mainly for advertising, packaging, brochures, catalogs, trade, P-O-P displays, posters, lettering and logos. Prefers composited and computer-generated artwork.

FIRST CONTACT & TERMS Contact through artist's agent or send query letter with brochure or tearsheets and slides. Samples are filed and are not returned unless requested with SASE; unsolicited samples are not returned. Responds in 1 week if interested or when artist is needed for a project. Does not respond to all unsolicited samples. "Only on request should a portfolio be sent." Pays for illustration by the project, up to $5,000. Buys all rights, and retains ownership of original in some situations. Finds artists through word of mouth, magazines, submissions and sourcebooks.

TIPS "Advertising artwork is becoming increasingly 'commercial' in response to very tightly targeted marketing. The artist has to respond to increased creative team input. Must be experienced in computer softwares; Quark, Photoshop, Acrobat, Illustrator, MS Office, Dreamweaver, and other design/web programs."

EVENTIV

10116 Blue Creek North, Whitehouse OH 43571. (419)877-5711. **E-mail:** jan@eventiv.com. **Website:** www.eventiv.com. **Contact:** Janice Robie, president/creative director. Agency specializing in graphics, promotions and tradeshow marketing.

NEEDS Assigns freelance jobs. Works with illustrators and designers on assignment only. Uses freelancers for brochures, P-O-P displays, AV presentations, posters and illustrations (technical or creative) electronic authoring, animation, web design. Requires computer skills.

FIRST CONTACT & TERMS E-mail samples. Responds only interested. Pays by the hour or by the project. Considers client's budget and skill and experience of artist when establishing payment. Retains rights purchased.

FLINT COMMUNICATIONS

101 Tenth St. N., Suite 300, Fargo ND 58102. (701)237-4850. **Fax:** (701)234-9680. **E-mail:** jodi.duncan@flint-

com.com. **Website:** www.flintcom.com. **Contact:** Jodi Duncan, business inquiries. Estab. 1946. Number of employees: 60. Approximate annual billing: $14 million. Ad agency; full-service multimedia firm. Product specialties are agriculture, manufacturing, health care, insurance, tourism and banking. Professional affiliations: AIGA, MN Ad Fed.

NEEDS Approached by 50 freelancers/year. Works with 6-10 freelance illustrators and 3-4 designers/year. Uses freelancers for annual reports, brochure design and illustration, lettering, logos and TV/film graphics. 40% of work is with print ads. 20% of freelance work demands knowledge of InDesign, Photoshop, QuarkXPress and Illustrator.

FIRST CONTACT & TERMS Send query letter and postcard-size or larger sample of work. Samples are filed. Will contact artist for portfolio review if interested. Pays for illustration by the project, $100-2,000. Rights purchased vary according to project.

FLINT GROUP ADVERTISING

101 10th St. North, Fargo ND 58201. (701)237-4850. **Fax:** (701)234-9680. **Website:** www.flint-group.com. Estab. 1947. Number of employees: 90. Approximate annual billing: $5.5 million. Ad agency. Specializes in magazine ads, collateral, documentaries, web design, etc. Product specialties are agriculture, gardening, fast food/restaurants, healthcare. Client list available upon request.

⚪ A division of Flint Communications, Fargo ND, with 5 locations in North Dakota and Minnesota. See listing for Flint Communications in this section.

NEEDS Approached by 3-6 freelancers/year. Works with 3 freelance illustrators and 2 designers/year. Works on assignment only. Uses freelancers mainly for illustration. Also for brochure, catalog and print ad design and illustration; storyboards; billboards; and logos. 10% of work is with print ads. 10% of freelance work demands knowledge of QuarkXPress, Photoshop, Illustrator.

FIRST CONTACT & TERMS Send postcard, tearsheets or digital submission. Samples are filed or are returned. Will contact artist for portfolio review if interested. Portfolio should include color thumbnails, roughs, tearsheets, and photographs. Pays for design and illustration by the hour, by the project, or by the day. Rights purchased vary according to project.

FORDESIGN GROUP

5405 South 550 East, Ogden UT 84405. (801)479-4002. **E-mail:** steven@fordesign.net. **Website:** www.fordesign.net. **Contact:** Steven Ford, owner. Estab. 1990. Specializes in brand and corporate identity, package and website design. Clients: corporations. Current clients include Sony, IBM, Cadbury Beverage, Carrs, MasterCard. Professional affiliations: AIGA, PDC.

NEEDS Approached by 100 freelancers/year. Works with 6-10 freelance illustrators and 4-6 designers/year. Uses illustrators mainly for brochures, ads. Uses designers mainly for corporate identity, packaging, collateral. Also uses freelancers for ad and brochure design and illustration, logos. Needs bright, conceptual designers and illustrators. 90% of freelance work demands skills in Illustrator, Photoshop, FreeHand and Dreamweaver.

FIRST CONTACT & TERMS Send postcard sample of work or send photostats, slides and transparencies. Samples are filed or returned by SASE if requested by artist. Will contact artist for portfolio review if interested. Portfolio should include b&w and color samples. Pays for design by the hour or by the project. Pays for illustration by the project.

TIPS "We review *Showcase*, *Workbook*, etc. We are impressed by great work, simply presented. Save money on promotional materials by partnering with printers. Create a joint project or tie-in."

FREEASSOCIATES

8117 W. Manchester Ave., Suite 417, Playa Del Rey CA 90293. (310)441-9950. **Fax:** (310)441-9949. **E-mail:** jfreeman@freeassoc.com. **Website:** www.freeassoc.com. **Contact:** Josh Freeman, president/creative director. Estab. 1993. Number of employees: 4. Design firm. Specializes in marketing materials for corporate clients. Client list available upon request. Professional affiliations: AIGA.

NEEDS Approached by 60 illustrators and 30 designers/year. Works with 3 illustrators and 3 designers/year. Prefers freelancers with experience in top level design and advertising. Uses freelancers mainly for design, production, illustration; also for airbrushing, brochure design and illustration, catalog design and illustration, lettering, logos, mechanicals, multimedia projects, posters, retouching, signage, storyboards, technical illustration and web page design. 30% of work is with print ads. 90% of design and 50% of il-

lustration demand skills in Photoshop, InDesign CS, Illustrator.

FIRST CONTACT & TERMS Designers: E-mail query letter with PDFs or JPEGs of work, résumé, website link. Illustrators: E-mail sample of work. Accepts Mac-compatible disk submissions to view in current version of major software or self-running presentations—CD OK. Samples are filed or returned by SASE. Will contact for portfolio review if interested. Pays for design and illustration by the project; negotiable. Rights purchased vary according to project. Finds artists through iSpot.com and other online resources, *LA Workbook*, *CA*, *Print*, *Graphis*, submissions and samples.

TIPS "Designers should have their own computer and high speed Internet connection. Must have sensitivity to marketing requirements of projects they work on. Deadline commitments are critical."

G2 PARTNERS

(888)309-5818. **E-mail:** jamie@g2partners.com. **Website:** www.g2partners.com. **Contact:** Jamie Greenebaum. Estab. 1975. Ad agency. Specializes in business-to-business marketing communications (advertising, direct mail, branding and identity, Internet presence, corporate literature, investor relations) for a variety of regional, national and international clients, large and small.

NEEDS Uses freelancers mainly for advertising, direct mail and literature; also for brochure and print ad illustration.

FIRST CONTACT & TERMS Samples are filed or are returned by SASE if requested by artist. Responds only if interested. Pays for illustration by the project: $500-3,500. Finds artists through online sources.

GIRVIN STRATEGIC BRANDING

3131 Western Ave. #510, Seattle WA 98121. (206)674-7808. **Fax:** (206)674-7909. **E-mail:** info@girvin.com. **Website:** www.girvin.com. Estab. 1977. Design firm. Number of employees: 20. Specializes in corporate identity and brand strategy, naming, Internet strategy, graphic design, signage and packaging. Clients: Kerzner, Kraft, NaturoMedica, Nintendo, Paramount, Procter & Gamble, Simon Golub & Sons and Schwartz Brothers.

NEEDS Works with some freelance copy writers, photographers, web programmers, illustrators, production artists and designers/year.

FIRST CONTACT & TERMS Designers: Send query letter with appropriate samples. Illustrators: Send postcard sample or other nonreturnable samples. Will contact for portfolio review if interested. Payment negotiable.

GLOBAL FLUENCY

1494 Hamilton Ave., San Jose CA 95125. (408)677-5300. **Fax:** (408)677-5301. **Website:** www.globalfluency.com. Estab. 1986. Communications, integrated marketing and PR firm. Specializes in promotions, corporate identity, collateral design, annuals, graphic and ad design and web design. Product specialties are Internet, high-tech, computer systems and peripherals, medical and consumer packaged goods. Clients include NTT Group, Host Analytics, Courtyard by Marriott Palo Alto, Netline, among others.

NEEDS Approached by 20 freelance artists/month. Works with 2-3 freelance illustrators and 2-3 freelance designers/month. Prefers local artists with experience in all areas of manual and electronic art capabilities. Works on assignment only. Uses freelance artists mainly for brochure design and illustration, print ad illustration, infographics, presentations and videography. Needs freelancers for design, illustration, production and presentation.

FIRST CONTACT & TERMS Send query letter with "best work samples in the area you're best in or e-mail it with links to online portfolio and profile." Pays for design by the hour. Negotiates rights purchased.

GRAPHIC DESIGN CONCEPTS

15329 Yukon Ave., El Camino Village CA 90260-2452. (310)978-8922. **Contact:** C. Weinstein, president. Estab. 1980. Specializes in package, publication and industrial design, annual reports, corporate identity, displays and direct mail. Clients: Trust Financial Financial Services (marketing materials). Current projects include new product development for electronic, hardware, cosmetic, toy and novelty companies.

NEEDS Works with 15 illustrators and 25 designers/year. "Looking for highly creative idea people, all levels of experience." All styles considered. Uses illustrators mainly for commercial illustration. Uses designers mainly for product and graphic design. Also uses freelancers for brochure, P-O-P, poster and catalog design and illustration; book, magazine, direct mail and newspaper design; mechanicals; retouching; airbrushing; model-making; charts/graphs; lettering; lo-

gos. Also for multimedia design, program and content development. 50% of freelance work demands knowledge of PageMaker, Illustrator, QuarkXPress, Photoshop or FreeHand.

FIRST CONTACT & TERMS Send query letter with brochure, résumé, tearsheets, photostats, photocopies, slides, photographs or transparencies. Accepts disk submissions compatible with Windows. Samples are filed or returned if accompanied by SASE. Responds in 10 days with SASE. Portfolio should include thumbnails, roughs, original/final art, final reproduction/product, tearsheets, transparencies and references from employers. Pays by the hour, $15-50. Considers complexity of project, client's budget, skill and experience of artist, how work will be used, turnaround time, and rights purchased when establishing payment.

TIPS "Send a résumé, if available. Send samples of recent work or *high-quality* copies. Everything sent to us should have a professional look. After all, it is the first impression we will have of you. Selling artwork is a business. Conduct yourself in a professional manner."

GRETEMAN GROUP

1425 E. Douglas Ave., Wichita KS 67211. (316)263-1004. **E-mail:** dharms@gretemangroup.com. **Website:** www.gretemangroup.com. **Contact:** Deanna Harms, media relations. Estab. 1989. Number of employees: 19. Marketing communications. Specializes in corporate identity, advertising, annual reports, signage, website design, interactive media, brochures, collateral. Professional affiliations AIGA.

NEEDS Approached by 20 illustrators and 20 designers/year. Illustration demands computer skills in Photoshop and Illustrator.

FIRST CONTACT & TERMS Send query letter with brochure and résumé. Accepts disk submissions. Send EPS files. Samples are filed. Will contact for portfolio review of b&w and color final art and photostats if interested. Pays for illustration by the project. Rights purchased vary according to project.

GREY NEW YORK

200 Fifth Ave., New York NY 10010. (212)546-2000. **Fax:** (212)546-2001. **E-mail:** jim.heekin@grey.com; inquiries@grey.com. **Website:** www.grey.com. **Contact:** Jim Heekin, chairman and CEO. Professional affiliations 4A's Art Services Committee.

NEEDS Approached by hundreds of freelancers/year. Clients include Pantene, DDF, Diago, and 3M. Works

with about 300 freelancers/year. Freelancers are needed mostly for illustration and photography, but also for model-making, fashion styling and lettering.

FIRST CONTACT & TERMS Works on assignment only. E-mail query with website link for initial contact. No follow-up e-mails. Does not respond unless interested and an appropriate project arises. Pays by the project. Considers client's budget and rights purchased when establishing fees.

TIPS "Show your work in a neat and organized manner. Have sample leave-behinds or website link and do not expect to leave with a job."

GRIFFIN MARKETING SERVICES, INC.

7357 International Place, Suite 102, Sarasota FL 34240. 941-312-5350. **E-mail:** shannon@griffinmarketingservices.com. **Website:** www.griffinmarketingservices.com. **Contact:** Shannon Luther, vice president/creative director. Estab. 1974. Number of employees 20. Approximate annual billing $4 million. Integrated marketing firm. Specializes in collateral, direct mail, multimedia. Product specialty is industrial. Current clients include Hyatt, USX, McDonald's.

NEEDS Works with 20-30 freelance illustrators and 2-30 designers/year. Prefers artists with experience in computer graphics. Uses freelancers mainly for design and illustration. Also uses freelancers for animation, model making and TV/film graphics. 75% of work is with print ads. Needs computer-literate freelancers for design, illustration, production and presentation. 95% of freelance work demands knowledge of PageMaker, FreeHand, Photoshop, QuarkXPress and Illustrator.

FIRST CONTACT & TERMS Send query letter with SASE or e-mail. Samples are not filed and are returned by SASE if requested by artist. Responds in 1 month. Will contact artist for portfolio review if interested. Pays for design and illustration by the hour, $20-150; or by the project.

TIPS Finds artists through *Creative Black Book*.

HANSEN BELYEA

109 West Denny Way, Suite 312, Seattle WA 98119. (206)682-4895. **E-mail:** hello@hansenbelyea.com; ron@hansenbelyea.com. **Website:** www.hansenbelyea.com. **Contact:** Ron Hansen. Estab. 1988. Creative agency specializes in branding, marketing and communication programs including corporate identity, websites and videos, marketing

collateral. Clients: B2B and B2C-professional services, education, manufacturers. Current clients include PEMCO Insurance, University of Washington, Washington Global Health Alliance, Robbins Tunnel Boring Machines.

NEEDS Approached by 20-30 freelancers/year. Works with 1-3 freelance illustrators/photographers and no designers/year. Works on assignment only. Also uses freelancers for calligraphy.

FIRST CONTACT & TERMS Direct mail and electronic communication accepted. Responds only if interested. Pays for illustration by the project. Rights purchased vary according to project. Finds artists through submissions and referral by other professionals.

TIPS "Illustrators and photographers must deliver digital files. Illustrators must develop a style that makes them unique in the marketplace. When pursuing potential clients, send something distinctive. Follow up. Be persistent (it can take 1 or 2 years to get noticed) but not pesky."

HARMON GROUP

807 Third Ave. S., Nashville TN 37210. (615)256-3393. **E-mail:** contact@harmongrp.com. **Website:** www. harmongrp.com. Estab. 1988. Approximate annual billing $7.2 million. Specializes in luxury consumer products, brand identity, display and direct mail design and signage. Clients: consumer product companies, corporations, mid-size businesses.

NEEDS Approached by 20 freelancers/year. Uses illustrators mainly for P-O-P. Uses designers mainly for flyers and catalogs. Also uses freelancers for ad, brochure, catalog, poster and P-O-P design and illustration, logos, magazine design, mechanicals and retouching. 85% of freelance work demands skills in Illustrator, Photoshop and QuarkXPress.

FIRST CONTACT & TERMS Send photographs, résumé, slides and transparencies. Samples are filed. Will contact artist for portfolio review if interested. Portfolio should include color final art, roughs, slides and thumbnails. Pays for design and illustration by the project. Rights purchased vary according to project. Finds artists through sourcebooks and portfolio reviews.

HILL AND KNOWLTON, INC.

+44 2074 133132. **E-mail:** sam.lythgoe@hkstrategies. com. **Website:** www.hkstrategies.com. Estab. 1927. Number of employees: 1,800 (worldwide). PR firm; full-service multimedia firm. Specializes in corporate communications, marketing communications, public affairs, health care/pharmaceuticals, technology. Creative services include reports, collateral materials, corporate identity, presentation design, signage and advertisements.

NEEDS Works with 0-10 freelancers/month. Works on assignment only. Uses freelancers for editorial, technical and medical illustration; also for storyboards, slide illustration, animatics, mechanicals, presentation design, retouching. 10% of work is with print ads. Needs computer-literate freelancers for illustration. Freelancers should be familiar with Adobe Creative Suite: Photoshop, Illustrator, InDesign, and Microsoft PowerPoint.

FIRST CONTACT & TERMS Send query letter with promo and samples. Samples are filed. Does not respond, in which case the artist should "keep in touch by mail—do not call." Call and drop-off only for a portfolio review. Pays freelancers by the project, $250-5,000. Negotiates rights purchased.

TIPS Looks for "variety; unique but marketable styles are always appreciated."

HORNALL ANDERSON

710 Second Ave., Suite 1300, Seattle WA 98104. (206)467-5800. **E-mail:** us@hornallanderson.com. **Website:** www.hornallanderson.com. Estab. 1982. Specializes in full-range integrated brand and communications strategy, corporate identity, digital and interactive experience design, packaging, corporate literature, collateral, retail and environmental graphics. Clients: Holland America Line, Redhook Brewery, Microsoft, Madison Square Garden, Starbucks, Skydeck Chicago at Willis Tower, Empire State Building, Pepsico, and HTC. Professional affiliations: AIGA, Seattle Design Association, Art Directors Club.

This firm has received numerous awards and honors, including the International Mobius Awards, London International Advertising Awards, ADDY Awards, Communication Arts, AIGA, Clio Awards, Webby Awards, and Graphis Awards.

NEEDS Interested in all levels, from senior print and interactive design personnel to interns with design experience. Additional illustrators and freelancers are used on an as-needed basis in design and online media projects

FIRST CONTACT & TERMS Designers: Send query letter with photocopies and résumé or e-mail. Illustrators: Send résumé/cover letter and samples (URL link, PDF, JPEGS, If appropriate hard copies are accepted, but won't be returned. Samples are filed. Responds only if interested. Portfolios may be dropped off, but must be picked up by owner following review. Finds designers through word of mouth and submissions; illustrators through sourcebooks, reps and submissions. No unsolicited third party recruiter résumé submissions.

HOWARD DESIGN GROUP

20 Nassau St., Suite 250W, Princeton NJ 08542. (609)924-1106. **Fax:** (609)924-1165. **E-mail:** diane@howarddesign.com; carl@howarddesign.com. **Website:** www.howarddesign.com. **Contact:** Diane Savoy, vice president. Estab. 1980. Number of employees: 10. Specializes in marketing and design for packaging websites, corporate identity, college recruitment materials and publication design. Clients: corporations, wholesalers, schools and colleges.

NEEDS Approached by 20 freelancers/year. Works with 10 freelance illustrators and 5 designers/year. Uses freelancers mainly for publication design; also for brochure design and illustration; catalog, direct mail, magazine and poster design; logos. Needs computer-literate freelancers for design and production. 100% of freelance work demands knowledge of Illustrator, Photoshop, FreeHand and QuarkXPress.

FIRST CONTACT & TERMS Send résumé. Samples are filed. Will contact artist for portfolio review if interested. Portfolio should include color final art, roughs and thumbnails. Pays for design and illustration by the project. Buys one-time rights. Finds artists through *Showcase*.

TIPS Looks for "innovative design in portfolio."

HOWARD/FROST ADVERTISING COMMUNICATIONS

1420 NW Gilman Blvd. #2756, Issaquah WA 98027. (206)310-4878. **E-mail:** jack@hofro.com. **Website:** www.hofro.com. Estab. 1994. Number of full-time employees 4. Ad agency. Specializes in media advertising, collateral, web design, web advertising and direct mail. Client list is available upon request.

NEEDS Approached by 20-30 illustrators and 10-15 designers/year. Works with 10 illustrators and 2 designers/year. Works only with artist reps. Uses freelancers mainly for illustration, design overload. Also

for airbrushing, animation, billboards, brochure, humorous and technical illustration, lettering, logos, multimedia projects, retouching, storyboards, web page design. 60% of work is with print ads. 60% of freelance design demands knowledge of PageMaker, FreeHand and Photoshop.

FIRST CONTACT & TERMS Designers: Send query letter with photocopies. Illustrators: Send postcard sample. Accepts disk submissions. Send files compatible with Acrobat, InDesign, Illustrator, Dreamweaver, Flash or Photoshop. Samples are filed and not returned. Responds only if interested. Art director will contact artist for portfolio review if interested. Pays for design and illustration by the project. Negotiates rights purchased.

TIPS "Be patient."

HOWARD/MERRELL

4800 Falls of Neuse Rd., Suite 300, Raleigh NC 27609. (919)848-2400. **Fax:** (919)845-9845. **E-mail:** sstyons@howardmerrell.com; info@howardmerrell.com. **Website:** www.howardmerrell.com/. **Contact:** Stephanie Styons. Estab. 1993. Number of employees: 60. Approximate annual billing: $90 million. Ad agency. Full-service, multimedia firm. Specializes in ads, collateral, full service TV, broadcast. Product specialties are industrial and high-tech. Clients include Colonial Bank, Interton, Zilla.

NEEDS Approached by 25-50 freelancers/year. Works with 10-12 freelance illustrators and 20-30 designers/year. Uses freelancers for brochure design and illustration, catalog design, logos, posters, signage and P-O-P. 40% of work is with print ads. Needs computer-literate freelancers for design, illustration, production and presentation. 100% of freelance work demands knowledge of Photoshop, InDesign and Illustrator.

FIRST CONTACT & TERMS Send postcard sample of work or query letter with photocopies. Samples are filed. Request portfolio review in original query. Will contact artist for portfolio review if interested. Portfolio should include b&w and color final art. Pays for design by the hour, $25-65. Pays for design and illustrator by the hour or project.

HOWRY DESIGN ASSOCIATES

354 Pine St., Suite 600, San Francisco CA 94104. (415)433-2035. **Fax:** (415)433-0816. **E-mail:** hello@howry.com. **Website:** www.howry.com. **Contact:** Jill Howry, principal/creative director. Estab. 1988. Full

service design studio. Number of employees: 10. Specializes in annual reports, corporate identity, print, advertising and multimedia. Clients: startups to Fortune 100 companies. Current clients include Del Monte, Affymetrix, Geron Corp., McKesson Corp., First Republic Bank. Professional affiliation: AIGA.

NEEDS Works with 30 freelance illustrators, photographers and Internet and print designers/year. Works on assignment only. Uses illustrators for "anything that applies." Uses designers mainly for newsletters, brochures, corporate identity. Also uses freelancers for production, programming, retouching, photography/illustration, logos and charts/graphs. 100% of design work, 10% of illustration work demands knowledge of InDesign, Illustrator or Photoshop.

FIRST CONTACT & TERMS Samples are filed. Responds only if interested. Portfolios may be dropped off every Thursday. Pays for design/production by the hour, or by the job, $25-60. Pays for photography and illustration on a per-job basis. Rights purchased vary according to project.

TIPS Finds artists through sourcebooks, samples, representatives.

HUTCHINSON ASSOCIATES, INC.

822 Linden Ave., Suite 200, Oak Park IL 60302. (312)455-9191. **Fax:** (312)455-9190. **E-mail:** hutch@hutchinson.com. **Website:** www.hutchinson.com. **Contact:** Jerry Hutchinson, president. Estab. 1988. Member of American Institute of Graphic Arts. Design firm. Number of employees: 3. Firm specializes in brand identity design, website design and development, annual reports, collateral, advertising, publication design, marketing brochures. Types of clients: industrial, financial, real estate, retail, publishing, nonprofit and medical. Recent client: Cardinal Growth.

Work from Hutchinson Associates has been published in the following design books: *Graphis Design* (Graphis Publications); *Revival of the Fittest: Digital Versions of Classic Typefaces* (North Light Books); *Simpson Paper Show Catalog* (Simpson Paper, San Francisco); *Working With Computer Type*, Vols. 1-3 (Rotovision); *Context One* (Sappi Papers); *Logo Lounge*, Vols. 1-3 (Rockport); *1,000 Invitations* (Rockport); *Publication Design Workbook* (Rockport); *Letterhead and Logo Design 9* (Rockport).

NEEDS Approached by 5-10 freelancers/year. Works with 3-4 freelance illustrators and 5-15 designers/year.

FIRST CONTACT & TERMS Send e-mail with link/postcard. Designers, please send letter, link and resume. Samples/links are filed/marked. Request portfolio review in original query. Artist should follow up with call. Will contact artist for portfolio review if interested. Pays by the project, $100-10,000. Rights purchased vary according to project. Finds artists through sourcebooks, submissions, websites and reps.

TIPS "Persistence pays off."

IDEA BANK MARKETING

701 W. Second St., Hastings NE 68901. (402)463-0588. **Fax:** (402)463-2187. **E-mail:** sherma@ideabankmarketing.com or via online contact form. **Website:** www.ideabankmarketing.com. **Contact:** Sherma Jones, creative director. Estab. 1982. Number of employees: 14. Approximate annual billing: $2.5 million. Ad agency. Specializes in print materials, direct mail. Product specialty is manufacturers. Client list available upon request. Professional affiliations: Advertising Federation of Lincoln, American Marketing Association.

NEEDS Approached by 2 illustrators/year. Works with 2 illustrators and 2 designers/year. Prefers local designers only. Uses freelancers mainly for illustration; also for airbrushing, catalog and humorous illustration, lettering. 30% of work is with print ads. 75% of design demands knowledge of Photoshop, Illustrator. 60% of illustration demands knowledge of Photoshop, Illustrator.

FIRST CONTACT & TERMS Designers/illustrators: Send query letter with brochure. Send follow-up postcard samples every 6 months. Accepts disk submissions compatible with original illustration files or Photoshop files. Samples are filed or returned by SASE. Responds only if interested. Will contact artist for portfolio review of b&w, color, final art, tearsheets if interested. Pays by the project. Rights purchased vary according to project and are negotiable. Finds artists through word of mouth.

IMAGE ASSOCIATES, INC.

5311 S. Miami Blvd., Suite G, Durham NC 27703. (919)876-6400. **Fax:** (919)876-6400. **E-mail:** info@imageassociates.com. **Website:** www.imageassociates.com. Estab. 1984. Marketing communications group offering advanced web-based solutions, multimedia and print. Visual communications firm specializing in computer graphics and AV, multi-image,

interactive multimedia, Internet development, print and photographic applications.

NEEDS Prefers freelancers with experience in web, CD and print. Works on assignment only. Uses freelancers mainly for Web design and programming. Also for print ad design and illustration and animation. 90% of freelance work demands skills in Flash, HTML, DHTML, ASP, Photoshop and Macromind Director.

FIRST CONTACT & TERMS Send query letter with brochure, résumé and tearsheets. Samples are filed or are returned by SASE if requested by artist. Responds only if interested. To show portfolio, mail roughs, finished art samples, tearsheets, final reproduction/product and slides. Pays for assignments by the project. Considers complexity of project, client's budget and how work will be used when establishing payment. Rights purchased vary according to project.

⌾ IMAGINASIUM, INC.

110 S. Washington St., Green Bay WI 54301. (920)431-7872, ext. 101 or (800)820-4624. **E-mail:** info@imaginasium.com. **Website:** www.imaginasium.com. **Contact:** Denis Kreft. Estab. 1992. Approximate annual billing: $4 million. Strategic marketing communications firm. Specializes in brand development. Product specialties are business to business.

NEEDS Prefer local designers. Uses freelancers mainly for overflow. 100% of design and 75% of illustration demands skills in Photoshop, QuarkXPress and Illustrator.

FIRST CONTACT & TERMS Send query letter with work samples. Accepts Mac-compatible disk submissions. Samples are filed and are not returned. Will contact for portfolio review if interested. Pays for design by the hour; illustration by the project. Rights purchased vary according to project. Finds artists through submissions, word of mouth, Internet.

IMPACT COMMUNICATIONS GROUP

(714)963-6760. **Fax:** (714)963-0080. **E-mail:** web@impactgroup.com; via online contact form. **Website:** www.impactgroup.com. **Contact:** Brad Vinikow, creative director. Estab. 1983. Number of employees: 15. Marketing communications firm; full-service multimedia firm. Specializes in electronic media, business-to-business and print design. Current clients include Yamaha Corp., Prudential, Isuzu. Professional affiliations: IICS, NCCC and ITVA.

NEEDS Approached by 12 freelancers/year. Works with 12 freelance illustrators and 12 designers/year. Uses freelancers mainly for illustration, design and computer production; also for brochure and catalog design and illustration, multimedia and logos. 10% of work is with print ads. 90% of design and 50% of illustration demands knowledge of Photoshop, QuarkXPress, Illustrator and Macro Mind Director.

FIRST CONTACT & TERMS Designers: Send query letter with photocopies, photographs, résumé and tearsheets. Illustrators: Send postcard sample. Samples are filed and are not returned. Will contact artist for portfolio review if interested. Portfolio should include b&w and color final art, photographs, photostats, roughs, slides, tearsheets and thumbnails. Pays for design and illustration by the project, depending on budget. Rights purchased vary according to project. Finds artists through sourcebooks and self-promotion pieces received in mail.

TIPS "Be flexible."

⌾ INNOVATIVE DESIGN & GRAPHICS

1327 Greenleaf St., Evanston IL 60202-1152. (847)475-7772. **E-mail:** sales@idgevanston.com. **Website:** idgevanston.com. Clients: corporate communication and marketing departments.

NEEDS Works with 1-2 freelance artists/year. Prefers local artists only. Uses artists for editorial and technical illustration and marketing, advertising and spot illustration. Illustrators should be knowledgeable in Adobe Illustrator and Photoshop.

FIRST CONTACT & TERMS Send query letter with résumé or brochure showing art style, tearsheets and photographs. Will contact artist for portfolio review if interested. Pays for illustration by the project, $200-1,000 average. Considers complexity of project, client's budget and turnaround time when establishing payment. Interested in buying second rights (reprint rights) to previously published work.

TIPS "Looking for people who can grasp complex ideas and turn them into high-quality illustrations. Ability to draw people well is a must. Do not call for an appointment to show your portfolio. Send nonreturnable tearsheets or self-promos; we will call you when we have an appropriate project for you."

⌾ JUDE STUDIOS

8000 Research Forest, Suite 115-266, The Woodlands TX 77382. (281)364-9366. **E-mail:** frontdesk@

judestudios.com. **Contact:** Judith Dollar, art director. Estab. 1994. Number of employees: 2. Design firm. Specializes in printed material, brochure, trade show, collateral, illustration, and logodesign. Product specialties are destination marketing, restaurant, homebuilder, financial, business to business, nonprofit, and event marketing materials.

NEEDS Uses freelancers mainly for illustration and lettering. Use of Adobe CS required.

FIRST CONTACT & TERMS Designers and illustrators can e-mail with link to webpage or blog (no attachments). Pays by the project; varies. Negotiates rights purchased. Finds artists through directories or online.

TIPS Wants freelancers with good type usage who contribute to concept ideas. "We are open to designers and illustrators who are just starting out their careers."

KETCHUM PLEON CHANGE

1285 Avenue of the Americas, New York NY 10019. (646)935-4300. **Website:** www.ketchum.com. **Contact:** Jon Abels. (Formerly Stromberg Consulting.) Specializes in direct marketing, internal and corporate communications. Clients: industrial and corporate. Produces multimedia presentations and print materials.

NEEDS Assigns 25-35 jobs/year. Prefers local designers only (Manhattan and its 5 burroughs) with experience in animation, computer graphics, multimedia and Macintosh. Uses freelancers for animation logos, posters, storyboards, training guides, Web Flash, application development, design catalogs, corporate brochures, presentations, annual reports, slide shows, layouts, mechanicals, illustrations, computer graphics and desktop publishing web development, application development.

FIRST CONTACT & TERMS "Send note on availability and previous work." Responds only if interested. Provide materials to be kept on file for future assignments. Originals are not returned. Pays hourly or by the project.

TIPS Finds designers through word of mouth and submissions.

KIZER INCORPORATED ADVERTISING & COMMUNICATIONS

13514 Vixen Ln., Suite B, Oklahoma City OK 73131. (405)708-4302. **E-mail:** mrkt@kizerincorporated.com. **Website:** www.kizerincorporated.com. Estab. 1998. Number of employees: 5. Creative shop specializing in campaign planning, creative development and production. 65% print, 20% web, 15% broadcast/other. 65% of work is print ads, brochures, annual reports, direct mail. InDesign is primary design software used. Professional affiliations: OKC Ad Club, AMA, AIGA.

NEEDS Approached by 30+ illustrators and designers/year. Works with varying number of illustrators and designers/year.

FIRST CONTACT & TERMS Direct mail or e-mail queries are both acceptable. For e-mail contacts, prefers link back to artist's portfolio to see samples. No large attachments, please. Responds if interested. Pays by the project. Rights purchased vary according to project. Finds artists through agents, sourcebooks, online services, magazines, word of mouth, artist's submissions.

LEKASMILLER

1460 Maria Lane, Suite 260, Walnut Creek CA 94596. (925)934-3971. **Fax:** (925)934-3978. **E-mail:** tina@lekasmiller.com. **Website:** www.lekasmiller.com. Estab. 1979. Specializes in annual reports, corporate identity, advertising, direct mail and brochure design. Clients: corporate, higher education, and retail. Current clients include UC Berkeley, UCSF, Stanford and UCLA, Mills College, Sutter Health, Dignity Health, John Muir Health Foundation.

NEEDS Approached by 80 freelance artists/year. Works with 1-3 illustrators and 5-7 designers/year. Prefers local artists only with experience in design and production. Works on assignment only. Uses artists for brochure design and illustration, mechanicals, direct mail design, logos, ad design and illustration. 100% of freelance work demands knowledge of InDesign, Photoshop and Illustrator.

FIRST CONTACT & TERMS Designers/illustrators: E-mail PDF or résumé and portfolio. Responds only if interested. Considers skill and experience of artist when establishing payment. Negotiates rights purchased.

LISA LELEU STUDIOS, INC.

187 E. Court St., Doylestown PA 18901. (215)345-1233. **E-mail:** contact@lisaleleustudios.com. **Website:** www.lisaleleustudios.com. Estab. 1986. (Formerly Fullmoon Creations, Inc.) Number of employees: 10. Specializes in new product ideas, new product concept development, product name generations, brand development, product design, packaging de-

sign, packaging structure design, packaging descriptive copy writing. Clients: Fortune 500 corporations to middle companies. Current clients are top manufacturers involved in new product and packaging development including health, cosmetic, food, candy, product and service of any kind. **FIRST CONTACT & TERMS** Freelance writers and illustrators are welcome to send postcards and/or e-mail to us for review.

LOHRE & ASSOCIATES, INC.

126A W. 14th St., 2nd Floor, Cincinnati OH 45202-7535. (513)961-1174. **Website:** www.lohre.com. **Contact:** Chuck Lohre, president. Number of employees: 6. Approximate annual billing: $1 million. Ad agency. Specializes in industrial firms. Professional affiliation: SMPS, U.S. Green Building Council, Cincinnati Regional Chapter.

NEEDS Approached by 24 freelancers/year. Works with 10 freelance illustrators and 10 designers/year. Works on assignment only. Uses freelance artists for trade magazines, direct mail, P-O-P displays, multimedia, brochures and catalogs. 100% of freelance work demands knowledge of InDesign, Photoshop and Illustrator.

FIRST CONTACT & TERMS Send postcard sample or e-mail. Accepts submissions on disk, any Mac application. Pays for design and illustration by the hour, $10 minimum.

TIPS Looks for artists who "have experience in chemical and mining industry, can read blueprints and have worked with metal fabrication. Also sustainable building materials." Also needs "Mac-literate artists who are willing to work at office, day or evenings."

☺ LORENC & YOO DESIGN, INC.

109 Vickery St., Roswell GA 30075-4926. (770)645-2828. **Fax:** (770)998-2452. **E-mail:** jan@lorencyoodesign.com. **Website:** www.lorencyoodesign.com; Blog: www.janondesign.com. **Contact:** Jan Lorenc, president. Celebrating over 38 years of practicing design for the world's finest brands in China, Korea, Japan, India, Europe, Middle East, Africa and the US. Specializes in architectural signage design; exhibit design for museums and trade shows. Clients: corporate, developers, product manufacturers, architects, real estate and institutions. Current clients include Delta Air Lines, Samsung, Sony, UPS, Georgia-Pacific, IBM, Simon Property Co., Mayo Clinic. Client list available upon request.

NEEDS Approached by 25 freelancers/year. Works with 2 illustrators and 5 designers/year. Local senior designers only. Uses freelancers for design, illustration, brochures, catalogs, books, P-O-P displays, mechanicals, retouching, airbrushing, posters, direct mail packages, model-making, charts/graphs, AV materials, lettering and logos. Needs editorial and technical illustration. Especially needs architectural signage and exhibit designers. 95% of freelance work demands knowledge of QuarkXPress, Illustrator and InDesign.

FIRST CONTACT & TERMS Send brochure, web-link, CD, résumé and samples to be kept on file. Prefers digital files as samples. Samples are filed or returned. Call or write for appointment to show portfolio of thumbnails, roughs, original/final art, final reproduction/product, color photostats and photographs. Pays for design by the hour, $40-100; by the project, $250-20,000; by the day, $80-400. Pays for illustration by the hour, $40-100; by the project, $100-2,000; by the day, $80-400. Considers complexity of project, client's budget, and skill and experience of artist when establishing payment.

TIPS "We utilize freelancers on specialized needs and project overload."

JODI LUBY & COMPANY, INC.

288 Twin Lakes Rd., Salisbury CT 06068. (860)824-7039. **E-mail:** jodiluby@gmail.com. **Website:** www.jodiluby.com; jodiluby.blogspot.com. **Contact:** Jodi Luby, president. Estab. 1983. Specializes in branding, direct marketing, packaging, and web design. Clients: major magazines, startup businesses and corporate clients.

NEEDS Uses freelancers for production and web production. 100% of freelance work demands computer skills.

FIRST CONTACT & TERMS Send e-mail samples only. Samples are not filed and are not returned. Will contact artist for portfolio review if interested.

TAYLOR MACK ADVERTISING

21 W. Mountain, Suite 227, Fayetteville AR 72701. (479)444-7770. **E-mail:** greg@taylormack.com. **Website:** www.taylormack.com. **Contact:** Greg Mack, managing director. Estab. 1990. Number of employees 16. Approximate annual billing $3 million. Ad agency. Specializes in collateral. Current clients include Cobb, Jose's, Rheem-Rudd and Bikes, Blues and BBQ. Client list available upon request.

NEEDS Approached by 12 illustrators and 20 designers/year. Works with 4 illustrators and 6 designers/year. Uses freelancers mainly for brochure, catalog and technical illustration, TV/film graphics and web page design. 30% of work is with print ads. 50% of design and illustration demands skills in Photoshop, Illustrator and InDesign.

FIRST CONTACT & TERMS Designers: E-mail website links or URLs. Samples are filed or are returned. Responds only if interested. Art director will contact artist for portfolio review of photographs if interested. Pays for design by the project or by the day; pays for illustration by the project, $10,000 maximum. Rights purchased vary according to project.

MAHAN GRAPHICS

4 Brickyard Way, Bowdoinham ME 04008. (207)666-1098. **E-mail:** ldelorme@mahangraphics.com; info@mahangraphics.com. **Website:** www.mahangraphics.com. Estab. 1986. Number of employees: 5. Approximate annual billing $500,000. Design firm. Specializes in publication design—catalogs and direct mail. Product specialties are furniture, fine art and high tech. Clients: Bowdoin College, Bath Iron Works and Monhegan Museum. Professional affiliations G.A.G., AIGA and Art Director's Club-Portland ME.

NEEDS Approached by 5-10 illustrators and 10-20 designers/year. Works with 2 illustrators and 2 designers/year. Uses freelancers mainly for production. Also for brochure, catalog and humorous illustration and lettering. 5% of work is with print ads. 100% of design demands skills in Photoshop, QuarkXPress and InDesign.

FIRST CONTACT & TERMS Designers: Send query letter with photocopies and résumé. Illustrators: Send query letter with photocopies. Accepts CD/DVD submissions. Samples are filed and are not returned. Responds only if interested. Art director will contact artist for portfolio review of final art roughs and thumbnails if interested. Pays for design by the hour, $15-40. Pays for illustration by the hour, $18-60. Rights purchased vary according to project. Finds artists through word of mouth and submissions.

MANGAN HOLCOMB PARTNERS

2300 Cottondale Lane, Suite 300, Little Rock AR 72202. (501)376-0321. **Fax:** (501)376-6127. **E-mail:** chip@manganholcomb.com; david@manganholcomb.com. **Website:** www.manganholcomb.com. **Contact:** Chip Culpepper, creative director. Number of employees: 12. Approximate annual billing: $3 million. Marketing, advertising and PR firm. Clients: recreation, financial, tourism, retail, agriculture. Current clients include Citizens Bank, Farmers Bank & Trust, The Wilcox Group.

NEEDS Approached by 50 freelancers/year. Works with 8 freelance illustrators and 20 designers/year. Uses freelancers for consumer magazines, stationery design, direct mail, brochures/flyers, trade magazines and newspapers. Needs computer-literate freelancers for production and presentation. 30% of freelance work demands skills in Mac-based page layout and illustration software.

FIRST CONTACT & TERMS Query with samples, flier and business card to be kept on file. Include SASE. Responds in 2 weeks. Call or write for appointment to show portfolio of final reproduction/product. Pays by the project, $250 minimum.

MARKEFXS

E-mail: mark@mfxs.com. **Website:** www.mfxs.com. **Contact:** Mark Tekushan, creative director. Estab. 1985. Full-service multimedia firm. Specializes in TV, video, advertising, design and production of promos, show openings and graphics. Current clients include ESPN and HBO.

Los Angeles office: (323)933-3673

NEEDS Prefers freelancers with experience in television or advertising production. Works on assignment only. Uses freelancers mainly for design production. Also for animation, TV/film graphics and logos. Needs computer-literate freelancers for design, production and presentation.

FIRST CONTACT & TERMS E-mail your website link or mail DVD/CD. Coordinating Producer will contact artist for portfolio review if interested. Pays for design by the hour, $25-50. Finds artists through word of mouth.

MARKETAIDE SERVICES, INC.

P.O. Box 500, Salina KS 67402. (785)825-7161; (800)204-2433. **Fax:** (785)825-4697. **E-mail:** creative@marketaide.com. **Website:** www.marketaide.com. **Contact:** production manager. Estab. 1975. Full-service ad/marketing/direct mail firm. Clients: financial, industrial and educational.

NEEDS Prefers artists within one-state distance who possess professional expertise. Works on assignment only. Needs computer-literate freelancers for design, illustration and web design. 90% of freelance work

demands knowledge of QuarkXPress, Illustrator and Photoshop.

FIRST CONTACT & TERMS Send query letter with résumé, business card and samples to be kept on file. Samples not filed are returned by SASE only if requested. Responds only if interested. Write for appointment to show portfolio. Pays for design by the hour, $15-75 average. "Because projects vary in size, we are forced to estimate according to each job's parameters." Pays for illustration by the project.

TIPS "Artists interested in working here should be highly polished in technical ability, have a good eye for design, and be able to meet all deadline commitments."

MARKETING BY DESIGN

2012 19th St., Suite 200, Sacramento CA 95818. (916)441-3050. **E-mail:** creative@mbdstudio.com. **Website:** www.mbdstudio.com. Estab. 1977. Specializes in corporate identity and brochure design, publications, direct mail, trade shows, signage, display and packaging. Clients: associations and corporations.

NEEDS Approached by 50 freelance artists/year. Works with 6-7 freelance illustrators and 1-3 freelance designers/year. Works on assignment only. Uses illustrators mainly for editorial; also for brochure and catalog design and illustration, mechanicals, retouching, lettering, ad design and charts/graphs.

FIRST CONTACT & TERMS Send query letter with brochure, résumé, tearsheets. Samples are filed and are not returned. Does not respond. Artist should follow up with call. Call for appointment to show portfolio of roughs, color tearsheets, transparencies and photographs. Rights purchased vary according to project. Finds designers through word of mouth; illustrators through sourcebooks.

SUDI MCCOLLUM DESIGN

(818)243-1345. **E-mail:** sudimccollum@earthlink.net. **Website:** www.sudimccollum.com. **Contact:** Sudi McCollum. Specializes in home fashion design, graphic design, web design and illustration. Clients: home furnishing and giftware manufacturers, advertising agencies, businesses and graphic design studios; majority of clients are medium- to large-size businesses in home fashion and graphic design industry.

NEEDS Uses freelance production people either on computer or with painting and product design skills. Potential to develop into full-time job.

FIRST CONTACT & TERMS "Send query letter with samples or e-mail with web link. Responds only if interested."

MEDIA ENTERPRISES

1440-4 S. State College Blvd., Suite J, Anaheim CA 92806. (714)778-5336. **Fax:** (714)778-6367. **E-mail:** john@media-enterprises.com. **Website:** www.media-enterprises.com. **Contact:** John Lemieux Rose. Estab. 1982. Number of employees: 10. Approximate annual billing: $22 million. Integrated marketing communications agency. Specializes in web, social network marketing, mobile applications, public relations, magazine publishing. Product specialty high-tech, medical, manufacturing, luxury goods, apparel, food. Client list available upon request. Professional affiliations Small Business Administration, Society of North American Goldsmiths, Software Council of Southern California, NCECA, CODA, IPCA.

NEEDS Approached by 30 freelance illustrators and 10 designers/year. Works with 8-10 freelance illustrators and 3 designers/year. Uses freelancers for animation, humorous illustration, lettering, logos, web design, video, trade show & display, packaging, POP. 20% of work is with print ads, 80% digital media. 100% of freelance work demands skills in 3D, video, Photoshop, InDesign, Illustrator.

FIRST CONTACT & TERMS E-mail digital samples or website; pays by project; negotiated. Buys all rights.

MEDIA LOGIC INC.

1 Park Place, Albany NY 12205. (518)456-3015. **Website:** www.mlinc.com. **Contact:** Carol Ainsburg, director of studio services. Estab. 1984. Number of employees: 75. Approximate annual billing: $50 million. Media Logic, a leader in marketing innovation, is ushering in a new era of conversation-centric marketing, putting social at the center of business to achieve better customer engagement, advocacy and revenue growth. Combining more than 25 years of experience with its breakthrough Zeitgeist & Coffee social management program, Media Logic is helping organizations harness the power of social media to drive marketing strategy and brand evolution. Prefers freelancers with experience on MAC platform. Uses freelancers for Multimedia/Rich Media full build (footage editing and element animation for video creation) using Adobe Flash (including Action Script 3.0), After Effects, Premiere, Apple Final Cut Pro, and Max-

on Cinema 4D. Interactive design, and build using HTML, PHP, CSS, CMS (especially WordPress and Expression Engine). Also, high-end traditional print projects (DM, collateral, trade show panels, P-O-P) using Photoshop, InDesign, Illustrator, QuarkXPress. Candidates must be able to work on site. Compensation via hourly rate.

DONYA MELANSON ASSOCIATES

5 Bisson Lane, Merrimac MA 01860. (978)346-9240; (800)521-9172. **Fax:** (978)346-8345. **E-mail:** dmelanson@dmelanson.com. **Website:** www.dmelanson.com. **Contact:** Donya Melanson. Advertising agency. Number of employees: 1. Clients: government, education, associations, publishers, financial services and industries. Current clients include US Geological Survey, Mannesmann, Cambridge College, American Psychological Association, Ledakka Enterprises and US Department of Agriculture.

NEEDS Approached by 30 artists/year. Works with 2-3 illustrators/year. Most work is handled by staff, but may occasionally use freelance illustrators and designers. Uses artists for stationery design, direct mail, brochures/flyers, annual reports, charts/graphs and book illustration. Needs editorial and promotional illustration. Most freelance work demands skills in Adobe Illustrator, InDesign, Photoshop, or QuarkXPress.

FIRST CONTACT & TERMS Query with brochure, résumé, photocopies, tearsheets or CD. Provide materials (no originals) to be kept on file for future assignments. Originals returned to artist after use only when specified in advance. Call or write for appointment to show portfolio or mail nonoriginal, nonreturnable materials. Pays for design and illustration by the project, $100 minimum. Considers complexity of project, client's budget, skill and experience of artist and how work will be used when establishing payment.

TIPS "Be sure your work reflects concept development."

THE M. GROUP

2512 E. Thomas Rd., Suite 12, Phoenix AZ 85016. (480)998-0600. **Fax:** (480)998-9833. **E-mail:** gary@themgroupinc.com. **Website:** www.themgroupinc.com. **Contact:** Gary Miller. Estab. 1987. Number of employees: 7. Approximate annual billing: $2.75 million. Strategic visual communications firm. Special-izes in annual reports, corporate identity, direct mail, package design, advertising. Clients: corporations and small business. Current clients include American Cancer Society, BankOne, Dole Foods, Giant Industries, Motorola, Subway.

NEEDS Approached by 50 freelancers/year. Works with 5-10 freelance illustrators/year. Uses freelancers for ad, brochure, poster and P-O-P illustration. 95% of freelance work demands skills in Illustrator, Photoshop and QuarkXPress.

FIRST CONTACT & TERMS Send postcard sample or query letter with samples. Samples are filed or returned by SASE if requested by artist. Responds only if interested. Request portfolio review in original query. Artist should follow-up. Portfolio should include b&w and color final art, photographs and transparencies. Rights purchased vary according to project. Finds artists through publications (trade) and reps.

TIPS Impressed by "good work, persistence and professionalism."

MILICI VALENTI NG PACK

999 Bishop St., 24th Floor, Honolulu HI 96813. (808)536-0881. **E-mail:** ideas@mvnp.com. **Website:** www.mvnp.com. Estab. 1946. Approximate annual billing: $40 million. Ad agency. Clients: travel/tourism, food, finance, utilities, entertainment and public service. Current clients include First Hawaiian Bank, Aloha Airlines, Sheraton Hotels.

NEEDS Works with 2-3 freelance illustrators/month. Uses freelance artists mainly for illustration, retouching and lettering for newspapers, multimedia kits, magazines, radio, TV and direct mail. Artists must be familiar with advertising demands; used to working long distance through the mail and over the Internet; and familiar with Hawaii.

FIRST CONTACT & TERMS Send brochure, flyer and tearsheets or PDFs to be kept on file for future assignments.

MONDERER DESIGN, INC.

2067 Massachusetts Ave., 3rd Floor, Cambridge MA 02140. (617)661-6125. **Fax:** (617)661-6126. **E-mail:** info@monderer.com. **Website:** www.monderer.com. stewart@monderer.com. **Contact:** Stewart Monderer, president. Estab. 1981. Specializes in corporate identity, branding, print collateral, website, event and interactive solutions. Clients: corporations (technology, education, consulting and life science). Current clients include Solidworks, Thermo Scientific, MIT

Sloan, Northeastern University, Progress Software, Kronos, Greenlight Fund, Canaccord Genuity.

NEEDS Approached by 40 freelancers/year. Works with 10-12 illustrators and photographers/year. Works on assignment only.

FIRST CONTACT & TERMS Send query letter with brochure, tearsheets, photographs, photocopies or nonreturnable postcards, or links to website/HTML e-mails. Will look at links and PDF files. Samples are filed. Will contact artist for portfolio review if interested. Negotiates rights purchased. Finds artists through submissions, self-promotions and sourcebooks.

MRW COMMUNICATIONS

6 Barker Square Dr., Pembroke MA 02359. (781)924-5282. **Fax:** (781)926-0371. **E-mail:** jim@mrwinc.com. **Website:** www.mrwinc.com. **Contact:** Jim Watts, president. Estab. 2003. Ad agency. Specializes in branding, advertising, collateral, direct marketing, website development, online marketing. Product specialties are high tech, health care, business to business, financial services, and consumer. Client list available upon request.

NEEDS Approached by 40-50 freelance illustrators and 40-50 designers/year. Works with 5-10 freelance illustrators and 2-5 designers/year. Prefers freelancers with experience in a variety of techniques: brochure, medical and technical illustration, multimedia projects, retouching, storyboards, TV/film graphics and web page design. 50% of work is with print ads. 90% of design and 90% of illustration demands skills in Free-Hand, Photoshop, QuarkXPress, Illustrator.

FIRST CONTACT & TERMS Designers: Send query letter with photocopies, photographs, résumé. Illustrators: Send postcard sample and résumé, follow-up postcard every 6 months. Accepts disk submissions compatible with InDesign. Send EPS files. Samples are filed. Will contact for portfolio review of b&w, color final art if interested. Pays by the hour, by the project or by the day, depending on experience and ability. Rights purchased vary according to project. Finds artist through sourcebooks and word of mouth.

MYERS, MYERS & ADAMS ADVERTISING INC.

934 N. Victoria Park Road, Ft. Lauderdale FL 33304. (954)523-6262. **E-mail:** pete@mmanda.com. **Website:** www.mmanda.com. Estab. 1986. Number of employees 6. Approximate annual billing $2 million.

Ad agency. Full-service, multimedia firm. Specializes in magazines and newspaper ads; radio and TV; brochures; and various collateral. Product specialties are consumer and business-to-business. Current clients include Harley-Davidson, Wendy's and Embassy Suites. Professional affiliation Advertising Federation.

NEEDS Approached by 10-15 freelancers/year. Works with 3-5 freelance illustrators and 3-5 designers/year. Uses freelancers mainly for overflow. Also for animation, brochure and catalog illustration, model-making, posters, retouching and TV/film graphics. 55% of work is with print ads. Needs computer-literate freelancers for illustration and production. 20% of freelance work demands knowledge of PageMaker, Photoshop, QuarkXPress and Illustrator.

FIRST CONTACT & TERMS Send postcard-size sample of work or send query letter with tearsheets. Samples are filed and are returned by SASE if requested by artist. Will contact artist for portfolio review if interested. Portfolio should include b&w and color final art, roughs, tearsheets and thumbnails. Pays for design and illustration by the project, $50-1,500. Buys all rights. Finds artists through *Creative Black Book*, *Workbook* and artists' submissions.

ⓝ THE NAPOLEON GROUP

48 W. 25th St., 7th Floor, New York NY 10010. (212)692-9200. **Fax:** (212)692-0309. **E-mail:** jobs@napoleongroup.com. **Website:** www.napoleongroup.com. Estab. 1985. Number of employees: 40. AV firm. Full-service, multimedia firm. Specializes in storyboards, comps, magazine ads, computer graphic art and animatics. Leading provider in the "TEST" market. Product specialty is consumer. Clients: "all major New York City ad agencies." Client list not available.

NEEDS Approached by 20 freelancers/year. Works with 15 freelance illustrators and 5 designers/year. Prefers local freelancers with experience in animation, computer graphics, film/video production and multimedia. Works on assignment only. Uses freelancers for storyboards, animation, direct mail, logos and retouching. Needs computer-literate freelancers for design, illustration, production and presentation. 80% of freelance work demands skills in Illustrator or Photoshop.

FIRST CONTACT & TERMS Send e-mail samples with attachments of current work, query letter with photocopies, tearsheets, DVD or CD. Samples are filed. Responds only if interested. Will contact art-

ist for portfolio review if interested. Currently seeking cutting edge contemporary artists that can produce fast clean and realistic storyboard and animatic artwork. Computer coloring and drawing skills desired in applicants. Also seeking 3D animation artists, modelers and animators for consideration. Pays for design and illustration by the project. Rights purchased vary according to project. Finds artists through word of mouth and submissions.

THE OFFICE OF LOUIS NELSON

P.O. Box 995, New York NY 10025. (212)620-9191. **E-mail:** info@louisnelson.com. **Website:** www.louisnelson.com. **Contact:** Louis Nelson, president. Estab. 1980. Number of employees: 3-4. Approximate annual billing: $1.2 million. Specializes in environmental, interior and product design and brand and corporate identity, displays, packaging, publications, signage and wayfinding, exhibitions and marketing. Clients: nonprofit organizations, corporations, associations and governments. Current clients include Sutter Gold Mining, Wildflower Records, Port Authority of New York & New Jersey, MTA and NYC Transit, Massachusetts Port Authority. Professional affiliations: IDSA, AIGA, SEGD, APDF.

NEEDS Approached by 30-40 freelancers/year. Works with 30-40 designers/year. Works on assignment only. Uses freelancers mainly for specialty graphics and 3D design; also for design, photo-retouching, model-making and charts/graphs. 100% of design demands knowledge of PageMaker, QuarkXPress, Photoshop, Velum, Autocad, Vectorworks, Alias, Solidworks or Illustrator. Needs editorial illustration. Needs design more than illustration or photography.

FIRST CONTACT & TERMS Send postcard sample or query letter with résumé. Accepts disk submissions compatible with Illustrator 10.0 or Photoshop 7.0. Send EPS/PDF files. Samples are returned only if requested. Responds in 2 weeks. Write for appointment to show portfolio of roughs, color final reproduction/product and photographs. Pays for design by the hour, $15-25; or by the project, negotiable.

TIPS "I want to see how the artist responded to the specific design problem and to see documentation of the process–the stages of development. The artist must be versatile and able to communicate a wide range of ideas. Mostly, I want to see the artist's integrity reflected in the work."

NICE, LTD.—NICOSIA CREATIVE EXPRESSO, LTD.

330 W. Fifth Ave., New York NY 10001. (212)515-6617. **E-mail:** andrew.j@niceltd.com. **Website:** www.niceltd.com. **Contact:** Andrew Jacobi, executive director of development. Estab. 1993. Number of employees: 100. Full-service multicultural creative agency. Specializes in brand strategy, holistic design, graphic design, corporate/brand identity, brochures, promotional material, packaging, fragrance bottles and 3D animations. Current clients include Albion, AmorePacific, Estée Lauder Companies, Procter & Gamble, Dunhill, Gillette, Montblanc, Old Spice and Pantene.

Additional locations in Singapore, Tokyo, Phuket and Bangkok (see website for details).

NEEDS Approached by additional 80 freelancers/year. Works with 10 illustrators and 12 designers/year. Works by assignment only. Uses photographers, illustrators, designers, 3D computer artists and computer artists familiar with Illustrator, Photoshop, After Effects, Premiere, Macromedia Director, Flash and Alias Wavefront.

FIRST CONTACT & TERMS Send query letter and résumé. Responds for portfolio review only if interested. Pays for design by the hour. Pays for illustration by the project. Rights purchased vary according to project.

TIPS Looks for "promising talent and the right attitude."

NOSTRADAMUS ADVERTISING

884 West End Ave., Suite #2, New York NY 10025. (212)581-1362. **E-mail:** nos@nostradamus.net. **Website:** www.nostradamus.net. **Contact:** B. Sher, creative director. Specializes in book design, Web design, fliers, advertising and direct mail. Clients book publishers, nonprofit organizations and politicians.

NEEDS Works with 3 artists/year. Needs computer-literate freelancers for design and production. Freelancers should know InDesign, Quark, Photoshop, Dreamweaver.

FIRST CONTACT & TERMS Send query letter with brochure, résumé, business card, samples and tearsheets. Do *not* send slides as samples; will accept "anything else that doesn't have to be returned." Samples not kept on file are not returned. Responds only if interested. Call for appointment to show portfolio. Pays for illustration by the project, $150 minimum.

Considers skill and experience of artist when establishing payment.

NOTOVITZ COMMUNICATIONS

15 Cutter Mill Rd., Suite 212, Great Neck NY 11021. (516)467-4672. **E-mail:** joseph@notovitz.com. **Website:** www.notovitz.com. **Contact:** Joseph Notovitz, president. Number of employees: 4. Specializes in marketing communications (branding, annual reports, literature, publications, websites), corporate identity, exhibit signage, event design and writing. Clients: finance, real estate and industry. Professional affiliation: Specialty Graphic Imaging Association.

NEEDS Approached by 100 freelancers/year. Works with 10 freelance illustrators and 10 designers/year. Uses freelancers for brochure, poster, direct mail and booklet illustration; mechanicals; charts/graphs; and logo design. Needs computer-literate freelancers for design, illustration and production. 90% of freelance work demands expertise in InDesign, Illustrator and Photoshop. Needs pool of freelance Web developers with expertise in Flash, coding and design. Also collaborates on projects that writers and freelancers bring.

FIRST CONTACT & TERMS Send résumé and links to online examples of work. Responds "if there is fit and need." Pays for design and production work by the hour, $25-75. Pays for illustration by the project.

TIPS "Do a bit of research on the firm you are contacting. Send pieces that reflect the firm's style and needs. If we never produce book covers, book cover art does not interest us. Stress what you can do for the firm, not what the firm can do for you."

NOVUS VISUAL COMMUNICATIONS

59 Page Ave., Suite 300, Tower One, Yonkers NY 10704. (212)473-1377. **E-mail:** novuscom@aol.com. **Website:** www.novuscommunications.com. **Contact:** Robert Antonik, managing director. Estab. 1988. Number of employees: 2 + Freelance. Specializes in integrated marketing, interactive display design, multimedia, packaging, software developers, industrial, financial, retail, health care, entertainment and nonprofits. Understanding all components of Adobe Creative Suite tools. "Don't give up on the fine art of what you can create."

NEEDS Considers oil, acrylic, watercolor, pastel, mixed media, collage, paper, sculpture, ceramics, craft, fiber, glass, photography, and all types of prints. Exhibits all styles. Genres include landscapes, abstracts, florals and figurative work. Prefers landscapes, abstract and figurative.

FIRST CONTACT & TERMS E-mail letter with a brief introduction. Do like to meet when possible to review a portfolio. Responds only if interested within 1 month. Files weblinks. Finds artists through credit lines, direct mail or e-mail, agents, visiting exhibitions, word of mouth, art publications and sourcebooks, submissions.

TIPS "Update with current work via postcard directing them to a website or send an e-mail in the future. Direct mail works."

OAKLEY DESIGN STUDIOS

Website: oakleydesign.com; oakleydesign.blogspot.com. **Contact:** Tim Oakley, creative director. Estab. 1992. Specializes in brand and corporate identity, display, package, feature film and television design, along with advertising. Clients: advertising agencies, record companies, motion picture studios, major television studios, surf apparel manufacturers, mid-size businesses. Current clients include NBC, Vineyard Horizons, Patrick Lamb Productions, Metro Computerworks, Tiki Nights Entertainment, Hui Nalu Brand Surf, Stona Winery, Mt. Hood Jazz Festival, Think AV, Audient Events and Portland Center for the Media Arts. Professional affiliations: GAG, AIGA, PAF, Type Directors Club, Society of Illustrators.

NEEDS Approached by 3-5 freelancers/year. Works with 3 freelance illustrators and 2 designers/year. Prefers local artists with experience in technical & freehand illustration, airbrush. Uses illustrators mainly for advertising. Uses designers mainly for brand and corporate identity. Also uses freelancers for ad and P-O-P illustration, airbrushing, catalog illustration, lettering and retouching. 60% of design and 30% of illustration demands skills in CS2 Illustrator, CS2 Photoshop and CS2 InDesign.

FIRST CONTACT & TERMS Contact through artist rep or send query letter with brochure, photocopies, photographs, plus resume. Samples are filed or returned by SASE if requested by artist. Request portfolio review in original query. Will contact artist for portfolio review if interested. Portfolio should include b&w and color final art, photocopies, photostats, roughs and/or slides. Pays for design by the project, $200 minimum. Pays for illustration by the project. Rights purchased vary according to project. Finds artists through design workbooks.

TIPS "Just be yourself and bring coffee."

ODEN MARKETING & DESIGN

119 S. Main St., Suite 300, Memphis TN 38103. (901)578-8055; (800)371-6233. **Website:** www. oden.com. **Contact:** design director. Estab. 1971. Specializes in annual reports, brand and corporate identity, design and package design. Clients: corporations. Current clients include International Paper, Federal Express.

NEEDS Works with 5-8 freelance illustrators and photographers/year. Works on assignment only. Uses illustrators mainly for collateral. 50% of freelance work demands knowledge of QuarkXPress, InDesign, Illustrator, or Photoshop.

FIRST CONTACT & TERMS Send query letter with brochure, photographs, slides and transparencies. Samples are filed and are not returned. Responds only if interested. Portfolio review not required. Pays for illustration by the project. Rights purchased vary according to project.

TIPS Finds artists through sourcebooks.

OMNI PRODUCTIONS

P.O. Box 302, Carmel IN 46082-0302. (317)846-2345. **Fax:** (317)846-6664. **E-mail:** omni@omniproductions. com. **Website:** www.omniproductions.com. **Contact:** Winston Long, president. Estab. 1984. AV firm. Full-service, multimedia firm. Specializes in video, Intranet, CD and Internet. Current clients include "a variety of industrial clients, government and international agencies."

NEEDS Works on assignment only. Uses freelancers for brochure design and illustration, storyboards, slide illustration, animation, and TV/film graphics. Needs computer-literate freelancers for design, illustration and production. Most of freelance work demands computer skills.

FIRST CONTACT & TERMS Send résumé. Samples are filed and are not returned. Artist should followup with call or letter after initial query. Pays by the project. Finds artists through agents, word of mouth and submissions.

ORIGIN DESIGN

One Origin Center, 2600 Travis, Suite 200, Houston TX 77006. (877)520-9544. **E-mail:** hola@originaction. com. **Website:** www.originaction.com. Design and marketing firm.

Recent Origin projects have been recognized in *HOW Magazine*, the national Summit Awards, the Dallas Society of Visual Communicators Annual Show, and the regional Addys.

FIRST CONTACT & TERMS Send query letter with résumé and samples.

OUTSIDE THE BOX INTERACTIVE, LLC

150 Bay St., Suite 706, Jersey City NJ 07302. (201)610-0625. **E-mail:** theoffice@outboxin.com. **Website:** www.outboxin.com. Estab. 1995. Number of employees: 6. Interactive design and marketing firm. "For over a decade we have been providing strategic and integrated solutions for branding, advertising, and corporate communications. Our skills lie in creating active experiences versus passive messages. We focus on the strengths of each particular delivery platform, whether multimedia, web or print, to create unique solutions that meet our client's needs. Our strategies are as diverse as our clients, but our focus is the same: to maximize the full potential of integrated marketing, combining the best in new media and traditional assets. We offer a unique blend of creativity, technology, experience and commitment." Clients include Society of Illustrators, Dereckfor Shipyards, Educational Testing Service, Nature's Best.

NEEDS Approached by 5-10 illustrators and 5-10 designers/year. Works with 2-5 freelance illustrators and 4-6 designers/year. Freelancers must be digitally fluent. Uses freelancers for airbrushing, animation, brochure and humorous illustration, logos, model-making, multimedia projects, posters, retouching, storyboards, TV/film graphics, web page design. 90% of design demands skills in Photoshop, QuarkXPress, Illustrator, Director HTML, Java Script and any 3D program. 60% of illustration demands skills in Photoshop, QuarkXPress, Illustrator, any animation and 3D program.

FIRST CONTACT & TERMS Send query letter with brochure, photocopies, photographs, résumé, SASE, slides, tearsheets, transparencies. Send follow-up postcard every 3 months. Accepts DVD/CD submissions. Samples are filed and are returned by SASE. Will contact if interested. Pays by the project. Rights purchased vary according to project.

○ OXFORD COMMUNICATIONS, INC.

11 Music Mountain Blvd., Lambertville NJ 08530. (609)397-4242. **Fax:** (609)397-5915. **E-mail:** solutions@oxfordcommunications.com. **Website:** www.oxfordcommunications.com. **Contact:** Chris Ledford. Estab. 1986. Ad agency. Full-service,

integrated multimedia firm. Specializes in branding, strategic planning, integrated marketing. Product specialties are retail, real estate, health care, education, and destination marketing.

NEEDS Approached by 6 freelancers/month. Works with 3 designers every 6 months. Currently all design and production handled by staff. Prefers local freelancers with experience in Illustrator, InDesign and Photoshop. Uses freelancers mainly for production and interactive development. 50% of work is with print ads.

FIRST CONTACT & TERMS E-mail résumé and PDF samples. Samples are filed. Responds only if interested. Will contact artist for portfolio review if interested. Pays for design and illustration by the project, negotiable. Rights purchased vary according to project.

PAPAGALOS STRATEGIC COMMUNICATIONS

7330 N. 16th St., Suite B-102, Phoenix AZ 85020. (602)279-2933. **Website:** www.papagalos.com. **Contact:** Nicholas Papagalos, creative director. Specializes in advertising, brochures, annual corporate identity, displays, packaging, publications and signage. Clients major regional, consumer and business-to-business. Clients include Tutor Perini, McMillan Fiberglass Stocks, Schuff Steel, Walsh Group and Targas.

NEEDS Works with 6-20 freelance artists/year. Works on assignment only. Uses artists for illustration, retouching, design and production. Needs computer-literate freelancers, web programmers and Web designers for design, illustration and production. 100% of freelance work demands skills in Illustrator, InDesign or Photoshop.

FIRST CONTACT & TERMS Mail résumé and appropriate samples. Pays for design by the hour or by the project. Pays for illustration by the project. Considers complexity of project, client's budget, skill and experience of artist when establishing payment. Exclusive nonrecurring rights payment.

⌂ PHOENIX LEARNING GROUP, INC.

141 Millwell Dr., Suite A, St. Louis MO 63043. (314)569-0211 or (800)221-1274. **Fax:** (314)569-2834. **E-mail:** info@phoenixlearninggroup.com. **Website:** phoenixlearninggroup.com. **Contact:** Erin Bryant, vice president of operations and management. Number of employees: 50. Produces and distributes educational films. Clients: libraries, museums, religious institutions, US government, schools, universities, film societies and businesses. Catalog available on website or by request.

NEEDS Works with 1-2 freelance illustrators and 2-3 designers/year. Prefers local freelancers only. Uses artists for motion picture catalog sheets, direct mail brochures, posters and study guides; also for multimedia projects. 85% of freelance work demands knowledge of PageMaker, QuarkXPress and Illustrator.

FIRST CONTACT & TERMS Send postcard sample and query letter with brochure (if applicable). Send recent samples of artwork and rates to director of promotions. "No telephone calls, please." Responds if need arises. Buys all rights. Keeps all original art "but will loan to artist for use as a sample." Pays for design and illustration by the hour or by the project. Rates negotiable.

⌂ PICCIRILLI DORSEY

502 Rock Spring Rd., Bel Air MD 21014. (410)879-6780. **Fax:** (410)879-6602. **E-mail:** hello@picdorsey.com. **Website:** www.picdorsey.com. **Contact:** Micah Piccirilli, creative director. Estab. 1974. Specializes in design and advertising; also annual reports, advertising campaigns, direct mail, brand and corporate identity, displays, packaging, publications and signage. Clients: recreational sport industries, fleet leasing companies, technical product manufacturers, commercial packaging corporations, direct mail advertising firms, realty companies, banks, publishers and software companies.

NEEDS Works with 4 freelance designers/year. Works on assignment only. Mainly uses freelancers for layout or production. Prefers local freelancers. 75% of design demands skills in Illustrator and QuarkXPress.

FIRST CONTACT & TERMS Send query letter with brochure, résumé and tearsheets; prefers originals as samples. Samples are returned by SASE. Responds on whether to expect possible future assignments. To show a portfolio, mail roughs and finished art samples or call for an appointment. Pays for design and illustration by the hour, $20-45. Considers complexity of project, client's budget, and skill and experience of artist when establishing payment. Buys one-time or reprint rights; rights purchased vary according to project.

TIPS "Portfolios should include work from previous assignments. The most common mistake freelancers make is not being professional with their presentations. Send a cover letter with photocopies of work."

POSNER ADVERTISING

71 Fifth Ave., 5th Floor, New York NY 10003. (212)727-4790. **Website:** www.posnermiller.com. Estab. 1959. Number of employees: 35. Full-service multimedia firm. Specializes in digital, branding, ads, collaterals, packaging, outdoor. Product specialties are hospitality, health care, luxury real estate, consumer business to business, corporate.

NEEDS Approached by 25 freelance artists/month. Works with 1-3 illustrators and 5 designers/month. Prefers local artists only with experience in digital and print design. Uses freelancers mainly for web and print design. 40% of work is with print ads. Needs computer-fluent freelancers for web and print design. 90% of freelance work demands knowledge of Adobe Creative Cloud.

FIRST CONTACT & TERMS Send query letter with samples/website. Samples are filed. Responds only if interested. Pays for design by the hour ($15-35) or by the project ($300-2,000). Negotiates rights purchased.

TIPS Advises freelancers starting out in advertising field to offer to intern at agencies for minimum wage.

RH POWER AND ASSOCIATES, INC.

9621 Fourth St. NW, Albuquerque NM 87114-2128. (505)761-3150 or (800)552-1993. **Fax:** (505)761-3153. **E-mail:** info@rhpower.com. **Website:** www.rhpower.com. Estab. 1989. Number of employees: 10. Ad agency. Full-service, multimedia firm. Specializes in TV, magazine, billboard, direct mail, marriage mail, newspaper, radio. Product specialties are recreational vehicles and automotive. Current clients include Albany RV, Ultra-Fab Products, Consolidated Solar Technologies, Bullyan RV, Holiday World. Client list available upon request.

NEEDS Approached by 10-50 freelancers/year. Works with 5-10 freelance illustrators and 5-10 designers/year. Prefers freelancers with experience in retail automotive layout and design. Uses freelancers mainly for work overload, special projects and illustrations. Also for annual reports, billboards, brochure and catalog design and illustration, logos, mechanicals, posters and TV/film graphics. 50% of work is with print ads.

FIRST CONTACT & TERMS Send query letter with photocopies or photographs and résumé. Accepts disk submissions in PC format compatible with Illustrator 10.0 or Adobe Acrobat (PDF). Send PC EPS files. Samples are filed and are not returned. Will contact artist for portfolio review if interested. Portfolio should include b&w and color final art, roughs and thumbnails. Pays for design and illustration by the hour, $25 minimum; by the project, $100 minimum. Buys all rights.

TIPS Impressed by work ethic and quality of finished product. "Deliver on time and within budget. Do it until it's right without charging for your own corrections."

PRECISION ARTS ADVERTISING, INC.

57 Fitchburg Rd., Ashburnham MA 01430. (978)855-7648. **E-mail:** info@precisionarts.com. **Website:** www.precisionarts.com. **Contact:** Terri Adams, president. Estab. 1985. Number of employees: 2. Full-service Web/print ad agency. Specializes in Internet marketing strategy, website/print design, graphic design.

NEEDS Approached by 5 illustrators and 5 designers/year. Works with 1 freelance illustrator and 1 designer/year. Prefers local freelancers. website design is now 75% and print marketing is 25% of the business. Freelance Web skills required in Macintosh DreamWeaver and Photoshop; freelance print skills required in QuarkXPress, Photoshop, Illustrator and Pre-Press.

FIRST CONTACT & TERMS Send résumé with links to artwork and suggested hourly rate.

PRINCETON MARKETECH

2 Alice Rd., Princeton Junction NJ 08550. **E-mail:** bzyontz@princetonmarketech.com. **Website:** www.princetonmarketech.com. **Contact:** creative director. Estab. 1987. Ad agency. Specializes in direct mail, multimedia, websites. Product specialties are financial, computer, senior markets. Current clients include Citizens Bank, ING Direct, Diamond Tours. Client list available upon request.

NEEDS Approached by 12 freelance illustrators and 25 designers/year. Works with 2 freelance illustrators and 5 designers/year. Prefers local designers with Mac experience. Uses freelancers for airbrushing, animation, brochure design and illustration, multimedia projects, retouching, technical illustration, TV/film graphics. 10% of work is with print ads. 90% of design demands skills in Photoshop, QuarkXPress, Illustra-

tor and Macromedia Director. 50% of illustration demands skills in Photoshop, Illustrator.

FIRST CONTACT & TERMS Send query letter with résumé, tearsheets, digital files or sample disk. Send follow-up postcard every 6 months. Accepts disk submissions compatible with QuarkXPress, Photoshop. Samples are filed. Responds only if interested. Pay negotiable. Rights purchased vary according to project.

PRO INK

200 NE First St., Suite 200, Gainesville FL 32605. (352)377-8973. **Fax:** (352)373-1175. **E-mail:** info@ proink.com. **Website:** www.proink.com. **Contact:** Terry Bachmann, president. Estab. 1979. Number of employees: 2. Specializes in publications, marketing, health care, engineering, development and ads. Professional affiliations: Public Relations Society of America, Society of Professional Journalists, International Association of Business Communicators, Gainesville Advertising Federation, Florida Public Relations Association.

NEEDS Works with 3-5 freelancers/year. Works on assignment only. Uses freelancers for brochure/annual report illustration and lettering. 100% of freelance work demands knowledge of Illustrator, InDesign, or Photoshop. Needs editorial, medical and technical illustration.

FIRST CONTACT & TERMS Send résumé, samples, tearsheets, photostats, photocopies, slides and photography. Samples are filed or are returned if accompanied by SASE. Responds only if interested. Call or write for appointment to show portfolio of original/final art. Pays for design and illustration by the project, $50-500. Rights purchased vary according to project.

QUALLY & CO., INC.

(312)280-1898. **E-mail:** iva@quallycompany.com; michael@quallycompany.com. **Website:** www. quallycompany.com. **Contact:** Michael Iva, creative director. Estab. 1979. Specializes in integrated marketing/communication, new product launches, antidotes for propaganda. Clients: major corporations, high net worth individuals and think tanks.

NEEDS Works with 10-12 freelancers/year. "Freelancers must have talent and the right attitude." Works on assignment only. Uses freelancers for design, copywriting, illustration, retouching, and computer production.

FIRST CONTACT & TERMS Send query letter with résumé, business card and samples that we can keep on file. Call or write for appointment to show portfolio.

TIPS Looking for "people with ideas, talent, point of view, style, craftsmanship, depth and innovation." Sees "too many look-alikes, very little innovation."

QUARACORE

1 East Wacker Drive, Suite 1900, Chicago IL 60601. (312)981-2540. **E-mail:** info@quaracore.com. **Website:** www.quaracore.com. Estab. 1982. Full-service product developer. Specializes in educational products. Clients: educational publishers.

NEEDS Approached by 400 freelancers/year. Works with 700-900 illustrators/year. Prefers freelancers with publishing experience. Uses freelancers for illustration, books, mechanicals, charts/graphs, lettering and production. Needs computer-literate freelancers for illustration. 50% of freelance illustration work demands skills in Illustrator, QuarkXPress, Photoshop or FreeHand. Needs editorial, technical, medical and scientific illustration.

FIRST CONTACT & TERMS Send query letter with brochure or résumé and samples to be circulated and kept on file. Prefers "anything that we can retain for our files–photocopies, color tearsheets, e-mail submissions, disks or dupe slides that do not have to be returned." Responds only if interested. Pays for illustration by the piece/project, $40-750 average. Considers complexity of project, client's budget, how work will be used and turnaround time when establishing payment.

TIPS Current job openings posted on website.

QUON DESIGN

543 River Rd., Fair Haven NJ 07704-3227. (732)212-9200. **E-mail:** studio@quondesign.com. **Website:** www.quondesign.com; www.quonart.com. **Contact:** Mike Quon, president/creative director. Specializes in corporate and brand identity, collateral, packaging, publications and web design. Clients: corporations (financial, healthcare, telecommunications), nonprofits (hospitals, museums), PR firms and ad agencies. Current clients include Pfizer, UNICEF, American Express, Hasbro, Verizon, AT&T. Professional affiliations: AIGA, Society of Illustrators, Graphic Artists Guild, Art Alliance, Guild of Creative Arts, MCAC.

FIRST CONTACT & TERMS E-mail résumé with website link or mail query letter with résumé and samples. Pays for illustration by the project, $100-500. Buys first rights.

GERALD & CULLEN RAPP

420 Lexington Ave., New York NY 10170. (212)889-3337. **Fax:** (212)889-3341. **E-mail:** info@rappart.com; nancy@rappart.com. **Website:** www.rappart.com. **Contact:** Nancy Moore. Estab. 1944. Clients: ad agencies, corporations and magazines. Client list not available. Professional affiliations: GAG, S.I.

NEEDS Approached by 500 freelance artists/year. Exclusive representations of freelance illustrators. Works on assignment only. Uses freelance illustrators for editorial advertising and corporate illustration.

FIRST CONTACT & TERMS E-mail query letter with samples or website link. Will contact artist for portfolio review if interested. Responds in 2 weeks. Pays for illustration by the project, $500-40,000. Negotiates fees and rights purchased with clients on per-project basis.

⌂ REALLY GOOD COPY CO.

(860)659-9487. **E-mail:** CopyQueen@aol.com. **Website:** www.reallygoodcopy.com. **Contact:** Donna Donovan, president. Estab. 1982. Number of employees: 1. Ad agency; full-service multimedia firm. Specializes in direct response, brochures, catalogs and collateral. Product specialties are medical/health care, business services, consumer products and services. Current clients include Eastern Connecticut Health Network, WSHU Public Radio, Wellspring, That's Amore Gelato Cafés, Buddy's Appliance and Furniture Retail, Avid Marketing, Glastonbury Chamber of Commerce. Professional affiliations: Connecticut Art Directors Club, New England Mail Order Association, Glastonbury Chamber of Commerce.

NEEDS Approached by 40-50 freelancers/year. Works with 1-2 freelance illustrators and 6-8 designers/year. Prefers local freelancers whenever possible. Works on assignment only. Uses freelancers for all projects. "There are no on-staff artists." 50% print, 50% Web. 100% of design and 50% of illustration demand knowledge of InDesign or QuarkXPress, Illustrator or Photoshop and HTML.

FIRST CONTACT & TERMS Designers: send query letter with résumé. Illustrators: send postcard samples. Accepts CD submissions, EPS or JPEG files only. Samples are filed or are returned by SASE, only if requested. Responds only if interested. Portfolio review not required, but portfolio should include roughs and original/final art. Pays for design by the hour, $50-125. Pays by the project or by the hour.

TIPS "Continue to depend upon word of mouth from other satisfied agencies and local talent. I'm fortunate to be in an area that's overflowing with good people. Send 2 or 3 good samples—not a bundle."

RIPE CREATIVE

1543 W. Apollo Rd., Phoenix AZ 85041. (602)304-0703. **Fax:** (480)247-5339. **E-mail:** mark@ripecreative.com; info@ripecreative.com. **Website:** www.ripecreative.com. **Contact:** Mark Anthony Munoz, principal. Estab. 2005. Number of employees: 5. Approximate annual billing: $500,000. Design firm. Specializes in branding, advertising, strategic marketing, publication design, trade-show environments. Clients: American Bar Association, AonConsulting, Healthways, LifeLock, Superior Case Coding, PetSmart. Client list available upon request. Professional affiliations: American Advertising Federation, National Organization of Women Business Owners, Greater Phoenix Chamber of Commerce, Arizona Hispanic Chamber of Commerce.

NEEDS Approached by 100 illustrators and 10 designers/year. Works with 10 illustrators and 3 designers/year. Works on assignment only. Uses freelancers mainly for illustration, graphic design, website design. Also for animation, brochure design/illustration, direct mail, industrial/structural design, logos, posters, print ads, storyboards, catalog design and technical illustration. 15% of work is assigned with print ads. 100% of design work demands skills in InDesign, Illustrator and Photoshop. 100% of illustration work demands skills in Illustrator, Photoshop and traditional illustration media.

FIRST CONTACT & TERMS Designers: Send query letter with contact information, résumé, samples, and URL if applicable. Illustrators: Send tearsheets, URL. Samples are returned if requested and SASE is provided. Designers and illustrators should attach PDF files or URL. Samples are filed or returned by SASE. Responds in 2 weeks. Company will contact artist for portfolio review if interested. Portfolio should include color finished art, photographs and tearsheets. Pays for illustration. Set rate negotiated and agreed to between RIPE and talent. Pays for design by the hour, $25-100. Rights purchased vary according to project. Finds artists through submissions, word of mouth, *Workbook*, *The Black Book*.

TIPS "Calls are discouraged. When making first contact, the preferred method is via mail or electronically. If interested, RIPE will follow up with talent electronically or by telephone. When providing samples, please ensure talent/rep contact is listed on all samples."

✪ RIVET

219 Dufferin St., Suite 200A, Liberty Village, Toronto, Ontario M6K 3J1 Canada. (416)483-3624. **E-mail:** todd.henwood@rivetglobal.com. **Website:** www.rivetglobal.com. Number of employees: 235. Approximate annual billing: $30 million. Full service marketing agency. Specializes in branding, promotion, digital, advertising, social media, event, CRM, direct marketing. Also maintains electronic design division that designs, develops and manages client websites, develops client intranets, extranets and CDs, consults on web marketing strategies, competitive analysis, and domain name research. Product specialties are food and beverage. Current clients include McNeil, Microsoft, Levi's, Visa, Johnson & Johnson, Purina, Dreyer's, Exxon Mobil. Client list available on website.

⌾ Also has locations in St. Louis, New York, San Francisco and Toronto.

NEEDS Approached by 200 illustrators and 50 designers/year. Works with 35 illustrators/year. Uses freelancers mainly for P-O-P displays, brochures; also for brochure design and illustration, model-making, posters and web graphics.

FIRST CONTACT & TERMS Send query letter with brochure or photocopies and résumé. Send postcard sample of work with follow-up postcard samples every 3 months. Accepts disk submissions. Samples are filed. Pays by the project, $300-8,000. Negotiates rights purchased. Finds illustrators through *American Showcase*, *The Black Book*, *Directory of Illustration* and submissions.

✪ SAATCHI & SAATCHI ADVERTISING WORLDWIDE

375 Hudson St., New York NY 10014. (212)463-2000. **Fax:** (212)463-9856. **E-mail:** talentteam@saatchiny.com. **Website:** www.saatchiny.com. Full-service advertising agency. Clients: Delta Airlines, Eastman Kodak, General Mills and Procter & Gamble. This company has 153 offices in 83 countries. See website for specific details of each location.

NEEDS Approached by 50-100 freelancers/year. Works with 1-5 designers and 15-35 illustrators/year. Uses freelancers mainly for illustration and advertising graphics. Prefers freelancers with knowledge of electronic/digital delivery of images.

FIRST CONTACT & TERMS Send query letter and nonreturnable samples or postcard sample. Prefers illustrators' sample postcards or promotional pieces to show around a half a dozen illustrations, enough to help art buyer determine illustrator's style and visual vocabulary. Files interesting promo samples for possible future assignments. Pays for design and illustration by the project.

SAI COMMUNICATIONS

P.O. Box 743, Media PA 19063. (215)923-6466. **E-mail:** saicommun@aol.com. **Website:** www.saicommunications.com. Full-service multimedia firm.

NEEDS Approached by 5 freelance artists/month. Works with 3 freelance designers/month. Uses freelance artists mainly for computer-generated slides; also for brochure and print ad design, storyboards, slide illustration and logos. 1% of work is with print ads.

FIRST CONTACT & TERMS Send query letter with résumé. Samples are filed. Call to schedule an appointment to show a portfolio. Portfolio should include slides. Pays for design by the hour, $15-20. Pays for illustration by the project. Buys first rights.

THOMAS SEBASTIAN COMPANIES

677 Evers Loop, Surfside Beach SC 29575. **E-mail:** sebastiancompanies@mac.com. **Website:** www.thomassebastiancompanies.com. **Contact:** Pete Secker, creative director; Thomas Sebastian, owner. Estab. 1996. Number of employees: 5. Integrated marketing communications agency and Internet service. Specializes in e-mail marketing and graphic design for print materials. Client list available upon request.

NEEDS Approached by 12 illustrators and 12 designers/year. Works with 2-3 illustrators and 1-2 designers/year. Uses freelancers mainly for design and computer illustration; also for humorous illustration, lettering, logos and web page design. 5% of work is with print ads. 90% of design and 70% of illustration demands knowledge of Adobe Creative Suite.

FIRST CONTACT & TERMS Send query via e-mail. Send follow-up postcard samples every 6 months. Accepts Mac-compatible submissions on CD or DVD. Samples are filed and are not returned. Responds only

if interested. Will contact artist for portfolio review if interested. Pays by the project. Negotiates rights purchased. Finds freelancers through *The Black Book*, creative sourcebooks, Internet.

SELBERT-PERKINS DESIGN COLLABORATIVE

5 Water St., Arlington MA 02476. (781)574-6605 x138. **E-mail:** joberto@selbertperkins.com. **Website:** www.selbertperkins.com. Estab. 1980. Number of employees 25. Specializes in annual reports, brand identity design, displays, landscape architecture and urban design, direct mail, product and package design, exhibits, interactive media and CD-ROM design and print and environmental graphic design. Clients: airports, colleges, theme parks, corporations, hospitals, computer companies, retailers, financial institutions, architects. Professional affiliations: AIGA, SEGD.

◗ This company has several locations throughout the world. See website for a complete listing.

NEEDS Approached by "hundreds" of freelancers/year. Works with 10 freelance illustrators and 20 designers/year. Prefers artists with "experience in all types of design and computer experience." Uses freelance artists for brochures, mechanicals, logos, P-O-P, poster and direct mail. Also for multimedia projects. 100% of freelance work demands knowledge of Photoshop, Canvas, InDesign, Illustrator.

FIRST CONTACT & TERMS Send query letter with brochure, résumé, tearsheets, photographs, photocopies, slides and transparencies. Samples are filed. Responds only if interested. Portfolios may be dropped off every Monday-Friday. Artist should follow up with call or letter after initial query. Will contact artist for portfolio review if interested. Pays for design by the hour, or by the project. Pays for illustration by the project. Rights purchased vary according to project. Finds artists through word of mouth, magazines, submissions/self-promotions, sourcebooks and agents.

STEVEN SESSIONS, INC.

One Riverway, Suite 1700, Houston TX 77056. (713)850-8450. **E-mail:** info@sessionsgroup.com. **Website:** www.sessionsgroup.com. **Contact:** Steven Sessions, president/creative director. Estab. 1981. Number of employees: 8. Approximate annual billing: $2.5 million. Specializes in annual reports; brand and corporate identity; fashion, package and publication design. Clients corporations and ad agencies. Current clients are listed on website. Professional affiliations AIGA, Art Directors Club, American Ad Federation.

NEEDS Approached by 50 freelancers/year. Works with 10 illustrators and 2 designers/year. Uses freelancers for brochure, catalog and ad design and illustration; poster illustration; lettering; and logos. 100% of freelance work demands knowledge of Illustrator, InDesign, QuarkXPress, Photoshop. Needs editorial, technical and medical illustration.

FIRST CONTACT & TERMS Designers: Send query letter with brochure, tearsheets, CDs, PDF files and SASE. Illustrators: Send postcard sample or other nonreturnable samples. Samples are filed. Responds only if interested. To show portfolio, mail slides. Payment depends on project. Rights purchased vary according to project.

◔ SIGNATURE DESIGN

949 West Marietta St. SW, Suite X-104, Atlanta GA 30318. (314)971-2869. **E-mail:** Therese@thesignaturedesign.com; info@thesignaturedesign.com. **Website:** www.thesignaturedesign.com. Estab. 1993. Signature Design seeks to convey the authentic story of ecological and manmade environments in a memorable and meaningful way. Specialists— Interpretive planning and design of exhibits and signage. Innovative—Design collaborative of diverse unique skills; designers, writers, illustrators interactive media producers/animators creating experiences that entertain, educate and engage visitors. Clients include Bureau of Land Management, Missouri Botanical Garden, US Post Office. Client list available upon request.

NEEDS Approached by 15 freelancers/year. Works with 1-2 illustrators and 4-6 designers/year. Prefers local freelancers. Works on assignment only. 90% of freelance work demands knowledge of InDesign, Flash animation, Illustrator or Photoshop. Helpful to have web and animation software skills.

FIRST CONTACT & TERMS Send query letter with résumé, tearsheets and photocopies. Samples are filed. Responds only if interested. Artist should follow up with letter after initial query. Portfolio should include "whatever best represents your work." Pays for design by the hour. Pays for illustration by the project.

◔ SILVER FOX ADVERTISING

Silver Fox Studios, 117 Ann St., North Providence RI 02904. (401)725-2161. **Fax:** (401)726-8270. **Website:** www.silverfoxstudios.com. **Contact:** Lysa Marzoc-

chi. Estab. 1979. Specializes in package and publication design, logo design, brand and corporate identity, display, technical illustration and annual reports. Clients: corporations, retail. Client list available upon request.

NEEDS Works only with artist reps. Prefers local artists. Uses illustrators mainly for cover designs. Also for multimedia projects. 50% of freelance work demands knowledge of Illustrator, Photoshop, PageMaker and QuarkXPress.

FIRST CONTACT & TERMS Send query letter with résumé and photocopies. Accepts disk submissions compatible with Photoshop, Illustrator. Samples are filed. Does not reply. Artist should follow up with call or letter after initial query. Portfolio should include final art, photographs, roughs and slides.

SMITH & DRESS, LTD.

432 W. Main St., Huntington NY 11743. (631)427-9333. **Fax:** (631)427-9334. **E-mail:** dress2@att.net. **Website:** www.smithanddress.com. Full-service ad firm. Specializes in branding, publications, websites, trade shows, and signage.

NEEDS Works with 2-3 freelance artists/year. Prefers local artists only. Works on assignment only. Uses artists for illustration, retouching, and lettering.

FIRST CONTACT & TERMS Send query letter with brochure showing art style or tearsheets to be kept on file (except for works larger than 8½×11). Pays for illustration by the project on a work for hire basis. Considers client's budget and turnaround time when establishing payment.

J. GREG SMITH

14707 California St., Suite 6, Omaha NE 68154. (402)444-1600. **Fax:** (402)444-1610. **Website:** jgregsmith.com. **Contact:** Greg Smith, senior art director. Estab. 1974. Number of employees: 8. Approximate annual billing: $1.5 million. Ad agency. Clients: financial, banking, associations, agricultural, travel and tourism, insurance. Professional affiliation: AAAA.

NEEDS Approached by 1-10 freelancers/year. Works with 4-5 freelancers illustrators and 1-2 designers/year. Works on assignment only. Uses freelancers mainly for mailers, brochures and projects; also for consumer and trade magazines, catalogs and AV presentations. Needs illustrations of farming, nature, travel.

FIRST CONTACT & TERMS Send query letter with samples showing art style or photocopies. Responds only if interested. To show portfolio, mail final reproduction/product, color and b&w. Pays for design and illustration by the project: $500-5,000. Buys first, reprint or all rights.

SMITH DESIGN

P.O. Box 8278, 205 Thomas St., Glen Ridge NJ 07028. (973)429-2177. **Fax:** (973)429-7119. **E-mail:** info@ smithdesign.com. **Website:** www.smithdesign.com. West Coast office: Carmel CA, 93922; (831)620-1198; Florida office: Ft. Lauderdale FL; (974)429-2177 ext. 2001. **Contact:** Laraine Blauvelt. Brand design firm. Specializes in strategy-based visual solutions for leading consumer brands. Clients: grocery, mass market consumer brands, electronics, construction, automotive, toy manufacturers. Current clients include Popsicle, Hain, Pfizer, Sika. Client list available upon request.

NEEDS Approached by more than 100 freelancers/ year. Works with 10-20 freelance illustrators and 3-4 designers/year. Requires experience, talent, quality work and reliability. Uses freelancers for package design, brochure design, print ads, illustration, POP display design, web programming. 90% of freelance work demands knowledge of Illustrator, Photoshop, 3D rendering programs. Design style must be current to trends. "Our work ranges from classic brands to cutting edge."

FIRST CONTACT & TERMS Send query letter with brochure/samples showing work, style and experience. Include contact information. Responds in 1 week. Call for appointment to show portfolio. Pays for design by the hour, $35-125; or by the project, $175-5,000. Pays for illustration by the project, $175-5,000. Considers complexity of project and client's budget when establishing payment. Buys all rights. (For illustration work, rights may be limited to a particular use TBD). Also buys rights for use of existing noncommissioned art. Finds artists through word of mouth, self-promotions/sourcebooks and agents.

TIPS "Know who you're presenting to (visit our website to see our needs). Show work which is relevant to our business at the level and quality we require. We use more freelance designers and illustrators for diversity of style and talent."

SOFTMIRAGE

201 E. Sandpointe Ave., Suite 125, Santa Ana CA 92707. (714)546-7030. **Fax:** (714)546-7038. **E-mail:** contact@softmirage.com. **Website:** www.softmirage.com. Contact: Steve Pollack, design director. Estab. 1999. Number of employees: 28. Approximate annual billing: $3 million. Visual communications agency. Specializes in architecture, luxury, real estate. Needs people with strong spatial design skills, modeling and ability to work with computer graphics. Current clients include Four Seasons Hotels, Ford, Richard Meier & Partners and various real estate companies.

NEEDS Approached by 15 computer freelance illustrators and 5 designers/year. Works with 6 freelance 3D modelers, and 10 graphic designers/year. Prefers West coast designers with experience in architecture, engineering, technology. Uses freelancers mainly for concept, work in process computer modeling. Also for animation, brochure design, mechanicals, multimedia projects, retouching, technical illustration, TV/film graphics. 50% of work is renderings. 100% of design and 30% of illustration demand skills in Photoshop, 3-D Studio Max, Flash and Director. Need Macromedia Flash developers.

FIRST CONTACT & TERMS Designers: Send e-mail query letter with samples. 3D modelers: Send e-mail query letter with photocopies or link to website. Accepts digital and video submissions. Samples are filed or returned by SASE. Will contact for portfolio review if interested. Pays for design by the hour, $15-85. Pays for modeling by the project, $100-2,500. Rights purchased vary according to project. Finds artists through Internet, AIGA and referrals.

TIPS "Be innovative, push the creativity, understand the business rationale and accept technology. Check our website, as we do not use traditional illustrators, all our work is now digital. Send information electronically, making sure work is progressive and emphasizing types of projects you can assist with."

SPECTRUM BOSTON CONSULTING, INC.

P.O. Box 689, Westwood MA 02090-0689. (508)660-1300. **Fax:** (508)660-1305. **E-mail:** gboesel@spectrumboston.com. **Website:** www.spectrumboston.com. **Contact:** George Boesel, president. Estab. 1985. Specializes in brand and corporate identity, display and package design and signage. Clients: consumer products manufacturers.

NEEDS Approached by 30 freelance artists/year. Works with 1 illustrator and 1 designers/year. All artists employed on work-for-hire basis. Works on assignment only. Uses illustrators mainly for package and brochure work.

FIRST CONTACT & TERMS Illustrators: Send query e-mail with images. Samples are filed. Responds only if interested.

⌾ SPIRIT CREATIVE SERVICES, INC.

3157 Rolling Rd., Edgewater MD 21037. (410)956-1117. **Fax:** (410)956-1118. **E-mail:** info@spiritcreativeservices.com. **Website:** www.spiritcreativeservices.com. Number of employees: 2. Approximate annual billing: $15,000. Specializes in publications, brochures, catalogs, signage, books, annual reports, brand and corporate identity, display, direct mail, packaging, website design, technical and general illustration, photography, copywriting, and marketing. Clients/ associations: corporations, government.

NEEDS Approached by 10 freelancers/year. Works with local Mac-based designers only. Uses freelancers for ad, brochure, catalog, poster and P-O-P design, technical illustration, books, direct mail, magazine, charts/graphs, logos, multimedia and design projects. 100% of design and 10% of illustration demands knowledge of Illustrator, Photoshop, Type Manager, InDesign and IWeb.

FIRST CONTACT & TERMS Call before sending submissions. Does not accept e-mail submissions without prior contact via phone. Portfolio samples and résumé. Responds in 1-3 weeks if interested. Portfolio should include b&w and color samples of artwork. Pays by the design project, $50-6,000.

TIPS "Being responsive to all communications and due dates is vital with attention to details, with emphasis on creativity and intuition."

SPLANE DESIGN ASSOCIATES

30634 Persimmon Lane, Valley Center CA 92082. (760)749-6018. **Fax:** (760)749-6388. **E-mail:** splanedesign@gmail.com. **Website:** www.splanedesign.com. **Contact:** Robson Splane, president. Specializes in product design. Clients: small, medium and large companies. Current clients include Lockheed Aircraft, Western Airlines, Liz Claiborne, Max Factor, Sunkist, Universal studios. Client list available upon request.

NEEDS Approached by 25-30 freelancers/year. Works with 1-2 freelance illustrators and 6-12 designers/year. Works on assignment only. Uses illustrators mainly for logos, mailings to clients, renderings. Uses designers mainly for sourcing, drawings, prototyping, modeling; also for brochure design and illustration, ad design, mechanicals, retouching, airbrushing, model making, lettering and logos. 75% of freelance work demands skills in FreeHand, Ashlar Vellum, Solidworks and Excel.

FIRST CONTACT & TERMS Send query letter with résumé and photocopies. Samples are filed or are returned. Responds only if interested. Will contact artist for portfolio review if interested. Portfolio should include color roughs, final art, photostats, slides and photographs. Pays for design and illustration by the hour, $7-25. Rights purchased vary according to project. Finds artists through submissions and contacts.

STEVENS STRATEGIC COMMUNICATIONS, INC.

Gemini Towers, Suite 500, 1991 Crocker Rd., Westlake OH 44145. (440)617-0100 or (877)900-3366. **Fax:** (440)614-0529. **E-mail:** estevens@stevensstrategic.com. **Website:** www.stevensstrategic.com. Estab. 1956. Ad agency. Specializes in public relations, advertising, corporate and crisis communications, integrated marketing, magazine ads and collateral. Product specialties are business-to-business, food, building products, technical products, industrial food service, health care, safety.

NEEDS Approached by 30-40 freelance artists/month. Prefers artists with experience in food, healthcare and technical equipment. Works on assignment only. Uses freelance artists mainly for specialized projects; also for brochure, catalog and print ad illustration and retouching. Freelancers should be familiar with InDesign, Adobe Creative Suite Master Collection, QuarkXPress, Illustrator and Photoshop.

FIRST CONTACT & TERMS Send query letter with résumé and photocopies. Samples are filed and are not returned. Responds only if interested. "Artist should send only samples or copies that do not need to be returned." Will contact artist for portfolio review if interested. Portfolio should include final art and tearsheets. Pay for design depends on style. Pay for illustration depends on technique. Buys all rights. Finds artists through agents, sourcebooks, word of mouth and submissions.

STRONGTYPE

(973)919-4265. **E-mail:** richard@strongtype.com. **Website:** www.strongtype.com. **Contact:** Richard Puder. Estab. 1985. Approximate annual billing: $300,000. Specializes in marketing communications, direct mail and publication design, technical illustration. Client history includes Hewlett-Packard, Micron Electronics, R.R. Bowker, Scholastic, Simon & Schuster and Sony. Professional affiliation: Type Directors Club.

NEEDS Approached by 100 freelancers/year. Uses designers mainly for corporate, publishing clients; also for ad and brochure design and illustration, book, direct mail, magazine and poster design, charts/graphs, lettering, logos and retouching. 100% of freelance work demands skills in Illustrator, Photoshop, FreeHand, Acrobat, QuarkXPress, Director, Flash, Fireworks and Dreamweaver.

FIRST CONTACT & TERMS E-mail with links and follow up with call, or send postcard sample, résumé and tearsheets. Samples are filed. Will contact artist for portfolio review if interested. Pays for design and production by the hour, depending on skills, $10-100. Pays for illustration by the job. Buys first rights or rights purchased vary according to project. Finds artists through sourcebooks (e.g., *American Showcase* and *Workbook*) and by client referral.

TIPS Impressed by "listening, problem-solving, speed, technical competency and creativity."

STUDIO WILKS

2148-A Federal Ave., Los Angeles CA 90025. (310)478-4442. **Fax:** (310)477-7888. **E-mail:** info@studiowilks.com. **Website:** www.studiowilks.com. Estab. 1990.

NEEDS Works with 6-10 freelance illustrators and 10-20 designers/year. Uses illustrators mainly for packaging illustration. Also for brochures, print ads, collateral, direct mail and promotions.

FIRST CONTACT & TERMS Designers: Send query letter with brochure, résumé, photocopies and tearsheets. Illustrators: Send postcard sample or query letter with tearsheets. Samples are returned by SASE if requested by artist. Will contact artist for portfolio review if interested. Pays for design by the project. Buys all rights. Considers buying second rights (reprint rights) to previously published work. Finds artists through *The Workbook* and word of mouth.

TIPS Specializes in print, collateral, packaging, editorial and environmental work. Clients ad agencies, architects, corporations and small business owners. Current clients include Walt Disney Co., Target, Nokia, City of Cerritos, Major League Soccer and Yoga Works.

SWANSON RUSSELL ASSOCIATES

1222 P St., Lincoln NE 68508. (402)437-6427. **Fax:** (402)437-6401. **E-mail:** daveh@swansonrussell.com; brianb@swansonrussell.com. **Website:** www.swansonrussell.com. **Contact:** Tracy Stanko, executive vice president/managing director; Dave Hansen, partner/CEO. Estab. 1962. Number of employees: 150. Approximate annual billing: $100 million. Integrated marketing communications agency. Specializes in collateral, catalogs, print and digital advertising, interactive/web development and direct mail. Product specialties are health care, agriculture, green industry, outdoor recreation and construction. Professional affiliations: PRSA, AIGA, Ad Club.

○ Second location: 14301 FNB Pkwy., Suite 312, Omaha NE 68154. (402)393-4940. Fax: (402)393-6926.

NEEDS Approached by 12 illustrators and 3-4 designers/year. Works with 5 illustrators and 2 designers/year. Prefers freelancers with experience in agriculture, pharmaceuticals, human and animal health. Uses freelancers mainly for collateral, ads, direct mail, storyboards; also for brochure design and illustration, humorous and technical illustration, lettering, logos, mechanicals, posters, storyboards. 10% of work is with print ads. 90% of design demands knowledge of Photoshop 7.0, FreeHand 5.0. 30% of illustration demands knowledge of Photoshop, Illustrator, FreeHand.

FIRST CONTACT & TERMS Designers: Send query letter with photocopies, photographs, photostats, SASE, slides, tearsheets, transparencies. Illustrators: Send query letter with SASE. Send follow-up postcard samples every 3 months. Accepts Mac-compatible disk submissions. Send self-expanding archives and player for multimedia, or JPEG, EPS and TIFFs. Software FreeHand or Adobe. Samples are filed or returned by SASE. Responds only if interested within 2 weeks. Art director will contact artist for portfolio review of final art, photographs, photostats, transparencies if interested. Pays for design by the hour; pays for illustration by the project. Rights purchased vary according to project. Finds artists through agents, submissions, word of mouth, *Laughing Stock*, *American Showcase*.

⌂ TASTEFUL IDEAS, INC.

7638 Bell Dr., Shawnee KS 66217. (913)722-3769. **Fax:** (913)722-3967. **E-mail:** john@tastefulideas.com. **Website:** www.tastefulideas.com. **Contact:** John Thomsen, president. Estab. 1986. Number of employees: 4. Approximate annual billing: $500,000. Design firm. Specializes in consumer packaging. Product specialties are largely, but not limited to, food and food service.

NEEDS Approached by 15 illustrators and 15 designers/year. Works with 3 illustrators and 3 designers/year. Prefers local freelancers. Uses freelancers mainly for specialized graphics; also for airbrushing, animation, humorous and technical illustration. 10% of work is with print ads. 75% of design and illustration demand skills in Photoshop and Illustrator.

FIRST CONTACT & TERMS Designers: Send query letter with photocopies. Illustrators: Send nonreturnable promotional sample. Accepts submissions compatible with Illustrator, Photoshop (Mac based). Samples are filed. Art director will contact artist for portfolio review of final art if interested. Pays by the project. Finds artists through submissions.

TGADESIGN

4649 Ponce De Leon Blvd., Suite 401, Coral Gables FL 33146. (305)669-2550. **Fax:** (305)669-2539. **E-mail:** info@tgadesign.com. **Website:** www.tgadesign.com. **Contact:** Tom Graboski, president. Estab. 1980. Also known as Tom Graboski Associates, Inc. Specializes in exterior/interior signage, environmental graphics, corporate identity, urban design and print graphics. Clients: corporations, cities, museums, a few ad agencies. Current clients include Universal Studios, Florida; Royal Caribbean Cruise Line; The Equity Group; Disney Development; Celebrity Cruises; Baptist Health So. Florida; City of Miami; City of Coral Gables.

NEEDS Approached by 20-30 freelance artists/year. Works with approximately 4-8 designers/draftspersons/year. Prefers artists with a background in signage and knowledge of architecture and industrial design. Freelance artists used in conjunction with signage projects, occasionally miscellaneous print graphics. 100% of design and 10% of illustration

demand knowledge of Illustrator, Photoshop and QuarkXPress.

FIRST CONTACT & TERMS Send query letter with brochure and résumé. "We will contact designer/artist to arrange appointment for portfolio review. Portfolio should be representative of artist's work and skills; presentation should be in a standard portfolio format." Pays by the project. Payment varies by experience and project. Rights purchased vary by project.

TIPS "Look at what type of work the firm does. Tailor presentation to that type of work. For this firm, knowledge of environmental graphics and detailing is a plus."

J. WALTER THOMPSON CO.

3630 Peachtree Rd. NE, Suite 1200, Atlanta GA 30326. (404)365-7300. **Website:** www.jwt.com. Ad agency. Current clients include Domino's, Ford, HSBC, Kraft, Shell, Unilever.

○ JWT has offices all over the world. See website for details.

NEEDS Works on assignment only. Uses freelancers for billboards, consumer and trade magazines and newspapers. Needs computer-literate freelancers for design, production and presentation. 60% of freelance work demands skills in Illustrator, Photoshop, InDesign, Flash, and Dreamweaver.

FIRST CONTACT & TERMS *Deals with artist reps only.* Send slides, original work, stats. Samples returned by SASE. Responds only if interested. Originals not returned. Call for appointment to show portfolio.

TIPS Wants to see samples of work done for different clients. Likes to see work done in different mediums; variety and versatility. Freelancers interested in working here should "be *professional* and do top-grade work."

TOKYO DESIGN CENTER

1508 Fillmore St., Suite 300, San Francisco CA 94115-3597. (415)543-4886. **Fax:** (415)543-4956. **E-mail:** info@tokyodesign.com. **Website:** www.tokyodesign.com. Specializes in annual reports, brand identity, corporate identity, packaging and publications. Clients: consumer products, travel agencies and retailers.

NEEDS Uses artists for design and editorial illustration.

FIRST CONTACT & TERMS Send business card, slides, tearsheets and printed material to be kept on file. Samples not kept on file are returned by SASE, if requested. Will contact artist for portfolio review if interested. Pays for design and illustration by the project, $100-1,500 average. Sometimes requests work on spec before assigning job. Considers client's budget, skill and experience of artist, turnaround time and rights purchased when establishing payment. Interested in buying second rights (reprint rights) to previously published work. Finds artists through self-promotions and sourcebooks.

THE TOMBRAS GROUP

630 Concord St., Knoxville TN 37919. (865)524-5376. **Website:** www.tombras.com. Estab. 1946. Number of employees: 68. Approximate annual billing: $75 million. Ad agency. Full-service multimedia firm. Specializes in full media advertising, collateral, interactive. Clients: National Highway Traffic, Safety Administration, Fred's Stores, Bristol Motor Speedway, Lowe's Motor Speedway, Atlanta Motor Speedway, and Farm Bureau Insurance. Client list available upon request. Professional affiliations AAAA, Worldwide Partners, AMA.

NEEDS Approached by 20-25 freelancers/year. Works with 20-30 freelance illustrators and 10-15 designers/year. Uses freelancers mainly for illustration and photography. Also for brochure design and illustration, model-making and retouching. 60% of work is with print ads. Needs computer-literate freelancers for design and presentation. 25% of freelance work demands skills in InDesign, Photoshop and QuarkXPress.

FIRST CONTACT & TERMS Send query letter with photocopies and résumé. Samples are filed. Will contact artist for portfolio review if interested. Portfolio should include b&w and color samples. Pays for design by the hour, $25-75; by the project, $250-2,500. Pays for illustration by the project, $100-10,000. Rights purchased vary according to project.

TIPS "Stay in touch with quality promotion. 'Service me to death' when you get a job."

A. TOMLINSON/SIMS ADVERTISING

250 S. Poplar St., P.O. Box 2530, Florence AL 35630. (256)766-4222 or (800)779-4222. **Fax:** (256)766-4106. **Website:** www.atsa-usa.com. **Contact:** Allen Tomlinson, president/managing partner. Estab. 1990. Number of employees: 9. Approximate annual billing: $5 million. Ad agency. Specializes in magazine, collateral, catalog, business-to-business. Product

specialties are home building products. Client list available upon request.

NEEDS Approached by 20 illustrators and 20 designers/year. Works with 5 illustrators and 5 designers/year. Uses freelancers for airbrushing, billboards, brochure and catalog design and illustration, logos and retouching. 35% of work is with print ads. 85% of design and illustration demand skills in PageMaker, Photoshop, Illustrator and QuarkXPress.

FIRST CONTACT & TERMS Designers: Send query letter with brochure and photocopies. Illustrators: Send samples of work, photocopies and résumé. Samples are filed and are not returned. Does not reply; artist should call. Artist should also call to arrange for portfolio review of color photographs, thumbnails and transparencies. Pays by the project. Rights purchased vary according to project.

⏏ T-P DESIGN, INC.

7007 Eagle Watch Court, Stone Mountain GA 30087. (770)413-8276. **Fax:** (770)413-9856. **E-mail:** tpdesign@att.net. **Website:** www.tpdesigninc.com. **Contact:** creative director. Estab. 1991. Number of employees: 3. Approximate annual billing: $500,000. Specializes in brand identity, display, package and publication design. Clients corporations. Current clients include Georgia Pacific, Cartoon Network, General Mills, KFC.

NEEDS Approached by 4 freelancers/year. Works with 2 freelance illustrators and 2 designers/year. Prefers local artists with Mac systems, traditional background. Uses illustrators and designers mainly for comps and illustration on Mac. Also uses freelancers for ad, brochure, poster and P-O-P design and illustration; book design, charts/graphs, lettering, logos, mechanicals (important) and page layout. Also for multimedia projects. 75% of freelance work demands skills in Illustrator, Photoshop, InDesign. "Knowledge of multimedia programs such as Director and Premier would also be desirable."

FIRST CONTACT & TERMS Send query letter or photocopies, résumé and tearsheets. Also accepts e-mail submissions. Samples are filed. Will contact artist for portfolio review if interested. Portfolio should include b&w and color final art, roughs (important) and thumbnails (important). Pays for design and illustration by the project. Rights purchased vary according to project. Finds artists through submissions

and word of mouth. Desires freelancers with web design or web programming experience and skills.

TIPS "Be original, be creative and have a positive attitude. Need to show strength in illustration with a good design sense. A flair for typography would be desirable."

⏏ TR PRODUCTIONS

2 13th St., Floor 3, Charleston MA 02129. (617)241-5500. **Website:** www.trprod.com. **Contact:** creative director. Estab. 1947. Number of employees: 12. AV firm; full-service multimedia firm. Specializes in Flash, collateral, multimedia, Web graphics and video.

NEEDS Approached by 15 freelancers/year. Works with 5 freelance illustrators and 5 designers/year. Prefers local freelancers with experience in slides, Web, multimedia, collateral and video graphics. Works on assignment only. Uses freelancers mainly for slides, Web, multimedia, collateral and video graphics; also for brochure and print ad design and illustration, slide illustration, animation and mechanicals. 25% of work is with print ads. Needs computer-literate freelancers for design, production and presentation. 95% of work demands skills in FreeHand, Photoshop, Premier, After Effects, Powerpoint, QuarkXPress, Illustrator, Flash.

FIRST CONTACT & TERMS Send query letter. Samples are filed. Does not reply. Artist should follow up with call. Will contact artist for portfolio review if interested. Rights purchased vary according to project.

TVN—THE VIDEO NETWORK

P.O. Box 270, Ashland MA 01721. (508)881-1800. **E-mail:** info@tvnvideo.com. **Website:** www.tvnvideo.com. Estab. 1986. AV firm. Full-service multimedia firm. Specializes in video production for business, broadcast and special events. Product specialties "cover a broad range of categories." Current clients include Marriott, Digital, IBM, VistaPrint, National Park Service.

NEEDS Approached by 1 freelancer/month. Works with 1 illustrator/month. Prefers freelancers with experience in Mac, 2D and 3D programs. Works on assignment only. Uses freelancers mainly for video production, technical illustration, flying logos and 3D work. Also for storyboards, animation, TV/film graphics and logos.

FIRST CONTACT & TERMS Send query e-mail and links. Will contact artist for portfolio review if

interested. Pays for design by the hour, $50; by the project, $1,000-5,000; by the day, $250-500. Buys all rights. Finds artists through word of mouth, magazines and submissions.

TIPS Advises freelancers starting out in the field to find a company internship or mentor program.

ULTITECH, INC.

Foot of Broad St., Stratford CT 06497. (203)375-7300. **Fax:** (203)375-6699. **E-mail:** ultitech@meds.com. **Website:** www.meds.com. Estab. 1993. Number of employees: 3. Approximate annual billing: $1 million. Integrated marketing communications agency. Specializes in interactive multimedia, software, online services. Product specialties are medicine, science, technology. Current clients include large pharmaceutical companies.

NEEDS Approached by 10-20 freelance illustrators and 10-20 designers/year. Works with 2-3 freelance illustrators and 6-10 designers/year. Prefers freelancers with experience in interactive media design and online design. Uses freelancers mainly for design of websites and interactive CDs/DVDs. Also for animation, brochure design, medical illustration, multimedia projects, TV/film graphics. 10% of work is with print ads. 100% of freelance design demands skills in Photoshop, QuarkXPress, Illustrator, 3D packages.

FIRST CONTACT & TERMS E-mail submission is best. Include links to online portfolio. Responds only if interested. Pays for design by the project or by the day. Pays for illustration by the project. Buys all rights. Finds artists through sourcebooks, word of mouth, submissions.

TIPS "Learn design principles for interactive media."

UNICOM

9470 N. Broadmoor Rd., Bayside WI 53217. (414)352-5070. **Fax:** (414)352-4755. **E-mail:** keichenbaum@wi.rr.com. **Contact:** Ken Eichenbaum, senior partner. Estab. 1974. Specializes in annual reports, brand and corporate identity, display, direct, package and publication design and signage. Clients: corporations, business-to-business communications, and consumer goods. Client list available upon request.

NEEDS Approached by 5-10 freelancers/year. Works with 1-2 freelance illustrators/year. Works on assignment only. Uses freelancers for brochure, book and poster illustration, prepress composition. Systems used include QuarkXPress and InDesign.

FIRST CONTACT & TERMS Send query letter with brochure. Samples not filed or returned. Does not reply; send nonreturnable samples. Write for appointment to show portfolio of thumbnails, photostats, slides and tearsheets. Pays by the project, $200-3,000. Rights purchased vary according to project.

⏻ UNO BRANDING – A CROSS-CULTURAL DESIGN AGENCY

111 E. Franklin Ave., Suite 101, Minneapolis MN 55404. (612)874-1920. **Fax:** (612)874-1912. **E-mail:** luis@unobranding.com. **Website:** www.unobranding.com. **Contact:** Luis Fitch, creative director. Estab. 1990. Number of employees: 6. Approximate annual billing: $950,000. Specializes in brand and corporate identity, display, package and retail design and signage for the US Hispanic markets. Clients: Latin American corporations, retail. Current clients include MTV Latino, Target, Mervyn's, 3M, Univision, Wilson's. Client list available upon request. Professional affiliations AIGA, GAG.

NEEDS Approached by 33 freelancers/year. Works with 40 freelance illustrators and 20 designers/year. Works only with artists' reps. Prefers local artists with experience in retail design, graphics. Uses illustrators mainly for packaging. Uses designers mainly for retail graphics. Also uses freelancers for ad and book design, brochure, catalog and P-O-P design and illustration, audiovisual materials, logos and model making. Also for multimedia projects (Interactive Kiosk, CD-Educational for Hispanic Market). 60% of design demands computer skills in Illustrator, Photoshop, FreeHand and QuarkXPress.

FIRST CONTACT & TERMS Designers: Send postcard sample, brochure, résumé, photographs, slides, or tearsheets. Illustrators: Send postcard sample, brochure, or tearsheets. Accepts disk submissions compatible with Illustrator, Photoshop, FreeHand. Send EPS files. Samples are filed. Will contact artist for portfolio review if interested. Portfolio should include color final art, photographs and slides. Pays for design by the project, $500-6,000. Pays for illustration by the project, $200-20,000. Rights purchased vary according to project. Finds artists through artist reps, *Creative Black Book* and *Workbook*.

TIPS "It helps to be bilingual and to have an understanding of Hispanic cultures."

UTOPIAN EMPIRE CREATIVEWORKS

P.O. Box 9, Traverse City MI 49865. (231)715-1614. **E-mail:** traverse_city@utopianempire.com. **Website:** www.utopianempire.com. Estab. 1970. Full-service multimedia firm. Specializes in corporate and industrial products, as well as TV and radio spots.

NEEDS Works on assignment. Uses freelance talent.

FIRST CONTACT & TERMS Send query letter with brochure, SASE, and tearsheets. Samples are filed to review for project relevancy or returned by SASE if requested by artist. Responds only if interested. To show portfolio, mail samples or CD/DVD media. Pays for design and illustration by the project, negotiated rate. Rights purchased vary according to project.

THE VAN NOY GROUP

3315 Westside Rd., Healdsburg CA 95448-9453. (707)433-3944. **Fax:** (707)433-0375. **E-mail:** vng@vannoygroup.com. **Website:** www.vannoygroup.com. **Contact:** Jim Van Noy. Estab. 1972. Specializes in brand and corporate identity, displays and package design. Clients: corporations, consumer product, beverage, health and beauty, lawn and garden and decorative hardware companies. Client list available upon request.

NEEDS Approached by 1-10 freelance artists/year. Works with 2 illustrators and 3 designers/year. Prefers artists with experience in Mac design. Works on assignment only. Uses freelancers for packaging design and illustration, Photoshop production and lettering.

FIRST CONTACT & TERMS Send query letter with résumé and photographs. Samples are filed. Will contact artist for portfolio review if interested. If no reply, artist should follow up. Pays for design by the hour, $35-100. Pays for illustration by the hour or by the project at a TBD fee. Finds artists through sourcebooks, self-promotions and primarily agents. Also have permanent positions available.

TIPS "I think more and more clients will be setting up internal art departments and relying less and less on outside designers and talent. The computer has made design accessible to the user who is not design-trained."

VIDEO RESOURCES

1809 E. Dyer Rd., #307, Santa Ana CA 92705. (949)261-7266 or (800)261-7266. **Fax:** (949)261-5908. **E-mail:** brad@videoresouces.com. **Website:** www.videoresources.com. **Contact:** Brad Hagen, producer. Number of employees: 15. Video and multimedia firm. Specializes in automotive, banks, restaurants, computer, health care, transportation and energy.

○ Additional location: 110 Campus Dr., Marlborough MA 01752; (508)485-8100.

NEEDS Approached by 10-20 freelancers/year. Works with 5-10 freelance illustrators and 5-10 designers/year. Works on assignment only. Uses freelancers for graphics, multimedia, animation, etc.

FIRST CONTACT & TERMS Send query letter with brochure showing art style or résumé, business card, photostats and tearsheets to be kept on file. Samples not filed are returned by SASE. Considers complexity of the project and client's budget when establishing payment. Buys all rights.

VISUAL HORIZONS

180 Metro Park, Rochester NY 14623. (585)424-5300; (800)424-1011. **Fax:** (585)424-5313. **E-mail:** cs@visualhorizons.com. **Website:** www.visualhorizons.com. Estab. 1971. AV firm; full-service multimedia firm. Specializes in presentation products, digital imaging of 35mm slides. Current: US government agencies, corporations and universities.

NEEDS Works on assignment only. Uses freelancers mainly for web design. 5% of work is with print ads. 100% of freelance work demands skills in Photoshop.

FIRST CONTACT & TERMS Send query letter with tearsheets. Samples are not filed and are not returned. Responds if interested. Portfolio review not required. Pays for design and illustration by the hour or project, negotiated. Buys all rights.

VML

261 E. Kalamazoo Ave., Suite 300, Kalamazoo MI 49007-3990. (269)349-7711. **Website:** www.vml.com. Ad agency; full-service digital marketing agency. Specializes in traditional advertising (print, collateral, TV, radio, outdoor), branding, strategic planning, e-business development, and media planning and buying. Product specialties are consumer, business-to-business, marine and health care. Clients include Morningstar Farms, Pfizer, Kellogg Co., Zimmer, Beaner's Coffee, United Way.

NEEDS Approached by 10 artists/month. Works with 1-3 illustrators and designers/month. Works both with artist reps and directly with artist. Prefers artists with experience with client needs. Works on assignment only. Uses freelancers mainly for completion of projects needing specialties; also for brochure, catalog and print ad design and illustration, story-

boards, mechanicals, retouching, billboards, posters, TV/film graphics, lettering and logos.

FIRST CONTACT & TERMS Send query letter with brochure, photocopies and résumé. Samples are filed. Responds only if interested. Call for appointment to show portfolio. Portfolio should include all samples the artist considers appropriate. Pays for design and illustration by the hour and by the project. Rights purchased vary according to project.

WALKER DESIGN GROUP

421 Central Ave., Great Falls MT 59401. (406)727-8115. **Fax:** (406)791-9655. **E-mail:** info@walkerdesigngroup. com. **Website:** www.walkerdesigngroup.com. **Contact:** Duane Walker, president. Number of employees: 6. Design firm. Specializes in annual reports and corporate identity. Professional affiliations: AIGA and Ad Federation.

NEEDS Uses freelancers for animation, annual reports, brochure, medical and technical illustration, catalog design, lettering, logos and TV/film graphics. 80% of design and 90% of illustration demand skills in PageMaker, Photoshop and Illustrator.

FIRST CONTACT & TERMS Send query letter with brochure, photocopies, postcards, résumé or tearsheets. Accepts digital submissions. Samples are filed and are not returned. Responds only if interested. To arrange portfolio review, artist should follow up with call or letter after initial query. Portfolio should include color photographs, photostats and tearsheets. Pays by the project; negotiable. Finds artists through *Workbook*.

TIPS "Stress customer service and be very aware of deadlines."

WARKULWIZ DESIGN ASSOCIATES, INC.

89 E. Wynnewood Rd., Merion Station PA 19066. (215)988-1777. **E-mail:** info@warkulwiz.com. **Website:** www.warkulwiz.com. **Contact:** Bob Warkulwiz, president. Estab. 1985. Number of employees: 6. Approximate annual billing: $1 million. Specializes in annual reports, publication design and corporate communications. Clients: corporations and universities. Client list available upon request. Professional affiliations: AIGA

NEEDS Approached by 100 freelancers/year. Works with 10 freelance illustrators and 5-10 photographers/ year. Works on assignment only. Uses freelance illustrators mainly for editorial and corporate work; also for brochure and poster illustration and mechanicals.

Freelancers should be familiar with most recent versions of Adobe Creative Suite.

FIRST CONTACT & TERMS Send query email with resume and portfolio sample under 2 mb. Samples are filed. Responds only if interested. Call for appointment to show portfolio of "best edited work—published or unpublished." Pays for illustration by the project, "depends upon usage and complexity." Rights purchased vary according to project.

TIPS "Be creative and professional."

WAVE DESIGN WORKS

55 Elmgrove Ave., Providence RI 02906. (774)254-0946. **E-mail:** ideas@wavedesignworks.com. **Website:** www.wavedesignworks.com. **Contact:** John Buchholz, principal. Estab. 1986. Specializes in corporate identity and display, package and publication design. Clients corporations primarily biotech, medical and health care, B2B.

NEEDS Approached by 24 freelance graphic artists/year. Works with 1-5 freelance illustrators and 1-5 freelance designers/year. Works on assignment only. Uses freelancers for brochure, catalog, poster and ad illustration; lettering; and charts/graphs. 100% of design and 50% of illustration demand knowledge of QuarkXPress, InDesign, Illustrator or Photoshop.

FIRST CONTACT & TERMS Designers send query letter with brochure, résumé, photocopies, photographs and tearsheets. Illustrators send postcard promo. Samples are filed. Responds only if interested. Artist should follow up with call or letter after initial query. Portfolio should include b&w and color thumbnails and final art. Pays for illustration by the project. Rights purchased vary according to project. Finds artists through submissions and sourcebooks.

WEST CREATIVE, INC.

10780 S. Cedar Niles Circle, Overland Park KS 66210. (913)839-2181. **Fax:** (913)839-2176. **E-mail:** stan@ westcreative.com. **Website:** www.westcreative.com. **Contact:** Stan Chrzanowski. Estab. 1974. Number of employees: 8. Approximate annual billing $600,000. Design firm and agency. Full-service multimedia firm. Client list available upon request. Professional affiliation AIGA.

Additional locations in Dallas and Tucson.

NEEDS Approached by 50 freelancers/year. Works with 4-6 freelance illustrators and 1-2 designers/year. Uses freelancers mainly for illustration. Also for animation, lettering, mechanicals, model-making, re-

touching and TV/film graphics. 20% of work is with print ads. Needs computer-literate freelancers for design, illustration and production. 95% of freelance work demands knowledge of FreeHand, Photoshop, QuarkXPress and Illustrator. Full service web design capabilities.

FIRST CONTACT & TERMS Send postcard-size sample of work or query letter with brochure, photocopies, résumé, SASE, slides, tearsheets and transparencies. Samples are filed or returned by SASE if requested by artist. Responds only if interested. Portfolios may be dropped off Monday-Thursday. Portfolios should include color photographs, roughs, slides and tearsheets. Pays for illustration by the project; pays for design by the hour, $25-60. "Each project is bid." Rights purchased vary according to project. Finds artists through *Creative Black Book* and *Workbook*.

WEYMOUTH DESIGN, INC.

332 Congress St.,, Floor 6, Boston MA 02210. (617)542-2647. **Fax:** (617)451-6233. **E-mail:** info@weymouthdesign.com. **Website:** www. weymouthdesign.com. Estab. 1973. Number of employees: 16. Specializes in annual reports, corporate collateral, website design, CDs and multimedia. Clients: corporations and small businesses. Member of AIGA.

Second location: 600 Townsend St., San Francisco CA 94103. (415)487-7900. Fax: (415)431-7200.

NEEDS Works with 3-5 freelance illustrators or photographers. Needs editorial, medical and technical illustration mainly for annual reports and multimedia projects.

FIRST CONTACT & TERMS Send query letter with résumé or illustration samples/tearsheets. Samples are filed or are returned by SASE if requested by artist. Will contact artist for portfolio review if interested.

DANA WHITE PRODUCTIONS

2623 29th St., Santa Monica CA 90405-2915. (310)450-9101. **E-mail:** dwprods@aol.com. **Contact:** Dana C. White, president. AV firm. "We are a full-service audiovisual and print design and production company, providing video and audio presentations for training, marketing, awards, historical and public relations uses. We now offer design and development of full-color books, brochures and other printed material. We have complete in-house production resources, including computer multimedia, photo digitizing,

image manipulation, program assembly, graphics, soundtrack production, photography and AV multi-image programming. We serve major industries such as US. Forest Services; medical, such as Whittier Hospital, Florida Hospital; schools, such as University of Southern California, Pepperdine University; publishers, such as McGraw-Hill, West Publishing; and public service efforts, including fundraising."

NEEDS Works with 8-10 freelancers/year. Prefers freelancers local to greater Los Angeles, "with timely turnaround, ability to keep elements in accurate registration, neatness, design quality, imagination and price." Uses freelancers for design, illustration, retouching, characterization/animation, lettering and charts. 50% of freelance work demands knowledge of Adobe InDesign, Illustrator, Photoshop, Quark and Premier.

FIRST CONTACT & TERMS Send query letter with brochure or tearsheets, photostats, photocopies, slides and photographs. Samples are filed or are returned only if requested. Responds in 2 weeks, only if interested. Call or write for appointment to show portfolio. Pays by the project. Payment negotiable by job.

TIPS "Be flexible. Negotiate. Your work should show that you have spirit, enjoy what you do, and that you can deliver high-quality work on time."

L.C. WILLIAMS & ASSOCIATES

150 N. Michigan Ave., 38th Floor, Chicago IL 60601. (312)565-3900; (800)837-7123. **E-mail:** info@lcwa. com. **Website:** www.lcwa.com. **Contact:** Monica McFadden, creative services manager. Estab. 2000. Number of employees: 28. Approximate annual billing: $3.5 million. PR firm. Specializes in marketing, communication, publicity, direct mail, brochures, newsletters, trade magazine ads, AV presentations. Product specialty is consumer home products. Current clients include Pergo, Ace Hardware, La-Z-Boy Inc. and Glidden. Professional affiliations: Chicago Direct Marketing Association, Sales & Marketing Executives of Chicago, Public Relations Society of America, Publicity Club of Chicago.

LCWA is among the top 15 public relations agencies in Chicago. It maintains a satellite office in New York.

NEEDS Approached by 50-100 freelancers/year. Works with 1-2 freelance illustrators and 2-5 designers/year. Works on assignment only. Uses freelancers

mainly for brochures, ads, newsletters. Also for print ad design and illustration, editorial and technical illustration, mechanicals, retouching and logos. 90% of freelance work demands computer skills.

FIRST CONTACT & TERMS Send query letter with brochure and résumé. Samples are filed. Does not reply. Request portfolio review in original query. Artist should call within 1 week. Portfolio should include printed pieces. Pays for design and illustration by the project, fee varies. Rights purchased vary according to project. Finds artists through word of mouth and queries.

TIPS "Many new people are opening shop and you need to keep your name in front of your prospects."

THE WILLIAMS MCBRIDE GROUP

P.O. Box 910433, Lexington KY 40591-0433. (859)253-9319. **E-mail:** tsmith@williamsmcbride.com;masinfo@williamsmcbride.com. **Website:** www.williamsmcbride.com. Estab. 1988. Number of employees: 12. Design firm specializing in brand management, corporate identity and business-to-business marketing.

NEEDS Approached by 10-20 freelance artists/year. Works with 4 illustrators and 3 designers/year. Prefers freelancers with experience in corporate design, branding. Works on assignment only. 100% of freelance design work demands knowledge of InDesign, Photoshop and Illustrator. Will review résumés of web designers with knowledge of Director and Flash.

FIRST CONTACT & TERMS Designers: Send query letter with résumé. Will review online portfolios or hardcopy samples. Illustrators: Send website link or postcard sample of work. Samples are filed. Responds only if interested. Pays for design by the hour, $50-65. Pays for illustration by the project. Rights purchased vary according to project. Finds artists through submissions, word of mouth, *Creative Black Book*, *Workbook*, *American Showcase*, artist's representatives.

TIPS "Keep our company on your mailing list; remind us that you are out there."

WISNER CREATIVE

18200 NW Sauvie Island Rd., Portland OR 97231-1338. (503)282-3929. **E-mail:** wizbiz@wisnercreative.com. **Website:** www.wisnercreative.com. **Contact:** Linda Wisner, creative director. Estab. 1979. Number of employees: 1. Specializes in brand and corporate identity, book design, publications and exhibit design. Clients:

small businesses, service businesses, non-profits, and book publishers.

NEEDS Works with 3-5 freelance illustrators/year. Prefers experienced freelancers and "fast, accurate work." Works on assignment only. Uses freelancers for technical and fashion illustration and graphic production. Knowledge of QuarkXPress, InDesign, Photoshop, Illustrator, Dreamweaver, and other software required.

FIRST CONTACT & TERMS Send query e-mail with résumé and samples. Prefers electronic "examples of completed pieces that show the fullest abilities of the artist." Will contact artist for portfolio review if interested. Pays for illustration by the project, by bid. Pays for graphic production by the hour, or by project, by bid.

⚙ MICHAEL WOLK DESIGN ASSOCIATES

31 NE 28th St., Miami FL 33137. (305)576-2898. **Fax:** (305)576-2899. **E-mail:** contact@wolkdesign.com. **Website:** www.wolkdesign.com. **Contact:** Michael Wolk, chairman/creative director. Estab. 1985. Specializes in corporate identity, displays, interior design and signage. Clients: corporate and private. Client list available on website.

NEEDS Approached by 10 freelancers/year. Works with 5 illustrators and 5 freelance designers/year. Prefers local artists only. Works on assignment only. Needs editorial and technical illustration mainly for brochures. Uses designers mainly for interiors and graphics; also for brochure design, mechanicals, logos and catalog illustration. Prefers "progressive" illustration. Needs computer-literate freelancers for design, production and presentation. 75% of freelance work demands knowledge of PageMaker, QuarkXPress, FreeHand, Illustrator or other software.

FIRST CONTACT & TERMS Send query letter with slides. Samples are not filed and are returned by SASE. Responds only if interested. To show a portfolio, mail slides. Pays for design by the hour, $10-20. Rights purchased vary according to project.

ERIC WOO DESIGN, INC.

Dillingham Transportation Bldg., 735 Bishop St., Suite 238, Honolulu HI 96813. (808)545-7442. **Fax:** (808)545-7445. **E-mail:** eric@ericwoodesign.com. **Website:** www.ericwoodesign.com. Number of employees: 3. Approximate annual billing: $500,000. Design firm. Specializes in identities and visual branding, product packaging, print and web design, envi-

ronmental graphics and signage. Majority of clients are government, corporations and nonprofits. Current clients include NOAA, Western Pacific Regional Fishery Management Council, Alexander & Baldwin, Inc.

NEEDS Approached by 5-10 illustrators and 10 designers/year. Works with 1-2 illustrators/year. Prefers freelancers with experience in multimedia. Uses freelancers mainly for multimedia projects and lettering. 5% of work is with print ads. 90% of design demands skills in Photoshop, Illustrator, Quark, Flash, Dreamweaver and InDesign.

FIRST CONTACT & TERMS Designers: Send query letter with web link. Illustrators: Send postcard sample of work or web link. Pays for design by the hour, $20-50. Pays for illustration by the project. Rights purchased vary according to project.

TIPS "Have a good sense of humor and enjoy life."

WORK

2019 Monument Ave., Richmond VA 23220. (804)358-9372. **Fax:** (804)355-2784. **Website:** worklabs.com. **Contact:** Cabell Harris, president/chief creative director. Estab. 1994. Number of employees: 5. Approximate annual billing: $44 million. Ad agency. Specializes in new product development and design, advertising, and strategic and creative problem solving. Current clients include DieHappy, Advanced Orthopaedics and Ortho On Call, Macy's and a variety of ad agencies. Client list available upon request. Professional affiliations Advertising Club of Richmond, AIGA.

NEEDS Approached by 25 illustrators and 35-40 designers/year. Works with 2-3 illustrators and 6-7 designers/year. Works on assignment only. Prefers freelancers with experience in animation, computer graphics, Macintosh. Uses freelancers mainly for new business pitches and specialty projects. Also for logos, mechanicals, TV/film graphics, posters, print ads, package design, and storyboards. 40% of work is with print ads. 95% of design work demands knowledge of FreeHand, Illustrator, Photoshop and QuarkXPress. 20% of illustration work demands knowledge of FreeHand, Illustrator, Photoshop and InDesign.

FIRST CONTACT & TERMS Send query letter with photocopies, photographs, résumé, tearsheets, URL. Accepts e-mail submissions. Check website for formats. Samples are filed or returned. Responds only if interested. Request portfolio review in original query. Company will contact artist for portfolio review if interested. Portfolio should include b&w and color finished art, photographs, slides, tearsheets and transparencies. Pays freelancers usually a set budget with a buyout. Negotiates rights purchased. Finds freelancers through submissions, sourcebooks and word of mouth.

TIPS "Send nonreturnable samples (JPEGs or PDFs) of work with résumé. Follow up by e-mail."

YASVIN COMMUNICATIONS

P.O. Box 116, Hancock NH 03449. (603)525-3000. **E-mail:** info@yasvin.com. **Website:** yasvin.com. **Contact:** Creative director. Estab. 1990. Number of employees: 3. Specializes in annual reports, brand and corporate identity, advertising, web design, commercials, corporate documentary films. Clients: corporations, colleges and non-profits.

NEEDS Approached by 10-15 freelancers/year. Works with 4 freelance illustrators and 2 designers/year. Uses freelancers for design, illustration, logos. Freelance work demands knowledge of Illustrator, InDesign, Photoshop and QuarkXPress.

FIRST CONTACT & TERMS Send postcard sample of work or e-mail with your URL. Pays for design by the project and by the day. Pays for work by the project. Rights purchased vary according to project.

SPENCER ZAHN & ASSOCIATES

2015 Sansom St., Philadelphia PA 19103. (215)564-5979. **Fax:** (215)564-6285. **E-mail:** szahn@erols.com. **Website:** www.spencerzahn.com. **Contact:** Spencer Zahn, CEO; J. McCarthy, art director. Estab. 1970. Member of GPCC. Three employees. Specializes in brand and corporate identity, Strategy, direct mail design, marketing, retail and business to business advertising. P.O.S. Clients: corporations, manufacturers, etc. Firm specializes in direct mail, electronic collateral, print ads.

NEEDS Works with freelance illustrators and designers. Prefers artists with experience in Macintosh computers. Uses freelancers for design and illustration; direct mail design; and mechanicals. Needs computer-literate freelancers for design, illustration and production. 80% of freelance work demands knowledge of Illustrator, Photoshop, FreeHand and QuarkXPress.

FIRST CONTACT & TERMS Send query letter with samples. Samples are filed and are returned if requested by artist. Responds only if interested. Portfolio

should include final art and printed samples. Buys all rights.

ZUNPARTNERS, INC.

676 N. La Salle Dr., Suite 426, Chicago IL 60654. (312)951-5533. **E-mail:** bill.ferdinand@zunpartners. com; hello@zunpartners.com. **Website:** www. zunpartners.com. **Contact:** William Ferdinand, partner. Estab. 1991. Number of employees: 9. Specializes in annual reports, brand and corporate identity, capability brochures, package and publication design, electronic and interactive. Clients: from Fortune 500 to Internet startup companies, focusing on high impact service firms. Current clients include Deloitte, Baker and McKenzie, Bracewell and Giuliani. Client list available upon request. Professional affiliations: AIGA, ACD, LMA.

NEEDS Approached by 30 freelancers/year. Works with 10-15 freelance illustrators and 15-20 designers/year. Looks for strong personal style (local and national). Uses illustrators mainly for editorial. Uses designers mainly for design and layout. Also uses freelancers for collateral and identity design, illustration; Web, video, audiovisual materials; direct mail, magazine design and lettering; logos; and retouching. Needs computer-literate freelancers for design, illustration, production and presentation. 90% of freelance work demands knowledge of Illustrator, Photoshop, InDesign.

FIRST CONTACT & TERMS Send postcard sample of work or send query letter with brochure or résumé. Samples are filed. Responds only if interested. Portfolios may be dropped off every Friday. Artist should follow up. Portfolio should include b&w and color samples. Pays for design by the hour and by the project. Pays for illustration by the project. Rights purchased vary according to project. Finds artists through reference books and submissions.

TIPS Impressed by "to the point portfolios. Show me what you like to do and what you brought to the projects you worked on. Don't fill a book with extra items (samples) for the sake of showing quantity."

SYNDICATES & CARTOON FEATURES

Syndicates are agents who sell comic strips, panels, and editorial cartoons to newspapers and magazines. If you want to see your comic strip in the funny papers, you must first get the attention of a syndicate. They promote and distribute comic strips and other features in exchange for a cut of the profits.

The syndicate business is one of the hardest markets to break into. Newspapers are reluctant to drop long-established strips for new ones. Consequently, spaces for new strips do not open up often. When they do, syndicates look for a "sure thing," a feature they'll feel comfortable investing more than $25,000 in for promotion and marketing. Even after syndication, much of your promotion will be up to you.

To crack this market, you have to be more than a fabulous cartoonist—the art won't sell if the idea isn't there in the first place. Work worthy of syndication must be original, salable, and timely, and characters must have universal appeal to attract a diverse audience.

Although newspaper syndication is still the most popular and profitable method of getting your comic strip to a wide audience, the Internet has become an exciting new venue for comic strips and political cartoons. With the click of your mouse, you can be introduced to *The Boiling Point* by Mikhaela Reid, *Overboard* by Chip Dunham, and *Strange Brew* by John Deering. (GoComics.com provides a great list of online comics.)

Such sites may not make much money for cartoonists, but it's clear they are a great promotional tool. It is rumored that scouts for the major syndicates have been known to surf the more popular comic strip sites in search of fresh voices.

HOW TO SUBMIT TO SYNDICATES

Each syndicate has a preferred method for submissions, and most have guidelines you can send for or access online. Availability is indicated in the listings.

To submit a strip idea, send a brief cover letter (fifty words or less is ideal) summarizing your idea, along with a character sheet (the names and descriptions of your major characters), and photocopies of twenty-four of your best strip samples on 8½×11 paper, six daily strips per page. Sending at least one month of samples shows that you're capable of producing consistent artwork and a long-lasting idea. Never submit originals; always send photocopies of your work. Simultaneous submissions are usually acceptable. It is often possible to query syndicates online by attaching art files or links to your website. Response time can take several months. Syndicates understand it would be impractical for you to wait for replies before submitting your ideas to other syndicates.

Editorial Cartoons

If you're an editorial cartoonist, you'll need to start out selling your cartoons to a base newspaper (probably in your hometown) and build up some clips before approaching a syndicate. Submitting published clips proves to the syndicate that you have a following and are able to produce cartoons on a regular basis. Once you've built up a good collection of clips, submit at least twelve photocopied samples of your published work along with a brief cover letter.

Payment and Contracts

If you're one of the lucky few to be picked up by a syndicate, your earnings will depend on the number of publications in which your work appears. It takes a minimum of about sixty interested newspapers to make it profitable for a syndicate to distribute a strip. A top strip such as *Garfield* may be in as many as 2,500 papers worldwide.

Newspapers pay in the area of $10–15 a week for a daily feature. If that doesn't sound like much, multiply that figure by 100 or even 1,000 newspapers. Your payment will be a percentage of gross or net receipts. Contracts usually involve a 50/50 split between the syndicate and cartoonist. Check the listings for more specific payment information.

Before signing a contract, be sure you understand the terms and are comfortable with them.

Self-Syndication

Self-syndicated cartoonists retain all rights to their work and keep all profits, but they also have to act as their own salespeople, sending packets to newspapers and other likely outlets. This requires developing a mailing list, promoting the strip (or panel) periodically, and developing a pricing, billing, and collections structure. If you have a knack for business and the required time and energy, this might be the route for you. Weekly suburban or alternative newspapers are the best bet here. (Daily newspapers rarely buy from self-syndicated cartoonists.)

⚙ ARTIZANS.COM

11136-75A St. NW, Edmonton, Alberta T5B 2C5, Canada. (780)471-6112 or (877)700-8666. **E-mail:** submissions@artizans.com. **Website:** www.artizans. com. **Contact:** submissions editor. Estab. 1998. Artist agency and syndicate providing commissioned artwork, stock illustrations, political cartoons, gag cartoons, global caricatures, and humorous illustrations to magazines, newspapers, websites, corporate and trade publications, and ad agencies. Artists represented include Jan Op De Beeck, Chris Wildt, Jerry King, Roy Delgado and Dusan Petricic.

NEEDS Works with 30-40 artists/year. Buys 30-40 features/year. Needs single-image gag cartoons, political cartoons, illustrations, and graphic art. Prefers established professional artists who create artwork regularly, and/or former professional artists who have an existing arhive of cartoons, caricatures, or illustrations.

FIRST CONTACT & TERMS Submission guidelines available online.

CITY NEWS SERVICE, LLC

P.O. Box 86, Willow Springs MO 65793-0086. (417)469-4476. **E-mail:** cns@cnsus.org. **Website:** www.cnsus.org. Estab. 1969. Editorial service providing editorial and graphic packages for magazines.

NEEDS Buys from 12 or more freelance artists/year. Considers caricatures, editorial cartoons, and tax and business subjects as themes; considers b&w line drawings and shading film.

FIRST CONTACT & TERMS Send query letter with résumé, tearsheets or photocopies. Samples should contain business subjects. "Send 5 or more b&w line drawings, color drawings, shading film or good line-drawing editorial cartoons." Does not want to see comic strips. Samples not filed are returned by SASE. Responds in 4-6 weeks. To show a portfolio, mail tearsheets, or photostats. Pays 50% of net proceeds; pays flat fee of $25 minimum. "We may buy art outright or split percentage of sales."

TIPS "We have the markets for multiple sales of editorial support art. We need talented artists to supply specific projects. We will work with beginning artists. Be honest about talent and artistic ability. If it isn't there, don't beat your head against the wall."

CONTINENTAL FEATURES/CONTINENTAL NEWS SERVICE

501 W. Broadway, P.M.B. #265, Plaza A, San Diego CA 92101-3802. (858)492-8696. **E-mail:** continentalnewsservice@yahoo.com. **Website:** www.continentalnewsservice.com. **Contact:** Gary P. Salamone, editor-in-chief. Estab. 1981. Syndicate serving 3 outlets—house publication and CF/CNS' periodic on-line Washington DC, Chicago, Boston, Miami, Atlanta, Houston, Rochester (NY), Minneapolis, San Diego, Honolulu, Anchorage, and Seattle News Editions; publishing business; and the general public—through the Continental Newstime general interest news magazine. Features include Portfolio, a collection of cartoon and caricature art. Guidelines available for #10 SASE with first-class postage.

NEEDS Approached by up to 200 cartoonists/year. Number of new strips introduced each year varies. Considers comic strips and gag cartoons. Does not consider highly abstract, computer-produced or stick-figure art. Prefers single-panel with gagline. Maximum size of artwork: 8×10; must be reducible to 65% of original size.

FIRST CONTACT & TERMS Sample package should include cover letter and photocopies (10-15 samples), but cartoonists should have 2-3 years' worth of material in reserve. Samples are filed or are returned by SASE if requested by artist. Responds in 1 month, if interested or if SASE is received. No telephone calls please. To show portfolio, mail photocopies, and cover letter. Pays 70% of gross income on publication. Rights purchased vary according to project. Minimum length of contract is 2-3 years. The artist owns the original art and the characters.

TIPS "We need single-panel cartoons and comic strips appropriate for an English-speaking international audience, including cartoons that communicate feelings or predicaments, without words. Do not send samples reflecting the highs and lows and different stages of your artistic development. *CF/CNS* wants to see consistency and quality, so you'll need to send your best samples."

⊕ CREATORS SYNDICATE, INC.

Editorial Review Board—Comics, Creators, 737 Third St., Hermosa Beach CA 90254. (310)337-7003. **Fax:** (310)337-7625. **E-mail:** info@creators.com. **Website:** www.creators.com. Estab. 1987. Serves 2,400 daily

newspapers, weekly and monthly magazines worldwide.

NEEDS Syndicates 100 writers and artists/year. Considers comic strips, caricatures, editorial or political cartoons and "all types of newspaper columns." Recent introductions: *Speedbump* by Dave Coverly; *Strange Brew* by John Deering.

FIRST CONTACT & TERMS Submission guidelines available online. "No submissions via e-mail! Do not send original art!"

KING FEATURES SYNDICATE

Hearst, 300 W. 57th St., 15th Floor, New York NY 10019-5238. (212)969-7550. **Fax:** (646)280-1550. **Website:** www.kingfeatures.com. **Contact:** submissions editor.

FIRST CONTACT & TERMS Send (1): A cover letter that briefly outlines the overall nature of your comic strip. Your letter should include your full name, address, and telephone number and shouldn't be much longer than a single page. (2): 24 b&w daily comic strips. You should reduce your comics to fit onto standard 8½×11 sheets of paper. Write your name, address and phone number on each page. Do not send your original drawings! Send photocopies instead. (3): A character sheet that shows your major characters (if any) along with their names and a paragraph description of each. "We do not accept work submitted via the Internet or on disk. Due to the extremely high volume of submissions we receive, it is easiest for us to receive, track, and account for the work if everything is sent in via regular mail or courier in the format described above. King Features is one of the world's largest syndicates. Each year, it gets more thousands of submissions of which only a few are chosen for syndication."

TIPS "The single best way of improving your chances for success is to practice. Only by drawing and writing cartoons do you get better at it. Invariably, the cartoonists whose work we like best turn out to be those who draw and write cartoons regularly, whether anyone sees their work or not. Another key to success it to read a lot. Read all sorts of things—fiction, magazines and newspapers. Humor is based on real life. The more you know about life, the more you have to humorously write about."

UNIVERSAL UCLICK

1130 Walnut St., Kansas City MO 64106. **E-mail:** submissions@amuniversal.com. **Website:** www.universaluclick.com. **Contact:** submissions editor.

Estab. 1970. Print and online syndicate serving over 300 online clients daily. Art guidelines available on website.

NEEDS Approached by 200 cartoonists and 50 illustrators/year. Introduces about 15 new strips/year. Recent introductions include *Wumo*, *Heavenly Nostrils*, *Dark Side of the Horse*. Considers caricatures, single- or multi-panel cartoons, comic strips, puzzles/games. Looking for conservative and liberal political cartoons; unique puzzles, games, and quizzes.

FIRST CONTACT & TERMS Send cover letter, character sheets and finished cartoons. Prefers to see 4 to 6 weeks worth of samples. Samples are not filed and are returned by SASE if requested by artist. Responds in 6-8 weeks. Will contact artist for portfolio review if interested. Pays on publication. "Royalties are based on negotiated rates, fees, or licenses depending on content and distribution channels." Rights are negotiated. Artist owns original art and characters. Minimum length of contract: 3-year term is preferred; offers automatic renewal.

WASHINGTON POST WRITERS GROUP

1150 15th St. NW, Washington DC 20071. (202)334-5375 or (800)879-9794, ext. 2. **E-mail:** cartoonsubmission@washpost.com; wpwgsales@washpost.com; syndication@washpost.com. **Website:** www.postwritersgroup.com. **Contact:** comics editor. Estab. 1973. Syndicate serving over 1,000 daily, Sunday and weekly newspapers in US and abroad. Submission guidelines available on website or for SASE with necessary postage.

NEEDS Considers comic strips, panel, and editorial cartoons.

FIRST CONTACT & TERMS Send at least 24 cartoons. "You do not need to send color or Sunday cartoons in your initial submission; we will ask for those later if we require them. Of course if you do include color work, we are happy to review it." No fax submissions. Include SASE for reply only; cannot return materials. Submissions without SASE will not receive a reply. Responds whenever possible due to volume of submissions. Can submit by e-mail, but only if you can send it as a multi-page PDF with at least 2 dailies to a page.

TIPS "Use letter-sized paper for your submission. Make sure cartoons will reduce to standard sizes. Send only copies; never send originals."

✚ WHITEGATE FEATURES SYNDICATE

71 Faunce Dr., Providence RI 02906. (401)274-2149. **E-mail:** webmaster@whitegatefeatures.com. **Website:** www.whitegatefeatures.com. Estab. 1988. Syndicate serving daily newspapers, book publishers, and magazines. Guidelines available on website.

○ Send nonreturnable samples. This syndicate says they are not able to return samples, "even with SASE," because of the large number of submissions they receive.

NEEDS Considers comic strips, gag cartoons, editorial/political cartoons, illustrations, and spot drawings; single, double, and multiple panel. Work must be reducible to strip size. Also needs artists for advertising and publicity. Looking for fine artists and illustrators for book publishing projects.

FIRST CONTACT & TERMS Send cover letter, résumé, tearsheets, photostats, and photocopies. Include about 12 strips. Does not return materials. To show portfolio, mail tearsheets, photostats, photographs, and slides; include b&w. Pays 50% of net proceeds upon syndication. Negotiates rights purchased. Minimum length of contract: 5 years (flexible). Artist owns original art; syndicate owns characters (negotiable).

TIPS Include in a sample package "info about yourself, tearsheets, notes about the strip and enough samples to tell what it is. Don't write asking if we want to see; just send samples." Looks for "good writing, strong characters, good taste in humor. No hostile comics. We like people who have cartooned for a while and are printed. Get published in local papers first."

ARTISTS' REPRESENTATIVES

//

Many artists find leaving promotion to a rep allows them more time for the creative process. In exchange for actively promoting an artist's career, the representative receives a percentage of sales (usually 25–30 percent). Reps generally focus on either the fine art market or commercial market, rarely both.

Fine art reps promote the work of fine artists, sculptors, craftspeople, and fine art photographers to galleries, museums, corporate art collectors, interior designers, and art publishers. Commercial reps help illustrators and graphic designers obtain assignments from advertising agencies, publishers, magazines, and other buyers. Some reps also act as licensing agents.

What Reps Do

Reps work with artists to bring their portfolios up to speed and actively promote their work to clients. Usually a rep will recommend advertising in one of the many creative directories such as *American Showcase* or *Workbook* so that your work will be seen by hundreds of art directors. (Expect to make an initial investment in costs for duplicate portfolios and mailings.) Reps also negotiate contracts, handle billing, and collect payments.

Getting representation isn't as easy as you might think. Reps are choosy about who they represent—not just in terms of talent but also in terms of marketability and professionalism. Reps will only take on talent they know will sell.

What to Send

Once you've gone through the listings in this section and compiled a list of art reps who handle your type and style of work, contact them with a brief query letter and nonreturnable copies of your work. Check each listing for specific guidelines and requirements.

AMERICAN ARTISTS REP, INC.

1 Chatsworth Ave., #518, Larchmont NY 10538. (212)682-2462. **Fax:** (212)582-0090. **Website:** www.aareps.com. Estab. 1930. Commercial illustration representative. Member of SPAR. Represents 40 illustrators. Markets include advertising agencies, corporations/client direct, design firms, editorial/magazines, paper products/greeting cards, publishing/books, sales/promotion firms.

HANDLES Illustration, design.

TERMS Rep receives 30% commission. "All portfolio expenses billed to artist." Advertising costs are split: 70% paid by talent; 30% paid by representative. "Promotion is encouraged; portfolio must be presented in a professional manner—8×10, 4×5, tearsheets, etc." Advertises in *American Showcase*, *The Black Book*, *RSVP*, *Workbook*, medical, and Graphic Artist Guild publications.

HOW TO CONTACT Send query letter, direct mail flyer/brochure, tearsheets. Responds in 1 week if interested. After initial contact, drop off or mail appropriate materials for review. Portfolio should include tearsheets, slides. Obtains new talent through recommendations from others, solicitation, conferences.

ARTISAN CREATIVE, INC.

(310)312-2062. **Fax:** (310)312-0670. **E-mail:** lainfo@artisancreative.com. **Website:** www.artisancreative.com. Estab. 1988. Represents creative directors, art directors, graphic designers, illustrators, animators (3D and 2D), storyboarders, packaging designers, photographers, web designers, broadcast designers, and flash developers. Markets include advertising agencies, corporations/client direct, design firms, entertainment industry.

○ Additional locations in San Francisco, Chicago, New York, and Indianapolis. See website for details.

HANDLES Web design, multimedia, illustration, photography, and production. Looking for web, packaging, traditional, and multimedia-based graphic designers.

TERMS 100% of advertising costs paid by the representative. For promotional purposes, talent must provide PDFs of work. Advertises in magazines for the trade, direct mail, and the Internet.

HOW TO CONTACT For first contact, e-mail résumé to creative staffing department. "You will then be contacted if a portfolio review is needed." Portfolio should include roughs, tearsheets, photographs, or color photos of your best work.

TIPS "Have at least 2 years of working experience and a great portfolio."

ARTWORKS ILLUSTRATION

(212)239-4946. **E-mail:** artworksillustration@earthlink.net. **Website:** www.artworksillustration.com. Estab. 1990. Commercial illustration representative. Member of Society of Illustrators. Represents 30 illustrators. Specializes in publishing. Markets include advertising agencies, design firms, paper products/greeting cards, movie studios, publishing/books, sales/promotion firms, corporations/client direct, editorial/magazines, video games. Artists include Dan Brown, Dennis Lyall, Deborah Chabrian, Peter Siu

HANDLES Illustration. Looking for interesting juvenile, digital science fiction/fantasy & romance images.

TERMS Rep receives 30% commission. Exclusive area representation required. Advertising costs are split: 75% paid by artist; 25% paid by rep. Advertises in *American Showcase* and on www.theispot.com.

HOW TO CONTACT For first contact, send e-mail samples. Responds only if interested.

⊕ CAROL BANCROFT & FRIENDS

P.O. Box 2030, Danbury CT 06813. (203)730-8270 or (800)720-7020. **Fax:** (203)730-8275. **E-mail:** cbfriends@sbcglobal.net. **Website:** www.carolbancroft.com. **Contact:** Joy Elton Tricarico, owner; Carol Bancroft, founder. Estab. 1972. Illustration representative for children's publishing. Member of Society of Illustrators, Graphic Artists Guild, SCBWI, and National Art Education Association. Represents over 30 illustrators. Specializes in, but not limited to, representing artists who illustrate for children's publishing—text, trade, and any children's-related material. Clients include Scholastic, HarperCollins, Random House, Pearson/Penguin, Simon & Schuster. Artist list available upon request. Illustration for children of all ages.

○ "Internationally known for representing artists who specialize in illustrating art for all aspects of the children's market. We also represent many artists who are well known in other aspects of the field of illustration."

TERMS Rep receives 25% commission. Advertising costs are split: 75% paid by talent; 25% paid by representative.

HOW TO CONTACT For promotional purposes, artist should provide "web address in an e-mail or samples via mail (laser copies, not slides; tearsheets, promo pieces, books, good color photocopies, etc.); 6 pieces or more; narrative scenes with children or animals interacting." Send samples and SASE. "Artists may call no sooner than one month after sending samples."

BERENDSEN & ASSOCIATES, INC.

5 W. Fifth St., Suite 300, Covington KY 41011. (513)861-1400. **Fax:** (859)980-0820. **E-mail:** bob@illustratorsrep.com; info@illustratorsrep.com. **Website:** www.illustratorsrep.com; www.photographersrep.com; www.designersrep.com; www.stockartrep.com. Estab. 1986. Commercial illustration, photography, design representative. Represents 70 illustrators, 15 photographers. Specializes in "high-visibility consumer accounts." Markets include advertising agencies, corporations/client direct, design firms, editorial/magazines, paper products/greeting cards, publishing/books, sales/promotion firms. Clients include Disney, CNN, Pentagram, F+W. Additional client list available upon request. Represents Bill Fox, Kevin Torline, Judy Hand, Frank Ordaz, Wendy Ackison, Jack Pennington, Ursula Roma, John Sledd, Richard Cowdrey, Corey Wolfe, John Margeson, Paul Lopez, and Tony Randazzo.

HANDLES Illustration, photography, and web design. "We are always looking for illustrators who can draw people, product, and action well. Also, we look for styles that are metaphoric in content, and it's a plus if the stock rights are available."

TERMS Rep receives 30% commission. Charges "mostly for postage, but figures not available." No geographic restrictions. Advertising costs are split: 70% paid by talent; 30% paid by rep. For promotional purposes, "artist can co-op in our direct mail promotions, and sourcebooks are recommended. Portfolios are updated regularly." Advertises in *RSVP, Creative Illustration Book, Directory of Illustration,* and *American Showcase.*

HOW TO CONTACT For first contact, send an e-mail with no more than 6 JPEGs attached; or send query letter and any nonreturnable tearsheets, slides, photographs, or photocopies.

TIPS Artists should have "a proven style" with at least 10 samples of that style.

BERNSTEIN & ANDRIULLI

58 W. 40th St., 6th Floor, New York NY 10018. (212)682-1490. **Fax:** (212)286-1890. **E-mail:** info@ba-reps.com. **Website:** www.ba-reps.com. Estab. 1975. Commercial illustration and photography representative. Member of SPAR. Represents 100 illustrators, 52 photographers. Markets include advertising agencies, corporations/client direct, design firms, editorial/magazines, paper products/greeting cards, publishing/books, sales/promotion firms.

HANDLES Illustration, new media, and photography.

TERMS Rep receives a commission. Exclusive career representation is required. No geographic restrictions. Advertises in *The Black Book, Workbook, Bernstein Andriulli International Illustration, CA Magazine, Archive, American Illustration/Photography.*

HOW TO CONTACT Send query e-mail with website or digital files. Call to schedule an appointment before dropping off portfolio.

JOANIE BERNSTEIN, ART REP

756 Eighth Ave. S., Naples FL 34102. (239)403-4393. **Fax:** (239)403-0066. **E-mail:** joanie@joaniebrep.com. **Website:** www.joaniebrep.com. Estab. 1984. Commercial illustration representative.

HANDLES Illustration. Looking for an unusual, problem-solving style. Clients include advertising, design, animation, books, music, product merchandising, developers, movie studios, films, private collectors.

TERMS Rep receives 25% commission. Exclusive representation required.

HOW TO CONTACT E-mail samples.

TIPS "I'd strongly advise an updated website. Also add 'What's New'—show off new work."

BLASCO CREATIVE ARTISTS

110 S. William St., Mount Prospect IL 60056. (847) 637-7986. **E-mail:** jean@blascocreative.com. **Website:** www.blascocreative.com. **Contact:** Jean Blasco. Estab. 1988. Commercial illustration and photography. Represents 20+ internationally acclaimed illustrators and 4 celebrated photographers. Markets include advertising agencies, corporations, design firms, editorial/magazines, publishing/books, promotion, and packaging. Clients include "every major player in the United States."

HANDLES Illustration. "We are receptive to reviewing samples by enthusiastic up-and-coming artists. E-mail samples and/or your website address."

TERMS Exclusive area representation is preferred. For promotional purposes, talent must provide printed promotional pieces and a well organized, creative portfolio. "If your book is not ready to show, be willing to invest in a new one." Advertises in *Workbook*, *Directory of Illustration*, *Folio Planet*, *Found Folios*, www.theispot.com.

HOW TO CONTACT For first contact, send samples via e-mail, or printed materials that do not have to be returned. Responds only if interested. Obtains new talent through recommendations from art directors, referrals, and submissions.

TIPS "You need to be true to yourself as an artist. Define your direction and style and don't bend to commercial whims. I like to see an artist who creates imagery not only for commissioned projects but also for his/her own personal fulfillment."

BROWN INK GALLERY

222 E. Brinkerhoff Ave., Palisades Park NJ 07650. (973)865-4966. **Fax:** (201)461-6571 (call first). **E-mail:** robert229artist@juno.com. **Website:** www.browninkgallery.com. **Contact:** Bob Brown, president/owner. Estab. 1978. Digital fine art publisher and distributor. Represents 5 fine artists, 2 illustrators. Specializes in advertising, magazine editorials, book publishing, fine art. Markets include advertising agencies, corporations/client direct, design firms, editorial/magazines, galleries, movie studios, paper products/greeting cards, publishing/books, record companies, sales/promotion firms.

HANDLES Fine art, illustration, digital fine art, digital fine art printing, licensing material. Looking for professional artists who are interested in making a living with their art. Art samples and portfolio required.

TERMS Rep receives 25% commission on illustration assignment; 50% on publishing (digital publishing) after expenses. "The only fee we charge is for services rendered (scanning, proofing, printing, etc.). We pay for postage, labels and envelopes." Exclusive area representation required (only in the NY, NJ, CT region of the country). Advertising costs are paid by artist or split: 75% paid by artist; 25% paid by rep. Artists must pay for their own promotional material. For promotional purposes, talent must provide a full-color direct mail piece, an 8½×11 flexible portfolio, digital files, and CD.

HOW TO CONTACT For first contact, send bio, direct mail flier/brochure, photocopies, photographs, résumé, SASE, tearsheets, slides, digital images/CD, query letter (optional). Responds only if interested. After initial contact, call to schedule an appointment, drop off or mail portfolio, or e-mail. Portfolio should include b&w and color finished art, original art, photographs, slides, tearsheets, transparencies (35mm, 4½ and 8×10).

TIPS "Be as professional as possible! Your presentation is paramount. The competition is fierce, therefore your presentation (portfolio) and art samples need to match or exceed that of the competition."

✪ CONTACT JUPITER, INC.

90 Queen Avenue, Montreal, Quebec H9R 4G4 Canada. (514)572-0388; (646)290-5405. **E-mail:** oliver@contactjupiter.com. **Website:** www.contactjupiter.com. **Contact:** Oliver Mielenz, creative facilitator. Estab. 1996. Commercial illustration representative. Represents 17 illustrators, 6 photographers. Specializes in creating images for advertising and publishing clients. Licenses illustrators and photographers. Markets include advertising agencies, paper products/greeting cards, record companies, publishing/books, corporations/client direct, and editorial/magazines.

HANDLES Illustration, multimedia, music, photography, design.

TERMS Rep receives 15-25% and rep fee. Advertising costs are split: 90% paid by artist; 10% paid by rep. Exclusive representation required. For promotional purposes, talent must provide electronic art samples only. Advertises in *Directory of Illustration*.

HOW TO CONTACT Send query by e-mail with several low-res JPEGs, along with your information, target markets, and experiences. "If we think you've got what we need, we'll be in touch."

TIPS "One specific style is easier to sell. Focus, focus, focus. Initiative, I find, is very important in an artist."

CORNELL & COMPANY, ILLUSTRATION AND DESIGN

44 Jog Hill Rd., Trumbull CT 06611. (203)454-4210. **E-mail:** merial@cornellandco.com. **Website:** www.cornellandco.com. **Contact:** Merial Cornell. Estab. 1989. Member of SCBWI and Graphic Artists Guild. Cornell & Company (formerly Cornell & McCarthy, LLC) represents a diverse group of talented, professional artists specializing in illustration of children's picture books, educational materials, magazines, stationery, kids products, and toys. "Please visit our website for an overview of our group illustrators. Cornell & Company also provides consulting, art buying services and support for large projects."

TERMS For first contact, send query letter, direct mail brochures or postcards, color copies. Samples are not returned. Will reply only if interested. Also interested in author/illustrators. Obtains new talent through recommendations from industry contacts, solicitation, submissions, and conferences.

CWC INTERNATIONAL, INC.

330 Pearl St., #2B, New York NY 10038. (646)486-6586. **E-mail:** agent@kokoartagency.com. **Website:** www.kokoartagency.com. Estab. 1999. Commercial ilustration representative. Represents 23 illustrators. Specializes in advertising, fashion, editorial. Markets include advertising agencies, corporations/client direct, design firms, editorial/magazines, galleries, paper products/greeting cards, publishing/books, record companies. Artists include Jeffrey Fulvimari, Stina Persson, Chris Long, and Kenzo Minami.

HANDLES Fine art, illustration.

TERMS Exclusive area representation required.

HOW TO CONTACT Submission guidelines available online.

TIPS "Please do not call. When sending any image samples by e-mail, be sure the entire file will not exceed 2MB."

LINDA DE MORETA REPRESENTS

(510)769-1421. **Fax:** (419)710-8298. **E-mail:** linda@lindareps.com. **Website:** www.lindareps.com. Estab. 1988. Commercial illustration, calligraphy/handlettering, storyboards/comps, motion graphics, and photography representative. Represents 10 illustrators, 2 photographers. Markets include advertising agencies, design firms, corporations/client direct, editorial/magazines, paper products/greeting cards, publishing/books. Represents Chuck Pyle, Pete McDonnell, Monica Dengo, James Yamasaki, John Howell, Shannon Abbey, Shan O'Neill, and Mack Dee.

HANDLES Photography, illustration, lettering/title design, storyboards/comps, motion graphics, and animation.

TERMS Commission, exclusive representation requirements, and advertising costs are according to individual agreements. Materials for promotional purposes vary with each artist. Advertises in *Workbook, Directory of Illustration.*

HOW TO CONTACT For first contact, e-mail samples or link to website. Responds to any inquiry in which there is an interest. Portfolios are individually developed for each artist.

TIPS Obtains new talent through client and artist referrals primarily, some solicitation. "We look for great creativity, a personal vision, and well developed style combined with professionalism and passion."

THE DESKTOP GROUP

420 Lexington Ave., 21st Floor, New York NY 10170. (212)916-0805. **Fax:** (212)867-1759. **E-mail:** info@desktopgroup.com. **Website:** www.thedesktopgroup.com. Estab. 1991. Specializes in recruiting and placing creative talent on a freelance basis. Markets include advertising agencies, design firms, publishers (book and magazine), corporations, and banking/financial firms.

HANDLES Artists with Mac and Windows software and multimedia expertise—graphic designers, production artists, prepress technicians, presentation specialists, traffickers, art directors, Web designers, content developers, project managers, copywriters, and proofreaders.

HOW TO CONTACT For first contact, e-mail résumé, cover letter, and work samples.

TIPS "Our clients prefer working with talented artists who have flexible, easy-going personalities and who are very professional."

LIBBY FORD ARTIST REPRESENTATIVE

320 E. 57th St., 10B, New York NY 10022. (212)935-8068. **Website:** www.libbyford.com. Represents over 45 illustrators. Specializes in children's trade books, young adult and educational markets.

TERMS Portfolios samples should be sent electronically. Will contact you for additional materials.

ROBERT GALITZ FINE ART & ACCENT ART

166 Hilltop Court, Sleepy Hollow IL 60118. (847)426-8842. **E-mail:** robert@galitzfineart.com. **Website:** www.galitzfineart.com. **Contact:** Robert Galitz, owner. Estab. 1986. Fine art representative. Represents 100 fine artists (including 2 sculptors). Specializes in contemporary/abstract corporate art. Markets include architects, corporate collections, galleries, interior decorators, private collections. Represents Louis De Mayo.

HANDLES Fine art.

TERMS Agent receives 25-40% commission. No geographic restrictions; sells mainly in Chicago, Wisconsin, Indiana, and Kentucky. For promotional purpos-

es, talent must provide "good photos and slides." Advertises in monthly art publications and guides.

HOW TO CONTACT Send query letter, slides, photographs. Responds in 2 weeks. After initial contact, call for appointment to show portfolio of original art. Obtains new talent through recommendations from others, solicitation, conferences.

TIPS "Be confident and persistent. Never give up or quit."

🌑 GRAHAM-CAMERON ILLUSTRATION

59 Hertford Rd., Brighton BN1 7GG, United Kingdom. +44(0)1273 385890. **E-mail:** enquiry@gciforillustration.com. **Website:** www.gciforillustration.com. **Contact:** Helen Graham-Cameron, art director. Estab. 1985. Commercial illustration representative. Represents 45 illustrators. Agency specializes in Childrens' and Educational Illustration. Markets include designer firms and publishing/books.

HANDLES Illustration.

TERMS Rep receives 30% standard commission. Exclusive representation required. Advertising costs are 100% paid by representative. May occasionally be asked to supply an illustration to representative's brief.

HOW TO CONTACT For first contact, talent should send link to website. Responds in 3 months.

TIPS Obtains new talent through submissions.

ANITA GRIEN REPRESENTING ARTISTS

155 E. 38th St., New York NY 10016. (212)697-6170 or (917)494-3826 (cell). **E-mail:** anita@anitagrien.com. **Website:** www.anitagrien.com. Representative not currently seeking new talent.

CAROL GUENZI AGENTS, INC. DBA ARTAGENT.COM

865 Delaware St., Denver CO 80204. (303)820-2599 or (800)417-5120. **Fax:** (303)820-2598. **E-mail:** carol@artagent.com; art@artagent.com. **Website:** www.artagent.com. **Contact:** Carol Guenzi, president. Estab. 1984. Commercial illustration, photography, new media, and film/animation representative. Represents 18 illustrators, 8 photographers, 4 film/animation developers, and 3 multimedia developers, copywriter. Specializes in a "worldwide selection of talent in all areas of visual communications." Markets include advertising agencies, corporations/client direct, design firms, editorial/magazines, paper products/greeting cards, sales/promotions firms.

Clients: Miller/Coors, Celestial Seasonings, Audi, Northface, Whole Foods, Western Union, American Blue Ribbon Holding, Coca-Cola, Bacardi, First Data, Quiznos, Starbucks, Boston Market, Nike, etc. Client list available upon request. Represents Christer Eriksson, Bruce Hutchison, Kym Foster, Jeff Pollard, Kelly Hume, and many more; Illustration, photography. Looking for "unique style application."

TERMS Rep receives 25-30% commission. Exclusive area representation is required. Advertising costs are split: 70-75% paid by talent; 25-30% paid by rep. For promotional purposes, talent must provide "promotional material; some restrictions on portfolios." Advertises in *Directory of Illustration*, *Workbook*, social marketing.

HOW TO CONTACT For first contact, e-mail PDFs or JPEGs with link to URL, or send direct mail flier/brochure. Responds only if interested. E-mail electronic files. Portfolio should include promotional material or electronic files. Obtains new talent through solicitation, art directors' referrals, and active pursuit by individual artists.

TIPS "Show your strongest style and have at least 12 samples of that style before introducing all your capabilities. Be prepared to add additional work to your portfolio to help round out your style. Have a digital background."

HOLLY HAHN & CO.

1852 W. Greenleaf, Chicago IL 60626. (312)371-0500. **E-mail:** holly@hollyhahn.com. **Website:** www.hollyhahn.com. Estab. 1988. Commercial illustration and photography representative.

HANDLES Illustration, photography.

HOW TO CONTACT Send direct mail flier/brochure and tearsheets.

RONNIE ANN HERMAN AGENCY

350 Central Park W., New York NY 10025. **E-mail:** ronnie@hermanagencyinc.com. **E-mail:** ronnie@hermanagencyinc.com. **Website:** www.hermanagencyinc.com. **Contact:** Ronnie Ann Herman. Estab. 1999. Literary and artistic agency for children's books. Member of SCBWI, Graphic Artists' Guild, and Authors' Guild. Some of the illustrators represented: Michael Rex, Troy Cummings, Geoffrey Hayes. Currently not accepting new clients unless they have been successfully published by major trade publishing houses.

HANDLES Illustration. Looking for authors and artists with strong history of publishing in the children's market.

TERMS Offers written exclusive contract. Advertising costs are split: 75% paid by illustrator; 25% paid by rep.

HOW TO CONTACT For first contact, e-mail only. Responds in 8-16 weeks. For first contact, artists or author/artists should e-mail a link to their website with bio and list of published books as well as new picture book or dummy to Ronnie. We will contact you only if your samples are right for us. For first contact, authors of middle-grade should e-mail bio, list of published books, and first ten pages. Finds illustrators and authors through recommendations from others, conferences, queries/solicitations.

TIPS "Check our website to see if you belong with our agency."

SCOTT HULL ASSOCIATES

Scott Hull, 3875 Ferry Rd., Bellbrook OH 45305. (937)433-8383. **E-mail:** scott@scotthull.com. **Website:** www.scotthull.com. **Contact:** Scott Hull. Estab. 1981. Specialized illustration representative. Represents 20+ illustrators.

HOW TO CONTACT Send e-mail samples or appropriate materials for review. No original art. Follow up with e-mail. Responds in 1 week.

TIPS Looks for interesting talent with a passion to grow, as well as a strong, in-depth portfolio.

VINCENT KAMIN & ASSOCIATES

(312)685-8834. **Fax:** (312)787-8834. **E-mail:** vincekamin@att.net. Estab. 1971. Commercial photography, graphic design representative. Member of SPAR. Represents 6 illustrators, 6 photographers, 1 designer, 1 fine artist (includes 1 sculptor). Markets include advertising agencies.

HANDLES Illustration, photography.

TERMS Rep receives 30% commission. Advertising costs are split: 90% paid by talent; 10% paid by representative. Advertises in *Workbook* and *Chicago Directory*.

HOW TO CONTACT Send tearsheets. Responds in 10 days. After initial contact, call to schedule an appointment. Portfolio should include tearsheets.

CLIFF KNECHT—ARTIST REPRESENTATIVE

309 Walnut Rd., Pittsburgh PA 15202. (412)761-5666. **E-mail:** cliff@artrep1.com. **Website:** www.artrep1.com. **Contact:** Cliff Knecht. Estab. 1972. Commercial illustration representative. Represents more than 20 illustrators. Markets include advertising agencies, corporations/client direct, design firms, editorial/magazines, paper products/greeting cards, publishing/books, sales/promotion firms.

HANDLES Illustration.

TERMS Rep receives 25% commission. No geographic restrictions. Advertising costs are split: 75% paid by the talent; 25% paid by representative. For promotional purposes, talent must provide a direct mail piece. Advertises in *Graphic Artists Guild Directory of Illustration*.

HOW TO CONTACT Send résumé, direct mail flier/brochure, tearsheets, and JPEG samples by e-mail. Responds in 1 week. After initial contact, call for appointment to show portfolio of original art, tearsheets, slides, photographs. Obtains new talent directly or through recommendations from others.

SHARON KURLANSKY ASSOCIATES

192 Southville Rd., Southborough MA 01772. (508)733-2761. **Fax:** (508)480-9221. **E-mail:** sharon@laughing-stock.com. **Website:** www.laughing-stock.com. **Contact:** Sharon Kurlansky. Estab. 1978. Commercial illustration representative. Represents illustrators. Clients: advertising agencies, corporations/client direct, design firms, editorial/magazines, paper products/greeting cards, publishing/books, sales/promotion firms. Client list available upon request. Represents Tim Lewis, Blair Thornley, and Ronald Slabbers. Licenses stock illustration for 150 illustrators at www.laughing-stock.com in all markets.

HANDLES Illustration.

TERMS Rep receives 25% commission. Exclusive area representation is required. Advertising costs are split: 75% paid by talent; 25% paid by representative. "Will develop promotional materials with talent. Portfolio presentation formatted and developed with talent also."

HOW TO CONTACT For first contact, e-mail with website address/online portfolio. Responds in 1 month if interested.

CRISTOPHER LAPP PHOTOGRAPHY

1211 Sunset Plaza Dr., Suite 413, Los Angeles CA 90069. (310)612-0040. **E-mail:** cristopherlapp.photo@gmail.com. **Website:** www.cristopherlapp.com. **Contact:** Cristopher Lapp. Estab. 1994. Specializes in

canvas transfers, fine art prints, hand-pulled originals, limited edition.

HANDLES Decorative art, fashionable art, commercial and designer marketing. Clients include: Posner Fine Art, Gilanyi Inc., Jordan Designs.

TERMS Keeps samples on file.

HOW TO CONTACT Send an e-mail inquiry.

MAGNET REPS

Magnet Arts Collective LLC, 1783 S. Crescent Heights Blvd., Los Angeles CA 90035. **E-mail:** art@magnetreps.com. **Website:** www.magnetreps.com. Estab. 1999. Commercial illustration, literary, and art licensing agency. Represents 18 illustrators. Clients: advertising agencies, corporations/client direct, design firms, editorial/magazines, movie studios, publishing/books, record companies, character development, and art licensing across all product categories. Represents: Red Nose Studio, Bella Pilar, Emiliano Ponzi, Yelena Bryksenkova, Graham Roumieu, Dinara Mirtalipova, Pieter Van Eenoge, and Eleanor Grosch among others.

HANDLES Illustration. "Looking for artists with the passion to illustrate every day, an awareness of cultural trends in the world we live in, and a basic understanding of the business of illustration."

TERMS Exclusive representation required. Advertising costs are split. For promotional purposes, talent must provide a well-developed, consistent portfolio.

HOW TO CONTACT Submit a web link to online portfolio, or send 3 sample low-res JPEGs for review via e-mail only. Responds in approximately 1 month. "We do not return unsolicited submissions." Will contact artist via e-mail if interested.

TIPS "Be realistic about how your style aligns with our agency. We do not represent scientific, technical, medical, science fiction, fantasy, military, hyper-realistic, story boarding, landscape, pin-up, cartoon ,or cutesy styles. We do not represent graphic designers or photographers, and we will not represent illustrators that imitate the style of a contemporary illustrator."

MARLENA AGENCY

278 Hamilton Ave., Princeton NJ 08540. (609)252-9405. **Fax:** (609)252-9408. **E-mail:** marlena@marlenaagency.com. **Website:** www.marlenaagency.com. Estab. 1990. Commercial illustration representative. Represents approx. 30 illustrators from France, Poland, Germany, Hungary, Italy, Spain, Canada and US. "We speak English, French and Polish." Specializes in conceptual illustration. Markets include advertising agencies, corporations/client direct, design firms, editorial/magazines, publishing/books, theaters.

HANDLES Illustration, fine art, and prints.

TERMS Rep receives 30% commission; 35% if translation needed. Costs are shared by all artists. Exclusive area representation is required. Advertising costs are split: 70% paid by talent; 30% paid by representative. For promotional purposes, talent must provide e-mailed and direct mail pieces, 3-4 portfolios. Advertises in *Workbook*. Many of the artists are regularly featured in *CA* annuals, The Society of Illustrators annuals, and American Illustration annuals. Agency produces promotional materials for artists, such as wrapping paper, calendars, and brochures.

HOW TO CONTACT Send tearsheets or e-mail low-resolution images. Responds in 1 week, only if interested. After initial contact, drop off or mail appropriate materials. Portfolio should include tearsheets.

TIPS Wants artists with "talent, good concepts, intelligent illustration, promptness in keeping up with projects, deadlines, etc."

MB ARTISTS

775 Sixth Ave., #6, New York NY 10001. (212)689-7830. **E-mail:** mela@mbartists.com. **Website:** www.mbartists.com. **Contact:** Mela Bolinao. Estab. 1986. Juvenile illustration representative. Member of Society of Illustrators and SCBWI. Represents over 60 illustrators. Specializes in illustration for juvenile markets. Markets include advertising agencies, editorial/magazines, publishing/books, toys/games.

HANDLES Illustration.

TERMS Exclusive representation required. Rep receives 25% commission. No geographic restrictions. Advertising costs are split: 75% paid by talent; 25% paid by representative. Advertises in *Picture Book*, *Directory of Illustration*, *Play Directory*, *Workbook*, folioplanet.com, and www.theispot.com.

HOW TO CONTACT E-mail query letter with website address or send portfolio with flier/brochure, tear sheets, published books if available, and SASE. Responds in 1 week. Portfolio should include at least 10-15 images exhibiting a consistent style.

TIPS Leans toward "highly individual personal styles."

MENDOLA ARTISTS

420 Lexington Ave., New York NY 10170. (212)986-5680. **Fax:** (212)818-1246. **E-mail:** info@mendolaart.com. **Website:** www.mendolaart.com. Estab. 1961. Commercial illustration representative. Member of Society of Illustrators, Graphic Artists Guild. Represents 60 or more illustrators. Markets include advertising agencies, corporations/client direct, design firms, editorial/magazines, sales/promotion firms. "Representing the industry's leading illustration talent worldwide, we work with the top agencies, magazine corporations, and publishers. Exclusive representation is usually required. Send us an e-mail with a link to your website or JPEGs. We will contact you if interested in seeing additional work."

MHS LICENSING

11100 Wayzata Blvd., Suite 550, Minneapolis MN 55305. (952)544-1377. **Fax:** (952)544-8663. **E-mail:** marty@mhslicensing.com; artreviewcommittee@mhslicensing.com. **Website:** www.mhslicensing.com. **Contact:** Marty H. Segelbaum, president. Estab. 1995. Licensing agency. Represents over 30 fine artists, photographers, illustrators and brands. Markets include paper products/greeting cards, publishing/books, and other consumer products including giftware, stationery/paper, tabletop, apparel, home fashions, textiles, etc. Artists include Al Agnew, Amy Hautman, Amylee Weeks, Audrey Jeanne Roberts, Christine Adolph, Collin Bogle, Corbert Gauthier, Cranston Collection, Darrell Bush, H. Hargrove, Hautman Brothers, James Meger, Josephine Kimberling, Judy Buswell, Julie Ingleman, Kathy Hatch, Lisa Weedn, Louise Carey, Luis Fitch, Marcie St. Clair, Paper D'Art, Patrick Reid O'Brien, Robin Roderick, Ron King, Stacey Yacula, Stephanie Ryan, Terry Doughty, Tina Higgins, Val Warner and Victoria Schultz. Brands include Buck Wear, Mamasana, Munki Munki, Museware by Sheree, Smirk, Sparky & Marie and The Girls.

HANDLES Fine art, illustration, photography, and brand concepts.

TERMS Negotiable with firm.

HOW TO CONTACT Send query letter with bio, tearsheets, approximately 10 low-res JPEGs via e-mail. See submission guidelines on website. "Keep your submission simple and affordable by leaving all the fancy packaging, wrapping, and enclosures in your studio. 8½×11 tearsheets (inkjet is fine) and your biography are all that we need for review." Responds in 6 weeks.

"No phone calls, please." Send SASE for return of material.

TIPS "Our mutual success is based on providing manufacturers with trend-forward artwork. Please don't duplicate what is already on the market but think instead, 'What are consumers going to want to buy in 9 months, 1 year, or 2 years?' We want to learn how you envision your artwork being applied to a variety of product types. Artists are encouraged to submit their artwork mocked-up into potential product collections ranging from stationery to tabletop to home fashion (kitchen, bed and bath). Visit your local department store or mass retailer to learn more about the key items in these categories. And, if you have multiple artwork styles, include them with your submission."

MORGAN GAYNIN, INC.

149 Madison Ave., Suite 1140, New York NY 10016. (212)475-0440. **E-mail:** info@morgangaynin.com; submissions@morgangaynin.com. **Website:** www.morgangaynin.com. **Contact:** Gail Gaynin. Estab. 1974. Currently not accepting submissions. See website for updates. Markets include advertising agencies, corporations/client direct, design firms, magazines, books, children's books, sales/promotion firms.

TERMS Rep receives 30% commission. Exclusive area representation is required. No geographic restrictions. Advertising costs are split: 70% paid by talent; 30% paid by representative. Advertises in directories, on the Web, direct mail.

HOW TO CONTACT Follow submission guidelines on website.

MUNRO CAMPAGNA ARTISTS REPRESENTATIVES

630 N. State St., #2109, Chicago IL 60654. (312)335-8925. **E-mail:** steve@munrocampagna.com. **Website:** www.munrocampagna.com. **Contact:** Steve Munro, president. Estab. 1987. Commercial illustration, photography representative. Member of SPAR, CAR (Chicago Artists Representatives). Represents 22 illustrators, 2 photographers. Markets include advertising agencies, corporations/client direct, design firms, publishing/books. Represents Pat Dypold and Douglas Klauba.

HANDLES Illustration.

TERMS Rep receives 25-30% commission. Exclusive area representation is required. Advertising costs are split: 75% paid by talent; 25% paid by representative. For promotional purposes, talent must provide 2

portfolios. Advertises in *The Black Book* and *Workbook*.

HOW TO CONTACT For first contact, send query letter, bio, tearsheets, and SASE. Responds in 2 weeks. After initial contact, write to schedule an appointment.

THE NEWBORN GROUP, INC.

(212)989-4600. **E-mail:** joan@newborngroup.com. **Website:** www.newborngroup.com. Estab. 1964. Commercial illustration representative. Member of Society of Illustrators; Graphic Artists Guild. Represents 15 illustrators. Markets include advertising agencies, design firms, editorial/magazines, publishing/books. Clients include Leo Burnett, Penguin Putnam, Time Inc., Weschler Inc.

HANDLES Illustration.

TERMS Rep receives 30% commission. Exclusive area representation is required. Advertising costs are split: 70% paid by talent; 30% paid by representative. Advertises in *Workbook* and *Directory of Illustration*.

HOW TO CONTACT "Not reviewing new talent."

PAINTED WORDS

310 W. 97th St., Suite 24, New York NY 10025. **Fax:** (212)663-2891. **E-mail:** info@painted-words.com; submissions@painted-words.com. **Website:** www.painted-words.com. Estab. 1993. Literary agent for children's books. Represents 40 authors and illustrators. Markets include children's publishing and licensed products.

HANDLES Illustration and author/illustrators.

TERMS Exclusive area representation is required.

HOW TO CONTACT "An artist seeking representation is encouraged to send a link to his or her website. We are currently seeking illustrators to add to our children's publishing group, specifically those who have a talent for writing. Please do not e-mail manuscripts. If we are interested in the art style, we will request a writing sample. All samples and unsolicited manuscripts submitted via regular mail will be returned unopened."

DEBORAH PEACOCK PRODUCTIONS

P.O. Box 300127, Austin TX 78703. (512)970-9024. **E-mail:** photo@deborahpeacock.com. **Website:** www.deborahpeacock.com; www.art-n-music.com. **Contact:** Deborah Peacock. Booking, graphic design, public relations, photography, and consultancy. Deborah Peacock Productions caters to businesses, products, actors and musicians, performing and visual artists; product photography, special events, videography, and graphic/web design. Represents entertainers for private parties and special events.

HANDLES Considers all media and all types of prints.

MARIA PISCOPO

1684 Decoto Rd., #271, Union City CA 94587. **E-mail:** maria@mpiscopo.com. **Website:** www.mpiscopo.com. **Contact:** Maria Piscopo. Estab. 1978. Commercial photography representative. Member of SPAR, Women in Photography, Society of Illustrative Photographers. Market includes: advertising agencies, corporate and designer firms. Interested in reviewing illustration, photography, fine art, and design. Representatives receive 25% commission.

TERMS Send query letter and samples via PDF to maria@mpiscopo.com. Do not call. Responds within 2 weeks, only if interested. E-mail for specifications of artwork.

TIPS Obtains new talent through personal referral and photo magazine articles. "Do lots of research. Be very businesslike, organized, professional, and follow the above instructions!"

CAROLYN POTTS & ASSOCIATES, INC.

P.O. Box 6214, Evanston IL 60204. (312)560-6400; (847)864-7644. **E-mail:** carolyn@cpotts.com. **Website:** www.cpotts.com. Estab. 1976. Commercial photography representative and marketing consultant for creative professionals. 30 years experience in landing assignments for commercial photographers. Specializes in contemporary advertising and design. Markets include advertising agencies, corporations/client direct, design firms.

HANDLES Photography.

TERMS Rep receives 30-35% commission. Artists share cost of their direct mail postage and preparation. Exclusive representation is required. Advertising costs are split: 70% paid by artist; 30% paid by rep (after initial trial period wherein artist pays 100%). For promotional purposes, talent must have website and provide direct mail piece.

HOW TO CONTACT For first contact, send e-mail. Responds within 3 days. After initial contact, write to schedule an appointment. Portfolio should include examples of published work.

TIPS Looking for artists with high level of professionalism, awareness of current advertising market, professional presentation materials and website, and a positive, proactive attitude.

CHRISTINE PRAPAS/ARTIST REPRESENTATIVE

8402 SW Woods Creek Court, Portland OR 97219. (503)245-9511. **E-mail:** christine@christineprapas. com. **Website:** www.christineprapas.com. Estab. 1978. Commercial illustration and photography representative. Member of AIGA and Graphic Artists Guild.

KERRY REILLY REPS

1826 Asheville Place, Charlotte NC 28203. (704)372-6007. **E-mail:** kerry@reillyreps.com. **Website:** www. reillyreps.com. **Contact:** Kerry Reilly. Estab. 1990. Commercial illustration and photography representative. Represents 16 illustrators, 2 photographers, and animatics. Markets include advertising agencies, corporations/client direct, design firms, editorial/magazines. Clients include GM, VW, Walt Disney World, USPO.

○ Kerry Reilly Reps is partnering with Steven Edsey & Sons.

HANDLES Illustration, photography. Looking for computer graphics: Photoshop, Illustrator, FreeHand, etc.

TERMS Rep receives 25% commission. Exclusive area representation is required. No geographic restrictions. Advertising costs are split 75% paid by talent; 25% paid by representative. For promotional purposes, talent must provide at least 2 pages printed leave-behind samples. Preferred format is 9×12 pages, portfolio work on 4×5 transparencies. Advertises in iSpot.

HOW TO CONTACT For first contact, send direct mail flier/brochure or samples of work. Responds in 2 weeks. After initial contact, call for appointment to show portfolio, or drop off or mail tearsheets, slides, 4×5 transparencies.

TIPS "Have printed samples and electronic samples (in JPEG format)."

RETRO REPS

Martha Productions, 7550 W. 82nd St., Playa Del Rey CA 90293. (310)670-5300. **Fax:** (310)670-3644. **E-mail:** contact@marthaproductions.com. **Website:** www.retroreps.com. **Contact:** Martha Spelman, president. Estab. 1998. Commercial illustration representative. Represents 22 illustrators. Specializes in artists working in vintage or retro styles from the 1920s through 1970s.

LILLA ROGERS STUDIO

(781)641-2787. **E-mail:** susan@lillarogers.com; joanneh@lillarogers.com. **Website:** www.lillarogers. com. **Contact:** Susan McCabe or Joanne Hus, agents. Estab. 1984. Commercial illustration representatives. Represents 30+ illustrators. Markets include advertising agencies, corporations/client direct, design firms, editorial/magazines, paper products, publishing/books, prints and posters, sales/promotion firms, children's books, surface design. Artists include Lisa Congdon, Helen Dardik, Sarah Walsh, Jillian Phillips, Mike Lowery, Carolyn Gavin, Bonnie Dain, and Susy Pilgrim Waters.

○ The studio has launched a worldwide new e-course, "Make Art That Sells," and a global talent search, which is the primary way they find their next artist to represent. Visit www.lillarogers.com/school for more details.

HANDLES Illustration.

TERMS Exclusive representation required. Promotions include Surtex NYC trade show, Printsource NYC trade show, Licensing Expo and other events; also runs extensive direct mail and e-mail newsletter campaigns.

HOW TO CONTACT For first contact, e-mail 3-5 low-resolution JPEGs or a link to your website. Responds only if interested.

TIPS "It's good to check out the agency's website to see if you feel like it's a good fit. Explain in your e-mail why you want an agent and why you think we are a good match. No phone calls, please. The very best way to get represented is to enter our annual Global Talent Search."

ROSENTHAL REPRESENTS

23725 Hartland Street, West Hills CA 91307. (818)222-5445 or (818)430-3850. **Fax:** (818)222-5650. **E-mail:** eliselicenses@earthlink.net. **Website:** www.rosenthalrepresents.com. **Contact:** Elise Rosenthal or Neil Sandler. Estab. 1979. Represents 25 artists and designers geared for creating products, such as: dinnerware, flags, gift bags, textiles (fabric), rugs, placemats, cutting boards, coasters, kitchen and bath textiles, bedding, wall hangings, children's and baby products, stationery, and more. Specializes in licensing, merchandising art. Markets include manufacturers of tabletop products (dinnerware), rugs, kitchen and bath textiles,

paper products/greeting cards, and more. Handles product designers and artists. Must know Photoshop and other computer programs to help artist adapt art into product mockups.

TERMS Rep receives 50% as a licensing agent. Exclusive licensing representation is required. No geographic restrictions. "Artist contributes $800 once a year to exhibit with us at our 2 all important trade shows, Surtex and Licensing Shows." For promotional purposes, talent must provide CD of artwork designs and website link if available. "We advertise in Total Art Licensing. Only contact us if you have done product design and if you are willing to work hard. Must be willing to accept critiques and make corrections."

HOW TO CONTACT Send e-mail, computer link, JPEGs of your work, direct mail flyer/brochure, tearsheets, photocopies, and SASE. Responds in 1 week. After initial contact, call for appointment to show portfolio of tearsheets, photographs, photocopies. Obtains new talent through seeing their work in trade shows, in magazines, and through referrals.

SALZMAN INTERNATIONAL

1751 Charles Ave., Arcate CA 95521. (212)997-0115 or (415)285-8267. **E-mail:** Richard@SalzmanArt.com. **Website:** www.salzmanart.com. Estab. 1982. Commercial illustration representative. Represents 20 illustrators. 20% of artwork is children's book illustration. Staff includes Richard Salzman. Open to illustrators seeking representation. Accepting both new and established illustrators.

LIZ SANDERS AGENCY

2415 E. Hangman Creek Lane, Spokane WA 99224-8514. (509)993-6400. **E-mail:** liz@lizsanders.com; artsubmissions@lizsanders.com. **Website:** www.lizsanders.com. **Contact:** Liz Sanders, owner. Estab. 1985. Commercial illustration representative. Represents small group of illustrators. Specializes in marketing of individual artists "within an ever-evolving illustration world." Markets include advertising agencies, corporations/client direct, design firms, editorial/magazines, juvenile markets, paper products/greeting cards, publishing/books, record companies, sales/promotion firms.

HANDLES Interested in illustration. "Looking for fresh, unique talent committed to long-term careers whereby the agent/talent relationship is mutually respectful, responsive, and measurably successful."

TERMS Rep receives 30% commission. Exclusive representation required. Advertises in *Picturebook, American Showcase, Workbook, Directory of Illustration*, direct mail material, traditional/electronic portfolio for agent's personal presentations; means to advertise—if not substantially, then consistently.

HOW TO CONTACT For first contact, send nonreturnable printed pieces or e-mailed web address. Responds only if interested. After initial contact, call to schedule an appointment, depending on geographic criteria. Portfolio should include tearsheets, photocopies, and digital output.

TIPS "Concisely present a single, focused style supported by 8-12 strong samples. Only send a true portfolio upon request."

JOAN SAPIRO ART CONSULTANTS

138 W. 12th Ave., Denver CO 80204. (303)793-0792. **E-mail:** info@sapiroart.com. **Website:** www.sapiroart.com. **Contact:** Kay Brouillette, principal. Estab. 1980. Specializes in "corporate art with other emphasis on hospitality, health care and art consulting/advising to private collectors."

HANDLES All mediums of artwork.

TERMS Artist must be flexible and willing to ship work on consignment. Also must be able to provide sketches, etc., if commission piece involved. No geographic restrictions.

HOW TO CONTACT Mail JPEG images encompassing the range of your work identified with your name, title of work, medium, dimensions, and pricing, contact information, pertinent information about your art and process. Optional inclusions: biography, CV, or resume. Be willing to work on a commission basis. Please enclose a SASE if you would like your CD or printed images returned.

TIPS Obtains new talent through recommendations, publications, travel, research, university faculty.

FREDA SCOTT, INC.

302 Costa Rica Ave., San Mateo CA 94402. (650)548-2446. **E-mail:** freda@fredascott.com. **Website:** www.fredascottcreative.com. **Contact:** Freda Scott, rep/president. Estab. 1980. Commercial photography, illustration, or photography, commercial illustration representative and licensing agent. Represents 12 photographers, 8 illustrators. Licenses photographers and illustrators. Markets include advertising agencies, architects, corporate/client direct, designer

firms, developers, direct mail firms, paper products/greeting cards.

HANDLES Illustration, photography.

TERMS Rep receives 25% as standard commission. Advertising costs paid entirely by talent. For promotional purposes, talent must provide mailers/postcards. Advertises in *Workbook* and *American Showcase/Illustrators.*

HOW TO CONTACT Send link to website. Responds, only if interested, within 2 weeks. Rep will contact the talent for portfolio review, if interested.

TIPS Obtains new talent through submissions and recommendations from other artists, art directors, and designers.

SUSAN AND CO.

(206)232-7873. **E-mail:** susan@susanandco.com. **Website:** www.susanandco.com. Estab. 1979. Artist representive for commercial illustrators. Represents 12 illustrators. Markets include advertising agencies, corporations, client direct, design firms, and publishing/books.

HANDLES Looks for "current illustration styles."

TERMS Rep receives 25% commission. National representation is required. Advertising costs are split: 75% paid by talent; 25% paid by representative.

HOW TO CONTACT For first contact, send e-mail letter and samples. Responds in 2 weeks, only if interested. Portfolio should "be representative of unique style."

⚙ TAENDEM AGENCY

P.O. Box 47054, 15-555 W. 12th Ave., Vancouver, British Columbia V5Z 4L6 Canada. (604)569-6544. **E-mail:** talent@taendem.com. **Website:** www.taendem.com. **Contact:** Corwin Hiebert, principal. Estab. 2006. International management agency. Represents a handful of designers and illustrators. Specializes in consulting with freelancers and assisting them with building and growing a successful small creative business. Also full-service business administration and marketing management for creative entrepreneurs. Offerings include: business planning, branding, marketing strategy, portfolio development, website development, social media planning, contract management, client management, project management, proposal writing, estimates and invoicing, itinerate speaking engagements, travel logistics, and production.

HANDLES Illustration, photography, fine art, design, and videography.

TERMS Upon acceptance, we charge a minimum monthly retainer of $200 for access and management rights; for specific tasks we use project costing—quoted and applied upon talent's approval. Additional work is quoted and billed upon talent request/approval. Itinerate speaking commission rate is negotiated on a case-by-case basis. Management representation is nonexclusive. Business development consultation available to qualified talent only; full-service management representation is selectively offered at the discretion of the agency. 100% of advertising costs paid by talent. Standard offering includes no paid advertising. Talent must provide full contact information, current headshot, website link, and a sample of their work. For photographers, we require 10 select portfolio images.

HOW TO CONTACT Send link to website and full contact information and a brief business description. Portfolio should include large thumbnails, videographers should provide demo reel (Vimeo or YouTube). A business manager will be in contact within 1 week.

TIPS Obtains new talent through submissions and recommendations from other artists. Keep e-mails short and friendly. No phone calls. "Creatives are more likely to generate demand when their business is well organized, and their marketing efforts elicit curiosity instead of trying to stand out in a crowd of talented peers. Growing your business network and developing your portfolio through personal and collaborative projects makes you more attractive to both reps and buyers. If you need help growing your creative small business, just remember: You are Batman. We are Robin."

THOSE 3 REPS

501 Second Ave., Suite A-600, Dallas TX 75226. (214)871-1316. **Fax:** (214)880-0337. **E-mail:** moreinfo@those3reps.com. **Website:** www.those3reps.com. Estab. 1989. Member of Dallas Society of Visual Community. Represents illustrators and photographers. Specializes in commercial art. Clients: advertising agencies, corporations/client direct, design firms, editorial/magazines.

HANDLES Illustration, photography (including digital).

TERMS Rep receives 30% commission. Exclusive area representation is required. Advertising costs are split: 70% paid by talent; 30% paid by representa-

tive. For promotional purposes, talent must provide 2 new pieces every 2 months, national advertising in sourcebooks, and at least 1 mailer. Advertises in *Workbook*, own book.

HOW TO CONTACT For first contact, send query letter and PDFs. Responds in days or weeks only if interested. After initial contact, call to schedule an appointment, drop off or mail in appropriate materials. Portfolio should include digital prints.

TIPS Wants artists with "strong unique consistent style."

✪ THREE IN A BOX, INC.

67 Mowat Ave., Suite 045, Toronto, Ontario M6K 3E3 Canada. (212)643-0896 (USA) or (416)367-2446 (Canada). **E-mail:** info@threeinabox.com. **Website:** www.threeinabox.com. Estab. 1990. Commercial illustration representative. Member of Graphic Artists Guild. Represents 53 illustrators, 2 photographers. Specializes in illustration. Licenses illustrators and photographers. Markets include advertising agencies, corporations/client direct, design firms, editorial/magazines, paper products/greeting cards, publishing/books, record companies, sales/promotion firms.

HOW TO CONTACT For first contact, e-mail query letter and URL. Responds in 1 week. After initial contact, rep will call if interested. Send only links to website.

CHRISTINA A. TUGEAU: ARTIST AGENCY, LLC

Ewers, Christina T., 3009 Margaret Jones Lane, Williamsburg VA 23185. (757)221 0666. **E-mail:** chris@catugeau.com. **E-mail:** Christy@catugeau.com. **Website:** www.catugeau.com. Blog: catugeau.wordpress.com. **Contact:** Christina Tugeau, owner; Christy Ewers, agent. Estab. 1994. Children's publishing market illustration representative (K-12). Member of SCBWI. Represents 30 illustrators. Specializes in children's book publishing and educational market and related areas. Represents Priscilla Burris, Christine Kornacki, Patrice Barton, Roger Motzkus, Melissa Iwai, Jason Wolff, John Kanzler, Martha Aviles, Ana Ochoa, Kelsey Garrity Riley, Lesley Withrow, Nicole Tadgell, and Sarah Beise, among other artists of North America.

HANDLES Illustration. Must be proficient at illustrating children and animals in a variety of interactive situations, backgrounds, full color/b&w, and with a strong narrative sense.

TERMS Rep receives 25% commission. Exclusive US representation is required. For promotional purposes, talent must provide direct mail promo(s), 8-10 good "back-up" samples (multiples). North American artists only.

HOW TO CONTACT Christy@catugeau.com. "For first contact, e-mail a few JPEG samples and a live link to website. Responds immediately!"

TIPS "You should have a style uniquely and comfortably your own. Be a cooperative team player and be great with deadlines. Will consider young, new artists to the market with great potential and desire, and of course published, more experienced North American illustrators. Best to study and learn the market standards and expectations by representing yourself for a while when new to the market."

V PRODUCTIONS

81 N. Roosevelt Ave., Apt. 11, Pasadena CA 91107. **E-mail:** workshopsonlocation@gmail.com. **Website:** www.workshopsonlocation.com. **Contact:** Gina Vriens, principal producer. Estab. 2014. Workshop & event organizer. Represents photographers, illustrators, designers, fine artists. "V Productions allows creative individuals to focus on their craft, while leaving the rest to us. We not only produce workshops, but also provide on-site workshop support and marketing consulting." Markets include corporate/client direct, festival/conference.

HOW TO CONTACT E-mail link to website and bio. Responds in 1 week.

GWEN WALTERS ARTIST REPRESENTATIVE

20 Windsor Ln., Palm Beach Garden FL 33418. (561)805-7739. **E-mail:** artincgw@gmail.com. **Website:** www.gwenwaltersartrep.com. **Contact:** Gwen Walters. Estab. 1985. Commercial illustration representative. Represents 60+ illustrators. Clients: children's book publishing (trade & educational), editorial/magazines, paper products/greeting cards, publishing/books, sales/promotion firms. "I lean more toward book publishing." Represents Gerardo Suzan, Rosario Valderrama, Lane Gregory, Susan Spellman, Judith Pfeiffer, Yvonne Gilbert, Gary Torrisi, Larry Johnson, Pat Paris, Tom Barrett, Linda Pierce, and many more.

HANDLES Illustration.

TERMS Rep receives 30% commission.

HOW TO CONTACT For first contact, e-mail portfolio. After initial contact, representative will call. Portfolio should include "as much as possible."

WATSON & SPIERMAN PRODUCTIONS

E-mail: info@wswcreative.com. **Website:** www.watsonspierman.com. Estab. 1992. Commercial illustration/photography representative. Represents 4 illustrators and 11 photographers. Specializes in general illustration, photography. Markets include advertising agencies, design firms, galleries, paper products/greeting cards, record companies, publishing/books, sales/promotion firms, corporations/client direct, editorial/magazines. Photographers include: Henrique Bagulho, Siri Berting, Chris Clor, George Kamper, Dale May, Kan Nakai, Zave Smith, Gandee Vasan, Michael Weschler, and Bret Wills. Illustrators include: Monica Lind, Meghann Powell, Paula Romani, and Ty Wilson. CGI: Plush Audio Post Productions, Chris Clor, and Kan Nakai.

HANDLES Comercial, illustration, and photography.

TERMS Rep receives 30% commission. Exclusive representation required. Advertising costs are paid by artist. Artist must publish every year in a sourcebook with all Watson & Spierman talent. Advertises in *The Workbook.*

HOW TO CONTACT For first contact, send link to website. Responds only if interested. After initial contact, drop off or mail portfolio. Portfolio should include b&w, color, finished art, original art, photographs, tearsheets.

TIPS "We love to hear if an artist has an ad out or recently booked a job. Those are the updates that are most important to us."

THE WILEY GROUP

1535 Green St., Suite 301, San Francisco CA 94123. (415)441-3055. **Fax:** (415)520-0999. **E-mail:** info@thewileygroup.com; david@thewileygroup.com. **Website:** www.thewileygroup.com. **Contact:** David Wiley, owner. Estab. 1984. Represents a broad spectrum of unique commercial artists. Over 29 years of experience in marketing, advertising, and promotional work paired with a long-time fascination and appreciation of the arts, marketing and communication. David matches up US and worldwide agencies in advertising, graphic design, publishing with illustrators who can best present their products in innovative, effective ways. Past clients have included Disney, Coca-Cola, Smithsonian, Microsoft, Nike, Oracle, Google, Random House, Eli Lilly Pharmaceuticals, National Geographic, Super Bowl XLII, Twinlab, FedEx, Nestle Corp. and Apple.

Mission statement: Building working relationships between illustrators and hiring professionals through individualized problem solving and creative processes.

TERMS Rep receives 25% commission with a bonus structure. No geographical restriction.

HOW TO CONTACT Actively seeking stop-motion, animation, and 3D artists with solid illustration skills. "First and foremost, we receive an extensive number of inquiries, so responses might be be delayed. If you do not hear back within 20 days, please resubmit, noting in the subject line that it is your second submission. Before submitting, please read the following: We *only* represent commercial illustrators, no photographers. It is important you familiarize yourself with our agency and the artists we represent, understanding the styles we currently manage and the work we do with our clients (also visit our blog or Facebook page). We are only interested in adding unique and well-developed styles that will fit within our portfolio of talent, so understanding our current portfolio is a big part of your submission process. Once you have done so, and feel there may be a fit, please e-mail your information. Be sure to include the following: Introduction (including who you are and your professional background), the style and medium that best describes you, a list of clients, sample images in JPEG format *only* (with a max total size of 3MB) and a link to your website, blog, Facebook page, or other relevant professional information. We do not accept mailed printed samples and will not return them if sent without previous agreement."

DEBORAH WOLFE, LTD.

731 N. 24th St., Philadelphia PA 19130. (215)232-6666. **Fax:** (215)232-6585. **E-mail:** info@illustrationonline.com. **Website:** www.illustrationonline.com. **Contact:** Deborah Wolfe. Estab. 1978. Commercial illustration and animation representative. Member of Graphic Artist Guild. Represents 40 illustrators. Markets include advertising agencies, corporations/client direct, design firms, editorial/magazines, publishing/books, animation.

HANDLES Illustration.

TERMS Rep receives 25% commission. Advertises in *Workbook, Directory of Illustration Picturebook* and *The Medical Sourcebook.*

HOW TO CONTACT For first contact, send an e-mail with samples or a web address. Responds in 3 weeks.

ART FAIRS

///

How would you like to sell your art from New York to California, showcasing it to thousands of eager art collectors? Art fairs (also called art festivals or art shows) are not only a good source of income for artists but an opportunity to see how people react to their work. If you like to travel, enjoy meeting people, and can do your own matting and framing, this could be a great market for you.

Many outdoor fairs occur during the spring, summer, and fall months to take advantage of warmer temperatures. However, depending on the region, temperatures could be hot and humid, and not all that pleasant! And, of course, there is always the chance of rain. Indoor art fairs held in November and December are popular because they capitalize on the holiday shopping season.

To start selling at art fairs, you will need an inventory of work—some framed, some unframed. Even if customers do not buy the framed paintings or prints, having some framed work displayed in your booth will give buyers an idea of how your work looks framed, which could spur sales of your unframed prints. The most successful art fair exhibitors try to show a range of sizes and prices for customers to choose from.

When looking at the art fairs listed in this section, first consider local shows and shows in your neighboring cities and states. Once you find a show you'd like to enter, visit its website or contact the appropriate person for a more detailed prospectus. A prospectus is an application that will offer additional information not provided in the art fair's listing.

Ideally, most of your paintings, prints, etc. should be matted and stored in protective wraps or bags so that customers can look through your inventory without damaging artwork and mats. You will also need a canopy or tent to protect yourself and your wares from the elements as well as some bins in which to store the prints. A display wall will allow you to

show off your best framed prints. Generally, artists will have 100 square feet of space in which to set up their tents and canopies. Most listings will specify the dimensions of the exhibition space for each artist.

If you see the 🎧 icon before a listing in this section, it means that the art fair is a juried event. In other words, there is a selection process artists must go through to be admitted into the fair. Many art fairs have quotas for the categories of exhibitors. For example, one art fair may accept the mediums of photography, sculpture, painting, metal work, and jewelry. Once each category fills with qualified exhibitors, no more will be admitted to the show that year. The jurying process also ensures that the artists who sell their work at the fair meet the sponsor's criteria for quality. So, overall, a juried art fair is good for artists because it means they will be exhibiting their work along with other artists of equal caliber.

Be aware there are fees associated with entering art fairs. Most fairs have an application fee or a space fee, or sometimes both. The space fee is essentially a rental fee for the space your booth will occupy for the art fair's duration. These fees can vary greatly from show to show, so be sure to check this information in each listing before you apply to any art fair.

Most art fair sponsors want to exhibit only work that is handmade by the artist, no matter what medium. Unfortunately, some people try to sell work that they purchased elsewhere as their own original artwork. In the art fair trade, this is known as "buy/sell." It is an undesirable situation because it tends to bring down the quality of the whole show. Some listings will make a point to say "no buy/sell" or "no manufactured work."

For more information on art fairs, pick up a copy of *Sunshine Artist* (www.sunshineartist. com) or *Art Calendar* (www.artcalendar.com), and consult online sources such as www. artfairsource.com.

4 BRIDGES ARTS FESTIVAL

30 Frazier Ave., Chattanooga TN 37405. (423)265-4282 ext. 3. **Fax:** (423)265-5233. **E-mail:** katdunn@avarts.org. **Website:** www.4bridgesartsfestival.org. **Contact:** Kat Dunn. Estab. 2000. 2-day fine arts & crafts show held annually in mid-April. Held in a covered, open-air pavilion. Accepts photography and 24 different mediums. Juried by 3 different art professionals each year. Awards: $10,000 in artist merit awards; the on-site jurying for merit awards will take place Saturday morning. Number of exhibitors: 150. Public attendance: 13,000. Public admission: $7/day or a 2-day pass for $10; children under 18 are free. Artists should apply at www.zapplication.org. Deadline for entry: early November (see website for details). Application fee: $40. Space fee: $450-550 for 10×12 ft.; $900-1,000 for 20×12 ft. Average gross sales/exhibitor: $2,923. For more information, e-mail, call or visit website. The event is held at First Tennessee Pavilion.

57TH STREET ART FAIR

1507 E. 53rd St., PMB 296, Chicago IL 60615. (773)234-3247. **E-mail:** info@57thstartfair.org. **Website:** www.57thstreetartfair.org. **Contact:** Linda or Ron Mulick, owners/promoters. Estab. 1948. Fine art & craft show held annually in June. Outdoors. Accepts painting, sculpture, photography, glass, jewelry, leather, wood, ceramics, fiber, printmaking. Juried. Free to public. Apply via www.zapplication.org. Deadline for entry: January 15. Application fee: $35. Space fee: $300. Exhibition space: 10×10. For more information, e-mail or visit website.

AKRON ARTS EXPO

220 Balch St., Akron OH 44302. (330)375-2836. **Fax:** (330)375-2883. **E-mail:** PBomba@akronohio.gov. **Website:** www.akronartsexpo.org. **Contact:** Penny Bomba, artist coordinator. Estab. 1979. Held in late July. "The Akron Arts Expo is a nationally recognized juried fine arts & crafts show held outside with over 160 artists, ribbon and cash awards, great food, an interactive children's area, and entertainment for the entire family. Participants in this festival present quality fine arts and crafts that are offered for sale at reasonable prices. For more information, see the website." Application fee $10. Booth fee: $200. Event held in Hardesty Park.

ALEXANDRIA KING STREET ART FESTIVAL

270 Central Blvd., Suite 107B, Jupiter FL 33458. (561)746-6615. **Fax:** (561)746-6528. **E-mail:** info@artfestival.com. **Website:** www.artfestival.com. **Contact:** Malinda Ratliff, communications manager. Estab. 2003. Fine art & craft fair held annually in late September. Outdoors. Accepts photography, jewelry, mixed media, sculpture, wood, ceramic, glass, painting, digital, fiber, metal. Juried. Number exhibitors: 230. Number attendees: 150,000. Free to public. Apply online via www.zapplication.org. Deadline: see website. Application fee: $35. Space fee: $575. Exhibition space: 10×10 and 10×20. For more information, artists should e-mail, call or visit website.

TIPS "You have to start somewhere. First, assess where you are, and what you'll need to get things off the ground. Next, make a plan of action. Outdoor street art shows are a great way to begin your career and lifetime as a working artist. You'll meet a lot of other artists who have been where you are now. Network with them!"

ALLEN PARK ARTS & CRAFTS STREET FAIR

City of Allen Park, P.O. Box 70, Allen Park MI 48101. (734)258-7720. **E-mail:** applications@allenparkstreetfair.org. **Website:** www.allenparkstreetfair.org. **Contact:** Allen Park Festivities Commission. Estab. 1981. Arts & crafts show held annually the 1st Friday and Saturday in August. Outdoors. Accepts photography, sculpture, ceramics, jewelry, glass, wood, prints, drawings, paintings. All work must be of fine quality and original work of entrant. Such items as imports, velvet paintings, manufactured or kit jewelry and any commercially produced merchandise are not eligible for exhibit or sale. Juried by 5 photos of work. Number of exhibitors: 200. Free to the public. Deadline: March 15 (first review) and May 13 (second review). Application fee: $25. Space fee: $175-$200. Exhibition space: 10×10 ft. Apply via www.zapplication.org. Artists should call or see website for more information.

ALLENTOWN ART FESTIVAL

P.O. Box 1566, Buffalo NY 14205. (716)881-4269. **E-mail:** allentownartfestival@verizon.net. **Website:** www.allentownartfestival.com. **Contact:** Mary Myszkiewicz, president. Estab. 1958. Fine arts & crafts show

held annually 2nd full weekend in June. Outdoors. Accepts photography, painting, watercolor, drawing, graphics, sculpture, mixed media, clay, glass, acrylic, jewelry, creative craft (hard/soft). Slides juried by hired professionals that change yearly. Awards/prizes: 41 cash prizes totaling over $20,000; includes Best of Show awarding $1,000. Number of exhibitors: 450. Public attendance: 300,000. Free to public. Artists should apply by downloading application from website. Deadline for entry: late January. Exhibition space: 10×13 ft. Application fee: $15. Booth fee $275. For more information, artists should e-mail, visit website, call or send SASE. Show held in Allentown Historic Preservation District.

TIPS "Artists must have attractive booth and interact with the public."

ALTON ARTS & CRAFTS EXPRESSIONS

P.O. Box 1326, Palatine IL 60078. (312)751-2500 or (847)991-4748. **E-mail:** asoaartists@aol.com. **Website:** www.americansocietyofartists.org. **Contact:** ASA Office. Estab. 1979. Fine arts & crafts show held annually indoors in Alton IL, in spring and fall, usually March and September. Accepts quilting, fabric crafts, artwear, photography, sculpture, jewelry, glass works, woodworking and more. Please submit 4 images representative of your work you wish to exhibit, 1 of your display set-up, your first/last name, physical address, daytime telephone number—résumé/show listing helpful. "See our website for online jury information." Number of exhibitors: 50. Free to the public. Artists should apply by submitting jury materials. Submit to: asoartists@aol.com. If juried in, you will receive a jury/approval number. Deadline for entry: 2 months prior to show or earlier if spaces fill. Space fee: to be announced. Exhibition space: approximately 100 sq. ft. for single space; other sizes available. For more information, artisits should send SASE, submit jury material and submit jury material to ASA, P.O. Box 1326, Palatine IL 60078.

TIPS "Remember that when you are at work in your studio, you are an artist. But when you are at a show, you are a business person selling your work."

AMERICAN ARTISAN FESTIVAL

P.O. Box 41743, Nashville TN 37204. (615)429-7708. **E-mail:** americanartisanfestival@gmail.com. **Website:** www.facebook.com/theamericanartisanfestival. Estab. 1971. Fine arts & crafts show held annually mid-June, Father's Day weekend. Outdoors. Accepts photography and 21 different medium categories. Juried by 3 different art professionals each year. 3 cash awards presented. Number of exhibitors: 165. Public attendance: 30,000. No admission fee for the public. Artists should apply online at www.zapplication.org. Deadline for entry: early March (see website for details). For more information, e-mail or visit the website. Festival held at Centennial Park, Nashville TN.

AMERICAN FINE CRAFT SHOW NYC

P.O. Box 480, Slate Hill NY 10973. (845)355-2400 or; (845)661-1221. **Fax:** (845)355-2444. **E-mail:** show.director@americanartmarketing.com; hello@americanartmarketing.com. **Website:** www.americanfinecraftshownyc.com. **Contact:** Richard Rothbard, director. Fine art & craft show held annually in October. Indoors. Accepts handmade crafts, basketry, ceramics, decorative fiber, furniture, glass, jewelry, leather, metal, mixed media, paper, wearable art, wood. Juried. Apply online. Deadline for entry: April 30. Application fee: $35. Space fee: $200. Exhibition space: varies. For more information, e-mail or visit website.

AMERICAN FOLK ART FESTIVAL

(707)246-2460. **E-mail:** gavitee@aol.com. **Website:** www.americanfolkartfestival.com. **Contact:** Susan Bartolucci. Arts & Antiques show held annually in September. Under a tent handmade one-of-a-kind folk art, Americana, & folk art antiques. Admission: $10. Invitation only. See website. For more information, e-mail or visit website.

TIPS "We are looking for outside of the norm, so feel free to experiment."

AMISH ACRES ARTS & CRAFTS FESTIVAL

1600 W. Market St., Nappanee IN 46550. (574)773-4188 or (800)800-4942. **E-mail:** amishacres@amishacres.com; beckymaust@amishacres.com. **Website:** www.amishacres.com. **Contact:** Becky Cappert, marketplace coordinator. Estab. 1962. Arts & crafts show held annually first weekend in August. Outdoors. Accepts photography, crafts, floral, folk, jewelry, oil, acrylic, sculpture, textiles, watercolors, wearable, wood. Juried by 5 images, either 35mm slides or e-mailed digital images. Awards/prizes: $5,000 cash including Best of Show and $1,000 purchase prizes. Number of exhibitors: 300. Public at-

tendance: 50,000. Admission: $7; $6 seniors; Children under 12 free. Artists should apply by sending SASE or printing application from website. Deadline for entry: April 1. Exhibition space: 10×12, 15×12, 20×12 or 30×12 ft.; optional stable fee, with tent, also available. For more information, artists should e-mail, call, visit website, or send SASE.

TIPS "Create a vibrant, open display that beckons to passing customers. Interact with potential buyers. Sell the romance of the purchase."

ANACORTES ARTS FESTIVAL

505 O Ave., Anacortes WA 98221. (360)293-6211. **Fax:** (360)299-0722. **E-mail:** staff@anacortesartsfestival. com. **Website:** www.anacortesartsfestival.com. Fine arts & crafts show held annually 1st full weekend in August. Accepts photography, painting, drawings, prints, ceramics, fiber art, paper art, glass, jewelry, sculpture, yard art, woodworking. Juried by projecting 3 images on a large screen. Works are evaluated on originality, quality and marketability. Each applicant must provide 5 high-quality digital images, including a booth shot. Awards/prizes: festival offers awards totaling $3,500. Number of exhibitors: 270. Apply via www.zapplication.org. Application fee: $30. Deadline for entry: early March. Space fee: $325. Exhibition space: 10×10 ft. For more information, artists should see website. Show is located on Commercial Ave. from 4th to 10th St.

ANN ARBOR STREET ART FAIR, THE ORIGINAL

721 E. Huron, Suite 200, Ann Arbor MI 48104. (734)994-5260. **Fax:** (734)994-0504. **E-mail:** production@artfair.org; mriley@artfair.org. **Website:** www.artfair.org. Estab. 1958. Fine arts & crafts show held annually beginning the 3rd Thursday in July. Outdoors. Accepts photography, fiber, glass, digital art, jewelry, metals, 2D and 3D mixed media, sculpture, clay, painting, drawing, printmaking, pastels, wood. Juried based on originality, creativity, technique, craftsmanship and production. Awards/prizes: cash prizes for outstanding work in any media. Number of exhibitors: 200. Public attendance: 500,000. Free to the public. Artists should apply through www.zapplication.org. Application fee: $35/40. Space fee: $650. Exhibition space: 10×12 ft. Average gross sales/exhibitor: $7,000. For more information, artists should e-mail, visit website, call.

ANN ARBOR SUMMER ART FAIR

118 N. Fourth Ave., Ann Arbor MI 48104. (734)662-3382. **Fax:** (734)662-0339. **E-mail:** info@theguild.org. **Website:** www.theguild.org. Estab. 1970. Fine arts and craft show held annually on the third Wednesday through Saturday in July. Outdoors. Accepts all fine art categories. Juried. Number of exhibitors: 325. Attendance: 500,000-750,000. Free to public. Deadline for entry is January; enter online at www. juriedartservices.com. Exhibition space: 10×10, 10×13, 10×17 ft. For information, artists should visit the website, call, or e-mail. Show is located on University of Michigan campus and in downtown Ann Arbor. Fine arts and craft show held annually on the third Wednesday through Saturday in July. Outdoors. Accepts all fine art categories. Juried. Number of exhibitors: 325. Attendance: 500,000-750,000. Free to public. Deadline for entry is January; enter online at www.juriedartservices.com. Exhibition space: 10×10, 10×13, 10×17 ft. For information, artists should visit the website, call, or e-mail. Show is located on University of Michigan campus and in downtown Ann Arbor.

THE ANNA MARIA ISLAND ARTS & CRAFTS FESTIVAL

270 Central Blvd., Suite 107B, Jupiter FL 33458. (561)746-6615. **Fax:** (561)746-6528. **E-mail:** info@ artfestival.com. **Website:** www.artfestival.com. **Contact:** Malinda Ratliff, communications manager. Fine art & craft fair held annually in mid-November. Outdoors. Accepts photography, jewelry, mixed media, sculpture, wood, ceramic, glass, painting, digital, fiber, metal. Juried. Number exhibitors: 106. Number attendees: 10,000. Free to public. Apply online via www.zapplication.org. Deadline: see website. Application fee: $15; free to mail in paper application. Space fee: $250. Exhibition space: 10×10 and 10×20. For more information, artists should e-mail, call, or visit website.

TIPS "You have to start somewhere. First, assess where you are, and what you'll need to get things off the ground. Next, make a plan of action. Outdoor street art shows are a great way to begin your career and lifetime as a working artist. You'll meet a lot of other artists who have been where you are now. Network with them!"

⏻ ANNUAL ARTS & CRAFTS ADVENTURE

American Society of Artists, P.O. Box 1326, Palatine IL 60078. (847)991-4748. **E-mail:** asoaartists@aol.com. **E-mail:** asoaartists@aol.com. **Website:** www.americansocietyofartists.org. **Contact:** ASA Office. Estab. 1991. Fine arts & crafts show held annually in May the Saturday before Mother's Day. Outdoors. Accepts fine art and handmade crafts. Juried. Number of exhibitors: 55. Free to the public. Apply be e-mailing asoaartists@aol.com or via mail with SASE. Send 4 images representative of your work you wish to exhibit, 1 of your display set-up, your first/last name, physical address, daytime phone number and résumé/show listing. Deadline for entry: varies. Space fee: $95 (price less or more for smaller or larger space). Exhibition space: 10×10 (smaller and larger spaces also available upon request). For more information, artists should visit website.

TIPS "Remember to present your work in a professional manner."

⏻ APPLE ANNIE CRAFTS & ARTS SHOW

4905 Roswell Rd., Marietta GA 30062. (770)552-6400, ext. 6110. **Fax:** (770)552-6420. **E-mail:** sagw4905@gmail.com. **Website:** www.st-ann.org/womens-guild/apple-annie. Estab. 1981. Handmade arts & crafts show held annually the 1st weekend in December. Juried. Indoors. Accepts handmade arts and crafts like photography, woodworking, ceramics, pottery, painting, fabrics, glass, etc. Number of exhibitors: 120. Public attendance: 4,000. Artists should apply by visiting website to print application form. Deadline: March 1 (see website for details). Application fee: $20, nonrefundable. Booth fee $200. Exhibition space: 80 sq. ft. minimum, may be more. For more information, artists may visit website.

TIPS "We are looking for vendors with an open, welcoming booth, who are accessible and friendly to customers."

⏻ APPLEWOOD ARTS

12897 W 78th Cir., Arvada CO (303)797-9656. **Fax:** (303)797-9656. **E-mail:** kness50@gmail.com. **Website:** www.applewoodartsandcrafts.com. **Contact:** Kathleen Ness. Estab. 1977. Arts & crafts show held annually 3 times in November. Indoors. Accepts original fine art & handmade crafts. Juried. Awards/prizes: 9 Most Original Booth prizes. Number of exhibitors: 100. Number of attendees: 4,000. Admission: $4.

Artists should apply via website. Deadline for entry: mid-June. Application fee: none. Space fee: $300. Exhibition space: 10×10; 12×12. For more information, artists should visit website.

⏺ Festival takes place at 3 locations: Highlands Ranch; Standley Lake; The Ranch-Loveland, Larimer Co. Fairgrounds

TIPS Present a creative, well-done booth.

⏻ ARLINGTON FESTIVAL OF THE ARTS

270 Central Blvd., Suite 107B, Jupiter FL 33458. (561)746-6615. **Fax:** (561)746-6528. **E-mail:** info@artfestival.com. **Website:** www.artfestival.com. **Contact:** Malinda Ratliff, communications manager. Estab. 2013. Fine art & craft fair held annually in mid-April. Outdoors. Accepts photography, jewelry, mixed media, sculpture, wood, ceramic, glass, painting, digital, fiber, metal. Juried. Number exhibitors: 140. Number attendees: 50,000. Free to public. Apply online via www.zapplication.org. Deadline: see website. Application fee: $25. Space fee: $395. Exhibition space: 10×10 and 10×20. For more information, artists should e-mail, call or visit website. Festival located at Highland St. in the Clarendon district of Arlington, VA.

TIPS "You have to start somewhere. First, assess where you are, and what you'll need to get things off the ground. Next, make a plan of action. Outdoor street art shows are a great way to begin your career and lifetime as a working artist. You'll meet a lot of other artists who have been where you are now. Network with them!"

⏻ THE ANNA MARIA ISLAND ARTS & CRAFTS FESTIVAL

270 Central Blvd., Suite 107B, Jupiter FL 33458. (561)746-6615. **Fax:** (561)746-6528. **E-mail:** info@artfestival.com. **Website:** www.artfestival.com. **Contact:** Malinda Ratliff, communications manager. Fine art & craft fair held annually in mid-November. Outdoors. Accepts photography, jewelry, mixed media, sculpture, wood, ceramic, glass, painting, digital, fiber, metal. Juried. Number exhibitors: 106. Number attendees: 10,000. Free to public. Apply online via www.zapplication.org. Deadline: see website. Application fee: $15; free to mail in paper application. Space fee: $250. Exhibition space: 10×10 and 10×20. For more information, artists should e-mail, call, or visit website.

TIPS "You have to start somewhere. First, assess where you are, and what you'll need to get things off the ground. Next, make a plan of action. Outdoor street art shows are a great way to begin your career and lifetime as a working artist. You'll meet a lot of other artists who have been where you are now. Network with them!"

ART & APPLES FESTIVAL®

Presented by Paint Creek Center for the Arts, 407 Pine St., Rochester MI 48307. (248)651-4110. **Fax:** (248)651-4757. **E-mail:** general@pccart.org. **E-mail:** general@pccart.org. **Website:** www.pccart.org. **Contact:** Tami Salisbury, Executive Director. Estab. 1965. Fine arts & crafts show held annually in September. OuFine art festival held annually the weekend after Labor Day in Rochester, Michigan. Outdoors. Accepts handmade fine art. Juried. Exhibitors: 290. Number of attendees: 200,000. Admission: $5 donation. Apply online. Deadline for entry: see website. Application fee: see website. Space fee: see website. Exhibition space: see website. For more information, e-mail or visit website.tdoors. Accepts handmade crafts and fine art. Juried. Exhibitors: 290. Number of attendees: 125,000. Admission: $5. Apply online. Deadline for entry: see website. Application fee: see website. Space fee: see website. Exhibition space: see website. For more information, e-mail or visit website. Fine art festival held annually the weekend after Labor Day in Rochester, Michigan. Outdoors. Accepts handmade fine art. Juried. Exhibitors: 290. Number of attendees: 200,000. Admission: $5 donation. Apply online. Deadline for entry: see website. Application fee: see website. Space fee: see website. Exhibition space: see website. For more information, e-mail or visit website.

ART-A-FAIR

P.O. Box 547, Laguna Beach CA 92652. (949)494-4514. **E-mail:** marketing@art-a-fair.com. **Website:** www.art-a-fair.com. Estab. 1967. Fine arts show held annually in June-August. Outoors. Accepts painting, sculpture, ceramics, jewelry, printmaking, photography, master crafts, digital art, fiber, glass, pencil, wood. Juried. Exhibitors: 125. Number of attendees: see website. Admission: $7.50 adults; $4.50 seniors; children 12 & under free. Apply online. Deadline for entry: see website. Application fee: $40 (per medium). Space fee: $200 + $35 membership fee. Exhibition space: see website. For more information, e-mail, call or visit website.

ART BIRMINGHAM

118 N. Fourth Ave., Ann Arbor MI 48104. (734)662-3382. **Fax:** (734)662-0339. **E-mail:** info@theguild.org. **Website:** www.theguild.org. Estab. 1981. Arts & crafts show held annually in May. Outoors. Accepts handmade crafts painting, ceramics, photography, jewelry, glass, wood, sculpture, mixed media, fiber, metal and more. Juried. Exhibitors: 150. Number of attendees: see website. Free to public. Apply online. Deadline for entry: see website. Application fee: see website. Space fee: see website. Exhibition space: see website. For more information, call or visit website.

ART FAIR AT LAUMEIER SCULPTURE PARK

Laumeier Sculpture Park, 12580 Rott Rd., St. Louis MO 63127. **E-mail:** smatthew@laumeier.org. **Website:** www.laumeiersculpturepark.org/art-fair/. **Contact:** Sara Matthew, special events manager. Estab. 1987. More than 15,000 patrons attend this annual three-day event on Mother's Day weekend, featuring local food vendors, a wine garden, live music and 150 juried artists from across the country exhibiting work in ten media categories: ceramics, fiber/textiles, glass, jewelry, mixed media 2D, painting, photography/digital, printmaking/drawing, sculpture and wood. Founded in 1976, Laumeier Sculpture Park is one of the first and largest dedicated sculpture parks in the country, making it an institution of international significance as well as a unique complement to the cultural landscape of the St. Louis region. Laumeier is a nonprofit, accredited art museum that operates in partnership with St. Louis County Parks. Laumeier presents 60 works of large-scale outdoor sculpture in a 105-acre park available free to the public year-round. Eligibility: All artists ages 18 and up who exhibit work of original concept, design and execution are eligible to apply. Artists may apply in more than one category; however, a separate application and jury fee must be submitted for each category. Artists may not apply more than once in the same category. Total event participation is limited to 150 artists. Apply via www.zapplication.org. Required images: 5 (booth shot required). Jury fee schedule: Laumeier Sculpture Park is a living laboratory where artists and audiences explore the relationship between contemporary art and the natural environment.

ART FAIR AT QUEENY PARK

GSLAA-Vic Barr, 1668 Rishon Hill Dr., St. Louis MO 63146. (636)724-5968. **Website:** www.artfairatqueenypark.com. Arts & crafts show held annually in August. Indoors. Accepts handmade crafts, clay, digital (computer) art, drawing/print, fiber (basketry, paper, wearable, woven), glass, jewelry, 2D/3D mixed media, oil/acrylic, photography, sculpture, water media, wood. Juried. Exhibitors: 140. Number of attendees: see website. Free to public. Apply online. Deadline for entry: see website. Application fee: $25; $50 for late application. Space fee: $225. Exhibition space: 10×8. For more information, call or visit website.

ART FAIR JACKSON HOLE

Art Association of Jackson Hole, Art Association of Jackson Hole, P.O. Box 1248, Jackson WY 83001. (307)733-6379. **Fax:** (307)733-6694. **E-mail:** artistinfo@jhartfair.org. **Website:** www.jhartfair.org. **Contact:** Elisse La May, Events Director. Estab. 1965. Arts & crafts show held annually the second weekends of July & August in Miller Park, Jackson Hole, WY. Outdoors. Accepts handmade crafts, ceramic, drawing, fiber, furniture, glass, graphics & printmaking, jewelry, leather, metalwork, 2D/3D mixed media, painting, photography, sculpture, toys & games, wearable fiber, wood. Juried. Exhibitors: 145. Number of attendees: 12,000. Free for art association members; $5 per day for non-members. Apply via Zapplication.org. Deadline for entry: see website. Application fee: $35. Space fee: Standard Booth space is 10X10. Other booth options vary. Exhibition space: varies. For more information, e-mail, visit website or call.

ART FAIR OFF THE SQUARE

P.O. Box 1791, Madison WI 53701-1791. (262)537-4610. **E-mail:** wiartcraft@gmail.com. **Website:** www.artcraftwis.org/AFOS.html. Estab. 1965. Arts & crafts show held annually in July. Outoors. Accepts handmade crafts ceramics, art glass, painting, fiber, sculpture, jewelry, graphics, papermaking, photography, wood and more. Juried. Awards/prizes: Best of Category. Exhibitors: 140. Number of attendees: see website. Free to public. Apply via Zapplication.org. Deadline for entry: see website. Application fee: $25. Space fee: $300. Exhibition space: 10×10. For more information, e-mail, visit website or call.

ART FAIR ON THE COURTHOUSE LAWN

P.O. Box 795, Rhinelander WI 54501. (715)365-7464. **E-mail:** assistant@rhinelanderchamber.com. **Website:** www.explorerhinelander.com. **Contact:** events coordinator. Estab. 1985. Arts & crafts show held annually in June. Outdoors. Accepts woodworking (includes furniture), jewelry, glass items, metal, paintings and photography. Number of exhibitors: 150. Public attendance: 3,000. Free to the public. Space fee: $75-300. Exhibit space: 10×10 to 10×30 ft. For more information, artists should e-mail, call or visit website. Show located at Oneida County Courthouse. **TIPS** "We accept only items handmade by the exhibitor."

ART FAIR ON THE SQUARE

July 9-10, 2016, Madison Museum of Contemporary Art, 227 State St., Madison WI 53703. (608)257-0158, ext 229. **Fax:** (608)257-5722. **E-mail:** artfair@mmoca.org. **Website:** www.mmoca.org/events/special-events/art-fair-square/art-fair-square. **Contact:** Annik Dupaty. Estab. 1958. Arts & crafts show held annually in July. Outoors. Accepts handmade crafts, ceramics, fiber, leather, furniture, jewelry, glass, digital art, metal, sculpture, 2D/3D mixed media, painting, photography, printmaking/graphics/drawing, wood. Juried. Awards/prizes: Best of Show; Invitational Award. Exhibitors: varies. Number of attendees: 150,000+. Free to public. Apply via www.zapplication.org. Deadline for entry: see website. Application fee: $35. Space fee: $520 (single); $1,075 (double). Exhibition space: 10×10 (single); 20×10 (double). For more information, e-mail, call or visit website.

ART FEST BY THE SEA

270 Central Blvd., Suite 107B, Jupiter FL 33458. (561)746-6615. **Fax:** (561)746-6528. **E-mail:** info@artfestival.com. **Website:** www.artfestival.com. **Contact:** Malinda Ratliff, communications manager. Estab. 1958. Fine art & craft fair held annually in early March. Outdoors. Accepts photography, jewelry, mixed media, sculpture, wood, ceramic, glass, painting, digital, fiber, metal. Juried. Number exhibitors: 340. Number attendees: 125,000. Free to public. Apply online via www.zapplication.org. Deadline: see website. Application fee: $25. Space fee: $415. Exhibition space: 10×10 and 10×20. For more information, artists should e-mail, call or visit website. Fair located

along A1A Between Donald Ross Rd. and Marcinski in Juno Beach FL.

TIPS "You have to start somewhere. First, assess where you are, and what you'll need to get things off the ground. Next, make a plan of action. Outdoor street art shows are a great way to begin your career and lifetime as a working artist. You'll meet a lot of other artists who have been where you are now. Network with them!"

ARTFEST FORT MYERS

1375 Jackson St., Suite 401, Fort Myers FL 33901. (239)768-3602. **E-mail:** info@artfestfortmyers.com. **Website:** www.artfestfortmyers.com. Fine arts & crafts fair held annually in February. Outdoors. Accepts handmade crafts, ceramics, digital, drawing/graphics, fiber, glass, jewelry, metal, 2D/3D mixed media, painting, photography, printmaking, sculpture, wearable, wood. Juried. Awards/prizes: $5,000 in cash. Exhibitors: 200. Number of attendees: 85,000. Free to public. Apply online. Deadline for entry: September 15. Application fee: $35. Space fee: $460.50. Exhibition space: 10×10. For more information, e-mail, call or visit website.

ART FESTIVAL BETH-EL

400 Pasadena Ave. S, St. Petersburg FL 33707. (727)347-6136. **Fax:** (727)343-8982. **E-mail:** annsoble@gmail.com. **Website:** www.artfestivalbethel.com. Estab. 1972. Fine arts & crafts show held annually the last weekend in January. Indoors. Accepts photography, painting, jewelry, sculpture, woodworking, glass. Juried by special committee on-site or through slides. Awards/prizes: over $7,000 prize money. Number of exhibitors: over 170. Public attendance: 8,000-10,000. Free to the public. Artists should apply by application with photos or slides; show is invitational. Deadline for entry: September. For more information, artists should call or visit website. A commission is taken.

TIPS "Don't crowd display panels with artwork. Make sure your prices are on your pictures. Speak to customers about your work."

ART FESTIVAL OF HENDERSON

P.O. Box 95050, Henderson NV 89009-5050. (702)267-2171. **E-mail:** info@artfestival.com. Arts & crafts show held annually in May. Outdoors. Accepts handmade crafts, paintings, pottery, jewelry, photography and much more. Juried. Exhibitors: varies. Number of attendees: 25,000. Free to public. Apply online. Deadline for entry: see website. Application fee: see website. Space fee: see website. Exhibition space: see website. For more information, call or visit website.

ARTFEST MIDWEST—"THE OTHER ART SHOW"

Stookey Companies, P.O. Box 31083, Des Moines IA 50310. (515)278-6200. **Fax:** (515)276-7513. **E-mail:** suestookey@att.net. **Website:** www.artfestmidwest.com. Fine art fair held annually in June. Indoors & outdoors. Accepts handmade fine art, ceramic, fiber, drawing, glass, jewelry, metal, 2D/3D mixed media, painting, photography, wood. Juried. Exhibitors: 240. Number of attendees: 30,000. Free to public. Apply via www.zapplication.org. Deadline for entry: March. Application fee: $30. Space fee: varies. Exhibition space: see website. For more information, e-mail suestookey@att.net, visit website at www.artfestmidwest.com, or call (515) 278-6200.

ARTIGRAS FINE ARTS FESTIVAL

5520 PGA Blvd., Suite 200, Palm Beach Gardens FL 33418. (561)746-7111. **E-mail:** info@artigras.org. **Website:** www.artigras.org. **Contact:** Hannah Sosa, director of special events. Estab. 2008. Annual fine arts festival held in February during Presidents' Day weekend. Outdoors. Accepts all fine art (including photography). Juried. $17,000 in cash awards and prizes. Average number of exhibitors: 300. Average number of attendees: 85,000. Admission: $10. Artists should apply by enclosing a copy of prospectus or by application form, if available; can also apply via www.zapplication.org. Deadline: September. Application fee: $40. Space fee: $450. Space is 12×12. For more information artists should e-mail or visit website.

ART IN BLOOM—CATIGNY PARK

(630)668-5161. **E-mail:** info@cantigny.org. **Website:** www.cantigny.org/calendar/signature-events/art-in-bloom. Fine arts & crafts show held annually in June. Outdoors. Accepts handmade crafts, ceramics, drawing, fiber nonfunctional, fiber wearable, paper nonfunctional, furniture, glass, jewelry, acrylic, oil, watercolor, pastel, sculpture, wood, mixed media, collage, photography, and printmaking. Juried. Exhibitors: 80. Number of attendees: 8,000. Free to public. Apply online. Deadline for entry: see website. Application fee: $10. Space fee: $300. Exhibition space: 10×10. For more information, e-mail, call or visit website.

ART IN THE BARN—BARRINGTON

Advocate Good Shepherd Hospital, Art in the Barn Artist Committee, 450 W. Highway 22, Barrington IL 60010. (847)842-4496. **E-mail:** artinthebarn. barrington@gmail.com. **Website:** www.artinthebarn-barrington.com. Estab. 1974. Fine arts & crafts show held annually in September. Indoors & outdoors. Accepts handmade crafts, ceramics, painting, jewelry, glass, sculpture, fiber, drawing, photography, digital media, printmaking, scratchboard, mixed media, wood. Juried. Awards/prizes: Best of Show; Best of Medium; Purchase Awards. Exhibitors: 185. Number of attendees: 8,500. Admission: $5; children 12 & under free. Apply online. Deadline for entry: see website. Application fee: $20. Space fee: $100 (indoors); $85 (outdoors). Exhibition space: varies. For more information, e-mail, call or visit website.

ART IN THE PARK (ARIZONA)

P.O. Box 748, Sierra Vista AZ 85636-0247. (520)803-0584. **E-mail:** Libravo@live.com. **Website:** www.artintheparksierravista.com. Estab. 1972. Oldest longest running arts & crafts fair in Southern Arizona. Fine arts & crafts show held annually 1st full weekend in October. Outdoors. Accepts photography, all fine arts and crafts created by vendor. No resale retail strictly applied. Juried by Huachaca Art Association Board. Artists submit 5 photos. Returnable with SASE. Number of exhibitors: 203. Public attendance: 15,000. Free to public. Artists should apply by downloading the application www.artintheparksierravista.com. Deadline for entry: postmarked by late June. Last minute/late entries always considered. No application fee. Space fee: $200-275, includes jury fee. Exhibition space: 15×30 ft. Some electrical; additional cost of $25. Some RV space available at $15/night. For more information, artists should see website, e-mail, call or send SASE. Show located in Veteran's Memorial Park.

ART IN THE PARK (GEORGIA)

P.O. Box 1540, Thomasville GA 31799. (229)227-7020. **Fax:** (229)227-3320. **E-mail:** roseshowfest@rose.net; karens@thomasville.org. **Website:** www.downtownthomasville.com. **Contact:** Laura Beggs. Estab. 1998-1999. Art in the Park (an event of Thomasville's Rose Show and Festival) is a 1-day arts & crafts show held annually in April. Outdoors. Accepts photography, handcrafted items, oils, acrylics, woodworking, stained glass, other varieties. Juried by a selection committee. Number of exhibitors: 60. Public attendance: 2,500. Free to public. Artists should apply by submitting official application. Deadline for entry: early February. Space fee varies by year. Exhibition space: 20×20 ft. For more information, artists should e-mail, call or visit website. Show located in Paradise Park.

TIPS "Most important, be friendly to the public and have an attractive booth display."

ART IN THE PARK (VIRGINIA)

20 S. New St., Staunton VA 24401. (540) 885-2028. **E-mail:** director@saartcenter.org. **Website:** www.saartcenter.org. **Contact:** Beth Hodges, exec. director. Estab. 1961. Fine arts & crafts show held annually every Memorial Day weekend. Outdoors. Juried by submitting 4 photos representative of the work to be sold. Award/prizes: $1,500. Number of exhibitors: 60. Public attendance: 3,000-4,000. Free to public. Artists should apply by sending in application. Exhibition space: 10×10 ft. For more information, artists should e-mail, call or visit website. Show located at Gypsy Hill Park.

ART IN THE PARK—FINE ARTS FESTIVAL

Swartz Creek Kiwanis, 5023 Holland Dr., Swartz Creek MI 48473. (810)282-7641. **E-mail:** aitp@hsaa.com. **E-mail:** aitp@hsaa.com. **Website:** www.swartzcreekkiwanis.org/art. **Contact:** Doug Stephens. Estab. 2008. Annual outdoor fine art festival held in August. Accepts all fine art. Juried by art professionals hired by the committee, monetary prizes given. Average number of exhibitors: 50. Average number of attendees: 2,500-3,000. Free admission. Artists should apply by accessing the website. Deadline: early July. Space fee of $125; $175 for late applications. Space is 144 sq. ft. For more information artists should e-mail or visit the website. Festival held at Elms Park.

TIPS "Bring unique products."

ART IN THE PARK FALL FOLIAGE FESTIVAL

Rutland Area Art Association, P.O. Box 1447, Rutland VT 05701. (802)775-0356. **E-mail:** info@chaffeeartcenter.org; artinthapark@chaffeeartcenter.org. **Website:** www.chaffeeartcenter.org. **Contact:** Meg Barros. Estab. 1961. A fine arts & crafts show held at Main Street Park in Rutland VT annually in October over Columbus Day weekend. Accepts fine art, specialty foods, fiber, jewelry, glass, metal,

wood, photography, clay, floral, etc. All applications will be juried by a panel of experts. The Art in the Park Festivals are dedicated to high-quality art and craft products. Number of exhibitors: 100. Public attendance: 9,000-10,000. Public admission: voluntary donation. Artists should apply online and either e-mail or submit a CD with 3 photos of work and 1 of booth (photos upon preapproval). Deadline for entry: early bird discount of $25 per show for applications received by March 31. Space fee: $200-350. Exhibit space: 10×12 or 20×12 ft. For more information, artists should e-mail, visit website, or call. Show located in Main Street Park.

TIPS "Have a good presentation, variety, if possible (in pricing also), to appeal to a large group of people. Apply early, as there are a limited amount of accepted vendors per category. Applications will be juried on a first come, first served basis until the category is determined to be filled."

ART IN THE PARK (HOLLAND, MICHIGAN)

Holland Friends of Art, P.O. Box 1052, Holland MI 49422. **E-mail:** info@hollandfriendsofart.com. **Website:** www.hollandfriendsofart.com. **Contact:** Beth Canaan, art fair chairperson. Estab. 1969. This annual fine arts and crafts fair is held on the first Saturday of August in Holland. The event draws one of the largest influx of visitors to the city on a single day, second only to Tulip Time. More than 300 fine artists and artisans from 8 states will be on hand to display and sell their work. Juried. All items for sale must be original. Public attendance: 10,000+. Entry fee: $90 includes a $20 application fee. Deadline: late March. Space fee: $160 for a double-wide space. Exhibition space: 12×12 ft. Details of the jury and entry process are explained on the application. Application available online. E-mail or visit website for more information. Event held in Centennial Park.

TIPS "Create an inviting and neat booth. Offer well-made quality artwork and crafts at a variety of prices."

ART IN THE PARK (KEARNY)

Kearney Artist Guild, P.O. Box 1368, Kearney NE 68848-1368. (308)708-0510. **E-mail:** artintheparkkearney@charter.net. **Website:** www.kearneyartistsguild.com. **Contact:** Daniel Garringer, (308)708-0510. Estab. 1971. Fine arts held annually in July. Outdoors. Accepts handmade fine crafts, ceramics, drawing, fiber, mixed media, glass, jewelry,

painting, photography, sculpture. Juried. Exhibitors: 90. Number of attendees: estimated 7,000. Free to public. Apply online. Deadline for entry: early June. Application fee: $10. Space fee: $50-$100. Exhibition space: 12'x12' or 12'x24' . For more information, e-mail, visit website at kearneyartaistsguild.com, or call.

ART IN THE PARK (PLYMOUTH, MICHIGAN)

P.O. Box 702490, Plymouth MI 48170. (734)454-1314. **Fax:** (734)454-3670. **E-mail:** info@artinthepark.com. **Website:** www.artinthepark.com. Estab. 1979. Arts & crafts show held annually in July. Outdoors. Accepts handmade crafts, paintings, sculpture, ceramics, jewelry, fiber, fine glass, woodwork, mixed media, photography, and folk art. Juried. Exhibitors: 400. Number of attendees: 300,000. Free to public. Apply online. Deadline for entry: see website. Application fee: $20. Space fee: $580. Exhibition space: 10×10. For more information, e-mail, visit website, or call.

ART IN THE VILLAGE WITH CRAFT MARKETPLACE

270 Central Blvd., Suite 107B, Jupiter FL 33458. (561)746-6615. **Fax:** (561)746-6528. **E-mail:** info@artfestival.com. **Website:** www.artfestival.com. **Contact:** Malinda Ratliff, communications manager. Estab. 1991. Fine art & craft fair held annually in early June. Outdoors. Accepts photography, jewelry, mixed media, sculpture, wood, ceramic, glass, painting, digital, fiber, metal. Juried. Number exhibitors: 150. Number attendees: 70,000. Free to public. Apply online via www.zapplication.org. Deadline: see website. Application fee: $25. Space fee: $450. Exhibition space: 10×10 and 10×20. For more information, artists should e-mail, call or visit website. Show located at Legacy Village in Cleveland, OH.

TIPS "You have to start somewhere. First, assess where you are, and what you'll need to get things off the ground. Next, make a plan of action. Outdoor street art shows are a great way to begin your career and lifetime as a working artist. You'll meet a lot of other artists who have been where you are now. Network with them!"

ARTISPHERE

101B Augusta St., Greenville SC 29601. (864)412-1040. **Fax:** (864)283-6580. **E-mail:** polly@artisphere.org. **Website:** www.artisphere.org. **Contact:** Polly Gaillard. Fine arts & crafts art festival held annually sec-

ond weekend in May (see website for details). Show-cases local and national fine art and fine craft artists on Artist Row along South Main Street. Accepts digital art and photography. Apply via www.zapplication. org. Free to public. E-mail, call, or visit website for more information.

✚ ✪ ARTIST PROJECT 2017

10 Alcorn Ave., Suite 100, Toronto, Ontario M4V-3A9 Canada. (416)960-5396. **Fax:** (416)927-8032. **E-mail:** info@theartistproject.com. **Website:** www. theartistproject.com. **Contact:** Claire Taylor, show director. Estab. 2007. Event held every February. Fine art event. Event held indoors. Accepts photography. Accepts all fine art mediums. Juried event. Awards and prizes given: Untapped Artist Competition and Travel Grants. Average number of exhibitors: 300. Average number of attendees: 14,000. Admission fee for public: $10-$15. Artists should apply online. Deadline for entry applications is . Application fee: $25. Space fee: Depends on booth size. Average gross sales for exhibitors: N/A. Artists should email, visit website or call for more information.

⊙ ART ON THE LAWN

Village Artisans, 100 Corry St., Yellow Springs OH 45387. (937)767-1209. **E-mail:** villageartisans.email@ yahoo.com. **Website:** www.villageartisans.blogspot. com. **Contact:** Village Artisans. Estab. 1983. Fine arts & crafts show held annually the 2nd Saturday in August. Outdoors. Accepts photography, all hand-made media and original artwork. Juried, as received, from photos accompanying the application. Awards: Best of Show receives a free booth space at next year's event. Number of exhibitors: 90-100. Free to public. Request an application by calling or e-mailing, or download an application from the website. Deadline for entry: July 31; however, the sooner received, the better the chances of acceptance. Jury fee: $15. Space fee: $75 before May; $85 until late July; $105 thereafter. Exhibition space: 10×10 ft. Average gross sales vary. For more information, artists should visit website, e-mail, call, send SASE or stop by Village Artisans at above address.

ART ON THE MALL

The University of Toledo, Office of Alumni Relations, 2801 W. Bancroft St., Mail Stop 301, Toledo OH 43606-3390. (419)530-2586. **Fax:** (419)530-4994. **E-mail:** artonthemall@utoledo.edu; ansley.abrams@ utoledo.edu. **Website:** www.toledoalumni.org. Shirley

Grzecki. **Contact:** Ansley Abrams-Frederick. Estab. 1992. Art show held annually on the last Sunday in July in Centennial Mall in the heart of the Main Campus of The University of Toledo. Outdoor juried art show. This show accepts submissions in the following categories: acrylic, glass, jewelry, mixed media, pen & ink, photography, pottery, oil, textiles/fibers/bas-ketry, watercolors, wood and other. Awards/prizes: UT Best of Show (has to have a UT connection), 1st place, 2nd place, 3rd place, Purchase Award. Number exhibitors: 105-115. Number attendees: 12,000. Free to public. Apply online or call the office to have an application mailed to you. Deadline for entry: April 30. Application fee: $25. Space fee: $100. Exhibition space: 10×10. For more information, e-mail, call, or visit website. "The purpose of the University of Toledo Alumni Association shall be to support the University by fostering a spirit of loyalty to the university among its alumni. This is accomplished by providing a communications link between alumni and the university, encouraging and establishing activities for alumni and promoting programs to assist int he academic and cultural development of the University of Toledo."

⊙ ART ON THE SQUARE

P.O. Box 23561, Belleville IL 62223. (618)233-6769. **E-mail:** clindauer@bellevillechamber.org. **Website:** www.artonthesquare.com. Estab. 2002. Fine arts & crafts show held annually in May. Outdoors. Accepts handmade crafts, photography, glass, jewelry, clay, sculpture, fine craft, mixed media, wood, and digital art. Juried. Awards/prizes: over $30,000 in cash. Exhibitors: 105. Number of attendees: varies. Free to public. Apply online. Deadline for entry: see website. Application fee: see website. Space fee: see website. Exhibition space: see website. For more information, e-mail, visit website, or call.

⊙ ART RAPIDS!

P.O. Box 301, Elk Rapids MI 49629. (231)264-6660. **E-mail:** art@mullalys128.com. **Website:** www.artrapids. org. **Contact:** Barb Mullaly. Art fair held annually last Saturday in June. Outdoors. Accepts handmade crafts, ceramic, drawing, fiber, glass, jewelry, painting, photography, printmaking, sculpture, wood, metal, paper, or mixed media. Juried. Awards/prizes: Best of Show, Honorable Mention, People's Choice. Exhibitors: 70. Number of attendees: 4,000. Free to public. Apply online. Deadline for entry: early April. Application fee:

$20. Space fee: varies. Exhibition space: 10×10. For more information, e-mail, visit website or call.

ARTS & CRAFTS ADVENTURE

American Society of Artists, P.O. Box 1326, Palatine IL 60078. (312)751-2500. **E-mail:** asoaartists@aol.com. **Website:** www.americansocietyofartists.org. **Contact:** ASA Office. Estab. 1991. Fine arts & crafts show held annually in early May and mid-September. Outdoors. Event held in Park Ridge IL. Accepts photography, pottery, paintings, sculpture, glass, wood, woodcarving, and more. Juried by 4 slides or photos of work and 1 slide or photo of display; a résumé or show listing is helpful. See our website for online jury. To jury via e-mail: asoaartists@aol.com. Number of exhibitors: 60. Free to the public. Artists should apply by submitting jury materials. Submit to asoaartists@aol.com. If juried in, you will receive a jury/approval number. Deadline for entry: 2 months prior to show or earlier if spaces fill. Space fee: to be announced. Exhibition space: approximately 100 sq. ft. for single space; other sizes available. For more information, artists should send SASE, submit jury material. Show located in Hodges Park.

TIPS "Remember that when you are at work in your studio, you are an artist. But when you are at a show, you are a business person selling your work."

AN ARTS & CRAFTS AFFAIR, AUTUMN & SPRING TOURS

P.O. Box 655, Antioch IL 60002. (402)331-2889. **E-mail:** hpifestivals@cox.net. **Website:** www.hpifestivals.com. **Contact:** Huffman Productions. Estab. 1983. An arts & crafts show that tours different cities and states. Autumn Festival tours annually October-November; Spring Festival tours annually in March & April. Artists should visit website to see list of states and schedule. Indoors. Accepts photography, pottery, stained glass, jewelry, clothing, wood, baskets. All artwork must be handcrafted by the actual artist exhibiting at the show. Juried by sending in 2 photos of work and 1 of display. Awards/prizes: 4 $30 show gift certificates; $50, $100 and $150 certificates off future booth fees. Number of exhibitors: 300-500 depending on location. Public attendance: 15,000-35,000. Public admission: $8-9/adults; $7-8/seniors; 10 & under, free. Artists should apply by calling to request an application. Deadline for entry: varies for date and location. Space fee: $350-1,350. Exhibition space: 8×11 ft. up to 8×22 ft. For more information, artists should e-mail, call or visit website.

TIPS "Have a nice display, make sure business name is visible, dress professionally, have different price points, and be willing to talk to your customers."

ARTS & CRAFTS FESTIVAL

Simsbury Woman's Club, P.O. Box 903, Simsbury CT 06070. (860)658-2684. **E-mail:** simsburywomansclub@hotmail.com; swc_artsandcrafts@yahoo.com. **Website:** www.simsburywomansclub.org. **Contact:** Shirley Barsness, co-chairman. Estab. 1978. Arts & crafts show held in mid-September. Juried event. Outdoors rain or shine. Original artwork, photography, clothing, accessories, jewelry, toys, wood objects and floral arrangements accepted. Manufactured items or items made from kits not accepted. Individuals should apply by submitting completed application, 4 photos or JPEG files, including 1 of display booth. Exhibition space: 11×14 ft. or 15×14 ft. frontage. Space fee: $160-175; late applications $170-185. Number of exhibitors: 120. Public attendance: 5,000-7,000. Free to public. Deadline for entry: August 15. For more information, artists should e-mail swc_artsandcrafts@yahoo.com or call Jean at (860)658-4490 or Shirley at (860)658-2684. Applications available on website. Show located in Simsbury Center.

TIPS "Display artwork in an attractive setting."

ARTS, BEATS & EATS

301 W. Fourth St., Suite LL-150, Royal Oak MI 48067. (248) 541-7550. **Fax:** (248)541-7560. **E-mail:** lisa@artsbeatseats.com. **Website:** www.artsbeatseats.com. **Contact:** Lisa Konikow, art director. Estab. 1997. Fine arts & crafts fair held annually in September. Outdoors. Accepts handmade crafts, ceramic, digital art, fiber, drawing, glass, jewelry, metal, 2D/3D mixed media, painting, photography, printmaking, wood. Juried. Awards/prizes: $7,500 in cash awards. Exhibitors: 145. Number of attendees: 400,000. Free to public. Apply online. Deadline for entry: March. Application fee: $25. Space fee: $490. Exhibition space: 10×10. For more information, artists should send e-mail, call or visit website.

ARTS ADVENTURE

P.O. Box 1326, Palatine IL 60078. (312)571-2500 or (847)991-4748. **E-mail:** asoaartists@aol.com. **Website:** www.americansocietyofartists.org. Estab. 2001.

American Society of Artists. Fine arts & crafts show held annually the end of July. Event held in Chicago. Outdoors. Accepts photography, paintings, pottery, sculpture, jewelry and more. Juried. Please submit 4 images representative of your work you wish to exhibit, 1 of your display set-up, your first/last name, physical address, daytime telephone number (résumé/show listing helpful). See our website for online jury. To jury: submit via e-mail to asoaartists@aol.com or to the above address. Include a business-size (#10) SASE please. Number of exhibitors: 50. Free to the public. If juried in, you will receive a jury/approval number. Deadline for entry: 2 months prior to show or earlier if spaces fill. Entry fee: TBA. Exhibition space: approximately 100 sq. ft. for single space; other sizes available. For more information, artists should send SASE.

TIPS "Remember that when you are at work in your studio, you are an artist. But when you are at a show, you are a business person selling your work."

⊕ ART'S ALIVE

200 125th St., Ocean City MD 21842. (410)250-0125. **Website:** oceancitymd.gov/recreation_and_parks/specialevents.html. **Contact:** Brenda Moore, event coordinator. Estab. 2000. Fine art show held annually in mid-June. Outdoors. Accepts photography, ceramics, drawing, fiber, furniture, glass, printmaking, jewelry, mixed media, painting, sculpture, fine wood. Juried. Awards/prizes: $5,250 in cash prizes. Number of exhibitors: 100. Public attendance: 10,000. Free to public. Artists should apply by downloading application from website or call. Deadline for entry: February 28. Space fee: $200. Jury Fee: $25. Exhibition space: 10×10 ft. For more information, artists should visit website, call or send SASE. Show located in Northside Park.

TIPS Apply early.

⊕ ARTS EXPERIENCE

P.O. Box 1326, Palatine IL 60078. (312)751-2500 or (847)991-4748. **E-mail:** asoaartists@aol.com. **Website:** www.americansocietyofartists.org. Estab. 1979. Fine arts & crafts show held in summer in Chicago. Outdoors. Accepts photography, paintings, graphics, sculpture, quilting, woodworking, fiber art, handcrafted candles, glass works, jewelry and more. Juried by 4 images representative of work being exhibited; 1 image of display set-up, résumé with show listings helpful. Submit to asoaartists@aol.com. Number of exhibitors: 50. Free to public. Artists should apply by submitting jury material and indicate you are interested in this particular show. When you pass the jury, you will receive jury approval number and application you requested. You may also submit to ASA, P.O. Box 1326, Palatine IL 60078. Include a SASE (business size, #10). Deadline for entry: 2 months prior to show or earlier if space is filled. Space fee: to be announced. Exhibition space: 100 sq. ft. for single space; other sizes are available. For more information, artists should send SASE to submit jury material.

TIPS "Remember that at work in your studio, you are an artist. When you are at a show, you are a business person selling your work."

⊕ ARTSFEST

P.O. Box 99, 13480 Dowell Rd., Dowell MD 20629. (410)326-4640. **Fax:** (410)326-4887. **E-mail:** info@annmariegarden.org. **Website:** www.annmariegarden.org. Estab. 1984. Fine arts & crafts fair held annually in September. Indoors & outdoors. Accepts handmade crafts, ceramic, digital art, fiber, drawing, furniture, glass, jewelry, metal, 2D/3D mixed media, painting, photography, printmaking, wood. Juried. Awards/prizes: Best of Show, Best Demonstration, Wooded Path Award, Best New Artsfest Artist Award. Exhibitors: 170. Number of attendees: varies. Admission: $6 adults; children 11 & under free; members free. Apply online. Deadline for entry: March. Application fee: $25. Space fee: varies. Exhibition space: varies. For more information, artists should send e-mail, visit website or call.

⊕ ARTS IN THE PARK

302 Second Ave. E., Kalispell MT 59901. (406)755-5268. **E-mail:** information@hockadaymuseum.com. **Website:** www.hockadaymuseum.org. Estab. 1968. Fine arts & crafts show held annually 4th weekend in July (see website for details). Outdoors. Accepts photography, jewelry, clothing, paintings, pottery, glass, wood, furniture, baskets. Juried by a panel of 5 members. Artwork is evaluated for quality, creativity and originality. Jurors attempt to achieve a balance of mediums in the show. Number of exhibitors: 100. Public attendance: 10,000. Artists should apply by completing the online application form and sending 5 images in JPEG format; 4 images of work and 1 of booth. Application fee: $25. Exhibition space: 10×10 or 10×20 ft. Booth fees: $170-435. For more information, artists should e-mail, call, or visit website. Show located in Depot Park.

⏺ ARTS ON THE GREEN

Arts Association of Oldham County, 104 E. Main St., LaGrange KY 40031. (502) 222-3822;. **E-mail:** maryklausing@bellsouth.net. **Website:** www.aaooc. org. **Contact:** Mary Klausing, director. Estab. 1999. Fine arts & crafts festival held annually 1st weekend in June. Outdoors. Accepts photography, painting, clay, sculpture, metal, wood, fabric, glass, jewelry. Juried by a panel. Awards/prizes: cash prizes for Best of Show and category awards. Number of exhibitors: 130. Public attendance: 10,000. Free to the public. Artists should apply online with website, call or visit www. zapplication.org. Deadline for entry: April 15. Jury fee: $25. Space fee: $200. Electricity fee: $20. Exhibition space: 10×10 or 10×12 ft. For more information, artists should e-mail, visit website, call. Show located on the lawn of the Oldham County Courthouse Square.

TIPS "Make potential customers feel welcome in your space. Don't overcrowd your work. Smile!"

⏺ ARTSPLOSURE

313 S. Blount St., #200B, Raleigh NC 27601. (919)832-8699. **Fax:** (919)832-0890. **E-mail:** sarah@artsplosure. org. **Website:** www.artsplosure.org. **Contact:** Sarah Wolfe, art market coordinator. Estab. 1979. Annual outdoor art/craft fair held the 3rd weekend of May. Accepts ceramics, glass, fiber art, jewelry, metal, painting, photography, wood, 2D and 3D artwork. Juried event. Awards: 6 totaling $3,500 cash. Number of exhibitors: up to 170. Public attendance: 75,000. Free admission to the public. Applications available in October, deadline is late January. Application fee: $32. Space fee: $330 for 12×12 ft.; $660 for a double space. Average sales: $2,500. To apply, visit www.artsplosure. org/visual-artist.

TIPS "We use entrythingy.com for processing applications."

⏺ ARTSQUEST FINE ARTS FESTIVAL

Cultural Arts Alliance of Walton County, Bayou Arts Center, 105 Hogtown Bayou Lane, Santa Rosa Beach FL 32459. (850)622-5970. **E-mail:** info@culturalartsalliance.com; jennifersmith@ culturalartsalliance.com. **Website:** www. artsquestflorida.com. **Contact:** Jennifer Smith. Estab. 1988. Fine arts & crafts fair held anually in May. Outdoors. Accepts handmade crafts, ceramic, digital art, fiber, drawing, glass, jewelry, metal, 2D/3D mixed media, painting, photography, printmaking, sculpture, wood. Juried. Awards/prizes: Best in Show, Awards of Excellence and Awards of Merit. Exhibitors: 125. Number of attendees: varies. Free to public. Apply online. Deadline for entry: February. Application fee: $40. Space fee: $300. Exhibition space: 10×10. For more information, artists should send e-mail, call or visit website.

⏺ ART STAR CRAFT BAZAAR

(231)264-6660. **E-mail:** info@artstarphilly.com. **Website:** www.artstarcraftbazaar.com. Estab. 2003. Arts & crafts fair held annually in May. Outdoors. Accepts handmade crafts, fabric, clay, glass, wood, paper, paintings/drawings, sculpture and more. Juried. Exhibitors: varies. Number of attendees: varies. Free to public. Apply online. Deadline for entry: see website. Application fee: see website. Space fee: see website. Exhibition space: see website. For more information, artists should send e-mail or visit website. Arts & crafts fair held annually in May. Outdoors. Accepts handmade crafts, fabric, clay, glass, wood, paper, paintings/drawings, sculpture and more. Juried. Exhibitors: varies. Number of attendees: varies. Free to public. Apply online. Deadline for entry: see website. Application fee: see website. Space fee: see website. Exhibition space: see website. For more information, artists should send e-mail or visit website.

⏺ ART UNDER THE ELMS

415 Main St., Lewiston ID 83501. (208)792-2447. **Fax:** (208)792-2850. **E-mail:** aue@lcsc.edu. **Website:** www. lcsc.edu/ce/aue/. **Contact:** Amanda Coleman. Estab. 1984. Fine arts & crafts fair held annually in April. Outdoors. Accepts handmade crafts, ceramic, digital art, fiber, drawing, furniture, glass, jewelry, metal, 2D/3D mixed media, painting, photography, prepackaged food, printmaking, wood. Juried. Awards/prizes: announced after jury. Exhibitors: 100. Number of attendees: varies. Free to public. Apply online. Deadline for entry: early January. Application fee: $20. Space fee: varies. Exhibition space: 10×10. For more information, artists should send e-mail, visit website or call.

⏺ ARTWORKS OF EAU GALLIE FINE ARTS FESTIVAL

P.O. Box 361081, Melbourne FL 32936-1081. (321) 242-1456. **E-mail:** artworksfestival@gmail.com. **Website:** www.artworksofeaugallie.org. **Contact:** Sharon Dwyer, president. Estab. 1996. Fine art & fine crafts

show held annually in November the weekend before Thanksgiving. Outdoors. Accepts various medium caategories: clay, digital art, drawing & pastel, fiber, glass, graphics & printing making, jewelry, leather, metal, mixed media, painting, photography, sculpture, watercolor, wood. Original artists' works only. Juried. Awards/prizes: Art Awards, Demonstrators' Awards, Sponsor Purchase Program. Number of exhibitors: 100. Public attendance: 15,000. Free to public. Artists apply online. Applications accepted beginning March 1. Deadline for entry: September 1. Application fee: $25. Space fee: $160. Exhibition space: 10 ft.×10 ft. Average gross sales/exhibitor varies. For more information, artists should visit website.

TIPS "Artists must be prepared to demonstrate their methods of work by creating works of art in their booths."

🎧 ATLANTA ARTS FESTIVAL

P.O. Box 724694, Atlanta GA 31139. (770)941-9660. **Fax:** (866)519-2918. **E-mail:** info@atlantaartsfestival.com. **Website:** www.atlantaartsfestival.com. Estab. 2006. Fine arts & crafts fair held annually in September. Outdoors. Accepts handmade crafts, ceramic, digital art, fiber, drawing, glass, jewelry, metal, 2D/3D mixed media, painting, photography, printmaking, wood. Juried. Awards/prizes: Best in Category, Best in Show. Exhibitors: 200. Number of attendees: varies. Free to public. Apply online. Deadline for entry: April. Application fee: $25. Space fee: varies. Exhibition space: 10×10. For more information, artists should send e-mail, visit website or call.

ATOMIC HOLIDAY BAZAAR

801 N. Tamiami Trail, Sarasota FL 34236. **E-mail:** atomicholidaybazaar@gmail.com. **Website:** www.atomicholidaybazaar.com. **Contact:** Adrien Lucas, event producer. Estab. 2006. Arts & Crafts show held annually the 1st or 2nd weekend of December. Indoors. Accepts handmade crafts, vintage clothing, kitsch, vintage jewelry, art, paper products, body products & makeup, homemade canned goods, fine jewelry, silversmiths, shoe cobblers, t-shirt screen printing, artists and plushie makers. Exhibitors: 200. Number of attendees: 1,200. Admission: $5 adults; 12 & under free. Apply via website. Deadline for entry: mid September. Space fee: $90 for full table or $45 for half-table; $280 booth; $80 stage; Bay Front room tables $75; Street Fair $300, $200, $160, $100. Exhibition

space: Main Room tables - 8'×3' (table); 12'×8' (booth); Bay Front tables 6'x3', street fair spaces vary but begin at 10'x10'. Average gross sales for typical exhibitor: n/a. For more information, artists should email *and* visit website to view vendor pics of past shows.

TIPS Atomic is an indie-craft show representing a wide spectrum of hand made arts and crafts, not interested in mass production products, think of off the beaten path, from rock n roll to whimsy, affordable, quality, amusing and colorful, punk to feminine, Atomic is not your typical craft show. Think of modern words such as upcycle, diy, repurposed, vintage or just plain beautiful to the darker nods of adult-tattoo,art. Atomic is family friendly but there are mature themes and words/images accepted if the style suits the Atomic show.

🎧 BARRINGTON ART FESTIVAL

Amdur Productions, P.O. Box 550, Highland Park IL 60035. (847)926-4300. **Fax:** (847)926-4330. **E-mail:** info@amdurproductions.com. **Website:** www.amdurproductions.com. Estab. 2009. Fine arts & crafts fair held annually in May. Outdoors. Accepts handmade crafts, ceramics, fiber, glass, jewelry, metal, photography, watercolors, and wood. Juried. Awards/prizes: announced at awards party. Exhibitors: 125. Number of attendees: 122,000. Free to public. Apply online. Deadline for entry: early January. Application fee: $25. Space fee: $415. Exhibition space: see website. For more information, artists should send e-mail, call or visit website.

🎧 BARTLETT FESTIVAL OF THE ARTS

118 W. Bartlett Ave., Suite 2, Bartlett IL 60103. (630)372-4152. **E-mail:** art@artsinbartlett.org. **Website:** www.artsinbartlett.org. Estab. 2002. Fine arts & crafts fair held annually in June. Outdoors. Accepts handmade crafts, paintings, photography, fiber, sculpture, glass, jewelry, wood, and more. Juried. Exhibitors: see website. Number of attendees: 3,000. Free to public. Apply online. Deadline for entry: April. Application fee: see website. Space fee: $150. Exhibition space: 10×10. For more information, artists should send e-mail, call or visit website.

🎧 BAYOU CITY ART FESTIVAL

38 Charles St., Rochester NH 03867. (713)521-0133. **E-mail:** info@bayoucityartfestival.com; carrie@bayoucityartfestival.com. **Website:** www.artcolonyassociation.org/bayou-city-art-festival-

memorial-park. Fine arts & crafts fair held annually in March. Outdoors. Accepts handmade crafts, ceramic, digital art, fiber, drawing, furniture, glass, jewelry, metal, 2D/3D mixed media, painting, photography, printmaking, sculpture, wood. Juried. Awards/prizes: Best of Show, 2nd place, 3rd place, Best Booth, Award of Excellence. Exhibitors: see website. Number of attendees: varies. Admission: $15 adults; $3 children 4-12; children 3 & under free. Apply online. Deadline for entry: November. Application fee: see website. Space fee: varies. Exhibition space: varies. For more information, artists should send e-mail, call or visit website.

🎧 BEAVER CREEK ART FESTIVAL

270 Central Blvd., Suite 107B, Jupiter FL 33458. (561)746-6615. **Fax:** (561)746-6528. **E-mail:** info@ artfestival.com. **Website:** www.artfestival.com. **Contact:** Malinda Ratliff, communications manager. Fine arts & crafts fair held annually in August. Outdoors. Accepts handmade crafts, clay, digital, fiber, glass, jewelry, mixed media, painting, photography, printmaking/drawing, sculpture, wood. Juried. Awards/prizes: announced after jury. Exhibitors: 150. Number of attendees: varies. Free to public. Apply online. Deadline for entry: see website. Application fee: $35. Space fee: $475. Exhibition space: 10×10 and 10×20. For more information, artists should send e-mail, call or visit website. Festival located at Beaver Creek Village in Avon, CO.

TIPS "You have to start somewhere. First, assess where you are, and what you'll need to get things off the ground. Next, make a plan of action. Outdoor street art shows are a great way to begin your career and lifetime as a working artist. You'll meet a lot of other artists who have been where you are now. Network with them!"

🎧 BEST OF THE NORTHWEST FALL ART & FINE CRAFT SHOW

Northwest Art Alliance, 7777 62nd Ave., NE, Suite 103, Seattle WA 98115. (206)525-5926. **E-mail:** info@ nwartalliance.com. **Website:** www.nwartalliance. com. Fine art & craft show held annually in October & November. Indoors. Accepts handmade crafts, ceramics, paintings, jewelry, glass, photography, wearable art, and other mediums. Juried. Number exhibitors: 110. Number attendees: varies. Admission: $5 online; $6 at door; children 12 & under free. Apply via www.zapplication.org. Deadline for entry: May. Ap-

plication fee: $35. Space fee: varies. Exhibition space: varies. For more information, artists should call, e-mail, or visit website.

🎧 BEST OF THE NORTHWEST SPRING ART & FINE CRAFT SHOW

Northwest Art Alliance, 7777 62nd Ave., NE, Suite 103, Seattle WA 98115. (206)525-5926. **E-mail:** info@ nwartalliance.com. **Website:** www.nwartalliance. com. Fine art & craft show held annually in March. Indoors. Accepts handmade crafts, ceramics, paintings, jewelry, glass, photography, wearable art, and other mediums. Juried. Number exhibitors: 110. Number attendees: varies. Admission: $5 online; $6 at door; children 12 & under free. Apply via www.zapplication.org. Deadline for entry: January. Application fee: $35. Space fee: varies. Exhibition space: varies. For more information, artists should call, e-mail, or visit website.

🎧 BEVERLY HILLS ART SHOW

(310)285-6836. **E-mail:** kmclean@beverlyhills. org; artshow@beverlyhills.org. **Website:** www. beverlyhills.org/artshow. **Contact:** Karen Fitch McLean. Estab. 1973. Fine arts & crafts show held biannually 3rd weekend in May and 3rd weekend in October. Outdoors, 4 blocks in the center of Beverly Hills. Accepts photography, painting, sculpture, ceramics, jewelry, glass, traditional printmaking and digital media. Juried. Awards/prizes: 1st place in category, cash awards, Best in Show cash award; Mayor's Purchase Award in May show. Number of exhibitors: 230-250. Public attendance: 30,000-50,000. Free to public. Deadline for entry: mid-February for the May show; mid-July for the October show. For more information, artists should e-mail, call or visit website or send SASE. Show located at historic Beverly Gardens.

TIPS "Art fairs tend to be commercially oriented. It usually pays off to think in somewhat commercial terms. Personally, I like risky and unusual art, but the artists who produce esoteric art sometimes go hungry! Be nice and have a clean presentation."

🎧 BLACK SWAMP ARTS FESTIVAL

P.O. Box 532, Bowling Green OH 43402. **E-mail:** info@blackswamparts.org. **Website:** www. blackswamparts.org. The Black Swamp Arts Festival (BSAF), held early September, connects art and the community by presenting an annual arts festival

and by promoting the arts in the Bowling Green community. Awards: Best in Show ($1,500); Best 2D ($1,000); Best 3D ($1,000); 2nd place ($750); 3rd place ($500); honorable mentions (3 awards, $200 each). Apply online at www.zapplication.org. Call, e-mail or visit website for more information. Application fee: $35. Single booth fee: $275. Double booth fee: $550. Show located in downtown Bowling Green.

◑ BOCA FEST

270 Central Blvd., Suite 107B, Jupiter FL 33458. (561)746-6615. **Fax:** (561)746-6528. **E-mail:** info@ artfestival.com. **Website:** www.artfestival.com. **Contact:** Malinda Ratliff, communications manager. Estab. 1988. Fine art & craft fair held annually in January. Outdoors. Accepts photography, jewelry, mixed media, sculpture, wood, ceramic, glass, painting, digital, fiber, metal. Juried. Number exhibitors: 210. Number attendees: 80,000. Free to public. Apply online via www.zapplication.org. Deadline: see website. Application fee: $25. Space fee: $395. Exhibition space: 10×10 and 10×20. For more information, artists should e-mail, call, or visit website. Festival located at The Shops at Boca Center in Boca Raton, FL.

TIPS "You have to start somewhere. First, assess where you are, and what you'll need to get things off the ground. Next, make a plan of action. Outdoor street art shows are a great way to begin your career and lifetime as a working artist. You'll meet a lot of other artists who have been where you are now. Network with them!"

◑ BOCA RATON FINE ART SHOW

Hot Works, P.O. Box 1425, Sarasota FL 34230. (248)684-2613. **E-mail:** info@hotworks.org; patty@ hotworks.org. **Website:** www.hotworks.org. **Contact:** Patty Naronzny. Estab. 2008. The annual Boca Raton Fine Art Show brings high-quality juried artists to sell their artworks in the heart of downtown Boca Raton. "The event takes place in a premium location on Federal Highway/US-1 at Palmetto Park Road. In its 3rd year, the Boca Raton Fine Art Show was voted no. 68 in the country by *Art Fair Source Book*." All work is original and personally handmade by the artist. "We offer awards to attract the nation's best artists. Our goal is to create an atmosphere that enhances the artwork and creates a relaxing environment for art lovers." All types of disciplines for sale including sculpture, paintings, clay, glass, printmaking, fiber, wood, jewelry, photography, and more. Art show also

has artist demonstrations, live entertainment, and food. Awards: 2 $500 Juror's Awards, 5 $100 Awards of Excellence. "In addition to the professional artists, as part of our commitment to bring art education into the event, there is a Budding Artists Art Competition, sponsored by the Institute for the Arts & Education, Inc., the 501(c)(3) nonprofit organization behind the event." For more information, see www.hotworks.org.

◑ BONITA SPRINGS NATIONAL ART FESTIVAL

P.O. Box 367465, Bonita Springs FL 34136-7465. (239)992-1213. **Fax:** (239)495-3999. **E-mail:** artfest@ artinusa.com. **Website:** www.artinusa.com/bonita. **Contact:** Barry Witt, director. Fine arts & crafts fair held annually 3 times a year. Outdoors. Accepts handmade crafts, paintings, glass, jewelry, clay works, photography, sculpture, wood, and more. Juried. Awards/ prizes: Best of Show, Best 2D, Best 3D, Distinction Award. Exhibitors: see website. Number of attendees: varies. Free to public. Apply online. Deadline for entry: early January. Application fee: $30. Space fee: $400. Exhibition space: 10×12. For more information, artists should send e-mail, call or visit website.

◑ BOSTON MILLS ARTFEST

(330)467-2242. **Website:** www.bmbw.com. Fine arts & crafts fair held annually in June and July. Outdoors. Accepts handmade crafts, ceramic, digital art, fiber, drawing, furniture, glass, jewelry, metal, 2D/3D mixed media, painting, photography, printmaking, wood. Juried. Awards/prizes: First in Category, Award of Excellence. Exhibitors: see website. Number of attendees: varies. Free to public. Apply online. Deadline for entry: see website. Application fee: see website. Space fee: see website. Exhibition space: see website. For more information, artists should send e-mail, call or visit website.

◑ BRICK STREET MARKET

E-mail: info@zionsvillechamber.org. **Website:** www. zionsvillechamber.org. **Contact:** Diane Schultz. Estab. 1985. Fine art, antique & craft show held annually the Saturday after Mother's Day. Outdoors. In collaboration with area merchants, this annual event is held on Main Street in the Historic Downtown of Zionsville IN. Please submit application found on line at www. zionsvillechamber.org and 3 JPEG images. All mediums are welcome. Artists are encouraged to perform demonstrations of their work and talk with visitors during the event. Tents will be provided. Artists may

use their own white 10×10 ft. tents if space is available. Artists must supply display equipment. Committee will not accept catalog or mass-produced products. Number of exhibitors: 150-180. Public attendance: 8,000-10,000. Free to public. Space fee: see website.

BROWNWOOD PADDOCK SQUARE ART & CRAFT FESTIVAL

270 Central Blvd., Suite 107B, Jupiter FL 33458. (561)746-6615. **Fax:** (561)746-6528. **E-mail:** info@ artfestival.com. **Website:** www.artfestival.com. **Contact:** Malinda Ratliff, communications manager. Estab. 1997. Fine art & craft fair held annually in mid-April. Outdoors. Accepts photography, jewelry, mixed media, sculpture, wood, ceramic, glass, painting, digital, fiber, metal. Juried. Number exhibitors: 205. Number attendees: 20,000. Free to public. Apply online via www.zapplication.org or visit website for paper application. Deadline: see website. Application fee: $15. Space fee: $265. Exhibition space: 10×10 and 10×20. For more information, artists should e-mail, call or visit website. Festival located at Brownwood in The Villages, FL.

TIPS "You have to start somewhere. First, assess where you are, and what you'll need to get things off the ground. Next, make a plan of action. Outdoor street art shows are a great way to begin your career and lifetime as a working artist. You'll meet a lot of other artists who have been where you are now. Network with them!"

BRUCE MUSEUM OUTDOOR ARTS FESTIVAL

1 Museum Dr., Greenwich CT 06830-7157. (203)869-0376, ext. 336. **E-mail:** cynthiae@brucemuseum. org; sue@brucemuseum.org. **Website:** www. brucemuseum.org. **Contact:** Sue Brown Gordon, festival director. Estab. 1981. Fine arts fair held annually in October & fine crafts fair in May. Outdoors. Accepts handmade crafts, painting, sculpture, mixed media, graphics/drawing (including computer-generated works), photography. Juried. Exhibitors: see website. Number of attendees: varies. Free/$8 to public. Apply online. Deadline for entry: June for October; November for May. Application fee: $25. Space fee: $370. Exhibition space: 10×12. For more information, artists should send e-mail, call or visit website.

BUFFALO GROVE INVITATIONAL FINE ART FESTIVAL

Amdur Productions, P.O. Box 550, Highland Park IL 60035. (847)926-4300. **Fax:** (847)926-4330. **E-mail:** info@amdurproductions.com. **Website:** www. amdurproductions.com. Estab. 2002. Fine arts & crafts fair held annually in July. Outdoors. Accepts handmade crafts, ceramic, digital art, fiber, drawing, furniture, glass, jewelry, metal, 2D/3D mixed media, painting, photography, printmaking, wood. Juried. Exhibitors: 120. Number of attendees: 20,000. Free to public. Apply online. Deadline for entry: see website. Application fee: $25. Space fee: $450. Exhibition space: 10×10. For more information, artists should send e-mail, call or visit website.

BUFFALO RIVER ELK FESTIVAL

Jasper AR 72641. (870)446-2455. **E-mail:** chamber@ ritternet.com. **Website:** www.theozarkmountains. com. **Contact:** Patti or Nancy, vendor coordinators. Estab. 1997. Arts & crafts show held annually in June. Outdoors. Accepts fine art & handmade crafts, photography, on-site design. Exhibitors: 60. Number of attendees: 6,000. Free to public. Artists should apply via website. Deadline for entry: June 1. Application fee: none. Space fee: $75. Exhibition space: 10×10. For more information, artists should visit website.

Event located on the Jasper Square.

BY HAND FINE ART & CRAFT FAIR

1 I-X Center Dr., Cleveland OH 44135. (216)265-2663. **E-mail:** rattewell@ixcenter.com. **Website:** www. clevelandbyhand.com. **Contact:** Rob Attewell, show manager. Estab. 2004. Fine arts & crafts show held annually in November. Indoors. Accepts photography, 2D, 3D, clay, digital, fiber, furniture, glass, jewelry, leather, metal, oil/acrylics, printmaking, sculpture, watercolor, wood, wearable art. Juried; group reviews applications and photos. Awards/prizes: ribbons, booths. Number of exhibitors: 150-200. Number of attendees: 20,000. Admission: free. Artists should apply via www.zapplication.org. Deadline: June 15. Application fee: $25. Space fee: $399 (8×10); $425 (10×10). Exhibition space: 10×10, 15×10, 20×10 ft. For more information, artists should e-mail or go to www.zapplication.org.

CAIN PARK ARTS FESTIVAL

City of Cleveland Heights, 40 Severance Circle, Cleveland Heights OH 44118-9988. (216)291-3669.

Fax: (216)291-3705. E-mail: jhoffman@clvhts.com; artsfestival@clvhts.com. Website: www.cainpark.com. Estab. 1976. Fine arts & crafts show held annually 2nd weekend in July (3-day event). Outdoors. Accepts photography, painting, clay, sculpture, wood, jewelry, leather, glass, ceramics, clothes and other fiber, paper, block printing. Juried by a panel of professional artists; submit digital images online or mail CD. Awards/prizes: Artist to Artist Award, $450; also Judges' Selection, Director's Choice and Artists' Award. Number of exhibitors: 150. Public attendance: 15,000. Fee for public: $5; Free on Friday. "Applications are available online at our website www.cainpark.com." Artists should apply by requesting an application by mail, visiting website to download application or by calling. Deadline for entry: early March. Application fee: $40. Space fee: $450. Exhibition space: 10×10 ft. Average gross sales/exhibitor: $4,000. For more information, artists should e-mail, call or visit website. Show located in Cain Park.

TIPS "Have an attractive booth to display your work. Have a variety of prices. Be available to answer questions about your work."

🎧 CALABASAS FINE ARTS FESTIVAL

100 Civic Center Way, Calabasas CA 91302. (818)224-1657. E-mail: artscouncil@cityofcalabasas.com. Website: www.calabasasartscouncil.com. Estab. 1997. Fine arts & crafts show held annually in late April/early May. Outdoors. Accepts photography, painting, sculpture, jewelry, mixed media. Juried. Number of exhibitors: 150. Public attendance: 10,000+. Free to public. Application fee: $25. Artists should apply online through www.zapplication.org; must include 3 photos of work and 1 photo of booth display. For more information, artists should call, e-mail or visit website. Show located at the Commons at Calabasas and the Calabasas Civic Center.

🎧 CAREFREE FINE ART & WINE FESTIVAL

101 Easy St., Carefree AZ 85377. (480)837-5637. Fax: (480)837-2355. E-mail: info@thunderbirdartists.com. Website: www.thunderbirdartists.com. Contact: Denise Colter, president. Estab. 1993. This award-winning, spring Carefree Fine Art & Wine Festival is produced by Thunderbird Artists, in conjunction with the Carefree/Cave Creek Chamber of Commerce and officially named a 'Signature Event' by the Town of Carefree. This nationally acclaimed fine art festival in Carefree is widely known as "..a collector's paradise." Thunderbird Artists' mission is to promote fine art and fine crafts, paralleled with the ambiance of unique wines and fine music, while supporting the artists, merchants and surrounding communities. It is the mission of Thunderbird Artists to further enhance the art culture with the local communities by producing award-winning, sophisticated fine art festivals throughout the Phoenix metro area. Thunderbird Artists has played an important role in uniting nationally recognized and award-winning artists with patrons from across the globe."

TIPS "A clean gallery-type presentation is very important."

🎧 CAROUSEL FINE CRAFT SHOW

OCA Renaissance Arts Center & Theatre, 1200 E. Center St., Kingsport TN 37660. (423)392-8414. E-mail: stephanos@kingsporttn.gov. Website: www.engagekingsport.com. Contact: Will Stephanos, show director. Estab. 2012. Fine art show held annually in March. Indoors. Accepts fine art & handmade crafts, photography, clay, fiber, paintings, furniture, wood, metal, jewelry, glass. Juried. Exhibitors: 38. Number of attendees: 5,000-8,000. Admission: $5 (1 day pass); $7 (2 day pass). Artists should apply online. Deadline for entry: December 1. Application fee: none. Space fee: $250. Exhibition space: 10×10. For more information, artists should e-mail, call or visit website.

🅾 Event held at Kingsport Farmer's Market Facility, 308 Clinchfield St.

TIPS Start with good work, photos, display, and personal connections.

🎧 CEDARHURST ART & CRAFT FAIR

P.O. Box 923, 2600 Richview Rd., Mt. Vernon IL 62864. (618)242-1236, ext. 234. Fax: (618)242-9530. E-mail: linda@cedarhurst.org; sarah@cedarhurst.org. Website: www.cedarhurst.org. Contact: Linda Wheeler, staff coordinator. Estab. 1977. Arts & crafts show held annually on the 1st weekend after Labor Day each September. Outdoors. Accepts photography, paper, glass, metal, clay, wood, leather, jewelry, fiber, baskets, 2D art. Juried. Awards/prizes: Best of most category. Number of exhibitors: 125+. Public attendance: 8,000. Public admission: $5. Artists should apply by filling out online application form. Deadline for entry: March. Application fee: $25. Exhibition space: 10×15 ft. For more information, artists should e-mail, call or visit website.

CENTERFEST: THE ART LOVERS FESTIVAL

Durham Arts Council, 120 Morris St., Durham NC 27701. (919)560-2722. **E-mail:** centerfest@durhamarts.org. **Website:** www.centerfest.durhamarts.org. Estab. 1974. Fine arts & crafts fair held annually in September. Outdoors. Accepts handmade crafts, clay, drawing, fibers, glass, painting, photography, printmaking, wood, jewelry, mixed media, sculpture. Juried. Awards/prizes: Best in Show, 1st place, 2nd place, 3rd place. Exhibitors: 140. Number of attendees: see website. Admission: $5 donation accepted at gate. Apply online. Deadline for entry: May. Application fee: see website. Space fee: $195 (single); $390 (double). Exhibition space: 10×10 (single); 10×20 (double). For more information, artists should send e-mail, call or visit website.

CENTERVILLE–WASHINGTON TOWNSHIP AMERICANA FESTIVAL

P.O. Box 41794, Centerville OH 45441-0794. (937)433-5898. **Fax:** (937)433-5898. **E-mail:** americanafestival@sbcglobal.net. **Website:** www.americanafestival.org. Estab. 1972. Arts, crafts and antiques show held annually on the 4th of July, except when the 4th falls on a Sunday and then festival is held on Monday the 5th. Festival includes entertainment, parade, food, car show and other activities. Accepts arts, crafts, antiques, photography and all mediums. "No factory-made items accepted." Awards/prizes: 1st, 2nd, 3rd places; certificates and ribbons for most attractive displays. Number of exhibitors: 275-300. Public attendance: 75,000. Free to the public. Exhibitors should send SASE for application form, or apply online. Deadline for entry: early June (see website for details). Space fee: $40-55 site specific. Exhibition space: 12×10 ft. For more information, artists should e-mail, call or visit website. Arts & crafts booths located on N. Main St., in Benham's Grove and limited spots in the Children's Activity area.

TIPS "Moderately priced products sell best. Bring business cards and have an eye-catching display."

CHAMBER SOUTH'S ANNUAL SOUTH MIAMI ART FESTIVAL

Sunset Dr. (SW 72nd St.) from US 1 to Red Rd. (SW 57th Ave.), South Miami FL 33143. (305)661-1621. **Fax:** (305)666-0508. **E-mail:** art@chambersouth.com. **Website:** www.chambersouth.com/events/south-miami-art-festival. **Contact:** Robin Stieglitz, art festival coordinator. Estab. 1971. Annual. Fine art & craft show held the 1st weekend in November. Outdoors. Accepts 2D & 3D mixed media, ceramics, clay, digital art, glass, jewelry, metalwork, painting (oil, acrylic, watercolor), printmaking, drawing, sculpture, textiles, wood. Juried by panel of jurors who meet to review work; includes artists and board members. Cash prizes, ribbons to display during event, exemption from jury in the following year's show. Average number of exhibitors: 130. Average number of attendees: 50,000. Admission: free. Artists should apply by www.zapplication.org. Deadline: July 31. Application fee: $25. Space fee: standard, $325; corner $375. Space is 10×10 (10×20 also available). For more information artists should e-mail, call or visit the website.

TIPS "Good, clean displays; interact with customers without hounding."

CHARDON SQUARE ARTS FESTIVAL

Chardon Square Association, P.O. Box 1063, Chardon OH 44024. (440)285-4548. **E-mail:** sgipson@aol.com. **Website:** www.chardonsquareassociation.org. **Contact:** Mariann Goodwin and Jan Gipson. Estab. 1980. Fine arts & crafts show held annually in early August (see website for details). Outdoors. Accepts photography, pottery, weaving, wood, paintings, jewelry. Juried. Number of exhibitors: 110. Public attendance: 4,000. Free to public. Artists can find application on website. Exhibition space: 12×12 ft. For more information, artists should call or visit website.

TIPS "Make your booth attractive; be friendly and offer quality work."

CHARLEVOIX WATERFRONT ART FAIR

P.O. Box 57, Charlevoix MI 49720. (231)547-2675. **E-mail:** cwaf14@gmail.com. **Website:** www.charlevoixwaterfrontartfair.org. "The Annual Charlevoix Waterfront Art Fair is a juried and invitational show and sale. Categories are: ceramics, glass, fiber; drawing; wood; painting; mixed media 2D and 3D; jewelry, fine and other; printmaking; photography; sculpture. To apply, each entrant must submit 4 digital images (3 images of your art work and 1 booth image) sized 1920 x 1920 pixels at 72 dpi for consideration by the jury (ZAPP images are acceptable). A non-refundable processing fee of $25, plus $15 for each additional category entered, must accompany the artist's application."

CHASTAIN PARK FESTIVAL

4469 Stella Dr., Atlanta GA 30327. (404)873-1222. **E-mail:** info@affps.com. **Website:** www.chastainparkartsfestival.com. **Contact:** Randall Fox. Estab. 2008. Arts & crafts show held annually early November. Outdoors. Accepts handmade crafts, painting, photography, sculpture, leather, metal, glass, jewelry. Juried by a panel. Awards/prizes: ribbons. Number of exhibitors: 175. Number of attendees: 45,000. Free to public. Apply online at www.zapplication.org. Deadline for entry: August 26. Application fee: $25. Space fee: $300. Exhibition space: 10×10. For more information, send e-mail or see website.

CHATSWORTH CRANBERRY FESTIVAL

P.O. Box 286, Chatsworth NJ 08019. (609)726-9237. **Fax:** (609)726-1459. **E-mail:** lgiamalis@aol.com. **Website:** www.cranfest.org. **Contact:** Lynn Giamalis. Estab. 1983. Arts & crafts show held annually in mid-October (see website for details). Outdoors. The festival is a celebration of New Jersey's cranberry harvest, the 3rd largest in the country, and offers a tribute to the Pine Barrens and local culture. Accepts photography. Juried. Number of exhibitors: 200. Public attendance: 75,000-100,000. Free to public. Artists should apply by sending SASE to above address (application form online). Requires 3 pictures of products and 1 of display. Deadline: September 1. Space fee: $225 for 2 days. Exhibition space: 15×15 ft. For more information, artists should visit website. Show located in downtown Chatsworth.

CHUN CAPITOL HILL PEOPLE'S FAIR

1290 Williams St., Suite 102, Denver CO 80218. (303)830-1651. **Fax:** (303)830-1782. **E-mail:** andreafurness@chundenver.org. **Website:** www.peoplesfair.com; www.chundenver.org. **Contact:** Andrea Furness, assistant director. Estab. 1972. Arts & music festival held annually 1st full weekend in June. Outdoors. Accepts photography, ceramics, jewelry, paintings, wearable art, glass, sculpture, wood, paper, fiber, children's items, and more. Juried by professional artisans representing a variety of mediums and selected members of fair management. The jury process is based on originality, quality and expression. Awards/prizes: Best of Show. Number of exhibitors: 300. Public attendance: 200,000. Free to public. Artists should apply by downloading application from website. Deadline for entry: March.

Application fee: $35. Space fee: $350-400, depending on type of art. Exhibition space: 10×10 ft. For more information, artists should e-mail, visit website or call. Festival located at Civic Center Park.

CHURCH STREET ART & CRAFT SHOW

Downtown Waynesville Association, P.O. Box 1409, Waynesville NC 28786. (828)456-3517. **E-mail:** info@downtownwaynesville.com. **Website:** www.downtownwaynesville.com. Estab. 1983. Fine arts & crafts show held annually 2nd Saturday in October. Outdoors. Accepts photography, paintings, fiber, pottery, wood, jewelry. Juried by committee: submit 4 slides or digital photos of work and 1 of booth display. Number of exhibitors: 110. Public attendance: 15,000-18,000. Free to public. Entry fee: $25. Space fee: $110 ($200 for 2 booths). Exhibition space: 10×12 ft. (option of 2 booths for 12×20 space). For more information and application, see website. Deadline: mid-August. Show located in downtown Waynesville NC on Main St.

TIPS Recommends "quality in work and display."

CITY OF FAIRFAX FALL FESTIVAL

10455 Armstrong St., Fairfax VA 22030. (703)385-7800. **Fax:** (703)246-6321. **E-mail:** leslie.herman@fairfaxva.gov; mitzi.taylor@fairfaxva.gov. **Website:** www.fairfaxva.gov. **Contact:** Mitzi Taylor, special event coordinator. Estab. 1985. Arts & crafts festival held annually the 2nd weekend in October. Outdoors. Accepts photography, jewelry, glass, pottery, clay, wood, mixed media. Juried by a panel of 5 independent jurors. Number of exhibitors: 400. Public attendance: 25,000. Free to the public. Deadline for entry: mid-March. Artists should apply by contacting Mitzi Taylor for an application. Application fee: $12. Space fee: $160 10×10 ft. For more information, artists should e-mail. Festival located in historic downtown Fairfax.

CITY OF FAIRFAX HOLIDAY CRAFT SHOW

10455 Armstrong St., Fairfax VA 22030. (703)385-1710. **Fax:** (703)246-6321. **E-mail:** katherine.maccammon@fairfaxva.gov. **Website:** www.fairfaxva.gov. **Contact:** Katherine MacCammon. Estab. 1985. Arts & crafts show held annually 3rd weekend in November. Indoors. Accepts photography, jewelry, glass, pottery, clay, wood, mixed media. Juried by a panel of 5 independent jurors. Number of exhibitors:

247. Public attendance: 5,000. Public admission: $5 for age 18 and older. $8 for 2 day pass. Artists should apply by contacting Katie MacCammon for an application. Deadline for entry: early March (see website for details). Application fee: $15. Space fee: 10×6 ft. $195; 11×9 ft. $245; 10×10 ft. $270. For more information, artists should e-mail.

✪ CITYPLACE ART FAIR

270 Central Blvd., Suite 107B, Jupiter FL 33458. (561)746-6615. **Fax:** (561)746-6528. **E-mail:** info@artfestival.com. **Website:** www.artfestival.com. **Contact:** Malinda Ratliff, communications manager. Fine art & craft fair held annually in early March. Outdoors. Accepts photography, jewelry, mixed media, sculpture, wood, ceramic, glass, painting, digital, fiber, metal. Juried. Number exhibitors: 200. Number attendees: 40,000. Free to public. Apply online via www.zapplication.org. Deadline: see website. Application fee: $25. Space fee: $395. Exhibition space: 10×10 and 10×20. For more information, artists should e-mail, call, or visit website. Fair located in CityPlace in downtown West Palm Beach, FL.

TIPS "You have to start somewhere. First, assess where you are, and what you'll need to get things off the ground. Next, make a plan of action. Outdoor street art shows are a great way to begin your career and lifetime as a working artist. You'll meet a lot of other artists who have been where you are now. Network with them!"

✪ COCONUT GROVE ARTS FESTIVAL

3390 Mary St., Suite 128, Coconut Grove FL 33133. (305)447-0401. **E-mail:** katrina@cgaf.com. **Website:** www.coconutgroveartsfest.com. **Contact:** Katrina Delgado. The Coconut Grove Arts Festival showcases the works of 360 internationally recognized artists who are selected from nearly 1,300 applicants. Jurors evaluate the artist's work and displays to select participants in such categories as mixed media, painting, photography, digital art, printmaking & drawing, watercolor, clay work, glass, fiber, jewelry & metalwork, sculpture, and wood.

✪ COCONUT POINT ART FESTIVAL

270 Central Blvd., Suite 107B, Jupiter FL 33458. (561)746-6615. **Fax:** (561)746-6528. **E-mail:** info@artfestival.com. **Website:** www.artfestival.com. **Contact:** Malinda Ratliff, communications manager. Es-

tab. 2007. Fine art & craft fair held annually in late December/early January & February. Outdoors. Accepts photography, jewelry, mixed media, sculpture, wood, ceramic, glass, painting, digital, fiber, metal. Juried. Number exhibitors: 200-280. Number attendees: 90,000. Free to public. Apply online via www.zapplication.org. Deadline: see website. Application fee: $25. Space fee: $395-425. Exhibition space: 10×10 and 10×20. For more information, artists should e-mail, call, or visit website. Festival held at Coconut Point in Estero, FL.

TIPS "You have to start somewhere. First, assess where you are, and what you'll need to get things off the ground. Next, make a plan of action. Outdoor street art shows are a great way to begin your career and lifetime as a working artist. You'll meet a lot of other artists who have been where you are now. Network with them!"

✪ COLORADO COUNTRY CHRISTMAS GIFT SHOW

Denver Mart, 451 E. 58th Ave., Denver CO 80216. (800)521-7469. **Fax:** (425)889-8165. **E-mail:** denver@showcase.events.org. **Website:** www.showcaseevents.org. **Contact:** Kim Peck, show manager. Estab. 2003. Annual holiday show held early November. Indoors. Accepts handmade crafts, art, photography, pottery, glass, jewelry, fiber, clothing. Juried. Exhibitors: 400. Number of attendees: 25,000. Admission: see website. Apply by e-mail, call or website. Deadline for entry: see website. Space fee: see website. Exhibition space: 10×10. For more information e-mail, call, send SASE, or see website.

✪ COLORSCAPE CHENANGO ARTS FESTIVAL

P.O. Box 624, Norwich NY 13815. (607)336-3378. **E-mail:** info@colorscape.org; art@colorscape.org. **Website:** www.colorscape.org. **Contact:** Peggy Finnegan, visual arts coordinator. Estab. 1995. A juried exhibition of art & fine crafts held annually the weekend after Labor Day. Outdoors. Accepts photography and all types of media. Juried. Awards/prizes: $6,000. Number of exhibitors: 120. Public attendance: 10,000-12,000. Free to public. Deadline for entry: see website for details. Application fee: $15 jury fee. Space fee: $175. Exhibition space: 12×12 ft. For more information, artists should e-mail, call, visit website or send SASE. Show located in downtown Norwich.

ART FAIRS

TIPS "Interact with your audience. Talk to them about your work and how it is created. People like to be involved in the art they buy and are more likely to buy if you involve them."

COLUMBIANA ARTIST MARKET

104 Mildred St., P.O. Box 624, Columbiana AL 35051. (205)669-0044. **E-mail:** info@shelbycountyartscouncil.com. **Website:** www.shelbycountyartscouncil.com. Member artists gather to offer their original artwork. Work available includes oil paintings, acrylic paintings, photography, jewelry, fabric arts, printmaking, pottery, and more.

CONYERS CHERRY BLOSSOM FESTIVAL

1996 Centennial Olympic Pkwy., Conyers GA 30013. (770)860-4190 or (770)860-4194. **E-mail:** rebecca.hill@conyersga.com. **Website:** www.conyerscherryblossomfest.com. **Contact:** Jill Miller. Estab. 1981. Arts & crafts show held annually in late March (see website for details). Outdoors. The festival is held at the Georgia International Horse Park at the Grand Prix Plaza overlooking the Grand Prix Stadium used during the 1996 Centennial Olympic Games. Accepts photography, paintings and any other handmade or original art. Juried. Submit 5 images: 1 picture must represent your work as it is displayed; 1 must represent a workshop photo of the artist creating their work; the other 3 need to represent your items as an accurate representation in size, style, and quality of work. Number of exhibitors: 300. Public attendance: 40,000. Free to public. Space fee: $135. Exhibition space: 10×10 ft. Electricity fee: $30. Application fee: $10; apply online. For more information, artists should e-mail, call or visit website. Show located at the Georgia International Horse Park.

CORAL SPRINGS FESTIVAL OF THE ARTS

270 Central Blvd., Suite 107B, Jupiter FL 33458. (561)746-6615. **Fax:** (561)746-6528. **E-mail:** info@artfestival.com. **Website:** www.artfestival.com. **Contact:** Malinda Ratliff, communications manager. "The Coral Springs Festival of the Arts has grown considerably over the years into a 2-day celebration of arts and culture with a fine art show, contemporary craft festival, theatrical performances, and full lineup of live music. Held in conjunction with the Coral Springs Art Festival Committee and the City, this event brings 250 of the nation's best artists

and crafters to south Florida. Stroll amidst life-size sculptures, spectacular paintings, one-of-a-kind jewels, photography, ceramics, a separate craft festival, Green Market, and much more. No matter what you're looking for, you'll be sure to find it among the array of various artists and crafters participating in this arts and crafts fair."

TIPS "You have to start somewhere. First, assess where you are, and what you'll need to get things off the ground. Next, make a plan of action. Outdoor street art shows are a great way to begin your career and lifetime as a working artist. You'll meet a lot of other artists who have been where you are now. Network with them!"

COTTONWOOD ART FESTIVAL

2100 E. Campbell Rd. Suite 100, Richardson TX 75081. (972)744-4582. **E-mail:** serri.ayers@cor.gov. **Website:** www.cottonwoodartfestival.com. **Contact:** Serri Ayers. The semiannual Cottonwood Art Festival is a juried show. Jurors have selected over 240 artists from 800 submissions to exhibit their museum-quality work at the festival. The artists compete in 14 categories: 2D mixed media, 3D mixed media, ceramics, digital, drawings/pastels, fiber, glass, jewelry, leather, metalwork, painting, photography, sculpture, and wood. Rated as 1 of the top art festivals in the United States, the prestigious show is the premier fine art event in north Texas.

COUNTRY FOLK ARTS AND CRAFTS SHOW

(248)634-4151, ext. 631. **E-mail:** shows@countryfolkart.com; Karen1@countryfolkart.com. **Website:** www.countryfolkart.com. **Contact:** Karen Kiley. Country Folk Art Shows has grown to 17 shows in 5 states. Every participant is juried and hand selected for their outstanding workmanship and integrity of creative design. Some of the more popular decorating items found at our shows are handcrafted furniture, home and garden decor, jewelry, textiles, holiday decor, wearable art, handmade candles and soaps, quilts, paintings, framed art, florals, iron work, wood carvings, baskets, stained glass, and much more.

CRAFT FAIR AT THE BAY

38 Charles St., Rochester NH 03867. (603)332-2616. **Fax:** (603)332-8413. **E-mail:** info@castleberryfairs.com. **Website:** www.castleberryfairs.com. Estab. 1988. Arts & crafts show held annually in July in Alton Bay NH. Outdoors. Accepts photography and all other

mediums. Juried by photo, slide or sample. Number of exhibitors: 85. Public attendance: 7,500. Free to the public. Artists should apply by downloading application from website. Deadline for entry: until full. Exhibition space: 100 sq. ft. For more information, artists should visit, call, e-mail or visit website.

TIPS "Do not bring a book; do not bring a chair. Smile and make eye contact with everyone who enters your booth. Have them sign your guest book; get their e-mail address so you can let them know when you are in the area again. And, finally, make the sale—they are at the fair to shop, after all."

CRAFTS AT PURCHASE

P.O. Box 28, Woodstock NY 12498. (845)331-7900. **Fax:** (845)331-7484. **E-mail:** crafts@artrider.com. **Website:** www.artrider.com. **Contact:** Laura Kandel, assistant director. Estab. 2012. Boutique show of fine contemporary craft held annually in late October or early November. Indoors. Accepts photography, fine art, ceramics, wood, mixed media, leather, glass, metal, fiber, jewelry. Juried. Submit 5 images of work and 1 of booth. Exhibitors: 100. Attendance: 3,500. Admission: $10. Artists should apply online at www.artrider.com or www.zapplication.org. Deadline for entry: end of May. Application fee: $45. Space fee: $545. Exhibition space: 10×10. For more information, artists should e-mail, call or visit website.

CRAFTWESTPORT

P.O. Box 28, Woodstock NY 12498. (845)331-7484. **Fax:** (845)331-7484. **E-mail:** crafts@artrider.com. **Website:** www.artrider.com. Estab. 1975. Fine arts & craft show held annually in the 3rd weekend before Thanksgiving. Indoors. Accepts photography, wearable and nonwearable fiber, jewelry, clay, leather, wood, glass, painting, drawing, prints, mixed media. Juried by 5 images of work and 1 of booth, viewed sequentially. Number of exhibitors: 160. Public attendance: 5,000. Public admission: $10. Artists should apply online at www.artrider.com or at www.zapplication.org. Deadline for entry: end of May. Application fee: $45. Space fee: $525. Exhibition space: 10×10 ft. For more information, artists should e-mail, call or visit website.

CROCKER PARK FINE ART FAIR WITH CRAFT MARKETPLACE

270 Central Blvd., Suite 107B, Jupiter FL 33458. (561)746-6615. **Fax:** (561)746-6528. **E-mail:** info@artfestival.com. **Website:** www.artfestival.com. **Contact:** Malinda Ratliff, communications manager. Estab. 2006. Fine art & craft fair held annually in mid-June. Outdoors. Accepts photography, jewelry, mixed media, sculpture, wood, ceramic, glass, painting, digital, fiber, metal. Juried. Number exhibitors: 125. Number attendees: 50,000. Free to public. Apply online via www.zapplication.org. Deadline: see website. Application fee: $25. Space fee: $395. Exhibition space: 10×10 and 10×20. For more information, artists should e-mail, call or visit website. Fair located in Crocker Park in Westlake/Cleveland, OH.

TIPS "You have to start somewhere. First, assess where you are, and what you'll need to get things off the ground. Next, make a plan of action. Outdoor street art shows are a great way to begin your career and lifetime as a working artist. You'll meet a lot of other artists who have been where you are now. Network with them!"

CUSTER FAIR

Piccolo Theatre, Inc., P.O. Box 6013, Evanston IL 60204. (847)328-2204. **E-mail:** office@custerfair.com. **Website:** www.custerfair.com. **Contact:** Amanda Kulczewski. Estab. 1972. Outdoor fine art craft show held in June. Accepts photography and all mediums. Number of exhibitors: 400. Public attendance: 60,000. Free to the public. Application fee: $10. Booth fee: $250-400. Deadline for entry: June 13, 2016. Space fee varies, e-mail, call or visit website for more details.

TIPS "Turn your hobbies into profits! Be prepared to speak with patrons; invite them to look at your work and broaden your patron base!"

A DAY IN TOWNE

Boalsburg Village Conservancy, 230 W. Main St., Boalsburg PA 16827. (814) 466 7813. **E-mail:** mgjohn@comcast.net; fisherjeff13@gmail.com. **Website:** www.boalsburgvillage.com. fisherjeff13@gmail.com. **Contact:** John Wainright; Jeff Fisher. Estab. 1976. Arts & crafts show held annually on Memorial Day, the last Monday in May. Outdoors. Accepts photography, clothes, wood, wool knit, soap, jewelry, dried flowers, children's toys, pottery, blown glass, other crafts. Vendors must make their own work. Number of exhibitors: 125-135. Public attendance: 20,000+. Artists should apply by sending an e-mail message to the above e-mail address. Deadline for application is Feb. 1 each year. Space fee: $75. Exhibition space: 10×15 ft.

TIPS "Please do not send fees until you receive an official contract. Have a neat booth and nice smile. Have fair prices—if too high, product will not sell here."

🎧 DEERFIELD FINE ARTS FESTIVAL

3417 R.F.D., Long Grove IL 60047. (847)726-8669. **E-mail:** dwevents@comcast.net. **Website:** www.dwevents.org. **Contact:** D&W Events, Inc. Estab. 2003. Fine art show held annually end of May/beginning of June. Outdoors. Accepts photography, fiber, oil, acrylic, watercolor, mixed media, jewelry, sculpture, metal, paper, ceramics, painting. Juried by 3 jurors. Awards/prizes: Best of Show; 1st place, awards of excellence. Number of exhibitors: 120-150. Public attendance: 20,000. Free to public. Free parking. Artists should apply via www.zapplication.com or our promoter website: www.dwevents.org. Exhibition space: 100 sq. ft. For more information artists should e-mail, call or visit website. Show located at Park Avenue and Deerfield Road adjacent to Jewett Park in Deerfield IL.

TIPS "Artists should display professionally and attractively, and interact positively with everyone."

🎧 DELAWARE ARTS FESTIVAL

P.O. Box 589, Delaware OH 43015. **E-mail:** info@delawareartsfestival.org. **Website:** www.delawareartsfestival.org. Estab. 1973. Fine arts & crafts show held annually the Saturday and Sunday after Mother's Day. Outdoors. Accepts photography; all mediums, but no buy/sell. Juried by category panels who are also artists. Awards/prizes: Ribbons, cash awards, free booth for Best of Show the following year. Number of exhibitors: 160. Public attendance: 50,000. Free to the public. Submit 3 photographs per category that best represent your work. Your work will be juried in accordance with our guidelines. Photos (no slides) will be returned only if you provide a SASE. Artists should apply by visiting website for application. Jury fee: $10 per category, payable to the Delaware Arts Festival. Space fee: $140. Exhibition space: 120 sq. ft. For more information, artists should e-mail or visit website. Show located in historic downtown Delaware OH, just 2 blocks from the heart of Ohio Wesleyan University Campus.

TIPS "Have high-quality, original stuff. Engage the public. Applications will be screened according to originality, technique, craftsmanship and design. Unaffiliated professional judges are hired to make all prize award decisions. The Delaware Arts Festival, Inc.

will exercise the right to reject items during the show that are not the quality of the media submitted with the applications. No commercial buy and resell merchandise permitted. Set up a good booth."

🎧 DELRAY MARKETPLACE ART & CRAFT FESTIVAL

270 Central Blvd., Suite 107B, Jupiter FL 33458. (561)746-6615. **Fax:** (561)746-6528. **E-mail:** info@artfestival.com. **Website:** www.artfestival.com. **Contact:** Malinda Ratliff, communications manager. Estab. 2013. Fine art & craft fair held annually in November. Outdoors. Accepts photography, jewelry, mixed media, sculpture, wood, ceramic, glass, painting, digital, fiber, metal. Juried. Number exhibitors: 100. Number attendees: 40,000. Free to public. Apply online via www.zapplication.org. Deadline: see website. Application fee: $25. Space fee: $350. Exhibition space: 10×10 and 10×20. For more information, artists should e-mail, call, or visit website. Festival located at Delray Marketplace off West Atlantic Ave. in Delray Beach, FL.

TIPS "You have to start somewhere. First, assess where you are, and what you'll need to get things off the ground. Next, make a plan of action. Outdoor street art shows are a great way to begin your career and lifetime as a working artist. You'll meet a lot of other artists who have been where you are now. Network with them!"

DICKENS CHRISTMAS SHOW & FESTIVAL

2101 N. Oak St., Myrtle Beach SC 29577. (843)448-9483. **Fax:** (843)626-1513. **E-mail:** dickensshow@sc.rr.com. **Website:** www.dickenschristmasshow.com. **Contact:** Samantha Bower, manager. Estab. 1981. Annual arts & crafts, seasonal/holiday show held in November. Indoors. Accepts all fine art. Average number of exhibitors: 350. Average number of attendees: 16,000. Admission: $8.50 (plus tax). Artists should apply by application. Deadline: see website. Space fee: $300-800. Space is 10×10. For more information artists should e-mail, call or visit the website. Show held at Myrtle Beach Convention Center.

TIPS "Make sure your products are good and your display is good."

🎧 DOLLAR BANK THREE RIVERS ARTS FESTIVAL

803 Liberty Ave., Pittsburgh PA 15222. (412)471-6070. **E-mail:** trafmarket@trustarts.org. **Website:** www.trustarts.org/traf. **Contact:** Melissa Franko,

artist market manager. Estab. 1960. Fine art show held annually in June. Outdoors. Accepts fine art & handmade crafts, photography, clay, ceramics, fiber, paintings, furniture, wood, metal, leather, mixed media, jewelry, glass, sculpture, drawing, digital art, printmaking. Juried. Awards/prizes: $10,000 in awards/prizes given away. Exhibitors: 360. Number of attendees: 600,000. Free to public. Artists should apply via www.zapplication.org. Deadline for entry: February 1. Application fee: $35. Space fee: $360-485. Exhibition space: 10×10. For more information, artists should visit website.

○ Event located at Gateway Center, Pittsburgh PA

TIPS "The only way to participate is to apply!"

⊙ ALDEN B. DOW MUSEUM SUMMER ART FAIR

Alden B. Dow Museum of Science & Art, Midland Center for the Arts, 1801 W. St. Andrews Rd., Midland MI 48640. **Fax:** (989)631-7890. **E-mail:** mills@ mcfta.org. **Website:** www.mcfta.org. **Contact:** Emmy Mills, executive assistant/special events manager. Estab. 1966. Fine art & crafts show held annually in early June. Outdoors. Accepts photography, ceramics, fibers, jewelry, mixed media 3D, painting, wood, drawing, glass, leather, sculpture, basket, furniture. Juried by a panel. Awards: $1,000 1st place, $750 2nd place, $500 3rd place. Average number of exhibitors: 150. Public attendance: 5,000-8,000. Free to public. Artists should apply at www.mcfta.org/specialevents. html. Deadline for entry: late March; see website for details. Application fee: jury $35, second medium $5/each. Space fee: $195/single booth, $365/double booth. Exhibition space: approximately 12×12 ft. Average gross sales/exhibitor: $1,500. Artists should e-mail or visit website for more information. Event takes place at Midland Center for the Arts.

⊙ DOWNTOWN ASPEN ART FESTIVAL

270 Central Blvd., Suite 107B, Jupiter FL 33458. (561)746-6615. **Fax:** (561)746-6528. **E-mail:** info@ artfestival.com. **Website:** www.artfestival.com. **Contact:** Malinda Ratliff, communications manager. Estab. 2003. Fine art & craft fair held annually in July. Outdoors. Accepts photography, jewelry, mixed media, sculpture, wood, ceramic, glass, painting, digital, fiber, metal. Juried. Number exhibitors: 150. Number attendees: 80,000. Free to public. Apply online via www.wzapplication.org. Deadline: see website. Application fee: $35. Space fee: $475. Exhibition space: 10×10 and 10×20. For more information, artists should e-mail, call, or visit website. Festival located at Monarch Street in Aspen, CO.

TIPS "You have to start somewhere. First, assess where you are, and what you'll need to get things off the ground. Next, make a plan of action. Outdoor street art shows are a great way to begin your career and lifetime as a working artist. You'll meet a lot of other artists who have been where you are now. Network with them!"

⊙ DOWNTOWN DELRAY BEACH FESTIVAL OF THE ARTS

270 Central Blvd., Suite 107B, Jupiter FL 33458. (561)746-6615. **Fax:** (561)746-6528. **E-mail:** info@ artfestival.com. **Website:** www.artfestival.com. **Contact:** Malinda Ratliff, communications manager. Estab. 2000. Fine art & craft fair held annually in mid-January. Outdoors. Accepts photography, jewelry, mixed media, sculpture, wood, ceramic, glass, painting, digital, fiber, metal. Juried. Number exhibitors: 305. Number attendees: 100,000. Free to public. Apply online via www.zapplication.org. Deadline: see website. Application fee: $25. Space fee: $395. Exhibition space: 10×10 and 10×20. For more information, artists should e-mail, call, or visit website. Festival located at Atlantic Ave. in downtown Delray Beach, FL.

TIPS "You have to start somewhere. First, assess where you are, and what you'll need to get things off the ground. Next, make a plan of action. Outdoor street art shows are a great way to begin your career and lifetime as a working artist. You'll meet a lot of other artists who have been where you are now. Network with them!"

⊙ DOWNTOWN DELRAY BEACH THANKSGIVING WEEKEND ART FESTIVAL

270 Central Blvd., Suite 107B, Jupiter FL 33458. (561)746-6615. **Fax:** (561)746-6528. **E-mail:** info@ artfestival.com. **Website:** www.artfestival.com. **Contact:** Malinda Ratliff, communications manager. Estab. 2000. Fine art & craft fair held annually in November. Outdoors. Accepts photography, jewelry, mixed media, sculpture, wood, ceramic, glass, painting, digital, fiber, metal. Juried. Number exhibitors: 150. Number attendees: 80,000. Free to public. Apply online via www.zapplication.org. Deadline: see website. Application fee: $25. Space fee: $395. Exhibition space: 10×10 and 10×20. For more information, artists should e-mail, call or visit website. Festival lo-

cated at 4th Ave. & Atlantic Ave. in downtown Delray Beach FL.

TIPS "You have to start somewhere. First, assess where you are, and what you'll need to get things off the ground. Next, make a plan of action. Outdoor street art shows are a great way to begin your career and lifetime as a working artist. You'll meet a lot of other artists who have been where you are now. Network with them!"

DOWNTOWN DUNEDIN ART FESTIVAL

270 Central Blvd., Suite 107B, Jupiter FL 33458. (561)746-6615. **Fax:** (561)746-6528. **E-mail:** info@ artfestival.com. **Website:** www.artfestival.com. **Contact:** Malinda Ratliff, communications manager. Estab. 1997. Fine art & craft fair held annually in January. Outdoors. Accepts photography, jewelry, mixed media, sculpture, wood, ceramic, glass, painting, digital, fiber, metal. Juried. Number exhibitors: 130. Number attendees: 40,000. Free to public. Apply online via www.zapplication.org. Deadline: see website. Application fee: $25. Space fee: $395. Exhibition space: 10×10 and 10×20. For more information, artists should e-mail, call, or visit website. Festival located at Main St. in downtown Dunedin, FL.

TIPS "You have to start somewhere. First, assess where you are, and what you'll need to get things off the ground. Next, make a plan of action. Outdoor street art shows are a great way to begin your career and lifetime as a working artist. You'll meet a lot of other artists who have been where you are now. Network with them!"

DOWNTOWN FESTIVAL & ART SHOW

City of Gainesville, P.O. Box 490, Gainesville FL 32627. (352)393-8536. **Fax:** (352)334-2249. **E-mail:** piperlr@cityofgainesville.org. **Website:** www. gainesvilledowntownartfest.org. **Contact:** Linda Piper, events coordinator. Estab. 1981. Fine arts & crafts show held annually in November (see website for more details). Outdoors. Accepts photography, wood, ceramic, fiber, glass, and all mediums. Juried by 3 digital images of artwork and 1 digital image of booth. Awards/prizes: $20,000 in cash awards; $2,000 in purchase awards. Number of exhibitors: 240. Public attendance: 100,000. Free to the public. Artists should apply by mailing 4 digital images. Deadline for entry: May. Space fee: $285, competitive, $260 noncompetitive. Exhibition space: 12×12 ft. Average gross sales/exhibitor: $6,000. For more information, artists

should e-mail, visit website, call. *The 35th Annual Downtown Festival & Art Show will be held Nov. 4 & 5, 2016 in historic downtown Gainesville.*

TIPS "Submit the highest quality digital images. A proper booth image is very important."

DOWNTOWN SARASOTA CRAFT FAIR

270 Central Blvd., Suite 107B, Jupiter FL 33458. (561)746-6615. **Fax:** (561)746-6528. **E-mail:** info@ artfestival.com. **Website:** www.artfestival.com. **Contact:** Malinda Ratliff, communications manager. "This popular annual craft festival has garnered crowds of fine craft lovers each year. Behold contemporary crafts from more than 100 of the nation's most talented artisans. A variety of jewelry, pottery, ceramics, photography, painting, clothing, and much more—all handmade in America—will be on display, ranging from $15 to $3,000. An expansive Green Market with plants, orchids, exotic flora, handmade soaps, gourmet spices, and freshly popped kettle corn further complements the weekend, blending nature with nurture."

TIPS "You have to start somewhere. First, assess where you are, and what you'll need to get things off the ground. Next, make a plan of action. Outdoor street art shows are a great way to begin your career and lifetime as a working artist. You'll meet a lot of other artists who have been where you are now. Network with them!"

DOWNTOWN SARASOTA FESTIVAL OF THE ARTS

270 Central Blvd., Suite 107B, Jupiter FL 33458. (561)746-6615. **Fax:** (561)746-6528. **E-mail:** info@ artfestival.com. **Website:** www.artfestival.com. **Contact:** Malinda Ratliff, communications manager. Fine art & craft fair held annually in mid-February. Outdoors. Accepts photography, jewelry, mixed media, sculpture, wood, ceramic, glass, painting, digital, fiber, metal. Juried. Number exhibitors: 305. Number attendees: 80,000. Free to public. Apply online via zapplication.org. Deadline: see website. Application fee: $25. Space fee: $395. Exhibition space: 10×10 and 10×20. For more information, artists should e-mail, call, or visit website. Festival located at Main St. at Orange Ave. heading east and ending at Links Ave. in downtown Sarasota, FL.

TIPS "You have to start somewhere. First, assess where you are, and what you'll need to get things off the ground. Next, make a plan of action. Outdoor street art shows are a great way to begin your career

and lifetime as a working artist. You'll meet a lot of other artists who have been where you are now. Network with them!"

☺ DOWNTOWN STEAMBOAT SPRINGS ART FESTIVAL ON YAMPA STREET, THE YAMPA ART STROLL

270 Central Blvd., Suite 107B, Jupiter FL 33458. (561)746-6615. **Fax:** (561)746-6528. **E-mail:** info@artfestival.com. **Website:** www.artfestival.com. **Contact:** Malinda Ratliff, communications manager. Estab. 2015. Fine art & craft fair held annually in August. Outdoors. Accepts photography, jewelry, mixed media, sculpture, wood, ceramic, glass, painting, digital, fiber, metal. Juried. Number exhibitors: see website. Number attendees: see website. Free to public. Apply online via www.zapplication.org. Deadline: see website. Application fee: $35. Space fee: $350. Exhibition space: 10×10 and 10×20. For more information, artists should e-mail, call or visit website. Festival located at Yampa Ave. in Steamboat Springs, CO.

TIPS "You have to start somewhere. First, assess where you are, and what you'll need to get things off the ground. Next, make a plan of action. Outdoor street art shows are a great way to begin your career and lifetime as a working artist. You'll meet a lot of other artists who have been where you are now. Network with them!"

☺ DOWNTOWN STUART ART FESTIVAL

270 Central Blvd., Suite 107B, Jupiter FL 33458. (561)746-6615. **Fax:** (561)746-6528. **E-mail:** info@artfestival.com. **Website:** www.artfestival.com. **Contact:** Malinda Ratliff, communications manager. Estab. 1991. Fine art & craft fair held annually in February. Outdoors. Accepts photography, jewelry, mixed media, sculpture, wood, ceramic, glass, painting, digital, fiber, metal. Juried. Number exhibitors: 200. Number attendees: 50,000. Free to public. Apply online via www.zapplication.org. Deadline: see website. Application fee: $25. Space fee: $395. Exhibition space: 10×10 and 10×20. For more information, artists should e-mail, call or visit website. Festival located at Osceola St. in Stuart, FL.

TIPS "You have to start somewhere. First, assess where you are, and what you'll need to get things off the ground. Next, make a plan of action. Outdoor street art shows are a great way to begin your career and lifetime as a working artist. You'll meet a lot of

other artists who have been where you are now. Network with them!"

☺ DOWNTOWN VENICE ART FESTIVAL

270 Central Blvd., Suite 107B, Jupiter FL 33458. (561)746-6615. **Fax:** (561)746-6528. **E-mail:** info@artfestival.com. **Website:** www.artfestival.com. **Contact:** Malinda Ratliff, communications manager. Estab. 1987. Fine art & craft fair held semiannually in early March & mid-November. Outdoors. Accepts photography, jewelry, mixed media, sculpture, wood, ceramic, glass, painting, digital, fiber, metal. Juried. Number exhibitors: 130-200. Number attendees: 50,000. Free to public. Apply online via www.zapplication.org. Deadline: see website. Application fee: $25. Space fee: $350-395. Exhibition space: 10×10 and 10×20. For more information, artists should e-mail, call, or visit website. Festival located at W. Venice Ave. in downtown Venice, FL.

TIPS "You have to start somewhere. First, assess where you are, and what you'll need to get things off the ground. Next, make a plan of action. Outdoor street art shows are a great way to begin your career and lifetime as a working artist. You'll meet a lot of other artists who have been where you are now. Network with them!"

☺ DURANGO AUTUMN ARTS FESTIVAL

802 E. Second Ave., Durango CO 81301. (970)422-8566. **Fax:** (970)259-6571. **E-mail:** daaf@durangoarts.org. **Website:** durangoarts.org/events/daaf. **Contact:** Jules Masterjohn. Estab. 1994. Fine arts & fine crafts show. September 17 & 18, 2016. Outdoors. Accepts photography and all mediums. Juried. Number of exhibitors: 90. Public attendance: 6,500. Free to public. Exhibition space: 10×10 ft. & 10×20 ft. Space fee $325 & $650. Application fee of $30. Apply via www.zapplication.org. For more information, artists should visit website.

☺ EDENS ART FAIR

P.O. Box 1326, Palatine IL 60078. (312)751-2500 (847)991-4748. **E-mail:** asoaartists@aol.com. **Website:** www.americansocietyofartists.com. **Contact:** ASA Office. Estab. 1995 (after renovation of location; held many years prior to renovation). American Society of Artists. Fine arts & fine selected crafts show held annually in mid-July. Outdoors. Event held in Wilmette IL. Accepts photography, paintings, sculpture, glass works, jewelry and more. Juried. Send 4

slides or photos of your work and 1 slide or photo of your display; #10 SASE; a résumé or show listing is helpful. Number of exhibitors: 50. Free to the public. Artists should apply by submitting jury materials. Please jury by submitting 4 images representative of your work you wish to exhibit, one of your display set-up, your first/last name, physical address, daytime telephone number—résumé/show listing helpful. Submit to: asoaartists@aol.com. If you pass jury you will receive a nonmember jury approval number. If juried in, you will receive a jury/approval number. Deadline for entry: 2 months prior to show or earlier if spaces fill. Entry fee: to be announced. Exhibition space: approximately 100 sq. ft. for single space; other sizes available. For more information, artists should send SASE, submit jury material.

TIPS "Remember that when you are at work in your studio, you are an artist. But when you are at a show, you are a business person selling your work."

EDINA ART FAIR

(952)922-1524. **Fax:** (952)922-4413. **E-mail:** info@50thandfrance.com. **Website:** www.edinaartfair.com. Fine arts & crafts fair held annually in June. Outdoors. Accepts handmade crafts, ceramics, enamel, fiber, glass, jewelry, mixed media, photography, sculpture, wearable art, wood. Juried. Awards/prizes: Best of Show, Best Display, awards of excellence, merit awards. Number exhibitors: 300. Number attendees: 165,000. Free to public. Apply online. Deadline for entry: February. Application fee: $35. Space fee: $425 (single); $850 (double). Exhibition space: 10×10 (single); 10×20 (double). For more information, artists should visit website or call.

EL DORADO COUNTY FAIR

100 Placerville Dr., Placerville CA 95667. (530)621-5860. **Fax:** (530)295-2566. **E-mail:** fair@eldoradocountyfair.org. **Website:** www.eldoradocountyfair.org. Estab. 1859. County fair held annually in June. Indoors. Accepts photography, fine arts and handicrafts. Awards/prizes given, see entry guide on website for details. Number of exhibitors: 350-450. Average number of attendees: 55,000. Admission fee: $9. Deadline: mid-May. Application fee: varies by class, see entry guide. For more information, visit website. Fair held at El Dorado County Fairgrounds in Placerville CA.

TIPS "Not a lot of selling at fair shows, competition mostly."

ELK RIVER ARENA'S SPRING CRAFT SHOW

1000 School St., Elk River MN 55330. (763)635-1145. **Fax:** (763)635-1145. **E-mail:** lestby@elkrivermn.gov. **Website:** www.elkriverarena.com. **Contact:** Laura Estby, office assistant. Estab. 1990. Annual fine arts & crafts show held late April/early May. Indoors. Accepts handmade crafts, paintings, ceramics, photography, upcycled items. Juried. Exhibitors: 85+. Number of attendees: 1,200. Free to public. Apply online at elkriverarena.com. Deadline for entry: until filled. Space fee: $50-75. Exhibition space: 90-126 sq. ft. For more information e-mail or see website.

ELMWOOD AVENUE FESTIVAL OF THE ARTS, INC.

P.O. Box 786, Buffalo NY 14213-0786. (716)830-2484. **E-mail:** directoreafa@aol.com. **Website:** www.elmwoodartfest.org. Estab. 2000. Arts & crafts show held annually in late August, the weekend before Labor Day weekend. Outdoors. Accepts photography, metal, fiber, ceramics, glass, wood, jewelry, basketry, 2D media. Juried. Awards/prizes: to be determined. Number of exhibitors: 170. Public attendance: 80,000-120,000. Free to the public. Artists should apply by e-mailing their contact information or by downloading application from website. Deadline for entry: April. Application fee: $25. Space fee: $295. Exhibition space: 10×15 ft. Average gross sales/exhibitor: $3,000. For more information, artists should e-mail, call or visit website. Show located on Elmwood Ave.

TIPS "Make sure your display is well designed, with clean lines that highlight your work. Have a variety of price points—even wealthy people don't always want to spend $500 at a booth where they may like the work."

ESSEX FALL CRAFT SHOW

Vermont Craft Workers, Inc., P.O. Box 8139, Essex VT 05451. (802)879-6837. **E-mail:** info@vtcrafts.com. **Website:** www.vtcrafts.com. **Contact:** Kathy Rose, owner. Estab. 1981. Arts & crafts show held annually in October. Indoors. Accepts fine art & handmade crafts. Exhibitors: 200. Number of attendees: 10,000. Admission: $8. Artists should apply via website. Deadline for entry: see website. Application fee: none. Space fee: $525. Exhibition space: 10×10. For more information, artists should visit website.

Event held at Champlain Valley Exposition, 105 Pearl St., Essex Junction, VT 05452

ESSEX SPRING CRAFT SHOW

P.O. Box 8139, Essex VT 5451. (802)879-6837. **E-mail:** info@vtcrafts.com. **Website:** www.vtcrafts.com. **Contact:** Kathy Rose, owner. Estab. 1997. Arts & crafts show held annually in May. Indoors. Accepts fine art & handmade crafts. Juried. Exhibitors: 120. Number of attendees: 8,000. Admission: $7. Artists should apply via website. Deadline for entry: see website. Application fee: none. Space fee: $350. Exhibition space: 10×10. For more information, artists should visit website.

Event held at Champlain Valley Exposition, 105 Pearl St., Essex Junction, VT 05452

ESTERO FINE ART SHOW

Hot Works, LLC, Miromar Outlets, 10801 Corkscrew Rd., Estero FL 33928. (941)755-3088. **E-mail:** patty@hotworks.org. **Website:** www.hotworks.org. **Contact:** Patty Narozny, executive director. Estab. 2008. Biannual fine art show held for 2 days in early January and early November. Outdoors. "This event showcases artists from around the globe. Art includes glass, clay, wood, fiber, jewelry, sculpture, painting, photography, and metal. There is artwork for every budget. Focus is on technique/execution, quality and originality." Juried by art professionals in the industry. 3 images of work, 1 of booth. Awards: $1,500 distributed as follows; 2 $500 Juror's Award of Excellence (purchase awards) and 5 $100 Awards of Excellence. Number of exhibitors: 110. Average number of attendees: 10,000. Free admission and free parking. Application fee: $30. Space fee: $385. Space: 11×11. For more information, artists should e-mail, call, see website, or visit www.zapplication.org for details.

Show located at Miromar Design Center, 10800 Corkscrew Road, Estero FL 33928.

TIPS "Bring enough work to sell that people want to see—original work! Stay positive."

EVERGREEN FINE ARTS FESTIVAL

Evergreen Artists Association, 22528 Blue Jay Rd., Morrison CO 80465. (303)349-3464. **E-mail:** director@evergreenfineartsfestival.com. **Website:** www.evergreenfineartsfestival.com; www.evergreenartists.org. **Contact:** Josh Trefethen, festival director. Estab. 1966. Fine arts show held annually the 4th weekend in August. Outdoors in Historic Heritage Grove Venue, next to Hiwan Homestead. Accepts both 2D and 3D media, including photography, fiber, oil, acrylic, pottery, jewelry, mixed media, ceramics, wood, watercolor. Juried event with jurors that change yearly. Artists should submit online 3 views of work and 1 of booth display by digital photograph high-res. Awards/prizes: Best of Show in 2D and 3D and 6 awards of excellence, monetary plus jury exempt next year. Number of exhibitors: 100. Public attendance: 6,000-8,000. Free to public. Deadline for entry: March 15. Application fee: $30. Space: $350 (upon acceptance). Exhibition space: 10×10 ft. Submissions only on www.zapplication.org begin in December and jurying completed in early April. "Currently ranked in the top 100 by Art Fair Source Book." For more information, artists should call or send SASE.

FAIRE ON THE SQUARE

117 W. Goodwin St., Prescott AZ 86303. (928)445-2000, ext. 112. **Fax:** (928)445-0068. **E-mail:** scott@prescott.org. **Website:** www.prescott.org. Estab. 1985. Arts & crafts show held annually Labor Day weekend. Outdoors. Accepts photography, ceramics, painting, sculpture, clothing, woodworking, metal art, glass, floral, home décor. No resale. Juried. Photos of work and artist creating work are required. Number of exhibitors: 160. Public attendance: 6,000-7,000. Free to public. Application can be printed from website or obtained by phone request. Deadline: spaces are sold until show is full. Exhibition space: $425; $460 for food booth; 10×15 ft. For more information, artist should e-mail, visit website, or call.

A FAIR IN THE PARK

6300 Fifth Ave., Pittsburgh PA 15232. **E-mail:** fairdirector@craftsmensguild.org. **Website:** www.afairinthepark.org. Estab. 1969. Contemporary fine arts & crafts show held annually the weekend after Labor Day outdoors. Accepts photography, clay, fiber, jewelry, metal, mixed media, wood, glass, 2D visual arts. Juried. Awards/prizes: 1 Best of Show and 4 Craftsmen's Guild Awards. Number of exhibitors: 105. Public attendance: 25,000+. Free to public. Submit 5 JPEG images; 4 of artwork, 1 of booth display. Application fee: $25. Booth fee: $350 or $400 for corner booth. Deadline for entry: see website. Exhibition space: 10×10 ft. Average gross sales/exhibitor: $1,000 and up. For more information artists should e-mail or visit website. Show located in Mellon Park.

TIPS "It is very important for artists to present their work to the public, to concentrate on the business aspect of their artist career. They will find that they can build a strong customer/collector base by exhibiting their work and by educating the public about their artistic process and passion for creativity."

FALL CRAFTS AT LYNDHURST

P.O. Box 28, Woodstock NY 12498. (845)331-7900. **Fax:** (845)331-7484. **E-mail:** crafts@artrider.com. **Website:** www.artrider.com. Estab. 1984. Fine arts & crafts show held annually in early to mid September. Outdoors. Accepts photography, wearable and nonwearable fiber, jewelry, clay, leather, wood, glass, painting, drawing, prints, mixed media. Juried by 5 images of work and 1 of booth, viewed sequentially. Number of exhibitors: 275. Attendance: 14,000. Admission: $10. Artists should apply at www.artrider.com or www.zapplication.org. Deadline for entry: end of May. Application fee: $45. Space fee: $795-895. Exhibition space: 10×10 ft. For more information, artists should e-mail, call or visit website.

FALL FEST IN THE PARK

117 W. Goodwin St., Prescott AZ 86303. (928)445-2000 or (800)266-7534. **E-mail:** chamber@prescott.org; scott@prescott.org. **Website:** www.prescott.org. Estab. 1981. Arts & crafts show held annually in mid-October. Outdoors. Accepts photography, ceramics, painting, sculpture, clothing, woodworking, metal art, glass, floral, home décor. No resale. Juried. Photos of work, booth, and artist creating work are required. Number of exhibitors: 150. Public attendance: 6,000-7,000. Free to public. Application can be printed from website or obtained by phone request. Deposit: $50, nonrefundable. Electricity is limited and has a fee of $15. Deadline: Spaces are sold until show is full. Exhibition space: $250; $275 for food booth; 10×15 ft. For more information, artists should e-mail, call or visit website.

FALL FESTIVAL OF ART AT QUEENY PARK

P.O. Box 31265, St. Louis MO 63131. (314)889-0433. **E-mail:** info@gslaa.org. **Website:** artfairatqueenypark.com. Estab. 1976. Fine arts & crafts show held annually Labor Day weekend at Queeny Park. Indoors. Accepts photography, all fine art and fine craft categories. Juried by 4 jurors; 5 slides shown simultaneously. Awards/prizes: 3 levels, ribbons, $4,000+ total prizes. Number of exhibitors: 130-140. Public attendance: 4,000-6,000. Admission: $5. Artists should apply online. Application fee: $25. Booth fee: $225; $250 for corner booth. Deadline for entry: mid-June, see website for specific date. Exhibition space: 80 sq. ft. (8×10) For more information, artists should e-mail or visit website.

TIPS "Excellent, professional slides; neat, interesting booth. But most important—exciting, vibrant, eye-catching artwork."

FALL FESTIVAL OF THE ARTS OAKBROOK CENTER

Amdur Productions, P.O. Box 550, Highland Park IL 60035. (847)926-4300. **Fax:** (847)926-4330. **E-mail:** info@amdurproductions.com. **Website:** www.amdurproductions.com. Estab. 1962. Fine arts & crafts fair held annually in September. Outdoors. Accepts handmade crafts, jewelry, ceramics, painting, photography, digital, printmaking, and more. Juried. Number exhibitors: see website. Number attendees: varies. Admission: Free to public. Apply online. Deadline for entry: see website. Application fee: $25. Space fee: $460. Exhibition space: 10×10. For more information, artists should e-mail, call or visit website.

FALL FESTIVAL ON PONCE

Olmstead Park, North Druid Hills, 1451 Ponce de Leon, Atlanta GA 30307. (404)873-1222. **E-mail:** lisa@affps.com. **Website:** www.festivalonponce.com. **Contact:** Lisa Windle, festival director. Estab. 2010. Arts & crafts show held annually mid-October. Outdoors. Accepts handmade crafts, painting, photography, sculpture, leather, metal, glass, jewelry. Juried by a panel. Awards/prizes: ribbons. Number of exhibitors: 125. Number of attendees: 45,000. Free to public. Apply online at www.zapplication.org. Deadline for entry: . Application fee: $25. Space fee: $275. Exhibition space: 10×10. For more information, e-mail or see website.

FALL FINE ART & CRAFTS AT BROOKDALE PARK

Rose Squared Productions, Inc., 473 Watchung Ave., Bloomfield NJ 07003. (908)874-5247. **Fax:** (908)874-7098. **E-mail:** info@rosesquared.com. **Website:** www.rosesquared.com. **Contact:** Howard Rose, vice president. Estab. 1998. Fine arts & crafts show held annually in mid-October. Outdoors. Accepts photography and all other mediums. Juried. Number of exhibitors: 160. Public attendance: 12,000. Free to public. Artists

should apply on the website. Deadline for entry: mid-September. Application fee: $30. Space fee: varies by booth size. Exhibitor space: 120 sq. ft. See application form on website for details. For more information, artists should visit the website. Promoters of fine art and craft shows that are successful for the exhibitors and enjoyable, tantalizing, satisfying artistic buying experiences for the supportive public.

TIPS "Have a range of products and prices."

FARGO'S DOWNTOWN STREET FAIR

Downtown Community Partnership, 210 Broadway N., #202, Fargo ND 58102. (701)241-1570 or (701)451-9062. **Fax:** (701)241-8275. **E-mail:** fargostreetfair@downtownfargo.com. **Website:** www.downtownfargo.com. **Contact:** Stephanie Holland, street fair consultant. Estab. 1975. "This juried event is located in historic downtown Fargo on Broadway in July. It is a street fair that successfully combines arts & crafts, food, marketplace, music and entertainment. It attracts a large number of visitors from the tri-state region/Winnepeg and many vacationers. The locals also look forward to it every year! The show is largely made up of traditional crafts, jewelry, clothing and is focused on increasing its fine arts entries each year." Outdoors. Accepts food/culinary, mixed media, pottery/ceramic, wood furniture, glass, music, printmaking, wood other, jewelry, naturals/floral, recycled/found object/green, leather, painting, sculpture, metal, photography, textiles/fibers/clothing. Number of exhibitors: 300. Public attendance: 130,000-150,000. Free to public. "Artists should apply online and submit 3 photos for the jury: 3 images of your work, 1 image of booth, and 4 images of process." All JPEG photos must be 300 dpi and be at least 1,800×1,200 pixels. Deadline for entry: mid-February. Space fee: $325-700 depending on size and/or corner. Exhibition space: 11×11. For more information, artists should visit www.downtownfargo.com. Fair located in downtown Fargo.

FESTIVAL FETE

P.O. Box 2552, Newport RI 2840. (401)207-9729. **E-mail:** pilar@festivalfete.com. **Website:** www.festivalfete.com. Fine arts & crafts fair held annually in July. Outdoors. Accepts handmade crafts, painting, sculpture, photography, drawing, fabric, crafts, ceramics, glass, and jewelry. Juried. Awards/prizes: see website. Number exhibitors: 150. Number attendees: varies. Free to public. Apply online.

Deadline for entry: see website. Application fee: see website. Space fee: $175. Exhibition space: 10×10. For more information, artists should email, call or visit website.

FESTIVAL IN THE PARK

1409 East Blvd., Charlotte NC 28203. (704)338-1060. **E-mail:** festival@festivalinthepark.org. **Website:** www.festivalinthepark.org. **Contact:** Julie Whitney Austin. Estab. 1964. Fine arts & crafts show held annually in late September (3rd Friday after Labor Day). Outdoors. Accepts photography and all arts mediums. Awards/prizes: $4,000 in cash awards. Number of exhibitors: 180. Public attendance: 100,000. Free to the public. Artists should apply by visiting website for application. Deadline: . Application fee: $45. Space fee: $345. Exhibition space: 10×10 ft. For more information, artists should e-mail, call or visit website.

FIESTA ARTS FAIR

Southwest School of Art, 300 Augusta St., San Antonio TX 78205. (210)224-1848. **Fax:** (210)224-9337. **Website:** www.swschool.org/fiestaartsfair. Art & craft market/show held annually in April. Outdoors. Accepts handmade crafts, ceramics, paintings, jewelry, glass, photography, wearable art, and other mediums. Juried. Number exhibitors: 125. Number attendees: 12,000. Admission: $16 weekend pass; $10 daily adult pass; $5 daily children pass; children 5 & under free. Apply via www.zapplication.org. Deadline for entry: November. Application fee: none. Space fee: varies. Exhibition space: varies. For more information, artists should call or visit website.

FILLMORE JAZZ FESTIVAL

Steven Restivo Event Services, LLC, P.O. Box 151017, San Rafael CA 94915. (800)310-6563. **Fax:** (415)456-6436. **Website:** www.fillmorejazzfestival.com. Estab. 1984. Fine arts & crafts show and jazz festival held annually 1st weekend of July in San Francisco, between Jackson & Eddy Streets. Outdoors. Accepts photography, ceramics, glass, jewelry, paintings, sculpture, metal clay, wood, clothing. Juried by prescreened panel. Number of exhibitors: 250. Public attendance: 100,000. Free to public. Deadline for entry: ongoing; apply online. Exhibition space: 8×10 ft. or 10×10 ft. Average gross sales/exhibitor: $800-11,000. For more information, artists should visit website or call.

🎧 FINE ART & CRAFTS AT ANDERSON PARK

274 Bellevue Ave., Upper Montclair NJ 07043. (908)874-5247. **Fax:** (908)874-7098. **E-mail:** info@rosesquared.com. **Website:** www.rosesquared.com. **Contact:** Howard and Janet Rose. Estab. 1984. Fine art & craft show held annually in mid-September. Outdoors. Accepts photography and all other mediums. Juried. Number of exhibitors: 160. Public attendance: 12,000. Free to the public. Artists should apply on the website. Deadline for entry: mid-August. Application fee: $30. Space fee varies by booth size; see application form on website for details. For more information, artists should visit the website. Promoters of fine art and craft shows that are successful for the exhibitors and enjoyable, tantalizing, satisfying artistic buying experiences for the supportive public.

TIPS "Create a range of sizes and prices."

🎧 FINE ART & CRAFTS AT VERONA PARK

Rose Squared Productions, Inc., 542 Bloomfield Ave., Verona NJ 07044. (908)874-5247. **Fax:** (908)874-7098. **E-mail:** info@rosesquared.com. **Website:** www.rosesquared.com. **Contact:** Howard Rose, vice president. Estab. 1986. Fine arts & crafts show held annually in mid-May. Outdoors. Accepts photography and all other mediums. Juried. Number of exhibitors: 140. Public attendance: 10,000. Free to public. Artists should apply on the website. Deadline for entry: mid-April. Application fee: $25. Space fee varies by booth size; see application form on website for details. For more information, artists should visit the website. Promoters of fine art and craft shows that are successful for the exhibitors and enjoyable, tantalizing, satisfying artistic buying experiences for the supportive public.

TIPS "Have a range of sizes and price ranges."

🎧 FINE ART FAIR

Foster Arts Center, 203 Harrison St., Peoria IL 61602. (309)637-2787. **E-mail:** fineartfair@peoriaartguild.org. **Website:** www.peoriaartguild.org. **Contact:** fine art fair coordinator. Estab. 1962. Fine art & fine craft fair held annually the last full weekend in September. Outdoors. Accepts handmade crafts, painting, sculpture, photography, drawing, fabric, ceramics, glass, and jewelry. Juried. Number exhibitors: 150. Number attendees: 25,000. Admission: $5 adults; children 12 & under free; Peoria Art Guild members free. Ap-

ply online. Deadline for entry: see website. Application fee: see website. Space fee: see website. Exhibition space: see website. For more information, artists should email, call or visit website.

🎧 FIREFLY ART FAIR

Wauwatosa Historical Society, 7406 Hillcrest Drive, Wauwatosa WI 53213. (414)774-8672. **E-mail:** staff@wauwatosahistoricalsociety.org. **Website:** www.wauwatosahistoricalsociety.org. **Contact:** Janel Ruzicka. Estab. 1985. Fine arts & crafts fair held annually first weekend in August. (August 6 & 7, 2016) Outdoors. Accepts painting, sculpture, photography, ceramics, jewelry, fiber, printmaking, glass, paper, leather, wood. Juried. Number exhibitors: 90. Number attendees: 4,000 to 5,000. $5.00 public admission. Apply online. Deadline for entry: March 15. Application fee: $15. Space fee: $140. Exhibition space: 10×10. For more information, artists should email, visit website, or call.

🎧 FOOTHILLS ARTS & CRAFTS FAIR

2753 Lynn Rd., Suite A, Tryon NC 28782-7870. (828)859-7427. **Fax:** (888)296-0711. **E-mail:** info@blueridgebbqfestival.com. **Website:** www.blueridgebbqfestival.com. Estab. 1994. Fine arts & crafts show and Blue Ridge BBQ Festival/Championship held annually the 2nd Friday and Saturday in June. Outdoors. Accepts contemporary, traditional and fine art by artist only; nothing manufactured or imported. Juried. Number of exhibitors: 50. Public attendance: 15,000+. Public admission: $8; 12 and under free. Artists should apply by downloading application from website or sending personal information to e-mail or mailing address. See website for deadline for entry. Jury fee: $25, nonrefundable. Space fee: $175. Exhibition space: 10×10 ft. For more information, artists should e-mail or visit website.

TIPS "Have an attractive booth, unique items, and reasonable prices."

🎧 FOUNTAIN HILLS FINE ART & WINE AFFAIRE

16810 E. Ave. of the Fountains, Fountain Hills AZ 85268. (480)837-5637. **Fax:** (480)837-2355. **E-mail:** info@thunderbirdartists.com. **Website:** www.thunderbirdartists.com. **Contact:** Denise Colter, president. Estab. 2005. "The 12th Annual Fountain Hills Fine Art & Wine Affaire is produced by

Thunderbird Artists, in conjunction with Sunset Kiwanis and the town of Fountain Hills. Thunderbird Artists again unite with Sunset Kiwanis of Fountain Hills to celebrate 12 years! Held on the picturesque Avenue of the Fountains, the signature fountain attracts thousands of visitors every year and runs at the top of each hour for 15 minutes 9-9 daily. Thunderbird Artists Mission is to promote fine art and fine crafts, (through an extensive and dedicated advertising campaign) paralleled with the ambiance of unique wines and fine music, while supporting the artists, merchants and surrounding communities. It is the mission of Thunderbird Artists to further enhance the art culture with the local communities by producing award-winning, sophisticated fine art festivals throughout the Phoenix metro area. Thunderbird Artists has played an important role in uniting nationally recognized and award-winning artists with patrons from across the globe."

TIPS "A clean, gallery-type presentation is very important."

☺ FOURTH AVENUE STREET FAIR

434 E. Ninth St., Tucson AZ 85705. (520)624-5004 or (800)933-2477. **Fax:** (520)624-5933. **E-mail:** kurt@ fourthavenue.org. **Website:** www.fourthavenue.org. **Contact:** Kurt. Estab. 1970. Arts & crafts fair held annually in late March/early April and December (see website for details). Outdoors. Accepts photography, drawing, painting, sculpture, arts & crafts. Juried by 5 jurors. Awards/prizes: Best of Show. Number of exhibitors: 400. Public attendance: 300,000. Free to the public. Artists should apply by completing the online application at www.zapplication.org. Requires 4 photos of art/craft and 1 booth photo. $35 application fee. Booth fee $505, additional $150 for corner booth. Deadline for entry: see website for details. Exhibition space: 10×10 ft. Average gross sales/exhibitor: $3,000. For more information, artists should e-mail, visit website, call, send SASE. Fair located on 4th Ave., between 9th St. and University Ave.

☺ FOURTH STREET FESTIVAL FOR THE ARTS & CRAFTS

P.O. Box 1257, Bloomington IN 47402. (812)575-0484 or (812)335-3814. **E-mail:** info@4thstreet.org. **Website:** www.4thstreet.org. Estab. 1976. Fine arts & crafts show held annually Labor Day weekend. Outdoors. Accepts photography, clay, glass, fiber, jewelry, painting, graphic, mixed media, wood. Juried by a 4-member panel. Awards/prizes: Best of Show ($750), 1st, 2nd, 3rd in 2D and 3D. Number of exhibitors: 105. Public attendance: 25,000. Free to public. Artists should apply by sending requests by mail, e-mail or download application from website at www.zapplication.org. Exhibition space: 10×10 ft. Average gross sales/exhibitor: $2,700. For more information, artists should e-mail, visit website, call or send for information with SASE. Show located at 4th St. and Grant St. adjacent to Indiana University.

TIPS Be professional.

☺ FREDERICK FESTIVAL OF THE ARTS

11 W. Patrick St., Suite 2, Frederick MD 21701. (301)662-4190. **Fax:** (301)663-3084. **E-mail:** info@frederickartscouncil.org. **Website:** www. frederickartscouncil.org. Juried 2-day fine arts festival held annually the 1st weekend of June along Carroll Creek Linear Park in downtown Frederick. Features approximately 110 artists from across the country, 2 stages of musical performances, children's crafts and activities, artist demonstrations, as well as interactive classical theater performances. For more information, including application deadlines and fees, visit website www.frederickartsfestival.org. Festival takes place in Carroll Creek Linear Park in downtown Frederick.

☺ FRIENDS OF THE KENOSHA PUBLIC MUSEUMS ART FAIR

5500 First Ave., Kenosha WI 53140. (262)653-4140. **Fax:** (262)653-4437. **E-mail:** pgregorski@kenosha.org. **Website:** www.kenoshapublicmuseum.org. **Contact:** Peggy Gregorski, deputy director. Estab. 1964. Fine arts & crafts show held annually 3rd Sunday of July. Indoors & outdoors. Accepts handmade crafts. Juried. Awards/prizes: 5 awards totaling $2,000. Exhibitors: 125. Number of attendees: 7,000. Free to public. Apply online. Deadline for entry: May 1. Application fee: none. Space fee: $125-200. Exhibition space: 10×10 (indoors); 15×15 (outdoors). For more information, artists should send e-mail or visit website. Fine arts & crafts show held annually 3rd Sunday of July. Indoors & outdoors. Accepts handmade crafts. Juried. Awards/prizes: 5 awards totaling $2,000. Exhibitors: 125. Number of attendees: 7,000. Free to public. Apply online. Deadline for entry: May 1. Application fee: none. Space fee: $125-200. Exhibition space: 10×10 (indoors); 15×15 (outdoors). For more information, artists should send e-mail or visit website.

FUNKY FERNDALE ART SHOW

Integrity Shows, P.O. Box 1070, Ann Arbor MI 48106. **E-mail:** info@integrityshows.com. **Website:** www. funkyferndaleartfair.com. **Contact:** Mark Loeb. Estab. 2004. Fine arts & crafts show held annually in September. Outdoors. Accepts photography and all fine art and craft mediums; emphasis on fun, funky work. Juried by 3 independent jurors. Awards/prizes: purchase and merit awards. Number of exhibitors: 120. Public attendance: 30,000. Free to the public. Application fee: $25. Booth fee: $295. Electricity limited; fee: $100. For more information, artists should visit our website.

TIPS "Show enthusiasm. Keep a mailing list. Develop collectors."

GAITHERSBURG-KENTLANDS DOWNTOWN ART FESTIVAL

270 Central Blvd., Suite 107B, Jupiter FL 33458. (561)746-6615. **Fax:** (561)746-6528. **E-mail:** info@ artfestival.com. **Website:** www.artfestival.com. **Contact:** Malinda Ratliff, communications manager. Estab. 2015. Fine art & craft fair held annually in September. Outdoors. Accepts photography, jewelry, mixed media, sculpture, wood, ceramic, glass, painting, digital, fiber, metal. Juried. Number exhibitors: see website. Number attendees: see website. Free to public. Apply online via www.zapplication.org. Deadline: see website. Application fee: $25. Space fee: $450. Exhibition space: 10×10 and 10×20. For more information, artists should e-mail, call, or visit website. Festival located at The Streets of Market and Main at Kentlands Downtown.

TIPS "You have to start somewhere. First, assess where you are, and what you'll need to get things off the ground. Next, make a plan of action. Outdoor street art shows are a great way to begin your career and lifetime as a working artist. You'll meet a lot of other artists who have been where you are now. Network with them!"

GARRISON ART CENTER'S JURIED FINE CRAFTS FAIR

23 Garrison's Landing, P.O. Box 4, Garrison NY 10524. (845)424-3960. **Fax:** (845)424-4711. **E-mail:** info@garrisonartcenter.org. **Website:** www. garrisonartcenter.org. Outdoor, riverside fine crafts show held annually on the third weekend in August. 85 exhibitors are selected to exhibit and sell handmade original work. Entries are judged based on creativity, originality and quality. Annual visitors 4,000-5,000. Visit our website for information, prospectus, and application. Fair located at Garrison's Landing.

TIPS "Have an inviting booth and be pleasant and accessible. Don't hide behind your product—engage the audience."

GASPARILLA FESTIVAL OF THE ARTS

P.O. Box 10591, Tampa FL 33679. (813)876-1747. **E-mail:** info@gasparillaarts.com. **Website:** www. gasparilla-arts.com. Estab. 1970. Fine arts & crafts fair held annually in March. Outdoors. Accepts handmade crafts, ceramic, digital, drawing, fiber, glass, jewelry, mixed media, painting, photography, printmaking, sculpture, watercolor, and wood. Juried. Awards/prizes: $74,500 in cash awards. Number exhibitors: 300. Number attendees: 250,000. Free to public. Apply online. Deadline for entry: September. Application fee: $40. Space fee: $375. Exhibition space: 10×10. For more information, artists should email, visit website, or call.

GATHERING AT THE GREAT DIVIDE

Mountain Art Festivals, P.O. Box 3578, Breckenridge CO 80424. (970)547-9326. **E-mail:** info@mountainartfestivals.com. **Website:** www. mountainartfestivals.com. Estab. 1975. Fine arts & crafts fair held annually in August. Outdoors. Accepts handmade crafts, painting, sculpture, photography, drawing, fabric, crafts, ceramics, glass, and jewelry. Juried. Number exhibitors: see website. Number attendees: varies. Free to public. Apply online. Deadline for entry: March 31. Application fee: $35. Space fee: $500. Exhibition space: 10×10. For more information, artists should email, visit website, or call.

GENEVA ARTS FAIR

8 S. Third St., Geneva IL 60134. (630)232-6060. **E-mail:** chamberinfo@genevachamber.com; lrush@ genevachamber.com. **Website:** www.genevachamber. com. Fine arts show held annually in late-July (see website for details). Outdoors. Juried. "The unprecedented Geneva Arts Fair transforms downtown Geneva into a venue for over 150 esteemed artists and draws a crowd of more than 20,000. The juried show was voted a Top 200 Fine Craft Fair by *Art Fair Source-Book* and a previous winner of 'Best Craft or Art Show' by *West Suburban Living* magazine." Accepts photography, ceramics, fiber, printmaking, mixed media, watercolor, wood, sculpture and jewelry. Application

deadline: early February. Please visit www.emevents.com to apply.

GERMANTOWN FESTIVAL

P.O. Box 381741, Germantown TN 38183. (901)757-9212. **E-mail:** gtownfestival@aol.com. **Website:** www.germantownfest.com. **Contact:** Melba Fristick, coordinator. Estab. 1971. Arts & crafts show held annually the weekend after Labor Day. Outdoors. Accepts photography, all arts & crafts mediums. Number of exhibitors: 400+. Public attendance: 65,000. Free to public. Artists should apply by sending applications by mail. Deadline for entry: until filled. Application/space fee: $200-250. Exhibition space: 10×10 ft. For more information, artists should e-mail, call or send SASE. Show located at Germantown Civic Club Complex 7745 Poplar Pike.

TIPS "Display and promote to the public. Price attractively."

✪ GLAM INDIE CRAFT SHOW

E-mail: glamcraftshow@gmail.com. **Website:** www.glamcraftshow.com. Fine arts & crafts fair held annually in December. Outdoors. Accepts handmade crafts, painting, sculpture, photography, drawing, fabric, crafts, ceramics, glass, and jewelry. Juried. Number exhibitors: varies. Number attendees: varies. Admission: $3 adults; children 10 & under free. Apply online. Deadline for entry: September. Application fee: see website. Space fee: varies. Exhibition space: varies. For more information, artists should email or visit website.

✪ GLENCOE FESTIVAL OF ART

Amdur Productions, P.O. Box 550, Highland Park IL 60035. (847)926-4300. **Fax:** (847)926-4330. **E-mail:** info@amdurproductions.com. **Website:** www.amdurproductions.com. Fine arts & crafts fair held annually in August. Outdoors. Accepts handmade crafts, painting, sculpture, photography, drawing, fabric, crafts, ceramics, glass and jewelry. Juried. Number exhibitors: 120. Number attendees: 35,000. Free to public. Apply online. Deadline for entry: see website. Application fee: $25. Space fee: varies. Exhibition space: varies. For more information, artists should e-mail or visit website.

✪ GLENVIEW OUTDOOR ART FAIR

Glenview Art League, P.O. Box 463, Glenview IL 60025-0463. (847)724-4007. **E-mail:** glenviewartleague@att.net. **Website:** www.

glenviewartleague.org. Fine arts & crafts fair held annually in July. Outdoors. Accepts handmade crafts, paintings, sculpture, hand-pulled artist's prints (e.g., etchings), drawings, mixed media, ceramics, photography, and jewelry. Juried. Awards/prizes: Best of Show, awards of excellence, merit awards. Number exhibitors: see website. Number attendees: varies. Free to public. Apply online. Deadline for entry: May. Application fee: $10. Space fee: varies. Exhibition space: 12×12. For more information, artists should email, call or visit website.

GLOUCESTER COUNTY SPRING CRAFT & HOME SHOW

B & K Enterprise, P.O. Box 925, Millville NJ 8332. (856)765-0118. **Fax:** (856)765-9050. **E-mail:** bkenterprisenj@aol.com. **Website:** www.gloucestercraftfair.com. **Contact:** Kathy Wright, organizer. Estab. 2010. Arts & crafts show held annually 1st Saturday in May. Indoors & outdoors. Accepts fine art & handmade crafts, home & garden, food. Awards/prizes: $100 for Best Spring Booth. Exhibitors: 150. Number of attendees: 2,500. Free to public. Artists should apply via website. Application fee: none. Space fee: $40 (one day) $75.00 (two days). Exhibition space: 10×10. For more information, artists should e-mail, visit website, or call.

○ Event held at Gloucester Co. Fairgrounds, 275 Bridgeton Pike, Mullica Hill, NJ 08098

✪ GLOUCESTER WATERFRONT FESTIVAL

38 Charles St., Rochester NH 03867. (603)332-2616. **E-mail:** info@castleberryfairs.com; terrym@worldpath.net. **Website:** www.castleberryfairs.com. **Contact:** Terry Mullen, events coordinator. Estab. 1971. Arts & crafts show held the 3rd weekend in August in Gloucester MA. Outdoors in Stage Fort Park. Accepts photography and all other mediums. Juried by photo, slide or sample. Number of exhibitors: 225. Public attendance: 50,000. Free to the public. Artists should apply by downloading application from website. Deadline for entry: until full. Space fee: $375. Exhibition space: 10×10 ft. Average gross sales/exhibitor: "Generally, this is considered an 'excellent' show, so I would guess most exhibitors sell ten times their booth fee, or in this case, at least $3,500 in sales." For more information, artists should visit website. Show located in Stage Fort Park, Hough Ave., Gloucester NH.

TIPS "Do not bring a book; do not bring a chair. Smile and make eye contact with everyone who enters your booth. Have them sign your guest book; get their e-mail address so you can let them know when you are in the area again. And, finally, make the sale—they are at the fair to shop, after all."

🎧 GOLDEN FINE ARTS FESTIVAL

1010 Washington Ave., Golden CO 80401. (303)279-3113. **E-mail:** info@goldencochamber.org. **Website:** www.goldenfineartsfestival.org. Fine arts & crafts fair held annually in August. Outdoors. Accepts handmade crafts, ceramics, fiber, glass, jewelry, mixed media, 2D, painting, photography, and sculpture. Juried. Number exhibitors: see website. Number attendees: 40,000. Free to public. Apply online. Deadline for entry: April. Application fee: $25. Space fee: $350. Exhibition space: 10×10. For more information, artists should e-mail, call or visit website.

GOLD RUSH DAYS

Dahlonega Jaycees, P.O. Box 774, Dahlonega GA 30533. **E-mail:** info@dahlonegajaycees.com. **Website:** www.dahlonegajaycees.com. Estab. 1954. Arts & crafts show held annually the 3rd full week in October. Accepts photography, paintings and homemade, handcrafted items. No digitally originated artwork. Outdoors. Number of exhibitors: 300. Public attendance: 200,000. Free to the public. Artists should apply online at dahlonegajaycees.com. Deadline: June 1st. Exhibition space: 10×10 ft. Artists should e-mail or visit website for more information. Show located at the public square and historic district.

TIPS "Talk to other artists who have done other shows and festivals. Get tips and advice from those in the same line of work."

🎧 GOOD OLD SUMMERTIME ART FAIR

Friends of the Kenosha Art Association, P.O. Box 1753, Kenosha WI 53141. (262)654-0065. **E-mail:** info@kenoshaartassociation.org. **Website:** www.kenoshaartassociation.org. Estab. 1975. Fine arts show held annually the 1st Sunday in June. Outdoors. Accepts photography, paintings, drawings, mosaics, ceramics, pottery, sculpture, wood, stained glass. Juried by a panel. Photos or slides required with application. Number of exhibitors: 100. Public attendance: 3,000. Free to public. Artists should apply by completing application form, and including fees and SASE. Deadline for entry: early April. Exhibition space:

12×12 ft. For more information, artists should e-mail, visit website or send SASE.

TIPS "Have a professional display, and be friendly."

🎧 GRAND LAKE FESTIVAL OF THE ARTS & CRAFTS

P.O. Box 429, Grand Lake CO 80447-0429. (970)627-3402. **Fax:** (970)627-8007. **E-mail:** glinfo@grandlakechamber.com. **Website:** www.grandlakechamber.com. Fine arts & crafts show held annually in June, July and AUgust. Outdoors. Accepts photography, jewelry, leather, mixed media, painting, paper, sculpture, wearable art. Juried by chamber committee. Awards/prizes: Best in Show and People's Choice. Number of exhibitors: 50-75. Public attendance: 1,000+. Free to public. Artists should apply by submitting slides or photos. Deadline for entry: early June, July and August. Application fee: $190; includes space fee and business license. No electricity available. Exhibition space: 12x12 ft. For more information, artists should e-mail or call. Show held at Town Square Park on Grand Ave in Grand Lake, CO.

GREAT LAKES ART FAIR

46100 Grand River Ave., Novi MI 48374. (248)486-3424. **Fax:** (248)347-7720. **E-mail:** info@greatlakesartfair.com. **Website:** www.greatlakesartfair.com. **Contact:** Andrea Picklo, event manager. Estab. 2009. Held in April. Accepts paintings, sculptures, metal and fiber work, jewelry, 2D and 3D art, ceramics and glass. Cash prizes are given. Number of exhibitors: 150-200. Public attendance: 12,000-15,000. Application fee: $30. Space fee: $400-800. Exhibition space: 10×12 ft.

TIPS E-mail, call or visit website for more information.

🎧 GREAT NECK STREET FAIR

Showtiques Crafts, Inc., 1 Orient Way, Suite F, #127, Rutherford NJ 07070. (201)869-0406. **E-mail:** showtiques@gmail.com. **Website:** www.showtiques.com. Estab. 1978. Fine arts & crafts show held annually in early May (see website for details) in the Village of Great Neck. "Welcomes professional artists, craftspeople and vendors of upscale giftware." Outdoors. Accepts photography, all arts & crafts made by the exhibitor. Juried. Number of exhibitors: 250. Public attendance: 50,000. Free to public. Deadline for entry: until full. Space fee: $150-250. Exhibition

space: 10×10 ft. For more information, artists should e-mail, call or visit website.

⊙ GREENWICH VILLAGE ART FAIR

711 N. Main St., Rockford IL 61103. (815)968-2787. **Fax:** (815)316-2179. **E-mail:** nsauer@rockfordartmuseum. org. **Website:** www.rockfordartmuseum.org/gvaf. html. **Contact:** Nancy Sauer. Estab. 1948. Juried. 2-day outdoor fine art fair held annually in September. $4,500 in Best of Show and Judges' Choice Awards. Number of exhibitors: 155. Public attendance: 7,000. Application fee $30.Booth fee: $225. Deadline for entry: April 30. Exhibition space: 10×10 ft. Apply online through www.zapplication.org.

⊙ GUILFORD ART CENTER'S CRAFT EXPO

Guilford Art Center, P.O. Box 589, Guilford CT 06437. (203)453-5947. **E-mail:** expo@guilfordartcenter.org. **Website:** www.guilfordartcenter.org. Estab. 1957. Fine craft & art show held annually in mid-July. Outdoors. Accepts photography, wearable and nonwearable fiber, metal and nonmetal jewelry, clay, leather, wood, glass, painting, drawing, prints, mixed media, sculpture. Juried by 5 images of work, viewed sequentially. Number of exhibitors: 180. Public attendance: 8,000. Public admission: $7 and $9. Artists should apply online at www.zapplication.org (preferred) or by downloading an application at www.guilfordartcenter.org. Deadline for entry: early January. Application fee: $40. Space fee: $680. Exhibition space: 10×10 ft. For more information, artists should e-mail, visit website or call.

⊙ HALIFAX ART FESTIVAL

P.O. Box 2038, Ormond Beach FL 32175-2038. (386)304-7247 or (407)701-1184. **E-mail:** patabernathy2012@hotmail.com. **Website:** www. halifaxartfestival.com. Estab. 1962. Fine arts & crafts fair held annually in November. Outdoors. Accepts handmade crafts, ceramics, fiber, glass, jewelry, mixed media, 2D, painting, photography, and sculpture. Juried. Awards/prizes: Best of Show, Judges' Choice, Awards of Excellence, Awards of Distinction, Awards of Honor, Awards of Merit, Student Art Awards, Purchase Award, Patron Purchase Award. Number exhibitors: 200. Number attendees: 45,000. Free to public. Apply online. Deadline for entry: August. Application fee: $30. Space fee: $225 (competitive); $125 (noncompetitive). Exhibition space: see website.

For more information, artists should e-mail, call or visit website.

⊙ HERKIMER COUNTY ARTS & CRAFTS FAIR

100 Reservoir Rd., Herkimer NY 13350. (315)866-0300, ext. 8459. **Fax:** (315)866-1706. **E-mail:** fuhrerjm@herkimer.edu. **Website:** www.herkimer. edu/ac. **Contact:** Jan Fuhrer, coordinator. Estab. 1976. Fine art & craft show held annually in mid-November on Veterans Day weekend. Indoors. Accepts photography and all handcrafted artwork. Juried by a committee. Awards/prizes: ribbons. Number of exhibitors: 120+. Public attendance: 4,000. Admission: $4. Deadline: May 1 or until filled. Application fee: $10. Exhibition space: 10×6 ft. Space fee: $155. For more information, artists should call, e-mail, or send SASE.

⊙ HIGHLAND MAPLE FESTIVAL

P.O. Box 223, Monterey VA 24465. (540)468-2550. **Fax:** (540)468-2551. **E-mail:** findyourescape@ highlandcounty.org. **Website:** www.highlandcounty. org. Estab. 1958. Fine arts & crafts show held annually the 2nd and 3rd weekends in March. Indoors and outdoors. Accepts photography, pottery, weaving, jewelry, painting, wood crafts, furniture. Juried by 5 photos or slides. Photos need to include one of setup and your workshop. Number of exhibitors: 150. Public attendance: 35,000-50,000. "Vendors accepted until show is full." Exhibition space: 10×10 ft. For more information, artists should e-mail, call or visit website.

TIPS "Have quality work and good salesmanship."

⊙ HIGHLANDS ART LEAGUE'S ANNUAL FINE ARTS & CRAFTS FESTIVAL

1989 Lakeview Dr., Sebring FL 33870. (863)385-6682. **E-mail:** director@highlandsartleague.org. **Website:** www.highlandsartleague.org. **Contact:** Martile Blackman, festival director. Estab. 1966. Fine arts & crafts show held annually first Saturday in November. Outdoors. Accepts photography, pottery, painting, jewelry, fabric. Juried based on quality of work. Awards/prizes: monetary awards. Number of exhibitors: 100+. Public attendance: more than 15,000. Free to the public. Artists should apply by calling or visiting website for application form. Deadline for entry: September 1. Exhibition space: 10×14 and 10×28 ft. Artists should e-mail for more information. Festival held in Circle Park in downtown Sebring.

HILTON HEAD ISLAND ART FESTIVAL WITH CRAFT MARKETPLACE

270 Central Blvd., Suite 107B, Jupiter FL 33458. (561)746-6615. **Fax:** (561)746-6528. **E-mail:** info@ artfestival.com. **Website:** www.artfestival.com. **Contact:** Malinda Ratliff, communications manager. Estab. 2009. Fine art & craft fair held annually in late May. Outdoors. Accepts photography, jewelry, mixed media, sculpture, wood, ceramic, glass, painting, digital, fiber, metal. Juried. Number exhibitors: 100. Number attendees: 60,000. Free to public. Apply online via www.zapplication.org. Deadline: see website. Application fee: $25. Space fee: $375. Exhibition space: 10×10 and 10×20. For more information, artists should e-mail, call or visit website. Festival located at Shelter Cove Harbour and Marina on Hilton Head Island.

TIPS "You have to start somewhere. First, assess where you are, and what you'll need to get things off the ground. Next, make a plan of action. Outdoor street art shows are a great way to begin your career and lifetime as a working artist. You'll meet a lot of other artists who have been where you are now. Network with them!"

HINSDALE FINE ARTS FESTIVAL

22 E. First St., Hinsdale IL 60521. (630)323-3952. **Fax:** (630)323-3953. **E-mail:** info@hinsdalechamber.com. **Website:** www.hinsdalechamber.com. Fine arts show held annually in mid-June. Outdoors. Accepts photography, ceramics, painting, sculpture, fiber arts, mixed media, jewelry. Juried by 3 images. Awards/ prizes: Best in Show, President's Award and 1st, 2nd and 3rd place in 2D and 3D categories. Number of exhibitors: 140. Public attendance: 2,000-3,000. Free to public. Artists should apply online at www.zapplication.org. Deadline for entry: First week in March. Application fee: $30. Space fee: $275. Exhibition space: 10×10 ft. For more information, artists should e-mail or visit website.

TIPS "Original artwork sold by artist."

HISTORIC SHAW ART FAIR

(314)771-3101. **E-mail:** greg@gobdesign.com. **Website:** www.shawartfair.org. **Contact:** Greg Gobberdiel, coordinator. Fine arts & crafts fair held annually in October. Outdoors. Accepts handmade crafts, ceramics, fiber, glass, jewelry, mixed media, painting, photography, and sculpture. Juried. Number exhibitors: see website. Number attendees: varies. Free to public.

Apply online. Deadline for entry: April. Application fee: $25. Space fee: $280. Exhibition space: 10×10. For more information, artists should e-mail, call, or visit website.

HOBE SOUND FESTIVAL OF THE ARTS & CRAFT SHOW

270 Central Blvd., Suite 107B, Jupiter FL 33458. (561)746-6615. **Fax:** (561)746-6528. **E-mail:** info@ artfestival.com. **Website:** www.artfestival.com. **Contact:** Malinda Ratliff, communications manager. Estab. 2006. Fine art & craft fair held annually in February. Outdoors. Accepts photography, jewelry, mixed media, sculpture, wood, ceramic, glass, painting, digital, fiber, metal. Juried. Number exhibitors: 130. Number attendees: 70,000. Free to public. Apply online via www.zapplication.org. Deadline: see website. Application fee: $25. Space fee: $395. Exhibition space: 10×10 and 10×20. For more information, artists should e-mail, call or visit website. Show located at A1A/Dixie Highway where the street intersects with Bridge Road in Hobe Sound, FL.

TIPS "You have to start somewhere. First, assess where you are, and what you'll need to get things off the ground. Next, make a plan of action. Outdoor street art shows are a great way to begin your career and lifetime as a working artist. You'll meet a lot of other artists who have been where you are now. Network with them!"

HOLIDAY CRAFTMORRISTOWN

P.O. Box 28, Woodstock NY 12498. (845)331-7900. **Fax:** (845)331-7484. **E-mail:** crafts@artrider.com. **Website:** www.artrider.com. Estab. 1990. Fine arts & crafts show held annually in early December. Indoors. Accepts photography, wearable and nonwearable fiber, jewelry, clay, leather, wood, glass, painting, drawing, prints, mixed media. Juried by 5 images of work and 1 of booth, viewed sequentially. Number of exhibitors: 165. Public attendance: 5,000. Public admission: $9. Artists should apply online at www.artrider.com or www.zapplication.org. Deadline for entry: end of May. Application fee: $45. Space fee: $545. Exhibition space: 10×10 ft. For more information, artists should e-mail, call or visit website.

HOLIDAY FINE ARTS & CRAFTS SHOW

60 Ida Lee Dr., Leesburg VA 20176. (703)777-1368. **Fax:** (703)737-7165. **E-mail:** lfountain@leesburgva. gov. **Website:** www.idalee.org. **Contact:** Linda Foun-

tain. Estab. 1990. Fine Arts & crafts show held annually the 1st full weekend in December. Indoors. Accepts handcrafted items only, including but not limited to: photography, jewelry, pottery, baskets, clothing, gourmet food products, wood work, fine art, accessories, pet items, soaps/lotions and florals. Juried. Number of exhibitors: 99. Public attendance: 2,500+. Free to public. Artists should apply by downloading application from website. Deadline for entry: August 18. Space fee: $110-150. Exhibition space: 10×7 ft. and 10×10 ft. For more information, artists should e-mail or visit website.

HOLLY ARTS & CRAFTS FESTIVAL

P.O. Box 64, Pinehurst NC 28370. (910)295-7462. **E-mail:** info@pinehurstbusinessguild.com. **Website:** www.pinehurstbusinessguild.com. Estab. 1978. Annual arts & crafts show held 3rd Saturday in October. Outdoors. Accepts quality photography, arts and crafts. Juried based on uniqueness, quality of product and overall display. Number of exhibitors: 200. Public attendance: 7,000. Free to the public. Submit 3 color photos, 2 of work to be exhibited, 1 of booth. Deadline: Late March. Application fee: $25 by separate check. Space fee: $75. Electricity fee: $5 Exhibition space: 10×10 ft. For more information, artists should call or visit website.

HOME, CONDO AND OUTDOOR ART & CRAFT FAIR

P.O. Box 486, Ocean City MD 21843. (410)213-8090. **Fax:** (410)213-8092. **E-mail:** events@oceanpromotions.info. **Website:** www.oceanpromotions.info. **Contact:** Starr or Mike. Estab. 1984. Fine arts & crafts show held annually in the Spring. Indoors. Accepts photography, carvings, pottery, ceramics, glass work, floral, watercolor, sculpture, prints, oils, pen and ink. Number of exhibitors: 50. Public attendance: 7,000. Public admission: $7/adults; $6/seniors & students; 13 and under free; military, fire and police free. Artists should apply by e-mailing request for info and application. Deadline for entry: until full. Space fee: $250. Exhibition space: 10×10 ft. For more information, artists should e-mail, call or visit website. Show held in the R.E. Powell Ocean City Convention Center.

HOME DECORATING & REMODELING SHOW

P.O. Box 230699, Las Vegas NV 89105-0699. (702)450-7984 or (800)343-8344. **Fax:** (702)451-7305. **E-mail:** showprosadmin@cox.net. **Website:** www.nashvillehomeshow.com. Estab. 1983. Home show held annually in early September (see website for details). Indoors. Accepts photography, sculpture, watercolor, oils, mixed media, pottery. Awards/prizes: Outstanding Booth Award. Number of exhibitors: 350-400. Public attendance: 15,000. Public admission: $10 (discount coupon available on website); Seniors 62+ free on Friday; children 12 & under free with adult. Artists should apply by calling. Marketing is directed to middle and above income brackets. Deadline for entry: open until filled. Space fee: starts at $950. Exhibition space: 10×10 ft. or complements of 10×10 ft. For more information, artists should call or visit website.

HOT SPRINGS ARTS & CRAFTS FAIR

308 Pullman, Hot Springs AR 71901. (501)623-9592. **E-mail:** sephpipkin@aol.com. **Website:** www.hotspringsartsandcraftsfair.com. **Contact:** Peggy Barnett. Estab. 1968. Fine arts & crafts show held annually the 1st full weekend in October at the Garland County Fairgrounds. Indoors and outdoors. Accepts photography and varied mediums ranging from heritage, crafts, jewelry, furniture. Juried by a committee of 12 volunteers. Number of exhibitors: 350+. Public attendance: 50,000+. Free to public. Deadline for entry: August. Space fee: $125 (single); $250 (double). Exhibition space: 10×10 or 10×20 ft. For more information, and to apply, artists should e-mail, call or visit website. Fair located at Garland County Fairgrounds.

HYDE PARK ARTS & CRAFTS ADVENTURE

P.O. Box 1326, Palatine IL 60078. (312)751-2500, (847)991-4748. **E-mail:** asoaartists@aol.com. **Website:** www.americansocietyofartists.org. Estab. 2006. Arts & crafts show held once a year in late September. Event held in Chicago. Outdoors. Accepts photography, painting, glass, wood, fiber arts, hand-crafted candles, quilts, sculpture and more. Juried. Please submit 4 images representative of your work you wish to exhibit, 1 of your display set-up, your first/last name, physical address, daytime telephone number—résumé/show listing helpful. Number of exhibitors: 50. Free to the public. Artists should apply by submitting

jury materials. Please submit to: asoaartists@aol.com. If juried in, you will receive a jury/approval number. See website for jurying online. Deadline for entry: 2 months prior to show or earlier if available. Entry fee: to be announced. Exhibition space: approximately 100 sq. ft. for single space; other sizes are available. For more information, artists should send SASE, submit jury material. Show located at University of Chicago's Hyde Park Shopping Center.

TIPS "Remember that when you are at work in your studio, you are an artist. But when you are at a show, you are a business person selling your work."

○ HYDE PARK SQUARE ART SHOW

P.O. Box 8402, Cincinnati OH 45208. **E-mail:** hpartshowinfo@aol.com. **Website:** www. hydeparksquare.org. Fine arts & crafts fair held annually in October. Outdoors. Accepts handmade crafts, ceramics, fiber, glass, jewelry, mixed media, 2D, painting, photography, and sculpture. Juried. Awards/prizes: Best of Show, 1st place, 2nd place, 3rd place, honorable mention. Number exhibitors: see website. Number attendees: see website. Free to public. Apply online. Deadline for entry: March. Application fee: $40. Space fee: $130. Exhibition space: see website. For more information, artists should email, call or visit website.

○ STAN HYWET HALL & GARDENS OHIO MART

714 N. Portage Path, Akron OH 44303. (330)315-3255. **E-mail:** ohiomart@stanhywet.org. **Website:** www.stanhywet.org. Estab. 1966. Artisan crafts show held annually 1st full weekend in October. Outdoors. Accepts photography and all mediums. Juried via mail application. Awards/prizes: Best Booth Display. Number of exhibitors: 150. Public attendance: 15,000-20,000. Deadline varies. Application fee: $25, non-refundable. Application available online. Exhibition space: 10×10 or 10×15 ft. For more information, artists should visit website or call.

○ IMAGES—A FESTIVAL OF THE ARTS

386-423-4733. **E-mail:** images@imagesartfestival. org. **Website:** www.imagesartfestival.org. Fine arts & crafts fair held annually in January. Outdoors. Accepts handmade crafts, ceramics, fiber, glass, jewelry, mixed media, 2D, painting, photography, and sculpture. Juried. Awards/prizes: $100,000 in awards and prizes. Number exhibitors: 225. Number attendees:

45,000. Free to public. Apply online. Deadline for entry: October. Application fee: $40. Space fee: $250. Exhibition space: 11×12. For more information, artists should e-mail, call or visit website.

○ INDIANA ART FAIR

650 W. Washington St., Indianapolis IN 46204. (317)233-9348. **Fax:** (317)233-8268. **E-mail:** cmiller@indianamuseum.org. **Website:** www.indianamuseum. org. Estab. 2004. Annual art/craft show held the 2nd weekend of February. Indoors. Juried; 5-6 judges award points in 3 categories. 60 exhibitors; 3,000 attendees. $13 admission for the public. Application fee $25. Space fee $165; 80 sq. ft. Accepts ceramics, glass, fiber, jewelry, painting, sculpture, mixed media, drawing/pastels, garden, leather, surface decoration, wood, metal, printmaking, and photography.

TIPS "Make sure that your booth space complements your product and presents well. Good photography can be key for juried shows."

○ INDIAN WELLS ARTS FESTIVAL

78-200 Miles Ave., Indian Wells CA 92210. (760)346-0042. **Fax:** (760)346-0042. **E-mail:** info@indianwellsartsfestival.com. **Website:** www. indianwellsartsfestival.com. **Contact:** Dianne Funk, producer. "A premier fine arts festival attracting thousands annually. The Indian Wells Arts Festival brings a splash of color to the beautiful grass concourse of the Indian Wells Tennis Garden. This spectacular venue transforms into an artisan village featuring 200 judged and juried artists and hundreds of pieces of one-of-a-kind artwork available for sale. Enjoy special exhibits and demonstrations. Watch glass blowing, monumental rock sculpting, wood carving, pottery wheel, weaving and painting. Wine tasting, gourmet market, children's activities, entertainment and refreshments add to the festival atmosphere." Apply online at indianwellsartsfestival. com/artists.html. See website for more information.

INDIE SOUTH FAIR

660 N. Chase St., Athens GA 30601. **E-mail:** indiesouthfair@gmail.com. **Website:** www. indiesouthfair.com. **Contact:** Serra Ferguson, organizer. Estab. 2007. Arts & Crafts show held semiannually the 1st weekends of May & December. Outdoors. Accepts handmade crafts and all other mediums. Exhibitors: 100. Number of attendees: 5,000. Free to public. Apply via website. Deadline

for entry: March for spring show; September 28 for holiday market. Application fee: $15. Space fee: $175 (10×10). Exhibition space: 10×10. Average sales: $800-1,200. For more information send e-mail. Arts & Crafts show held semiannually the 1st weekends of May & December. Outdoors. Accepts handmade crafts and all other mediums. Exhibitors: 100. Number of attendees: 3,000. Free to public. Apply via website. Deadline for entry: March for spring show; September 28 for holiday market. Application fee: $15. Space fee: $175 (10×10); $90 (6×4). Exhibition space: 10×10; 6×4. Average sales: $800-1,200. For more information send e-mail.

TIPS "Create beautiful and functional art, present it well, and have a friendly, outgoing demeanor."

INTERNATIONAL FOLK FESTIVAL

Arts Council Fayetteville/Cumberland County, 301 Hay St., Fayetteville NC 28301. (910)323-1776. **Fax:** (910)323-1727. **E-mail:** bobp@theartscouncil.com. **Website:** www.theartscouncil.com. Estab. 1978. Fine arts & crafts show held annually the last weekend in September. Outdoors. Accepts photography, painting of all mediums, pottery, woodworking, sculptures. Work must be original. Number of exhibitors: 120+. Public attendance: 85,000-100,000 over 2 days. Free to public. Artists should apply on the website. Exhibition space: 10×10 ft. For more information, artists should e-mail or visit website. Festival held in Festival Park/downtown Fayetteville.

TIPS "Have reasonable prices."

ISLE OF EIGHT FLAGS SHRIMP FESTIVAL

P.O. Box 17251, Fernandina Beach FL 32035. (904)701-2786 or 904-261-7020. **Website:** www.islandart.org. Estab. 1963. Fine arts & crafts show and community celebration held annually the 1st weekend in May. Outdoors. Accepts all mediums. Juried. Awards: $9,000 in cash prizes. Number of exhibitors: 300. Public attendance: 150,000. Free to public. Artists should apply by downloading application from website. Slides are not accepted. Digital images in JPEG format only must be submitted on a CD/DVD with application. Deadline for entry: January 31. Application fee: $30 (non-refundable). Space fee: $225. Exhibition space: 10×12 ft. Average gross sales/exhibitor: $1,500+. For more information, artists should visit website.

JOHNS HOPKINS UNIVERSITY SPRING FAIR

3400 N. Charles St., Mattin Suite 210, Baltimore MD 21218. (410)516-7692. **Fax:** (410)516-6185. **E-mail:** springfair@gmail.com. **Website:** www.jhuspringfair.com. Estab. 1972. Fine arts & crafts, campus-wide festival held annually in April. Outdoors. Accepts photography and all mediums. Juried. Number of exhibitors: 80. Public attendance: 20,000+. Free to public. Artists should apply via website. Deadline for entry: early March. Application and space fee: $200. Exhibition space: 10×10 ft. For more information, artists should e-mail, call or visit website. Fair located on Johns Hopkins Homewood Campus.

TIPS "Artists should have fun displays, good prices, good variety and quality pieces."

JUBILEE FESTIVAL

Eastern Shore Chamber of Commerce, Olde Towne Daphne, P.O. Drawer 310, Daphne AL 36526. (251)621-8222 or (251)928-6387. **Fax:** (251)621-8001. **E-mail:** lroberts@eschamber.com; office@eschamber.com. **Website:** www.eschamber.com. **Contact:** Liz R. Thomson. Estab. 1952. Fine arts & crafts show held in late September in Olde Towne of Daphne AL. Outdoors. Accepts photography and fine arts and crafts. Juried. Awards/prizes: ribbons and cash prizes total $4,300 with Best of Show $750. Number of exhibitors: 258. Free to the public. Jury fee: $20. Space fee: $100 for single; $200 for double. Exhibition space: 10×10 ft. or 10×20 ft. For more information, and application form, artists should e-mail, call, see website. Festival located in "Olde Towne" Daphne on Main St.

KALAMAZOO INSTITUTE OF ARTS FAIR

Kalamazoo Institute of Arts, 314 S. Park St., Kalamazoo MI 49007. (269)349-7775. **Fax:** (269)349-9313. **E-mail:** joeb@kiarts.org. **Website:** www.kiarts.org/artfair. **Contact:** Joe Bower. Estab. 1951. Fine jurored art fair held annually in June. Outdoors. "The KIA's annual art fair has been going strong for 64 years. Still staged in shady, historic Bronson Park, the fair boasts more hours, more artists and more activities. It now spans 2 full days. The art fair provides patrons with more time to visit and artists with an insurance day in case of rain. Some 190 artists will be invited to set up colorful booths. Numerous festivities are planned, including public art activities, musical performances, a beer garden and an artist dinner. For more infor-

mation, visit www.kiarts.org/artfair." Apply via www.zapplication.org. Application fee: $30. Booth fee: $275.

KENTUCK FESTIVAL OF THE ARTS

503 Main Ave., Northport AL 35476. (205)758-1257. **Fax:** (205)758-1258. **E-mail:** kentuck@kentuck.org. **Website:** www.kentuck.org. **Contact:** Amy Echols, executive director. Call or e-mail for more information. General information about the festival available on the website. "Celebrates a variety of artistic styles ranging from folk to contemporary arts as well as traditional crafts. Each of the 250+ artists participating in the festival is either invited as a guest artist or is juried based on the quality and originality of their work. The guest artists are nationally recognized folk and visionary artists whose powerful visual images continue to capture national and international acclaim." Festival held at Kentuck Park.

KETNER'S MILL COUNTY ARTS FAIR

P.O. Box 322, Lookout Mountain TN 37350. (423)267-5702. **E-mail:** contact@ketnersmill.org. **Website:** www.ketnersmill.org. **Contact:** Dee Nash, event coordinator. Estab. 1977. Arts & crafts show held annually the 3rd weekend in October held on the grounds of the historic Ketner's Mills, in Whitwell TN, and the banks of the Sequatchie River. Outdoors. Accepts photography, painting, prints, dolls, fiber arts, baskets, folk art, wood crafts, jewelry, musical instruments, sculpture, pottery, glass. Juried. Number of exhibitors: 170. Number of attendees: 10,000/day, depending on weather. Artists should apply online. Space fee: $125. Electricity: $10 limited to light use. Exhibition space: 15×15 ft. Average gross sales/exhibitor: $1,500. Fair held at Ketner's Mill.

TIPS "Display your best and most expensive work, framed. But also have smaller unframed items to sell. Never underestimate a show: Someone may come forward and buy a large item."

KEY BISCAYNE ART FESTIVAL

270 Central Blvd., Suite 107B, Jupiter FL 33458. (561)746-6615. **Fax:** (561)746-6528. **E-mail:** info@artfestival.com. **Website:** www.artfestival.com. **Contact:** Malinda Ratliff, communications manager. Estab. 1964. Fine art & craft fair held annually in March. Outdoors. Accepts photography, jewelry, mixed media, sculpture, wood, ceramic, glass, painting, digital, fiber, metal. Juried. Number exhibitors: 125. Number attendees: 50,000. Free to public. Apply

online via www.zapplication.org. Deadline: see website. Application fee: $25. Space fee: $395. Exhibition space: 10×10 and 10×20. For more information, artists should e-mail, call, or visit website. Festival located at Village Green Park in Key Biscayne, FL.

TIPS "You have to start somewhere. First, assess where you are, and what you'll need to get things off the ground. Next, make a plan of action. Outdoor street art shows are a great way to begin your career and lifetime as a working artist. You'll meet a lot of other artists who have been where you are now. Network with them!"

KINGS DRIVE ART WALK

Festival in the Park, Little Sugar Creek Greenway, 600 South Kings Drive, Charlotte NC 28203. (704)338-1060. **E-mail:** festival@festivalinthepark.org. **E-mail:** festival@festivalinthepark.org. **Website:** www.festivalinthepark.org. **Contact:** Julie Whitney Austin, executive director. Estab. 1964. Fine art & craft show held annually the first weekend of May. Outdoors. Accepts photography. Juried. Number of exhibitors: 85. Public attendance: 35,000+. Free to public. Artists should apply online at www.festivalinthepark.org/kingsdrive.asp. Deadline for entry: March 1. Application fee: $25. Space fee: $235. Exhibition space: 10×10 ft. For more information, artists should e-mail, call or visit website.

KINGS MOUNTAIN ART FAIR

13106 Skyline Blvd., Woodside CA 94062. (650)851-2710. **E-mail:** kmafsecty@aol.com. **Website:** www.kingsmountainartfair.org. **Contact:** Carrie German, administrative assistant. Estab. 1963. Fine arts & crafts show held annually Labor Day weekend. Fundraiser for volunteer fire dept. Accepts photography, ceramics, clothing, 2D, painting, glass, jewelry, leather, sculpture, textile/fiber, wood. Juried. Number of exhibitors: 138. Public attendance: 10,000. Free to public. Deadline for entry: January 30. Application fee: $20 (online). Exhibition space: 10×10 ft. Average gross sales/exhibitor: $3,500. For more information, artists should e-mail or visit website.

TIPS "Located in Redwood Forest South of San Francisco. Keep an open mind and be flexible."

KPFA WINTER CRAFTS FAIR

1929 MLK Jr. Way, Berkeley CA 94704. (510)848-6767, ext. 243. **E-mail:** jan@kpfa.org. **Website:** www.kpfa.org/craftsfair/winter. **Contact:** Jan Etre, coordinator.

Estab. 1970. Fine arts & crafts fair held annually in December. Indoors. Accepts handmade crafts, ceramics, fiber, glass, jewelry, mixed media, 2D, painting, photography, and sculpture. Juried. Number exhibitors: 200. Number attendees: see website. Admission: $12; disabled, 65+: $8, and children under 17 free. Apply online. Deadline for entry: see website. Application fee: $25. Space fee: varies. Exhibition space: 10x6, 10×10. For more information, artists should e-mail, call or visit website.

🎧 Show located at: Craneway Pavilion at the Richmond Waterfront, 1414 Harbour Way S., Richmond, CA 94804

🎧 KRASL ART FAIR ON THE BLUFF

707 Lake Blvd., St. Joseph MI 49085. (269)983-0271. **Fax:** (269)983-0275. **E-mail:** info1@krasl.org. **Website:** www.krasl.org. **Contact:** Julia Gourley. Estab. 1962. Fine arts & fine craft show held annually the 2nd weekend of July (see website for details). Outdoors. Accepts art in 19 media categories including photography, painting (oils, acrylics & watercolors), digital art, drawing, pastels, fibers (wearable and decorative), clay (functional and nonfunctional), glass, jewelry (precious and nonprecious), sculpture, printmaking and graphics, metals (mixed media 2D and 3D) and woods. Number of exhibitors: 200. Number of attendees: thousands. Free to public. Application fee: $30. Applications are available online through www.zapplication.org. Deadline for entry: early January. There is on-site jurying the same day of the fair and approximately 30% are invited back without having to pay the $30 application fee. Space fee: $275. Exhibition space: 10×10 to 15×15 ft. or $300 for 20×20 ft. (limited). "Krasl Art Fair on the Bluff is ranked: #10 in the *Sunshine Artist Magazine's* 200 Best for 2014; #8 on the Art Fair Calendar's new Best Art Shows List from their 2014 survey; #48 in the *Art Fair Source Book's* Top 100 shows." For more information, artists should e-mail or visit website.

🎧 LAKE CITY ARTS & CRAFTS FESTIVAL

P.O. Box 1147, Lake City CO 81235. (817)343-3305. **E-mail:** info@lakecityarts.org; kerrycoy@aol.com. **Website:** www.lakecityarts.org. Estab. 1975. Fine arts/arts & craft show held annually 3rd Tuesday in July. One-day event. Outdoors. Accepts photography, jewelry, metal work, woodworking, painting, handmade items. Juried by 3-5 undisclosed jurors. Prize: Winners are entered in a drawing for a free booth space in the fol-

lowing year's show. Number of exhibitors: 85. Public attendance: 500. Free to the public. Space fee: $85. Jury fee: $10. Exhibition space: 12×12 ft. Deadline for submission: mid April. Average gross sales/exhibitor: $500-$1,000. For more information, and application form, artists should visit website. Festival located at the Lake City Town Park and along Silver St.

TIPS "Repeat vendors draw repeat customers. People like to see their favorite vendors each year or every other year. If you come every year, have new things as well as your best-selling products."

🎧 LAKEFRONT FESTIVAL OF ART

700 N. Art Museum Dr., Milwaukee WI 53202. (414)224-3853. **E-mail:** lfoa@mam.org. **Website:** www.mam.org/lfoa. **Contact:** Krista Renfrew, festival director. Estab. 1963. Fine art show held annually the 3rd week in June. Indoors & outdoors. Accepts printmaking, sculpture, wood, painting, jewelry, ceramics, digital, drawing/pastel, MM2, fiber-non, wearable fiber, glass, photography, metal, NM. Juried. Awards/prizes: Artist Awards (10), Honorable Mention (10), Sculpture Garden. Exhibitors: 176. Number of attendees: 25,000. Admission: $17 general; $10 members & advance; 12 & under free. Apply via www.zapplication.org. Deadline for entry: November 25. Application fee: $35. Space fee: $500; $600 corner. Exhibition space: 10×10. For more information send e-mail or visit website.

🎧 LAKELAND CRAFT FESTIVAL, THE

270 Central Blvd., Suite 107B, Jupiter FL 33458. (561)746-6615. **Fax:** (561)746-6528. **E-mail:** info@artfestival.com. **Website:** www.artfestival.com. **Contact:** Malinda Ratliff, communications manager. Estab. 2013. Fine art & craft fair held annually in late March. Outdoors. Accepts photography, jewelry, mixed media, sculpture, wood, ceramic, glass, painting, digital, fiber, metal. Juried. Number exhibitors: 110. Number attendees: 18,000. Free to public. Apply online via www.zapplication.org or visit website for paper application. Deadline: see website. Application fee: $15. Space fee: $250. Exhibition space: 10×10 and 10×20. For more information, artists should e-mail, call or visit website. Festival located at Lakeside Village in Lakeland, FL.

TIPS "You have to start somewhere. First, assess where you are, and what you'll need to get things off the ground. Next, make a plan of action. Outdoor street art shows are a great way to begin your career

and lifetime as a working artist. You'll meet a lot of other artists who have been where you are now. Network with them!"

LAKE ST LOUIS FARMERS AND ARTISTS MARKET

P.O. Box 91, Warrenton MO 63383-0091. (314)495-2531. **E-mail:** lakestlouisfarmersmarket@gmail.com. **Website:** www.themeadowsatlsl.com. Farmer & craft market held annually every Saturday, April-October. Outoors. Accepts handmade crafts, jewelry, art, pottery, soap, candles, clothing, wood crafts and other crafts. Exhibitors: varies. Number of attendees: varies. Free to public. Apply online. Deadline for entry: see website. Application fee: none. Space fee: $325 (full season); $25 (daily vendor). Exhibition space: 10×10. For more information, artists should send e-mail, visit website, or call. Farmer & craft market held annually every Saturday, April-October. Outdoors. Accepts handmade crafts, jewelry, art, pottery, soap, candles, clothing, woodcrafts, and other crafts. Exhibitors: varies. Number of attendees: varies. Free to public. Apply online. Deadline for entry: see website. Application fee: none. Space fee: $325 (full season); $25 (daily vendor). Exhibition space: 10×10. For more information, artists should send e-mail, visit website, or call.

LAKE SUMTER ART & CRAFT FESTIVAL

270 Central Blvd., Suite 107B, Jupiter FL 33458. (561)746-6615. **Fax:** (561)746-6528. **E-mail:** info@artfestival.com. **Website:** www.artfestival.com. **Contact:** Malinda Ratliff, communications manager. Estab. 2010. Fine art & craft fair held annually in mid February. Outdoors. Accepts photography, jewelry, mixed media, sculpture, wood, ceramic, glass, painting, digital, fiber, metal. Juried. Number exhibitors: 205. Number attendees: 20,000. Free to public. Apply online via www.zapplication.org or visit website for paper application. Deadline: see website. Application fee: $15. Space fee: $265. Exhibition space: 10×10 and 10×20. For more information, artists should e-mail, call, or visit website. Festival located at Lake Sumter Landing in The Villages, FL.

TIPS "You have to start somewhere. First, assess where you are, and what you'll need to get things off the ground. Next, make a plan of action. Outdoor street art shows are a great way to begin your career and lifetime as a working artist. You'll meet a lot of other artists who have been where you are now. Network with them!"

LA QUINTA ARTS FESTIVAL

78150 Calle Tampico #215, La Quinta CA 92253. (760)564-1244. **Fax:** (760)564-6884. **E-mail:** helpline@lqaf.com. **Website:** www.lqaf.com. **Contact:** artists: Kathleen Hughes, events manager; photographers: Christi Salamone, executive director. Estab. 1983. Fine arts & crafts festival held annually. Outdoors. Accepts mixed-media 2D/3D, printmaking, photography, drawing and pastel, painting, jewelry, ceramics, fiber, sculpture, glass, wood. Juried over 3 days online by 5 jury members per each of the 11 media categories. Awards/prizes: cash, automatic acceptance into future show, gift cards from premier local restaurants, hotel package, ad in *SW Art*. Number of exhibitors: 230. Public attendance: 28,000+. Admission: $15-day pass; $20 multiday pass. Artists should apply via www.zapplication.org only. Deadline for entry: September 30. Jury fee: $50. Space fee: $275. Exhibition space: 12×12 ft. Average exhibitor sales: $13,450. For more information, artists should visit website.

TIPS "Make sure that booth image looks like an art gallery! Less is more."

LAS OLAS ART FAIR

270 Central Blvd., Suite 107B, Jupiter FL 33458. (561)746-6615. **Fax:** (561)746-6528. **E-mail:** info@artfestival.com. **Website:** www.artfestival.com. **Contact:** Malinda Ratliff, communications manager. Fine art & craft fair held annually in January, March, and mid-October. Outdoors. Accepts photography, jewelry, mixed media, sculpture, wood, ceramic, glass, painting, digital, fiber, metal. Juried. Number exhibitors: 280/January, 260/March, 150/October. Number attendees: 100,000/January, 100,000/March, 70,000/October. Free to public. Apply online via www.zapplication.org. Deadline: see website. Application fee: $25. Space fee: $400/January, $400/March, $395/October. Exhibition space: 10×10 and 10×20. For more information, artists should e-mail, call or visit website. Fair located on Las Olas Blvd. in Ft. Lauderdale, FL.

TIPS "You have to start somewhere. First, assess where you are, and what you'll need to get things off the ground. Next, make a plan of action. Outdoor street art shows are a great way to begin your career and lifetime as a working artist. You'll meet a lot of other artists who have been where you are now. Network with them!"

○ LEAGUE OF NH CRAFTSMEN ANNUAL FAIR

League of NH Craftsmen, 49 S. Main St., Suite 100, Concord NH 03301-5080. (603)224-3375. **Fax:** (603)225-8452. **E-mail:** twiltse@nhcrafts.org. **Website:** www.nhcrafts.org/craftsmens-fair-overview.php. **Contact:** Susie Lowe-Stockwell, executive director. The Lansdowne Arts Festival is a weekend-long event featuring an array of creative and performing arts, including painting, crafts, sculpture, jewelry, live music, demonstrations, and children's events. Set in the historic suburb of Lansdowne, Pennsylvania, the festival has grown to include dozens of exhibiting artists and musical acts. All festival events will be held at the historic Twentieth Century Club at 84 S. Lansdowne Ave. See website for more information.

○ LEEPER PARK ART FAIR

22180 Sundancer Court, #504, Estero FL 33928. (574)276-2942. **E-mail:** Studio266@aol.com. **Website:** www.leeperparkartfair.org. **Contact:** Judy Ladd, director. Estab. 1968. Fine arts & crafts show held annually in June. Outdoors. Accepts photography and all areas of fine art. Juried. Awards/prizes: $3,700. Number of exhibitors: 120. Public attendance: 10,000. Free to public. Artists should apply by going to the website and clicking on "To Apply." Deadline for entry: early March. Space fee: $340. Exhibition space: 12×12 ft. Average gross sales/exhibitor: $5,000. For more information, artists should e-mail, call or visit website.

TIPS "Make sure your booth display is well presented and, when applying, slides are top notch!"

○ LEESBURG FINE ART FESTIVAL

Paragon Fine Art Festivals, 8258 Midnight Pass Rd., Sarasota FL 34242. (941)487-8061. **Fax:** (941)346-0302. **E-mail:** admin@paragonartfest.com; spadagraphix@yahoo.com. **Website:** www.paragonartevents.com/lee. **Contact:** Bill Kinney. Fine arts & crafts fair held annually in September. Outdoors. Accepts handmade crafts, ceramics, fiber, glass, jewelry, mixed media, painting, photography, and sculpture. Juried. Number exhibitors: 115. Number attendees: varies. Free to public. Apply online. Deadline for entry: July. Application fee: $30. Space fee: $395. Exhibition space: see website. For more information, artists should e-mail, call or visit website.

○ LES CHENEAUX FESTIVAL OF ARTS

P.O. Box 147, Cedarville MI 49719. (517)282-4950. **E-mail:** lcifoa@gmail.com. **Website:** www.lescheneaux.net/?annualevents. **Contact:** Rick Sapero. Estab. 1976. Fine arts & crafts show held annually 2nd Saturday in August. Outdoors. Accepts photography and all other media; original work and design only; no kits or commercially manufactured goods. Juried by a committee of 10. Submit 4 slides (3 of the artwork; 1 of booth display). Awards: monetary prizes for excellent and original work. Number of exhibitors: 70. Public attendance: 8,000. Public admission: $7. Artists should fill out application form to apply. Deadline for entry: March 15. Booth fee: $75; Jury fee: $5. Exhibition space: 10×10 ft. Average gross sales/exhibitor: $5-500. For more information, artists should call, send SASE, or visit website.

○ LEVIS COMMONS FINE ART FAIR

The Guild of Artists & Artisans, 118 N. Fourth Ave., Ann Arbor MI 48104. (734)662-3382, ext. 101. **E-mail:** info@theguild.org; nicole@theguild.org. **Website:** www.theguild.org. **Contact:** Nicole McKay, artist relations director. Fine arts & crafts fair held annually in September. Outdoors. Accepts handmade crafts, jewelry, ceramics, painting, glass, photography, fiber, and more. Juried. Number exhibitors: 130. Number attendees: 35,000. Free to public. Apply online. Deadline for entry: April. Application fee: $25 members; $30 non-members. Space fee: varies. Exhibition space: varies. For more information, artists should email, call or visit website.

○ LEWISTON ART FESTIVAL

P.O. Box 1, Lewiston NY 14092. (716)754-0166. **Fax:** (716)754-9166. **E-mail:** director@artcouncil.org. **Website:** www.artcouncil.org. **Contact:** Irene Rykaszewski, Executive Director. Arts & crafts show held annually in August. Outdoors. Accepts handmade crafts, drawing, printmaking, computer-generated art, 2D/3D mixed media, photography, ceramics, fiber, glass, jewelry, sculpture, wood. Juried. Exhibitors: 175. Number of attendees: 35,000. Free to public. Apply online. Deadline for entry: early May. Application fee: $15. Space fee: $175. Exhibition space: 10×10. For more information, artists should send e-mail, visit website. Arts & crafts show held annually in August. Outdoors. Accepts handmade crafts, drawing, printmaking, computer-generated art, 2D/3D mixed media, photography, ceramics, fiber, glass, jewelry, sculp-

ART FAIRS

ture, wood. Juried. Exhibitors: 175. Number of attendees: 35,000. Free to public. Apply online. Deadline for entry: early May. Application fee: $15. Space fee: $175. Exhibition space: 10×10. For more information, artists should send e-mail, visit website.

LIBERTY ARTS SQUARED

P.O. Box 302, Liberty MO 64069. **E-mail:** staff@libertyartssquared.org. **Website:** www. libertyartssquared.org. Estab. 2010. Outdoor fine art/craft show held annually. Accepts all mediums. Awards: prizes totaling $4,000; Visual Arts for Awards $1,500; Folk Art for Awards $1,500; Overall Best of Show Award $500. Free admission to the public; free parking. Application fee: $25. Space fee: $200. Exhibition space: 10×10 ft. For more information, e-mail or visit website.

LILAC FESTIVAL ARTS & CRAFTS SHOWS

26 Goodman St., Rochester NY 14607. (585)244-0951 or (585)473-4482. **E-mail:** lyn@rochesterevents.com. **Website:** www.rochesterevents.com. Estab. 1985. Arts & crafts shows held annually in mid-May (see website for details). Outdoors. Accepts photography, painting, ceramics, woodworking, metal sculpture, fiber. Juried by a panel. Number of exhibitors: 120. Public attendance: 25,000. Free to public. Exhibition space: 10×10 ft. Space fee: $200. For more information, and to apply, artists should e-mail or visit website. Festival held at Highland Park in Rochester NY.

LINCOLN ARTS FESTIVAL

(402)434-2787. **E-mail:** lori@artscene.org. **Website:** artscene.org/events/lincoln-arts-festival/. Fine arts & crafts fair held annually in September. Outdoors. Accepts handmade crafts, jewelry, ceramics, painting, glass, photography, fiber, and more. Juried. Awards/prizes: $6,000 in awards & prizes. Number exhibitors: see website. Number attendees: varies. Free to public. Apply online. Deadline for entry: May. Application fee: $25. Space fee: $190 (10×10); $310 (10×20). Exhibition space: 10×10; 10×20. For more information, artists should e-mail or visit website.

LINCOLNSHIRE ART FESTIVAL

Amdur Productions, P.O. Box 550, Highland Park IL 60035. (847)926-4300. **Fax:** (847)926-4330. **E-mail:** info@amdurproductions.com. **Website:** www. amdurproductions.com. Fine arts & crafts fair held annually in August. Outdoors. Accepts handmade crafts, jewelry, ceramics, painting, glass, photography, fiber, and more. Juried. Awards/prizes: given at festival. Number exhibitors: 130. Number attendees: 30,000. Free to public. Apply online. Deadline for entry: January. Application fee: $25. Space fee: $430. Exhibition space: 10×10. For more information, artists should e-mail or visit website.

LIONS CLUB ARTS & CRAFTS FESTIVAL

Henderson Lions Club, P.O. Box 842, Henderson KY 42419. **E-mail:** lionsartsandcrafts@gmail.com. **Website:** www.lionsartsandcrafts.com. Estab. 1972. Formerly Gradd Arts & Crafts Festival. Arts & crafts show held annually 1st full weekend in October. Outdoors. Accepts photography taken by crafter only. Number of exhibitors: 100-150. Public attendance: 10,000+. Artists should apply by calling to be put on mailing list. Space fee: $100. Exhibition space: 15×15 ft. For more information, artists should e-mail, visit website, or call. Festival located at John James Audubon State Park.

TIPS "Be sure that only hand-crafted items are sold. No buy/sell items will be allowed."

LOMPOC FLOWER FESTIVAL

414 W. Ocean Ave., Lompoc CA 93436. (805)735-8511. **Fax:** (805)7359228. **E-mail:** lompocvalle1@ verizon.net. **Website:** lompocvalleyartassociation. com/. **Contact:** Kathy Badrak. Estab. 1942. Sponsored by Lompoc Valley Art Association, Cyprus Gallery. Show held annually last week in June. Festival event includes a parade, food booths, entertainment, beer garden and commercial center, which is not located near arts & crafts area. Outdoors. Accepts photography, fine art, woodworking, pottery, stained glass, fine jewelry. Juried by 5 members of the LVAA. Vendor must submit 3 photos of their work and a description on how they make their art. Artists should apply by downloading application from website. Deadline for entry: early May. Space fee: $375 (single); $575 (double); $100 cleaning deposit (to be refunded after show-see application for details). Exhibition space: 12×16 ft. For more information, artists should visit website.

LONG'S PARK ART & CRAFT FESTIVAL

Long's Park Amphitheater Foundation, 630 Janet Ave., Suite A-111, Lancaster PA 17601-4541. (717)735-8883. **Website:** www.longspark.org. Fine arts & crafts fair held annually Labor Day weekend. Outdoors. Accepts

handmade crafts, jewelry, ceramics, painting, glass, photography, fiber, and more. Juried. Number exhibitors: 200. Number attendees: varies. Admission: see website. Apply online. Deadline for entry: February. Application fee: see website. Space fee: $510 (single); $645 (double). Exhibition space: 10×10 (single); 10×20 (double) . For more information, artists should call or visit website.

🎧 LOUISVILLE FESTIVAL OF THE ARTS WITH CRAFT MARKETPLACE AT PADDOCK SHOPS

270 Central Blvd., Suite 107B, Jupiter FL 33458. (561)746-6615. **Fax:** (561)746-6528. **E-mail:** info@artfestival.com. **Website:** www.artfestival.com. **Contact:** Malinda Ratliff, communications manager. Estab. 2008. Fine art & craft fair held annually in mid-June. Outdoors. Accepts photography, jewelry, mixed media, sculpture, wood, ceramic, glass, painting, digital, fiber, metal. Juried. Number exhibitors: 130. Number attendees: 50,000. Free to public. Apply online via www.zapplication.org. Deadline: see website. Application fee: $25. Space fee: $375. Exhibition space: 10×10 and 10×20. For more information, artists should e-mail, call or visit website. Show located at Paddock Shops on Summit Plaza Dr. in Louisville, KY.

TIPS "You have to start somewhere. First, assess where you are, and what you'll need to get things off the ground. Next, make a plan of action. Outdoor street art shows are a great way to begin your career and lifetime as a working artist. You'll meet a lot of other artists who have been where you are now. Network with them!"

🎧 LUTZ ARTS & CRAFTS FESTIVAL

18105 Gunn Hwy, Odessa FL 33556. Estab. 1979. Fine arts & crafts show held annually in December in Odessa, FL. Outdoor and indoor spaces available. Accepts fine arts, jewelry, painting, photography, sculpture, crafts. Juried. Number of exhibitors: 250+. Public attendance: 35,000. Admission fee: $3 per car (for parking). Deadline for entry: September 1 or until category is full. Exhibition space: 12×12 ft. For more information, artists should e-mail fsincich@gmail.com or call. Festival takes place at Lake Park.

🎧 MADEIRA BEACH THANKSGIVING WEEKEND CRAFT FESTIVAL

270 Central Blvd., Suite 107B, Jupiter FL 33458. (561)746-6615. **Fax:** (561)746-6528. **E-mail:** info@artfestival.com. **Website:** www.artfestival.com.

Contact: Malinda Ratliff, communications manager. Estab. 2012. Fine art & craft fair held annually in November. Outdoors. Accepts photography, jewelry, mixed media, sculpture, wood, ceramic, glass, painting, digital, fiber, metal. Juried. Number exhibitors: 80. Number attendees: 13,000. Free to public. Apply online via www.zapplication.org or visit website for paper application. Deadline: see website. Application fee: $15. Space fee: $250. Exhibition space: 10×10 and 10×20. For more information, artists should e-mail, call, or visit website. Festival located at Madeira Way between Gulf Blvd. & 150th Ave.

TIPS "You have to start somewhere. First, assess where you are, and what you'll need to get things off the ground. Next, make a plan of action. Outdoor street art shows are a great way to begin your career and lifetime as a working artist. You'll meet a lot of other artists who have been where you are now. Network with them!"

🎧 MADISON CHAUTAUQUA FESTIVAL OF ART

601 W. First St., Madison IN 47250. (812)571-2752. **Fax:** (812)273-3694. **E-mail:** info@madisonchautauqua.com. **Website:** www.madisonchautauqua.com. **Contact:** Amy Fischmer and Jenny Youngblood, coordinators. Estab. 1971. Premier juried fine arts & crafts show, featuring painting, photography, stained glass, jewelry, textiles pottery and more, amid the tree-lined streets of Madison's historic district. Held annually the last weekend in September. Stop by the Riverfront FoodFest for a variety of foods to enjoy. Relax and listen to the live performances on the Lanier Mansion lawn, on the plaza and along the riverfront. Takes place in late September. Painting (2D artists may sell prints, but must include originals as well), photography, pottery, sculpture, wearable, jewelry, fiber, wood, baskets, glass, paper, leather. The number of artists in each category is limited to protect the integrity of the show. Festival held in Madison's National Landmark Historic District.

🎧 MAGNOLIA BLOSSOM FESTIVAL

Magnolia/Columbia County Chamber of Commerce, P.O. Box 866, Magnolia AR 71754. (870)901-2216, (870)693-5265, or 870-234-4352. **E-mail:** jpate006@centurytel.net; jpate002@centurytel.net. **Website:** www.blossomfestival.org. Craft show held annually in May. Outdoors. Accepts handmade crafts, ceramics, paintings, jewelry, glass, photography, wearable

art, and other mediums. Juried. Number exhibitors: see website. Number attendees: varies. Free to public. Apply online. Deadline for entry: late March. Application fee: none. Space fee: varies. Exhibition space: varies. For more information, artists should e-mail, call or visit website.

MAINSAIL ARTS FESTIVAL

E-mail: artist@mainsailart.org. **Website:** www.mainsailart.org. Fine arts & crafts fair held annually in April. Outdoors. Accepts handmade crafts, ceramics, digital art, fibers, glass, graphics, jewelry, metal, mixed media, oil/acrylic, photography, sculpture, watercolor, and wood . Juried. Awards/prizes: $60,000 in cash awards. Number exhibitors: 270. Number attendees: 100,000. Free to public. Apply online. Deadline for entry: December. Application fee: $35. Space fee: $275. Exhibition space: 10×10. For more information, artists should e-mail or visit website.

MAIN STREET TO THE ROCKIES ART FESTIVAL

270 Central Blvd., Suite 107B, Jupiter FL 33458. (561)746-6615. **Fax:** (561)746-6528. **E-mail:** info@artfestival.com. **Website:** www.artfestival.com. **Contact:** Malinda Ratliff, communications manager. Estab. 2007. Fine art & craft fair held annually in mid-August. Outdoors. Accepts photography, jewelry, mixed media, sculpture, wood, ceramic, glass, painting, digital, fiber, metal. Juried. Number exhibitors: 100. Number attendees: 60,000. Free to public. Apply online via www.zapplication.org. Deadline: see website. Application fee: $35. Space fee: $475. Exhibition space: 10×10 and 10×20. For more information, artists should e-mail, call, or visit website. Festival located at Main St. in Downtown Frisco, CO.

TIPS "You have to start somewhere. First, assess where you are, and what you'll need to get things off the ground. Next, make a plan of action. Outdoor street art shows are a great way to begin your career and lifetime as a working artist. You'll meet a lot of other artists who have been where you are now. Network with them!"

MANAYUNK ARTS FESTIVAL

4312 Main St., Philadelphia PA 19127. (215)482-9565. **E-mail:** info@manayunk.org; cmaloney@manayunk.org. **Website:** manayunk.com/signature-events/manayunk-arts-festival/. **Contact:** Caitlin Maloney, director of marketing & events. Estab. 1990. Arts &

craft show held annually late June. Outdoors. Accepts handmade crafts, fiber, glass, ceramics, jewelry, mixed media, painting, photography, wood, sculpture. Juried. Awards/prizes: Best in each category; Best in Show. Exhibitors: 300. Number of attendees: 200,000. Free to public. Apply via www.zapplication.org. Deadline for entry: March 1. Application fee: $30. Space fee: $450. Exhibition space: 10×10. Average sales: $2,000-7,000. For more information, e-mail or call.

TIPS "Displaying your work in a professional manner and offering items at a variety of price points always benefits the artist."

MARCO ISLAND FESTIVAL OF THE ARTS

270 Central Blvd., Suite 107B, Jupiter FL 33458. (561)746-6615. **Fax:** (561)746-6528. **E-mail:** info@artfestival.com. **Website:** www.artfestival.com. **Contact:** Malinda Ratliff, communications manager. Estab. 2014. Fine art & craft fair held annually in mid-March. Outdoors. Accepts photography, jewelry, mixed media, sculpture, wood, ceramic, glass, painting, digital, fiber, metal. Juried. Number exhibitors: 175. Number attendees: 40,000. Free to public. Apply online via www.zapplication.org. Deadline: see website. Application fee: $25. Space fee: $415. Exhibition space: 10×10 and 10×20. For more information, artists should e-mail, call, or visit website. Festival located at Veteran's Park off N. Collier Blvd. in Marco Island, FL.

TIPS "You have to start somewhere. First, assess where you are, and what you'll need to get things off the ground. Next, make a plan of action. Outdoor street art shows are a great way to begin your career and lifetime as a working artist. You'll meet a lot of other artists who have been where you are now. Network with them!"

MARION ARTS FESTIVAL

1225 Sixth Ave., Suite 100, Marion IA 52302. **E-mail:** mafdirector@marioncc.org. **Website:** www.marionartsfestival.com. Fine arts & crafts fair held annually in May. Outdoors. Accepts handmade crafts, jewelry, ceramics, painting, photography, digital, printmaking, and more. Juried. Awards/prizes: Best of Show, IDEA Award. Number exhibitors: 50. Number attendees: 14,000. Free to public. Apply via www.zapplication.org. Deadline for entry: January. Application fee: $25. Space fee: $225. Exhibition space: 10×10. For more information, artists should visit website.

MARSHFIELD ART FAIR

New Visions Gallery, 1000 N. Oak Ave., Marshfield WI 54449. (715)387-5562. **E-mail:** newvisions.gallery@ frontier.com. **Website:** www.newvisionsgallery. org. Share a Marshfield tradition with family and friends at this FREE community celebration of the arts, held each year on Mother's Day. Marshfield Art Fair offers a wide variety of fine art and craft by more than 100 Midwestern artists. Musicians and performers entertain throughout the day. Hands-On-Art activities are available for kids. See website for more information.

MASON ARTS FESTIVAL

Mason-Deerfield Arts Alliance, P.O. Box 381, Mason OH 45040. (513)309-8585. **E-mail:** masonarts@gmail. com; info@the-arts-alliance.org; mraffel@the-arts-alliance.org. **Website:** www.masonarts.org. Fine arts & crafts show held annually in mid-September (see website for details). Indoors and outdoors. Accepts photography, graphics, printmaking, mixed media; painting and drawing; ceramics, metal sculpture; fiber, glass, jewelry, wood, leather. Juried. Awards/ prizes: $3,000+. Number of exhibitors: 75-100. Public attendance: 3,000-5,000. Free to the public. Artists should apply by visiting website for application, e-mailing or calling. Deadline for entry: see website. Jury fee: $25. Space fee: $75. Exhibition space: 12×12 ft.; artist must provide 10×10 ft. pop-up tent.

City Gallery show is held indoors; these artists are not permitted to participate outdoors and vice versa. City Gallery is a juried show featuring approximately 30-50 artists who may show up to 2 pieces.

MCGREGOR SPRING ARTS & CRAFTS FESTIVAL

McGregor-Marquette Chamber of Commerce, P.O. Box 105, McGregor IA 52157. (800)896-0910 or (563)873-2186. **E-mail:** mcgregormarquettechamber@gmail.com. **Website:** www.mcgreg-marq.org. Fine arts & crafts fair held annually in May & October. Indoors & outdoors. Accepts handmade crafts, jewelry, ceramics, painting, photography, digital, printmaking, and more. Number exhibitors: see website. Number attendees: varies. Free to public. Apply via online. Deadline for entry: see website. Application fee: none. Space fee: $75 outdoor; $100 indoor. Exhibition space: 10×10. For more information, artists should e-mail, call, or visit website.

MEMORIAL WEEKEND ARTS & CRAFTS FESTIVAL

38 Charles St., Rochester NH 03867. (603)332-2616. **Fax:** (603)332-8413. **E-mail:** info@castleberryfairs. com. **Website:** www.castleberryfairs.com. **Contact:** Sherry Mullen. Estab. 1989. Arts & crafts show held annually on Memorial Day weekend in Meredith NH. Outdoors. Accepts photography and all other mediums. Juried by photo, slide or sample. Number of exhibitors: 85. Public attendance: 7,500. Free to the public. Artists should apply by downloading application from website. Deadline for entry: until full. Space fee: $225. Exhibition space: 10×10 ft. For more information, artists should visit website. Festival held at Mill Falls Marketplace.

TIPS "Do not bring a book; do not bring a chair. Smile and make eye contact with everyone who enters your booth. Have them sign your guest book; get their e-mail address so you can let them know when you are in the area again. And, finally, make the sale—they are at the fair to shop, after all."

MENDOTA SWEET CORN FESTIVAL CRAFTERS MARKET PLACE & FLEA MARKET

2016 Dates: August 11, 12,13,14, Mendota Area Chamber of Commerce, P.O. Box 620, Mendota IL 61342. (815)539-6507. **Fax:** (815)539-6025. **E-mail:** rfriedlein@mendotachamber.com. **Website:** www. sweetcornfestival.com. **Contact:** Roberta Friedlein, administrative assistant. Estab. 1979. Arts & crafts show held annually in August. Outdoors. Accepts handmade crafts, fine art, antiques, flea market items. Exhibitors: 200. Number of attendees: 55,000. Free to public. Apply by calling or sending e-mail. Deadline for entry: until full. Application fee: none. Space fee: $70. Exhibition space: 10×10. For more information send e-mail, call, or visit website.

MESA ARTS FESTIVAL

Mesa Arts Center, One E. Main St., Mesa AZ 85201. (480)644-6627. **Fax:** (480)644-6503. **E-mail:** shawn. lawson@mesaartscenter.com. **Website:** www. mesaartscenter.com. Fine arts & crafts fair held annually in December. Outdoors. Accepts handmade crafts, jewelry, ceramics, painting, photography, digital, printmaking, and more. Number exhibitors: see website. Number attendees: varies. Free to public. Apply online. Deadline for entry: see website. Application fee: $25. Space fee: $250. Exhibition space:

10×10. For more information, artists should e-mail, call or visit website.

MICHIGAN STATE UNIVERSITY HOLIDAY ARTS & CRAFTS SHOW

49 Abbot Rd., Room 26, MSU Union, East Lansing MI 48824. (517)355-3354. **E-mail:** uab@rhs.msu. edu; artsandcrafts@uabevents.com. **Website:** www. uabevents.com. **Contact:** Brian D. Proffer. Estab. 1963. Arts & crafts show held annually the 1st weekend in December. Indoors. Accepts photography, basketry, candles, ceramics, clothing, sculpture, soaps, drawings, floral, fibers, glass, jewelry, metals, painting, graphics, pottery, wood. Selected by a committee using photographs submitted by each vendor to eliminate commercial products. They will evaluate on quality, creativity and crowd appeal. Number of exhibitors: 139. Public attendance: 15,000. Free to public. Artists should apply online. Exhibition space: 8×5 ft. For more information, artists should visit website or call.

MICHIGAN STATE UNIVERSITY SPRING ARTS & CRAFTS SHOW

49 Abbot Rd., Room 26, MSU Union, East Lansing MI 48824. (517)355-3354. **E-mail:** artsandcrafts@ uabevents.com. **Website:** www.uabevents.com. **Contact:** Brian Proffer, 517-884-3338. Estab. 1963. In its 52nd year, the Spring Arts and Crafts show will take place, once again, on the grounds of the MSU Union, which is located on the corner of Grand River Avenue and Abbot Road in East Lansing, Michigan. This year's show is going to host more than 300 artisans with many new vendors as well as include many returning favorites! There will be a broad range of handmade items including candles, furniture, jewelry, home and yard décor, aromatherapy, clothing, children's toys, paintings, graphics, pottery, sculpture, photography and much more! For more information about the show visit our website: uabevents.com/retailad/arts-and-crafts-show.

MID-MISSOURI ARTISTS CHRISTMAS ARTS & CRAFTS SALE

P.O. Box 116, Warrensburg MO 64093. (660)441-5075. **E-mail:** mbush22@yahoo.com. **Website:** www. midmissouriartists.webs.com. Mary Bush. **Contact:** Pam Comer 660-441-5075. Estab. 1970. Holiday arts & crafts show held annually in November. Indoors. Accepts photography and all artist/crater made arts and crafts (no resale items). Juried by 3 good-quality color photos (2 of the artwork, 1 of the display). Number of exhibitors: 60. Public attendance: 1,200. Free to the public. Artists should apply by e-mailing or calling for an application form. Entry form also available at www.midmissouriartists.webs.com. Deadline for entry: early November. Space fee: $50. Exhibition space: 10×10 ft. For more information, artists should e-mail or call. 1-day show 9 a.m. Sat., Warrensburg Community Center, 445 E. Gay St.

TIPS "Items under $100 are most popular."

MIDSUMMER ARTS FAIRE

1515 Jersey St., Quincy IL 62301. (217)779-2285. **Fax:** (217)223-6950. **E-mail:** info@artsfaire.org. **Website:** www.artsfaire.org. **Contact:** Kayla Obert, coordinator. Fine art show held annually in June. Outdoors. Accepts photography, paintings, pottery, jewelry. Juried. Awards/prizes: various totaling $5,000. Exhibitors: 60. Number of attendees: 7,000. Free to public. Apply via www.zapplication.org. Deadline for entry: February 5. Application fee: $20. Space fee: $100. Exhibition space: 10×10. Average sales: $2,500. For more information, artists should e-mail, call, see Facebook page or visit website.

TIPS "Variety of price points with several options at a lower price point as well."

MILL VALLEY FALL ARTS FESTIVAL

P.O. Box 300, Mill Valley CA 94942. (415)381-8090. **E-mail:** mvfafartists@gmail.com. **Website:** www.mvfaf. org. Steve Bajor. Estab. 1955. The Mill Valley Fall Arts Festival has been recognized as a fine art and craft show of high-quality original artwork for 60 years. The festival draws well-educated buyers from nearby affluent neighborhoods of Marin County and the greater San Francisco Bay Area. The event provides an exceptional opportunity for the sale of unique, creative, and high-end work. Artists interested in participating must apply via www.zapplication.org. Applications open mid-January and close mid-April. See website for more information.

MILWAUKEE DOMES ART FESTIVAL

Fine arts & crafts fair held annually in August. Indoors & outdoors. Accepts handmade crafts, jewelry, ceramics, painting, photography, digital, printmaking, and more. Juried. Awards/prizes: $10,500 in awards and prizes. Number exhibitors: see website. Number attendees: varies. Free to public. Apply online. Deadline for entry: see website. Application fee:

$35. Space fee: $250 outdoor; $450 indoor. Exhibition space: 10×10. For more information visit website.

MINNESOTA WOMEN'S ART FESTIVAL

2924 4th Ave S., Minneapolis MN 55408. **E-mail:** naomiotr@aol.com. **Website:** www.womensartfestival.com. The mission of the Women's Art Festival is to provide a welcoming place for women artists to show and sell their creations and to provide a fun and festive atmosphere for guests to shop, gather, and enjoy community. Supporting local women artists of all experience levels, from first-time exhibitors to experienced professionals, we are a non-juried show with the expectation that all goods are of excellent quality, made and sold by local women. We do not accept dealers or importers and define local as any woman who wants to travel to Minneapolis for a day of fun, camaraderie, community, and creativity. Now held at the Colin Powell Youth Leadership Center, 2924 Fourth Ave. S., in Minneapolis, the event has grown to include over 130 women artists working in a large variety of media. There is live music by women performers throughout the day and a women-owned coffee shop providing food, beverages, and treats. Artists and guests alike comment on the quality of the artistic work, the fun and comfortable atmosphere, the caliber of the music, and the wonderful addition of good food, good coffee, and the chance to see good friends. See website for more information.

MISSION FEDERAL ARTWALK

2210 Columbia St., San Diego CA 92101. (619)615-1090. **Fax:** (619)615-1099. **E-mail:** info@artwalksandiego.org. **Website:** www.artwalksandiego.org. Fine arts & crafts fair held annually in April. Outdoors. Accepts handmade crafts, jewelry, ceramics, painting, photography, digital, printmaking, and more. Juried. Number exhibitors: 350. Number attendees: 90,000. Free to public. Apply online. Deadline for entry: January. Application fee: none. Space fee: varies. Exhibition space: varies. For more information, artists should e-mail, call or visit website.

MONTAUK ARTISTS' ASSOCIATION, INC.

P.O. Box 2751, Montauk NY 11954. (631)668-5336. **E-mail:** montaukart@aol.com. **Website:** www.montaukartistsassociation.org; www.montaukchamber.com. **Contact:** Anne Weissman. Estab. 1970. Arts & crafts show held annually Memorial Day weekend; 3rd weekend in August.

Outdoors. Accepts photography, paintings, prints (numbered and signed in bins), sculpture, limited fine art, jewelry and ceremics. Number of exhibitors: 90. Public attendance: 8-10,000. Free to public. Exhibition space: 12×12. For more information, artists should call or visit website.

MONTE SANO ART FESTIVAL

706 Randolph Ave., Huntsville AL 35801. (256)519-2787. **E-mail:** amayfield@artshuntsville.org. **Website:** www.montesanoartfestival.com. Estab. 1987. Annual fine art show held the 3rd weekend in June. Outdoors. Accepts handmade crafts, sculpture, glass, ceramics, paper, wood, paint, mix, fiber/textile, photography, jewelry. Juried. Awards/prizes: Best of Show in each category. Exhibitors: 195. Number of attendees: 7,000. Admission: $9-$16. Apply via www.zapplication.org. Deadline for entry: March 1. Application fee: $25 Space fee: $500-$800. Exhibition space: 10×10, 10×20. For more information see website.

MOUNTAIN STATE FOREST FESTIVAL

P.O. Box 388, 101 Lough St., Elkins WV 26241. (304)636-1824. **Fax:** (304)636-4020. **E-mail:** msff@forestfestival.com. **Website:** www.forestfestival.com. **Contact:** Cindy Nucilli, executive director. Estab. 1930. Arts, crafts & photography show held annually in early October. Accepts photography and homemade crafts. Awards/prizes: cash awards for photography only. Number of exhibitors: 50+. Public attendance: 75,000. Free to the public. Artists should apply by requesting an application form. For more information, artists should visit website, call, or visit Facebook page (search "Mountain State Forest Festival").

MOUNT DORA ARTS FESTIVAL

Mount Dora Center for the Arts, 138 E. Fifth Ave., Mount Dora FL 32757. (352)383-0880. **Fax:** (352)383-7753. **E-mail:** nancy@mountdoracenterforthearts.org or kristina@mountdoracenterforthearts.org. **Website:** www.mountdoracenterforthearts.org/arts-festival. **Contact:** Nancy Zinkofsky, artist/vendor submissions; Kristina Rosenburg, sponsors & marketing. Held the 1st weekend of February. "Join us for the upcoming 42nd Annual Mount Dora Arts Festival on Saturday & Sunday, February 4-5, 2017 from 9-5." A juried fine arts festival for art lovers, casual festival-goers, and families. In addition to the endless rows of fine art, including oil paintings, watercolors, acrylics, clay, sculpture, and photography, the festival features local and regional musical entertainment at a

main stage in Donnelly Park. See website for more information.

MOUNT GRETNA OUTDOOR ART SHOW

P.O. Box 637, Mount Gretna PA 17064. (717)964-3270. **Fax:** (717)964-3054. **E-mail:** mtgretnaart@comcast. net. **Website:** www.mtgretnaarts.com. Estab. 1974. Fine arts & crafts show held annually 3rd full weekend in August. Outdoors. Accepts photography, oils, acrylics, watercolors, mixed media, jewelry, wood, paper, graphics, sculpture, leather, clay/porcelain. Juried by 4 professional artists who assign each applicant a numeric score. The highest scores in each medium are accepted. Awards/prizes: Judges' Choice Awards: 30 artists are invited to return the following year, jury exempt; the top 10 are given a monetary award of $250. Number of exhibitors: 250. Public attendance: 15,000-19,000. Public admission: $10; children under 12 free. Artists should apply via www.zapplication.org. Deadline for entry: April 1. Application fee: $25. Space fee: $350 per 10×12 ft. space; $700 per 10×24 ft. double space. For more information, artists should e-mail, visit website or call.

MYSTIC OUTDOOR ART FESTIVAL

E-mail: Cherielin@MysticChamber.org. **Website:** www.mysticchamber.org/?sec=sec&s=44. The annual Mystic Outdoor Art Festival has evolved in many ways from its humble beginnings. In 1957, Milton Baline and several other local business owners and art lovers proposed that Mystic pattern a festival after the famous Washington Square Festival in New York. That first show featured 105 artists and 500 paintings. Between 4,000 and 6,000 visitors came to admire and purchase art. Today the Mystic Outdoor Art Festival stretches over 2 miles and is the oldest of its kind in the Northeast. The Mystic Outdoor Art Festival has grown to over 250 artists who come from all corners of the United States and bring more than 100,000 works of art. See website for more information.

NAMPA FESTIVAL OF ARTS

131 Constitution Way, Nampa ID 83686. (208)468-5858. **Fax:** (208)465-2282. **E-mail:** burkeyj@cityofnampa.us. **Website:** www. nampaparksandrecreation.org. **Contact:** Wendy Davis, program director. Estab. 1986. Fine art & craft show held annually mid-August. Outdoors. Accepts handmade crafts, fine art, photography, metal, anything handmade. Juried. Awards/prizes: cash.

Exhibitors: 180. Number of attendees: 15,000. Free to public. See website for application. Deadline for entry: July 10. Space fee: $40-90. Exhibition space: 10×10, 15×15, 20×20. For more information send e-mail, call or visit website.

TIPS "Price things reasonably and have products displayed attractively."

NAPERVILLE WOMAN'S CLUB ART FAIR

(630)803-9171. **E-mail:** naperartfair@yahoo.com. **Website:** www.napervillewomansclub.org. **Contact:** Marie Gnesda. Over 100 local and national artists will be displaying original artwork in clay, fiber, glass, jewelry, mixed media, metal, painting, photography, sculpture, and wood. Ribbons and cash prizes are awarded to winning artists by local judges and NWC. The Naperville Woman's Club Art Fair is the longest continuously running art fair in Illinois. Activities at this event include entertainment, a silent auction, artist demonstrations, the Empty Bowl Fundraiser to benefit local food pantries, and the Petite Picassos children's activities tent. This is the largest fundraiser of the year for the Naperville Woman's Club. Proceeds from the event help fund a local art scholarship and local charities. Admission and parking are free. For more information please e-mail us at: naperartfair@ yahoo.com.

NEW ENGLAND CRAFT & SPECIALTY FOOD FAIR

38 Charles St., Rochester NH 03867. (603)332-2616. **Fax:** (603)332-8413. **E-mail:** info@castleberryfairs. com. **Website:** www.castleberryfairs.com. Estab. 1995. Arts & crafts show held annually on Veterans Day weekend in Salem NH. Indoors. Accepts photography and all other mediums. Juried by photo, slide or sample. Number of exhibitors: 200. Public attendance: 15,000. Artists should apply by downloading application from website. Deadline for entry: until full. Space fee: $350-450. Exhibition space: 10×6 or 10×10 ft. Average gross sales/exhibitor: "Generally, this is considered an 'excellent' show, so I would guess most exhibitors sell 10 times their booth fee, or in this case, at least $3,000 in sales." For more information, artists should visit website. Fair is held at Rockingham Park Racetrack.

TIPS "Do not bring a book; do not bring a chair. Smile and make eye contact with everyone who enters your booth. Have them sign your guest book; get their e-

mail address so you can let them know when you are in the area again. And, finally, make the sale—they are at the fair to shop, after all."

🎧🎧 NEW MEXICO ARTS AND CRAFTS FAIR

2501 San Pedro St. NE, Suite 110, Albuquerque NM 87110. (505)884-9043. **E-mail:** info@ nmartsandcraftsfair.org. **Website:** www. nmartsandcraftsfair.org. Estab. 1962. Fine arts & craft show held annually in June. Indoors. Accepts decorative and functional ceramics, digital art, drawing, fiber, precious and non-precious jewelry, photography, paintings, printmaking, mixed media, metal, sculpture and wood. *Only New Mexico residents 18 years and older are eligible.* See website for more details.

NEW SMYRNA BEACH ART FIESTA

City of New Smyrna Beach, 210 Sams Ave., New Smyrna Beach FL 32168. (386)424-2175. **Fax:** (386)424-2177. **E-mail:** kshelton@cityofnsb.com. **Website:** www.cityofnsb.com;. **Contact:** Kimla Shelton. Estab. 1952. Arts & crafts show held annually in February. Outdoors. Accepts photography, oil, acrylics, pastel, drawings, graphics, sculpture, crafts, watercolor. Awards/prizes: $15,000 prize money; $1,600/category; Best of Show. Number of exhibitors: 250. Public attendance: 14,000. Free to public. Artists should apply by calling to get on mailing list. Applications are always mailed out the day before Thanksgiving. Deadline for entry: until full. Exhibition space: 10×10 ft. For more information, artists should call. Show held in the Old Fort Park area.

🎧 NEWTON ARTS FESTIVAL

Piper Promotions, 4 Old Green Rd., Sandy Hook CT 6482. (203)512-9100. **E-mail:** staceyolszewski@ yahoo.com. **Website:** www.newtownartsfestival. com. **Contact:** Stacey Olszewski. Fine arts & crafts fair held annually in September. Outdoors. Accepts handmade crafts, jewelry, ceramics, painting, photography, digital, printmaking, and more. Juried. Number exhibitors: see website. Number attendees: varies. Admission: $5; children 12 & under free. Apply online. Deadline for entry: August. Application fee: none. Space fee: $105 (booth); $225 (festival tent). Exhibition space: 10×10. For more information, artists should e-mail, call or visit website.

🎧 NEW WORLD FESTIVAL OF THE ARTS

P.O. Box 2300, Manteo NC 27954. (252) 473-5558. **E-mail:** dareartsinfo@gmail.com. **Website:** darearts. org. Fay Davis Edwards. **Contact:** Louise Sanderlin. Estab. 1963. Fine arts & crafts show held annually in mid-August (see website for details). Outdoors. Juried. Location is the Waterfront in downtown Manteo. Features 80 selected artists from Vermont to Florida exhibiting and selling their works. Application fee: $15. Space fee: $85.

🎧 NIANTIC OUTDOOR ART & CRAFT SHOW

P.O. Box 227, Niantic CT 6357. (860)705-7800. **E-mail:** artshowwoody@yahoo.com. **Website:** www. nianticartsandcraftshow.com. **Contact:** Craig Woody. Estab. 1960. Fine art & craft show held annually in July. Outdoors. Accepts handmade crafts, ceramics, fiber, glass, graphics, jewelry, leather, metal, mixed media, painting, photography, printmaking, sculpture, woodworking. Juried. Number exhibitors: 142. Number attendees: varies. Free to public. Apply online. Deadline for entry: March. Application fee: $20. Space fee: varies. Exhibition space: varies. For more information, artists should e-mail, call, or visit website.

🎧 NORTH CHARLESTON ARTS FESTIVAL

P.O. Box 190016, North Charleston SC 29419-9016. (843)740-5854. **E-mail:** culturalarts@northcharleston. org. **Website:** www.northcharlestonartsfest.com. Fine arts & crafts fair held annually in May. Outdoors. Accepts handmade crafts, jewelry, ceramics, painting, photography, digital, printmaking, and more. Juried. Number exhibitors: see website. Number attendees: 30,000. Admission: see website. Apply online. Deadline for entry: January. Application fee: see website. Space fee: see website. Exhibition space: see website. For more information, artists should e-mail, call or visit website.

NORTH CONGREGATIONAL PEACH & CRAFT FAIR

17 Church St., New Hartford CT 06057. (860)379-2466. **Website:** www.northchurchucc.com. **Contact:** K.T. "Sully" Sullivan. Estab. 1966. Arts & crafts show held annually in mid-August. Outdoors on the Green at Pine Meadow. Accepts photography, most arts and crafts. Number of exhibitors: 50. Public attendance: 500-2,000. Free to public. Artists should call for ap-

plication form. Deadline for entry: August. Application fee: $60. Exhibition space: 11×11 ft.

TIPS "Be prepared for all kinds of weather."

NORTHERN VIRGINIA FINE ARTS FESTIVAL

(703)471-9242. **E-mail:** info@restonarts.org. **Website:** www.northernvirginiafineartsfestival.org. Fine arts & crafts fair held annually in May. Outdoors. Accepts handmade crafts, jewelry, ceramics, painting, photography, digital, printmaking, and more. Juried. Number exhibitors: 200. Number attendees: varies. Admission: $5; children 18 & under free. Apply online. Deadline for entry: see website. Application fee: see website. Space fee: see website. Exhibition space: see website. For more information, artists should e-mail, call or visit website.

NORTH SHORE FESTIVAL OF ART

Amdur Productions, P.O. Box 550, Highland Park IL 60035. (847)926-4300. **Fax:** (847)926-4330. **E-mail:** info@amdurproductions.com. **Website:** www.amdurproductions.com. Fine arts & crafts fair held annually in July. Outdoors. Accepts handmade crafts, jewelry, ceramics, painting, photography, digital, printmaking, and more. Juried. Number exhibitors: 100. Number attendees: 84,000. Free to public. Apply online. Deadline for entry: see website. Application fee: $25. Space fee: $445. Exhibition space: 10×10. For more information, artists should e-mail, call or visit website.

OAK PARK AVENUE-LAKE ARTS & CRAFTS SHOW

P.O. Box 1326, Palatine IL 60078. (312)751-2500; (847)991-4748. **E-mail:** asoaartists@aol.com. **E-mail:** asoaartists@aol.com. **Website:** www.americansocietyofartists.org. **Contact:** ASA Office. Estab. 1974. Fine arts & crafts show held annually in mid-August. Event held in Oak Park IL. Outdoors. Accepts photography, painting, graphics, sculpture, glass, wood, paper, fiber arts, mosaics and more. Juried. Please submit 4 images representative of your work you wish to exhibit, 1 of your display set-up, your first/last name, physical address, daytime telephone number—résumé/show listing helpful. Number of exhibitors: 150. Free to the public. Artists should apply by submitting jury materials. To jury online, submit to: asoaartists@aol.com. If juried in, you will receive a jury/approval number. Deadline for entry: 2 months prior to show or earlier if spaces

fill. Entry fee: $195. Exhibition space: approximately 100 sq. ft. for single space; other sizes available. For more information, artists should send SASE with jury material to the above address. Show takes place in Scoville Park (located in Oak Park).

TIPS "Remember that when you are at work in your studio, you are an artist. But when you are at a show, you are a business person selling your work."

OC FAIR VISUAL ARTS COMPETITION

88 Fair Dr., Costa Mesa CA 92626. (714)708-1718. **E-mail:** sanderson@ocfair.com. **Website:** www.ocfair.com/competitions. **Contact:** Stephen Anderson. Annual fine art and craft show held from mid-July to mid-August. Indoors. Accepted media includes: photography, 2D media, sculpture, ceramics, graphic arts, fine woodworking and film. Juried event with cash and purchase awards. Digital submissions only. Over 2,000 exhibitors each year. 1.3 million attendees. 20,000 sq. ft. exhibition space. Fair admission fee: $12. Artists should apply online at www.ocfair.com/competitions after April 1. Deadline for entry: June 1. Application fee of $10 per entry. Open to California residents 19 and older; young adults 13-18. E-mail or visit website for more information.

OCONOMOWOC FESTIVAL OF THE ARTS

P.O. Box 651, Oconomowoc WI 53066. **Website:** www.oconomowocarts.org. Estab. 1970. Fine arts & crafts fair held annually in August. Outdoors. Accepts handmade crafts, jewelry, ceramics, painting, photography, digital, printmaking, and more. Juried. Awards/prizes: $3,500 in awards & prizes. Number exhibitors: 140. Number attendees: varies. Admission: Free to public. Apply online. Deadline for entry: March. Application fee: $40. Space fee: $250. Exhibition space: 10×10. For more information, artists should visit website.

OHIO MART

Stan Hywet Hall and Gardens, 714 N. Portage Path, Akron OH 44303. (330)836-5533 or (888)836-5533. **E-mail:** info@stanhywet.org. **Website:** www.stanhywet.org. Estab. 1966. Fine arts & crafts fair held annually in October. Outdoors. Accepts handmade crafts, jewelry, ceramics, painting, photography, digital, printmaking, and more. Juried. Number exhibitors: see website. Number attendees: varies. Admission: $9 adults; $2 youth. Apply online. Deadline for entry:

see website. Application fee: see website. Space fee: see website. Exhibition space: see website. For more information, artists should call, e-mail or visit website.

☺ OHIO SAUERKRAUT FESTIVAL

P.O. Box 281, Waynesville OH 45068. (513)897-8855, ext. 2. **Fax:** (513)897-9833. **E-mail:** barb@waynesvilleohio.com. **Website:** www.sauerkrautfestival.com. **Contact:** Barb Lindsay, office and event coordinator. Estab. 1969. Arts & crafts show held annually 2nd full weekend in October. Outdoors. Accepts photography and handcrafted items only. Juried by jury team. Number of exhibitors: 458. Public attendance: 350,000. Jury fee: $20. Space fee: $200 + $25 processing fee. Exhibition space: 10×10 ft. For more information, artists should visit website or call. **TIPS** "Have reasonably priced items."

☺ OKLAHOMA CITY FESTIVAL OF THE ARTS

Arts Council of Oklahoma City, 400 W. California, Oklahoma City OK 73102. (405)270-4848. **Fax:** (405)270-4888. **E-mail:** info@artscouncilokc.com. **Website:** www.artscouncilokc.com. Estab. 1967. Fine arts & crafts fair held annually in April. Outdoors. Accepts handmade crafts, jewelry, ceramics, painting, photography, digital, printmaking, and more. Juried. Number exhibitors: 144. Number attendees: varies. Free to public. Apply online. Deadline for entry: see website. Application fee: see website. Space fee: see website. Exhibition space: see website. For more information, artists should call, e-mail or visit website.

☺ OLD CAPITOL ART FAIR

P.O. Box 5701, Springfield IL 62705. (405)270-4848. **Fax:** (405)270-4888. **E-mail:** artistinfo@yahoo.com. **Website:** www.socaf.org. **Contact:** Kate Baima. Estab. 1961. Fine arts & crafts fair held annually in May. Outdoors. Accepts handmade crafts, jewelry, ceramics, painting, photography, digital, printmaking, and more. Juried. Awards/prizes: 1st place, 2nd place, 3rd place, awards of merit. Number exhibitors: see website. Number attendees: varies. Free to public. Apply online. Deadline for entry: November. Application fee: $35. Space fee: $300 (single); $550 (double). Exhibition space: 10×10 (single); 10×10 (double). For more information, artists should call, e-mail or visit website.

☺ OLD FOURTH WARD PARK ARTS FESTIVAL

592 N. Angier Ave. NE, Atlanta GA 30308. (404)873-1222. **E-mail:** info@affps.com. **Website:** www.oldfourthwardparkartsfestival.com. **Contact:** Randall Fox, festival director. Estab. 2013. Arts & crafts show held annually late June. Outdoors. Accepts handmade crafts, painting, photography, sculpture, leather, metal, glass, jewelry. Juried by a panel. Awards/prizes: ribbons. Number of exhibitors: 130. Number of attendees: 25,000. Free to public. Apply online at www.zapplication.com. Deadline for entry: late April. Application fee: $25. Space fee: $225. Exhibition space: 10×10. For more information, send e-mail or see website.

OLD TOWN ART FAIR

1763 N. North Park Ave., Chicago IL 60614. (312)337-1938. **E-mail:** info@oldtowntriangle.com. **Website:** www.oldtownartfair.com. Estab. 1950. Fine art festival held annually in early June (see website for details). Located in the city's historic Old Town Triangle District. Artists featured are chosen by an independent jury of professional artists, gallery owners and museum curators. Features a wide range of art mediums, including 2D and 3D mixed media, drawing, painting, photography, printmaking, ceramics, fiber, glass, jewelry and works in metal, stone and wood. Apply online at www.zappplication.org. For more information, call, e-mail or visit website. Fair located in Old Town Triangle District.

☺ OLD TOWN ART FESTIVAL

Old Town San Diego Chamber of Commerce, P.O. Box 82686, San Diego CA 92138. (619)233-5008. **Fax:** (619)233-0898. **E-mail:** rob-vslmedia@cox.net; otsd@aol.com. **Website:** www.oldtownartfestival.org. Fine arts & crafts fair held annually in September. Outdoors. Accepts handmade crafts, jewelry, ceramics, painting, photography, digital, printmaking, and more. Juried. Number exhibitors: see website. Number attendees: 15,000. Free to public. Apply online. Deadline for entry: September 1. Application fee: $25. Space fee: varies. Exhibition space: varies. For more information, artists should call, e-mail or visit website.

☺ OMAHA SUMMER ARTS FESTIVAL

P.O. Box 31036, Omaha NE 68131-0036. (402)345-5401. **Fax:** (402)342-4114. **E-mail:** ebalazs@vgagroup.

com. **Website:** www.summerarts.org. **Contact:** Emily Peklo. Estab. 1975. Fine arts & crafts fair held annually in June. Outdoors. Accepts handmade crafts, jewelry, ceramics, painting, photography, digital, printmaking, and more. Juried. Number exhibitors: 135. Number attendees: varies. Free to public. Apply online. Deadline for entry: see website. Application fee: see website. Space fee: varies. Exhibition space: varies. For more information, artists should call, e-mail or visit website.

☺☻ ONE OF A KIND CRAFT SHOW (ONTARIO)

10 Alcorn Ave., Suite 100, Toronto, Ontario M4V 3A9 Canada. (416)960-5399. **Fax:** (416)923-5624. **E-mail:** jill@oneofakindshow.com. **Website:** www.oneofakindshow.com. **Contact:** Jill Benson. Estab. 1975. Fine arts & crafts fair held annually 3 times a year. Outdoors. Accepts handmade crafts, jewelry, ceramics, painting, photography, digital, printmaking, and more. Juried. Number exhibitors: varies per show. Number attendees: varies per show. Free to public. Apply online. Deadline for entry: see website. Application fee: see website. Space fee: varies. Exhibition space: varies. For more information, artists should call, e-mail or visit website.

☻ ON THE GREEN FINE ART & CRAFT SHOW

P.O. Box 304, Glastonbury CT 06033. (860)659-1196. **Fax:** (860)633-4301. **E-mail:** info@glastonburyarts. org. **Website:** www.glastonburyarts.org. **Contact:** Jane Fox, administrator. Estab. 1961. Fine art & craft show held annually 2nd week of September. Outdoors. Accepts photography, pastel, prints, pottery, jewelry, drawing, sculpture, mixed media, oil, acrylic, glass, watercolor, graphic, wood, fiber, etc. Juried (with 3 photos of work, 1 photo of booth). Awards/prizes: $3,000 total prize money in different categories. Number of exhibitors: 200. Public attendance: 15,000. Free to public. Artists should apply online. Deadline for entry: early June. Jury fee: $15. Space fee: $275. Exhibition space: 12×15 ft. Average gross sales/exhibitor varies. For more information, artists should visit website. Show located at Hubbard Green.

☻ ORANGE BEACH FESTIVAL OF ART

26389 Canal Road, Orange Beach AL 36561. (251)981-2787. **Fax:** (251)981-6981. **E-mail:** helpdesk@orangebeachartcenter.com. **Website:** www.orangebeachartsfestival.com. Fine art & craft

show held annually in March. Outdoors. Accepts handmade crafts, ceramics, paintings, jewelry, glass, photography, wearable art, and other mediums. Juried. Number exhibitors: 90. Number attendees: varies. Free to public. Apply online. Deadline for entry: See website. Application fee: see website. Space fee: varies. Exhibition space: varies. For more information, artists should call, e-mail or visit website.

☻ ORCHARD LAKE FINE ART SHOW

P.O. Box 79, Milford MI 48381-0079. (248)684-2613. **E-mail:** info@hotworks.org. **Website:** www.hotworks. org. **Contact:** Patty Narozny, executive director and producer. Estab. 2003. Voted in the top 100 art fairs nationwide the last 8 years in the row by *Sunshine Magazine* out of more than 4,000 art fairs. "The Orchard Lake Fine Art Show takes place in the heart of West Bloomfield, located on a street with high visibility from Orchard Lake Road, south of Maple Road, in an area that provides plenty of free parking for patrons and weekend access for local businesses. West Bloomfield MI is located adjacent to Bloomfiled Hills, listed as the #2 highest income city in the US, according to Wikipedia.org, and home of Cranbrook Art Institute. West Bloomfield has been voted one of *Money Magazine*'s 'Best Places to Live,' and is an upscale community with rolilng hills that provide a tranquil setting for beautiful and lavish homes. $5 admission helps support the Institute for the Arts & Education, Inc., a 501(c)(3) nonprofit organization whose focus is visual arts and community enrichment. 12 & under free. This event follows Ann Arbor, has great event hours and provides ease of move-in and move-out. All work must be original and personally handmade by the artist. There is $2,500 in professional artist awards. We accept all disciplines including sculpture, paintings, clay, glass, wood, fiber, jewelry, photography and more." Professional applications are accepted "manual" or via www.zapplication.org. Please include 3 images of your most compelling work, plus one of your booth presentation as you would set up at the show. Space fee: $375, 10×10; 10×15, $525; 10×20, $650; add $75 for corner. "Generators are permitted as long as they do not bother anyone for any reason." Deadline to apply is March 15. "No buy/sell/import permitted. As part of our commitment to bring art education into the community, there is the Chadwick Accounting Group's Youth Art Competition for grades K-8 or ages 5-12, in which we encourage budding artists to

create their original and personally handmade artwork that is publicly displayed in the show the entire weekend." $250 in youth art awards. The deadline to apply for youth art is July 1. More information can be found on the web at www.hotworks.org.

PALMER PARK ART FAIR
E-mail: info@integrityshows.com. **Website:** www.palmerparkartfair.com. **Contact:** Mark Loeb. Estab. 2014. Fine arts & crafts show held annually in May. Outdoors. Accepts photography and all fine art and craft mediums. Juried by 3 independent jurors. Awards/prizes: purchase and merit awards. Number of exhibitors: 80. Public attendance: 7,000. Free to the public. Apply online. Deadline for entry: see website. Application fee: $25. Booth fee: $295. Electricity limited; fee: $100. For more information, visit website.

PALM SPRINGS FINE ART FAIR
HEG—Hamptons Expo Group, 223 Hampton Rd., Southampton NY 11968. (631)283-5505. **Fax:** (631)702-2141. **E-mail:** info@hegshows.com. **Website:** www.palmspringsfineartfair.com. Fine art fair held annually in February. Indoors. Accepts fine art from galleries. Juried. Number exhibitors: 60. Number attendees: 12,000. Admission: see website. Apply online. Deadline for entry: see website. Application fee: none. Space fee: varies. Exhibition space: varies. For more information, artists should e-mail, call, or visit website.

PANOPLY ARTS FESTIVAL
The Arts Council, Inc., 700 Monroe St. SW, Suite 2, Huntsville AL 35801. (256)519-2787. **Fax:** (256)533-3811. **E-mail:** info@artshuntsville.org; vhinton@artshuntsville.org. **Website:** www.panoply.org. Estab. 1982. Fine arts show held annually the last weekend in April. Also features music and dance. Outdoors. Accepts photography, painting, sculpture, drawing, printmaking, mixed media, glass, fiber. Juried by a panel of judges chosen for their in-depth knowledge and experience in multiple mediums, and who jury from slides or disks in January. During the festival 1 judge awards various prizes. Number of exhibitors: 60-80. Public attendance: 140,000+. Public admission: $5/day or $10/weekend (children 12 and under free). Artists should e-mail, call, or go online for an application form. Deadline for entry: January. Space fee: $185. Exhibition space: 10×10 ft. (tent available, space fee $390). Average gross sales/exhibitor: $2,500.

For more information, artists should e-mail or visit website. The festival is held in Big Spring International Park.

PARADISE CITY ARTS FESTIVALS
30 Industrial Dr. E, Northampton MA 01060. (413)587-0772. **Fax:** (413)587-0966. **E-mail:** artist@paradisecityarts.com. **Website:** www.paradisecityarts.com. Estab. 1995. 4 fine arts & crafts shows held annually in March, May, October, and November. Indoors. Accepts photography, all original art and fine craft media. Juried by 5 digital images of work and an independent board of jury advisors. Number of exhibitors: 150-275. Public attendance: 5,000-20,000. Public admission: $12. Artists should apply by submitting name and address to be added to mailing list or print application from website. Deadlines for entry: April 1 (fall shows); September 9 (spring shows). Application fee: $30-45. Space fee: $855-1,365. Exhibition space varies by show, see website for more details . For more information, artists should e-mail, visit website or call.

PARK FOREST ART FAIR
367 Artists Walk, Park Forest IL 60466. (708)748-3377. **Fax:** (708)748-9132. **E-mail:** tallgrass367@sbcglobal.net; jmuchnik@sbcglobal.net. **Website:** www.tallgrassarts.org. **Contact:** Janet Muchnik, president. Estab. 1955. Fine arts & crafts festival held annually 3rd weekend in September. Outdoors. Accepts photography and any media that would fit the criteria and meet the standards of fine art or craft. Juried by professional artists (representing several media). Jurying opens in January when "call for artists" is posted on website; closes at end of June. Jurying is done on a monthly basis so successful applicants can make plans to participate. Juried artists may also exhibit in the Tall Grass Gallery and Gift Shop. Awards/prizes: Best 2D work: $750; Best 3D work: $750; Best Jewelry: $750; 2 director's prizes: $100 each; Judge's Choice (any media); several purchase awards and 1 Purchase Prize for the Tall Grass Permanent Collection. Number of exhibitors: 70-100. Public attendance: 3,000-4,000. Free to the public. Artists should apply online. Submit 6 photographs of work by CD or e-mail. Deadline for entry: June 28. Jury fee: $35. Space fee: $175. Exhibition space: 12×10 ft. tent with space around it. "Some spaces are under an awning and do not require the use of a tent but should

be requested early." For more information, artists should e-mail or visit website.

TIPS "A good display is a large key to sales; however, in recent years, fair attendees have also looked for a range of prices. This includes prints or smaller-size artworks. Exhibitors should be prepared (and willing) to talk about their artworks and techniques."

PARK POINT ART FAIR

(218)428-1916. **E-mail:** coordinator@parkpointartfair. org. **Website:** www.parkpointartfair.org. **Contact:** Carla Tamburro, art fair coordinator. Estab. 1970. Fine arts & crafts fair held annually the last full weekend in June. Outdoors. Accepts handmade crafts, jewelry, ceramics, painting, photography, digital, printmaking, and more. Juried. Awards/ prizes: $1,300 in awards. Number exhibitors: 120. Number attendees: 10,000. Free to public. Apply online. Deadline for entry: March. Application fee: $15. Space fee: $185. Exhibition space: 10×10. For more information, artists should e-mail, call or visit website.

PATTERSON APRICOT FIESTA

P.O. Box 442, Patterson CA 95363. (209)892-3118. **Fax:** (209)892-3388. **E-mail:** patterson_apricot_ fiesta@hotmail.com. **Website:** www.apricotfiesta. com. **Contact:** Jaclyn Camara, chairperson. Estab. 1984. Arts & crafts show held annually in May/June. Outdoors. Accepts photography, oils, leather, various handcrafts. Juried by type of product. Number of exhibitors: 140-150. Public attendance: 30,000. Free to the public. Deadline for entry: mid-April. Application fee/space fee: $225/craft, $275/commerical. Exhibition space: 12×12 ft. For more information, artists should call, send SASE. Event held at Center Circle Plaza in downtown Patterson.

TIPS "Please get your applications in early!"

PEND OREILLE ARTS COUNCIL

P.O. Box 1694, Sandpoint ID 83864. (208)263-6139. **E-mail:** poactivities@gmail.com. **Website:** www. artinsandpoint.org. Estab. 1978. Arts & crafts show held annually, second week in August. Outdoors. Accepts photography and all handmade, noncommercial works. Juried by 8-member jury. Number of exhibitors: 120. Public attendance: 5,000. Free to public. Artists should apply by sending in application, available in February, along with 4 images (3 of your work, 1 of your booth space). Deadline for entry: April. Appli-

cation fee: $25. Space fee: $185-280, no commission taken. Electricity: $50. Exhibition space: 10×10 ft. or 10×15 ft. (shared booths available). For more information, artists should e-mail, call or visit website. Show located in downtown Sandpoint.

PENNSYLVANIA GUILD OF CRAFTSMEN FINE CRAFT FAIRS

Center of American Craft, 335 N. Queen St., Lancaster PA 17603. (717)431-8706. **E-mail:** nick@pacrafts. org; handmade@pacrafts.org. **Website:** www.pacrafts. org/fine-craft-fairs. **Contact:** Nick Mohler. Fine arts & crafts fair held annually 5 times a year. Outdoors. Accepts handmade crafts, jewelry, ceramics, painting, photography, digital, printmaking, and more. Juried. Number exhibitors: varies per show. Number attendees: varies per show. Free to public. Apply online. Deadline for entry: January. Application fee: $25. Space fee: varies. Exhibition space: 10×10. For more information, artists should call, e-mail or visit website.

PENTWATER FINE ARTS & CRAFT FAIR

Pentwater Jr. Women's Club, P.O. Box 357, Pentwater MI 49449. **E-mail:** pentwaterjuniorwomensclub@ yahoo.com. **Website:** www.pentwaterjuniorwomen-sclub.com. Always the 2nd Saturday in July, the fair is held on the beautiful Village Green located in downtown Pentwater MI during the height of the summer resort season. The fair is held regardless of the weather, and space is limited for this juried show. Artists can apply via www.zapplication.org. See website for more information.

PETERS VALLEY FINE CRAFT FAIR

19 Kuhn Rd., Layton NJ 07851. (973)948-5200. **E-mail:** craftfair@petersvalley.org; info@petersvalley. org. **Website:** www.petersvalley.org. Estab. 1970. Fine craft show held annually in late September at the Sussex County Fairgrounds in Augusta NJ. Indoors/enclosed spaces. Accepts photography, ceramics, fiber, glass, basketry, metal, jewelry, sculpture, printmaking, paper, drawing, painting. Juried. Awards. Number of exhibitors: 150. Public attendance: 7,000-8,000. Public admission: $9. Artists should apply via www. juriedartservices.com. Deadline for entry: April 1. Application fee: $35. Space fee: $455 (includes electricity). Exhibition space: 10×10 ft. Average gross sales/ exhibitor: $2,000-5,000. For more information artists should e-mail, visit website or call.

PIEDMONT CRAFTSMEN'S FAIR

601 North Trade St., Winston-Salem NC 27101. (336)725-1516. **E-mail:** craftsfair@piedmontcraftsmen.org. **Website:** www.piedmontcraftsmen.org/programs/crafts-fair. **Contact:** Deborah Britton, fair coordinator. Estab. 1963. Annual showcase held 3rd weekend in November. Indoors. Open to public. Accepts clay, wood, glass, fibers, leather, metal, photography, printmaking, and mixed media. Number exhibitors: see website. Number attendees: see website. Admission: $7 adults; $6 students/seniors; children 12 & under free; weekend pass $11. Apply online. Deadline for entry: mid-April. Application fee: $35. Space fee: starts at $625. Exhibition space: see website. For more information, e-mail, visit website, or call. Annual showcase held 3rd weekend in November. Indoors. Open to public. Accepts clay, wood, glass, fibers, leather, metal, photography, printmaking, and mixed media. Number exhibitors: see website. Number attendees: see website. Admission: $7 adults; $6 students/seniors; children 12 & under free; weekend pass $11. Apply online. Deadline for entry: mid-April. Application fee: $35. Space fee: starts at $625. Exhibition space: see website. For more information, e-mail, visit website, or call.

PIEDMONT PARK ARTS FESTIVAL

1701 Piedmont Ave., Atlanta GA 30306. (404)873-1222. **E-mail:** Info@affps.com. **Website:** www.piedmontparkartsfestival.com. **Contact:** Randall Fox. Estab. 2011. Arts & crafts show held annually in mid-August. Outdoors. Accepts handmade crafts, painting, photography, sculpture, leather, metal, glass, jewelry. Juried by a panel. Awards/prizes: ribbons. Number of exhibitors: 250. Number of attendees: 60,000. Free to public. Apply online at www.zapplication.com. Deadline for entry: June 3. Application fee: $25. Space fee: $300. Exhibition space: 10×10. For more information artists should visit website.

PRAIRIE ARTS FESTIVAL

201 Schaumburg Court, Schaumburg IL 60193. (847)923-3605. **Fax:** (847)923-2458. **E-mail:** rbenvenuti@villageofschaumburg.com. **Website:** www.prairiecenter.org. **Contact:** Roxane Benvenuti, special events coordinator. Estab. 1988. Outdoor fine art & fine craft exhibition and sale featuring artists, food truck vendors, live entertainment and children's activities. Held over Saturday-Sunday of Memorial Day weekend. Located in the Robert O. Atcher Municipal Center grounds, adjacent to the Schaumburg Prairie Center for the Arts. Artist applications available in mid-January; due online or postmarked by March 4. 150 spaces available. Application fee: $110 (for 15×10 space); $220 (30×10 space). No jury fee. "With thousands of patrons in attendance, an ad in the Prairie Arts Festival program is a great way to get your business noticed. Rates are reasonable, and an ad in the program gives you access to a select regional market. Sponsorship opportunities are also available." For more information, e-mail, call or visit the website.

TIPS "Submit your best work for the jury since these images are selling your work."

PUNGO STRAWBERRY FESTIVAL

P.O. Box 6158, Virginia Beach VA 23456. (757)721-6001. **Fax:** (757)721-9335. **E-mail:** pungofestival@aol.com; leebackbay@gmail.com; robinwlee23@gmail.com. **Website:** www.pungostrawberryfestival.info. Estab. 1983. Arts & crafts show held annually on Memorial Day weekend. Outdoors. Accepts photography and all media. Number of exhibitors: 60. Public attendance: 120,000. Free to public; $5 parking fee. Artists should apply by calling for application or downloading a copy from the website and mail in. Deadline for entry: early March; applications accepted from that point until all spaces are full. Notice of acceptance or denial by early April. Application fee: $50 refundable deposit. Space fee: $200 (off road location); $500 (on road location). Exhibition space: 10×10 ft. For more information, artists should e-mail, call or visit website.

PYRAMID HILL ANNUAL ART FAIR

1763 Hamilton Cleves Rd., Hamilton OH 45013. (513)868-8336. **Fax:** (513)868-3585. **E-mail:** pyramid@pyramidhill.org. **Website:** www.pyramidhill.org. Art fair held the last Saturday and Sunday of September. Application fee: $25. Booth fee: $100 for a single, $200 for a double. For more information, call, e-mail or visit website. Fair located at Pyramid Hill Sculpture Park and Museum.

TIPS "Make items affordable! Quality work at affordable prices will produce profit."

QUAKER ARTS FESTIVAL

P.O. Box 202, Orchard Park NY 14127. (716)667-2787. **E-mail:** opjaycees@aol.com; kelly@opjaycees.com.

Website: www.opjaycees.com. Estab. 1961. Fine arts & crafts show held annually in mid-September (see website for details). 80% Outdoors, 20% indoors. Accepts photography, painting, graphics, sculpture, crafts. Juried by 4 panelists during event. Awards/prizes: over $10,000 total cash prizes, ribbons and trophies. Number of exhibitors: up to 300. Public attendance: 75,000. Free to the public. Artists can obtain applications online or by sending SASE. Deadline for entry: May 31 for returning exhibitors and then first come, first serve up to festival date (see website for details). Space fee: Before September 1: $185 (single) or $370 (double); after September 1: $210 (single) or $420 (double). Exhibition space: 10×12 ft. (outdoor), 10×6 ft. (indoor). For more information, artists should visit website or send e-mail.

TIPS "Have an inviting booth with a variety of work at various price levels."

RATTLESNAKE AND WILDLIFE FESTIVAL

P.O. Box 292, Claxton GA 30417. (912)739-3820. **E-mail:** rattlesnakewildlifefestival@yahoo.com. **Website:** www.evanscountywildlifeclub.com; Facebook page: Rattlesnake & Wildlife Festival. **Contact:** Heather Dykes. Estab. 1968. Arts & crafts show held annually 2nd weekend in March. Outdoors. Accepts photography and various mediums. Number of exhibitors: 150-200. Public attendance: 15,000-20,000. Artists should apply by filling out an application. Click on the "Registration Tab" located on the Rattlesnake & Wildlife Festival home page. Deadline for entry: late February/early March (see website for details). Space fee: $100 (outdoor); $200 (indoor). Exhibition space: 10×16 (indoor); 10×10 (outdoor). For more information, artists should e-mail, call or visit website.

TIPS "Your display is a major factor in whether people will stop to browse when passing by. Offer a variety."

🎧 RHINEBECK ARTS FESTIVAL

P.O. Box 28, Woodstock NY 12498. (845)331-7900. **Fax:** (845)331-7484. **E-mail:** crafts@artrider.com. **Website:** www.artrider.com. **Contact:** Stacey Jarit. Estab. 2013. Festival of fine contemporary craft and art held annually in late September or early October. 150 indoors and 40 outdoors. Accepts photography, fine art, ceramics, wood, mixed media, leather, glass, metal, fiber, jewelry, sculpture. Juried. Submit 5 images of your work and 1 of your booth. Public attendance: 10,000. Public admission: $10. Artists should apply online at www.artrider.com or www.zapplica-tion.org. Deadline for entry: first Monday in January. Application fee: $45. For more information, artists should e-mail, visit website, or call. Application fees: $0 first time Artrider applicant, $40 mailed in or online, $65 late. Space fee: $495-545. Exhibition space: 10×10 and 10×20 ft. For more information, artists should e-mail, call or visit website.

🎧 RILEY FESTIVAL

312 E. Main St., Suite C, Greenfield IN 46140. (317)462-2141. **Fax:** (317)467-1449. **E-mail:** info@rileyfestival.com. **Website:** www.rileyfestival.com. **Contact:** Sarah Kesterson, public relations. Estab. 1970. Fine arts & crafts festival held in October. Outdoors. Accepts photography, fine arts, home arts, quilts. Juried. Awards/prizes: small monetary awards and ribbons. Number of exhibitors: 450. Public attendance: 75,000. Free to public. Artists should apply by downloading application on website. Deadline for entry: mid-September. Space fee: $185. Exhibition space: 10×10 ft. For more information, artists should visit website.

TIPS "Keep arts priced for middle-class viewers."

🎧 RIVERBANK CHEESE & WINE EXPOSITION

6618 Third St., Riverbank CA 95367-2317. (209)863-9600. **Fax:** (209)863-9601. **E-mail:** events@riverbankcheeseandwine.org. **Website:** www.riverbankcheeseandwine.org. **Contact:** Chris Elswick, event coordinator. Estab. 1977. Arts & crafts show and food show held annually 2nd weekend in October. Outdoors. Accepts photography, other mediums depends on the product. Juried by pictures and information about the artists. Number of exhibitors: 250. Public attendance: 60,000. Free to public. Artists should apply by calling and requesting an application. Applications also available on website. Deadline for entry: early September. Space fee: $300-500. Exhibition space: 12×12 ft. For more information, artists should e-mail, visit website, call or send SASE. Show located at Santa Fe & 3rd St., Riverbank CA.

TIPS Make sure your display is pleasing to the eye.

🎧 ROTARY KEY BISCAYNE ART FESTIVAL

270 Central Blvd., Suite 107B, Jupiter FL 33458. (561)746-6615. **Fax:** (561)746-6528. **E-mail:** info@artfestival.com. **Website:** www.artfestival.com. **Contact:** Malinda Ratliff, communications manager. Estab. 1963. "The annual Key Biscayne Art Fair benefits

our partner and co-producer, the Rotary Club of Key Biscayne. Held in Key Biscayne, an affluent island community in Miami-Dade County, just south of downtown Miami, the annual Key Biscayne Art Festival is one not to be missed! In fact, visitors plan their springtime vacations to South Florida around this terrific outdoor festival that brings together longtime favorites and the newest names in the contemporary art scene. Life-size sculptures, spectacular paintings, one-of-a-kind jewels, photography, ceramics, and much more make for one fabulous weekend." See website for more information.

TIPS "You have to start somewhere. First, assess where you are, and what you'll need to get things off the ground. Next, make a plan of action. Outdoor street art shows are a great way to begin your career and lifetime as a working artist. You'll meet a lot of other artists who have been where you are now. Network with them!"

ROYAL OAK CLAY GLASS AND METAL SHOW

(734)216-3958. **E-mail:** info@integrityshows.com. **Website:** www.clayglassandmetal.com. **Contact:** Mark Loeb. Estab. 1994. Art show featuring works made of clay, glass, or metal only held annually in June. Outdoors. Accepts clay, glass and metal only. We encourage demonstrations. Juried by 3 independent jurors. Awards/prizes: purchase and merit awards. Number of exhibitors: 120. Public attendance: 35,000. Free to the public. Apply online. Deadline for entry: see website. Application fee: $25. Booth fee: $295. Electricity limited; fee: $100. For more information, visit website.

ROYAL OAK OUTDOOR ART FAIR

211 Williams St., P.O. Box 64, Royal Oak MI 48068. (248)246-3180. **E-mail:** artfair@ci.royal-oak.mi.us. **Website:** www.romi.gov. **Contact:** recreation office staff. Estab. 1970. Fine arts & crafts show held annually in July. Outdoors. Accepts photography, collage, jewelry, clay, drawing, painting, glass, fiber, wood, metal, leather, soft sculpture. Juried. Number of exhibitors: 125. Public attendance: 25,000. Free to public. Free adjacent parking. Artists should apply with online application form at www.royaloakarts.com and 3 images of current work. Space fee: $260 (plus a $20 nonrefundable processing fee per medium). Exhibition space: 15×15 ft. For more information, artists should e-mail, call or visit website. Fair located at Memorial Park.

TIPS "Be sure to label your images on the front with name, size of work and 'top.'"

SACO SIDEWALK ART FESTIVAL

P.O. Box 336, 12½ Pepperell Square, Suite 2A, Saco ME 04072. (207)286-3546. **E-mail:** sacospirit@hotmail.com. **Website:** www.sacospirit.com. Estab. 1970. Event held in late June. Annual event organized and managed by Saco Spirit, Inc., a nonprofit organization committed to making Saco a better place to live and work by enhancing the vitality of our downtown. Dedicated to promoting art and culture in our community. Space fee: $75. Exhibition space: 10×10 ft. See website for more details. Festival located in historic downtown Saco.

TIPS "Offer a variety of pieces priced at various levels."

SALT FORK ARTS & CRAFTS FESTIVAL

P.O. Box 250, Cambridge OH 43725. (740)439-9379 or (740)732-2259. **E-mail:** director@saltforkfestival.org. **Website:** www.saltforkfestival.org. The Salt Fork Arts & Crafts Festival (SFACF) is a juried festival that showcases high-quality art in a variety of mediums, painting, pottery, ceramics, fiber art, metalwork, jewelry, acrylics, mixed media, photography, and more. Between 90 and 100 artists come from all over the U.S., for this 3-day event. In addition, the festival heralds Heritage of the Arts. This program offers a look at Early American and Appalachian arts and crafts, many of which are demonstrated by craftsmen practicing arts such as basket weaving, flint knapping, spindling, flute making, quilting, blacksmithing, and more. Area students are given the opportunity to display their work , visitors are entertained throughout the weekend by a variety of talented performing artists, concessionaires offer satisfying foods, and there are crafts for kids and adults. See website for more information.

SALT LAKE'S FAMILY CHRISTMAS GIFT SHOW

South Towne Exposition Center, 9575 S. State St., Sandy UT 84070. (800)521-7469. **Fax:** (425)889-8165. **E-mail:** saltlake@showcaseevents.org. **Website:** www.showcaseevents.org. **Contact:** Dena Sablan, show manager. Estab. 1999. Seasonal holiday show held annually in November. Indoors. Accepts gifts, handmade crafts, art, photography, pottery, glass, jewelry,

clothing, fiber. Juried. Exhibitors: 450. Number of attendees: 25,000. Admission: $12.50 (for all 3 days); 13 & under free. Apply via website or call or e-mail for application. Deadline for entry: October 31. Space fee: contact via website, phone, email. Exhibition space: 10×10. For more information send e-mail, call, send SASE, or visit website.

TIPS "Competitive pricing, attractive booth display, quality product, something unique for sale, friendly & outgoing personality."

SANDY SPRINGS ARTSAPALOOZA

6100 Lake Forrest Dr. NE, Sand Springs GA 30328. (404)873-1222. **E-mail:** info@affps.com. **Website:** www.sandyspringsartsapalooza.com. **Contact:** Randall Fox, festival director. Estab. 2011. Arts & crafts show held annually mid-April. Outdoors. Accepts handmade crafts, painting, photography, sculpture, leather, metal, glass, jewelry. Juried by a panel. Awards/prizes: ribbons. Number of exhibitors: 150. Number of attendees: 25,000. Free to public. Apply online at www.zapplication.org. Deadline for entry: February 2. Application fee: $25. Space fee: $225. Exhibition space: 10×10. For more information, see website.

SANDY SPRINGS FESTIVAL & ARTISTS MARKET

6075 Sandy Springs Circle, Sandy Springs GA 30328. (404)873-1222. **E-mail:** info@affps.com. **Website:** www.sandyspringsartsapalooza.com. **Contact:** Randall Fox, festival director. Estab. 1986. Arts & crafts show held annually late June. Outdoors. Accepts handmade crafts, painting, photography, sculpture, leather, metal, glass, jewelry. Juried by a panel. Awards/prizes: ribbons. Number of exhibitors: 120. Number of attendees: 40,000. Free to public. Apply online at www.zapplication.com. Deadline for entry: July 26. Application fee: $25. Space fee: $250. Exhibition space: 10×10. For more information, see website.

SANTA CALI GON DAYS FESTIVAL

210 W. Truman Rd., Independence MO 64050. (816)252-4745. **E-mail:** lois@ichamber.biz. **Website:** www.santacaligon.com. Estab. 1973. Market vendors 4-day show held annually Labor Day weekend. Outdoors. Ranked in top 20 for vendor profitability. Accepts handmade arts & crafts, photography, and other mediums. Juried by committee. Number of exhibitors: 250. Public attendance: 300,000. Free to public. Artists should apply online. Application requirements include completed application, full booth fee, $20 jury fee (via seperate check), 4 photos of product/art and 1 photo of display. Exhibition space: 10×10 ft. For more information, artists should e-mail, call or visit website.

SANTA FE COLLEGE SPRING ARTS FESTIVAL

3000 NW 83rd St., Gainesville FL 32606. (352)395-5355. **Fax:** (352)336-2715. **E-mail:** kathryn.lehman@sfcollege.edu. **Website:** www.sfspringarts.com. **Contact:** Kathryn Lehman, cultural programs coordinator. Estab. 1969. Fine arts and crafts festival held in mid-April (see website for details). "The festival is one of the 3 largest annual events in Gainesville and is known for its high-quality, unique artwork." Held in the downtown historic district. Public attendance: 130,000+. For more information, e-mail, call or visit website.

SARASOTA CRAFT FAIR

270 Central Blvd., Suite 107B, Jupiter FL 33458. (561)746-6615. **Fax:** (561)746-6528. **E-mail:** info@artfestival.com. **Website:** www.artfestival.com. **Contact:** Malinda Ratliff, communications manager. "Behold contemporary crafts from more than 100 of the nation's most talented artisans. A variety of jewelry, pottery, ceramics, photography, painting, clothing, and much more—all handmade in America—will be on display, ranging from $15-3,000. An expansive Green Market with plants, orchids, exotic flora, handmade soaps, gourmet spices, and freshly popped kettle corn further complements the weekend, blending nature with nurture." See website for more information.

TIPS "You have to start somewhere. First, assess where you are, and what you'll need to get things off the ground. Next, make a plan of action. Outdoor street art shows are a great way to begin your career and lifetime as a working artist. You'll meet a lot of other artists who have been where you are now. Network with them!"

SAUSALITO ART FESTIVAL

P.O. Box 10, Sausalito CA 94966. (415)332-3555. **Fax:** (415)331-1340. **E-mail:** info@sausalitoartfestival.org. **Website:** www.sausalitoartfestival.org. **Contact:** Paul Anderson, managing director; Lexi Matthews, operations coordinator. Estab. 1952. Premiere fine art festival held annually Labor Day weekend. Outdoors. Ac-

cepts painting, photography, 2D and 3D mixed media, ceramics, drawing, fiber, functional art, glass, jewelry, printmaking, sculpture, watercolor, woodwork. Juried. Jurors are elected by their peers from the previous year's show (1 from each category). They meet for a weekend at the end of March and give scores of 1, 2, 4 or 5 to each applicant (5 being the highest). 5 images must be submitted, 4 of art and 1 of booth. Number of exhibitors: 280. Public attendance: 40,000. Artists should apply by visiting website for instructions and application. Applications are through Juried Art Services. Deadline for entry: March. Exhibition space: 100 or 200 sq. ft. Application fee: $50; $100 for late applications. Booth fees range from $1,425-3,125. Average gross sales/exhibitor: $7,700. For more information, artists should visit website. Festival located in Marinship Park.

SAWDUST ART FESTIVAL

935 Laguna Canyon Rd., Laguna Beach CA 92651. (949)494-3030. **Fax:** (949)494-7390. **E-mail:** info@sawdustartfestival.org; tkling@sawdustartfestival.org. **Website:** www.sawdustartfestival.org. Estab. 1967. Annual arts & crafts show held annually June-August (see website for dates; also has winter shows). Outdoors. Accepts handmade crafts, all art mediums. Awards/prizes: peer awards. Exhibitors: 210 (summer); 175 (winter). Number of attendees: 300,000 (summer); 20,000 (winter). Admission: $8.50, adults; $7, seniors; $4 children ages 6-12; children 5 & under free. Application release date varies (see website). Deadline for entry: varies (see website). Application fee: $30 per show. Space fee: $1,250+ (summer). Exhibition space: 10×8. For more information, call, e-mail, or see website. Annual arts & crafts show held annually June-August (see website for dates; also has winter shows). Outdoors. Accepts handmade crafts, all art mediums. Awards/prizes: peer awards. Exhibitors: 210 (summer); 175 (winter). Number of attendees: 300,000 (summer); 20,000 (winter). Admission: $8.50, adults; $7, seniors; $4 children ages 6-12; children 5 & under free. Application release date varies (see website). Deadline for entry: varies (see website). Application fee: $30 per show. Space fee: $1,250+ (summer). Exhibition space: 10×8. For more information, call, e-mail, or see website.

SCOTTSDALE ARTS FESTIVAL

7380 E. Second St., Scottsdale AZ 85251. (480)874-4671. **Fax:** (480)874-4699. **E-mail:** festival@sccarts.

org. **Website:** www.scottsdaleartsfestival.org. Estab. 1970. Fine arts & crafts show held annually, this year March 10-12, 2017. Outdoors at the Scottsdale Civic Center Park. Accepts photography, jewelry, ceramics, digital art, sculpture, metal, glass, drawings, fiber, paintings, printmaking, mixed media, wood. Juried. Awards/prizes: 1st in each category and Best of Show. Number of exhibitors: 170. Public attendance: 25,000. Public admission: $10/single day; $15/2-day pass. Artists should apply through www.zapplication.org starting July 5, 2016. Deadline for entry: October 14, 2016. Exhibition space: 100 to 200 sq. ft. For more information, artists should visit website www.scottsdaleartsfestival.org.

SCOTTSDALE CELEBRATION OF FINE ART

Celebration of Fine Art, 7900 E. Greenway Rd., Suite 101, Scottsdale AZ 85260-1714. (480)443-7695. **Fax:** (480)596-8179. **E-mail:** info@celebrateart.com. **Website:** www.celebrateart.com. The Celebration of Fine Art™ is a 10 week long, juried show taking place from mid-January through mid-March in Scottsdale, AZ. We jury not only for quality but variety. This helps insure that direct competition is minimized and that you will have the best opportunity for success. All styles of art in all mediums are welcome. In addition to painting and sculpture we also have fine crafts such as furniture, jewelry, ceramics, basketry, and weaving. Only work created by the artist and handmade work is accepted. We do not allow manufactured goods of any kind. Artists who have previously been selected for the show will be juried in the two months following the current exhibit. Additional details, prices, and other information are contained in the artist application packet. See website for more information.

SELL-A-RAMA

Tyson Wells Sell-A-Rama, P.O. Box 60, Quartzsite AZ 85346. (928)927-6364. **E-mail:** tysonwells@tds.net. **Website:** www.tysonwells.com. Arts & craft show held annually in January. Outdoors & indoors. Accepts handmade crafts, ceramics, paintings, jewelry, glass, photography, wearable art, and other mediums. Juried. Number exhibitors: see website. Number attendees: varies. Free to public. Apply online. Deadline for entry: see website for dates. Application fee: none. Space fee: varies. Exhibition space: varies. For more information, artists should email, call or visit website.

⊙ SHADYSIDE ART & CRAFT FESTIVAL

270 Central Blvd., Suite 107B, Jupiter FL 33458. (561)746-6615. **Fax:** (561)746-6528. **E-mail:** info@ artfestival.com. **Website:** www.artfestival.com. **Contact:** Malinda Ratliff, communications manager. Estab. 1996. Fine art & craft fair held annually in late May. Outdoors. Accepts photography, jewelry, mixed media, sculpture, wood, ceramic, glass, painting, digital, fiber, metal. Juried. Number exhibitors: 125. Number attendees: 60,000. Free to public. Apply online via www.zapplication.org. Deadline: see website. Application fee: $25. Space fee: $395. Exhibition space: 10×10 and 10×20. For more information, artists should e-mail, call, or visit website. Festival located at Walnut St. in Shadyside (Pittsburgh, PA).

TIPS "You have to start somewhere. First, assess where you are, and what you'll need to get things off the ground. Next, make a plan of action. Outdoor street art shows are a great way to begin your career and lifetime as a working artist. You'll meet a lot of other artists who have been where you are now. Network with them!"

➕ 🎧 SHIPSHEWANA QUILT FESTIVAL

P.O. Box 245, Shipshewana IN 46565. (260)768-4887. **E-mail:** info@shipshewanaquiltfest.com. **Website:** www.shipshewanaquiltfest.com. **Contact:** Nancy Troyer, show organizer. Estab. 2009. Quilt & vendor show held annually late June. Indoors. Accepts handmade crafts and other mediums. Juried. Awards/prizes: cash. Exhibitors: 20. Number of attendees: 4,000. Admission: $8/day; $12/week. Apply online. Deadline for entry: see website. Application fee: none. Space fee: varies. Exhibition space: varies. Average sales: $5,000-10,000. For more information, artists should send e-mail, call, or visit website. Quilt & vendor show held annually late June. Indoors. Accepts handmade crafts and other mediums. Juried. Awards/prizes: cash. Exhibitors: 20. Number of attendees: 4,000. Admission: $8/day; $12/week. Apply online. Deadline for entry: see website. Application fee: none. Space fee: varies. Exhibition space: varies. Average sales: $5,000-10,000. For more information, artists should send e-mail, call, or visit website.

SIDEWALK ART MART

Downtown Helena, Inc., Mount Helena Music Festival, 225 Cruse Ave., Suite B, Helena MT 59601. (406)447-1535. **Fax:** (406)447-1533. **E-mail:** jmchugh@mt.net. **Website:** www.downtownhelena. com. **Contact:** Jim McHugh. Estab. 1974. Arts, crafts and music festival held annually in June. Outdoors. Accepts photography. No restrictions except to display appropriate work for all ages. Number of exhibitors: 50+. Public attendance: 5,000. Free to public. Artists should apply by visiting website to download application. Space fee: $100-125. Exhibition space: 10×10 ft. For more information, artists should e-mail, call or visit website. Festival held at Women's Park in Helena MT.

TIPS "Greet people walking by and have an eye-catching product in front of booth. We have found that high-end artists or expensively priced art booths that had business cards with e-mail or website information received many contacts after the festival."

🎧 SIERRA MADRE WISTARIA FESTIVAL

19 Suffolk Ave., Unit A, Sierra Madre CA 91024. (626)355-5111 or (626)233-5524. **Fax:** (626)306-1150. **E-mail:** smadrecc@gmail.com. **Website:** www.sierramadrechamber.com/wistaria/photos.htm. Fine arts, crafts and garden show held annually in March. Outdoors. Accepts photography, anything handcrafted. Juried. Craft vendors send in application and photos to be juried. Most appropriate are selected. Awards/prizes: Number of exhibitors: 175. Public attendance: 12,000. Free to public. Artists should apply by sending completed and signed application, 3-5 photographs of their work, application fee, license application, space fee and 2 SASEs. Deadline for entry: late December. Application fee: $25. Public Safety Fee (nonrefundable) $25. Space fee: $185. Exhibition space: 10×10 ft. For more information, artists should e-mail, visit website or call. Applications can be found on chamber website.

TIPS "Have a clear and simple application. Be nice."

🎧 SIESTA FIESTA

270 Central Blvd., Suite 107B, Jupiter FL 33458. (561)746-6615. **Fax:** (561)746-6528. **E-mail:** info@artfestival.com. **Website:** www.artfestival. com. **Contact:** Malinda Ratliff, communications manager. Estab. 1978. Fine art & craft fair held annually in April. Outdoors. Accepts photography, jewelry, mixed media, sculpture, wood, ceramic, glass, painting, digital, fiber, metal. Juried. Number exhibitors: 85. Number attendees: 40,000. Free to public. Apply online via www.zapplication.org. Deadline: see website. Application fee: $25. Space fee: $350. Exhibition space: 10×10 and 10×20. For

more information, artists should e-mail, call, or visit website. Festival located at Ocean Blvd. in Siesta Key Village.

TIPS "You have to start somewhere. First, assess where you are, and what you'll need to get things off the ground. Next, make a plan of action. Outdoor street art shows are a great way to begin your career and lifetime as a working artist. You'll meet a lot of other artists who have been where you are now. Network with them!"

SKOKIE ART GUILD FINE ART EXPO

Devonshire Cultural Center, 4400 Greenwood St., Skokie IL 60077. (847)677-8163. **E-mail:** info@skokieartguild.org; skokieart@aol.com. **Website:** www.skokieartguild.org. Outdoor fine art/craft show open to all artists (18+) in the Chicagoland area. Held in mid-May. Entrance fee: $20 (members); $30 (nonmembers). Awards: 1st, 2nd, 3rd place ribbons, Purchase Awards. Deadline for application: early May. Event held at Oakton Park.

TIPS Display your work in a professional manner: matted, framed, etc.

SMITHVILLE FIDDLERS' JAMBOREE AND CRAFT FESTIVAL

P.O. Box 83, Smithville TN 37166. (615)597-8500. E-mail: eadkins@smithvillejamboree.com. **Website:** www.smithvillejamboree.com. **Contact:** Emma Adkins, craft coordinator. Estab. 1971. Arts & crafts show held annually the weekend nearest the Fourth of July holiday. Indoors. Juried by photos and personally talking with crafters. Awards/prizes: ribbons and free booth for following year for Best of Show, Best of Appalachian Craft, Best Display, Best New Comer. Number of exhibitors: 235. Public attendance: 130,000. Free to public. Artists should apply online. Deadline: May 1. Space fee: $125. Exhibition space: 12×12 ft. Average gross sales/exhibitors: $1,200+. For more information, artists should call or visit website. Festival held in downton Smithville.

SMOKY HILL RIVER FESTIVAL FINE ART SHOW

(785)309-5770. **E-mail:** sahc@salina.org. **Website:** www.riverfestival.com. Fine art & craft show held annually in June. Outdoors. Accepts handmade crafts, ceramics, jewelry, fiber, mixed media, painting, drawing/pastels, glass, metal, wood, graphics/printmaking, digital, paper, sculpture, and photography. Juried. Awards/prizes: Jurors' Merit Awards, Purchase

Awards. Number exhibitors: 90. Number attendees: 60,000. Admission: $10 in advance; $15 at gate; children 11 & under free. Apply via www.zapplication.org. Deadline for entry: February. Application fee: $30. Space fee: $275. Exhibition space: 10×10. For more information, artists should e-mail or visit website.

SOLANO AVENUE STROLL

1563 Solano Ave., #101, Berkeley CA 94707. (510)527-5358. **E-mail:** info@solanostroll.org. **Website:** www.solanostroll.org. **Contact:** Allen Cain. Estab. 1974. Fine arts & crafts show held annually 2nd Sunday in September. Outdoors. "Since 1974, the merchants, restaurants, and professionals, as well as the twin cities of Albany and Berkeley have hosted the Solano Avenue Stroll, the East Bay's largest street festival." Accepts photography and all other mediums. Juried by board of directors. Number of exhibitors: 150 spaces for crafts; 600 spaces total. Public attendance: 250,000. Free to the public. Artists should apply online in April, or send SASE. Space fee: $150. Exhibition space: 10×10 ft. For more information, artists should e-mail, visit website, or send SASE. Event takes place on Solano Ave. in Berkeley and Albany CA.

TIPS "Artists should have a clean presentation; small-ticket items as well as large-ticket items; great customer service; enjoy themselves."

SOUTH COUNTY FAMILY YMCA GIFT & CRAFT FAIR

12736 Southfork Rd., St. Louis MO 63128. (314)849-9622. **E-mail:** teri.varble@gwrymca.org. **Website:** www.gwrymca.org/southcounty. **Contact:** Teri Varble, program executive. Estab. Early 1980's. Semi-annual. Held in March/October. Seasonal/holiday show. Vendor fair - gifts & crafts. Held indoors and outdoors. Accepts handmade crafts. Other mediums: misc. (call for further inquiry). Event juried: No. No prizes given. Average number of exhibitors: 100+. Average number of attendees: 3,000+. Admission fee for public: free. Deadline: Until filled to capacity. Application fee: $25 non-refundable deposit. Inside (8x5) $65. Outside (10x10) $87. Average gross sales varies per vendor. For more information, artists should e-mail or call.

SOUTH JERSEY PUMPKIN SHOW

B & K Enterprise, P.O. Box 925, Millville NJ 8332. (856)765-0118. **Fax:** (856)765-9050. **E-mail:** sjpumpkinshow@aol.com; bkenterprisenj@aol.com. **Website:** www.sjpumpkinshow.com. **Contact:** Kathy Wright, organizer. Estab. 2003. Arts & crafts show

held annually 2nd weekend in October. Indoors & outdoors. Accepts fine art & handmade crafts, wood, metal, pottery, glass, quilts. Awards/prizes: $100 for Fall Booth. Exhibitors: 175. Number of attendees: 10,500. Admission: $5/car (good all 3 days). Artists should apply via website. Deadline for entry: late September. Application fee: none. Space fee: $40 (one day); $100 (weekend). Exhibition space: 10×10. For more information, artists should e-mail, visit website, or call.

○ Event held at Salem Co. Fairgrounds, 760 Harding Hwy., Woodstown, NJ.

THE SOUTHWEST ARTS FESTIVAL

Indio Chamber of Commerce, 82921 Indio Blvd., Indio CA 92201. (760)347-0676. **Fax:** (763)347-6069. **E-mail:** jonathan@indiochamber.org;swaf@indiochamber.org. **Website:** www.southwestartsfest.com. Estab. 1986. Featuring over 275 acclaimed artists showing traditional, contemporary and abstract fine works of art and quality crafts, the festival is a major, internationally recognized cultural event attended by nearly 10,000 people. The event features a wide selection of clay, crafts, drawings, glass work, jewelry, metal works, paintings, photographs, printmaking, sculpture and textiles. Application fee: $55. Easy check-in and check-out procedures with safe and secure access to festival grounds for setup and breakdown. Allow advance set-up for artists with special requirements (very large art requiring the use of cranes, forklifts, etc., or artists with special needs). Artist parking is free. Disabled artist parking is available. Apply online. For more information, artists should call, e-mail, or visit website. Show takes place in January.

○ SPANISH SPRINGS ART & CRAFT FESTIVAL

270 Central Blvd., Suite 107B, Jupiter FL 33458. (561)746-6615. **Fax:** (561)746-6528. **E-mail:** info@artfestival.com. **Website:** www.artfestival.com. **Contact:** Malinda Ratliff, communications manager. Estab. 1997. Fine art & craft fair held biannually in January & November. Outdoors. Accepts photography, jewelry, mixed media, sculpture, wood, ceramic, glass, painting, digital, fiber, metal. Juried. Number exhibitors: 210. Number attendees: 20,000. Free to public. Apply online via www.zapplication.org or visit website for paper application. Deadline: see website. Application fee: $15. Space fee: $265. Exhibition space:

10×10 and 10×20. For more information, artists should e-mail, call, or visit website. Festival located at Spanish Springs, The Villages, FL.

TIPS "You have to start somewhere. First, assess where you are, and what you'll need to get things off the ground. Next, make a plan of action. Outdoor street art shows are a great way to begin your career and lifetime as a working artist. You'll meet a lot of other artists who have been where you are now. Network with them!"

○ SPANKER CREEK FARM ARTS & CRAFTS FAIR

P.O. Box 5644, Bella Vista AR 72714. (479)685-5655. **E-mail:** info@spankercreekfarm.com. **Website:** www.spankercreekfarm.com. Arts & craft show held biannually in the spring & fall. Outdoors & indoors. Accepts handmade crafts, ceramics, paintings, jewelry, glass, photography, wearable art, and other mediums. Juried. Number exhibitors: see website. Number attendees: varies. Free to public. Apply online. Deadline for entry: see website for dates. Application fee: none. Space fee: varies. Exhibition space: varies. For more information, artists should call, e-mail, or visit website.

○ SPRING CRAFTMORRISTOWN

P.O. Box 28, Woodstock NY 12498. (845)331-7900. **Fax:** (845)331-7484. **E-mail:** crafts@artrider.com. **Website:** www.artrider.com. Estab. 1990. Fine arts & crafts show held annually in March. Indoors. Accepts photography, wearable and nonwearable fiber, jewelry, clay, leather, wood, glass, painting, drawing, prints, mixed media. Juried by 5 images of work and 1 of booth, viewed sequentially. Number of exhibitors: 150. Public attendance: 5,000. Public admission: $9. Artists should apply online at www.artrider.com or at www.zapplication.org. Deadline for entry: January 1. Application fee: $45. Space fee: $495. Exhibition space: 10×10 ft. For more information, artists should e-mail, call or visit website.

○ SPRING CRAFTS AT LYNDHURST

P.O. Box 28, Woodstock NY 12498. (845)331-7900. **Fax:** (845)331-7484. **E-mail:** crafts@artrider.com. **Website:** www.artrider.com. Estab. 1984. Fine arts & crafts show held annually in early May. Outdoors. Accepts photography, wearable and nonwearable fiber, jewelry, clay, leather, wood, glass, painting, drawing, prints, mixed media. Juried by 5 images of work and

1 of booth, viewed sequentially. Number of exhibitors: 275. Public attendance: 14,000. Public admission: $10. Artists should apply at www.artrider.com or can apply online at www.zapplication.org. Deadline for entry: January 1. Application fee: $45. Space fee: $775-875. Exhibition space: 10×10 ft. For more information, artists should e-mail, call or visit website.

SPRINGFEST

Southern Pines Business Association, P.O. Box 831, Southern Pines NC 28388. (910)315-6508. **E-mail:** spbainfo@southernpines.biz. **Website:** www. southernpines.biz. **Contact:** Susan Harris. Estab. 1979. Arts & crafts show held annually last Saturday in April. Outdoors. Accepts photography and crafts. We host over 160 vendors from all around North Carolina and the country. Enjoy beautiful artwork and crafts including paintings, jewelry, metal art, photography, woodwork, designs from nature and other amazing creations. Event is held in conjunction with Tour de Moore, an annual bicycle race in Moore County, and is co-sponsored by the town of Southern Pines. Public attendance: 8,000. Free to the public. Deadline: March (see website for more details). Space fee: $75. Exhibition space: 10×12 ft. For more information, artists should e-mail, call, visit website or send SASE. Apply online. Event held in historic downtown Southern Pines on Broad St.

🎧 SPRING FESTIVAL, AN ARTS & CRAFTS AFFAIR

P.O. Box 655, Antioch IL 60002. (402)331-2889. **E-mail:** hpifestivals@cox.net. **Website:** www. hpifestivals.com. Annual tour takes place in Omaha (March & April), Minneapolis (March & April) and Chicago (April). Application available online. Artists should e-mail or see website for specifics on each location and exhibitor information.

🎧 SPRING FESTIVAL ON PONCE

Olmstead Park, North Druid Hills, 1451 Ponce de Leon, Atlanta GA 30307. (404)873-1222. **E-mail:** info@affps.com. **Website:** www.festivalonponce. com. **Contact:** Randall Fox, festival director. Estab. 2011. Arts & crafts show held annually early April. Outdoors. Accepts handmade crafts, painting, photography, sculpture, leather, metal, glass, jewelry. Juried by a panel. Awards/prizes: ribbons. Number of exhibitors: 125. Number of attendees: 40,000. Free to public. Apply online at www.zapplication.org. Deadline for entry: February 6. Application fee: $25. Space

fee: $275. Exhibition space: 10×10. For more information, see website.

🎧 SPRING FINE ART & CRAFTS AT BROOKDALE PARK

Rose Squared Productions, Inc., 473 Watchung Ave., Bloomfield NJ 07003. (908)874-5247. **Fax:** (908)874-7098. **E-mail:** info@rosesquared.com. **Website:** www. rosesquared.com. **Contact:** Howard and Janet Rose. Estab. 1988. Fine arts & craft show held annually at Brookdale Park on the border of Bloomfield and Montclair NJ. Event takes place in mid-June on Father's Day weekend. Outdoors. Accepts photography and all other mediums. Juried. Number of exhibitors: 180. Public attendance: 16,000. Free to the public. Artists should apply by downloading application from website or call for application. Deadline: 1 month before show date. Application fee: $30. Space fee: varies by booth size. Exhibition space: 120 sq. ft. For more information, artists should e-mail, call or visit website. Promoters of fine art and craft shows that are successful for the exhibitors and enjoyable, tantalizing, satisfying artistic buying experiences for the supportive public.

TIPS "Create a professional booth that is comfortable for the customer to enter. Be informative, friendly and outgoing. People come to meet the artist."

🎧 SPRING GREEN ARTS & CRAFTS FAIR

P.O. Box 96, Spring Green WI 53588. **E-mail:** springgreenartfair@gmail.com. **Website:** www. springgreenartfair.com. Fine arts & crafts fair held annually June. Indoors. Accepts handmade crafts, glass, wood, painting, fiber, graphics, pottery, sculpture, jewelry, photography. Juried. Awards/prizes: Best of Show, Award of Excellence. Number exhibitors: see website. Number of attendees: varies per show. Admission: varies per show. Apply online. Deadline for entry: mid February. Application fee: $10-20. Space fee: $150. Exhibition space: 10×10. For more information, artists should send e-mail or visit website.

🎧 ST. ARMANDS CIRCLE CRAFT FESTIVAL

270 Central Blvd., Suite 107B, Jupiter FL 33458. (561)746-6615. **Fax:** (561)746-6528. **E-mail:** info@ artfestival.com. **Website:** www.artfestival.com. **Contact:** Malinda Ratliff, communications manager. Estab. 2004. Fine art & craft fair held biannually in January & November. Outdoors. Accepts

photography, jewelry, mixed media, sculpture, wood, ceramic, glass, painting, digital, fiber, metal. Juried. Number exhibitors: 180-210. Number attendees: 80,000-100,000. Free to public. Apply online via www.zapplication.org. Deadline: see website. Application fee: $25. Space fee: $415-435. Exhibition space: 10×10 and 10×20. For more information, artists should e-mail, call, or visit website. Fair held in St. Armands Circle in Sarasota FL.

TIPS "You have to start somewhere. First, assess where you are, and what you'll need to get things off the ground. Next, make a plan of action. Outdoor street art shows are a great way to begin your career and lifetime as a working artist. You'll meet a lot of other artists who have been where you are now. Network with them!"

ST. CHARLES FINE ART SHOW

2 E. Main St., St. Charles IL 60174. (630)443-3967. E-mail: info@downtownstcharles.org. **Website:** www.downtownstcharles.org/fineartshow. **Contact:** Jamie Blair. Fine art show held annually in May during Memorial Day weekend. Outdoors. Accepts photography, painting, sculpture, glass, ceramics, jewelry, nonwearable fiber art. Juried by committee: submit 4 slides of art and 1 slide of booth/display. Awards/prizes: Cash awards in several categories. Free to the public. Artists can apply via website. Deadline for entry: early January. Jury fee: $35. Space fee: $375. Exhibition space: 10×10 ft. For more information, artists should e-mail or visit website.

STEPPIN' OUT

Downtown Blacksburg, Inc., P.O. Box 233, Blacksburg VA 24063. (540)951-0454. **E-mail:** dbi@downtownblacksburg.com; events@downtownblacksburg.com. **Website:** www.blacksburgsteppinout.com. **Contact:** Laureen Blakemore. Estab. 1980. Arts & crafts show held annually 1st Friday and Saturday in August. Outdoors. Accepts photography, pottery, painting, drawing, fiber arts, jewelry, general crafts. All arts and crafts must be handmade. Number of exhibitors: 230. Public attendance: 40,000. Free to public. Space fee: $200. An additional $10 is required for electricity. Exhibition space: 10×16 ft. Artists should apply by e-mailing, calling or downloading an application on website. Deadline for entry: May 1. Downtown Blacksburg, Inc. (DBI) is a non-profit (501c6) association of merchants, property owners, and downtown advocates whose mission is to sustain a dynamic, vital, and diverse community through marketing, events, economic development, and leadership.

TIPS "Visit shows and consider the booth aesthetic—what appeals to you. Put the time, thought, energy and money into your booth to draw people in to see your work."

ST. GEORGE ART FESTIVAL

50 S. Main, St. George UT 84770. (435)627-4500. **E-mail:** artadmn@sgcity.org; gary.sanders@sgcity.org; leisure@sgcity.org. **Website:** www.sgcity.org/artfestival. **Contact:** Gary Sanders. Estab. 1979. Fine arts & crafts show held annually Easter weekend in either March or April. Outdoors. Accepts photography, painting, wood, jewelry, ceramics, sculpture, drawing, 3D mixed media, glass, metal, digital. Juried from digital submissions. Awards/prizes: $5,000 Purchase Awards. Art pieces selected will be placed in the city's permanent collections. Number of exhibitors: 110. Public attendance: 20,000/day. Free to public. Artists should apply by completing application form via EntryThingy, nonrefundable application fee, slides or digital format of 4 current works in each category and 1 of booth, and SASE. Deadline for entry: January 11. Exhibition space: 10×11 ft. For more information, artists should check website or e-mail.

TIPS "Artists should have more than 50% originals. Have quality booths and set-up to display art in best possible manner. Be outgoing and friendly with buyers."

STILLWATER ARTS FESTIVAL

P.O. Box 1449, Stillwater OK 74076. (405)747-8070. E-mail: stillwaterartsfestival@stillwater.org; rjanway@stillwater.org. **Contact:** Rachel Janway. Estab. 1977. Fine art show held annually in April. Outdoors. Accepts photography, oil, acrylic, watercolor and multi media paintings, pottery, pastel work, fiber arts, jewelry, sculpture, glass art, wood and other. Juried. Awards are based on entry acceptance on quality, distribution and various media entries. Awards/prizes: Best of Show, $500; 1st place, $200; 2nd place, $150; 3rd place, $100. Number of exhibitors: 80. Public attendance: 7,500-10,000. Free to public. Artists should apply via www.zapplication.org. Deadline for entry: early spring (visit website for details). Jury fee: $20. Booth fee $140; $240 for 2 booths. Exhibition space:

10×10 ft. For more information, artists should e-mail or call. Festival held at 8th & Husband Streets.

ST. JAMES COURT ART SHOW

P.O. Box 3804, Louisville KY 40201. (502)635-1842. **Fax:** (502)635-1296. **E-mail:** mesrock@stjamescourtartshow.com. **Website:** www.stjamescourtartshow.com. **Contact:** Marguerite Esrock. Estab. 1957. Annual fine arts & crafts show held the first full weekend in October. Accepts photography; has 17 medium categories. Juried in April; there is also a street jury held during the art show. Number of exhibitors: 260. Public attendance: 200,000. Free to the public. Artists should apply by visiting website and printing out an application or via www.zapplication.org. Deadline for entry: March 31 (see website for details). Application fee: $40. Space fee: $575. Exhibition space: 10×12 ft. For more information, artists should visit website. The 2016 St James Court Art Show will be celebrating its 60th Anniversary. The 2016 show will be held . Consistently in the top ten Fine Art and Craft Shows reported by Sunshine Artists Top 200 List (September issue).

TIPS "Have a variety of price points."

ST. JOHN MEDICAL CENTER FESTIVAL OF THE ARTS

(440)808-9201. **E-mail:** ardis.radak@csauh.com. **Website:** www.sjws.net/festival_of_arts.aspx. **Contact:** Ardis Radak. Art & craft show held annually in July. Outdoors. Accepts handmade crafts, ceramics, glass, fiber, glass, graphics, jewelry, leather, metal, mixed media, painting, photography, printmaking, sculpture, woodworking. Juried. Awards/prizes: Best of Show, 1st place, 2nd place, honorable mention. Number exhibitors: 200. Number attendees: 15,000. Free to public. Apply via www.zapplication.org. Deadline for entry: May. Application fee: $15. Space fee: $300 (single); $600 (double). Exhibition space: 10×10 (single); 10×20 (double). For more information, artists should e-mail, call or visit website.

ST. LOUIS ART FAIR

225 S. Meramec Ave., Suite 105, St. Louis MO 63105. **E-mail:** info@culturalfestivals.com. **Website:** www.culturalfestivals.com. **Contact:** Laura Miller, director of operations. Estab. 1994. Fine art/craft show held annually in September, the weekend after Labor Day. Outdoors. Accepts photography, ceramics, drawings, digital, glass, fiber, jewelry, mixed-media, metalwork, printmaking, paintings, sculpture and wood. Juried event, uses 5 jurors using 3 rounds, digital app. Total prize money available: $21,000—26 awards ranging from $500-1,000. Number of exhibitors: 180. Average attendance: 130,000. Admission free to the public. $40 application fee. Space fee: $625-725. 100 sq. ft. space. Average gross sales for exhibitor: $8.500. Apply at www.zapplication.org. For more information, call, e-mail or visit website. Fair held in the central business district of Clayton MO.

TIPS "Look at shows and get a feel for what it is."

STOCKLEY GARDENS FALL ARTS FESTIVAL

801 Boush St., Suite 302, Norfolk VA 23510. (757)625-6161. **Fax:** (757)625-7775. **E-mail:** aknox@hopehouse.org ljanosk@hope-house.org. **Website:** www.stockleygardens.com. **Contact:** Anne Knox, development coordinator. Estab. 1984. Fine arts & crafts show held biannually in the 3rd weekends in May and October. Outdoors. Accepts photography and all major fine art mediums. Juried. Number of exhibitors: 135. Public attendance: 25,000. Free to the public. Artists should apply by submitting application, jury and booth fees, 5 slides. Deadline for entry: February and July. Exhibition space: 10×10 ft. For more information, artists should visit the website.

STONE ARCH BRIDGE FESTIVAL

(651)398-0590. **E-mail:** stacy@weimarketing.com; heatherwmpls@gmail.com. **Website:** www.stonearchbridgefestival.com. **Contact:** Sara Collins, manager. Estab. 1994. Fine arts & crafts and culinary arts show held annually on Father's Day weekend in the Riverfront District of Minneapolis. Outdoors. Accepts drawing/pastels, printmaking, ceramics, jewelry (metals/stone), mixed media, painting, photography, sculpture metal works, bead work (jewelry or sculpture), glass, fine craft, special consideration. Juried by committee. Awards/prizes: free booth the following year; $100 cash prize. Number of exhibitors: 250+. Public attendance: 80,000. Free to public. Artists should apply by application found on website or through www.zapplication.org. Application fee: $25. Deadline for entry: early April. Space fee: depends on booth location (see website for details). Exhibition space: 10×10 ft. For more information, artists should call (651)228-1664 or e-mail Stacy De Young at stacy@weimarketing.com.

TIPS "Have an attractive display and variety of prices."

ST. PATRICK'S DAY CRAFT SALE & FALL CRAFT SALE

P.O. Box 461, Maple Lake MN 55358-0461. **Website:** www.maplelakechamber.com. **Contact:** Kathy. Estab. 1988. Arts & crafts show held biannually in March and early November. Indoors. Number of exhibitors: 30-40. Public attendance: 300-600. Free to public. Deadline for entry: 2 weeks before the event. Exhibition space: 10×10 ft. For more information or an application, artists should visit website.

TIPS "Don't charge an arm and a leg for the items. Don't overcrowd your items. Be helpful, but not pushy."

STRAWBERRY FESTIVAL

Downtown Billings Alliance, 2815 Second Ave. N., Billings MT 59101. (406)294-5060. **Fax:** (406)294-5061. **E-mail:** inatashap@downtownbillings.com. **Website:** www.downtownbillings.com. **Contact:** Natasha. Estab. 1991. Fine arts & crafts show held annually 2nd Saturday in June. Outdoors. Accepts photography and only finely crafted work. Handcrafted works by the selling artist will be given priority. Requires photographs of booth set up and 2-3 of work. Juried. Public attendance: 15,000. Free to public. Artists should apply online. Deadline for entry: April. Space fee: $160-195. Exhibition space: 10×10 ft. For more information, artists should e-mail or visit website. Show located at N. Broadway & 2nd Ave. N in downtown Billings.

SUMMER ART IN THE PARK FESTIVAL

16 S. Main St., Rutland VT 05701. (802)775-0356. **E-mail:** info@chaffeeartcenter.org. **Website:** www.chaffeeartcenter.org. Estab. 1961. A fine arts & crafts show held at Main Street Park in Rutland VT annually in mid-August. Accepts fine art, specialty foods, fiber, jewelry, glass, metal, wood, photography, clay, floral, etc. All applications will be juried by a panel of experts. The Art in the Park Festivals are dedicated to high-quality art and craft products. Number of exhibitors: 100. Public attendance: 9,000-10,000. Public admission: voluntary donation. Artists should apply online and either e-mail or submit a CD with 3 photos of work and 1 of booth (photos upon preapproval). Deadline for entry: early bird discount of $25 per show for applications received by March 31. Space fee: $200-350. Exhibit space: 10×12 or 20×12 ft. For more information, artists should e-mail, call or visit website. Festival held in Main Street Park.

TIPS "Have a good presentation, variety if possible (in price ranges, too) to appeal to a large group of people. Apply early as there may be a limited amount of accepted vendors per category. Applications will be juried on a first come, first served basis until the category is determined to be filled."

SUMMER ARTS & CRAFTS FESTIVAL

38 Charles St., Rochester NH 03867. **E-mail:** info@castleberryfairs.com. **Website:** www.castleberryfairs.com. Estab. 1992. Arts & crafts show held annually 2nd weekend in August in Lincoln NH. Outdoors. Accepts photography and all other mediums. Juried by photo, slide or sample. Number of exhibitors: 100. Public attendance: 7,500. Free to the public. Artists should apply by downloading application from website. Application fee: $50. Space fee: $225. Exhibition space: 10×10 ft. For more information, artists should visit website. Festival held at Village Shops & Town Green, Main Street.

TIPS "Do not bring a book; do not bring a chair. Smile and make eye contact with everyone who enters your booth. Have them sign your guest book; get their e-mail address so you can let them know when you are in the area again. And, finally, make the sale—they are at the fair to shop, after all."

SUMMERFAIR

7850 Five Mile Rd., Cincinnati OH 45230. (513)531-0050. **E-mail:** exhibitors@summerfair.org. **Website:** www.summerfair.org. Estab. 1968. Fine arts & crafts show held annually the weekend after Memorial Day. Outdoors. Accepts photography, ceramics, drawing, printmaking, fiber, leather, glass, jewelry, painting, sculpture, metal, wood and mixed media. Juried by a panel of judges selected by Summerfair, including artists and art educators with expertise in the categories offered at Summerfair. Submit application with 5 digital images (no booth image) through www.zapplication.org. Awards/prizes: $18,000 in cash awards. Number of exhibitors: 300. Public attendance: 20,000. Public admission: $10. Deadline: February. Application fee: $35. Space fee: $450, single; $900, double space; $125 canopy fee (optional—exhibitors can rent a canopy for all days of the fair). Exhibition space: 10×10 ft. for single space; 10×20 ft. for double space. For more information, artists should e-mail, visit website, call. Fair held at Cincinnati's historic Coney Island.

SUMMIT ART FESTIVAL

Website: www.summitartfest.org. Fine arts & crafts fair held annually October. Outdoors. Accepts handmade crafts, jewelry, ceramics, painting, glass, photography, fiber, and more. Juried. Awards/prizes: Best of Show, 2nd place, 3rd place, Mayor's Award, Jurors' Merit Award. Number exhibitors: see website. Number attendees: varies. Free to public. Apply online. Deadline for entry: July. Application fee: $25. Space fee: $255. Exhibition space: 10×10. For more information, artists should visit website.

SUN FEST, INC.

P.O. Box 2404, Bartlesville OK 74005. (918)331-0456. **Fax:** (918)331-3217. **E-mail:** sunfestbville@gmail.com. **Website:** www.bartlesvillesunfest.org. Estab. 1982. Fine arts & crafts show held annually in early June. Outdoors. Accepts photography, painting and other arts and crafts. Juried. Awards: $2,000 in cash awards along with a ribbon/award to be displayed. Number of exhibitors: 95-100. Number of attendees: 25,000-30,000. Free to the public. Artists should apply by e-mailing or calling for an entry form, or completing online, along with 3-5 photos showing your work and booth display. Deadline: April. Space fee: $125. An extra $20 is charged for use of electricity. Exhibition space: 10×10 ft. For more information, artists should e-mail, call or visit website.

SUN VALLEY CENTER ARTS & CRAFTS FESTIVAL

Sun Valley Center for the Arts, P.O. Box 656, Sun Valley ID 83353. (208)726-9491. **Fax:** (208)726-2344. **E-mail:** festival@sunvalleycenter.org. **Website:** www.sunvalleycenter.org. **Contact:** Sarah Kolash, festival director. Estab. 1968. Annual fine art & craft show held 2nd weekend in August. Outdoors. Accepts handmade crafts, ceramics, drawing, fiber, glass, jewelry, metalwork, mixed media, painting, photography, printmaking, sculpture, woodwork. Juried. Exhibitors: 140. Number of attendees: 10,000. Free to public. Apply via www.zapplication.org. Deadline for entry: . Application fee: $35. Space fee: $450 & $900, $500 or $1000 for corner spaces. Exhibition space: 10×10 & 10×20. Average sales: $3,700. For more information e-mail or see website.

SURPRISE FINE ART & WINE FESTIVAL

15940 N Bullard Ave., Surprise AZ 85374. (480)837-5637. **Fax:** (480)837-2355. **E-mail:** info@thunderbirdartists.com. **Website:** www.thunderbirdartists.com. **Contact:** Denise Colter, president. Estab. 2012. "The Surprise Fine Art & Wine Festival, produced by Thunderbird Artists and in conjunction with the City of Surprise and Surprise Sundancers, is back by popular demand! The sales, attendance and support were spectacular for a newer event and the most popular quote used by vendors.. "What a wonderful surprise!" This event will receive an extensive and dedicated advertising campaign, like all events produced by Thunderbird Artists. The Thunderbird Artists Mission is to promote fine art and fine crafts, paralleled with the ambiance of unique wines and fine music, while supporting the artists, merchants and surrounding community." It is the mission of Thunderbird Artists to further enhance the art culture with the local communities by producing award-winning, sophisticated fine art festivals throughout the Phoenix metro area. Thunderbird Artists has played an important role in uniting nationally recognized and award-winning artists with patrons from across the globe.

TIPS "A clean, gallery-type presentation is very important."

SYRACUSE ARTS & CRAFTS FESTIVAL

115 W. Fayette St., Syracuse NY 13202. (315)422-8284. **Fax:** (315)471-4503. **E-mail:** mail@downtownsyracuse.com. **Website:** www.syracuseartsandcraftsfestival.com. **Contact:** Laurie Reed, director. Estab. 1970. Fine arts & crafts show held annually in late July. Outdoors. Accepts photography, ceramics, fabric/fiber, glass, jewelry, leather, metal, wood, computer art, drawing, printmaking, painting. Juried by 4 independent jurors. Jurors review 4 digital images of work and 1 digital image of booth display. Number of exhibitors: 165. Public attendance: 50,000. Free to public. Artists should apply online through www.zapplication.org. Application fee: $25. Space fee: $280. Exhibition space: 10×10 ft. For more information, artists should e-mail, call or visit website.

TALLMAN ARTS FESTIVAL

426 N. Jackson St., Janisville WI 53548. (608)756-4509. **E-mail:** astrobelwise@rchs.us. **Website:** www.rchs.us. **Contact:** Amanda Strobel Wise, volunteer and internship program manager. Estab. 1957. Held in early August. Fine art/craft show. Event held outdoors. Accepts photography, ceramics, fiber arts, painting,

mixed media. Juried event. No awards or prizes given. Average number of exhibitors: 70-100. Average number of attendees: 1,800-2,000. Admission fee: $5 adults. Artists should apply online. Deadline for entry: TBD. Application fee: TBD. Space Fee: TBD. Space: 10x10 sq. ft. For more information, artists should e-mail, call, visit website or send SASE.

⊙ ⊙ TAOS FALL ARTS FESTIVAL

P.O. Box 675, Taos NM 87571. (575)758-4648. **E-mail:** tfafvolunteer@gmail.com. **Website:** www.taosfallarts. com. **Contact:** Patsy S. Wright. Estab. 1974. This festival is the oldest art festival in Taos, premiering in 1974 and only showcasing artists that reside in Taos County. It includes 3 major art shows: the curated exhibit titled 'Distinguished Achievement Award Series', a juried exhibit titled Taos Select, and the Taos Open, as its name implies, an exhibit open to all artists working in Taos County. The festival represents over 250 Taos County artists working in a variety of mediums. Each year a limited-edition poster is printed to commemorate the arts festival. The proceeds from the shows will benefit art programs for Taos County children. See website for more information.

⊙ TARPON SPRINGS FINE ARTS FESTIVAL

111 E. Tarpon Ave., Tarpon Springs FL 34689. (727)937-6109. **Fax:** (727)937-2879. **E-mail:** reggie@tarponspringschamber.org. **Website:** www. tarponspringschamber.com. Estab. 1974. Fine arts & crafts show held annually in late March. Outdoors. Accepts photography, acrylic, oil, ceramics, digital, fiber, glass, graphics, drawings, pastels, jewelry, leather, metal, mixed media, sculpture, watercolor, wood. Juried by CD or images e-mailed. Awards/prizes: cash, ribbons and Patron Awards. Number of exhibitors: 200. Public attendance: 20,000. Public admission: $5 (includes free drink ticket: wine, beer, soda or water); free-age 12 and under and active duty military. Artists should apply by submitting signed application, CD or e-mailed images, fees and SASE. Deadline for entry: late December. Jury fee: $30. Space fee: $230. Exhibition space: 10×12 ft. For more information, artists should e-mail, call or send SASE. **TIPS** "Produce good CDs for jurors."

THREE RIVERS ARTS FESTIVAL

803 Liberty Ave., Pittsburgh PA 15222. (412)456-6666. **Fax:** (412)471-6917. **Website:** www.3riversartsfest.org. **Contact:** Sonja Sweterlitsch, director. Estab. 1960.

"Three Rivers Arts Festival has presented, during its vast and varied history, more than 10,000 visual and performing artists and entertained millions of residents and visitors. Three Rivers Arts Festival faces a new turning point in its history as a division of the Pittsburgh Cultural Trust, further advancing the shared mission of each organization to foster economic development through the arts and to enhance the quality of life in the region." Application fee: $35. Booth fee: $340-410. See website for more information. Festival located at Point State Park in downtown Pittsburgh.

⊙ TALUCA LAKE FINE ARTS FESTIVAL

West Coast Artists, P.O. Box 750, Acton CA 93510. (818)813-4478. **Fax:** (661)526-4575. **E-mail:** info@ westcoastartists.com. **Website:** www.westcoastartists. com. Open to all media of original fine art and fine crafts. All work will be juried. Categories will be limited. No commercial, manufactured, imported, mass produced or purchased for resale items will be accepted. No clothing. No representatives. See website for more information.

⊙ TUBAC FESTIVAL OF THE ARTS

P.O. Box 1866, Tubac AZ 85646. (520)398-2704. **Fax:** (520)398-3287. **E-mail:** assistance@tubacaz.com. **Website:** www.tubacaz.com. Estab. 1959. Fine arts & crafts show held annually in early February (see website for details). Outdoors. Accepts photography and considers all fine arts and crafts. Juried. A 7-member panel reviews digital images and artist statement. Names are withheld from the jurists. Number of exhibitors: 170. Public attendance: 65,000. Free to the public; parking: $6. Deadline for entry: late October (see website for details). Application fee: $30. Artists should apply online and provide images on a labeled CD (see website for requirements). Space fee: $575. Electrical fee: $50. Exhibition space: 10×10 ft. (a limited number of double booths are available). For more information, artists should e-mail, call or visit website.

⊙ TULSA INTERNATIONAL MAYFEST

2210 S. Main St., Tulsa OK 74114. (918)582-6435. **Fax:** (918)517-3518. **E-mail:** comments@tulsamayfest.org. **Website:** www.tulsamayfest.org. Estab. 1972. Fine arts & crafts show annually held in May. Outdoors. Accepts photography, clay, leather/fiber, mixed media, drawing, pastels, graphics, printmaking, jewelry,

glass, metal, wood, painting. Juried by a blind jurying process. Artists should apply online at www.zapplication.org and submit 4 images of work and 1 photo of booth set-up. Awards/prizes: Best in Category and Best in Show. Number of exhibitors: 125. Public attendance: 350,000. Free to public. Artists should apply by downloading application in the fall. See website for deadline entry. Application fee: $35. Space fee: $350. Exhibition space: 10×10 ft. For more information, artists should e-mail or visit website.

🎧 UPPER ARLINGTON LABOR DAY ARTS FESTIVAL

(614)583-5310. **Fax:** (614)437-8656. **E-mail:** arts@uaoh.net. **Website:** www.uaoh.net/department/index.php?structureid=101. Fine art & craft show held annually in September. Outdoors. Accepts handmade crafts, ceramics, fiber, glass, graphics, jewelry, leather, metal, mixed media, painting, photography, printmaking, sculpture, woodworking. Juried. Awards/prizes: $1,350 in awards. Number exhibitors: 200. Number attendees: 25,000. Free to public. Apply via www.zapplication.org. Deadline for entry: February. Application fee: see website. Space fee: varies. Exhibition space: varies. For more information, artists should call or visit website.

🎧 UPTOWN ART FAIR

1406 W. Lake St., Lower Level C, Minneapolis MN 55408. (612)823-4581. **Fax:** (612)823-3158. **E-mail:** maude@uptownminneapolis.com; info@uptownminneapolis.com; jessica@uptownminneapolis.com; hannah@uptownminneapolis.com. **Website:** www.uptownartfair.com. **Contact:** Maude Lovelle. Estab. 1963. Fine arts & crafts show held annually 1st full weekend in August. Outdoors. Accepts photography, painting, printmaking, drawing, 2D and 3D mixed media, ceramics, fiber, sculpture, jewelry, wood and glass. Juried by 4 images of artwork and 1 of booth display. Awards/prizes: Best in Show in each category; Best Artist. Number of exhibitors: 350. Public attendance: 375,000. Free to the public. The Uptown Art Fair uses www.zapplication.org. Each artist must submit 5 images of his or her work. All artwork must be in a high-quality digital format. Five highly qualified artists, instructors, and critics handpick Uptown Art Fair exhibitors after previewing projections of the images on 6-ft. screens. The identities of the artists remain anonymous during the entire review process. All submitted images must be free of signatures, headshots or other identifying marks. Three rounds of scoring determine the final selection and waitlist for the show. Artists will be notified shortly after of their acceptance. For additional information, see the links on website. Deadline for entry: early March. Application fee: $40. Space fee: $550 for 10×10 space; $1,100 for 10×20 space. For more information, artists should call or visit website. Fair located at Lake St. and Hennepin Ave. and "The Mall" in Southwest Minneapolis.

🎧 A VICTORIAN CHAUTAUQUA

1101 E. Market St., Jeffersonville IN 47130. (812)283-3728 or (888)472-0606. **Fax:** (812)283-6049. **E-mail:** hsmsteam@aol.com. **Website:** www.steamboatmuseum.org. **Contact:** Roger Fisher, festival chairman. Estab. 1993. Fine arts & crafts show held annually 3rd weekend in May. Outdoors. Accepts photography, all mediums. Juried by a committee of 5. Number of exhibitors: 80. Public attendance: 3,000. Exhibition space: 12×12 ft. For more information, artists should e-mail, call or visit website.

VILLAGE SQUARE ARTS & CRAFTS FAIR

P.O. Box 176, Saugatuck MI 49453. **E-mail:** artclub@saugatuckdouglasartclub.org. **Website:** www.saugatuckdouglasartclub.org. Estab. 2004. The art club offers 2 fairs each summer. See website for upcoming dates. This fair has some fine artists as well as crafters. Both fairs take place on the 2 busiest weekends in the resort town of Saugatuck's summer season. Both are extremely well attended. Generally the vendors do very well. Booth fee: $95-140. Fair located at corner of Butler and Main Streets, Saugatuck MI.

TIPS "Create an inviting booth. Offer well-made artwork and crafts for a variety of prices."

🎧 VIRGINIA BEACH DOWNTOWN ART FAIR

270 Central Blvd., Suite 107B, Jupiter FL 33458. (561)746-6615. **Fax:** (561)746-6528. **E-mail:** info@artfestival.com. **Website:** www.artfestival.com. **Contact:** Malinda Ratliff, communications manager. Estab. 2015. Fine art & craft fair held annually in April. Outdoors. Accepts photography, jewelry, mixed media, sculpture, wood, ceramic, glass, painting, digital, fiber, metal. Juried. Number exhibitors: 80. Number attendees: see website. Free to public. Apply online via www.zapplication.org. Deadline: see website. Application fee: $25. Space fee: $395. Exhibition space:

10×10 and 10×20. For more information, artists should e-mail, call or visit website. Festival located Main St. between Central Park Ave. and Constitution Dr.

TIPS "You have to start somewhere. First, assess where you are, and what you'll need to get things off the ground. Next, make a plan of action. Outdoor street art shows are a great way to begin your career and lifetime as a working artist. You'll meet a lot of other artists who have been where you are now. Network with them!"

VIRGINIA CHRISTMAS MARKET

The Exhibition Center at Meadow Event Park, 13111 Dawn Blvd., Doswell VA 23047. (804)253-6284. **Fax:** (804)253-6285. **E-mail:** bill.wagstaff@virginiashows. com. **Website:** www.virginiashows.com. Indoors. Virginia Christmas Market is held the last weekend in October at the Exhibition Center at Meadow Event Park. Virginia Christmas Market will showcase up to 300 quality artisans, crafters, boutiques and specialty food shops. Features porcelain, pottery, quilts, folk art, fine art, reproduction furniture, flags, ironwork, carvings, leather, toys, tinware, candles, dollcraft, wovenwares, book authors, musicians, jewelry, basketry, gourmet foods—all set amid festive Christmas displays. Accepts photography and other arts and crafts. Juried by 3 photos of artwork and 1 of display. Attendance: 15,000. Public admission: $7; children free (under 10). Artists should apply by calling, e-mailing or downloading application from website. Space fee: $335. Exhibit spaces: 10×10 ft. For more information, artists should email, call or visit website.

TIPS If possible, attend the show before you apply.

VIRGINIA SPRING MARKET

11050 Branch Rd., Glen Allen VA 23059. (804)253-6284. **Fax:** (804)253-6285. **E-mail:** bill.wagstaff@virginiashows.com. **Website:** www.virginiashows.com. **Contact:** Bill Wagstaff. Estab. 1988. Holiday arts & crafts show held annually 1st weekend in March at the Exhibition Center at Meadow Event Park, 13111 Dawn Blvd., Doswell VA. Virginia Spring Market will showcase up to 300 quality artisans, crafters, boutiques and specialty food shops. Features porcelain, pottery, quilts, folk art, fine art, reproduction furniture, flags, ironwork, carvings, leather, toys, tinware, candles, dollcraft, wovenwares, book authors, musicians, jewelry, basketry and gourmet foods, all set amid festive spring displays.

Accepts photography and other arts and crafts. Juried by 3 images of artwork and 1 of display. Public attendance: 12,000. Public admission: $7; children free (under 10). Artists should apply by calling, e-mailing, or downloading application from website. Space fee: $335. Exhibition space: 10×10 ft. For more information, artists should email, call or visit website.

TIPS "If possible, attend the show before you apply."

VIRTU ART FESTIVAL

45 Broad St., Westerly RI 2891. (401)596-7761. **Fax:** (401)596-2190. **E-mail:** lkonicki@oceanchamber. org. **Website:** www.oceanchamber.org. **Contact:** Lisa Konicki, Executive Director. Estab. 1996. Arts & crafts show held annually in May. Outdoors. Accepts original fine art & handmade crafts, oils, acrylics, prints, wood, watercolor, pottery, glass, jewelry, sculpture. Juried. Exhibitors: 150. Number of attendees: 20,000. Free to public. Artists should apply via website. Deadline for entry: February 20. Application fee: none. Space fee: $200. Exhibition space: 12×12. For more information, artists should e-mail.

- Event located in Wilcox Park in downtown Westerly.

WASHINGTON SQUARE OUTDOOR ART EXHIBIT

P.O. Box 1045, New York NY 10276. (212)982-6255. **Fax:** (212)982-6256. **E-mail:** jrm.wsoae@gmail.com. **Website:** www.wsoae.org. Estab. 1931. Fine arts & crafts show held semiannually Memorial Day weekend and Labor Day weekend. Outdoors. Accepts photography, oil, watercolor, graphics, mixed media, sculpture, crafts. Juried by submitting 5 slides of work and 1 of booth. Awards/prizes: certificates, ribbons and cash prizes. Number of exhibitors: 150. Public attendance: 100,000. Free to public. Artists should apply by sending a SASE or downloading application from website. Deadline for entry: March, spring show; July, fall show. Exhibition space: 5×10 ft. up to 10×10 ft., double spaces available. Jury fee of $20. First show weekend (3 days) fee of $410. Second show weekend (2 days) $310. Both weekends (all 5 days) fee of $525. For more information, artists should call or send SASE.

TIPS "Price work sensibly."

WATERFRONT FINE ART & WINE FESTIVAL

7135 E Camelback Rd, Scottsdale AZ 85251. (480)837-5637. **Fax:** (480)837-2355. **E-mail:** info@thunderbirdartists.com. **Website:** www.

thunderbirdartists.com. **Contact:** Denise Colter, president. Estab. 2011. 125 juried fine artists will line the banks of Scottsdale Waterfront's pedestrian walkway, along with wineries, chocolate vendors and musicians. The Waterfront is an elegant backdrop for this event, adding romantic reflections across the waters - mirroring tents, art and patrons. Thunderbird Artists Mission is to promote fine arts and fine crafts, paralleled with the ambiance of unique wines and festive music, through a dedicated, extensive advertising campaign.

TIPS "A clean, gallery-type presentation is very important."

🎧 WATERFRONT FINE ART FAIR

P.O. Box 176, Saugatuck MI 49453. **E-mail:** artclub@ saugatuckdouglasartclub.org. **Website:** www. saugatuckdouglassartclub.org. Fee is $135. This includes application fee, booth fee, and city license. Applications juried in early April. For information, e-mail, call or visit the website. Fair held at Cook Park.

TIPS "Create a pleasing, inviting booth. Offer well-made, top-quality fine art."

🎧 WESTMORELAND ARTS & HERITAGE FESTIVAL

252 Twin Lakes Rd., Latrobe PA 15650-3554. (724)834-7474. **E-mail:** info@artsandheritage.com; diane@ artsandheritage.com. **Website:** www.artsandheritage. com. **Contact:** Diane Shrader, executive director. Estab. 1975. Juried fine art exhibition & crafts show held annually in early July (see website for details). Juried art exhibition is indoors. Photography displays are indoors. Accepts photography, all handmade mediums. Juried by 2 jurors. Awards/prizes: $3,400 in prizes. Number of exhibitors: 190. Public attendance: 125,000. Free to public. Artists should apply by downloading application from website. Application fee: $25/craft show vendors; $35/art nationals exhibitors. Deadline for entry: early March. Space fee: $375-750. Artist Market exhibition space: 10×10 or 10×20 ft. For more information, artists should visit e-mail, call, or visit website. Please direct questions to our executive director.

🎧 WHITEFISH ARTS FESTIVAL

P.O. Box 131, Whitefish MT 59937. (406)862-5875. **E-mail:** wafdirector@gmail.com. **Website:** www. whitefishartsfestival.org. **Contact:** Clark Berg; Angie Scott. Estab. 1979. High-quality art show held annually the 1st full weekend in July. Outdoors. Accepts photography, pottery, jewelry, sculpture, paintings, woodworking. Art must be original and handcrafted. Work is evaluated for creativity, quality and originality.120 booths. Public attendance: 3,000–5,000. Free to public. Juried entry fee: $35. Deadline: see website for details. Space fee: $230. Exhibition space: 10×10 ft. For more information, and to apply, artists should visit website.

TIPS Recommends "variety of price range, professional display, early application for special requests."

🎧 WHITE OAK CRAFTS FAIR

1424 John Bragg Hwy, Woodbury TN 37190. (615)563-2787. **E-mail:** mary@artscenterofcc.com; artscenter@ artscenterofcc.com; carol@artscenterofcc.com. **Website:** www.artscenterofcc.com. Estab. 1985. Arts & crafts show held annually in early September (see website for details) featuring the traditional and contemporary craft arts of Cannon County and Middle Tennessee. Outdoors. Accepts photography; all handmade crafts, traditional and contemporary. Must be handcrafted displaying excellence in concept and technique. Juried by committee. Send 3 slides or photos. Awards/prizes: more than $1,000 cash in merit awards. Number of exhibitors: 80. Public attendance: 6,000. Free to public. Applications can be downloaded from website. Deadline: early July. Space fee: $120 ($90 for Artisan member) for a 10×10 ft. under tent; $95 ($65 for Artisan member) for a 12×12 ft. outside. For more information, artists should e-mail, call or visit website. Fair takes place along the banks of the East Fork Stones River just down from the Arts Center.

🎧 WILD WIND FOLK ART & CRAFT FESTIVAL

P.O. Box 719, Long Lake NY 12847. (207)479-9867 (814)688-1516. **E-mail:** wildwindcraftshow@yahoo. com; info@wildwindfestival.com. **Website:** www. wildwindfestival.com. **Contact:** Liz Allen and Carol Jilk, directors. Estab. 1979. Traditional crafts show held annually the weekend after Labor Day at the Warren County Fairgrounds in Pittsfield PA. Barn locations and outdoors. Accepts traditional country crafts, photography, paintings, pottery, jewelry, traditional crafts, prints, stained glass. Juried by promoters. Need 3 photos or slides of work plus 1 of booth, if available. Number of exhibitors: 160. Public attendance: 9,000. Artists should apply by visiting website

and filling out application request, calling or sending a written request. Request application form on website page or by phone.

⊕ WINDY CITY GIFT SHOW

Greater Philadelphia Expo Center, Rosemont IL 60660. (800)318-2238. **Website:** www.windycitygiftshow.com. **Contact:** Robin Flaherty, sales manager. Semi-annual event. Wholesale show. Event held indoors. Not for general public. Accepts handmade craft merchants. Accepts pattern/magazine/book publishers. Select sections are juried. No prizes given. Admission fee: n/a. Deadline for entry applications: n/a. Application fee: n/a. Space fee: See prospectus for booth rates. For more information, exhibitors should email, visit web site or call.

ⓖ WINNEBAGOLAND ART FAIR

South Park Ave., Oshkosh WI 54902. **E-mail:** oshkoshfaa@gmail.com. **Contact:** Kathy Murphy. Estab. 1957. Fine arts show held annually the second Sunday in June. Outdoors. Accepts painting, wood or stone, ceramics, metal sculpture, jewelry, glass, fabric, drawing, photography, wall hangings, basketry. Artwork must be the original work of the artist in concept and execution. Juried. Applicants send in photographs to be reviewed. Awards/prizes: monetary awards, purchase, merit and Best of Show awards. Number of exhibitors: 125-160. Public attendance: 5,000-8,000. Free to public. Deadline for entry: Previous exhibitors due mid-March; new exhibitors due late March. $25 late entry fee after March. Exhibition space: 20×20 ft. For more information, artists should e-mail or see website. The updated entry form will be added to the website in early January.

TIPS "Artists should send clear, uncluttered photos of their current work which they intend to show in their booth as well as a photo of their booth setup."

WOODSSTOCK MUSIC & ARTS FESTIVAL

(419)862-3182. Fine art & craft show held annually in August. Outdoors. Accepts handmade crafts, ceramics, drawing, fiber, glass, jewelry, leather, metal, mixed media, painting, photography, sculpture, wood. Juried. Awards/prizes: Best of Show, honorable mention. Number exhibitors: see website. Number attendees: varies. Admission: $25 general; $45 VIP. Apply via www.zapplication.org. Deadline for entry: June. Application fee: $20. Space fee: $100 (single); $150 (double). Exhibition space: 10×10 (single); 10×20 (double). For more information, artists should visit website.

ⓖ WYANDOTTE STREET ART FAIR

2624 Biddle Ave., Wyandotte MI 48192. (734)324-4502. **Fax:** (734)324-7283. **E-mail:** hthiede@wyan.org. **Website:** www.wyandottestreetartfair.org. **Contact:** Heather Thiede, special events coordinator. Estab. 1961. Fine arts & crafts show held annually 2nd week in July. Outdoors. Accepts photography, 2D mixed media, 3D mixed media, painting, pottery, basketry, sculpture, fiber, leather, digital cartoons, clothing, stitchery, metal, glass, wood, toys, prints, drawing. Juried. Awards/prizes: Best New Artist $500; Best Booth Design Award $500; Best of Show $1,200. Number of exhibitors: 300. Public attendance: 200,000. Free to the public. Artists may apply online or request application. Deadline for entry: early February. Application fee: $20 jury fee. Space fee: $250/single space; $475/double space. Exhibition space: 10×12 ft. Average gross sales/exhibitor: $2,000-$4,000. For more information, and to apply, artists should call, email, visit website or send SASE.

⊕ YOUNG ART TAIPEI

3F, No. 295, Sec. 4, Zhong Xiao E. Rd., 10694 Taipei Taiwan. (886)2-8772-6017. **E-mail:** info@youngarttaipei.com. **Website:** www.youngarttaipei.com. Estab. 2009. Event held annually. Fine art/craft show. Event held indoors. Accepts photography. Accepts all mediums. Juried. Prizes given. Avg. number of exhibitors: 60-90. Avg. number of attendees: 10,000. Admission fee for public: $300 daily pass. We only accept applications from galleries. Deadline: December 2016. No application fee. Space fee: Upon request. Sq. footage of space: 340-717 sq. ft. For more information, artists should email or visit website.

CONTESTS

//

Whether you're a seasoned veteran or a newcomer still cutting your teeth, you should consider entering contests to see how your work compares to that of other artists or graphic designers. The contests in this section range in scope from tiny juried county fairs to massive international competitions. When possible, we've included entry fees and other pertinent information in our limited space. Contact sponsors for entry forms and more details.

Once you receive rules and entry forms, pay particular attention to the sections describing rights. Some sponsors retain all rights to winning entries or even submitted images. Be wary of these. While you can benefit from the publicity and awards connected with winning prestigious competitions, you shouldn't unknowingly forfeit copyright. Granting limited rights for publicity is reasonable, but you should never assign rights of any kind without adequate financial compensation or a written agreement. If such terms are not stated in the contest rules, ask the sponsors for clarification.

If you're satisfied with the contest's copyright rules, check with contest officials to see what types of images won in previous years. By scrutinizing former winners, you might notice a trend in judging that could help when choosing your entries. If you can't view the images, ask what styles and subject matters have been popular.

✚ 10 INTERNATIONAL PHOTOGRAPHIC CALLS FOR ENTRY EACH YEAR

400 North College Ave., Fort Collins CO 80524. (970)224-1010. **E-mail:** coordinator@c4fap.org. **Website:** c4fap.org. **Contact:** Sunshine Divis, programs manager. Contests held: Ten Themed Contests Yearly, Annual Black and White, Portraits, Center Forward and Portfolio ShowCase plus more.

440 GALLERY ANNUAL SMALL WORKS SHOW

440 Sixth Ave., Brooklyn NY 11215. (718)499-3844. **E-mail:** gallery440@verizon.net. **Website:** www.440gallery.com. **Contact:** Nancy Lunsford, director. Annual juried exhibition hosted by 440 Gallery, a cooperative run by member artists. An exhibition opportunity for US artists whose work is selected by a different curator each year. All work, including frames and mounting materials must be less than 12 inches in all directions. Open to all 2D and 3D media. Videos are considered if the monitor provided is also under 12". Three prizes awarded with small cash awards: The Curator's Choice Award (decided by the juror), the 440 Award (decided by the members of the cooperative), the People's Choice Award (decided by "liking" images posted on our Facebook page). Deadline: early November. For more information about entering submissions, visit website in late September/early October, go to "Call for Entry" page.

440 GALLERY ANNUAL THEMED SHOW

440 Sixth Ave., Brooklyn NY 11215. (718)449-3844. **E-mail:** gallery440@verizon.net. **Website:** www.440gallery.com. **Contact:** Nancy Lunsford. National juried exhibition with a stated theme, and the subject varies from year to year. Past themes have been: animals, Brooklyn, text. An outside curator is invited to judge entries. All media and styles welcome. There is no size limitation, but extremely large work is unlikely to be chosen. Open to all US artists ages 18 and over. Deadline: mid-May. Interested artists should see website for more information.

◐ AESTHETICA ART PRIZE

Aesthetica Magazine, P.O. Box 371, York YO23 1WL United Kingdom. **E-mail:** info@aestheticamagazine.com; artprize@aestheticamagazine.com. **Website:** www.aestheticamagazine.com. There are 4 categories: Photograpic & Digital Art, Three-Dimensional Design & Sculpture, Painting & Drawing, Video Installation & Performance. See guidelines at Artwork & Photography, Fiction, and Poetry. See guidelines at www.aestheticamagazine.com. The Aesthetica Art Prize is a celebration of excellence in art from across the world and offers artists the opportunity to showcase their work to wider audiences and further their involvement in the international art world.

✚ AMERICAN ICON ART COMPETITION

P.O. Box 10, Sausalito CA 94955. (415)332-3555. **Fax:** (415)331-1340. **E-mail:** americanicon@sausalitoartfestival.org. **Website:** www.americanicon.net. **Contact:** Louis Briones, co-chair.

AMERICAN SOCIETY OF AVIATION ARTISTS INTERNATIONAL ART EXHIBITION

American Society of Aviation Artists, 581 Airport Road, Bethel PA 19507. (732)735-6545. **E-mail:** ASAAcontact@asaa-avart.org. **Website:** www.asaa-avart.org. **Contact:** Nanette O'Neal. Entry fee: $50/entry for non-ASAA members. This annual contest is held to promote aerospace art. Several prizes will be awarded. Open to all skill levels. See website for more information including deadlines for submission.

✚ ANNUAL HOYT REGIONAL ART COMPETITION

124 E. Leasure Ave., New Castle PA 16105. (724)652-8882. **Fax:** (724) 657-8786. **E-mail:** hoytexhibits@hoytartcenter.org. **Website:** www.hoytartcenter.org. **Contact:** Patricia, Exhibition Coordinator. Cost: $25. Contest held Annually. Open to artists within 250-mile radius of New Castle, PA. All media except video and installation not previously exhibited before. 1st place: $500. 2nd place: $300. 3rd place: $150. 6 $50 Merits. Open to all skill levels. Next contest is January 28, 2017. Contestants should e-mail.

✚ ANOTHER WORLD ART CONTEST

Diana Perry Books, P.O. Box 1001, Reynoldsburg OH 43068. **E-mail:** dianaperryenterprises@yahoo.com. **Website:** www.dianaperrybooks.com. Cost: $15 money order. Annual contest. "The purpose of this contest is to give exposure to artists/illustrators trying to break in to the business and get noticed." Open to all skill levels. Create a scene from an undiscovered world here on earth that contains people/animals/plants from the past, present and future. Rules on website. One Page, Any Media. Prizes: 1st place – $200, trophy, mention on website, DianaPerryBooks T-shirt, press releases in your local newspapers. 2nd place - $150, trophy, mention on website, T-shirt, press releases in

your local newspapers. 3rd place - $100, trophy, mention on website, T-shirt, press releases in your local newspapers. 4th/5th places - $50/$25, plaque, mention on website, T-shirt, press releases in your local newspapers. We also list names of next 25 honorable mention on website. Contest guidelines and entry form on DianaPerryBooks.com. Check website for guest judges. E-mail your picture via JPEG or PDF no later than end of June with "Another World Art Contest" as subject. Also write your full name and address in body of text so we can match up with your snail mail submission. Mail entry form and a $15 money order only to Another World Art Contest at above address post marked no later than end of June. Winners announced both on website and via snail mail August 1st. Prizes mailed within 10 days of announcement.

ARTIST FELLOWSHIPS/VIRGINIA COMMISSION FOR THE ARTS

1001 E. Broad St., Suite 330, Richmond VA 23219. (804)225-3132. **Fax:** (804)225-4327. **E-mail:** arts@arts.virginia.gov; tiffany.ferreira@vca.virginia.gov. **Website:** www.arts.virginia.gov. The purpose of the Artist Fellowship program is to encourage significant development in the work of individual artists, to support the realization of specific artistic ideas, and to recognize the central contribution professional artists make to the creative environment of Virginia. Grant amounts: $5,000. Emerging and established artists are eligible. Open only to artists who are legal residents of Virginia and are at least 18 years of age. Applications are available in July. See Guidelines for Funding and application forms on the website or write for more information.

ARTISTIC DREAMS

159 N. Main St., Smithfield UT 84335. (435)755-8126. **Fax:** (435)713-4422. **E-mail:** editor@celebratingart.com. **Website:** www.artisticdreams.net. Annual contest to create a larger audience for artists and poets, and a place to record their work. Open to anyone living in the US or Canada, 18 year or older. Any art that can have a still digital image (not a photography contest) or any poem 21 lines or less is eligible. Rolling deadline, entries are judged as they are received. You will know 2-3 weeks after entering if your art/poetry is accepted to be published. When enough entries are accepted for a book, the artists and writers who are invited to be published will be notified. Entries can be entered online after registering an account. No mailed entries will be accepted. You may submit one art piece and one poem per theme. There are 3 art winners and 3 poetry winners per book. Each winner will receive $100 and a free copy of the anthology. No entry fee and open to all skill levels.

Contestants should see website for more information.

ARTISTS ALPINE HOLIDAY

Ouray County Arts Association, P.O. Box 167, Ouray CO 81427. (970)626-5513. **E-mail:** jbhazen@yahoo.com. **Website:** www.ourayarts.org. **Contact:** DeAnn McDaniel, registrar. Cost: $30, includes up to 2 entries. Annual fine arts show. Juried. Cash awards for 1st, 2nd and 3rd prizes in all categories total $7,200. Best of Show: $750; People's Choice Award: $50. Open to all skill levels. Photographers and artists should call or see website for more information.

THE ARTIST'S MAGAZINE'S ALL-MEDIA

F+W, a Content + eCommerce Company, Competition Dept., 10151 Carver Rd., Suite 200, Blue Ash OH 45242. (715)445-4621, ext. 13430. **E-mail:** art-competition@fwmedia.com. **Website:** www.artistsnetwork.com/competitions/all-media-online-competition. **Contact:** Nicole Howard, customer service specialist. Cost: $25/entry. Annual contest held to recognize the best work being done in various mediums. Awards: the grand prize winner receives a $500 prize, as well as a subscription to *The Artist's Magazine* and $50 worth of North Light Books. All 8 first place winners receive $100, complimentary subscriptions to *The Artist's Magazine* and $100 worth of North Light Books. Honorable mentions receive complimentary subscriptions to *The Artist's Magazine* and $50 worth of North Light Books. Open to all skill levels. Deadline: October. E-mail or see website for more information.

THE ARTIST'S MAGAZINE'S OVER 60 COMPETITION

F+W, a Content + eCommerce Company, Competitions Dept., 10151 Carver Rd, Suite 200, Blue Ash OH 45242. (715)445-4621, ext.13430. **E-mail:** art-competition@fwmedia.com. **Website:** www.artistsnetwork.com/competitions/over-60-art-competition. **Contact:** Nicole Howard, customer service specialist. Cost: $25/slide or image. Annual contest for artists age 60+ working in all traditional art media. Entries can be submitted online using the online entry form. There is no limit to the number of

images you may enter. You may mail all your entries in on one CD. You *must* include a cover sheet that lists the title, medium/media, and dimensions of each image. The titles of the images on the CD must match the titles on the sheet. Image files cannot exceed 5MG. The file format must be JPEG. If your work is selected for the top 10, we will contact you at a later date and ask that you provide a high-res replacement file. Incomplete entry forms and information sheets, and improperly marked CDs will be disqualified. See website for complete submission details. Awards: $1,000 in prizes; 10 winners each receive $100. Winners will be published in the March issue of *The Artist's Magazine* and on the website. Open to all skill levels; however, participants must be 60 years of age or older. Deadline: September. E-mail or see website for more information.

THE ARTIST'S MAGAZINE'S ANNUAL ART COMPETITION

F+W, a Content + eCommerce Company, Competition Dept., 10151 Carver Rd., Suite 200, Blue Ash OH 45242. (715)445-4621, ext. 13430. **E-mail:** art-competition@fwmedia.com. **Website:** www.artistsnetwork.com/competitions/the-artists-magazine-annual-art-competition. **Contact:** Nicole Howard, customer service specialist. Cost: All entries in the Student/Beginner Division (for artists age 16 and over who (1) have been enrolled in a posthigh school art program for no more than 4 years or (2) have pursued art on their own or in workshops/lessons for no more than 4 years) are $15 per image. All others are $25 per image. Entries submitted after April 1 are $20 for students entries and $30 for all other entries. Held annually. "You may enter work in any and all categories; there is no limit to the number of images you may enter. Enter online. Image files cannot exceed 5MB. The file must be saved as a JPEG in RGB color mode (not CMYK). File names should include only letters, numbers and spaces. See website for complete submission details; and a list of eligible categories. Awards: More than $25,000 in cash prizes; 5 1st Place awards: $2,500 each; 5 2nd Place awards: $1,250 each; 5 3rd Place awards: $750 each; 15 Honorable Mentions: $100 each. Winners will be featured and finalists' names will be published in an upcoming issue of *The Artist's Magazine*. Nine finalists will be featured in the "Competition Spotlight" in *The Artist's Magazine*, 12 finalists will be featured as "Artist of the Month" on our website

and the works of 12 finalists will be offered on our website as desktop wallpaper. All award winners and Honorable Mentions receive a 1-year membership to the North Light VIP Program. See website for prizes to be won in the Student/Beginner Division category. Open to all skill levels. Deadline: mid-April. E-mail or see website for more information.

⭘ ARTIST TRUST FELLOWSHIP AWARD

1835 12th Ave., Seattle WA 98122. (209)467-8734, ext. 11. **Fax:** (866)218-7878. **E-mail:** info@artisttrust.org. **Website:** www.artisttrust.org. **Contact:** Miguel Guillen, program manager. Fellowships award $7,500 to practicing professional artists of exceptional talent and demonstrated ability. The Fellowship is a merit-based, not a project-based award. Recipients present a Meet the Artist Event to a community in Washington state that has little or no access to the artist and their work. Awards 14 fellowships of $7,500 and 2 residencies with $1,000 stipends at the Millay Colony. Artist Trust Fellowships are awarded in two-year cycles. Applicants must be 18 years of age or older, Washington State residents at the time of application and payment, and generative artists. Fellowships award $7,500 to practicing professional artists of exceptional talent and demonstrated ability. The Fellowship is a merit-based, not a project-based award. Recipients present a Meet the Artist Event to a community in Washington state that has little or no access to the artist and their work. Awards 14 fellowships of $7,500 and 2 residencies with $1,000 stipends at the Millay Colony.

⭘ ARTSLINK PROJECTS AWARD

CEC Artslink, 291 Broadway, 12th Floor, New York NY 10007. (212)643-1985, ext. 23. **Fax:** (212)643-1996. **E-mail:** mtumenev@cecartslink.org. **Website:** www.cecartslink.org. Estab. 1962. "CEC ArtsLink is an international arts organization. Our programs encourage and support exchange of artists and cultural managers in the United States and abroad. We believe that the arts are a society's most deliberate and complex means of communication, and that artists and arts administrators can help nations overcome long histories of reciprocal distrust, insularity, and conflict. CEC ArtsLink promotes communication and understanding through innovative, mutually beneficial collaborative projects. CEC was founded in 1962 to enable citizens of the United States and the Soviet Union to accomplish what their governments could not by opening doors, sharing ideas and building mu-

tual trust. In today's transformed and complex world, citizen diplomacy is still urgently needed."

BUCKTOWN ARTS FEST POSTER CONTEST

2200 N. Oakley, Chicago IL 60647. **E-mail:** postercontest@bucktownartsfest.com. **Website:** www.bucktownartsfest.com/posters. **Contact:** Amy Waldon, committee member. Annual contest. "We hope you wil share your creativity and passion for the Bucktown Arts Fest by entering our poster contest! The purpose of the contest is to design a poster promoting the Bucktown Arts Fest. Just create an original artwork in your media that you think best exemplefies the Bucktown Arts Fest and submit it in JPEG format. The deadline for entries is March 31. There is no fee to enter. Winners will receive a prize and complimentary admission into the festival. Plus, your artwork will be used to promote the Fest, including the Bucktown Arts Fest website, festival merchandise (posters, t-shirts, hangtags, postcards, program), collateral, press releases, and signage." One winner will be selected. Winner will be announced May 31 via an e-mail blast.

CAMERA USA: NATIONAL PHOTOGRAPHY EXHIBITION AND AWARD

Naples Art Association, 585 Park St., Naples FL 34102. (239)262-6517. **Fax:** (239)262-5404. **E-mail:** jack.obrien@naplesart.org. **Website:** www.naplesart. org/callforartistcat/exhibit-opportunities. **Contact:** Jack O'Brien, curator. Estab. 1954. Cost to enter one photograph for the jury process: $32. Sixth-annual photography competition. Open to artists residing in the US. Enter one photograph taken in the USA after Jan. 1, 2011: One cash award of $5,000. Open to all skill levels. Deadline: March 16, 2016. Photographers should visit www.naplesart.org/callforartistcat/ exhibit-opportunities or www.juriedartservices.com for complete details and to enter. Founded in 1954 the Naples Art Association is a non-profit visual arts organization. Programs included exhibitions, art classes, lectures, and outdoor-art festivals. Galleries are open free of charge. Hours are Monday through Friday from 10 am to 4 pm.

COLORED PENCIL MAGAZINE ANNUAL ART COMPETITION

P.O. Box 183, Efland NC 27243. (919)400-8317. **E-mail:** admin@coloredpencilmag.com. **Website:** www. coloredpencilmag.com. **Contact:** Sally Robertson, editor-in-chief. Contest held annually. Open to all skill levels. Contestants should see website for more information.

COMIC BOOK ART CONTEST

Diana Perry Books, P.O. Box 1001, Reynoldsburg OH 43068. **E-mail:** artcontest@dianaperrybooks. com. **Website:** www.dianaperrybooks.com. Cost: $15 money order. Annual contest. "The purpose of this contest is to give exposure to artists/illustrators trying to break into the business and get noticed." Open to all skill levels. Create a scene from an undiscovered world here on earth that contains people/animals/plants from the past, present and future. Rules on website. One Page, Any Media. Prizes: 1st place – $200, trophy, mention on website, DianaPerryBooks T-shirt, press releases in your local newspapers. 2nd place - $150, trophy, mention on website, T-shirt, press releases in your local newspapers. 3rd place - $100, trophy, mention on website, T-shirt, press releases in your local newspapers. 4th/5th places - $50/$25, plaque, mention on website, T-shirt, press releases in your local newspapers. We also list names of next 25 honorable mention on website. Contest guidelines and entry form on DianaPerryBooks. com. Check website for guest judges. E-mail your picture via JPEG or PDF no later than end of August with "Comic Book Art Contest" as subject. Also write your full name and address in body of text so we can match up with your snail mail submission. Mail entry form and a $15 money order to Comic Book Art Contest at above address postmarked no later than end of August. Winners announced both on website and via snail mail October 1st. Prizes mailed within 10 days of announcement.

CREATIVE QUARTERLY CALL FOR ENTRIES

244 Fifth Ave., Suite F269, New York NY 10001-7604. (718)775-3943. **E-mail:** coordinator@cqjournal. com. **Website:** www.cqjournal.com. Entry fee: varies. Quarterly contest. "Our publication is all about inspiration. Open to all art directors, graphic designers, photographers, illustrators, and fine artists in all countries. Separate categories for professionals and students. We accept both commissioned and uncommissioned entries. Work is judged on the uniqueness of the image and how it best solves a marketing problem. Winners will be requested to submit an image of a person, place or thing that inspires their work. We will reprint these in the issue and select one for our cover image. *Creative Quarterly* has the rights to

promote the work through our publications and website. Complete rights and copyright belong to the individual artist, designer or photographer who enters their work. Enter online or by sending a disc. Winners will be featured in the next issue of *Creative Quarterly* corresponding with the call for entries and will be displayed in our online gallery. Runners-up will be displayed online only. Winners and runners-up both receive a complimentary copy of the publication." Open to all skill levels. Deadline: Last Friday of January, April, July and October. See website for more information.

DIRECT ART MAGAZINE

SlowArt Productions, 123 Warren St., Hudson NY 12534. (518)828-2343. **E-mail:** slowart@aol.com. **Website:** www.slowart.com. **Contact:** Tim Slowinski, director. Cost: $35. Annual contest. "This contest is to select artists for publication in the annual edition of *Direct Art Magazine*." Open to all skill levels. Awards: publication in *Direct Art Magazine*, front and back covers; 4-to-6 page coverage; full-page display awards. Value of awards: $22,000. Deadline: March 31, annually. E-mail or see website for more information.

DIRECT ART MAGAZINE PUBLICATION COMPETITION

SlowArt Productions, 123 Warren St., Hudson NY 12534. **E-mail:** slowart@aol.com; limnerentry@aol.com. **Website:** www.slowart.com. **Contact:** Tim Slowinski, director. Cost: $35. Annual contest. National magazine publication of new and emerging art in all media. Cover and feature article awards. Open to all skill levels. Send SASE or see website for more information. SlowArt Productions presents the annual group thematic exhibition. Open to all artists, national and international, working in all media. All forms of art are eligible. *Entrants must be 18 years of age or older to apply.* 96 inch maximum for wall hung work, 72 inch for free-standing sculpture.

➕ EMBRACING OUR DIFFERENCES

P.O. Box 2559, Sarasota FL. (941)404-5710. **E-mail:** info@embracingourdifferences.org. **Website:** www.embracingourdifferences.org. **Contact:** Michael Shelton. No cost. Contest held annually. For rules, please see website. Prize: $4,000. Open to all skill levels. Deadline: January 10, 2017. Contestants should see website for more information.

EMERGING ARTISTS

SlowArt Productions, 123 Warren St., Hudson NY 12534. (518)828-2343. **E-mail:** slowart@aol.com. **Website:** www.slowart.com. **Contact:** Tim Slowinski, director. Cost: $35. Annual contest. "This contest is dedicated to the exhibition, publication, and promotion of emerging artists." Open to all skill levels. Awards: exhibition at the Limner Gallery; $1,000 cash; $2,200 in publication awards. Deadline: November 30, annually. E-mail or see website for more information.

EXHIBITIONS WITHOUT WALLS FOR PHOTOGRAPHERS AND DIGITAL ARTISTS

130 SW 20th St., Cape Coral FL 33991. (239)223-6824. **E-mail:** ewedman@exhibitionswithoutwalls.com. **Website:** www.exhibitionswithoutwalls.com. **Contact:** Ed Wedman, co-founder. Cost: $25 for up to 5 images, each additional image up to 10 is an additional charge of $4. Contest is held quarterly. Online international juried competitions for photographers and digital artists. Prizes vary, but a minimum of $900 in cash awards and additional prizes. Open to all skill levels. Deadline: 30 days after submissions open. Contestants should see website for more information.

HOW INTERACTIVE DESIGN AWARDS

F+W, a Content + eCommerce Company, Competition Dept., 10151 Carver Rd., Suite 200, Blue Ash OH 45242. (715)445-4612, ext. 13430. **E-mail:** HOW-interactive@fwmedia.com. **E-mail:** HOWcompetition@fwmedia.com. **Website:** www.howdesign.com/interactivedesignawards. **Contact:** Nicole Howard. Annual contest to recognize the best in digital design. See website for complete submission details and a list of categories. Awards: All winning entries will be featured online at HOWInteractiveDesign.com, at the HOW Design Live event, at the HOW Interactive Design Conferences and receive a $100 discount to the HOW Design Conference. One "Best of Show" winner will get a free trip to the HOW Conference (round-trip airfare, hotel, and registration) and will be prominently featured in the HOW July 2015 issue. Open to all skill levels. **Deadline: November.** E-mail or see website for more information.

HOW INTERNATIONAL DESIGN AWARDS

F+W, a Content + eCommerce Company, Competition Dept., 10151 Carver Rd., Suite 200, Blue Ash OH 45242. (715)445-4612, ext. 13430. **E-mail:** howcompetition@fwmedia.com. **Website:** www.

howdesign.com/internationaldesignawards. **Contact:** Nicole Howard. Annual contest to recognize the best graphic design work from around the world. Awards: All Outstanding Achievement entry winners will be featured in HOW's International Design Annual and get a $100 discount to the HOW Design Conference. One "Best of Show" winner will get a free trip to the HOW Design Conference (roundtrip airfare, hotel, and registration), will be featured in the HOW Design Annual issue and will be showcased in the online design competition gallery. Open to all skill levels. **Deadline: mid-August.** E-mail or see website for more information.

HOW LOGO DESIGN AWARDS

F+W, a Content + eCommerce Company, Competition Dept., 10151 Carver Rd., Suite 200, Blue Ash OH 45242. (715)445-4612, ext. 13430. **E-mail:** howcompetition@fwmedia.com. **Website:** www.howdesign.com/logodesignawards. **Contact:** Nicole Howard. Annual contest. "There are no categories, and it doesn't matter if your logo was created for yourself, for work or just for fun...we want to see what you can do! So take this wide-open media and run with it! All logos must be submitted online at howdesign.com. The image size must not exceed 1280×1024 pixels. The image can be saved at a resolution that will enable us to zoom in to see details during judging, but the file size must not exceed 5MB." Cost: $45/logo. Awards: 10 winners will be featured on the HOW website, receive a prize pack of design books from HOW's official online store and receive a graphic to post on your website announcing your winning status. From the top 10 winners, visitors to HOWDesign.com will have a window of time to vote for one Reader's Choice Best of Show winner, which will receive additional attention as the featured project in Behind the Design, a column in HOW magazine. Open to all skill levels. **Deadline: July.** E-mail or see website for more information.

HOW POSTER DESIGN AWARDS

F+W, a Content + eCommerce Company, Competition Dept., 10151 Carver Rd., Suite 200, Blue Ash OH 45242. (715)445-4612, ext. 13430. **E-mail:** howcompetition@fwmedia.com. **Website:** www.howdesign.com/posterdesignawards. **Contact:** Nicole Howard. Annual contest. "There are no categories, and it doesn't matter if your poster was created for yourself, for work or just for fun...we want to see what you can do! So take this wide-open media and run with it! All posters must be submitted online at howdesign.com. The image size must not exceed 1280×1024 pixels. The image can be saved at a resolution that will enable us to zoom in to see details during judging, but the file size must not exceed 5MB." Awards: 10 winners will be featured on the HOW website, get $150 worth of HOW books and a 1-year subscription to *HOW* magazine, and receive a graphic to post on your website announcing your winning status. Open to all skill levels. **Deadline: early December.** E-mail or see website for more information.

HOW PROMOTION & MARKETING DESIGN AWARDS

F+W, a Content + eCommerce Company, Competition Dept., 10151 Carver Rd., Suite 200, Blue Ash OH 45242. (715)445-4612, ext. 13430. **E-mail:** self-promo-competition@fwmedia.com. **Website:** www.howdesign.com/design-competitions/promotion-marketing-design-awards/. **Contact:** Nicole Howard, customer service specialist. Estab. 1988. Annual contest. HOW's longest-running design competition. "This is the only awards program to specifically recognize outstanding promotional work—whether it's a self-promo to showcase a design firm's capabilities, a project for a client's goods or services, an announcement or a student résumé or portfolio. HOW's Promotion & Marketing Design Awards celebrates design work that's engaging, memorable and effective at moving the viewer toward action." See website for complete submission details and a list of categories. Accepts actual samples of annual reports, brochures, catalogs, direct mail, book and magazine covers and interior pages, invitations, announcements, greeting cards, letterhead, logos, packaging, posters, print advertising, calendars, wearables, 3D objects interactive work, and more. Designs may be entered in more than one category. Submit a separate entry and fee for each category. Awards: All winning entries will be featured in HOW's Self-Promotion Design Annual and winners will get a $100 discount to HOW Design Live. Best of Show awarded a free trip to the annual HOW Design Live (round-trip airfare, hotel and registration) and an award to be presented at the conference. Open to all skill levels. **Deadline: March.** E-mail or see website for more information.

IN-HOWSE DESIGN AWARDS

F+W, a Content + eCommerce Company, Competition Dept., 10151 Carver Rd., Suite 200, Blue Ash OH 45242. (715)445-4612, ext. 13430. **E-mail:** howcompetition@fwmedia.com. **Website:** www.howdesign.com/in-howsedesignawards. **Contact:** Nicole Howard. Cost: Single entry—$115 (stationery systems count as single entries); campaign—$140 (3 or more pieces that function as a system or series). Payment must accompany entries. Entries received without payment will be disqualified. Entry fees are nonrefundable. Annual contest held to recognize the best creative work produced by designers working in corporations, associations and organizations. Submissions are evaluated by business category to ensure that a broad range of design work is represented. Accepts actual samples of annual reports, brochures, catalogs, direct mail, book and magazine covers and interior pages, invitations, announcements, greeting cards, letterhead, logos, packaging, posters, print advertising, calendars, wearables, 3D objects, and other print projects. Also accepts color print-outs of workspaces, signage and other environmental graphic design. Does not accept videos, CDs, DVDs, websites or other interactive work, or digital images or slides of print work. Digital work is eligible in Interactive Design Awards. Designs may be entered in more than one category (see website for category listing). See website for complete submission details; and a list of eligible categories. Awards: Best of Show winner will receive: 2-page spread in *HOW*'s January issue; representation in the online gallery and archive; press release to the design community promoting your win; and a trip to the 2014 HOW Design Live Conference. Merit winners will receive publication in *HOW* magazine and a $100 gift certificate toward the HOW Design Live Conference. Open to all skill levels. Deadline: July. Call, e-mail or see website for more information.

KENTUCKY ARCHAEOLOGY MONTH POSTER CONTEST

109-A W. Poplar St., Elizabethtown KY 42701. (270)855-9780. **E-mail:** christywpritchard@gmail.com. **Website:** www.kyopa-org.org/kentucky_archaeology_month.html. **Contact:** Christy Pritchard, chair. Estab. 2014. Winning artwork and design will be used as the official poster for the first annual Kentucky Archaeology Month, "Celebrating Kentucky Archaeology." Calling all artists and graphic designers to submit poster designs that reflect their interpretation of Kentucky's rich heritage. The KAM steering committee will select 3 finalists from the designs submitted. Finalists will be e-mailed to the KyOPA membership and the winner will be selected by a membership vote. The official Kentucky Archaeology Month poster will be distributed to the Governor's office, members of Kentucky House, Kentucky Senate, as well as Kentucky libraries, schools, and various parks within the state. See website for submission deadline. Artists should submit proposed artwork in electronic, camera-ready format. Submitting artists must also complete the entry form. Submission must be original artwork. Submissions must be 2-dimensional artwork. No syndicated, copyrighted or clip art images may be submitted. Reproducibility will be a factor in the committee's decision. High contrast and bright colors are recommended, the estimated size of the poster will be 18×24. Selected artwork for the poster will be artistic, positive in approach and informative for use as a teaching tool. Selected artwork for the poster will commemorate Kentucky Archaeology Month celebrating the long history of archaeology and heritage studies in Kentucky. Selected artwork for the poster will have broad appeal to Kentuckians, educators, students, those considering Kentucky for travel and vacation, historians, artists, and the general public. A committee will select 3 finalists from the artwork submitted. The selection committee will consist of members from KyOPA, the Kentucky Heritage Council, and the Office of State Archaeology. Artwork will be judged based upon: quality of artwork, creativity and originality of artwork, positive, and thematically appropriate artwork, reproducibility. The winner will be selected by electronic vote, via e-mail, from the KyOPA membership. The Kentucky Organization of Professional Archaeologists will retain rights of ownership for all final artwork commissioned via this solicitation. The committee reserves the right to use the artwork for additional purposes, such as websites and print materials.

LOS ANGELES CENTER FOR DIGITAL JURIED COMPETITION

1515 Wilcox Ave., Los Angeles CA 90028. (323)646-9427. **E-mail:** info@lacphoto.org. **Website:** www.lacphoto.org. The Los Angeles Center of Photography (LACP) is dedicated to supporting photographers and

the phtographic arts. LACP provides high-caliber classes, local and travel workshops, exhibitions, screenings, lectures, and community outreach efforts, including grants, need-based scholarships, and focused programming for youth and low-income families.

LOVE UNLIMITED FILM FESTIVAL & ART EXHIBITION

100 Cooper Point Rd., Suite 140-136, Olympia WA 98502. E-mail: entries1@loveanddiversity.org; volunteers@loveanddiversity.org. Website: www.communitygardenlove.org. Contact: submissions administrator. Accepts art (ceramics, drawings, fiber, functional, furniture, jewelry, metal, painting, printmaking, digital or graphics, mixed media 2D, mixed media 3D, sculpture, watercolor, wood, other or beyond categorization (specify), photography, music, writing, photos, and all types of designs, as well as film and scripts. Accepts poetry, hip-hop, spoken word, and zine excerpts, autobiography/memoir, children's, fiction, horror, humor, journalism, mystery, nature, novels, short stories, nonfiction, poetry, romance, science fiction/fantasy, screenwriting, travel, young adult, and other topic areas. We accept writing in all these topic areas provided these topic areas are directly, indirectly, literally or symbolically related to love. Awards: over $30,000 in cash and prizes and 120 given out during a red carpet gala event in Los Angeles and in Austin TX. Photos and videos of past events are online. Open to all skill levels. Deadlines: October for art, November for all other categories. See website for more information.

MICHIGAN ANNUAL XLIII (ART COMPETITION & EXHIBITION)

125 Macomb Place, Mt. Clemons MI 48043. (586)469-8666. Fax: (586)469-4529. E-mail: exhibitions@theartcenter.org; sahazzard@theartcenter.org. Website: www.theartcenter.org. Contact: Stephanie Szmiot, exhibition manager. Cost: $35.00 per artist for up to two entries to be juried. Annual statewide juried art competition. Open to resident Michigan artists ages 18 and older. No size or media restrictions. Featuring new guest juror each year. Up to 50 selected artworks are on display for about 4 weeks in main gallery. Prize/Award: 1st place $1,000, 2nd place $600, 3rd place $400, in addition to 5 honorable mention awards. Deadline for submissions: late December-ear-

ly January. Contestants should write, send SASE, call, e-mail, and see website for more information.

⊕ MOTION IN ART AND ART IN MOTION

Art League of Long Island, 107 E. Deer Park Rd., Dix Hills NY 11746. (631) 462-5400. E-mail: info@artleagueli.org. Website: www.artleagueli.org. Sue Peragallo. Estab. 1955. Cost: 2 images, $40; $5 each additional image up to 3; total maximum 5 images. Non-members: First 2 images $50; $5 each additional image up to 3; total maximum 5 images. Open to artists residing in Suffolk, Nassau, Brooklyn and Queens. 2D and 3D work in any medium may be submitted, including photography and fine craft. Prize/award: $500 awards of excellence and honorable mentions of 1 year memberships in ALLI will be given at the discretion of the judge. Deadline for submissions: late February. Contestants should call or see website for more information. The Art League of Long Island is a not-for-profit organization dedicated to broad-based visual arts education, providing a forum and showcase for artists of all ages and ability levels. Since its inception in 1955, the mission has focused on enhancing Long Island's cultural life by promoting the appreciation, practice and enjoyment of the visual arts. Collaborative events and outreach programs spread the joy of creativity among every segment of the population.

⊕ NABA ARTISTS CONTEST

4 Delaware Rd., Morristown NJ 07960. Website: www.naba.org. Contest held annually. Photography contest held in 2016 and every 2nd year. Artist Contest held in 2017 and every 2nd year.

NICKELODEON ARTIST PROGRAM

231 W. Olive Ave., Burbank CA 91502. (818)736-3663. E-mail: info.artist@nick.com. Website: www.nickartist.com. Annual program developed to broaden Nickelodeon's outreach efforts. Nickelodeon's Artist Program offers aspiring artists with diverse backgrounds and experiences the opportunity to hone their artistic skills while working on our 2D and CG animated television shows. The program provides a salaried position for up to 6 months. General Track participants will have hands-on interaction with established background designers, character designers and more, while Storyboard Track participants will receive hands-on experience working with lead storyboard artists. Submission period from March 1-April 1. Application information and submission guidelines are available

on our website at www.nickartist.com. No entry fee. Open to intermediate and advanced creative artists. Follow us on Twitter @NickArtists; Like us on Facebook: www.facebook.com/NickArtist.

PASTEL 100

F+W, a Content + eCommerce Company, Competitions Dept., 10151 Carver Rd., Suite 200, Blue Ash OH 45242. (715)445-4621, ext. 13430. **E-mail:** pjedit@fwcommunity.com. **Website:** www. artistsnetwork.com/pasteljournalcompetition. **Contact:** Anne Hevener. Cost: $25/image for early bird entries, $30/image after early bird deadline. Annual contest sponsored by *The Pastel Journal*. Offers cash, prizes and publicity to winners. Enter files online or via regular mail. "All digital files submitted via regular mail must be accompanied by an Official Entry Form or facsimile. There is no limit to the number of images you may enter. If you mail all your entries in on one CD, please include a separate sheet that gives the title and dimensions of each image. Image files cannot exceed 5MB. The file format must be JPEG. If your work is selected for the top 100, we will contact you about sending a high-res replacement. Incomplete entry forms and information sheets, and improperly marked CDs will be disqualified. *Slides will not be accepted.* CDs will not be returned." See website for a listing of categories. All top prizewinners and placewinners will receive features in *The Pastel Journal.* Honorable mentions (70 awarded) will be featured in *The Pastel Journal.* See website for a complete list of awards. Open to all skill levels. Artists must be 16 or older. Work must be at least 80% soft pastel; no oil pastel. Nupastels and other "harder" pastels are considered soft pastels. The contest is open to artists in the US and abroad. All works must be original. Compositions based on published material or other artists' work are *not* considered original and are not eligible. See website for complete eligibility details. **Deadline: September.** E-mail or see website for more information.

PRINT'S REGIONAL DESIGN ANNUAL

F+W, a Content + eCommerce Company, Competition Dept., 10151 Carver Rd., Suite 200, Blue Ash OH 45242. (715)445-4612, ext. 13430. **Fax:** (715)445-4087. **E-mail:** printcomp@fwmedia.com. **Website:** www.regionaldesignannual.printmag. com/competition-details. **Contact:** Nicole Howard, customer service specialist. Cost: (see website for current rates/dates): Single entries: $95 each piece; campaigns and series: $120 (3 or more pieces in each submission). Ad campaigns, book cover series, corporate brochure series, or poster series will all be considered campaigns. Any packaging entry, whether a single package or a family of packages, will be considered a single entry (fee: $95). Any letterhead entry that consists of stationery, envelope, and business card will be considered a single entry. Held annually. "The *Regional Design Annual* is more than just a catalog of the best American design created over the year. For 30 years, this highly-anticipated collection of art and design has displayed the considerable breadth and depth of high-quality work being generated in every corner of the country. For many designers, the *RDA* symbolizes the pinnacle of design accomplishment, while at the same time directly reflecting the aesthetics and zeitgeist of the regions included." Enter online. You may submit up to 10 digital photos per entry (5MB per file). If your work is selected as a finalist you may be asked to send a sample. See website for complete submission details; and a listing of categories. Awards: Winners will be published in the December issue of *Print,* as well as featured in an online gallery. Open to all skill levels. **Deadline: early March** (see website for details). E-mail or see website for more information.

✚ SHOEBOX: AN INTERNATIONAL SCULPTURE EXHIBITION

1672 Greenland Dr., Murfreesboro TN 37132. (615)898-5532. **E-mail:** gallery@mtsu.edu. **Website:** www.mtsu.edu/art. **Contact:** Eric Snyder, Gallery Coordinator.

A SHOW OF HEADS

SlowArt Productions, 123 Warren St., Hudson NY 12534. (518)828-2343. **E-mail:** slowart@aol.com. **Website:** www.slowart.com. **Contact:** Tim Slowinski, director. Cost: $35. Annual contest. "This contest is to select artists for exhibition in The Show of Heads at Limner Gallery. The show features work based on the portrayal and interpretation of the human head." Open to all skill levels. Awards: exhibition at Limner Gallery; 3 artists receive publication in *Direct Art Magazine*; 1 artist receives 2 full pages; 2 artists receive 1 page. Value of awards: $2,200. Deadline: August 31, annually. E-mail or see website for more information.

SPLASH: THE BEST OF WATERCOLOR

F+W, a Content + eCommerce Company, Competition Dept., 10151 Carver Rd., Blue Ash OH 45242. (715)445-4612, ext. 13430. **Website:** www.splashwatercolor.com; www.artistsnetwork.com/splashwatercolor. **Contact:** list manager. Cost: $30 for the first painting and $30 for each additional digital submission. Annual contest showcasing the finest watercolor paintings being created today. A new book in the series is published every year by North Light Books and features nearly 140 paintings by a wide variety of artists from around the world, each with instructive information about how it was achieved—including inspiration, tips and techniques. "We look for excellence in a variety of styles and subjects. The dominant medium must be transparent watercolor, though minor uses of other media are acceptable." Your digital images may be submitted online or on CD/DVD (please label the disks with your name and address). Mailed entries must be accompanied by a color printout and an entry form. Disks will not be returned. For judging purposes, these images must be high-quality, in RGB color mode, JPEG format, and 72 dpi. All digital files must be smaller than 5MB. Digital files submitted by mail must be labeled with your last name, first name, the entry number (should correspond to the number on the entry form), with no punctuation marks until the file extension (example: Wolf Rachel 3.jpg). Awards: winning paintings will be published in a beautiful hardcover book. Open to all skill levels. **Deadline: December.** E-mail or see website for more information.

STROKES OF GENIUS: THE BEST OF DRAWING

F+W, a Content + eCommerce Company, Competition Dept., 10151 Carver Rd., Suite 200, Blue Ash OH 45242. (715)445-4612, ext. 13430. **E-mail:** bestofnorthlight@fwmedia.com; art-competition@fwmedia.com. **Website:** www.artistsnetwork.com/competitions/strokes-of-genius. **Contact:** Nicole Howard, customer service specialist. Cost: $30 for the first drawing and $25 for each additional drawing. Annual contest showcasing the finest drawings being created today. A new book in the series is published every year by North Light Books and features nearly 140 drawings by a wide variety of artists from around the world, each with instructive information about how it was achieved—including inspiration, tips and techniques. Artwork can be in any dry medium, or wet medium applied in a linear fashion that would be traditionally considered drawing. Final judgment on whether a work of art fits into the "drawing" category will be determined by the editors. All submissions will be reviewed by Rachel Wolf and the editorial staff of North Light Books. Art will be selected on the basis of general quality as well as suitability for this publication. Your digital images may be submitted online. For judging purposes, these images must be high-quality, in RGB color mode, JPEG format, and 72 dpi. All digital files must be smaller than 5MB. Awards: winning drawings will be published in a beautiful hardcover book. Open to all skill levels. **Deadline: April.** E-mail or see website for more information.

TALLAHASSEE INTERNATIONAL JURIED COMPETITION

530 W. Call St., Rm. 250FAB, Tallahassee FL 32306-1140. (850)644-3906. **Fax:** (850)644-7229. **E-mail:** tallahasseeinternational@fsu.edu. **Website:** www.mofa.cfa.fsu.edu/participate/tallahassee-international. **Contact:** Jean D. Young, coordinator. Cost: $20/2 images. Annual art contest. Artists worldwide, 18+ are eligible. All media and subject matter eligible for consideration. Juried by panel of FSU College of Fine Arts faculty. One entry/person. Awards: 1st- $1,000; 2nd- $500. Color catalog is produced. Open to all skill levels. Photographers should e-mail or visit website for more information.

⊕ UNDISCOVERED WORLD ART CONTEST

Diana Perry Books, P.O. Box 1001, Reynoldsburg OH 43068. **E-mail:** artcontest@dianaperrybooks.com. **Website:** www.dianaperrybooks.com. Cost: $15 money order. Annual contest. "The purpose of this contest is to give exposure to artists/illustrators trying to break into the business and get noticed." Open to all skill levels. Create a scene from an undiscovered world here on earth that contains people/animals/plants from the past, present and future. Rules on website. One page, any media. Prizes: 1st place: $200, trophy, mention on website, DianaPerryBooks T-shirt, press releases in your local newspapers. 2nd place: $150, trophy, mention on website, T-shirt, press releases in your local newspapers. 3rd place: $100, trophy, mention on website, T-Shirt, press releases in your local newspapers. 4th/5th places: $50/$25,

plaque, mention on website, T-shirt, press releases in your local newspapers. We also list names of next 25 honorable mention on website. Contest guidelines and entry form on DianaPerryBooks.com. Check website for guest judges. E-mail your picture via JPEG or PDF no later than end of December with "Undiscovered World Art Contest" as subject. Also write your full name and address in body of text so we can match up with your snail mail submission. Mail entry form and a $15 money order to Undiscovered World Art Contest at above address postmarked no later than end of December. Winners announced both on website and via snail mail February 1st. Prizes mailed within 10 days of announcement.

WATERCOLOR ARTIST'S WATERMEDIA SHOWCASE

F+W Media, Competition Dept., 10151 Carver Rd., Suite 200, Blue Ash OH 45242. (513)278-2532. **E-mail:** tara.johnson@fwcommunity.com. **Website:** www.artistsnetwork.com/watermediashowcase. **Contact:** Tara Johnson. Cost: $20/image for early bird entries (submitted on or before July 1). Entries submitted after July 1 are $25/image. Annual contest. You must enter online and all entries must be submitted as digital files. You may enter work in any and all categories; there is no limit to the number of images you may enter. If your work is selected as a winner, we may contact you about sending a high-res replacement. Incomplete entry forms and information sheets, and improperly named image files will be disqualified. See website for complete submission details. Award: Best of Show: $2,500; 2nd Place: $1,250; 3rd Place: $750. Award winners will be published and Honorable Mentions' names will be listed in the April issue of *Watercolor Artist*. All winners and honorable mentions will receive a certificate suitable for framing. Open to all skill levels. **Deadline: August 1.** E-mail or see website for more information.

⌂ FRED WHITEHEAD AWARD FOR DESIGN OF A TRADE BOOK

E-mail: tilsecretary@yahoo.com. **Website:** www.texasinstituteofletters.org. Offered annually for the best design for a trade book. Open to Texas residents or those who have lived in Texas for 2 consecutive years. See website for guidelines. **Deadline: Early January**; see website for exact date. Offered annually for the best design for a trade book. Open to Texas residents or those who have lived in Texas for 2 consecutive years. See website for guidelines.

WORKSHOPS & ART TOURS

Taking an art or design workshop or tour is one of the best ways to improve your creative skills. There is no substitute for the hands-on experience and one-on-one instruction you can receive at a workshop. Besides, where else can you go and spend several days with people who share your passion for art or design?

Plein air drawing and painting are perennial workshop favorites. Creativity is another popular workshop topic. You'll also find highly specialized workshops such as Celtic design and forensic art. Many tours specialize in a specific location and the great artistic opportunities that location affords.

As you peruse these pages, take a good look at the quality of workshops and the skill level the sponsors want to attract. It is important to know if a workshop is for beginners, advanced amateurs, or professionals. Information from a workshop organizer can help you make that determination.

These workshop listings contain only the basic information needed to make contact with sponsors and a brief description of the styles or media covered in the programs. We also include information on costs when possible. Write, call, or e-mail the workshop/tour sponsors for complete information. Most have websites with extensive information about their programs, when they're offered, and how much they cost.

A workshop or tour can be whatever the artist or designer wishes—a holiday from the normal working routine or an exciting introduction to new skills and perspectives on the craft. Whatever you desire, you're sure to find in these pages a workshop or tour that fulfills your expectations.

3 DAY COLOR INTENSIVE WITH KITTY WALLIS

10915 SW 37th Ave., Portland OR 97219. (503)307-1142 (cell). **E-mail:** walliscorp@yahoo.com. **Contact:** Kitty Wallis, artist and teacher. Students will learn about color as a tool for the artist. How to achieve light, and life in their work. Designed for pastel artists. Open to all skill levels. Three workshops held summer of 2015. Small classes limited to 5 students; scheduled over 3 day weekends. Cost: $360 including Wallis Archival Sanded Pastel Paper and some materials. Lodging and meals not included. Please write with SASE, call, or e-mail for more information.

ACADIA WORKSHOP CENTER

7 Bernard Rd., Bernard ME 04612. (207)460-4119. E-mail: awcmaine@gmail.com. **Website:** www.acadia-workshopcenter.com. **Contact:** Gail Ribas, director/owner. 4-5 day workshops with top instructors in all painting media on the coast of Maine. Workshops are held during the summer and early fall. Interested parties should check the website for details.

UNDERSTANDING THE ATMOSPHERE: ADVANCED LANDSCAPE PAINTING

(808)873-0597. **E-mail:** julie@pleinairjourneys.com. **Website:** www.pleinairjourneys.com. **Contact:** Julie Houck. Annual workshops teaching the fundamentals of light on the landscape. Split Rock Cove, South Thomaston, Maine.

ARROWMONT SCHOOL OF ARTS AND CRAFTS

556 Pkwy., Gatlinburg TN 37738. (865)436-5860. **Fax:** (865)430-4101. **E-mail:** ltuttle@arrowmont.org; info@arrowmont.org. **Website:** www.arrowmont.org. Offers weekend, 1- and 2-week workshops in photography, drawing, painting, clay, metals/enamels, kiln glass, fibers, surface design, wood turning, and furniture. Residencies, studio assistantships, work-study, and scholarships are available. See individual course descriptions for pricing.

ART ESCAPES WORKSHOPS WITH DORY KANTER

E-mail: dory@dorykanter.com. **Website:** www.dorykanter.com. **Contact:** Dory Kanter, artist and workshop organizer. Next workshops: check website for dates. "Chronicling impressions with quick sketches and visual storytelling is an everyday practice for Dory Kanter, whose best-selling book *Art Escapes* provides daily exercises and inspirations for artists, to help them build confidence and cultivate creativity. Join Dory as she makes it easy to create art every day with original Art Escape projects designed to spark your creativity and capture the sights and scenes around you. Learn enlivening observational art projects to record your wanderings at home or on the road. Dory will demonstrate how to create luminous watercolor mixes with her 4 color triads. All skill levels will experience both inspiration and success." E-mail and see website for more information.

ART IMMERSION TRIP WITH WORKSHOP IN NEW MEXICO

P.O. Box 1473, Cullowhee NC 28723. (828)342-6913. **E-mail:** contact@cullowheemountainarts.org. **Website:** www.cullowheemountainarts.org. **Contact:** Norma Hendrix, director. Cost: $1,379-$1,579 (includes lodging, 2-4 day workshop, breakfasts, 1 dinner, some transportation, and museums). "Cullowhee Mountain Arts offers exceptional summer artist workshops in painting, drawing, printmaking, book arts, ceramics, photography, and mixed media. Our distinguished faculty with national and international reputations will provide a week-long immersion in their topic supplemented with lectures, demonstrations or portfolio talks. Cullowhee Mountain Arts is committed to supporting the personal and professional development of every artist, whatever their level, by providing the setting and facilities for intense learning and art making, shared in community. We believe that are enlivens community life and that in a supportive community, art thrives best. Our studios are located on Western Carolina University's campus, surrounded by the natural beauty of the Blue Ridge Mountains in North Carolina." Upcoming workshops in New Mexico include: Debra Fitts (Ceramic Sculpture: Intermediate to Advanced), "The Spirit & The Figure"; Ron Pokrasso (Printmaking: All Levels), "Monotype and More: Mixed Media Printmaking"; Nancy Reyner (Acrylic: Intermediate, Advanced, Masters), "Acrylic Innovation: Inventing New Painting Techniques & Styles"; and Sandra Wilson (Painting: All Levels), "Acrylic Textures, Transfers, and Layers." Call, e-mail, or see website for more detailed information including exact dates and locations.

ARTIST'S NETWORK UNIVERSITY

E-mail: service@artistsnetworkuniversity.com. **Website:** www.artistsnetworkuniversity.com. For more than 25 years, the experts at North Light Books have

been publishing books designed to connect artists with ideas and inspiration. Now, Artist's Network University brings North Light Books' friendly, accessible style of fine are instruction to online art classes. Get personal instruction on your own schedule in the mediums/topics you want and at the skill level that best fits you wherever you are in art. Cost: $159.99/$169.99. Classes start every Tuesday and run for 4 weeks. Send e-mail for more information.

ART WORKSHOPS IN GUATEMALA

4758 Lyndale Ave. S., Minneapolis MN 55419-5304. (612)825-0747. **E-mail:** info@artguat.org. **Website:** www.artguat.org. **Contact:** Liza Fourre, director. Estab. 1995. Art & cultural workshops held in Antigua, Guatemala. See website for a list of upcoming workshops. Art & cultural workshops held year-round. Maximim class size: 10 students per class.

⊕ CHEAP JOE'S ARTIST WORKSHOPS

374 Industrial Park Dr., Boone NC 28607. (800)227-2788. **Fax:** (800)257-0874. **E-mail:** edwina@cheapjoes@com. **Website:** cheapjoes.com. **Contact:** Edwina May, workshop coordinator. Cost: Varies per instructor, discount given for registrations at least 6 months prior to workshop. Workshops held annually: weekly/mid-April through October. Next workshop will be held April 24, 2017. Last workshop begins Oct. 23, 2017. Taking a workshop at Cheap Joe's is more than a painting class—it's an experience! Learn from the best instructors in the business. You'll have an individual workstation, discounts on supplies, hotel discounts, delicious lunches provided, awesome customer service, and much more! Classes vary weekly from mid-April through October. Early registration discount available. Open to all skill levels. Interested parties should e-mail or see website for more information.

COASTAL MAINE ART WORKSHOPS/ ROCKLAND AND BEYOND!

Paint Way Art Workshops: Art Classes Abroad!, P.O. Box 845, Camden ME 04843. (207)594-4813. **E-mail:** info@coastalmaineartworkshops.com. **Website:** www.coastalmaineartworkshops.com. **Contact:** Lyn Donovan, Director. Estab. 2006. Tuition in Maine includes free parking at our Studio locations, all instruction and a Class Monitor for extra help! Costs for classes abroad vary depending on location and what is included, usually lodging, ground transportation once at your hotel, and many meals, plus of course, instruction! Maine students make their own arrangements for lodging and meals; many establishments offer breakfast and there are plenty of nearby options for great food. Workshops in Maine are held weekly July through early-October with nationally and internationally known instructors teaching 5-day Plein Air classes in watercolor, oils/acrylics and pastels. We have glorious scenery, fine studios and a reputation for lavish personal attention. Rockland and Belfast, our 2nd local site, are halfway up the coast of Maine and full of great art, friendly places to stay and terrific food. We have now added Portland as a 3rd location (no need for a car!) Our classes in Europe thru 'Paint Away: Art Classes Abroad!' are generally in the Spring and Fall." Both programs have classes for all skill levels. Artists should visit our website for more information or contact us directly. We're always happy to answer questions!

CREATIVE EXPLORATIONS IN MIXED MEDIA SERIES

E-mail: lisa@cyrstudio.com. **Website:** www.cyrstudio.com; www.cyrstudio.com/videos.html. **Contact:** Lisa L. Cyr. Recorded webinars available for download with Artist's Network. *Session 1—Collage Techniques for the Mixed-Media Artist*: This video covers an array of exciting collage techniques from gluing, sealing, tearing, scoring, punching, die-cutting, and custom inlays; to wrinkling, creasing, burning, peeling-back, stitching, weaving, embossing and debossing handmade, custom treated and machine-made papers, foils, and ephemera. If you love working in collage, this recorded workshop with artist Lisa L. Cyr is for you (www.northlightshop.com/creating-explorations-in-mixed-media-digital-download-u7890)! *Session 2—Transforming the Surface With Mixed-Media Painting Techniques*: This video covers a striking array of creative approaches in which to alter and transform the mixed-media painting surface. Lushly painted passages and rich transitions employing resist, blotting, lift-off, dissolve, marbling, sponging, distressing, aging, and printmaking techniques will be shown in inventive combinations. Utilizing both traditional and unconventional tools and techniques, this audiovisual presentation will certainly ignite the creative juices (www.northlightshop.com/transforming-the-surface-with-mixed-media-painting-techniques-download-u7891)! *Session 3—Assemblage Accents: Employing Faux Finishes and Patinas*: This video covers creatively customizing found objects, assemblage accents, and sculptural creations with

unique finishes and patinas. To enliven the mixed-media landscape, a diverse array of techniques and materials from repurposed and custom treated material and man-made elements are explored. With the addition of faux finishes and decorative techniques, the everyday object can be transformed into a one-of-a-kind accent, communicating a concept or illuminating a subject in a unique way. Working in bas-relief and dealing with the structural issues of assemblage accents and 3D work are also discussed (www.northlightshop.com/creative-explorations-mixed-media-digital-download-u7892). Cost: Each audiovisual presentation is available for download for $20. See download links to purchase on Northlightshop.com. www.northlightshop.com/catalogsearch/result/?q=cyr.

EILEEN CORSE—PAINTING WITH PASSION
4144 Herschel St., Jacksonville FL 32210. (904)388-8205. **E-mail:** eileencorse@gmail.com. **Website:** eileencorse.com. **Contact:** Eileen Corse, owner. Eileen Corse teaches how to apply oil paint with a palette knife to create lively and colorful paintings. Each day, Corse will demonstrate her technique. Open to all skill levels. One-day workshops held once a month. Tuition is $100. Interested parties should e-mail or see website for more information.

CREALDÉ SCHOOL OF ART
600 St. Andrews Blvd., Winter Park FL 32792. (407)671-1886. **E-mail:** pschreyer@crealde.org; rberrie@crealde.org. **Website:** www.crealde.org. **Contact:** Peter Schreyer, executive director; Robin Berrie, marketing manager. Crealdé School of Art is a community-based nonprofit arts organization established in 1975. It features a year-round curriculum of over 100 visual arts classes for students of all ages, taught by a faculty of over 40 working artists; a renowned summer art camp for children and teens; a visiting artist workshop series, 3 galleries, the contemporary sculpture garden, and award-winning outreach programs. Offers classes covering traditional and digital photography; b&w darkroom techniques; landscape, portrait, documentary, travel, wildlife and abstract photography; and educational tours. See website for more information and upcoming workshops.

CREATIVE ARTS WORKSHOP
80 Audubon St., New Haven CT 06511. (203)562-4927. **E-mail:** haroldshapirophoto@gmail.com. **Website:** www.creativeartsworkshop.org. **Contact:** Harold Shapiro, photography department head. A nonprofit regional center for education in the visual arts that has served the Greater New Haven area since 1961. Located in the heart of the award-winning Audubon Arts District, CAW offers a wide-range of classes in the visual arts in its own 3-story building with fully equipped studios and an active exhibition schedule in its well-known Hilles Gallery. Offers exciting classes and advanced workshops. Digital and traditional b&w darkroom. See website for more information and upcoming workshops.

CREATIVE COMPOSITION AND DEPTH WITH INSTRUCTOR LAURIE HUMBLE
Cheap Joe's Art Stuff, 374 Industrial Park Dr., Boone NC 28607. (800)227-2788 ext. 1123. **E-mail:** edwina@cheapjoes.com. **Website:** www.cheapjoes.com; www.lauriehumble.com. **Contact:** Edwina May, workshop coordinator. Workshop dates change annually. "Learn how to compose your work and use a sense of depth to draw the viewer in and hold their interest longer. Discover the key to editing reference material, whether you are working from photos or life. Laurie will provide subject matter for days 1, 2, and 3 while teaching you how to choose and make your subject work as a successful painting. On days 4 and 5, bring your own photo references or work from photos provided by Laurie. Both beginners and advanced painters will come away with a new understanding of how to create great design and achieve a sense of visual depth. Lessons learned can be applied to any painting style or skill level. There will be plenty of painting time, demos and individual instruction. You will be amazed at the new levels of dimension you create!" Workshop is held at Cheap Joe's Art Stuff. Call, e-mail, or see website for more information. 3-, 4-, and 5-day Artist Instructional Workshops available in watercolor, acrylic, oil, colored pencil, and mixed media. In total, 25-30 workshops per year, May through October. For registration or more information, visit the website or contact Edwina. Terrific views from studio, covered porch with rocking chairs, many local attractions and discounted lodging rates for workshop participants. Classes are held in a spacious workshop studio with color correct lighting, individual adjustable artist tables, ergonomic adjustable chairs, separate demo area with camera and 70" TV screen/monitor, convenient parking, and no stairs to climb. Delicious full lunches provided Monday-Thursday, free coffee, hot tea, fresh fruit and other goodies. Free gift each morning, Re-

tail outlet store next door for supplies, true southern hospitality, and the friendliest customer service in the world.

CULLOWHEE MOUNTAIN ARTS SUMMER WORKSHOP SERIES

598 W. Main St., Sylva NC 28779. (828)342-6913. **E-mail:** contact@cullowheemountainarts.org. **Website:** www.cullowheemountainarts.org. **Contact:** Norma Hendrix, director (norma@cullowheemountainarts.org). "Cullowhee Mountain Arts offers exceptional summer artist workshops in painting, ceramics, mixed media, encaustic, printmaking, and book arts. The distinguished faculty with national and international reputations will provide an immersion in their topic supplemented with lectures, demonstrations, or portfolio talks. Cullowhee Mountain Arts is committed to supporting the personal and professional development of every artist, whatever their level, by providing the setting and facilities for intense learning and art-making, shared in community. Upcoming workshops on the WCU campus include: Pop up books and Sculptural Bookbinding (book arts), Carol Barton; Pattern & Design (ceramics), Sean O-Connell; Advanced Cold Wax and Oil Painting (painting), Rebecca Crowell; Perceptual Craft in the Painting Studio (painting), Stuart Shills; Encaustic Monotype intensive (printmaking), Paula Roland; Layering Story, Feeling & Thinking in Poems (Creative Writing), Patrick Donnelly. Also offering workshops, trips and retreats to Taos NM, Gloucester, MA, and spring and fall artist and writer retreats at Lake Logan NC. www.cullowheemountainarts.org.

✪ DAWSON COLLEGE CENTRE FOR TRAINING AND DEVELOPMENT

4001 de Maisonneuve Blvd. W., Suite 2G.1, Montreal, Quebec H3Z 3G4 Canada. (514)933-0047. **Fax:** (514)937-3832. **E-mail:** ctd@dawsoncollege.qc.ca. **Website:** www.dawsoncollege.qc.ca/ciait. Workshop subjects include imaging arts and technologies, computer animation, photography, digital imaging, desktop publishing, multimedia, and web publishing and design. See website for course and workshop information.

DRAWING FOR THE ABSOLUTE BEGINNER

E-mail: mmwillenbrink@gmail.com. **Website:** www.shadowblaze.com. **Contact:** Mark or Mary Willenbrink. Mark Willenbrink, with his wife Mary, is the best-selling author of the *Absolute Beginner* series,

which includes *Watercolor for the Absolute Beginner* and *Drawing for the Absolute Beginner*. Mark enjoys sharing the fundamentals of art in understandable terms, encouraging others to pursue their creative potential. He is a professional illustrator, a fine artist and he teaches art classes and workshops. For more information on his latest workshops and books, visit www.shadowblaze.com; like Mark's Facebook page at www.facebook.com/pages/ Mark-Willenbrink-Artist-Author-and-Illustrator/153942411304719.

ETRUSCAN PLACES LANDSCAPE PAINTING IN ITALY & IPSWICH, MA (USA)

10 Ashland St., Newburyport MA 01950. (212)780-3216. **E-mail:** info@landscapepainting.com. **Website:** www.landscapepainting.com. **Contact:** Maddine Insalaco, director. Annual workshop held May through October in Italy and May in USA. Intensive one-week plein-air landscape painting workshops in Tuscany and the Roman Campagna. Cost: $2,250-2,950 depending on location and occupancy. Fees include: workshop, most or all meals, equipment and all supplies except paint and brushes, trips, museum visits, accommodations, and local transportation. Open-air landscape painting all the time, rain, or shine. Open to all skill levels. Interested parties should call, e-mail, or see website for more information.

EXPERIMENTAL PAINTING: INSPIRATIONAL APPROACHES IN MIXED MEDIA

E-mail: lisa@cyrstudio.com. **Website:** www.cyrstudio.com. **Contact:** Lisa L. Cyr. "This highly visual, hands-on workshop will investigate exploratory methodologies, techniques, and approaches in mixed-media art. Throughout the workshop, many exciting in-depth demonstrations will be shown, providing an extensive array of visually-stimulating possibilities for artists to explore. Both 2D and 3D mixed-media techniques will be covered, including employing alternative working grounds, using custom tools, toning the painting surface in imaginative ways, creating a tactile ground, building the visual architecture, and utilizing innovative mixed-media techniques to create intriguing effects. To assist artists in their own creative path, topics on nurturing the creative spirit, developing personal content through journalism, embracing a multidisciplinary mindset and creating message-driven art will also be discussed. For

artists that are looking to push their work to a new level, this workshop will be a valuable resource and an ongoing source for creative inspiration. You can view the book that the workshop is based upon at www.cyrstudio.com/workasplay.html." See website for more information including dates and locations.

⊕ FANTASTICAL DREAMSCAPES: CREATING MAGICAL ENVIRONMENTS IN MIXED MEDIA

E-mail: lisa@cyrstudio.com. **E-mail:** lisa@cyrstudio.com. **Website:** http://www.cyrstudio.com/dreamscapes.html. **Contact:** Lisa L. Cyr. This highly informative online workshop explores experimental approaches to painting dreamy vistas in mixed media, using both two-dimensional and three-dimensional techniques. The workshop covers the creation of mystical landscapes, waterscapes, and cityscapes in imaginative, abstract settings that are inspired from mythology, fairy tales, folklore, classical literature, and poetry. With visually inspiring imagery, insightful readings, thought-provoking videos, creative exercises and step-by-step demonstrations, artists will discover a plethora of exciting two-dimensional and three-dimensional techniques to employ in their own fantastical dreamy vistas. For intermediate and advanced artists who are looking to create magical, dream-like environments, this workshop will be a valuable resource and an ongoing source for creative inspiration! Six weeks online workshop www.cyrstudio.com/dreamscapes.html. Work in-process using three-dimensional mixed-media techniques. The workshop runs as a 6-week online class. Every day during the work week, I will have articles, videos, downloads, and links that will act as valuable supplementation to the class critiques. I will be in the classroom Monday through Friday reviewing in-process and finished works.

FINE ARTS WORK CENTER

24 Pearl St., Provincetown MA 02657. (508)487-9960, ext. 103. **Fax:** (508)487-8873. **E-mail:** workshops@fawc.org. **Website:** www.fawc.org. Estab. 1968. Faculty includes Connie Imboden, David Hilliard, Pam Houston, Nick Flynn, Shellburne Thurber, Salvatore Scibona, John Murillo, Joanne Dugan, Rob Swainston and many more.

FRANCISCAN LIFE PROCESS CENTER ART SCHOOL

11650 Downes, Lowell MI 49331. (616)897-7842, ext.352. **Fax:** (616)897-7054. **E-mail:** kbechtel@lifeprocesscenter.org. **Website:** www.lifeprocesscenter.org (click visual arts tab, and then adult workshops). **Contact:** Kathy Bechtel. Estab. 2014. Monthly workshops. Oil, painting, and pastel. Open to all skill levels. Cost varies. See website for complete workshop schedule. Topics include figure painting, expressive portraits, alla prima figure and portrait painting, figure drawing, colored pencil and ink wash on canvas, plein air painting, woodcut with chine colle, and color and light. Interested parties should e-mail or visit website for more information. The Franciscan Life Process Center Art School brings in visual artists from all over the United States and Canada. In the two years we have been doing this we are fortunate to have teachers (some of which are atelier trained) who have won awards nationally and internationally for their skills at portraits, still lifes, and landscapes in different media and different painting and drawing styles. We also are bringing in writers, and have also established a writing group.

HORIZONS: ARTISTIC TRAVEL

P.O. Box 634, Leverett MA 01054. (413)367-9200. **Fax:** (413)367-9522. **E-mail:** horizons@horizons-art.com. **Website:** www.horizons-art.com. **Contact:** Jane Sinauer, director. "Horizons offers one-of-a-kind small-group travel adventures in Southern Africa: Sea to Safari; Peru: the Inca Heartland; Ecuador: Andes to the Amazon; Southeast Asia: Burma and Laos (2014); and new for 2013, A Foodie's Italy: Parma and Bologna. As of 2013, our catalog will solely be online to ensure that you always have the most up-to-date information. If you would like a detailed itinerary for any trip or have specific questions, please let us know."

☯ JEANNE ROSIER SMITH PASTEL PAINTING IN CROATIA WITH SLIKAMILINA PAINTING TOURS

#38 Racisce, Lumbarda 20263, Croatia. (385)98 974 5683. **E-mail:** slikamilina@yahoo.ca; jeannersmith@verizon.net. **Website:** www.slikamilina.ca. Cost: $3,000 CAD. Single occupancy including meals, lodging, and transportation. Airfaire not included. "Join me on my next pastel painting trip to the beautiful island of Korcula, off the coast of Dubrovnik, Croatia. You'll fly into Dubrovnik, and we'll take a boat to

the island. From our base there we will explore coastal towns, olive groves, and mountain perches. This all-inclusive painting trip includes stunning coastal views, great food and wine, travel around the island, and a day tour of Dubrovnik. My painting trips include lots of specific pastel demonstration and instruction, plenty of individual attention at your easel in an enthusiastic, supportive atmosphere. Contact Jeanne or Lynda at Slikamilina for more information." Open to all skill levels. Interested parties should e-mail or visit website for more information.

KRISTY KUTCH COLORED PENCIL WORKSHOPS

11555 W Earl Rd., Michigan City IN 46360. (219)874-4688. **E-mail:** kakutch@earthlink.net. **Website:** www.artshow.com/kutch. Instruction focuses on using "traditional," water-soluble pencils, and water-soluble wax pastels to create painting-like works of art. Multiple workshops throughout the year. Prices vary. See website for more details.

LANDSCAPE PAINTING IN SOUTHERN FRANCE

(808)280-6083. **E-mail:** juliehouck@gmail.com. **Website:** www.pleinairjourneys.com. **Contact:** Julie Houck. Advanced landscape painting painting in the lovely Lot region of southwestern France. Fee $3,600. Includes lodging, instruction and most meals. Single supplement $1,000. Contact Julie Houck (808)280-6083 or julie@pleinairjourneys.com, or visit www.pleinairjourneys.com.

LIGHT & COLOR WORKSHOPS

10030 Fair Oaks Blvd., Fair Oaks CA 95628. (916)966-7517. **E-mail:** sarback@lightandcolor.com. **Website:** www.lightandcolor.com. **Contact:** Susan Sarback. These in-depth workshops focus on specific seeing and painting techniques based on the light and color of the Impressionists. Through painting a variety of subjects, the students learn the foundation needed to paint any subject—landscape, still life, portraiture, etc. Open to all skill levels. Interested parties should call or e-mail for more information.

THE MACDOWELL COLONY

100 High St., Peterborough NH 03458. (603)924-3886. **Fax:** (603)924-9142. **E-mail:** admissions@macdowellcolony.org. **Website:** www.macdowellcolony.org. Estab. 1907. Provides creative artists with uninterrupted time and seclusion to work and enjoy the experience of living in a community of gifted artists. Residencies of up to 8 weeks for writers, playwrights, composers, film/video makers, visual artists, architects, and interdisciplinary artists. Artists in residence receive room, board and exclusive use of a studio. Average length of residency is 30 days. Ability to pay for residency is not a factor; there are no residency fees. Limited funds available for travel reimbursement and artist grants based on need. Application deadlines: January 15: summer (June-September); April 15: fall/winter (October-January); September 15: winter/spring (February-May). Visit website for online application and guidelines. Questions should be directed to the admissions director. Open to writers, playwrights, composers, visual artists, film/video artists, interdisciplinary artists, and architects. Applicants submit information and work samples for review by a panel of experts in each discipline. Application form submitted online at macdowellcolony.org/apply.html.

MADELINE ISLAND SCHOOL OF THE ARTS

978 Middle Rd., P.O. Box 536, LaPointe WI 54850. (715)747-2054. **E-mail:** misa@cheqnet.net. **Website:** www.madelineschool.com. **Contact:** Jenna J. Erickson, director of programs. Workshop tuition $425-760 for 5-day workshops. Lodging and meals are separate, both are provided on-site. Workshops held annually between May-October. Workshops offered in writing, painting, quilting, photography, and yoga. Open to all skill levels. Interested parties should call, e-mail or see website for more information.

MAINE MEDIA WORKSHOPS

70 Camden St., P.O. Box 200, Rockport ME 04856. (207)236-8581 or (877)577-7700. **Fax:** (207)236-2558. **E-mail:** info@mainemedia.edu. **Website:** www.mainemedia.edu. "Maine Media Workshops is a non-profit educational organization offering year-round workshops for photographers, filmmakers, and media artists. Students from across the country and around the world attend courses at all levels, from absolute beginner and serious amateur to working professional; also high school and college students. Professional certificate and low-residency MFA degree programs are available through Maine Media College." See website for the fall calendar.

NIGHTSCAPES: EXPLORING THE DARK SIDE IN PASTEL

(203)235-1417. **E-mail:** christineiversartist@gmail.com. **Website:** www.christineivers.com. **Contact:**

Chris Ivers. Cost: varies. Workshops held throughout the year. This workshop will explore painting night cityscapes on textured black boards that students prepare the first day of the workshop. Color temperature, atmosphere perspective, drawing and the making of glowing lights are all part of the fun. This is a workshop or relaxation and encouragement. Demos and critiques are always included. Open to all skill levels. See website for complete workshop schedule. Interested parties should call, e-mail, or visit website for more information.

✚ ONLINE WORKSHOP: EXPERIMENTAL FIGURE PAINTING IN MIXED MEDIA: THE MYTHICAL REALM

E-mail: lisa@cyrstudio.com. **E-mail:** lisa@cyrstudio.com. **Website:** www.cyrstudio.com/expfigurepaint_mythical.html. **Contact:** Lisa L. Cyr. The mythical figure has inspired artists for centuries. Let it inspire you too! This highly informative online workshop explores experimental approaches to painting the mythical figure in thematic fantastical settings, using both two-dimensional and three-dimensional mixed-media techniques. Topics include drawing and painting the fantastical figure, altering and restructure facial features and body proportions to create believable characters, as well as painting magical environments using mixed-media techniques.All assignments encourage exploration into a multitude of mythological, cultural, and historical sources. Artists are also encouraged to develop their own mythological stories to illustrate. Other topics include the use of costuming, decorative motifs and ornamentation, cultural iconography, and architectural detail in works of the mythical realm. With visually inspiring imagery, insightful readings, thought-provoking videos, creative exercises, and step-by-step demonstrations, artists will discover a plethora of exciting two-dimensional and three-dimensional techniques to employ in their own fantastical works. This online workshop is for intermediate and advanced figurative artists who are interested in using mixed-media techniques to add that magical, transforming element to their work!

PAINTERLY PORTRAIT, 3-DAY WORKSHOP, THE

31 Main St., Newton CT 06470. (203)297-1399. **E-mail:** alain@picardstudio.com. **Website:** www.picardstudio.com. **Contact:** Alain J. Picard, artist/instructor. "Learn to develop life-like portrait paintings, whether working from the live model or photographic references. Using the live model as our reference, we'll learn all the techniques necessary to create stunning portraits in pastel and oil. Lighting and posing the model, photographing the model for reference, designing the portrait, creating lifelike skin tones, learning the painterly approach, and refining your portrait will all be covered in a relaxed and friendly environment. Alain will demonstrate each morning and students will work throughout the day to develop life-like portraits. The workshops will conclude with an encouraging group critique. Medium: oil and pastel. Open to all skill levels. Artists should see website for more information and dates."

PAINTING IN PROVENCE

Website: ianroberts.com. **Contact:** Ian Roberts. Workshops focuses on painting. Two 4-hour sessions daily. The emphasis is on strong design and composition. All media and levels of experience welcome. Spectacular landscape. Gourmet food and wine. Double or single occupancy $3,390-4,190. Covers all costs from time picked up in Avignon until dropped off again 10 days later. Workshops held annually. Workshops held annually. Interested parties should e-mail or visit website for more information.

PENINSULA SCHOOL OF ART

P.O. Box 304, 3900 County Rd. F, Fish Creek WI 54212. (920)868-3455. **E-mail:** info@peninsulaschoolofart.org. **Website:** www.peninsulaschoolofart.com. "With instruction in all media, and for every skill level, we've brought excellence to art education for 50 years. Within the inspirational setting of Door County WI, nationally-recognized artist educators lead 1- to 5-day workshops throughout the year. Themed gallery exhibitions of master artists' works, including the annual Door County Plein Air Festival, enhance the School's curriculum." Cost per workshop varies. Nearby lodging and meals not included in cost.

PENNELLATE D'ITALIA–ITALIAN ART SOJOURN WITH BRIAN KEELER

P.O. Box 397, Wyalusing PA 18853. (570)746-1187. **E-mail:** bkeeler@epix.net. **Website:** www.briankeeler.com. **Contact:** Brian Keeler, instructor/organizer. The workshop is a plein air landscape and studio figure painting workshop in Tuscany and Umbria. The art sojourn includes trips to several museums and many charming small towns plus Florence and Rome. Art

history slide lecture too. Open to all skill levels. Held annually May-June. Cost is $3,450 and includes all ground transport, most lodging and meals. Interested parties should call, e-mail or see website for more information.

PETERS VALLEY SCHOOL OF CRAFT

19 Kuhn Rd., Layton NJ 07851. (973)948-5200. **Fax:** (973)948-0011. **E-mail:** info@petersvalley.org. **Website:** www.petersvalley.org. Offers workshops May, June, July, August and September; 2-5 days long. Immersive hands-on workshops taught by talented nationally known professional artists in blacksmithing/metals, ceramics, fibers, glass, jewelry, photography weaving, woodworking, and more. Located in northwest New Jersey in the Delaware Water Gap National Recreation Area, 70 miles west of New York. Call for catalog or visit website for more information.

PLEIN AIR PAINTING & SKETCHING IN SOUTHERN FRANCE

Alan Flattmann Painting Workshops, (985)809-6332. **E-mail:** art@alanflattmann.com. **Website:** www.alanflattmann.com. **Contact:** Alan Flattmann, artist/teacher. Cost: $3,700. 10 days of plein air painting and sketching in the beautiful Lot River Valley of Southern France. Open to all skill levels. See website for complete workshop schedule. Interested parties should call, e-mail, or visit website for more information.

PLEIN AIR PAINTING FOR THE STUDIO ARTIST

(203)235-1417. **Fax:** (203)630_0503. **E-mail:** christine_ivers@yahoo.com. **Website:** www.christineivers.com. **Contact:** Chris Ivers. Cost: varies. Workshops held throughout the year. This workshop is perfect for studio artists who are afraid to go outside to paint. We spend the mornings with our sketchbooks, cameras, smartphones, etc., gathering reference information from which we will work when we come back to the studio. Critical drawing, good note taking skills and more help us to create wonderful landscapes all within the safety and convenience of a studio. All mediums are welcome. Demos & critiques always included. Open to all skill levels. See website for complete workshop schedule. Interested parties should call, e-mail, or visit website for more information.

PLEIN AIR PAINTING WORKSHOPS (FRANCE, SPAIN, BELGIUM, ITALY)

French Escapade, 2389 Blackpool Place, San Leandro CA 94577. (510)483-5713. **E-mail:** contact@frenchescapade.com. **Website:** www.frenchescapade.com. **Contact:** Jackie Grandchamps. Cost: $2,640-3,590—includes lodging, most meals, painting classes, and cultural visits. Held more than 5 times a year between April and October. See website for all upcoming workshops. "American teachers are running the art aspect of the workshop. Since the tours are limited to 10 guests, each participant will receive private consult from the teacher in addition the the demos and daily critiques. We stay in one accommodation for the 8 days and paint different sceneries, villages, and flower fields each day. A bilingual guide will be accompanying you at all times so that you not only get the best experience in painting, but also in experiencing the fine cuisine and culture of the country." Open to all skill levels. See website for more information.

JULIE GILBERT POLLARD WATERCOLOR, OIL & ACRYLIC WORKSHOPS AND CLASSES

(623)849-2504. **E-mail:** JulieGilbertPollard@cox.net. **Website:** www.juliegilbertpollard.com. **Contact:** Julie Gilbert Pollard. See website for upcoming schedule. "Julie Gilbert Pollard has taught watercolor and oil classes for over 30 years. While glowing, brilliant color in a format of painterly realism is her personal painting objective, her goal when teaching is to assist in the search for the individual artistic personality of each student, leaning heavily on the fundamentals of art as the gateway to fulfilling personal expression and intuitive painting." Most classes and workshops are open to all skill levels. Recurring theme: the components of a landscape with rocks, water, and flowers figuring prominently—in both studio and plein air. See website for listings. Many venues are available including Scottsdale Artists' School, Scottsdale, AZ, and Sedona Arts Center in Sedona, AZ. Costs vary with venue and length of program. Call, e-mail, or visit www.juliegilbertpollard.com for more information. Julie's North Light publications (books and videos) include *Brilliant Color* (eBook), *Watercolor Unleashed* and *Discover Oil Painting* (coming April 2016), plus nine videos for North Light Shop/ArtistsNetwork.tv.

POSSIBILITIES

Surprise AZ 85388. (623)487-4031. **E-mail:** nancy@nchristy.com. **Website:** www.nchristy.com. **Contact:** Nancy Christy-Moore, artist/instructor. Expanding your creativity and knowledge of mixed water-media techniques is this workshop's main focus. Cost: fees range from $85-100 per day and $200-275 for 2 or more days. No lodging or food is included. Open to all skill levels. Artists should call, e-mail or see website for more information.

RICE PAPER COLLAGE & MIXED MEDIA

(623)487-4031. **Fax:** (623)487-4031. **E-mail:** nancy@nchristy.com. **Website:** www.nchristy.com. **Contact:** Nancy Christy-Moore, artist/instructor. This workshop is an excellent venue for both beginners and advanced watercolorists, offering creative play with delicate rice papers combined with mixed media techniques with inks, enamels, oil pastels, and more. After this workshop you will never again consider a failed watercolor anything but a new beginning. Taught locally at various venues throughout Arizona; scheduled at various times for art groups and art centers. Listings are updated frequently on website. Cost: fees range from $85-100 per day and $200-250 for 2 or more days. No lodging or food is included. Open to all skill levels. Artists should call, e-mail, or see website for more information.

THE SCHOOL OF LIGHT & COLOR

10030 Fair Oaks Blvd., Fair Oaks CA 95628. (916)966-7517. **E-mail:** sarback@lightandcolor.com. **Website:** www.lightandcolor.com. **Contact:** Susan Sarback, artist/instructor. Workshops offer instruction on painting with oils or pastels. Workshops for all skill levels. Call, e-mail, or see website for more information.

⊕ SHENANDOAH ART DESTINATION

325 Union Run, Lexington VA 24450. (612)221-1140. **E-mail:** nancy@shenandoahartdestination.com. **Website:** www.shenandoahartdestination.com. **Contact:** Nancy Boer, owner. Cost: Weekend: $475; 4-day: $730; 7-Day: $1415. Includes art tuition, meals, and lodging. Experience an all-inclusive art vacation (meals, lodging, and art instruction) for artists of all levels from beginner to advanced for painting (all media), drawing, and printmaking. Spacious art studios and many beautiful locations in the Shenandoah Valley for plein air painting. The perfect setting to focus on art and at the same time have a refreshing vacation.

Open to all skill levels. Interested parties should call, e-mail, or see website for more information.

SOHN FINE ART—MASTER ARTIST WORKSHOPS

6 Elm St., 1B-C, Stockbridge MA 01230. (413)298-1025. **E-mail:** info@sohnfineart.com. **Website:** www.sohnfineart.com. **Contact:** Cassandra Sohn, owner. Workshops held every 1-3 months, taught by our represented master artists. Cost: $100-500, depending on the workshop (meals and lodging not included). Frequent areas of concentration are unique workshops within the photographic field. This includes all levels of students: beginner, intermediate, and advanced, as well as Photoshop and Lightroom courses, alternative process courses, and many varieties of traditional and digital photography courses. Interested parties should call, e-mail, or see the website for more information.

SOUTH SHORE ART CENTER

119 Ripley Rd., Cohasset MA 02025. (781)383-2787. **Fax:** (781)383-2964. **E-mail:** info@ssac.org. **Website:** www.ssac.org. South Shore Art Center is a non-profit organization based in the coastal area south of Boston. The facility features appealing galleries and teaching studios. Offers exhibitions and gallery programs, sales of fine art and studio crafts, courses and workshops, school outreach, and special events. See website for more information and a list of upcoming workshops and events.

CARRIE STUART PARKS DRAWING WORKSHOPS

P.O. Box 73, Cataldo ID 83810. (208)682-4564. **Fax:** (208)682-4773. **E-mail:** carrie@stuartparks.com. **Website:** www.stuartparks.com. **Contact:** Carrie Stuart Parks. These workshops teach basic drawing skills, focusing on portrait drawing. As classes are constantly being added, artists should see website for information on upcoming workshops. Cost varies with each workshop but averages $695, depending on the location. Open to all skill levels. Artists should call, e-mail or see website for more information.

CARRIE STUART PARKS FORENSIC ART WORKSHOPS

P.O. Box 73, Cataldo ID 83810. (208)682-4564. **Fax:** (208)682-4773. **E-mail:** carrie@stuartparks.com. **Website:** www.stuartparks.com. **Contact:** Carrie Stuart Parks. Held monthly in various locations across the country. A variety of classes are offered to civilian and law enforcement. Each class is 40 hours (1 week)

in length. As classes are constantly being added, artists should see website for information on upcoming workshops and a helpful FAQ section. Cost varies with each workshop, but averages $695. Open to all skill levels. Artists should call, e-mail, or see website for more information.

CARRIE STUART PARKS WATERCOLOR WORKSHOPS

P.O. Box 73, Cataldo ID 83810. (208)682-4564. **Fax:** (208)682-4773. **E-mail:** carrie@stuartparks.com. **Website:** www.stuartparks.com. **Contact:** Carrie Stuart Parks. These workshops focus on general subjects and portraits. Cost varies with each workshop but averages $450, depending on the location. Open to all skill levels. Artists should call, e-mail, or see website for more information.

TETON ARTS COUNCIL SUMMER ART WORKSHOP SERIES

P.O. Box 627, Driggs ID 83422. (208)354-4ART (4278). **E-mail:** info@tetonartscouncil.com. **Website:** www.tetonartscouncil.com. Annual. "Teton Arts Council hosts several art workshops in Teton Valley for painters and digital photographers. The west side of the Bridger-Teton mountain range provides warm and high-quality sunlight during the long summer days. The workshop schedule varies each summer based on the teaching artists and grants available; see the website for scheduled workshops. All workshops include a welcome social, instruction anddemonstration, and a salon at the end of the workshop. Most workshops include guided excursions on conservation lands or back country. We work with local hotels and B&Bs to offer discounts to participants. Open to all skill levels." Cost: Ranges $35-165 per workshop; lodging and travel expenses are separate. Artists should see website for more information.

TRIPLE D GAME FARM

P.O. Box 5072, Kalispell MT 59903. (406)755-9653. **Fax:** (406)755-9021. **E-mail:** info@tripledgamefarm.com. **Website:** www.tripledgamefarm.com. **Contact:** Triple D office and staff. "We raise wildlife and train our species for photographers, artists, and cinema. Wolves, bears, mountain lions, bobcats, lynx, tigers, snow leopards, coyotes, fox, fisher, otter, porcupine, and more are available." Open to all skill levels. Interested parties should write, call, e-mail, or see website for more information.

TUCSON ART ACADEMY ONLINE, GABOR SVAGRIK

E-mail: questions@tucsonartacademyonline.com. **Website:** www.svagrikfineart.com; www.tucsonartacademyonline.com. **Contact:** Christine Svagrik, co-owner Tucson Art Academy Online. Estab. 2008. Refer to website for workshop dates. Gabor will guide all levels of landscape painters (oil, pastels, or acrylics) to further their understanding of color, value, and light in their outdoor and studio paintings. Each student will be taught the importance of composition through concise drawing and editing. Cost: $595 for a 4-week online workshop. See website for details. See the website or send an e-mail for more information.

✚ WETHERSFIELD ACADEMY FOR THE ARTS

431 Hartford Ave., Wethersfield CT 06109. (860)436-9857. **E-mail:** info@wethersfieldarts.org. **Website:** www.wethersfieldarts.org. **Contact:** Betty Standish. Workshops held monthly. Lectures series on art related topics. See website for more details. Open to all skill levels. Please e-mail with questions or interest.

WHIDBEY ISLAND FINE ART STUDIO

813 Edge Cliff Dr., Langley WA 98260. (360)637-4690. **E-mail:** info@whidbeyislandfas.com. **Website:** www.whidbeyislandfas.com. **Contact:** Cary Jurriaans, director. Cost varies by workshop; see website for details. Annual. Drawing and painting workshops from the still life, figure and landscape in studio and plein air. Individual attention and a personalized approach. Location: Langley; a shuttle will be provided, if needed, to pick up students from the ferry in Clinton. See website for dates. Open to all skill levels. Artists should call, e-mail, or see website for more information.

THE HELENE WURLITZER FOUNDATION

P.O. Box 1891, Taos NM 87571. (575)758-2413. **Fax:** (575)758-2559. **E-mail:** hwf@taosnet.com. **Website:** www.wurlitzerfoundation.org. **Contact:** Michael A. Knight, executive director. Estab. 1954. The foundation offers residencies to artists in the following creative fields: visual and literary arts and music composition. There are two 12-week sessions from mid-January through mid-April, early September-early December, and 1-10 week session from early June to mid-August. Application deadline: January 18 for following year. For application, request by e-mail or visit website to download.

YADDO

The Corporation of Yaddo Residencies, P.O. Box 395, 312 Union Ave., Saratoga Springs NY 12866-0395. (518)584-0746. **Fax:** (518)584-1312. **E-mail:** chwait@ yaddo.org. **Website:** www.yaddo.org. **Contact:** Candace Wait, program director. Estab. 1900. 2 seasons: large season is May-August; small season is October-May (stays from 2 weeks to 2 months; average stay is 5 weeks). Accepts 230 artists/year. Accommodates approximately 35 artists in large season. "Those qualified for invitations to Yaddo are highly qualified writers, visual artists (including photographers), composers, choreographers, performance artists and film and video artists who are working at the professional level in their fields. Artists who wish to work collaboratively are encouraged to apply. An abiding principle at Yaddo is that applications for residencies are judged on the quality of the artists' work and professional promise." Site includes four small lakes, a rose garden, woodland, swimming pool, tennis courts. Yaddo's nonrefundable application fee is $30, to which is added a fee for media uploads ranging from $5-10 depending on the discipline. Application fees must be paid by credit card. 2 letters of recommendation are requested. All application materials, including contact information, résumé, work sample, and reference letter, must be submitted online. Applications are considered by the Admissions Committee and invitations are issued by March 15 (deadline: January 1) and October 1 (deadline: August 1). Information available on website.

GRANTS
State & Provincial

///

Arts councils in the United States and Canada provide assistance to artists in the form of fellowships or grants. These grants can be substantial and confer prestige upon recipients; however, only state or province residents are eligible. Because deadlines and available support vary annually, query first (with a SASE) or check websites for guidelines.

UNITED STATES ARTS AGENCIES

Alabama State Council on the Arts, 201 Monroe St., Montgomery AL 36130-1800. (334)242-4076. E-mail: staff@arts.alabama.gov. Website: www.arts.state.al.us.

Alaska State Council on the Arts, 161 Klevin St., Suite 102, Anchorage AK 99508-1506. (907)269-6610 or (888)278-7424. E-mail: aksca.info@alaska.gov. Website: www.eed.state.ak.us/aksca.

Arizona Commission on the Arts, 417 W. Roosevelt St., Phoenix AZ 85003-1326. (602)771-6501. E-mail: info@azarts.gov. Website: www.azarts.gov.

Arkansas Arts Council, 323 Center St., Suite 1500, Little Rock AR 72201-2606. (501)324-9766. E-mail: online form. Website: www.arkansasarts.org.

California Arts Council, 1300 I St., Suite 930, Sacramento CA 95814. (916)322-6555 or (800)201-6201. E-mail: info@arts.ca.gov. Website: www.cac.ca.gov.

Colorado Creative Industries, 1625 Broadway, Suite 2700, Denver CO 80202. (303)892-3840. E-mail: online form. Website: www.coloradocreativeindustries.org.

Connecticut Commission on Culture & Tourism, One Constitution Plaza, 2nd Floor, Hartford CT 06103. (860)256-2800. Website: www.cultureandtourism.org.

Delaware Division of the Arts, Carvel State Office Bldg., 4th Floor, 820 N. French St., Wilmington DE 19801. (302)577-8278. E-mail: delarts@state.de.us. Website: www.artsdel.org.

District of Columbia Commission on the Arts and Humanities, 200 I St. SE, Washington DC 20003. (202)724-5613. E-mail: cah@dc.gov. Website: www.dcarts.dc.gov.

Florida Division of Cultural Affairs, R.A. Gray Bldg., 3rd Floor, 500 S. Bronough St., Tallahassee FL 32399-0250. (850)245-6470. Website: http://dos.myflorida.com/cultural/.

Georgia Council for the Arts, 75 Fifth St. NW, Suite 1200, Atlanta GA 30308. (404)685-2787. Website: www.gaarts.org.

Guam Council on the Arts and Humanities, P.O. Box 2950, Hagatna GU 96932. (671)300-1204. E-mail: info@caha.guam.gov. Website: www.guamcaha.org.

Hawai'i State Foundation on Culture & the Arts, 250 S. Hotel St., 2nd Floor, Honolulu HI 96813. (808)586-0300. Website: sfca.hawaii.gov.

Idaho Commission on the Arts, P.O. Box 83720, Boise ID 83720-0008. (208)334-2119 or (800)278-3863. E-mail: online form. Website: www.arts.idaho.gov.

Illinois Arts Council Agency, James R. Thompson Center, 100 W. Randolph, Suite 10-500, Chicago IL 60601-3230. (312)814-6750 or (800)237-6994. E-mail: iac.info@illinois. gov. Website: www.arts.illinois.gov.

Indiana Arts Commission, 100 N. Senate Ave., Room N505, Indianapolis IN 46204. (317)232-1268. E-mail: IndianaArtsCommission@iac.in.gov. Website: www.in.gov/ arts.

Iowa Arts Council, 600 E. Locust, Des Moines IA 50319-0290. (515)281-5111. E-mail: online form. Website: iowaculture.gov/arts.

Kansas Creative Arts Industries Commission, 1000 SW Jackson, Suite 100, Topeka KS 66612. (785)296-3481. E-mail: pjasso@kansascommerce.com. Website: www. kansascommerce.com/caic.

Kentucky Arts Council, 500 Mero St., Suite 2100, Frankfort KY 40601-1987. (502)564-3757 or (888)833-2787. E-mail: kyarts@ky.gov. Website: www.artscouncil.ky.gov.

Louisiana Division of the Arts, P.O. Box 44247, Baton Rouge LA 70804-4247. (225)342-8180. E-mail: online form. Website: www.crt.state.la.us/cultural-development/arts.

Maine Arts Commission, 193 State St., 25 State House Station, Augusta ME 04333-0025. (207)287-2724. E-mail: MaineArts.info@maine.gov. Website: mainearts.maine.gov.

Maryland State Arts Council, 175 W. Ostend St., Suite E, Baltimore MD 21230. (410)767-6555. E-mail: msac@msac.org. Website: www.msac.org.

Massachusetts Cultural Council, 10 St. James Ave., 3rd Floor, Boston MA 02116-3803. (617)858-2700. E-mail: mcc@art.state.ma.us. Website: www.massculturalcouncil.org.

Michigan Council for Arts and Cultural Affairs, 300 N. Washington Square, Lansing MI 48913. (517)241-4011. E-mail: artsinfo@michigan.org. Website: www.michicganbusiness.org/arts.

Minnesota State Arts Board, Park Square Court, Suite 200, 400 Sibley St., St. Paul MN 55101-1928. (651)215-1600 or (800)866-2787. E-mail: msab@arts.state.mn.us. Website: www.arts.state.mn.us.

Mississippi Arts Commission, 501 N. West St., Suite 1101A Woolfolk Bldg., Jackson MS 39201. (601)359-6030. Website: www.arts.state.ms.us.

Missouri Arts Council, 815 Olive St., Suite 16, St. Louis MO 63101-1503. (314)340-6845 or (866)407-4752. E-mail: moarts@ded.mo.gov. Website: www.missouriartscouncil.org.

Montana Arts Council, P.O. Box 202201, Helena MT 59620-2201. (406)444-6430. E-mail: mac@mt.gov. Website: art.mt.gov.

National Assembly of State Arts Agencies, 1200 18th St. NW, Suite 1100, Washington DC 20036. (202)347-6352. E-mail: nasaa@nasaa-arts.org. Website: www.nasaa-arts.org.

Nebraska Arts Council, Burlington Bldg., 1004 Farnam St., Omaha NE 68102. (402)595-2122 or (800)341-4067. E-mail: nac.info@nebraska.gov. Website: www.artscouncil.nebraska.gov.

Nevada Arts Council, 716 N. Carson St., Suite A, Carson City NV 89701. (775)687-6680. E-mail: infonvartscouncil@nevadaculture.org. Website: http://nac.nevadaculture.org.

New Hampshire State Council on the Arts, 19 Pillsbury St., 1st Floor, Concord NH 03301. (603)271-2789. Website: www.nh.gov/nharts.

New Jersey State Council on the Arts, P.O. Box 306, Trenton NJ 08625-0306. (609)292-6130. E-mail: feedback@sos.nj.gov. Website: nj.gov/state/njsca.

New Mexico Arts, Bataan Memorial Bldg., 407 Galisteo St., Suite 270, Santa Fe NM 87501. (505)827-6490 or (800879-4278). Website: www.nmarts.org.

New York State Council on the Arts, 300 Park Ave. S., 10th Floor, New York NY 10010. (212)459-8800. Website: www.nysca.org.

North Carolina Arts Council, MSC 4632, Department of Cultural Resources, 109 E. Jones St., Raleigh NC 27699-4632. (919)807-6500. E-mail: ncarts@ncdcr.gov. Website: www.ncarts.org.

North Dakota Council on the Arts, 1600 E. Century Ave., Suite 6, Bismarck ND 58503-0649. (701)328-7590. E-mail: comserv@nd.gov. Website: www.nd.gov/arts.

Ohio Arts Council, 30 E. Broad St., 33rd Floor, Columbus OH 43215-3414. (614)466-2613. Website: www.oac.ohio.gov.

Oklahoma Arts Council, P.O. Box 52001-2001, Oklahoma City OK 73152-2001. (405)521-2931. E-mail: okarts@arts.ok.gov. Website: www.arts.ok.gov.

Oregon Arts Commission, 775 Summer St. NE, Suite 200, Salem OR 97301-1280. (503)986-0082. E-mail: oregon.artscomm@state.or.us. Website: www.oregonartscommission.org.

Pennsylvania Council on the Arts, 216 Finance Bldg., Harrisburg PA 17120. (717)787-6883. E-mail: RA-arts@pa.gov. Website: www.arts.pa.gov.

Institute of Puerto Rican Culture, P.O. Box 9024184, San Juan PR 00902-4184. (787)724-0700. E-mail: mgarcia@icp.gobierno.pr. Website: www.icp.gobierno.pr.

Rhode Island State Council on the Arts, One Capitol Hill, 3rd Floor, Providence RI 02908. (401)222-3880. Website: www.arts.ri.gov.

American Samoa Council on Arts, Culture and the Humanities, P.O. Box 1540, Fagatogo, Pago Pago AS 96799. (684)633-5613. Website: https://www.facebook.com/american-samoa-council-on-arts-culture-humanities-990206257693940.

South Carolina Arts Commission, 1026 Sumter St., Suite 200, Columbia SC 29201-3746. (803)734-8696. E-mail: info@arts.sc.gov. Website: www.southcarolinaarts.com.

South Dakota Arts Council, 711 E. Wells Ave., Pierre SD 57501-3369. (605)773-3301 or (800)952-3615. E-mail: sdac@state.sd.us. Website: www.artscouncil.sd.gov.

Tennessee Arts Commission, 401 Charlotte Ave., Nashville TN 37243. (615)741-1701 or (800)848-0299. E-mail: online form. Website: www.tnartscommission.org.

Texas Commission on the Arts, E.O. Thompson Office Bldg., 920 Colorado, Suite 501, Austin TX 78711-3406. (512)463-5535. E-mail: front.desk@arts.texas.gov. Website: www.arts.texas.gov.

Utah Division of Arts and Museums, 617 E. South Temple, Salt Lake City UT 84102. (801)236-7555. Website: heritage.utah.gov/utah-division-of-arts-museums.

Vermont Arts Council, 136 State St., Montpelier VT 05633-6001. (802)828-3291. E-mail: info@vermontartscouncil.org. Website: www.vermontartscouncil.org.

Virginia Commission for the Arts, 1001 E. Broad St., Suite 330, Richmond VA 23219. (804)225-3132. E-mail: arts@vca.virginia.gov. Website: www.arts.virginia.gov.

Virgin Islands Council on the Arts, 5070 Norre Gade, Suite 1, St. Thomas VI 00802-6762. (340)774-5984. Website: vicouncilonarts.org.

Washington State Arts Commission, P.O. Box 42675, Olympia WA 98504-2675. (360)753-3860. E-mail: online form. Website: www.arts.wa.gov.

West Virginia Commission on the Arts, The Culture Center, Capitol Complex, 1900 Kanawha Blvd. E., Charleston WV 25305-0300. (304)558-0240. Website: www.wvculture.org/arts.

Wisconsin Arts Board, P.O. Box 8690, Madison WI 53708-8690. (608)266-0190. E-mail: artsboard@wisconsin.gov. Website: artsboard.wisconsin.gov.

Wyoming Arts Council, 2301 Central Ave., Barrett Bldg., 2nd Floor, Cheyenne WY 82002. (307)777-7742. E-mail: online form. Website: wyoarts.state.wy.us.

CANADIAN PROVINCES ARTS AGENCIES

Alberta Foundation for the Arts, 10708-105 Ave., Edmonton, Alberta T5H 0A1. (780)427-9968. E-mail: online form. Website: www.affta.ab.ca.

British Columbia Arts Council, P.O. Box 9819, Stn. Prov. Govt., Victoria, British Columbia V8W 9W3. (250)356-1718. E-mail: BCArtsCouncil@gov.bc.ca. Website: www.bcartscouncil.ca.

Canada Council for the Arts, 150 Elgin St., P.O. Box 1047, Ottawa, Ontario K1P 5V8. (613)566-4414 or (800)263-5588. E-mail: info@canadacouncil.ca. Website: http://canadacouncil.ca.

Manitoba Arts Council, 525-93 Lombard Ave., Winnipeg, Manitoba R3B 3B1. (204)945-2237 or (866)994-2787. E-mail: info@artscouncil.mb.ca. Website: http://artscouncil.mb.ca.

New Brunswick Arts Board, 649 Queen St., 2nd Floor, Fredericton, New Brunswick E3B 1C3. (506)444-4444 or (866)460-2787. E-mail: online form. Website: www.artsnb.ca.

Newfoundland and Labrador Arts Council, P.O. Box 98, St. John's, Newfoundland A1C 5H5. (709)726-2212 or (866)726-2212 (within Newfoundland). Website: www.nlac.ca.

Nova Scotia Department of Communities, Culture, and Heritage, P.O. Box 456, STN Central, Halifax, Nova Scotia B3J 2R5. (902)424-2170. E-mail: cch@novascotia.ca. Website: http://cch.novascotia.ca

Ontario Arts Council, 121 Bloor St. E., 7th Floor, Toronto, Ontario M4W 3M5. (416)961-1660 or (800)387-0058. E-mail: info@arts.on.ca. Website: www.arts.on.ca.

Prince Edward Island Council of the Arts, 115 Richmond St., Charlottetown, Prince Edward Island C1A 1H7. (888)734-2784. Website: www.peiartscouncil.com.

Quebec Council for Arts & Literature, 79 boul. René-Lévesque Est, 3e étage, Québec, Québec G1R 5N5. (418)643-1707 or (800)608-3350. Website: www.calq.gouv.qc.ca.

Saskatchewan Arts Board, 1355 Broad St., Regina, Saskatchewan S4R 7V1. (800)667-7526. E-mail: info@saskartsboard.ca. Website: www.artsboard.sk.ca.

Yukon Arts Section, Cultural Services Branch, P.O. Box 2703 (L-3), Whitehorse, Yukon Y1A 2C6. (867)667-3535 or (800)661-0408. Website: www.tc.gov.yk.ca/arts.html.

REGIONAL GRANTS & AWARDS

The following opportunities are arranged by state since most of them grant money to artists in a particular geographic region. Because deadlines vary annually, check websites or call for the most up-to-date information.

Connecticut

Martha Boschen Porter Fund, Inc. For artists in northwestern Connecticut, western Massachusetts, and adjacent areas of New York (except New York City). Website: www. berkshiretaconic.org.

Idaho

See Betty Bowen Memorial Award, under Washington.

Illinois

Illinois Arts Council, Individual Artist Support Program, (312)814-6753. For Illinois artists only. Website: www.arts.illinois.gov/Individual Artist Support.

Kentucky

Kentucky Foundation for Women Grants Program, 332 W. Broadway, Suite 1215, Louisville KY 40202. (502)562-0045 or (866)654-7564. E-mail: team@kfw.org. Website: www.kfw.org/grants. For female artists living in Kentucky only.

Massachusetts

See Martha Boschen Porter Fund, Inc., under Connecticut.

Minnesota

McKnight Artist Fellowships, Website: www.mcknight.org/grant-programs/arts/artist-fellowships. For Minnesota artists only.

New York

A.I.R. Gallery Fellowship Program, 155 Plymouth St., Brooklyn NY 11201. (212)255-6651. E-mail: info@airgallery.org. Website: www.airgallery.org/fellowship-program/. For female artists from New York City metro area only.

Arts & Cultural Council for Greater Rochester, 31 Prince St., Rochester NY 14607. (585)473-4000. Website: www.artsrochester.org.

New York Foundation for the Arts: Artists' Fellowships, 20 Jay St., Suite 740, Brooklyn NY 11201. E-mail: fellowships@nyfa.org. Website: www.nyfa.org. For New York artists only.

See Martha Boschen Porter Fund, Inc., under Connecticut.

Oregon

See Betty Bowen Memorial Award, under Washington.

Pennsylvania

Leeway Foundation—Philadelphia, Pennsylvania Region, The Philadelphia Bldg., 1315 Walnut St., Suite 832, Philadelphia PA 19107. (215)545-4078. E-mail: info@leeway. org. Website: www.leeway.org. For female and trans artists in Philadelphia only.

Texas

Houston Arts Alliance, Individual Artist Grant Program—Houston, Texas, 3201 Allen Pkwy., Suite 250, Houston TX 77019-1800. (713)527-9330. E-mail: online form. Website: www.houstonartsalliance.com/grants/individuals. For Houston artists only.

Washington

Betty Bowen Memorial Award, administered by the Seattle Art Museum. (206)654-3131. E-mail: bettybowen@seattleartmuseum.org. Website: www.seattleartmuseum.org/about-sam/art-submissions#bet. For artists in Washington, Oregon, and Idaho only.

RESIDENCIES & ORGANIZATIONS

///

RESIDENCIES

Artists' residencies (also known as communities, colonies, or retreats) are programs that support artists by providing time and space for the creation of new work. There are over 500 residency programs in the United States and approximately 1,000 worldwide. These programs provide an estimated $40 million in support to independent artists each year.

Many offer not only the resources to do artwork but also to have it seen by the public. While some communities are isolated in rural areas, others are located near urban centers and may provide public programming such as workshops and exhibitions. Spending time as a resident at an artists' community is a great way to network and cultivate relationships with other artists.

Alliance of Artists Communities: www.artistcommunities.org
Offers an extensive list of international artists' communities and residencies.

Anderson Ranch Arts Center: www.andersonranch.org
Nonprofit visual arts community located in Snowmass Village CO.

Arrowmont School of Arts and Crafts: www.arrowmont.org
Nationally renowned center of contemporary arts and crafts education located in Gatlinburg TN.

Bogliasco Foundation/Bogliasco Study Center for the Arts & Humanities: www.bfny. org
Located on the Italian Riviera in the village of Bogliasco, the Bogliasco Study Center provides residential fellowships for creative or scholarly projects in the arts and humanities.

Fine Arts Work Center: www.fawc.org
> Nonprofit institution devoted to encouraging and supporting young artists, located in Provincetown MA.

Hall Farm Center: www.transartists.org/air/hall_farm_center_for_arts___education.7203.html.
> A 221-acre retreat in Townshend VT, that offers residencies, workshops, and other resources for emerging and established artists.

Kala Art Institute: www.kala.org
> Located in the former Heinz ketchup factory in Berkeley CA, Kala provides exceptional facilities to professional artists working in all forms of printmaking, photography, digital media, and book arts.

Lower Manhattan Cultural Council: www.lmcc.net
> Creative hub for connecting residents, tourists, and workers to Lower Manhattan's vast and vibrant arts community. Provides residencies, studio space, grants, and professional development programming to artists.

The MacDowell Colony: www.macdowellcolony.org
> A 100-year-old artists' community consisting of 32 studios located on a 450-acre farm in Peterborough NH.

Santa Fe Art Institute: www.sfai.org
> Located on the College of Santa Fe campus in Santa Fe NM, SFAI is a nonprofit organization offering a wide range of programs to serve artists at various stages of their careers.

Vermont Studio Center: www.vermontstudiocenter.org
> The largest international artists' and writers' residency program in the United States, located in Johnson VT.

Women's Studio Workshop: www.wsworkshop.org
> Visual arts organization in Rosendale NY, with specialized studios in printmaking, hand papermaking, ceramics, letterpress printing, photography, and book arts.

Yaddo: www.yaddo.org
> Artists' community located on a 400-acre estate in Saratoga Springs NY, offering residencies to professional creative artists from all nations and backgrounds.

ORGANIZATIONS

There are numerous organizations for artists that provide resources and information about everything from industry standards and marketing tips to contest announcements and legal advice. Included here are just a handful of groups that we at *Artist's & Graphic Designer's Market* have found useful.

American Institute of Graphic Arts: www.aiga.org

> AIGA is the oldest and largest membership association for professionals engaged in the discipline, practice, and culture of designing.

Art Dealers Association of America: www.artdealers.org

> Nonprofit membership organization of the nation's leading galleries in the fine arts.

The Art Directors Club: www.adcglobal.org

> The ADC is the premier organization for integrated media and the first international creative collective of its kind. Founded in New York in 1920, the ADC is a self-funding, not-for-profit membership organization that celebrates and inspires creative excellence by connecting visual communications professionals from around the world.

Artists Unite: www.artistsunite-ny.org/about/about-AU.html

> Nonprofit organization dedicated to providing quality arts programming and to helping artists of all genres collaborate on projects.

Association International du Film d'Animation (International Animated Film Association): www.asifa.net

> International organization dedicated to the art of animation, providing worldwide news and information on chapters of the group, as well as conferences, contests, and workshops.

The Association of American Editorial Cartoonists: editorialcartoonists.com

> Professional association concerned with promoting the interests of staff, freelance, and student editorial cartoonists in the United States.

Association of Medical Illustrators: http://.ami.org

> International organization for anyone interested in the highly specialized niche of medical illustration.

Association of Science Fiction and Fantasy Artists: www.asfa-art.org

> Nonprofit association organized for artistic, literary, educational, and charitable purposes concerning the visual arts of science fiction, fantasy, mythology, and related topics.

Association Typographique Internationale: www.atypi.org

> Not-for-profit organization run by an elected board of type designers, type publishers, and graphic and typographic designers.

The Canadian Association of Professional Image Creators: http://capic.org

> Not-for-profit association dedicated to safeguarding and promoting the rights and interests of photographers, illustrators, and digital artists working in the communications industry.

Canadian Society of Children's Authors, Illustrators, and Performers: www.canscaip.org

>This organization supports and promotes all aspects of children's literature, illustration, and performance.

College Art Association: www.collegeart.org

>CAA promotes excellence in scholarship and teaching in the history and criticism of the visual arts and in creativity and technical skill in the teaching and practices of art. Membership is open to all individuals with an interest in art, art history, or a related discipline.

Comic Book Legal Defense Fund: http://cbldf.org

>Nonprofit organization dedicated to the preservation of First Amendment rights for members of the comics community.

Graphic Artists Guild: www.graphicartistsguild.org

>National union of illustrators, designers, production artists, and other creatives who have come together to pursue common goals, share experiences, and raise industry standards.

Greeting Card Association: www.greetingcard.org

>Trade organization representing greeting card and stationery publishers, and allied members of the industry.

National Cartoonists Society: www.reuben.org

>Home of the famed Reuben Awards, this organization offers news and resources for cartoonists interested in everything from caricature to animation.

New York Foundation for the Arts: www.nyfa.org

>NYFA offers information and financial assistance to artists and organizations that directly serve artists, by supporting arts programming in the community, and by building collaborative relationships with others who advocate for the arts in New York State and throughout the country.

Society of Children's Book Writers and Illustrators: www.scbwi.org

>With chapters all over the world, SCBWI is the premier organization for professionals in children's publishing.

Society of Graphic Designers of Canada: www.gdc.net

>Member-based organization of design professionals, educators, administrators, students, and associates in communications, marketing, media, and design-related fields.

Society of Illustrators: www.societyillustrators.org

>Since 1901, this nonprofit organization has been working to promote the interests of professional illustrators through exhibitions, lectures, and education, and by fostering a sense of community and open discussion.

The Type Directors Club: www.tdc.org

> Organization dedicated to raising the standards of typography and related fields of the graphic arts through research, education, competitions, and publications.

United States Artists: www.unitedstatesartists.org

> Provides direct financial support to artists across all disciplines. Currently offers one grant program: USA Fellows.

US Regional Arts Organizations: http://usregionalarts.org

> Six nonprofit entities created to encourage development of the arts and to support arts programs on a regional basis. Funded by the NEA, these organizations—Arts Midwest, Mid-America Arts Alliance, Mid Atlantic Arts Foundation, New England Foundation for the Arts, Southern Arts Federation, and Western States Arts Federation—provide technical assistance to their member state arts agencies, support and promote artists and arts organizations, and develop and manage arts initiatives on local, regional, national, and international levels.

PUBLICATIONS, WEBSITES, & BLOGS

///

In addition to the thousands of trade publications written for visual artists, there are now countless websites, blogs, and online artists' communities intended to connect, inspire, and support artists in their careers. Listed here are just a handful of books, magazines, and online resources to get you started; most will lead to additional sources, especially websites that provide links to other sites.

BOOKS

AIGA Professional Practices in Graphic Design, 2nd ed., edited by Tad Crawford (Allworth Press)

Art Marketing 101: A Handbook for the Fine Artist, 3rd ed. by Constance Smith (ArtNetwork)

The Artist-Gallery Partnership: A Practical Guide to Consigning Art, 3rd ed. by Tad Crawford and Susan Mellon (Allworth Press)

The Artist's Guide to Public Art: How to Find and Win Commissions by Lynn Basa (Allworth Press)

The Artist's Guide to Selling Work by Annabelle Ruston (A&C Black)

Breaking Into Freelance Illustration: The Guide for Artists, Designers and Illustrators by Holly DeWolf (HOW Books, F+W, a Content + eCommerce Company)

Breaking Into Graphic Design by Michael Jefferson (Allworth Press)

Build Your Own Brand by Robin Landa (HOW Books, F+W, a Content + eCommerce Company)

Business and Legal Forms for Fine Artists, 3rd ed. by Tad Crawford (Allworth Press)

Business and Legal Forms for Graphic Designers, 4th ed. by Tad Crawford and Eva Doman Bruck (Allworth Press)

Business and Legal Forms for Illustrators by Tad Crawford (Allworth Press)

The Business of Being an Artist by Daniel Grant (Allworth Press)

Career Solutions for Creative People: How to Balance Artistic Goals With Career Security by Dr. Ronda Ormont (Allworth Press)

Children's Writer's & Illustrator's Market edited by Chuck Sambuchino (Writer's Digest Books, F+W, a Content + eCommerce Company)

Comic Books 101: The History, Methods and Madness by Chris Ryall and Scott Tipton (IMPACT Books, F+W, a Content + eCommerce Company)

Comics and Sequential Art: Principles and Practices From the Legendary Cartoonist by Will Eisner (Poorhouse Press)

Create Your Art Career by Rhonda Schaller (Allworth Press)

Create Your Own Website Using WordPress in a Weekend by Alannah Moore (Focal Press)

The Creative Person's Website Builder by Alannah More (HOW Books, F+W, a Content + eCommerce Company)

Creativity for Graphic Designers by Mark Oldach (North Light Books, F+W, a Content + eCommerce Company)

The Designer's Guide to Business and Careers: How to Succeed on the Job or on Your Own by Peg Faimon (HOW Books, F+W, a Content + eCommerce Company)

The Designer's Guide to Marketing and Pricing: How to Win Clients and What to Charge Them by Ilise Benun and Peleg Top (HOW Books, F+W, a Content + eCommerce Company)

The Digital Creative's Survival Guide by Paul Wyatt (HOW Books, F+W, a Content + eCommerce Company)

The Fine Artist's Guide to Marketing and Self-Promotion by Julius Vitali (Allworth Press)

Fingerprint: The Art of Using Handmade Elements in Graphic Design by Chen Design Associates (HOW Books, F+W, a Content + eCommerce Company)

Freelance Design in Practice: Don't Start Work Without It by Cathy Fishel (HOW Books, F+W, a Content + eCommerce Company)

Graphic Artists Guild Handbook: Pricing & Ethical Guidelines (Graphic Artists Guild)

The Graphic Design Business Book by Tad Crawford (Allworth Press)

The Graphic Designer's Guide to Clients by Ellen Shapiro (Allworth Press)

Graphic Storytelling & Visual Narrative by Will Eisner (Poorhouse Press)

Guide to Getting Arts Grants by Ellen Liberatori (Allworth Press)

How to Draw and Sell Comics by Alan McKenzie (IMPACT Books, F+W, a Content + eCommerce Company)

How to Survive and Prosper as an Artist: Selling Yourself Without Selling Your Soul by Caroll Michels (Owl Books)

IdeaSelling: Successfully Pitch Your Creative Ideas to Bosses, Clients and Other Decision Makers by Sam Harrison (HOW Books, F+W, a Content + eCommerce Company)

Inside the Business of Graphic Design: 60 Leaders Share Their Secrets of Success by Catharine Fishel (Allworth Press)

Inside the Business of Illustration, by Steven Heller and Marshall Arisman (Allworth Press)

Legal Guide for the Visual Artist, 5th ed. by Tad Crawford (Allworth Press)

Licensing Art 101: Publishing and Licensing Your Artwork for Profit, 3rd ed. updated by Michael Woodward (ArtNetwork)

Licensing Art & Design: A Professional's Guide to Licensing and Royalty Agreements by Caryn R. Leland (Allworth Press)

Logo, Font & Lettering Bible: A Comprehensive Guide to the Design, Construction and Usage of Alphabets and Symbols by Leslie Cabarga (HOW Books, F+W, a Content + eCommerce Company)

Making Comics: Storytelling Secrets of Comics, Manga and Graphic Novels by Scott McCloud (HarperCollins)

Marketing and Buying Fine Art Online: A Guide for Artists and Collectors by Marques Vickers (Allworth Press)

New Markets for Artists by Brainard Carey (Allworth Press)

Selling Art Without Galleries: Toward Making a Living From Your Art by Daniel Grant (Allworth Press)

Starting Your Career as a Freelance Illustrator or Graphic Designer by Michael Fleishman (Allworth Press)

The Successful Artist's Career Guide by Margaret Peot (North Light Books, F+W, a Content + eCommerce Company)

Successful Syndication: A Guide for Writers and Cartoonists by Michael Sedge (Allworth Press)

What they Didn't Teach You in Design School by Phil Cleaver (HOW Books, F+W, a Content + eCommerce Company)

MAGAZINES

Advertising Age: http://adage.com
Weekly print magazine delivering news, analysis, and data on marketing and media. Website provides a database of advertising agencies as well as daily e-mail newsletters: Ad Age Daily, Ad Age's Mediaworks, and Ad Age Digital.

Art Business News: http://artbusinessnews.com

Monthly magazine that reports on art trends, news, and retailing issues. Offers profiles on emerging and established artists, as well as in-depth articles on merchandising and marketing issues.

Artforum: www.artforum.com

International magazine widely known as a decisive voice in its field. Features in-depth articles and reviews of contemporary art, as well as book reviews and columns on cinema and popular culture.

Art in America: www.artinamericamagazine.com

"The World's Premier Art Magazine," covering the visual art world both in the US and abroad, but concentrating on New York City. Provides news and criticism of painting, sculpture, photography, installation art, performance art, video, and architecture in exhibition reviews, artist profiles, and feature articles. Every August issue is the *Annual Guide to Museums, Galleries, and Artists*.

The Artist's Magazine: www.artistsnetwork.com/the-artists-magazine

Features color reproductions, interviews with artists, practical lessons in craft, and news of exhibitions and events.

ARTnews: www.artnews.com

Oldest and most widely circulated art magazine in the world. Reports on the art, personalities, issues, trends, and events shaping the international art world.

Art Papers: www.artpapers.org

Dedicated to the examination, development, and definition of art and culture in the world today.

Communication Arts: www.commarts.com

Leading trade journal for visual communications. Showcases the top work in graphic design, advertising, illustration, photography, and interactive design.

Creativity: http://creativity-online.com

Monthly magazine about the creative process. Website features what its editors believe to be the best video, print, and interactive ads.

Drawing: www.artistsnetwork.com/drawing-magazine

Each issue of *Drawing* provides working artists with information and inspiration regarding the foundation of all art: drawing. If you work with charcoal, graphite, pen, colored pencil, or any other drawing media, this is the magazine for you.

Eye: The International Review of Graphic Design: www.eyemagazine.com

Published in the United Kingdom, this quarterly print magazine is for anyone involved in graphic design and visual culture.

Graphic Design USA: http://gdusa.com

Magazine for graphic designers and other creative professionals.

HOW: www.howdesign.com

Provides graphic design professionals with essential business information, covers new technology and processes, profiles renowned and up-and-coming designers, details noteworthy projects, provides creative inspiration, and publishes special issues featuring the winners of its annual competitions. Website is a trusted source for business advice, creative inspiration, and tools of the trade.

JUXTAPOZ Art & Culture Magazine: www.juxtapoz.com

Monthly art and culture magazine based in San Francisco. Features profiles and exhibition announcements of "lowbrow" or "underground" artists—art establishment conventions do not apply here.

Pastel Journal: www.artistsnetwork.com/pastel-journal

The leading publication devoted to pastel artists of all skill levels, from the passionate amateur to the working professional. Each issue is packed with gorgeous artwork, insight and creative inspiration from top working artists.

PRINT: www.printmag.com

Bimonthly magazine about visual culture and design that documents and critiques commercial, social and environmental design from every angle.

Professional Artist: www.professionalartistmag.com

(Formerly named *Art Calendar.*) Business magazine devoted to connecting artists with income-generating opportunities and resources for a successful art career.

Southwest Art: www.southwestart.com

With more than 40 years of experience, *Southwest Art* is the leading magazine devoted to American Western art. Each issue puts readers in touch with the artists, galleries, and collectors that shape the market.

Target Marketing: www.targetmarketingmag.com

The authoritative source for hands-on, how-to information concerning all direct response media, including direct mail, e-mail and the Web. Readers gain insight into topics such as using databases and lists effectively, acquiring new customers, upselling and cross-selling existing customers, fulfillment strategies, and more.

Watercolor Artist: www.artistsnetwork.com/watercolor-artist

Go inside the studios of the best and brightest of today's watermedia artists. Learn about making art from the inside out—from inspiration to pinpointing materials and techniques. Each issue includes the most reliable information available on must-have painting tools and materials, from paint to paper to brushes and beyond.

WEBSITES & BLOGS

The Alternative Pick: http://altpick.com

"The best source for creatives on the Web." Allows artists to display samples of their work that can be searched by art buyers and directors. Offers industry news, classifieds, job postings, and more.

Animation World Network: www.awn.com

Comprehensive and targeted coverage of the international animation community has made AWN the leading source of animation industry news in the world. It provides an industry database, job postings, education resources, discussion forums, newsletters, and a host of other resources covering everything related to animation.

ArtBusiness.com: www.artbusiness.com

Provides art appraisals, art price data, news, articles, and market information for art collectors, artists and fine arts professionals. Also consults on marketing, promotion, public relations, website construction, Internet selling, and career development for artists at all stages.

ArtDeadline.com: http://artdeadline.com

"The Professional Artist's Resource," offering thousands of income and exhibition opportunities and resources for artists of all disciplines. Subscriptions start at $12/year, or you can get a one-day trial for $8.

Art Deadlines List: www.artdeadlineslist.com

Great source for calls for entries, competitions, scholarships, festivals, and plenty of other resources. Subscription is free, or you can purchase a premium edition for $12/year.

Artist Career Training: www.artistcareertraining.com

Offers valuable information to help you market your art and build your career. Sign up for a monthly newsletter and weekly tips.

Artist Help Network: www.artisthelpnetwork.com

Designed to help artists take control of their careers, the network assists artists in locating information, resources, guidance, and advice on a comprehensive range of career-related topics.

Artist's Market Online: www.artistsmarketonline.com

The Internet's most comprehensive guide to launching or growing your freelance creative career so that you can sell your art. The best reference guide for artists, designers and photographers who want to establish or grow a successful career in fine art, photography, illustration, cartooning or graphic design.

Artists Network: www.artistsnetwork.com

Offers art contests, art videos, online art classes, books for artists and more. Connect to *The Artist's Magazine*, *Watercolor Artist*, *Drawing*, and *Pastel Journal*, as well as other helpful resources.

Artists Network Television: www.artistsnetwork.tv

Online resource for art videos from leading contemporary artists. These streaming videos can be viewed 24/7 from any computer or hand-held viewing device with a high-speed Internet connection, making it easy to take these online art workshops from the comfort of your home.

Artlex Art Dictionary: www.artlex.com

Online dictionary that provides definitions, examples, and cross-references for more than 3,600 art terms.

Artline: www.artline.com

Offers news and events from eight reputable art dealer associations: Art Dealers Association of America, Art Dealers Association of Chicago, Art Dealers Association of Greater Washington, Association of International Photography Art Dealers, Fine Art Dealers Association, International Fine Print Dealers Association, San Francisco Art Dealers Association, and The Society of London Art Dealers.

Art Schools: http://artschools.com

Free online directory with a searchable database of art schools all over the world. Also offers information on financial aid, majors, and lots more.

Artsy: www.artsy.net

Artsy's mission is to make all the world's art accessible to anyone with an Internet connection. An online platform for discovering, discussing, and collecting art. Collection comprises 50,000+ artworks by 11,000+ artists from leading galleries, museums, private collections, foundations, and artists' estates spanning diverse cultures and time periods. Provides one of the largest collections of contemporary art available online.

Children's Illustrators: www.childrensillustrators.com

Online networking community for children's illustrators, agents, publishing houses, advertising agencies, and design groups from around the world.

The Comics Reporter: www.comicsreporter.com

Offers an overview of the history of comics, as well as resources and information about publishing comic books and syndicating comic strips.

Creative Talent Network: www.creativetalentnetwork.com

Online networking community of experienced animators, illustrators, designers, Web creators, production artists, and other creatives.

The Drawing Board for Illustrators: www.thedrawingboardforillustrators.com

Information and resources for illustrators, including pricing guidelines, marketing tips, and links to publications, organizations, and associations.

EBSQ: Self-Representing Artists: www.ebsqart.com

Online art association whose members represent their own work to the public. Membership is open to artists at all stages of their careers, and all media and styles are welcome.

Greetings etc.: www.greetingcardassociation.org.uk/

Official website of the Greeting Card Association, featuring timely information for everyone doing business in the greeting card, stationery, and party goods markets.

Illustration Friday: http://illustrationfriday.com

Online forum for illustrators that offers a weekly challenge: a new topic is posted every Friday, and then participants have a week to submit an illustration of their own interpretation.

The Medical Illustrators' Home Page: www.medartist.com

A site where medical illustrators can display and market their work.

The Nose: www.the-nose.com

A place for caricature artists to showcase their work.

Theispot.com: www.theispot.com

Widely recognized as "the world's premier illustration site," allowing illustrators from all over the world to showcase and market their work.

UnderConsideration: www.underconsideration.com

A network of blogs (Speak Up, Brand New, Quipsologies, The Design Encyclopedia) dedicated to the progress of the graphic design profession and its practitioners, students, and enthusiasts.

Volunteer Lawyers for the Arts: http://vlany.org

Provides education and other services relating to legal and business issues for artists and arts organizations in every discipline.

WetCanvas: www.wetcanvas.com

Largest online community of visual artists, offering forums, critiques, art lessons and projects, marketing tools, a reference image library, and more—all for FREE!

GLOSSARY

Acceptance (payment on). An artist is paid for his/her work as soon as a buyer decides to use it.

Adobe Illustrator®. Drawing and painting computer software.

Adobe InDesign®. Revised, retooled version of Adobe PageMaker.

Adobe PageMaker®. Page-layout design software. Product relaunched as InDesign.

Adobe Photoshop®. Photo manipulation computer program.

Advance. Amount paid to an artist before beginning work on an assigned project. Often paid to cover preliminary expenses.

Airbrush. Small pencil-shaped pressure gun used to spray ink, paint, or dye to obtain gradated tonal effects.

Anime. Japanese word for animation.

Art director. In commercial markets, the person responsible for choosing and purchasing artwork and supervising the design process.

Artist's statement. A short essay, no more than a paragraph or two, describing an artist's mission and creative process.

Biannual. Occurring twice a year. See also *semiannual*.

Biennial. Occurring once every two years.

Bimonthly. Occurring once every two months.

Biweekly. Occurring once every two weeks.

Book. Another term for a portfolio.

Buyout. The sale of all reproduction rights (and sometimes the original work) by the artist; also subcontracted portions of a job resold at a cost or profit to the end client by the artist.

Calligraphy. The art of fine handwriting.

Camera-ready. Art that is completely prepared for copy camera platemaking.

Capabilities brochure. A brochure, similar to an annual report, outlining for prospective clients the nature of a company's business and the range of products or services it provides.

Caption. See *gagline*.

Caricature. An illustrated representation that distorts, exaggerates, or oversimplifies specific features.

Carriage trade. Wealthy clients or customers of a business.

Cartoon. A comical or satirical drawing.

CD-ROM. Compact disc read-only memory—nonerasable electronic medium used for digitized image and document storage and retrieval on computers.

Collateral. Accompanying or auxiliary pieces, such as brochures, especially used in advertising.

Color separation. Photographic process of separating any multi-color image into its primary component parts (cyan, magenta, yellow, and black) for printing.

Commission. 1) Percentage of retail price taken by a sponsor/salesman on artwork sold. 2) Assignment given to an artist.

Comprehensive. Complete sketch of layout showing how a finished illustration will look when printed; also called a comp.

Consignment. Arrangement by which items are sent by an artist to a sales agent (gallery, shop, sales rep, etc.) for sale with the understanding that the artist will not receive payment until work is sold. A commission is almost always charged for this service.

Copyright. The exclusive legal right to reproduce, publish, and sell the matter and form of a literary or artistic work.

Direct mail package. Sales or promotional material that is distributed by mail. Usually consists of an outer envelope, a cover letter, brochure or flier, SASE, and postpaid reply card, or order form with business reply envelope.

dpi. Dots per inch—the unit of measure used to describe the scanning resolution of an image or the quality of an output device. See also *resolution*.

Dummy. A rough model of a book or multipage piece, created as a preliminary step in determining page layout and length. Also, a rough model of a card with an unusual fold or die cut.

Edition. A set of identical prints published of one piece of art.

Engraving. A print made by cutting into the printing surface with a point. See also *etching*.

Environmental graphic design (EGD). The planning, designing, and specifying of graphic elements in the built and natural environment; signage.

EPS. Encapsulated PostScript—a computer format used for saving or creating graphics.

Estimate. A ballpark figure given to a client by a designer anticipating the final cost of a project.

Etching. A print made by the intaglio process, creating a design in the surface of a metal or other plate with a needle and using a mordant to bite out the design. See also *engraving.*

Exclusive area representation. Requirement that an artist's work appear in only one outlet within a defined geographical area.

Finished art. A completed illustration, mechanical, photo, or combination of the three that is ready to go to the printer. Also called camera-ready art.

Gagline. The words printed with a cartoon (usually directly beneath); also called a caption.

Giclée. Method of creating limited and unlimited edition prints using computer technology in place of traditional methods of reproducing artwork. Original artwork or transparency is digitally scanned, and the stored information is manipulated on screen using computer software (usually Photoshop). Once the image is refined on screen, it is printed on an Iris printer, a specialized ink-jet printer designed for making giclée prints.

GIF. Graphics Interchange Format—a computer format used for saving or creating graphics.

Gouache. Opaque watercolor with definite, appreciable film thickness and an actual paint layer.

Halftone. Reproduction of a continuous tone illustration with the image formed by dots produced by a camera lens screen.

Honorarium. Token payment—small amount of money and/or a credit line and copies of the publication in which an artist's work appears.

Informational graphics. Information, especially numerical data, visually represented with illustration and text; charts/graphs.

Intaglio. A printmaking process in which lines are incised into the suface of a plate or print form such as in engraving or etching.

IRC. International Reply Coupon—purchased at the post office to enclose with artwork sent to a foreign buyer to cover his/her postage cost when replying.

Iris print. Limited and unlimited edition print or giclée output on an Iris or ink-jet printer (named after Iris Graphics of Bedford, MA, a leading supplier of ink-jet printers).

JPEG. Joint Photographic Experts Group—a computer format used for saving or creating graphics.

Keyline. An outline drawing on completed art for the purpose of indicating its shape, position, and size.

Kill fee. Portion of an agreed-upon payment an artist receives for a job that was assigned, started, but then canceled.

Layout. Arrangement of photographs, illustrations, text, and headlines for printed material.

Licensing. The process whereby an artist who owns the rights to his or her artwork permits (through a written contract) another party to use the artwork for a specific purpose for a specified time in return for a fee and/or royalty.

Linocut. A relief print made from linoleum fastened to a wooden block. See also *relief*.

Lithograph. A print made by drawing on fine-grained porous limestone or on a zinc plate with greasy material, then wetting the stone or plate and applying greasy ink, which will adhere only to the drawn lines. Dampened paper is applied to the stone and is rubbed over with a special press to make the final print.

Logo. Name or design of a company or product used as a trademark on letterhead, direct mail packages, in advertising, etc., to establish visual identity.

Mechanicals. Preparation of work for printing.

Mezzotint. A method of engraving in which the artist works from dark to light. The entire painting surface is first covered with a regular fine scratching made by using a rocking tool called a cradle. This takes the ink and appears as a black background. The design is burnished onto it, does not take the ink, and therefore appears in white.

Multimedia. A generic term used by advertising, public relations, and audiovisual firms to describe productions involving a combination of media such as animation, video, Web graphics or other visual effects. Also, a term used to reflect the varied in-house capabilities of an agency.

Offset. Printing process in which a flat printing plate is treated to be ink-receptive in image areas and ink-repellent in nonimage areas. Ink is transferred from the printing plate to a rubber plate and then to the paper.

On spec. Abbreviation for "on speculation." See also *speculation*.

Overlay. Transparent cover over copy, on which instruction, corrections, or color location directions are given.

Panel. In cartooning, the boxed-in illustration; can be single panel, double panel, or multiple panel.

PDF. Portable Document Format—Adobe® file format for representing documents in a manner that is independent of the original application software, hardware, and operating system used to create those documents.

P-O-P. Point-of-purchase—in-store marketing display that promotes a product.

Print. An impression pulled from an original plate, stone, block screen, or negative; also a positive made from a photographic negative.

Production artist. In the final phases of the design process, the artist responsible for mechanicals and sometimes the overseeing of printing.

Publication (payment on). An artist is not paid for his/her work until it is actually published, as opposed to payment on acceptance.

QuarkXPress. Page layout computer program.

Query. Letter to an art director or buyer eliciting interest in a work an artist wants to illustrate or sell.

Quote. Set fee proposed to a client prior to commencing work on a project.

Relief. A composition or design made so that all or part projects from a flat surface.

Rendering. A drawn representation of a building, interior, etc. in perspective.

Resolution. The pixel density of an image, or the number of dots per inch a device is capable of recognizing or reproducing.

Retail. The sale of goods in small quantities directly to the consumer.

Roughs. Preliminary sketches or drawings.

Royalty. An agreed percentage paid by a publisher to an artist for each copy of a work sold.

SASE. Self-addressed, stamped envelope.

Self-publishing. In this arrangement, an artist coordinates and pays for printing, distribution, and marketing of her own artwork and in turn keeps all ensuing profits.

Semiannual. Occurring twice a year. See also *biannual.*

Semimonthly. Occurring twice a month.

Semiweekly. Occurring twice a week.

Serigraph. Silkscreen; method of printing in which a stencil is adhered to a fine mesh cloth stretched over a wooden frame. Paint is forced through the area not blocked by the stencil.

Simultaneous submission. Sending the same artwork to more than one potential buyer at the same time.

Speculation. Creating artwork with no assurance that a potential buyer will purchase it or reimburse expenses in any way; referred to as work "on spec."

Spot illustration. Small illustration used to decorate a page of type or to serve as a column ending.

Storyboard. Series of panels that illustrate a progressive sequence or graphics and story copy of a TV commercial, film, or filmstrip. Serves as a guide for the eventual finished product.

Tabloid. Publication whose format is an ordinary newspaper page turned sideways.

Tearsheet. Page containing an artist's published illustration, cartoon, design, or photograph.

Thumbnail. A rough layout in miniature.

TIFF. Tagged Image File Format—a computer format used for saving or creating graphics.

Transparency. A photographic positive film such as a color slide.

Type spec. Type specification; determination of the size and style of type to be used in a layout.

Unsolicited submission. Sample(s) of artwork sent to a buyer without being requested.

Velox. Photoprint of a continuous tone subject that has been transformed into line art by means of a halftone screen.

Wash. Thin application of transparent color or watercolor black for a pastel or gray tonal effect.

Wholesale. The sale of commodities in large quantities usually for resale (as by a retail merchant).

Woodcut. A print made by cutting a design in side-grain of a block of wood, also called a woodblock print. The ink is transferred from the raised surfaces to paper.

GEOGRAPHIC INDEX

CO

OH

INTERNATIONAL INDEX

NICHE MARKETING INDEX

Medical Illustration

Mugs

Multicultual

Multimedia

Religious/Spiritual

GENERAL INDEX

Ideas. Instruction. Inspiration.

Receive FREE downloadable bonus materials when you sign up for our free newsletter at artistsnetwork.com/Newsletter_Thanks.

These and other fine North Light products are available at your favorite art & craft retailer, bookstore, or online supplier. Visit our websites at artistsnetwork.com and artistsnetwork.tv.